DOUBLE VISION

DOUBLE VISION

THE UNERRING EYE OF ART WORLD AVATARS
DOMINIQUE AND JOHN DE MENIL

WILLIAM MIDDLETON

ALFRED A. KNOPF New York 2018

THIS IS A BORZOI BOOK
PUBLISHED BY ALFRED A. KNOPF

All rights reserved. Published in the United States by Alfred A. Knopf,
a division of Penguin Random House LLC, New York, and distributed in Canada
by Random House of Canada, a division of Penguin Random House Canada
Limited, Toronto.

www.aaknopf.com

Knopf, Borzoi Books, and the colophon are registered trademarks
of Penguin Random House LLC.

Library of Congress Cataloging-in-Publication Data
Names: Middleton, William, 1961–
Title: Double vision : the unerring eye of art world avatars Dominique and
 John de Menil / by William Middleton.
Description: New York : Alfred A. Knopf, 2018. | Includes bibliographical
 references and index.
Identifiers: LCCN 2017027976 | ISBN 9780375415432 (hardcover) |
 ISBN 9781524732943 (ebook)
Subjects: LCSH: Menil, John de. | Menil, Dominique de. | Art—Collectors and
 collecting—United States—Biography.
Classification: LCC N5220.M555 M53 2018 | DDC 707.5—dc23 LC record available at
 https://lccn.loc.gov/2017027976

Jacket design by Chip Kidd
Front-of-jacket photograph by Budd, courtesy of the Menil Archives, The Menil
Collection, Houston. Spine-of-jacket photograph by Hickey-Robertson, courtesy of
the Rothko Chapel; *Broken Obelisk* by Barnett Newman © 2018 The Barnett
Newman Foundation, New York / Artists Rights Society (ARS), New York. Back-
of-jacket photograph by Paul Hester, courtesy of the Menil Archives, The Menil
Collection, Houston

Manufactured in the United States of America

First Edition

I feel like I am with friends, trading fond recollections, and, as one often does, I am telling you how we got drunk. Because that's what it is. Art is intoxicating. It is not a rarefied nicety—it's hard liquor.

And then there is a remorse of some sort. How can one drink and enjoy it when there is the war in Vietnam, when people are hungry in the world, when there is the ugly reaction to the moderate move of the school board? When there are people around us, police and others, who treat the blacks as I wouldn't treat a stray dog? And this at a time when the blacks have revealed their greatness by producing some of the best writers and poets in the country.

Well, man does not live by bread alone and there is redeeming value in art. Look at great artists. They can be difficult, dissolute, but they are never base and in their quest for perfection they come closer to eternal truths than pious goody-goodies.

So we are collectors without remorse.

—*JOHN DE MENIL (1904–1973)*[1]

•

I regret very much that the word "controversial" is so disparaging. To be controversial means to have original ideas that not everybody has. What's accepted is never what is the most important or the most interesting. To be not controversial is to remain at the lowest common denominator.

—*DOMINIQUE DE MENIL (1908–1997)*[2]

CONTENTS

Acknowledgments *ix*

PART ONE THE MUSEUM IMAGINED

1 Fanfare *3*

PART TWO THE OLD WORLD

2 A Family Château *33*
3 A Protestant Dynasty *48*
4 Return to France *58*
5 Foreign Affairs *78*
6 Honor and Sacrifice *89*
7 *Monsieur le Baron* *110*
8 At First Sight *127*
9 *Une Jeunesse* *135*
10 Horizons Broadened *148*
11 A Shared Life *162*
12 Engaged *185*

PART THREE WAR

13 *Drôle de Guerre* *205*
14 The Debacle *215*
15 Landings *249*
16 Postwar *289*

PART FOUR NEW FRONTIERS

17 Home *327*
18 Nail Hit This Time *367*

19	The Sky Is the Limit	396
20	A Big Splash	422
21	Worth the Candle	457
22	Nothing and Everything	475
23	Faith Can Be Alive	493

PART FIVE A VERY STRONG WOMAN

24	Aftermath	519
25	What Now?	527
26	Other Voices, Other Lands	537
27	Toward a New Museum	545
28	Global Visions	554
29	A Museum with Walls	574
30	From Civil Rights to Human Rights	588
31	Byzantium	601
32	A New Generation	618
33	*Un Acte Final*	634

Notes	659
Bibliography	719
Illustration Credits	727
Index	731

ACKNOWLEDGMENTS

This book is enormously indebted to many people and institutions. First and foremost, I want to thank the five children of Dominique and John de Menil and their husbands and wives—Christophe, Adelaide and Edmund Carpenter, Lois and Georges, Susan and François, and Fariha Friedrich—for the many interviews, family photographs, and access to the de Menil Family Archives.

Other family members who generously gave me their time include Odile de Rouville, Anne Schlumberger, São Schlumberger, Henriette de Vitry, Pauline Lartigue, Claire Delpech, Bénédicte Pesle, Michaël Grunelius, Jean-Marie Grunelius, and two de Menil grandchildren, Jason de Menil and Aziz Friedrich. Several former sons-in-law were very helpful: Robert Thurman, Francesco Pellizzi, and Heiner Friedrich. And I must also thank the following artists for so generously speaking to me: Jasper Johns, Philip Glass, Robert Wilson, David Novros, and Marc Riboud, as well as the many art world colleagues of the de Menils including Walter Hopps, Leo Steinberg, Werner Spies, Alfred Pacquement, Jean-Yves Mock, Remo Guidieri, Richard Koshalek, Carol Mancusi-Ungaro, Helen Winkler, Paul Winkler, Bertrand Davezac, Fredericka Hunter, Elisabeth Glassman, Neil Printz, David Anfam, Ashton Hawkins, Paula Cooper, Peter Marzio, Gary Tinterow, Alison de Lima Greene, John Richardson, Sarah Whitfield, Christopher Rothko, and Kate Rothko Prizel.

Other friends or colleagues of the de Menils to whom I owe a debt include President Jimmy Carter, Renzo Piano, Claude Pompidou, Jack Lang, Merete Angelica Baird and Euan Baird, Earl Allen, Gail and Louis Adler, Surpik Angelini, Eugene Aubry, Bud Aubry, Marguerite Barnes, Susan Barnes, Dominique Browning, Ladislas Bugner, Ginny and Bill Camfield, Sarah Cannon, Arvin Conrad, Sylvia de Cuevas, Bessie de Cuevas, Kathy Davidson, Nabila Drooby, Anne Duncan, Christian Dupavillon, Don Easum, Ralph Ellis, Sissy Farenthold, Anthony Fredericks, Nora Fuentes, Laura Furman, Roland Génin, Danielle Giraudy, Miles Glaser, André Gouzes, James Harithas, Glenn Heim, Fred Heinz, Jackson Hicks, Ann Holmes, Yves-André Istel, William Jordan, Mimi Kilgore, Karl Kilian, William Lawson, Homer Layne, Jim Love, Edward Mayo, Robin McCorquodale, Wil McCorquodale, Shelby Miller, Gerald O'Grady, George Oser,

Chris Powell, Jean Rougier, Gladys Simmons, Eve Sonneman, Eduardo Souchon, Richard Stout, Simone Swan, Cynthia Taylor, Wendy Watriss and Fred Baldwin, Stephen Whittaker, Walter Widrig, and Geoff Winningham.

I am particularly grateful to have been able to interview two people who worked closely with the de Menils: Solange Picq, who was John de Menil's Paris assistant at Schlumberger Limited in the 1950s and then worked with Dominique in Paris for the rest of her life, and Elsian Cozens, the Houston assistant for John who, after his death, was the lifelong assistant of Dominique.

I also cannot stress enough how indebted I am to those who enabled me to keep working on the book over the years: The Houston Artists Fund allowed contributions from foundations and individuals in Houston and New York. A key element of the fund-raising was the formation of a group of supporters led by Lynn Wyatt, Sara Paschall Dodd, Ann and Mathew Wolf, and Marion and Ben Wilcox, each of whom also became major donors, taking a great leap of faith with this project and empowering us to approach others. Their combined efforts led to a trio of lead funders for the de Menil biography: the Brown Foundation, Inc., Houston Endowment, and Louisa Stude Sarofim. It is no exaggeration to say that the book would not exist without the hugely generous support of these three entities.

Other major patrons included the Anchorage Foundation of Texas, the Margaret and James A. Elkins Jr. Foundation, Amber Capital, Nina and Michael Zilkha, Leslie and Brad Bucher, the Asen Foundation, Charles Butt, Franci and Jim Crane, Wendy and Mavis Kelsey, Jeanne and Mickey Klein, Alexandra and Brady Knight, Becca and John Thrash, and Mark Wawro. Leading patrons who also granted interviews were Suzanne Deal Booth, Susan O'Connor, Jane Blaffer Owen, Mary and Roy Cullen, Sissy and Denny Kempner, Marilyn Oshman, and Herbert Wells. There were dozens of individual donors including Carol Ballard, the Charles Englehard Foundation, Toni and Jeffery Beauchamp, Susie and Sanford Criner, Les Engelhard, Glen Gonzalez and Steve Summers, Meg Goodman, Cornelia and Meredith Long, Mr. and Mrs. S. I. Morris, Dr. Maconda B. O'Connor, Anita and Mike Stude, Bettie Cartwright, Leslie Elkins, Ed Filipowski and Mark Lee, Ann and Tom Kelsey, Muffy and Mike McLanahan, Fan and Peter Morris, William Stern, Stuart West Stedman, and Wallace Wilson.

The Houston Artists Fund is the brainchild of Jody Blazek, chairman of the group, whose accounting firm, Blazek & Vetterling LLP, was responsible for receiving and distributing the funds and verifying the progress of the de Menil project. Jody and her team contributed untold hours of work on the making of this book. The other board members of the Houston Artists Fund, artist Jack Massing and sculptor Joe Havel, were equally

committed, as was Harriet Latimer, an independent development officer in Houston. I cannot thank them enough.

Because of the fund-raising, I was able to hire research assistants. In Paris, Anaïs Beccaria, as she completed her master's thesis in art history at the Sorbonne, conducted detailed historical research in museums and libraries. In Houston, Frédérique de Montblanc helped decipher French handwriting in the de Menil Family Archives and transcribed French interviews, as did Marie-Pascale Ware, eventually transcribing hundreds of pages of correspondence. Mary Jane Victor, who worked for the de Menils as a collections curator since the 1970s, was a valued partner in the research of this book, particularly for all questions about objects in the collection. Kevin Cassidy, who knew the de Menils since the 1960s and has long lived in one of the gray bungalows that surround the museum, did a heroic job transcribing some two thousand pages of interviews.

Any serious study of history requires the assistance of librarians and archivists. In Paris, I spent long days in the Archives nationales, the Bibliothèque nationale de France, the Fonds Conrad Schlumberger at the École des Mines de Paris and the Centre d'archives d'architecture du XXe siècle, where Alexandre Ragois, the *chargé de recherches,* provided documents and photographs from the archives of Pierre Barbe. Aude Raimbault at the Foundation Henri Cartier-Bresson shared correspondence between the photographer and the de Menils. In New York, I gained vital information at the New York Public Library; the Museum of Modern Art Archives, guided by Michelle Harvey, the Rona Roob museum archivist; the Metropolitan Museum of Art Archives, where James Moske, the managing archivist, uncovered key de Menil correspondence, and the Metropolitan Museum curator Jan Reeder, who provided important information on Charles James; and the Meyer Schapiro Collection at Columbia University, aided by Tara C. Craig, reference services supervisor for the Rare Book & Manuscript Library at Butler Library. At the Archives of the Brooklyn Museum, Alan Felsenthal worked with archivist Angie Park to assess the de Menils' long relationship with the museum. In Los Angeles, Eliza Osborne and Jayme Wilson provided access to crucial correspondence and documents relating to the Centre Pompidou Foundation.

In Texas, I was helped by Samantha Bruer, the architectural archivist of the Houston Metropolitan Research Center. In the Texas Room of the Houston Public Library, the great reading room of the beautifully restored 1926 Julia Ideson Building, I was able to peruse historical photographs, maps and newspapers of the city of Houston essential for understanding the place the de Menils chose to call home. At Rice University, the elegant work environment of the Fondren Library was a godsend for its extensive

holdings of French language books, and volumes of art history and Texas history. An important archival source at Rice, at the Woodson Research Center, was the Marguerite Johnston Barnes Research Materials for *Houston: The Unknown City, 1836–1946*. Rice University historian Melissa Kean was indispensable for her knowledge about the de Menils' relationship with Rice. At the Museum of Fine Arts, Houston, archivist Lorraine Stuart and her successor, Melissa Gonzales, provided important documents, interview transcripts, and key archival photography for publication.

The most important source of information has been the Menil Collection. Geraldine Aramanda, who knew the de Menils beginning in the 1960s and worked for many years on *The Image of the Black in Western Art*, managed to turn herself into an archivist and process the mass of documentation gathered by the couple over the decades. Her personal knowledge of the subject and familiarity with the material made a profound difference in the quality of research in both the Menil Archives and the de Menil Family Archives. Her successor, archival associate Lisa Barkley, has carried forward her professionalism. Collections registrar Mary Kadish was instrumental in sharing her knowledge of the fifteen thousand objects in the collection. Early on in the research, Mary provided a dozen reports on works of art owned by the de Menils—organized by date of acquisition, by artist or by dealer—hundreds of pages that became some of the most precious research material of the entire project. Her successor, David Aylsworth, fielded interminable questions about objects in the collection with grace. Many members of the museum staff shared their areas of expertise including non-Western curators Kristina Van Dyke and Paul Davis, curators Michelle White, Allegra Pesenti, Toby Kamps, and Susan Sutton, chief conservators Liz Lunning and Brad Epley, head librarian Eric Wolf, director of publishing Joseph Newland, and exhibitions designer Brooke Stroud. Imaging services specialist Margaret McKee provided hundreds of photographs for publication, a massive task in addition to her daily duties at the museum. And director Rebecca Rabinow, who joined the Menil in 2016 after a twenty-five-year career at the Metropolitan Museum, has been enthusiastic about the project and shown herself to be serious about the history of the institution she leads.

This project has been given great support and encouragement over the years by many members of the French diplomatic corps including Bénédicte de Montlaur, the cultural counselor for the French embassy in Washington, D.C.; Anne-Sophie Hermil and Gabriel Fabrice, cultural attachés for the French consulate in New York; successive consuls général in Houston— Hélène and Denis Simonneau, Pierre Grandjouan and his art historian

wife, Kate, and Sujiro Seam—along with successive cultural attachés in Houston: Joël Savary, Dominique Chastres, and Sylvie Christophe.

The following have contributed more than they may ever know: Nick Flynn, George Hodgman, Jerry Stafford, Mark Stafford, Tilda Swinton, Sandro Kopp, Paul Johnson, Nick Wooster, Amanda Harlech, Natasha Fraser-Cavassoni, Kate Betts, Jean-Charles de Ravenel, Michèle Montagne, Martine Sitbon, Marc Ascoli, Jack Pierson, Mike Quinn, Liz Ghitta Segall, Brian Daly, Federica Matta, Brad Gooch, Billy Norwich, John Fairchild, Patrick McCarthy, Mike Carragher, Conner Habib, Carter and Mac Wilcox, Angela and Ben Wilcox, Gail Rubin, Stuart Rosenberg, Jessica Phifer, Ian Glennie, Bill Arning, Mark Flood, Farès el-Dahdah, Hiram Butler, Josh Pazda, Don Kelly, Bette Daily, Colin Beavan, Bob Roche, Ronnie Self, Bernard Bonnet, John Blackmon, John Roberson, Amy Purvis, Karen Sumner, Sam Lassiter, Cristina Girard, Carol Barden, Carrie and Sverre Brandsberg-Dahl, Sarah Raper Larenaudie, Alicia Drake, Stephen Wallis, Margaret Russell, Stefano Tonchi, Armand Limnander, Holly Moore, Catherine Anspon, Paul Hester, and Guillaume de Laubier. My parents, Virginia and Bill Middleton, were incredibly encouraging about this book even when it must have seemed like a mission that was quixotic. Although they did not live to see publication, their support was essential.

I want to thank my agent at ICM, Binky Urban, who was the first to suggest the editor and publisher, while Amy Williams negotiated the contract and selflessly encouraged the project for years. Binky helped push the book across the finish line and was a perceptive reader of the manuscript.

It is rare with a project of this length to have one key figure who has overseen publication from beginning to end. My editor at Alfred A. Knopf, Shelley Wanger, showed the patience of a saint while firmly shepherding the manuscript and helping to give it shape. Her keen intelligence and wry sense of humor have made the process a pleasure. Her assistants, Ken Schneider and Brenna McDuffie, were as patient and professional as the entire team at Knopf: Bette Alexander, Bill Adams, Nicholas Latimer, and Katie Schoder; particular thanks to the brilliant copyediting of Ingrid Sterner; and for the book's amazing interior design thanks go to Maria Carella and to Chip Kidd for its perfect jacket.

Biographies, by their very nature, are fragmentary, particularly with two lives that were as expansive as those of Dominique and John de Menil. Any errors of interpretation, omission, or emphasis, it should go without saying, are entirely the responsibility of the author.

The Menil Collection, 1987, designed by Renzo Piano.

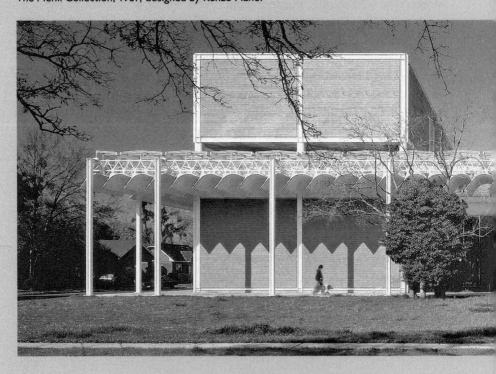

PART ONE

THE MUSEUM
IMAGINED

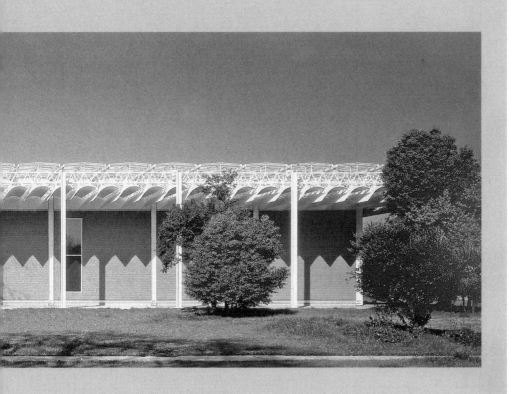

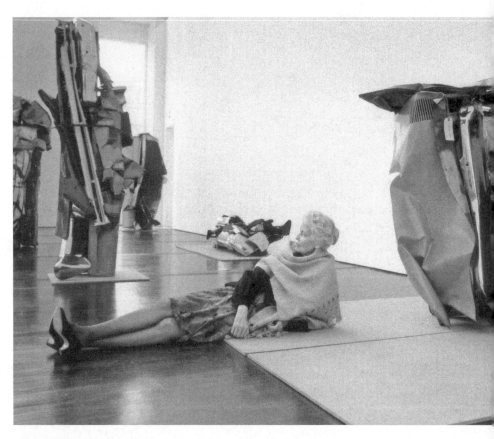

Dominique de Menil taking a break from the installation of John Chamberlain sculptures for the opening of the Menil Collection in 1987.

ONE

FANFARE

Art doesn't call for marble floors nor pedestals. It is part of our
life, our emotions and our delights. It can be deeply moving
but never stuffy.
—*JOHN DE MENIL*[1]

The sweltering summer afternoon of June 4, 1987, was the official opening of the Menil Collection, and seventy-nine-year-old Dominique de Menil stood in front of her new museum. Her adopted hometown of Houston, Texas, had seen oil prices plummet in the mid-1980s as the rest of the country recovered from recession. With 70 percent of the city's wealth tied to the oil industry, Houston construction stagnated, unemployment soared, banks failed.[2] At elegant La Colombe d'Or, a few blocks from the museum, the price of a three-course lunch had been slashed to the going rate for a barrel of crude, which had gone as low as $9.06.[3] The inauguration of the Menil Collection at this particular moment only further underscored the staggering artistic, civic, and philanthropic contributions that Dominique and her husband, John de Menil, had been making to the city for nearly half a century. Designed by Renzo Piano and Richard Fitzgerald & Associates, the building was a bold, graceful two-story structure of white steel, clear glass, and gray cypress siding with an interior of pristine white walls, glistening black wood floors, and floor-to-ceiling windows opening onto lush tropical gardens. Inside were more than 10,000 works of art, one of the largest and most important private collections of art assembled in the twentieth century: Paleolithic bone carvings, Cycladic idols, Byzantine relics, African totems, and Oceanic effigies as well as modernist masterpieces from Cézanne, Picasso, Braque, Magritte, Ernst, Calder, Rothko, Rauschenberg, Warhol, and Johns.

The day before, thundershowers had swept through town, flooding streams, sweeping cars off roads, and throwing funnel clouds out over Galveston Bay.[4] But the two thousand invited guests were not deterred by a touch of weather. At 5:00 p.m., just in time for the local news, all eyes were fixed on the new museum.[5] "The event is grabbing the attention of the art world and getting word out that Houston has more to offer than cowboy

hats and pickup trucks," announced one local reporter. "*The New York Times* says the collection could make Houston a center for the visual arts," suggested a newsman. "That's a switch—just a few years ago, that newspaper said that Houston had a few nice buildings but they were surrounded by 2,000 gas stations."

As Dominique de Menil stepped to the lectern at the entrance of her new museum, surrounded by the blocks of modest bungalows that she and her husband had bought over the years, all painted the same shade of soft gray, she was determined to focus on what really mattered.[6] "Artists are economically useless and yet they are indispensable," she said with conviction. "A political regime where artists are persecuted is stifling, unbearable . . . We need painters, poets, musicians, filmmakers, philosophers, dancers, and saints." And at a moment when she might have been expected to make a case for patronage, she went the other way. It was a small but significant sleight of hand. "The gifted artists are the great benefactors of the world," Dominique announced. "Life flows from their souls, from their heart, from their fingers. They invite us to celebrate life and to meditate on the mystery of the world, on the mystery of God. Artists constantly open new horizons and challenge our way of looking at things. They bring us back to the essential."[7]

Instead of being a monument to the collectors, the Menil Collection was intended to be a celebration of the artists. The building did not house a café, because that would be seen as disruptive. The bookstore, a profit center for most museums, had been banished to a bungalow across the street. "No boutiques and no blockbusters," Dominique said of her ethic.[8] The walls surrounding the art were free from any explanatory text or curatorial remarks, except for the name of the artist, the work, the year, and the medium. There would be nothing here to interfere with the emotion that the art could inspire in the viewer. The names of major donors, often given great prominence on the walls inside other museums, were to be placed outdoors, on a bronze plaque, under a Michael Heizer stone sculpture. Even the name of the museum was spelled out in white letters that were affixed to the *outside* of the glass.[9] The interior was reserved only for the purpose of art.

It might have seemed a surprisingly strong message for the woman who stood at the lectern, an elegant widow who was almost eighty. Dominique looked not unlike many women of a certain age who could be found on the streets of her native Paris, if rather more distinguished and slightly more modern. She wore a chic pale yellow waffle-weave dress that fell just below the knee, designed by her daughter Christophe, with a black sash, dark stockings, and sensible shoes with low heels. Her long silver hair was pulled up into a chignon.

Dominique could certainly be severe, even imperious. "She was very warm but very determined, as the ladies in this family tend to be," said Henriette de Vitry, the daughter of her older sister, Annette, and a noted Paris psychoanalyst.[10] Dominique was interested in the opinions of others but only up to a point. Walter Hopps, the founding director of the Menil Collection who was there that day as she spoke, learned the limits of her patience. As he explained, "If I came up with an idea that she found challenging or she didn't understand, she would say, 'I don't think so, but let me think about it.' That gave me the clue that I could come back to her again. I always had the chance to come back to her twice, but that was it." Hopps realized that after the third try he had better drop it.[11]

And Dominique abhorred small talk. Ralph Ellis, whom she had hired to oversee the thirty acres of real estate that she and John had acquired in the neighborhood around the museum, would often greet her with "Good morning." Dominique always replied cordially. But if he asked, "How are you?" she just looked at him.[12] Susan de Menil, the wife of Dominique's son François, once phoned her mother-in-law from New York and, as one does, asked how she was. Silence. "Don't ask me how I am when you call," Dominique replied. "It was so shocking to me," Susan de Menil remembered. "Do you ever even think about that? But she was angry. And she made it very clear that going forward it was to be, 'Hello, Dominique,' then we would begin the conversation."[13]

A decade after the opening of the Menil Collection, in April 1997, the final year of her life, there was a dinner in Dominique's honor at the museum. One of the two hundred guests was the theater director Robert Wilson. When Dominique, not feeling well, left before the end of the evening, he walked with her to the museum entrance. "I gave her a hug, which was not something easy to do," Wilson remembered. "And I said, 'Good night, have sweet dreams.' She looked me in the eye and said, 'I do not want to have sweet dreams.'"[14]

•

At the time of the museum opening, Dominique de Menil had been working in the world of art for more than two decades, beginning with the taking over, in the mid-1960s, of the art history department of the University of St. Thomas, a nearby school run by the Basilian order. At this tiny institution, with its de Menil–funded campus buildings designed by Philip Johnson, she curated and installed a series of nationally and internationally significant exhibitions of art. One of her students at St. Thomas, Fredericka Hunter, described Dominique in those years:

Her presence was charismatic. Her personality was unconventional as far as intellectual drive and curiosity. Extremely articulate, extremely curious, loved mystery, was very involved with the idea of the soul and God and art as an expression of the ineffable. She was also authoritarian and demanding and quixotic and could change quickly. I got chewed out by her more than once, and it was quite something. She was tenacious and acquisitive, and admitted to it.

Everything was really no-nonsense; it was to the point. It wasn't frivolous; everything was sort of a matter of life and death. Didn't like idiots—she didn't suffer fools well. She was pretty hard on women; she adored men. She could be coquettish—very sensual, very sexy. Women came in for a harder time. But she would be respectful if you were intelligent and forthright. She accorded each of us, if you could stand up to it, your own respect. I never felt condescended to; you either went along and kept up or you didn't.[15]

Many present for the dedication of the museum were aware of the contradictions of Dominique's character. "She was turned toward others in a way that was quite moving, but she was also extremely determined, with a personality that you could not make deviate from her intentions," said Alfred Pacquement, director of the Pompidou Center, who was in from Paris. "There was a mix of generosity and determination to the point of almost ignoring advice other people might have. It was a mix that was quite striking, and it was all lit up by what was, without a doubt, an enormous intelligence."[16]

A leading curator from the Pompidou Center, Jean-Yves Mock, had known Dominique since the 1950s. "Madame de Menil was never arbitrary; her decisions were always built on principles," Mock explained. "She did not have a cold way of thinking, nor a brutal, knee-jerk kind of reaction." Mock was effusive about Dominique's flair for the installation of art exhibitions. As he said, "I have known three people who really knew how to mount exhibitions, meaning conceive and hang them: Erica Brausen, Alexandre Iolas, and Dominique de Menil."[17]

Her engagement with art, at least in part, was an intellectual exercise. Primarily self-taught, she was a perfectionist who was fascinated by the act of learning. Her interiors, whether in Houston, New York, or Paris, were always packed with books: art tomes in English, French, or German as well as major works of history, archaeology, theology, poetry, and fiction. Volumes that she and John acquired early in their marriage and always remained in their library in Houston included Yves Congar's *Divided Chris-*

tendom: A Catholic Study of the Problem of Reunion (1937), a treatise on Catholic ecumenism that had been an essential text for the de Menils; Le Corbusier's *Vers une architecture* (1923); André Breton's *Le surréalisme et la peinture* (1928); and *De Van Eyck à Bruegel le Vieux au Musée de l'Orangerie* (1935), the catalog for the first important art exhibition they had seen together in Paris. When she traveled, Dominique often took with her an exquisite edition of the complete works of Charles Baudelaire (*Oeuvres complètes*, 1954), with notable poems and prose that she had meticulously marked with a single line in pencil on the outside margins.

•

How this complex, sophisticated Parisian came to live in South Texas had to do with her father, Conrad Schlumberger. When Dominique was still a young girl, he had an idea that electricity could be used to chart what lay below the ground, and Schlumberger Limited, the company that he formed along with his brother Marcel, soon became the largest oil services firm in the world. In those years, it was estimated that Schlumberger logged 70 percent of the world's wells.[18] On the day the museum opened, the company had fifty thousand employees and, although the numbers were down due to the oil slump, annual revenues of $4.7 billion.[19]

Dominique and her husband, John, had moved to Houston during World War II because it was the U.S. headquarters for Schlumberger. John, a key figure in the development of the firm, was the first to oversee issues relating to finance, management, personnel, and marketing, putting the systems in place that allowed Schlumberger to become a huge multinational. He even coined the company slogan: "Wherever the drill goes, Schlumberger goes." By the time he retired in 1969, at the age of sixty-five, he was chairman of the board.[20]

In attendance at the opening of the museum were dozens of members of her family, including Dominique and John's five children in from New York: Christophe, Adelaide, Georges, François, and Philippa, who, in 1981, had converted to Sufism and changed her name to Fariha. The year before the museum opening, the significance of Dominique and her children as collectors and patrons was made clear when they were the subjects of a cover story in *The New York Times Magazine* titled "The de Menil Family: The Medici of Modern Art."[21]

Also over from Paris were Dominique's two sisters, Anne Gruner Schlumberger, or Annette, and Sylvie Boissonnas. The extended, international family was impressive in its own right. In those days, of the twenty wealthiest people in France, nine were from the Schlumberger family. And

all nine were from Dominique's branch: sisters, cousins, nieces, and nephews.[22] The generation that followed hers, the grandchildren of Conrad and Marcel, were said to be worth a total of $3.7 billion.[23]

Inspired by the example of Dominique, many in the family had supported the arts. Her older sister, Annette, was a discerning collector and patron who gave a host of works to the Pompidou Center and, at her estate in the south of France, Les Treilles, had important antiquities, nineteenth- and twentieth-century paintings, and major sculptures by Giacometti, Dubuffet, Ernst, Laurens, and Takis.[24] Dominique's younger sister, Sylvie Boissonnas, donated essential works to the Pompidou Center by Mondrian, Giacometti, Dubuffet, Miró, Braque, and Picasso. Sylvie and her husband, Eric Boissonnas, hired Philip Johnson to build a house in New Canaan, six years after he had finished the de Menils' in Houston.[25] Once Sylvie and Eric returned to Europe in the 1960s, they had Johnson create an even more spectacular villa on Cap Bénat, a protected enclave of more than six thousand acres on the southern coast of France between Hyères and St.-Tropez.[26] And it was Sylvie and Eric who commissioned Bauhaus architect Marcel Breuer to design Flaine, a bold, brutalist ski complex in the Alps. Flaine also included an ambitious center for the arts, a concert hall, and monumental outdoor sculptures by Dubuffet and Picasso.[27]

The de Menils, though they were moving toward opening their own museum for some time, were spectacularly generous to other institutions, from the Pompidou Center and the Museum of Modern Art in New York to the Museum of Fine Arts, Houston. "John and Dominique gave extraordinary things to the Museum of Fine Arts, including the only work they had by Jackson Pollock [until the 1990s]," noted Walter Hopps. "When the Centre Pompidou was being formed, Dominique offered a spectacular later Pollock, *The Deep*, that Sam Wagstaff had owned. I mean, how many people have given away Jackson Pollocks, twice, for heaven's sake?"[28]

An often-overlooked aspect of Dominique de Menil's character was her sense of humor and appreciation for the absurd. Walter Hopps knew that Roberto Matta, the Chilean/Parisian surrealist who had been one of John de Menil's favorite artists, made Dominique a little nervous: his abstract paintings contained strange squiggles and forms that could seem quite sexual. Whenever Hopps suggested doing a major show of Matta, Dominique demurred. "We just can't put up that much Matta," she said to Hopps. When he asked why, she replied, "Don't you see what's going on in those paintings?" As Hopps recalled, "Finally, she sort of blushed and said, 'They're fucking! There's a lot of fucking going on in those paintings!' I said, 'Dominique, the public isn't going to see that.' She stopped and said, 'How can they miss it?'"[29]

In planning the opening of the museum, Dominique was, of course, rigorously involved in every detail. She worked closely with a young Houston caterer, Jackson Hicks, for a black-tie dinner held the night before the dedication. In the course of planning the event, Hicks realized that he needed to produce several options for every decision. For table napkins, he assumed that she would want a simple rectangular fold, but he also produced more extravagant choices, including a pope's hat and a peacock elaborately folded and placed in a glass. Dominique studied all three designs. When she saw the most extravagant, she narrowed her eyes and said, "That looks like a very grand party in a very small town in the South of France—I think not."[30]

Seven years before the dedication of the museum, Dominique sat in a Paris bistro near the Pompidou Center with the young architect she had hired to design the building, Renzo Piano. It was only their second meeting, a few days after the first. She had just been to Piano's office, where she handed him a one-page, handwritten letter of agreement, formalizing their new relationship. As Piano and Dominique began a celebratory lunch, she made him aware of how much this museum meant to her and how demanding she intended to be. She looked at Piano and said, "Welcome to hell!"[31]

•

Generations of asceticism had had a definite effect on Dominique de Menil, who came from one of the most prominent Protestant families in France. When she built the Menil Collection, her famous directive to Piano was that it be "small on the outside but big on the inside." It was an edict that could have come from any French Protestant settlement. Once the museum was completed, the aesthetic was characterized by one observer as "opulence denied." John Richardson met the de Menils in the 1950s, when he was staying in the South of France with the collector Douglas Cooper. "I'd lived near Nîmes, where there was a big French Protestant colony," Richardson said. "I had a lot of Protestant friends there, the HSP, or Haute Société Protestante. So I knew why Dominique was the way she was." Asked if he felt there was a connection between her Protestant background and her sense of restraint, Richardson replied, "Oh, Lord yes!"[32]

Dominique acknowledged that her family's puritanism had made it difficult for her to buy something as rarefied as art. "My father came from an Alsatian Protestant family and Alsatian Protestants thought that indulging in the good things of life was definitely dissolute," she explained. "For instance, giving parties was dissolute. Wealthy Alsatians never gave more than one party a year, at New Year, and they never invited anybody but

strictly family. I was brought up with this notion that money is never to be spent on things that are not really necessary for life. So I couldn't even entertain the idea of collecting—it was a complete block."[33]

Others helped to break that block, Dominique said, and none more than John de Menil. A nineteenth-century writer had once asserted of the Alsatian industrialists like the Schlumbergers, "These millionaires are without any sense of aristocratic flair."[34] Baron de Menil dropped his title when he moved to America; it seemed too pretentious in the New World. But it would have been impossible for him to let go of one characteristic he had throughout his life: a confident sense of flair.

Roberto Matta, who knew the couple in the 1950s, suggested that Dominique's approach to art could be tentative, as though in atonement. "I have the impression that Dominique was the real compass but that John was pretty amused by Dominique's expiation, this expiation of her sins," Matta explained. "I feel that each time she buys something it is with fear. Everyone becomes attached to their own identity, so I think Dominique has a sense of danger—the dangerousness of changing her life, changing what she's all about." The artist sensed that John had a much different approach. "He was more ironic and sardonic . . ."[35]

The day the museum opened, Dominique told many—friends, family, journalists—that John was the one who really had a passion for art.[36] He insisted on the exceptional, she explained, crediting him with some of the

John de Menil in the 1940s, after arriving in the United States.

greatest works in the collection. And she recalled how much he enjoyed the company of artists, particularly the pleasure he took in entertaining them.[37] Though her husband had died fourteen years before, it was no exaggeration to suggest that without the force of his personality there would have been no museum. Because Dominique accomplished so much during the almost twenty-five years that she was a widow, many people forgot that their achievements were shared.

John de Menil has been described as cool, gentle, witty, but with definite opinions. Philip Johnson, for example, received scathing letters from him, criticizing many of his buildings. As Johnson recalled, "*The New York Times* architecture critic was nothing compared to John de Menil!"[38] When Anne Schlumberger went through a divorce, Dominique remained friendly with her ex-husband. Anne was miffed that her great-aunt would continue a friendship with her former husband. Dominique asked why that would be a problem. "It was just very hard being married to him," Anne replied, assuming that would settle the situation. Dominique's response: "Do you think it was easy being married to John?"[39]

•

Throughout much of his life, John de Menil identified with the underdog, and had an impatience with injustice, that compelled him to fight for civil rights. He had helped Mickey Leland, a promising student at American Texas Southern University, turn from an antiwhite radical into an accomplished U.S. congressman. John's unflinching support of progressive school board candidates contributed to their election and the elimination of segregation in Houston schools.[40] And when a group of Texas Southern University students was wrongly accused of inciting a riot, young men who came to be known as the TSU Five, John de Menil footed the bill for their defense. Were there others in town who were doing this sort of thing? "Not rich white men from River Oaks," said Deloyd Parker, a black community activist. "Not at all."[41] But his experience as a clear-eyed, tough executive permeated other areas of his life. He was committed to doing good, but he was pragmatic. "I don't care if a politician is honest," John once told a younger friend, "but I expect him to be effective."[42]

When friends were visiting Texas, John de Menil knew how to create a sense of western adventure. He took the surrealist painter René Magritte out to buy an authentic cowboy hat and then, with Dominique, to the rodeo in Simonton, a small town west of Houston.[43]

He made sure Warhol and his entourage, like many other visiting artists, were offered shopping sprees at Stelzig Saddlery Company, a historic

Dominique with Magritte at the Simonton Rodeo, west of Houston, 1965.

western store downtown filled with Lee Riders, Nocona boots, and leather chaps. Once everyone was properly rigged, they were taken for a prime rib dinner at the Stables, an old-school steak house on Main Street.[44]

"On collecting, they were absolutely a partnership," said Walter Hopps of the relationship between Dominique and John. "They always shared together, no matter what else was going on in their life. And they had their own personal favorites. Dominique always said, 'John loved Picasso more than I did. And I loved Braque more than Picasso.' Braque had a warmth and a humanity, and Picasso had a bold, kind of macho swagger." John often kept one particular Picasso painting, *Violon sur une table* (1920), a strong cubist still life, over his desk at Schlumberger.[45]

The chief curator for the new museum, Bertrand Davezac, who had known the family since the 1950s, agreed. "Picasso has this energetic intensity which is in opposition to the much more contemplative painter of still lifes that Braque represents," Davezac suggested. "The same parallel could be made between Bob Rauschenberg and Jasper Johns. She was more Johns, and he was more Rauschenberg. She responded in much the same way to Barnett Newman and Rothko; the stillness of Newman and the silence of Rothko was something she reacted to very quickly."[46]

Although they almost always made decisions together about works of art, John was bolder. "He really gave her confidence, but he was the mover and doer," according to Christophe de Menil. "He supported her and encouraged her, but most of the major works at the museum were

bought either by myself or John de Menil. Dominique was so afraid to spend money."[47]

John was bolder in many ways, but Dominique was also very formidable, and their relationship was entirely reciprocal. About a year and a half before his death, John wrote her a note about the Rothko Chapel. The conclusion: "Copied in the car, while waiting for the traffic to move, in intense communion with you."[48] And a little more than a year before her death, Dominique gave a work to the Menil Collection in honor of her husband. It was a watercolor by Magritte called *Les fanatiques,* a mysterious picture set in a barren, surrealist landscape. It showed a big, dark bird circling above a bright orange bonfire. The creature appeared to be fearless, flying just above flames that licked at the sky. Dominique inscribed the piece, in the shaky handwriting of an eighty-eight-year-old, "I give this *gouache* by Magritte in memory of John de Menil who dared . . . and did."[49]

•

As Dominique took her place on a dais under the portico of her new $25 million museum,[50] she was joined by Renzo Piano, Walter Hopps, the Menil Collection founding director, and Paul Winkler, assistant director. At the lectern was Kathy Whitmire, the first woman mayor of Houston, who cited the international importance of what was behind those double doors. At the ceremony, during the opening weekend, were some of the leading American contemporary artists: Robert Rauschenberg, John Chamberlain, Ed Kienholz, Brice Marden, Ed Ruscha, Sam Francis, Tony Smith, and Dennis Hopper.

The artist Dorothea Tanning, the widow of Max Ernst, who had first come to Houston at the de Menils' invitation three decades before, made the trip from New York. Also in town was Annalee Newman, the widow of Barnett Newman, and Fred Hughes, a protégé whom the de Menils had introduced to Andy Warhol twenty years before and who had played a critical role in that artist's career.

The international museum world was represented by J. Carter Brown, director of the National Gallery; Pontus Hultén, founding director of the Centre Pompidou; Richard Koshalek, director of MOCA; and Henry Geldzahler, the legendary contemporary curator from the Metropolitan Museum. Among the collectors were Joseph Pulitzer, Leonard Lauder, and Agnes Gund. There were important dealers: Paula Cooper, Mary Boone, and Adrien Maeght, as well as art historians Werner Spies, David Sylvester, and Susan Vogel. The architects present, besides Renzo Piano, were Philip Johnson and I. M. Pei. Many prominent Texans had flown in for the occa-

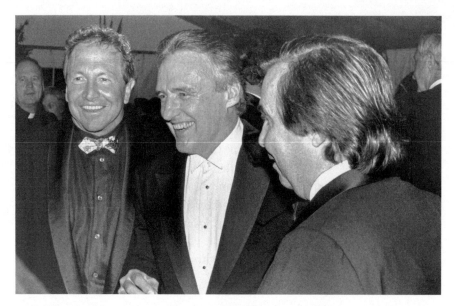

Artist Robert Rauschenberg, actor and photographer Dennis Hopper, and composer Richard Landry at the gala opening for the Menil Collection, June 3, 1987.

sion, such as Sid Bass from Fort Worth and Stanley Marcus from Dallas, while European dignitaries included the French ambassador to the United States, Emmanuel de Margerie, and two first ladies of France: Danielle Mitterrand, wife of President François Mitterrand, and Claude Pompidou, widow of President Georges Pompidou.

Dominique told everyone at the dedication about those who had helped make the museum happen, beginning with patrons Alice and George Brown, whose Brown Foundation had contributed $5 million, and the Cullen Foundation, which had also donated $5 million. "They gave me the courage to go ahead at a critical time when the economic situation made everything difficult," she explained. "It convinced me to commit my own resources to an incredible extent at the very moment when the oil crisis had depleted them dramatically."

She brought out two of her grandchildren, Victoria and Benjamin de Menil, to cut the ribbon. And she introduced two of her great-grandchildren, Caroline and Dash Snow. Young Caroline held her black shoulder bag, while six-year-old Dash carried the scarf Dominique always had on hand for the Houston air-conditioning that tended to be glacial. "The participation of the children symbolizes the part my family has played in the museum," she explained. "My children have been a source of encouragement and strength. I hope that their descendants for many generations to come will be proud of what was accomplished here."

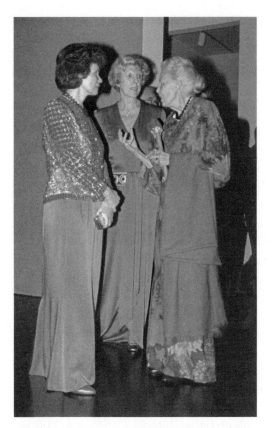

At the Menil opening, Danielle Mitterrand, the first lady of France, Claude Pompidou, the former first lady of France, and Dominique.

The black-tie dinner for seven hundred the night before the dedication of the Menil was being characterized as a dinner in her honor, given by her children. The evening began with a visit to the galleries, the first time an invited crowd had seen the finished museum. Dominique wore a beautiful crimson evening gown designed by her daughter Christophe. From the great hall of the museum, everyone made their way on a covered walkway to the east and into a large, air-conditioned tent that had been built in a park across from the new building. Georges de Menil, as the eldest son, rose to make a toast. "Mother had an innate visual sensitivity, but she was timid; she could not make up her mind," Georges said. "Dad's eye was more passionate. He was always trying for something new. Without his energy, this collection could not have been imagined. I feel that he is very close to us tonight, perhaps just outside the door, looking at the Picasso paintings he loved, certainly wearing a bright red tie."

Georges proposed a series of toasts: to the people of France and to all of those in Texas who had helped make the museum possible, singling out the presence of Governor William Clements and Mayor Kathy Whitmire as well as the great generosity of the Brown and Cullen families. But his lead toast was for Dominique. And though it was playful, it was also a bit poignant. As Georges de Menil said,

First, we want to thank you, Mother. We want to thank you for having us. That may sound to some of you like a superfluous remark, but Mother is indeed very busy; she always has three or four projects going, she can be absentminded, and she could have

forgotten to have us or have overlooked one or two of us along the way. And I, for one, would certainly have hated to miss the events of the last forty years.[51]

•

At the museum opening, as soon as her grandchildren had cut the ribbon, Dominique waved everyone inside. An ensemble of horns played *Fanfare,* a short piece she had commissioned from Pierre Boulez, as guests filed into the building.[52] "The dedication of the museum was unbelievable," recalled Claude Pompidou. "And the little fanfare composed by Pierre Boulez was divine. It made for a real feeling of family."[53]

What everyone discovered that day, even for those who knew the collection, was a revelation. The museum occupied a large city block, measuring almost three acres.[54] The building was an extended rectangle, 140 feet wide and 400 feet long, lined up from east to west. The low-lying structure fit in with the surrounding neighborhood, determined not to be monumental. Ignoring the postmodern excess that had plagued architecture at that time, the design returned to an earlier era. The exterior was made of wide boards of Louisiana cypress that had been painted gray, with tall windows that were shielded by white sunscreens and peripheral columns fashioned from slender white steel.[55] It was a nod to mid-century Case Study Houses from Southern California, light, industrial architecture and pure, Miesian modernism. There was also the sense of the human hand; it felt crafted.

The approach was from the north, coming off one of the neighborhood streets lined with one- and two-story bungalows. Dominique and John had been acquiring land in the area since the 1960s—first for the University of St. Thomas, several blocks to the east of the museum, then for the Rothko Chapel, directly east, and finally for the new museum. All of the original, modest structures on the land they acquired, many with wooden frames and dating from the 1940s, were, in the 1970s, painted the same shade of gray. It was a modernist act that gave a sense of unity to the disparate elements that made up the neighborhood, a visual harmony that the museum was designed to complement. As was the case with the other properties, the grounds of the museum were covered with thick green turf, a blend of Bermuda and Saint Augustine grasses, and dotted with mature trees, primarily live oaks and magnolias. The west side of the building was shaded by rows of perfectly manicured crape myrtles.[56]

The most striking architectural element was the roof. The top of the building was a block-long series of glass skylights, a system the architect referred to as a "light platform."[57] Supporting the skylights was a hori-

zontal layer of high-tech, ductile-iron trusses in white. Suspended below
was a series of poetic, curved forms, called "leaves," also in a gentle white,
that were designed to filter out the intense subtropical light. There were
three hundred of them, each forty feet long and weighing seven thousand
pounds,[58] all lined up to the north to capture the sun.[59] The leaves came
from one of Dominique's most pressing requirements: that the museum
have daylight and that it be of an intimate nature. She wanted the dynamic
illumination of a residential setting, changing from season to season, from
time of day, or when the sun passes behind a cloud.[60]

Years before she hired an architect, Dominique planned to make her
museum something quite different from other institutions. "I want peo-
ple to get a kick out of seeing something new—be enchanted with a space
and an environment," she said. "The museums of today are tiresome and
boring—they overdo things, give the person too much to see. I want a place
where people can sit down and rest . . . relax, enjoy the paintings—like I
do in my home."[61] With a collection that contained more than ten thou-
sand works, Dominique was intent on avoiding what she called "museum
fatigue." Her solution was to display only a few hundred pieces at any one
time; the rest would wait their turn. "Habit blunts vision," she explained.
"People who live in Chartres take the cathedral for granted."[62]

Her philosophy and aesthetic were perfectly evoked in the entry of the
museum. The walkway leading to the front door, bordered by a ground
cover of Asiatic jasmine, was level; steps up would have smacked of trium-
phalism. A wall of windows, twenty feet high and forty feet wide, held a
pair of double glass doors. Inside were soft pine floors that had been stained
jet-black, white walls, twenty-foot ceilings, and daylight that filtered in
through the lyrical white curves (as architectural writer Peter Buchanan
characterized it, "The leaves of the Menil neither overwhelm nor distract
from the art as they float, indeed seem to swim upwards, in the magical
light that floods down between them").[63] To the right of the door, there was
one desk, a perfect black rectangle; in the center of the room, there was a
large heptagonal ottoman, eight feet in diameter, in tufted chocolate suede.

The entry was a dramatic twenty-four-hundred-square-foot space that
held only four works of art.[64] Straight ahead, on the facing wall, twenty-
seven feet wide, hung a monumental painting by Barnett Newman, *Anna's
Light,* a throbbing red canvas with narrow white vertical stripes on each
end. It was, at more than eight and a half feet tall and twenty feet wide,
the largest painting Newman ever did.[65] It was a work awarded the high-
est level of "wattage," a term Newman used to describe the intensity and
magnitude of his colors.[66] On the wall to the right was another Barnett
Newman, *Now II,* a black-and-white vertical work, eleven feet high by just

The opening installation of the museum's twentieth-century galleries, with paintings by Braque, Miró, Matisse, and Picasso.

over four feet wide; it had one wide black stripe in the center surrounded by a pair of stripes in white.[67] The monochromatic piece stood in stark opposition to the vivid red painting. On the opposite side of the room were two wooden Boyo sculptures, from Congo, of standing male figures. The pair, nearly identical, were almost three feet tall and were placed on white pedestals.[68] Ancestral figures, which often greeted visitors to the de Menils' living room, they were used as guardians.

Dominique's intention in the entry was to focus attention immediately on the art, to emphasize one artist who was important to the collection and to suggest scope by mixing in another world, another time.[69] "What we did in the lobby—and tried to continue—was to place on the big wall a large contemporary work and then, in other parts of the foyer, add something that relates to it from an older culture," explained Walter Hopps. "So right away, as soon as you come in, you see the juxtaposition of civilizations, of the past and the present."[70]

Toward the end of the lobby, off to the left and right, was a wide corridor, lit from above, that ran for 320 feet from one end of the building to the other.[71] To the left, the east end, suspended from the ceiling in a window, was a large black Calder mobile. At the west end, hanging on the wall, was a towering, brightly colored sculpture of automotive scrap metal, crushed and painted, by John Chamberlain.

There were two main galleries on either side of the entrance, well-

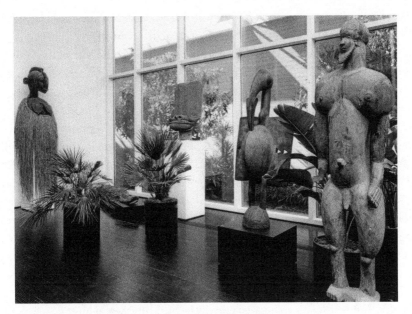

African sculpture in the non-Western galleries of the Menil.

curated excursions through some high points of the history of art. To the left, the first gallery began with antiquities—stylized Cycladic idols in white marble, an ancient Greek terra-cotta model of chariot and horses, a small, dazzling alabaster statue of a Sumerian prince in a tiered skirt, with wide, all-seeing eyes made of lapis lazuli. A few rooms with striking medieval pieces flowed into a single gallery with Byzantine icons and relics. Ancient European works gave way to non-Western art from Africa, Oceania, and the Pacific Northwest—a remarkable fifteenth-century male figure from Nigeria, of the Mboi people, that stood six feet tall, as well as a nineteenth-century Janus-headed dog, a fetish sculpture from the Congo, embedded with hundreds of nails, animal teeth, and shells. Towering relics from Africa and New Guinea were placed in front of windows looking onto interior atriums filled with palms, exotic grasses, and tropical plants.

The second gallery was art of the twentieth century, starting with the most recent works and working backward: a study of a male body by Francis Bacon, Andy Warhol's *Double Mona Lisa*, a pair of monochrome paintings by Yves Klein, one in blue and one in gold leaf, as well as abstract expressionist canvases by Mark Rothko and Barnett Newman. It concluded with the birth of modernism, a painting by Cézanne, *Trees at Le Tholonet*, 1904, and a drawing by van Gogh, *Garden with Weeping Tree, Arles*, 1888. And there were quiet, perfect enchantments: a small gallery, its four walls holding a dozen cubist drawings, collages, and paintings by

Léger, Gris, Braque, and Picasso, with, in the center of the room, a simple wooden bench with a comfortable brown suede cushion.[72]

On the opposite side of the entrance hall was the surrealist gallery. The walls were painted a dark gray, the skylights disappeared to heighten the sense of mystery, and the series of rooms held what was considered the most important collection of surrealism in the world. The de Menils had acquired 103 paintings and sculptures by Max Ernst—photographic collages, frottage forests, mythical birds, bronze sculptures, and such significant oversize paintings as *Le surréalisme et la peinture*—and fifty-four paintings and sculptures by René Magritte covering five decades of the artist's career. The galleries featured *Golconde*, Magritte's famous image of men falling from the sky in suits and bowler hats; an enormous bright green apple that took over an entire room; and the seminal image of a pipe with the words "*Ceci n'est pas une pipe.*" Other evocative examples of surrealism were Picasso portraits, Man Ray photographs, and Cornell boxes as well as paintings by Francis Picabia and Matta.

The final gallery, on the west end of the building, was a huge space, eighty feet by eighty feet, without interior walls, containing sculptures, drawings, and collages by John Chamberlain. The artist's painted, chromium-plated steel sculptures were positioned across the expanse of black floors, illuminated by natural light from above. As Walter Hopps said of the Chamberlain exhibition, "Trying to orchestrate thirty plus pieces of sculpture in there—some on the walls, some standing around on the floor—so that everything wasn't in the way of everything else was a real trick."[73]

The scope of the collection was not intended to be exhaustive. Dominique saw her museum as a series of archipelagoes, a succession of islands loosely tied together. "She never had a desire to be encyclopedic with the museum," explained Hopps. "There are four major areas. First, modern, with a great emphasis on surrealism, also including contemporary, primarily important contemporary American as well as French. Then there is the tribal or non-Western, the Byzantine—because of her great spiritual passion and the lovely art as well—and the antiquities; it's one of the rare places in the country that has antiquity work going back to 20,000 B.C."[74]

Other surprising innovations involved the museum's work environment. Dominique insisted that functions usually hidden from view, including conservation and framing, be given pride of place. The conservation laboratory was a large space with a wall of north-facing windows that opened onto a courtyard and the front portico. Visitors were able to observe the conservators—the scientists of the art world—and their sophisticated machinery and materials as they tended to the museum's holdings. The framing studio contained rows of gilded frames lining the walls from

floor to ceiling. It, too, had a wall of windows that opened onto a portico, this one near the rear entrance, with some privacy afforded by a row of tall bamboo planted just outside.

A second floor of the museum, barely visible from the front, housed a series of spaces, which Dominique called Treasure Rooms, dedicated to the storage of paintings, sculptures, and objects that were not on view in the galleries. There were six Treasure Rooms lining a long corridor that extended the length of the building, each measuring thirty feet by forty feet. They were divided by school: modernism, postwar abstraction, and pop art; surrealism; Byzantine icons; prints and drawings; non-Western; antiquities and medieval. In each of the Treasure Rooms, paintings were hung on the walls from floor to ceiling—salon style—sculptures were clustered throughout, while glass cases contained shelves filled with tiny objects. Curators and researchers used the Treasure Rooms to prepare exhibitions and study the collection. It was not surprising that *Art in America* termed the building "the revenge of the museum professional."[75]

Dominique had managed to create a museum that was as distinctive as its founders. It was filled with their spirit of generosity—first in assembling the collection, then building a home for it, and finally offering it to the public. Of course, she made sure that the admission would always be free. The building was infused with her sense of restrained elegance, her combination of poetry and rigor, humility and grandeur.

And there was an unmistakable sense of the sacred: the way the natural light streamed down from above, the intense care given to the presentation of works of art without historical explanation—almost as though they were relics—as well as the silence around the paintings, sculptures, and objects in order to heighten their presence. In such a vast grouping of periods and cultures there were common threads. Many of the works had a certain aesthetic simplicity or spareness—though they were not necessarily minimal. The entire venture was designed to be on a human scale. "The building is kept simple and clean and manageable," explained Walter Hopps. "It is all on one floor, so once you get into the museum, you can figure out the layout without a hell of a lot of difficulty. It's not vastly beyond their own house. In fact, Piano went out of his way to incorporate a lot of the qualities that are in the house—and as simple as possible."[76]

The Pompidou's Pacquement responded immediately. "It is a museum in opposition to most modern cultural institutions, where there are lots of spectacles and lots of noise," he explained. "She made a more intimate kind of music, much softer and, to my way of thinking, more correct—a place where everything is done to put the spectator in direct contact with a work of art and bring out a sense of emotion."[77]

•

Dominique's choice of architect was an example of the de Menils' openness to promising talent. She first met Renzo Piano, in November 1980 at her apartment in Paris, very reluctantly and only at the insistence of legendary museum director Pontus Hultén. Piano was forty-three years old and had never built a new building on his own, though with Richard Rogers he had designed the Pompidou Center, a structure she disliked. Dominique and her team worked together with Piano for more than a year before presenting plans to the public. Then they continued for another two years before starting construction.[78] When some had doubts about the design—even her children—Dominique decided to build one section of the building at full scale. They put up a full-size section, twenty by forty feet, at a cost of about $100,000.[79] Any doubts were swept away.

The building was under construction for three and a half years. During that time, no detail was too small for Dominique's attention. To decide on the benches that would be outside the building, she and an architect went all over the city testing exterior seating;[80] once construction was finished, she and her team spent almost nine months building out the galleries and installing the art;[81] Dominique, Walter Hopps, and Paul Winkler would each take a section of a gallery, hang art, and then critique one another's work.[82] The entire project was an example of sustained, integrated precision.

It is not surprising that the Menil Collection, from the moment Dominique opened the doors, received constant praise, from John Russell at *The New York Times* ("It's just perfect") to Robert Hughes at *Time* ("It treats the visitor as an adult and lets him draw his own conclusions"). "The objects sing," exclaimed the National Gallery's J. Carter Brown. "I love your dark floors, the way the light comes in, the sense of discreet rooms—instantly one of the great museums in America."[83] Philip Johnson, in discussing the building, first had to confess his "natural and despicable jealousy." Once past that, he wrote, "I always thought you needed more of an architectural statement. You don't."[84] Dorothea Tanning couldn't even wait to get back to New York to tell Dominique how strongly she felt. "Talk about artists," Tanning wrote from her room at Houston's Warwick Hotel. "*You* are the artist *par excellence*."[85]

•

Although Dominique always said that she hated calling attention to herself, she was elated by the attention the museum was getting. At the dedication, her arms were filled with flowers that she had been handed by

her grandchildren and great-grandchildren, bunches of exotic blossoms and branches.

As the guests had their first look at the art and the architecture, she had more plans. Dominique had long believed that guests should be amused every night, that a visitor should never be abandoned, so after the dedication she organized a series of dinners.[86] The 350 guests from across the United States and Europe, probably the most high-voltage group ever assembled in the city, were invited to seven houses around Houston. Assigned to start at one reception, they were given the possibility of shuttling from house to house. Transportation was provided by a fleet of twenty-five black Reagan-era limousines.[87] The evening gave the city a chance to meet its visitors; it also allowed out-of-town guests an opportunity to see this place called Texas.

One of the dinners was at the home of Louisa and Fayez Sarofim. Mrs. Sarofim had grown up in the house of Herman Brown, founder of Brown and Root, the powerful construction conglomerate.[88] Fayez Sarofim, her Egyptian-born, Harvard-educated husband, was one of the country's most respected investment managers, responsible for a portfolio of $13 billion.[89] They lived in a modern house by noted Dallas architect Frank Welch, a two-story box with a redwood exterior and an angled roof, sitting on a thickly wooded lot that went down to Buffalo Bayou.[90] The interior had well-chosen eighteenth-century French furniture and a spectacular collection of art. In the entrance was a Jackson Pollock collage and a de Kooning drawing, the dining room had a huge Franz Kline painting, while outside, amid the towering oaks and pines, were a pair of bronze sculptures by Henry Moore.[91] Upstairs was a vivid red Rothko from 1957.[92]

Also receiving that night, in their neoclassical house made out of buff Texas limestone, were Lynn and Oscar Wyatt. On six acres at the entrance to the River Oaks Country Club, originally built by legendary oilman Hugh Roy Cullen in 1933,[93] it was a Regency-style house with floors of black-and-white polished marble, a sweeping white marble staircase with fleur-de-lis balusters of Steuben glass, and a long gallery lined with clusters of palm trees in porcelain chinoiserie. Mr. Wyatt was one of the last of the great wildcatters; he mortgaged his Ford for $400 in the 1950s and turned it into the multibillion-dollar Coastal Corporation. Mrs. Wyatt was an internationally known, best-dressed beauty. On the walls were an oversize Dubuffet, a large Frankenthaler, and, over the fireplace, a pair of Warhol portraits of Mrs. Wyatt.[94]

Just up the street were Mary and Roy Cullen. He was the grandson of Hugh Roy Cullen, and Mary was a perceptive new collector who had been inspired by Dominique. They lived in a two-story, redbrick Georgian-style

house on two acres that backed onto the golf course of the River Oaks Country Club.[95] Large and elegant, it was filled with nineteenth-century landscapes, including Hudson River school, and eighteenth-century European paintings.[96] Caroline Huber, the wife of Walter Hopps, remembered that party. "Many of the artists from out of town who came in for the opening were there," Huber recalled. "You went up to this big house in River Oaks, with valet parking, there was a mariachi band and a tray of margaritas, and Mary was standing there in a beautiful dress greeting you before you even walked in the house. It was fun—a real celebration."[97]

A couple doors down from the Cullens were Sally and Nathan Avery. He was the CEO of the Galveston-Houston Company, a leading oil services company.[98] The Averys lived in a two-story, stucco, Mediterranean-style house with a red-tiled roof. Inspired by the Museo del Greco in Toledo, it had been built in 1926 and restored several years before.[99]

At the other end of River Oaks were two very different settings. Mary Ralph Lowe lived on Lazy Lane in a dramatic modern house by Howard Barnstone, an architect who had worked closely with the de Menils since the 1950s. The 1964 design was of light brick, dark steel, and somber tinted glass with a living room, a thirty-by-fifty-five-foot pavilion, that was raised up on brick pylons one full flight in the air.[100] Inside were five paintings by French academician Bouguereau and several drawings by Delacroix, as well as paintings by Albers, Stella, and Frankenthaler. Around the corner was a house called Rienzi, owned by Carroll and Harris Masterson. She was a daughter of Frank Sterling, a founder of Humble Oil, which became Exxon Mobil, and former governor of Texas.[101] Built in 1954, Rienzi had a clean Palladian design that sat on a ridge overlooking Buffalo Bayou. In back, a glass-walled ballroom and gallery gave onto a formal terrace that stepped down to a large pool.[102] The Mastersons had achieved an impressive level of connoisseurship: eighteenth- and nineteenth-century European art and antiques including English and French furniture, English portraits, and Worcester porcelain (at Harris Masterson's death in 1997, Rienzi became a house museum for the Museum of Fine Arts, Houston).[103]

The final party that night, not far from Rienzi, was at the house of Caroline and Ted Law. Her father, Harry C. Wiess, was a Princeton-educated civil engineer who was yet another founder of Humble Oil.[104] It was a simplified French manor–style structure of pale brick with wings at either end, a dark, sloped roofline, and four towering chimneys.[105] The interior, primarily in beige and white, was filled with major paintings. Mrs. Law—chic, irreverent, and passionate about art—had works by Picasso, Miró, Motherwell, de Kooning, Franz Kline, and Anselm Kiefer.[106] There were a pair of slashed canvases by Lucio Fontana, in red and in green, as well as some challenging

works by Arshile Gorky.[107] Several years before, she had a big party to celebrate the arrival of her portraits by Andy Warhol, personally delivered by the artist and Fred Hughes.[108] Her contribution to the building of the Menil had been a cool $1 million, but her primary emphasis was elsewhere. When Caroline Wiess Law died in 2003, her bequest to the Museum of Fine Arts, Houston, was an astounding $450 million—one of the largest single contributions ever made to an existing cultural institution.[109]

•

Those seven gatherings offered an impressive view of the city; not only a couple of centuries of great art, but some very good design; and a few generations of big Texas personalities. It was a grouping that also illustrated the breadth and depth of support for the de Menils. Roy Cullen remembered that it was not hard for his family foundation to decide to give $5 million to help build the Menil. "We looked at that list of works in the collection and said, 'We're not letting this go to Paris.' "[110]

The de Menils, throughout their lives, had a vast field of action. Since their move to the United States, they had been involved with artists, museums, collectors, and scholars across the globe. Whether it was having lunch with Braque at his retreat on the coast in Normandy[111] or touring the Betty Parsons Gallery with Columbia University historian Meyer Schapiro, they were engaged with, and learning about, art at the highest level.[112] The great Paris-based art historian Christian Zervos initiated them into his two areas of expertise: cubism and prehistoric Greek antiquities.[113] The de Menils always maintained a home in New York; since April 1961, it was a town house at 111 East Seventy-Third Street.[114] They also had an apartment on the Left Bank in Paris and a country estate in Pontpoint, an hour north of the city. As Walter Hopps said of the scope of their lives, "Houston–New York–Paris: that's the milk run!"[115]

They could have always stepped up their activities in the established capitals. Instead, they made a conscious decision to focus on Texas. When John was on the board of the Museum of Modern Art, he explained that their participation in New York would be limited. "As you know, our first responsibility is in Houston," he wrote. "And that is where our efforts must be concentrated because here we are almost alone."[116]

Over that opening weekend in June 1987, there would be a series of masses with a composition by Philip Glass's collaborator Richard Landry, *Mass for Pentecost Sunday,* performed in Latin before the Rothko Chapel's fourteen monumental paintings by the artist. On Sunday, over eight thousand people would pour into the new museum as a host of local artists play-

ing popular, jazz, classical, and gospel music, as well as spirited marching bands and their dancers, performed throughout the grounds.[117] Dominique would sign autographs for her adoring public, and take delight in doing so, before poring over the guest books to study everyone's reaction. The opening became one of those rare moments, both joyful and meaningful. Dominique and John de Menil had managed to show how a young American city, with only the thinnest cultural or intellectual history, could be pulled up to international standards.

Years before, the couple had a hunch, one that was proven to be correct. A friend in New York once dismissed Houston as a cultural desert. John's reply: "It's in the desert that miracles happen."[118]

•

In Houston, there was a time, not so long ago, when even the air was thick with oil. In the summer of 1941, when Dominique and John de Menil first arrived, there were working wells scattered all over town. In the city and its surrounding counties, there were more than a hundred oil fields and seven thousand producing wells.[119]

Founded in 1836, Houston had been the largest city in Texas since 1930, but compared with Dallas, its North Texas rival, the place was shiny and new.[120] There was one institution of higher learning, the Rice Institute, and one museum, the Museum of Fine Arts, opened only sixteen years before the de Menils arrived.[121] The symphony played in an art deco structure that it shared with the local rodeo and livestock show.[122] During World War II, as a way to sell war bonds, someone had the idea, unconventional to say the least, of pairing a performance of the Houston Symphony with a night of professional wrestling. According to one observer, "The orchestra, conducted by Ernst Hoffmann, sat on the stage in formal dress. The wrestlers, who performed in a ring in the center of the auditorium, were hardly dressed at all."[123] More than four thousand Houstonians attended; it raised $1 million.[124] "At one point, a bloodied 230-pound wrestler leaped onstage and began conducting the orchestra. Houston's image as a cultural center was a long time changing and the smirks must have stretched all the way from Dallas."[125]

In 1941, the city limits extended no farther than five miles from the center of downtown. Houston is now the fourth-largest city in the United States and stretches for thirty to forty miles in every direction. Its industry was based on cattle, cotton, rice, construction, and, since the turn of the century, petroleum. By 1914, the main waterway, the sluggish Buffalo Bayou, had been dredged into the Houston Ship Channel, which reached

Galveston Bay, turning a city fifty miles inland into a seaport on the Gulf of Mexico.[126] Although it was located on the frontier with the West, it also had, in those days, a definite southern character. Before the war, it was known as the Magnolia City.[127] As Dominique described the place they first encountered, "Houston was a provincial town with a pioneering mentality and a lingering sense of Southern gentility."[128]

One of the first residents to greet the new couple was Jane Blaffer Owen. Her maternal grandfather, William Thomas Campbell, was one of the founders of the company that became Texaco, while her father, Robert Lee Blaffer, was another founder of Humble Oil.[129] Given her family background, Mrs. Owen was about as close as anyone could get to Texas oil aristocracy. From the time she was a teenager, she knew of Dominique's family's business. "I've always been very conscious of the debt my family owes Schlumberger," Owen explained. "Much as an X-ray peers for signs of life in a woman's body, they were able to answer the drillers' question: Was the earth pregnant with oil?" Her only personal contact had been what appeared in the mail from France, letters of introduction, engraved wedding invitations, or announcements of deaths bordered in black. Dominique and John were her first chance to meet flesh-and-blood representatives of the Schlumberger family, and she had a vivid memory of the occasion. "I was struck by Dominique's slender, otherworldly beauty and her alabaster complexion," Owen said. "Her blond hair was an aureole around her head; I couldn't tell whether it was short or gathered in a knot. Her husband was handsome, much earthier, and his Gallic charm was undeniable. I wouldn't have been surprised, however, to learn that he kept a general's uniform in his closet."[130]

In Houston in those years there were places of discreet sophistication. The parents of Jane Blaffer Owen, for example, were avid collectors. Their house, in the private enclave of Shadyside, was lit entirely by candlelight. Chandeliers—hanging over a sweeping staircase, in the living room, and in the parlor—were lowered daily for fresh candles.[131] Her mother had such works as a Blue Period Picasso, a ballet dancer by Degas, and a floral still life by Manet.[132] Jane even had a cultural connection to Spindletop, the turn-of-the-century gusher, ninety miles east of Houston, that jump-started the state's oil industry. "In 1901, when Daddy was drilling for oil at Spindletop," she said, a phrase that many a Houstonian would love to be able to call their own, "while other men were getting drunk, he was reading Gibbon's *Decline and Fall of the Roman Empire*."[133]

The city also had Ima Hogg, the unfortunately named only daughter of Texas governor James Stephen Hogg. Learned, charming, and more than a little imperious, Miss Ima, as she was mercifully known, was an accom-

plished musician and a discriminating collector. In 1928, while staying in New York, she bought an important painting by Matisse. On annual trips to Europe in the 1920s and 1930s, Miss Ima purchased pastels by Picasso and expressionist works by Klee and Kandinsky.[134] By the time the de Menils arrived, she had already given eighty-four works to the MFA including a watercolor by Sargent, Dürer woodcuts, and a lithograph by Diego Rivera.[135]

Miss Ima's most important realization was her house, Bayou Bend. Completed in 1928, it sat on a fourteen-acre chunk of prime River Oaks property overlooking a turn in Buffalo Bayou.[136] It was a pale pink stucco structure with twenty-two rooms.[137] She filled its twelve thousand square feet with an exquisite collection of eighteenth- and nineteenth-century American furniture.[138] One decorative arts expert considered Bayou Bend "the largest, finest collection this side of Winterthur."[139] Then, after a decade spent turning Bayou Bend into a house museum, Miss Ima simply gave it to the Museum of Fine Arts. One fine Monday morning in the fall of 1965, she handed the keys to the new twenty-eight-year-old curator, David Warren, and drove off toward her new apartment on the ninth floor of Inwood Manor, a modern high-rise about a mile away.[140]

Dominique was aware of these collections when she first arrived, not only Miss Ima's paintings, but the Greek, Roman, and Byzantine objects given to the museum by Annette Finnigan in the 1930s as well as the old masters given by Percy S. Straus, the president of Macy's in New York, in 1944.[141] Still, for someone who was raised in Europe, it must have seemed a bit of a wasteland. "It's true that when we came here, I felt a vacuum," Dominique later explained. "There was the Museum of Fine Arts, but in France in every village there's a little church, there are a couple of stones that tell you a story—everywhere, you're nourished by the past."[142]

Dominique's first reason for building their collection, then, was to surround herself with history. "I have an immense curiosity about the traces left by man," she explained. "The further back in history it goes, the more I find it to be moving."[143] It is no accident that the earliest pieces in the museum were Paleolithic bone fragments. They were three small white objects that had been carved in caves in France and Spain between 22,000 and 15,000 B.C.[144] It was Dominique's decision to track down, and bring to Houston, signs and symbols that went right back to the beginning of man.

•

Houston, in the first few years that the de Menils lived here, was hurtling toward the future. Since it was first settled, the city had one serious

obstacle to greater growth: the relentless climate. As one of Houston's first visitors, in 1838, described it, "The heat is so severe during the middle of the day, that most of us lie in the shade and pant."[145] A form of air-conditioning had appeared locally as early as 1923, but it wasn't until after the war that it was widespread and Houston was billing itself as "the most air-conditioned city in the world."[146] World War II stimulated Houston's economy, and during the war and the years immediately following, investment in local petrochemical facilities, to take only one segment, amounted to $900 million.[147] As petroleum became an increasingly important resource to America, Houston consolidated its position as the nation's oil capital. Soon, it was the fastest-growing city in the United States, with postwar population up by 50 percent.[148]

"Booming Houston," announced *Life* magazine in October 1946: "Texas' Biggest City Is Suddenly Growing Bigger and Wealthier." The ten-page feature opened with an aerial view of the downtown skyline ("The towers of Houston rise right out of the level Texas plain over whose flatlands the growing city's new suburbs spill like lava"). It featured such leading citizens as Jesse Jones, a seventy-two-year-old lumber and real estate magnate, and the wildcatter Hugh Roy Cullen, estimated to be worth $100 million. The population was pegged at 675,000, and the amount of construction coming out of the ground was estimated to be half a billion dollars. "Houston is undergoing one of U.S. history's spectacular booms."[149]

Very quickly, it became known for a particular kind of resident. As *Time* suggested in an article that looked mainly at the leading city, "The Lone Star State is one of the few places left in the world where millionaires hatch seasonally, like May flies."[150] A new, freewheeling mythology was being born. It was an image that encouraged many to head south, while spurring those who were already there to live large. And that was just fine with John de Menil. "My mother always remained somewhat European," said their eldest son, Georges. "But my father loved being an American, he loved being a Texan, and he loved being a Texas oilman!"[151]

The 1946 *Life* article acknowledged some shortcomings. Amid all of the construction, Houston had slums that housed many African Americans and Mexican Americans (one-quarter of the population). "The city is proceeding with plans for a $100 million medical center but it still dumps its garbage out on the edge of town," the magazine noted. "Houstonians draw less than 100,000 volumes a year from their library but they pack wrestling shows. Yet sitting in its cars, as it still does, to watch the Saturday night crowds along Main Street, Houston can see the evidences of its material blessings and can conclude there is time and opportunity for culture."[152]

The Val-Richer, the family château of François Guizot and the descendants
of Paul and Marguerite Schlumberger.

PART TWO

THE OLD
WORLD

TWO

A FAMILY CHÂTEAU

The house, halfway up a hill, overlooked a narrow valley;
solitary; silent. There were no nearby villages; not a rooftop
in sight. The fields were vivid green, the thick woods filled
with towering trees; a stream wound its way through the
valley, while a spring, lively and abundant, was located next
to the house. It was picturesque without being too precious,
both pastoral and pleasant. I vowed to renovate the house,
pull down some walls, begin a series of plantings—lawns,
embankments, allées, clearings, and clusters of trees. I then
bought the Val-Richer.
—*FRANÇOIS GUIZOT (1787–1874)*[1]

A little more than a dozen miles inland from the coast of Normandy is the Val-Richer, an estate on some seven hundred acres that has been the spiritual center of this branch of the Schlumberger family since the nineteenth century. It was in the dense woods and along the winding roads of the Val-Richer that young Dominique Schlumberger spent the best days of her youth; it was in its open fields that Conrad pioneered the field of applied geophysics, conducting experiments that would turn his family into one of the richest in the world; and it was in the Louis Philippe rooms of the Val-Richer that François Guizot, the family's most illustrious ancestor and Dominique's great-great-grandfather, burnished his reputation as statesman, historian, and one of the brightest lights of post-revolutionary France.

When turning the property into his family compound, Guizot had a motto carved in stone on a classical pediment high above the entrance, "*Omnium recta brevissima*": "The straight line is the shortest of all." All of the successive generations of his family who have returned to the Val-Richer have been greeted by that line in Latin, promising, or demanding, directness. As her younger sister summed up the life of Dominique de Menil, "It was a single trajectory with nothing wasted."[2] *Omnium recta brevissima.*

•

The Val-Richer is located in a region known as the Pays d'Auge, an idyllic corner of Normandy that extends sixty miles inland from the storied seaside towns of Deauville, Cabourg, and Honfleur. To reach the château, you travel an hour and a half northwest of Paris to Lisieux, a small city known as the home of Saint Thérèse. It is in the *département* of Calvados, source of the aged brandy distilled from the dozens of varieties of apples grown in the area. Driving west from Lisieux toward the commune of St.-Ouen-le-Pin, you take winding roads through little villages, rolling hills, streams, apple orchards, fields with brown and white cows, stud farms, and half-timbered manor houses. The Pays d'Auge is part of a region that has fired the imaginations of such writers as Proust, Balzac, and Flaubert. "It is the most shaded, moist country I know," wrote André Gide, who spent much of his youth at La Roque-Baignard, his family château next to the Val-Richer. "There is hardly a horizon—just woods filled with mystery. There are planted fields and grazing pastures with soft slopes and thick grass cut twice a year. In every hollow and crevice, there is a stream, pond, or river; you constantly hear the sound of rustling water."[3]

A simple split-rail wooden fence surrounds the Val-Richer, marking what is roughly one square mile of farmland and forest. A long black asphalt drive winds through groves of towering oak and pine trees. As it reaches the crest of a hill, it gives way to crunchy, pale gravel that leads to a circle of manicured verdant grass. On the left are two small buildings, once used as garages and stables, in the Norman style of pale stucco, ornate red brick, and half timber. Straight ahead is the main house. The three-story structure, in beige limestone with doors and windows trimmed in the palest of blues, is commanding, serene, and deeply classical. The entrance is a pair of French doors with Palladian arches. The first and second floors are marked by rows of oversize windows. The top floor has dormer windows, and a series of stone chimneys cut through a steep roof covered in dark red ceramic tiles. The massive roofline, formerly covered in gray slate, created what Jean Schlumberger called "the great slate slope of the main building."[4]

Originally the guesthouse of an ancient Cistercian monastery, the main house dates primarily from the seventeenth century. In 1836, the estate was acquired from the state by François Guizot, who spent decades turning it into a home for his extended family. The interior, perfectly preserved by subsequent generations, is a classified historic monument and one of the most important examples of the Louis Philippe style of design in existence. The soaring entrance, with over fifteen-foot-high ceilings, has light marble floors, limestone walls, two clusters of elegant upholstered chairs, and carved tables with marble tops. From the entry, a pale marble staircase sweeps up along three walls and is bordered with a dark brown railing of

ABOVE: The Louis
Philippe–style library of
the Val-Richer, 1912.

RIGHT: The château's
second-floor gallery.

rich lacework in wild cherry and pear wood. Extending up the stairs is a series of etchings of the battles of Louis XIV, a gift to Guizot from King Louis Philippe. The ground-floor salon has parquet floors in a chevron pattern, walls covered in crimson fabric, a black concert grand piano, and a portrait of Louis Philippe by Winterhalter. The adjacent library's mahogany sofas and chairs covered in pale silks are surrounded by floor-to-ceiling bookcases on all four walls, filled with some twenty thousand volumes. Upstairs, a main corridor, ninety feet long with fourteen-foot ceilings, has a floor of burnished hexagonal tile, a historic reproduction of the Michelangelo sculpture of Moses, and bookcases filled with thousands of volumes.[5]

At one end of the hallway, Guizot's office and bedroom are modest in scale with a small desk and a rolling ladder to access shelves filled with books as well as intimate portraits of family and friends.[6]

•

To understand the character of this branch of the Schlumberger family, it is necessary to understand the life of François Guizot. "He is the thread that runs through the entire family," said one of his Schlumberger descendants. "He holds this family together."[7] Although now largely forgotten outside France, Guizot was one of the most powerful figures in Europe under the reign (1830–1848) of Louis Philippe, the last king of France.

Responsible for the country's domestic and foreign affairs during much of that time, Guizot was such an illustrious figure that Karl Marx included him in the opening lines of *The Communist Manifesto*. "All the powers of old Europe have entered into a holy alliance . . . Pope and Tsar, Metternich and Guizot, French radicals and German police spies," Marx wrote, charging the French leader with holding back social progress. One of Guizot's best-known remarks added to that reputation. "Enrich yourself through work and through savings," Guizot said, intending to encourage personal responsibility and expand voting rights.[8] When shortened to the first two words, "*Enrichissez-vous*," the meaning shifted. "Enrich yourself" became the "Let them eat cake" of the nineteenth century.

Guizot began his political life as a liberal, and by the end of his career he was viewed as a conservative, but his true goal was seeking the *juste milieu*. He was something of a determined centrist, trying to build on the progressive elements of the revolution, to avoid the twin dangers of anarchy and tyranny that plagued the country throughout the nineteenth century, and to establish a connection to its royalty through constitutional monarchy. In the midst of turmoil, Guizot sought political stability hoping to con-

struct the systems that would allow France to be a constitutional monarchy like England.[9]

Swept from his role of prime minister by the revolution of 1848, Guizot became an unqualified success as historian and author. A member of the Académie Française and founder of the Académie des Sciences Morales et Politiques, he wrote a wide range of books including a multivolume history of the seventeenth-century English Revolution, a biography of George Washington, and *The History of France as Explained to My Grandchildren*. His memoirs, covering only his decades in political life, ran to eight volumes and forty-five hundred pages.[10] Guizot was, in fact, a founder of the very idea of French history: the title of one book from the era was *Our Historians: Guizot, Tocqueville, Thiers*.[11] Beginning in 1828, Guizot gave a remarkable series of lectures at the Sorbonne, developing his expansive views of European history. The university's huge amphitheater was filled with a capacity crowd eager to hear this new interpretation delivered in his commanding voice. Alexis de Tocqueville, twenty-three years old, attended every session. "He is prodigious in his breaking down of ideas and the clarity of his language," Tocqueville wrote to a friend. "He is prodigious in getting at the truth."[12] Tocqueville learned from Guizot the importance of discovering archival sources, how to reason historically, and how to apply historical facts to society in general. Tocqueville had been searching for a career, and these lectures helped show him the way.[13] Guizot published the transcripts of his Sorbonne lectures, *Histoire de la civilisation en France* and *Histoire de la civilisation en Europe,* in six briskly selling volumes.[14] As the great German author Johann Wolfgang von Goethe observed, "I am still reading the lectures of Guizot, and they hold up wonderfully. Guizot has more depth and penetration than I have seen in any other historian."[15]

•

Guizot's family was originally from the village of St.-Geniès-de-Malgoirès, near Nîmes, a part of Provence that has been a Protestant stronghold in France. His parents, André Guizot, a young lawyer, and Elisabeth Sophie Bonicel, also from a leading Protestant family, married on December 27, 1786. François, their first son, was born on October 4, 1787, just as the clouds were gathering for the Revolution. After the fall of the Bastille, André Guizot, like most Protestants, supported the ideals of the Revolution. He joined the local chapter of the Girondin party, addressing public meetings and defending the idea of a constitutional regime. In the fall of 1793, however, the leading Girondists in Paris were tried, convicted,

and guillotined; the Terror had begun. It was a period that would be particularly brutal in the Cévennes, where it had an added element of religious persecution.[16]

On Sunday, April 6, 1794, André Guizot was jailed in Nîmes. That night, his brother brought his two sons, François, aged six, and Jean-Jacques, four, to see their father. His wife was too distraught to visit. The lawyer encouraged his elder son to become a skillful speaker. Late into the night, he wrote a letter of farewell to his wife, imploring her to take care of the education of their sons. On Monday afternoon, he was brought before the court to have his identity confirmed. On Tuesday morning at 8:00, he was taken to court to hear his sentence: death and the confiscation of all of his possessions. That afternoon, at 2:15, André Guizot, twenty-seven years old, was taken to the guillotine and executed.[17]

Madame Guizot, only twenty-nine years old, was overwhelmed by grief.[18] Relatives of those who had been guillotined in the Terror were prohibited from exhibiting any signs of mourning, to keep the public unaware of how many were being killed. So Madame Guizot shut herself up in her house for the next three years. She said that she cried herself to sleep for twenty years. "When she died, fifty-four years later, close to her heart was the farewell letter her husband had written her in prison," wrote Guizot's biographer Gabriel de Broglie. "Her final words were 'I'm going to be reunited with him.'"[19]

In the meantime, Madame Guizot channeled her energy, faith, and what was left of her funds into raising her sons. When François was eleven, Madame Guizot's father helped her move with her two sons to Geneva. His first two years in Switzerland, Guizot studied at the *gymnase,* the school founded by Calvin in 1559. Guizot then progressed to the Académie de Genève, the institution of

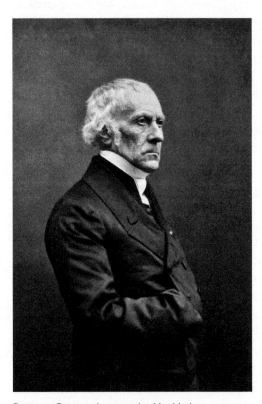

François Guizot, photographed by Nadar.

higher education also founded by Calvin, now the University of Geneva. By the end of his first two years at the academy's Auditoire des Belles-Lettres, he was fluent in five languages: Latin, Greek, Italian, English, and German.[20] He then entered the Auditoire de Philosophie for advanced studies. Guizot developed a passion for art and literature, founding a study group with fellow students that published its own literary journal, *Les Archives Littéraires de l'Europe*.[21] His work ethic also began quite early. During his six years of studies in Geneva, he rarely left the city or took a day off.[22]

In 1805, while his mother moved with her younger son back to Nîmes, the eighteen-year-old Guizot set off for Paris.[23] He studied law and started working as a journalist.[24] Guizot began to meet such luminaries of French thought as Madame de Staël[25] and François-René de Chateaubriand.[26] "Monsieur Guizot has the knowledge that was always required before anyone even dared take up a pen," Chateaubriand wrote with customary flair. "He has a politeness and nobility of character that inspires admiration and respect for his talent."[27] Guizot soon published his first book, *De l'état des beaux-arts en France et du salon de 1810*, a study of one of the most brilliant art exhibitions of the Napoleonic era, a show with eight hundred paintings by David, Gérard, and Guérin.[28] Two years later, Guizot published a new translation, in thirteen volumes, of Gibbon's *Decline and Fall of the Roman Empire*.[29] He was only twenty-five.

•

In his first years in Paris, Guizot met Pauline de Meulan; a member of an aristocratic family that had made it through the Revolution, she was writing for *Le Publiciste* to support herself. She had just turned thirty-four; he was not yet twenty.[30] Despite the difference in their ages and the fact that she was Catholic, their relationship became romantic. On April 7, 1812, Guizot and Pauline de Meulan were married.[31] The Protestant service was held in the historic Temple de l'Oratoire, near the Louvre, while the Catholic rite was performed at the Église de la Madeleine.[32] They moved to the rue St.-Dominique, in the Faubourg St.-Germain (coincidentally, the same street where Schlumberger Limited was founded and is still headquartered).[33] In the early years of their marriage, they had their first son, François-Jean, as Guizot branched out into education and politics. Guizot was named professor of modern history at the Sorbonne[34] and in 1814 accepted a position at the Ministry of the Interior.[35] He started to publish more political works, including *Du gouvernement de la France depuis la Restauration et du ministère actuel*, a well-reasoned attack on those seeking to restore the ancien régime. The book went through four editions in two months

and made Guizot a darling of the left.[36] *Des origines du gouvernement représentatif* was another popular work that earned him some enemies in the Restoration government.[37]

Pauline, however, had always suffered from fragile health. In 1827, she died of tuberculosis.[38] As he mourned his wife, Guizot became closer to her niece, Elisa Dillon. Guizot was forty; Elisa was twenty-four; he had known her since she was a child. She was attractive, with large eyes and dark hair swept up in a chignon with ringlets falling down on her elegant neck. During the weeks of mourning, Elisa took care of his children, and they shared their memories of Pauline. And he began to see in the niece what he had lost in his wife. Exactly one year after Pauline's death, Guizot announced his engagement to Elisa.[39]

Elisa and François Guizot were married on December 8, 1828. As in his first wedding, the services were at the Protestant Temple de l'Oratoire and the Église de la Madeleine. The couple moved into Elisa's house on the rue de la Ville-l'Évêque. The marriage coincided with the beginning of a period of tremendous political activity for Guizot. Seeking a district to represent as deputy in the French Parliament, he found an opening in the Calvados. He traveled to Lisieux and Pont-l'Évêque to register his candidacy and, in January 1830,[40] was easily elected.[41]

Barely six months later, another social upheaval changed the direction of Guizot's life. The three-day revolution that culminated on July 29, 1830, toppled the Restoration monarchy and brought to power King Louis Philippe, from the Orléans branch of the royal family, on a program of constitutional legitimacy.[42] Over the next eighteen years, Guizot assumed a succession of powerful positions including minister of the interior, minister of public education, and *président du conseil,* essentially prime minister.[43]

In 1833, Guizot instituted an ambitious program of public education. His initiative, called *la loi Guizot,* created a complete organizational structure, from elementary school to university, and required every commune in France to have a public school. The law had an immediate impact. The number of local schools, 27,333 by 1830, increased to 43,514 in 1837, while the number of students doubled, from 1,200,000 to 2,450,600. The Guizot Law is still in effect and is considered one of the major accomplishments of Louis Philippe's reign.[44]

And Guizot continued his cultural activities. He founded and edited *La Revue Française,* a leading literary and philosophical journal;[45] he was named to the Académie Française by unanimous vote;[46] within the Institut de France, Guizot resurrected the Académie des Sciences Morales et Politiques, the oldest institution dedicated to the social sciences, begun by Talleyrand in 1791 and then suppressed by Napoleon in 1803;[47] he created

the first commission to protect historical monuments in France, he alerted Louis Philippe to the need to begin a restoration of the Château of Versailles, and he oversaw the completion of the spectacular bas-reliefs on the Arc de Triomphe constructed under Napoleon;[48] and in an effort to heal a societal breach with the Bonapartists, he negotiated with the English to have Napoleon's remains returned from St. Helena and oversaw the building of his tomb at Les Invalides.[49]

Elisa became completely involved in Guizot's work: publishing, teaching, journalism, and politics.[50] She hosted a salon at their home that became one of the most important political gatherings of the day.[51] They had two daughters, Henriette, the great-grandmother of Dominique Schlumberger, and Pauline; and one son, Guillaume.[52] Madame Guizot *mère,* after the death of her relatives in Nîmes, moved in with the couple.

In March 1833,[53] shortly after the arrival of their son, Elisa died, probably from a puerperal fever infection associated with childbirth.[54] Married just over four years, she was only twenty-nine. For more than a year, Guizot was plunged back into mourning. He had the sculptor Foyalier make a bust of Elisa in white marble and commissioned court favorite Ary Scheffer to paint a posthumous portrait of her with their three children. Guizot meticulously recopied the correspondence they had exchanged and every year commemorated the anniversaries of their engagement and wedding.[55]

•

It was in these years of immense productivity and loss that Guizot found the Val-Richer. A friend took him to see the property, which was some ten miles across fields and rough paths from Lisieux, in the district he represented in the Assemblée. Founded in the twelfth century, the Cistercian abbey was destroyed during the Revolution. The monks left the Val-Richer in 1789, when church assets were seized and declared to be the property of the nation. In 1797, the Val-Richer was sold to an absentee landlord who demolished the Norman-style church, cloisters, and monastic buildings.[56] When Guizot found it, the Val-Richer consisted of 185 acres of fields and dilapidated gardens, 247 acres of forest, and a twenty-room limestone main house that was a beautiful ruin.[57] As he wrote of his first visit,

> The ancient abbey's church and monastic buildings had been destroyed during the Revolution so nothing was left except the abbot's house, hardly old itself in that it was reconstructed in the middle of the eighteenth century. The interior of the house, solid and spacious, was imperfectly finished and already going to ruin.

All that remained of the ancient constructions were walls. Old apple trees and vegetable gardens were planted haphazardly. Tubs for cleaning were stacked everywhere, some as high as the window-sills. It all seemed crudely rustic, even a little abandoned. There was hardly any road to get there; the only way to do so was to come on horseback or to ask permission from the neighbors to cross their fields. But I liked the place.[58]

Guizot negotiated with local authorities to have roads built and set about renovating the property. He redid the parquet floors, used demolition stones for the floor of the dining room, turned the second-floor hallway into a long, light-filled library, and built his monastic bedroom and office at the end of the hall. Aline de Meulan, the sister-in-law of Pauline, oversaw the interior work, designing such pieces as the dramatic carved-wood banister on the main staircase. Guizot hired a gardener to restore the grounds, planting dozens of pines, larch trees, firs, willows, and chestnuts. The Jardin des Plantes in Paris donated two hundred trees.[59]

As he was renovating his family home, Guizot entered into a liaison with Princess Dorothée de Lieven, a well-known figure among the European aristocracy. Born in East Prussia, as Dorothea von Benckendorff, and married to the Russian Prince de Lieven, she lived in London when her husband served as his country's ambassador. Intensely focused on political life, she once quipped that she "loved politics more than sunlight."[60] When her husband was recalled to St. Petersburg, she was reluctant to be so far removed from the action. Eluding the czar's interdiction to travel, she, through a skillful maneuver, moved to Paris.[61] There, from an apartment on the rue St.-Florentin that had belonged to legendary diplomat Talleyrand, the Princess de Lieven launched one of the most sophisticated political salons of the nineteenth century.

When Guizot and de Lieven began their relationship, they were united by their common bereavement; each had just lost a son.[62] In a beautiful gesture of intimacy, Guizot invited the princess to read his entire correspondence with Pauline and Elisa. "I devoured it," she said, "like a novel."[63] The liaison between Guizot and the princess lasted twenty years, until her death. During that time, they exchanged five thousand letters, a correspondence that has been called "a political, diplomatic, social, and sentimental monument."[64]

With his family and de Lieven by his side, Guizot went through a series of impressive appointments. In 1840, he was named ambassador to England. He moved into the French embassy, Hertford House on Manchester Square, which today houses the Wallace Collection, and proceeded to

dazzle the English. "Monsieur Guizot has arrived and he is very popular," wrote Lady Palmerston to de Lieven. "He was the lion of my soirée."[65] While in London, Guizot began a lifelong friendship with Lord Aberdeen, the Scottish-born prime minister of England. It was their close relationship that led to the entente cordiale.[66] During that time, Guizot met the young queen Victoria, who hosted a dinner for twenty-eight in his honor, with Guizot seated to her right, and included him in a weekend at Windsor Castle.[67]

Returning to France, he was named minister of foreign affairs, responsible for significant diplomatic achievements with Egyptian leaders and rulers across Europe.[68] In 1846, he successfully negotiated a series of complicated marriages between the royal families of France and Spain, also securing the approval of England, arrangements that solidified Franco-Spanish ties. But as the July Monarchy became increasingly unpopular, Guizot became a target of ire. In one heated session of the French Parliament, the Assemblée Nationale, he was subjected to attacks from his political adversaries that were purposefully deceptive. After an hour and a half, standing alone against his shouting opponents, Guizot, in his authoritative voice, delivered one of his most famous dictums: "You can pile on your insults, your slander, your fits of anger as high as you would like, but you will never reach the height of my disdain!"[69]

Guizot's determination proved to be his undoing and that of the regime. As one historian concluded, "In a society that was changing enormously, his error was to maintain an immobile *juste milieu,* a fixed median that lost its sense of objectivity and reference value."[70] Both the left and the right began criticizing Guizot, and the public turned against him. On February 22, 1848, a group of ninety-two opposition deputies organized a demonstration on the Champs-Élysées. The following day, barricades were constructed around the city. Cries were heard of "Down with Guizot" and "Long live reform!" He met with Louis Philippe, explaining that he was unwilling to reform the government or fire on the National Guard. The king reluctantly relieved him of his responsibilities. That night, demonstrators clashed with troops in front of Guizot's office at the Ministry of Foreign Affairs. The National Guard opened fire on the crowd, killing sixteen. Their bodies were piled onto carts and taken around the city to incite the public to bring down the monarchy. The next day, February 24, 1848, Louis Philippe abdicated. Guizot fled to Belgium and then to London, where he was reunited with his children.[71]

Guizot lived in exile in London from March 1848 until July 1849.[72] His mother, eighty-four years old, made the journey to join him, announcing that now that she had seen her family again, she could die in peace.

While in England, Guizot made his return to publishing with *Democracy in France,* a short historical work that quickly sold twenty thousand copies in France. "You are one of these superior natures that find serenity up above the clouds," Victor Hugo wrote to Guizot. "In reading your work, I constantly find myself saying, 'That's so true!' Providence has an important, useful future for you; our country needs your pen and your voice."[73]

•

When Guizot, sixty-three years old, returned with his family to France, it was in retreat to the Val-Richer. A photograph from this time, by Nadar, shows him with a shock of gray hair combed forward, his right arm folded into his black waistcoat and his weathered, well-lined face with high cheekbones, thin lips, and clear, determined eyes. Short of funds, Guizot arranged with Sotheby's in London to auction eight hundred volumes from his library, a sale called "The Catalog of a Valuable Collector of Books Removed from the Val-Richer."[74] In 1850, his daughters, Henriette and Pauline, were married to Conrad and Cornélis de Witt, two friends of Guillaume Guizot's.[75] The de Witt brothers were distant relatives of Johan de Witt (1625–1672), the statesman from the golden age of the Netherlands. The family fortune, though long gone, had been earned in the Dutch West India Company.[76]

The two marriages, not arranged by Guizot, seem to have been mismatched.[77] The younger sister, Pauline, who was sweet but not terribly interesting, was paired with Cornélis, who was a very distinguished young man. The other marriage was the opposite. Henriette, her father's favorite, who was accomplished in history, literature, and art, was married to Conrad, a simple, rustic man. "He lacked a little spark," wrote André Gide, who knew the couple well. "He had a difficult time trying to project the same stature as his wife, whose superiority was exhausting for him."[78] Henriette and Conrad moved into the Val-Richer and had two daughters, Marguerite, Dominique's grandmother, and Jeanne.

The Val-Richer became a very lively, though costly, household. Twenty-five were able to live comfortably in the main house. The property required a live-in staff of ten, between the garden, greenhouse, stables, farm buildings, sawmill, and main house. For the festival celebrating the harvest, more than a hundred workers and their families danced all night in the courtyard.[79] The retired statesman would spend at least six months a year at the Val-Richer, and they were always periods of great activity. As one historian wrote,

Guizot began the day at 5:30 a.m., after seven hours of sleep. He would drink a large glass of mineral water and begin his work, like a brand-new man starting life anew. His days were incredibly full: writing correspondence, articles, speeches, and books; paying or receiving visits; attending meetings, academic sessions, receptions, dinners; taking trips between Paris and the Val-Richer; taking walks (Guizot was a committed walker); gardening; reading to, and playing games with, his grandchildren.[80]

Guizot continued to be extraordinarily productive in his final years. Not only did he publish his six-volume history of the English Revolution and his memoirs, but he became more involved with the national leadership of the Protestant church. Combining his background in education and experience in politics, Guizot was one of the founders of the privately funded École Libre des Sciences Politiques, where Jean de Menil would later study.[81] And Guizot's public speaking continued to captivate. In 1861, he was responsible for inducting into the Académie Française Father Lacordaire, the Catholic intellectual who was taking the place of Tocqueville after his death. Some six thousand people requested seats for the session, held in the presence of the empress Eugénie.[82]

As he aged, Guizot had one more burst of tragic French history to witness, in 1871, when the country lost the Franco-Prussian War and Paris was ravaged by the Commune. And he continued to bury some of his closest friends, including King Louis Philippe, the Princess de Lieven, the Duchess of Dino, and Victor de Broglie.[83] In the last year of his life, he lost his younger daughter, Pauline, forty-three, after she suffered chest pains (having already laid to rest his beloved eldest son, François, who died of pleurisy, in 1836, when he was only twenty-two).[84] Guizot was also made aware of a scandal involving his younger son, Guillaume. Ten years prior, in order to cover gambling debts, Guillaume had secured 50,000 francs from Napoleon III. When he learned of his son's behavior, Guizot was horrified. In order to pay back the amount, plus interest, to the empress Eugénie, he was forced to sell a painting by Murillo that had been given to him by the queen of Spain.[85] His work, however, continued. His last book was *The History of France as Told to My Grandchildren*, a five-volume publication, with illustrations by Alphonse de Neuville. Made up of the lessons he had given his children and grandchildren for the past thirty-five years, it was a great commercial success and was reprinted throughout the nineteenth century.[86]

François Guizot died at the Val-Richer on September 12, 1874. He was just shy of his eighty-seventh birthday, an exceptionally long life. He was

attended to by his daughter Henriette and surrounded by his family. His final words: "No one is more certain than me!"[87]

•

The Val-Richer—the château, its land, and all of its contents—was left to Henriette Guizot de Witt, eldest child and a formidable presence.[88] Her most important goal was making sure the property stayed in the family. She continued to publish her father's works, to complete works that he had begun, and to author books of her own. Raising her two children along with the five that were her sister's, Henriette struggled to support the entire family and keep the Val-Richer going. "She worked like a buffalo," said one Schlumberger relative.[89] Her husband was of little help. He continued to focus on the crops, which never seemed to produce revenue, and racked up a huge amount of debt. She was forced to take a mortgage. Selling part of the land would have helped, but Henriette was intent on protecting the entire estate.

The Gide family witnessed those years firsthand. Their home, La Roque-Baignard, was a soaring redbrick affair, with a steep slate roof, surrounded by a moat. It sat on 766 acres of land and 370 acres of forest that blended directly into the Val-Richer.[90] André Gide spent some of the most magical days of his youth there, turning his memories of the two properties into literature: his family château became La Morinière in *L'immoraliste,* while the Val-Richer became the Blancmesnil of *Si le grain ne meurt.*[91]

Gide's regular trips to the adjacent château were a special event; as he put it, "It was agreed that Sunday was the day I would taste the Val-Richer."[92] Gide attended the Sunday services in the salon, overseen by Henriette and her daughter Marguerite. What really attracted the future author to the Val-Richer was the intellectual life. He would dive into the library, devouring such finds as the *Encyclopédie,* that monument of eighteenth-century French intellectual fervor, the complete works of Corneille and Pascal, or the correspondence of Montalembert. Gide often stayed for family meals in the dining room. He noted how everyone, as Guizot had been, was fully engaged with the world at large. "The mailman would bring the post from Lisieux while we were seated for lunch," Gide remembered. "Everyone, young or old, would stop eating and grab a newspaper. Then, even though I was supposed to be a guest, all around the table and for quite some time, I no longer saw as much as one face."[93]

Henriette worked to make sure that the Val-Richer maintained the intellectual and spiritual heft that it had under Guizot. His political fall had led to a loss of favor with much of the public, so she fought to keep his repu-

tation alive. She organized his extensive archives, still the largest private archive in France. She published biographical works, including *Monsieur Guizot in Private Life,* which was translated into English and published in America. She made sure that the Val-Richer's interiors and art remained as they had always been, and she actively encouraged veneration of her father, asking children to keep their voices down in his former office.[94] She was determined that the château would be a monument to the man.

After paying off the first mortgage, Henriette was forced to take a second, and she looked to the next generation to help secure the Val-Richer. "She tried so hard to marry her daughters," explained Henriette's descendant Pauline Lartigue. "Until the candidates would ask about the dowry. Well, there was no dowry—she didn't have a cent!" Eventually, a matchmaker, an old woman, told Henriette about two brothers from a good Protestant family in Alsace. "They are very nice, very well raised, and they have lots and lots and lots of money. Oh, and as for the dowry: they could not care less!"[95]

On July 1, 1876, at a ceremony in Paris, Henriette's daughter Marguerite de Witt married Paul Schlumberger (her other daughter, Jeanne, wedded Paul's brother Léon).[96] The union meant that an intellectual and moral dynasty begun by Guizot, combined with a grand family of the ancien régime and a leading Dutch Protestant clan, was brought together with an industrial dynasty from Alsace. Marguerite and Paul Schlumberger, who would be the grandparents of Dominique, divided their time between his native village, Guebwiller, and the Val-Richer. Eventually, they settled into the family estate, which they, and their descendants, preserved intact. As Henriette headed back to Normandy from that summer wedding in Paris, there were still plenty of uncertainties in her life. Restoring her father's reputation was not a given; she had years of work to do in that domain. But the future of the Val-Richer was coming into focus. And there was one major issue that had finally vanished: money.

A PROTESTANT DYNASTY

Ne touchez pas aux choses d'Alsace.
—LOUIS XIV[1]

The story of the Schlumberger family begins four hundred miles to the east of the Val-Richer, in the region of Alsace, where the Rhine River flows down from the Alps, marking the borders of France, Switzerland, and Germany. The fertile, productive land is set off by the Vosges Mountains on the French side and thousands of square miles of the Black Forest on the German side. The Vosges range is covered with hundreds of thousands of acres of forests: conifers and beech, oak, ash, birch, and elm trees. The area is planted with wild cherry trees, its fruit used for making kirsch, as well as plums, apples, pears, cherries, walnuts, and chestnuts. Alsace has produced wine since the third century.[2] As early as 1540, a visitor suggested that there was no other region in the Rhineland with such natural abundance.[3] A seventeenth-century observer detailed the many copper, iron, and silver mines, fields of wheat and other grains, and large herds of livestock.[4] Louis XIV had looked across the land and said, "What a beautiful garden."[5]

Its position at the frontier of two great powers, however, meant that for centuries the Alsatian region had produced immense wealth and been the source of tremendous conflict. "The history of Alsace and Lorraine is made to unleash passions," noted one historian. "There are lovely images of young girls in Alsatian villages wearing big black bows or the little bonnets of Lorraine topped by rosettes in *bleu, blanc, rouge*. But behind this folklore, there is the shadow of five Franco-German wars, or international conflicts, that used this region as a battlefield."[6] Alsace has played a major role—as either the setting, the cause, or the spoils—for the Thirty Years' War, the Napoleonic Wars, the Franco-Prussian War, World War I, and World War II, a series of struggles that has meant five changes of nationality and two violent annexations by Germany.

The very idea of modern Europe can be traced to Alsace. On May 8, 1950, five years after the end of World War II, French foreign minister Robert Schuman unveiled a plan to pool the coal and steel production of France

and Germany. His bold proposal, directly connected to the industrial riches of Alsace-Lorraine, became the founding act of the European Union.

•

At the northern part of the long, narrow *plaine d'Alsace* is Strasbourg, with its medieval, half-timbered buildings in black and white, a soaring Gothic cathedral, and the modernist home of the European Parliament. To the south is a succession of historic towns such as Colmar, Ribeauvillé, and Thann. There are dozens of fortified medieval castles and a scenic path through the vineyard country, where fields thick with grapes are planted on the sides of the Vosges. Southern Alsace is dominated by Mulhouse, a center of textiles beginning in the eighteenth century that, during the Industrial Revolution, was considered the Manchester of France. Fourteen miles northwest of Mulhouse is Guebwiller (pronounced *Geb-vee-lair*), a grouping of dark stone structures with steep red-tiled roofs and a small skyline dotted by church spires. The Vosges Mountains rise up from the edge of the town to form a dramatic backdrop, including, just a few miles west, the highest point in the range, the Grand Ballon. The vale that cradles the town is called Florival, or Valley of Flowers.

Mulhouse and Guebwiller represent the roots of the Schlumberger family. In ways large and small, its presence is still visible. In Mulhouse, there is a rue Schlumberger as well as the Maison Loewenfels, a Louis XV structure in beige limestone with ornate wrought-iron balconies. A former Schlumberger family house, this is the most important example of eighteenth-century architecture in the city.[7] In Basel, there is a dinner bread called the *Schumbergerli*. It is a round roll, made from wheat and rye and baked until it is golden in color, crunchy on the outside, and soft on the inside.[8]

In Guebwiller, running up the steep slope of the Vosges Mountains, is the Domaines Schlumberger. Covering more than four hundred acres, this is the largest vineyard in Alsace and producer of one of the area's finest Rieslings and Pinot Gris.[9] Near the top of the hillside, a series of large white letters spell out "Schlumberger" ("It's like the Hollywood sign," says one family member).[10] In town, there is a rue Jean Schlumberger, named after Dominique's great-grandfather, and a hospital that he originally funded.[11] The street ends at the headquarters of Nicolas Schlumberger & Cie., the sprawling family business founded in 1810 by Dominique's great-great-grandfather. Still one of the leading manufacturers of textile machinery in the world, the NSC Group has approximately one thousand employees and annual sales of $150 million.[12] There are dozens of factory buildings on fifteen acres of land with over 600,000 square feet of work space.[13]

Across from a looming neo-Gothic redbrick building at NSC is a three-story house of rose-colored stone, pale yellow stucco, varnished wooden shutters, and a red-tiled roof. It sits in a tree-shaded lawn that runs right up to the gates of the great factory. This was the residence of Marguerite and Paul Schlumberger, where Dominique's father, Conrad, was born and raised.

•

The first trace of the family lies 120 miles east of Alsace, on the other side of the Black Forest, a full sixteen generations before the birth of Dominique. Hans Schlumberger, born in 1400, lived in the village of Setzingen, about a dozen miles from the imperial city of Ulm, in the historic region of Swabia, now the German province of Baden-Württemberg. Hans, who lived to be seventy-four, was a farmer, hotelier, and officer of the Teutonic Knights.[14] Although considered a serf, Hans ran a country inn, Zum Adler, for the Knights.[15] That relatively prestigious position—hotelier and bailiff to the Teutonic Knights—was passed down by the next four generations, through the sixteenth century.

Claus Schlumberger, born in 1510, was the fifth generation to come from Setzingen. He chose the occupation of leather tanner and, at the age of thirty, moved to Alsace, the neighboring territory with the most opportunities. Claus settled in Guebwiller, then a small principality ruled since 623 by the powerful Benedictine priests of the Abbey of Murbach.[16] It was there that he converted to Protestantism, at a time when others in the village who followed the Reformation were being burned alive. Claus was protected by his financial success and membership in the Knights, until he was encouraged by the Murbach priests to move to the nearby Protestant city.[17]

In 1545, Claus was admitted into Mulhouse.[18] A fortified city since 1420, it was one of the most secure settlements in the region.[19] After seven years in Mulhouse, Claus was named *bourgeois privilégié,* the highest level in the social hierarchy.[20] His second marriage, with Catharina Eck, the daughter of the local pharmacist, produced three children, including one surviving son.[21]

During a relatively brief life—Claus died at forty-seven—he had moved his family from Germany to Alsace, converted to Protestantism, settled in Mulhouse, and ascended to the bourgeoisie. Claus's accomplishments meant that eleven generations and over 350 years before Dominique's birth, the prominence of the Schlumberger family was established on French soil.

•

The profession of tanner passed through the next three generations until Georg Jacob Schlumberger, born in 1706, left the family field.[22] He made and sold woolen fabrics, one of eighty *maître drapiers* in Mulhouse.[23] He married Catherine Ermendinger, whose family, like his, had been in Mulhouse since the sixteenth century.[24] The couple had three sons and one daughter.[25] All three Schlumberger sons followed their father into textiles and the newest specialty in town, *les indiennes*,[26] printed cottons, known as calicoes, that became popular around the world and were the first fabric to be favored by both the aristocracy and the mass market.[27]

The youngest, Peter, born in 1750, spent four years learning the business in Zurich, Bern, Lausanne, Geneva, and Lyon.[28] Returning home, he joined Jean-Henri Dollfus as partner in what became the largest manufacturer of printed cottons in town. He married Anna Catharina Hartmann, whose father was a leading manufacturer of *indiennes*. In 1789, when he was still in this thirties, Peter bought the grandest house in Mulhouse at 44, rue des Champs-Élysées.[29] On a pair of shields on the building's pediment, Peter carved lions from the Schlumberger coat of arms and named the house Le Loewenfels, Rock of Lions.[30]

He and Anna Catharina had four daughters and four sons.[31] His eldest daughter died when she was still only a teenager, and then, the following year, he lost his wife. Never remarrying, Peter dedicated himself to the education of his seven children.[32] One member of the next generation would take the family to its greatest heights yet.

•

Nicolas Schlumberger, Peter's third son, was born in Mulhouse in 1782. When he was thirteen, his father sent him to Vevey in Switzerland for his French education. Back in Mulhouse, Nicolas began an apprenticeship at the firm at the age of fifteen. His two older brothers would need to be partners, so, realizing that his opportunities were limited, at nineteen years old Nicolas moved to London. Working for James Siordet, an importer of cashmere, he traveled to Manchester and Liverpool, witnessing firsthand the burgeoning textile industry and the new steam-powered machinery.[33] During the four years he spent in England, Nicolas saw the beginning of the Industrial Revolution.

Returning to Alsace, he felt the country was twenty years behind its rival.[34] "Sensing the importance of what was happening," wrote a local newspaper, "he made plans to ensure the participation of Alsace in this great movement."[35] In 1806, at age twenty-four, Nicolas Schlumberger married Marie-Elisabeth Bourcart, or Lise, whose father was a leading industrialist

from nearby Wesserling.[36] Four years after the marriage, Nicolas left his father's firm to strike out on his own.

Twenty-eight-year-old Nicolas—with his thin lips, long sideburns, and dark hair combed forward in the style of Napoleon—found the perfect site for his new business in the sleepy village of Guebwiller. For 70,000 francs, he bought a property that included a rustic mill house, some pastureland, and a large house.[37] The house, where Nicolas would live for the rest of his life, was four stories, plus a towering tile roof that covered several levels of attics.[38] It was surrounded by a big garden, with a two-story, covered veranda that ran the length of the house. Lise, responsible for running the Schlumberger home, wore her long hair parted in the middle, and favored the pale, high-waisted Empire dresses of the day.

Nicolas began his own mechanized mill in his house, but his effort, which quickly expanded to the adjacent mill, faced many early difficulties, including a local population completely unfamiliar with machinery.[39] In 1810, Nicolas Schlumberger & Cie. produced 12,000 kilos of cotton. The following year, it produced 74,150 kilos. By 1812, it employed three hundred workers;[40] two years later, NSC had doubled that number.[41]

In order to be able to produce the finest knits, Nicolas decided to construct his own machinery.[42] The sophisticated material he had in mind was only found in England, which prohibited the export of industrial secrets under penalty of death.[43] Nevertheless, he traveled across the channel, found an engineer, and purchased his plans. Then he hired the inventor, also arranging to bring him and a team of his workers back to Guebwiller. Crossing into France, Nicolas did something bold and, from an English point of view, illegal: he smuggled the mechanical drawings into the country in the lining of his coat.[44]

NSC began selling this new machinery in 1824.[45] Within two years, it had a thousand workers, producing textiles valued at 2.2 million francs,[46] and was the largest mill in France.[47] Nicolas then turned to Josué Heilmann, an Alsatian inventor, to develop a machine that could sort fabrics by the length of each fiber. After seven years of development, NSC launched the "rectilinear comber."[48] Still the most widely used apparatus for processing cottons and wools, it is often called a "French comb" or "Schlumberger comb."[49] Within a decade, NSC had over fifteen hundred employees, nine hundred in the mills and six hundred assembling machinery.[50]

Nicolas was also involved in politics, working with the regional administration and the Guebwiller city council, a post he held for forty-five years. He co-authored a national law limiting children's work hours, passed in 1841.[51] There was a movement to have him elected to the National Assem-

In the Alsatian town of Guebwiller, Nicolas Schlumberger & Cie., the textile machinery manufacturer that gave the family one of its first great fortunes.

bly, but he declined because it would have taken him away from his business.[52]

Nicolas preferred to concentrate on building NSC and on his charming hometown of Guebwiller. Like the company, the town had blossomed. His wife's family, the Bourcarts, having relocated there, were supporters of Franz Liszt and brought the pianist to town. They sponsored concerts in the Dominican convent and donated civic buildings.[53] Guebwiller's new industrialists made sure their homes had impressive gardens. The Frey family grew exotic tulips, the Bourcarts grew Louisiana cypress, while the Schlumbergers had ginkgo trees and magnolias. They cultivated countless varieties of roses and had large pots filled with orange and lemon trees, and oleander. Wisteria and honeysuckle climbed the facades. In his greenhouse, Nicolas grew rare species of flowers, trees, and tropical fruits such as pineapple. A botanist from Paris's Jardin des Plantes came to study all of the specimens in his garden and greenhouse.[54]

Nicolas and Lise had nine children, five sons and four daughters.[55] Managing the house required a staff of fifteen: maids, valets, chefs, coach drivers, grooms, cowherds, and several gardeners. For the children, there were governesses, teachers, and private tutors. In the summer of 1858, they celebrated their fiftieth wedding anniversary. A wooden chalet was built at the base of the house, toasts were made, and daughters and daughters-in-

law were given gold brooches. Family and staff posed for a series of group photographs, organized into garland-covered albums and given as mementos to all.[56]

When Nicolas died in 1867 at the age of eighty-four, he was still working at the vast company he had built from scratch. Hundreds attended his funeral. Nicolas had received an inheritance of 17,143 francs from his father. He left his children, along with an untold number of acres of vineyards, farmland, and forest, 14,541,953 francs.[57] "He had multiplied his inheritance by one thousand."[58] The motto Nicolas Schlumberger had kept throughout his life: "Justice. Order. Integrity."[59]

•

Three years after the death of Nicolas, on July 15, 1870, the emperor Napoleon III, who had presided over the Second French Empire since 1852, made a rash decision. Egged on by an aggressive empress, Eugénie, a hostile Paris press, and a crafty Otto von Bismarck, Napoleon III declared war on Prussia.[60] On September 2, after only six weeks, in the northern town of Sedan, the emperor, along with 104,000 of his troops, was encircled by Prussian and German forces and taken prisoner. Two days later, the Third Republic was proclaimed in Paris.[61] On May 10, 1871, once all hostilities had finally ended, the Treaty of Frankfurt was signed, awarding Alsace and Lorraine to Germany. The area became known as the Imperial Territory of Alsace-Lorraine.

"Alsace lived four of the darkest, most painful decades of its history," wrote historians of the region Michel Hau and Nicolas Stoskopf.[62] It was a time of great emotion. "Whole villages went into mourning. One village hung a sign in a public place, 'Die French rather than live Prussian!' "[63] Alsatians were given the choice of maintaining their residency in the region or immigrating to France, which led to an exodus.[64] In the first year, 8.5 percent of the population of Alsace and Lorraine, around 128,000, left for French territory.[65] Between annexation and World War I, over 267,000 moved, almost 20 percent of the population.[66] Most who moved immediately were artisans, laborers, or members of the middle class.[67] For Alsatian industrialists, abandoning the region was more complicated.

At the time of the conflict, Nicolas's son Jean was the leading partner in NSC. Short, stocky, with a full white beard, Jean had graduated from the École Centrale des Arts et Manufactures in Paris, a leading engineering university.[68] He had also studied law in Paris and wanted to pursue politics, until his father made it clear that he was expected to return to the family firm. So he moved back to Guebwiller and became a partner in NSC. In

1845, Jean married Clarisse Dollfus, from a prominent Mulhouse family, and eventually had four sons.

During negotiations connected with the Treaty of Frankfurt, delegations of Alsatian industrialists were dispatched to Paris and Berlin to make a case for protecting local industry. Jean went to the German capital.[69] After annexation, he was named to the Landesauschutz, a parliament of Alsatian dignitaries.[70] He became president in 1874, a title he held for more than twenty-five years.[71] Jean was given military honors by the German government[72] and, on his fiftieth wedding anniversary, in 1895, was ennobled by Kaiser Wilhelm II, raised to the level of hereditary nobility. His surname was altered to Jean von Schlumberger, also changing the official names of all of his offspring.[73]

Yet for someone who was supposed to be cooperating with the Germans, Jean made some unusual choices. He was never able to speak the language without mistakes, so in the German Alsatian assembly he addressed Prussians in French. When the town of Guebwiller gave him the title *bourgeois d'honneur,* he found the occasion more touching than all of his German awards.[74] And five years after the annexation, he allowed two of his sons to slip across the border to marry the granddaughters of French statesman François Guizot.

The eldest son of Clarisse and Jean, twenty-three years old at the time of annexation, was Paul, Dominique's grandfather. Although he had wanted to be a science professor, his father insisted he go to Liverpool for an apprenticeship. "My stay in England is commercializing me," Paul noted. Two years later, he was back in Guebwiller, working in the family factory. "My one ambition," he wrote in his diary, "is to love a woman and marry well."[75]

In 1876, Paul traveled from Guebwiller to Paris for his wedding with Marguerite de Witt.[76] Both couples then settled in occupied Alsace. "In letting two of his sons marry in France and bring back to Guebwiller two granddaughters of Guizot," wrote Paul and Marguerite's son Jean, "my grandfather must have had no doubt about the sense of rebelliousness these two de Witt sisters would bring to his family."[77]

•

In a family photograph taken around 1880, Marguerite posed with her first three sons. The young Jean and Conrad stood on either side of their mother, while the infant Daniel sat on her lap. A few years later, another photograph showed the three boys standing next to their mother with the infant Pauline on her lap. In both portraits, Marguerite had her long hair

The children of Paul and Marguerite Schlumberger: (back row) Jean, Conrad, Daniel; (front row) Marcel, Pauline, Maurice.

up in a single braid and was dressed *à l'Alsacienne,* in the folkloric, patchwork skirts of the region. Fixing her very determined eyes on the camera, she looked for all the world like a hostage. "For someone like Marguerite, an intellectual, who had been raised with a sense of history, to find herself with an industrialist, stuck in a village in Alsace where only Alsatian or German could be spoken, with a father-in-law who was pro-German—that must have been hard," said one of her descendants.[78]

Marguerite and her sister, Jeanne, were confined to a small town that had been cut off from its country. "They had lived with the radiance of a statesman who had a leading role in the great events of Europe," wrote Dominique's uncle Jean. "They had known him when he was active, working on historical or political studies, surrounded by eminent friends, and with a passionate and lively spirit until a very old age." These strong young women brought a burst of fresh air into the little valley of Guebwiller, but they also brought a sense of confrontation.[79] "Marguerite, very proud to be a granddaughter of Guizot, was resistance incarnate."[80]

In that house across from the family factory, there were conflicts all around them, what Jean Schlumberger remembered as "a vast combat of light and shadows."[81] The undertow could be exciting. They saw students taken to the police for whistling "La Marseillaise" or denounced for wearing French colors. At school and at home, they had to be prepared to quickly rip off the wall old maps that showed Alsace still connected to France.[82]

Although they did have some sympathy for their grandfather's position, the children did not approve of his actions.[83] When the Schlumberger patriarch appeared in Guebwiller leading a procession with a German dignitary,

chancellor Prince Hohenlohe-Schillingsfürst, the family made a show of its loyalty to France. As Jean Schlumberger described the scene,

> All of our shutters were closed. Between the blinds we could see my grandfather walking next to the prince, in front with the other officials. When the prince stopped near our place, it was probably to catch his breath, instead, as we wanted to think, to wonder about the significance of this house that was so disrespectfully dead. But we hoped that our closed shutters, which made such a solemn impression on us, were not missed by our grandfather. We wanted him to know how passionately we condemned his attitude.[84]

The boys were educated at home by Swiss tutors, the only outside instructors permitted by the regime. At the age of thirteen, they went to a local German school, with an almost-military regimen.[85] Conrad often did his homework with the smartest boy in class, from the Prussian province of Westphalia, a friendship that helped him humanize Germans. And the young Conrad excelled at the piano, particularly Mozart and Bach, with an instructor from Basel.[86]

Growing up in occupied Guebwiller, where even the local industry seemed to be running on inertia, the children had little poetry in their lives. They received the same gifts from their grandparents, 20 marks at Christmas and 5 marks for birthdays, so as not to show any favoritism. The brief kisses they received from their grandmother, only on the tops of their heads, were said to be something like the peck of a bird.[87] And their grandparents' house, which had been the home of Nicolas, was devoid of warmth or any sense of fantasy.[88] "Though I did not even know what I was missing, there was no sense of art, either a pleasant *art de vivre* or a taste for beautiful things," wrote Jean Schlumberger in his memoirs, *Éveils* (Awakenings).[89]

It is not surprising that their maternal family, and the Val-Richer, captured their imaginations. The world created by Guizot's daughter Henriette de Witt was as enchanting to the young Schlumberger clan as Alsace was dark and gray. "We felt that we were loved there; our arrival was a party for the entire house," wrote Dominique's uncle Jean. "The trip from Alsace to the Calvados was always the event of the year. We crossed the frontier with France in the middle of the night as French customs officers surged through the carriage, waving their lanterns like angels at the gates of heaven."[90]

RETURN TO FRANCE

There was a family tradition of continuity, idealism,
and engagement.
—DOMINIQUE DE MENIL[1]

In 1893, when he was fifteen years old, the age required to enroll for German military service, Conrad Schlumberger left Alsace for Paris, joining his older brother, Jean, who had emigrated the year before. His parents and his other siblings stayed in Guebwiller. One at a time, as the boys turned fifteen, they moved on their own to France. In 1901, when the youngest son, Maurice, hit the age limit, Paul, Marguerite, and their daughter, Pauline, left Alsace. Why wait, instead of moving everyone with the first child? "Money, of course," said Odile de Rouville, the daughter of Maurice, noting the time it took for Paul to negotiate his exit from the family firm. "The Germans tried to keep these industrialists as long as possible; they were part of the riches of Alsace. So they made it difficult to leave and discouraged lots of back-and-forth between France and Alsace."[2]

Conrad moved into his grandparents' apartments on the rue la Boétie, in the Faubourg St.-Honoré.[3] His schooling was overseen by his grandfather Conrad de Witt and his grandmother Henriette Guizot de Witt.[4] As the boys settled in Paris, the character of Guizot was still very much alive, especially in Henriette. "She had a very natural way, which really impressed us, of saying things like 'More than once, my father criticized the king for . . . ,'" Dominique's uncle Jean remembered. "And woe to anyone not convinced by her supreme argument, 'My father felt that . . .' One night at the dinner table, her nephew François de Witt made a comment somewhat disrespectful of Guizot. She drew herself up, terrifyingly, and let out a cry, '*Monster!*'"[5]

In Paris, young Conrad was able to focus on his education. There were no distractions—no music, no light reading—just some fencing and bicycling in order to maintain his physical condition. He studied first at the prestigious Lycée Condorcet, then at the Lycée St.-Louis, the intensely competitive institution on the Left Bank where the most promising French stu-

dents were prepared for higher education.[6] He was at the head of his class in both institutions.[7] "He soon gained admission to the great engineering school, the École Polytechnique. After his first year, Conrad was fifth in his class."[8] When he graduated in 1900, he was second.[9]

Following his military service as a second lieutenant at Rueil, on the outskirts of Paris, Conrad entered the École des Mines de Paris as a student with the National Mining Corps. He and some of his classmates took a trip around the world, but even that was an occasion to work: he used it as a study trip focusing on the United States and Japan.[10] Returning to France, Conrad became a Mining Corps engineer in the mountain town of Rodez and then in Toulouse. He taught physics at the École des Mines in St.-Étienne, southwest of Lyon, for one year, before moving back to the French capital to join the faculty at the École des Mines de Paris.[11]

•

In 1904, Conrad married Louise Delpech (1883–1976), a very self-assured young woman from another historic Protestant family.[12] Louise, or Madame Conrad as she became known, was from Clairac, a small town in the Lot-et-Garonne in southwestern France, midway between Bordeaux and Toulouse. Louise was quite beautiful, with a full face, strong cheekbones, and dark hair swept up into a chignon. She was also very elegant, in her pale-colored, corseted dresses of the belle epoque (a collection of her antique lace and historic gowns was later given to the Musée des Arts Décoratifs in Paris).[13]

Louise was the eldest child of Henriette Oberkampf de Dabrun and Édouard Delpech. Her mother was from a line that began in the German town of Wittenberg; her father, with whom she was quite close, was Baron Émile Oberkampf

Jean and Conrad Schlumberger, the two eldest brothers, were the first of their siblings to leave Alsace for Paris.

de Dabrun, who lived in a splendid seventeenth-century château in the Dordogne; family descendants had created the renowned printed fabric toile de Jouy.[14] Louise's paternal grandfather was the former mayor of Clairac, while her grandmother Clémence de Suriray de la Rue hailed from an aristocratic family in Normandy.[15] Louise's father, Édouard Delpech, was quite rich, his family inheritance supplemented by income from land and property in nearby Bordeaux.[16]

Dominique's mother had been born and raised in Clairac. It was a quaint, ancient town, predominantly Protestant, of course, with the languor of a southern settlement. It was positioned on and above the banks of the Lot River, a wide tributary of the Garonne. Most of the roads were narrow, with houses built right up to the street line. Women did their washing in the river, pounding their clothes on stones and washboards. Even by the mid-twentieth century, Clairac was said to have been like walking into the Middle Ages.[17]

The Delpech family house, north of Clairac, was the Château de Roche. Located at the top of a hill, at the end of a path lined with chestnut trees and stately cedars, the property had a beautiful view that went toward the small town and over the valley of the Lot.[18]

Louise's father had acquired Roche in 1885, originally a simple, square, two-story house that dated from the early seventeenth century.[19] Two years later, just before Louise was born, her father had the house renovated and expanded, turning it into an imposing neo-Renaissance structure. He

Édouard and Henriette Delpech, Dominique's maternal grandparents, with their driver.

hired a noted architect from nearby Bordeaux, Jean Alaux.[20] The design, a three-story house in pale pink limestone with a red-tiled roof, had been inspired by a château Monsieur Delpech had seen in the Loire valley.[21] The expansive grounds of Roche also featured a tall stone fountain from the Renaissance that had been dismantled and relocated from the Oberkampf de Dabrun family château near Montignac in the Dordogne (since 2012, the fountain has been listed as a National Historic Monument).[22]

The house was imposing, with an interior that, true to the spirit of the late nineteenth century, was dark and heavy. In the grand salon, historical ancestral portraits stared down.[23] "Roche was sober but not austere," said Claire Delpech, daughter of Louise's younger brother, Jacques. Yet, regardless of the attention to aesthetics, the very Protestant Delpech family, much like the Schlumbergers, had little room for art. Louise's mother wanted to buy a painting by Gauguin, at a time when they were still affordable. Monsieur Delpech nixed the idea. "Of course not," he said. "Buying a Gauguin—what an idea!"[24]

The wedding of Louise and Conrad took place at her uncle's house in the elegant Paris suburb of Neuilly. The young couple—she was twenty-one, he was twenty-six—were striking. Louise wore a floor-length white bustle gown, with long sleeves and a high neck, adorned with antique lace. Her dark hair was pulled up in a loose chignon. His costume consisted of a double-breasted waistcoat, a formal white vest, a wing-collar shirt, and a black tie held down by a pearl pin. The newlyweds used her generous dowry to buy their apartments on the rue Las Cases, in the Faubourg St.-Germain, the most elegant, aristocratic neighborhood in Paris.[25] Henry James, in *The American,* had hero Christopher Newman discover the quartier, puzzled by its sense of concealed luxury:

> He walked across the Seine, late in the summer afternoon, and made his way through those gray and silent streets of the Faubourg St. Germain, whose houses present to the outer world a face as impassive and as suggestive of the concentration of privacy within as the blank walls of Eastern seraglios. Newman thought it a queer way for rich people to live; his ideal of grandeur was a splendid façade, diffusing its brilliancy outward too, irradiating hospitality.[26]

The Schlumberger apartments were marked on the street by a severe limestone wall, windows covered with heavy wooden shutters, and a large, discreet set of double doors. A porte cochere led to a paved interior courtyard, open to the Paris sky. Straight ahead was the entrance to the family apartments, three full floors of the building connected by marble staircases

The marriage of Louise Delpech and Conrad Schlumberger, Dominique's parents, in Neuilly-sur-Seine, 1904.

in the front and rear. The interiors were a restrained, elegant interpretation of the style of the belle epoque: polished parquet floors, dark eighteenth- and nineteenth-century furniture, and ornate ceiling moldings. In the rear, French doors exposed views of the glorious formal garden of the building next door, the Hôtel de Rochechouart, a historic monument with a manicured lawn and mature plantings including one towering plane tree, said to have been the tallest in Paris, that dated from before the French Revolution. Across the garden the three-story limestone Hôtel de Rochechouart had a classical facade with a mansard roof designed by the official architect of Louis XVI, which since 1839 had been the National Ministry of Education.[27]

Even quite young, Louise and Conrad were a mix of Calvinist austerity and charisma. "They gave a ball, Monsieur and Madame Conrad," one longtime friend recalled of a party they hosted at the rue Las Cases. "I still remember this extraordinary statue of them that was placed up on the stairway. And they were up there, greeting guests with a kind of splendor that was more reminiscent of Roman emperors than the Protestant life they led."[28]

•

Dominique Izaline Zélie Henriette Clarisse de Schlumberger, to give her full name at birth, came into the world in Paris on March 23, 1908. Her great-grandmother Henriette de Witt died the same year she was born, so, by the time she was being raised, it was Dominique's grandparents Paul Schlumberger, the grandson of a great Alsatian industrialist, and Marguerite de Witt Schlumberger, the granddaughter of Guizot, who reigned over her branch of the family.

Paul, with his three-piece tweed suits, was very much the handsome country gentleman. He had gray hair, long enough to cover his ears, that was combed back from a receding hairline, full gray eyebrows with a matching bushy mustache, and kind, smiling eyes. Marguerite had a look that managed to be both kindly and stern with her gray hair parted in the middle and swept up behind. She wore long, full skirts in dark colors and matching somber tops with three-quarters sleeves and limited her jewelry to a double strand of pearls, an occasional brooch, and her wedding ring.

Dominique's grandmother was an activist for feminism, the temperance movement, and the rehabilitation of prisoners and former prostitutes.[29] Within the family, it was said that she was *"le pasteur manqué de la famille."*[30] Her greatest wish was for at least one of her five sons to become a Protestant pastor. Marguerite was the founder and president of the Union Française pour le Suffrage des Femmes, fighting for women's right to vote. Her 1918 letter to Woodrow Wilson, thanking the president for his encouraging words on the suffrage movement, was published by *The New York Times.*[31] And Marguerite was not shy about bringing her zeal into the family. She sent a New Year's greeting to Dominique's cousin Pierre on

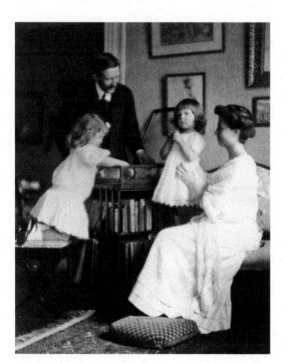

Louise and Conrad with their daughters Annette and Dominique in their apartment on the rue Las Cases.

a postcard with a series of dark-clad ladies lined up at a polling booth, one with her fist raised in the air. The caption read, "Women want to vote," while a sign declared, "Against: Alcohol, Slums, War."[32] It was a strident message to send an eight-year-old.

The strong personality of her grandmother inspired Dominique from an early age to feel that the best way to live up to the example set by her ancestors was action.[33] During one stay at the Val-Richer, Dominique, known as Dodo at the time, decided to host her own version of one of the charity sales her

grandmother often organized. So Dodo, along with her younger sister and some cousins, found newspapers and magazines that were lying around the house and cut out the most striking images. Taking plates from the kitchen, they used the bottoms of the dishes as molds for papier-mâché. They waited for the works to dry, then broke them off from the plates, creating a round sculpture that could be hung on the wall. And they sold the finished papier-mâché works to family members and the Val-Richer staff.

The girls took the proceeds and hurried off to the only café within walking distance, Chez la Mère Larcher. There, they bought caramels and barley sugar candies, wrapped in thick brown paper, that they devoured on the walk home.[34] Their grandmother sensed that something was amiss. "But, my little ones, where are the funds going from this charity sale?" Marguerite asked. "We looked at one another and said, 'Well, obviously: to us!'" The confession brought the venture to an immediate halt. "Grandmother was really shocked! She explained that it was very dishonest and that it shouldn't be done."[35]

•

By the time Dominique was growing up, all of Marguerite and Paul's children—her three uncles and one aunt—were well settled in France. Jean married Suzanne Weyher and had one son and two daughters, while Daniel wed Swiss-born Fanny de Turckheim and had one daughter, Antoinette. Pauline, the only daughter, married Albert Doll, from Mulhouse, in a ceremony at the Val-Richer. Marcel, a brilliant mechanical engineer who would become Conrad's partner in business, married Jeanne Laurans. Tall and strikingly handsome, Marcel was an intimidating presence even to his niece, Dominique's older sister.[36] Marcel had two daughters, Geneviève and Françoise, and one son, Pierre. And Maurice, who became an important private banker, married Françoise Monnier and had two daughters and three sons.[37] All of these unions were with prominent Protestant families.

Once installed in France, they turned their attention to something that had been an issue for a while: the nobiliary particle that had been granted to Jean von Schlumberger. Even translated, de Schlumberger went against the family's sense of restraint and was a change that had been foisted on everyone by the German kaiser. So they launched a legal process to eliminate the "de." "This was incredibly difficult," remembered Maurice's daughter Odile, with a laugh. "There are plenty of people who want to add a particle. But trying to have one removed became a real problem!"[38]

Out of respect for the patriarch in Alsace, they waited until he died, six months after Dominique was born. The case went all the way to the

Conseil d'État, something of the French Supreme Court, and it wasn't until September 29, 1921, and a decree from the president of France, that it was finally removed.[39]

Dominique's uncle Jean Schlumberger made a valiant, though ultimately unsuccessful, effort to fulfill his mother's hope that he become a pastor. Uncertain of what professional path to take, he was helped by his neighbor in Normandy André Gide, eight years his senior. "You are practically family," the younger man wrote to Gide.[40] Long interested in history, Jean had penned some essays for Protestant publications.[41] Once he began to pursue the idea of writing, he and Gide became closer friends. Jean showed him some poems he had written, seeking the author's advice.[42] In 1903, Jean dedicated his first book of poetry to Gide, *Poèmes des temples et des tombeaux*. Gide returned the favor by dedicating *The Pastoral Symphony* to Jean.[43] Soon, Jean was publishing essays, novels, poetry, plays, and regular columns for *Le Figaro*. The two remained close for the rest of their lives, with Jean becoming Gide's literary executor.

Together, the two writers touched off a remarkable movement. First, they founded a literary review, *La Nouvelle Revue Française*, in 1908, the same year Dominique was born. A monthly publication of literature and criticism, the *NRF* was the most important cultural journal up through World War I and in the years between the wars.[44] Its covers were simple but distinctive: cream stock with black type and "*Revue Française*" in vivid red. The *NRF* featured the best French writers of the era including Guillaume Apollinaire, Marcel Proust, Louis Aragon, Antoine de Saint-Exupéry, Romaine Rolland, Alain-Fournier, and Jean-Paul Sartre.[45] "Genius alone leads to glory, and it comes only when it's ready," declared Jean Schlumberger in the opening statement of the first issue. "But it is up to everyone to explain it, to prop it up, to surround it with an atmosphere of admiration and intelligence."[46] Jean was the founding editor, and for the first years the office address on every cover was his Paris apartment on the rue d'Assas.[47] He even designed the famous monogram for the journal, the letters *NRF*, underscored by an elegant, swooping line (since 1999, the *NRF* has been a quarterly).[48]

In 1911, Gide and Schlumberger hired a literary dandy named Gaston Gallimard and founded a book publishing house, Éditions de la Nouvelle Revue Française. By 1919, the imprint was known as Librairie Gallimard and had become the most prestigious in France (in 1961, it was renamed Éditions Gallimard). Gide and Schlumberger provided initial funding, 20,000 francs each, and all editorial decisions were shared by the two partners and Gallimard.[49] Their high standards were echoed in the design of their book covers, which were, like the *NRF*, cream with red and black type. Also

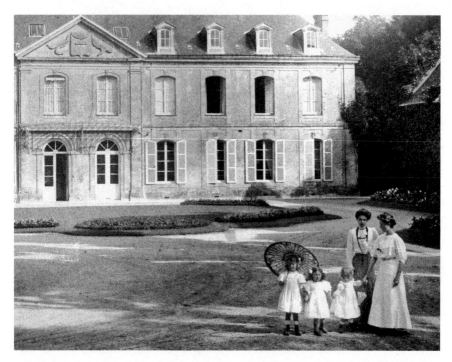

Left to right: Antoinette Schlumberger, Jacqueline Doll, Dominique Schlumberger, her aunt, Fanny Schlumberger, and her mother, Louise Schlumberger at the front of the Val-Richer.

included was Jean's *NRF* logo, underscoring the connection with the journal. Many authors appeared in both, including Gide, Jean Schlumberger, Roger Martin du Gard, and Jacques Rivière. In its first decade, Gallimard published work by Paul Claudel, Stéphane Mallarmé, and Proust (he won its first Prix Goncourt, the famous literary prize, in 1919, for his *À l'ombre des jeunes filles en fleurs,* the second volume of *À la recherche du temps perdu*). In 1929, the publisher moved into elegant offices at 5, rue Sébastien-Bottin, a small Left Bank street between the rue Montalembert and the rue de l'Université. It has since taken over most of the block (in 2011, the street was renamed the rue Gaston-Gallimard).[50]

As one recent observer noted of the house, "Gallimard still profits from the work of a master Nobel-winning literary scout, André Gide, who wrote prefaces to give newcomers a helping hand and created the best backlist in the world."[51] Gallimard authors have received thirty-five Prix Goncourt, thirty-six Nobel Prizes for Literature, and ten Pulitzer Prizes.[52] The *NRF* circle, through the monthly journal and through Gallimard, became a vital new school of French literature.

In addition to the publishing house, Jean founded, along with Gide,

Gallimard, and fellow *NRF* contributor Jacques Copeau, the Théâtre du Vieux-Colombier. The goal of this Left Bank theater, directed by Copeau, was the "renovation of the dramatic arts."[53] With its stripped-down sets and naturalist style of acting, it was a reaction against the artificial, over-wrought commercial theater in Paris. The Vieux-Colombier featured plays by contemporary writers—Gide, Schlumberger, Alfred du Musset, Paul Claudel—as well as the classics: Molière, Racine, Shakespeare, Chekhov. During World War I, the theater spent two very successful years in New York, in the Garrick Theatre on Thirty-Fifth Street. According to Albert Camus, "In the history of French theater, there are two periods: before Copeau and after Copeau."[54]

Jean Schlumberger was also active in the larger world of ideas. In 1910, he joined with philosopher and literary critic Paul Desjardins to launch the Décades de Pontigny, a series of annual retreats in an ancient abbey in Burgundy. The gatherings were held over a period of ten days and have been called "one of the greatest intellectual institutions of the 20th century."[55] There were three every year—for literature, philosophy, and religion—where a select group of academics, writers, and philosophers led discussions with an invited audience. Each had between thirty and fifty intellectuals, writers, students, and politicians from across Europe including André Malraux, Heinrich Mann, Lytton Strachey, and Saint-Exupéry.[56] Subjects included modern European literature, the existence of evil, and the place of religion in contemporary life.[57]

Eventually, cautiously, Jean Schlumberger and Gide realized that they had more in common than literature. When Gide gave the younger writer a copy of *The Immoralist,* his response was "I was moved, not by a general emotion, but very personally." In another letter, Jean wrote, "I am one who has always been interested in Oscar Wilde."[58] In January 1904, Jean and his wife joined Gide and his wife on holiday in Rome.[59] Using the coded language of the time, Gide asked the younger man, "If, by chance, you too . . ." Their halting communication led to the understanding that both were homosexual. "In the grandiose decor of antique Rome, the recipro-cal, simultaneous confession of their idiosyncrasy sealed a real alliance," wrote the editor of their massive correspondence.[60] Once asked, the elder author gave specific instructions on how to move from theory into action.[61] When it came to issues of sexuality, Gide was spectacularly indiscreet; Jean Schlumberger was the very picture of discretion.[62]

There was, soon after their shared confidence, one complication. In the fall of 1904, Gide fell in love with a man for the first time: eighteen-year-old Maurice Schlumberger, Jean's younger brother, Dominique's uncle.[63] "My

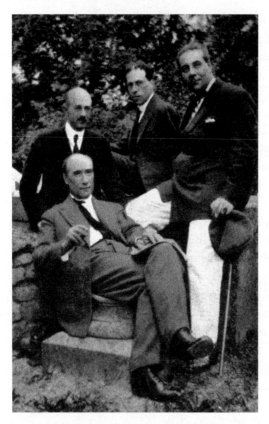

Leading figures of *La Nouvelle Revue Française*: André Gide, seated, with, from left, Jean Schlumberger, Jacques Rivière, and Roger Martin du Gard at the Décades de Pontigny in 1922.

mind is inhabited by him," Gide wrote. "From one end of the week to the other, I rush to the day when I may hope to see him again."[64] Another member of the *NRF* group, Henri Ghéon, also fell for the young man. According to Gide's biographer Alan Sheridan, "Once Ghéon had been introduced into the situation, it became, for Gide, literature." The trio copied their letters to one another, combining them in one volume to make an epistolary account of the relationship. "Yes, everything in our story is marvelous," wrote Maurice. "Every chapter, from the beginning, there's no falling-off of interest in any point."[65] By the summer, the relationship had run its course, but Maurice Schlumberger became an important inspiration for one of Gide's most compelling characters, Lafcadio, the antihero of *Les caves du Vatican*.[66]

Jean Schlumberger merged his literary world with his family life. Gide would meet with Conrad for advice on mining investments he held[67] and asked Jean to give the professor "a warm handshake from me."[68] Jean would stay at the Conrad family apartments; when Dominique was eighteen months old, Gide sent a pneumatic to the younger writer in care of the rue Las Cases.[69] And Madame Conrad and Jean became very close. When the author installed himself in Braffy, one of the outer houses at the Val-Richer, Madame Conrad would stay there. She also participated in the Décades. As Dominique grew older, she, too, became close to her uncle. She went to the retreats at Pontigny, and they wrote a book together about the life and career of her father.

Jean Schlumberger, although little read today even in France, has a

style that is as pared down and pure as a Protestant church. As his friend Marguerite Yourcenar suggested,

> There is a game of mirrors that takes place in the work of Jean Schlumberger. On first glance, his writings appear to be such beautiful rooms, perfectly arranged and stripped of all excess, filled with the bourgeois elegance of Flemish painters (which bring to mind his Dutch de Witt ancestors). And yet, the longer they are studied, the spaces reveal themselves to be steeped with the secret lives of their inhabitants, and of those who came before within the same walls, while a window left discreetly ajar, perhaps seen only as a reflection in the mirror, allows the interiors to be pierced by the outside world.[70]

Not everyone was so appreciative. When Jean Schlumberger published his first slender novel, *Le mur de verre* in 1904, it earned some of the best reviews of his career. As he described his grandfather's reaction, back in Alsace, "Delivering this once-respectable family name into the hands of journalists was not much different from dragging it toward prostitution."[71]

•

Dominique's father, Conrad, as a young physics professor was a key member of the faculty at the École des Mines de Paris, an imposing limestone building on the Jardin du Luxembourg. The institution, begun in 1783 by Louis XVI, specialized in the intersection of science and industry.[72] Conrad, with his experience in mining, geology, and physics, had a multidisciplinary background that fit in perfectly. "He was one of those who are cut out to work at the frontiers of knowledge," Dominique said of her father.[73]

Of the three Schlumberger daughters, Annette was three years older than Dominique, while Sylvie was four years younger. Annette was poised and serious, with strong cheekbones and shoulder-length light brown hair she kept pulled back. The younger Sylvie had dark blond hair cut into a bob and a knowing smile. Dominique was strong and radiant, and clearly had a favored place in the family. In photographs, her mother's arms were draped protectively around her shoulder, or she stood proudly clasping the hand of her father.

The academic year left Conrad plenty of time to pursue his own work. The entire family, mother and daughters, would spend Sundays together at the École des Mines as he conducted his experiments. The girls would explore the university galleries, with its encyclopedic displays of minerals

and rocks. As they peered up at the specimens, Dominique would taunt Annette, older but not as tall as she: "You're too little! You're too little!"

•

As a father who was an inspired professor, Conrad was eager to emphasize a formal education for Dominique. In a postcard he wrote when she was four, the earliest known written communication between them, Conrad focused on her learning. "I hear that you are eagerly awaited at school," he wrote. "Before and after, though, you still have to work hard."[74]

Having such an intellectual father established a rigorous academic mood. "I was especially interested in math and physics," Dominique remembered. "And since my father had no sons he tutored me in those areas."[75] Regular lessons from Conrad sparked a fascination with science that she would have throughout her life. His skill as an instructor and the strength of his personality, combined with her early interest and a natural aptitude, helped give her an agile, scientific mind.

Dominique's earliest education was not very inspiring. In Paris, she and her sisters had tutors who came to the house weekly (though her older sister, Annette, had a drawing instructor from a good Protestant family, Jean de Brunhoff, who went on to create Babar).[76] When visiting her mother's family in Clairac, she had lessons from the local schoolteacher and other private tutors.[77] Dominique felt the sessions were tedious. "The tutor always asked, 'Have you understood?' And I responded automatically, 'Yes, I've understood.' Because what she said was so boring, I certainly didn't want her to repeat it! So, because she never repeated anything, very little learning actually took place."[78]

Eventually, Dominique, and her younger sister, Sylvie, were sent to a school in Paris, still unusual for young girls just before and after World War I. "Conrad was very antibourgeois," said Catherine Coste, the daughter of Dominique's sister Sylvie Boissonnas. "My mother always said that it was his idea and that they were really the only ones from their social class."[79] Dominique's education began around the corner from the family apartments at the Lycée et Collège Victor Duruy, the notable school on the boulevard des Invalides. Victor Duruy was housed in the exquisite eighteenth-century Hôtel Biron. The château, built in 1727, became, in 1820, a school for wellborn girls run by the Society of the Sacred Heart. In 1905, after French leaders decreed a separation of church and state, the Hôtel Biron was confiscated by the government and prepared for demolition. It became an unofficial artists colony, its vast spaces converted into apartments and studios used by Henri Matisse, Jean Cocteau, Isadora

Duncan, Rainer Maria Rilke, and Auguste Rodin among others.[80] In October 1912, when Dominique was four, the Lycée Victor Duruy opened in the south wing of the château.[81] After World War I, at the sculptor's insistence, the entire structure became the Rodin Museum (though its vast private garden is still shared with the buildings that make up the Lycée Victor Duruy).

Dominique's memories of her time at the school were not rosy. When she first began, she was barely able to read and write. Her family often returned late from their holidays, so she was constantly playing catch-up with the other students.[82] One of her most vivid recollections was a classmate named Henri (though a girls' school, Victor Duruy had boys in the earliest classes). Henri was the only student who was even less accomplished than Dominique. When he was in class, she was safe from scorn. But when he was absent, she was singled out as lagging behind the rest of the class. So young Dominique's greatest fear was an absence by Henri.[83]

Dominique and her sisters also studied drawing, watercolor, and dance. "They were expected to learn these things," said Walter Hopps, who was one of the rare individuals to discuss with Dominique de Menil her early education. "Even though they didn't collect art, to draw and make little paintings was something that they were taught; they were gracious young ladies."[84] But between the fragmented nature of her first education and the early difficulties she had in the classroom, it is not surprising that she would be so captivated by the holidays at the Val-Richer.

•

Dominique, the sixth of Marguerite and Paul's twenty grandchildren, was the third generation to grow up at the Val-Richer. The Schlumberger girls lived in Paris on the rue Las Cases, but every summer and for major holidays throughout the year they joined their grandparents, parents, uncles, aunts, and flock of cousins at the château.

They took the train from Paris's Gare St.-Lazare to Lisieux, where someone from the Val-Richer would collect them in one of the family cars. At a time when owning cars was a rarity, the Schlumberger family managed to have quite a collection. There was a De Dion–Bouton, one of the great prewar sedans, and a Lorraine-Dietrich, with little curtains at the windows. When it finally broke down, the Lorraine-Dietrich was housed in the Val-Richer farm, in a hangar that was used to store firewood, and became an ideal place for the children to play. Dominique's uncle Jean had a blue Citroën 10CV convertible, called *Célestine;* Maurice had a gray Citroën, known as *The Lemon;* while Marcel had another 10CV that was called *Old Servant Job.* The family fleet might not have been the most reliable; Jean

Schlumberger suggested their cars were good at going down the road but it was never clear if they would make it back.[85]

Though this branch of the Schlumberger family was very serious, focused on achievement, there was also a real sense of familial devotion. One of Dominique's first memories in life, which she believed happened when she was two years old, involved her parents at the Val-Richer. In her small room on the third floor, with a window looking over the lawn, she woke up in the middle of the night, realizing that she had wet the bed. She began to cry. Her parents, hearing the commotion, checked on her. To calm their daughter, they took her back to their room. "And there I was, lying between both of them," Dominique remembered over eight decades later. "And I was overcome by an indescribable sense of happiness."[86]

The main house of the Val-Richer had been divided in such a way that each of Marguerite and Paul's children had his or her own wing. *L'aisle Conrad,* still called that today, was on the third floor of the main part of the house. *La chambre de Dominique* was a small room with a twin bed and a dormer window that looked out over the great green lawn of the château and all of the trees and hills stretching toward the horizon. Dominique's room, like the others, had a cabinet with a water basin. "In the morning and the evening, domestics would bring a pitcher of hot water with a thick towel on top so that it wouldn't get cold again," remembered Sylvie. "That's the way it was for every bourgeois family."[87]

Life at the Val-Richer required some effort. As late as the 1950s, a relative living in the United States, accustomed to the convenience of modern American life, was startled to see the old-fashioned, high-maintenance routine of the family home, where a big, jolly woman outside in the courtyard, using large buckets filled with water, spent hours scrubbing the laundry and hanging the sheets out to dry by the garage.[88] It wasn't until 1919 that the château had electricity, thanks to Paul Schlumberger. In the nineteenth century, Dominique's grandfather had installed an Alsatian stove in a corner of the main entrance, an oversize affair in dark green ceramic tile that soared up through the space and into the floors above. *Le bois alsacienne,* as the woodstove was known, was effective, but the damp Norman winters still left the château very cold.[89] The house had only one bathroom for everyone. There were often two dozen members of the family at the Val-Richer, so the lone bathroom took on a major role in the life of the house. Water was heated on enormous stoves in the large kitchen, carried upstairs, and stored in the bathroom's big circular reservoir. In order to conserve hot water, several of the children always bathed together.[90]

But life at the château, from a child's point of view, was mostly about having fun. The farm had ducks and pigs and cows; swans floated about

the lake; the number of paths to explore was practically unlimited—all this was enchanting for a youngster. "We used to climb trees all the time and try to get as high as possible," remembered one Schlumberger daughter. "And we lived in the garden—*le potager*—with fruits and vegetables. During June, we ate cherries all day long. Then there were peaches, apricots, and strawberries. We were like wild kids."[91]

On the grounds of the Val-Richer, family picnics were held for the children. There were rounds of croquet on the lawn and afternoons of tennis on the courts. Because rain did not drain properly off the courts, Dominique would siphon off the water with a kitchen ladle and a pot.[92] One afternoon in the forest, her uncle Maurice made an impromptu seesaw. All of the children took turns riding it, and a young Dominique told her mother it was "extraordinarily amazing!"[93] On another of those summer days, the children organized a bike race. They rode the three and a half miles to Cambremer, up and down the rolling hills of Normandy, and back to the Val-Richer.[94]

Dominique's father had a glistening black dachshund named Nika, who was very important for Dominique and was always part of the entertainment at the Val-Richer (later, Sylvie had a chow). There was a stable near the house and all of the children rode on the property and to neighboring villages. They motored for day trips to Coup de Vent, her mother's place at the beach in Blonville-sur-Mer, where they swam, canoed, and did calisthenics. Nika lounged with the girls on the sand; Dominique and Sylvie also often brought him out in the canoe for an "ocean promenade."[95]

At the Val-Richer, the children took all their meals together. After being summoned indoors by a sequence of two ringing bells, they would head to the dining room, a long, stately space on the ground floor with fifteen-foot ceilings, two windows on the far end that looked out onto the courtyard, and four windows on the side that gave onto the front lawn. The room contained two tables—one for adults that seated twenty-five and a separate *table basse,* or children's table, that held eighteen.[96] Dominique joined her sisters and cousins there for lunch and dinner. The children, under the watchful eye of the nearby adults, were also chaperoned by some of their governesses.

The young Dominique kept a notebook recording all of her expenses, underscoring her grandparents' appreciation for value, while her grandfather, to make her time outside more productive, assigned her such jobs as trapping a variety of insects.[97] "We got more for wasps than caterpillars and cabbage butterflies," Dominique remembered. "After all, we were stung from time to time." Using a large breakfast glass to measure her harvest, she was paid five sous per glass.[98] Dominique so enjoyed the activity, and the funds that went with it, that decades later she could recount the

Dominique ready for a round of croquet at the Val-Richer.

process. "You took a plate of soapy water and put it near the wasp nest that you'd found—the wasps made holes in the ground—and you covered it all with a melon cloche," she said. "They swirled around in the cloche, and every morning and evening, when the soapy water was changed, it was thick with wasps."[99]

The Val-Richer was captivating for Dominique. She spent hours exploring the grounds, from the grand lawn that slopes away from the house to the elegant *allée des marronniers,* with its two rows of towering chestnut trees, to the thick, mysterious forest that covered much of the estate. She took long walks observing all of the wild sows and boars on the property. She played tennis on the château's red clay courts (after a long winter without playing, she was competitive enough to opt out of a game and just hit balls on her own).[100] Their days were so full that Dominique and her sisters were known not to make it down to breakfast until 10:00 a.m.—a fact that raised the eyebrows of some of their cousins.[101]

And, hovering over everything at the estate was the presence of Guizot. During those years, the family's intellectual genealogy was dominated by the great historian. "The Val-Richer," Dominique wrote: "This place of thought and culture."[102] Between lunch and dinner, family members would read aloud from a work of literature, a tradition begun by Guizot. Just walking around the château, the children were constantly exposed to his scholarly example. They were surrounded by the thousands of volumes of Guizot's leather-bound books that were spread throughout the house, his thick files of correspondence with historic figures that were stacked in his office, and, of course, the furniture, objects, and works of art that he had gathered throughout his long life.

•

From the time she was a young girl, Dominique developed a passionate interest that had little precedence in her family: the desire to collect. She was fascinated by small objects. "Children have a direct and sensual approach to art," Dominique once wrote, in notes for a 1971 exhibition she curated, *For Children*. "Colors, textures, shapes, charm them. True representation fascinates them and minute reductions of people, animals or familiar objects throw them into raptures."[103] She had a very early sensitivity to these objects, or at least some of these objects. "I had only one doll, which I broke in the midst of a bad temper, and I never had another one," Dominique said. "I had no dolls, no soldiers, no cars. But I loved things like those wonderful little objects the Japanese would make. Tiny, miniature things would enrapture me."[104]

Once she and her husband became two of the most adventurous art collectors of the twentieth century, Dominique assembled a poetic little grouping that was inspired by her philosophy about children and art. The master bedroom of their house in Houston had a simple, Spartan bed sitting under an oversize, abstract painting by Jean Dubuffet, *Texturologie III,* hung below a wooden and bronze crucifix from Africa. Between the bed and the door to the living room was a provincial Louis XV cabinet, in light beech wood with squared cabriolet legs.[105] The rectangular case, often covered by a pile of books, was easy to overlook; many who worked around the house were unaware of its contents.[106] This collection was not meant for adults; its audience was children who were visiting the house. When the books were cleared and the top opened, or a smaller drawer slid out from the center of the piece, the case revealed something magical: two compartments filled with little objects. There was a tiny box covered with miniature shells, an old ceramic ball from a Ouija board, small rattan and ivory perfume bottles, an electric-blue butterfly in a box, and an eighteenth-century Persian carving of a fish. The cases, divided into smaller compartments, contained a few fantastical seashells, several tiny starfish, and some flat white sand dollars. Artists' works—a wooden jackknife sculpture by William Christenberry or a fanciful collection of Christmas ornaments in a gift-wrapped box by Charles Eames—were paired with old coins, clear glass marbles, and one oversize gold pocket watch. A pale blue button had two hands, one black, one white, holding a dove.

The cabinet now sits in the museum housing the couple's collection, in a gallery called Witnesses, with objects that were owned by, or inspired, the surrealists. "Dominique de Menil assembled this treasure chest of sundry items to enchant young people who visited her home," reads the description from the Menil Collection. The case has been tidied up, a pair of old, wooden artists' palettes are no longer there, but its intention is clear: play-

ing with these objects was meant to stimulate the same sort of engagement that she had felt as a child.[107] "Children hate to be spoon-fed, once they can hold the spoon," she wrote. "They like to help themselves, to discover, to pick. Effort is an added pleasure."[108]

Discovery was an essential part of her interest in collecting. In Paris, she was enchanted by *les petits brocantes,* small shops filled with bric-a-brac, and would go to the local flea markets with her mother.[109] Paris was a rich environment, while the Val-Richer became a veritable *Wunderkammer.* The interior was filled with Guizot's possessions, many quite beautiful, but Dominique would scour the property in order to assemble groupings of pebbles, fossils, dead insects, and boxes of matches. She also put together a collection of Valentine's cards.[110] "I always had a passion for finding, as on a treasure hunt," Dominique said.[111]

And, quite young, she wanted to make these items her own. "What I admire I must possess," she once said with a flourish.[112] Although she regretted the drama of the phrase, it accurately summed up a feeling that she had had since childhood. On rainy days at the family home, when the cousins had to stay indoors, the children set up their version of a trading post. Any items were up for negotiation. One day, Paul Schlumberger's secretary had a fake amethyst necklace, in marbled mauve. The others remembered it as being hideous, but Dodo really wanted it. "You would have done anything for that necklace," Sylvie reminded her sister.[113]

One of her cousins at the Val-Richer, Jacqueline Doll, had an African pinecone that Dominique coveted, but Jacqueline did not want to give it up. So Dominique made a bet, something that certainly would not be done, although she underestimated her adversary. With the other girls looking on, Dodo marched out to the pasture and sat down in the middle of a cow patty. "I'm not sure Jacqueline thought that Dominique would actually do it," remembered Sylvie. "She must have been quite disappointed to have lost."[114] Dominique said, a full seventy years later, "And I still have that pinecone."[115]

For someone who had such an urge, it was not easy to learn that there were some things that were out of her grasp. "This inclination to possess small objects had been whet by early frustrations," Dominique wrote. Every winter, in the grand entrance of the Val-Richer, her grandmother Marguerite would supervise the decoration of the family Christmas tree. It was one of the large pines that had been cut down from the property's woods, carried back to the house, and then covered with Christmas gifts: small, handcrafted items such as geometric forms, miniature animals, and tiny human figures. These were the sorts of savory items that were magical for Dominique, and she had vivid memories of how they dangled from the

branches. They were not, however, for her. "We were not allowed to take any of them because the tree was to be reused the following day," Dominique wrote.[116] Trees in other French homes were filled with toys for the children; these tantalizing gifts, at the direction of her grandmother, went straight from the Schlumberger tree to a nearby home for unwed mothers.

There were other childhood disappointments as well. When she was growing up, one of Dominique's favorite moments of the day was her round of bedtime prayers. "It is one of my very first recollections, before World War I," she said. "In those days, the child, before going to bed, said a little prayer: 'God bless Daddy and Mammy and everybody.' And I loved that. One day, my father said to me, very logically and with his scientific mind, 'We don't believe, so we are not going to say those prayers anymore.' "[117] By that time, Conrad was a confirmed atheist. And he told her, "God doesn't exist. We can't speak with him. It is more honest not to pray."[118] Dominique had a vivid memory, even seven decades later, of the sting that came from his instructions. "I remember being overcome by sadness," she said. "A tremendous sadness."[119]

•

Throughout her youth, even within this family of strong figures, Dominique was a leader. Her parents took a special interest in her development; her older sister felt inferior to her, while her younger sister looked to her for inspiration.[120] Other children, when they were playing on the nearby Norman beaches, would dare her to eat *puces de mer,* the little sand hoppers that scurried about the coastline. "They tasted like grasshoppers," Dominique remembered. "The problem was that, because everyone so enjoyed it, they would want me to eat more, so it became a bit of a bore."[121] Dominique's parents sensed that she had a certain amount of boldness, and they seemed intent on encouraging it.

There was one incident Dominique remembered that was telling.[122] Conrad, his wife, Louise, and their three daughters would regularly drive through the countryside around the Val-Richer, to and from the coastal towns of Normandy. It was a time, before World War I, when cars were not equipped with headlights. Once the sun began to slip below the horizon, her father came up with a solution. It was a clever, if startling, idea. He gave young Dominique a lantern and strapped her to the fender. As they drove slowly along the quiet country roads, she stood at the front of the car, shining a light into the dark, illuminating, for her and for her family, the way forward.[123]

FIVE

FOREIGN AFFAIRS

Life is too short to forgive much lack of discipline. You have to choose a goal and focus on it—or be a failure.
—CONRAD SCHLUMBERGER[1]

During one of those long, joyful summers at the Val-Richer, when Dominique was six years old, a series of events took place that were seared into her memory for the rest of her life. On June 28, 1914, Archduke Franz Ferdinand of Austria was assassinated in Sarajevo. On July 31, Russia announced a full mobilization, which earned a quick ultimatum from Germany. France, allied with Russia and still seething over the annexation of Alsace four decades before, seemed poised for conflict. "As the hours drew out on 31 July—the twelve demanded for a response from Russia, the eighteen demanded from France—only a hair's breadth kept the potential combatants apart," wrote historian John Keegan.[2]

The following afternoon at the Val-Richer, the family, like the rest of France, waited. Letters and newspapers arriving from Paris increased the pressure.[3] Within the family, there was much at stake. All five brothers, between twenty-eight and thirty-seven years old, could be considered of military age. And they all would be personally affected by another clash with Germany, given that much of their family, back in Alsace, would be fighting for the other side. "It wasn't pacifism," Jean Schlumberger said of their position on the idea of war. "It was an active humanism."[4]

Out in the Norman countryside, Marguerite and Paul, along with their children and grandchildren, were desperate for news. In the years before the telephone, regular communication was limited. So Marcel drove the family's De Dion–Bouton into nearby Lisieux. "We were all so upset as we waited for Uncle Marcel," said Dominique, almost eight decades later. "I remember the exact day, the exact hour. We had just finished our baths and suddenly heard 'The car is back!' We ran to the window above the service stairway. And, it was very striking, I remember such a sense of despair, when we heard '*C'est la guerre!*'"[5]

•

The night before, at their apartment in Paris, Conrad Schlumberger prepared for the conflict. "*Papa* is leaving for the war," he wrote to Dominique and Annette. "A war is a very sad thing, so I urge you to be nice and sweet to *Maman,* who is going to need comforting."[6] Although he had excelled at a leading military institution, L'École Polytechnique, and had become an officer during his military service, Conrad was more attracted to the ideas of the pacifist movement and belonged to a Franco-German friendship society. The moment hostilities began, however, he was back in his officer's uniform.[7] "Your father is pleased and proud to be a part of this war," he wrote to his daughters, "because in France we are defending a good cause. It is Germany that wanted a fight, so a fight they will get."[8]

A strong-willed, fiercely intelligent man, Conrad had a way of cutting through over-intellectualism, of reducing issues to their essentials. His published writings, his correspondence, even his penmanship, suggested a man of tremendous precision. The lectures he gave when Dominique was growing up were prepared with detailed notes that he archived meticulously. "Rereading these old copied pages, I am struck by their clarity," Dominique noted years later. "Each question is approached in the most concrete way possible; ideas are connected together so naturally that the reasoning flows smoothly, effortlessly."[9]

In August, Conrad reported for duty as captain of the Forty-Second Infantry Artillery Regiment of the French army. He went first to the Alpine town of Briançon, on the border with Italy, where he commanded one of the citadels built by Vauban, the renowned military engineer for Louis XIV. Captain Schlumberger was responsible for a company of some 140 men and their 155 long-range cannons. By January, his troops, which became known as the "Schlumberger heavy artillery," were positioned on the hills around St.-Mihiel, in the region of Lorraine. Conrad had pathways cleared through the wooded camp and supervised the construction of barracks, lines of communication, and observation towers. He used his scientific knowledge to determine the position of enemy batteries and to regulate the firing of his troops.[10]

In the first winter of the war, Dominique, her mother, and her sisters went to visit Conrad near the front lines. They stayed in a nearby village, in houses made available by local residents.[11] "It was very cold," Dominique remembered. "Even with bottles of hot water, we weren't able to stay warm."[12] He wanted his family to see clearly the horrors of the conflict.[13]

Like all of the other officers and soldiers, Conrad had to contend with the muddy ground around the battlefield. When Madame Conrad was in Lorraine, she extracted some of the dried muck from his boots. She then carefully placed it in a small beige envelope. "Dirt from the Forêt des

Koeurs, near St. Mihiel," Louise wrote on the front of the envelope. "Summer 1915." She wrapped the envelope in tissue paper and placed it carefully in a drawer. She kept this memento for sixty years. Only after she died was it discovered by her daughters.[14]

In January 1916, Conrad's regiment was sent to Verdun, one of the most devastating battles in the entire war. "Our encampment buildings have caught fire," Conrad wrote in a letter to Louise from an underground shelter in the midst of the battle. "Everything above us is engulfed in flames, burning all of our horses and all of my material. It is the start of the bombardment of Verdun, which, before too long, will be reduced to dust."[15]

After Verdun, Conrad was promoted to major and *chef d'escadron*.[16] The following year, he returned fully to his regiment for battles on the Somme, on the Aisne, and in Belgian Flanders. He was then assigned full-time to army headquarters at Bergues, near the Belgian border, and Breteuil-sur-Noye in the department of the Oise.

His wartime performance was exemplary. On June 15, 1915, Captain Schlumberger was awarded the Croix de Guerre, the newly created highest military honor (the following year, he was made an officer of the Legion of Honor).[17] "The citation that accompanied his Croix de Guerre mentioned the exceptional efficiency with which he organized and commanded his unit of cannoneers," Dominique noted of her father.[18]

In the midst of the conflict, she, too, had been swept up by patriotism. In the first weeks of the war, Dominique made a crayon drawing, in *bleu, blanc, rouge,* of a French fighter, most likely her father, heading off to the front.[19] When Conrad received his Croix de Guerre, Dominique had just turned seven. To congratulate him, she dictated a letter to her mother. "I promise to behave myself," Dominique told her father. "I want to see your Croix. When are you coming back? I send you a kiss, and then another one because now you have the Croix."[20]

•

During World War I, the sounds of shelling on the western front could be heard from the grounds of the Val-Richer. Braffy, the adjacent manor house, was used for wounded soldiers to convalesce. Dominique and her sisters gathered herbs around the estate to be used in ointments to soothe the injured.[21] In the nearby coastal town of Trouville-sur-Mer, the casino, a grand structure from the belle epoque, was converted into a major military hospital. Dominique's aunt Pauline, her father's only sister, and aunt Suzanne, the wife of the writer Jean Schlumberger, underwent nurses' training. They worked at Trouville's makeshift hospital, caring for the

Conrad on his first leave during World War I, taking Sylvie, Dominique, and Annette for a ride around Normandy.

wounded, where Madame Conrad also volunteered. "My mother knew nothing about nursing," noted Dominique's sister Sylvie. "But she assisted doctors who performed amputations and attended to very serious wounds without flinching at all."[22]

When Conrad first left for the war, Dominique stayed with her family at the Val-Richer.[23] Because of the complications between Dominique's mother and her mother-in-law Marguerite de Witt Schlumberger, that steely descendant of Guizot, Madame Conrad rented a villa at Houlgate. Moving to the charming resort town on the coast, about fifteen miles from the Val-Richer, allowed Louise to be near her in-laws but not too close. When Conrad had his first leave during the war, he stayed with his family at Houlgate. He hired a small horse-drawn carriage and took everyone for rides on the country roads around coastal Normandy.[24]

•

Conrad's initial enthusiasm for the war soon faded. His military citation announcing his Croix de Guerre was effusive: "A very distinguished officer—unrivaled, indefatigable, dynamic—showing complete dedication at all times." Conrad viewed the award with skepticism. "Such grandilo-

quence certainly feels good," he wrote to Louise. "But the next citation would have to go even further. I suggest, 'An officer so remarkable that Napoleon, by comparison, was nothing more than a Pygmy!' "[25]

His older brother, Jean, also contributed to the French effort, while his younger brother Marcel was, like Conrad, a highly esteemed officer who was awarded the Légion d'Honneur.[26] But the family did not make it through the conflict unscathed. Daniel Schlumberger, born a year after Conrad, was the closest in age to Dominique's father. Of the five brothers, he was the only one who seemed to share their mother's interest in religion. Like his brothers, Daniel served on the front. On June 18, 1915, while he was in Paris, Daniel killed himself. Had he deserted? Was he overwhelmed by the family pressure to be a tremendous success? Had he felt the strain of fighting with Alsatian family and friends on the other side?

Suicide was so shameful that it was little discussed. In the official French publication honoring the war dead, Daniel was listed with two relatives, Christian and Raymond Schlumberger, brothers who died in combat and received posthumous military decorations. The entries for the brothers were extensive and vainglorious, while the text on Dominique's uncle did not include his rank, date of death, or place of death. "Daniel Schlumberger," it read in full, "married to Mademoiselle Fanny de Turckheim."[27] If his death was surrounded by silence, its cost was clear: Conrad's closest sibling was dead at the age of thirty-five, leaving a thirty-four-year-old widow and a seven-year-old daughter, Antoinette, one of Dominique's favorite cousins.[28]

By the following February, Conrad was fully against the conflict. "Starting to find the war an absurdity," he wrote in his journal.[29] By the final year of the war, he was convinced that the military and political leadership of France was hopeless.[30] "As the war dragged on, Conrad Schlumberger witnessed more and more atrocities," Dominique later explained. "He read the letters found on German soldiers who had been killed—so similar to the letters received by French soldiers—and he saw no purpose in prolonging a murderous conflict. Reconquering Alsace was not enough of a motive."[31]

Conrad Schlumberger, a decorated war hero, had become a pacifist. In the midst of the fighting, Conrad began writing a text that would lay out his beliefs. He had been a backer of *L'Humanité,* the Socialist newspaper that later became Communist. During the war, however, he found the paper too patriotic and "dull." He asked his wife to send the *Journal du Peuple,* a union publication, to have a sense how the far left was responding to the conflict.[32] As the fighting came to an end, Conrad concentrated on his text on pacifism. His final wartime post was in Strasbourg, overseeing Alsatian mines, mostly potash, for the French military.[33]

He then left the army to devote himself entirely to the completion and publication of his treatise on world peace, which he titled "Our Wrongs, Our Responsibilities."[34] He also planned to resign from the faculty of the École des Mines.[35] His family, of course, was opposed. His brother Marcel discouraged publication.[36] His father, Paul, felt that such a move in the midst of the postwar patriotism would be a kind of suicide. Paul was able to persuade his son to drop the idea. Within a year of the end of hostilities, in November 1919, after a five-year wartime hiatus, Conrad Schlumberger returned, reluctantly, to teaching at the university.[37]

•

There was another important factor that influenced his decision. In the years between his marriage and the outbreak of war, Conrad had begun to pursue an intellectual exercise.

The end of the nineteenth century and beginning of the twentieth was an era of remarkable scientific innovation and experimentation in France. Louis Pasteur, of course, was the legendary chemist and microbiologist responsible for such advances as pasteurization and vaccination, while Marie and Pierre Curie shared the 1903 Nobel Prize in Physics for their work in radioactivity. There were many others, including Henri Poincaré, the mathematician and physicist, Marcellin Berthelot, considered one of the most accomplished chemists of all time, and Henri Becquerel, credited with the discovery of radioactivity.[38]

It was also an era when electricity was the big idea. Georg Ohm had identified the laws of electrical currents in 1827, while Heinrich Hertz discovered electromagnetic waves in 1888. In the last two decades of the nineteenth century, the first twenty years of Conrad Schlumberger's life, Alexander Graham Bell invented the telephone (1876), Thomas Edison invented the phonograph (1877) and the lightbulb (1879), Wilhelm Röntgen discovered X-rays, and Guglielmo Marconi successfully completed the first wireless telegraph transmission (1896).[39]

The Exposition Universelle of 1900, a world's fair held in Paris, was dominated by the Palais de l'Électricité, an astonishing rococo structure built on the Champ de Mars behind the Eiffel Tower. It was a monumental building, over 1,300 feet wide and 220 feet high, crowned by a 20-foot-tall, brightly lit star. Electrical-powered fountains shot water into the sky. Some six thousand lights lit the entire ensemble.[40] Its intent: to capture the magic of the new energy. "What is Electricity?" asked writer Paul Morand, after his visit. "It is progress, poetry for the working class and for the rich; it is the great Signal; it is the religion of 1900."[41]

On November 5, 1906, Marie Curie was the first woman to lecture at the Sorbonne (her husband had died earlier that year when, lost in thought, he wandered into traffic on the rue Dauphine and was struck by a carriage). "When one considers the progress of physics in the past decade," said Madame Curie, "one is surprised by the changes it has produced in our ideas about electricity and about matter."[42]

It was within this intellectual environment that Professor Schlumberger sensed a scientific application for the new technology. He felt that electrical current could be used to unlock geological secrets, that it could be used for the detection of minerals.

When Dominique was still a toddler, her father focused on his hunch. Deep in the basement of the university, Conrad would be bent over wooden crates filled with sand and wires, connected to a black box. He wore clunky earphones that connected to the device, called a "potentiometer." Mother and daughters would sit quietly with him in the basement as he worked. Madame Conrad was seated with her legs crossed, her foot rotating like a prayer wheel.[43]

One Sunday in 1911, when Dominique was only three, the university basement was the setting for a key event in the development of what would become the family business. To further his experiments, Conrad borrowed a big copper bathtub from the family apartment and hauled it down to the school basement. He filled the tub with clay and sand and sat at his polished wooden desk with a typewriter and the black box. The *baignoire* was on the floor, some five feet long and several feet high. It curved up gently at each end with rounded rims. Conrad decided to work with the bathtub because of the heightened electrical resistivity of copper (the bath is now showcased, like a relic, in the Schlumberger Museum at the Château de Crèvecoeur, a medieval edifice not far from the Val-Richer). This old copper tub, before it turned up in the basement of the École des Mines, leading to the discovery that would revolutionize the international search for oil, was where Dominique had been given her childhood baths.

•

The following summer, 1912, during the school break at the Val-Richer, Conrad took his theories out into the real world. As he described his early work,

> Electrical prospecting belongs to a category of mixed studies built
> on tremendously varied ideas, neither fish nor fowl, displeasing to
> researchers who limit themselves, quite sensibly, to classic science.

To attack the problem, you effectively need to be an *engineer-mathematician-physicist-technician-geologist,* with a taste for experimentation in the open air.[44]

Dominique traipsed over the pastures with her father at the Val-Richer and at Clairac, helping to hold some of the long electrical cables. "His first field tests confirmed that the process could have a larger application than just the search for metallic mines," Dominique wrote. "He was able to produce a chart that showed the entire structure of the subsurface, the stratigraphic and the tectonic."[45] Conrad's idea seemed to work.

Before the war, his younger brother Marcel had been skeptical about Conrad's research. Marcel was considered the practical one, more of an "adapter" than an innovator. He had studied civil engineering at L'École Centrale des Arts et Manufactures.[46] Passionate about airplane engines, Marcel dreamed of working in aviation engineering. He listened doubtfully to the wild ideas of his older brother, often laughing at him.

Marcel Schlumberger was vigorous, athletic, and very good-looking. "Physically, he didn't resemble Conrad at all," remembered a co-worker of the two brothers. "Marcel was taller and thinner. He was, to be frank, a very handsome man—beautiful face." A heart ailment meant that Marcel was given a deferment for the war. He refused to take advantage of it. "He was one of the first military motorcyclists in France," recalled the colleague. "He was very courageous. During the early years of the war, he was one of the first to act as a liaison, driving his motorcycle to the front lines."[47]

During World War I, Conrad and Marcel met several times. They spoke about Conrad's idea of using electricity underground and its possibilities for the future.[48]

One of Conrad's inspirations was Auguste Rateau (1863–1930), a fellow professor at a mining school. Rateau had had the same education as Conrad, graduating at the head of his class at the École Polytechnique and with honors from the École des Mines de Paris. He then taught at the École des Mines in St.-Étienne, where Conrad had also been a part of the faculty. Professor Rateau started a company producing steam turbines, centrifugal pumps, and mine ventilators, turning his scientific knowledge into a business empire.[49] "That's exactly what we should be doing," Conrad told his brother.[50]

Reluctantly, Marcel decided to join forces with his sibling. From his perspective, it was a forced marriage. Marcel closed his workshop near the Bastille, where he had been trying to develop an aeronautic automatic transmission (an innovation that would be realized twenty years later). Although Marcel never regretted the partnership with his brother, he did

LEFT: Conrad experimenting with electrical surveying at the Val-Richer.

BELOW: Sylvie and Dominique assisting their father with his experiments at Clairac.

admit, according to his wife, "It is pretty sad for me to devote myself to electrical prospecting."[51]

In order to get this new venture off the ground, Conrad's father, Paul Schlumberger, decided to support his sons financially. He wanted to make sure that his sons would not feel the same paternal pressure he had to abandon a career in science.[52] Less altruistically, funding them was also a way to discourage one son from publishing ideas on world peace and divert another from the study of airplanes. Regardless of the exact motivation, Paul made a significant gesture of patronage. "Few inventions have been supported by such a strong family collaboration," noted Jean Schlumberger.[53]

On November 12, 1919, an interest-free loan of 500,000 francs was established to pursue Conrad's idea of electrical prospecting. His father authored a simple agreement:

> I undertake to supply my sons Conrad and Marcel Schlumberger with the necessary funds, not to exceed five hundred thousand francs, for research on the use of electrical measurements for the exploration of the subsurface.
>
> For their part, my sons agree not to dilute their efforts by working in other areas. This field is large enough to occupy fully their inventive genius and to explore it properly they must devote themselves entirely to it.
>
> In this undertaking, the interests of scientific research take precedence over financial ones. I will be kept informed of, and may give my opinion on, important developments and the necessary expenses required. The money given by me is my contribution to a work primarily scientific and secondarily practical.
>
> I consider this work of great importance and I am greatly interested in it. Marcel will bring to Conrad his remarkable ability as an engineer and his common sense. Conrad, on the other hand, will be the man of science. I will support them.[54]

The company they formed would be called the Société de Prospection Électrique, Procédés Schlumberger. It would be headquartered at 42, rue St. Dominique, just off the Place des Invalides. SPE was the official shorthand, but it was known within the family, and out in the field, as La Pros.

In sending Marcel his copy of the pact, Paul Schlumberger wrote, "Conrad and you complement one another very well. If you can pull in the same direction, you will certainly succeed."[55]

Conrad, from the beginning of his period of experimentation, had a sense of the importance of his idea. In 1913, after some of the earliest tests, he wrote, "We might just be in possession of a magic wand."[56]

Yet even the most exhilarating inventions can rise or fall according to timing. And it just so happened that in the same weeks that Conrad was lugging the girls' bathtub into the basement, something of great historical import was taking place. During the summer of 1911, Kaiser Wilhelm made a show of sending a German naval vessel, the *Panther,* to the Moroccan port of Agadir. For British home secretary Winston Churchill, the act was a wake-up call, an early declaration of German aggressiveness. In *The Prize: The Epic Quest for Oil, Money, and Power,* Daniel Yergin described Churchill's dilemma:

> The issue was whether to convert the British Navy to oil . . in place of coal . . . for it meant that the Navy could no longer rely on safe, secure Welsh coal, but rather would have to depend on distant and insecure oil supplies from Persia, as Iran was then known . . . There was no choice—in Churchill's words, "Mastery itself was the prize of the venture."[57]

Several years later, another British subject had an equally momentous idea. The grinding nature of World War I was clear from its earliest weeks. How to gain some kind of leverage and break this deadlock? In October 1914, Lieutenant Colonel Sir Ernest Dunlop Swinton proposed a solution to the Committee of Imperial Defence: an armored vehicle, equipped with guns, mounted on the caterpillar tracks used for farm machinery.[58] Swinton, soon a major general, called his invention the tank.[59]

Interestingly, Marcel Schlumberger also played a role in the development of the tank, from the French side. "The assault tank is something of your baby," Marcel was told by a colonel who helped direct the French effort. "Thanks to your work, the mechanical elements were fine-tuned. From the day you were involved in this new weapon, December 1917, you were eager to see them in action. You can be proud that your work allowed for the perfecting of vital elements of the Schneider, St. Chamond, Renault, and 2C tanks."[60]

Suddenly, within the span of several years, between Churchill's decision just before World War I to convert the British navy to oil and Swinton's invention of the tank that helped end the conflict, the most important resource in the world was petroleum. And Conrad Schlumberger had just come up with a scientific way to find it.

HONOR AND SACRIFICE

The world of my in-laws—their social circle, that entire
era—has been well described in many books. It was a French
military milieu that had a great sense of tradition, sacrifice,
and nobility. But it was a closed society, not really interested in
the events and ideas of the modern, outside world.
—*DOMINIQUE DE MENIL*[1]

As the guns of August plunged the Continent into conflict, Colonel Georges Menu de Menil, his wife, Madeleine, and their eight children were at home in Paris. As might be expected from a family that had served as military officers since the time of Napoleon, led by three successive generations decorated with the Legion of Honor, it was a strong-willed group, not shy about expressing ideas and opinions. Their large apartment, on the *étage noble* of an eighteenth-century building, was a place of heated discussions and spirited arguments.[2] Even compared with the rest of the family, however, Jean de Menil, the sixth child, distinguished himself early.

By the time he was ten years old, with his father and his two older brothers off in the French army, Jean began to step into his role as young master of the house. He would take his little brother, Patrice, out to play in the large garden behind their apartments. As World War I settled into its murderous stalemate, he decided that the family garden would be the perfect spot for a game of war. "Naturally, Jean was the battalion commander," Patrice mused. Inspired by the news from the western front—the Battle of the Somme was just ninety miles from Paris—Jean conceived their very own version of the conflict. Their first duty: to dig opposing trenches. Then they took small piles of mud and patted them into missiles. And they crouched down in position to lob their artillery at each other, aiming straight for the head.[3]

Whenever Jean deemed it necessary, he called for a break in hostilities, a momentary cease-fire. He then dug out some of his pocket money, gave it to his younger brother, and sent him scurrying around the corner to the neighborhood bakery. "That was part of his role as leader of the war,"

Patrice said. "To make sure his soldiers were well-nourished."[4] Even in the midst of combat, there was no reason to be deprived of something so pleasant as warm, fresh croissants; Jean de Menil would be a fighter and a bon vivant.

The family apartment was at 371, rue de Vaugirard, on the southwestern edge of the city. The former village of Vaugirard had been, since the end of the eighteenth century, a place of country retreats for notable Parisians. In a bucolic setting of vineyards and market gardens, gracious houses were set amid large, well-groomed grounds.[5] The de Menils' street ended at the Porte de Versailles, the gate that led to the royal palace. Directly adjacent to the family property was the Collège de l'Immaculée Conception, the well-tended grounds of one of the most respected Jesuit schools in France. Down the street toward Paris was the Église St.-Lambert, a neo-Gothic parish church in light limestone with a tall, slender spire; this was the Roman Catholic church where the de Menil family regularly attended Mass.

To access the family apartment, a large wrought-iron gate flanked by two small buildings on either side led to a courtyard covered with Belgian paving stones. To the left was an enormous catalpa tree.[6] The main build-

The de Menil apartment at rue de Vaugirard, Paris; standing left to right: Jean, Marcel, Emmanuel, and Patrice on lap of Georges, July 1917.

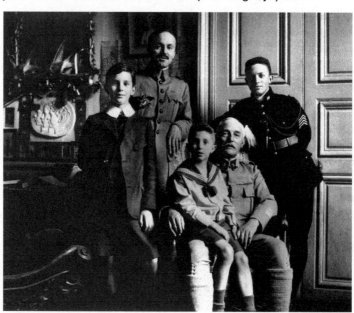

ing was at the back of the courtyard. The de Menil apartment, up one flight of a curved wooden staircase, was a spacious twenty-one-hundred-square-foot domain that had been carved out of the formal reception rooms of the former country pavilion.[7] It had high ceilings and ancient, burnished wood floors in eighteenth-century *parquet de Versailles*.[8] There were carved marble fireplaces in all the major rooms and double doors of thick, carved oak. The well-proportioned spaces were crowded with heavy, upholstered armchairs and ottomans, oversize, somber armoires and bookcases, and embroidered area rugs. All dark and conventional, it also had a certain elegance.[9] "The house was very beautiful," remembers Bénédicte Pesle, Jean de Menil's niece. "It was a bit of a ruin—and it became progressively more run-down over the years—but it was very beautiful."[10]

One of the most striking features was the garden behind the house, larger than an acre,[11] that ran to the next street.[12] Surrounded by tall walls, with ivy crawling up them, the garden was filled with tall shade trees, primarily chestnuts.[13] The ground was covered, in patches, with thick grass.[14] In the center was a large fish pond.[15] Looking out of their apartment's oversize windows, the family saw their private *jardin,* a second one on an adjacent property, and then, in the distance, a third that was on the grounds of a hospital.[16] The succession of green space made for a pastoral view that stretched off for close to a mile in the distance.[17]

Like the other settlements on the edge of Paris, notably Montmartre and Belleville, Vaugirard retained the feel of a village. Every morning, the colonel had his horses brought over from his nearby garrison. From inside the house, the children were delighted to hear the sound of mooing cows from a neighboring milk farm.[18] Jean, although it was surprising for someone who would become so urbane, was sensitive to the rustic environment. At a very young age, he was interested in the outdoors and the country. One of his earliest goals was going to college to study agriculture. *Bauer,* his family called him teasingly; German for "peasant."[19]

Jean took a protective role with his siblings. His final years of high school were at the Collège Stanislas, a prestigious Catholic school.[20] His brother Patrice, five years his junior, was also at Stanislas (as their older brothers had been before them).[21] Jean would prop Patrice up on the frame of his bike and head down the rue de Vaugirard to the school's famous campus on the rue Notre-Dame-des-Champs, peddling the two miles there and then back. "He was a big *première* and I was a little *sixième* but he took care of me," Patrice remembered.[22]

Jean lived on the rue de Vaugirard from the age of seven until, almost twenty years later, he fell in love with and married Dominique Schlumberger. He was always dressed immaculately, in well-tailored jackets and

trousers, projecting a sense of responsibility. One morning, at the start of his career, Jean was in a rush to leave for the bank. Shining his shoes was one of his early rituals. He was pressed for time, so he asked his younger brother to do the honors. Though a sign of trust, the request did not come without expectations. To hurry, Patrice concentrated on the leather uppers, skimping on the lowest edge, around the sole of the shoe. When Jean saw what was happening, he called his brother on it. "You're just going to get them dirty again," Patrice said. "What do you mean," Jean snapped. *"That's the most important part!"*[23]

•

That same sense of mission and militaristic intensity could be found in his great-grandfather Paul-Alexis-Joseph Menu, the first Baron de Menil (1764–1834). For almost a quarter of a century, Paul-Alexis was a driven army officer on the revolutionary and Napoleonic battlefields throughout Europe.[24] He served in the infantry, working his way up to the rank of colonel, one of 1,574 to serve under Napoleon.[25] "Colonel Menu de Menil marched his men into historic battles from the arid mountains of Spain to the frozen tundra of Russia. Awarded the title of Baron of the Empire by Napoleon, one of only 556 colonels to be so honored, he was still fighting a full two weeks after the Battle of Waterloo."[26]

Paul-Alexis was born and raised in Douai, in the north of France, part of an affluent, bourgeois family. Both his grandfather Jean-Paul-Claude (born 1696) and his father, Antoine-Joseph (1733–1812), had been *maître bateliers,* or master boatmen.[27] The family owned a fleet of boats used on the canals that crisscrossed the region.[28] His mother, Marie-Noelle Desmoulin (1740–1773), having given birth to five children, died when Paul-Alexis was nine. At the height of the Revolution, in 1791, when he was twenty-seven years old, Paul-Alexis married Marie-Albertine Bruneau (who died within a few years and about whom little is known).[29]

His military calling began in the summer of 1792, when he was twenty-eight, as revolutionary France prepared for war with Austria and Prussia. He joined as a sergeant major with the Second Battalion,[30] one of 300,000 volunteers.[31] By February, he and his infantry contingent were sent from Douai to Bruges[32] and then into Holland with the Army of the North, under Generals Dumouriez and Custine.[33] He was named captain in his second year of service.[34]

Captain Menu became part of one of the most significant, sustained, and difficult military migrations in history. For the next decade, he commanded the Forty-Sixth Half-Brigade of Line. He was part of the Army of

the West, under General Lazare Hoche, the Army of the Rhine-Moselle, led by General Pierre Augereau, and the Army of the Rhine, under General Victor Moreau, and the Army of England, led by Napoleon, who christened the force *la Grande Armée.*

Paul-Alexis achieved an impressive advancement through the officer ranks. His achievements, like those of many other members of the officer corps, had a sense of urgency. That was intentional, for Napoleon had decided that was the key to motivating his forces. "Just like their ancestors the Gauls, they are proud but rather shallow," Napoleon said of the French. "There is really only one idea that matters to them: honor. That feeling, therefore, must be heightened; they need accolades, marks of distinction!"[35]

By 1804, Captain Menu was made a chevalier of the Legion of Honor, the merit order initiated by Napoleon. The Legion marked outstanding service to the French Republic.[36] By 1805, there were over eleven thousand honorees, almost 90 percent of whom were members of the military.[37]

The following year, forty-one-year-old Captain Menu entered into his second marriage, with Madeleine-Eléonore Martinet (1778–1854). She was twenty-seven and from a grand family of the ancien régime.[38] In addition to her background and apparent wealth, Madeleine-Eléonore was considered very attractive. She had large eyes, pale skin, and dark hair that ringed her face.[39] Jean's father always called her "my beautiful grandmother."[40]

Napoleon was enthusiastic about his men marrying members of the former aristocracy (and he took great care to marry each of his brothers and sisters into the great aristocratic ruling families of Europe).[41] Just after Paul-Alexis and Madeleine-Eléonore were wed, a new regulation gave officers the right to marry only if the bride had an income of 600 francs and was from an honorable family.[42] In 1810, a startling directive was sent to prefects across the empire demanding the full name, family background, age, physical attributes, fortune, and size of dowry for every single aristocratic girl in the nation; the lists were being made to arrange marriages for his officers,[43] a scheme that has been called the *conscription dorée,* or gilded draft.[44]

Madeleine-Eléonore was from Boulogne-sur-Mer, in the Pas de Calais. Her grandfather Jean-Jacques Martinet held the ancient title of *écuyer* and was a noted engineer and architect to Louis XV.[45] Her father, Jean-Charles, also *écuyer,* held a variety of administrative positions for the royal court and owned a large town house in Boulogne as well as a château in the country. During the Terror, her father was arrested for being an "ex-aristocrat." On June 7, 1794, he was guillotined. Within weeks, his brother and sister were also beheaded.[46]

On February 6, 1805, nine years after the execution of most of her fam-

ily, Madeleine-Eléonore married Captain Menu. The couple lived in a large country house that he had acquired outside Boulogne-sur-Mer.[47] The stone structure, the Château Campigneulles-les-Grandes, dating from the seventeenth century, belonged to Paul-Alexis and his family for decades.[48]

In 1807, during Napoleon's conquest of Prussia, Captain Menu was at the famous Battle of Eylau in Poland, considered one of the bloodiest in European history.[49] On the first long, snow-filled day, February 7, instead of surprising the enemy, thirty thousand French forces fell on a fully prepared army of sixty-seven thousand Austrians and Russians.[50] That morning, Paul-Alexis's armor successfully deflected a bullet. Later in the day, he was shot in the chest,[51] one of several thousand casualties from both sides.[52] "The countryside was covered with a dense layer of snow, pierced here and there by the dead, the wounded and debris of every kind," was an infantryman's description of the scene. "There were nothing but corpses, men dragging themselves over the ground and heartrending cries. I came away horrorstruck."[53]

Five days after Eylau, Paul-Alexis was promoted to major. By that fall, seven months later, Major Menu had recovered enough from his gunshot wound that he reenlisted. He rejoined *la Grande Armée* in Westphalia (and received 2,000 francs for his demonstration of loyalty).[54]

Shortly after the union of Paul-Alexis and Madeleine Eléonore, Napoleon, who had long believed that the revolutionary suppression of the ancien régime had been a mistake, began creating his own nobility.[55] "In making it hereditary, I am creating a monarchy," Napoleon admitted. "But I am true to the principles of the Revolution because it is not exclusionary. My titles are a sort of civic crown, earned by hard work."[56]

In December 1809, Paul-Alexis was named chevalier of the empire, the first level of the new aristocracy, one of 502 men to be ennobled that year.[57] Not surprisingly, the imperial aristocracy was heavily weighted toward the armed forces. Some 59 percent were members of the military; it has been termed "a nobility of the sword."[58] Paul-Alexis's title included an endowment.[59] The funds came from a *majorat* he was awarded in the Kingdom of Westphalia, in what is now northern Germany, lands seized by Napoleon after victory over Prussia.[60]

After Eylau, and for the next four years, Major Menu was assigned to the Army of Spain, serving in the conflict with Spain and Portugal.[61] He served under three of Napoleon's marshals, Auguste de Marmont, André Masséna, and Michel Ney. The war involved stiff resistance from regular forces as well as fierce fighting from citizens (the term "guerrilla warfare" came from this confrontation).

By 1811, Paul-Alexis was given command of the Ninety-Third Regi-

ment of Line, Army of Spain.[62] The conflict, however, had reached a stale-mate and was beginning to draw to a close (260,000 French forces would be killed in the Peninsular War).[63] "The wars in Portugal and Spain left a bitter taste of thankless struggles, endless atrocities, and inglorious con-frontations," noted one historian. "It has been a dirty war, a conflict that no one really wanted to talk about."[64]

•

While the Peninsular War was still grinding on, the emperor made the decision to attack Russia. On January 12, 1812, the minister of war ordered Major Menu to report for duty in France with the Ninety-Third Regiment of Line. By the spring, when he was given control of his regiment, Paul-Alexis was assigned to the VII Corps, under General Jean Reynier.[65]

By June, Major Menu joined over 600,000 soldiers who were gathered in eastern Poland preparing to enter the vast Russian plain. Napoleon's Army of Russia, the largest force ever assembled on the Continent, included 32,700 wagons and carts, 183,911 army horses, and 150,000 horses that had been confiscated from occupied countries, requiring a support staff of over 25,000 civilians. The conflict inspired one of the best military memoirs of all time, *Napoleon's Russian Campaign* by Philippe Paul de Ségur, as well as some of the most stirring passages of Tolstoy's *War and Peace*.

On September 7, there were 130,000 imperial forces facing 128,000 Russian forces, just outside Moscow, at the Battle of Borodino. General Reynier, Major Menu, and some 30,000 Austrian soldiers made up the right wing. The Russians eventually retreated, making Borodino, tech-nically, a French victory. It was, however, the most deadly battle of the empire.[66] French allies had 40,000 dead or wounded (the Russians closer to 50,000).[67] What remained of the *Grande Armée,* including Captain Menu, limped home (even that retreat has been termed a "Death March," with the French losing another 60,000 on the way out of Moscow).[68]

Once Paul-Alexis was back in France, his performance on the battle-field earned him greater honors: he was named an officer of the Legion of Honor, the second of five grades, and awarded the title of baron of the empire. The letters patent for the new Baron Menu de Ménil, dated Septem-ber 16, 1813, were issued from Napoleon's headquarters at the Château de St.-Cloud. They were signed by the empress Marie-Louise, in the place of Napoleon, and Prince-Arch-Chancellor Cambacérès, the emperor's trusted adviser.[69]

Paul-Alexis was one of fifteen hundred barons created during the six years of the imperial aristocracy. The new title, which coincided with his

two decades of service in the military, included a larger endowment and conferred a new coat of arms with specific heraldic symbols,[70] including a white upright sword to symbolize barons who hailed from the army.[71]

•

Several months after gaining the title of baron in September 1813, Paul-Alexis was promoted to colonel. Immediately, he was back into battle, with the 133rd Regiment of Line, Army of Germany, under General Pierre Durutte. Shortly after the Battle of Dresden, one of the last great victories for the French, Colonel de Menil was at the nearby Battle of Juterbock.[72] Seventy thousand French forces faced forty thousand Prussians, who held their own until they were joined by Russian allies. Their combined forces—70 battalions, 10,000 horses, and 150 pieces of artillery preceded by a charge of four thousand Russian and Swedish cavalry—were suddenly unleashed. The huge army advanced in columns, breaking the French lines. Over six thousand French troops were killed; five thousand taken prisoner.[73]

Colonel de Menil was wounded twice at Juterbock, in the right leg and the left shoulder, and had his horse killed out from under him. He was placed in a convoy of the wounded that was captured by the Austrians. For the next eight months, he was a prisoner of war at Weissenfels.[74] When he returned to his home in Montreuil-sur-Mer, at the beginning of May 1814, it was only three weeks after the Allies had forced Napoleon to renounce his throne. The former emperor was sent to exile in Elba; Louis XVIII was the ruler of France.[75]

That fall, Colonel de Menil was in the royal army, assigned to command the Thirty-Ninth Regiment of Line, Army of the Interior. By the start of the New Year, he was made a chevalier of the Royal and Military Order of Saint Louis.[76] It was one of the great decorations of the ancien régime that had been restored by Louis XVIII.[77]

In his full uniform, Colonel Baron de Menil was an impressive sight. He had a well-proportioned face with a strong nose, thin lips, and penetrating eyes. His sideburns extended down the side of his neck, while his dark hair was cut into a bowl and combed forward in the Napoleonic style. His uniform was topped by a dark, high-collared jacket with big brass buttons down the center and oversize gold epaulets with fringe hanging over the shoulders. Pinned on his left chest, dangling from two red ribbons, were a pair of military medals. His gilded Officer of the Legion of Honor was a five-armed Maltese cross with a profile of Napoleon in the center and surmounted by an imperial crown.[78] The Order of Saint Louis was an eight-sided cross, surrounded by fleurs-de-lis, with an effigy of Saint Louis in the

center.[79] Managing to be both imperialist and royalist, he was a nineteenth-century French military officer to his core.

·

When Napoleon returned from Elba in the spring of 1815, fighting his way back to Paris, the king fled the country and Colonel de Menil reenlisted. He joined the Army of the Rhine, under General Jean Rapp,[80] until Napoleon's Hundred Days came to its abrupt conclusion on June 18, when French forces lost decisively at Waterloo.[81]

Earlier in June, the Austrians had launched an aggressive offensive from the east, over the Alps and across the Rhine, in order to ensure that the French Empire was actually finished.[82] On June 29, 1815, Colonel de Menil and his men were still fighting to hold the eastern border. By September, following twenty-three years of military service including a full twenty years in the midst of campaigns, he retired to his house near Montreuil-sur-Mer.[83]

Fifteen years later, at the start of the reign of Louis Philippe in 1830, Colonel Baron Menu de Menil requested, at the age of sixty-six, to return to active duty. The old soldier was denied. Within four years, on December 30, 1834, Paul-Alexis was dead.[84] He was buried at his property in Mauvaisville, in the cemetery next to St.-Martin-des-Champs.[85]

·

Paul-Alexis and Madeleine-Eléonore had three daughters and one son, Antoine Menu de Menil (1812–1864), the grandfather of Jean de Menil. Antoine, the second Baron de Menil, was born in Besançon, the fortified, military settlement in the east of France.[86]

Antoine went to university in Paris, at the École Polytechnique. He then completed his education at another of the great French universities, the École Nationale des Ponts et Chaussées (a literal translation would be the National School of Bridges and Highways). Since its founding in 1747, Ponts et Chaussées had been one of the leading engineering schools in the world. Graduates were entered into a national organization, the Corps des Ponts et Chaussées, the team of engineers and civil engineers responsible for building the infrastructure of the country.[87]

After graduation, Antoine was assigned to the Finistère department in the region of Brittany. Initially, he built lighthouses along the rugged Breton coast. Then he went to the port city of Brest, where he was the engineer of an ambitious new shipyard. He designed three enormous halls, 16 meters

wide and 160 meters long, of limestone, steel, and glass.[88] The complex included a series of ateliers, bridges, and railroad terminals. Construction required ten years and cost 6 million francs.[89] "They are excellent examples of the technical perfection of the Industrial Revolution," noted one cultural historian.[90] Due to his work on the port, Antoine was named, at thirty-two, chevalier of the Legion of Honor.[91]

Ten years into his marriage, Antoine's wife, Emilie Riou-Kerhallet, and their two daughters, died in an epidemic in a nearby village.[92] Three years later, he married Marie-Thérèse Martinet (1832–1881), making it the second time that the families were connected.

After a series of assignments across northwestern France, Antoine was named engineer in charge of Poitiers, south of the Loire valley. Within several years, his responsibilities also included nearby Niort, where he was working on the navigation of the Sèvre River.[93] It was in the peaceful, historic town of Niort, on July 21, 1864, that Antoine died, only fifty-two years old.[94]

•

Antoine and Marie-Thérèse had two boys, Félicien (1860–1930) and Georges (1863–1947), the father of Jean de Menil. Georges was born in Poitiers, on April 20, 1863, in the family's house at 10, rue St.-Hilaire. From a young age, Georges had a strong personality and a sharp tongue. He once told a boarding school priest, "I'm not going to be staying here anyway and if you keep bugging me, I'll go spend the night in a brothel!"[95]

The formative event in his early life was the Franco-Prussian War, which happened when he was seven. Struck by the quick defeat of the French and the ensuing chaos in Paris, Georges decided that he wanted to become an army officer.[96] After early studies in Paris at an important Jesuit institution, the École St.-Geneviève on the rue des Postes, Georges completed his education at the École Spéciale Militaire de St.-Cyr, the leading French school for military officers, founded by Napoleon, near Versailles.[97] On graduation from St.-Cyr in 1884, Georges was in the top quarter of his class. Just twenty-two when he began his military career in the cavalry, he didn't retire until the 1920s, four and a half decades later.

Good-looking with a well-groomed gray mustache and kind gray eyes,[98] Georges de Menil in his uniform of high, dark leather riding boots, light jodhpurs with double stripes down the side, a dark jacket covered with medals, and a full riding cape, cut an impressive figure.[99] By the time he retired, he had attained the rank of colonel, earned numerous citations for bravery in action, and was named commander of the Legion of Honor.[100]

Because his father died when he was only one year old, and his mother when he was seventeen, Georges was raised primarily by his grandmother Martinet, in Douai,[101] and his maternal uncle, Augustin Martinet (1829–1893), a prosecutor and magistrate.[102]

Georges was also taken up by a great friend of his father's, Jean Baptiste Louis Marcellin Rougier (1823–1901), who, for over twenty-five years, was the general director of the Compagnie du Chemin de Fer de Paris à Orléans,[103] one of the six great private railroads in France.[104] When Georges went to school in Paris and at St.-Cyr, Monsieur Rougier was his local guardian.[105]

Jean Baptiste Louis Marcellin Rougier was born in Aix-en-Provence, part of a prosperous local family. His father was a leading jurist in Aix. He grew up just outside town in the Château Simone, a palatial house and vineyard looking out over fields of lavender toward Mont St.-Victoire (still a noteworthy Provençal vineyard, it has been in the Rougier family since 1830).[106] After his engineering studies, Marcellin worked on the Atlantic coastal port of Sables d'Olonne, in the Vendée, helped construct roads in the southwestern department of the Lot, and built dams and reservoirs in the Pyrenees near the Spanish border. In the 1850s, he began to work on the new network of railroads being planned for France. By 1858, he took his leave from the corps to enter the private workforce.[107]

The Compagnie d'Orléans was a great railway that covered the southwest and west of France: Brittany, Touraine, the Auvergne, and the Pyrenees.[108] It was well-known for its turn-of-the-century Paris terminus, the Gare d'Orsay, the grandest train station in Paris.[109] Marcellin played such a significant role in the development of the line, and in the life of the de Menils, that he became known within the family as "Big Daddy Railroad": *Bon papa chemin de fer.*

"I am certain that Jean was much like him," said Dominique, "a great worker with tremendous physical resistance, a builder, and an organizer."[110] Marcellin was credited for such achievements as one of the country's first metallic bridges, designed by the young engineer Gustave Eiffel. Completed in 1860, the five-hundred-meter-long structure led into the St. Charles station in Bordeaux. The striking covered bridge, spanning the Garonne River, had interconnected steel trusses in the form of St. Andrew's crosses (known as the Passerelle Eiffel, it is now a national historical landmark).[111] Whenever the de Menils pulled into Bordeaux, they had a moment of silence on the bridge in memory of *Bon papa chemin de fer.*[112]

Marcellin, short and stocky—only five feet four inches[113]—with a soft face and big, bushy mustache, was undeniably charismatic and led a rich, rounded life. He had an impressive apartment on the boulevard St.-Michel,

just down from the Luxembourg Gardens, and an elegant country house in Passy, on the western outskirts of Paris. His office at the Compagnie d'Orléans was in an imposing limestone structure near the Austerlitz train station.[114] After the Siege of Paris in 1871, he was one of the first to make it into the city with supply trains.[115]

Marcellin managed to marry into a glittering clan, the d'Aboville family, twice. D'Aboville was an aristocratic name that could be traced back to 1356. When he was twenty-six, Marcellin married Caroline Regnard, whose mother was Thérèse d'Aboville. After his first wife died, he married her first cousin, Adèle d'Aboville, also known as Adélaïde.

Marcellin and Adèle's son, Stanislas (1863–1937), and daughter, Marie-Madeleine (1866–1929),[116] were born at the Rougier house in Passy. There was a family story that when the couple's daughter was born, Adèle Rougier received a letter from her friend Antoine de Menil's widow, Marie-Thérèse: "That will be a wife for my son Georges."[117] Two decades later, Georges de Menil and Madeleine Rougier were married, making Big Daddy Railroad Jean de Menil's maternal grandfather.

·

Madeleine Rougier, Jean's mother, was an active, inquisitive child. One day, her maternal grandfather read her the La Fontaine fable "The Wolf and the Lamb." General d'Aboville finished with words of consolation, saying, "Oh, the poor little lamb." Her response: "Well, there really wasn't much he could say, *Grand-papa,* he'd already been eaten!"[118]

Madeleine was of average height with a long, handsome face and light brown hair. Having lost her mother when she was seventeen, she became the close companion of her father. They read together, played music, and went to weekly concerts of classical music.[119] She actively pursued an education, earning her baccalaureate from the Collège Stanislas, a rarity for the nineteenth century.

Georges, who had known Madeleine since they were infants, was also very close to her brother, Stanislas Rougier. Even in the high-achieving atmosphere of these families, Stanislas stood out: he was top of his class at the École Polytechnique, became an artillery officer in the army, attaining the rank of general, and was named commander of the Legion of Honor.[120] On November 9, 1887, the day when twenty-four-year-old Georges de Menil married twenty-one-year-old Madeleine Rougier, Stanislas watched his younger sister being led from the church by his best friend.[121]

·

Georges and Madeleine, like many in the military, moved often. In the first years of their marriage, they lived in Madeleine's father's apartment on the boulevard St.-Michel. Over time, Georges was stationed in Rueil-Malmaison (west of Paris), Châlons-sur-Marne (in the region of Champagne), Dijon (Burgundy), and Nantes (Brittany). They led the lives typical of many military families, going horseback riding in the country, attending concerts, recitals, or local operas.

In the first decade of their marriage, they had five children, two sons and three daughters: Marcel (1889–1918), Marguerite (1890–1979), Simone (1892–1968), Mirèse (1895–1988), and Emmanuel (1897–1918). In the following years, Georges was often out of the country in conflicts in Tunisia, in Algeria, and, for more than a year, as part of the international force that responded to the Boxer Rebellion.

Shortly after he returned from China, the colonel, still in his late thirties, had a serious accident. One morning, while doing dressage, the horse struck the barrier and fell. As they hit the ground, the full weight of the animal came down on his right leg.[122] Poor medical attention and returning to service before he was fully recovered meant he would walk with a limp and use a cane for the rest of his life.[123]

Seven years after the couple's first set of children came the final three: Jean (1904–1973), Monique (1906–1998), and Patrice (1909–1989). Jean was born on January 4, 1904, a Monday, at 9:30 a.m. The birth was witnessed by his father, then a *chef d'escadrons,* his uncle Stanislas, an artillery captain assigned to the Ministry of War, and another senior officer.[124]

Jean was born in the family's new Paris apartment at 4, rue Monsieur,[125] in the Faubourg St.-Germain, near the corner of the rue de Babylone only a few blocks from the rue Las Cases, where Dominique would be born four years later. The rue Monsieur had been built in the eighteenth century by the

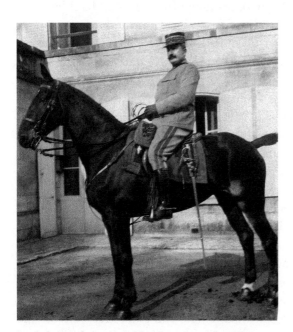

Jean's father, Georges de Menil, was a cavalry officer.

Jean, as an infant, with his mother, Madeleine, and his brother Emmanuel in the apartment on rue Monsieur before the family's reversal of fortunes.

brother of Louis XVI—known simply as Monsieur—as a path from his stables. It was a quiet street, just one block long, lined with elegant town houses and apartments.[126] A few doors down from the de Menil building was the Hôtel de Bourbon-Condé, a particularly outstanding town house completed in 1782, its exterior decorated with bas-reliefs of a children's bacchanalia that were later acquired by the Louvre and the Metropolitan Museum.[127]

Next door, in the Hôtel de Montesquiou, was a storied religious order that was very important to the de Menils: Les Bénédictines de l'Adoration Perpétuelle du Très Saint Sacrement, better known as the Benedictines of the rue Monsieur. Housed within a small nunnery, the simple, elegant chapel held services seven times per day. They included recitations of psalms in Latin along with a choir of some sixty holy sisters, dressed entirely in black and obscured behind a metal grille, singing Gregorian chants. It was a mystical, meditative experience that attracted such major artistic figures as Degas, J. K. Huysmans, Max Jacob, Alain-Fournier, Jacques Copeau, François Mauriac, Jacques Maritain, and Georges Rouault.[128]

The de Menils lived in a beautiful limestone building on the rue Monsieur, with a refined neoclassical exterior and oversize French windows. Behind was a spacious garden with chestnuts and plane trees. Across the

street was La Pagode, an architectural folly, built in 1896 by the founder of the nearby department store Le Bon Marché (from 1931 to 2015, La Pagode was a famous cinema).[129] The de Menil apartments looked directly onto the structure; it had a five-story tiered tower, a red-tiled roof, and raised corners, decorated with ornate ceramics and stained glass. They also overlooked the building's beautiful gardens; Jean's mother, even decades later, remembered the view of those grounds.[130]

The de Menil family were closely knit and often gathered in their salon, the women sewing or embroidering, while all read aloud the latest literature. They focused on popular contemporary writers—Paul Bourget and Henry Bordeaux—as well as such timeless works as Balzac's *Le père Goriot,* Zola's *Germinal,* and Stendhal's *The Red and the Black.*[131] For musical evenings at home, typically each family member was expected to learn an instrument or to train his or her voice. Madeleine played the piano, and all of the children began with that instrument.[132] One son went on to play the violin; a daughter joined the church choir; Jean learned the cello. The musical selection was classic: Beethoven, Mozart's piano trios, the Piano Quintet by Schumann.[133] They also attended concerts. There, too, their taste was restrained; they were reluctant to sample anything more adventurous than Ravel or Saint-Saëns.[134]

Madeleine de Menil, who could be incredibly strict, was a strong presence in the family.[135] And, in this profoundly Roman Catholic one, Jean's mother set the religious tone. Colonel de Menil was politically conservative and was considered a monarchist.[136] He was completely at ease in Latin, teaching the language to his children by using scripture from his Latin Bible.[137] He had a notebook with jaunty phrases such as "Intellectual bric-a-brac" and "Four ways to waste your time." He kept track of historical dates, information about composers like Mozart and Bach, and passages from Martin Luther or Shakespeare. Self-improvement was key to the colonel. He stressed the importance of having a goal in life, and Georges always told his children that they should make an effort to be positive. As he wrote in his notebook, "A good mood is power."[138]

•

That sense of optimism would be seriously tested, for, just as Jean de Menil was born, the family entered a grim period.

Three years before, in 1901, Marcellin Rougier had died. He left what remained of his sizable fortune to his son, Stanislas, and to his daughter, Madeleine. Upon his death, his heirs discovered the extent to which *Bon*

papa had been involved in a series of investments with a nephew in Aix-en-Provence, Albert Rougier (1851–1954).[139] Albert—the son of Marcellin's older brother Augustin—was a favorite nephew whom Marcellin viewed almost as a son.

According to notes taken at the time by Stanislas Rougier, Albert had found himself in financial difficulties and asked his uncle for a sizable loan. Marcellin gave him the money with the understanding that he would be repaid once profits returned. In time, additional funds were given. Although Albert began to make money in other investments, the sum was never repaid.[140]

In 1899, Albert Rougier obtained the rights to a small railroad leading to an iron mine in the eastern Pyrenees, north of Spain.[141] Marcellin checked on the viability of the plans and chose to invest. Georges also invested 180,000 francs, while Stanislas put in 25,000 francs—not inconsiderable sums. After Marcellin's death, Albert approached Stanislas and Georges. He wanted 250,000 francs to complete the railroad, claiming to have someone who would advance the funds. He needed their signatures, though, to guarantee the loan. They agreed.[142]

Then, on an almost monthly basis, Albert went back to Georges and Stanislas for additional money. When they became reluctant, he suggested that a refusal would endanger their earlier investments.[143] Eventually, Georges and Stanislas said that they would give no more. Albert decided to cash the loan guarantees they had already signed: 250,000 francs. He then went further. He forged their signatures a second time and cashed those drafts: another 250,000 francs. Remarkably, in order to avoid scandal, Georges and Stanislas paid both drafts.[144]

Even that amount, however, was not enough for Albert. By the end of 1904, the year that Jean de Menil was born, he declared bankruptcy.

By that time, Georges had lost over 800,000 francs, while his brother-in-law was out over 500,000 francs. Jean Rougier, the grandson of Stanislas and a French banker, spent years unraveling the affair. He estimated that the 1.3 million francs that were lost, taking into consideration inflation and the difference in buying power, would be the current equivalent of more than $25 million.[145] To put those figures in perspective, just over a decade later, only 500,000 francs was used to launch the company that became Schlumberger Limited.

The incident was made worse by the commercial inexperience of these two army officers. "They had the insecurities that a military man can have about an entrepreneur," Jean Rougier said. "Having been a banker for more than forty years, I can say that this was a classic situation in the field

Jean de Menil, age seven, dressed for
his first Communion.

of finance: knowing when to say
'No,' cutting off your hand to save
the body."[146]

But the affair also illustrated
the character of Jean's father. "This
bankruptcy could have caused the
imprisonment of a member of the
family," said Dominique de Menil.
"Georges did not hesitate to sacri-
fice his entire fortune even though it
was not his family; it was his wife's.
He lost everything in order to save
the family honor. It was that impor-
tant to him: *honor*."[147]

The ramifications, social and
economic, were extreme. Although
they still maintained two live-in
domestics, they were a clan that had
been rich for generations, ennobled
by Napoleon, but suddenly had to
worry about how to survive.[148] Their loss of fortune meant they became cut
off from their social class.[149] Most army officers were expected to have their
own independent incomes, and a military salary did not go very far for a
family of eight.[150] The colonel and his wife were not able to accept invita-
tions to dinner. The reason was simple: they could not afford to return the
invitation.[151]

Their lack of money was reflected in their lifestyle. After a few years
stationed in Dijon and Nantes, the family returned to Paris when Jean was
seven, moving into the apartment on the rue de Vaugirard on October 4,
1911.[152] Compared with the rue Monsieur, or Madeleine's father's apart-
ment near the Luxembourg Gardens, it was a step down. Stanislas Rougier
and his family had lived in a beautiful belle epoque building at 7, rue de la
Pompe in the 16th arrondissement.[153] After the affair, the Rougier family
lived across on the rue de Vaugirard.

The de Menils' mobility was also curtailed. Once settled in their apart-
ments, they remained there for decades (until the building was demolished
in the 1960s). Their financial hardship was such a big issue that it was a
difficult subject to discuss. Even years later, all Georges de Menil would say
was "It was a dirty business."[154]

The affair had a tremendous impact on Jean de Menil's life.[155] As he

took his first steps in life, he saw his family brought down in the world in a dramatic way.

•

The tough times were just beginning, however: on August 3, 1914, Germany declared war on France. It was the start of four years and three months of unprecedented death and destruction, a time characterized by Henry James as "the plunge of civilization into this abyss of blood and darkness."[156]

By the end of August, Colonel de Menil, who had been serving in Morocco, was back in France as a chief of staff.[157] On the first day of the conflict, Jean's eldest brother, Marcel, a tall, dashing young man of twenty-five, volunteered. By 1914, he had already served half of his two-year military service, as a sergeant in Morocco, and was just finishing his engineering degree at the École des Ponts et Chaussées. Marcel's education meant that he entered the army as an officer, second lieutenant; within two years, he was Lieutenant de Menil.[158] "He was a real heartbreaker," remembered Mirèse. "He was very good-looking, very seductive."[159]

One of Marcel's first tasks was to build the trenches on the front lines.[160] He was eager for action, however, and within six months he was in northern France and Belgium. Lieutenant de Menil was wounded twice, on his wrist and shoulder, and received a pair of citations for bravery.[161] He was assigned to aviation for six months but was disenchanted. Finally, he gained admission to the Sixth Battalion of the Chasseurs Alpins, the elite, mountainous infantry unit. "I've never been so happy in my life," he wrote to his father, "to go to battle at the head of a company of Chasseurs!"[162]

In November 1914, Jean's next eldest brother, Emmanuel, joined the army.[163] He enlisted as soon as he turned seventeen, although he looked even younger. Emmanuel was kept back from the front lines, to give him some training. As one officer wrote to his mother, "My God, madame, your son is young—so young!" When he was moved closer to the front, his father brought him onto his staff, making him a messenger.[164] Emmanuel insisted on joining the light infantry, the Twenty-Fifth Battalion of the Chasseurs à Pied, and was promoted to second lieutenant.[165]

Emmanuel, like Conrad Schlumberger, fought at the Battle of Verdun.[166] One of the longest, deadliest battles of the war, Verdun lasted from February to December 1916. Over 300,000 were killed; half a million were wounded; some 20 million shells were fired. "The shape of the landscape had been permanently altered," noted one historian. "Forests had been reduced to splinters, villages had disappeared, the surface of the ground

had been so pockmarked by explosion that shell hole overlapped shell hole and had been overlapped again."[167]

•

In July 1917, just before Bastille Day, all three of the de Menils in uniform were back in the family apartment, gathered in the salon for a photograph. The colonel was in the center, wearing cavalry jodhpurs and favoring his right leg. To his right was Marcel—several inches taller, with his dark hair, mustache, and cryptic smile. To his left, in a dark, belted uniform, was Emmanuel, with light hair and a clean-shaven face and appearing younger than nineteen.[168]

The following summer, August 1918, weeks before the end of the war, Emmanuel, aged twenty, was killed in action. He was downed at Tartiers, in the Picardy region near the Compiègne Forest. "There was an attack and he was shot," Mirèse summarized. "All that was said was that he died with a smile on his lips and a bullet right in the middle of the heart."[169]

The following month, a service was held for Emmanuel, who was posthumously awarded the Legion of Honor and the Croix de Guerre.[170] The service took place at the Benedictine Chapel on the rue Monsieur, steps away from where Emmanuel had been born and where the family had lived during happier times.[171]

The eulogy was given by Monsignor Alfred Baudrillart, noted historian, rector of the Catholic Institute of Paris, member of the French Academy, and future cardinal.[172] To the de Menil family gathered there, Monsignor Baudrillart asked, "What did you want for your son? You wanted his life to be beautiful. You wanted his life to be useful. You wanted his life to be happy. Well, God has made sure that it will be frozen forever in beauty, in splendor, in the merit of great service, and in happiness."[173]

•

Two months later, at 11:00 a.m. on November 11, 1918, the guns fell silent. Bells rang from churches across Paris. World War I was finally over. Civilians and soldiers poured onto the Champs-Élysées. For days, there was a carnival atmosphere throughout the city.[174]

As the parades and the parties wound down, a Te Deum was held at the Cathedral of Notre-Dame, a solemn ceremony marking the end of the conflict.[175] In attendance in the cathedral was the youngest son of Stanislas Rougier, Dominique, nineteen years old. Soldiers were pouring back into Paris, and when he saw the battalion of his cousin Marcel, Dominique went

to find him. Nothing. "Have you seen Lieutenant de Menil," he asked the members of the Chasseurs Alpins. The response was devastating: "He was killed eight days ago."

Dominique Rougier returned immediately to the rue de Vaugirard to tell the de Menils that their eldest son was dead. Since the loss of Emmanuel, Marcel had been sending daily cards to his mother in order to reassure her. Although the family had not received anything recently, they weren't worried. "We said to ourselves, 'Obviously, the fighting is over—it's the end of the war—he just didn't have time,'" remembered Mirèse. "We found out that he had been killed on November 4, the week before the armistice, during the attack on the Sambre Canal. He was machine-gunned—literally cut in two."[176]

The Battle of the Sambre in northern France, where English poet Wilfred Owen also died, was one of the last great Allied victories. Just four months earlier, on July 7, Marcel had been the victim of German chemical weapons, presumably mustard gas. He was back on the battlefield within six weeks.[177] As he was later memorialized: "To be hospitalized, away from the action, even after being gassed, was painful for him, knowing that his comrades were still fighting and remembering the sacrifice of his younger brother."[178]

By September 20, Lieutenant de Menil had returned to the command of his battalion. On October 18, he led a series of brilliant maneuvers at night, pursuing an enemy in retreat, taking prisoners, securing the safety of civilians. A large body of water stopped their advance; the bridges had been destroyed.

The makeshift grave of Marcel on the battlefield of the Sambre Canal, 1918.

Marcel was awarded the Chevalier of the Legion of Honor and the Croix de Guerre. According to the official army citation, "He was a magnificent officer who brilliantly enabled his company to cross the Sambre. Mortally wounded, standing on the bank of the canal under intense machine gun fire and relentless bombings, he encouraged his Chasseurs and gave them a sublime example of dedication."[179] Thanks to

the Allied efforts that day, eleven French and seventeen British divisions were able to cross the waterway, creating an advance that led directly to the armistice just one week later.

Ten days after learning of his death, the de Menils were back in the Benedictine Chapel, the somber sanctuary of meditation and Gregorian chants. The eulogy was given by L'Abbé Nicolas, the chaplain from the École Stanislas, whom Marcel, in the event of his death, had asked to officiate. The chapel, where he had been an altar boy, had particular meaning for the young man. "He was completely at home in this house of eternity, where the outside world can feel so far away," the abbot said. "He was passionate about the services here; they touched his artist's soul."

L'Abbé Nicolas spoke of Marcel's positive spirit, his infectious good humor, and his interest in helping those around him, particularly his younger brothers.[180] The two who were still alive were seated in the chapel: Jean, fourteen years old, and Patrice, nine. He told of Marcel's extreme sense of duty, whether he was wounded, exhausted, or gassed. "He had a delirious happiness that made him seem like a child, a deep sense of responsibility that turned him into a man, and an ardor of feelings that made him seem like an ancient knight. Also, with his carefree attitude and his extreme sensitivity, Marcel was not made for this world. *Pater, fiat voluntas tua.*"[181]

MONSIEUR LE BARON

I knew what hunger was.
—JEAN DE MENIL[1]

World War I was the most bitter of victories for France. Some 1.5 million soldiers had been killed, or 10.8 percent of the active population (the United States, by comparison, lost 0.2 percent).[2] The conflict left 600,000 French widows and 750,000 orphans.[3] The losses were dramatic up and down the scale, from officers to infantry. Entire generations of leaders had been decimated. As a French demographer wrote, "The death of many young intellectuals deprived the country of its creative geniuses or of distinguished talents that had not yet had the time to reveal themselves."[4]

Financially and materially, the country was in dire straits. The value of the franc plummeted, its exchange with the pound, between 1914 and 1920, dropping 70 percent.[5] Twenty thousand factories were destroyed. More than three thousand miles of railroad lines, a thousand canals, and five thousand bridges were out of commission.[6] Almost five million acres of agricultural land had been rendered useless.[7] On the western front, the level of destruction was unimaginable. "The horror and desolation of war was made visible to sight on an extraordinary scale of blasted grandeur," wrote John Maynard Keynes. "For mile after mile nothing was left. No building was habitable and no field fit for the plow. The sameness was also striking. One devastated area was exactly like another—a heap of rubble, a morass of shell-holes, and a tangle of wire."[8]

For the de Menil family, like so many of their compatriots, World War I was devastating. The colonel, a seasoned war veteran, had nightmares for the rest of his life.[9] Madeleine's hair went white. Her health deteriorated. There was a great sadness about her for the remaining eleven years of her life.[10] The rue de Vaugirard, regardless of any efforts at good cheer, was pervaded by a feel of funereal gloom.[11] Every November 11, to mark the end of the conflict, a ladder was used to climb to the top of the pillars at the entrance of their building and affix two French flags.[12] It was a mournful patriotism.

The family's very first wartime loss had occurred shortly after hostilities began, when the one-year-old child of Jean's older sister died of a sudden infection. Then came the battlefield deaths: first, the two fiancés of Jean's older sisters, followed by the son of Stanislas Rougier, and, finally, Marcel and Emmanuel. A table in the salon had photographs of the young men killed in action. Another table was reserved for the two de Menil sons.[13] As Dominique de Menil said of the deaths of Jean's two older brothers, "The family had been decapitated."

Memorial plaques for Marcel and Emmanuel were installed at the local parish, the St.-Lambert Church, where the family could grieve over them every time they went to Mass.[14] "It wasn't morbid, necessarily," recalled Jean's niece Bénédicte Pesle. "It was just the way things were."[15] The battlefield graves where the two young men were buried were marked with rough, wooden crosses. Their names, ranks, and dates of death were spelled out in dark block letters along with the phrase "Died for France." The graves were photographed, the images were sent to the family. The pair of crosses were also recovered by Jean's parents. They decided to take the planks of coarse wood and nail them to the wall of their bedroom. And there the crosses remained for decades, grim reminders of the two deaths (and have since, along with the grave photographs, been passed down within the family).[16] "These two wooden crosses were tough to take," remembered Jean's nephew.[17]

Marcel's body was exhumed from the battlefield and buried in the family tomb at the Montparnasse Cemetery.[18] The family held a belated funeral marking the transfer. During the service, the coffin, somehow, was opened, and Jean, only a teenager, was given a ghoulish sight: the decomposing remains of his older brother. More than fifty years later, he remembered the scene. Looking at a dark, somewhat ominous abstract painting at an exhibition curated by his wife, Jean said it reminded him of his brother's body; the vision was still seared on his memory.[19]

Given the de Menil history, military war heroes were particularly revered. So the specter of his two older brothers was cruel for Jean. Comparing himself with the magnetic Marcel was not a winning game. "He was the only one who made the comparison," said his sister Mirèse. "Marcel had a lot of charm, while Jean, who was short and burly, looked more like *Bon papa chemin de fer*. He also resembled our father, but he didn't have the impressive appearance of Marcel; Jean imposed himself by his personality."[20]

It was decided early that his younger brother, Patrice, would become a priest, so Jean came to be viewed as the only son. "He became the one on whom all of the future rested."[21]

•

For Jean, still only a child during World War I, life during the conflict was not entirely negative. Though he stood in long lines for coal needed for fuel and used a pushcart to haul manure necessary for the family garden, years later he remembered this as a positive, formative experience. "It was a guaranty against the deformation caused by wealth," as Jean described those times.[22]

One of the family's greatest difficulties, however, was their increasing lack of money. Friends, even relatives, distanced themselves. "There was this contempt in which we were held because we didn't have any money," said Mirèse. "We were ruined, and we were forced to fight as hard as we could just to stay alive."[23] By 1914, their financial situation had been bleak for a decade. But between the colonel's salary and those of the two sons, the family was able to get by. The deaths of the young men also meant the loss of two salaries. Colonel de Menil cashed in his pension, to try to keep his family afloat. Jean's elder sisters Simone and Mirèse went to work in factories, something unheard of in their social class.

After their fiancés were killed in action, the young women—Simone was twenty-six years old, Mirèse was twenty-three—remained single for the rest of their lives. Although the sheer volume of young Frenchmen killed during the war decreased the number of suitors for all women, that was not the main reason for their spinsterhood. In that era, within the French bourgeoisie, fortune and social status were essential. Theirs had been severely compromised. Jean Rougier, the son of their cousin Dominique, had no doubt why the women remained single. "The girls never married because they didn't have a dowry," he said flatly. "And at that time, if you didn't have a dowry, you kept your mouth shut."[24]

Their once-grand apartment became threadbare while all who knew the rue de Vaugirard remembered how cold and dark it was too, in order to save money. The family held on to a set of silver, with the de Menil crest, and a gilded eighteenth-century Boulle commode. But over the years, many heirlooms were sold. One striking example of the family's hardship could be seen in the jewelry box that had belonged to Jean's mother. Throughout their marriage, Georges had given Madeleine jewels for special occasions: anniversaries, birthdays, Christmas, and so on. Judging from his courtliness, Colonel de Menil would have chosen elegant, generous gifts. Years after their mother's death, Jean's sister Mirèse showed the case to a relative. When the box was opened, its contents were surprisingly sparse. In fact, instead of being packed with jewelry, most of the compartments were

empty. Asked about her mother's missing pieces, Mirèse was blunt: "Well, we had to eat, didn't we?"[25]

•

Contributing to the sense of isolation, and even antagonism, that surrounded the de Menil household was a political development that was a direct result of the Dreyfus affair, the highly emotional controversy over the wrongly convicted captain that split the nation. The most conservative elements of the Catholic church were determined to persecute an innocent man and provoked a crisis in the life of the Republic. Consequently, by the turn of the century, many political leaders were eager to curb the power of Roman Catholics.

So in 1904, as Jean de Menil was born, the French Chamber passed a law proclaiming the separation of church and state (ratified finally on December 11, 1905).[26] Church property was taken over by the state, Catholic schools were closed, and priests and bishops were removed from the public payroll.[27] Pope Pius X vigorously condemned the law and excommunicated every Catholic deputy who voted to pass it. The divisiveness was particularly acute in the French army. The conflict around the separation between church and state resolved itself prior to World War I, yet there were serious, long-lasting ramifications. The most momentous was to increase the ranks of antirepublican, pro-royalist Catholics. It was a movement stoked by the powerful group known as the Action Française. The group's newspaper, launched in 1908, was lively, widely read, and venomous. Its youth organization, Camelots du Roi, also founded in 1908, when Jean was four, sought to drum into French boys the group's militant message.

The founder of Action Française, and its fire-breathing leader, was Charles Maurras. A lapsed Catholic, Maurras was truly loyal toward the monarchy and the most extreme ideas and prejudices of the far right. The Action Française chief was also, it has to be said, quite a piece of work:

His hates were endless: the Revolution, the Republic, democracy, Parliament, the common people, popular education, the rights of man. He had a specially brewed venom for what he called "the four alien poisoners of the motherland": Protestants, Jews, Freemasons and naturalized foreigners, whom he cursed as *métèques*. An agnostic who once described the Christian gospels as fairy tales written by "four shabby Jews" (his anti-Semitism was notorious)

and Christianity as a religion for the rabble, Maurras would seek and receive the support of the Church and the militant Catholics.[28]

The young Jean de Menil gravitated to the circles founded by Maurras. Deeply Catholic, like his family, he considered himself a royalist. He felt that the kings of France had made the country great, and he longed for their return.[29] Jean became a member of the Action Française youth group, Camelots du Roi.

Given the noxious, increasingly violent rhetoric of the Maurras crowd—racist, antirepublican, antilabor—it might seem surprising that a young Jean de Menil would have been attracted to it. But the de Menils, devout Catholics and royalists, were also financially strained, increasingly isolated, and not shy about expressing their anger. It was fertile ground for the resentment-fueled message of Maurras.[30] "Many good Catholic families were torn to pieces at that time," said Dominique de Menil. "I can't believe it—and later Jean switched completely—but he was in Camelots du Roi, ready to break the strikes of those poor people who didn't have even a week of paid vacation."[31]

With time, relations between the Action Française and Rome became strained. On December 29, 1926, Pope Pius XI placed Maurras's books and *L'Action Française,* the newspaper, on the *Index.*[32] The papal condemnation certainly caused Jean de Menil to distance himself from the group and its leader. On January 5, 1927, the day after his twenty-third birthday, Jean signed a remarkable eleven-page, typewritten letter to Charles Maurras. It was co-written with a friend, Pierre Jean Robert. "Writing to you today are two young men, born with the new century, whom you wanted to help form and spare from miserable, terrible illusions," the letter begins. "As we chose our paths in life, becoming conscious of the ways of the world, we had just finished reading your books. You were a teacher for us, and it is in that way that we now wish to address you."[33]

The letter charged that by fighting the condemnation from Rome, Maurras was proving right those who believed he used the interests of the Catholic church to advance his own political beliefs. "We are Romans," the text announced. Maurras, by continuing to fight, was disrespecting authority, in this case a supreme authority, which he had always told them was essential. "Disobeying," the letter asked, "wasn't that the original sin?"[34]

Without the involvement of Jean de Menil and those like him who moved to the left, the Action Française groups went further to the right, siding with Franco in Spain and openly battling French leftists. In December 1932, thirty thousand members of the Camelots du Roi clashed with six thousand police and guardsmen as they battled from the Latin Quar-

ter to the Palais Bourbon, home of the National Assembly.[35] As twentieth-century historian William Shirer, who was a firsthand witness to the events of those years, wrote of the Action Française,

> It introduced a new technique of political warfare to the Right. The streets before had belonged to the Left, which had carried out revolution behind the barricades. Now the young thugs of the Camelots du Roi disputed possession of the streets with Socialists and trade unionists and with the police, the first example of the rowdy tactics of later brownshirts and blackshirts in two adjacent lands.[36]

•

For Jean de Menil, the difficult times, particularly the economic hardship, helped form some of his most notable characteristics. "He had an almost physical revulsion for mediocrity, against the acceptance of a mediocre life and, above all, against a mediocre intellectual life," said Dominique. "He could have, as many do, lived happily with very little, very simply, but everything had to be impeccable."

Early on, Jean had developed high standards, often in opposition to his surroundings. It was a pleasure when his older sister Marguerite first returned to the fold on the rue de Vaugirard with the beginnings of her new family; it became more challenging once she and her husband had eleven children. "Marguerite had all of these children and raised them, more or less, there in the house," Dominique said. "There were so many babies and baby bottles scattered everywhere, laundry drying all over the place. Jean felt crushed by all of these material difficulties, and he was determined not to accept this, not to settle into an intellectual mediocrity."[37]

He began to challenge beliefs that were commonly accepted or behavior that was conformist. As Dominique explained, "He became critical of conventional thinkers, people who had standard ideas about religion, about virtue, or those who were satisfied with a lack of thinking, a lack of deciding what was important."[38] The years immediately after the war seemed to toughen Jean, sharpen his personality. He started his career in banking and became a financial whiz, ensuring that what had happened to his father and uncle would never happen to him. His family's economic difficulties also gave him a greater sense of urgency. "Everyone had such a profound disgust for us, because we didn't have any money," said Jean's older sister. "So he decided that he would be the one to restore luster to the family name. He felt that he had to do something, create something, make something of his life."[39]

Patrice, who was ordained as a Dominican priest, believed that the pressure was motivating for Jean. "We were surrounded by pain, by sadness, by the difficulties of living," Patrice remembered. "We all felt a little run over, and Jean reacted strongly against that. It pushed him to be energetic and to rush toward the opposite, toward the revival of life."[40]

•

In the classroom, however, Jean struggled. During the war, he did have one teacher who believed in him and offered encouragement.[41] But he had a hard time applying himself and failed his baccalaureate on his first try. He might have been unable to get his degree as many as three times.[42] "A form of dyslexia called dysgraphia would probably explain why Jean had problems with the *bac*," suggested Lois de Menil. "He was doubtless slow in composition, and made mistakes. That exam rewards quick composition and accurate syntax and spelling."[43]

Her observation is borne out by comparing the handwriting of Dominique and Jean de Menil. Dominique's penmanship—though not as rigorous as her father's—was excellent. Spelling, punctuation, grammar, accents—all were without fault. Jean's handwriting was incredibly loose, often free from accents, with misspelled words and little or no punctuation. In some of their early exchanges, Dominique corrected his spelling. Particularly at a time when writing longhand was the principal means of communication, Jean's limitations were notable.

Not passing his exams was frustrating for Jean, embarrassing even. His sisters tried to help: Mirèse tutored him in French grammar and composition, while Simone gave him math lessons. On weekends, there was an instructor who came to the house, a priest who offered tutorials and tough love. "He was this fat guy named Father Chauvot," remembered a childhood friend. "Instead of helping, he yelled at him. So, obviously, Jean was traumatized."[44]

Particularly because his sisters had been forced to work, Jean decided that it was time to start making a living. His father disagreed initially but then consented.[45] Jean explained the situation simply: "I hated school, I made poor grades and there wasn't a cent in the house."[46]

At seventeen years old, he was hired by the Protestant-run Banque de l'Union Parisienne, one of the top two investment banks in France.[47] His starting position at the BUP was junior clerk,[48] or, as one friend termed it, "a grunt."[49] But he advanced rapidly, moving from department to department. "He started at the bottom of the ladder, but he had this drive to succeed, this will to one day be the chairman," said Dominique de Menil.[50]

He began to have a different take on education. "When I was slogging through school, I could see no sense to it at all," Jean said. "But after I went to work at the bank, I saw a purpose. Overnight, I changed from a mediocre student to a motivated one."[51] So, while beginning his career, he also studied to retake his baccalaureate. He worked during lunch, in the evenings, in the mornings, and on weekends. Neighbors across the courtyard at the rue de Vaugirard saw the light on in his room throughout the night and worried about his well-being. The next time Jean sat for the exam, he passed.[52]

For years, he worked to advance his career at the BUP while he continued his education. He enrolled first at the University of Paris, the Sorbonne. There, he studied law, obtaining, over time, two out of three degrees necessary to practice. Then, while continuing to work full-time, he was accepted into another important university, one of the greatest of the *grandes écoles*.[53]

In 1922, Jean entered the École Libre des Sciences Politiques, a private institution that specialized in social science, political science, and international relations. Sciences Po was established in 1872, just after the disastrous Franco-Prussian War, as a means of reformulating the political and economic leadership of the country. It was long considered "a factory for French elites."[54] Since 1882, the university had been housed in a seventeenth-century town house on the rue St.-Guillaume in St.-Germain-des-Prés. The elegant structure included a monumental stairway in light stone and black wrought iron, a large amphitheater, and a cavernous library with books stacked floor to ceiling and large wooden tables filled with studious young gentlemen in suits and ties (a handful of young women were first admitted after World War I).[55] When Jean de Menil enrolled, the school had just celebrated its fiftieth anniversary.

Jean's studies at Sciences Po included public finance, political economics, social economics, banking, and industrialization. His foreign language was English.[56] By the time he was there, he was completely dedicated to his education. In the ten days before exams, Jean would study almost all night. One sister would study with him until 1:00 a.m., and the other would take over until 4:00 a.m. He then had a quick bath and a short nap and was off to the office first thing in the morning.[57] He graduated in the summer of 1924, aged twenty. The subject of his oral examination was bank management; his degree was in private finance.[58]

It was at Sciences Po that Jean came into contact with André Siegfried, historian, sociologist, and economist.[59] Professor Siegfried was also a prolific author on a vast range of subjects including contemporary England and the United States, nineteenth-century France, and the construction of the Suez Canal. His classes were so popular that in Jean's first year at the school he outgrew the amphitheater. Students packed into the adjacent

room, where loudspeakers were installed for the spillover, and he repeated the class the following morning. Jean took two important Siegfried courses. Economic Geography focused on the industrial production of Germany, England, and the United States, and Commercial Politics looked at the trade policies of those countries as well as the Far East. "What attracted so many students was the way in which the facts were presented," noted a school historian. "His classes were real psychological studies, analyzing the souls of people from other countries. He was not a great romantic orator, but his method was so subtle, sophisticated, and bursting with intelligence that even a course that might seem dry became a delight for the mind."[60]

Professor Siegfried was very much an internationalist, a value that became important for Jean de Menil. He was fluent enough in English to have been an interpreter during World War I. Siegfried's global perspective was fueled by a trip around the world that he took when he was young, a defining event that he would help make happen for Jean.[61]

Siegfried also extolled the virtues of America, which would be such a key destination for Jean. "The United States has become its own center of gravity," Siegfried wrote.[62] An illustration for one of his Sciences Po courses showed the vast swath of prairie and forest that swept across the North American continent. The caption: "There, everything is bigger."[63]

•

The United States might have represented the future, but since 1922 France had been in the midst of a remarkable postwar reconstruction. As the British trade representative in Paris noted, "France had benefitted, for the past five years, from uninterrupted prosperity. During that time, she alone was responsible for the enormous task of reconstructing the regions that had been devastated by the war and developing her means of production."[64] This great expansion was built on a corresponding growth of credit.[65] It was not surprising, then, that a young Jean de Menil would be attracted to finance—in postwar Paris, where much of the action was—nor that this young man who was eager to make his mark would find his way to the BUP, one of the Continent's most important investment banks.

Culturally, Paris was at this time a place of astonishing innovation ("Paris was where the twentieth century was," in Gertrude Stein's famous phrase).[66] It was the place of the birth of modernism, and Jean de Menil, in his early twenties, was in the thick of it: listening to Darius Milhaud, Francis Poulenc, and Erik Satie, raving about Paul Claudel's dense play *The Tidings Brought to Mary,* going with a friend to the Bal Nègre, a famous Left Bank bar that brought the Charleston to Paris, or to the Champs-Élysées

Theatre to see the *Revue Nègre,* the legendary performances by Josephine Baker clad only in a skirt of bananas.[67]

Jean was reading the poetry of Jean Cocteau,[68] he made friends with the family of Etienne Gilson, the important Thomist philosopher,[69] and when he wasn't working or studying, he played the cello with his family, picking out Ravel's *Pavane for a Dead Princess* or the short, sparkling pieces by Satie.[70] He once took his sisters up to the hillside neighborhood of Montmartre, where a group of young people were giving a poetry reading. "It was *A Season in Hell* by Rimbaud," remembered Mirèse. "The name didn't mean anything to us; Jean introduced us to Rimbaud."[71]

It was during those years that Jean really began to hit his stride. Friends made sure that he was invited to society events. He was an avid reader of such important contemporary authors as André Gide and others from the *Nouvelle Revue Française.* He often went to the Théâtre de Vieux-Colombier while also following Diaghilev and the Ballets Russes. "He completely opened up at that time," remembered one friend. "He was climbing the ladder at the bank, and he started to go out; he came to life."[72]

•

On October 16, 1924, a group of seven young men from the leading institutions of France gathered together in the port of Marseille.[73] They had arrived that morning, having taken Le Train Bleu overnight from Paris's Gare de Lyon. It was the start of a six-month-long cruise around the world, sponsored by the Ligue Maritime et Coloniale, an organization formed several years before to encourage exchanges between the French colonies.[74] There was an official ceremony as a group of dignitaries gathered in the clear light of that Mediterranean port to see the young men onto the ship; the departure was covered in the Paris newspapers.[75]

Professor Siegfried's support meant that Jean was chosen to represent the École des Sciences Politiques. "It must have been a good selection process because they found one of our best students," wrote the director of Sciences Po.[76] Joining Jean was an impressive set that included Henri-Charles Puech, from the prestigious École Normale Supérieure, a religious historian who was later involved in the famous discovery of the Gnostic Gospels at Nag Hammadi, and Paul-Louis Chigot, who became a leading surgeon and would perform one of the first hip transplants in France, for Jean's father.[77] "We were supposed to represent a full range of students; excuse the term but we were meant to be the *elite* of French youth," said Henri-Charles Puech. "It was an unforgettable experience."[78]

Over the next six months, the seven students went to Egypt, Africa,

Ceylon, Madagascar, Australia, New Caledonia, New Hebrides, Tahiti, the Panama Canal, Martinique, and Guadeloupe, as well as St. Pierre and Miquelon off the coast of Canada.[79]

The journey began on a great ocean liner, following its route between Marseille and Japan, taking five days to reach the first destination, Port Said, at the entrance of the Suez Canal. There, Jean was struck by the vivid scene. As he described Port Said, "Through the window came the extraordinary sounds of this city, the stomping, laughing, shrieking of the passing crowd as they bought trinkets, drank, danced, and made love in sordid shacks."[80]

Later, in Djibouti, the group changed to a cargo vessel where they shared space and meals with the crew, a few stray passengers, and a load of coconuts. When the gentlemen appeared in tropical climes, they wore two- and three-piece linen suits, ties, and white pith helmets (there was a Vietnamese staff on board who spent their days washing and ironing their clothes).[81] But this was not luxurious. Passage had been paid in advance by the organizers, but once the group arrived in Ceylon, they found that additional food and lodging was up to them. As they ran out of money, Jean stepped in to organize finances and handle local diplomacy. He negotiated rates, made payments, and disbursed spending money. When conducting business with his fellow travelers, Jean announced, in English, "De Menil's Bank!"[82]

The trip was a mixture of seriousness and youthful fun. Jean, for his reading, brought such weighty tomes as *The Philosophy of St. Thomas Aquinas,* a book by Etienne Gilson, and the text of a course he had just taken from Professor Siegfried on the economics of Australia. The group traveled into the center of Sri Lanka to see the Buddhist temple in Kandy. While in Nouméa, they went deer hunting (the crew would often push back their departure for a day or two so they could do as much as possible). In one South Pacific port, Jean slipped on a boulder covered with slugs, scraped himself on some coral, and had to be fished out of the water.[83] In another, he fell asleep in a lifeboat that managed to drift away; the boat had to circle back around to retrieve him.[84] The group's arrival in Australia was considered significant enough to be on the front page of a Sydney newspaper.[85]

The stop in Tahiti had loomed large in everyone's imagination since the beginning of the journey. As the ship approached the island of Mooréa, the captain kept as close to the shore as possible. At sunrise, they pulled into Papetoaï Bay, a sparsely populated, narrow inlet with vivid blue waters surrounded by towering volcanic peaks. Also known as Opunohu Bay, it was a place Jean de Menil considered one of the most beautiful in the world. "It is

ridiculously easy to be ecstatic about this kind of a spectacle," Jean wrote of their arrival at dawn. "But this was not only beautiful; it stirred the soul—the view exploding in three dimensions."[86]

If the trip sounded like cultural imperialism—these young gentlemen from leading French schools out to tour the colonies—Jean did not see it that way. He was convinced that the islands of Sri Lanka and Tahiti, for example, were powerful places in spite of the European influence, not because of it. "White men, with the superiority afforded them by steam engines, vaccinations, and gunpowder, wanted to demolish everything without so much as a second look," he would later write to Dominique. "Fortunately, the missionaries and the different kinds of people who follow them in colonization have not yet destroyed everything." He also acknowledged the inability of an outsider to truly understand the cultures, a sense of humility not associated with colonialists. "Tahiti is famous for the flavor of its manners, Ceylon for the flavor of its tea, and both for how they stir the heart," Jean wrote. "Everything has been said about them, yet they have rarely been truly understood. As soon as you try to decipher them, they shut up tight once and for all."[87]

On January 4, 1925, he was thrilled to celebrate his twenty-first birthday in Tahiti.[88] On the voyage from Papeete to Panama, the group spent a full twenty-one days at sea without seeing as much as another ship on the horizon.[89] They then passed through the Panama Canal, which had opened only nine years before. Their vessel went from the Pacific Ocean, through the Culebra Cut, and into Gatun Lake, the largest man-made reservoir in the world and a key component of the canal passage. There, Jean was struck by "the gaunt branches that stuck up out of the water, relics of the forest that had extended throughout these valleys before they were transformed into a gigantic reservoir to provide water for the locks of the canal."

In a larger sense, Jean was fascinated by the Panama Canal as a feat of engineering. He felt that the great work, which began with an idea by Ferdinand de Lesseps in the nineteenth century, suggested the importance of leadership as well as its limitations. "How bold was the original idea of Lesseps, though it was completed after him by the Americans," Jean wrote. "There is a lesson, as well, in that failure. The glory of Suez pushed him toward a new venture that wasn't commercially viable. It could be achieved only by a government that was concerned about its own reasons of state."[90]

At such a critical time in his life, his thoughts became more existential. As the group made its way through the canal toward the Caribbean Sea, and the start of a swift passage back to Europe, Jean had serious doubts. "I was a low-level employee of a bank scanning the future for signs of a great love and a grand destiny," Jean, twenty years later, wrote to Dominique.

"After five months of a marvelous journey, Panama, for me, was the door to a return that I dreaded, toward a mediocrity from which I didn't know if I would ever be able to escape."[91]

•

Weeks after returning to Paris, Jean de Menil was off on the next adventure: military service. On May 10, 1925, he reported for duty in the northern city of Cambrai.[92] As the eldest son of a large family, with two brothers killed in action, he qualified for a release, but that was not his nature.[93] In Morocco, it was the time of the Rif Revolt, Berber leader Abd el-Krim's war against French and Spanish colonialists,[94] and France was in need of fresh forces. Because of the difficulty of the assignment, his captain refused to go. Indignant, Jean volunteered.

He discovered that in order to do his service in Morocco, he would have to renounce his officer status, second lieutenant, and start at the bottom, as an enlisted man. "He just clenched his teeth and did it," Dominique explained.[95] Before setting off for North Africa, Jean was awarded a section chief brevet, giving him command authority.[96] He joined the Sixty-Seventh Regiment in May 1925 as a soldier, second class. By October, he was in the First Regiment of Zouaves, stationed in Casablanca. By January 1926, he was a corporal.[97]

His military service in Morocco, a full six months spent in a war zone, was not easy.[98] Water, for example, became a precious commodity. "They drank water from wherever they could find it," remembered Dominique. "And at times there was very little to be found. He developed techniques to do anything with one quart; you could drink a little bit, then wash yourself entirely, starting with your teeth, your face, and then, with the rest of the water, you could wash your shirt."[99] After his tour of duty, Jean was always mistrustful of plain tap water, preferring to drink his out of a bottle.[100]

While he was in action, Corporal de Menil often found himself serving alongside the French Foreign Legion. One day, they were guarding a source of water when attacked. "One or two legionnaires flinched and they were overrun," remembered one of Jean's friends. "He had to get everything back under control. The Legion is the toughest there is. He didn't tell me at first that he fought with the Legion, but that's what he was like: he went as far as he could."[101]

During his time in Morocco, Jean was nominated for the Legion of Honor. It was for an action in which his regiment performed admirably. One of his troops was not nominated, however, and risked being disci-

Jean, standing at left in a light shirt, with his regiment during his military service in Morocco, 1925.

plined. Out of a sense of solidarity and justice, Jean renounced the Legion of Honor.[102] Principle was more important than a distinction.

Jean's time in Morocco had a real impact on his character. The difficult conditions helped encourage his lifelong interest in equality, suffering, and human rights.[103] And those months in North Africa, even more than the exposure he had on the cruise, were the beginning of his great fascination with the continent. He was so struck by the country that five years later he would return with Dominique de Menil for their honeymoon.[104]

•

Once back in Paris, before he left for his military service, Jean wrote a report on his trip around the world for his bank. The thirty-eight-page document told of the "picturesque cosmopolitanism" of Port Said as well as the "extraordinary fertility of the land" in the New Hebrides. He studied the challenges for French firms that hoped to do business in Ceylon, in the wool market in Australia, and in the production of coffee and sugar on the islands of Martinique and Guadeloupe. And he wrote about leadership, something that he understood profoundly. "Competent and energetic

citizens—in other words, leaders—are not as rare as some might think," Jean wrote, "but they have to be encouraged, educated, directed, allowed to thrive."[105]

His bank offered him a bonus because of the strength of the report on his trip. It asked him to draw up a list of books he wanted and then gave him a complete library, a starter kit for a young man of culture.[106] And he continued to excel at the office. By the end of 1929, when he was still just twenty-five, he was promoted to management within the BUP.[107] His salary tripled, from 10,600 francs in 1927 to 31,100 francs, plus a bonus, in 1930.[108]

Another significant event in his life took place at that time. After the death of Jean's grandfather Antoine, the title of baron went to his eldest son, Félicien. Baron Félicien Menu de Menil was accomplished if very different from others in the family. He was an instructor of musical history at the École Niedermeyer, a well-known institution of classical and sacred music.[109] He was also, surprisingly enough, the author of operettas and comic operas, including *La Janelière* (1894) and *Gosses* (1901), and he composed scores for ballets. He was also an author. One of his books, *The History of Dance Throughout the Ages,* became a well-respected reference book and was republished as recently as 1980.[110]

Félicien had another unusual characteristic: he was an advocate of Esperanto. The language, begun in the late nineteenth century, was intended to be a simplified means of communication that could unify the world.[111] Around the time the de Menils settled into their apartment on the rue de Vaugirard, Uncle Félicien composed the music for *La espero,* set to a poem by Ludwik Lejzer Zamenhof, the founder of the language. It was a spirited, sprightly hymn and is still the international anthem of the movement.

It was not surprising that Jean's family—military, religious, conventional—was a little leery of Uncle Félicien: operetta composer, dance historian, and Esperanto activist. He had also made a trip around the world, highly unusual at that time, and, having never lost his fortune, lived in grand style.[112] "Uncle Félicien was kept at a distance from the family," remembered Jean's niece Bénédicte Pesle, "because, it was said, he led a frivolous life. But these were just whispered allusions, background talk."[113]

Félicien died on March 28, 1930, at his home in the affluent Paris suburb of Neuilly-sur-Seine. Because his only child was a daughter, the title, following the custom of primogeniture, was given to the eldest living male in the family, Georges. Soon, the colonel transferred it to his eldest son, making Jean the fourth Baron Menu de Menil.[114]

The reasoning behind his decision not to use the title himself, though not entirely clear, must have involved several factors. Georges was sixty-

seven years old, retired from the army, and a recent widower. His son, twenty-six, was just beginning his career. It would have been logical to pass the title to the next generation. The colonel could have felt that a title would make his son a more attractive marriage prospect. Passing it to his eldest son would also have been the gracious thing to do. "My father was a nice guy," Jean once said, "an absolutely nice guy."[115] Given the family's economic situation, there were also financial considerations. The new title meant the payment of taxes and registration fees with the Ministry of Justice as well as the hiring of a special lawyer that served the Conseil d'État—a significant expense.[116] The young investment banker would have been better able to handle these costs. Regardless of the precise reason, or combination of factors, 1930 marked the birth of Baron Jean Menu de Menil.

•

As the 1920s gave way to the 1930s, Jean began to reflect more of his family's characteristics. Both his mother and his father gave him an appreciation of faith, though Jean's was softer, less dogmatic. Much like his father, his two older brothers, and his great-grandfather, he had a militaristic passion and a sense of duty. His rise at the bank showed him to be an effective businessman and leader, similar to his grandfather Marcellin Rougier, *Bon papa chemin de fer*. There were cultural stimuli as well. He had a love for music and literature that had been encouraged by his mother. Like his older brother Marcel, who played the violin and was sensitive to Gregorian chants, or even Uncle Félicien, the dance historian and composer, he had an artistic soul.

But Jean took these characteristics, many rather conventional, and turned them into something that was much more robust. "Although he still cared very much about his family, he no longer felt in harmony with us," said his sister Mirèse. "He was comfortable in a more open cultural environment."[117] Jean began to transcend his heritage, defining his own track. He engaged in the cultural life of the city, both high and low, and he developed what his family had been lacking: a sensitivity to what was modern and meaningful.

It had long been felt that Parisians had a difficult time moving beyond the borders of their own country; there was a saying, for example, that the French didn't travel well, except in exile. Jean's six-month trip around the world helped him to break with that tradition. "It opened his mind enormously," Dominique de Menil said of his experience.[118] Between his trip abroad and his military service in Morocco, he was able to see the world from a much broader perspective. He began to evolve into an international-

ist and a humanist. "If I try to sum up Jean's ideal, I keep coming back to words such as honesty and truthfulness and brotherhood," Dominique later pointed out. "He himself started in life at the bottom of the ladder—he had vowed that if he would ever get to a position of authority that he would not forget those who see things from below, those who are never given a voice."[119]

After his trip, Jean didn't return to the rue de Vaugirard empty-handed. He had acquired many objects on his expeditions. From Africa, he brought back ceremonial masks as well as a large rug made of bark. In Tahiti, he bought records of traditional music.[120] From Polynesia, he brought back floral wrap skirts, *lava-lava,* that he wore over his swimsuit at the beach.[121] And he was eager to share his exotic finds with family and friends.[122]

By 1930, this newly minted baron had managed to turn himself into quite a distinctive figure. He had developed an engaged view of the world and was fulfilling his quest for success. Deeply religious, he also had begun to have an intense connection with the inventive arts that were around him in postwar Paris. These were the earliest seeds—of a connoisseur, of a patron—that would be brought to life in the most spectacular way on the other side of the world.

AT FIRST SIGHT

It is such a great miracle when two people love each other.
When that is achieved, anything is possible.
—DOMINIQUE DE MENIL[1]

I am determined to foster our fusion, as you so beautifully
call it, with the patience of those madmen who built the great
cathedrals.
—JEAN DE MENIL[2]

It all began with a *coup de foudre,* one evening early in
May 1930, at a ball at a grand house in Versailles.[3] That
was the night that Baron Jean Menu de Menil, an ambitious twenty-six-
year-old junior executive at the Banque de l'Union Parisienne, met Domi-
nique Schlumberger, a self-possessed, serious twenty-two-year-old who
had recently graduated from the Sorbonne.

Only five feet six inches, Jean de Menil was a small man who cut a
forceful figure. With his vivid brown eyes, protruding ears, high forehead,
and thick, dark hair, he was just this side of handsome. Any physical short-
comings were offset by strength of personality and sheer panache. Because
money was tight, he still lived at home, on the less-than-fashionable rue de
Vaugirard. Yet by sheer force of will, he pulled himself out of the darkness
of his family life; in fact, one close friend called him "Jean-the-Comet."[4]

The young baron was a committed Anglophile who favored such signs
of connoisseurship as tweed jackets, well-tailored suits *à l'anglaise,* and the
perfect pair of round tortoiseshell glasses. He kept his dark hair closely
cropped and neatly combed and had his slacks ironed every evening. As
soon as he had started making his own money, Jean didn't hesitate to spend
it. He had his dress shirts custom-made at Lanvin[5] and was a habitué of La
Coupole, the Left Bank brasserie that attracted everyone from Hemingway
to André Breton and Man Ray.[6]

Jean's favorite dish at La Coupole was the extravagant *truffe sous la
cendre,* consisting of a chunk of truffles doused in champagne, wrapped

Dominique, age twenty-two, in 1930 just before she met Jean.

Jean in the salon at rue de Vaugirard.

in parchment paper, roasted under hot coals, and served with melted butter.[7] There was no doubt that Jean de Menil was determined to restore luster to his family name; this was a young man on a mission.

Dominique Schlumberger was on a different sort of quest. Familial grandeur was not a concern. She also still lived with her parents, though in that grand nineteenth-century building on the rue Las Cases, in the center of the Faubourg St.-Germain. Dominique had vivid blue eyes, high cheekbones, and an engaging smile. Her dark blond hair was kept shoulder length and pulled back. Her inner strength had been stimulated by growing up in a matriarchal family, with a history of strong women on both sides. She was a particular favorite of both parents. Her mother adored her middle daughter because she reminded her of her husband, Conrad.[8] It was said in the family that Dominique was "the son her father never had" or simply "Daddy's little boy."[9]

That spring, 1930, she had just begun working for the Société de Prospection Électrique, Procédés Schlumberger, the firm founded by her father. La Pros was still a young organization with about ninety-five employees, including fifty-three engineers, and had just turned

its first profit of 14 million francs for 1929.[10] Young Dominique and her crisply dressed father walked from their building on the rue Las Cases across the Esplanade des Invalides to the offices of La Pros on the rue St.-Dominique. There she edited *Proselec,* the confidential publication sent to teams of engineers scattered around the globe. She was usually in the office, deep in concentration with a pencil stuck behind her ear.[11] She often slipped into the language of engineering, talking of logarithmic tables and using technical terms like "overburden." The conversation could be so dense, and her vocabulary so expansive, that even her older sister often found her difficult to understand.[12]

However, the twenty-two-year-old Dominique was interested in more than science. She was fascinated by history and literature and film. And she had long been interested in discussions of metaphysics. She studied philosophy at the Sorbonne with Louis Lavelle, one of the most important French Christian philosophers of the twentieth century.[13] As she described the contradiction, in one of her earliest letters to Jean, "There is a relentless logic and a mystical faith that emanate from the depth of my heart."[14] Whether it was through science or art or faith, Dominique Schlumberger was looking for meaning.

•

If both found just what they were looking for that night in Versailles, it was a chance encounter that almost didn't happen. The ball was given by René de Renusson d'Hauteville, a dashing, dark-haired gentleman who was known as the Comte d'Hauteville.

René d'Hauteville, his wife, Solange, and their three children lived in the Orangerie on the Domaine de Montreuil, an eighteenth-century estate that had once belonged to Madame Élisabeth, the younger sister of Louis XVI. The house was a rigidly classical, two-story structure. The ground floor had seven sets of French doors and sat on seventeen acres of manicured grounds. The Orangerie was an admirable example of the architectural classicism of Versailles. René d'Hauteville worked at the same bank as Jean. His family, like Dominique's, was one of the grandest Protestant families in France.[15]

At his family apartment at 371, rue de Vaugirard, Jean de Menil was not in the mood for a night out. As his older sister Mirèse remembered, "We told him, 'You have to go for the sake of your career.' "[16] A friend came to pick up Jean, and they drove the ten miles southwest of Paris to Versailles.

Over at 7, rue Las Cases, it was 10:00 p.m., and Dominique and her younger sister, Sylvie, were sitting around their apartment, hesitant about

going out. Dominique had never cared much for parties. "*Oh, let's go,*" said Sylvie, persuading her sister to make an effort. So the two young women put on their evening dresses, got into their father's car, and headed out onto the avenue de Versailles toward the ball.[17]

Invariably, at a party, Dominique would pull on her sister's sleeve to signal an early exit. "Oh, come on, Sylvie, let's go home—we've had enough," was the usual refrain. That did not happen on this night. Once introduced, Dominique and Jean were completely focused on each other. They talked until the early morning and exchanged addresses, while the rest of the party faded into the background. When other guests left to go back to Paris, Jean lost his friend, while Dominique's younger sister was left to fend for herself. "I ended up alone with the host and hostess of the house while they were off together, completely enchanted to be getting to know each other," remembered Sylvie. "The hostess finally had to ask us to leave."[18] It was inappropriate for the young women to give a single man a lift to Paris, so Dominique and Sylvie drove together to the rue Las Cases. René d'Hauteville, much to the amusement of Jean de Menil in retelling the story, had to give him a ride back to the rue de Vaugirard.[19]

The complicity of that first night continued in their early courtship. Dominique's first letter to him, with its salutation "*Cher Monsieur,*" suggested this was a couple who would not rely on conventions: *she* invited *him* to dinner.[20] On their first dates, the pair were chaperoned by her eighteen-year-old younger sister. With Sylvie behind the wheel, Dominique and Jean sat in the back of her father's Citroën B14, a solid convertible sedan with windshields for the front and back seats and running boards along the sides. "Instead of a conversation, it was all of this whispering in back," remembered Sylvie. "I made the tour around all of Paris, from Montmartre to Montrouge, from Belleville to Meudon!"[21]

Other family members were clear about what was happening. "They had themselves taken around the streets of Paris so that they could keep talking," Jean's sister Mirèse said of those first dates. "They never wanted it to end; it was unbelievable, that kind of thing."[22]

The first months of their relationship had a playful, ironic quality. Jean's earliest letters to Dominique often concluded with a send-up of French formality. In May 1930, he ended with "All that remains is for me to thank you for your tremendous benevolence toward me, an obligation that I am all too pleased to fulfill, asking you to kindly accept, mademoiselle, the expression of my greatest and most respectful reminiscences."[23]

Dominique was equally spirited. Staying at her mother's house on the coast of Normandy, in Blonville-sur-Mer, in August 1930, she wrote to Jean from the beach, wearing a swimsuit and slathered in coconut butter that

baked in the summer sun. The water was as calm as a lake, there was not a cloud in the sky, and a light breeze blew her hair. "Yet my memory is being clouded, and little by little I find myself overcome by the senility of the sun," Dominique wrote. "Do you know this feeling, not unpleasant at all, of your thoughts becoming heavier and heavier, disintegrating, dissolving?" She helpfully inserted a drawing with the sun in the center and a stick figure that began upright and ended horizontal with the various steps in the transformation numbered from one to seven. "Having reached the seventh stage," Dominique concluded, "I will now stop."[24]

A couple of weeks later, back in Paris, she invited him for a workday swim at the Piscine Molitor, the remarkable art deco pool that had opened the year before in the Bois de Boulogne. On stationery from her father's company, Dominique wrote, "What would you say about a swim tomorrow at the Piscine Molitor? I'm planning on going tomorrow after work, so looking forward to it that I'm planning a day in advance! You can call me here to set a time."[25]

There was a sense that both were discovering a new world together. In October 1930, Jean went to the Théâtre Montparnasse to see the first French production of Bertolt Brecht and Kurt Weill's *Threepenny Opera* (which had opened in 1928, in Berlin, to a lukewarm reception but later great success starring Lotte Lenya). "It is a piece by a contemporary of Shakespeare transported into the present," Jean wrote. He summarized the story, its indictment of societal hypocrisy, and conveyed the significance of the piece to Dominique:

> The music is perfectly apt—everything is sung—it is very well directed, and it has a tremendous sense of fantasy built around some important truths. There are moving passages such as the end of the second act, when, from different corners of the dark, faded stage, appear a chorus of beggars, prostitutes, thieves—all lit individually by spotlight—seeming to accuse the audience in a lament, what feels like a leitmotif: those of you who judge us and give us sermons need to understand that life is relentlessly subjected to this one rule: grub first, ethics later.[26]

The following Wednesday, a night they had picked for regular meetings, Jean hoped to have a conversation about *The Threepenny Opera*. "What a great idea these Wednesday evenings," he exclaimed. "Why isn't every day Wednesday night?"[27]

•

The depth of their first feelings suggested more than just the excitement of early romance, but there was one significant hurdle. The de Menils, mirroring Stendhal's *The Red and the Black,* stood squarely behind the military, the monarchy, and the Catholic church. The Schlumberger family had been Protestant since the sixteenth century. Historically, the percentage of Protestants in the French population has hovered at just 2 percent, so they were leading members of a very small minority.[28]

The first book Jean sent Dominique was *The Thibaults* by Roger Martin du Gard, a multivolume novel that began with the story of a deep emotional friendship between two boys, one Catholic, the other Protestant.[29] In the first volume, Dominique was touched by its portrayal of the dignity of Protestantism and the beauty of passionate friendships. "It would be hard for you to give me a book that affects me as much as this one," she wrote to Jean. "Did you know it would or was it just an accident? It has released in me a flood of passion along with some regret about no longer being a fourteen-year-old girl madly in love with another girl and ready to take on the entire world."[30]

The difference of religion between their families was not easily brushed aside, for there is no country in Europe that has persecuted its Protestants with quite as much fervor as France. Since Martin Luther nailed his Ninety-Five Theses to the door of the church in Wittenberg on October 31, 1517, France has known violent, enduring struggles between Protestants and Catholics. "Huguenots," the name given to French Protestants, originally began as a slur in the sixteenth century. It wasn't until the eve of the French Revolution that anti-Protestant laws were relaxed. Louis XVI, in 1787, signed the "Edict of Tolerance,"[31] although it fell to Napoleon, in 1802, both to conclude a pact with the Vatican and to officially recognize the Protestant church.[32] Throughout the nineteenth century, the Protestant minority exercised a disproportionate influence in banking and industry. Financial success made them an even greater target of resentment. Well into the twentieth century, Protestantism was the subject of harsh articles, essays, and denunciations. As one study contended, "All of these attacks, often very close to those targeting Jews and Freemasons, suggested the existence of a 'Protestant Party.' "[33]

By the spring of 1930, as the Great Depression reached Europe and France entered a decade of great political unrest, the gulf separating the two faiths was vast. In a study on French Protestantism of the era, André Siegfried, Jean de Menil's mentor, suggested there were areas of France where memories of the past were so vivid that it was as though they were still fighting the battles of the sixteenth and seventeenth centuries.[34] "If you

are born Protestant, you stay Protestant, just as those who are born white, stay white," Siegfried wrote.[35]

In the midst of such polarity, the young couple didn't flinch. Dominique even felt that Jean liked the idea of her being Protestant—that, if anything, she should pretend to be *more* Protestant. They made an early decision, which would be severely tested, not to allow religious background to interfere with their relationship. As Dominique wrote to Jean, weeks after they met,

> It is absurd to think that the difference of religion between us could be a source of dissension. That would be an ecclesiastic, sectarian way of seeing things, an abstraction of the humane and divine points of view. We are brought together by the most human emotion, love, and by our common belief in God. As long as we are united in this feeling and in this belief, neither churches, nor rules, nor pastors, nor priests will be able to keep us apart.[36]

•

In the summer of 1930, only a few months after they had met, Dominique and Jean gave an indication of how powerful their bond was, even at this point. High in the French Alps, the mountain resort of Chamonix was the setting for what they both considered their first act of love.[37] Almost seven decades later, in the summer of 1997, when Dominique had only months to live, she would be making notes about that moment. She was frail by that time, eighty-nine years old, but she penned an eighteen-page document on some of her earliest memories in life. The final paragraphs focused on Chamonix in 1930.[38]

That summer, Dominique and a group of friends decided to spend their holiday up in the Alps. Chamonix, at that time, was a charming, elegant town that had been a high-altitude tourist destination for decades. The setting extended along a scenic valley that ran for ten miles, adjacent to the majestic Mont Blanc, which, at 15,780 feet, was the highest peak in Europe.

When they first arrived, Dominique's best childhood friend, Anne Bargeton, stayed at a cousin's place in town, while Dominique took a room at a house up in the mountains. She was near the path of a historic train, the Montenvers, a picturesque line, only three miles long, that climbed to almost three thousand feet above Chamonix.[39] "Your mother is worried," Conrad Schlumberger wrote to Dominique at the beginning of her stay in the Alps, "worried about the imprudence of mountain climbing, worried

about your extreme independence in the midst of a group of young people that we barely know. To me, the second point is more important than the first."

Her father was heartened by the fact that Dominique would be surrounded by family: her uncle Jacques Delpech, the Protestant pastor, would be there in the coming days, as would Conrad's brother Maurice, a leading banker, and his son Rémy.[40] Unbeknownst to Dominique's father, however, Jean de Menil was also on his way.

The Montenvers train ran from Chamonix to the Mer de Glace, or Sea of Ice, a remarkable natural phenomenon that was the largest glacier in the French Alps. With an elevation starting at sixty-two hundred feet, the Mer de Glace was more than four miles long with ice that was six hundred feet thick. Discovered in the eighteenth century, the awe-inspiring scene was chronicled by such writers as Chateaubriand and Alexandre Dumas.[41] When Jean arrived in Chamonix from Paris, he discovered that Dominique was not staying in town. To find her, he set off along the road to Montenvers and the Mer de Glace.

That day, Dominique had been for a hike in the summer mountains, wearing a pleated skirt and a beret pushed back on her head. She knew that Jean was coming in from Paris, so she went into town. She spent the late afternoon walking up and down the arcades and streets of Chamonix. Unable to locate him, she left to go back to her place, toward the Montenvers road and the Mer de Glace.[42] Dominique knew that the slow-moving formation, with its cracks and crevasses, could be quite perilous. "By day, crossing the glacier was an easy walk," she noted. "You simply followed along those who were in front of you, like a swarm of ants. But in the evening, it was difficult to find your bearings, to know where to go to avoid the crevasses."[43]

Dominique had been so intent on finding Jean that she reached the Mer de Glace very late.[44] She decided to risk crossing the glacier at night. She walked very slowly, fearfully, trying to keep her balance and avoid the obstacles. As she approached the other side of the glacier, Dominique was stunned: there, coming toward her, was Jean.[45] He had spent the afternoon in the mountains, searching for her.

That evocative moment above Chamonix was talked about in their families for decades, although the details had become vague. On that summer night at the end of July 1930, standing on top of a historic glacier, surrounded by dazzling Alpine peaks, sharp light, and pure mountain air, was a young couple exceedingly determined to be together.

NINE

UNE JEUNESSE

You ask if I believe in God and you are expecting me to
answer. It is difficult because I am not sure what to say. Yes,
I am certain there is a divine force; it can be felt in every
masterpiece, in art, in that which we can neither be taught nor
fully understand, in everything that is a part of our most noble
sentiments. Where does that come from? It is not at all logical
and yet we gain from it. A flame inside of you that gives you
strength is God.
—ANNEMARIE SCHWARZENBACH TO DOMINIQUE SCHLUMBERGER[1]

When Dominique Schlumberger met Jean de Menil, she was coming out of a youth that made a match with someone like him both extremely improbable and absolutely obvious. The most significant male relationship she had had until that point was, of course, with her father. And if there was anyone who could have paved the way for a young man who was strong willed and intelligent and had a great sense of flair, it was Conrad Schlumberger, because those were the primary characteristics he presented to his daughter: will, intelligence, and flair.

When Dominique was nineteen years old and taking a holiday in the Alps with a friend, she received a short missive from her father. "Your mother and I are swimming in ignorance about your future movements and plans," Conrad wrote emphatically. "Are those to be dictated only by the size of your budget and how far your feet can take you?"[2]

Conrad also had a sense of wonder about everything that he shared with his children. When he sent Annette a postcard from the Prado Museum in Madrid of the Goya painting *Portrait of doña Tadea Arias de Enríquez* (1789), it came with a story he authored: "Tulle gown, big blue ribbon, hair plastered, and slathered with makeup, she puts on her gloves and makes her way to a garden party."[3] His card to Dominique from the Prado read, "Black hair, black eyes, black beard, dressed entirely in black except for the collar, he is, like a true Spaniard, delivering a grand discourse."[4] By coming up with a charming fiction about the paintings, Conrad encouraged his daughters to consider these works of art in a more playful way.

For Dominique's tenth birthday, he sent her a letter, both tender and ironic. Conrad reminisced about a slingshot Dominique had made when she was much younger, much like the one he had as a boy. He included a present, a large alarm clock that he thought would probably keep time, more or less. And he finished with a rousing personal mantra: "Work, eat, sleep, be cheerful!"[5]

That kind of bemused firmness was to be expected from Dominique's father. In August 1919, when she was eleven, he wrote to her from Strasbourg:

> I am coming to your rescue because of your frequent warning cries for freedom, more freedom, constant freedom!
>
> First, you must specify with exactitude why you need to have so much freedom. Is it to better work on your English, to improve your table manners, or is it to run around with your cousin Jacqueline or perhaps something else? As long as you have not clarified your objectives, I can do little more than join you as you shout, *freedom*!
>
> Though it can be a little frustrating, it is very good, and very healthy, not to act on every idea that comes into your head. It teaches us the difficult art of making the best out of a situation that might not be ideal. We can also learn how to prevent ourselves from getting angry at the slightest denial, turning bright red or completely white, depending on the individual. We also learn the excellent value of patience.[6]

His sense of authority appeared in any discussion connected with Dominique's education, scrutiny that followed her into adulthood. "Watch your spelling, Milady," Conrad wrote when Dominique was nineteen. "In your letter to Sylvie, you corrected some mistakes, but there were still a good dozen. Affectionately, your old father."[7] Having Conrad Schlumberger as a parent would certainly make a child sit up a little straighter.

It might also have contributed to a certain willfulness on Dominique's part. When Conrad was stationed in Strasbourg after the end of the war, his family came to live with him. Out of an excess of postwar patriotism, Dominique and her sisters were made to dress up in traditional Alsatian garb, as though they were war trophies.

Soldiers put them on horses and paraded them through the Place Kléber, the central square of Strasbourg, and the girls were photographed in their costumes. Dominique sat with her legs crossed at the knee, obviously displeased. Years later, she recalled seething at the experience. "They called

the Germans 'Krauts' and taunted them," Dominique remembered. "That brought out my spirit of rebellion."[8]

In fact, Conrad often had to step in to try to curb some of her behavior. One summer, Dominique was at the Val-Richer, planning a trip to Alsace for the baptism of the eldest son of her cousin Antoinette. "You just went to Alsace to see Antoinette," Conrad wrote. "You just made a trip to Brittany. All of that makes for a very hectic, expensive life, and we think another trip to Alsace is too much. I don't want to place a firm veto on this, because I know that you are mature and reasonable. We can discuss this Saturday morning at Val-Richer, if we need to."[9]

Cost was a constant refrain in the family exchanges. When Dominique needed to travel from Paris to Roche for the funeral of her maternal grandfather, Conrad recommended the sleeper cars on the night train, second class of course.[10] This was an affluent family, with a very elegant way of living and a great range of activities, yet one of Conrad's most serious concerns was frivolous spending.

In September 1926, when Dominique was eighteen, Conrad Schlumberger made a business trip to the United States to work, for the first time, on American oil fields. He wrote to Dominique from on board the SS *France,* considered the grandest French ship built at that time.[11] Conrad wrote to his daughter about his passage: the rolling Atlantic waves, the newspaper printed on board, and how the ocean looked by moonlight. He suggested that Dominique would love it. The cost, he confided, was close to 50,000 francs. "If we hit a gusher, you can come with me on a trip to the United States," Conrad wrote. "So pray for a gusher!"[12]

•

Growing up, Dominique was always kept apprised by Conrad of the development of the company, still called the Société de Prospection Électrique, or La Pros. When she was only sixteen, he made an important business trip to Morocco. "I am very excited about this mine," he wrote to her from Rabat. "I found an extraordinary mineral that had been hidden in the muck. This enormous swindle might actually turn into a proper business; it's like something out of a novel."[13]

Conrad also shared the excitement he felt around this strange new business, the worlds he was discovering. Dominique was desperate for his news. "And Texas, is it filled with cotton fields, vast prairies, and towering trees or nothing but rocks, thin grass, and oil wells?" she asked, during her father's first trip to the United States. "I am sure that New York will make a

great impression on you. I have seen photos of the harbor and the buildings you see as you arrive; it seems to be extraordinary, almost supernatural."[14]

On that trip, Conrad sent Dominique a postcard showing all of the great skyscrapers of New York, including the Singer Building, the Metropolitan Building, and the Woolworth Building, along with the taller structures that were planned. "Prophetic," Conrad wrote. "Much less improbable than they might appear at first sight."[15]

From Manhattan, he traveled by train to Dallas. From there, he drove, in an old Ford, across bumpy, muddy roads, southwest to Laredo—"the boondocks: untamed and isolated"—on the border with Mexico. After working in the oil fields around Laredo, he took a bus to San Antonio. He then traveled by Pullman to Houston, where the company had been working the past year on four oil-rich salt domes—Humble, Blue Ridge, Pierce Junction, and Goose Creek.[16]

Conrad had vivid impressions of his first look at the Texas oil fields. He arrived after midnight in Laredo, meeting up with the local team from La Pros. They stayed in what looked like an abandoned house, sleeping on cots, seven or eight men in the same room, which, Conrad confessed, "really reminded me of the war." They ran their cables across the Texas scrubland, using a compass for direction because of the difficulty of identifying any roads. Conrad wrote Louise his assessment of Texas oil country, to be shared with all of the family. He described the abundant wildlife he had seen: deer, wolves, puma, rabbits, and many varieties of birds and snakes. He had shot a rattlesnake with his revolver and would be bringing the rattler back to Paris. There were also, Conrad explained, vast herds of cattle and horses on the open land. Twice a week, cowboys with lassos would round them up and drive them over to water troughs. "Dominique," Conrad wrote, "would absolutely love this way of life!"[17]

•

The young life of Dominique Schlumberger, her late teenage years until early adulthood, was interesting, accomplished, and busy. She could be determined, certainly, but she was also very introspective, known for drifting off in her own world. Dominique's daydreaming became such a regular occurrence that her sister Sylvie, in order to snap her out of it, took to ringing a bell.[18]

Reserved, even shy, Dominique was not lacking in self-confidence. To explain the differences between the three Schlumberger siblings, she often said, "Sylvie is the nice sister, Annette is the fast sister, I'm the smart sister." Annette's reputation, Dominique noted, came from being the eldest

and therefore the first to go out with boys.[19] Dominique's reputation as the smart Schlumberger sister came through her work.

In 1925, Dominique passed the oral and written components of her high school examinations. She received a total of 242 points in her exams, gliding past the 190 required to graduate, for grades that were considered *Assez Bien*.[20] She continued her studies at the Université de Paris, Faculté des Sciences. After World War I, more women began to study, though, at the time Dominique entered the Sorbonne, only one in five students was female.[21] In July 1928, she was one of the rare women to be awarded a scientific degree from the Sorbonne, earning her *Licence* in mathematics, again with a grade of *Assez Bien*.[22]

Shortly after she turned seventeen, Dominique went to England, her first trip outside France on her own. She began in London, then stayed with a family in the West Sussex village of Amberley. Although she did take some golf lessons, and was pleased with her swing, she was there primarily to work on her English. She bought a copy of poems by Kipling that she loved and, along with a small group, read aloud Dickens's *Tale of Two Cities*.[23]

As Dominique was growing up, culture had had a major role in her family life. She and her mother had regular appointments to go to the Louvre Museum. In advance of one of their weekly visits, Dominique began studying the painting of great French neoclassicist Jacques-Louis David.[24] As with Jean's family, though, there were many relatives who were not artistically adventurous. During a stay at her maternal family home in the Lot-et-Garonne, Dominique joined the women on a visit to an exhibition of modern paintings in nearby Bordeaux. Dominique's grandmother and an aunt praised an abstract work they had seen. A less open relative was horrified. "*Grand-mère* tried to explain to her the significance of cubist painting," Dominique noted, "but without success."[25] By the mid-1920s, Dominique, still only a teenager, was open to the idea of modern art.

Dominique's best childhood friend was Anne Bargeton, who also went to the Lycée Victor Duruy. Dominique and Anne were inseparable. After both had graduated, Dominique spent a day out at the Bargeton country house, at Fontenay-St.-Père west of Paris. The party included Anne's family, Conrad, Dominique, Sylvie, and Marcel's daughter Geneviève. Afterward, Anne, to mark the end of school in a suitably dramatic way, made a bonfire and torched all of her girlhood notebooks and homework.[26]

When she was eighteen, Dominique spent a semester at a Swiss German boarding school for well-raised young women, the Hochalpines Institut Ftan (its full name at the time was the Hochalpines Töchterinstitut Fetan).[27] It was located in the Engadin, one of the most beautiful parts

in the Swiss Alps. Founded in the eighteenth century, the school was an imposing three-story baroque building, painted a pale yellow, perched in splendid isolation on the side of a mountain. "There, you will learn that the mix of discipline, fresh air, and community living makes for a delightful salad," Conrad wrote to Dominique.[28]

At Ftan, Dominique had German courses every morning, six days a week. She also had English classes four times a week as well as history, literature, gym, and typing.[29] The main outdoor activity was skiing, which Dominique did as often as possible. Sunday nights were reserved for dance lessons.[30] Dominique was surprised to find that the students appeared in dresses most of the time, with pants reserved for skiing. She wore a gray dress in alpaca so often that the seams almost gave out.[31] Letters went home to her mother pleading for her to send more, including one in black crepe de chine.[32]

It was at Ftan that Dominique met one of the more intriguing friends of her youth, Annemarie Schwarzenbach (1908–1942), who was from one of the grandest families in Switzerland; her father was a textile magnate and her mother came from the famous German von Bismarck family. Annemarie was extremely beautiful, statuesque, and very complex. She dressed as a *garçonne,* the sexually ambiguous style that was all the rage in those years. With her hair cropped short, she favored men's tailored clothing: severe jackets, high-waisted pants, dress shirts with ties, double-breasted overcoats. An accomplished writer and a very good photographer, she was openly lesbian. She was also quite troubled, with a difficult relationship with her domineering mother and an ongoing problem with drugs, particularly morphine. The great German author Thomas Mann called her "the devastated angel." She was best friends with his son Klaus Mann and in love with his daughter Erika. French novelist Roger Martin du Gard said Annemarie had "the face of a beautiful, broken-hearted angel."[33]

At Ftan, and throughout her short life, Annemarie caused a stir. "She stayed away from most of the other girls at school," noted a biography. "And those lucky enough to be a part of her inner circle had to contend with violent jealousy on the part of the others."[34] Young Annemarie was mysterious, flirtatious. As she wrote in the notebook of another girl at school, "You are one of those whom I will miss the most—you know, when I'm cold."[35]

Dominique was close to Annemarie. She even started wearing her hair short, very much against the wishes of her parents, who were worried about its impact on Dominique's marital prospects.[36] The dozens of letters Annemarie and Dominique exchanged over the years were tender, sophisticated, and smart, an intellectual intimacy between two strong, forceful women. "It was a very strong friendship—a passionate friendship,"

Annemarie Schwarzenbach who was at a
Swiss boarding school with Dominique.

explained Fariha Friedrich, the youngest child of Dominique and Jean de Menil, who discussed Annemarie with her mother. "She said that she was very taken by her; you felt a love. She implied that if she had not met my father that she might have lived with Annemarie."[37]

Just after Dominique encountered Jean de Menil, she explained to him the difference in her two great friends Anne Bargeton and Annemarie Schwarzenbach. "Anne is the only person in the world who is for me a continual ray of light, warm, calm, and soothing," Dominique wrote. "When I am with her, I enjoy the kind of bliss that a dog feels when seated at the feet of his master. With Annemarie, it is very different. She often, unconsciously, makes me suffer tremendously. As I do her. I am too in love with her, so her presence never gives me a sense of calm."[38]

After Dominique finished at Ftan, she and Annemarie, both nineteen, corresponded frequently. When Annemarie went back to school, she was pleased to see a letter from Dominique on the day she arrived.[39] The next year, she visited Dominique in Paris.[40] The following spring, she returned to the French capital, spending time with the Schlumberger family. Annemarie, who was also an accomplished pianist, played duets with Conrad.

Dominique also traveled to Switzerland to stay at Bocken, Annemarie's historic family house on Lake Zurich. "Bocken is absolutely ravishing," Dominique informed her mother. "It has a beautiful view out over the lake with terraces and lawns that extend down the hill."[41] After a few days with her family, Annemarie took Dominique and four other young women to the Schwarzenbach chalet in the Alps for a couple of weeks.[42] They hiked, lounged around outdoors, and watched as workmen built new stables. Annemarie played the piano, while Dominique photographed many of the festivities.[43]

Dominique was also perceptive about Annemarie's limitations. In a photograph in Dominique's scrapbook, Annemarie stood between Dominique and another guest. Dominique smiles and looks at Annemarie, who

turns her charismatic gaze directly on the camera. Dominique wryly noted next to the image, "Annemarie, showing, yet again, how much she *hates* being photographed."[44]

Dominique sent some of the pictures to Annemarie's mother, Renée Schwarzenbach-Wille (1883–1959), who thanked her for the "ravishing photos." Schwarzenbach *mère* took the opportunity to inform Dominique about one of their Alpine traveling companions who had been a troublesome lover of her daughter's. She mentioned Annemarie's "peculiar friendships," approaching the subject in a way that was both sophisticated and harsh. "Poor Annemarie," Mrs. Schwarzenbach wrote to Dominique. "She often has such terrible taste."[45]

Renée Schwarzenbach's father was the Swiss general Ulrich Wille, commander in chief of the Swiss army, while her mother was Clara Countess Bismarck, the daughter of Count Wilhelm and granddaughter of the famous Prussian statesman Otto von Bismarck. She was an avid photographer and passionate horsewoman who often competed. Renée Schwarzenbach, along with her husband, Alfred, was a generous supporter of the opera, particularly of Wagner and the Bayreuth Festival. Annemarie's mother also had her own "peculiar friendship," entering into a long-term romantic relationship with a noted Wagnerian diva, the soprano Emmy Krüger. Their relationship seems to have been accepted within the family; the singer was given her own rooms on the estate. "The Schwarzenbachs are just charming with me," Dominique wrote to her own mother during another stay at Bocken. "And I have the great and very unusual honor of staying in the room of Mademoiselle Krüger."[46]

The contact between Annemarie Schwarzenbach and Dominique would taper off over the years, while Annemarie would go on to receive her master's in history and write stories for Swiss newspapers on her travels in the African Congo, Morocco, and Lisbon. Spending time in Persia, she married a French diplomat who was gay. In 1939, Annemarie took a long journey to Afghanistan, touring the rugged country in a glossy white Ford convertible that she had shipped over from Switzerland. On a trip to America, she photographed the bleak lives of blacks in the South. In New York in 1940, she met Carson McCullers, a literary sensation who had just published *The Heart Is a Lonely Hunter.* McCullers was immediately taken by Annemarie and dedicated *Reflections in a Golden Eye* to her.

Annemarie was wildly anti-Nazi, unlike her mother, who was very much a Hitler sympathizer. After repeated attempts to quit drugs, suicide attempts, and psychiatric hospitalizations, she returned to the family house in Zurich in 1942, where her mother suggested she was no longer welcome. She went to her chalet in Sils Maria in the Engadin, above St. Moritz, where

she had a bike accident and smashed her head on the side of a rock. Within ten weeks, she was dead, only thirty-four years old. Annemarie Schwarzenbach has been rediscovered in recent decades: her essays and novels have been republished, while the centennial of her birth, in 2008, was marked by exhibitions and documentaries in Europe.

•

Self-destructiveness was not in Dominique's nature; she had too strong a sense of her own identity for that. Her youth was more joyful, partly marked by weddings, which were always major events. When Dominique was sixteen, her older sister, Annette, married Henri-Georges Doll at the Val-Richer. Two years later, her cousin Antoinette married Alexandre Grunelius, known as Alexis or Lexi, from a grand Alsatian family.[47] And Dominique's parents, in those years, were certainly interested in seeing Dominique find the right partner. There were young men to be avoided and those who became prospects. One, from a grand Alsatian family, held no appeal for Dominique.[48] One summer, when she was twenty-one, she stayed with friends on Lake Geneva. One evening, they went to a dinner dance. "I met an Italian man who was charming and completely captivating," Dominique wrote to Conrad. "The only drawback: he barely comes up to my shoulders."[49]

She also continued to see the world. For the Christmas holidays of 1927, Dominique returned to the French Alps, joining Sylvie and her uncle Marcel and his family for a long stay at the ski resort of Mont Revard. The following summer, Dominique took another major hiking tour with Anne Bargeton, this time around the Black Forest. The intellectual highlight of the trip was a visit to Königsfeld to meet Dr. Albert Schweitzer, the Alsatian-born theologian, physician, and philosopher. Over one weekend, August 25–26, 1928, Dominique and Anne walked around the Black Forest countryside with Schweitzer and his wife, Helene.[50]

She also made two extended visits to England. Earlier that year, Dominique stayed with the Orlebar family at their historic, eighteenth-century Hinwick House, in Bedfordshire. In October, Dominique returned to England, this time to spend two months in Cambridge. Staying with a local family, the Chapples, she noted the sights: Trinity College, Cambridge Market, King's College Chapel.[51] She audited classes at the University of Cambridge in the mornings and afternoons. "I was the only young woman, which was an odd sensation," Dominique wrote. "I was also the only one not in 'costume,' those curious black robes that students and faculty wear for classes, like something from the Middle Ages."[52]

Her Cambridge classes were on Greek poetry, English prose writers of the seventeenth century, French philosopher René Descartes, and the life of Saint Francis of Assisi. One course that was particularly interesting was on Greek sculpture, which also involved studying antiquities at the university's Fitzwilliam Museum.[53] Outside her classes, she continued to take English lessons, attended her first rugby match, and went to the theater to see George Bernard Shaw's *Heartbreak House,* a cautionary tale about Europe and World War I.[54] "I think it is safe to say that as much as is humanly possible, I have thrown myself into the life of Cambridge."[55]

Dominique also had a weekend stay at Oxford, the other great university town, with new English friends.[56] There, she had lunch with an acquaintance at Christ Church College, then tea with another friend at Balliol College. "Balliol is supposed to be the most intellectual of the colleges," she wrote to her father. "It is one of the rare ones where the students do not spend most of their time playing sports. We talked for a long time, mostly about painting and cinema, and then a servant brought a very nice tea."[57]

After Dominique's stay in Cambridge, she returned to Paris to resume studies at the Sorbonne. The highlight of the summer of 1929 was her parents' twenty-fifth wedding anniversary, celebrated in style at the Val-Richer. Louise and Conrad looked resplendent, she in a dark, drop-waisted sleeveless dress, her graying hair up in a chignon, he in white summer trousers, a pin-striped jacket, and an open-collared light shirt. At dinner, gifts were discovered at everyone's places, including a beautiful silver milk pitcher for Dominique and a pearl necklace for Sylvie. "I know that I am still very young and not very serious," Dominique said when it was time for toasts. "But I found an old proverb suggesting that fifty years of marriage is a mountain. Well, twenty-five years is half of that, so congratulations on a semi-mountain!"[58]

For the Christmas holidays that year, Dominique and Sylvie took the train together from Paris to Gstaad. In that storied Swiss resort, they joined Marcel Schlumberger and his family for the holidays. They stayed in the Hotel Bernerhof, an elegant inn in the center of Gstaad. For New Year's Eve, her cousin Pierre organized a small party, though Dominique, exhausted from too much skiing on the second day of the trip, stayed in her room after dinner.

On the morning of January 1, 1930, a year that would be so momentous for Dominique, she sat in the window of her hotel room and wrote to her mother. The sun came in through the open windows; the mountains around Gstaad were covered with fresh snow. "I cannot tell you how magical the view is this morning," Dominique wrote. "When I become a film director, and am shooting in places that are gorgeous, I'll bring you with me."[59]

•

After she graduated from the Sorbonne, Dominique began contemplating her future. Jean de Menil, decades later, would characterize the moment in a pithy way:

> She could not stand the idea of dividing her time, as George Bernard Shaw would have said, between tea parties as a substitute for social life, committee meetings as a substitute for philanthropy and magazine reading as a substitute for culture. She wanted to work—isn't that strange? She wanted to work, but at what?[60]

Throughout her young life, Dominique Schlumberger had been interested in cinema. She had filmed her parents' silver wedding anniversary, taking footage of the swans on the grounds of the family château and of her cousins boating on the coast near Deauville. She also planned a film about François Guizot. Dominique lay on the great man's bed at the Val-Richer while writing the script. Starring roles were to go to her uncle Jean Schlumberger and André Gide.[61]

Her family seemed to share her interest. Conrad, after seeing Abel Gance's masterful *Napoléon,* took some of Dominique's young cousins on a drive out to Château de Malmaison. "To soak up the mood of Napoleon," he told Dominique.[62] One evening, when she was still a teenager, Dominique joined her father, her uncle Marcel, and his wife, Jeanne, for a night at the movies. They saw *The Adventures of Prince Achmed,* a feature using *ombres chinoises,* considered the first animated film.[63]

Regardless of his own interest, Conrad was not enchanted with the idea of his daughter seeking a career in the world of cinema. "Conrad Schlumberger was a brilliant man, as the years have shown," Jean de Menil later explained. "He knew that the best way to go past a wall is not to hit it head on. He said, 'Okay.'" Dominique, armed with parental consent, began gaining experience in the French studios on the outskirts of Paris.[64]

She discussed her interest with Annemarie Schwarzenbach, who, uncertain of her own path, admired her friend for her decisiveness.[65] Annemarie put Dominique in touch with Karl Vollmöller, a well-known German writer and creative catalyst in Weimar Berlin.[66] Annemarie had recently become acquainted with Vollmöller in St. Moritz. "I have met a new girl, very lovely with a doctorate in philosophy," Vollmöller wrote to his companion, the actress Ruth Landshoff. Annemarie became a protégée of Vollmöller's and also had an affair with Landshoff (a liaison that seems to have been fully sanctioned by the libertine writer).[67]

Working from a novel by Heinrich Mann, Vollmöller had just completed the screenplay for *The Blue Angel*. Thanks to Annemarie's introduction, Dominique was given the chance of spending a week in Berlin on the set of the film. She left Gstaad for Zurich, where she stayed a few days with Annemarie at her grand family house. She set off for Germany with letters of introduction from her uncle Jean Schlumberger, from one of her cousins, and from Nicolas Nabokov, the author's composer cousin.[68]

Dominique took the night train from Zurich to Berlin, arriving in the German capital at 9:00 a.m. "I was in second class," she assured her parents. The Schwarzenbachs had suggested she stay at the Hotel Excelsior, the largest hotel in Europe, which had inspired the 1929 novel *Menschen im Hotel* by Austrian writer Vicki Baum, which would become the 1932 film *Grand Hotel*. "It is a very big hotel, but it has rooms at every price level," Dominique wrote, with her usual emphasis on economy.[69]

Louise and Conrad were willing to allow their twenty-one-year-old daughter to spend a week on her own on a film set in Weimar Berlin.[70] To reassure them, Dominique wrote as soon as she arrived in the German capital, making it clear, in an insightful fashion for someone so young, that she understood the privileges and the responsibilities of her position:

> I think that you and *Papa* are really worried for no reason. In Berlin, and generally wherever I go, I realize the significance of what father has always worked to make me understand: the importance of relationships, of having a fortune, of social standing, of behaving correctly, and so on. At home, these concepts might seem superfluous, but abroad their truthfulness becomes clear in a forceful way. So I hope that *Papa* won't worry about me. Whether it is in Zurich or in Berlin, I understand that I would not be received as I am if I didn't have behind me your fortune, your name, your relationships, and your reputation. They are real gifts from above, and from you, and they would be absolutely impossible for me to acquire on my own.[71]

•

The Blue Angel was filmed at the famous UFA studios in Babelsberg, southwest of Berlin. On more than one occasion, Vollmöller gave Dominique a ride out to the studio in his white Rolls-Royce convertible.[72] Directed by Josef von Sternberg, the great Austrian-American filmmaker, *The Blue Angel* starred Emil Jannings and Marlene Dietrich, in her first major role and the performance that made her an immediate international star.

Dominique insisted that on the set of *The Blue Angel* she was noth-

ing more than "a microscopic speck of dust behind the stage."[73] Yet she watched closely as Jannings embodied his tragic character, observing the seductive Dietrich only from a distance.[74]

"Generally, the film is excellent," Dominique wrote in a "Letter from Berlin" published in the March 1930 issue of *La Revue du Cinéma,* the leading film journal in France. "It is realistic, vigorous, and devoid of too much sentimentality. Nothing artificial, except possibly the ending. No overemphatic gestures, no forced situations, nothing but life: brutal, unpoetic, true."[75] Founded in December 1928, *La Revue du Cinéma* was published by Gallimard. Presumably through her uncle Jean Schlumberger, Dominique was able to join such illustrious contributors as Charlie Chaplin, Georges Méliès, F. W. Murnau, and Luis Buñuel.[76]

In the following issue of *La Revue du Cinéma,* which also included a manifesto on Russian cinema by Sergei Eisenstein, Dominique authored a second article, "Diverse Processes of Talking Film," an in-depth, ten-page exploration of the various methods by which sound was being incorporated in cinema. It included technical drawings penned by Dominique.[77] The text—dry as a bone—and the illustrations were indicative of her scientific intellect.

By March 1930, and her twenty-second birthday, Dominique had finished her time on *The Blue Angel* and written her stories. Being involved with such a significant project in Berlin had made her feel that the French film industry was less promising. Having considered the possibility for months, she decided to join her father's company, La Pros. As Jean de Menil observed, "Conrad Schlumberger had won his bet."[78]

She had been encouraged to join the family firm by Henri Doll, Conrad's intellectual heir.[79] "I want to be able to make money and to spend it as I would like," she wrote to Conrad. "You often said that I need to look after your interests. I am ready to do whatever kind of work will be profitable for you."[80] Dominique shared the news with Annemarie Schwarzenbach, with whom she had discussed the challenges of women trying to make their way in the world. Annemarie was thrilled. "I can already imagine you in your father's office," she wrote to Dominique. "Really, you're becoming a true businessman, *un vrai homme d'affaires.*"[81]

HORIZONS BROADENED

Oh, Dominique with her little baron!
—*MARCEL SCHLUMBERGER*[1]

During their furtive trip to Chamonix in the summer of 1930, Dominique and Jean, along with Anne Bargeton, went climbing in the mountains and took a train over to Lausanne, the Swiss city on Lake Geneva, where they were joined by Annemarie Schwarzenbach. They saw the sights, posing for photographs in front of the lake. Jean took off his suit jacket and fedora, while Dominique set aside her sensible cardigan and scarf, and they rowed a boat on Lake Geneva.

Another plan was then hatched. Karl Vollmöller invited them to Venice, to stay at his place in the historic Palazzo Vendramin. Why shouldn't the three have a Venetian getaway? "Your mother said something to me today about a stay in Venice," Conrad wrote to Dominique. "I would prefer, for both of you, the beautiful weather in the Alps to the dubious atmosphere of the Palazzo Vendramin."[2] A later telegram from Conrad was more discouraging. Of course, he was unaware of the presence of a young man.

Nevertheless, in the first week of August, Dominique, Anne, and Jean went together to Venice. In order to be able to make the trip, Jean had to scrape together any money he could find. His verdict on their Venetian holiday: "It was prodigious."[3]

Conrad, when told about some of her summer adventures, was displeased. "*Papa* was very angry about this trip that the three of us took," Dominique admitted to Jean, when she was back at the Val-Richer. "*Maman* and Sylvie managed to calm him, to make him feel better."[4] In the midst of the tension, there were also moments of light relief. Conrad forwarded to Dominique a letter from Jean, sharing his concern about how thick the contents seemed to be. Her response: "You would be much less alarmed about the thickness of the envelope if you had seen all of the photographs of mountains that it contained."[5]

But she was also prepared to make her case. Dominique assured her father that this de Menil was very correct.[6] "The ground is shifting, I agree,

but the parental cords are not as fragile as you might think," she wrote to Conrad. "In fact, I happen to believe that they are very strong."[7]

She detailed for her parents the story of Jean's family, being clear about their loss of fortune. "There is something about this boy that is spontaneous, loyal, and generous," Dominique wrote to her father. "He is ambitious, but ambitious to succeed through his own faculties and efforts." She also told her parents, regardless of what they actually felt, that there had been no discussion of marriage. "Jean has made no advance at all. I don't consider the trip to Switzerland an advance. Anne and I were treated in the same way; he followed us like a kid who tags along with other kids."[8]

•

With the arrival of fall, Dominique and Jean became increasingly close. Each made sure that their respective friends spent time together. She passed along the address for Annemarie, who often asked after Jean, while he also spent time with Anne Bargeton. "I am almost spoiled to have friends like Anne, Annemarie, and you," Dominique wrote to Jean, "and to see that each of you have become friends with one other."[9]

They began to exchange presents. Jean asked for a photograph of Dominique, so she gave him one in a frame of galalith, a synthetic, milk-based material used by Chanel for her buttons and costume jewelry.[10] Another photograph Dominique sent was surprising: she stood next to her car, wearing a pair of mechanic's overalls and holding up a can of Antar motor oil,

Anne Bargeton, Jean, and Annemarie at Chamonix.

The photograph Dominique gave to Jean showing her changing the oil on her car at the Val-Richer.

looking not unlike a young man. "I thought you might find this funny," she wrote. "If the image was a little sharper, I might have sent it to Antar suggesting it could be used for advertising."[11] Jean loved the photograph.[12]

His first gift to her was a large eighteenth-century map of the world, beautifully framed. "I was stunned when I saw your map," Dominique wrote. "I thought someone had the wrong address. I imagined something the size of a passport, or a piece of typing paper. Instead, I receive an object that is so immense and sumptuous."[13] That same day, she had made an art purchase for herself. "I forgive you for the madness of your gesture," Dominique continued, "because I too committed an act of madness." She bought a portrait of a black child by Foujita, the Japanese artist who was a key figure in Montparnasse. "Naturally, it's an engraving," Dominique explained.[14] Naturally, nothing too excessive.

They might have felt that their relationship was moving in the direction of marriage, but by October it was nearly derailed. This young man was a very different match than Conrad, who was accustomed to the world of arranged unions, would ever have imagined for his favorite daughter.

Six years earlier, when Dominique's sister Annette married Henri Doll, it was orchestrated by Conrad. As Dominique later characterized it,

Pressure was put on Annette to marry Henri-Georges Doll, in whom our father, Conrad Schlumberger, had recognized his quasi-genius in science and selected him as his successor. Henri-Georges Doll enabled Schlumberger to move from electricity to electronics and to remain at the forefront of research. In a sense, Annette was "sacrificed to the altar of Prospection Électrique." The word "sacrifice" is not too strong because she was very attractive to the young

men she met when she was out at dances, and one of them, full of promise himself, was, for quite some time, inconsolable.[15]

The Dolls, of course, were from a leading Protestant family. The relationship between Annette and Henri Doll became, without a doubt, a loving one. But it began when Conrad selected for her the son he never had and thus brought into his business a brilliant colleague.

Jean de Menil was not a scientific genius. He was also poor and Catholic. Dominique's maternal grandmother chose that moment to send her a book, casually mentioning that it was being sent and that it might interest her. The title: *The Genius of Protestantism*. As Dominique wrote to Jean with delight, "Clearly, there is panic up and down the line!"[16]

Conrad wanted some background on this young man. A friend of Dominique's sister Sylvie knew someone who claimed to know Jean, a certain Georges Lewandowski.[17] This information, though thirdhand, made its way back to the rue Las Cases. And it was explosive.

Dominique fired off an urgent distress signal to Jean:

I would like to scream like a five-year-old child. Sylvie tracked me down this morning to tell me all sorts of disagreeable stories about you. Luckily, there were things that were obviously false so that I could only laugh. Did you know that you are a braggart and unscrupulous? That you have only a so-so position at the BUP? That you have let it be known to all who would listen that you will make whatever kind of a marriage you want to make? The implication being that you intend to marry someone who is completely loaded and that you expect that to be a breeze. And so on and so forth.

Dear Jean, do not feel badly about this—Anne and I agree that it is all lies from the first word to the last. One of the worst things is not having faith in people. And I would prefer to be fooled than to have failed to trust someone. Anne and I have confidence in you and will continue to as long as you do not break it yourself in some flagrant way. We will try to let this ugly gossip go like water running off the back of a duck.

It is so simple to build something up out of a few little morsels. Example: de Menil was in Tahiti, so he is clearly not serious. De Menil is never tired in the evening and always seems ready to go out, so he is obviously not a hard worker nor a sensible young man who goes to bed early. De Menil has a modest salary at the BUP, so he is surely not a boy with a future nor any real value. He refused a legal position at the Neuflize Bank, so he is either a cad or a liar,

and so on. Blend all of these bits together, sprinkle a few of your own crumbs on top, throw it in the oven, and there you go. Nothing could be easier.[18]

Conrad was alarmed, to say the least. He asked Dominique not to see Jean until he could get to the bottom of the situation. Colonel de Menil was intent on meeting with Dominique's father, to set the record straight. Jean said no. He also declined to see Conrad himself. "He didn't want to be too forward," remembered Mirèse. "He wanted to make sure that he was wanted."[19]

Dominique was sent by her father to her maternal grandmother's house at Roche, near Bordeaux. Jean, however, accompanied her to the station.[20] "I am convinced that everything will work out," he wrote to Dominique. "You know the admiration I have for your father's freedom of thought. I cannot imagine that he would make a definitive judgment based on sec-ondhand gossip and any social conventions that we might have violated."[21]

By the beginning of October, she was back in Paris and still not permit-ted by her father to have contact with Jean.[22] "I am sad not to see you, but I will be patient like the Mozabites who wait for rain," Dominique wrote to him. "Patient like these madmen who built the cathedrals, as you once wrote. Patient, finally, like those whose conscience is at peace."[23]

In order to break the impasse, Dominique asked her uncle Jean Schlum-berger if he would meet with Jean. Her uncle was clearly impressed. As the writer told his brother about Jean, "Listen, this is not at all the impression that he made on me. If I were in your position, I would double-check my information."[24]

To assess the situation for himself, Conrad offered to meet the young man on neutral ground. On a Tuesday evening at 6:15, Conrad drove to the Place de la Concorde, picking up Jean at the entrance of the Jardin des Tuileries.[25] Although the content of their exchange is unknown, Jean clearly won over Dominique's father.

Their clandestine meeting, and Jean Schlumberger's benevolent inter-vention, made Conrad open to the relationship, allowing it to continue to develop. "This day I spent with you was so incredible that I can hardly believe that it was not a dream," Dominique wrote to Jean. "If you would really like to make me happy, in a week or two ask me to lunch at your house so that I can meet your father and your sisters."[26]

Jean was equally euphoric, although they continued to address each other using the formal *vous*. "What a fabulous day, Dominique," Jean wrote, after she invited him to the rue Las Cases. "First, because you had an adorable little blue cap and then because I am almost no longer intimidated

by Sylvie. Also, you have a father who is so charming—talking with him put me in a great mood—I must have been unbearable by the end!"

He also reread two of Jean Schlumberger's novels, *L'inquiète pater-nité* (1911) and *Un homme heureux* (1920), and looked forward to knowing him better.[27] Spending more time with Louise and Conrad, Jean was increasingly impressed. He asked Dominique for a photograph of them. "Your parents are really very chic," he wrote. "The way they received me on Sunday touched me in a way that I cannot quite explain."[28]

•

Within a couple of weeks, however, another difficulty presented itself, more intractable than the first. As Dominique wrote to Jean,

> You told me once that it seemed to you that there was no obstacle between us that was insurmountable. Unfortunately, I am certain there is. It is a difficulty that is even more cruel because it comes not from you nor from me. I am convinced that, on our own, we could easily arrive at a common understanding about issues of religion. But to spell out the insoluble obstacle: it is the religion of the children.
>
> For many reasons, but particularly for *Papa,* I cannot bring children into the world in order to make them Catholic. I have already caused my father too many problems and created too many worries to hurt him in this way. I may not be explaining the situation very well, because I am expressing myself in a way that is very sectarian, when he is absolutely not. In reality, his reasons are only pragmatic; he has no dislike of Catholicism like some Protestants. *Papa* is an old skeptic who feels that Catholicism has many positives, but he wants only to have a certain homogeneity in his lineage, like the world in which he lives. Whatever the reasons, I have decided to respect them.
>
> You might think that one solution would be for you to accept having children who are Protestant. But that doesn't help at all; it is not a solution that I want. I would consider it degrading for us. If your older brothers were not dead or your brother Patrice was not a Dominican priest, if, in other words, you were not the only male descendant of your family, perhaps I could agree to something that would feel to me like prostitution.
>
> I am not even taking into consideration my own desires, which would be to have children who are Catholic. But Catholic as I

understand it, meaning to be baptized, and to take Communion, but not be brainwashed by a bunch of stupidities, not forced to memorize Sunday school prayers and spit out a bunch of nonsense. I would want them only to belong, heart and soul, to this big family that we love and which is called the church.

You see that there is no way out?[29]

One possible option, Dominique suggested, would be, as had been done in the past, to have any boys adopt the religion of their father while the girls would stay with the religion of their mother. "But your church is too intransigent to agree to half measures. In asking for all or nothing, it forces those who cannot give everything to distance themselves." Though she understood the reasoning, she felt that the obstinacy of the Catholic church forced the issue. "I have a great attraction for Catholicism, and my dream would be to baptize my children Catholic, but circumstances require me to anchor myself to my heresy."[30]

The only solution Dominique could see was to end their relationship. Before Jean received the letter, she called him, clearly upset. Jean hesitated to open the envelope. He spent the night formulating a response. Just before sunrise in his room at the rue de Vaugirard—it also happened to be his twenty-seventh birthday—he penned a letter hoping to calm the situation.

As Jean wrote,

I wonder if you might be considering the issue with a little too much rigor. Directly adjacent to a harsh beam of light, there are penumbral shadows that are more humane, although with a radiance that is still perfectly clear, and whose creative value cannot be disputed. We can apply all of our efforts to find a solution to a particularly human problem. It is not really an issue of religious doctrines as much as it is the feelings you have for your father and the difficulties you would like to avoid with your children. I do not want to be guilty of what your uncle Jean termed a certain lack of imagination, considering that you will have eighteen years to prepare for the wedding of your daughters, that marriages between Protestants and Catholics are no longer impossible or deplorable, and that in spite of the exclusively Protestant world you grew up in, it is a Catholic that you found on the road in front of you.[31]

Jean felt that her suggestion of ending the relationship was unnecessarily drastic. Considering his family's deep attachment to their religion, he made a surprising statement: that he had been considering the possibility of

a marriage outside the Catholic church. "I know, Dominique, how upsetting this is for you, and I would like to be able to help you, in any way that I can, resolve this worry for which I am unintentionally the cause."[32]

Conrad addressed the situation with Dominique's grandmother, Henriette Delpech, his mother-in-law. He explained to her that Dominique and Jean had met the previous spring and that while nothing had yet been formalized, they were moving quickly toward an engagement. As he wrote to Madame Delpech,

> You probably know the essentials: Jean de Menil, who inherited the title of baron from his uncle, belongs to a family that is very honorable, although completely ruined financially. He currently has what is still a very modest position at the Banque de l'Union Parisienne, but he is said to have great promise. He makes a good impression; both Sylvie and Henri approve. His mother has died; his father is a colonel in the cavalry, now retired, commander of the Legion of Honor. The difficulty is the question of religion, the de Menil family being very Catholic. Jean de Menil does not seem at all to be doctrinaire, though one of his brothers is a Dominican priest and one of his sisters, currently an engineer at Thomson, has undergone a novitiate.[33]

Conrad suggested a compromise. Dominique and Jean would both keep their respective religions; neither would convert in order to marry. The children would receive first a Protestant benediction, then a Catholic one. They would be baptized Catholic but also receive a Protestant religious education. Once they reached the age of reason, they could make their own decisions about religion. "And everything must be in writing," Conrad added, "particularly the last point."[34]

Next, Conrad wrote to Jean de Menil. He made it clear why he wanted this to be put on paper: "So that a trace remains in the future." He explained that neither he nor his wife cared particularly for the dogma of religion, but he went to the heart of the issue. "We belong to two families that have been entirely Protestant for quite a few centuries, and we know the implicit force that comes from such a long tradition."[35]

Jean tried to reassure Dominique. "I will be joining your family more than you are joining mine," he wrote. "And our children, regardless of their baptism, will be raised by you. It is you they will have as a model, you who will form their way of thinking, their character, their religion. I don't think that could ever disturb, on a profound level, the unity which your father rightly values."[36]

Conrad wrote to Jean to elaborate on his wishes. He insisted the children receive Protestant religious instruction, "allowing them to know well the religion of our families and to be able to make an informed decision about which dogma they would prefer." Conrad also specified that he and Louise, if they were still alive, be allowed to choose the pastor for this instruction. "Even if Dominique, in agreement with this point today, changes her mind," Conrad added. "We ask that no pressure be placed on the children to divert them from this religious education."[37]

In reply, Jean thanked Conrad for his openness. "I believe in the sacraments, the main source of my attachment to Catholicism, but I also feel strongly about this freedom of thought that I find so seductive in Protestantism and in which I would be happy to have the children immersed," Jean wrote. "I am afraid, as are you, that our desire to receive a double benediction is a problem that will be difficult to solve, but, along with my father, I will do everything I can."[38]

The apparent resolution meant Dominique and Jean were able to move forward; it also marked the moment when they began using the more familiar *tu*. Within ten days, an engagement party was held. She received congratulatory notes and beautiful bouquets of flowers from Henri Doll's mother, from her sister Sylvie, and from her cousin Jacqueline. "You realize that I do not think very often about our future; it still seems so unreal," Dominique wrote to Jean, just before the party. "I know that one day we will get married, but I know it like a story that is happening to someone else."[39]

•

When Dominique agreed to their engagement, this young banker gave his Protestant fiancée a striking diamond ring, a 2.75-carat, round brilliant-cut stone in a simple, timeless setting in platinum.[40] As Dominique opened the box, with her initials "D.S." engraved on the outside, and discovered the ring, she was in ecstasy. "It's just a little bit of light," Jean said, playing down his gesture with charm. "He was far from rich," their eldest child, Christophe de Menil, later said. "But he gave her this exquisite diamond. And nothing else. Most people give various things for an engagement, but that was his whole character. Choose one major artist—Rothko, Barnett Newman—give one *major* thing."[41]

The next step: call in the lawyers. Working from notes Conrad had provided, his attorney, a certain Maître Poisson, drafted a typewritten, six-page marriage contract between "Monsieur le Baron Jean Marie Joseph

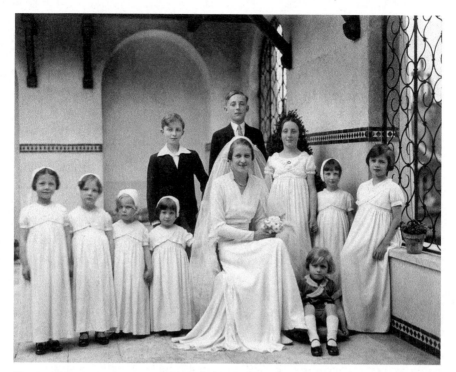

The wedding party of Dominique and Jean on May 9, 1931, on the Moroccan-style rooftop patio Conrad designed at rue Las Cases.

Menu de Ménil" and "Mademoiselle Dominique Izaline Zélie Henriette Clarisse Schlumberger." The dowry amounted to 550,000 francs. Attention was paid to making sure that the dowry was equal to that given to her older sister. It included 100,000 francs in cash plus an additional 50,000 francs for linens and other gifts.[42] A sum of 450,000 francs was placed in an interest-generating account, to be overseen by Conrad, that would pay Dominique and Jean 5,000 francs per month, an amount that was twice as large as his salary at the bank.[43]

The civil ceremony was held on Friday, May 8, 1931, at 4:30 p.m. It took place at the town hall for the 7th arrondissement, a historic *hôtel particulier* on the rue de Grenelle. The two witnesses were Jean Schlumberger and Colonel de Menil. Also present were Louise and Conrad.[44] It would be the first joint appearance by the new Baron and Baroness Menu de Menil, twenty-seven and twenty-three years old.

The following day, May 9, were the religious services. Jean's father insisted that there also be a Protestant service.[45] The events began with an open-minded pastor, Jean Meunier, on the roof garden of the rue Las Cases

for the Protestant ceremony. The terrace was a splendid, indoor-outdoor space, a Moorish design that had been conceived by Conrad five years before based on his travels in North Africa for his new company. Arched windows, covered with wrought-iron grilles, afforded views of the adjacent gardens, the rooftops of the Left Bank, the gilded dome of the Hôtel des Invalides, and, off in the distance, the Eiffel Tower.

Dominique was radiant in a white satin dress, with long sleeves and a full skirt cut on the bias, along with a long veil of white tulle. Jean, with his dark hair slicked back, wore a traditional morning coat with a matching black vest and formal gray striped trousers. The attendants were members of both of their families, with boys in black suits and girls in long white dresses. The guests, not more than fifty, consisted of family and close friends. Men were dressed formally while women wore long springtime dresses, many with cloche hats, gloves, and stoles. Also members of the party: Conrad's dog, Nika, and Sylvie's chow, Ting Fou.[46]

In order for this mixed marriage to be conducted, they needed to have approval from the Catholic church. The representative of Jean's parish signed an official document, "Dispensation from the Impediment of Difference of Religion."[47] Dominique had to agree to raise her children Catholic. And the service, because of her religion, could be held only in a vestry or a chapel without a sacristy.[48]

They found a small chapel on the rue Vaneau, around the corner from the rue Las Cases, the Chapelle St. Dominique. Under the direction of the Sisters of Mercy of Sées, it was a small structure, inside a courtyard, that had been built in 1910 and restored the year before.[49] Because there was no sacristy, this modest chapel, with its vaulted ceiling and simple wooden chairs, allowed the service to be conducted in a proper church. After the ceremony, the wedding party returned to the rooftop of the rue Las Cases for a reception.

•

When Dominique's parents were on their honeymoon in 1904, they went no farther than Brittany, a few hundred miles from the Val-Richer. Louise and Conrad motored around the coastal roads, with his brother Marcel joining them for part of the trip. But their *voyage de noces* was a relatively modest affair.

Dominique and Jean's honeymoon was remembered in the family as particularly enchanting. They went first from Paris to Belgium, to visit Jean's brother Patrice, who had not been able to attend the wedding.[50] He was at Abbaye du Saulchoir, the Cistercian monastery in Kain, just over the

border from France, the spiritual center for the French Dominican order. Dominique and Jean walked with Patrice, in his long white habit, around the wooded grounds of the monastery and the peaceful country roads.

They then took the night train to Barcelona and sailed to the Spanish island of Majorca. They stayed on the Badia de Pollença, on the northern end of Majorca, at the hotel Formentor, a recently completed resort.

It was a long, three-story structure in white stucco, an International Style design that had been translated to the Mediterranean. The hotel held a commanding position looking out over the pristine bay. Dominique and Jean walked around the tropical grounds and explored the coastline. She wore casual cotton sundresses and flats, while he favored light-colored, high-waisted linen trousers and white cotton shirts. When going for a swim, Jean had one of his Tahitian floral print wraps tied around his waist.

One day, Dominique and Jean took a tour of the north side of Majorca in a large Ford over small roads with splendid views. They stopped in Valldemossa, the scenic, historic village that had been home to Chopin and George Sand. They visited the Royal Charterhouse, an ancient monastery where the composer had spent a year. "It turned out that the day we visited was a celebration of Chopin," Dominique wrote to her grandmother. "There was an orchestra playing his compositions in the cloister. The cellist: none other than Pablo Casals."[51]

From Majorca, they flew over Gibraltar, with Jean taking photographs out of the plane, and on to Morocco. In Fez, they visited the beautiful

Jean in front of the recently completed Formentor, their hotel in Majorca, taken by Dominique on their honeymoon.

Another honeymoon picture, this one taken by Jean in Morocco.

fourteenth-century Moorish Bou Inania Madrasa with its carved and inlaid columns, and one of the most distinguished and powerful families, the Fassis, on the banks of the Oued River. They stopped in Meknes, the ancient Moorish city that combines Islamic and European sensibilities, and Rabat, where they saw the Hassan Tower, the remarkable minaret of a twelfth-century mosque. In Marrakech, they admired the towering fourteenth-century Ben Salah Mosque and lost themselves in the great souk in the medina.

From Marrakech, they took a bus south to the breathtaking desert town of Ouarzazate, at an elevation of almost four thousand feet. There, they ran into Olivier Glaenzer, an engineer from Dominique's father's company. They took in camel races together and admired the views of the Atlas

Mountains. Dominique and Jean continued on the bus south and west to Tiznit, where Berber tribesmen gathered at the city gates. On the coast, they visited Agadir and finally Mogador, now Essaouira.

In their first travels together as newlyweds, Dominique and Jean showed that they would be fascinated and engaged by broad horizons. Their time in Mallorca and Morocco also suggested the international turn their lives would take, as well as a certain passion for life. "Their honeymoon was something fantastic," remembered Dominique's sister Sylvie. "The main impression is that Jean de Menil brought something very new into our world: his zest for life."[52]

ELEVEN

A SHARED LIFE

Because we love each other so much, we do not need to fear
being apart. We will know, with the same certitude that the
devout believe in God, that our love will not perish during
our separations, that it will not fray on contact with our
friends, that any separation, any difference, will enrich rather
than tarnish. As you told me once when I was afraid of being
satiated, our love is not an end in itself but a shared means of
living a shared life.
—DOMINIQUE DE MENIL[1]

The Château de Kolbsheim was a striking three-story
eighteenth-century structure in pale pink stucco, its
facade punctured by three rows of large windows, set off by light blue shut-
ters, and surmounted by a steep roof in red tile. Located just west of Stras-
bourg, Kolbsheim held a commanding position, atop thirty acres of land,
on the crest of a hill, looking out over the plain of Alsace. Off the terrace
from the house was a large lawn and formal French garden—oversize ever-
greens trimmed into topiary, perfectly manicured boxwood hedges, classi-
cal marble statues and fountains. Walkways of crushed red clay led under
arches fashioned from arbors covered with vines. Descending the hill, a
boxwood hedge marked a border, where the design transitioned into an
English garden: natural grasses and ground covers, towering century-old
trees. "It was a superb house," Dominique said of Kolbsheim.[2]

Built in 1703, Kolbsheim had belonged to the Grunelius family since
1874. In the 1920s, the gardens, which had been destroyed during World
War I, were restored by Alexis Grunelius (1890–1977),[3] who, in 1926,
had married Dominique's cousin and close friend Antoinette Schlum-
berger (1908–1994). As impressive as the house was, however, the interior
had been altered in the nineteenth century, with large rooms split up into
smaller spaces that were easier to heat. Antoinette and Alexis, better known
as Lexi, decided to renovate.

The composer Nicolas Nabokov, their good friend, suggested a young
modernist in Paris, Pierre Barbe (1900–2004), whose work he had seen at

the famous house of Marie-Laure and Charles de Noailles on the Place des États-Unis.[4] Barbe's intervention on Kolbsheim was profound and long-lasting (it remains within the Grunelius family and is virtually intact).

On the ground floor, he removed the château's nineteenth-century walls, restoring the entrance to its original scale, creating a dramatic gallery with floors of gray stone, matching walls, and spare, semicircular sconces in pale alabaster. It was furnished with seventeenth-century French tables and chairs in dark, carved woods and new, low banquettes upholstered in soft shades of velvet. Barbe replaced a wooden staircase with a larger one, made of the same gray Vosges stone, and a banister of stainless steel, like an eighteenth-century ironwork brought into the machine age.[5] "Pierre Barbe had done something very clever," Dominique explained. "He reestablished the historic proportion of the entrance hall, he restituted the past grandeur, but he made a staircase and banister that were totally modern. Also, all the doors had beautiful, modern handles, shaped just to the hand."[6] The Kolbsheim interior seemed to reflect the Latin motto that Antoinette and Lexi had had carved into the fireplace in the library: "*Integritas, Consonantia, Claritas.*" Dominique noted that it was Saint Thomas Aquinas's definition of beauty.

The de Menils decided to hire Pierre Barbe to renovate their new apartment in Paris, a collaboration that would prove to be the beginning of a very specific, de Menil aesthetic. There would be a straight, stylistic line leading from their Left Bank apartment, to their country house outside Paris, also renovated by Barbe, to their town house at 111 East Seventy-Third Street in New York overseen by Dominique and Texas architect Howard Barnstone, to the de Menil house in Houston by Philip Johnson and Charles James, to the Menil Collection with its spare architecture by Renzo Piano. The earliest signs can be traced to Kolbsheim: a quiet kind of modernism fused with well-considered elements from the past and executed in an exquisite palette of colors.

•

When Dominique and Jean were married, her parents gave them, as a wedding present, part of the upper floors of their spacious, three-floor apartment on the rue Las Cases. They carved out most of the third floor and the maids' rooms on the fourth.[7] It was a U-shaped space, with side rooms facing into the courtyard of the building and the garden at the rear. The decision to hire Barbe to renovate was driven by Jean. "I would have just painted the walls and bought a few pieces of antique furniture, chosen some fabric for the curtains, and that's that," Dominique explained.[8]

Front hall, above, of the eighteenth-century Château de Kolbsheim, owned by Dominique's cousin Antoinette and Alexis Grunelius in Alsace and renovated by Pierre Barbe in 1930. A side view, below, of Kolbsheim's exterior.

Born on the Left Bank, Pierre Barbe studied architecture at the prestigious École Nationale Supérieure des Beaux-Arts, obtaining his final diploma at the precocious age of twenty-eight and immediately starting his own architectural firm.[9] His early constructions were unapologetically modern. A soaring atelier apartment for art collector Paul du Bousquet (1927) had black linoleum floors, tubular steel railings, and white walls with paintings by Léger, Dufy, and Picasso,[10] while a massive private residence in Neuilly, L'Hôtel Lambiotte (1930–1934), was a rigorous, International Style design, with a long, flat roof, walls of pale concrete, and rows of horizontal windows in black steel and dark glass (the house has been classified a historic monument since 1984).[11] In 1929, Barbe was one of the founders and director of a rebellious band of modernist architects and designers—Robert Mallet-Stevens, Pierre Chareau, Francis Jourdain, René Herbst, and Charlotte Perriand—who launched their own group, the Union des Artistes Modernes, or UAM, intended as a French echo of the Bauhaus.

As a young architect, Barbe moved in the world of Paris artists. A habitué of La Coupole, he was particularly identified with the art scene of Montparnasse. He was friends with many, including Mondrian, Giacometti, and Léger,[12] and played a role in introducing the de Menils to Max Ernst and Christian Bérard.[13]

Dominique and Jean began slowly with Barbe, first renovating only the living room. "Jean decided that if we were just going to do one room, that one room would be beautiful."[14] Over the next several years, the project expanded throughout the apartment. The transformation was made clear right from the entrance: at the top of the sweeping, grand staircase in faux marble, on both sides of a carved set of double doors, they punched horizontal windows through the walls—six strips of opaque glass, on both sides of the doors. It was a modernist gesture that let in a gentle light from the courtyard windows. Inside the new entrance, a corridor extending along the courtyard side of the building was painted a pale shade of gray. In the entry and throughout the apartment, they stripped all the crown moldings and the ornate plasterwork on the ceiling. The entrance was given a gently vaulted ceiling in white; all other walls and ceilings were left spare. Wooden doors were covered with thick sheets of plain oak and painted to match the walls.

A set of double doors led from the entrance to the living room, with a sweeping view over the garden and, beyond it, the lush gardens of the eighteenth-century Hôtel de Rochechouart. The living room walls were painted a soft white, and the curtains, initially, were also white. The chevron-patterned wooden floor was covered in places with light carpets. As Dominique remembered, "My father said, 'Well, it's all white; you

Dominique in 1933 in the living room of their apartment designed by Pierre Barbe on the rue Las Cases.

should be in your white living room, entertaining in a white dress, to set off one beautiful green emerald on your finger.' He thought it was absurd to have everything white."[15]

Barbe also designed striking new pieces of furniture for the salon. One of the most dramatic was a semicircular sofa in dark velvet with curved legs in black tubular steel.

A matching gueridon had three legs in lacquered steel and a round top in black glass.[16] A cocktail table Barbe designed for the de Menil living room was a critical success at the UAM exhibition of 1932 and was published in the prestigious *L'Architecture d'Aujourd'hui.*[17]

At the other end of the entrance corridor was the dining room, painted a pale shade of striated yellow.[18] Barbe designed a large rectangular dining table in light lemon wood, with legs of gunmetal steel. A pair of steel and black lacquered shelves, with rounded corners, were affixed to the wall, under two black lacquer wall sconces, gently curved and pointing upward. It was a discreet, beautifully proportioned modernism. The de Menils' apartment also included many antiques.

The result was both modern and timeless (the apartment is still in the family and is essentially unchanged). "It seems so simple now," Barbe later commented. "But at the time, there was the impression of having demolished what had been there before."[19] Dominique was excited about the

result. "Our beautiful apartment," as she once characterized it in a letter to Jean, "for which we decided together even the smallest details."[20]

Dominique painted a striking fresco for the living room. In 1931, she and Jean visited the International Colonial Exposition held at the Bois de Vincennes, an expansive colonial fair with some two hundred exhibitions. In a pavilion focusing on Protestant missionaries, Dominique saw a painting of a herd of animals done by a minister who had studied Bushmen rock paintings in caves across southern Africa. It was decided that a work of art was needed over the black marble fireplace in the salon, so Dominique borrowed the canvas from the exhibition and brought it back to the rue Las Cases, and re-created the work directly on the wall, altering the colors slightly, painting it in soft browns and beige. After World War II, she considered painting over the piece. Jean strongly objected. Instead, he had a frame placed around it so that the significance of the painting was made explicit.[21]

Barbe and the de Menils became close and lifelong friends. They would visit the site together, discuss progress, and then have dinner.[22] By the mid-1930s, Barbe would complete a turn away from modernism, toward a

A corner of the Barbe-designed salon with two of the de Menils' first works of art: a Russian Orthodox icon and Christian Bérard's *Othello*.

hybrid style that was more classical. For decades, Barbe's work was rarely published, and he is virtually unknown today. His later style was less editorial, certainly, and his clients were increasingly private: the Domaine d'Aiglemont for the Aga Khan, a house in Versailles for Roland Petit and Zizi Jeanmaire, and a retreat in Marnes-la-Coquette for Jean Marais and Jean Cocteau, among others.

Barbe would also go on to become, in effect, the house architect of the Schlumberger family and was known affectionately as "Oncle Pierre."[23] In addition to transforming the de Menils' seventeenth- and eighteenth-century country manor house north of Paris, he did the interior design for the Conrad Schlumberger wing at the Val-Richer and designed many other family projects, small and large.

Working with Dominique's cousin Pierre Schlumberger, Barbe designed the interior of his house on Lazy Lane in Houston. For Pierre and his first wife, Claire, he restored a retreat on the coast in Normandy and designed their house in the South of France at Tourrettes-sur-Loup. With Pierre's second wife, São, Barbe renovated their apartment on New York's Sutton Place, restored their exquisite eighteenth-century Left Bank *hôtel particulier* on the rue Férou, and spent ten years, 1965–1975, building, in honor of São's roots, the Quinta do Vinagre, a sprawling estate on the coast of Portugal.[24]

For Dominique's sister Annette, Barbe renovated her apartment on the rue de Varenne and designed her expansive estate in the Var, a Provençal *mas*, the Domaine des Treilles. The property, now the Fondation des Treilles, was on over seven hundred acres of land and was constructed over two decades, from 1960 to 1980.[25] For Dominique's sister Sylvie Boissonnas and her husband, Eric, Barbe obtained permission to build an imposing, new four-story house on the Cité de Varenne—a remarkable site surrounded by gardens, directly adjacent to the Hôtel Matignon, the residence of the prime minister.[26] As a skeptical family member said of the architect, "He became something of a guru for all those ladies."[27]

The architect could be amusing about the restrained aesthetic of Dominique and her relatives. Barbe once told Solange Picq, Dominique and Jean's Paris assistant, "Cost is really not that important to the Schlumberger family as long as you can manage to make silk that looks like burlap."[28]

•

It was through Pierre Barbe that the de Menils took their first serious steps toward art. As soon as they were married, Dominique and Jean, like

other young couples, began buying a few pieces of art to add to those they had gathered on their own. That first year, they purchased an Egyptian falcon head, representing the god Horus, in bronze. It was a small sculpture that could fit in the palm of a hand, only one and a half by two and a quarter inches.[29] Their next object was an African mask, from Gabon, representing the face of a woman, using pigment and kaolin on wood.[30] This Punu mask would later be termed by a curator at the Menil Collection "unexceptional."[31] They were just starting and, like many, learning.

It was felt that the de Menils' living room, facing the garden, was lovely but that the dining room, on the courtyard side, was rather dull. So Barbe suggested Max Ernst, then a little-known artist in Paris, to paint a fresco. All the de Menils really knew about Ernst was that he painted birds. "I imagined something like Pompeian frescoes, with foliage and birds," Dominique remembered with a laugh. "Then we meet Max Ernst and discover what kind of birds Max Ernst paints; I was not prepared at all."[32]

The de Menils went to Ernst's Montmartre atelier to have lunch with the artist. One canvas he had just finished, likely still in his studio, was *Human Form* (now in the Moderna Museet in Stockholm). Over six feet tall, it showed a vivid green figure—part bird, part human, part grasshopper—standing, waving, with a vegetal phallus that extended to the ground.[33] "Max's painting frightened us," Dominique recalled, "almost shocked us."[34]

The artist, however, they found delightful. "Knowing Max Ernst was one of the greatest joys imaginable," said Werner Spies, the esteemed curator whom the de Menils would commission to produce the artist's *catalogue raisonné.* "He had a depth, a tremendous sense of humor. The de Menils adored Max and he adored them."[35] The couple had already given a struggling painter the idea that he would earn some money, so Dominique felt that canceling would have been impolite. "To save ourselves from a *faux pas,* Jean spotted the portrait that Max had done of his wife, Marie-Berthe Aurenche."[36] Painted in 1930, *Loplop présente le portrait de Marie-Berthe* showed the head of the artist's wife, in a partial profile, floating within a rectangle in the frame, a small bird at the base.[37] Jean asked for a painting of Dominique in the same style. She returned several times to Ernst's studio to sit for the portrait, completed in several weeks. The painting, which would become known as *Portrait of Dominique* (ca. 1932), showed her in profile, within a caramel-colored rectangle that floated on a dark blue background with fragments of shells scattered about the field.

When the de Menils returned to the artist's studio to see their first commission, however, they were underwhelmed. "We felt that Ernst had not

captured a resemblance and that he botched the motifs surrounding the portrait," Dominique reminisced. "We even disliked the colors." Jean sent the artist the price they had agreed upon, 2,000 francs. After that, the de Menils heard nothing more about the painting.[38]

The artist seemed to have forgotten the portrait. Its patrons certainly had. Some two years later, a priest from the de Menils' parish church, the Basilica St. Clotilde, went into a frame shop, Samson, on the rue St. Dominique. Although just around the corner from the rue Las Cases, it was part of the street where they rarely had reason to venture. The framer showed the St. Clotilde priest a portrait he had placed in the window, asking if it was, by any chance, one of his parishioners. He immediately recognized Dominique. "Ah," he said, "*c'est la Baronne de Menil!*"[39] So the framer called the de Menils, saying that he had her portrait and that he wanted to get rid of it.[40]

"We still didn't like it," Dominique said, once it had made its mysterious way to their apartment. So they took the painting, wrapped it up, and placed it on top of an armoire in the attic. And there it stayed, out of sight and gathering dust, for almost fifteen years.[41]

•

On their visits to Max Ernst's studio, the de Menils made another noteworthy cultural contact, Jacques Viot, who lived on the same floor. A writer who was also the artist's dealer (through a gallery called simply Jacques), Viot was a significant figure in the surrealist movement. He was friends with André Breton, Paul Éluard, Joan Miró, René Crevel, Claude Cahun, and Jean Arp. "He was funny and sarcastic," Dominique de Menil remembered about their new acquaintance. In the mid-1920s, Viot had given up his life in Paris and spent three years traveling the world, primarily Tahiti and New Guinea. Returning to France, he brought what was considered the most important collection of Oceanic art in Europe.[42] In 1932, the de Menils bought some of their earliest significant works of art from Viot: two loincloths on painted bark cloth from Humboldt Bay in Papua New Guinea.[43]

The following spring, Georges-Henri Rivière, the founder of the Musée d'Ethnographie at the Palais du Trocadéro and one of the great pioneers of ethnographic museums, organized an exhibition, *Tapas of Dutch New Guinea,* held April 1–23, 1933.[44] "Jacques Viot suggested I contact you to ask if you would loan us the two beautiful examples that you own," Rivière wrote to the de Menils.[45] The Trocadéro exhibition presented the objects not only as works of art but as ethnographic representations of the societ-

ies from which they came.[46] The two bark cloths marked the first time that pieces collected by the de Menils were selected for a museum exhibition.

That winter, when Dominique was on a business trip with her father in Moscow, she bought a large early sixteenth-century Russian Orthodox icon. From the Novgorod region, it depicted Saint George slaying the dragon.[47] She found it at a gallery, Torgsin, that was established by the Soviets to sell works of art, primarily to foreign visitors. "On the day we left, I committed an act of madness," Dominique wrote to Jean from the train back to Paris. "I bought an icon, immense and splendid, for 2,000 francs. It is for our salon. I would never have been able to find a historic painting for this price, and no modern painting would be as good." The icon showed Saint George mounted atop a white horse, a spear in his hand, the dragon below, mountains in the background. The painting was in the traditional, two-dimensional style of Orthodox icons, painted on wood, in shades of brown, dark red, green, and gold. "The religious element is sufficiently discreet that it can be hung in our salon," Dominique explained to Jean. "I think you will really like it."[48] The de Menils considered this the first painting they made the decision to buy together.

Just after, they purchased a contemporary painting by Christian Bérard, a larger-than-life Paris personality known to his friends as Bébé. A prolific illustrator, set designer, costume designer, and artist, Bébé was a captivating figure in Paris between the wars who moved among the worlds of art, fashion, and society. Throughout his short life—he died in 1949, at forty-six—he was close with such diverse figures as Jean Cocteau, Christian Dior, Jean Genet, Cecil Beaton, Louis Jouvet, and Jean Giraudoux. By the time Dominique and Jean acquired their first Bérard painting, he had already had exhibitions at several leading galleries in Paris and at Julien Levy in New York.[49]

Viot sold the de Menils *Othello,* a 1931 oil on canvas, a Bérard painting from his personal collection. It was a somber bust on a light background, its brooding subject clad in dark clothing. Jean de Menil was struck by his "piercing gaze."[50] Through their friendship with Viot and with Pierre Barbe, the de Menils became acquainted with Bérard and his circle; they would eventually acquire sixteen oil paintings, watercolors, and drawings by Bérard, including a 1931 portrait of the great Russian dancer Tamara Toumanova.[51]

•

Dominique, who had been brought into de Menil family life at the rue de Vaugirard, was pleased with how comfortable Jean was with the

Schlumberger family. He was very active at the Val-Richer, spending long weekends in Normandy, going hunting with her father and uncles, discussing the family business.[52]

In those years, the de Menils also started their own family. By July 1932, Dominique found out that she was pregnant with their first child. On February 5, 1933, at a clinic in Neuilly, instead of a Paris hospital or at home, she gave birth to Marie-Madeleine de Menil (later known as Christophe). "Because my mother didn't want my grandmother to be around at the birthing," explained Christophe de Menil.[53] Her given first names were in honor of Jean's mother. Within a month, Dominique was at the Val-Richer with their newborn, who was being taken care of by a governess, Emilie. "Our baby amuses herself by looking at the vase of tulips I place every morning in front of her crib," Dominique wrote to Jean in Paris. "You would barely recognize her. She is chubby now with a double chin and a patch of brown hair on her head. Emilie thinks she looks like you."[54]

Two years later, on May 21, 1935, their second daughter, Louise Adelaide de Menil, was born in Paris. Her first name came from Dominique's mother, though her chosen name, from the de Menil family, was Adelaide. "She already observes everything, so serious in her stroller," Dominique noted. "I was so touched by her the other night. After dinner, I went into the children's room. Marie was sleeping. I turned on a light and saw two big baby's eyes looking right at me."[55]

The de Menils were charmed by their daughters, but they were also intensely focused on each other, in a way that must have crowded out young children. Dominique often reflected on an observation by Jean Jardin, one of the couple's best friends: "He feels that the real engine of society is the couple, not the family," she reminded Jean. "Between parents and children, there is not any lasting support, nor reciprocity. It is really only through a partner that each is empowered."[56]

•

As Jean continued his successful career as a young investment banker, he viewed the Schlumberger family business with a mix of skepticism and admiration. "He had the impression that this was a little business we were all very passionate about but that seemed to be something of a fantasy," remembered Annette, Dominique's older sister. "He said, 'I don't know what's going to happen, but it's a fantasy that I like.' "[57]

Toward the end of their first year of marriage, Jean made a career move. Only twenty-eight years old, he had worked at the Banque de l'Union Parisienne for a decade, having ascended to head of the investment bank's

financial department. In April 1932, he accepted a management position at the Banque Nationale pour le Commerce et l'Industrie, or BNCI, one of the five great commercial banks in France.[58] Jean's mentor at the BNCI was Alfred Pose, the founder and chairman and a legend in French banking. "The creation of the BNCI was one of the great economic adventures in France between the wars and one of its great successes," noted a financial journalist.[59] (Over the decades, the BNCI would transform itself into the massive international financial services firm BNP Paribas.)

As his career accelerated, concern about the amount of work Jean did was a constant refrain in the de Menils' exchanges. "Why did I let you leave?" Dominique wrote from the Val-Richer, after he had returned to Paris. "You don't know how to relax when you are not with me."[60]

•

The most significant area of attention in their first years together, more than art or architecture, was religion. "I was interested in Catholicism because I was curious about everything," she once explained. "To me, Catholicism seemed like something exotic and I considered it vaguely, in a rather philosophical way. I was not preoccupied by specific religions, all of which seemed to have equally questionable assertions."[61]

Marrying someone who was profoundly Catholic forced the issue for her, made her consider theology more deeply. By the second year of their marriage, she was studying the Roman Catechism, the great theological document from the Counter-Reformation also known as the Catechism of the Council of Trent. "I so enjoy teaching myself all of this," she wrote to Jean.[62] Later that summer, Dominique reviewed a book that Jean had given her, *The Spirit of the Liturgy* by the German Catholic theologian Romano Guardini.[63]

It was a close relationship with a member of the de Menil family, even more than education, that led to the evolution of her views. Emmanuel Pesle was Jean's nephew, the teenage son of his older sister Marguerite.

Born in October 1918, Emmanuel was named after Jean's older brother, killed just a few months before his namesake's birth. Known affectionately as Pinchet, he was thirteen years old when Dominique and Jean were planning their wedding. The boy was visited by a doctor on the afternoon of their engagement party. The prognosis was rough: "One year . . . two years . . . six months . . . eight days?"[64]

Pinchet had contracted scarlet fever when he was young, which, having been maltreated, developed into rheumatic heart disease. "We knew that he would not live long past adolescence," remembered Dominique. "He was a

marvelous child but as fragile as a flower—like an orchid."[65] The de Menils were very close to the boy. "*Le petit Pinchet* was the emotional focus of our entire family," Jean's sister Mirèse recalled. "Dominique showed him a degree of kindness and attention that was exquisite. She became his favorite aunt."[66]

On the morning of Dominique and Jean's first wedding anniversary, Mirèse brought Pinchet to the rue Las Cases early in the morning. He was allowed to wake up the couple, surprising them with a bouquet of fresh spring flowers.[67] By the fall of 1932, Dominique was devoted to Pinchet. At that point, as Dominique characterized it, "he had only a breath of life left."[68] She and Jean considered him their adoptive child.[69]

•

Anguished about his condition, Dominique turned to Antoinette and Lexi Grunelius. Her cousins had also been studying Catholicism and considering a conversion. Antoinette and Lexi had become close to the important Catholic philosopher Jacques Maritain (1882–1973). Raised Protestant, Maritain and his Russian-born wife, Raïssa, had converted to Catholicism over twenty-five years before. He was the leader of a movement called the *renouveau catholique,* a blossoming of more progressive Catholic thought that sprang up in the wake of the papal condemnation of the Action Française. Maritain had a galvanizing effect on those who were considering Catholicism. Antoinette and Lexi made the decision to convert. "He was the example," Dominique noted, "the saintliness of Maritain."[70]

Dominique's cousins would become intimate friends and patrons of the Maritains over the decades. After his death, Antoinette and Lexi assembled the contents of the Maritains' personal library, all of their manuscripts and correspondence, and housed them in a wing at the Château de Kolbsheim. The Cercle d'Études Jacques et Raïssa Maritain became a leading center of research and publication. The construction of the Maritain archives, though very few have been aware of the fact, was paid for by Dominique.[71]

•

Distraught over the failing health of *Le petit Pinchet,* Dominique discussed his condition with her cousins. Lexi suggested, with all the enthusiasm of the convert, that she pray to the Holy Virgin. As Dominique later explained, "You know that if all the physicians have let you down, you decide to go to a witch doctor or a bonesetter? I told myself, 'Well, why

not? Let's pray to the Holy Virgin, since nothing else is working.' "[72] Dominique wrote to Jean to let him know that she had followed Lexi's suggestion. "Last night, I prayed for our adopted child."[73]

As Dominique continued to pray for the teenager, it occurred to her that if she was asking for something, she should probably be prepared to offer something in return. "I had the certitude that the only thing that was asked of me was to convert," she remembered. "At that very moment I said, well, I am going to convert."[74] Dominique was going against centuries of custom in her family, yet she characterized her choice as a pure act of personal faith.[75] "It was very simple: I have to convert, that's all, without any hesitation, no emotion, no big deal."[76]

Dominique's first pregnancy also factored into her decision. "Would you be sad if I decide to convert?" she wrote to Jean in the summer of 1932. "I have been thinking about it since knowing that I would have a child this winter. I would not feel that I am being forced to baptize this child if I actually was Catholic. And it would be marvelous to take Communion together."[77] By the middle of December, she and Jean were going to Mass.[78]

Pinchet, unknown to Dominique, had been praying for her. As his health deteriorated, he had one great hope: that she would become Catholic. Dominique was able to tell *Le petit Pinchet* that his prayer had been answered: his favorite aunt was adopting the religion that meant so much to him. On December 23, 1932, Emmanuel Pesle died, fourteen years old.[79]

•

In January 1936, Dominique and Jean went to a series of lectures that helped invigorate their lives. The talks were given by a leading Dominican priest, Yves Marie-Joseph Congar, who would become one of the leading Roman Catholic theologians of the century. The occasion was the celebration of an octave dedicated to unity of the Christian world, from January 18 to January 25. The lectures were held in Sacré-Coeur Basilica, that white Roman-Byzantine fantasy perched on top of Montmartre.[80]

The subject was ecumenism: that the Catholic church should open itself to other faiths, other spiritual paths. Congar, who had been ordained only six years before, made a case for expanding the idea of belief, for seeing where others were right. For those eight consecutive days, the de Menils ascended the steep hill of Montmartre to listen to Congar. Jean had just turned thirty-two years old, Dominique was twenty-seven. They had been married for five years. "I had the privilege to hear him," she said of Congar's talks, "and it marked me for life."[81]

His talks suggested that ecumenism was a new approach to belief. "Ecumenism begins with the admission that others—and not just individuals but entire ecclesiastic bodies—are right, though they differ from us," he explained. "Even if they are not Christian, they also possess truth, holiness, and the gifts of God. Ecumenism exists by understanding what is Christian in someone else not in spite of their particular confession but *because* of it and *through* it."[82]

Dominique was so taken by Congar's ideas that she wrote an essay about the experience, published in *La Vie Intellectuelle,* a leading bimonthly journal of Catholic thought.[83] In her story, which ran over six pages, she explored Congar's thoughts on the division between Catholics and Protestants, summarized his ideas on how unity should be facilitated, and informed readers that he would be combining the lectures into a book (*Divided Christendom: A Catholic Study of the Problem of Reunion,* published internationally the following year). What the book would be lacking, Dominique suggested, was the physical presence of Father Congar. "His entire being illuminated his discourse," she wrote. "Perhaps it was because he was so reserved, so self-contained, that his message was so powerful."[84]

Congar had a sweeping view of how ecumenism should be incorporated into everyday life. "An ecumenical conference doesn't conclude with a plan of action," he explained in his final session. "What it requires, from the point of view of the Church, is living more intensely. It is not just a question of doing certain things; it is really a question of *living* in a certain way."[85] Being guided by ethical and spiritual principles, Congar revealed to the de Menils, meant that a life, more than any single achievement, would become a true masterwork.

•

On January 26, 1936, the day after the conclusion of Congar's lectures, the de Menils were the force behind a major initiative in the great nave of the Cathedral of Notre Dame in Paris. For centuries, Roman Catholic Mass had involved a fully self-contained performance by a priest, with worshippers left only a limited role. As one authority described it, the faithful had become "mute spectators" instead of active participants in the liturgical action.[86] By the twentieth century, progressive figures within the church sought to increase involvement,[87] leading, during the 1920s and 1930s, to the flowering of the liturgical movement. It was determined that one way to reinvigorate the service was the *messe dialoguée,* or dialogue Mass, when the faithful, instead of passively observing, participated. "In response to the priest, all of the Latin that was normally mumbled by altar boys was

instead proclaimed loudly by all of the faithful," remembered one partici-
pant.[88] Dialogue masses were a humanist gesture, a way to empower the
flock. "The whole thing gives the atmosphere of being alive," suggested an
Irish priest, who discovered the services in France. "It grips attention from
beginning to end."[89]

Dialogue masses were an innovation championed by *Sept,* a weekly
publication of the Dominican order. Dominique and Jean were very active
in the Amis de *Sept,* a group of friends of the journal. Beginning in the fall
of 1935, the de Menils were part of the *Sept* initiative to increase the popu-
larity of dialogue masses.[90] They sought guidance from Father Congar and
Jacques Maritain. Up to that point, these modernized services had taken
place primarily in Catholic youth assemblies but had rarely been attempted
in churches.[91] The de Menils organized the first at Notre-Dame, also the
largest, with approximately a thousand celebrants. "Without your support,
we would have never dared taken the necessary action," Dominique wrote
to Jacques Maritain. "And it is likely that much more time would have
passed before these masses were given the importance that they suddenly
have; it almost feels providential."[92]

Jean introduced the new services to the Basilica of St. Clotilde, their
neighborhood church.[93] And the group extended its efforts throughout the
country. Some weeks, *Sept* had a full page of announcements with some
twenty dialogue masses taking place across France.[94] Later that spring,
Jean was asked to deliver a talk on the Notre-Dame dialogue masses for
a large meeting of Dominicans.[95] By the fall, Jean noted that a Franciscan
had conducted a dialogue Mass at Notre-Dame, a development he felt was
heartening.[96]

Over twenty-five years later, on December 4, 1963, the Second Vatican
Council's Constitution on the Sacred Liturgy, *Sacrosanctum concilium,*
was approved by a remarkable majority: 2,147 in favor, 4 against. It codified
many of the innovations that had begun earlier. As one historian suggested,
"The extraordinary unanimity was the fruit of the fifty-year Liturgical
Movement that had preceded the Council."[97]

Dominique and Jean and their friends at *Sept* took an idea that had
been shaped by others, but had only limited exposure, and moved it onto
a larger stage.[98] The dialogue masses at Notre-Dame and other churches
have to be considered the first joint projects of Dominique and Jean de
Menil, involving principles that would be present throughout their lives:
an enlightened humanism, the need to inspire others to join them, and an
urgent desire to make a difference.

•

Two of the couple's closest friends were Simone and Jean Jardin. Like Jean de Menil, Jean Jardin was a graduate of the École des Sciences Politiques. Having begun his career in banking, Jean Jardin worked for Raoul Dautry, a noted executive and administrator who was responsible for organizing all of the country's train lines into the French National Railways (SNCF).

When Jardin visited the de Menils' newly renovated apartment on the rue Las Cases, he struck up an immediate friendship with them. "Jean came back one evening and told me, 'I've just seen the most marvelous apartment,'" remembered Simone Jardin. "'You have to see it!'" Several days later, she went to Dominique and Jean's and was equally enthusiastic. "Very quickly, they decided that we had to live on the same street," so Dominique and Jean found an apartment for their new friends. By July 1934, Simone and Jean Jardin were living at 16, rue Las Cases.[99]

The de Menils entertained often, and for one big party Dominique wore a striking piece by the great-grandson of Victor Hugo, a silversmith who

Jean with Jean Jardin, one of the de Menils' closest friends, and Antoinette Grunelius at her house Kolbsheim.

made jewelry by such artists as Cocteau, Picasso, and Ernst (and whose wife, Maria Ruspoli, would become a great friend of the de Menils' in New York). As Simone remembered of the de Menil evening, "François Hugo had made some extraordinary jewels with moonstones that were wrapped around her arms."[100]

One obstacle to their closeness, according to Simone Jardin, was Dominique's mother. "Madame Conrad didn't care for me," Simone explained. "She was very jealous of her daughter. She couldn't accept the idea that someone from the outside would come into her world," Simone remembered, about having to sneak over to their apartment to avoid being thwarted by Dominique's mother. "When she would catch me, she would send the elevator back," Simone Jardin said with a laugh. "She opened the elevator door, closed it again, and made me go right back down."[101]

Jean Jardin and Jean de Menil also shared an interest in style. "They both had a certain cult of elegance and especially English elegance," remembered Simon Jardin, one of the Jardins' sons. It was an interest they shared with Dominique's father. "There was a connection to Conrad— Schlumberger elegance, English elegance—all of that was important."[102]

•

The offices of Schlumberger were off the Esplanade des Invalides at 42, rue St.-Dominique, on the corner of rue Fabert. Dominique's father had given up teaching at the École des Mines to dedicate himself full-time to the family company in 1923. By the mid-1930s, La Pros was beginning to prosper, but it had taken considerable time and effort.

The Schlumberger process of electrical prospecting had been used successfully for the first time to discover oil in 1923, near Ariceştii, Romania, north of Bucharest, where geological studies suggested the existence of a dome formation, often a sign of the presence of petroleum. "Electrical resistance charts were able to indicate the placement of the dome and to trace its contour," wrote Dominique de Menil. "Numerous wells drilled afterward confirmed the tests. The detection at Ariceştii is probably the first geophysical discovery in oil exploration."[103]

On September 5, 1927, near Pechelbronn in Alsace, La Pros made another major advance. Henri Doll conceived of dropping a probe, called a sonde, into a well to take the exact geological measurements up and down the well. In addition to measuring above ground, this drew a more continuous, precise picture. That process, called "electrical coring" until 1933, has since been known as "electrical logging."[104] Doll's innovation was a major advance for Schlumberger. "By taking measurements of localized resistance

in the interior of a well, they were able to determine the different layers being pierced," Dominique wrote. "Drilling to tremendous depths is a difficult art. When it comes to petroleum, it becomes a problem of enormous complexity."[105]

La Pros, however, was slow to benefit. The first use of electrical logging was for the Royal Dutch Shell group, in 1929, in its fields in Venezuela, then, in 1930, in the Dutch West Indies. There was very little interest in the Depression-era United States.[106] "Doll and the Schlumberger brothers were ecstatic, expecting oil companies to line up for the services of their company," wrote Ken Auletta, who studied the history of Schlumberger in *The Art of Corporate Success*. "That did not happen. French oil companies were wary of turning over their secrets to an outside service company, and non-French companies suspected that these three unknown Frenchmen were quacks."[107] The larger public was equally skeptical. One of the earliest newspaper stories about Conrad's invention, from 1921, was titled "It's Like Witchcraft: M. Schlumberger, Gold Prospector."

Relief came from a surprising source: the Soviet Union. In the spring of 1929, a Soviet official responsible for geology arrived at the Paris office of La Pros with a contract to help his country find oil.[108] Across the U.S.S.R., Schlumberger instituted an ambitious program of surface prospecting and electrical logging. "An industry that had been nationalized was not hindered by the vicissitudes of the world market," Dominique wrote of the company's new business relationship. "The results were so encouraging that the new process became standard procedure on the sites, first at Grozny, then at Baku, where it found an enormous field of application."[109]

The Soviet Union quickly became a major market for La Pros, with contract extensions signed in 1932 and 1934.[110] Operations in the country's immense, far-flung oil fields were an essential source of revenue for Schlumberger. The work was also important scientifically, because it allowed the company access to many fields so it could test more fully its techniques.

In January 1933, outside Russia, there were only eight teams of Schlumberger engineers in the field: one in Pechelbronn, one in Morocco, one in Romania, two in the United States, two in Venezuela, and one in Trinidad. And many of those teams had very little to do. By 1934, there were twenty teams of Schlumberger engineers throughout the world; the following year, forty. And all were said to be working around the clock.[111] In 1934, an American division was formed in Houston, the Schlumberger Well Surveying Corporation.

The trucks used by Schlumberger teams, all painted the same shade of soft blue, were huge affairs packed with sophisticated electronics and oversize spools holding hundreds of meters of cables. By 1936, one fully

equipped Schlumberger truck each month was being produced, rolled out of the Paris headquarters, and shipped around the globe. Workdays at the rue St.-Dominique often stretched to twelve hours and extended throughout the night. "Compared with the irregular progress of the first decade, the 1930s was a time of uninterrupted growth," noted a company historian.[112]

•

The beginning of the relationship between Schlumberger and the Soviet Union was very promising. As the country descended further into the Stalin era, however, relations became difficult. As early as 1932, communications were strained between Paris and Moscow. Within a couple of years, the exchange of information became increasingly difficult. "We could send information into Russia, but it was absolutely impossible to get any out," noted one engineer.[113]

As early as 1933, members of the family had seen firsthand the horrible suffering resulting from the historic famine that winter and personally witnessed the agony of forced deportations to Siberia.[114] Conrad, as soon as the news was published in Moscow, was made aware of the beginning of the Stalinist purges and show trials. "The ones who go to trial are lucky," announced Mikhail Opochinin, a White Russian who worked at La Pros and summarized the newspapers for Conrad. "The rest will disappear without a trace. Sabotage, sabotage—it is the only word the commissars know."[115]

By the spring of 1936, communications with Moscow were essentially blocked. The seven-year-long relationship between Schlumberger and the U.S.S.R. was coming to an end.[116]

•

In April 1936, Conrad Schlumberger made another trip, with Louise, to the Soviet capital. "Out of a sense of scrupulousness, he felt obligated to go one more time to Moscow," wrote Conrad's brother Jean Schlumberger.[117] He was met at the train station by Vahe Melikian, a Russian-born, Paris-educated engineer who had worked for Schlumberger since 1928 and represented the company in the U.S.S.R.[118] Conrad asked Melikian about the leading officials who had been their clients. "Zametov?" Conrad asked. "Arrested." "Glutchko?" "Arrested." "Grigoriev?" "Arrested."[119]

One of the Schlumberger engineers who was with Conrad on that stay in Moscow remembered that he was quite tense.[120] Dominique was concerned about her father's health and realized that he went to great lengths

to conceal his difficulties and moments of discouragement. "Even his closest collaborators were unaware that his perseverance required such self-control," she wrote. "Because he had bet his life on an idea, he had to play it out to the very end."[121]

Conrad spent those weeks in Moscow having lengthy, frustrating encounters with Soviet authorities. High-level figures seemed to have become puppets. Issues settled in the morning were up for renegotiation again by the end of the day. The outcome was not encouraging: Schlumberger would thereafter function in the Soviet Union only as technical advisers, primarily for the local manufacture of equipment.[122]

Louise and Conrad were accompanied to the Moscow train station by Vahe Melikian. On the platform, farewells between the two friends were strained as both took measure of their situation (within two years, Melikian would perish in a Stalinist camp).[123] Louise and Conrad boarded the train to Leningrad, then got on a ship for Sweden. There was a patent issue that Conrad hoped to resolve in Stockholm, and a short stay in Scandinavia would be a good occasion for some rest before returning to his full schedule in Paris. On a beautiful, sunny day in Stockholm, he played a round of golf, a sport that he had always loved.

The following day, May 7, 1936, at a meeting with an attorney at his office in Stockholm, Conrad Schlumberger, only fifty-seven years old, collapsed onto the floor, struck down suddenly by a cerebral hemorrhage.

•

When her parents left for Russia, Dominique went to stay with her cousins at Kolbsheim.[124] During her visit, Antoinette Grunelius showed Dominique a copy of correspondence she had made at the Val-Richer, memorial letters that Guizot had written to his wife, Elisa, after her death. Dominique copied two pages of Guizot's letters for Jean. "There is something heartbreaking about these," she wrote to him. "The realization of how terrible death is when two people love each other so intensely."[125]

From Kolbsheim, Dominique went to the spa town of Baden, in Switzerland, northwest of Zurich, taking Marie and Adelaide with her, along with their governess.[126] On Thursday, May 7, Dominique received an urgent phone call in Baden. She was told that her father, the man who had been the guiding force in her life for as long as she could remember, had had a seizure.

Louise summoned their daughters to join them in Sweden as soon as possible. Dominique, of course, was intent on making it there in time. From

Baden, she jumped on the train to Basel, in order to fly to Stockholm. As the train pulled along the Rhine, Dominique wrote to Jean,

> I have been holding this pen between my fingers and this pad of paper on my lap for a long time now, without finding anything to say to you. I think nothing, I know nothing, I understand nothing. Like a fool, I am impassibly participating in the collapse of the entire world.
>
> That's what it is: it seems to me as though the entire world has just fallen apart. Some horrible catastrophe has brought me down, though I am having a hard time understanding just which one. I can't really grasp that my father is lying unconscious in a hospital bed in Stockholm.
>
> Since he left for Russia, I was worried that he might have some kind of attack. I promised myself that I would write about his life as soon as possible, to do it in spite of any objections or discouragements. The decision was clear, though it was a project that seemed far off in the future. No more.
>
> I will write you as soon as I arrive in Stockholm. I am going there without hope. But it will be so soothing just to see his face one last time.
>
> I wish I could be in your arms right now and cry.[127]

•

Dominique made her way quickly to Stockholm. Conrad had been transported to a room at the Grand Hôtel, a historic structure on the waterfront. The room had a view looking out over a bay of the Baltic Sea to the Royal Palace, the Swedish Parliament, and city hall.[128] She took photographs, documenting the beautiful view of Stockholm: the boats working in the harbor, the historic buildings on the skyline.

Two days after his collapse, on May 9, Conrad Schlumberger died. In a sad coincidence, the day also marked the fifth anniversary of Dominique and Jean's marriage.

Along with her sister Annette, Dominique accompanied their father's body by train from Stockholm, through the great Nordic forests of birch trees, and back to Paris.[129] His coffin was carried by hearse to the Val-Richer.

There, in the grand salon, he lay in state. The funeral bier was in dark, sculpted oak, positioned on a pedestal of Norman pine branches. Conrad's

body, wrapped in a white sheet, was placed on a long, magnificent pillow of crimson and rose.[130]

For the funeral service, family members and dignitaries were transported by a special train from Paris to the family estate. In the courtyard, Conrad's coffin was placed in a hearse drawn by a pair of horses. The procession was led by a group of World War I veterans. Dominique and Jean joined the other members of her family, walking solemnly behind the carriage. The mourners followed a path up the tree-lined drive to the nearby cemetery of St.-Ouen-le-Pin.

A simple service was conducted by a Protestant pastor. Conrad Schlumberger was buried in the family tomb of pale granite, where François Guizot had been placed in 1874 and where his parents, Marguerite and Paul Schlumberger, had been laid to rest only a decade before.[131]

That summer and fall, Dominique and her two young children spent months with Louise at her family house in Clairac. Dominique's letters back to Paris were on formal, mourning stationery, framed with thick borders of black. She began drafting a text about her father, which would be jointly authored with her uncle Jean Schlumberger and published after the war.

In those months at Clairac, Dominique's sense of loss was sharp. As she remembered decades later, "When my father died, there was really only one thing that consoled me: that, in turn, I, too, would die."[132]

ENGAGED

Dominique, your phone call was a marvelous moment for me.
The sound of your voice was clear and dynamic, and there was
that perfect harmony between us. I will be taking that along
on my travels like a priceless treasure. I have to leave now, but
I want you to know as soon as possible how thrilled I am that
you are always right here with me.
—*JEAN DE MENIL*[1]

Later that year, in the fall of 1936, when she returned to Paris, Dominique immersed herself in her many activities connected to philosophy and religion. One important venue was Jacques Maritain's house in Meudon, a suburb southwest of Paris. On Sunday afternoons, Raïssa and Jacques Maritain held meetings for a variety of like-minded thinkers including writers, artists, musicians, philosophers, and even those who were not overtly religious.[2] "It was one of the intellectual chapels of Paris," according to one participant.[3] At one of those Sunday gatherings at the Maritain house in Meudon, shortly after her return in the fall of 1936, Dominique had her first encounter with someone who would be exceedingly important in her life and that of her husband.

Father Marie-Alain Couturier, O.P. (1897–1954), a thirty-nine-year-old Dominican priest, was a fierce advocate for the spiritual power of modern art. At the Maritain gathering, Father Couturier appeared in his Dominican habit, a striking ensemble in black and white that dated from the Middle Ages and the Spanish founder of the order, Saint Dominic Guzmán. It consisted of a long white robe, tied at the waist with a leather belt, a white scapular covering the shoulders, and a white capuchin, a sleeveless garment that covered the torso and also had a hood. To protect from the elements, Father Couturier also wore a floor-length, hooded coat in solid black.[4]

The Dominican had a lean, rounded face with premature gray hair that was kept closely cropped, like a priestly version of a military man. He wore rounded black eyeglasses, much like Le Corbusier (with whom he would later build the Chapel of Notre Dame du Haut at Ronchamp, one of the most significant architectural and spiritual monuments of the twentieth

century). Couturier was intelligent, engaging, and passionate about art. And he was not shy about making sweeping, declarative statements. From their first conversation, Dominique was fascinated by Father Couturier. As the Maritain gathering began to wind down, they both prepared to leave. Dominique was relieved to have a companion. Not entirely familiar with Meudon, she was unclear of the path to the train station. So, once outside the Maritain house, she started to walk alongside the priest, an initiative that was torpedoed by Father Couturier. "I never walk in the street next to a woman," he announced brusquely. "He then took his cape, doubled his pace, and left me there in the middle of the street," Dominique remembered. "I was absolutely flabbergasted; it was as if I had committed a sin!"[5]

·

For centuries, leading artists in France and the Catholic church had become very adept at ignoring each other. Following the uproar of the Reformation, the church retreated toward the comfort of classical, academic art. "Academicism is really a mode of feeling and seeing, or perhaps better, of not feeling and not seeing," wrote William S. Rubin, the noted art historian and MoMA curator who studied ecclesiastic art for his Ph.D. from Columbia University. "Its institutionalized and hence conservative character made it a defensive mode par excellence for Catholic art after the Reformation, particularly in France."[6]

Church-endorsed art became safe, saccharine, even kitsch. That it was sentimental rather than challenging was seen by most of the clergy as an advantage. The notable exception was at the Paris Church of St.-Sulpice, where Delacroix, from 1855 to 1861, was allowed to paint a series of frescoes for the Chapel of the Holy Angels. Roundly condemned at the time by Catholic leaders, Delacroix's frescoes have been considered a "pure and unique accident" in the history of religious art.[7]

Early in the twentieth century, an effort began in France to reconnect significant contemporary artists with the Catholic church: the sacred art movement. Father Couturier became one of its leaders in the years before and after World War II.

Pierre Couturier, his given name, was from Montbrison, in the Loire department in central France, and a family of millers. "He was a happy-go-lucky fellow as a young man," Dominique de Menil explained. "He was of a good family, with enough affluence that everybody read, played music. That was the background of good Catholics in the French provinces— people who were not immensely rich, who did not have great paintings but had a few things like books and engravings."[8] His father, who collected

faience and was a painter, encouraged the young Pierre to pursue a career in art.

After being shelled in World War I, Pierre moved to Paris to make his way as an artist in Montparnasse, becoming one of the first members of the Atelier of Sacred Art, a school started by Maurice Denis, intended to educate students on spirituality and art. In 1925, outside the well-known Montparnasse brasserie La Rotonde, Couturier experienced a sudden, intense calling to become a priest. "He decided on the spot to become a priest and to enter the Dominican order," Dominique said.[9] He was ordained, as Père Marie-Alain Couturier, in 1930.[10]

When Dominique met him, Father Couturier had just taken over the direction of a small publication, L'Art Sacré, focusing on art, architecture, music, theater, and cinema, including coverage of contemporary creations as well as historical works.[11] It had an editorial committee consisting of leading ecclesiastics, art historians, and critics as well as such significant cultural figures as Paul Claudel, Jacques Copeau, Henri Ghéon, Robert Mallet-Stevens, and Jean Puiforcat. In the fall of 1936, L'Art Sacré, which had been publishing independently for several years, was purchased by two patrons and given to the publishing house of the Dominican order.[12] The editorship was shared by Father Couturier and a fellow Dominican priest, Father Raymond Régamey. "Under their joint editorship, L'Art Sacré would become an outspoken organ in the fight against academicism and what Father Couturier would vilify as the faux-moderne in church art."[13]

The de Menils became financial supporters of L'Art Sacré.[14] Dominique met several times with Couturier, discussing the direction of the magazine and exploring a host of cultural and spiritual issues. One afternoon, at the Dominicans' Paris monastery, at 222, rue du Faubourg St.-Honoré, they met from 3:30 until 6:00. "For him, the mediocrity of today's religious art is more than a deficiency; it is a sin," Dominique told Jean about their meeting. "I am not far from thinking he is right."[15]

As for the personal relationship between Dominique and Father Couturier, any sensitivity about the abrupt conclusion of their first encounter was soon forgotten. She later admitted that he was right to walk away in the street. "People can be such gossips," Dominique said with a laugh. "Among those were François Mauriac, a fervent Catholic with many newspapers at his disposal; if he could say something nasty, he would."[16]

•

Dominique authored several articles for L'Art Sacré. When Dominique and Father Couturier discussed her writing, he was not shy about being

critical. "He is not in agreement with the fundamental ideas of my article for theological and philosophical reasons that seem fair to me," Dominique wrote to Jean, about a story she had written involving art, which was never published and whose subject is unknown.[17] In May 1937, however, she published an article on Joseph Lacasse, a Belgian painter, celebrated at the time, though now virtually unknown.[18] She also wrote about architecture for *L'Art Sacré*. A story Dominique published in April 1937 was about a small church in Japan, the Karuizawa Chapel, that was a modest wooden structure. She used its handcrafted architecture and humble interior to stress the significance of design that was artisanal, on a human scale.[19]

The most revealing text she authored for *L'Art Sacré*, published in March 1937, was on a small chapel built by her cousins Antoinette and Lexi Grunelius at Kolbsheim. In the traditionally Protestant enclave, a village church had been used for Protestant and Catholic services. Because the church was not consecrated, Antoinette and Lexi sought permission to build a sanctified Catholic chapel adjacent.

Dominique was convinced of the significance of the Kolbsheim chapel. In her assessment of the visual appeal, she could have been describing the de Menil aesthetic. "Everything is so simple, with the charm of this chapel coming primarily from the excellence of its proportions and the finesse of its details," Dominique wrote in *L'Art Sacré*. "Here, nothing is left to chance, and yet the work has a real sense of spontaneity. Everything has been well considered, and yet it feels effortless. The lines are precise, taut, yet they give a sense of peace."[20]

•

In the summer of 1937, Jean de Menil was sent by his bank, BNCI, to work in London. He spent almost a full year at Kleinwort, Sons & Company, better known as Kleinwort's, a private bank in the financial district dating to the eighteenth century.[21] On one of his first days at the bank Jean met a young man who would become one of the couple's closest friends, Gerald Thompson (1910–1994). Fluent in French, the Englishman seemed destined to be friends from his first sight of Jean. "I was enormously impressed by him from the word 'go,'" Thompson recalled of their first meeting. "He was quiet, receptive, with this beautiful deep voice, dark hair, and a very perceptive eye for what really mattered."[22]

Gerald Thompson was the son of Sir John Perronet Thompson, who had been a high-ranking official with the Indian Civil Service, notably as chief commissioner of Delhi.[23] His mother, Lady Thompson, was Ada Lucia Tyrrell, whose father, Robert Yelverton Tyrrell, was a noted profes-

sor of Greek and Latin at Trinity College, Dublin (he taught Oscar Wilde and signed a petition requesting his early release from prison). Thompson was born in Simla, India, and was a graduate of King's College, Cambridge, with a degree in the classics, and also studied at the London School of Economics. After starting at Kleinwort's in 1933, he would spend his entire career with the bank until 1975.[24]

Thompson, whose father had died in 1935, lived with Lady Thompson in a grand house at 20 Melbury Road, in Kensington, near Holland Park.[25] The day he and Jean met, he invited him home for dinner.[26] Jean saw his new friend as a living example of the qualities he so admired in the English. Clearly intelligent and cultured, he was also, in that fine British tradition, very no-nonsense. "My father was very impressed with the British view of low-key excellence," remembered Christophe de Menil. "In the field, in petroleum company camps, the British would settle in—get a parrot, buy their roses, make a garden—while the French never stopped complaining. That was a very big influence for Jean, the British and his great friend Gerald Thompson."[27]

Working at an English bank and living in London were life-changing experiences for Jean de Menil. As Gerald Thompson explained,

> The world has changed shape so much that one doesn't remember it, but before the First World War, London was the center of the

Dominique flanked by the de Menils' good friends Philippa and Gerald Thompson at a party the de Menils gave in their honor at rue Las Cases.

universe. It was undoubtedly the biggest and most important city in the whole world. As a result, all the trading, all the communications, went through London . . . All the markets were there and the relics of this great past fascinated Jean. And the traditions to which they had given rise—of not absolute honesty, perhaps, but a very, very high tradition of probity in the City of London—that was something Jean greatly admired because it was akin to him. It was part of his spirit and his nature to be absolutely straightforward.[28]

Jean became a committed Anglophile. In fact, by 1939, when the de Menils hired an English nanny, Evelyn Best, who was known by all as Miss Best, to take care of their daughters, she was struck by the Britishness of the Frenchman. "The first time I saw him, Mr. de Menil arrived in complete English gentleman, with an umbrella rolled up like the English and a bowler hat," recalled Miss Best, who would move with the family to America. "That made a fantastic impression on me. He had an English tie, an English vest, and he spoke English very well. I later realized that he was so pro-English that I no longer thought of him as French."[29]

Gerald Thompson became very close to both Dominique and Jean, suggesting, wryly, that he could play an official role in helping the couple to understand the English. "I feel that I am sort of an ambassador appointed to explain this country to you and Jean," Gerald wrote to Dominique. "You may be sure that I will never leave my post."[30]

•

By the middle of August 1937, Dominique had arrived in London, staying with Jean for several months. One of their first outings was to the National Gallery, where they studied the paintings by Rembrandt.[31] During their time together in London, Dominique and Jean attended the October 1937 opening of Parliament by King George VI. "The costumes were tremendously beautiful," Dominique wrote to her family, describing the officers' red tailcoats covered with medals and their helmets adorned with feathers and judges with their long gray wigs. She singled out the lord chief justice clad in a sweeping black coat, its train embroidered with gold. "The king and queen were in ceremonial costume, as for the coronation," she wrote. "It is hard for us to imagine this pomp; it could be like a costume party, but here the ceremonial feels alive and natural."[32]

Gerald Thompson also introduced the de Menils to his youngest sister, Philippa Thompson, also fluent in French, a very attractive young woman who became a close friend of the couple's.[33] There was something incred-

ibly gentle and otherworldly about Philippa, who loved animals. Her room at Melbury Road contained a collection of animal figurines in porcelain and wood, from a chalet filled with bears to a small glass that held a tiny white mouse.[34]

Philippa was also quite charming and amusing, something like a character out of Nancy Mitford. To describe a weekend wedding at a house in the country in Devon, not far from Exeter, Phip wrote Dominique a thirty-page letter, with additional notes scrawled on the back of the envelope. Apologizing for the epic length, she wanted the de Menils to know every detail of the wedding festivities.[35]

Once Dominique and Jean were back in Paris, they invited the brother and sister to spend time in France, where they were introduced to Marie and Adelaide and other members of the de Menil and Schlumberger families. Philippa and Gerald Thompson also took the ferry over from England for long weekends at the Val-Richer. And they traveled together around France, visiting Dominique's cousins at Kolbsheim and going skiing in the Alps.[36] In Paris, the de Menils made sure Gerald became friends with Simone and Jean Jardin.[37] And Dominique and Jean gave a ball for Philippa Thompson at the rue Las Cases: in the rose-filled apartment, guests wore evening attire while a small orchestra played.[38] Dominique wore white satin, with a tiara. Philippa chose a black strapless gown, while her brother appeared in white tie.

Even in the elegant swirl of 1930s Paris, their English friends seemed to be quite dashing. "I must have been three or four years old, but I remember very well that I would be at the window and see her arrive, in her convertible American car, a Packard perhaps, going into 7, rue Las Cases," said Simon Jardin, the son of the de Menils' friends who lived across the street. "I remember Philippa Thompson as though in a dream."[39]

•

Jean de Menil, shortly after joining the BNCI, was promoted to vice president. He collaborated closely on growth strategies for a host of French enterprises. At only thirty-four years old, having worked in finance for half his life, he was a senior executive at a leading Paris bank overseeing six hundred employees.[40]

Meanwhile, the Schlumberger family business, in its second decade of operations, experienced explosive growth. In 1936, the headquarters on the rue St.-Dominique expanded greatly. La Pros, housed in two adjacent buildings, consisted of bustling offices, workshops, laboratories, and testing stations. The bulk of the business growth was scattered around the

world. In 1933, there were twenty-eight engineers working in the field; two years later, there were seventy; in 1938, there were a hundred Schlumberger engineers around the globe.[41]

Annual income from the American operations tripled in two years, from $254,000 in 1935 to $940,000 for 1937.[42] By 1938, Schlumberger had a dozen offices across the state of Texas and sixteen more branches nationally, from California to Illinois, Louisiana to Wyoming.[43] The number of wells analyzed by Schlumberger was another sign of its growth. In 1935, Schlumberger performed 2,471 jobs for American oil companies. By 1938, the number was 10,851, and in 1940 it was 14,508.[44] The same exponential growth was being achieved by Schlumberger in other oil-producing countries. The world was heading toward war, and petroleum became an increasingly essential resource.

With La Pros expanding so quickly, it seemed more involvement from the Schlumberger family was needed. Between Conrad and Marcel there were six children, five daughters, and one son. The second generation— meaning the five husbands of the daughters and the one Schlumberger son—were either working for the firm or expected to join. The first, of course, was Henri Doll, the husband of Dominique's older sister, Annette, who had been hired by Conrad for his technical brilliance in January 1926. In 1937, René Seydoux, married to Marcel's daughter Geneviève, became part of La Pros.[45] The following year, Paul-Louis Primat, a 1930 graduate of the prestigious École Polytechnique, joined the firm as soon as he married Marcel's second daughter, Françoise. Also in 1938, Eric Boissonnas, the young geophysicist married to Dominique's younger sister, Sylvie, began working for the family firm.[46] Dominique, even though she was no longer in the office, remained very close to the company. She had regular contact with her uncle, her cousins, and the technical staff.

By the late 1930s, only Jean de Menil and Pierre Schlumberger had not yet joined La Pros. At that time, Pierre, Marcel's only son, was still in his early twenties (he would move to Houston and join the American subsidiary in 1941).[47] Jean had long resisted any overtures. After he married Dominique, he was approached by Conrad Schlumberger about working for the family company. Jean demurred. After Conrad died, the conversation was continued with Marcel. Reluctant to give up his successful career in banking, Jean was also worried that joining Schlumberger would make it look like he was taking advantage of his marriage to Dominique. "He said, 'I didn't marry the boss's daughter and I'm just fine,'" remembered Christophe de Menil. "Marcel finally said, 'Okay, Jean, that's enough: we know you don't want to marry the boss's daughter, but we need you!'"[48]

If Jean were to join La Pros, he would be the first executive whose

expertise was in finance, management, and what would now be considered human resources. The other Schlumberger executives were trained as scientists or engineers. René Seydoux, prior to joining La Pros, had been the director of Sciences Po, so he was clearly a capable administrator. But no one else—and this would be critical for a company experiencing such tremendous growth—had the kind of financial and managerial experience of Jean de Menil.

In the fall of 1937, Marcel Schlumberger initiated a serious dialogue with Jean about joining the company.[49] One of his beliefs, which came from an admirable desire to avoid favoritism, was unacceptable to Jean. Marcel felt that all members of the second generation should be brought into management positions in the company on a basis that was strictly equal. Jean strongly disagreed.

As he wrote to Marcel Schlumberger,

> My work in banking has allowed me to see too many examples of family businesses led to ruin by a soviet of sons and sons-in-law, all drenched in their right to equality, dealing with everything and nothing, giving orders left and right, the least experienced and the least active smothering the sense of innovation and authority of the best and making their task impossible.[50]

Jean was not opposed to the idea of family members working for the company. But he felt that the second generation should be placed in positions based on their individual experience and qualities. "Management should be based only on real needs," Jean wrote to Marcel. "Not everyone should have the *right* to be a managing director."[51] Jean sent a draft copy of his letter to Lexi Grunelius, who agreed. "It is madness to put all the members of the family on the same level," Lexi wrote to Jean. "If the business is well managed, all of the shareholders will receive their share of the profits and all will be beautifully compensated."[52] Strong management, rather than nepotism, would mean that all would prosper.

By the summer of 1938, Jean de Menil was still reluctant, though he was leaning toward joining La Pros. A letter from a Schlumberger engineer, whom Dominique and Jean had spent time with in Morocco on their honeymoon, was encouraging. As Jean mused to Dominique, "Does a taste of adventure suddenly seem more attractive because of a disappointing day at the bank? Or is there a sudden desire to be finished with all of this uncertainty, heightened because of a sense of solitude following an uneventful evening? Or is it something authentic?"[53]

He wanted to have a conversation with her the following day at lunch

so that she could weigh in on the decision.[54] "It is not worries about money that motivate me," he wrote to Dominique. "It is the desire to be the kind of leader who won't disappoint those who work for him."[55]

Dominique's older sister, Annette, felt that Jean was most attracted to the opportunity to work outside France. When the American office opened, most members of the Schlumberger family were unenthused. "All of the family said, 'Ah, it's lovely, this America, but none of us want to go live there,' " remembered Annette. "And Jean de Menil said, 'But you really have no idea where you'd like to be living!' "[56]

•

In December 1938, a full year after he began discussions with Marcel, Jean de Menil joined the family firm[57] and made his first trip to the United States for Schlumberger.[58] The purpose was to help solve a serious tax issue that had developed for the American branch. While Dominique rented the Chalet St. Nicolas in Megève with her daughters and members of her family,[59] Jean sailed on the *Conte di Savoia,* an Italian transatlantic ocean liner that left Europe from Naples.[60] Jean recorded his impressions of sailing into New York ("thrilling"), his stay in downtown Chicago ("a sad city blackened by coal"), and a visit to Mattoon, Illinois, just beginning an oil boom ("The appearance of petroleum has given an amazing animation to a simple place, a transformation repeated thousands of times across the United States, like the gold rush").[61]

But it was Jean's first stay in Texas, at the Schlumberger headquarters in Houston, that was the most revealing. He wrote a fourteen-page letter to Dominique back in Megève, wanting to make the trip come alive for her. Jean was startled by the look of American suburbs, where, unlike Europe, houses sat in the middle of spacious lawns, facing the street. "There are no walls surrounding the houses," he wrote to Dominique. "It is as though they are in a park, scattered across the grass." He also noted the dense Gulf Coast foliage, with trees that were a somewhat dull green ("live oaks, conifers"), and the vivid plushness of the lawns, even in winter. "A thick, dense carpet that crunches as you walk across it."

Jean described the vast convoys of freight trains that pulled through the city and the red-lidded fire hydrants that appeared on street corners. At a Rotary luncheon in the banquet room of a thirty-story downtown hotel, he encountered several hundred businessmen wearing large plastic name tags that listed only their profession and their first names. And he witnessed other Texas customs unusual enough that he described them in great detail for Dominique, both bemused and anthropological:

Yesterday at La Pros there was a barbecue. Barbecue is a piece of meat—originally lamb or a slab of beef—that has been slowly roasted for twelve hours. From time to time, the company orders a barbecue from a black man who lives in the neighborhood. And everyone from the director to the receptionist has lunch together, served from a small stand built just for the occasion on the grass in the courtyard of the building. Everyone eats this spicy meat off paper plates, using their hands, while drinking Coca-Cola or milk. *C'est très sympathique.*

Jean also made his first trips into the field, joining teams of Schlumberger engineers as they took measurements on oil wells outside Houston. He admired the intensity of the work. "I waded happily in the mud that surrounds the well, communed with the din and the brutality, taken in by this drilling industry, one of the few remaining that still has a sense of poetry."

Other elements of the New World were less encouraging. For leisure activities, Jean saw only the possibility of swimming pools and golf, played at local country clubs, or fishing on the bayous and the Gulf of Mexico. "Other than that, there is nothing, no place for a walk in the country. Around Houston are a few wooded areas infested with mosquitoes and, apparently, snakes, then it is just flatlands as far as the eye can see."[62]

His primary contact in Houston was René Seydoux, who, along with Dominique's cousin Geneviève, had been in Texas since 1937.[63] They lived in a white colonial-style house, with an imposing portico, near Brays Bayou. "Spacious rooms, light colors, glossy doors, simple lines, sparely furnished. It is not what we would have built, but it is lovely." Jean told Dominique that René Seydoux seemed to be thriving and that he had been successful at La Pros, though Geneviève was clearly unhappy living in Texas ("She is glum and seems to be bored and a little tense"). On that first trip, Jean was not encouraging about the prospect that they would settle in Houston. "I hope that we will not have to move here," he wrote to Dominique. "I know that you would not like it."[64]

After Houston, he stopped again in New York before sailing back to France. By the end of January, as Jean was crossing the Atlantic, Marcel Schlumberger arrived in Megève and gave Dominique good news about Jean's work in Texas. His strategy for their meetings with the Bureau of Internal Revenue, as it was called at that time, had solved the tax issue. "He convinced them that we were acting in good faith," Dominique wrote to her grandmother. "A great thorn in our side has been removed."[65]

•

Shortly after returning to France, Jean was off for another business trip, to Qatar, where the vastness of the desert reminded him of a poem by Claudel on the endless Indian Ocean. His next trip was to the main oil-producing country in Europe, Romania.[66] He was sent there by Marcel to reorganize the activities of La Pros and to look at another tax issue.[67] Jean left for Bucharest in May 1939.[68] He expected the trip to last for fifteen days; he was there for more than a year.[69]

The tax issue turned out to be revelatory for Jean. The problem stemmed from La Pros being paid in Romanian currency and subjected to uncertain, black market exchange rates. "I began to understand the economics of the oil companies and to realize that we were in a position of strength that would allow us to be paid in solid currency, particularly U.S. dollars," Jean later explained. "So, this experience in Romania, which was challenging and disappointing in many ways, turned out to be extraordinarily important in the international evolution of Schlumberger."[70]

As a new employee of La Pros, Jean de Menil had a lot to learn. One engineer remembered a lesson he had to give him that year in Bucharest. Having spent the previous night taking readings on an oil well, the engineer, André Poirault, decided to go to an afternoon movie. On his way into the cinema, he ran into Jean de Menil. "What's going on here?" Jean asked. "You're spending your afternoons going to the movies?"

As Poirault remembered, with a laugh, "I explained, 'Absolutely. I was summoned in the middle of the night, woke up for the good of the company, and worked all night—a reading is not something you can delay—so, I'm going to relax a little at the cinema.' But he was very nice about it."[71]

Jean divided his time between the Romanian capital and Câmpina, in the mountains northwest of Bucharest, the center of the Romanian petroleum industry.[72] "Jean is fascinated by his first trip into the field," Dominique wrote to her grandmother. "Now that he has left his former career, Jean is immersing himself into the mysteries of 'electrical prospecting.'"[73]

•

In July 1939, Dominique joined Jean in Romania, while their daughters remained at the Val-Richer. Dominique, who, after all, knew the science of Schlumberger much better than her husband, went with him to Câmpina.[74] They lived and worked in the rugged camps, surrounded by active wells and bustling refineries. She spent three weeks with him in and around Câmpina, a time she saw as one of great peace and intimacy between them.[75]

Dominique's first reaction to Bucharest was that it was dusty and noisy.[76] Soon, however, she was fascinated by Romanian culture. She and

Jean became acquainted with the country's folkloric music, particularly the singer Sarah Gorby, buying many records that they took back to Paris.[77]

In Bucharest, the de Menils lived at 18, Aleea Eliza Filipescu,[78] a modern, machine-age building in an elegant, central section of the city, just off the historic Filipescu Park. They were staying in the apartment of a Frenchman, Pierre Angot. A graduate of the École Polytechnique and the École des Mines, Angot had become a director of Steaua Română, one of the country's leading oil companies. Angot and his wife gave Dominique and Jean one of the children's rooms, with its own entrance and bath. Another Schlumberger executive had a room in the same building.[79]

Monsieur Angot, having taken a research trip to the United States, had been brought to Romania to modernize the company. He would become a fierce Nazi resister, first in Romania and then when he returned to France; after continued anti-Nazi actions in occupied France, Angot would be arrested in June 1944 and deported to Buchenwald, where he died in February 1945.[80]

•

The rise of the Nazis in Germany and the fragility of peace across Europe seemed to dawn slowly on Dominique and Jean. Though they were not, in any way, sympathetic to the fascists, they were determined not to be anti-German.

Both had deep personal and historical ties to the country. Dominique was fluent in German, while Jean also spoke the language. She, of course, had lived in Berlin before the rise of Hitler and traveled there regularly during the 1930s. One of Dominique's first trips after their marriage, accompanied by Lexi and Antoinette, was to stay with Felix von Bethmann-Hollweg, from a leading Prussian family, at their remarkable estate, Hohenfinow, in the eastern German province of Brandenburg; arriving by a late train, they found their hosts seated at dinner, in black tie and evening gowns.[81] German friends, including the Bethmann-Hollwegs, regularly visited the de Menils in Paris. Dominique and Jean hired nannies who were German or Swiss German, and Christophe, by the time she was three, seemed more fluent in German than in French.

Their feelings toward Germans were no different from their esteem for the people of France or England or Morocco. Also, like many who had lived through World War I and whose families had experienced such great loss only two decades before, they were eager to avoid another deadly military conflict. Dominique's father, after the horrors of World War I, had been on the brink of abandoning his career to publish an antiwar manifesto, while

Jean's family had been decimated by the conflict. Why would either wish to see that repeated?

In retrospect, however, the de Menils' lack of alarm about the rise of the Nazis is unexpected especially considering that they would go on to show such ardent support for the Free French and the Allies. When first confronted by the rise of Hitler, the de Menils' good intentions, their idealism, even their religious beliefs—they would not have been the only Catholics in Europe to have downplayed the threat posed by Hitler—might have made them a little naive.

The threat of another military conflict at first seemed to be remote. "I can imagine how the Austrian crisis must appear more serious in Paris than here in England," Gerald Thompson wrote to Dominique in the spring of 1938, after the Germans annexed Austria. "Even in London, where invasion is completely unknown, we are starting to ask ourselves about war."[82]

The de Menils appeared to be less inclined to consider the question. Later that year in Paris, Jean had a long lunch with Nicolas Nabokov at the Brasserie Weber on the rue Royale. They discussed their mutual friends Antoinette and Lexi Grunelius, Franklin Roosevelt, and the cultural life of America. As Jean wrote to Dominique, "We decided to talk about really serious things and not to bother ourselves with Hitler."[83]

In September 1938, Dominique went to Salies-de-Béarn, a historic town in southwestern France with saltwater springs that fed spas and baths. She had been experiencing a circulation ailment in her leg and spent several weeks in Béarn. To keep an eye on international affairs, she read the newspaper from Bordeaux, *La Petite Gironde,* as well as *Paris-Soir* and *Le Figaro* from the French capital.[84] She sorely missed *The Times* of London, so Jean had issues sent to her from Paris.[85] "The events in Czechoslovakia are hardly encouraging," Dominique wrote to Jean. "But I have a hard time believing in the possibility of a catastrophe."[86]

On Sunday, September 25, Dominique went to a 7:00 a.m. Mass, where the priest spoke of the failure of the peace after World War I and the importance of having faith in every aspect of life. At 8:30 p.m., Dominique returned for a special service, requested by Pope Pius XI, to pray for peace.[87] After Mass, Dominique wrote to Jean,

> I don't know why, but since this morning I feel that war is less likely. The *Times* articles from Monday and Tuesday, the second telegram from Roosevelt addressed directly to Hitler, the guarantee by Chamberlain to Hitler of the return of the Sudeten territory, and, finally, that everyone is putting all of their cards on the table

(historically unprecedented)—all of that makes me think that Hitler will not be marching off, his head down, toward catastrophe.[88]

On Friday of that week, September 30, 1938, the Munich Agreement was announced. Dominique, in Salies-de-Béarn, noted a sense of euphoria. "Peace is signed, madame," exclaimed the young lady who delivered breakfast to her room. There was a sense of jubilation, Dominique believed, as though an armistice had been signed. "It is only now that we realize how tenuous the thread that had been holding together peace," Dominique wrote to Jean. "The speech of Chamberlain in the House of Commons made that clear. What a beautiful session. It will remain a high point of history."[89]

Of course, the Munich Accords have since been judged as one of the most misguided attempts at appeasement in history. Though many in England and France were relieved, others saw the danger ahead as it was happening. When French prime minister Édouard Daladier returned to Paris to be greeted by cheering crowds, he was shocked and was said to have remarked under his breath, "Idiots!" Winston Churchill spoke forcefully against the agreement in Parliament. "This is only the beginning of the reckoning," Churchill warned. "This is only the first sip, the first foretaste of a bitter cup which will be proffered to us year by year unless by a supreme recovery of moral health and martial vigor, we arise again."[90]

The following month, October 1938, Dominique and Jean, along with Marie and Adelaide, were in Kolbsheim with Antoinette and Lexi Grunelius as well as Gerald Thompson. Dominique, Gerald, and Lexi spent hours engaged in political conversations.[91] Several weeks later, on November 8 and 9, synagogues throughout Germany, Austria, and the Sudetenland were systematically vandalized. Jewish residents were beaten up, arrested, taken to government camps, and then fined 1 billion marks for the damage. *Kristallnacht*, as it became known, was front-page news around the world and has been considered the first act of the Final Solution. *Kristallnacht* went unmentioned in the de Menil correspondence.

Later that fall, Gerald Thompson signed up to be an auxiliary fireman. He spent two nights a week in training (and would go on to be an officer in the Royal Air Force).[92] The mood in England was darkening. "It is now felt that war is more likely than peace," Gerald wrote to Dominique at the end of November 1938. "This week has seen a great increase in feeling against Germany."[93]

The de Menils continued to be hopeful. The following spring, in May 1939, as Jean traveled through Germany en route to Romania, he wrote to the family back in France,

For the first time, in Europe, I have gone east. All of the countries we passed through, including Romania, although they are very distant, give a very strong impression of kinship. They have farmers, their fields look like ours, they drink wine, as we certainly have. Because we feel closer to them than we do to Americans, for example, what becomes very clear is the maleficent nature of this family quarrel that does not seem to be dissipating. A maleficence of which, unfortunately, our hands are not entirely clean.[94]

With Dominique, he was more explicit about his feelings. Traveling through Germany reminded him of what he loved about the country, including *Fliegende Blätter,* an illustrated satire magazine of his youth, and *Siegfried,* a play by Jean Giraudoux, exploring the shared humanity of the French and Germans. "Oh, Dominique: all these fields of wildflowers with names that you would know," he wrote enthusiastically as the train continued from Vienna to Budapest. "My first contact with Germany was so stirring. These landscapes, these houses, these full-cut jackets in thick green wool (like corduroy jackets at home), these porcelain pipes, these barefoot children all along the roads and out in the green fields. All of this I know and love!"[95] This passion for Germany came a year after the *Anschluss,* six months after *Kristallnacht,* and just as Hitler announced an alignment with Mussolini, the Pact of Steel.

Also in the spring of 1939, after the Nazis had invaded and occupied Czechoslovakia, Jean wrote to Jacques Maritain about the journal *Temps Présent.* Jean found the tone of some articles too inflammatory and predictably anti-German. In contrast, Jean included an editorial from *The Times* of London expressing concern about Hitler's militarism and justifying a British military buildup supporting Chamberlain. Though it expressed some nuance, the editorial was pro-appeasement. "The thirty thousand readers of *Temps Présent,* with their profound Christianity, common desire for unity, friendship, and mutual support, deserve a substantial sustenance," Jean concluded to Maritain. "We are serving them leftovers."[96]

Dominique forwarded Jean pages from *The Times* and kept him informed of her editorial discussions at *Temps Présent.* She lobbied the editor for publication of an article by Jean Jardin, which had been refused. "I told him that it was a different opinion from the editorial point of view but that it was one that deserved to be heard," Dominique explained. "He agreed but said that he was in a difficult position; it would be very serious to give the impression of supporting Hitler's demands."[97]

By summer 1939, however, the de Menils began to see that war was inevitable. And they became increasingly clear about their opposition to

the Nazis. In June, Dominique had a meeting with an editor of *Temps Présent*. They discussed the bleak situation in Germany and in Spain and agreed that the Vatican's lack of understanding of the crises was only going to encourage totalitarianism. "Franco is moving more and more toward tyranny," Dominique noted. "And we see very well the failure of the German protectorate of Czechoslovakia. The yoke is becoming more and more oppressive."[98]

On July 2, visiting London again, Dominique, accompanying Gerald, attended a military rally in Hyde Park. Parading in front of the king and queen and tens of thousands of spectators were over twenty thousand male and female volunteers for the national defense, from every corner of England, and two hundred military vehicles. The march past the reviewing stand took more than an hour. Dominique found the mass of volunteers, with their modest, imperfect uniforms, to be moving. "There was something appealing about such spontaneous discipline, free from rigidity," she wrote to Jean. "It was the opposite of Hitlerian demonstrations, those vast deployments of automatons that are as inhumane as they are grandiose."[99]

Refugees fleeing the arrival of German troops in northern France, June 1940.

PART THREE

WAR

DRÔLE DE GUERRE

*It is awful to think that we are now going to repeat the same
battles that vanquished a generation. It is going to be a fight to
the death. Hitler is going all out now, and we have to oppose
him with all our force.*
—DOMINIQUE DE MENIL[1]

In the Kremlin, on the night of August 23, 1939, Joseph Stalin
and German foreign minister Joachim von Ribbentrop drank
a toast to Adolf Hitler. The following day, when the news was announced
that Russia and Germany had signed an anti-aggression treaty, it was, in
the phrase of one historian, "the pact that rocked the world."[2] Dominique
was with Jean in Bucharest. "I left the next day or the following day," she
remembered. "Jean said, 'You have to leave.'"[3]

Dominique traveled by train west across Europe to reunite with their
daughters in Baden, Switzerland. "I don't know what the future has in store
for us," Jean wrote from Bucharest. "It certainly seems dark. But now that
you have left and, I hope, arrived, I am very relieved."[4] For Dominique, in
the bucolic spa town, the news that followed the Nazi-Soviet Nonaggres-
sion Pact was menacing. "I don't know when or where this letter will reach
you," she wrote to Jean. "Everything is so dark and we had better expect
the worst. Yesterday in Zurich, I bought a copy of *The Times* from Fri-
day. The Berlin correspondent believes that Hitler has decided to use force
against Poland."[5]

During her stay in Switzerland, Dominique had her first experience of
the force of Nazi propaganda. One of their daughters' nannies, Néné, had
taken time off to visit a cousin in the German province of Sarre. The day
after Dominique arrived in Baden, they appeared unexpectedly. Dominique
explained their rushed departure from Germany:

> The atmosphere there had become unbearable. Overnight, orders
> had been given for a partial mobilization (a third of all men in
> the Sarre are now mobilized). The people have been fanaticized,
> according to Néné. They have complete confidence in the Führer.

They blindly believe everything in the newspapers and on the radio. No one is interested in broadcasts from Switzerland or Strasbourg. The hatred against England and France is immense. If the German public feels this way, the situation is much worse than I thought.[6]

Dominique wrote to the superintendent of their building on the rue Las Cases, asking him to take some pieces of furniture, paintings, and objects from their apartment and secure them in the basement. She spoke with Gerald Thompson, who was visiting Paris, asking him to pack her suitcases with jewelry, letters, photographs, and personal documents that she would be able to transport to the Val-Richer. Dominique planned to make a quick trip to Paris and the Val-Richer, then return to Bucharest to be with Jean.[7] After reading the newspapers the next day, Dominique decided to return immediately to Paris. "Oh, Jean, we must not delude ourselves. The situation is very serious and the future is precarious. Everything that we wanted to build together—all of our projects, ourselves—everything is now in the hands of God."[8]

•

After an overnight train ride, Dominique arrived in Paris on August 31. She was met at the station by Gerald Thompson and Jean's sisters Mirèse and Simone. They went first to the rue de Vaugirard, then to the rue Las Cases. Dominique and Gerald worked with Madame Dale, the building's concierge, and her son Georges to finish packing up the apartment, even putting the piano in the basement. "At 10:00 p.m., after a full day working, we had a bottle of champagne brought up from the cellar and drank it in the apartment of Madame Dale," Dominique wrote. "It was a fantastic evening! It seemed that all was not irredeemably lost. Madame Dale was full of verve, that French, working-class verve that you love so much."[9]

Dominique and Jean in Bucharest, in 1939.

Dominique spent the night with Jean's family on the rue de Vaugirard. That morning, she went to Mass

with his sisters. She returned to the rue Las Cases to organize a few more things. Her next stop was near the Paris stock market to see her uncle Maurice at his private bank, Schlumberger & Cie.,[10] who gave her the news that Hitler had just invaded Poland. "I felt faint," Dominique wrote to Jean. "The night before there still seemed to be some hope."[11]

She rushed back to the rue Las Cases, where she found Jean Jardin. "He was crushed. He seemed to have aged by ten years." Jardin suggested she take the first train for Normandy, at 1:00 p.m., but they then decided that it would be best for them to drive. At 12:30 p.m., Gerald Thompson arrived. After a gloomy, quiet lunch, they went down to the courtyard, where Jean Jardin was waiting with his Ford, along with his children and the de Menil daughters. Madame Dale was there, also with tears in her eyes. As they crossed the porte cochere, Gerald Thompson stood on the sidewalk in front of the building, waving, while Jardin drove down the rue Las Cases.

That morning in Bucharest, Jean listened to the radio as Hitler delivered his speech to the Reichstag, announcing the war on Poland. He was notified by the French military attaché in Romania that he could expect to be mobilized within two days. "It feels a little humiliating," he wrote to Dominique. "Wage war from an office? When I think of all of the simple people—farmers, workers—who are now being delivered packages of machine gun cartridges. My place is with them."[12]

During his lunch, Jean and his colleagues listened to various broadcasts about the conflict. "And we discussed the comparative charms of a campaign in Poland or one in Syria, of warships torpedoed in the Mediterranean." Much like Dominique, however, at the other end of a troubled Europe, Jean focused on the spiritual and on their communion. "Dominique, you gave me a taste for life; you helped me become myself; you taught me how to pray. And, tonight, it is with you, our hands joined together, that I say, 'Pater fiat voluntas tua.'"[13]

•

After driving to Jean Jardin's place in Normandy, in Évreux, Dominique and her children made their way to her mother's house on the coast at Blonville-sur-Mer. Stopping at a gas station, they came across a woman who had just heard the news about the invasion of Poland. Panicked, she exclaimed to Dominique, "But what's going to happen to us?"[14]

Given the remarkable series of events they were witnessing, it seemed necessary to explain what was happening to their six-year-old daughter, which she then described to Jean:

When Marie was in bed, I told her that a war was probably going to take place. I explained the aggression against Poland. Her first reaction was, "Wouldn't it be better to give the Germans a little piece of Poland?" I told her that a little piece would not have been enough, that then they would have wanted a bigger piece. Oh, Jean, her reaction was so moving. I told her the story of Czechoslovakia. She followed carefully the history of the Sudetenland, though it seemed a little complicated to her. But she suddenly said, "Oh, I see. It had all been worked out, but then Hitler wanted to take everything for himself. But why do the Germans listen to Hitler?" I told her that there are a lot of Germans who think like Hitler. She lives this drama with all the intensity of an adult.

I hesitated to say anything, but that became impossible. She could see very well for herself that extraordinary things were happening. I tried to ensure that she would not be too upset, and I told her that everyone will find one another in heaven but we have to pray a lot for that to happen.

She asked this adorable question: "Has a soldier already been killed?" I told her, "More than one, I think." "So, two or three?" And then she said, which was heartbreaking, "It's already pretty terrible, isn't it?"

Now we finish our prayers with "God, bless *Papa* and bless all of the soldiers."[15]

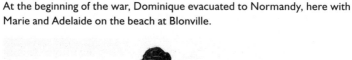

At the beginning of the war, Dominique evacuated to Normandy, here with Marie and Adelaide on the beach at Blonville.

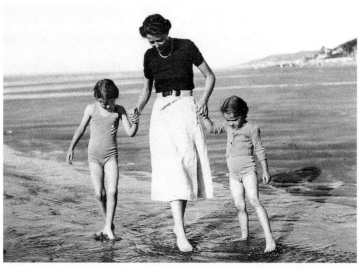

The next day, Sunday, September 3, 1939, Dominique was with her family in Blonville. No newspapers had appeared. The churches in Blonville and Benerville were packed. Dominique had barely slept in several days. After lunch, Madame Conrad read aloud from works by François-René de Chateaubriand and André Maurois. "Reading is better than having to talk," Dominique noted. "But it is hard to be interested right now in Chateaubriand."[16]

Her sister Sylvie was impressively positive, making an effort at good cheer, though Dominique had a more difficult time. In the evening, on the radio, it was announced: World War II had begun.

Jean was thirty-five years old; Dominique was thirty-one. "At 6:00 p.m., I hear the news," she wrote to him. "War was triggered in England at noon; in France at 5:00 p.m. The catastrophe is here; we have entered a nightmare."[17]

•

The French government gave the command for a complete military mobilization. In Bucharest, Jean's orders came from the military attaché of the French embassy. He was informed that he would be assigned to Le Deuxième Bureau de l'État-Major Général.[18] The Deuxième Bureau, or Second Office, was the division of the French army responsible for intelligence on enemy troops, much like a French version of the CIA or MI5 (founded in 1871, the Deuxième Bureau would be dissolved in 1940 under the German occupation).

Jean took advantage of a diplomatic courier to convey the news to Dominique, freed from the worry of being indiscreet. He made sure she had the name of his contact at the French embassy as well as its address in an imposing building at Strada Biserica Amzei 13, not far from their apartment.[19]

The de Menils found themselves at the start of what would later be called the *drôle de guerre*, the *Sitzkrieg*, or the "Phony War." Although often ridiculed afterward, those months were a time of great tension. "The *drôle de guerre* was not just a parenthesis between peace and war," historian Julian Jackson noted.[20] It was a period of jockeying for position, of ratcheting up the pressure, of waiting.

Dominique and her two daughters settled at the Val-Richer within days of the declaration of war. Her uncle Maurice, also at the family château, summed up the absurdity of the situation. "Happily, for the moment, everyone is still searching for the right place to kill one another," the banker said to Dominique. "And it is likely the whole winter will be spent that way."[21]

Like many, Jean assumed that the ambitious fortifications of the Maginot Line would protect the country. "I think behind our Great Wall of China, France will be relatively calm, spared, at least, an invasion," he suggested to Dominique. "The game will be played in eastern Europe. The table has not yet been set."[22]

As he waited for his orders, Jean continued to be frustrated that he was not back in France, moving toward the front lines. "It is not that I want to come under fire, but I want to share the fate of all of those poor bastards the war has ripped from their homes, their wives, their work, only to throw them, pell-mell, into a lengthy period of waiting," Jean wrote to Dominique. "I would rather be in my modest position as an infantry corporal with only a rucksack. Here, my bathroom and my bed feel like a reproach."[23]

Dominique was convinced that it was better for him to stay in Romania than return to France. "However secondary you might feel your work is there, it is more useful and appropriate to your capacities than peeling potatoes or sweeping the courtyard of a barracks in Dijon, Melun, or Rouen," she wrote to Jean. "You have no idea the number of people we know who, like you, wanted to be on the front lines and are now growing moldy in some barracks far to the rear."[24]

As Dominique and her family went about their daily lives, the war was increasingly present. The atelier of La Pros had been mobilized in the interest of national defense. Around the Val-Richer, they took care of refugees who had begun to appear.[25]

Dominique and Sylvie drove a truck weighted down with blankets, mattresses, and clothing for those who had been displaced. As she described the scene in Normandy,

> It may not yet be war, but it was very much the atmosphere of one, seeing big vehicles, carrying mattresses, driven by a woman. There were kind greetings from soldiers guarding the roads, big smiles from the English soldiers. We see them often now, strolling the streets of the villages, trying to explain themselves in the cheese shop—to the great delight of locals who put in their two cents— and playing soccer with the children from the village.[26]

Fall 1939 in France was a time of great fear, whether it was shown or not, of trying to carry on with daily life while waiting for the worst. One beautiful autumn day at the Val-Richer, Dominique was struck by the bittersweet mood of the moment. Alone in her room, she crafted a letter to Jean. "I am writing you with the window open wide," she wrote. "A bird is singing on the chestnut tree near the farm. Chilly flies buzz about the sunlit panes of

glass. Here, it is peaceful, while, out there, all those poor soldiers are jittery. A German offensive is said to be in the works. The heart aches."[27]

•

As fall 1939 turned to winter, Jean continued to hope for a return to France.[28] Dominique, however, began to make plans to return to Romania.[29] She hoped to be able to stay with him in Bucharest for at least a couple of months, even though, to Dominique, the idea of a trip across Europe during the war felt like it could be as demanding as an expedition to India. At the Val-Richer, Dominique planned the first Communion for Marie, hired a new nanny, and worked with other members of her family to see if parts of the property could be used for medical facilities.[30] Jean, at the French embassy in Bucharest, filed the paperwork that would allow her to leave France.[31]

Meanwhile, life, even on the cusp of world war, continued to intrude. Marie had appendicitis, and the emergency operation was handled in nearby Lisieux. The recovery was smooth, but her Communion needed to be delayed. Then, as Dominique planned a departure from the Val-Richer, she received an urgent telegram from Gerald Thompson in London: "Phip is gravely ill. *Ora pro nobis.*"[32]

Dominique placed an emergency telephone call to Gerald, who told her of the seriousness of Philippa's condition. She was being attended to at the family's country house in Amwell, Hertfordshire, north of London. Dominique quickly wrote to Bucharest: "Jean, Philippa is dying."[33]

That afternoon, Dominique went to Lisieux to the Carmel chapel, the historic convent where Saint Thérèse of Lisieux had retreated from the world. She was struck by the Carmelite nuns there who had followed Saint Thérèse's path. "I spent a long time in the chapel, on my knees, in prayer. Behind the chapel, the sisters, by their renouncement of everything, are proof of hidden realities."[34]

Between Marie's appendicitis and the first wire from Gerald, Dominique barely slept. Two days later, she received a second telegram from Gerald: "Tests show tubercular meningitis. Specialists give no hope." Dominique wrote to Jean, "This sudden confrontation with death, in someone so close, brings us back to basics. Everything is purified."[35]

The following morning, she received another message from Gerald: "Last night at compline. Happily resigned. Tell Lexi and Vaugirard."[36] Philippa Thompson had been stricken on Saturday. By Wednesday night, she was dead. Dominique sent Jean a telegram: "Philippa died. Fulminant meningitis. Telegraph Amwell."[37]

Jean was speechless. "It's like something from the Old Testament and not unlike the feeling I had at the beginning of the war. Poor Phip. Poor Lady Thompson."[38] The tragedy made Dominique reflect on the ball that she and Jean had given for Phip on the rue Las Cases. "All those roses, the music, the beautiful gowns, now have the feeling of something celestial," she wrote to Jean. "We were celebrating someone God had already reserved for Himself."[39]

•

The political and military pressures that were building in western Europe were also on the rise in the east. Romania was the primary source of petroleum for Germany, so the country's oil fields became an important asset.[40] Nazi soldiers were visible throughout the country, and there were pro-German demonstrations in Bucharest. Though ostensibly still an ally of France, Romania was drifting closer to its German neighbors.

As soon as Jean reported for his military duty, he was told that there could be some challenging assignments for him to fulfill. "The work that has been suggested to me is one that appears very exciting," Jean informed Dominique. "But I am afraid that these sorts of things happen only in adventure novels."[41]

If Jean did not receive a more active assignment in the coming weeks, he planned to formally request a return to France, to be incorporated within the ranks. "It is not that I imagine that I would be that much more useful than here," he admitted to Dominique. "But with those whom I would be leading after the war, I want to be able to retain the ability to look them in the eye."[42]

•

Just before Christmas 1939, Dominique returned to Romania, joining Jean at their apartment in Bucharest. He continued his new career at La Pros, while she slept late, read, and took walks in the snow and the winter sun.[43] And the work that had been suggested by the Deuxième Bureau finally materialized. It was exciting, challenging, and more than a little dangerous. Jean was in charge of a small team meant to sabotage shipments of oil, and other materials, as they were transported out of the country by train.[44] Jean's brother-in-law Eric Boissonnas was also in Romania working as an engineer for La Pros. According to Boissonnas, the goal of Jean's missions was "to dry up Romanian oil shipments to Germany in order to slow down its effort in the war."[45]

The first plan conceived by the Deuxième Bureau involved time bombs. The small devices, made with a timer and a magnet, were to be placed on the sides of trains to be detonated once they were out of Romania. Considered military transport, the trains were well guarded by Romanian authorities and possibly Germans.[46] Jean and his team, which included two Schlumberger engineers, dressed up as railway workers.[47] On their first attempt, Jean and his team were discovered by a guard. Forced to slip away quickly, they were unable to disable the timing device and found themselves stuck with a ticking time bomb. "So they had to drive all the way to the Danube, a hundred kilometers away," Boissonnas remembered. "They threw it in, so that it exploded at the bottom of the Danube. That, already, was quite something."[48]

The second plan hinged on a certain rubber that was to be inserted directly into the trains' storage tanks. This material was intended to dissolve itself in gas, meaning that when the shipments arrived in Germany, the fuel would be infused with rubber. According to Boissonnas, "Later, when the gas was placed in tanks, it would clog up the carburetor nozzles, and they would break down during combat."[49] This operation was even more challenging: Jean and his group had to climb on top of a train that was being guarded in a station. They were able to do this successfully two or three times.

Then, in the middle of the winter of 1939–1940, Jean and the Schlumberger engineer Denis Tanguy were caught in the act by, it is believed, Romanian police. There was some distraction, and both were able to take off running across the frozen fields. "I fell and the cops were on me right away," Tanguy remembered. "But de Menil managed to get away."[50] Tanguy was tied to the railroad tracks, arrested by the Romanian authorities, and then sent back to France.[51] Jean kept running as fast as he could. "They didn't shoot at him, thank God," remembered Dominique. "But it was a tremendous effort, running through fields that had been plowed. He made it back home in the middle of the night, having run so much that it took him over an hour to catch his breath."[52]

The mission was considered important enough by the Deuxième Bureau that a new plan was developed, one that was thought to be less dangerous. It involved the wheel journals of trains, where grease was inserted to lubricate the powerful friction between steel wheels and tracks. Jean and his team, working at night, placed a material into the grease; it might have been emery, graphite, or iron filings. "Grease and emery didn't go very well together," recalled Eric Boissonnas. "When enough was put in, you heard these horrible screeches and the axles overheated."[53] Dominique recalled, "That residue of iron would scratch and heat up very quickly, burn, and

overheat. The train would have to be stopped, the following one as well, so it created a bottleneck."[54] Jean and his team were able to complete many of these missions. "Practically all of the trains were broken down somewhere," said Boissonnas. "They didn't have any more to transport oil, so it turned out to be a very good plan."[55]

•

For his work with the Deuxième Bureau, Jean was awarded the Croix de Guerre, further distinguished by a silver star. "Corporal Jean Menu de Menil, general staff, has been an essential collaborator during sensitive missions that required a tremendous sense of initiative and courage," the citation read. The order was signed by General Maurice Gamelin, the chief of staff for the national defense and commander in chief of French forces.[56]

Jean sent the cross and the citation to his father back in France and wrote to Marcel Schlumberger to inform him about the honors. "But other than that," Jean wrote to Dominique, "let's have complete silence." The Croix de Guerre was a prestigious honor and proof of Jean's service to his country, yet he wanted to be discreet about it. It was rarely discussed, even in the family. "We never talked about it because it was signed by General Gamelin," Dominique later explained, "who, even at the time, before the fall of France, was looked upon as such an ineffective general."[57]

The French embassy in Bucharest also wrote to thank Jean for his "generous participation" in the war effort. "Not content to offer the country your services in the exercise of your professional duties, you chose to participate personally and directly in the task we had undertaken, a demonstration of the correctness of our cause and the nobility of our intentions."[58]

By 1940, Dominique and Jean were on a war footing. One evening in February, the de Menils were at home at their apartment in Bucharest when an organ grinder appeared on the street below. Already enchanted by the exotic music of Romania, they went to the window to take in the show. They spoke with the performer, presumably in French (France and Romania had a long shared history; many locals were French speakers and Francophiles). Once the performer realized the de Menils were from Paris, he offered an impromptu tribute. He struck up "La Marseillaise."

Delighted, the de Menils threw down some money for his coffers, 20 Romanian lei, roughly equivalent to 20 francs. But then Jean, mischievously, with that sense of flair that came so naturally, shouted down to the street, "I'll give you three times more than that if you go and play the same song underneath the windows of the German embassy!"[59]

THE DEBACLE

This fight looks like it is going to be extremely tough. God
grant that we don't lose too many people.
—JEAN DE MENIL[1]

At the beginning of April 1940, Dominique and Jean de Menil received a piece of news that was particularly welcome: she was pregnant. Their first child had been born two years after they married; their second was some two years later. Following a gap of five years, they were expecting a third.

As the spring began, Jean continued his new career with Schlumberger while Dominique kept to her daily routine in Bucharest. She studied German and English, though she had given up on Romanian, feeling that she knew as much as she would need. "I mend my stockings and Jean's socks," she wrote to her family back in France. "I read; I write; I go out some; recently, for instance, there was a nice tea at the French embassy. There are some very interesting people here, particularly connected with the universities."[2]

Given her pregnancy, and the uncertainties about the war, Dominique planned to return to France by the end of May or the beginning of June.[3] In the six months since France and England had declared war on Germany, there had been little military action in western Europe. Instead, Germany and Russia had begun carving up the east. By the end of September 1939, after a period of combat that had lasted just one month, Poland surrendered (its government fleeing into exile through Romania). At the end of November, Finland was attacked by the Soviet Union; by March, it had concluded an armistice, ceding significant territory.

On the evening of April 9, flush with the news of their expanding family, Dominique and Jean dressed for a performance at the Teatrul National, the Romanian national theater. The elegant edifice, in pale limestone, completed in 1852, featured three stories of classical, arched windows, an oversize porte cochere, and a foyer with dramatic staircases of Carrara marble. The interior was a vertiginous, baroque affair with three tiers of loges, white and gilded plasterwork, and, suspended from the center of the ceil-

ing, a massive crystal chandelier (the Teatrul National would be destroyed by Luftwaffe bombing in August 1944).

The de Menils were attending a performance of *L'annonce faite à Marie* by French writer Paul Claudel. It was a well-known mystical work about two sisters in medieval France—one dedicated to the flesh, the other to the soul. The play was directed by Jacques Copeau, founder of Paris's Théâtre du Vieux-Colombier and a longtime friend of Dominique's, first through her uncle Jean Schlumberger, then from their joint involvement with *L'Art Sacré*. Dominique and Jean, as expatriates in the midst of war, missed intellectual companionship and the world of French ideas. So it was significant for them that Copeau and his company were performing in Bucharest. They went with friends that evening to the Teatrul National.

Between acts of the Claudel performance, a dramatic announcement was made in the theater: Germany had just invaded Denmark and Norway. A tense murmur went through the theater. Hitler's Nordic invasion was particularly meaningful for Copeau because his wife, Agnès, was Danish. The announcement, as members of the audience remembered even years later, drove Copeau's company to a heightened sense of emotion in their performance.[4]

It became clear that evening of April 9 that the pace of the war was quickening (Denmark surrendered the day of the attack; Norway would manage to continue fighting for two months, until the first week in June). So the de Menils decided that night that it was time for her to return to Paris.[5] An early June departure, particularly in light of her pregnancy, was no longer realistic. Both felt that she would be safer surrounded by her family.

No one knew, of course, that returning to France would put Dominique in the direct path of an enemy army that was quietly assembling in western Europe and preparing to unleash an almost unthinkable level of force: Hitler's Wehrmacht.

•

Within days, Dominique left Bucharest by train, traveling west through Romania, Yugoslavia, and eastern Europe. As she passed through Mussolini's Italy, on a gorgeous sunny day, she observed the Italian customs officers, dapper in their suits and wide-brimmed hats, laughing and pinching cheeks. "They love life—shouldn't we be able to get along with people like this?" The train stopped in Venice, then continued across the Po plain to Milan and back through France to Paris.[6]

From the start of their wartime separation, Jean made an effort to write to Dominique almost every day, as she did him. Between the end of April, when Dominique left Romania, and the beginning of June, when France fell to the Nazis, they wrote each other some fifty letters.

On Jean's first day without her, he found himself walking up and down the sidewalks of Bucharest, whistling a "Veni, Creator Spiritus" to try to buck up his spirits. He spent a long afternoon at the apartment, typing business letters. He went out for a professional appointment, then stopped at the Nestor Café, where he had a strong tea and an unappetizing pastry. Jean was very conscious that he was alone. As he wrote to her from the apartment they had shared, "Nothing would appear to have changed in this room, yet it has lost its life."[7]

Both Dominique and Jean were aware of how fortunate they were to have been together in Bucharest. "I think of those four months that we stole from the war, which usually only separates and destroys," Jean wrote to Dominique. "I remember all of the unadulterated moments of communion that we shared together, no matter how brief or insignificant they might have seemed at the time. No amount of adversity will be able to take that away."[8]

•

By the beginning of May, it was clear that Hitler's next target would be France. As the militaries jockeyed for position, Parisians began to plan for evacuation.

Jean's family had just purchased a place in the country, a dilapidated seventeenth-century manor house, converted to a farm in the village of Pontpoint, in the Oise, northeast of Paris. They were able to buy the property at a reasonable price because it was thought to be along the invasion route to Paris. Dominique helped Jean's two maiden sisters and aging father organize their move to Pontpoint, staying with them a couple of nights on the rue de Vaugirard, while also arranging her own departure for the Val-Richer. Several months pregnant, and despite the pain she had begun to have in her leg, she insisted on taking the Paris Metro, lugging her suitcase up and down the stairs. "The idea of spending money on myself has become so painful that I can't bring myself to splurge on a taxi if it can possibly be avoided."[9]

Dominique left for Normandy. Not for the last time, there was a great contrast between the splendor of their natural environment and the darkness of current events. "The Val-Richer has never been more beautiful,"

Dominique wrote to Jean. "The meadow is thick with flowers. The smell of wisteria and the laughter of children rise from the windows of the gallery."[10]

The house filled up with members of Dominique's extended family. Although she was still early in her pregnancy, her younger sister, Sylvie, was further along, and her cousin Odile de Rouville, the daughter of banker Maurice Schlumberger, was due in early June. As Jean Schlumberger commented, with mock exasperation, "Girls, how can you all be pregnant at a time like this?"[11]

As the family refuge, the Val-Richer was the logical place for everyone to regroup. Because the World War I battlefields had been to the east and northeast, closer to the border with Germany, it was assumed that Normandy would be out of harm's way. Soon, however, there was concern that the Nazis were turning their attention west. Everyone followed the news very closely.

Dominique installed herself in the room of her sister Annette. She had a panoramic view out over the Val-Richer. From the window, she could see a corner of the farm, the crest of a hill, and the extensive woods. "A dark green yew makes a shadow on the pale stone wall of the farm," Dominique wrote. "On the right, the clearing gives way to the woods. Farther along in the allée, the first chestnut tree is still flowering. It is all so simple and striking."[12]

On the bedside table, next to a vase of fresh flowers, she had a photograph of Jean that had been taken in Romania. "Oh, that smile—I never go to sleep without looking at it."[13] Opposite the bed, on a shelf, she placed the Eastern Orthodox icon she had bought in Moscow of Saint George slaying the dragon, the large panel she had taken off their living room wall in Paris and transported to Normandy. Just below, she placed a gilded bronze vase, a piece that the de Menils had acquired together at an antiques dealer on the rue Jacob. "There is a perfect harmony between this painting and the vase, between an image that is so flat and a form that is so modeled and pure, between the warm brown, brick red, and green of the dragon and the gold of the object," Dominique wrote to Jean. "It is such a joy to see beautiful things again after four months of complete deprivation. It is clear how essential beauty can be. It is not a luxury; it is really ugliness that is abnormal."[14]

•

On Friday, May 10, 1940, Germany attacked western Europe with remarkable speed and force. The combined Nazi militaries included over 150 divisions, some three million men, attacking Luxembourg, Holland,

Belgium, and France. The sudden strike was given a term that would become famous: "blitzkrieg."

On that first day, Luxembourg fell, German paratroopers were dropped into Rotterdam and The Hague, while eighty-nine Nazi paratroopers captured a major Belgian fortress.[15] In England, Neville Chamberlain, architect of the failed Munich Agreement, resigned, replaced by a militant Winston Churchill. That Friday, family members present at the Val-Richer included Dominique and her young daughters, Madame Conrad, Sylvie Boissonnas, Geneviève Seydoux, Françoise Primat, and their uncle Maurice Schlumberger. There was a rushed lunch and a great commotion.[16] Fierce fighting between the Germans and the Allies took place within a couple of hundred miles of the house. What had been feared for months had suddenly happened: war had erupted around them. "The big news is that the Germans have entered Holland and begun bombing Belgium," Dominique wrote to Jean. "The great fire has been set; the great battle has begun. God have pity on us—us and everyone else."[17]

.

Dominique and her family were about to live through one of the most tragic periods in the long history of France. "The year 1940 was, without a doubt, the greatest trauma of the twentieth century," noted a historian of the era. "It marked an entire generation that was exposed to the relentless barrage of events."[18]

Initial news reports suggested that the Belgians and the Dutch were effectively resisting the German invasion. Yet by May 15, after waves of relentless bombing of Rotterdam killed some nine hundred people and leveled the center of the city, the Dutch surrendered to Germany. Two days later, Antwerp and Brussels fell.[19] "The German advance is moving quickly," Dominique wrote to Jean from the Val-Richer. "Who knows what will have happened by the time you read this letter. Will we be able to stop the German flood? If Hitler throws all of his forces into the breach, will we be able to stem the tide?"[20]

By 9:00 that evening, the news was even worse. "We just heard on the wireless that Holland has had to lay down its arms," Dominique wrote. "Now the Germans can position themselves opposite England. As Churchill said yesterday, it is one of the worst moments in the history of the British Empire."[21]

At the start of hostilities on May 10, British and French forces were in the midst of belated defensive preparations in the north of France. Within five days, Nazi forces had entered French territory at the Meuse River. At

dawn on May 15, French prime minister Paul Reynaud called Winston Churchill to announce, "We have lost the battle; the front has been broken at Sedan."[22]

Incredulous, Churchill replied, "That certainly cannot have happened so quickly!"

Yet it had. In only a matter of days, German forces had gained ground in a way that they had not been able to do in four years of fierce combat during World War I.[23] The quick collapse became known simply as *la débâcle*. One historian opined,

> Anticipating the main offensive through Belgium, this was where the high command had sent the best French troops. In fact, the brunt of the German attack came further south through the Ardennes. The French, believing that this sector of the frontier was protected by the natural barriers of the Meuse river and the Ardennes forest, had guarded it only by ill-equipped reservists, unprepared for the massive assault of German panzers. Within three days, the French line had been breached; on May 15, Rommel was advancing so fast that he was overtaking the French in retreat; on May 16, nothing lay between the Germans and Paris. Officials in the Quai d'Orsay began to burn their archives in preparation for an evacuation of the capital.[24]

The Val-Richer began to fill up with those who had been displaced. By May 16, Normandy was packed with refugees fleeing south from Holland, Belgium, and northern France. As Maurice Schlumberger's assistant noted, "Every road now has an endless line of Belgian refugees who have made it to the region."[25] Many family members did what they could to help. "Annette has really risen to the occasion," Dominique said of her older sister. "For four days straight, she has not stopped transporting refugees from one train station to another in her car. She has also been a German interpreter at police stations for the German refugees who have arrived from Holland."[26]

Those who had been to the nearby town of Lisieux reported that its streets were filled with cars where refugee families were sleeping, children with fear in their eyes. "Last night on the radio, it was announced that there are already four million Belgians in France," Dominique wrote to Jean. "Meaning a good part of the country has already folded itself into our borders."[27]

By the third week in May, the situation had grown increasingly bleak. The Nazis had swept south from Belgium and quickly conquered French

territory. Dominique noted that the Germans were said to be installed near the French town of St.-Quentin in Picardy, about a hundred miles northeast of Paris. She confided to Jean,

> I won't write about the most recent events that you know as well as I. It is remarkable to think that we have just had eight months of inaction during which soldiers were killing time playing cards and we were not able to build a better line of defense. Last night, the BBC affirmed that there was almost nothing at the spot where the Germans crossed our lines. What happens now is no one's responsibility but our own.[28]

As the military situation deteriorated, it was unclear whether they would be able to stay at the Val-Richer. Dominique's sister Sylvie had been told by her husband, Eric Boissonnas, to leave the family château once they could hear the sound of the German cannons. By the time the Nazis had advanced to Forges-les-Eaux in upper Normandy, the sounds of cannons could be heard from the lawn of the Val-Richer. Sylvie Boissonnas said about those days in May 1940, "We had the impression of being on an iceberg that just kept melting."[29]

•

Jean was forced to follow the developments from his isolated post in Bucharest, where the mood, particularly among French expatriates, was dark. One evening, he walked into the office to find a worried group of workers conducting their very own war council. "It was a whole Areopagus, unproductive and panicked," Jean wrote to Dominique. "I said to them, calmly but forcefully, 'What you are talking about makes absolutely no sense; you might be better off praying.'"[30]

Romanian residents were subjected to persistent misinformation about the war. One report, for example, insisted that the border between France and Italy had been closed. The story was quickly debunked. Yet this kind of untrue and incomplete information increased the tension. As Jean explained to Dominique,

> In such a vast theatre of war, how can we tell from brief communiqués or second hand chatter the real meaning of any one retreat, advance, or counter attack? In light of what is now happening in Western Europe, the events of just a few weeks ago in Norway take

on a completely different meaning. So how can we be certain of the significance of an episode that is just being described in today's newspaper?[31]

Jean asked to break the embargo he had instituted about his wartime performance. "Please make an exception for Gerald about the rule of silence about my Croix de Guerre," he wrote to Dominique. "Under the condition that he see if he can find a way to secure a spot for me on the front lines with the BEF [British Expeditionary Force] and to get me out of here, where there is no longer anything interesting to do."[32]

Throughout those weeks, Jean prepared for the worst. In one of his letters to Dominique, he enclosed two small photographs of her, yellowed with age, that he had kept in his wallet for the past eight years.[33] They were photographs that he cherished. "The only reason I am giving these up now is the likelihood they would be confiscated if I were to be taken prisoner. Any comments about them by others would be unbearable to me."[34]

The rapid defeat of his country brought out so much of the character of Jean de Menil. "There is a mystical need to persevere that is so obvious that, despite the painful news, I still have complete confidence," he wrote to Dominique. "It is hideous to think of the price that will have to be paid for this victory, but we are fighting this struggle for the entire world. I hope that each of us will be redeemed by all of this blood and anguish, that we will come out of this trial completely transformed."[35]

•

In those final days of May 1940, the military situation around Normandy became increasingly bleak. The escalating combat throughout northern France added to the vast stream of refugees fleeing through the region. Joining the Dutch and Belgians were residents from the French departments of the Nord, the Pas-de-Calais, the Somme, the Aisne, and even the Seine-Inférieure (now the Seine-Maritime), the department just on the other side of the Seine from the Val-Richer.[36]

By May 27, it had become clear that Dominique would have to leave. She began organizing the correspondence and photographs she had with her. "A sad, delicious task," she told Jean. She planned to take only their correspondence as well as some letters from her father, Jean's father, his brother Patrice, and the World War I missives from her two older brothers.[37]

It had been decided that the Schlumberger family would organize its own evacuation to the family home of Dominique's mother at Clairac, in southwestern France. It would be a retreat that included La Pros, Mau-

rice Schlumberger's bank, and other members of the family, such as Jean Schlumberger. Roche, Madame Conrad's family house, was large enough to be a new family refuge. And there were many smaller houses and buildings in the village that could also be used. "Uncle Marcel has sent in advance some trucks, documents, and equipment," Dominique wrote of plans for the retreat to Clairac. "At the last minute, he will go down with the staff from La Pros. I will be taking other documents, papers that Uncle Maurice gave me for safekeeping at the rue Las Cases."[38]

Dominique began to organize their departure during a key moment in the Battle of France. King Leopold of Belgium, having seen his country overrun by the Germans, surrendered on May 28.[39] When the development was reported on the radio at 8:30 a.m., it was felt by many in France to be a great betrayal by an important ally. "Treason by the king of Belgium" was how the news was received at the Val-Richer.[40]

That time also marked the beginning of the evacuation of Dunkirk. Some two hundred miles up the coast from the Val-Richer, more than eight hundred British ships and other vessels began to execute a frantic retreat and rescue operation. Overseen by Churchill, Operation Dynamo, as it was called, took place over nine full days, from May 26 until June 4.[41]

Dominique wrote to Jean about Dunkirk and the continued clashes throughout France:

This northern army has not been able to evacuate completely, can't yet be entirely saved—all these regiments folding themselves into the form of a square, like the Imperial Guard at Waterloo, trying to clear a path to the sea. Today on the radio, we heard that the Germans are bombing them with all of their heavy artillery. Two or three more days of that and there will no longer be a single man standing.

Almost every day, we can hear the cannons on the Somme—sometimes barely perceptibly, sometimes very distinctly; our cannons, luckily. It is a continuous burst that rumbles, subsides slightly, and then takes off again, as during the final eruption of the firework displays on Bastille Day at Versailles, when everything is detonated at once.

When you realize that all of these volleys are, in fact, enormous shells—we can only hear the heavy artillery—you can imagine how hellish it must be.[42]

Operation Dynamo managed to extract more than 330,000 forces, including more than 120,000 French. It also came with a steep price: 5,000

Allied soldiers were killed crossing the channel, 3,000 died on the beaches, and 40,000 were taken prisoner.[43]

As the fighting around Normandy intensified, Dominique pressed forward with plans for a departure. She sent a domestic ahead to Clairac with a trunk of clothes, personal papers, and business correspondence. "That way, we will be able to travel light," she wrote to Jean. "I have bought a steel trunk for our most precious objects: the icon, the Bérard, the naval chronometer, a few pieces of old silver." Dominique intended to hide the trunk in the attic of the Val-Richer, deciding that would be the safest spot. "Even if the house is occupied, it is unlikely that the attic would be searched, and there would be quite a few other things to take first."[44]

On Monday, June 3, the Germans bombed Paris, with air raid sirens screaming over the city beginning at 1:30 p.m., and also shelled the railways between Paris and Normandy. By the middle of the week, trains filled with refugees from Belgium and Dunkirk had arrived at Lisieux. Maurice Schlumberger's assistant, who was staying with the family at the Val-Richer, noted in her journal: "A painful impression speaking with these disarmed combatants, covered with mud and dust, who seem to have escaped from hell, their eyes still filled with visions of horror."[45]

At the Val-Richer, there was great consternation about a family member: René Seydoux, who was fighting with French forces in the north. He had not been heard from since the middle of May.[46] Once his regiment returned from the battlefield, he was nowhere to be found. "I don't need to tell you how devastated I am," Dominique wrote to Jean. "Will he be the first to die of those we are close to? Geneviève has remained impressively calm, but she must be anguished."[47] Marcel Schlumberger and Geneviève Seydoux went to the nearby town of St.-Germain-la-Campagne to track down the colonel of her husband's regiment. He reported that René Seydoux had probably been taken prisoner (he would remain in a German camp for French officers for the remainder of the war).[48]

In the midst of the deteriorating military situation, Dominique's young cousin Odile de Rouville, a daughter of Maurice Schlumberger, went into labor. She was transported from the Val-Richer to nearby Deauville to give birth. Her obstetrician, concerned about the safety of the city's hospital, installed her in a makeshift military hospital in the Grand Hotel in Deauville. The Nazis were extending their push through the department to the north, the Seine-Inférieure, and the military hospital was filled with troops that had been wounded at the Battle of Dunkirk.

After giving birth to her daughter Marie, Odile de Rouville returned to the Val-Richer. Her parents transported her in their Citroën Traction Avant; Maurice Schlumberger was behind the wheel, while Odile lay in the

backseat with her newborn daughter. As they left Deauville around 11:00 a.m., they were suddenly engulfed by a huge black cloud. It was only a sixteen-mile drive to the Val-Richer, yet they arrived enveloped by darkness, their headlights fully illuminated.[49] It was determined only later that the source of this mysterious phenomenon was just on the other side of the bay from Deauville. French forces had torched a massive complex of oil refineries at Port Jérôme, near Le Havre. It was a dramatic, strategic sabotage meant to ensure that the facility could not be seized by the Nazis. "Only later did we find out it was an oil cloud," remembered Dominique's cousin. "We thought it was the end of the world."[50]

•

France was falling to the Germans. As French historian Marc Bloch described those days, "It was the most terrible collapse in the long history of our national life."[51] American journalist William Shirer, who was based in Berlin, noted in his journal, "I have a feeling that what we're seeing here is the complete breakdown of French society—a collapse of the army, of government, of the morale of the people. It is almost too tremendous to believe."[52]

The residents of the Val-Richer were right in the middle of the turmoil. By Sunday, June 9, German forces had advanced on the historic city of Rouen, some sixty miles northeast. Orders had been given by French leaders to blow up bridges. The nearby towns of Mantes-la-Jolie, Dreux, and Évreux were bombed by the Germans. Trains to and from Paris and all postal service had been discontinued. That day, a final Sunday lunch was held at the Schlumberger family château. There were twenty-one seated at the big table, twenty-two at the children's. There was great commotion throughout the meal, with many conversations hinging on plans for departures.[53]

By the following day, news arrived at the Val-Richer that Italy had joined Germany in the war against France. The Germans had crossed the Seine at multiple points, notably at the Norman village of Vernon. There were poignant scenes in every settlement throughout the Calvados. It was the beginning of a great exodus from Lisieux, only seven miles from the Val-Richer. All public services, banks, and retailers were closed. Residents were panicked at the news that German motorcyclists were no more than fifteen miles away from the city.[54]

In Paris, much of the population prepared to flee the capital. It has been estimated that in only five days, from June 9 to June 13, two million men, women, and children left Paris. By the time the Germans entered the city,

on June 14, French police estimated that out of a population of 5 million only 700,000 residents remained.[55] Those who fled were headed, primarily, for the center and South of France. Many who left were able to pack only a few belongings in their small cars, on the backs of motorcycles or bicycles, in vendor's carts, wheelbarrows, or any other contraption with wheels.[56]

In Paris, Simone de Beauvoir described the scene she witnessed on June 10:

> By midday, I saw for the first time a sight that I would see so often later: carts filled with refugees. There were about a dozen large wagons, each pulled by four or five horses, loaded with hay that protected and held down one end of a green tarp—bicycles and mattresses stacked together on the sides, with people in the middle, motionless groups under big umbrellas. The scene was composed with the precision of a work of art—like a painting by Breughel. Later, I saw them fully defeated, disorganized, but on that day they were beautifully realized and noble, like a procession in a sacred, solemn ceremony.[57]

•

The morning of Monday, June 10, was a critical one at the Val-Richer. It marked the first of three successive waves of departures, spread over the next two days. There was a trio of convoys made up of seven cars, with over two dozen family members, including children and staff.[58]

The first to leave, at 4:30 a.m., was Dominique.[59] Her party consisted of two cars, with mattresses strapped to the roofs.[60] Along with Dominique were her two daughters, aged five and seven, her mother, her also-pregnant younger sister, Sylvie, her young daughter Catherine, a governess, and a midwife.[61] "We were there before dawn, in front of the house, tying suitcases onto the cars," Dominique wrote to Jean. "Marie and Adelaide ran around the cars, delighted. I was upset and a little ashamed about leaving."[62] The mattresses, more than deterrents for actual bombs, were there in the event that Sylvie, who was due in a couple of weeks, needed to give birth while they were on the road.[63]

Clairac was directly south, just over four hundred miles from the Val-Richer. "The roads were not yet too congested," as Dominique described the journey to Jean. "There were a few cars, but mostly bicycles and people on foot, carrying a bundle of their belongings or a suitcase tied to a stick. It was heartbreaking."[64] They were fortunate, of course, to have cars and

fuel; most did not. And the timing of their departure turned out to be auspicious: it was one day before many French hit the roads. Yet a trip that would normally be achieved in a matter of hours required three full days of travel.

By June 11, Dominique and her family were in the midst of a tremendous, tumultuous exodus. The earlier departures from Paris and the north of France, on June 5 and 6, had been but preludes. Because of the suddenness of the Nazi advance, the country, from June 11 to 14, experienced one of the most dramatic mass migrations in history: more than one-third of French territory emptied itself out into the other two-thirds. "It was a massive, panicked mess," noted one French historian. It has been estimated that more than eight million refugees packed onto the roads throughout northern and central France. Some put the figure as high as ten million.[65]

The chaos was compounded by the fact that the French government was in complete disarray. On June 11, Dominique's second day of driving, French political and military leadership abandoned Paris, with plans to retreat to Bordeaux. But because the roadways were so clogged with refugees, after twenty-four hours of stop-and-go travel the cabinet had made it no farther than the Loire valley.[66]

William Shirer, who went from Berlin to Paris to cover the Nazi advance, saw firsthand the extent of the crisis:

> No provision for food, drink or lodging had been made for so many suddenly uprooted millions . . . At night, these desperate people, when they were not on the move, slept in their cars or in the fields. By day, they scrounged for food where they could find it and sometimes pillaged. The towns and villages through which they inched their way on the jammed roads were usually emptied of their own dwellers, who, in a sort of chain reaction, had joined the first column of refugees that appeared, so that food stores and bakeries were closed or their shelves empty. A few peasants along the route dispensed food and even water, sometimes at a highly profitable price, but this was but a drop in the bucket.
>
> In Paris, we heard from returning correspondents of this frightened, leaderless swarm of citizenry fleeing down the roads so choked with traffic that even when the gasoline held out and the overheated motors continued to function, a man was lucky to make twenty-five or thirty miles in twenty-four hours in a car packed tight with the members of his family . . . For the German Luftwaffe was now bombing civilian refugees, especially those crowding the approaches to bridges and crossroads.[67]

As Dominique drove, she was surprised to realize the scale of the collapse of the French military. Throughout their trip south, they did not encounter any troops, cannons, or tanks protecting their positions. "There were some sad barricades at the entrance to every village; wagons filled with stones or sand, tree trunks, a beat-up tractor, some old men with shotguns," she wrote to Jean. "Along the roads, there were only soldiers who no longer had their weapons, headed, it seemed, to some new gathering point, somewhere in the south. The heart sank."[68]

For the children, Dominique made an effort to defuse the tension of the trip. Their eldest daughter remembered that her mother tried to turn the experience into something of a game, suggesting they could play at being refugees. "It was a great tribute to Dominique that we were never afraid," Christophe said. "And we certainly could have been."[69]

Their first day, they made it to the town of Issoudun, in the Indre department in the center of France, just over two hundred miles from the Val-Richer. There, they found a local aristocrat who allowed them to spend the night in one of her outbuildings. Dominique noted that she had reserved several rooms for refugees, but only those who came from good families.[70] And as Sylvie Boissonnas observed wryly, "When she learned that her houseguests were the Baroness de Menil and her daughters, she broke out the good silver!"[71]

That night, they heard German bombers circling the town. "The sound of those engines is so disagreeable," Dominique explained to Jean, "like being buzzed by insects about to drop their poisoned eggs."[72] Sylvie's obstetrician was a military doctor in Issoudun. "He said, 'My child, if you can go farther, go quickly.'" The next day, after Dominique and her family had left, the hospital at Issoudun was bombed.[73]

For their second night, Dominique and her convoy made it to Angoulême, in the Charente department, some 150 miles southwest. There, they were able to stay in a lovely house where Dominique felt that she was "received like a queen." On Wednesday, June 12, they made the final 100 miles, through the city of Bordeaux, to Clairac, the picturesque village on the Lot River. By the time they arrived in the Lot-et-Garonne, there was no longer any question of the extent of France's collapse. Noting the presence of enemy forces in the region, Dominique wrote, "I would have never imagined that the Germans could have gone as far as the Pyrenees."[74]

The following day in Bucharest, Jean heard from the French embassy that he had a matter of minutes before a diplomatic courier left for France. He dashed off a letter to Dominique. "How to pull together in such a short time everything I want to say to you?" Jean wrote. He asked her to send him

a telegram, as soon as possible, with news of his sisters and his nephews as well as the new addresses of La Pros, the Schlumberger bank, and the main office of his former bank, BNCI. All letters were to be sent through diplomatic courier in Paris, if that continued to be operative. "Since Sunday, I have not stopped thinking about you. I have imagined you all along those routes, worrying about you and the children, as you go through the ordeal of those bombings."[75]

•

On June 16, 1940, less than a week after Dominique had left the Val-Richer, French prime minister Paul Reynaud resigned and was replaced by Marshal of France Philippe Pétain, the eighty-four-year-old French hero of World War I, known by all as the Lion of Verdun. Pétain immediately announced that an armistice would be sought with Germany. From London, on June 18 and again on June 22, Colonel Charles de Gaulle broadcast his dramatic appeal to the French Resistance. "France is not alone," de Gaulle declared. "She has a vast empire behind her. She can join with the British Empire, which controls the seas, to continue the fight. Along with England, she can use the limitless industrial resources of the United States."[76]

As France fell, both La Pros and Maurice Schlumberger's bank had successfully relocated their headquarters to Clairac. Family members who found themselves in this small village included three of Dominique's uncles—Jean, Marcel, and Maurice Schlumberger—her mother and grandmother, and her sisters, Annette and Sylvie. "Marcel and Maurice thought of Clairac as a retreat because it was a place, like the Val-Richer, where we were known," remembered Dominique. "Uncle Maurice allowed us to have funds right away, while my sister Annette, an extraordinary organizer, quickly prepared a canteen."[77] Housed in an ancient Benedictine abbey, the canteen was used for employees of La Pros and the family bank.[78] Annette also coordinated housing for family and employees.

Dominique moved into the Château de Roche, her mother's family house. She was grateful for how much easier life was there: Her grandmother kept ample stocks of food and supplies. A doctor was able to travel quickly from Clairac, even if there was no gas.[79] On Sundays, Dominique woke up at 6:30 a.m. in order to make the 7:30 a.m. Mass in Clairac. She and her elder daughter would go between the château and the village in a cart pulled by a donkey.[80] But for weeks after the disastrous defeat, Dominique, understandably, was depressed.[81] And she was not entirely pleased

to be staying at Roche. "I'm here, but I could be anywhere," she confessed to Jean. "The house is ugly. The garden is ugly. I'm not at home. But the children are happy, and I love being close to *Grand-mère*."[82]

Dominique informed Jean that she was keeping a journal for him, to let him know everything that happened during the war. One of her first priorities was finding out as much as possible about family and friends and ascertaining where everyone stood politically. Her uncles Jean, Maurice, and Marcel, she explained to Jean, were all having a difficult time sorting out the terrain, deciding what to do about their concerns back in Paris. Dominique reviewed how everyone in their families was reacting and how she could encourage them to share their thinking on Free France.[83]

Their great friend Jean Jardin was very hopeful about the political situation and was relieved that, as he told Dominique, "so many ineptitudes are coming to an end." Six months later, Jardin would become the chief of staff of Yves Bouthillier, the finance minister for the Vichy government. By the spring of 1942, he was the chief of staff for Prime Minister Pierre Laval, who probably did more than any one figure to establish the collaborationist regime and was executed for treason by firing squad in 1945. Dominique described for Jean the attitude of their close friend in 1940: "I share some of his hope, but his joy is very foreign to me."[84]

•

During those first weeks in Clairac, Dominique was often upset. "But our little girls are there to console me," she wrote in her journal for Jean. "Marie covers me in kisses. This evening, she and Adelaide decorated my place at the dinner table with flowers: a crown of yellow blooms on my plate, bouquets to the right and left, and everything topped by a semicircle of bonbons placed in rose petals."[85]

One evening in early July, Dominique was alone in the salon at Roche listening to the radio when the broadcast was interrupted with an important announcement from London by English diplomat Harold Nicolson. She was pleased to be able to understand his French over the static disruptions from German radio. Nicolson explained the painful decision that had been made: in order to avoid the French navy being commandeered by the Nazis, French battleships had been bombed by the British in the Algerian port of Mers-el-Kébir. Dominique wondered, "Have we really abandoned our friends to the point that they have to destroy our ships?"[86]

She was struck by the swiftness with which many in France threw their support to Pétain and the Germans along with the abrupt demonization of England. "What to do about this betrayal by our own leaders," Dominique

wrote in her journal. "A choleric old man inveighs against our great friends and sworn allies who came to our aide, applauded by a pathetic press that could just as well have been printed in Berlin as Bordeaux." Dominique noted that the regional newspaper, *La Petite Gironde,* had a front page filled with German and Italian communiqués without a word from the English. One article mentioned the Germans had bombed Scottish ports "successfully." She noted in her journal, "It is the revenge of those in France who have just been waiting to give the Nazi salute."[87]

Dominique understood the wider political implications of those who were choosing to collaborate. "You must feel as strongly about this as I," she wrote to Jean. "What to say to all of those friends of France who, worried about what has happened, watch us fall into line with Germany and criticize England, now in the position of fighting all alone against the Nazi plague." And she was also remarkably perceptive about the historical consequences: "No matter how slight a chance the English may have, they are, in fact, our only chance. And is it really that weak? Many don't think so. If England does win, the Pétain government will be judged by history to have been utterly pathetic."[88]

•

In Bucharest, Jean made an effort to be positive. "This is all very difficult," he wrote to Dominique, "but I still think that we will win."[89] After the fall of France, many felt that Germany would quickly turn its attention to oil-rich Romania. So the Deuxième Bureau advised Jean, Eric Boissonnas, and other employees of La Pros to leave the country as soon as possible. Jean and his brother-in-law decided to go to Istanbul. They needed to organize foreign funds and to arrange for the export of important Schlumberger equipment. Jean explained to an English ambassador, "I had to secure diplomatic cover to get out of Romania three Schlumberger automatic recorders that we wanted to keep away from German curiosity." He was able to have the devices shipped to Beirut.[90]

What remained of the French diplomatic corps in Bucharest facilitated the departure of Jean, Eric, and other Schlumberger executives. "Until the point when we needed to cross the border and the border had been closed," remembered Eric Boissonnas. "We felt as if we were trapped in a film." Eventually, they were able to secure passage to Turkey in a Yugoslav boat.[91]

Jean and Eric arrived in Istanbul toward the end of June. Shortly afterward, they read the famous speech of General de Gaulle, broadcast on June 18, calling on his countrymen to resist the German occupation. "We heard of this announcement and felt that we had to do something," Eric

remembered. "We immediately got into contact with the English consulate in Istanbul." Jean, working with another French executive from Schlumberger, began negotiations to provide their services to the English forces.[92]

Jean and Eric stayed in a historic hotel of Istanbul, the Grand Hotel de Londres in the center of the city. Initially, they had little money and were forced to do what they could to survive. There were days when they consumed little more than milk and raisins. Boissonnas remembered, "We didn't have enough money to pay for the subway. We always went back to the hotel by foot from the coast. We were able to sneak a shower or a bath, without paying for it, and so on." Their main source of income was the French consulate, which gave them a small stipend.[93]

Jean continued to explore the possibility of volunteering for the British forces. "We were still trying to convince the English when the catastrophe of Mers-el-Kébir took place," Boissonnas recalled. "At the next meeting, they said, 'It's not really worth continuing negotiations. We were happy to work with you and we thank you for your good intentions, but we can't do anything.'"[94]

After the first month in Istanbul, they were able to establish contact with the Schlumberger office in Houston and secure funds.[95] Jean spent much of his time in his hotel, answering telegrams and dispatching letters to staff scattered around the world.[96]

Communication back home was exceedingly difficult. It usually took more than a week for a letter to reach France, and some seemed to have

Jean with Schlumberger engineer Louis Laguilharre in a silk cocoon market in Bursa, Turkey, 1940.

been lost along the way. "Sending you this letter is like throwing a message in a bottle into the ocean," Jean wrote to Dominique. "When will we see each other again? Will it be weeks? Months? Years?"[97]

Though Jean continued to hope to join de Gaulle and the Free French in London, he began to realize that he was needed at the family company. La Pros was in a difficult situation: its main office closed, the bulk of senior management cut off from the rest of the world, and an American branch that was not experienced enough to direct all international operations. So, after a flurry of letters to Marcel Schlumberger in Clairac, Jean prepared to leave Turkey. Instead of going to London to help in the fight against the Nazis, he would be heading east, on a path that would take him around the world for the second time in his life, to Texas.[98]

•

Dominique carried on with her wartime life in Clairac. One afternoon in the village, she had a casual lunch with Marcel Schlumberger and his wife, Jeanne. Dominique reclined on a chaise longue on the grass, in the shade of a tree, while her daughters delightedly ran around the garden plucking blackberries and placing them in straw baskets. "Meanwhile, at the same time, an aerial battle rages in the skies over England," she wrote to Jean. "On the night of September 8, fourteen hundred were injured. The following night even more. The old lion clinging to its rock: Will it be able to hold on?"[99]

Dominique took advantage of her isolation in Clairac to read all of the back issues of *La Nouvelle Revue Française* from its beginning. She focused particularly on Gide, his literary criticism, journals, and his 1909 novel, *Strait Is the Gate*. She also pored over the correspondence of Rimbaud and an early play by Paul Claudel, *L'otage,* as well as the first publication of Alain-Fournier's classic *Le grand Meaulnes*.[100] By the end of September, food and supplies had become scarce in Clairac. "Everything is now rationed: bread, meats, oils, soap, pasta, and so on," she wrote to Jean. "But we will not be dying of hunger or suffering; in the country, something can always be found to eat."[101]

The chill of fall had already begun. Their daughters were wearing wool sweaters, while Dominique sat in the greenhouse of Roche, bundled up in a coat. "Let's hope the winter is not too harsh," she confided to Jean. "Here, there is wood, but in Paris there is neither wood nor coal."[102] Dominique corresponded with family and friends to try to determine what was happening back in the occupied zone. Jean's sisters were staying in Paris but had ridden their bicycles out to their place in Pontpoint and confirmed that

everything was fine, though a nearby bridge had been blown up by the Germans not long after they passed.

On the Schlumberger side, the Val-Richer was calm.[103] The extended family, led by Pauline Doll, did what it could to protect the property. "Aunt Pauline, who spoke German fluently, obtained from the Kommandantur the promise that the Val-Richer would be respected as the historic residence of François Guizot," Dominique later remembered. "The main house was occupied several times but only by officers." As the occupation continued, there would also be German troops on the farm, in the Norman building, and at the Pressoir, another large house on the grounds.[104]

Dominique discovered that several of the family's houses in the leafy suburbs of Paris had been requisitioned by the Nazis. Maurice Schlumberger and his wife, Françoise, lived in a gracious house, Le Haut Bois, in the Parc de Marnes in Marnes-la-Coquette, an exceedingly private area west of Paris. "The Parc de Marnes seems to have really pleased the gentlemen officers," Dominique reported to Jean. "All of the houses are occupied." Françoise Schlumberger stayed in the house to protect it. Dominique's sister Annette also had a small house in Marnes-la-Coquette. It, too, was taken over by Nazi officers. "Annette's lovely little place has four or five Germans," Dominique wrote to Jean. "They are eating her cornflakes and preserves. I can imagine them relaxing on one of the green canvas chairs out on the lawn, signing postcards of the Eiffel Tower. Horrible!"[105]

Dominique learned that the neighborhood around their apartment seemed to be free from Nazis. "No one has been in our house," she reported to Jean. Just across the Invalides, however, the offices of Schlumberger were not as fortunate. The reason Marcel Schlumberger had relocated staff and material from Paris to Clairac was to ensure that the company and its technology were less likely to fall into Nazi hands. His fears were well-founded. "Two German professors have made themselves at home at La Pros," she wrote to Jean. "If the situation doesn't change, we will soon be reporting to them."[106]

•

By mid-August, having been in Turkey for almost two months, Jean was ready to leave. His final night was a sleepless one, packing and preparing sensitive telegrams. From the platform of the Istanbul train station, he made time to write to Dominique: "I have such a heavy heart about the months that we are going to be apart. This departure feels like the lowering of the guillotine, but how marvelous this journey would be if I were taking it with you."[107]

Jean traveled on the Taurus Express, an overnight train from Istanbul, across Turkey and the Kingdom of Iraq, to Baghdad. There, he found time to visit the museum, before flying to the port city of Basra. Jean was struck by the intensity of the sun, the heat, and the aridity of the desert. Flying over Iraq, looking down at the baked land, he was reminded of ancient tablets in the library of Babylon.[108] From Basra, Jean flew across the Persian Gulf to the Pakistani port of Karachi. Because of strict wartime censorship, authorities seized his personal correspondence.[109] From Pakistan, he continued east. "He went to India, the Dutch Indies, and all of the important Schlumberger offices," remembered Eric Boissonnas. "He was there to rebuild the organization, making it independent of France, at that time."[110] The pace was swift. In India, Jean spent four nights on a train to reach Simla, in the Himalayan mountains, in order to meet Schlumberger employees. He stayed only forty-eight hours.[111]

His next stop was the South Pacific. "At that time, Schlumberger had business in Indonesia, essentially in Sumatra, and also Borneo, New Guinea, and Assam," remembered one company executive.[112] Jean kept Dominique advised of his contact with Schlumberger employees. "In a very short time, I was able to see all of the teams in the Far East," he wrote to her. "This was helpful because everyone has been feeling isolated and I now feel that I understand better the local issues for La Pros. Only in Houston will I be able to see it all in perspective and, I hope, contribute to the solution."[113]

In Bangkok, Jean began to finalize his journey to America. He sent Dominique a telegram that said, in its entirety, "Beloved."[114] The last legs of Jean's trip took place entirely by plane, still a novel means of transport. Pan American Airways' propeller planes were very slow moving, requiring frequent stops for refueling.

Jean's journey to the United States began in Manila, in the middle of October.[115] First was a twelve-hour flight to Guam,[116] then a day's layover, followed by a ten-hour passage to Wake Island, an isolated landing strip on an uninhabited coral reef. Arriving a couple of hours before sunset, Jean borrowed a motorboat from Pan American and went fishing in lagoons and the open Pacific.[117] From Wake Island, he flew another eight hours to Midway Island, the atoll that would, two years later, become the site of a major battle between the U.S. Navy and Japanese forces. As their flight was preparing to leave Midway, it was announced that it would be delayed for twenty-four hours.[118] Once the plane made its way from Midway to Honolulu, Jean wrote to Dominique from on board, worried about her condition. "I think of the exhaustion you must be having in these last months of pregnancy," he wrote. "I think of your sense of sentimental isolation, as well as the tenderness you are shown by our daughters, and an emotion comes to

my eyes that would be startling to my traveling companions, if they had discerned it."[119] Jean spent an evening and a morning in Honolulu. He felt that it would have been an amusing place but not at this time. He then boarded the Clipper for an eighteen-hour flight to San Francisco.[120]

He made his way to Houston and then, by the end of October, to the Schlumberger offices in New York. Jean worked in Manhattan for more than a week, without so much as a moment to write to Dominique. His stay in New York coincided with the final days of the 1940 presidential election, Franklin Roosevelt against Wendell Willkie, and Jean was fascinated. He noted the oversize plastic buttons affixed to men's lapels and women's hats, pithy phrases that had been developed, such as "Better a third term than a third rater," and speakers on the streets positioned in front of American flags extolling the virtues of their candidates. "Sometimes, an opponent steps in front of one of these open-air speakers, drowning out his voice with a megaphone," Jean explained to Dominique. "As I write you, this commotion is rising up through an open window on the fifteenth floor."[121]

After another tense office conversation, Jean carved out thirty minutes to visit the Frick museum. He sent Dominique postcards of *St. John the Evangelist* by Piero della Francesca, *St. Jerome* by El Greco, and *Vincenzo Anastagi,* a portrait of a Roman nobleman by El Greco. He was struck by the artistic and spiritual values of the works but also saw them as a symbol of a certain idea of European civilization. "Oh, Dominique: the thrill I had of seeing these three paintings and all that they represent."[122]

•

Dominique was elated to learn that he had made it to the United States.[123] By the time Jean was in New York, Dominique, having been alerted by her uncle Marcel, was worried about La Pros. "The financial situation is very serious," she explained to Jean. "It is not clear if there will be enough money to pay the staff."[124]

Dominique's mother found a house for her to rent in the village of Clairac, allowing for a move from her family's house at Roche.[125] "The house has a spectacular view, is clean and comfortable," Dominique told Jean. "It also has running water, which is a great luxury for Clairac."[126] It was a small but prominent residence positioned high on a hill with a view that stretched over the Lot River and its valley for some twenty miles. Built partially on the medieval ramparts of the village, it was a lovely two-story structure, U-shaped with a garden in front and a red-tiled roof. The bulk of the house dated from the eighteenth and nineteenth centuries.[127]

Dominique felt that the house was perfectly suited to their needs. She would be able to receive guests in the small salon. There was also a laundry room and an attic for storing chestnuts and potatoes. "My bedroom is rustic with a weathered wooden floor, an old bed, an armoire, two windows with a view of red-tiled roofs, trellises, the Lot, and the fields beyond," Dominique wrote to Jean. "Below the windows, there is a big terrace where Adelaide can play and I can relax when the weather permits. In this peaceful house, I will be awaiting the arrival of our mysterious child."[128] Finally in her own place, she felt at home, peaceful, and happy. Dominique loved working in the kitchen, preparing what she could with their dwindling fresh food. After dinner, she would often be alone and listen to the radio. "I love these solitary evenings, spent with my knitting, listening to the entire world."[129]

The scarcity of all goods encouraged Dominique to improvise for her daughters. "She made us a dollhouse," remembered Christophe. "She had the tinsmith make little pots and pans and spoons and forks. If you take dough from bread and mix it with water, it becomes like clay. So she used dough and made all of the dishes and glasses."[130] Dominique even fashioned miniature toothbrushes for the dolls.[131] And much of the dolls' wardrobes was made by her sister Sylvie.[132]

In October, Dominique's sister Annette left Clairac, to go to Spain, then Tangier, to meet her husband, Henri Doll. They were expected to reach Houston by November.[133] Communication with the occupied zone became increasingly difficult. Dominique received a brief postcard from the Val-Richer, suggesting that the Germans had left the property.[134] She also received a very brief note from Jean's family in Pontpoint, assuring her that all were well. It was only five lines, typewritten. "That is what correspondence has been reduced to," she pointed out to Jean.[135]

Dominique was also giving thought to important political and existential matters. One afternoon in early November, she had a lovely moment walking around the village: a gentle autumn sun, the rosebushes still in blossom, a slight chill in the air, people seated at the entrances of their houses. "How sweet everything appears in this soft light," Dominique wrote to Jean. "You can understand the Jardins, who want to do everything to save all of this. It requires heroism to give up the peaceful life in villages. Madness or heroism? Everything depends on the price."[136] Dominique was attempting to understand the position of those who would become collaborationists, many who began with a desire to save what remained of France. She quoted Guizot on the French Revolution: "There are events that cannot be fully understood by their contemporaries—proceedings so large, and so

complex, that they long remain obscured, there in the depths where history-making events are created."[137]

•

In the midst of so much pain and conflict, there was one happier de Menil project that sprang to life: a small, singular chapel, known as Notre-Dame des Neiges, in a village high in the Alps. Beginning in the mid-1930s, Dominique and Jean had been skiing in the relatively new resort of Alpe d'Huez. When the de Menils learned that the village was in need of a chapel, they decided to help. They assembled a group of supporters, including the writer François Mauriac, and commissioned Pierre Barbe to build a place of worship.[138]

The design was inspired by the simple, regional vernacular of the mountains. It was rectangular, entirely in wood, approximately forty feet wide and seventy feet long. It had a steep sloping roof covered in slate and crowned on one end by a modest steeple. The roof was supported by interior columns, dividing the space into three naves, which were fashioned from tree trunks. Light entered primarily through a series of small windows that were placed just below the eaves of the roof.[139]

Construction began in 1939, before being interrupted by the war. It was restarted after the French defeat, in the summer of 1940.[140] Early that fall, Barbe traveled to Alpe d'Huez to make several corrections in the design.

Notre-Dame des Neiges in Alpe d'Huez, a chapel designed by Pierre Barbe, November 1940.

By the end of October, Dominique was delighted to learn that the chapel was finished. The interior was to have been supervised by her, although she was confined to Clairac. "The priest will improvise the interior until I am able to take care of it," Dominique wrote to Jean. "I hope I will be able to go before leaving France."[141] When the priest announced the date of the inauguration, Dominique realized that it was the one-year anniversary of the

death of their great friend Philippa Thompson. "What an extraordinary coincidence."[142]

The inauguration of Notre-Dame des Neiges, on November 21, 1940, was led by Monsignor Caillot, bishop of the nearby city of Grenoble. A solemn Mass was conducted, with vocal performances by artists from the Conservatory of Paris and the Conservatory of Lyon, along with an organist from the Conservatory of Toulouse. The liturgical hymns were performed by a regional choir.[143] The event was significant enough to be covered by the Paris press, while a local newspaper praised the chapel's "elegant rusticity."[144]

Dominique dashed off a full report to Jean:

> Yesterday, I received the photographs of the chapel at d'Huez. In spite of a mistake made with the steeple—an error that will be corrected—it is a charming building. It manages to be both serious and inviting. The interior was entirely provisional, fashioned in the most simple way possible. There were no errors of taste. The altar is a plank of wood on top of two trunks of fir trees. As you can see from the enclosed photographs from *Paris-Soir,* the inauguration was a ceremony of some importance.
>
> There you go, enterprising and hardworking man: a successful production that would not have happened without you.[145]

•

Once he arrived in Houston, Jean de Menil settled into a room in his sister-in-law's house in the elegant new residential neighborhood of River Oaks.[146] He started to write to Dominique about how they might live in Texas. They would build a small, charming house across the street from the one that Annette and Henri Doll had just purchased. Jean even considered involving Pierre Barbe. "That would allow us to have something more personal, a little less straightforward than the other houses here, pleasant as they are," Jean wrote. "Barbe should probably be inspired by what is done in the South of France. It will also need good ventilation and a screened-in porch (enclosed by screens of metal mesh for mosquitoes)."[147]

Writing to Sylvie, Jean was more candid about the difficulties he found with the family business in the United States. The arrival of Henri Doll would help the situation in the United States, Jean felt, and both would be there to bolster Pierre Schlumberger, also on his way to Texas and still a very young man with little professional experience. "Poor Dominique," Jean

wrote to Sylvie about the challenging situation in Houston. "She doesn't know what she is going to find here, and it will be a rude awakening. But she will have Annette, and they will be able to support each other."[148]

Jean suggested to Dominique that social life would not be too demanding in Texas, so she would have time for reading and for correspondence with Gerald. And the family, for the first time in two years, would be together again. "And you would get to know New York," Jean wrote to Dominique. "A city with a generosity and vitality that is so engaging. In its own way, it is as compelling as the sense of tradition and self-assurance offered by London."[149]

On another trip to New York, Jean spent a long Sunday afternoon at the Metropolitan Museum. "I sat on the museum's sad benches, looking at the Manets and Renoirs—particularly the Manets," he wrote to Dominique. Jean spent more than an hour before *Boating* by Manet, the masterful painting of an elegant woman and a straw-hatted man who steers their vessel that he had first seen two years before. He also studied *Mademoiselle Victorine in the Costume of an Espada,* Manet's famous canvas of a female model dressed up as a matador, and *The Dead Christ with Angels,* the brutally realistic religious scene painted by Manet of Jesus in his tomb flanked by a pair of angels. "The mastery of painting is astounding," Jean wrote of the Manet pictures.[150]

He spent Christmas alone in New York, taking the subway to a midnight Mass in Harlem.[151] Jean was in the city for more than a month, working, of course, and spending time with the European expatriates who had begun to arrive. He called on Raïssa and Jacques Maritain, who seemed to be suspicious about what Jean termed his "attitude of appeasement" before the war. Jean spent time with Nicolas Nabokov, accompanying him to a performance by the New York Philharmonic, which included a new Nabokov composition. Jean and Nabokov shared information about mutual friends who had been dispersed or were still back in France.[152]

In order to secure his permanent visa for the United States, Jean needed to go to Montreal. Through Nicolas Nabokov, he learned that Father Couturier was also there. The Dominican priest had arrived in New York in January 1940 and was making regular trips to Montreal. Once fighting began on French soil, he was advised by his order to stay in North America. During the week he spent in Montreal, Jean reconnected with the Dominican priest.[153]

Jean told Father Couturier about the promises he had made to Conrad before their wedding: to give their children a Catholic baptism and a Protestant confirmation, something forbidden by his church; and then, when they were eighteen, to offer a Protestant education so that the children

could choose their own religion. Not having done either, or intending to, Jean confessed to Father Couturier and asked for absolution. "He was the first priest with whom I had the chance to discuss the situation in detail," Jean explained to Dominique. "I told him that I was not satisfied by a confession I had once made about this to a priest who was closed up in his box and who did not seem to understand what I was going on about! I thought you would be pleased to know that this has been clarified."[154]

•

On December 4, at their house in Clairac, Dominique gave birth to the couple's first son, Georges de Menil. Dominique sent a telegram to Jean: "Little boy arrived last night—he looks like you—we will baptize him Georges François Conrad."[155]

His name, which Dominique had been mulling over all fall, had several inspirations. First was the name of the Russian icon of Saint George and the dragon. It was also a way to honor Jean's father, Colonel de Menil. The final source was surprising: Dominique had been reading François Guizot's biography of George Washington. She was fascinated by her ancestor's depiction of the American leader. "He would please you so much," Dominique wrote to Jean of Washington. "As Guizot wrote, 'Very reserved in the exercise of power, sage about committing himself when undertaking a new venture, but firm in his decisions.' "[156]

Shortly after giving birth, Dominique accelerated plans for joining Jean in the United States, hoping to be able to leave within days. The goal was to cross the Spanish border and then sail to America from a port in Spain or Portugal. It was incredibly difficult, however, to secure the proper authorizations, at a time when so many others were attempting to flee France. Dominique recounted the host of bureaucratic hurdles: "A Spanish visa was needed to cross Spain, but a Spanish visa would be given only if you had a ticket on a ship, but a ticket on a ship could be obtained only if you had a visa."[157]

By mid-January, Dominique had traveled to Marseille, site of the American consulate. It was the first time she had been in a city for six months. "The streets are packed like the Place de l'Opéra used to be at noon."[158] Making the trip with Dominique were her two daughters, her cousin Pierre Schlumberger, his wife, Claire, and Dominique's sister Sylvie.[159] They stayed at the Grand Hôtel de Noailles, an imposing structure dating from the belle epoque.[160]

Dominique found the American consulate packed, primarily with Jewish refugees from Germany trying to reach the United States. On her first

visit, she was told to fill out a brief form explaining her request. After waiting for most of the morning, she was told that her request had not been received, without any additional explanation. Back at the hotel, Dominique decided to go through a Marseille phone book to see if she knew anyone who might be able to help. "I didn't even need to look so long, because by the time I got to the letter C I found someone I knew."[161] Her acquaintance happened to know two of the American vice-consuls.[162]

The following morning at the consulate, she spent hours waiting but was finally able to secure an appointment. She was received by an American who was very pleasant but overwhelmed.[163] During her meeting, Dominique discovered there was no trace of her application for a visa. All of the supporting documents, which had been organized by Jean through an office in Lyon and transferred by Sylvie to Marseille, had failed to arrive. To give some background on the family company, Dominique sat down and typed out a summary of Schlumberger.[164]

The American representative questioned Dominique about her husband's job. She was pressed as to whether she would, in fact, be able to support herself in the United States. In response, Dominique made a very uncharacteristic move. In Marseille she had been wearing, discreetly turned around, the three-carat diamond engagement ring that Jean had given her a decade before. Realizing that it might help answer the diplomat's question about her means, she slowly rotated the ring and flashed the diamond.[165]

•

In order to finalize their visas for the United States, Dominique and Sylvie had to make an unscheduled trip to Lyon. They spent several days there in order to recover the missing documents. It was a bitter-cold January, with strong winds and snow. "I would love to be three months older," she wrote to Jean, "being bitten by the mosquitoes of Houston and sweating almost as much as I am freezing today."[166]

During their time in Lyon, Dominique and Sylvie sent and received half a dozen telegrams every day and read newspapers from Geneva and Lausanne, to follow the latest news of the war. Dominique became despairing about whether she would actually make it to America. "I feel like I'm in the middle of a nightmare," she wrote to Jean. "I arrive breathlessly at the dock just as the boat is pulling away. I am running, but the point that I want to reach slips farther into the distance."[167]

Dominique returned to Clairac, and Jean—from Houston and New York—continued to help facilitate his family's departure.[168] Marcel Schlumberger wrote to him with suggestions about Dominique's trip and offered

ideas on their life in the United States. Dominique's uncle was convinced that Jean could play a key role in mentoring his son, Pierre, in his new position, overseeing the American operations. As Marcel wrote to Jean, "Collaborating with you in your areas of expertise will be very productive to Pierre."[169]

Dominique was increasingly frustrated by the administrative obstacles of obtaining her exit visa from France. Finally, on February 12 in the nearby city of Agen, she was given permission to leave. After receiving that documentation, she made another trip to Marseille. Two weeks later, on February 24, she was officially given a visa for the United States.[170]

It took almost three more months for everything to be finalized and for the trip to begin. Making the journey with Dominique were the couple's two daughters, their newborn son, and Miss Best, the English nanny.[171] Madame Conrad accompanied Dominique to Pau, the historic French city in the Pyrenees, just over the border from Spain. They stayed in a small, charming hotel with such welcome luxuries as fresh roses placed in their rooms and a bountiful supply of butter for breakfast.[172] Because of its strategic location, Pau was flooded with refugees hoping to leave France. There were over thirty guests in their hotel, mostly German Jewish refugees and older French couples.

On May 16, Dominique left Pau and crossed the border into Spain.[173] Madame Conrad went with them to the frontier and a settlement called Canfranc, where they were joined by a few friends of her uncle Jean Schlumberger, including the director of the French Institute in Barcelona. Along for the journey were eighteen pieces of luggage and assorted boxes with food and treats from France.[174]

Dominique and her group traveled by train, over the Pyrenees, to the Spanish city of Zaragoza. After a night there, they had another full day of traveling by train to Bilbao.[175] In the Basque port city, they stayed in the Hotel Torrontegui, an impressive modernist hotel on a central square adjacent to the river that led to the harbor. Only one room was available, a rather large suite, and three cots were produced. What worried Dominique about the hotel, in fact, was the luxury. "I was afraid that this decor, like something by Pierre Barbe, and the impeccable service, worthy of the best places in London, would lead to some astronomical bills. So I went the next day to see if someone could help us find a small *pension*." After calling half a dozen inns and more modest hotels, she determined that there were no more rooms in the city.[176]

From the United States, Jean was able to procure places for Dominique on the *Marqués de Comillas*, a passenger ship of the Compañía Transatlántica Española, a Spanish firm. Christened in 1927, the *Marqués de Comil-*

las was 475 feet long and 56 feet wide and weighed 13,200 tons,[177] able to accommodate between five hundred and eight hundred passengers.[178] If not for Jean's intervention, and the help of a professional acquaintance in Houston, there would have been no places on the ship until September. He also had placed on the *Marqués de Comillas* an assortment of condensed milk, sugar, and cereals for their newborn.[179]

On the evening of May 22, Dominique prepared to board the ship bound for Havana. She sat in a chair on the side of the dock, while an attendant helped pass their luggage through customs. Miss Best was seated next to her on a rolling gangplank, with Georges on her lap. "Marie and Adelaide are running up and down the gangplank, from one end to the other, trying to get it to move and having a blast," Dominique wrote to her mother. Their cabin, located at the rear of the ship, was a spacious corner suite with four large portholes, two standard beds, a cot for the children, and two sinks. There were a pair of armchairs, a large armoire, and a makeup stand with an electrical outlet, just what was needed to prepare food for the baby.[180] About 3:00 a.m., the *Marqués de Comillas* sailed from Bilbao.[181]

Everyone slept very well that first night but woke to a violent, churning ocean. Dominique had made sure to distribute Mothersill's Seasick Remedy to everyone before boarding, yet all were incredibly ill.[182] Only

Dominique with Marie (holding baby Georges) and Adelaide on the deck of the *Marqués de Comillas* en route to New York from Bilbao.

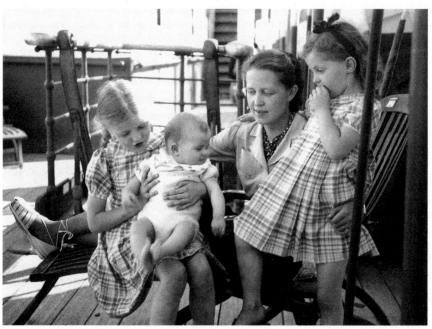

Miss Best was spared. As Dominique noted, the position of their cabin at the farthest point of the stern intensified the rocking.[183] Dominique was so seasick, as Miss Best remembered, that the only thing that seemed to help was cognac.[184] The de Menil daughters also suffered. "Marie vomits every half hour, while crying, cursing, and moaning," Dominique informed her grandmother Delpech, in a twenty-page missive from on board. "Every once in a while, Marie says, 'And I am never getting back on a boat, never, *ever*!' Adelaide vomits as well but less often and more discreetly."[185]

Once they were feeling better, the girls played with other children on the ship, mostly Jewish refugees from Belgium and Holland and two sisters who were Franco-Polish princesses (one, Elena Poniatowska, would go on to be a leading writer and progressive activist in Mexico).[186] Christophe de Menil has vivid memories of the trip. "It was a wonderful little ship," she recalled. "It wasn't big by today's standards, but to us it was paradise." One deck contained a small swimming pool. Never having had one, she and her sister adored being able to swim on board. "There weren't so many people in it, probably because they were scared of what was going on."[187]

It was at the pool, in fact, that the seven-year-old was reminded of the seriousness of their journey. "I remember very clearly, on a map by the pool, seeing our trajectory to Cuba. The boat went way south and then north—it wasn't a straight line at all—because there were mines. But I didn't think of asking my mother about it. She made us feel calm so that we wouldn't be afraid, because, really, we could have been blown up at any moment."[188]

Because of such an indirect route, their passage continued into a second week. By then, the sea had calmed, and Dominique noted the trip felt more like a cruise, although one where there was nothing to see. After leaving the Spanish port of Vigo, just north of Portugal, they had not crossed another ship nor seen as much as an island. "We went to the north of the Azores. This morning, according to the map, we were near the Bahamas, but it was, in fact, a great distance. The only sign of life has been one English airplane, the first we have sighted since leaving the Spanish coast." Dominique spent time with the other passengers or with the telegraph operator to send and receive wires and find out more about what was happening in the world. A telegram informed her that Jean had succeeded in arranging their visas for Cuba and that he would be meeting their ship in Havana.[189]

•

As the *Marqués de Comillas* approached Cuba the first week in June, the crew began repainting the ship and polishing up the brass, while officers and waitstaff changed into their tropical white uniforms.[190] Meeting

the ship at the dock was Jean de Menil. It had been fourteen months since he had seen Dominique, almost two years since he last saw his daughters, and he had never set eyes on his son. "I had forgotten what he looked like," remembered Christophe de Menil. "But, of course, when I saw him on the dock, I recognized him. We were waving, and it was quite a while before the boat docked and we could actually go to him."[191]

Dominique, their daughters, six-month-old Georges, and Miss Best greeted Jean. "It was a very emotional moment," recalled Miss Best. "He looked at this little package I had in my arms, the son he had never seen, and it was, obviously, an extraordinary joy."[192]

The de Menils had two days to explore Havana and the island of Cuba. They spent one afternoon in the country, visiting a small farm and a charming old gardener. For the children, he sliced off fresh bananas, pineapples, sugarcane, and a branch from a coffee plant. "Cuban policemen on horseback, revolvers at their waist, stopped by to have a drink," Dominique noted. "They are so perfect that they don't seem real. But, no, there is no cameraman nearby."[193]

Dominique and Jean went with a business acquaintance to a dinner that lasted until 2:00 a.m., with all the guests making their way out to the veranda. "The custom is to have all of the doors and windows open for air," Dominique explained to her family in France. "Many shops, cafés, businesses, are completely open to the street. Houses have only three walls—like a theatrical set."[194] Their elder daughter, Christophe, remembered well those days in Cuba. "I marveled at the beauty of the island. This water that was turquoise and all these people diving for coins when there was a big ship." She also recalled the novelty of the baby for her father. "He couldn't get over the fact that baby Georges, whenever he was being fed, being cleaned, needed so many things; he hadn't been around a baby in a long time."[195]

By June 9, all the de Menils were on board the *Marqués de Comillas*. Dominique sat on the upper deck, writing to her grandmother. Jean sat next to her, reading a work by Guizot on the English Revolution, *Monk: Chute de la république et rétablissement de la monarchie en Angleterre en 1660*. Nearby were two nuns from Czechoslovakia, making their way to Peru. One was knitting while the other was writing everything that had happened since leaving Slovakia in her journal. The de Menil daughters, after instructions from their father on how to hold themselves upright on the parallel bar, played on the gymnastic equipment.[196] Instead of sailing to New Orleans as Dominique had envisioned, they headed north. Jean had work to do for Schlumberger, so the de Menils went to a city that would become another home.

•

On June 10, 1941, the *Marqués de Comillas* pulled into New York Harbor. They sailed by the Statue of Liberty, that glorious symbol of Franco-American friendship that had welcomed so many to the United States. Greeting them at the dock was Dominique's cousin Pierre Schlumberger, his wife, Claire, and a lawyer from Schlumberger.[197] The day of their arrival marked precisely one year since Dominique had left the Val-Richer, joining the mass exodus as France fell to the Nazis. Knowing how fortunate they were to have made it to the New World, she was sad and concerned about those who were still back in France. The first letter she wrote to her mother from New York came to a poignant conclusion: "I am returning your handkerchief. You need it more than I."[198]

The de Menils stayed in a suite at the Stanhope, at Fifth Avenue and East Eighty-First Street, across from the Metropolitan Museum of Art. It was a two-bedroom apartment with a large living room, two bathrooms, and a small kitchen. "I wish you could see us," Dominique wrote to her mother. "See the joy of Jean as he throws Georges up in his arms, see Marie and Adelaide in their nightshirts coming to wake us up in bed in the morning, see all of us having our dinner in the salon around a bridge table."[199] The reunited family was still new to the daughters, and Adelaide, observing her father in shorts, was horrified to discover his hairy legs. One evening, when Dominique and Jean were dressed for dinner, she in an evening gown,

Marie and Adelaide in New York at the Battery with the Statue of Liberty in the distance, summer 1941.

he in a tuxedo, Marie said, "Oh, you're so handsome, Daddy; you look just like a maître d'!"[200]

Dominique and Miss Best prepared most of the family's meals. "It can't really be called cooking," Dominique noted. "Whether it is potatoes or soup, all you do is open a can and reheat it. Then you can add in some cheese, ham, fruits, croutons, rice, or pasta." She also helped Miss Best wash the dishes, surprised that it took them no more than ten minutes.[201] In fact, one of Dominique's most vivid first impressions of the city was of how functional it was compared with life in Europe. As she wrote back to her family,

> Apparently, you pick up the telephone here and, without having to hang up and wait, you are put directly through to a number. America is a triumph of technique and good organization. Everything works impeccably and the quality of the food seems to be excellent. There are a few too many vacuum cleaners, for my taste, and an excess of sterilization. The church this morning seemed more like someone's living room, everything lacquered, polished, and scrubbed.[202]

In those first days in New York, the de Menils and Miss Best made a tour of the city by car, with Georges on his mother's lap in the front seat. They went along the East River, down to Chinatown, around the Battery, and up the Hudson.[203] Dominique was enchanted. "I have been seduced by New York," she wrote to Madame Conrad. "Expecting to have a feeling of being overwhelmed, I have been surprised to find a city that is so inviting. Of course, the skyscrapers are veritable Towers of Babel. But you are not overwhelmed by them, any more than you would be overwhelmed by the spires of a cathedral."[204]

LANDINGS

It's no longer a question of whether or not to be political.
Politics has grabbed us by the throat, whether we want it
or not.
—*FATHER MARIE-ALAIN COUTURIER, O.P.[1]*

When they first arrived together in America in the summer of 1941, Dominique de Menil was thirty-three years old, and Jean was thirty-seven. Their children were eight years old, six years old, and six months. The family's first stay in New York, intended to be only a few days, lasted for more than a month. Jean had just been promoted to his official position within the family company: president of Schlumberger Surenco, the South American division, as well as president of Schlumberger Overseas, covering Asia and the Middle East. Marcel Schlumberger ran the company's European operations from occupied France, although, in fact, all European operations ceased during the war, while he named his twenty-seven-year-old son, Pierre, president of the American division, Schlumberger Well Surveying Corporation. But a great part of the world, from Caracas to Jakarta to Baghdad, was placed under the direction of Jean de Menil.

Dominique was delighted that her sister Annette was also in New York. Annette's husband, Henri Doll, had been assigned to apply his technical and scientific genius to the somewhat shaky American operations (the Dolls had managed to sail from Lisbon to New York the prior fall, before buying a house in Houston and settling there).[2] Jean and Henri Doll were working well together, a collaboration that was helping stabilize U.S. operations. "It's wonderful to see how close Henri and Jean have become," Dominique wrote to her mother. "Henri has great confidence in Jean when it comes to the management of staff and the political leadership of the affair. Without Jean, Henri would not have had the courage, nor the control, to regain the upper hand on our collaborators."[3]

During this stay in New York, Dominique found Father Couturier again. She and Jean would go with the Dominican priest to the Metropolitan Museum, standing in front of the paintings and discussing them

together. She wrote to her family in France about how pleased she was to spend time with him again.[4] "Marie-Alain Couturier was a French Dominican extremely sensitive to art," Dominique later wrote, in notes for a talk on Couturier. "Having once been a struggling painter himself, he was mostly a man of vision, of sober eloquence and of deep spirituality."[5]

Father Couturier had been living in North America for a year and a half, a stay that had been eventful and provocative. He was assigned to St. Vincent de Paul, the French-language Catholic church at 123 West Twenty-Third Street.[6] "I have started to get used to this hard, inhumane city of New York," Father Couturier noted in his journal. "There are also some remarkable things here, and those outshine everything else."[7] In the midst of war and unfamiliar surroundings, Father Couturier focused on two subjects to make it through: the power of great art and, once France fell to Germany, the French Resistance. Both, as far as he was concerned, were existential issues.

Father Couturier took trips to Montreal to give talks on religious as well as modern art. One of his lectures, at the University of Montreal, was attended by Henri Laugier, a French scientist and researcher who had been the minister of education during the Popular Front. "Father Couturier, in his white robe, with his handsome, slender silhouette like something out of El Greco, rose to take his place behind the lectern, exuding a powerful, contagious intellectual honesty," Laugier later wrote. "He spoke about the all-consuming life of modern painting with a knowledge that was vast and profound, with a precise sense of people and ideas and of the artists themselves—Rouault, Matisse, Léger, Picasso, Bazaine, Dufy, and many others."[8]

Laugier was fascinated by Couturier and filled with admiration for someone who, in such a conservative world as the church, wanted to understand the new and was able to draw parallels with the past, present, and future of art. At the end of his talk, Couturier asked for questions. As often happens, there was silence. So Laugier decided to be bold. He asked, "How do you explain that a cultivated elite, which has had such a real knowledge and pronounced taste for the most militant avant-garde in literature, poetry, and music, would, with a few exceptions, cut itself off so completely from modern painting?" The question sparked a long, lively discussion. After the lecture, Laugier introduced himself to Father Couturier, "the beginning," Laugier noted, "of a great, deep, and open friendship."[9]

During his stay in North America, Father Couturier had an equally galvanizing effect on the American acceptance of the Free French (later the Fighting French). A young Frenchwoman named Élisabeth de Miribel, who had typed de Gaulle's famous speech from London on June 17, 1940,

went to Montreal to rally support for the cause. Her efforts were aided by her encounters with Father Couturier, in Montreal and New York. "I had found a friend who revealed the soul of our resistance to me. Thanks to him, I could make it through loneliness and the multiple intrigues that awaited me, without losing my mind."[10]

Along with Jacques Maritain, Father Couturier was one of the first prominent pro-Resistance voices in the United States. Robert Schwartzwald, a literary and cultural scholar who studied his engagement, wrote, "In radio broadcasts, sermons, and articles in newspapers and journals, Father Couturier developed a civil presence in North America that rallied support for the Free French and denounced the moral cowardice of the Vichy regime."[11]

In fact, Couturier's political stance ruffled feathers in the American Catholic church. Francis Spellman, the archbishop of New York, later Cardinal Spellman, prohibited Father Couturier from receiving confessions or preaching in any church in his diocese.

Jacques Maritain, who was also in New York during the war, was very helpful to Couturier. He arranged for him to live in a servant's room in the house of the Marquis de Cuevas on East Sixty-Eighth Street. The Chilean-born ballet impresario had married Margaret Rockefeller Strong, a granddaughter of John D. Rockefeller, and he would found the Grand Ballet du Marquis de Cuevas in 1944. Staying in the de Cuevas household, Maritain felt, would allow Couturier to be independent financially, to develop his own personal ministry, and to avoid difficulties with the more conservative elements of the American church.[12] He also became a regular traveling companion for the de Cuevas family and something of a tutor for the de Cuevas's two teenage children, John and Elizabeth.[13]

Falling out of favor with the Catholic hierarchy also allowed Father Couturier to connect with other communities, including African American churches in Harlem. He befriended many members of the Harlem Renaissance including Ethel Waters and Carl Van Vechten.[14] On the de Menils' first trip to New York, Father Couturier made sure to take them on a tour of the neighborhood. "We went to a black church in Harlem, where everyone was clapping their hands and singing and had big smiles on their faces," remembered the family's English nanny, Miss Best. "Monsieur de Menil said, 'If only we had such joy in our churches.' "[15]

The de Menils benefited from Couturier's connection to artists and to the still-nascent art world in America; his influence was decisive in their education. "When we did not like something, he made us see more of it," Dominique recalled. "I remember our first visit to the Modern [the Museum of Modern Art]. We were just beginning to appreciate cubist paintings. In

front of a Mondrian, I said, 'Now, this is going too far. You cannot pretend that those few rectangles are beautiful.'" Father Couturier insisted, however.[16] He said to Dominique and Jean, "You may not like it but it is serious and you have to take it seriously."[17]

And soon enough Mondrian became a very meaningful artist for the de Menils. Once, Dominique was asked what work she would try to save if their house was on fire. She decided on a very specific piece by Mondrian, a small pencil sketch on an envelope for a future painting. For her, the tiny Mondrian was a treasure of reflection and knowledge, of simplicity and beauty.[18]

Dominique was continually struck by the boldness of Couturier's vision. She told her mother of one revealing evening at the Museum of Modern Art. The occasion was a screening of two films: a saccharine view of Saint Thérèse of Lisieux, *Thérèse Martin* by Maurice de Canonge, and an anticlerical work on the Mexican Revolution by the great avant-garde Russian filmmaker Sergei Eisenstein, *¡Qué Viva México!* Dominique felt that the film on the French saint was less than mediocre while the Eisenstein work, though unfinished, was quite beautiful. After the screenings, Father Couturier was invited to share his views with the museum audience. As Dominique relayed the story,

> He said that if decisions on censorship were up to him, he would ban the film on Saint Thérèse, which was overtly tasteful and gave a completely false impression of her character, and encourage the release of the other, which was obviously quite beautiful. Although it attacked quite openly the church, those attacks, he explained, given the behavior of the Mexican clergy, are justified. The audience was stunned, particularly an American priest who was there. But they soon saw his point, and even the other priest soon agreed.[19]

Couturier, as the former editor of *L'Art Sacré* and a leading priest committed to modern art, was in contact with the European artists who had begun flooding into New York. Léger, for example, was very impressed by Couturier. He dedicated a painting to him and asked him to compose an essay for a book on his work. In thanking the priest for his contribution, Léger wrote, "You say things about my work that have never been said and this touches me deeply."[20]

The de Menils also made a quick trip to Philadelphia with Father Couturier. There, they visited the Philadelphia Museum of Art, while Couturier, thanks to Henri Laugier, was able to spend hours viewing the collection

of Dr. Albert C. Barnes, the important and notoriously difficult collector. Couturier wrote of the visit,

> It is unimaginable. It gives the impression of never having seen modern painting until viewing this collection. Pierre Matisse had told me that I would feel as if my head were about to explode. True, but exploding with bedazzlements, with enchantments. And Barnes was delightful. He gave me his big book on Cézanne. My American friends can't believe it, because he has the reputation of being a horrible man, despising Catholics, priests, Jews, and so on. He has more than two hundred Renoirs, a hundred Cézannes, marvelous works by Matisse and Picasso, and some important pieces of African art.[21]

When he wrote to Dr. Barnes to thank him for the hours spent showing his collection, Couturier made it clear what it meant to see such stirring examples of Paris art in the midst of World War II. "At a time when all that is good in the world is threatened it is, for someone from France, a great joy and a great comfort to be reminded that what one's country has given to the world that is the most pure will never be at the mercy of a military defeat," Couturier wrote. "Seeing that helps bring hope for the future."[22]

In Philadelphia, as he had in New York, the Dominican encouraged the de Menils to better understand artists. A pair of adjacent galleries at the Philadelphia Museum of Art, one with paintings by Braque, the other by Picasso, was the perfect setting for comparing the two artists. "I am pleased with your thoughts on Braque and Picasso," Couturier later wrote to Dominique. "Do you remember the impression we had in Philadelphia with those two contiguous galleries? Thinking more about it, in spite of that off-putting part of his personality that can make him seem like a circus performer, I continue to feel that Picasso is the greater talent. Both, though, are tremendous painters; loving their work enriches us."[23]

Thanks in large part to their friendship with Father Couturier, Dominique and Jean's first stay together on the East Coast was a huge success. The weeks they spent, mostly in New York, provided the earliest outline of a social, intellectual, and artistic world that they would inhabit for the remainder of their lives.

But, as with any trip, there were trying moments. One day in Manhattan, the de Menils decided to buy a Packard to drive cross-country to Houston. They went to a bank, withdrawing more than $1,000 in cash. They then made their way to the local Packard dealership to pick out a new

car. When they returned to their rooms at the Stanhope, Dominique was in tears. She seemed to be sobbing uncontrollably. She was so upset that she ran directly into the bathroom to take a long, soothing shower. Jean went in to try to make her feel better.

What had happened was, after they had been to the bank, the de Menils stopped to buy some chocolates for the children. Then they took a taxi to the dealership. Once they were inside, Dominique realized that she had left the envelope filled with cash in the taxi. It was a time in their marriage when funds were still tight, and, of course, it was in the midst of a war, when everyone needed to be cautious about finances. And for Dominique, who had always been so impeccably organized and who had long lived under a moral imperative not to spend money frivolously, the lapse must have been particularly galling. But Jean made an effort, and a charming one, to defuse the situation. "Oh, let's give the children their bonbons," he said to Dominique, with a sense of enthusiasm. "Let's give these to Marie and Adelaide and ask them to eat them *very* slowly, because they cost more than a thousand dollars!"[24]

•

A little over a month after arriving in New York, the family left by train, changing in St. Louis, to arrive in Houston in July 1941. They disembarked at Union Station, a five-story brick and terra-cotta affair with a polished marble interior. Arriving in the middle of the summer, they were exposed to the full onslaught of Houston's heat and humidity. Large windows and porches were part of the design of every house to help capture any breeze that might happen in from the Gulf of Mexico. In those days, before the widespread use of air-conditioning, Houston was considered a hardship post by consular staffs, like being assigned to a country in the midst of economic free fall or a war zone. Although Houston had been the largest city in Texas since the late 1920s, when it edged out Dallas it was still relatively modest in size, with a population of just under 400,000. Downtown was filled with a collection of mostly unremarkable office buildings, small retailers with loud neon signs, and a few ornate cinemas with elaborate marquees, but even a cursory glance confirmed that it was not New York and certainly not Paris.

Several miles south of downtown on Main Street, the Museum of Fine Arts was a two-story neoclassical stone structure that had been completed only sixteen years before. Architecturally handsome, it was a very green institution. Exhibitions in the past year included the *16th Annual Exhibition of Work by Houston Artists,* the *4th Annual Exhibition of the Hous-*

ton Camera Club, and *Historic and Modern Examples of "Cattle in Art."* The museum did organize more promising shows too, including *European Masters Lent by Knoedler Galleries, Corot to Picasso: A Review of French Art in Oils, Watercolors, and Prints,* and *Indian Art of the Southwest, Lent from the Collection of Miss Ima Hogg.*[25] But there was no doubt that the caliber of the shows was generally quite different from those at the Museum of Modern Art or the Metropolitan Museum or the Louvre, which both Dominique and Jean had known since they were children.

The downtown Houston skyline was dominated by the Gulf Building, a thirty-seven-story art deco structure in limestone on Main Street. When completed in 1929, the Gulf Oil headquarters was the tallest building west of the Mississippi River. Sakowitz Brothers, probably the most notable local department store, took up five floors in the base of the building.[26] A few blocks away on Main was the Humble Oil Building, a seventeen-story Italian Renaissance tower that had recently become the first local building with a form of air-conditioning. Another prominent addition to downtown was the Houston City Hall, a seventeen-story art deco building in a public plaza that had been finished only two years before the de Menils arrived.

A dozen miles east of downtown, where the Buffalo Bayou opened onto the Ship Channel, was the newly completed San Jacinto Monument, a moderne masonry tower, 567 feet tall, topped by a stylized Lone Star, symbol of the state of Texas. Built to be taller than the Washington Monument by some 13 feet, the octagonal tower of Texas limestone marked the site of a decisive battle for the state's independence and was begun in 1936, the year of the Texas centennial.

The family focus, however, was on a more modest art moderne structure that housed the headquarters of Schlumberger Well Surveying Corporation. Located just east of downtown, at 2720 Leeland Street, it was a three-story, flat-roofed building, in the form of a U. The classically detailed exterior was marked by glass bricks, rows of windows, and the word "Schlumberger" etched in stone across the roofline. In addition to the offices, the complex included extensive workshops used for the fleet of company trucks and its technical equipment. It was the first new building ever constructed by Schlumberger. Most members of the extended family chose to live several miles west on the Buffalo Bayou from downtown, in the still-developing residential neighborhood of River Oaks. Not everyone was thrilled. "It was like settling down on a new planet," recalled Dominique's older sister, Annette. Annette and Henri Doll moved into a redbrick house at 1824 Larchmont Road. "Oak trees surrounded the house while clumps of Spanish Moss hung like beards in the branches of the trees, nourished by the humid air and swaying with the slightest breeze," Annette wrote.[27]

Dominique and Jean began to prepare to leave for South America, placing the children in the care of Annette. Georges stayed with the Dolls, while a nearby house was rented for the de Menil girls.[28] And how did these young European children see this new world? Christophe de Menil recalls her first impressions of Texas as being like a paradise. "I remember being introduced to orange juice there," she said. "In France, citrus was so precious. In Clairac, my great-grandmother grew citrus trees that were out on this huge terrace. But we never had any; only grownups could have the fruit."[29] Annette's daughter Henriette was struck by the natural environment of the subtropical city. "I particularly remember the quality of the grass in Houston," she explained. "It was this grass with big blades that didn't seem to grow one by one; you lift it and the whole thing would come up, as though it were carpet. It was great for playing; it seemed like an adventure."[30]

•

Dominique and Jean had planned their joint trip to South America because operations for Schlumberger were in dire need of attention. Their final day in Houston, Jean stayed up all night working.[31] Paul Lepercq, whose investment banking firm Istel, Lepercq and Company was instrumental in the financial development of Schlumberger, and who knew the history of the company as well as anyone, termed the years the de Menils would end up spending in Venezuela and Trinidad as "The Heroic Period of Caracas."[32]

Dominique and Jean arrived in Caracas on August 14, 1941.[33] Throughout the 1930s and 1940s, Venezuela was an incredibly important producer of petroleum. World oil production in those years was always led by the United States, the Soviet Union, and Venezuela. The South American nation was occasionally second but usually third. "But the two world leaders consumed nearly all their production whereas Venezuela exported nearly all hers," noted an expert on the subject. "In the international petroleum trade, Venezuela's exports were nearly equal to the combined exports of the rest of the world."[34] Before the 1950s, and the discovery of the vast reserves in the Middle East, Venezuela had a prominence in the petroleum industry that was much like that of Saudi Arabia. The year before the de Menils arrived, Venezuela, because of the war, was cut off from European markets. Its surplus production was absorbed by Canada, Latin America, and the U.S. military. In 1941, Dominique and Jean's first year there, Venezuela produced 228 million barrels of oil, 22 percent higher than the preceding year and 10 percent more than what had been a historic peak in 1939.

In the preceding decade, Venezuelan oil production had been centered

on the western part of the country, in and around Lake Maracaibo. An official push for more oil exploration meant that major new fields were discovered in the eastern part of Venezuela, notably at Jusepin, Oficina, and El Tigre.[35] Caracas was in the center, on the coast of the Caribbean, roughly equidistant from the two largest centers of production.

On December 7, 1941, only several months into the de Menils' stay in South America, the Japanese attack on Pearl Harbor brought the United States into World War II. That led to Venezuela breaking officially with the Axis. Its commitment to the Allies meant that the country's oil production became a major German target. According to a history of Venezuela's petroleum industry,

> Nazi submarines headed for the Caribbean. Their hunting ground was the sea lane between the Paraguaná Peninsula and the Dutch West Indies. Their aim was to cut off the Allies' vital Maracaibo Basin petroleum supply. They waited for the slow, loaded lake tankers to come out into deep water, then attacked. Seven tankers were torpedoed on the night of February 14, 1942, another the following night. The subs also attacked ocean tankers and shelled the refineries at Curaçao and Aruba. A convoy system was promptly set up. Lake tankers, in groups of five to ten, steamed to the Dutch islands only at night, blacked out and shielded by armed escorts; allied planes patrolled the route by day.[36]

The German aggression was wreaking havoc on the company's supply lines. "Attacks by submarines made the shipment of materials very hazardous," Jean recalled. "We went through two or three years of extreme tension."[37] The de Menils saw the significance of what was happening in South America. "The oil of Venezuela was particularly useful in the war because it's a light oil, easily refined," Dominique later explained. "But many of the company's engineers had left for France, and there were serious supply shortages. America in those days was building heavy bridges and cars but not highly technical instruments—no refined galvanometers to take the slightest measurements—everything had to come from Europe."[38] One Schlumberger executive, Henri de Chambrier, witnessed Jean's role in finding a solution. As he recalled, "He took these draconian measures and very quickly—in a year or a year and a half—reequipped almost all of the Schlumberger centers with modern material that came from Houston and that was the equal of material used by Schlumberger in the United States."[39] Dominique and Jean also discovered that the supply issue was connected to a larger problem, that the director for Venezuela had misman-

aged the operations. "Because this has been happening for years, the staff is demoralized," Dominique explained to her family back in France. "If the situation had continued, we risked losing the best of our engineers, given the demand for technical staff right now." There were other ramifications as well. "Staffing is not the only concern to be dealt with," Dominique informed her family. "Although our business here is prosperous, it is at a turning point. Our reputation here is not as good as it should be and the quality of our work is not up to snuff. All of this comes from poor management."[40]

Dominique watched how Jean approached the situation. Working practically around the clock, he usually rose at 5:30 a.m. and often did not go to bed until well after midnight. His days were spent meeting staff, becoming acquainted with clients, and formulating a plan, while evenings were for social gatherings with the Schlumberger team or entertaining clients. "Jean has given himself over entirely to it, like with everything he does," Dominique wrote. "He is studying everything in great detail, speaking with everyone involved. When he has finished his tour, he will have demoted some who have been poor managers to the level of engineer and will give additional responsibilities to those who had been kept at distance by an insecure leader."[41] Henri de Chambrier, the Schlumberger executive, witnessed firsthand Jean's managerial approach. "He had a very perceptive intelligence and always sought to understand fully any problem, never making snap judgments," de Chambrier remembered. "No one ever complained about the conclusions of Jean de Menil because they were always fair and based on a tremendous sense of humanism."[42]

De Chambrier, promoted by Jean to be the director of operations for eastern Venezuela, worked very closely with him. In trying to understand how he made personnel decisions, de Chambrier kept hearing the English word "poise." "This man has no *poise*," Jean would say. Or, "This man has *poise;* he should be pushed ahead." So de Chambrier finally asked, "What is this *poise* that you are always talking about?" In response, Jean said, "There has to have been something that you have done in life that really marked you. It doesn't matter what—it can be an intellectual performance, an athletic achievement, any kind of accomplishment, a particular challenge—but it is something that affects you for life."[43]

There is no doubt what Jean de Menil saw as the source of his own drive to succeed: the death of his brothers and the financial ruin that had been brought on his family. For his part, however, de Chambrier doubted whether he had this *poise.* "I've never done anything that really marked me. I went to university, then Schlumberger hired me in 1936 at a salary of 300 francs, I've done my little jobs in petroleum camps, and here I am."

But Jean felt that all of the positive reviews he had heard about the young man meant that he did, in fact, have this quality. So one night, over a glass of whiskey, the two pored over his past to discover the source. It soon came out that he had played the violin as a teenager, when he participated in competitive auditions for the conservatory in the Swiss city of Neuchâtel, playing violin concertos in front of an audience of hundreds. And Jean said, "That's the source of your *poise!*"[44]

In addition to the challenges of management and staffing, Jean realized that Schlumberger pricing was not what it should be. He felt that it was important to be as direct as possible with their clients, the oil companies. As he told them, "You want a good service, you complain that ours is not as good as it should be, and you are right, but if you want a good service, you are going to have to pay for it." Jean proposed a corporate price increase that he termed "spectacular." He had a meeting with one senior executive, from Gulf Oil, who was outraged by the new rates. Jean was asked what rate of profit Schlumberger expected to earn. He suggested that the goal would be between 20 percent and 25 percent. The oil executive asked if that also included expenditures for research and development. Jean informed him that it did. And the response was surprising: "That seems fair; that is our goal as well."[45]

It was a gentlemanly conversation that was revealing for Jean. "I learned that day what Marcel Schlumberger had often said," Jean recalled. "There is no reason to be afraid of charging clients. What you really have to be worried about is not providing a quality service."[46]

•

Conditions at that time were particularly brutal. It was common for Schlumberger engineers to work twelve-hour days. "A day often went from 4:00 a.m. until 5:00 p.m., doing very fastidious work," remembered one field engineer. "So we were often very tired and would be relaxing in the evening when a geologist would call or send a messenger asking us to leave again at 11:00 p.m., or 2:00 a.m., to take a measure of another well."[47]

Another Schlumberger engineer recalled,

It was the war, and we were working twenty-four hours a day. There was one period when I didn't have one Sunday off in twenty-five weeks. Another time, and I know I wasn't the only one, I went without sleeping for seventy-two hours. At twenty-seven years old, you can do that, but then, to go back at night, I had to drive some thirty miles on rough roads. I would have hallucinations. I saw

cows everywhere because the big danger coming back was all of the cattle on the dark road. They were sleeping near the roadways, and they were black; we were exhausted and saw them everywhere. I don't want to complain, because it was the war, but at a certain point you can no longer function intellectually. And our work was demanding, reading technical logs in order to tell oil companies where they should be drilling.[48]

Dominique and Jean also sized up the living conditions of Schlumberger engineers, who were usually housed with the oil companies. "We were put in a bull pen to sleep because there wasn't any place else," remembered one Schlumberger worker. "It was an enormous sleeping dorm for roughnecks. Work on the derricks took place twenty-four hours a day; when someone went to sleep, someone else would get up to go to work. It was really like a frontier village."[49]

The de Menils saw the disadvantage of this. "Before Jean de Menil, Schlumberger engineers were living like rats in the desert," recalled one engineer. "They were these poor single men lodged in these barracks, four guys to each hut—one in each corner. And meals were taken in a canteen. Jean de Menil said, 'This won't do at all.'"[50]

Dominique and Jean decided to build field housing for Schlumberger employees. "Soon, we are going to start building a new camp, with little houses of concrete block," Dominique informed Madame Conrad. "I have already worked on the project, particularly for the engineers who are married."[51] Dominique and Jean spent the next year designing the new camps, building them, furnishing them, and even living in them.

Arriving in the midst of these challenging situations in South America, in the middle of the war, and looking to make major changes to the company, the de Menils were certainly noticed. One of Jean's inspection tours took him across the border from Venezuela to Colombia, to a place called El Banco. He arrived by seaplane, touching down on the Magdalena River. "Monsieur de Menil was wearing something remarkable, a watchband made of white canvas," remembered the Schlumberger employee who met his plane. "I heard that Dominique washed it for him every night. That evening, we were at the dinner table, in the middle of all of these oil people, roughnecks, and someone asked, 'Who is this guy?' And I said, 'He's my boss.'"[52]

One day, Dominique and Jean took a small plane to Maturín, in the far eastern part of Venezuela. Two Schlumberger employees met them at the airport. Dominique, as a young, attractive woman from Paris, who was the daughter of the founder of the company and who knew the science as

well as most of the men on staff, was bound to be noticed. "We usually communicated in Spanish as our French was a little fuzzy," remembered the Schlumberger engineer who went to collect them. "Madame de Menil stepped off the plane—I will always remember the expression—and said, 'I hope I won't be an *impedimenta*!'"[53]

•

After their first tour of Venezuela, Dominique and Jean spent two weeks in the Republic of Trinidad and Tobago, the British colony a few miles off the northeast coast of Venezuela, which was an important base for Schlumberger. Dominique termed their time in Trinidad "delicious."[54]

Schlumberger had just finished a new headquarters on the island, a modernist concrete box, much like the Houston headquarters, positioned on a prominent hill at the edge of the city of San Fernando. The de Menils helped organize its inauguration, with Dominique writing a company history for the occasion. The party attracted hundreds of guests, including many "oils," as Dominique called those who worked with the oil companies, as well as the governor of Trinidad and Tobago. "I had made for myself a white dress in silk crepe," Dominique informed her mother. "The only ornament I wore was a simple necklace of green stones that I had bought in New York."[55]

During her time on Trinidad, Dominique also became acquainted with the local nuns. For their church, Dominique commissioned, and also designed, a beautiful monstrance. It was a bold liturgical vessel, over eighteen inches tall, with a dramatic sunburst extending out from the center. "Working with a black jeweler, I made a silver monstrance for the nuns," Dominique explained to her mother. "I worked on the drawings and oversaw the production. The effort was worthwhile: it is the most beautiful monstrance I have ever seen. It is fashioned like Indian jewelry, entirely by hand."[56]

From Trinidad, they went directly into the working oil fields throughout Venezuela. Dominique described the experience for her mother:

> I am writing to you from one of the Venezuela camps, in the middle of the jungle. It is sunset; the frogs are beginning to croak. It would be beautiful if we could see anything. But, strangely, in these immense, uninhabited areas, we are confined to a little piece of land behind a village. From the airplane, you can see the jungle, sources of water, an impressive flora, and yet, after landing, there is the feeling of being an ant in the middle of a field. The few roads

Dominique in front of Schlumberger headquarters in Trinidad, 1941.

that exist skirt the jungle without penetrating it. Behind a curtain of vines, there is a sense of mystery, but nothing can be seen.

But don't think that all of Venezuela is covered with virgin forest. In some regions, the ground is covered with only the slightest amount of grass. It is the savanna. The camp Oficina, where we will go tomorrow, is on a prairie.[57]

Jean's moves to reorganize Schlumberger operations in Venezuela were quickly successful. In just over one month, he diminished the power of the former director, gave additional authority to regional managers, and promoted a younger executive, Édouard Souchon, to an important post in Caracas.[58] Once the reorganization was complete, in two more months, the mood in the company was considerably lightened.[59]

Dominique and Jean spent several days at an improvised camp in Oficina. In the evening, they presided over a large dinner with more than a dozen Schlumberger engineers, in a makeshift meeting space that was normally a darkroom. Dominique placed a large bouquet of red flowers she had been given as she left Trinidad in the center of the table. Jean led the conversation with tales of his experiences in banking and stories about friends back in France. By 10:00 or 11:00 p.m., the engineers went back to the barracks or out into the field to work. "It is rare to go one evening without out a 'driller' who comes by to announce a job. The last few days have seen a great amount of activity, so there were fewer at dinner."[60]

On their first trip to Oficina, Jean took the plane back to Caracas while Dominique stayed behind. Returning to the camp, she was greeted with enthusiasm. "To make up for not having made the flight, I went to see the parakeets fly," Dominique wrote to her mother. "It's a beautiful spectacle in the tropics. Around a small river, a mile or so away, parakeets nest in palm trees, the only nearby vegetation. Then, just before night falls, they take flight around the trees—a mass of vivid green and bluish gray."[61]

•

By the beginning of October, Dominique and Jean had flown back to the United States. Right after leaving Caracas, they spent a couple of days in Jamaica, and then, following a layover in Miami, where they phoned the children back in Houston, they had another stop for several hours in Jacksonville. "A prosperous and boring city like all the cities in the United States," Dominique alerted her mother. "I prefer Venezuela with its roughness and its absence of civilization."[62]

After a couple of weeks with Jean in New York, Dominique returned to Houston. She rented a house at 2121 Inwood Drive, just a few doors away from the River Oaks Shopping Center. It was a two-story white house, vaguely Cape Cod. As she described it for her family in France,

> It is a charming little house. I have hired two blacks, a nanny who focuses entirely on Georges and another who cooks and does the housework. Georges adores his Negress. Every day, around 5:00 p.m., she sits on the steps in front of the house facing the street, with Georges next to her in a stroller. And they watch the cars go by. Seen from the house, it is a delightful scene: a large black woman in her green uniform sitting on a step and the little blond boy in his tiny stroller, together, watching the passing cars.[63]

Dominique spent a couple of weeks in Houston, pleased to note that their daughters had started ballet lessons, then went back to New York with Jean, staying again at the Stanhope.[64] While Jean made an excursion to Washington, D.C., noting that the U.S. bureaucracy seemed to advance slowly, Dominique saw a doctor in New York, who was finally able to solve her leg ailment. Dominique went to the Metropolitan Museum for a major Renoir exhibition, *Renoir Centennial Loan Exhibition, 1841–1941.* "Three galleries of paintings and only the best," she wrote to her family back home. She so enjoyed the show that she returned again with Jean and Father Couturier. "After, we went to see other paintings in other galleries," she wrote

to Madame Conrad. "Father Couturier has managed to help us understand and love Picasso. I so wish that you could know this Father Couturier; he is someone you would really appreciate. He has become a great friend for both of us."[65]

Dominique and Jean returned to Houston after spending a full month in New York. They took the long cross-country train, changing in St. Louis, and were met at the station in Houston by Miss Best and their children. There was a welcome-home dinner at the house, where the cook prepared special dishes and a cake with icing that spelled out the letter *M*. "We hadn't yet cut the cake when the doorbell rang," Dominique remembered. "It was Annette and Henri, come to say hello. We all sat around the table and talked and talked."[66]

As they planned their return to South America, Dominique expected to be able to come back to Houston in a matter of weeks, by the middle of January. It would be another two years before she was finally back in Texas again.[67]

•

In December 1941, after stops in Trinidad and Caracas, Dominique and Jean made a business trip to Argentina. There, they saw a friend of Jean Jardin's, an artist called Jean Dries, whose primary residence was at Honfleur in Normandy. During the four days the de Menils spent with Dries and his wife, they met a friend of the painter's, Pierre Verger. Originally from Paris, Verger had traveled around the world, working as a commercial photographer. In a matter of years, using his trusty Rolleiflex, he had shot everywhere from Tahiti to the West Indies, Indochina to Senegal. In Argentina, he was eking out a living, working primarily for French magazines.

After an initial dinner at Dries's house, Dominique, Jean, and Pierre Verger went out together several times to explore Buenos Aires. Verger recalled that the de Menils, most likely Jean, wanted to see a side of the city that did not involve expensive hotels or chic restaurants. As Verger later wrote,

So one night I took them to places that were off the beaten path, even a bit bohemian, that my state of chronic pennilessness had caused me to frequent. We had dinner in a small *churrascaria* in the harbor. Then we went to some working-class places in the old port-side neighborhood of La Boca. And we finished the evening in Liberty Inn, a bar that was run with authority by a robust lady

known as Kitty, whose vocabulary was as saucy as the sailors who
made up her clientele.[68]

In the midst of their nights on the town, Verger happened to mention
that Buenos Aires was not of great photographic interest for him. He sug-
gested that Peru, and the indigenous people of South America, would be
something that he would really like to document. For the photographer, his
comment was just conversation during some amusing nights on the town.
For Dominique and Jean, his statement was meaningful.

A few months later, in April 1942, completely out of the blue, Verger
received a note from the de Menils asking him to accept a check that was
large enough to fund his trip to Peru. "I was so surprised by your letter that
I do not even know how to thank you," he wrote to Jean. "I find myself
rereading it, from time to time, in order to assure myself that I am not the
victim of hallucinations or an overactive imagination until I see again, there
in black and white, that my trip has now become possible."[69]

Verger began studying his atlas—triumphantly, he suggested—and
applying for a Peruvian visa. "I hope that the photos I will send you will
be able to evoke the pleasure that I will have from being back on the road,
thanks to you, and will be able to convey, however faintly, how grateful I
am to you."[70] Because of their check, Verger was able to travel for months
across Peru, Bolivia, and Ecuador, documenting the festivals and rituals of
the indigenous people along the Cuzco and Andes Mountains. During the
religious rites, he paid particular attention to elements that had Catholic
colonial origins and those that had been handed down from the Incas.[71]

In March 1945, he published a book of his photographs, *Festivals and
Dances in Cuzco and in the Andes*. It was a fascinating, beautifully pro-
duced volume of photography, with text and captions in English, French,
and Spanish. The introduction was by the director of the National Museum
of Lima, Peru.[72] The book was dedicated to the de Menils. Pierre Verger
would go on to be one of the great ethnographic photographers in South
America, focusing primarily on documenting the powerful connection
between Africa and Brazil. A foundation and cultural center in his name
was founded in Bahia in 1988. A director of the Fundação Pierre Verger
suggested that *Festivals and Dances in Cuzco and in the Andes,* though less
well-known than other tomes, was a key moment in Verger's career. "It was
the first book that was more anthropological in nature, foreshadowing the
work he would do in the future on afro-Brazilian tribes."[73]

The Verger book, more than the *Portrait of Dominique* by Max Ernst,
must be considered the first act of artistic patronage by the de Menils. It

was perfectly in keeping with the style of Jean de Menil: the fact that such an idea would be conceived while they were hanging out in the dive bars and barrios of Buenos Aires. But it was a gesture of support for someone they had just met that turned out to be life changing.

•

In addition to the work they were doing for Schlumberger, Dominique and Jean had fascinating, multilayered lives in South America. For New Year's Eve 1942, the de Menils flew from Buenos Aires to Rio de Janeiro. "Rio is gorgeous," Dominique announced to her mother. "The bay is extraordinary. The jungle is ten minutes from town. The city itself is the most colorful in South America."[74]

They began the New Year back in Trinidad, with Jean making short trips over to Venezuela. Dominique regularly drove around the island in an old Buick owned by a Schlumberger engineer, having passed her examination for a driver's license. "I'm now the proud owner of a ravishing little green booklet with the words 'Trinidad and Tobago Motor Driver's Permit,' " she wrote to Jean, when he was back in Venezuela. "You would be very jealous."[75]

She was increasingly appreciative of the voluptuous sense of nature in the tropics. She wrote of Trinidad,

> This island is really beautiful. It is quite varied and with an extraordinary richness of vegetation. We just witnessed one of the most beautiful spectacles of the year: the flowering of orange trees, called here *immortelles* (in Venezuela, they are known as *bucarés*). I have never seen such extraordinary blossoms—a conflagration that lasts an entire month.[76]

But being based in Caracas was, for the de Menils, an enriching experience on many levels. The city, at that time, had an impressive number of distinguished art collectors and a vibrant sense of culture. There was also a clear French flavor to Caracas society. One of the de Menils' favorite restaurants was Le Paris, owned by a Monsieur Anatole. "There was a lot of French influence in Caracas," recalled Surpik Angelini, a Venezuelan who was a later acquaintance of Dominique's. "In those years, much of the fashion and the food was French—even our educational system was very French—we modeled ourselves after French culture in many ways."[77]

Caracas art collectors also gravitated toward work from Europe and particularly Paris. By the time the de Menils were settled there, a handful

of prominent local collectors—Inocente Palacios, Pedro Vallenilla, Clara de Otero Silva, and the architect Carlos Raúl Villanueva—were buying such modernist masters as Cézanne, Renoir, Gauguin, and Monet, such surrealists as Ernst, Dalí, Picabia, and Miró, and leading contemporary artists like Braque, Léger, Matisse, and Picasso.[78] At the same time, partially because much of the world was cut off from Europe, there was new interest in South American and Latin American art. In 1942, Alfred Barr and Lincoln Kirstein traveled for MoMA to Mexico, Cuba, and South America, acquiring some two hundred new works for the museum's permanent collection. "Thanks to the Second World War, we are dropping those blinders in cultural understanding which have kept the eyes of all the American republics fixed on Europe with scarcely a side glance at each other during the past century and a half," Barr wrote.[79]

During their stay in Caracas, the de Menils crossed paths with one of the country's most compelling contemporary artists, Armando Reverón. Raised in an affluent Venezuelan family, Reverón had been interested in art since he was a child. He studied in Spain and Paris, where he was influenced by the works of Velázquez, Goya, and Cézanne. Returning to Caracas, he settled about an hour north in Macuto, a small village on the Caribbean. There, beginning in the 1920s, he painted abstract landscapes of blinding whiteness as well as darker, sepia studies of a nearby industrial port.[80] The artist, who was described at the time as one of the most important living Venezuelans, also developed a singular lifestyle. At Macuto, he built a series of primitive huts out of mud and stones, surrounded himself with a menagerie of monkeys and dogs, and dressed himself in a fanciful interpretation of indigenous clothing, often including loincloth and feathers. As a Venezuelan cultural journal described the scene at the time, "Half-naked, wearing a belt of vines that he says creates a border between sex and the mind, surrounded by trained monkeys in surreal costumes that he taught to handle brushes, Reverón plays the extravagant, great artist, selling with a gentle innocence his reputation as a madman."[81]

Dominique and Jean made the trip to Macuto, just over thirty miles north of Caracas, to meet Reverón, thanks to a Schlumberger engineer who knew him. They joined him for a meal, Dominique clad in a light summer dress, the artist clad in his loincloth and covered in vines. André Stoll, the Schlumberger engineer, gave them *Macuto* by Reverón, an oil on burlap from 1943. The following year, the de Menils purchased two just-finished works from Reverón, *La Guaira Harbor,* an oil on canvas, and *Chaparros by the Sea,* an oil on burlap. They were the first significant works of art acquired by the de Menils since the portrait by Max Ernst, ten years before.

The architecture of Caracas also had an impact on their lives. Founded

in the sixteenth century, the city had a handsome collection of colonial and historical architecture and graceful public spaces. The population was under 400,000, but because of the Venezuelan oil boom it had begun a period of great growth. In the late 1930s, a new city plan for Caracas was conceived by Maurice Rotival, a French urban planner who left Venezuela, about the time the de Menils arrived, to join the faculty at Yale University.[82] The Rotival Plan created a grand boulevard, really more of a highway, that sliced through the city.

While Dominique and Jean were living there, Rotival's approach was modified greatly and implemented by a leading Venezuelan architect, Carlos Raúl Villanueva. After a classical architectural education at Paris's École des Beaux-Arts, Villanueva returned to Caracas to begin his practice. For the city, he devised an urban renewal plan—arcaded streets, tall buildings, interior courtyards—that was modern yet complemented the colonial nature of the settlement.[83] Villanueva was one of the leaders of a modernist movement in Venezuela. By the 1930s, the International Style had arrived in Caracas. As a result, when the de Menils were there, the city had scores of flat-roofed white stucco houses, office buildings, and public institutions.

The most striking example, begun in 1940, was Villanueva's masterwork, the University City of Caracas. By the time it was finished, two decades later, the campus included a concert hall topped with a series of biomorphic ceiling panels by Alexander Calder, a ceramic wall mural, and a stained-glass window by Fernand Léger as well as a monumental bronze sculpture by Jean Arp. The entire campus, a UNESCO World Heritage site since 2000, is considered "a masterpiece of city planning, architecture and art."[84]

Bucharest also had a sizable number of International Style structures: villas, hotels, office buildings, federal offices, and apartment buildings, including the one where the de Menils stayed. During World War II, they spent close to five years in Bucharest and Caracas. In each, they were able to observe more modernist architecture than could be found in Houston, of course, but more even than they had been exposed to in Paris. Because they were already sensitive to the style, their exposure to so much modernism in Romania and Venezuela sharpened their eye.

•

The elegant Hotel Madrid, however, in the center of Caracas, where the de Menils stayed on their first visits, was a more historic property. Once they found a place to live, also an older structure, it turned out to make a lasting impression. Dominique and Jean rented a colonial hacienda known

as Sans Souci. Built by a coffee planter, Sans Souci was a one-story struc-
ture that dated from the nineteenth century. It was described in 1878 as "the
elegant ranch house of Señor J. Rohl, with its beautiful flower garden and
coffee plantation."[85] When the de Menils found it, Sans Souci was located
in a pastoral setting on the edge of the city, not far from the Caracas Coun-
try Club. Beyond the property was the jungle and a view of the Cordillera
de la Costa in the distance. Dominique loved watching the morning fog that
drifted down the mountains and over the grounds.

Sans Souci was in the form of a U, turned away from the street, built
around a central courtyard, and topped by a red-tiled roof. The front ele-
vation featured a wide porch, supported by classical columns that were
painted white. Some have suggested the house was modest; others have
described it as being quite impressive. All agree that it was beautiful.[86] The
property included an inner courtyard with large potted plants and a ter-
race garden with orchids as well as a kitchen garden, which gave way to the
tropical jungle. The grounds also included mango trees, banana trees, and
even a chicken coop. Dominique was delighted to work on the grounds. "I
plan to expand the garden," she announced to Jean. "I think the neighbors
would support the idea of carving out another chunk from the jungle. I
would like to try to arrange everything for the arrival of the children. And

Dominique reading a letter from Adelaide at Sans Souci, their
house in Caracas, where they lived for three years.

I would love to have an aviary; I saw some at the market that were ravishing and cost only one bolivar."[87]

Often while Jean was out in the oil fields, Dominique would entertain at Sans Souci. One day, she had twelve for lunch, a mix of Free French expatriates and Schlumberger staff. She found a Venezuelan cook who she felt was "marvelous," and a young man who could serve meals, providing him with a new white jacket for the occasion.[88] Jean had a typewriter brought to the house so he could type out memos for the Schlumberger staff. The engineer who introduced the de Menils to Armando Reverón, André Stoll, stayed with them for a time at Sans Souci. "I had dinner there and even breakfast," Stoll recalled. "That is when I began to appreciate the elegance of Jean de Menil, who always came to breakfast in a jacket and tie, never in a robe."[89]

Sans Souci and its surroundings were tremendously inspiring for Dominique and Jean. A few years later, when they began to build their house in Houston with Philip Johnson, they would make sure that it was modeled after the hacienda in Caracas. Johnson's house, too, would be a single-story structure, built around a courtyard with tropical plants. Adelaide de Menil remembered Dominique sitting in the living room of the house in Houston, explaining to a group of young people visiting how it reflected their modestly scaled house in Venezuela.[90] Dominique made it clear that the design of their Houston house was meant to incorporate the landscape with the interior architecture much like Sans Souci and other Venezuelan houses, both modern and historic.[91] And decades after the completion of their residence, its design would inform the architectural development of the Menil Collection. There is a clear connection between the de Menils' nineteenth-century Caracas hacienda, the 1950 modernist house by Philip Johnson and Charles James, and the 1987 museum by Renzo Piano.

•

While they were in South America, Dominique knew that her mother was very concerned about the state of the firm founded by her husband. So she wrote Madame Conrad a summary of their activities:

There is still so much to do that Jean had not expected at the beginning. Our entire operation has to be built from the ground up. It was past time that this task be taken on. Without Jean, given the poor quality of our firm here, oil companies would have sought out our competition, and, fairly quickly, we would have capsized. Since Jean has taken over, the competition is something that is far off in

the distance. It was primarily the fault of the poor service we were offering.

I think that we will not be going back to the United States before April. This separation from the children is very difficult for me. But I am happy to be here with Jean and to support him in his effort. I take care of other related issues, smaller but not unimportant: the furnishing of our new offices in Caracas, the furnishing of our houses out in the field. We are constructing two camps. One is large with offices, workshops, clubhouse, two houses for married couples, and three for those who are single. A smaller camp will have two large houses, one will serve as a clubhouse, a smaller house, and a workshop.

So engineers will have nice houses. It was necessary. They do a tremendous amount of work. We could no longer allow them to be housed like hikers in a cabin in the mountains. Everything will be in good taste but also simple and as economical as possible.[92]

For the camps, Dominique designed all of the furniture. The most prominent material was a simply waxed, light mahogany. The living rooms had large tables with six chairs, a sideboard, and a small bookcase. A sofa and several matching armchairs were made with upholstery webbing in dark red. The bedrooms had iron beds that were painted a light cream, matching dressers in the same soft color, and a pair of webbed armchairs in blue canvas.[93]

In all of the Schlumberger offices, Dominique hung photographs of the founders, Conrad and Marcel. They were mounted in simple light wood frames and placed prominently on the wall. In a dining hall at one camp, she placed a series of photographs of Versailles that she had bought in Argentina. "It will please our engineers. They are nostalgic for France." Dominique felt that the dining hall, as a central meeting place, was the perfect location for such a gesture. "Because there are no telephones, each time a geologist or a driller needs us, they drive twenty-five or fifty miles to come find us."[94] As they were completed, the camps provided a new way for Schlumberger staff to entertain clients. "Each night, there were some American families in one or another of the houses, having a little whiskey before dinner or going horseback riding," remembered de Chambrier. "At Camp Oficina, we had a stable of around ten horses. Geologists and petroleum engineers from Standard Oil would come to Jusepin to do a little riding on the savannas in the evening and then have cocktails. It made for such a lovely, friendly way of life."[95]

The de Menils worked closely together during their time in South

America. Schlumberger employees were aware that the changes that were taking place were team efforts. As one noted,

> Jean de Menil really organized everything. He determined the number of houses that would be necessary, while Dominique de Menil took over the construction of the bungalows, working with a Basque contractor from Caracas, then also furnished these houses, which she did with much passion and art. We lived for five or six years in bungalows furnished as they would have been in California, Florida, or New York. We were living very, very well. The Americans even envied our way of life, which was equal to theirs if not slightly better.[96]

Dominique and Jean regularly discussed the qualities and drawbacks of Schlumberger employees, the best ways to structure the management, and even salary levels of the various executives.[97] She went into great detail with him about specific equipment that was needed in the various camps, how well readings were progressing, and what their competition was doing. She sent telegrams to the offices in Argentina and Houston, in search of critical supplies.[98] When Dominique was staying in one of the camps and Jean was in Trinidad, he asked her for input on how two executives were working together. "I have the feeling that there is a little tension between them right now. Will that be heightened by this new plan? You are there, living and working with them while I am far away; your input would be very helpful."[99] Dominique responded with a twelve-page letter, detailing her thoughts on the character of the various executives, her impressions of how they worked together, and suggestions on how to structure the operation in the future.[100]

Dominique spent more than two months living in Oficina, while Jean was in Trinidad. She worked from 7:30 a.m. until 6:00 p.m., typing letters, keeping the books, and supervising the construction of the workers' housing. "I was the secretary and accountant, sharing the single life of our engineers," Dominique wrote to Gerald Thompson in Europe. "I planned gardens, transplanted trees, oversaw construction, painted walls, churned butter, and even opened a little grocery store. It was a lot of work but a lot of pleasure as well, the pleasure of seeing the formation of a small community."[101]

Though still worried about the war, and her family back in France, Dominique was convinced that what she and Jean were doing in South America was important. As she wrote to her grandmother,

I have a life here that is very interesting. If I was not separated from the children, not worried about all of you, and if there was not going to be much more suffering before the end of the war, I would be perfectly happy. Jean and I are very conscious of how fortunate we are to be together, to share all of the joyful times as well as the difficulties. I often think of what all of these long trips would have been for Jean if he did not have me here.[102]

·

Dominique and Jean's distance from their children, beginning early in their South American adventure, was a cause of great concern for many. "I am sure it must be painful for you to be far from your children," Father Couturier wrote to the de Menils during the 1941 Christmas holiday. "Being childless must be a great deprivation."[103]

In March 1942, Jean was in Trinidad, having tea at Queen's Park Hotel in Port of Spain and reading a letter from Annette. He was confused about exactly where his children were living. He wondered, if he was understanding the letter correctly, if the house they had rented on Inwood Drive had been abandoned and if Georges had moved in with Annette and Henri Doll while the daughters were with Pierre Schlumberger and his family.[104] A few months later, Dominique breezily informed her grandmother, "As for Georges, we have practically forgotten his existence. Nevertheless, we did recognize him in the little photographs that Annette sent us, even with his shorter hair and his look of being a big boy now."[105]

In Houston, Dominique's cousin Pierre Schlumberger seemed concerned about the children and wrote a harsh and probably exaggeratedly dark letter about the situation to his mother, Madame Marcel, back in occupied France:

Jean and his wife are still in South America and continue to delay their return. Their children and Miss Best are going to be thrown out of their house tomorrow. Annette will take the baby and the black governess; I'll take Miss Best and the two girls. I'm happy for these two little ones who will certainly be happier at my place than all alone with Miss Best, who doesn't look after them very much. Everyone feels sorry for them. The other day, Mrs. Smith, Anne-Marie's nurse, took them to Mass. When the taxi driver, who is the same each Sunday, saw these two little girls, all sad and poorly dressed, he thought they were impoverished refugees. Very seri-

ously, he suggested to Mrs. Smith that he take the two little ones to his house, explaining that he had three children around the same age and that he could give them "a good home."

Pierre Schlumberger went on to apologize for painting such a dark picture of the situation in Houston. But he did not let the subject drop. "I think I'm going to have to go see a priest to ask that he give a sermon to the parents," Pierre wrote to his mother. "Happily, the baby Georges has a black woman who is very nice; the only problem is that he can no longer see white people without squealing."[106] Pierre's tone could be attributed to intra-family rivalry: it was, perhaps, in his interest to denigrate the de Menils. But it was a remarkable document to send to his mother, who was also, of course, married to Jean's boss.

Christophe had a different memory of that time. She felt that she and Adelaide were shuffled off to other houses because her aunt Annette wanted only a boy in her house. Christophe also remembered her mother making an attempt to get the children to Venezuela. Because the flights were so complicated, involving multiple stops and layovers, the de Menils had arranged for Schlumberger employees to meet them along the way. But Annette nixed the idea.

Contemporary accounts confirm her impression. In January 1943, Jean wrote to Dominique to tell her that the mother of a Schlumberger employee had managed to fly to Caracas through Miami. It had required a week of waiting in Florida, but Jean felt that a Schlumberger staff member would be able to help. "It is encouraging about the possibility of organizing a trip here for the children. Every day, I dream of the moment they will arrive."[107]

While the de Menils were in Venezuela, Dominique sent a series of charming drawings to their daughters that were built around characters that the de Menils had first developed while they were separated from the children and living in Romania. Mouseky and Frisky were a pair of mice; he usually sported a pair of blue-plaid walking shorts, while she wore a simple red-checked summer dress. Dominique was responsible for the drawings, while Jean often came up with the story.

For Easter, Dominique penned a fanciful drawing for their daughters. It was a peaceful scene in a tropical garden. A dog rested in its house, a couple of chairs were set up for tea, a pair of trees supported a hammock. Mouseky and Frisky were on the top of the drawing, he carrying a walking stick, she with a basket of brightly colored eggs. "Mouseky and Frisky, saddened to think that Papa and Mother would not have Easter eggs this year, decided to hide some," read a playful caption. "Where are the eggs? There are seventeen to be found."[108]

La maison de ~~l~~ papa et maman.

Où sont Mouseky et Frisky?

Dominique's drawing of their house in Caracas, featuring Mouseky and Frisky, sent to the children back in Texas.

•

In Trinidad, Jean had one professional achievement that was of capital importance. When Marcel Schlumberger saw that war was imminent, he had the foresight to organize the company into a series of independent international groups. The idea was to allow each to exist on its own, rather than as a subsidiary of a French company. Once France fell to the Nazis, however, that arrangement became a problem. As an occupied country, France was seen as an extension of Germany. So, for Allied nations, doing business with a division of Schlumberger could be seen as doing business with the enemy. As Jean recalled, "English authorities were dissatisfied with the arrangement. They suggested, correctly, that there was nothing to stop us from being obligated to make payments to the French branch, meaning to an occupied country."[109] Schlumberger's international operations were the only functioning part of the company during the war. If they were to continue, a solution would need to be found.

Jean concentrated on solving this issue. He worked with a very capable

accounting executive at Price Waterhouse in London, with the Schlumberger attorneys in New York, and with a notable figure in Trinidad, Sir Lennox O'Reilly, a black lawyer and politician who was considered a "silver-tongued legendary advocate."[110] Jean and O'Reilly persuaded the attorney general of Trinidad to link Schlumberger's South American and international operations and to incorporate them in Trinidad. A special law needed to be passed, but it was a crucial advance: Schlumberger became, for legal and political reasons, an English company.[111] "I have to tip my hat to Sir Lennox O'Reilly, whom the great landowners shunned because he had dark skin but who was a very intelligent and very sophisticated man," Jean recalled. "It was thanks to him that we were able to settle this issue."[112]

It took more than two years of complicated international maneuvering to complete all of the arrangements. "There were two remarkable results," remembered Jean de Menil. "Schlumberger was completely disassociated from all connections with an enemy-occupied country. So, Schlumberger became either an American company, for the U.S. operations, or an ensemble of international companies, at the service of an international industry, paid in an international currency, the dollar."[113]

The significance of the achievement was clear within the company. As one Schlumberger executive recalled,

> There is a memorandum, in English, that I still have in my safe. It states specifically that the assets of Schlumberger have now been transferred—that they are no longer French—and that the English government is the guarantor of this agreement. The German submarines were not far away in the Caribbean. There were always fears of an attack; in 1941 and 1942, we were just waiting for those to happen. So here comes Monsieur Jean de Menil, and he really brought everything into focus. He managed to get Schlumberger assets out of the French orbit.[114]

•

Several days after finalizing that agreement, Jean went to a 6:00 a.m. Mass in Trinidad. "In honor of Saint Joseph, a group of the nuns' students sang the solemn service," he explained to Dominique. "During the benediction, after the Mass, out came your monstrance. It was magnificent! I prayed for you—for everything we have in common—for your father and for Uncle Marcel. It was very moving."[115]

That Mass was the first appearance of the silver solar monstrance

Dominique had designed. To honor the piece, and as a tribute to her, Jean decided to begin a novena. He went to the same 6:00 a.m. Mass for nine consecutive days.[116] He also decided to commission an additional pair of monstrances and secured permission to export them.[117] Those pieces are now in the Menil Collection.

That summer, in Trinidad, Jean made an effort to rally French expatriates and those of French extraction to the cause of de Gaulle. The encounters took place over rum punch and conversations about French literature. Some were reluctant to support de Gaulle because they still had positive memories about World War I hero Pétain. Others were anti-English or mistrustful of the de Gaulle consul on the island. "The question should be posed as clearly as this," Jean suggested: "Are you for collaboration with the Allies or for collaboration with Germany?" He was able to win over some and decided to draft a letter that could be sent to a couple dozen residents of the island. He invited several supporters to a club to help draft the text, signed by Jean, a couple of Schlumberger engineers, and others based in Trinidad.[118]

Back in Caracas, Dominique was asked to be president of the women's committee for the Fighting French (France Combattante). She accepted the position and decided to open a shop in support of the cause. It was a charming bookstore, gallery, and boutique that Dominique called La France (while Jean made sure to have it incorporated as a proper business).[119]

As she described La France to Gerald Thompson, "It is a shop where we sell the kinds of honest, thoughtful designs that we used to have in France, as though we were having them made in Paris. And so, once again, here I am designing tables, choosing woods, selecting books, etc."[120] All proceeds went to the French Resistance.

Dominique wrote to Father Couturier to have him send French literature and art books from New York. Couturier placed orders with New York bookstores, including the Librairie de France, sending down to Venezuela the latest works by Paul Claudel, a grouping of art books, and *Morceaux choisis* by Charles Péguy, with translations by Julien Green, a friend of Couturier's.[121] For La France, Dominique found seamstresses in Caracas who could produce clothes that looked French-made. The shop sold hats, jewelry, prints, and furniture, of metal and wood, that Dominique designed. "We made lamps turned on a lathe, stools, mirrors, tables and other small pieces," she recalled.[122] Jean was delighted to let her know that the boutique earned Dominique her first personal press coverage: "The best way to distract yourself is going to see Señora de Menil in a shop called La France," announced the local journal *Ahora,* in a column titled "Caracas Merry-Go-

Dominique in La France, her shop in Caracas, a fund-raiser for the French Resistance.

Round." "Señora de Menil is a fascinating woman, full of energy and good taste, who spends her time fishing for new designs and new ideas in this boutique that supports the cause of the Free French."[123]

Even with all of their activities, Dominique and Jean found time for relaxation. They took a trip with friends to the mountains of Venezuela. It was a six-hour drive from Caracas and then another six hours by mule up to a small village. As they rode up through the mountainous jungle, they passed women leading their mules down, loaded with sacks of coffee. "It takes you back five hundred years," Dominique observed.[124]

Another evening, they left Caracas for a moonlit picnic on a secluded beach bordered by a grove of coconut palms. "Jean loved it. It reminded him of the scenery he loved so much on the Pacific islands," Dominique wrote to her grandmother Delpech. "The moon rose fairly late, and as we waited for it, we fell asleep on the sand."[125]

•

In December 1942, Dominique and Jean met another European expatriate, the author and activist Jean Malaquais, who would become a lifelong friend. The Polish-born Malaquais had had a singular life and career. He

worked a succession of harsh jobs around the world, which helped develop his fervent leftist views, published fiction and nonfiction, was mentored by André Gide, and would go on, after World War II, to teach European literature at American universities including Wellesley College and to develop a long working relationship and friendship with Norman Mailer, who considered Malaquais his mentor.[126]

Born Wladimir Jan Pavel Malacki to a nonpracticing Jewish family in Warsaw, Malaquais was gripped early by the world of literature. His father taught Latin and Greek. Malaquais left Poland at the age of seventeen to discover the world, but his parents and all of his family would die in German concentration camps. He spent time in such far-flung countries as Romania, Turkey, Egypt, Algeria, and Morocco, working any kind of job including truck driver, dockworker, miner in phosphate excavations in Morocco, and merchant marine on a freighter that sailed to Dakar.[127]

By the time he was twenty, Malaquais had settled in France, working in silver and lead mines in Provence[128] and unloading crates overnight in Paris's central market, Les Halles.[129] He spent any spare time in Paris's historic St.-Geneviève Library, teaching himself the language and devouring French literature.[130] While in France, he took as his companion a Russian émigré and painter Galy Yurkevich.

Jean with the writer Jean Malaquais at Sans Souci.

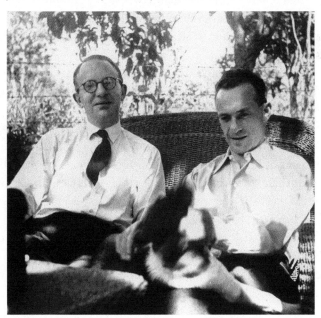

In 1935, at the age of twenty-seven, Malaquais wrote to André Gide, considered the moral conscience of French literature, initiating a correspondence with the older author that would last until Gide's death in 1951. In 1939, working in his adopted language of French, Malaquais published his first novel, *Les javanais*.[131] Malaquais gave great credit to Gide for his own development into a novelist.[132] It was a social realist work, based on Malaquais's life, depicting the harsh working conditions of the collection of international workers in a French mine in Provence. The French press gave the novel glowing reviews.[133] *Les javanais* won the prestigious Prix Renaudot. Leon Trotsky, from exile in Mexico, enthused, "Jean Malaquais is a great new writer."[134]

By October 1942, thanks to an intervention by Gide, Galy and Jean Malaquais managed to secure permission to leave occupied France for Mexico. After a long Atlantic crossing, however, they made it no farther than Venezuela. The couple was detained by difficulties in obtaining a visa for Panama. Their limited funds dwindled, leaving them with only enough for another week.

Invited to a dinner by de Gaulle's representative in Venezuela, the Malaquais couple met the de Menils. Dominique and Jean offered to have them stay at their house in Caracas. The writer was thrilled to realize the connection between Dominique, her uncle, and his literary mentor. "Oh, how the world is small," Malaquais wrote to Gide. "Proof is that we just met this young French couple, the de Menils, and Madame de Menil is none other than the niece of Jean Schlumberger."[135] Galy and Jean Malaquais moved in with the de Menils in their colonial hacienda in Caracas, staying there for several months.

Finally, by early March, Galy and Jean Malaquais made their way to Mexico. As they were leaving Caracas, Jean de Menil surprised his new friends with a traveler's check for $500.[136]

In Mexico City, the couple was met at the airport by Russian revolutionary Victor Serge. They stayed in the neighborhood of Coyoacán, first with a friend, the sister of Frida Kahlo. The $500 from the de Menils allowed the couple to rent their own apartment in the Mexican capital, furnish it, and live for several weeks.[137] They made plans for Dominique and Jean to stop over on their next trip back to Texas.

"Bless your new friends the de Menils," Gide wrote to Malaquais, "if they, by their example, have encouraged you to consider humanity to be less abject and contemptible than a great number of others might have led you to believe."[138]

By the beginning of 1943, Dominique and Jean learned that she was again pregnant. Of course, they were thrilled. Toward the end of January, Jean was out in the oil fields, working at El Tigre, in eastern Venezuela. He hoped that Dominique might be able to join him. She sent a telegram: "I would love to come, but right now the baby requires extreme caution."[139] Galy and Jean Malaquais were staying with them in Caracas during her pregnancy. Dominique sat for a painting by Galy, a portrait of an expectant Dominique in the garden of their colonial hacienda.

By the end of the spring, Dominique had miscarried.[140] The tragedy was compounded because it took place late in her pregnancy—probably close to six months. It was a wrenching loss for Dominique and Jean; it has been suggested that the distraught parents had a funeral for the fetus. They learned that it would have been a second boy.

Dominique was sure that the miscarriage had been caused by how active she had been. Gerald Thompson, however, reminded her that the last time she gave birth, it was in the midst of a war. He also issued a mock warning: "I am afraid I shall not be able to arrange for a German invasion of South America to ensure the necessary tranquility for you to bring a son into this world! It is a bit late in the day for that."[141]

In the summer of 1943, the de Menils flew to Mexico City to see Galy and Jean Malaquais. Together, they visited the sights of the city. Galy and Jean Malaquais introduced them to Trotsky's widow, and they visited his grave; of course, Jean had to photograph the final resting place of a revolutionary. They also stopped by local art galleries, where Dominique and Jean bought a small stone Olmec sculpture of a jaguar and a pre-Columbian ceramic of a hunchback playing the flute. The most spectacular purchase was a massive wooden cross, late eighteenth century or early nineteenth century, engraved with symbols of the Passion.

On August 5, 1943, Dominique and Jean arrived in the United States, at Brownsville, Texas, where they were observed by the Federal Bureau of Investigation. An FBI informant explained that the de Menils were living in Venezuela because considerable activity was taking place in the country's oil fields. The de Menils' relationship to Conrad Schlumberger was detailed for the FBI as well as their connection to Surenco and Schlumberger Overseas. "De Menil is said to be pro-ally and anti-Vichy," the report summarized. "His wife has been a leader in the Free French movement in Caracas, Venezuela, and is said also to be pro-ally." As to the de Menils' probable return to Venezuela, the FBI informant suggested, "He is a very unpredictable individual."[142]

•

Arriving back in the United States, Dominique did not immediately settle in Houston. Instead, she and Jean spent four months together in New York, returning to Texas at the end of November.[143] Before she had left South America, Dominique imagined how their life might look in the United States. She sketched out the scene for Jean:

Whatever house we will have, I do not plan on giving up taste for function. I would like to transform the inevitable Houston salon into a living room/atelier. In one corner, I would like to have a drafting table; in another, a workbench. I would like to have a few tools for repairing the children's toys, making dollhouses, doing odd jobs around the house; we can find an elegant cabinet to hold the tools. On the walls, we would have a few paintings by Dries and some watercolors by Bérard, and a few nice photographs can make the room beautiful. I can hardly wait to move in![144]

By February 1944, Jean was back in South America, sending photographs that he had taken with his Contax, while Dominique and the children were together in Houston, living in another rented house, at 3465 Wickersham.[145] When the de Menils had first left the United States, their children were eight, six, and nine months; upon their return, they were eleven, almost nine, and three.

By the late spring, Dominique had purchased a new house on 3859 Chevy Chase in River Oaks.[146] "I was unable to find anything to rent," she explained to her mother. "Not one new house has been constructed since 1942, and the housing situation has become critical." Their new house was a two-story, redbrick saltbox, with large windows and, around the front door, stone pilasters and a swan pediment. It included an additional lot to the east. Because it was positioned on the western edge of the neighborhood, the view was of nothing but woods. "It feels like being in the country."[147]

As she and the children were settling into their new place in Houston, Dominique began reading news reports about the German concentration camps. She knew several French Jews who had been taken away from Paris and Clairac.[148] She was, of course, horrified. "To be ripped away from your children, your husband, sent to a concentration camp, to wither there, frozen, starving, and finally to die without any medical attention, without knowing anything about your loved ones," Dominique wrote to Jean. "That is what is happening to thousands today. How can we even think about complaining when we have everything here in such abundance?"[149]

That spring, Dominique helped entertain Free French sailors hosted by

Schlumberger while their ship was in port being repaired. She was struck by the stories of how they joined de Gaulle: a fisherman from Brittany who left France the year before on a fishing boat, one man who fled Martinique by canoe, another who had been evacuated from Dunkirk. "You would have loved speaking with them," she told Jean.[150]

Dominique knew that René Seydoux, the husband of her cousin Geneviève, remained in a German prison camp. She learned that Pierre Schlumberger had sent him a subtly coded message of hope from the United States. To make it past the censors, Pierre wrote as though he were actually complaining. He told of how difficult it had become to sleep in their house on MacGregor Way because of the constant noise from all of the nearby factories producing war matériel around the clock as well as the squadrons of jet fighters making test runs over the area. He said that it was no longer feasible to travel in America, that passenger trains to New York were constantly pulled aside in favor of military trains packed with soldiers. "Using this whiny tone, Pierre conveyed to René that America was building up a military power that would be able to crush Germany," Dominique explained to Jean. "The letter passed the censor in Washington, and the Germans allowed it to be delivered. I am sure that René was inspired and shared the letter with his fellow prisoners."[151]

In Caracas, Jean prepared to make his move back to the United States. He converted Dominique's shop, La France, solely into a bookstore of the same name. He oversaw the design of new display windows and interior. He also had several pieces of furniture moved from their house to the boutique.[152] Although the war in Asia would not end for many months, American advances in the region meant that oil companies were planning to resume operations. The director of Shell Oil in Caracas asked Jean whether Schlumberger would be prepared for work in the Dutch East Indies. It was a question that intrigued Jean—of course the company would be prepared—and it led to the slogan that he coined at that time: "Wherever the drill goes, Schlumberger goes."[153] Jean's wartime turn of phrase became a corporate motto that would be used for decades.

There were other important, long-lasting Schlumberger initiatives he implemented in South America during World War II. Seeing that there was a great gap in how employees of different countries were treated, Jean began what he called the International Staff, giving parity to all employees. "It meant that an engineer who was French, Argentinian, English, or German was treated exactly the same way," Jean explained. "He had the same salary, the same living expenses, the same vacation time."[154] It was a bold, humanist gesture that is still an important characteristic of the company. "It was revolutionary at the time and is still, to some degree, revolutionary,"

explained Stephen Whittaker, the director of corporate communications of Schlumberger Limited. "At a company such as Shell in the 1970s, whether you were French, German, English, or American, you were on a different pay scale. So you had people from around the world working on location, and they were all paid differently. Schlumberger didn't do that."[155] Jean also initiated a savings plan and stock ownership plan for employees, what he called a "Saving Agency." And he decided that English, rather than French, should become the company's official language. "I think that was a significant step in the development of Schlumberger," Jean later explained. "We stopped being a French artisanal enterprise and became an international concern, without losing, however, the national character of each individual engineer. It is one of the great strengths of the company."[156]

Even today, Schlumberger Limited highlights those innovations. As the corporate communications director summarized, "The adoption of the U.S. dollar and the English language early in the company's history were far-thinking ideas that were not common at the time and were instrumental in the company's growth."[157]

•

As World War II was winding down, Jean, still in Caracas, organized the correspondence that he and Dominique had received during the conflict, as well as drafts of their letters, sending several shipments back to Dominique. "Here is our most recent correspondence, which I have just finished sorting," he wrote to her. "As with the others, I have numbered the letters in pencil so that you will not have trouble putting them in chronological order. I am now turning my attention to those that remain and will send them to you little by little as soon as they are processed."[158]

Dominique, at Jean's request, returned to Venezuela that summer for several months.[159] They needed to work together to pack up the house in Caracas. "I know it is exhausting to move, pack trunks, prepare crates," Jean wrote to her from Sans Souci. "And I would be happy to spare you what will also be quite sad, because we formed some lovely plans together in this garden, a space that you had managed to carve out of the wilderness and where the light bounced so beautifully off the leaves."[160]

By the end of October, Dominique was back in Houston. She wrote to Jean in Venezuela, imploring him to return to the United States. Instead, she went back to South America for a couple of weeks. Once she returned to Houston, in mid-November, Dominique assured Jean that the new house was charming, though a little empty. "I am waiting impatiently for our furniture from Caracas," she wrote. "But more than the furniture I am waiting

for you. You will be very happy here in this pleasant house with our adorable children. It is cool now and beautiful, the perfect weather for riding. We are right on the border of the woods; you can see them from our bedroom window."[161]

Writing to her mother, Dominique reflected on the challenges all had been going through:

> I can imagine how your life has been at Roche and how much these years must have seemed interminable. For us, also, they were very long. It has barely been one year that we have started to live again. The life we led in 1941, 1942, and 1943 can hardly be called living, far from the children or temporarily set up with them in New York, always from hotel to hotel, Jean never having a day of rest, and I, too, often overwhelmed with work. But, finally, all of that is like something from a bad dream.

As she waited for Jean to relocate to Houston, Dominique looked forward to a trip to New York. "It is the only city where there is an intellectual and artistic life," she explained to her mother. "We go there like people from the provinces go to Paris."[162]

•

In the fall of 1944, Dominique found that she was again pregnant.[163] "This will be the one that causes me to lose my figure," she wrote to Jean. In April 1945, in Houston, she gave birth to their second son, François de Menil. "He is a little angel," Dominique told Jean, when the newborn was little more than a week old. "When you speak to him, he turns his head and looks at you. Georges was studying him in his crib and said, 'He's cuter than the cat!' "[164]

That spring, Jean made an important business trip to New York. Marcel Schlumberger had been able to leave France and make it to the United States. He conducted a series of meetings with Jean, and the investment bankers Istel, Lepercq and Company about the status of the American and international operations. Jean also made time to see art. He telephoned Dominique to tell her about some works that he had fallen in love with, particularly a spare watercolor by Cézanne, *Montagne,* that he had seen at the Valentine Dudensing Gallery. "I am so excited by all of the pictures you spoke to me about. I would like to see the Cézanne that you like so much. Please wait for me before making a new purchase; I have decided to go with you to New York in the fall."[165]

Jean with his newborn son François, Houston, 1945.

Father Couturier had recommended purchasing the Cézanne. Because they had just received a tax refund, a completely unexpected development, Jean decided to buy it. It was their first significant purchase of art in the United States, and he did not wait for Dominique to see it.

Montagne was a spare, poetic work, with the uppermost portion of the picture containing a sweeping outline of Mont de Cengle, part of the same chain as Mont St.-Victoire in Provence. The foreground was held by several splotches of color. It was a modestly sized piece, ten and a half by eighteen and seven-eighths inches. Jean carried the watercolor back to Houston. Dominique's first reaction was of being underwhelmed. As she said at the time, "It seemed like an awful lot of money for such a small amount of paint," but she came to understand and appreciate the significance of the work. "It's a lovely little gouache," she explained much later. "At first I didn't fall particularly in love, but now I understand. It's a miracle of tension—the void means as much as the paint—nobody is able to find that tension."[166]

She also came to understand the importance of the artist's work to so many who came after. As she would say fifty years later, "It's interesting that we have so many by Cy Twombly, who always leaves a big piece of void as well. But Cézanne has influenced all the moderns; they have all been influenced by Cézanne and Matisse." In fact, Dominique used her delayed reaction to the Cézanne piece as an example. She might have been slow off the mark, but she learned. "It shows you can be educated."[167]

Her elder sister felt that the Cézanne purchase proved another important point. "It was Jean," Annette said emphatically. "He pushed the door

open for her. He chose it—she would have never chosen it herself—that was *his* choice."[168]

•

Tuesday, May 8, 1945, was VE Day, Victory in Europe Day, marking the Allies' acceptance of the unconditional surrender of the Nazis. Hundreds of thousands of Parisians took to the streets, celebrating the conclusion of five and a half years of war and enemy occupation.

The New Yorker's legendary correspondent Janet Flanner wrote,

> France and the rest of Europe are tired to death of death, and of destruction. Much of the comfort which should have arrived automatically with the peace has been lost in the news of the German concentration camps, which, arriving near the end of the war, suddenly became the most important news of all its nearly six years of conquests, defeats, campaigns, and final victories. The stench of human wreckage in which the Nazi regime finally sank down to defeat has been the most shocking fact of modern times.[169]

By early July, just as Marshal Pétain's trial for treason began at the Palace of Justice in Paris, Jean de Menil returned to France, the first member of the family to make the trip. He was given the responsibility of visiting many members of Dominique's family, his own family, and as many friends as possible. He was charged with taking photographs, to show everyone once he returned to America. The country was still decimated by the war, with strict rationing of food and fuel;[170] daily living was exceedingly challenging. Jean visited friends and family around Paris, in the suburbs, and made the trip to the Val-Richer. He even made the long journey to Clairac, to see Dominique's mother and grandmother.[171] "I am so happy to think that Jean was able to give you a kiss," Dominique wrote to her grandmother from Houston. "He will be in New York on Sunday. I leave tomorrow to meet him. I cannot wait to hear all of his news."[172]

That Jean would make his return to the family apartments on the rue de Vaugirard was exciting for everyone. While he had been off in the United States or South America, he was a constant subject of conversation within his family. His father, Colonel de Menil, talked of him often. "You can imagine what America meant for France when we were going through the occupation," said his nephew Jean Rougier. "We often said, 'One of these days, this is going to end, the Americans are going to debark, and Jean is going to bring us some little bars of soap.' "[173]

Then, one day in July 1945, the doorbell rang at the rue de Vaugirard. Jean's niece, Bénédicte Pesle, had just turned eighteen and had not seen her uncle since she was seven. "I went to open the door and saw before me someone who was obviously Uncle Jean," Bénédicte remembered. "He was standing there, with a raincoat simply resting on his shoulders, as he often did, and with that smile that he had. He gave off this impression of quiet power."[174]

The most poignant moment of Jean's return to France had to have been that day at the rue de Vaugirard, when he had a reunion with his father. This proud colonel had lived through the fall of France and then five years of darkness as many French cooperated with Nazis, some with tremendous zeal. The colonel had decided to install himself during the war in Pontpoint, in the country house, because he did not want to see the Germans.[175] Colonel de Menil had long been such an upright man, someone who had sacrificed most of his wealth to protect the honor of the family name, a struggle he had endured for four decades. The colonel was eighty-two years old and nearing the end of his life (he would die on March 19, 1947, less than two years later).

Jean was escorted to the bedroom by his niece Bénédicte and his older sister Mirèse. The colonel was sitting up in bed. When he and Jean saw each other, for the first time in seven years, there was a formality, a sense of reserve, to their reunion. Jean did not move to hug his father, and the colonel seemed uninterested in any such intimacy. Jean stood near the window as they spoke.

"Have you succeeded? Are you pleased with your work?" he asked his son.

"Yes," Jean replied.

"So, are you a millionaire?"

Jean's response, firm but softened with a smile: "Many times over."[176]

POSTWAR

*When I read letters from France, I realize how much we
must have changed. I sometimes feel a sense of detachment,
a somber separation from having had such a profound
experience living in a foreign land. I now know that there are
certain boundaries that I will no longer be able to accept.*
—MARIE-ALAIN COUTURIER, O.P.[1]

In July 1945, Jean made his way from Paris back to New
York. Dominique was there at the Stanhope to meet him. He
filled her in on all of the news of family and friends that he had gathered
from France, while they processed and organized the film he had shot on
his trip.[2] They also finalized plans to take their four children on a long-
delayed family holiday—their first as a family—to the Perry Park Ranch in
the Rocky Mountains of central Colorado.

The de Menils had returned to Houston, and the last week in July Domi-
nique and the four children flew to Dallas, then boarded a night train. Jean
stayed in Texas working. The train was packed, as the plane had been, and
there was no shortage of brutish traveling companions: a man in the Dal-
las airport who tried to pick her up, a sailor sitting next to her on the train
whose head rolled onto her shoulder as he fell asleep. Left with little to do
but look out the windows, Dominique observed the bleakness of the North
Texas plains, punctuated only by the occasional wood-frame farmhouse.
It made her think of some desolate stretches of Patagonia. The roughness
reminded her of an observation by the writer Julien Green: "Other than a
few houses from the eighteenth century, America is a blank page."[3]

As the train made its way west, however, the view became more inspir-
ing. "Once we were past Amarillo, the country became grandiose," Domi-
nique wrote to Jean. "It is as though nature has no longer been touched by
man. There are only some cows here and there and a few fences of barbed
wire. You can imagine a band of Indians galloping on their horses along the
great mesas, following the path of a stream."[4]

The family's destination, Perry Park Ranch, was a rustic setting near

Larkspur, between Denver and Colorado Springs. With an elevation of over sixty-four hundred feet, the property abutted the Pike National Forest and had spectacular views of mountains, lakes, and large formations of red rock. "The ranch is perfect," Dominique wrote as soon as she settled in. "You couldn't ask for a better place to relax."[5]

Joining the family on their vacation was Maria Hugo, an Italian aristocrat living in New York whom the de Menils had befriended, and her son, Georges Hugo. Jean was still in Houston. "The children are in a great state of impatience and excitement about your arrival," Dominique wrote. "Adelaide promised that for the day you come, she would put on her best blouse."[6] By mid-August, Jean was able to join his family. It was a relief that after all of the intense work, travel, and pressure during the war years he was having some much-needed downtime. "He is finally relaxing and taking advantage of this beautiful vacation, the first real holiday we have had since we were married." Dominique was worried, however, that his trip to France, on top of what had come before, had been too much for him.[7]

Little more than a week after his arrival, the vacation took a dramatic turn. One afternoon, the family was out on a small lake. Jean and Marie swam, while Dominique and Adelaide floated quietly in a canoe. Suddenly Jean lost his breath, struggled in the water, and cried out for help. Marie, distraught at what was happening to her father, burst into tears in the middle of the lake. Dominique began to maneuver the boat over to Jean. A stiff headwind made their task more difficult. "Adelaide reacted with great sangfroid," Dominique later explained in a letter to her mother. "She grabbed the paddle and, standing up with her short, muscular legs, paddled with all of her strength."[8] They managed to reach Jean and pull him into the boat.

He seemed to be fine. Knowing how frightening it would have been to see their father struggle, Dominique and Jean made an effort to reassure the girls. As they rowed back to shore, they downplayed the incident. By the time everyone was back on dry land, they were laughing.

Three days later, Jean de Menil, forty-one years old, had a massive heart attack.[9]

•

An ambulance, its lights blaring and sirens shrieking, was summoned to Perry Park Ranch. Jean was immediately transported to a hospital in Colorado Springs. Doctors there stressed the seriousness of the attack. After Jean was released from the hospital, Dominique stayed with him at

the Antlers Hotel, a turn-of-the-century lodge in the city's downtown.[10] She was sure that the cause had been the frantic pace of their lives the past five years. "I am certain that he will not repeat the excesses that he has committed, due primarily to the difficulties from the war," Dominique wrote to her mother. "In the oil fields of Venezuela, we were often so short staffed and lacking material as to be unable to function, worries that exhausted Jean."[11]

The medical staff was enthusiastic about his initial response to treatment. They suggested that he would need at least six months of convalescence but that he was expected to make a full recovery and would be able to have a normal life. Dominique was encouraged by the prognosis. As she noted, "The heart specialist from Denver said that his wife had the same thing almost twenty years ago and that she is now adept at mountain climbing, not a sport usually associated with someone who has a heart condition."[12]

Dominique was sure Jean would treat his recovery in the same conscientious way he approached every issue. And it was fortunate, she felt, that he was still young so that he could make the necessary changes to his lifestyle. "I am convinced that this heart attack, happening now, is a blessing and a sign of longevity," she wrote to her mother. "Don't you think that with two little sons, who don't even have five years between them, Jean wants to conserve his strength and live long enough to see them established in their lives?"[13]

•

The de Menil family returned to the house in Houston, where Jean was looked after by local physicians. His medical regime included regular injections of strophanthin, a cardiac glycoside.[14] He was under strict orders to rest, allowing him to work, in a limited way, but only from home.[15] The children were instructed to be as quiet as possible. The de Menils' fifth and final child, Philippa, was born in June 1947, almost two years after Jean's attack. "My brother François and I grew up with the shadow of his heart attack," said Philippa de Menil, now Fariha Friedrich. "I always had the feeling that he was going to die. I always had the feeling of his vulnerability. He had to be careful, he couldn't run, even though he was a strong man. And then, of course, he had a temper, and that was something that you wanted to stay away from and out of the way of."[16]

Dominique, after a few months in Houston, traveled on her own to New York. She stayed in the apartment of Annette and Henri Doll at 65

East Ninety-Third Street.[17] The letters she sent back to Houston, filled with news of her life in New York, were inspiring to Jean. "I see you looking beautiful, smiling, being intelligent and good-hearted, attracting looks and love interests," Jean wrote to Dominique. "It gives me a great joy; I am proud of you. Extend your vacation, in which I participate so intensely."[18]

Dominique had admirers, and one, who seemed to become a bit obsessed, was a senior executive with an oil company whom the de Menils had met several years before in Venezuela. He announced to Dominique that he was in love with her; he, too, was married. Dominique and Jean discussed the situation in their letters. "I'm not at all made for this kind of an adventure, yet I seem to be able to handle myself pretty well," she wrote to Jean.[19]

Jean's reaction was surprising; he understood why the other man would be so attracted to Dominique and found it touching. "You are bothered by this, made uncomfortable by a situation that displeases you," Jean wrote to Dominique. "But I hope that you are also flattered, in some way, to have affected so deeply a man who is anything but mediocre. I am very proud of you—yes, proud of this success as I would have been, and as I will be, of all of your successes in any domain."[20]

Jean offered his thoughts on how to handle a conversation about the advance, suggesting the need for directness. "You could explain, 'You do not want me to be your mistress, and I would not be able to be your mistress, because I know your wife and really care for her,'" Jean wrote to Dominique. "'Also, I would not be able to give myself without first having ceded my heart, and that is not something that I can do lightly or for only a moment. So let's not start down what would only be an impasse.'"[21]

The situation continued for several weeks, while Dominique kept Jean advised. One Friday night dinner became awkward. "It is such a shame that he is so in love with me; seeing each other could be so much more pleasant," Dominique wrote. "I wanted him to agree on a joint policy, but each time he sees me, he forgets everything, that I am married and he is too."[22] Several days later, Dominique was able to bring the unwanted advance to an end. "I think that we will be able to remain friends without disappointing him too much," she told Jean.[23]

Jean's health, several months into his Texas convalescence, was greatly improved. "The beginning of the work week was very hectic," he wrote. "But when the doctor came to give me a shot, he was not worried. He said my heart was 200 percent better than in December. I should be able to drive soon."[24] From New York, Dominique corresponded about his condition with Dr. Sauvage, the Paris doctor who had been a friend since he and

Jean went on their youthful trip around the world. And she spoke with a heart specialist in New York whom she thought Jean should also consult. Both doctors agreed that it would be better medically if he did not spend the hot summer in Houston. And Dr. Sauvage assured them that he would be able to find a doctor in Paris who could provide excellent care, were they to make a return trip to France.

As he worked from home, trying to slow down, Jean seemed more reflective about his career. One day, over a difference of opinion with a Schlumberger executive in Paris, Jean made his case in his usually forceful way. By the end of the week, he received a telegram: his Paris colleague had "capitulated." It was a victory that felt hollow for Jean. "Sometimes I wonder if this is worth all of the trouble," he wrote to Dominique of the professional strife. "It is true, though, that it is agreeable to be able to help people here and there and to be able to buy a beautiful painting from time to time."[25]

•

From that first trip on her own to New York, Dominique began to engage with the city's art world. One evening, she stopped by an opening at the Pierre Matisse Gallery. "There were some thirty people there and about as many paintings," she wrote to Jean. "It was hard to know where to look. I really like Tanguy, an intelligent man from Brittany. I also chatted with a very nice young man named Matta—a friend of Gordon, that English sailor. And Tamayo was there, simple and kind, from Oaxaca—more comfortable in Spanish than in English."[26]

When she traveled to New England to visit a boarding school for their daughters Christophe and Adelaide—High Mowing School, the Waldorf school in Wilton, New Hampshire—the first night was spent in Cambridge, Massachusetts. Before leaving, she and the girls made time to visit a singular work of art. "We ran to the Museum of Natural History at Harvard, where there is this extraordinary collection of glass flowers," Dominique enthused to Jean. "Only nineteenth-century Germans—father and son—could have executed this gigantic work of botany. It surpasses the imagination in its perfection, like seeing real plants, and by the scale of the achievement."[27]

As Jean was able to slowly resume his travels to New York, South America, and Europe, there was still an open question about where they would permanently settle. Should they stay in Houston, or might they return to France? Or was there somewhere else in the United States? In New York, Dominique discussed the situation with the financier André Istel, who felt

that they should settle in Manhattan for professional reasons and for the city's culture. Dominique was unconvinced, not only by Houston, but by other young American cities. "Personally, I prefer New York," she wrote to Jean. "We can only truly develop ourselves in cities. The American system that encourages everyone to move outside the center, into a suburb that is lush but lifeless, seems to be deadly for any kind of intelligence."[28]

Jean, in consultation with the other members of management—Marcel Schlumberger, Henri Doll, Pierre Schlumberger—decided that it made the most sense for Dominique and him to remain in Houston. He would be at the American headquarters, and able to supervise from Texas the far-flung operations in South America and the Far East.

•

The first wave of Schlumberger relatives to land in Houston, Geneviève and René Seyoux, who had moved to the city in 1937, were impressed with the modern American conveniences, but some of the local disadvantages were equally clear. As early as March, Geneviève complained about the heat,[29] and she was amazed by the intensity of the subtropical rains, suggesting that the sudden downpours looked like something that could only be produced on a Hollywood soundstage. Her parents, Jeanne and Marcel Schlumberger, visited them in Houston in those years and were equally horrified. "It was more than ninety-one degrees on Palm Sunday," wrote Madame Marcel. "This place is rich in heat and insects, like an Egyptian plague."[30]

When their family took a drive out into the country to see the bluebonnets, it was so hot that they were unable to stop along the road. "But we had a picnic in a little wooded area that was already prepared with tables, benches, and grills," wrote Madame Marcel. "There were iron spikes for sticking sausages and roasting them outdoors. All Americans eat that way: cured sausages."[31]

Dominique's older sister, Annette, remembered how challenging it was for her to adapt to life in Houston. "I was a little depressed to be in Texas," she recalled. Even though Annette had a slew of outside activities and was very active in hosting the technical staff of Schlumberger, she felt adrift. She loved getting out of the city, driving around the vast plains and wooded areas of the Gulf Coast. In fact, Jean de Menil, in order to help his sister-in-law, made a typically grand gesture. "He knew that I really enjoyed beautiful cars," Annette recalled. "He did too. So he bought me a Packard convertible, navy blue with beige leather interior. It was so beauti-

ful. I drove everywhere on the roads of Texas, as fast as I could to chase away the blues."[32]

Dominique, too, did not have an easy time adjusting. She found herself with a shortage of familiar stimuli. Living in the United States, she missed such simple pleasures as the sound of church bells ringing out.[33] The difficulties were deeper however.

It cannot have been easy for these European women to have settled in a place like Houston in the 1930s and 1940s, so dramatically different from the world they had known. Intelligent, interesting, and strong, they were cut off from their native language and from their own rich culture. Their husbands spent their long days and many evenings running a dynamic international business, while they were forced to find their own way in a very new society.

Houston matriarch Jane Blaffer Owen always felt that Dominique went through a depression in her early years in Texas. When that explanation was suggested as a reason—that these European women were left on their own with little to do while their husbands were off running the world—her response was immediate and withering: "Well, she did have five children."[34]

Dominique and Jean adored their children, but they also formed such a tight partnership that the children could have felt excluded. And as the scale of their lives became expansive—both physically, with homes in the United States and Europe and work obligations around the world, and intellectually, with fields of engagement that included spirituality, art, architecture, civil rights, and human rights—the children were often alone for long periods of time. It was also a different era when parents were not at the beck and call of their children. Dominique, within months of giving birth to their first daughter, Marie, traveled to Russia with her father for an extended business trip. After the birth of Adelaide, Dominique spent months with Jean in London, where he was working for a year. Once Jean joined Schlumberger and went to Romania for business, Dominique twice traveled across Europe to be with him for months at a time. After the move to Houston, when Jean needed to be in Venezuela and Dominique joined him, they had left their children in the care of her sister Annette and assorted nannies. "They were a young couple in love, saying, 'Bye-bye— we'll leave you the children—we'll be back soon.' That lasted for more than two years."[35]

Having joined the family firm only two years before, Jean knew little about the engineering side of the business. Dominique, on the other hand, knew it intimately and could be of vital help to her husband. It was also a

time of war, and many were separated from their children. "Once in South America, Jean faced such difficult problems that we remained for over two years," Dominique later explained. "It was really only after Paris was liberated that we started settling down in Houston. But I had left my children with my elder sister, which was traumatic for them."[36]

There is no doubt that the prewar and wartime separations reverberated within the family. They created resentments in some of the children, or at least a certain reserve, and led to tremendous guilt in the mother. "I will burn in hell for the way I treated my children," Dominique once told a young acquaintance. To another she said, "The way I treated my children is a sin."

The correspondence between the de Menils proved how much they cared about their children; they often wrote of parental concern and pride, but they could be wry and frank. In February 1946, Dominique wrote to Jean about how she much preferred living in cities. As she noted, "Nature, like children, absorbs you and smothers you."[37] Later that spring, when their younger son, François, was not yet a year old, Dominique hired a governess, Essie Barnes, to take the children to Europe for the summer. Pleased to have someone capable, she was also delighted that it would liberate her and Jean. "If Barnes also has her mother to help her," Dominique wrote to Jean, "she can take François as well, and we will be as free as the wind!"[38] A few weeks later, Jean was with the children at their house in Houston. He raved to Dominique about Georges, who was five. He was a perceptive reader, his memory was sharp, and his young mind was agile. "He makes me happy to have children," Jean wrote to Dominique, "which, no matter how charming they may be, I am really not made to have, at least while they are younger than eighteen."[39]

A friend of the de Menils remembered having a meeting with Dominique in their house in Houston in the early 1950s. As a governess brought one of the younger children into the room, the guest stood to say hello. That led to a stern look from Dominique. The guest sat down. The child—François or Philippa—was taken through the room, and the meeting continued.[40] Those were the same years when Jean began spending long hours in his office cataloging the works of art they had acquired. He sent letters to museums, dealers, and scholars, seeking background on each of the paintings and sculptures. He developed his own cataloging system and applied discreet round labels on the works with their object numbers. One evening, Christophe walked up to his desk as he worked. She had placed a sticker on her forehead. "Look at me," she said to her father, in words both revealing and heartbreaking, "I'm a work of art too!"

Dominique's niece Henriette de Vitry, the Paris psychoanalyst, felt that
to be a very illuminating incident. She also wondered how deeply Domi-
nique actually cared about her shortcomings as a parent. "I think she was
aware of the problem, but I don't think she was really moved by it," de Vitry
suggested. "I cannot imagine her ever having held a baby, in the profound
sense of the word. The psychoanalyst Donald Winnicott wrote of 'the
good-enough mother.' I don't think she was; I don't think she was ever a
very present mother."[41]

Yet even Christophe, who had been critical of her mother, was posi-
tive about many aspects of her upbringing. "Jean and Dominique always
included their kids in everything they were doing," Christophe said. "By the
time I was twenty, in 1953, I had met many artists—Matisse, Max Ernst,
Magritte, Giacometti—and they changed my life. And they did that with
all their children; it was very, very significant."[42]

Jean Daladier, whose father, Édouard Daladier, had been prime min-
ister of France at the beginning of World War II, was very close to Domi-
nique and Jean beginning in the 1940s. "Their children had a hard time
understanding parents like that," Daladier explained. "They were so open
to everyone, and everyone wanted to see them, that the kids felt that they
were always last in line." Adelaide de Menil once suggested to Jean Dala-
dier that her mother, in particular, did not really love them because she was
so often away. Daladier insisted that was not true—that she adored her
children. "But she also did what she was destined to do . . . there was the
art, of course, and all of the others whom she loved to help."[43]

Solange Picq was the longtime assistant of Jean de Menil at Schlum-
berger in Paris. She worked for Jean until he died. Dominique then hired
her to be her assistant in Paris, and she held that position until Dominique's
death. So, for five decades, Madame Picq knew all of the de Menil family
very well. "It must not have been easy for the children," Picq suggested.
"Very few are put in the position of understanding and appreciating people
of such worth. Parents in a more conventional family, less preoccupied by
important issues, where everything is at a slower pace, would have had the
time to give the de Menil children what they never had."[44]

•

To expand their lives, the de Menils began inviting friends to Texas
and forming new, meaningful friendships. Just after the war, Galy and Jean
Malaquais stayed with them at their Houston house. There, he finished
writing a novel on World War II and the French occupation, *Planète sans*

visa. Published in 1947, the sprawling work was considered his masterpiece; Malaquais dedicated the book to the de Menils.

Daladier was another expatriate friend. Having stayed in France during the occupation, when he fought for the Resistance, the twenty-two-year-old Daladier made his way to the United States in 1945. After a brief stay in Washington, D.C., he decided he wanted to see more of America. So he moved to Houston, to work with the cotton trader Anderson, Clayton and Company, the largest producer of cotton in the world.

A mutual friend took him to the de Menils' house, where their initial meeting was so successful that they asked him to come by the next day for lunch. When Jean discovered that Daladier's bachelor lodgings were only temporary, he said, "Look, it's very simple, why don't you pack your bags and come live with us?" He stayed with the de Menils at their house in Houston for two years, feeling that he had become something like their younger brother. "They had a sense of openness and sincerity that was just staggering," Jean Daladier recalled. "I learned what it meant to have a profound, humane friendship."[45]

They had conversations about art, of course, which Daladier said were passionate. The couple peppered him with questions about what life had been like in France during the occupation and his plans for the future. And he was there for the very beginnings of the de Menils' collection—he saw that they had already acquired some beautiful paintings—and he witnessed the role that relationships played in assembling it. "They were starting to make friends in that world," Daladier recalled. "Those who met them had but one thought in mind: to come back. Rich, powerful people who were also intelligent and open to others in that way—that just doesn't happen very often."[46]

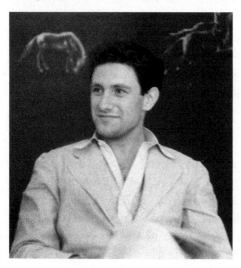

Jean Daladier, son of the former French prime minister Édouard Daladier, was an expatriate and a great friend of the de Menils.

During the de Menils' early years in the United States, Jean Daladier sensed a spiritual component to their actions. "Many people do not realize how much their lives were inspired by Christianity," he suggested. "Everything they did was with a great sense of modesty. They could have acted like stars.

Instead, they were modest with their money, modest with their paintings. I've seen them interact with artists but in a very low-key way; it was deeply Christian."[47]

Dominique and Jean made another lifelong friend in those first years in America, Marguerite Johnston Barnes, and her geologist husband, Charles Barnes, originally from Birmingham, Alabama. Friendly with Jean Daladier, Marguerite Barnes was given a letter of introduction by him to Dominique and Jean.

A journalist who would go on to be an important writer with *The Houston Post,* she began her career for the Birmingham newspaper, covering Washington, D.C., then moved to Texas shortly after World War II. She was fluent enough in French to have interviewed Resistance leader Jean Moulin and André Malraux, the minister of culture under de Gaulle. "They soon became our best friends in life," Marguerite Barnes said of meeting the de Menils. "I'm a Francophile, so it was an easy friendship to start."[48]

She had clear memories of the first de Menil house on Chevy Chase. "It was on a double lot so that the children could have swings and room to play," Marguerite remembered. "It was a very pleasant house, with a living room, dining room, screened porch, and four bedrooms. It was centrally heated but not air-conditioned, and it had just the first buds of the collection."[49] Neither she nor her husband had been particularly exposed to art and certainly not modern art. So the de Menils' house, even though it contained only a handful of works, stood out. As Marguerite Barnes remembered,

> There was a small Tanguy, about 12 to 15 inches, that hung on the right of the door from the living room out to the screened porch. We were just charmed by that Tanguy. And then there was a Miró hanging that was often near the table in the dining room. There was a painted screen with wonderful wild horses on it. And, as you walked in the front door, on the side wall of the staircase, facing the entrance, was a Tamayo. I don't know the name of the painting but it was of a strange Tamayo-colored red man, a huge, heavy body playing a tiny little flute. And for some reason, that appealed to me as much as any painting ever has—there were other paintings but that was the start.[50]

Even as the de Menils' adopted hometown began to experience a postwar boom, the local cultural scene remained quite limited. So how did arts-minded residents see Houston in those years? "Shall we say unsophisticated," said Edward Mayo, who was, for decades, the registrar for the Museum of Fine Arts, Houston. "There were people here who were a lot

more sophisticated than is known, but generally speaking, it was barely a burgeoning entity. There was one local artist, named Robert Joy, who was the only person in Houston to make a living out of art, and that was because he painted portraits."[51]

The de Menils began acquiring significant contemporary paintings, watercolors, and objects—primarily from dealers in New York—and bringing them down to their house in Houston. They bought a pair of pen drawings by Christian Bérard. They also acquired a pair of impressive still life paintings by Braque and an abstract oil on canvas by Léger—*Study in Violet and Yellow* (1944)—done while the artist was in exile in New York, with unusual, vivid colors that appealed greatly to Dominique.[52]

And they began early to buy the surrealists. They acquired an ink drawing by Victor Brauner, *Figure of a Woman* (1948); an oil on canvas by Max Ernst, *Design in Nature* (1947), featuring Loplop, the bird they found so puzzling the decade before; and a strikingly simple Magritte, *The Alphabet of Revelations* (1929), with silhouette figures of objects dear to the artist including a key, a goblet, and a pipe.

The works that began to appear on the de Menils' walls were surprising to some. "Everyone was up in arms about Léger, Picasso, Brauner," recalled Miss Best, the nanny. "Jean was in ecstasy, but some people were saying, 'It's so odd that he is buying things like this.'"

Jean's response: "You'll see."[53]

•

By the late 1940s, the de Menils began to build their collection in earnest. "He was a fanatic for art," noted Jean Mathieu, a Schlumberger executive who started working for the firm in 1929. "But he did not buy a lot before the company issued stock. Because dividends were not issued before '45, what they bought before was through their salary."[54] Postwar, thanks to Schlumberger dividends, the de Menils' income began to soar.

Many had means, of course, but Dominique and Jean were fortunate enough to have an inspiring set of mentors. Father Couturier, still in New York shortly after the war, continued to play his role. "Arriving from Venezuela, Jean was like a provincial who knows nothing," Dominique recalled. "So Father Couturier took him around to museum exhibitions, to Gallery Dudensing, Pierre Matisse, and other galleries that existed at the time."[55] The Dominican was one of the first to give the de Menils a truly inside look at the art world as it was beginning to take off in postwar New York. He made it clear that though still small, the American scene was already filled with colorful characters.

In the spring of 1945, Couturier advised Robert de Rothschild, from the French branch of the grand European family, to write to Albert Barnes to inquire about the possibility of seeing his collection. Not having heard anything after several weeks, Rothschild sent a second letter. He suggested, in an amusing way, that the first note must have escaped Barnes's attention. To facilitate a response, he attached a list printed with a variety of dates that could simply be checked off. He also included a self-addressed stamped envelope. It was a playful letter that led to a thundering response. Rothschild mailed Couturier a photostat of the Barnes missive, suggesting that without visual proof it might not be believed.[56]

The letter, ostensibly authored by his secretary, Peter Kelly, on stationery emblazoned with "Albert C. Barnes," read,

> Letters like yours of May 22nd and April 23rd meet all the requirements for our methods of dealing with self-appraised important people who try to muscle in where they don't fit and are not wanted. Letters from fresh guys and bad-mannered people predominate in this category. Such letters are never answered except when a self-addressed envelope is enclosed for reply.
>
> I read your letter to Dr. Barnes and he said, "Tell him that, as far as I am concerned, any of the days specified in the list of dates enclosed in his letter of May 22nd are satisfactory for him to go to hell."[57]

·

By 1946, Father Couturier had returned to Paris, so all advice continued from overseas. The de Menils had given him funds to buy books and have them shipped back to Houston. Couturier sent a magnificent volume on Braque, an illustrated tome on the great historic houses of Paris, and a beautifully illustrated book on Poussin with a text by Gide, *Les demi-dieux*. And he provided regular artistic reports from Paris. "When it comes to Bérard, I no longer know what to think," Couturier wrote to Dominique. "He too often crosses the line that separates good painting from bad. Cocteau is on the same path. But Matisse, Bonnard, Rouault, and of course Picasso and Braque are always admirable. The younger artists here are full of life, if not always originality." From Paris he alerted them when he came across a potential acquisition in a gallery or an artist interested in selling. Braque, he regretfully informed the de Menils, after much procrastination, was reluctant to part with a recent painting. "Neither he nor Picasso wants to sell much in the immediate future," Couturier

informed Dominique. "The most enterprising dealers are pulling out their hair."[58]

The priest made some interesting discoveries. He knew a prominent dealer, Pierre Loeb of the Galerie Pierre, who had fled the German occupation, living with his family in Cuba. There, Monsieur Loeb encountered a man who was painting signs, Rafael Moreno. According to Dominique, the dealer sensed a real talent. "So he gave him canvas, color tubes, brushes, some money, and let him paint," she recalled. "And then, after the war, he had those paintings for sale." (Moreno was included in Alfred Barr's 1944 MoMA show, "Modern Cuban Painters.") Notified by Father Couturier, Dominique and Jean bought a few paintings by Moreno, colorful folk-style Cuban landscapes with bright blue skies, lush green hills, and fields of tobacco and sugarcane. They placed two large canvases in the dining room of the Paris apartment on the rue Las Cases, the vibrant colors of the paintings set off by the pale yellow walls.[59]

Thanks largely to the artistic education they had received from the Dominican priest, the de Menils, on their first trip together back to France in the summer of 1946, had a profound reaction to one of their earliest acquisitions, a painting they had owned for more than a decade. In their apartment on the rue Las Cases, they brought down from the top of the armoire that c. 1932 Max Ernst painting, *Portrait of Dominique*. It had been hidden away in the same place, wrapped in brown paper, for most of the 1930s and all of World War II. "We were instantly taken by the subtle colors, the imaginative shells, and the unusual composition," Dominique recalled. "It was as if we were seeing the painting for the first time, our eyes open at last."[60] They took *Portrait of Dominique* back to the United States, where it became, and has remained, a key piece in the collection.

Father Marie-Alain Couturier, D.P., at the de Menils' first house, Houston, 1947.

•

During those years, Father Couturier also played a major

role in freeing Dominique from some of the limiting aspects of her French Protestant background. He helped her to understand—and it was a realization that was essential to their development as collectors and patrons—that the de Menils' multiplying fortune meant they had a responsibility to give back. Art was not something frivolous, nor was it an egotistical act, meant only for their own enjoyment or something used as a monument to themselves. Instead, Couturier argued, they should be acquiring great works and allowing them to enrich the lives of others, just as they themselves had been enriched in the galleries and museums of New York. "Father Couturier was an ascetic but he certainly was not a puritan," Dominique recalled. "He cured me of my puritanical block against collecting. He made it an obligation for us—a *moral* obligation—to buy good paintings, if and when we could afford it."[61]

Dominique would still struggle with a reluctance to spend lavishly on art. Jean was much more adept at making the big, splashy purchase. But had Couturier not positioned it as an imperative, it is unlikely they would have amassed such a meaningful collection. He helped elevate the significance of artistic expression for Dominique and Jean, providing them with an intellectual justification for spending vast amounts of money and giving a higher purpose to their acquisition of art.

•

Relationships, friendships, acquaintances—what might be called networking—were essential to the de Menils' place in the art world. When Dominique made her first solo journey to New York after the war, Jean encouraged her to stay longer in order to meet more people. "Trips need to be long," he wrote. "That is how contacts can be established that will allow us to venture off the beaten path, to have more than just a few of the same old friends."[62] After that first stay at her sister's, the de Menils rented a small apartment at 40 East Sixty-Eighth Street. And she and Jean began to meet some lively new friends.

Princess Maria Ruspoli (1888–1976), who had been with Dominique and Jean on their trip to Colorado, hailed from a particularly grand clan of the Italian aristocracy. The Ruspoli family, which traced its roots to thirteenth-century Florence, though based in Rome since the seventeenth century, was best known for the sixteenth-century Castello Ruspoli in Vignanello, with its Renaissance knot garden, as well as the magnificent seventeenth- and eighteenth-century Palazzo Ruspoli on via Corso in Rome. Designed by Bartolomeo Ammannati, the architect of the Palazzo Pitti in Florence, the Palazzo Ruspoli was where Maria was raised.[63]

Maria Ruspoli and friends at the 1929 Bal
Bibliothèque Rose, Paris.

Her life changed when she was still in her teens, with a family visit in Rome from the well-known French aristocrat Antoine XI Alfred Agénor de Gramont, Duc de Gramont (1851–1925). It was said that the Duc de Gramont, recently widowed, traveled to Rome to pursue a marriage with Maria's mother, Princess Clelia Ruspoli, a widow. Instead, he decided that he preferred the daughter. The wedding took place in Paris in 1907, making Maria the Duchesse de Gramont. The groom was fifty-six years old; the bride was nineteen.

It was the third marriage for the Duc de Gramont. His first had been to Isabelle de Beauvau-Craon, from one of the oldest aristocratic families of France; his second to Marguerite de Rothschild, from one of the richest families in France. His marriage to the young Italian—almost four decades younger than he—raised eyebrows in elegant Paris society. It was said that the Duc de Gramont married his first wife for the *écu* (coat of arms), his second wife for the *écus* (money), and his third wife for the *cul* (sex).

They were a couple that was certainly noticed. The writer Élisabeth de Gramont, a daughter from the duke's first marriage, loathed Maria, who was thirteen years younger than she. In 1910, the Duc and Duchesse de Gramont attended the coronation of King George in London. In Paris, the young Maria—attractive and vivacious—was said to have taken lovers, including the writer Gabriele D'Annunzio, who, when he left France to return to Italy during World War I, gave Maria one of his prizewinning Italian greyhounds.[64] Maria had two sons, Gabriel de Gramont (who, in 1943, would be killed in action fighting for the RAF) and Gratien de Gramont.[65]

When the duke died, in 1925, the Duchesse de Gramont became a very rich thirty-seven-year-old widow. She was a fixture in the social and artistic circles in Paris and London. Maria sank most of her money into acquiring

ABOVE: The eighteenth-century Château de Kolbsheim owned by Dominique's cousin Antoinette Schlumberger and her husband, Alexis Grunelius.

BELOW: A partial view of Pierre Barbe's 1930 entrance hall at Kolbsheim.

LEFT: The entrance to the nineteenth-century building on rue Las Cases in Paris's Faubourg St.-Germain where Dominique Schlumberger grew up.

BELOW, LEFT: The hall leading from the entrance to the salon of Dominique and John's apartment on the rue Las Cases, renovated in 1931 by Pierre Barbe.

BELOW, RIGHT: A pair of gouaches by Luis Fernández: *Crâne*, 1953, and *La mer grise*, 1960–1963, hang on the wall in the de Menils' Paris salon behind, and to the right of, a sixteenth-century Spanish table and a Louis XIII armchair. An ancient Tang dynasty marble head that was bought in 1949 with Father Couturier is on the bookshelf.

On a visit to Max Ernst's Paris studio, the de Menils commissioned *Portrait of Dominique*, ca. 1932, 25¾" x 21¼".

Maro, nineteenth to twentieth century, bark cloth with pigment, 26½" x 31". This was the first piece of non-western art the de Menils acquired in 1932 from the Paris art dealer Jacques Viot.

Paul Cézanne, *Montagne*, ca. 1895, pencil and watercolor on paper, 10½" x 18⅞".
John de Menil bought this in 1945 from the Valentine Dudensing Gallery in New York.

Henri Matisse,
Brook with Aloes,
1907, oil on canvas,
23¾" x 23⅝". In May
1950 the de Menils
acquired this from
Alexandre Iolas after
encouragement from
Dr. Albert Barnes.

Iolas sold the de Menils their first Picasso in 1950:
Pablo Picasso, *Female Nude,* 1910, oil on canvas, 28¾" x 21¼".

Philip Johnson built the de Menil Houston house between 1948 and 1950, and Charles James did the interior design.

In the entrance hall with a view of the atrium garden, an eighteenth-century Venetian sofa found by James is on the Mexican tile floor, and Yves Klein's monumental painting *People Begin to Fly*, 1961, is to the right; African sculptures are in the background.

Max Ernst, *Capricorn*, 1964, bronze, 94½" x 80⅝" x 51¼"; the massive surrealist sculpture is at the rear of the de Menil garden.

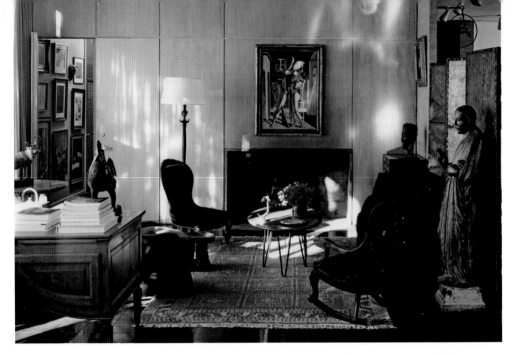

In the Houston living room, on the left, is an eighteenth-century French architect's desk, and Giorgio de Chirico's *Hector and Andromache*, 1918, hangs over the fireplace; a Diego Giacometti standing lamp is behind one of the nineteenth-century Belter chairs to the left of the fireplace; a third- to fourth-century wooden Celtic head and a fifteenth-century Italian *Angel of the Annunciation* are at the far right in front of a seventeenth-century Spanish screen.

Over the piano in the living room is René Magritte's *Glass Key*, 1959; to the right is Charles James's Lips sofa, 1952; the heptagonal ottoman was designed by Dominique.

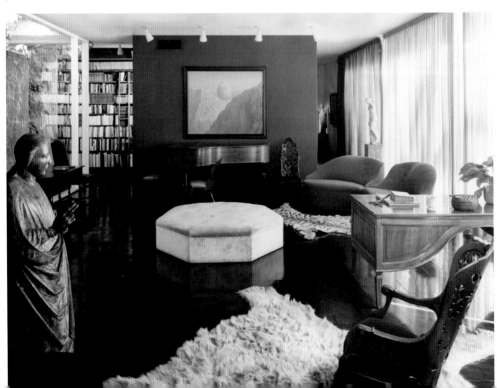

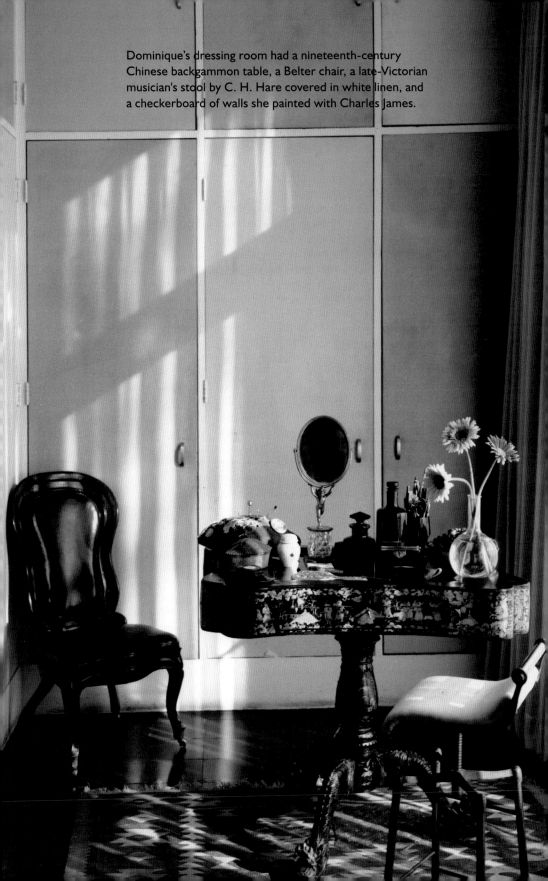

Dominique's dressing room had a nineteenth-century
Chinese backgammon table, a Belter chair, a late-Victorian
musician's stool by C. H. Hare covered in white linen, and
a checkerboard of walls she painted with Charles James.

Joseph Cornell, *A Swan Lake for Tamara Toumanova (Homage to the Romantic Ballet)*, 1946, a glass-paned, painted wood box with photostats on wood, mirrors, feathers, velvet, and rhinestones, 9½" x 13" x 4"; this was the de Menils' first Cornell box, a gift from Alexandre Iolas in 1951.

Georges Braque, *The Bottle of Marc Brandy*, ca. 1912, collage of charcoal and paint on cut-and-pasted lacquered paperboard mounted on wood, 14⅜" x 11½". This collage was bought in 1951 from Galerie Kahnweiler in Paris.

Mask, possibly Duma or Mbédé, Gabon and Republic of the Congo, early twentieth century, wood and pigment, 13" x 7½" x 7/18". This almost cubist African mask was acquired by the de Menils in 1954 from Galerie Carrefour in Paris.

René Magritte, *Le chant des sirènes*, 1952, oil on canvas, 18¼" x 14¼". Iolas sold the de Menils this mysterious Magritte in 1953.

LEFT: René Magritte, *The Invisible World*, 1954, oil on canvas, 77" x 51⅝". Norman Mailer was fascinated by this 1954 painting, bought from Iolas, that he first saw in the Houston house.

BELOW: René Magritte, *Golconde*, 1953, oil on canvas, 31½" x 39½"; an iconic Magritte painting the de Menils acquired in 1954 from Iolas that hung in the salon of Pontpoint, the country house north of Paris.

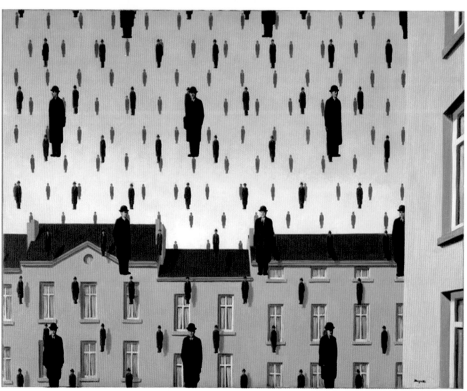

Mark Rothko, *The Green Stripe,* 1955, oil on canvas, 67" x 55⅛".
The de Menils' first Rothko painting was purchased in 1955 from
Sidney Janis in New York.

LEFT: Fernand Léger, *Mother and Child*, 1951, oil on canvas, 36½" x 25¹¹⁄₁₆". This painting, also bought from Iolas in 1954, originally was at Pontpoint.

BELOW: Georges Braque, *Large Interior with Palette*, 1942, oil and sand on canvas, 55⅝" x 77". This 1953 painting, purchased from Iolas, was Dominique's favorite Braque and often hung over the piano in Houston.

Max Ernst, *Untitled,* ca. 1920, collage of cut, printed, and photographic reproductions with pencil mounted on paperboard, 2⅜" x 5¾". Dominique was very fond of this tiny, early Ernst, bought at Berggruen & Cie in Paris.

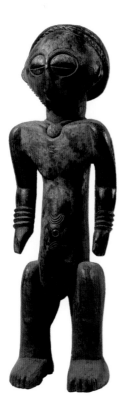

LEFT: *Standing Male Figure,* Boyo, Democratic Republic of the Congo, nineteenth or twentieth century, wood, 38⅜" x 11⅞". Bought in 1961 from J. J. Klejman in New York, this sculpture was usually in the living room in Houston.

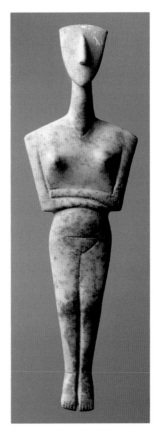

RIGHT: *Reclining Female Figure,* attributed to the Ashmolean Master, Greece, Early Cycladic II, 2700–2300 B.C., white marble, 14½" x 4 7/16" x 1¼". This Cycladic idol representing, as Dominique wrote, "a world dominated by the mystery of women" was purchased in 1963 from Geneva dealer Nicolas Koutoulakis.

Max Ernst, *A l'intérieur de la vue: L'oeuf,* 1929, oil on canvas, 38¾" x 31¼". The de Menils bought this painting from the artist in 1952 for their daughter Christophe.

Yves Klein, *People Begin to Fly,* 1961, oil on paper mounted on canvas, 98½" x 156½". This large, important Klein painting, bought from Iolas in 1968, always hung in the entrance of their Houston house.

and restoring an Italian medieval fortress, the Castello di Vigoleno, south of Milan in the province of Piacenza, and turning it into a cultural destination. Guests included Jean Cocteau, Arthur Rubinstein, and Max Ernst (while staying at Vigoleno, Ernst painted *The Embalmed Forest,* 1933, a magnificent oil on canvas that was purchased by Adelaide de Menil and, according to Dominique, destined for the Menil Collection).[66]

In 1934, Maria married François-Victor Hugo, a great-grandson of the French writer Victor Hugo, making her Maria Hugo. Through his older half brother, the painter Jean Hugo, François became acquainted with such artists as Cocteau, Duchamp, Picabia, and Picasso. A noted silversmith, he translated their works into jewelry.[67] Maria and François had one son, Georges Hugo.[68]

When France fell to Germany, Maria Hugo, having run through her fortune, managed to immigrate to New York. She had separated from her husband but brought their son with her to the United States. "I will always be grateful to François for how he helped me grow in life," she wrote to a mutual friend during the war. "As for Vigoleno, it is already part of another world—the one in which I was born."[69] Maria Hugo was said to have been an incredibly elegant woman, charming, captivating.[70] In New York, she was well acquainted with Father Couturier, Baron de Cuevas, and Robert de Rothschild, whom Dominique knew because he had been a classmate of Conrad Schlumberger's at École Polytechnique.[71] And it was through this expatriate circle that Dominique and Jean became good friends with Maria Hugo. In fact, they chose their first New York apartment, on Sixty-Eighth Street, because she lived in the same building.

"She hated to be called by an American *Maria,*" Dominique recalled. "She cringed; she was in her fifties, and you don't call somebody from a very good aristocratic family *Maria.* That sounded so vulgar to her, so we always called her Donna Maria."[72] During the war, Donna Maria, along with an American friend, Gerry Winter, were hired by Elizabeth Arden. The Italian worked primarily as an ambassadress as Arden launched a fashion salon, on the second floor of her elegant building at the corner of Fifth Avenue and Fifty-Fourth Street.[73]

One night, Dominique and Maria had dinner while their mutual friend stayed late at Arden, putting the final touches on a collection that would be presented the following day (by Antonio Castillo, who had replaced Charles James as the designer at the salon). "Gerry works very hard and seems to be pleased," Dominique wrote to Jean. "She receives $75 per week, with no commission on sales, which is what Maria receives for doing nothing."[74] The Elizabeth Arden employee was really the de Menils' first American

friend. Jean admired her sense of fun, her authenticity, her Americanness.[75] Because Dominique worried that Gerry's salary did not allow her to dress the way she would like, she gave her a check for $250 to help buy clothes.[76]

The de Menils developed a diverse group of friends and associates, those whom they brought along for the ride and those who brought them along. "There are all kinds of people who are fulfilling in some way," Dominique explained to Jean. "Donna Maria is one example. Gerry is another. They can be found in high society, as you know, which is why I try not to cut myself off from anything."[77]

•

Their friendship with Donna Maria turned out to be more than just a social encounter. In October 1945, backed by Elizabeth Arden and Robert de Rothschild, Maria opened an art gallery in New York.[78] Capitalizing on the renown of her married name, she called it the Hugo Gallery.[79] It was located at 26 East Fifty-Fifth Street.[80]

One Saturday afternoon in February 1946, Dominique made her first trip to the Hugo Gallery. She was delighted and wrote to Jean,

> I loved this gallery and the boldness with which Maria launched herself in the adventure. With only about $200 in her pocket, Maria rented a little gallery on the sixth floor of a building on Fifty-Fifth Street. The decor is not meant to be sensational, which surprised me. It has three small rooms, perfectly arranged from a technical standpoint to enhance the paintings, with a very sophisticated lighting system that uses small spotlights in the ceiling, pointing in all directions.
>
> Every painting, every engraving, is lit individually. The picture is bathed in light, and yet the source of the illumination is not immediately clear. The colors of the walls, like the lighting, are very well studied. The effect is like being bathed in a warm dusk. Each part of the wall is in a different gray, but all of the tones are harmonious, complementing one another: there is a dark gray with a hint of mauve, a lighter gray, and one that has some blue in it.
>
> There were some beautiful drawings by an Italian, Corrado Cagli, of the war and the camps in Germany. There are so many possible traps in this kind of subject, and it is quite an achievement to be able to avoid that, to remain a work of art without falling into over-sentimentality or illustration. Next Tuesday, she will have the

first New York exhibition of a Spanish painter, Óscar Domínguez. I don't yet know what to think; it seems to be a mix of Picasso and Max Ernst without being either one. It is certainly full of personality. And the next exhibition will be of drawings and watercolors of Wallace Berman; Maria said some things to him that made me excited to see his work."[81]

Dominique felt strongly enough about the new gallery that by the following week she gave Maria $1,000. The considerable sum, five times the initial investment used to launch the venture, was to purchase shares in the Hugo Gallery. "Maria had not asked, but I felt that it was the right thing to do," she told Jean, "and that it was something you would have done."[82]

When Dominique returned for the opening of the Domínguez exhibition, she was enthusiastic about the artist, but, more important, Maria Hugo introduced her to someone who would be essential in building the de Menils' collection: Alexandre Iolas. As Dominique wrote to Jean of that first encounter, "Maria has associated herself with a Greek, a certain Iolas. I think he's very much on the same team."[83]

•

Alexandre Iolas (1907–1987) was born Constantine Koutsoudis to Greek parents in Alexandria, Egypt. "Everyone called him 'Iolas,' and he had an exceptional flair for art and a talent for selling," Dominique later explained.[84] "He came from the ballet and did not have an art education, which, in a way, is better; it was purely his eye."[85]

Iolas would go on to establish galleries in New York, Paris, Geneva, and Milan. He built long-lasting relationships with leading European surrealists Ernst, Magritte, Victor Brauner, and de Chirico; with new American artists Warhol, Ed Ruscha, William Copley, and Joseph Cornell; and with the subsequent generation of French talent, including Yves Klein, Martial Raysse, Les Lalanne, Takis, Jean Tinguely, and Niki de Saint Phalle. Iolas gave Warhol his first solo exhibition, in New York in 1953, and commissioned his final one, *The Last Supper,* held in 1986 in Milan (both would die within months of the exhibition, Warhol in February 1987, Iolas, of AIDS, in June 1987).[86]

Iolas was much more closely involved with many of his artists than most dealers. His impressive correspondence with Magritte, lasting two decades and comprising more than three hundred letters, showed that he did not hesitate to involve himself in artistic decisions.[87] After the Hugo

Gallery had its first Magritte show in 1947, Iolas wrote to the artist, "I cannot tell you how thrilled I am to hear that your painting is going back to your former pictorial concepts with a new evolution—that makes me very happy."[88]

By January 1950, as they worked toward another New York exhibition, the dealer was very direct about what he expected from the artist. "Please send me preparatory drawings of the new paintings because we can no longer allow ourselves the luxury of presenting to the American public paintings that do not well represent you and are not masterpieces," Iolas warned Magritte. "Do not judge me harshly if I try to enlighten you about the American public. You must really impose yourself with the next exhibition—it has to be sublime and startling."[89] In response, the artist sought to reassure his dealer about his recent work. "I have made great progress," Magritte wrote to Iolas. "The paintings, the bottles, and the gouaches are becoming more and more sublime."[90] Until the artist's death in 1967, he and his dealer had a remarkably close relationship, more like a creative collaboration.

Throughout his long life, Alexandre Iolas—he might have been born a decade or more earlier than he ever admitted—was a fascinating, flamboyant figure. As John Russell wrote of the dealer in his obituary for *The New York Times,* "In promoting work that initially found few to favor it, he was able to reassure the potential client by his hierophantic manner, his often sensational mode of dress and his mischievous and sometimes irresistible charm."[91]

Iolas grew up in Alexandria, a classically beautiful boy who became friends with such inspiring local figures as the poet Constantine Cavafy. There never seemed to be a question about the young man's homosexuality. Just a taste of his early life can be gleaned from a remarkable conversation he had in 1965 with French art expert Maurice Rheims:

> IOLAS: I loved my mother too much to be contemptuous of women. She was too blond to be disliked. First of all, she had a marvelous name, Persephone. She was very tactful. She was a dancing liar of a lady and highly erratic. I learnt many things.
> RHEIMS: What impression of love did she give you?
> IOLAS: She aroused every man.
> RHEIMS: Were you jealous?
> IOLAS: But, not at all: I was taking notes![92]

A natural show-off, he was always driven to perform.[93] In 1924, still in his teens, he moved to Berlin to study dance. As Hitler came to power, he fled to Paris, and he continued to perform in France and across Europe.

Alexandre Iolas dancing with Teddy Roosevelt's goddaughter Theodora at Copacabana Casino in Rio, 1942.

In the mid-1930s, after leaving a dance class at the Place de Clichy, Iolas walked by an art gallery, Raul Levin on the avenue Matignon, that was exhibiting the mysterious mannequin paintings of Giorgio de Chirico. He was fascinated by the pictures. Iolas claimed that he walked up and down in front of the gallery, about an hour each day, for the next month.[94] When he finally found the courage to inquire about the price, either 6,000 francs or 20,000 francs, depending on when Iolas told the story, he asked if he could pay in installments of 100 francs.[95]

By the time he wrote his final check, three years later, he was friendly with the artist. "How to get more paintings, I asked myself, and later asked de Chirico, one of the men who most influenced my life," Iolas later explained. "We both agreed that I was a good looking young fellow and could pose in exchange for a drawing or small painting instead of a monetary fee"[96] (Iolas suggested that the painting he posed for, probably *Palafreniere con due cavalli*, 1937,[97] had been commissioned by Helena Rubinstein).[98] During his years in Paris, Iolas became acquainted with other artists, many of whom created theatrical sets, including Cocteau, Man Ray, and Max Ernst. He began to develop an eye for painting and was increasingly fascinated by what was new and modern.

By 1940, Iolas had become the principal dancer for the Ballet Russe de Monte Carlo.[99] He toured the United States and Latin America. In

New York during the war, he joined the Ballet de Cuevas.[100] Iolas was also involved in the creative direction of the company; he might have been considered the artistic adviser. Though, as he later said of the more conventional tastes of the Marquis de Cuevas, "I introduced him to Balanchine, but he wanted to keep doing *Scheherazade*."[101]

Bénédicte Pesle, Jean de Menil's niece, met Iolas at the Hugo Gallery in 1950. "There was some kind of fight, a misunderstanding, and from one day to the next the Marquis de Cuevas said, 'You no longer work for me,'" she recalled of the dealer's start. "So Iolas left during the night, calling the artists he knew, saying, 'Lend me one or two works so that you'll have a gallery and I'll be able to live.'"[102]

Bénédicte would go on to work with Iolas in the 1960s and 1970s at his Paris gallery at 196, boulevard St.-Germain. As a close collaborator, she was very clear about his unconventional nature. "He certainly was not your average art dealer," she suggested. "That is why he attracted certain artists and not others. He was not someone who was methodical and classic. He was not a businessman; more than anything, he was just someone who was passionate about art."[103]

Iolas was extravagant in appearance, ornately bejeweled, with made-to-measure suits and often dramatic furs. Sensitive about his height, he had elevator shoes custom made in London.[104] A 1968 profile in *Women's Wear Daily* described his mustard-colored Mao suit, turtleneck in sheer navy chiffon, and long red fox coat. Iolas also mentioned having a pink Mao suit that he paired with a black turtleneck and a large gold pin. For the interview, he sported a diamond pinkie ring that flashed as he spoke, as well as serpent bracelets on each wrist, one in white diamonds, the other in pink diamonds.[105]

The curator Jean-Yves Mock, when he was working for the Hanover Gallery in London, saw Iolas's exhibitions at the Hugo Gallery in the early 1950s. He closely followed his work throughout his life. "He was an exceptional man," Mock explained. "Twisted people may have stupid things to say about him, but Iolas was the first to do an exhibit of Yves Klein. At the Hugo Gallery in 1952, he did the most beautiful exhibit you can imagine of Braque in the 1930s and 1940s."[106]

Picasso's biographer John Richardson knew Iolas from the 1960s and his Paris gallery. "He didn't leave you of two minds whether he was gay or not but this grotesque little queen horrified others in those days, over made-up, carrying on and shrieking," Richardson recalled. "But his humor and wit would always disarm people, along with his magnificent eye, above all, for Surrealism. I suppose in a way one could see Iolas himself as a Surrealist item, a sort of living Surrealist *objet*." Richardson admired Iolas as

a dealer and understood his significance for the de Menils. "Despite the frivolity, despite the chaos of his private life and his taste for louche life, Iolas was one of the most brilliant modernist dealers of his time," Richardson said. "No wonder Dominique de Menil—most serious of avant-garde collectors—trusted his exceedingly perceptive eye. They constituted a great modernist team."[107]

Both Dominique and Jean developed a great admiration for Iolas. The first time they went to the gallery together, as Iolas recalled, they huddled in a corner, deciding whether to buy a small landscape by Jean Hugo (in short order, they acquired that gouache, *Paysage provençale,* and three others by the artist).

Iolas told the de Menils something of his background: "I used to be a dancer before, but I started to be too old, and now the only thing that interests me is art."

Iolas asked Jean what he did for a living. "Me? I find oil," Jean said with a laugh.

Iolas responded, "Oil? What do you do with oil?"

Jean replied, "We do something with oil that is fundamental, indispensable."

"More indispensable than art?" asked Iolas.

The response from Dominique: "I don't think so—not more indispensable than art."

Jean said with a smile, "So there's the answer: you're more indispensable!"[108]

•

During the de Menils' long relationship with Alexandre Iolas, both parties, in fact, were mutually indispensable. Over the forty years of their friendship, Dominique and Jean would acquire more than 450 important works of art from Iolas, including the core of their great surrealist collection.

The de Menils purchased from Iolas more than forty-two paintings and sculptures by Max Ernst, spanning the length and breadth of his career, including *The Forest* (1927), a painting from his mysterious *Histoire naturelle* series; *Loplop Presents Loplop* (1930), his avian alter ego in a surreal, double self-portrait; and *Marlene* (1940–1941), a striking mythological female figure with child. The artist brought *Marlene* with him to the United States, displaying it to customs agents as he crossed the Spanish border who, struck by its beauty, cried out, "¡Bonito! ¡Bonito!"[109]

Ernst sculptures ranged from *Young Man with a Fluttering Heart*

(1944), a small bronze male form with an abstracted visage, to *Capricorn* (1964), a massive bronze grouping of many of his iconic animalistic forms that was eight feet tall, six feet wide, and four feet deep and weighed just over one ton.[110]

The de Menils also acquired from Iolas twenty-two paintings, drawings, and objects by Magritte. Among their first purchases was *Golconde* (1953), which would become one of the artist's most famous paintings, depicting a swarm of bowler-hatted men descending from the sky. Other key paintings included *The Invisible World* (1954), with a large boulder positioned inside a room blocking the view of a seascape, and *The Glass Key* (1959), featuring a massive rock hovering on top of a mountain range. There were also six Magritte sculptures, outstanding works such as *David's Madame Récamier* (1967), a funerary bronze inspired by David's famous painting, except the nineteenth-century French socialite, reclining on her famous chaise longue, was replaced by a coffin.

"Iolas was everywhere and nowhere," Dominique said of their relationship. "But he was very interested to build our collection. It was a point of pride that ours would be a great one, so he always kept paintings for us, and since he had a very good eye, they were the best. For instance, we bought one Magritte every year from him, the one Iolas considered the most outstanding."[111]

Other important surrealist works acquired by the de Menils from Iolas included six paintings and drawings by de Chirico, fourteen by Matta, fourteen paintings and one sculpture by Victor Brauner, and four photographs by Man Ray. But Iolas's influence was not limited to only one school. He was able to acquire for the de Menils an impeccable canvas by Mondrian, *Composition with Yellow, Blue, and Blue-White* (1922), their first painting by the artist.

Iolas, right, with surrealist René Magritte in Iolas's Paris gallery, 1965.

Among the eleven paintings, drawings, and collages by Picasso were *Female Nude* (1910), a golden cubist figure in descent; *Violin on a Table* (1912), a cubist collage in ivory, brown, blue, and gray; and *Woman in a Red Armchair* (1929), a menacing abstract

portrait in vivid red. Iolas also provided the de Menils with six works by Braque, including *The Bottle of Marc Brandy* (1912), an important cubist charcoal collage, and *Large Interior with Palette* (1942), a monumental, bold, abstracted interior in beige, green, and black.

Iolas sold the de Menils fourteen drawings and paintings by Léger, including *Mother and Child* (1951), an idealized maternal image that became an essential piece in the collection. He was the source of seventeen paintings and drawings by Wols, the underappreciated Paris-based abstract artist associated with the existentialists; thirteen paintings and drawings by Luis Fernández including a pair of paintings, *Two Pigeons V* (1963–1964) and *Two Pigeons VIII* (1965), mirror images of each other that Dominique adored; and four key pieces by Yves Klein including one massive canvas, *People Begin to Fly* (1961), that would be given pride of place on the main wall of the entrance of their house in Houston.

As important as the dealer was for the de Menils, they were also crucial for him. Immediately after the war, Dominique and Jean were with Iolas in Maria Hugo's small apartment, enjoying a dinner of her delicious, homemade pasta. Because many of the expatriate artists were returning to Europe, it did not seem that there was a lot of new work available in New York. So the de Menils said to Iolas, "Shouldn't you go back to go find new paintings?"[112]

Robert de Rothschild arranged for Iolas to stay at his family's famous *hôtel particulier* at 23, avenue de Marigny, while the de Menils provided the funds for the dealer's first return trip to Paris.[113] As Dominique recalled, "We advanced some money to Iolas so he could buy things, and then when he came back, we reimbursed ourselves by keeping this and that, and his profit was for the gallery."[114]

The de Menils also worked closely with Iolas to help strengthen the reputations of his artists. In 1949, the dealer approached James Thrall Soby, Alfred Barr, and Dorothy Miller of the Museum of Modern Art about the possibility of having one of Magritte's recent works enter the permanent collection. All three came by the Hugo Gallery to see the latest work. The Magritte painting that was chosen, *The Empire of Light, II* (1950), was a landscape of a city at dusk below bright, puffy clouds in a daytime sky. It was purchased by the de Menils and given to the museum (six years later, they would buy from Iolas their own version from Magritte's small series, *The Dominion of Light,* 1954).[115]

Not everyone in the de Menils' world, however, was enthusiastic about the dealer. "I was amazed, one day, at the arrival of Iolas and all of his treasures," Father Couturier wrote to Dominique from Paris, in an ironic tone. "Then he was gone. His perceptions on painting strike me as pretty

simplistic."[116] Iolas was equally unconvinced about Couturier. His characterization of the priest: he was unattractive, his hair was too short, and his English was atrocious.[117]

Shortly after the war, the de Menils, due to Couturier's urging, bought an expressionist painting by Chaim Soutine. Though he did not initially know of the priest's counsel, Iolas was unconvinced by the picture. He insisted the de Menils needed a Braque. So Iolas exchanged the Soutine for an important painting by Braque, *Pitcher, Candlestick, and Black Fish* (1943), a handsome, warm-hued still life.[118] Although both Couturier and Iolas were absolutely committed to art, there was, perhaps, too great a gulf between the two. One of Couturier's preferred artists was the often spiritual Rouault, while one of Iolas's early favorites was the sensualist Bérard. The de Menils did not feel the need to choose between the views of two important advisers; they simply incorporated both.

Dominique always gave Couturier great credit for their development, though she paid Iolas the supreme compliment. She insisted that she was able to buy a work of art only when she fell in love, but Iolas had helped her to rise above that requirement. "Sometimes, Iolas insisted that I buy a painting that I really did not like," Dominique explained. "But because he insisted, I did. I would realize later that it was not only a beautiful painting but that it was one that was essential for me."[119] That happened with *Hector and Andromache* (1918), by de Chirico, one of the artist's mysterious mannequin canvases. "It's a very big painting, and my first reaction was, 'That is really odd,'" Dominique remembered. "But Iolas insisted that it was interesting, and so I trusted him. It took several years, little by little, for it to speak to me. Now it is a painting that just blows me away."[120]

The de Menils did not always follow Iolas's advice. There was one massive painting by Max Ernst, *Surrealism and Painting* (1942), that they refused to buy. It depicted an oversize bird dabbing its brush on a canvas, its avian forms strangely sexualized. Dominique found the painting too overwhelming, too difficult. Iolas insisted it was a masterpiece. The de Menils demurred. So he sold it instead to William Copley.[121]

Three decades later, in 1979, after her daughter Christophe insisted on the importance of the painting, Dominique bought *Surrealism and Painting* in the Copley sale at Sotheby Parke Bernet. It immediately became an essential component of their Ernst assemblage and a centerpiece of the entire surrealist collection. According to Iolas, in the late 1940s, he had offered Ernst's *Surrealism and Painting* to the de Menils for $6,000. He ended up selling it to Copley for $10,000. "So she finally bought it," Iolas said with glee. "But instead of paying $6,000 she paid $775,000!"[122]

A similar lapse nearly happened with a painting that Iolas brought back from Paris on his first trip over after the war: *Brook with Aloes* (1907) by Matisse, a pastoral landscape in greens and blues. The painting was exhibited at the Hugo Gallery in the fall of 1947, when it was passed over for purchase by MoMA's Alfred Barr.[123] The de Menils began looking at it in 1949.[124] They took it back to their apartment for consideration but hesitated to make the purchase. So they returned the painting to Iolas's gallery.[125]

One day, Albert Barnes stopped by and spotted *Brook with Aloes*. He was rapturous. "He bought a lot of paintings, and when he saw this picture, he said, 'I will exchange this against an *Odalisque*,'" Iolas recalled. "*Odalisque*s were the most important, the most successful paintings of Matisse from 1926."

Iolas told him, untruthfully, that the painting was promised to the de Menils. Dr. Barnes returned to the gallery, insisting that he really wanted to trade one of Matisse's great orientalist canvases. Cleverly, Iolas suggested that Barnes write in the guest book how he felt about the painting. According to the dealer, the entry read, "This is one of the greatest Matisse ever painted. Signed, Albert Barnes."[126]

Iolas showed the Barnes note to the de Menils, who immediately purchased *Brook with Aloes*.

•

If the only important contact the de Menils made through Maria Ruspoli had been Iolas, that would have already been quite an achievement. But their new Italian friend also brought another singular figure into their lives: Charles James (1906–1978), the Anglo-American fashion designer. Known for his sumptuous evening gowns in icy-colored silks and satins sculpted into bold, sensual shapes, Charles James was one of the most original designers America had ever produced. In a career that began in his mother's hometown of Chicago, included important stints in London and Paris, and ended in New York, his clients included Standard Oil heiress Millicent Rogers, Marlene Dietrich, and such social leaders as Mrs. William Randolph Hearst, Mrs. Cornelius Vanderbilt Whitney, and Babe Paley.

Salvador Dalí said that James's white satin, down-filled evening jacket of 1937 was the first piece of soft sculpture. In the spring of 1947, when Christian Dior launched his famous New Look, he credited James as the inspiration. Balenciaga said that James had raised fashion "from an applied art form to a pure art form."[127]

In 1943, Elizabeth Arden hired James to create a fashion salon on the

second floor of her beauty empire, at 689 Fifth Avenue. The designer went to great personal expense to build a spacious showroom, atelier, and fitting room at Arden. The walls were pale pink, and the windows were covered with sweeping curtains in thick green satin. High ceilings held dramatic crystal chandeliers. Eighteenth-century French furniture was paired with contemporary upholstered pieces in elegant fabrics and towering crystal lamps with oversize shades.[128] James's relationship with Arden, as tumultuous as most of his collaborations would be, lasted only two years. But in 1945, toward the end of his time there, Maria Hugo took Dominique de Menil to the second floor of Elizabeth Arden. There, she met Charles James and began to buy from him.[129]

By the end of that year, James had used a small inheritance from his mother to create his own couture house at 699 Madison Avenue, at Sixty-Second Street. The new space had large crystal chandeliers, walls in mysterious shades such as dark red and indigo, sofas and chairs in beige satin,

Cecil Beaton's portrait of Charles James inscribed to the de Menils.

Dominique wearing a Charles James evening gown in their first house in Houston.

and such startling antique objects as an alabaster urn that must have been over six feet tall. A window between the showroom and the workrooms was covered with a sheer, pale curtain so that clients would be able to perceive the delicate craft of the *petites-mains*.[130]

Dominique began wearing signature evening clothes by James. She had a sleeveless concert gown that consisted of a fitted bodice of ruby-red velvet, a long overskirt of garnet satin—asymmetrical and draped—and at the base an irregular flash of underskirt in pleated ivory organza.[131] She bought many of the designer's formal looks, from a long-sleeved evening coat dress in black satin, with a dramatic red lining,[132] to an opera coat in an antique saffron brocade, lined with ice-blue satin.[133] She also purchased more practical items—a tailored coat dress in camel-colored wool[134]—and accessories, including a fitted matador hat in black velvet and satin.[135]

Dominique was friendly enough with James to invite him to their first New York apartment. On one occasion, in the fall of 1947, she had the designer over for lunch, bringing a large crimson comforter and violet pillows into the living room to set the scene. She served oysters, herb omelets, strawberries, and imported Neuchâtel cheese. Maria Hugo stopped by for coffee and pronounced it "a real lovers' lunch!"[136]

Dominique wrote to Jean about her afternoon with Charles James,

He was delighted by the apartment, feeling that it had aged well. He really admired the love seat and the organization of the room. He would not stop raving about the colors—the browns, the greens, the mauve in the pillows, against the yellow of the bedroom, adjacent to the white organdy. It was perfect. He also loved the Braque,

particularly with the gold frame, in which the painting looked pretty good.

It's going to be an expensive lunch, though. It will cost me a star-tling ensemble (almost an evening gown) in a beautiful ink-colored satin. But can you believe that I do not even consider it an extrava-gance? I am unsure why or how, but I feel like I now have the wind in my sails and thanks to this incredible ensemble I will capture the breeze in Houston, New York, and Caracas.[137]

•

There is no doubt that the impetus for such dramatic fashion statements came from her husband and Dominique's desire to please him. "If I remem-ber correctly, tonight is the opening of Berman at Maria Hugo's gallery," Jean wrote to her. "You are in your black dress, refined, elegant, animated; it is an image in my mind that I relish."[138] One of the earliest memories of their youngest child, Philippa, was being in her crib, seeing her parents dressed to go out in Houston, Dominique in a Charles James ensemble. "I can just see the flair of it," she recalled of her mother. "I thought she was the most beautiful thing I had ever seen."[139]

From the beginning, the de Menils appreciated James's insistence on perfection. "He would have redone a dress ten times in a row rather than permit the slightest flaw," Dominique explained. "He started making a few dresses for me, and I ended up with many of his dresses, coats, and suits. And, I swear that it was not any more expensive than if they had been from Chanel in Paris."[140] Dominique and Jean viewed James as more than just a fashion designer. Over the thirty years of their friendship, they would gather a very significant collection of his works, including fifty garments, ten accessories, five pieces of furniture, seven prints and photographs, and one small sculpture. They also acquired fifty-five James drawings, includ-ing his designs for jewelry and flexible sculpture.

The year before Dominique met James, he had arranged to have three of his designs enter the Brooklyn Museum, making him one of the first liv-ing fashion designers with work considered significant enough to be in a museum collection.[141] James envisioned an entire record of his work that would be documented by the institution, and the de Menils actively assisted him.

The de Menils would give a total of sixty-nine works by Charles James to the Brooklyn Museum, including some of James's most legend-ary designs: the Butterfly dress, a tightly fitted bustle dress in chocolate and champagne silk, with a dramatic train; his Diamond dress, a geometric

evening gown in taupe, ivory, and black silk; and a Pouf dress in black silk (the entire James collection is now part of the Costume Institute at the Metropolitan Museum of Art).

Dominique would be one of the few to maintain a relationship with the designer throughout his life. Faced with the sheer volume of hectoring correspondence sent by James, Jean advised Dominique to stop opening his letters. She took a larger view of his harsh personality. "He was so combative, very neurotic, but it was a neuroticism that he tapped into, that drove his design," Dominique remembered. "Everyone said, 'Oh, he's his own worst enemy.' But it's not that simple; he needed confrontation, opposition, in order to give the best of himself."[142]

James had long been overlooked by anyone other than fashion aficionados, but Dominique was always convinced of his importance. At eighty-nine, in the last year of her life, she was planning an exhibition on Charles James, making notes on his life, his personality, and his work. As she wrote, "Among all the people who have a name in the art world—the movers, the doers, the poets, famous couturiers, culinary chefs; anyone, finally, who has a right to a signature—let us place a forgotten name: Charles James."[143]

•

The de Menils began to carve out a life for themselves in the United States. In New York, their apartment on Sixty-Eighth Street was small, but they were at ease in the city and, regardless of where they happened to be, were always in contact with each other. "The apartment is charming," Dominique wrote to Jean during a 1947 stay. "But without you, it is devoid of real substance. Take care of yourself. I couldn't live without you."[144]

In Houston, the de Menils continued to bring new art and interesting friends into their world. In May 1947, Father Couturier returned from Paris to the United States and made the long trip down to Texas to stay with Dominique and Jean. While he was there, a large Mexican cross arrived, plus a Rouault painting, *Le juge* (1937), a somber figurative canvas of a bearded, berobed judge. The Dominican priest had encouraged Dominique and Jean to buy it (although it was actually purchased through Iolas). They were having lunch when the work was delivered. Dominique was ready to scale the table to hang the painting, but Father Couturier insisted on doing the honors. Then they all sat down and admired the new piece.[145]

One of the most striking pictures they bought in their first years as collectors, while still living in the house on Chevy Chase, was Joan Miró's *Painting (The Magic of Color)* (1930). It was a big, rectangular canvas, five feet by seven feet, with a background of textured beige, two large round

forms floating near each other—one a reddish orange, the other in yellow—and, in the center of the frame, floating near the colors, a very small dot in black. It was a spare, beautiful painting with a surprising sense of force.

The Miró was hung upstairs, at the foot of the de Menils' bed. One afternoon, Miss Best, the English nanny, came back early from an appointment at the British consul. As she went to her room, she was surprised to see Theodore, the African American gardener, who would normally not be inside the house. He was standing in the de Menils' bedroom.

Miss Best said, "Theodore, what are you doing there?"

He replied, "You surprised me, ma'am. But I just *has* to come and look at this picture every day."[146]

•

It was while living in that first house in Houston that the de Menils made another discovery that would have long-lasting consequences for their family. After Miss Best returned to England, Dominique hired a woman named Essie Barnes to look after the children. A widow whose husband had been a Methodist minister, Essie took everyone back to Europe for the summer, crossing on the *Queen Elizabeth*. She even wrote a memoir of their travels, *I Went with the Children*, a touching tale of shepherding the five youngsters, a travelogue, and a rather treacly meditation on her Christian beliefs.

In order to find a longer-term solution, Dominique had an inspired idea. In Houston's Fifth Ward, a neighborhood of primarily black and Latino residents, was a Catholic church called Our Mother of Mercy. Twenty years before, the Great Mississippi Flood of 1927, considered the most destructive river flood in American history, had displaced 700,000 people along the Mississippi River, including 330,000 African Americans. Many Louisiana Creoles—of French, Spanish, and African descent—had relocated to Houston and a part of the historic Fifth Ward that became known as French Town. Our Mother of Mercy, built for, and by, the Creole community, celebrated its first Mass in June 1929.[147]

Dominique went to Our Mother of Mercy, advising the parish priest that she was looking for someone who spoke French who would be able to take her children to France for the summer. She specified that she hoped for someone they could really depend on, someone who would be able to go every year for as long as possible. The priest found a member with a young niece who seemed to be a good candidate.

Gladys Mouton Simmons (1921–2012) was beautiful, charming, and wise beyond her years, though she, too, might have shaved a decade off her true age. Thanks to her Creole origins, Gladys spoke French. So she went to

River Oaks for an interview with Dominique and Jean. Gladys remembered that first meeting as being effortless. As she recalled, "They said, 'Okay, you're just the type of person we were looking for.'"[148]

Gladys became a true member of the de Menil family, and she remained so for six decades. Because the youngest child, Philippa de Menil, could not pronounce "Gladys," she became known, to friends and family, as Gaga. "The whole world called me Gaga," she remembered with a laugh. "Even some of Mr. de Menil's business friends would call me Gaga."[149]

She would provide a crucial sense of balance to the family, particularly for the two youngest children. "In truth, Gladys was my mother because she was really in charge of us, Phip and I, for extended periods," explained François de Menil. "I don't know where my parents were necessarily—they could have been in Paris or New York or wherever—so Gladys became, in a practical sense, our mother."[150] His younger sister said that Gladys was definitely a second mother for her. "She adored us and protected us and did the best for us," remembered Fariha. "My brother and I did not grow up with that feeling of lack, from our parents traveling all over the world. We had an emotional stability that our other siblings may not have always had because of the war displacement and a lot of things."[151]

Gladys Simmons, who took care of all the children, particularly the two youngest, here with François, was part of the family for over fifty years.

By the time they had five children, the de Menils' lives were very busy, so finding someone who could be there for the two youngest children was essential. That they were able to find someone so capable was fortunate. Gaga was compassionate and loving but firm with her charges. "Gladys and my father had a very close relationship," François recalled. "I don't remember anything specific that was said, but I remember feeling that authority had been transferred directly from my father to Gladys."[152] As Gladys remembered it, there was an easy understanding with Dominique and Jean. "If I said no to the

kids about something they wanted to do and they went to their father, he would say, 'Did you ask Gladys? Did she say no?' If they went to their father first and then came to me, I would say, 'What did your father say?' 'No?' Then it's no!"[153]

After picking up the children from school, Gladys would give them French lessons, run errands with them, take them to visit friends. "I was always busy with them," she recalled, "we were always on the go."[154] Particularly in the South, there were racial issues that needed to be navigated. Gladys drove the children around Houston, and yet some outings could become complicated. "I would be sent into the drugstore to buy something," François remembered. "It wasn't good for Gladys to go in because she was black."[155]

François felt that the relationship with Gladys connected with his parents' sense of humanism, their sensitivity to racial issues, their openness to others. One of Gladys's responsibilities was to bathe the children. Once, as François was being washed, they looked closely at each other's hands. They studied the differences in color, also noting how similar the shades were in their palms. "She said to me that we were all the same. That you could see there on the palm of the hand that we were the same—that always stuck with me."[156]

Gladys became a true confidante of Dominique's and of Jean's. She traveled with the de Menil children, took them to school, had meals with them. When François and Philippa moved to New York to finish school, Gladys moved with them. All of their friends knew Gladys; she was with the children in every major moment throughout their lives.

"It was not like this woman was the help," François explained. "She was part of our life sphere. It was this was our world and this is my family."[157]

•

A few years into the de Menils' time in Texas, Jean wrote an essay for a book that was published locally, *Houston*. He titled his contribution "A Provincial Town."

It began,

I was born in Paris: Paris, France. So, after a few drinks, my friends talk about Paris and how wonderful it is and, since I have also had a few, and since Paris is not such a bad place after all, I sort of like what they say. But the next morning they go off on a hunting trip to their ranch or on a trout fishing vacation in Canada or a supernatu-

ral loafing in Chichicastenango. And they are right because it is wonderful to shoot a quail—if you are a good enough shot—or to catch a trout—if you have enough wits pretending you are a fly—or to go to Guatemala—if you know how to relax. Some also go to Paris, and this is fine too, but let us come to the point: you must not go to London, Paris, or New York to be cosmopolitan. Just open your ears and your eyes and here you have it, right in Houston.[158]

Jean went on to offer a lighthearted city history, beginning with pirates anchored at the mouth of the Buffalo Bayou and Houston becoming, through the dredging of the Ship Channel, the third most important port in the United States. "I had heard of Houston long before I made it my home," he wrote. "I was in the banking business at the time and we had a branch at Le Havre which was actively engaged in financing the cotton import trade."[159] When studying all of the bales being unloaded from the ships, he noticed how many were stamped "Houston" for their port of origin.

After settling in the United States, Jean had long since stopped using the title of baron (even though Father Couturier still addressed many of his envelopes "Baron et Baronne de Ménil"). But at the end of his essay, for the first time, he made the official decision to Americanize his name.

November 1949, then, was the precise moment when Monsieur le Baron Jean Menu de Ménil became, simply, John de Menil.

Barnett Newman's *Broken Obelisk* being installed in front of the Rothko Chapel, 1970.

PART FOUR

NEW FRONTIERS

HOME

*I believe in stubbornly following certain paths but also in
changing and experimenting. One should not be too specific
in advance. One should remain open and sensitive to anything
worthwhile.*
—DOMINIQUE DE MENIL[1]

Not everyone in the de Menils' circle was enthusiastic about
their new lives in the United States. Some, particularly
their European friends, were mystified. "Of course, when I was in Houston,
I admitted that you were right to be there," wrote Father Couturier, once he
had safely sailed back to Paris in the fall of 1947. "Seen from here, however,
I think of your little patch of green grass and the impossibly proportioned
rooms that have the privilege of sheltering you. And I ask myself to what
degree of absurdity has this world come that people like you are reduced to
living in such a place, so far from all civilization."[2]

From their first years in Texas, the de Menils had already started
importing their own sense of civilization. It came in the form of paintings,
watercolors, and a certain *art de vivre*. But they had become a family with
five children, and they were beginning to acquire more and more works of
art, so they needed more space.

Both had always been sensitive to their environment. "I had a friend who
used to avoid certain streets in Paris," Dominique noted. "He found them
too depressing." And both were convinced of the power of great design.
"Beautiful architecture gives me a lift," she stated. "I feel exhilarated, opti-
mistic, ready to work. Bad architecture depresses me and actually tires me.
Many people are tired and depressed because they live surrounded by bad
architecture."[3]

Surprisingly, for a major city, there was very little significant archi-
tecture in Houston. There were certainly some handsome buildings at
Rice University—a series of neo-Gothic/Romanesque/Byzantine struc-
tures constructed before World War I by a Boston architect, Ralph Adams
Cram—and, in parts of the city, some very gracious houses. But there were
no skyscrapers by Louis Sullivan, no public monuments by McKim, Mead

& White, no 1920s prairie houses by Frank Lloyd Wright. The first great example of modernism in Houston, Mies van der Rohe's Cullinan Hall for the Museum of Fine Arts, would not be constructed until 1958.

As they settled into their lives in Texas, the de Menils became aware of this missing element. "There was nothing particularly exciting to look at in those days," Dominique noted. "Cullinan Hall had not been built—there was not even a nice building downtown—and it took away much of my pleasure to know that the best houses were only copies."[4] Dominique and John lived in one of those imitations, a perfectly handsome saltbox that had somehow managed to wander quite a ways from its historic origins in New England. The traditional houses in the city, no matter how lovely many were, were not inspiring.

But it was precisely that lack, in fact, that inspired the de Menils. "Where there is nothing, we need to start creating," Dominique later explained. "Houston has the means and the power; it is important they not be used for things that are inopportune or kitsch."[5]

·

The de Menils decided to build a new house that, instead of a facsimile, would be an authentic gesture of modernism. What they managed to create would also become a stage set on which they enacted their cultural ambitions.

Their first decision was to select the right architect. In New York, Dominique and John were friendly with a group who gravitated to the Museum of Modern Art. One was Mary Callery, a sculptor and artist whose work had entered the permanent collection and had been exhibited at the museum. Callery had long lived in Europe but had a large circle of friends in the United States; she played a real role in importing Parisian artistic modernism to America. She was also known to have been the mistress of Mies van der Rohe. The de Menils decided to consult her. As Dominique remembered, "Mary Callery said, 'If you want a $100,000 house, ask Mies van der Rohe. If you want a $75,000 house, ask Philip Johnson.'" Spending $100,000 on a new house, which would be over $800,000 today, felt excessive to Dominique and John. So they decided to meet with Callery's second suggestion.[6]

Born and raised in Cleveland, Philip Johnson (1906–2005) had turned himself into one of New York's most prominent advocates for pure, modern buildings. He had been associated with the Museum of Modern Art since 1932, when he founded the Department of Architecture and Design. That

year, he co-authored, with Henry-Russell Hitchcock, the groundbreaking book *The International Style,* a catalog for an exhibition also curated by Johnson: *Modern Architecture: International Exhibition.* At that time, however, Johnson's own architectural practice was limited. Few had seen any examples of his work. Yet he had planned, and was beginning to build, an unusual structure that would fascinate the worlds of art, architecture, and design: his Glass House in New Canaan, Connecticut.

The de Menils first met Philip Johnson at Mary Callery's apartment, a converted garage in Murray Hill. Dominique was impressed with Johnson's intelligence, enthusiasm, and energy. John and the architect quickly bonded. "As you know," Dominique said of Philip Johnson, "he's quite the charmer."[7]

So, in the spring of 1948, Johnson was hired. The de Menil house has often been characterized, incorrectly, as the architect's first commission. As he worked on his own Glass House, he also began other projects, some of which were completed before he finished the house in Houston. But Johnson always considered the commission from Dominique and John "my first important house."[8]

Dominique, wearing a Charles James opera coat, with Philip Johnson.

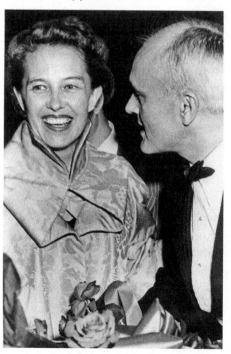

There were other reasons, besides cost, why the de Menils were interested in hiring a promising, though inexperienced, architect. They already had their own strong ideas about design. Collaboration with a younger architect was more likely than with an established name. "With all due respect to Mies' genius, Philip was more flexible and understood our problems better," Dominique later explained.[9] Another reason the de Menils were interested in Johnson was part of their larger mission. In early 1948, Johnson was a New York architect, affiliated with MoMA, who embodied the authority of modernism. "They wanted to set an example," suggested their friend Marguerite

Barnes. "They thought that if they brought someone like Philip Johnson to Houston and he designed a nice house, it would lead to better architecture in the city."[10]

•

In the summer of 1948, Dominique and John invited Philip Johnson to fly down for a weekend to have a look at Houston. They had settled on a heavily wooded property at the center of River Oaks, three lots that they combined to make one large, three-acre site. Together, they visited the land, still wooded and rough. It contained a variety of oak trees—live oaks, water oaks, willow oaks—pine trees, and a regional shrub, yaupon holly.

At the de Menils' house on Chevy Chase, they spent time together discussing ideas for the new house. Dominique showed the architect some ceramic tiles from Mexico, inexpensive black squares that had been made in Monterrey, that she intended to use for the flooring. "I am still as enthusiastic as I was in Houston about your new house," Johnson wrote to the de Menils from New York, on MoMA stationery. "The combination of those great oak trees and the beautiful Mexican brick makes my mouth water already."[11]

Johnson did not mention something else about that first trip: he found the lack of grandeur in their Houston lives to be disappointing. The de Menils were quite clear, however, about their intentions to build a serious house. They wanted it to be gracious, of course, and to reflect the spirit of the time, but they wanted something with substance. It was important, Dominique once noted, "to have more ambitions than a pool in our backyard and cocktail parties."[12]

From that first trip, the de Menils told Johnson about their design goals for the structure. As the curator James Johnson Sweeney later wrote, "They were still haunted by a nostalgic recollection of the old plantation house they had owned in Caracas."[13] Dominique and John told Johnson of their desire for a single-story structure, similar to Sans Souci. "The idea for the design came from having lived in a ranch type of house where half of your meals are taken outside on a patio," Dominique later explained.[14]

The de Menils were very involved in every step of the design process. They had, after all, already renovated their Paris apartment with an accomplished architect and spent several years in Venezuela building a number of structures for Schlumberger. So the process of design and construction was not new for them.

One of their first decisions was to shift the orientation 180 degrees, placing the front of the house to the north. Instead of being accessed from a

quiet suburban street, it would open onto San Felipe Road, a thoroughfare that, at that point, was used only as a service road. It was as though the house were meant to turn its back on River Oaks in order to face a street that was used mainly by maids. Was that intentional? "It fits their style to be contrary and meaningful," said Christophe de Menil. "That was certainly his attitude."[15]

Johnson completed the first plans for the house by October 1948, three months after first seeing the site.[16] Once she studied the drawings, Dominique requested a rethink. She wanted to expand the size of the entrance, to flip the entrance of the garage to the back, and to add windows in the kitchen, even though they would break the purity of Johnson's exterior. Dominique could not imagine herself, or anyone else, standing at the sink washing dishes and looking directly at a wall. "I will certainly do the best I can," Johnson wrote to her. "Be assured that I am covering my floor with sheets of tracing paper full of discarded ideas."[17]

As they worked on the project, Dominique and John went with Johnson to his Glass House, just as it was being completed.[18] Entirely constructed of a steel frame and glass, with a floor and foundation of glazed brick, the house was rigorous and restrained. The structure owed an obvious debt to Mies van der Rohe. Yet it has been said that when Mies saw the Glass House, he had only one word: "Brunelleschi!" He felt that Johnson's design had all of the precision and refinement of important Renaissance buildings such as Filippo Brunelleschi's Basilica of San Lorenzo in Florence.[19]

As the de Menils continued to work with their architect, they met together in New York, corresponded regularly, and discussed the project over the phone.[20] Dominique and John wanted Johnson to continue refining the design and to make another trip to the site, and she continued to have detailed comments and questions about his plans. Dominique was worried, however, that her flurry of requests might anger the architect.

When he received her letter, Johnson was alone in the Glass House, without a secretary. Wanting to respond swiftly, he took out a typewriter and propped it on his knees. "Excuse the bad typewriting," he wrote to Dominique, "but please don't think that I could ever get 'mad' at you. *Au contraire,* you are the one client I have ever had who can understand things before they are built. You are saving yourself many headaches by getting these things clear at this time when we still have the opportunity to straighten everything out."[21]

Just as the design of the de Menil house was almost finished, in December 1948, there was a burst of publicity around the completion of Johnson's own house in Connecticut. "All-Glass Home on Ponus Ridge Startles New Canaan Residents," announced *The New York Times.* "Visitors Create

Traffic Jam at Philip Johnson's Ultra-modern Residence and Guest House in Old Connecticut Village."[22] Johnson let the de Menils know others were enthusiastic. "Annette came by the New Canaan house the other day with Jean Arp," Johnson wrote, about Dominique's sister. "I think that Jean Arp liked the house better than Annette did, but one never knows. I certainly wish you could see it now. It is really turning into a very impressive place."[23]

Annette did approve of the architect and his Glass House and what he was doing for Dominique and John: she and Henri Doll hired Johnson to design the first Schlumberger Research Center. When completed in 1952, it would be a sprawling International Style complex in Ridgefield, Connecticut, low-slung and flat-roofed in light gray brick, steel, and glass, renamed, in 1965, the Schlumberger-Doll Research Center.

The architect made two more trips to Houston to work with Dominique and John. By February 1949, he was confident that the plans were suitable to all. He instructed the local project architect, Hugo Neuhaus, to begin staking out the driveway and the footprint of the house.[24] The de Menils' Houston friend Marguerite Barnes visited the site at that moment. As she recalled of that first glimpse, "It looked just miles long."[25]

•

Johnson's finished design for the de Menil house was arresting. It was a 5,500-square-foot, single-story, flat-roofed structure in dusty-rose brick, steel, and glass. Commanding its wooded setting, the house was 162 feet long and 70 feet wide, with an exterior that was 12 feet tall.[26] It was long and lean and low. When one entered the grounds from the north, a lengthy drive, initially covered with crushed oyster shells, was positioned at the right, or western, end of the house. One path curled around the right corner to a three-car garage that faced the rear; another circled left through the lush green lawn forming a circle at the front door.

So the front perspective was, essentially, one long wall of brick. At the top of the walls, a wide white fascia ran unbroken around the house, setting off the brick and the flat roof. The uniformity of the main exterior was interrupted only by a square central entrance in glass and, on the right, the two pairs of horizontal windows at the kitchen that had been so important to Dominique. The back of the house consisted primarily of walls of glass or sliding panes of glass that opened onto the patio and the garden, bringing together the indoors and the outdoors.

After entering through the front door, one found a generously proportioned entrance hall, as Dominique had requested: eighteen feet wide

A view from the back of the Philip Johnson house, looking over the patio into the living room.

by twenty-eight feet long.[27] The floors were the glistening black tiles, the opposing wall was brick, while on the left was floor-to-ceiling glass with views of an expansive courtyard. Concealed behind the front wall of the house, the courtyard was surrounded on three sides by glass. Also a rectangle, twenty-two feet wide and thirty-four feet long, it had been built around an oak tree and would be filled with tropical plants.

To the left of the entrance, a wide hallway led along the atrium to the central focus of the interior, the large, rectangular living room. Also twenty-two feet wide and thirty-four feet long, echoing the scale of the courtyard, the great space was framed by two walls of glass, one opening onto the atrium, the other giving onto the patio and the garden beyond.[28]

The right, or west, end of the living room was a paneled wall in limed oak with a large fireplace at the center. To the left of the fireplace, a set of double doors concealed a closet bar and a corridor that led to a wing with four bedrooms for the children. On the opposite end of the living room, was one large wall that held the space. To the right, a doorway led to Dominique and John's bedroom while, on the left, past floor-to-ceiling bookcases, was a corridor that led along the atrium to John's office.

From the entrance of the house, a corridor to the right led to the dining room, with another wall of limed oak, a second large fireplace, and floor-to-ceiling glass out to a small garden. Off the dining room was the large kitchen, roughly twenty-one feet by twenty-three feet,[29] with views of the

small back garden, horizontal windows bringing in light from the front, and a spacious area for meals. Beyond the kitchen were rooms for staff and the three-car garage.

"By the standards of Houston in 1950, the de Menil house was without precedent," wrote architectural historian Stephen Fox, who has closely studied the building. "The discipline of Johnson's mentor, Mies van der Rohe, was reflected in the house's slab-sided composition, flat roof, elongated fascia, and glass walls. The house's carefully studied proportions . . . were similarly Miesian." Yet Fox has noted that Dominique and John's house lacked the "exquisite clarity" of the architect's other projects at that time, including his Glass House. "The floor plan suggested Johnson's struggle to organize the varied spaces required by a family with five children into a one-story configuration," he wrote. "Perhaps for reasons of economy, the structural design of the house was not as rigorous as in Johnson's publicized early houses."[30]

There is no doubt that what he built for the de Menils was an impressive example of modernist architecture. And it was certainly the first important modern building in Houston and in Texas. But it was not a truly exceptional example of International Style design: it was not the Farnsworth House; it was not the Villa Savoye.

"So how is the work going on the house?" Father Couturier asked the de Menils in the fall of 1948. "Is it starting to resemble your dreams? That is when the real danger begins, actually, when our dreams start to become reality."[31]

•

Dominique and John knew that Couturier was onto something. Even before their new place was finished, they recognized that when it came to the interior, they did not have the same vision as their architect. "We realized that the house would not be very adventurous," Dominique later explained. "Philip felt that we should have a Mies van der Rohe settee, a Mies van der Rohe square glass table, and two Mies van der Rohe chairs on a little, square musty-colored rug. All of the houses furnished by Philip Johnson had been like that; we could see right away how we would get bored."[32]

They came upon an inspired solution. As Dominique recalled, "John, who was always full of extraordinary, creative ideas—*dangerous ideas*—thought of inviting Charles James."[33] Hiring James to work on the interior design was not an idea that was entirely out of the blue. Dominique

had known the designer for five years, longer than they had known Philip Johnson. She had seen and admired James's interiors at Elizabeth Arden and at his own salon. And having worn his clothes for some time, she was certainly sensitive to his aesthetic.

The fashion designer approved of many elements of Philip Johnson's design: the brick walls, the extensive glass, and Dominique's beautiful black floors of square Mexican tiles. But James took one look at the plans and determined that the ceilings were too low, insisting they be raised, by approximately ten inches, to ten and a half feet. "And he was damn right," Dominique exclaimed. "That enormous living room, with a low ceiling, would not have the same effect. The beauty of that room is that it has the proper height for its length."[34]

Word began to filter out about James's involvement in the new house. New York magazine editor Fleur Cowles, the legendary founder of *Flair*, heard and dashed off a note to the designer, suggesting the house might be perfect for *Flair*. As Cowles wrote to James, "Tell me about Madame De Mensil's [*sic*] house in Houston, which I hear you've done (versatile, versatile man!)."[35]

•

Philip Johnson, once Dominique advised him of James's involvement, was not nearly as enchanted. "Your letter of the 16th of April has been lying on my desk for a long time because I was in doubt how it should be answered," he wrote to Dominique, addressing various design details. "But the other point in your letter that bothers me is the appointment of Charles James as the consultant on the interior. I admire his work as a dress designer enormously but you can imagine the disappointment of an architect when someone else finishes his work."[36]

Johnson, though, was at his diplomatic best. He concluded by adding, "This disappointment, however, is lessened by my recognition of your incomparable good taste so I know the house will turn out to be beautiful."[37] The architect was exhibiting an impressive amount of self-restraint. He always maintained a sincere friendship with the de Menils and a loyalty to the couple; even years later, he signed letters, "Your faithful architect."[38] Yet he would distance himself from the house for decades. Elements of the design were acceptable; for example, Johnson permitted publication of an article about mercury-vapor spotlights that he had positioned below the oak trees, "to shoot up into hanging Spanish moss."[39] But he refused to include the de Menil house in publications of his work.

Johnson was appalled at what he saw as the indignities planned for his design.

•

Charles James made at least four trips to Houston in the fall of 1949 and the spring of 1950 to work with Dominique on the house. The arrival of the designer did not go unnoticed. On his first visit, James phoned from the airport to announce that he was bringing his own tubes of colors. As he exclaimed, "I'm coming with Japan colors!" James had some business to conduct with Neiman Marcus, so he arrived late. It was almost time for lunch, and the painters wanted to go, but they postponed their break. "And Charles finally arrives—we were expecting something extravagant or glamorous—and he eventually announces that he is going to imitate the color of cement from the garage," Dominique remembered with a laugh. "And then it was the color of cardboard!"[40]

Insisting that she was not exaggerating, Dominique said, "No, it's true!"[41]

One of the designer's first edicts involved the dark Mexican tiles that had been used throughout the house. As Dominique recalled, "He told me that he couldn't be inspired unless the living room floor of black tiles was polished until you could see your face in it."[42]

At a dealer in New York, James had found an oversize nineteenth-century vase—in gilded green opaline—that he somehow was able to fly down to Texas. "He called us from the airport to ask that we send a truck for him because he had something for the house and it was too big to fit in a taxi," Dominique remembered with a laugh. "He arrived, carrying in his arms this big vase in green opaline. To be inspired, he had to fill the vase with white lilies. So he had California lilies delivered and placed the piece on the floor, which was kept completely bare and impeccable. So there it was, a white island in all the black."[43]

Christophe de Menil also witnessed the Jamesian process. "He would arrive late, at 11:00 a.m., put on some army jumpsuit, and mix colors," she remembered. "The painters would leave at noon for lunch, and he would sit in the rocking chair, just filled with outrage. At 4:00 p.m., my sister Adelaide and I would hold up lights so that he and Dominique could evaluate the colors."[44]

And James loved the idea of provoking the architect. "Oh, he was thrilled," Dominique said with a laugh. "He really had fun teasing Philip Johnson. He would say, 'Now we're going to do a Turkish patio—it will be very Middle Eastern!'"[45]

•

The actual design objective of Charles James's intervention was quite serious: to take Johnson's rigorous, rational architecture and infuse it with the curve. Straight lines would be offset by sensuality. "Charles James always loved curves, beautiful curves," as Dominique remembered. "It was the time when Philip Johnson was completely under the sway of Mies van der Rohe, for whom there was only the straight line and the straight angle. It is amusing, considering how much Philip used the curve himself in his later career, but at that time it was heretical."[46]

One of James's primary means of introducing the curvilinear to the interior was by adding antique furniture. In every room of the house, he used dramatic old pieces, often eighteenth and nineteenth century, that he placed on the bold black floors. In the entrance, he used a pair of eighteenth-century Venetian sofas that he had purchased for the de Menils in New York. He placed one, covered in vivid yellow silk, against a pale wall. The other Venetian sofa was positioned along the wall of glass in front of the atrium and covered in a bright green silk, a shade that tied it directly to the greens of the tropical plants beyond. The arms, legs, and backs of both sofas were a series of daring curves.

As they hunted together for interesting antiques, James procured a series of rococo pieces by mid-nineteenth-century furniture maker John Henry Belter. They were beautifully polished stools, tables, chairs, and armchairs, some covered in an aged black leather, that were placed in the entrance and throughout the living room. "Belter was originally from Germany and he had specialized in violins, which require a very thin wood," Dominique said. "So, Belter learned how to curve the wood, to make layers and to carve them. There are seven different layers of wood—completely remarkable."[47]

Having always been sensitive to music, and an excellent piano player, James determined that the living room needed to be anchored by a large piano. As soon as he arrived, he began building a model out of orange crates and moving boxes, trying to assess the size that would be required and measure the visual weight the instrument would impose. After an extensive search, the designer secured a Victorian Steinway grand piano for the de Menils. The case, of course, was curved, while its ornate legs were carved, curved, and fluted.[48] And James positioned the grand piano against the great wall of the living room.

Also for the main room, James sold the de Menils his own nineteenth-century sofa, covered in a dark crimson velvet and matching fringe, and acquired a large Louis XVI desk, with a central section defined by swoop-

ing lines, which he positioned between the fireplace and the windows. "If you look at the legs, you see that it is absolutely Louis XVI," Dominique explained. "Charles James loved it because it had a curve that was made so that one person could sit and, when the leaves were opened, the surface of the desktop could be doubled. We said that it had to have been the desk of an architect, or someone who liked to unroll plans, some kind of Jefferson."[49]

•

The de Menils also commissioned James to design and build outstanding pieces of new furniture. For the dining room, he created a sweeping, swirling banquette, consisting of two interlocking pieces, that was covered in a cream-colored raw silk. The piece was molded along two walls, adjacent to the fireplace, seeming to flow out the corner.

In the living room, James produced a prominent chaise longue, standing on arched legs of dark iron that supported an undulating seat covered in raw silk. The fabric on the top of the seat was soft gray, but it flipped up at the base to reveal a flash of saffron.

In the opposite corner of the living room, adjacent to the fireplace, James created his most impressive piece for Dominique and John. The design was inspired by a noted Man Ray painting, *Observatory Time: The Lovers* (1934), a depiction of the scarlet lips of his departed lover, Lee Miller, floating off in the sky. James used the famous image as a starting point for the forms of the de Menils' Lips sofa. The piece, actually a pair of interlocking love seats, was remarkably complicated to produce. "It's as well researched as the wings of an airplane," Dominique said.[50]

The process, which took several years to complete, was tumultuous. James, instead of using drawings, made templates for the design out of string. "The upholsterers, at first, were so enthusiastic about what he told them," Dominique recalled. "But, very quickly, they understood that it was incredibly difficult, and it unnerved them so much that they no longer wanted to hear any talk about it. So we went from one upholsterer to another to another. And, each time, they were about ready to throw it out of the window."[51]

The de Menils were able to secure for their living room one flawless example of James's Lips sofa, in a neutral tone of fawn wool (they would later commission duplicate versions). It was positioned in a corner of the living room, close to the fireplace, its back to a screen that separated the space from the entry.

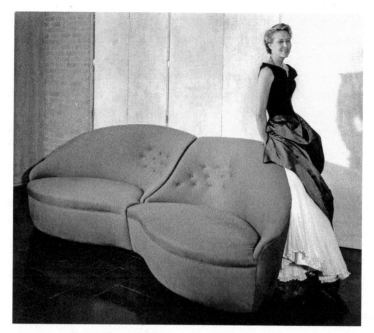

Dominique in a James gown leaning against the designer's Lips sofa in the Houston house.

By the time they were working with James, John de Menil had begun compiling detailed records of every work of art that they acquired. For the Lips sofa, he noted that its cost had ballooned to more than $6,000, or, accounting for inflation, over $59,000. John could not help but be amused. As he noted, "Kidney-shaped sofa, original by Charles James, the making of it was a three year adventure with many tragic-comedies, in the best Charles James style."[52]

•

James also injected the de Menils' interior with bold materials and colors. The designer flew down to Texas with the exquisite fabrics for which he was known: twelve yards of red velvet, ten yards of turquoise taffeta and orange satin, four yards of white linen, three yards of antique silk gauze.[53] He arrived with rolls and rolls of wallpaper—in mauve and yellow—fifteen yards of sheer white voile, and twenty-two yards of felt in muted shades and jewel tones.[54]

Windows were covered with floor-length curtains of luxurious taffetas in chartreuse, champagne, or tobacco, set off by a layer of delicate white

sheers. The colors of the majority of the walls throughout the house were restrained—tans and whites—although the main hall in the living room, the backdrop for the piano, was painted an assertive dark gray.

But there were smaller flashes of more original shades. Off the entrance, a vestibule that led to a guest bath was covered in mustard-colored felt. Partially concealed behind the gray wall of the living room, floor-to-ceiling bookcases were covered in bottle-green felt. In John's office, the doors of a closet opened to reveal that it had been lined with flocked floral wallpaper in beige and brown.

One of the more magical uses of color was in the corridor that led to the children's rooms. The walls and ceiling were painted a soft pink, offset by the black floors and doors covered in an antique, aged red velvet. "Charles had ideas that were revolutionary," Dominique explained. "To make the little corridors rich and the inside of the closets interesting and keep the outside very pure. It was always doing the reverse than what people expected. And, of course, that pleased my husband to no end: always do the unexpected."[55]

•

Together, Dominique and Charles James created one of the most poetic spaces in the house. Her dressing room, just off the de Menils' bedroom, had one wall of windows facing east and two perpendicular surfaces with a grid of closets, from floor to ceiling. There were two rows of rectangular doors, six taller closets along the bottom, six more compact cabinets above. They were plain, flat-surfaced wooden doors that opened out with simple stainless pulls.

The day they were to work on the room, Charles James went downtown to do some shopping. He returned with a pair of fuchsia stockings. He was elated! As with other inspirations, however, the find had nothing to do with the final result. Dominique and James were able to begin painting only toward the end of the day. "There was very little light when we started working," Dominique recalled. "That's when he marbleized those doors. It's so subtle; it's like a checkerboard, but each one is slightly musty colored, slightly marbleized, and the others are pale blue and pale green."[56]

Much of the work might have been done by candlelight, or by holding up lamps, but the result was ethereal. The two walls became one large checkerboard of subtle grays, pale blues, and soft greens, set off by pale ivory door frames and floorboards.

"He took her in as a collaborator," Christophe de Menil recalled of her mother and James working together. "Most important artists would not

have asked her to participate; that's very rare. I remember coming home from school and seeing them with sponges working on those doors."[57]

The pale colors were enhanced by the glistening black floors, the soft light coming in through the windows, and the dark gray walls of the room. Directly adjacent to the closet was the entrance to a bathroom, which James covered with a theatrical curtain in heavy red velvet, draped at the top in an elegant valance and sweeping onto the floor.

It was a diminutive room that contained a virtuoso performance by Charles James: subtle colors, dramatic gestures, extreme elegance, and a heightened sense of emotion.

●

Dominique felt that the pieces James produced, and the lessons she learned from him, were well worth all of the time and trouble. "He was a great master," she explained. "He taught me never to be easily satisfied, that the minute it's too easy, you have to find something else."[58]

On her own, Dominique designed a major piece for the living room: a heptagonal ottoman in a tufted, light golden velvet. It was a large addition that was placed in the center of the room and often covered with books and journals. It formed an elegant, functional oasis (Dominique's seven-sided ottoman would be reproduced at a much larger scale, and covered in chocolate brown suede, for the entrance of the Menil Collection).

John de Menil was elated with James's contribution to their house. He, too, felt that there were important life lessons to be gained from the designer. "Charles James has the courage and devotion to look for the difficult solution," John explained. "He taught us to meet difficult problems in taste."[59]

●

When the house was finished, many in Houston were bewildered.

Some thought it was an office building, a Laundromat, or some kind of a clinic.[60] Others insisted that a flat-roofed house was a folly—that they would never be able to sell it. Truck drivers, when making deliveries, assumed they had reached the service entrance and pulled right up to the front door. "I was very embarrassed," recalled Christophe de Menil. "And my sister speaks of being too embarrassed to have friends over. We did understand that it was notable, however. In the first few months, so many people came by to see it that Adelaide and I had to study up on the roof."[61]

Compared with their first house, the scale was impressive. "I remember

the immensity of it," recalled François de Menil. "It seemed huge, with ceilings that were so high. In the passageway that connected our bedrooms, there were these skylights that made noises at night because of the air-conditioning; these cracking sounds always made me think something was going on."[62] His younger sister, Philippa, said, "I remember all of a sudden this joy and this expansiveness; I thought I was in paradise or something."[63]

John felt that the ultimate success of the finished environment was due primarily to Dominique. "Here, it is nothing but *ordre et beaute, luxe, calme et . . .*," he wrote from the house one evening, when Dominique was in Paris. "I feel your influence and presence in every corner."[64] The de Menils continued to work on the interior. They moved furniture, added new pieces, tested out new works of art. "Today, the furniture and objects were delivered from the New York storage, and I waltzed it all around until everything found its proper place," Dominique wrote to John. Of course, some new additions worked, while others did not. "The big African statue from Guinea is superb but not right for the scale of the house," Dominique continued. "Everything becomes too small in comparison; it makes Max's sculpture of the king look like a pygmy. However, the statue from Lake Sentani is beautiful against that expanse of glass, next to the Braque still life with the black fish."[65]

In their bedroom, Dominique changed the placement of many things, including furniture, adding a new Italian writing table, adjusting the position of a Mies van der Rohe Barcelona daybed, working to reduce the presence of the curtains. "This renewed beauty of our room, and the view of the garden that I now have as I wake up, make me want to get to work."[66]

As soon as the de Menils settled into their new home, Gladys Mouton moved in as well. She would wake early, make sure the children had breakfast, then take them to school. John usually left early for Schlumberger, while Dominique stayed at home. Gladys then returned to the house, where she and Dominique would spend much of the day together. "She read a lot," Gladys recalled of those early days. "She would be in her books all the time. And she loved the garden. Sometimes we would both take a cart and go look for flowers. Or we would go to the nursery. And in the garden we helped the yardman, Cleo, a colored guy who worked at the house for a long time."[67]

The de Menils were pleased with the environment they had created. But for Dominique, there was still a lack of stimulation in Houston. "It has to be said that I am living here as though in a convent," she wrote to Father Couturier from the new house in 1951. "Entire days go by without my having gone any farther than the end of the lawn. Because there is noth-

ing around me that really excites me, I do not feel that I am really missing anything by staying at home."[68]

•

Dominique and John published their new house in the March–April 1953 issue of *L'Art Sacré*, Father Couturier's publication on the sacred arts. It was very revealing about the ideas that had gone into the project. The story, splashed on the cover and all thirty-two pages of the publication, was an aesthetic manifesto from the de Menils.

The text was written by Dominique; some of the photographs were by John. Titled "American Impressions in France," the feature traveled from Texas to New York and throughout France. The epigraph was a poem by Apollinaire:

Along the coast of Texas
Between Mobile and Galveston, there is a
Large garden, filled with roses.

"Apollinaire was not wrong," Dominique wrote. "There are gardens filled with roses along the coast of Texas. I live in one of them."[69] She sketched in the local scene. "There are also cowboys to be found, just like in the geography books, but there is much more; the reality is richer than the dream, or a postcard, and it is filled with contradictions." The first page contained a photograph of the back of their house, showing the flat roof, the brick, steel, and glass, and the giant oak trees. On the opposite page: a dramatic photograph of the United Nations Headquarters under construction in Manhattan.

From Houston, the article moved on to New York, with a full-page image of the pristine slabs, in steel and glass, of the just-completed Lever House, by Gordon Bunshaft. As Dominique wrote, "It is a building that is as rigorous and as exultant for me as the pyramids in Egypt."[70]

After New York, the story shifted to Paris. "Once you have grown to love a beautifully cut diamond, it is hard to accept small stones that have been poorly mounted," Dominique wrote. "When one arrives in Paris after the Lever Brothers building, then, it is not surprising to be filled with disappointment about all of the modern construction. Timorous designs, filled with compromises—problems not resolved completely or courageously—no unity, no conceptual grandeur, no practicality."[71] The de Menils were reacting to the fussy French architecture that began to arise after World

War II. Only a few years later, that style, combining the impersonal excesses of modernism with the worst of French formality, would be satirized by Jacques Tati in *Mon oncle*. The de Menils believed in modern design but with integrity.

Dominique also described their visit with Léger in his studio on the rue Notre-Dame-des-Champs. The artist gave them a preparatory drawing for a painting he had already sold to them. "We leave with one of the drawings for *The Builders*," Dominique wrote, "along with the beneficent memory of this native of Normandy, his cheerful disposition and quiet strength."[72]

Next they were off, with Father Couturier, on an artistic and architectural road trip around France. At Audincourt, an industrial town in eastern France, they admired Father Couturier's recently completed Église du Sacré-Coeur, with stained-glass windows by Léger. They visited another Couturier initiative, the Église Notre-Dame de Toute Grâce at Assy, a towering stone structure built on a plateau in the Alps near the border with Italy. Assy featured an exterior of soaring, brightly colored mosaics by Léger, stained-glass windows by Rouault, a depiction of Saint François de Sales by Bonnard, tapestries by Jean Lurçat, a portrait of Saint Dominique by Matisse, and a small tabernacle door by Braque.

Their enthusiasms spanned the centuries, from the noble restoration of the Cistercian Abbey of Fontenay to the ruins of a seventeenth-century Benedictine monastery near Arles, the Montmajour Abbey, to the model for yet another Couturier project, Le Corbusier's soon-to-be-completed chapel at Ronchamp, Notre Dame du Haut. They admired the restrained Roman monastery St. Paul de Mausole outside St. Rémy de Provence, site of the psychiatric hospital where van Gogh lived and painted in the last year of his life, as well as the bold forms of Le Corbusier's just-completed Cité Radieuse in Marseille, a remarkable eighteen-story apartment building in poured concrete.

In Vence, on the Côte d'Azur, they went to another important project that Father Couturier had just completed, the Matisse Chapel, or Chapelle du Rosaire de Vence. It was a lyrical structure, with white concrete walls and a roof of blue tiles, that had been entirely conceived and executed by Matisse. It was a project he considered his masterpiece. "Four years of work for a few stained-glass windows and some black lines on white tile," Dominique wrote of the Matisse Chapel. "As George III said of Shakespeare, 'It's dull stuff.' No, Vence will be a touchstone for our sensibility, possibly even for our spiritual sensibility. So many churches today are oppressive by their conventional style or injurious by their aggressive forms; this chapel feels like a new proclamation."[73]

Couturier took the de Menils to meet Matisse. They discussed his work on the chapel, his love of the French coast, his trip to the United States in 1929. "He spoke about the beauty of New York, as he arrived in the evening," Dominique noted. "He said it was like a chunk of pyrite, glimmering in the night."[74]

For *L'Art Sacré,* the de Menils ended their trip with a stop in Antibes, at the Musée Grimaldi (now the Musée Picasso), where Picasso had painted and which contained a significant collection of his works. And then to the site of a future Couturier project, a vast underground basilica that Le Corbusier was to carve out of a Provençal hillside at St.-Baume (an ambitious project that would never be realized). "And now, in a series of quick journeys, it is time to head north, to Paris," Dominique concluded. "And once more to New York and to Houston."[75]

•

As Dominique and John continued to build their collection, and began to install the art, the house gained in authority.

Initially, the art was relatively spare. In the entrance, they hung their first two Picassos, *Female Nude,* the magnificent cubist painting, and *Bottle and Glass on a Table* (1912), the cubist collage. Off the entry, a nook that led to the guest bathroom had a surrealist painting by Victor Brauner, *The Ideal Lover* (1947), which was one of the first works the de Menils acquired by Brauner, an artist they would come to prize.

On the main wall of the living room, above the piano, was a large painting by Rufino Tamayo, *The Bird Charmer* (1945), of a massive red man, in a blue room, blowing his horn to soothe a few birds in flight. Behind James's modern chaise longue, along a wall of windows, was a square pedestal supporting an elegant ancient Greek sculpture in white marble, *Statue of Venus* (second century B.C.).[76] On the opposite end of the living room, with its wood paneling, were three enigmatic paintings by de Chirico. In the center, over the fireplace, was *Hector and Andromache,* an oil that had once seemed too challenging for Dominique.

The kitchen had a long rectangular table and matching chairs in polished pecan, made by German craftsmen who had immigrated to Texas. On the wall above was the massive wooden cross from Mexico, the symbols of the Passion of Jesus carved onto its rough surface, that the de Menils had suspended by a heavy rope.[77]

Their daughter Philippa remembered being told, as they started installing art, not to touch it. "So that was one of the things that brought our

Philippa photographed by Eve Arnold on the kitchen table
under the wooden cross from Mexico.

attention to it." She recalled a beautiful Picabia painting of a couple danc-
ing with their arms around each other, *Printemps* (1938). Often placed on
the way back to the children's rooms, it reminded her of her parents. There
was also a thin white sculpture by Giacometti, *Nu debout* (1953). "I always
thought that was my mother," Fariha said.[78]

As the de Menils' collection grew, and the scale of their interests
enlarged, the house became increasingly crowded with artworks. Within a
decade, the Picassos at the entrance were replaced by a massive painting of
the nave and aisles of an ornate Gothic cathedral by seventeenth-century
artist François de Nomé, *Interior of a Cathedral*. Over the living room fire-
place, the de Menils placed a large painting by Dubuffet, *The Pink Desert*
(1954), flanked by a Paul Klee and a Max Ernst.[79] The Grecian *Statue of*

Venus was joined by a fifteenth-century Sienese *Angel of the Annunciation,* as well as a stylized representation of a snake, from the Baga tribe of southern Guinea, a curved, painted effigy more than eight and a half feet tall.

In the 1960s, Dominique and John's house was given twelve pages in *Vogue,* with a text by James Johnson Sweeney. As he wrote of the layered interior, "A painting by Mondrian flanks a Magritte; a Max Ernst, a Dubuffet; a Chirico, a Picasso; a Zurbarán, a Desiderio; while Cycladic, Mayan, Dogo and New Guinean wood carvings, terra-cottas and marbles mingle with provincial French tables, Charles James couches, Belter chairs."[80]

Three decades after it was completed, the interior was positively thick with art and objects from an immense array of periods and worlds. In 1984, when it was photographed by Marc Riboud, he was sent a list of the works of art that appeared in his images. It was a single-spaced, typewritten inventory that ran to thirteen pages, accounting for approximately two hundred artworks.[81]

In those years, the main wall of the entrance was held by Yves Klein's *People Begin to Fly,* the monumental canvas that was over eight feet tall and thirteen feet long. Also in the entrance, the massive François de Nomé cathedral was joined by the charming pair of pigeons by Fernández, two little bronze orbs by Takis positioned on the floor, and, on top of a Victorian cast-iron garden table, one small geometric wrought iron by Chillida, *Lugar de silencios* (1958).[82]

Looking down the hall to the right, with the Yves Klein in the foreground, revealed a Senufo people's bird figure standing proudly on the left, an important Dogon sculpture commanding the right side of the hall, and, at the end, in front of a window, a thirteenth-century wooden sculpture of Madonna and Child.[83]

In the living room, the main wall above the piano was held by one of Max Ernst's key paintings, *Return of the Beautiful Gardener* (1967), a lyrical nude woman. Elsewhere in the room, in addition to the antique furniture and the contemporary pieces designed by James, was an imaginary landscape by Magritte, *The Origins of Language* (1955), a first century A.D. Egypto-Roman funerary portrait, and a late Hellenistic bronze statuette of a bull.[84]

In the bedroom over the couple's bed, as noted before, was the Dubuffet and an eighteenth-century crucifix used by missionaries in Africa.[85] On one wall, a prickly portrait of Dora Maar by Picasso, *Seated Woman with a Hat* (1938), was positioned over a nineteenth-century table holding a grouping of close to a dozen statues, figurines, and masks from Africa.[86]

The bedroom and the dressing room also contained a Joseph Cornell box, *Pharmacy* (1950), a Schwitters collage, a Klee drawing, and an abstract painting by Léger, *Paysage, fond bleu* (1947).[87]

The interior of the de Menils' house became a condensed collection of civilizations and art through the ages.

•

Dominique and John's house in Houston would have a rich publishing history; it would be photographed and written about extensively over the decades.

In 1957, they brought Henri Cartier-Bresson to Houston for the American Federation of Arts Convention. Cartier-Bresson photographed the surroundings from many angles: a trio of wasp-waisted women in full skirts standing on the black tile, art historian Meyer Schapiro having tea on Dominique's ottoman, John de Menil reading the newspaper on the Charles James chaise longue. "The relaxed, poetical few days in Houston" was how John referred to that trip, in a letter to Eli Cartier-Bresson.[88]

Even as Dominique and John became public figures, they remained guarded about their privacy, so publishing their personal residence was a big decision. There had to be a justification, and it was not for self-glorification. They used the house over the years to promote projects they believed in, to advance ideas that were important to them.

As a story on the house was being prepared for publication in the March 1983 issue of *House & Garden,* Dominique sent the magazine's copy editor very detailed notes on every line of the text. "On the whole it is correct," she wrote of the story, "though a bit too laudatory."[89]

•

The de Menils began inviting people to Houston, and over the years a remarkable procession of artists and architects, old friends and new acquaintances, and scholars and museum professionals passed through the house.

One of their first houseguests was Jean Malaquais. He and Galy stayed with the de Menils for three weeks just after they moved in.[90] The first artist to visit was Alexander Calder, in Houston for an exhibition the de Menils organized at the Contemporary Arts Museum, Calder–Miró (October 14–November 4, 1951). The show included thirty-three Calder sculptures and twenty-three works by Miró that were lent by museums and collectors from across the United States. On that first trip to Texas, the artist, a com-

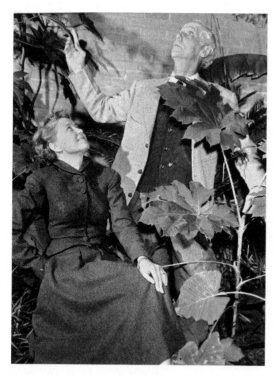

Dominique, wearing Charles James, playfully posing in the garden atrium with Max Ernst, one of their first artist houseguests.

mitted Francophile, became fast friends with Dominique and John. And they purchased two works from him: *Red and Many White on Black Skirt* (1951), a small tabletop mobile, and *Two Acrobats* (1929), a poetic sculpture, in painted black wire, of two interlocking male forms. The de Menils donated *Two Acrobats* to the museum (until, in the 1960s, they were able to buy it back—the first of many artworks they would pay for twice). Several months later, Max Ernst, who was living in Sedona, Arizona, with Dorothea Tanning, drove to Texas in their station wagon with their two Lhasa apsos— Katchina and Dreamy— and stayed in John's study.[91] Although the de Menils had met Ernst in Paris, they began their lifelong friendship during that stay. They introduced the artist's dogs to theirs: a handsome Doberman named Kiebitz.[92] (Later Dominique and John had black Standard poodles, first Cokie, then Natasha.)

During such relaxed times at home, the de Menils began to gain a better understanding of artists' personalities. Dominique soon had an amusing summary of the complicated marital history of Max Ernst. She explained that he began with a German wife, Luise Straus, the mother of Jimmy Ernst, then married Marie-Berthe Aurenche. After arriving in America, he married Peggy Guggenheim, who had helped him leave Europe. "And then he eloped with Dorothea Tanning," Dominique concluded with a laugh, "who never let him out of her sight!"[93]

In the fall of 1951, John de Menil's former academic mentor André Siegfried visited Houston for one week. Dominique and John organized a variety of events for him, including a trip to a working oil well and a meeting with the president of an African American institute of higher learning, then known as the Texas Southern University.

John wrote to William P. Hobby, the former governor of Texas and publisher of *The Houston Post,* to advise him of Siegfried's visit.[94] And he invited him and his wife, Oveta Culp Hobby, the executive vice president of *The Houston Post,* who had, during the war, been selected by Roosevelt to organize and direct the WACs, to meet the French visitor and his wife.[95]

Many New Yorkers began to fly down to Texas to visit the de Menils. Dorothy Miller, the first curator of the Museum of Modern Art, went in November 1952. She made notes for Alfred Barr on the twenty paintings that she felt were the most impressive: Picasso, Ernst, Magritte, Braque, Brauner, Calder, de Chirico, Rouault, Miró, Bérard, Tamayo, Forrest Bess, and Léger.

Also that year, Daniel Wildenstein was in Houston to see the de Menils. "What a precious source of information about all of the painters his father had known," Dominique noted of Daniel and his father, Georges Wildenstein.[96]

Quite quickly, the de Menils' house became an appealing stop for the art world.

•

In 1961, Dominique and John brought James Johnson Sweeney to Houston to be the director of the Museum of Fine Arts. Sweeney was, far and away, the most important art professional who had ever worked in Texas. He had been a leading art critic in New York, the director of the Department of Painting and Sculpture at the Museum of Modern Art, and the first director of the Guggenheim Museum. Sweeney built the Fifth Avenue institution with Frank Lloyd Wright.

It has to be said, though, that he did not always ingratiate himself with the residents of his new city. He sent his shirts back to New York to be laundered. And he seemed to have a hard time seeing past Dominique and John. "I only know two roads in Houston," Sweeney once quipped. "From the airport to the museum and from the museum to the de Menils' house!"[97]

They continually opened their doors for Sweeney, organizing lunches, dinners, and receptions to try to encourage Houstonians to support him and the museum. In one ten-day period, the de Menils had a Saturday night dinner for the Sweeneys with twenty guests, another the following Saturday, including São and Pierre Schlumberger, and then a third dinner party that Monday.[98]

John de Menil was also a big supporter of the Institute of International Education, and in 1964 he and Dominique had the idea of bringing Marlene Dietrich to Houston to raise funds for the IIE. Although they had both been

on the set of *The Blue Angel* in 1930, Dominique met the star only[99] in 1954 in New York when she and John were introduced to Dietrich at a dinner party hosted by Tatiana and Alexander Liberman, the editorial director of Condé Nast. Dominique, noting that Dietrich was not interested in men, was impressed with her intelligence and impeccable French.[100] The actress agreed to come to Houston for the de Menils but, once she heard about the late summer mosquitoes in that part of the world, was prepared to cancel.

With the couple's friend Marguerite Barnes, John sat down and wrote Dietrich a letter. "Miss Dietrich. In the frontline battles of World War II, you were not afraid," Marguerite remembered their letter suggesting. "These little mosquitoes here have to fight their way through air-conditioned automobiles, air-conditioned rooms, air-conditioned everything. We can't believe that you are in as great a threat here as you were during the war."[101]

Dietrich decided to make the trip, giving a benefit performance for the IIE at the Music Hall, a modern building downtown, in front of an audience of three thousand. After the performance, Dominique and John entertained her at home, as they had at their New York town house.[102]

The de Menils had Magritte down to Houston to stay at the house. The artist was traveling with his wife, Georgette, their dog—a Pekingese named Loulou—his dealer Alexandre Iolas, and the French writer Louise de Vilmorin. At the house, Dominique and Magritte sat together in the living room, engaged in a long conversation about his work and the world of ideas. Magritte admitted to Dominique that form was less important to him than the thinking behind the work of art. "I'm interested in ethics, not aesthetics," he told her.

"But your paintings are beautiful," Dominique replied.

"Ethics, too, are beautiful" was Magritte's response.

"How long does it take you to paint a picture?" Dominique asked.

"Forty years of reflection and twenty hours of manipulation," Magritte answered.[103]

One Wednesday afternoon at the house, Dominique and John had Claes Oldenburg over; the following Saturday they had a supper for Jean-Luc Godard. They invited the collector and connoisseur Douglas Cooper down to give a talk on cubism and threw a dinner party for him at the house. "Ultra Violet came with Andy Warhol," remembered former University of St. Thomas student Fredericka Hunter. "Paul Morrissey, Joe Dallesandro, were all here. Until some things disappeared—I think it was Holly Woodlawn who swiped things out of the house and Mrs. de Menil got mad and then they didn't stay at the house anymore."[104]

The de Menils met composer Morton Feldman in New York in 1966. The following spring they invited him down to Houston to deliver a talk to

students at the University of St. Thomas. He stayed with the de Menils, in the environment he termed "palatially intimate."

A composer would certainly be sensitive to music. One morning, Feldman heard a melody emanating from another part of the house. "While shaving, I heard a tune being whistled over and over again," the composer recalled. "A tune which in some places is still controversial. It was John whistling *The Internationale*."[105]

•

By that time, John de Menil was beginning to organize a film department at the University of St. Thomas. He hired a young professor from the State University of New York at Buffalo, Gerald O'Grady, to get it off the ground. One summer day in 1967, John was in New York, as was O'Grady, so he asked if he could be free for a few days for a trip down to Houston. O'Grady was picked up by limousine and bundled onto the Schlumberger plane, where a chef prepared a steak dinner for the two of them.[106]

When they arrived at the de Menil house, John showed the young professor to his room, one of the children's rooms, and said that he would come collect him at 7:30 p.m. At the appointed hour, John met his guest and ushered him into the living room. Sitting there waiting for them was Italian film director Michelangelo Antonioni.

For anyone interested in European cinema in those years, Antonioni was the master. He had just finished a remarkable run of films that included *L'avventura, La notte, L'eclisse,* and, the year prior, *Blow-Up.* Of course, O'Grady was stunned to find him there in the middle of the de Menils' living room.[107]

Antonioni was in Texas to look for locations for his only American film, *Zabriskie Point* (which he would eventually shoot in Southern California). "He was interested in places of violence," O'Grady remembered. "And Houston at that point was the murder capital of the world."[108] So O'Grady joined de Menil protégé Helen Winkler and University of St. Thomas art history student Karl Kilian, who had been tasked by John with giving Antonioni the big tour. They took him out to the industrial Ship Channel, clogged with oil tankers, to enormous, churning oil refineries, and to the historic port of Galveston, tattered and languishing, and to observe the artificial insemination of herds of cattle. For three days and nights they soaked up the local color. Finally, Antonioni said that what he really wanted to do was "meet a lot of rich Texans."[109]

Dominique was in Paris, but John decided to host a party for the director. Held outdoors at the house, on an early summer evening, the dinner

consisted of several tables of guests, probably thirty-six in total.[110] One of the leading examples of local wealth was given the seat of honor to the right of Antonioni: Lyndall Wortham, the redoubtable wife of insurance tycoon Gus Wortham, who was wearing a full-length coat of blond mink.[111] "There was all this jewelry and all of these great, old, eccentric, wonderful people there," remembered Helen Winkler.[112]

Another Texan included for dinner was Dominique and John's next-door neighbor, John Blaffer, from the important oil family and the brother of Jane Blaffer Owen. Mr. Blaffer was known for being very conservative, quick with a drink, and loose with the tongue.

Also there that night was Gertrude Barnstone, the wife of architect Howard Barnstone, the great friend and collaborator of the de Menils'. Gertrude was Jewish and unapologetically liberal, having been engaged in fighting for integration of the local schools and supported in her efforts by Dominique and John.

Gertrude Barnstone often had run-ins with John Blaffer. Her father had been a petroleum engineer, and the conversations often began amicably. "He would always start out, 'Gertrude, how's your father?'" she remembered. "Then there would be a little more conversation, and he would drink a little more. And it would escalate until he became so brutal about integration, about blacks, about me."[113]

The de Menils loved to include young people at their dinners, so, in addition to Helen Winkler, John invited University of St. Thomas student Karl Kilian as well as Patricia Carter, a formidable, youthful heiress whose family had been friendly with the Blaffers for three generations.

It was a charming al fresco dinner for Antonioni that night at the de Menils' house, until it took a turn that would become notorious. As Helen Winkler remembered,

> I sat at this table with Gertrude Barnstone, Karl Kilian, and Ed Hudson, who had been John Blaffer's brother-in-law. This was after integration, but Gertrude continued her political work and was a local figure of extreme liberalism. And, of course, John Blaffer was very conservative, and he was also drunk. He kept calling her a "nigger lover," which she was used to; that was nothing new for her. Some of the people serving were black, but that didn't mean anything to him. He continued, and at a certain point Ed Hudson, who was sitting next to him, says, "Why don't you shut up, you son of a bitch?"
>
> So Blaffer just reached back and whacked him—knocked him totally over in his chair. Ed Hudson knew better than to get up. So

he just stayed there. John's wife, Camilla Blaffer, came over from another table and tried to calm him, and he just pushed her down to the ground.

So at that point, Karl stood up across the table and said, "Come on, why don't you hit me? I'm nobody, why don't you hit me?" So Blaffer walks around the table and just grabs Karl by the tie and neck. At that point, Patricia Carter stands between Blaffer and Karl while I'm pushing Karl back.

Then John de Menil quietly comes up behind John Blaffer, who is six feet two inches. John de Menil is not as tall as I am. He comes up behind John Blaffer and just whacks him on the back!

Blaffer wheels around, ready to hit somebody else, and he sort of pauses because it's John de Menil. John says, "You cannot treat my guests this way; you're going to have to go home."

So he just backs off and went home.[114]

If it was violence Antonioni was looking for and rich Texans, he certainly got it that night. Other guests were disturbed.

Karl Kilian also remembered Camilla Blaffer tried to hold her husband around his waist, causing him to push her. "So she was holding him around the legs, and he was sort of dragging her across the lawn as they left," Karl recalled. "It was incredible. Savage."[115] Another guest disputed the suggestion that Camilla Blaffer was dragged across the yard but did remember seeing a furious John Blaffer, his wife following behind, crash through the hedges between his house and the de Menils'.[116]

Gertrude Barnstone was astounded that it had gone that far. "Well, that was the end of the dinner party," she later said with a laugh. "Everyone who didn't go home went inside and had some drinks. We huddled together and tried to figure out what had just happened. It was very strange—this lovely evening, this beautiful house, magnolia fragrance in the air, and then this totally volcanic eruption."[117]

•

Thankfully, outbreaks of violence were rare at the de Menils' house. More often, visitors had an intense response to the setting.

In the summer of 1969, Norman Mailer, who knew the de Menils through Jean Malaquais, was in Texas for the Apollo 11 mission to the moon. The year before, he had written *The Armies of the Night*, his nonfiction account of the October 1967 anti–Vietnam War rally in Washington, D.C., that won both the Pulitzer Prize and the National Book Award.

Jean Tinguely's *Fountain* on the back lawn of the de Menils' house.

This time, he was producing an extraordinary account of the space program and the lunar landing that was published in three separate issues of *Life* and then as a book, *Of a Fire on the Moon*. Because it was the 1960s and it was Norman Mailer, he wrote in the third person and assigned himself the name Aquarius.

On July 21, 1969, the Apollo 11 space module lifted off Tranquility Base, its lunar station, and began its two-and-a-half-day journey back to earth. That night, Mailer accepted an invitation to dinner at the de Menils' house. "His host and hostess were wealthy Europeans with activities which kept them very much of the time in Texas," Mailer wrote. "Since they were art collectors of distinction, invariably served a good meal, and had always been kind to him, the invitation was welcome."[118]

Mailer had been spending his time at NASA headquarters at the Johnson Space Center, thirty miles southwest of the de Menils' house. "To go from the arid tablelands of NASA Highway 1 to these forested grounds now damp after the rain of a summer evening was like encountering a taste of French ice in the flats of the desert," Mailer wrote. "Even the trees about the house were very high, taller than the tallest elms he had seen in New England."[119]

Outside, off the back patio, Mailer observed how the de Menils had fused the lush garden with contemporary art. "On the lawn, now twice-green in the luminous golden green of a murky twilight, smaller tropical trees with rubbery trunks twisted about a large sculpture by Jean Tinguely which waved metal scarecrow arms when a switch was thrown and blew spinning faucets of water through wild stuttering sweeps."[120]

Mailer had great admiration for the space program as a scientific achievement, but he also found it unsettling. At the de Menils', he encoun-

tered an African American acquaintance from New York, identified in the text as an Ivy League professor but probably the literary agent Ronald Hobbs. As Mailer described the guest, he was "a big and handsome Black man with an Afro haircut of short length, the moderation of the cut there to hint that he still lived in a White man's clearing, even if it was on the very edge."[121]

The two guests entered into a discussion about the space mission. As Mailer wrote,

> "You know," said the professor, "there are no Black astronauts."
> "Of course not."
> "Any Jewish astronauts?"
> "I doubt it."
> The Black man grunted. They would not need to mention Mexicans or Puerto Ricans. Say, there might not even be any Italians.
> "Did you want them," asked Aquarius, "to send a Protestant, a Catholic, and a Jew to the moon?"
> "Look," said the Black professor, "do they have any awareness of how the money they spent could have been used?"
> "They have a very good argument: they say that if you stopped space tomorrow, only a token of the funds would go to poverty."
> "I'd like to be in a position to argue about that," said the Black.[122]

Those were the kinds of conversations, not always easy, that took place at the de Menils' house. Exchanges such as that came from combining interesting, intelligent people from a variety of worlds.

Then there was the always-present impact of the art. In the entrance of the house, Mailer was blown away by the Magritte painting *The Invisible World*. "[It was] a startling image of a room with an immense rock situated in the center of the floor," Mailer wrote of the Magritte. "The instant of time suggested by the canvas was comparable to the mood of a landscape in the instant just before something awful is about to happen, or just after, one could not tell. The silences of the canvas spoke of Apollo 11 still circling the moon."[123] Mailer was so struck by the painting that he reproduced it on the cover of his book (identified as belonging only to a "Private Collection").

It was a large Magritte, over four feet wide and five feet high, that Dominique and John had boldly hung on a brick wall in the entry. It depicted a room with an elegant pair of open French doors framing a view out to the ocean blocked in the center of the room by an enormous vertical boulder. Studying the painting, Mailer reflected on the artist's intent: How could Magritte, working in gray gloomy Brussels fifteen years earlier, have so

captured the anxiety of that particular American moment that Mailer was living? As he wrote,

> As Aquarius met the other guests, gave greetings, took a drink, his thoughts were not free of the painting. He did not know when it had been done—he assumed it was finished many years ago—he was certain without even thinking about it that there had been no intention by the artist to talk of the moon or projects in space, no. Aquarius would assume the painter had awakened with a vision of the canvas and that vision had he delineated. Something in the acrid breath of the city he inhabited, some avidity emitted by a passing machine, some tar in the residue of a nightmare, some ash from the memory of a cremation had gone into the painting of that gray stone—it was as if Magritte had listened to the ending of one world with its comfortable chairs in the parlor, and heard the intrusion of a new world, silent as the windowless stone which grew in the room, and knowing not quite what he had painted, had painted his warning nonetheless. Now the world of the future was a dead rock, and the rock was in the room.[124]

•

There was no shortage of well-known figures who visited the de Menils at home. But some of the most meaningful contacts were with those who had not yet made a name for themselves. One afternoon, three African American students were given a tour: Charles Freeman from Rice, Kenneth Ford from TSU, and David Jolivet, also from TSU. Dominique was so moved by their enthusiasm over the African statues and masks that she showed them around the house. Afterward, she made sure to send each a copy of Howard University professor Frank M. Snowden Jr.'s recent book, *Blacks in Antiquity: Ethiopians in the Greco-Roman Experience*.[125]

One day, another of the couple's protégés, Fred Hughes, stopped by the house with a fellow student from the University of St. Thomas, Kevin Cassidy. Over lunch in the kitchen, Dominique discussed Cassidy's Catholic upbringing in the Detroit suburb of Grosse Point and his family's reaction to the reforms of Vatican II. As they walked through the living room, he noticed *The Phenomenon of Man* by Pierre Teilhard de Chardin. Dominique was intrigued to know that the young man had read it. He became a friend and confidant of Dominique and John's for the remainder of their lives.

The de Menils were just as inclined to open their house for classes of

art history students down from Southern Methodist University in Dallas or a group of fifty women from the River Oaks Garden Club.[126] One day, there was a lunch for Margaret Mead and a group of anthropology professors from the University of Houston and Rice University. Dominique had never been one for small talk. At that lunch, she turned to a young professor seated next to her, someone she had never met, and, for an opening gambit, asked, "What's your passion?"

•

When the distinguished art historian Leo Steinberg stayed in the house in 1968, he was immediately fascinated by the overall environment. "What impressed me was the character of every object and the way they worked together," Steinberg explained. Two years later, in March 1970, the de Menils invited him back to give three lectures on Michelangelo. "No less agreeable was the invitation to spend the week as a houseguest," Steinberg remembered.[127]

They had agreed on an honorarium, $2,000 for three lectures and two seminars. After the first talk, the art historian returned to his room at the house to find an envelope on his pillow. Even though he had not completed his work, the de Menils had given him a check. The amount, however, was $3,000.[128]

"The next morning at breakfast with Dominique, I suggested that there was a mistake in the amount," Steinberg said. "Dominique replied in her slow, measured way, 'No, there was no mistake. But sometimes, when we can, we like to surprise our friends.'"[129]

Back in New York, there was a small dealer on Madison Avenue who had a painting Steinberg coveted. It was an allegorical work, seventeenth-century Flemish, unattributed, of Apollo rising on his chariot delivering the dawn. The historian could tell that it was Flemish, 1630s or 1640s, possibly the school of Rubens. The price had been lowered, but it was still more than he could afford.

Steinberg told the dealer about the de Menils' increasing his fee. He said he had an extra $1,000 and asked if that would be acceptable. The dealer agreed. "So I bought the painting and that's it," Steinberg said, gesturing to the large Flemish work in his Upper West Side apartment. "I look at it every day. Dominique was here once, and I showed it to her. I said, 'That painting is your gift.'"[130]

•

Dominique and John met Rosamond Bernier in Paris in the 1950s. An American expatriate married to a Frenchman, she was the founder and editor of *L'Oeil,* an elegant arts publication that had published the de Menils' country house north of Paris, Pontpoint. By the fall of 1970, Rosamond had divorced her husband and moved back to the United States, to her native Philadelphia. It was a difficult moment in her life; she was uncertain about what to do next.

Knowing of her great friendships with such artists as Picasso, Léger, Ernst, and Miró, Dominique thought that she would do an excellent job of making art history come to life. She wanted her to come to Texas to present a series of lectures and seminars at the Institute for the Arts at Rice University.

Rosamond Bernier would go on to become one of the most popular lecturers on art and artists at her sold-out lectures at the Metropolitan Museum in New York; she was usually dressed in haute couture: Madame Grès, Balenciaga, Chanel.[131] Rosamond always included anecdotes about her friendship with the artists illustrated with personal snapshots, creating an insider appeal.

But in November 1970, she told Dominique that she just could not imagine doing anything like a lecture. The de Menils brought her down to Texas and installed her in the guesthouse, a small modern structure that had been designed by Howard Barnstone and was nestled behind the main house. "Dominique was absolutely insistent," recalled Rosamond Bernier. "And she was very persuasive. She just put everything at my disposal."[132] One of her first objections was that she had no slides. So Dominique enlisted art history students from Rice University to help. She was given access to all of the de Menil slides, and any others that she required were made. Rosamond Bernier stayed in the de Menils' guesthouse for five months. She took her meals with Dominique and John, usually in the kitchen. They insisted she continue to stay even when they were not in town.

In February and March, Rosamond delivered her lectures and gave her seminars, a series that was titled "Paris Masters." Audiences were electrified. Louisa Stude Sarofim, then a young woman only beginning to think about art, credited those lectures with spurring her to become a collector.

•

One evening, Rosamond Bernier looked across the room and was startled to see the Italian director Roberto Rossellini.[133] He was there with his three children, Isabella Rossellini and her twin sister, Isotta, from his mar-

riage to Ingrid Bergman, and Gil Rossellini, from his union with Indian-born Sonali Das Gupta.

An acquaintance of the de Menils' since the 1960s, Rossellini and the couple became great friends. He first came to Houston in 1968. Two years later, the director suggested making a documentary series on science. John invited him to stay in the house, to work with the Media Center at Rice University, and to interview the school's leading scientists. For more than four years, Rossellini commuted between Rome, Paris, and Houston, often making thirty trips per year.[134] The Menil Foundation supported his work financially, while John, personally, and Schlumberger Limited were also exceedingly generous. The de Menils might not have loved all of his films, though Rossellini was considered by the French New Wave to be the father of its movement. But they shared his commitment to humanist principles and were enamored of his big personality.

One evening at the house, Dominique noted a story he had just shared about his life during World War II. As she described it in her diary,

> Rossellini told me about the period between September and June 1943 when Mussolini returned to power. During a period of eight months, he lived on herbs that he gathered at the Colosseum and cooked with water. Each night, he slept in another house, organized by the resistance network to which he belonged. He was almost arrested three times. Once, he was in the mountains, near a village where he had placed his children, living alone in a cabin. At one point, he was hiding three English soldiers who had escaped from a concentration camp. That day, he was able to procure some pasta.
>
> They were all sitting at the table, the English in their uniforms, when the door opened. A German officer and a few other men began to enter the room. Roberto had the brilliant instinct to throw himself at the German, making a show of kissing him around the neck. The German was horrified, quickly pushed him away and didn't even see the English soldiers. He asked for directions and promptly left. As he walked away, Roberto blew him kisses.[135]

•

When Susan Sontag stayed at the house several times over the years, Dominique always organized dinner parties for her.[136] Not only did they become friends, but Dominique was an attentive reader of Sontag's work. *On Photography* spurred her to fill eight pages of one of her notebooks with quotations from the book and references.[137]

In 1973, Dominique arranged for Philip Glass to give a concert out-doors on the Rice University campus. Afterward, she invited him to have tea at the house. They sat together in the kitchen engaged in a long conversation. That first time, they spoke about his rigorous education with Nadia Boulanger in Paris. "The classical training that Boulanger forced on him became an obsession, a straightjacket," Dominique noted. "Everything was perfectly planned, regulated, impeccable." Glass told her about how he heard the great Indian composer Ravi Shankar and was enchanted. "He spent two weeks with him and then tried to emulate Indian music," Dominique noted. "He failed. His failure (he talks about his mistakes) interested him and he decided to develop it. His music came right out of his mistakes."[138]

Philip Glass remembered very well that first occasion in the house. "From that time on, whenever I was in Houston, I went and had tea with her," Glass said. "She became a really good friend." And he was enchanted by the informal tone the de Menils set in the house for their guests. "We often met in the morning, usually for tea," he recalled. "If the servants were not there, she would go into the kitchen, make the tea herself, and serve it in the kitchen."[139]

In 1972, when Dominique curated an installation of the work of Dan Flavin for the Institute for the Arts at Rice, Jasper Johns came to town for the opening. The artist had known the de Menils since the 1960s, when they began to buy his work. He had been to their town house in New York, but the Flavin exhibition was his first trip to Houston.

At the time, Dominique, surprisingly, was driving around town in a high-performance Shelby GT500 in candy apple red. "I rode from the exhibition with Dominique, in her little car, to the de Menil house," Jasper Johns remembered of that trip. "She entered the house and without removing her raincoat, went directly to stand at a buffet table and began to carve ham for the many guests."[140]

Two decades later, in February 1996, the artist was back in Houston for an exhibition of his sculptures at the Menil Collection. There was, of course, a dinner at the house in his honor. As Johns recalled the end of the evening, "Dominique told a waiter, who was taking away the dishes, to put her unfinished plate in the refrigerator so that she could have it for lunch the following day."[141]

•

The de Menils' house was a place for living and for entertaining, but it was, above all, a place to work. Beginning in the 1950s, John had his

assistants from Schlumberger spend at least some of their days at the house. Anne Duncan started working for John in 1955 in his office in the original Schlumberger building on Leeland Street. She worked with the couple on their personal affairs, paid household bills, and checked on the property when they were traveling. She also helped record information on their burgeoning collection of art. Once they had too many paintings to be accommodated at the house, John arranged to have important contemporary pictures hung at the Schlumberger offices.

Anne Duncan often had working lunches with Dominique, in the kitchen or at a table with two chairs in the entrance. A kitchen garden in back was used for meals. "She and Gladys picked the lettuce and made the salad," Anne remembered. "It was fresh lettuce with this delicious salad dressing that was like nothing I had ever had—very simple, just vinegar and oil. It was so French; those were the first really good salads I ever had."[142]

Chris Powell became John de Menil's assistant from 1956 until he retired in 1969. The first thing on her schedule was a 7:30 a.m. meeting at the de Menils' house. "Most of my days started at the breakfast table," Powell remembered with a laugh. "I'd go by there on the way to work. He would dictate letters across the breakfast table." John spent some days working at the house, meaning that she would return there later in the day to continue. "He found that he could work better from home," she remembered. "And he liked to work long hours because the phones weren't as busy in the evening. Many times we worked at the house until 7:00 p.m. or 8:00 p.m."[143]

When he retired from the family company, John worked from home, hiring a young Scottish-born woman, Elsian Cozens, to assist him; she would work with John until his death, in 1973, and then continue with Dominique for the rest of her life. In her first week working at the house, she had one small, instructive experience. He was giving dictation, mentioning an outing to the theater from the night before. He stopped the dictation and asked, "Elsian, do you know the name of the play that I saw last night?"

Without giving it much thought, she quickly replied, "Oh, I don't know."

John de Menil paused. Then he asked her to return to the dictation. And he continued, "Well, I just asked my assistant the name of the play, and she tells me she doesn't know the name of the play, but by the time she gives me this letter for my signature, I am sure that she will have found out!"

"I learned very early that to say 'I don't know' is a blank page," recalled Cozens, in what she specified was the first interview she had given in twenty-nine years of working directly for the de Menils. "It is dead. It takes you

nowhere. You have to say 'I'll find out' or 'I will look that up.' One had to be very precise and very correct all the time, and it was a great lesson for me."[144]

By the time John was no longer working at Schlumberger, the de Menils had their architect Howard Barnstone convert the garage into what they called the Collection Room. They hired one researcher, Ginny Camfield, whose husband, Bill, was an art history professor at the University of St. Thomas, for their massive, ongoing project on African and African American iconography, *The Image of the Black in Western Art.*

The Collection Room was then staffed with three young women, curator Kathy Davidson, administrative curator Mary Jane Victor, and collections assistant Mary Kadish. Although there were not titles at the time, the new staff was responsible for organizing the collection, documenting it with John de Menil, working with Dominique on her ambitious exhibition program, and arranging for loans from the collection to museums across the United States and around the globe.

By 1970, it was said the de Menil house, with its low-slung lines, expansive collection, and expanding staff, was "like some well-concealed, art power plant, its rays of influence extending outward over the international art world."[145]

•

Richard Koshalek began to know Dominique de Menil in the late 1970s, when he was selected to be the director of the Museum of Contemporary Art in Los Angeles. He was struck by the relationship between Dominique and the environment she and John had created. "Very seldom do you see a complete connection between the individual and their sensibility and the design of the house," Koshalek said. "And that was it. There was a complete, genuine connection between her and her sensibility and the house in which she lived. That house told you a lot about who she is—how she saw the world of art."[146]

Walter Hopps was already a legend in the art world when, in 1979, Dominique contacted him about the new museum she was beginning to plan. At the time, he was living in Washington, D.C., the curator of twentieth-century American art at what is now the Smithsonian American Art Museum. "She knew of my work and she called me down and I interviewed with her," Walter remembered of their 1979 encounter. "She explained she wanted to do a new museum, was keeping that very quiet, and that she wanted me to be the founding director."[147]

Walter began commuting between Washington, D.C., and Houston.

Dominique thought he should stay at the house. So he moved into one of the children's bedrooms.

The curator, of course, was very sensitive to the art in the house:

In my bedroom, I had three extraordinary paintings: a beautiful Mondrian, a Georges Braque, and a surrealist Victor Brauner. There was also an Edward Kienholz watercolor that he had given her.

In the living room, on the gray wall, was a beautiful Mark Rothko. Over the fireplace was a Picasso. In the kitchen was a wonderful study by Matisse, a gouache and cut paper in a simple black frame—she loved that—and another Picasso. Lastly, in the kitchen, she had one of her favorite Victor Brauners—not one of the more famous surrealists, but one who was very close to her.

In the front hall, she had the famous Yves Klein, *People Begin to Fly*, and an antique painting, very mysterious and surreal in spirit, by baroque painter François de Nomé. There was also a little contemporary sculpture in wrought iron by Chillida. She had in the hallway a fourteenth-century marble statue of Virgin and Child and a good piece of tribal art; there always was a mixture of things. Also in the living room, a couple of black African figures.

She was fascinated by some African tribes that had converted to Christianity, and over her bed she had the most amazing crucifix done by black Africans. At the same time, in her dressing room, she had a black African mask that had a cloth around it in the most mysterious way; she called that her black Madonna. It wasn't Christian at all, but she thought it was totally spiritual. It was unusual in that it was an African woman. So, in two very different senses, she had a very personal connection with a couple of African pieces that she kept very close to her.[148]

Dominique's office was down the hall in another of the children's rooms. Walter remembered that there was a proper desk, with a van Gogh painting above it, where Elsian worked. Dominique usually sat at a card table, with two telephones and four or five separate phone lines. "The whole damn Menil Foundation was run off a card table, with four phone lines and an intercom," Walter said. "On her bulletin board, she had pictures of her grandchildren and all sorts of mementos. If you went in that room, you would think that elderly lady was the assistant and the secretary was in charge."[149]

He felt that living in the house with Dominique was a fascinating way for them to shape the new museum. "I'd be working at my desk past midnight, she would get up to have a yogurt, and we'd have an absolutely uninterrupted hour to talk in the middle of the night," Walter remembered. "And no matter how early I got up, she was already at breakfast, so we could talk then. And we'd have lunch together with the rest of the staff that worked in the house; it was extraordinary."[150]

After Renzo Piano met Dominique de Menil at her Paris apartment in the fall of 1980, and she hired him on the spot to design her new museum, he made his first trip to Houston in January 1981. Going to the house was always a priority for the architect. After he arrived on an evening flight from Europe, his first stop was on San Felipe Road. "She was often with Ollie, the lady who worked in the kitchen," Piano said of Dominique. "But sometimes, I remember she cooked something, simply, and then we had dinner on the kitchen table with a beautiful little sculpture in the garden and a fantastic painting on the wall. And the conversation was about art, light, intensity of emotion."[151]

Piano often traveled with a large team, so they usually stayed together in a hotel. But Dominique also wanted him to stay in the house. "That was beautiful," Piano recalled. "Fantastic! It was this idea of sharing silence with her."[152]

Piano was struck by the extreme humility of his client. On Dominique's transatlantic flights, she insisted on flying coach, which meant, he said with amusement, that everyone else on Piano's team had to do the same. She made dinner in such a casual way, served it at a table in the kitchen, and then stood at the sink doing dishes. There was a quality, so fundamental that it did not even need to be expressed, that was channeled from the house to the museum.

As Piano explained,

This idea, simplicity, was never discussed, but it was clearly what we had to do. I learned from her that modesty was something you never talk about. "Simplicity" is one of those words that disappear if you name them. Like if you talk about sunlight and the sun goes away. Talking about simplicity, modesty goes away. We talked for ages with Dominique; we talked so much, about everything. But simplicity and modesty was never part of the discussion. It was the *essence* of what happened, but it was not part of the discussion.[153]

•

The house that the de Menils were able to create was not entirely unprecedented in their lives. But it was on an entirely different scale. The International Style architecture was new for them, and the sensuality of the interior, thanks primarily to Charles James, was much greater than anything they had seen or lived in before. The new pieces of furniture were more spectacular, and the historic pieces, also more extravagant, were given a more visible role in Texas. As she worked on the house and lived there, Dominique came to believe that it was crucial to combine the ancient, the antique, and the modern. "To me the old and the new do not exclude one another, they are indispensable to one another," she noted. "The new, the modern, without the old, is like a child without a family, without a tradition, or a man without memory. The old without the new is even worse. It's like a family where there would be only great grandparents, great aunts and uncles and no youngsters."[154]

Then there was the collection of art. As it expanded in size, quality, and scope, it became an indispensable element of the experience of the house. There was no way to separate the paintings, sculptures, and objects from any other aspect of the environment. And there was the remarkable gathering of people and ideas and events that filled the house over the decades. That any one location contained such a singular, powerful set of stimuli was exceedingly rare. That, too, became an intangible quality of the environment.

More than any single entity, it was all of the components together that made for such a remarkable atmosphere. There was a synthesis that took place within the walls of the house. It was like a controlled detonation, a discreet blast of good modernist architecture, exceptional interior design, a dizzying array of art, a fascinating collection of people, and a vibrant exchange of ideas.

Dominique and John—although the lack of humility associated with the idea would horrify them—managed to build their very own *Gesamtkunstwerk*, a total work of art.

NAIL HIT THIS TIME

*I am never happy with the notion of influencing someone. All
we can do is expose people to the art we believe in ourselves,
the art we love, and let them absorb what they are ready to
absorb. We can do no more than plant a seed and hope it will
germinate. Let the plant grow and blossom.*
—DOMINIQUE DE MENIL[1]

On February 4, 1951, the city of Houston discovered the
power of great art. The setting was a modest new build-
ing downtown that was called, rather optimistically, the Contemporary
Arts Museum. The asymmetrical, A-frame structure in corrugated metal
and glass, designed by a local modernist architect, Karl Kamrath, had
been built by the Contemporary Arts Association, a group that had been
founded less than three years before.

In the fall of 1950, only months after settling into their new house, John
de Menil took over the chairmanship of the Contemporary Arts Associa-
tion, an all-volunteer organization. He was forty-six years old; Dominique
was forty-two. They had begun collecting only five years before.

For the CAA, the de Menils offered to organize their first exhibition
of art. And they decided to begin with Vincent van Gogh. The choice was
revealing. They did not start with an artist they had already acquired—
Picasso, Braque, or Matisse. They did not choose one of the surrealists in
their young collection such as Ernst, Magritte, or de Chirico. Choosing
van Gogh was a way of luring their audience in with one of the most iconic
figures of modern art.

Dominique and John first contacted Theodore Rousseau, curator of
paintings at the Metropolitan Museum of Art, securing one of van Gogh's
famous *Sunflowers* (1887). When they asked the Museum of Modern Art,
they were lent two paintings: a peaceful Provençal hillside perspective,
Landscape in the Neighborhood of St. Rémy (1889–1890), and an ominous
watercolor of the insane asylum where van Gogh was a patient, *Corridor of
St. Paul's Hospital at Saint Rémy* (1889).

The de Menils estimated they sent close to a thousand letters to museums and collectors around the world, spending months coordinating with scholars and dealers, transporters and insurance companies, security firms and contractors. By the time Dominique and John opened their exhibition, they had managed to assemble twenty-one paintings, watercolors, and sketches by van Gogh, a concentrated, penetrating look at every period of the artist's short life. On opening day, two thousand visitors poured into the galleries. During the three-week run of the show, there were over fourteen thousand. "Vincent van Gogh Is in Houston," exclaimed *The Houston Post*. "In the living, flaming oils of some of his finest masterpieces. It is one of the most exciting events in Houston's cultural history."[2]

To spread the word, Dominique penned a letter to their friend the Columbia University professor Meyer Schapiro. "People used to dash by in their swanky Cadillacs, never stopping to see what was going on in our small building of corrugated iron that looks like a barn," Dominique wrote to Schapiro. "Now they come and to their amazement and enchantment, they discover beautiful and world-famous masterpieces." Schapiro had been one of their first contacts when they began to organize the show, so Dominique was pleased to advise him of the show's success. "Among the 1,266 visitors that came Sunday, there were fathers with babies in their arms, nurses, policemen, office girls, even cowboys—the Fat Stock Show is in full swing just across the street—maybe Hopalong Cassidy will come too, with a bunch of kids," Dominique wrote to Schapiro.[3]

The works Dominique and John had gathered traced the story of the artist's development. New York dealer Justin Thannhauser provided an early drawing from Holland, *The Potato Eaters* (1885). Paintings from van Gogh's time in Paris included, from Millicent Rogers, an expansive urban perspective, *View of Paris from the Studio of Toulouse Lautrec in Rue Lepic* (1886).

There were key works from van Gogh's time in Arles like John Hay Whitney's *Novel Reader* (1888), and from the artist's months in St. Rémy, Pierre Matisse lent a portrait of a Provençal field worker at work, *The End of the Day* (1889).

From the artist's final, tragic days in the Paris suburb of Auvers-sur-Oise, the de Menils persuaded Siegfried Kramarsky to lend one of van Gogh's most revered paintings, *The Portrait of Dr. Gachet* (1890). The painting had arrived in New York in 1939 and, until this show, never left. It had to be transported to Houston by train, in a special Pullman car. Dominique and Jean came to get it. "They traveled themselves by train to New York to pick up *The Portrait of Dr. Gachet*," remembered Christophe

de Menil, who was seventeen at the time. "It is just astonishing that Kramarsky was willing to let two unknowns borrow such a major, already-expensive painting; it was so extraordinary."[4]

There was an undeniable boldness to the entire undertaking. "It was just a potting shed," Christophe said of the museum. "It was a little A-frame building, and they had these super major paintings. It may be that the people involved recognized the very rare gall of Dominique and John de Menil to do this. They were not known, at all, at that point; later in New York it would have been easier."[5]

Dominique admitted that she was amazed they had attempted such an ambitious exhibition. "I can't think how naive I was—a van Gogh show," she said with a laugh. "We had beautiful van Goghs, but we almost slept there, John and I, we were so scared. Anything could have happened—no, the responsibility!"[6]

•

Dominique and John produced a fifty-page van Gogh catalog, with an introduction by Theodore Rousseau of the Met, the first of many publications they would create over the decades. An unsigned foreword, written by John, explained the point of the exhibition. The goals were to expose the city, and the South, to its first exhibition of the Dutch master, to explore an artist whose use of color was influential for other contemporary artists, and to highlight someone whose work was not appreciated until many years after his death.[7]

The de Menils sent their van Gogh catalogs to all of the lenders and those who had helped the show. Most were enthusiastic. MoMA's Alfred Barr wrote back to John to congratulate them, suggesting that the catalog was handsome and the format was interesting. The MoMA director, however, had one "minor criticism" for the de Menils. They had chosen to have some of the images extend off the page. As Barr wrote to John,

> It seems to me not a good practice to "bleed" reproductions of paintings and drawings. The bleeding process actually cuts off as much as one quarter inch of the image, giving the eye an uncomfortable feeling that the picture goes on at one or two sides, whereas it is closely defined on the other sides. In the case of our two pictures for instance, with the landscape I see the whole picture, in the corridor, a considerable strip is missing from the left and the picture itself seems to be slipping off the page.[8]

The de Menils were still learning, and in the scores of catalogs they published after Barr's observations, there would not be works of art that bled off the page.

For the show, the de Menils had the museum open every day from 2:00 p.m. to 9:00 p.m. Admission was free.[9] They also made sure there was something of a film series, with a van Gogh documentary that was shown at local high schools, community centers, and universities.[10] The exhibition increased membership in the CAA; by the end of the show, the group counted around five hundred members.[11]

Shortly after the exhibition opened, John Hay Whitney wrote to John de Menil saying he and his wife were delighted to receive his telegram about how admired the painting they had lent had been and that they intended to give it to the Contemporary Arts Association of Houston for its permanent collection. Whitney told John that he had been involved with MoMA since its inception and that he had seen the impact that the museum could have on people who had no prior interest in art. "From my experience here, I know many of the difficulties now confronting your organization. This, together with the knowledge of your efforts to fill a niche that heretofore has been somewhat by-passed, has given Mrs. Whitney and myself the desire to assist you."[12]

The Whitney gift generated much coverage in the local press.[13] The success of the exhibition was significant for the local perception of the de Menils, the first real sign of a public presence. "It cemented their position here," recalled Gertrude Barnstone. "They put down roots with that exhibition; a lot of people became supporters. There was some opposition and jealousy, mostly from some people in society, but right away there were others in Houston who adored them and recognized them."[14]

•

Throughout the 1950s, Dominique and John, and this distinguished them from many collectors, were fascinated with the lives, the thinking, the worlds of artists. It was not just what they produced that appealed to them, it was the character—good and bad—that surrounded the work.

Dominique took notes on various artists. Some of her earliest notes, which she kept in red Daily Reminder agendas or plain spiral, lined notebooks, came from a 1945 conversation with Pierre Matisse at his New York gallery. "He was telling us about the cruelty of painters," Dominique noted. "The cruelty of some great painters. Picasso and Matisse offered to exchange paintings. Picasso chose the worst Matisse and hung it in his studio."[15]

In the summer of 1952, Dominique and John went with Father Couturier to Varengeville-sur-Mer, on the northern coast of Normandy, to meet Braque. She was first struck by the artist's garden. "Scrubland sculpted into Braque-like forms," she noted. "Not one flower. Irregular aisles of herbs between shrubs trimmed to about one meter in height. Squares, intersections, roundabouts, niches—a real labyrinth with a studied sense of fantasy."[16]

Dominique thought Braque was thinner, more bony than she had seen in portraits. She showed him slides of some of his works that they had acquired. Braque admired the quality of the reproductions and gave them dates and background on the pictures. When she showed the little cubist collage *The Bottle of Marc Brandy,* the artist was effusive. "Oh, you have a collage," Braque said to the de Menils. "I only know two or three people who do. Even I was unable to secure one for a recent exhibition."[17]

In discussing their large still life *Pitcher, Candlestick, and Black Fish,* Dominique told Braque that some of their friends had offered to buy it. "I told him that others had gradually become accustomed to the painting; that it is only time that can allow us to judge a work of art. Although, I also added, that there are some paintings that can no longer be tolerated after a few days. He smiled at all of that."[18]

At the de Menils' apartment in Paris, the sculptor Alberto Giacometti spent the afternoon talking with Dominique. As she wrote to John,

> Giacometti just left. He stayed three and a half hours, and during that time we never stopped talking about art. He is exceptionally intelligent. In my mind right now, everything is a little jumbled but, slowly, as things come to the surface, I will note them: Braque, Picasso, Matisse, Mondrian, Chardin. I will need hours to retrieve everything he spoke about and to try to put it in his style. It was a wealth of ideas about art that I will draw on for a long time.[19]

In a conversation with Victor Brauner, the Romanian-born, Paris-based surrealist, Dominique was pleased to see how positive he could be about a fellow artist. "Picasso is a sun, a Mithra," Brauner told Dominique. "He is successful at everything he does, and all of the women are in love with him. Now, after sixty years of career, he has started to work like a twelve-year-old—he can paint however he likes—complete liberty." Brauner explained to Dominique how he responded to the Spaniard's work. "Whenever I am in front of a Picasso painting, I feel good. It makes me want to work."[20]

Dominique spent time at the house with the sculptor Jacques Lipchitz. As they looked at the de Menils' paintings, she noted his scathing remarks about virtually every other artist.

Lipchitz on de Chirico: "Poorly painted. I knew Chirico in 1914. Along with a few others, we found it interesting, but it is not painting."

Lipchitz on Rouault: "A talent, an artist, a profoundly religious man, a good illustrator, a sincere artist, but he is not a great painter."

Lipchitz on Léger: "It is strong, like a fist in the gut, some very good qualities but not a great painter."

As Dominique noted, "In front of the admirable Ernst in the kitchen he said nothing. He turned away from Brauner so that he would not have to say anything negative. When questioned, he said, 'It's nothing but daubs of paint.' He does not like the surrealists. Does not like the abstract expressionists."[21]

But Dominique enjoyed Lipchitz's seriousness about the artistic process. He told her about a lecture he had heard at MoMA suggesting that anyone who could understand the beauty of a spoon could understand Michelangelo. As the artist told Dominique, "It's a long way from a spoon to Michelangelo!"[22]

•

The de Menils continued to buy major works of art, pushing their collection into new areas in the 1950s. From Iolas, they bought three boxes by Joseph Cornell: the first was *A Swan Lake for Tamara Toumanova (Homage to the Romantic Ballet)* (1946). It was a sensitive shrine to the famous Russian dancer, in painted wood, vivid blue glass, velvet, and rhinestones. As John wrote in his meticulous curatorial notes, "An actual wisp or two of a white feather from a headpiece worn by Toumanova in *Swan Lake* mingles with the larger ones bordering the box."[23] The de Menils would go on to own twenty-one perfect, poetic Cornell boxes.

They also began acquiring works from the New York dealer John J. Klejman, who specialized in African and Oceanic objects as well as Byzantine, Greek, and Roman antiquities. The J. J. Klejman Gallery, located across from the Carlyle hotel, became an important source of antiquities and non-Western pieces for the Metropolitan Museum and such leading collectors as Nelson Rockefeller. "John Klejman made buying African art very tempting," Dominique explained. "He lived just a couple of blocks from us in New York and he had fabulous African and Pacific Islands pieces. We started slowly, but every year added a few more primitive works."[24]

The de Menils acquired their first piece from Klejman in 1957. In only three years, they bought forty-two objects from the dealer, ranging from a prehistoric bone carving to early twentieth-century African masks. Non-Western pieces that were particularly important included, from New

Guinea, a large, double wooden figure, *Finial for a Ceremonial House*. It had come from the house of a chieftain and was constructed on pillars that rose out of Lake Sentani. Also acquired at Klejman was *Rooster,* a large representation of the bird in a heavy cast brass, from the Edo peoples of Nigeria, that came from a royal, maternal altar. Over the years, Dominique and John would go on to buy over five hundred pieces from J. J. Klejman.

As Kristina Van Dyke, a curator at the Menil Collection, wrote in 2008 about the African pieces from the de Menils' non-Western works,

> The African holdings at the Menil Collection number close to one thousand objects, ranging from a miniature Kongo ivory finial to a near life-size Bongo grave marker. There are areas of concentration, including Dogon sculpture and Bamana masks and headdresses, Inland Niger Delta terra-cottas, Benin bronzes and Lega ivories and "maskettes." Punctuating these groups of objects are unique works, such as a Jukun figure or a Luba mask. Assembled largely between the 1950s and 1970s, the African collection is self-consciously idiosyncratic, like the de Menils' collecting in other areas. The couple did not have a predetermined agenda and did not aim to be encyclopedic in this or any part of their collection.[25]

Throughout the 1950s, the de Menils also continued exploring their earlier areas of interest. They expanded their holdings of surrealism, particularly Ernst, Magritte, Brauner, and Matta. At the time, particularly in America, where abstract expressionism was the exciting new art form, most collectors and curators were uninterested in the surrealists. "I always had the feeling that Surrealism was looked upon as one looks upon a member of the family who has gone astray, an unsavory character one does not mention too often," Dominique recalled. "At the Museum of Modern Art, only Jim Soby was truly interested in Surrealism. Alfred Barr was very interested in Max Ernst and would have liked to acquire more but he had no money for such acquisitions—he told me this himself."[26]

Other artists also spurned surrealism. "The taboo against any representation was strong, particularly in art schools and in artists' circles," Dominique said. "A mere suggestion of the human body or a glimpse of a landscape seemed to disqualify an artist. In front of paintings that showed some representation like the Surrealists' paintings did, the avant-garde artists seemed indignant."[27]

The de Menils did acquire important abstract works. In 1957, they bought their first two paintings by Mark Rothko from the Sidney Janis Gallery. *The Green Stripe* (1955) was a large canvas, over four and a half feet

by five and a half feet, in a vibrant yellow, with, on the lower third, a darker orange rectangle set off with a thin green stripe. The second, *Untitled (No. 10)* (1957), was even larger, five feet by almost six feet, also painted in bold yellows with, in the center, a smaller, pale rectangle that seemed to vibrate off the canvas.

But there was a fierce competition for the abstract expressionists. "Things were not always available," Dominique recalled. "One would go to the Leo Castelli Gallery and the whole show would already have been sold."[28]

So the de Menils focused on what was available and gravitated toward areas that were reasonable. They acquired an exquisite van Gogh drawing, *Garden with Weeping Tree, Arles* (1888). And John, in an act of great generosity, purchased a Gauguin painting for Dominique's mother, who had always wanted to buy one.[29] But by the time Dominique and John were collecting, the impressionists were already priced beyond their budget.

As they continued to buy, they also encountered difficulties. Just after hearing the good news that an Ife sculpture had been cleared for export by the government of Nigeria, John was advised that a Matisse cutout they owned, depicting apples, was a fake. "I showed it to Pierre Matisse," John wrote to Dominique. "He was categorical, and the explanations he gave me were convincing." John learned that the Matisse initials were hesitant, the form of the apple was tentative, and the paper was of poor quality.[30]

Both Dominique and John had disliked the term "collectors" and were reluctant to accept the label. They felt that it conjured images of the great fortunes of the nineteenth century. "It's like listening to people talking about Cadillacs when one can only afford a second hand Chevrolet," Dominique once said. "Collecting was a fine occupation for tycoons living in the pre–World War I era—it belongs to the past."[31]

But it was during the 1950s that the de Menils were forced to admit that they had, indeed, become art collectors. John explained, in his style, why:

So, there are the fakes and the lemons and the total involvement and the engulfing passion. There is all of that but it's worth it. It keeps you going—to live in the wake of the artists of today—a marvelous cure against sclerosis. You learn a lot in the process of researching and cataloguing. A lot about civilizations—about men and their yearnings and their fears.

And then there is the delicious companionship with this painting on your wall or this object on your table. A quiet companionship and a sound one as, indeed, in our days of high voltage activity we have to learn to sit and do nothing and let our mind come to rest

and then, little by little, it will start meandering through new ideas, discovering new feelings.[32]

•

The increasing pace of Dominique and John's lives and their collecting in the 1950s was fueled by the fact that the family company was performing exceedingly well.

Marcel Schlumberger died in 1953, creating great concerns about inheritance and the future direction of the company. In the wake of his death, John's World War II initiative—to have the international divisions of the company chartered as an English firm—was expanded and solidified. In 1956, a group holding company, Schlumberger Limited, was incorporated in Curaçao, overseeing all Schlumberger businesses.[33] It was, for better or for worse, the beginning of "the great post–World War II expansion of multinational corporations," and Schlumberger Limited was at the forefront.[34] After the formation of the new group, John de Menil was named director and chairman of the executive committee of Schlumberger Limited.[35]

During the 1950s, the company was also on a buying spree and had begun diversifying.[36] Significant benefits began to flow throughout the Schlumberger family. Dominique's niece—Henriette de Vitry, the daughter of Annette—was married in 1953. "I learned that, as shareholders, my two sisters and I had capital of $1 million," explained Henriette de Vitry, which would be comparable to a shared net worth in 2016 of $23 million.[37] "I was overwhelmed. We had different reactions. My eldest sister wanted to transport a cloister from France to America with that money. My other sister and I wanted to hang on to it. So this was 1953, and I had around $300,000; you can see how it exploded."[38]

Henriette de Vitry was part of the third generation of the Schlumberger family. So their shares of the company were diluted. Dominique, her two sisters, and her three cousins—the senior generation of the family after the deaths of Conrad and Marcel—benefited exponentially more from the great commercial success of Schlumberger Limited. Henriette de Vitry heard Dominique's cousin Geneviève Seydoux say during those years, "You know, it's all multiplying so fast that we can barely get it to the bank!"[39]

•

As they moved into their second decade of being based in the United States, Dominique and John led busy and exciting lives, culturally and socially, particularly when they were visiting Europe.

In the summer of 1950, Dominique went with Maria Ruspoli to Venice. They stayed at the Hotel Bauer Grünwald, on the Grand Canal, and explored the city. As Dominique wrote to John,

> Every time you turn a corner there is another surprise: a small square with an ancient column, the terrace of a house covered with wisteria, a small pink palace that looks like lace, marble steps that descend to the water, and then these gondoliers in white smocks, in their large straw boaters with red ribbons, who, with such a beautiful movement of their bodies, gently glide their gondolas.[40]

Several years later, in the early autumn of 1954, Dominique and her mother went to the Venice Biennale, where they met up with Iolas. Dominique and Iolas toured the final days of the fair. She admired a display of sculptures by Fazzini and a few Brauners in the French Pavilion. The American Pavilion was represented by Ben Shahn and Willem de Kooning. Peggy Guggenheim was in Venice at her palazzo. At Iolas's urging, she had just purchased the last version of Magritte's *Empire of Light,* which had been created for the Biennale. The dealer took Dominique to meet the American collector.

When she was in Paris, Dominique often hosted dinners at the rue Las Cases, such as one, on a Wednesday evening in April 1955, for Philippe and

Dominique and Maria Ruspoli in Venice, summer 1950.

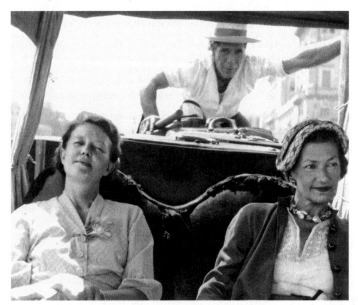

Pauline de Rothschild (formerly Pauline Potter), who came to Paris just for the occasion from their Château Mouton Rothschild estate in Bordeaux. Other guests included Jean Paulhan, writer and director of the *Nouvelle Revue Française;* Henri Bonnet, the architect of the European Union; Georges-Henri Rivière, founder of the Musée de l'Homme and the Musée National des Arts et Traditions Populaires; and James Thrall Soby, the collector, curator, and writer long affiliated with MoMA. Schlumberger executive Jean Riboud, and his Indian-born wife, Krishna, stopped by Les Halles to buy flowers; another Schlumberger executive, Guy Babouin, brought the champagne.[41]

During one week in January 1959, Dominique hosted a Monday dinner at her apartment for Giacometti, with her mother and Joseph Breitbach, a German writer who was the lover of her uncle Jean Schlumberger; both were great friends of Madame Conrad.[42] The following night was something of a political gathering with Jean Riboud and a few French diplomats.[43]

Dominique also went to a lunch given by Nelly de Vogüé, the former lover of and literary executor for Antoine de Saint-Exupéry. Guests included a curator from the Louvre, an aging Count de Montesquiou and his wife, an architect who had designed the French Pavilion at the 1958 World's Fair in Brussels, and the son of Camille Groult, an industrialist who had been a major art collector in the nineteenth century. "This kind of gathering is perfect for me," Dominique wrote to John. "I am at ease; I laugh; I have the unmistakable feeling that I am thought to be more intelligent than I really am—if they only knew about all of the wastepaper baskets where I picked up my knowledge!"[44]

Dominique also met more figures in the art world, including Christian Zervos, the Greek-born critic, connoisseur, and curator who had founded *Cahiers d'Art.* Zervos had begun exhibitions of modern art in the Papal Palace at Avignon in 1945, which led, in 1947, to the beginning of the Avignon Festival, the oldest and most important multidisciplinary arts festival in France. Dominique spoke with Zervos about doing similar art events in Houston. "He proposed doing exhibitions of groups of painters, very simply, as he had done in Avignon," Dominique wrote to John. "It seemed refreshing to do exhibitions in a simple way with one or two or three or four painters. Too much sophistication ends up missing the point: making others love the best works by great artists."[45]

And she continued her contact with artists. Max Ernst and Dorothea Tanning had moved back to France. Dominique and Iolas went by his studio. "Iolas thinks that works by Max Ernst will reveal themselves," Dominique wrote to John. "And that people, who are always twenty years behind, will take time to understand what he is saying."[46]

•

In the fall of 1954, the de Menils moved into an apartment at 120 East Eightieth Street.[47] It was a handsome federalist-style redbrick town house originally built in 1930 for the banker George Whitney. Its entrance had a semicircular portico in limestone and Doric columns.[48] A large staircase led to the de Menil family apartments on the second floor. The apartment had an entrance, also used as a dining room, bedrooms, and a large, wood-paneled study, with a fireplace, and balconies overlooking the street. Dominique and John allowed their daughter Christophe, in her early twenties, to help with the interior, including dramatic dark gray walls in the entrance.[49]

John's niece Bénédicte Pesle remembered being very taken with the paintings she saw at their New York apartment, particularly the latest work of the surrealists. "I had never been confronted by contemporary painting," Bénédicte recalled. "In France, we saw Picasso, Matisse, and Dubuffet. But not too much of either Max Ernst or Magritte."[50]

On one afternoon in New York, in the summer of 1955, Dominique had encounters with the work of two very different figures in her life. "I just saw the latest collections of Charles James and Mies van der Rohe," she wrote to John. "I ran from one to the other, in the rain, under a large coral-colored umbrella."[51]

She was pleased to discover the evolution of James's recent work. "It becomes more and more personal, more and more original, more and more avant-garde. He is at the zenith of his genius, ready to make a real name for himself if the opportunity is there, but he is still so little understood except by his rare clients, his wife, Nancy, and his first assistant."[52]

Several weeks before in Houston, Dominique had had dinner with Mies van der Rohe as the Museum of Fine Arts embarked on a new building by the German modernist. "An architect doesn't have to express himself," Mies declared that night over dinner, "he has to find the best solution to a given problem." Dominique was particularly impressed by another of the architect's pronouncements that evening. "I'm a stonemason," Mies told her. "My father was also a stonemason."[53]

In New York, the day she visited James, Dominique was alerted by Howard Barnstone that some people in Houston, having seen Mies van der Rohe's first drawings, were turning against the project. The architect was in New York, working on his majestic Seagram Building. So, following her afternoon with James, Dominique had a 5:00 p.m. drink with Mies. The goal of their conversation was "to explain to him that if this was not ended quickly the hostile forces could kill the project."[54] The project was not derailed.

John, during his time in New York, became increasingly involved in the Museum of Modern Art. He joined the board of the International Council, the group credited with solidifying the worldwide reputation of MoMA.

John gave thought to the group's goals. "The purpose of the International Council—if I understand it correctly—is to acquaint other nations with the cultural contributions of America in the field of art, the ultimate purpose being a better understanding of this country," John wrote to Bliss Parkinson, the longtime MoMA trustee who oversaw the program.

> I also understand that while the emphasis is on Contemporary Art, the Council feels free to draw on the past where it can help to show our selective eye or where it can connect our past to artistic traditions of other countries. It is an intelligent approach and perhaps, I would dare to say, the only intelligent approach . . . People are much too inclined to be partisan in their like and dislike of modern art and, failing to see the forest for the trees, they also fail to realize the continuity of artistic creation over the ages. Showing this continuity should, I believe, be an important part of our program.[55]

•

By the 1950s, John de Menil felt that he had fully recovered from his heart attack. "Five years of life: how good that is," he wrote to his doctor in Colorado Springs, in September 1950, also delivering a case of fine French wine to the physician on the five-year anniversary of his attack.[56]

John remained vigorous in his career at Schlumberger. His assistant Chris Powell was astounded at the sheer amount of work that he could do. "There were six or eight of us secretaries over at Leeland," Powell remembered. "He would dictate letters to one girl—all she could take—then he'd move down to the next one and give some more, then the next one and do some more. And I thought, 'Where do all of these words come from?'"[57]

She felt that John could be tough but that he was fair. "He was very demanding and very fractious," she said with a laugh. "But he worked just as hard as he worked everybody else." She also witnessed his unsolicited acts of generosity around the office "Once when he came back from Europe, he brought every girl in the office a bottle of French perfume," Powell remembered. "He would put it on our desks; I don't think he ever made a trip to Europe that he didn't bring back some kind of a little present for everybody."[58]

The same visual flair the de Menils exhibited at home was extended to the first Schlumberger offices at 2720 Leeland. By the mid-1950s, John was bringing art from the house to hang on the walls at work. "It was a beautiful office, so modern, with modern art and charcoal-gray floors and white walls," recalled Powell. "I'd never seen an office like that before; I thought I'd died and gone to heaven."[59]

The Museum of Fine Arts registrar remembered visiting Schlumberger and being struck by the de Menil style. "He had a dark carpet on the floor and the walls were white," said Edward Mayo. "And there was a big Fernand Léger painting, a constructivist one, with beams and building materials."[60]

In 1957, after the formation of Schlumberger Limited, John moved his offices to the Bank of the Southwest Building, a twenty-four-story modern tower in glass and steel that had just been completed.[61] A Schlumberger executive, Pierre Pelen, showed the space to John, who told him not to worry, that he would take care of everything. John enlisted Howard Barnstone, and together they created a modern space with natural flooring, spare furniture by Knoll, and muted walls with flashes of color. "And I suddenly found myself in an office that was beautifully furnished with tremendous taste and restraint. There was a very sober desk and behind me a marble table that was very useful; it was superb."[62]

•

The de Menils also continued with a variety of building projects.

In 1952, they heard that a parish west of River Oaks, St. Michael's, was hoping to expand. They offered to pay St. Michael's fees for a significant architect, and they quickly contacted Philip Johnson. "Dominique told me about the possibility on the church and I am already hard at work," Johnson wrote to Howard Barnstone.[63]

Johnson came to Houston to see the site and discuss the project with the St. Michael's priest. "He meets Philip and Philip charms him and it's all decided," Dominique recalled. Johnson conceived what he later characterized as one of his first Romanesque designs. "Philip does something not very interesting, not at all what one could call modernistic, but nothing that a bishop could ever be against," Dominique remembered. "Well, the bishop turns it down! The bishop says, 'Absolutely not!'"[64]

Several years later, Dominique and John heard that St. Thomas University, which occupied a few historic buildings scattered over several blocks in the Montrose section of Houston, between River Oaks and downtown,

was interested in building a new campus. The main building was the Link-Lee mansion, completed in 1912, a ten-thousand-square-foot house in pale brick and glazed terra-cotta at the corner of Montrose Boulevard and West Alabama Street. In 1952, around the corner, the university bought a redbrick colonial-style house that had been the childhood home of Howard Hughes. Two years later, it constructed a flat-roofed library in pale brick.[65]

The Basilian fathers at the University of St. Thomas approached the de Menils. "We had not had contact with St. Thomas," Dominique recalled, "but they had heard that John had offered to help this pastor [at St. Michael's] and that the bishop had turned it down."[66] The Basilians insisted that the final decisions would be the de Menils'.

Dominique and John hired Philip Johnson to design a master plan for a campus for the University of St. Thomas, one that would be constructed in several phases over the years. The architect returned to Houston to meet the administration. "Of course, Philip absolutely charmed them," Dominique de Menil recalled. "And he made the mall on the idea of that campus by Thomas Jefferson, the University of Virginia."[67]

Johnson's design for the University of St. Thomas involved two-story, flat-roofed structures in light brick, black steel, and dark glass. In a pure Miesian style, the buildings were reminiscent of some of the German's work for the Illinois Institute of Technology.

But Johnson's University of St. Thomas buildings were to march down both sides of a quadrangle, a large open space with a spacious lawn and large oaks. To unify the various structures, he devised two-story porticoes on each side, graceful units of black steel that ran the length of the quadrangle. The pure lines of the buildings, and the walkways that connected them, were set off by the large, leafy courtyard.

Dominique worked closely with Philip Johnson on his plans for the building. She was in Paris, however, when he arrived in Houston with his final drawings. "Magnificent News," Howard Barnstone wired to Dominique. "Philip here with beautiful, beautiful plans. Presenting them to the Fathers Monday. It's everything you'd hoped and more."[68] After the meeting, Barnstone sent Dominique another telegram. "The Fathers accepted enthusiastically today allover scheme and plans for first building. He's going into working drawings immediately. Looks like everything going greatly."[69]

The campus's first buildings—funded by other Houston patrons—were Jones Hall, an auditorium completed in 1958, Strake Hall, a 1958 classroom building, and Welder Hall, a cafeteria and student center finished in 1959.

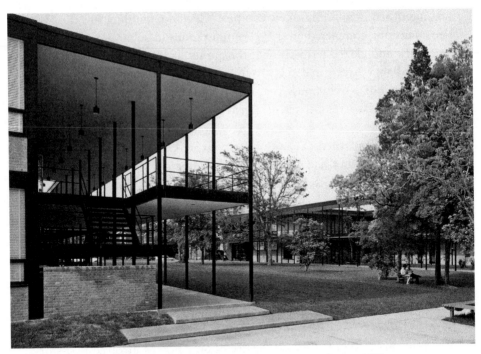

The campus of the University of St. Thomas designed by Philip Johnson, 1958.

The school cafeteria with a changing installation of the de Menils' art.

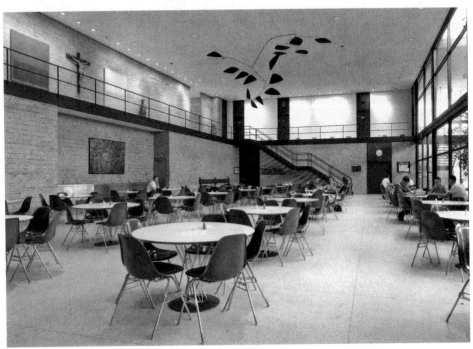

Thanks to the de Menils' initiative, and their insistence on hiring Philip Johnson, the University of St. Thomas had become a rigorous, modernist campus of real architectural significance.

•

Around the same time, Dominique and John began working on their country house outside Paris in the village of Pontpoint. When it was bought by John's family before the war, the seventeenth-century manor house was partially a ruin. Over the years, John's father and siblings had worked to restore it. But by 1954, the de Menils had engaged Pierre Barbe to conduct a major renovation.

Pontpoint, a small village in the Seine-et-Oise about an hour northeast of Paris, was a peaceful spot along the Oise River adjacent to the forest that ran south to Chantilly and beyond. The de Menil property, marked by a discreet stone wall that ran along the main street, the rue des Écoles, was originally called the Maison Basse. "Meaning that they were able to find a superb ancient manor house with the most modest name possible," said Ladislas Bugner, a Paris acquaintance of the de Menils'.[70] The house was large blocks of limestone, with oversize French doors and windows, two stories tall, with a high mansard roof of dark red ceramic tiles. Within the family, the house became known simply as Pontpoint.

Simon Jardin, the son of the de Menils' great friends, helped supervise the renovation. The team included Barbe, some ten contractors, and Dominique overseeing it all. "I did everything according to her directions," Simon Jardin recalled. "We redid the electricity, reworked the heating, which meant the walls had to be taken apart." John visited Pontpoint every six months to check on the progress. As Jardin remembered, "At one point, he said, 'It's really starting to get expensive; try to slow things down a little.'"[71]

What the de Menils, and the team, were able to create at Pontpoint was remarkable. "It had been practically abandoned," Jardin said. "It was a house with an extraordinary soul that became a magnificent place."[72] The proportions of the rooms were large and gracious. Many of the floors were red tile, walls were pale stones, and the ceilings were supported by large wooden beams. There were oversize fireplaces with large stone mantels and dark wooden doors. A curving staircase upstairs had steps of rough, unpolished wood and aged metal railings. Bedrooms were monastic, with white walls and floors of unvarnished rough wood planks.

Rosamond Bernier immediately published Pontpoint in *L'Oeil,* with photographs by Marc Riboud. As the story announced,

The interior is of a beautiful sobriety that sets off the quality of the material: stone walls, exposed beams, tile floors. This intentional austerity is enlivened by paintings from the important art collection that has been assembled by the de Menils. They have also used beautiful rustic furniture, many pieces from Spain, but also modern furniture that goes perfectly with the decor. The sofas and curtains of the ground floor are in neutral colors and are the perfect backdrop for the art.[73]

Hanging on the seventeenth-century stone walls of Pontpoint were de Menil pictures such as Léger's majestic *Mother and Child,* Rouault's somber *Le juge,* and a Picasso painting in blues and whites, *Caged Owl* (1947). There were elegant canvases by Bérard, surrealist abstractions by Brauner, Gothic wooden sculptures, and African masks. In the library, between a pair of windows above a simple contemporary sofa, was a large oil on plywood by Matta, *We Arrive Flying* (1951).

A small salon, with a new sofa and antique Louis XIII table, was dominated by the expansive Rothko canvas in vivid yellow, *Untitled (No. 10).* Simon Jardin was not convinced about some of the art. "Simon, you have to educate yourself a little," Dominique said to him. "It's important to know the art of our era, and it goes very well with these old stones."[74]

The exterior of Pontpoint, the de Menils' seventeenth-century manor house northeast of Paris.

Magritte's *Golconde* hangs in the living room of Pontpoint.

Pontpoint became an important base for the family over the decades. The grounds even contained, for the children who had been deprived of one in Houston, a swimming pool. Dominique and John were pleased with the result, of course. But their ultimate goals were elsewhere. And they kept their eyes on that objective. "I don't want to invest too heavily in Pontpoint," Dominique wrote to John, once the renovation was completed, in 1958. "I am worried about the future of France, and I would also like to continue buying works of art. I want to leave a mark on Houston, so there is a level of quality that has to be maintained."[75]

•

Integral to the de Menil mission was a curator, museum director, and great friend who would arrive in Texas in 1955, Dr. Jermayne MacAgy (1914–1964), née Smart. Known to everyone as Jerry, she was eternally characterized as "young, dark-haired, and vivacious." She was small, five feet three inches, with an outsize personality.

Born and raised in Cleveland, MacAgy graduated from Radcliffe and remained in Cambridge for two years, studying for her master's at the Fogg

Museum. Returning to Cleveland, she continued her graduate studies at Western Reserve University, earning her master's in 1938, and, the following year, receiving a Ph.D. in art history with a dissertation on folk art.[76]

While working at the Cleveland Museum of Art, she met and married Douglas MacAgy, who was also a curator at the museum. When he was hired by the San Francisco Museum of Art, the couple moved to California. Jerry MacAgy began working at the California Palace of the Legion of Honor, the neoclassical building in Lincoln Park. In 1943, with the wartime absence of the director, she became the institution's acting director, making her, at twenty-nine, the youngest museum director in the United States.

At the Palace of the Legion of Honor, MacAgy was able to conceive shows, install them, and forge real friendships with artists. "Among museum people she was one of the most lovable persons I have encountered," said Mark Rothko. "Her taste, her courage, her drive in presenting what she believes in I have found seldom surpassed."[77] Clyfford Still was equally enthusiastic. "To speak of Jermayne MacAgy—she was always 'Jerry' to many of us—is to recall a bundle of life-force," the artist wrote. "One of the qualities that most endeared her to us was her aliveness and her lack of fear in letting everyone know it. It is a very rare condition."[78]

MacAgy was one of the first to sense the genius of Joseph Cornell. She acquired some of the most beautiful boxes by the artist, even though her

Jermayne MacAgy, director of the Contemporary Arts Museum, in front of her 1958 exhibition *The Trojan Horse: The Art of the Machine*. Photograph by Eve Arnold.

budget was very limited. As Dominique recalled, "In her correspondence there is a letter from Cornell apologizing for charging her thirty-five dollars for a box."[79]

Walter Hopps had seen MacAgy's exhibitions in San Francisco. He, too, was enthusiastic about the curator. "She had an innate sense of visual theater, and, with resourceful alchemy, mounted exhibitions of exceptional appeal and invention," Hopps wrote. "She pioneered thematic exhibitions, mingling periods, cultures, and genres."[80]

MacAgy had a very personal philosophy about how to curate and exhibit works of art. Her education had been rigorous, her curatorial research was impeccable, but she was also convinced that an exhibition had to be alluring. John de Menil described her distinctive approach as "scholarly but seductive."[81] A sharp summary of MacAgy's qualities, it would also become a précis of the de Menils' cultural activities. MacAgy, as well as Dominique and John, began with a solid base of scholarship but added a sense of seduction, a desire to charm others into the appreciation of art. *Scholarly but seductive.*

•

In 1952, Dominique and John were still involved with the Contemporary Arts Association, but they had done enough at that point to know that committees were not the best use of their abilities. There was the feeling that a professional director should be hired. The de Menils knew Douglas MacAgy, through MoMA, and proposed him. He was not available and suggested his wife.

Jerry MacAgy was invited to Houston. She met the trustees, including Dominique and John, and left a report on the Contemporary Arts Association. MacAgy's recommendations were for bold thematic exhibitions, shows that would span the eras of art history. An exhibition of Hieronymus Bosch, for example, would also include contemporary painters that were in a similar vein. MacAgy also suggested the importance of incorporating non-Western works, proposed doing shows of local artists, and advocated for exhibitions of the latest works by New York painters in order to keep the city current on the latest contemporary developments.[82]

It was a thoughtful report that was, essentially, ignored. No decision was made on hiring a director; the Contemporary Arts Association continued as before. Several years later, the report was given another look. As Dominique recalled, "Margie Selden, the chairman of Contemporary Arts Association, looks in the file, reads Jerry's report, and says, 'Well, it's extremely intelligent what she has written—what about Jerry?'"[83]

In the fall of 1955, Jerry MacAgy arrived in Houston as the first director of the Contemporary Arts Museum. Dominique and John soon discovered how talented she was. Supported and encouraged by the de Menils, MacAgy was responsible for twenty-one exhibitions there from 1955 to 1959, many of them groundbreaking and ahead of their time. "Jerry MacAgy made a big impression, probably swinging the art world more into the public fore than anyone else had in Houston at that time—even the Museum of Fine Arts," suggested Edward Mayo, registrar for the Museum of Fine Arts.[84]

The Contemporary Arts Museum building, after its modest lease expired downtown, was cut in half and relocated several miles south on Main Street to its new location on the grounds of the Prudential Building, a new eighteen-story structure. MacAgy's shows in the A-frame museum ranged from a portrait show, with works from Frida Kahlo to Lucian Freud, titled *Let's Face It* (November 8–December 2, 1956), to a small but powerful sculpture show called *Monumentality in Modern Sculpture* (December 13, 1956–January 13, 1957). There were sixty objects from such artists as Degas, Matisse, and Rodin; the de Menils lent Giacometti's *Nu debout,*

MacAgy's 1957 *Mark Rothko* exhibit.

one of his signature elongated figures, just over eight inches tall, in white plaster.

The following year, MacAgy organized *The Sphere of Mondrian* (February 27–March 24, 1957), fifty-one paintings and sculptures that connected with the great de Stijl artist. *Mark Rothko* (September 5–October 6, 1957) was an important exhibition of seventeen of the artist's paintings. The de Menils lent two of their Rothkos, *The Green Stripe* and *Plum and Brown* (1956), while most of the paintings came directly from the Sidney Janis Gallery.

•

From MacAgy's first shows, everyone realized that a big part of the excitement was the museum director herself. "She was totally delightful," remembered Gertrude Barnstone. "And a funny sort of a gravelly voice— she smoked a lot—she was wonderful, just an open, rich personality."[85] Another Houston artist, Richard Stout, was equally taken with her: "She put exhibitions together so you would see things differently and it would shock you, astonish you into seeing them clearly."[86]

MacAgy was adept at finding talented people who could help her achieve what she wanted. One was a young artist named Jim Love. Working on sets for the Alley Theatre, Love received a phone call from MacAgy. She hired him as a technician, at $75 per week. MacAgy and Love went on to be great collaborators. He helped build the installations and worked with her closely on many aspects of the shows. "We hung them ourselves," Love recalled of their string of shows. "They had to be small because the money was limited. When installing, her decisions were immediate; it was fast and pleasant."

MacAgy and Love operated with little additional staff, tiny budgets, and limited space at the small museum building. "The place had no backstage, no space for unpacking or repacking crates, except the backyard, which was ridiculous," Love recalled. "At the de Menil house, they had a three-car garage, and that became the workshop. That's where the crates were sent, that's where they were unpacked, stored, and so forth."

Love felt that what most distinguished a MacAgy exhibition was the mixing of high and low, the sense of joy and discovery, and such personal touches as split-leaf philodendrons that she placed around the galleries. "I haven't seen anything that could match what she produced visually," Love recalled. "I think it showed in Houston, too. After Jerry, the standard was set so high you didn't see much sloppy work."[87]

In 1957, the de Menils conceived and executed an event that would be key to their cultural plans for Houston. They brought to the city the American Federation of Arts Convention, held on April 3–6 at the Shamrock Hilton, the eleven-hundred-room hotel built by legendary oilman Glenn McCarthy. The theme was "The Perpetual Discovery: An Investigation of What the 20th Century Has Contributed to Creative Thought and Expression."[88]

Participants included Marcel Duchamp, abstract artist Stuart Davis, Jimmy Ernst, Meyer Schapiro, James Johnson Sweeney, Sidney Janis, James Thrall Soby, and many other art professionals and academics. The event was co-chaired by John de Menil along with Stanley Marcus, of Dallas's Neiman Marcus; there were pool parties at the Shamrock, cocktails and suppers hosted by *Life* magazine, a variety of panel discussions and lectures, and a banquet dinner where actor and collector Vincent Price gave the keynote address. Two art exhibitions opened: *Three Brothers: Jacques Villon, Raymond Duchamp-Villon, Marcel Duchamp,* at the Museum of Fine Arts, Houston, which had been curated by James Johnson Sweeney from the Guggenheim; and *Pacemakers,* at the Contemporary Arts Museum, a MacAgy show of Texas painters and sculptors. Participants were invited to visit three collections: the colonial furniture and art of Ima Hogg at Bayou Bend, the contemporary American works owned by Mr. and Mrs. Robert Straus, and the "Contemporary European" art, as it was characterized, of Dominique and John.[89]

One of the highlights of the event was the Friday panel discussion: "The Creative Act: How Style Evolves in the Creative Mind" with William C. Seitz, professor of art, Princeton University;

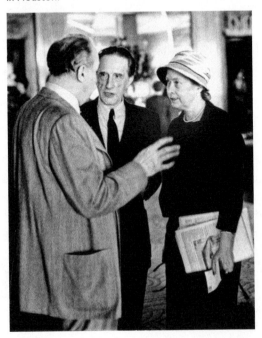

Stuart Davis talking to Teeny and Marcel Duchamp at the 1957 American Federation of Arts Convention in Houston.

Rudolf Arnheim, professor from Sarah Lawrence College; Gregory Bateson, the noted anthropologist; and Marcel Duchamp.

Duchamp's intervention was a brief talk—only eight hundred words—but made a unique even radical case for the importance of the viewer in the process of a work of art: "The creative act is not performed by the artist alone. The spectator brings the work in contact with the external world by deciphering and interpreting its inner qualifications and thus adds his contribution to the creative act."[90]

John de Menil generously invited participants on a day trip flying around the state. The first stop was San Antonio, taking a historic tour of the city, including the Alamo, then visiting the Witte Museum and the McNay Art Institute. From San Antonio, everyone flew to Dallas, where they could visit private collections in Fort Worth and the Fort Worth Community Art Center, or see private collections in Dallas and make a visit to the Dallas Museum of Fine Arts. Everyone then flew back to Houston, returning to the Shamrock Hilton at midnight.[91]

•

Jerry MacAgy continued her string of remarkable shows for the Contemporary Arts Association. *The Disquieting Muse: Surrealism* (January 9–February 16, 1958), included eighty-four works from Leonora Carrington to Marcel Duchamp, Piranesi to Picabia, while *The Trojan Horse: The Art of the Machine* (September 25–November 9, 1958) celebrated the tenth anniversary of the Contemporary Arts Association, looking at the development of the machine from the Renaissance to the twentieth century. It was a dizzying selection of objects, artworks, and machinery: sixteenth-century engravings and steel drill bits, Matta paintings and a Brancusi sculpture, a nineteenth-century potato peeler and a selection of rusted forms plucked right out of the junkyard.

•

The following year, MacAgy produced her most spectacular show for the Contemporary Arts Museum: *Totems Not Taboo* (February 26–April 23, 1959). The title, an inversion of Freud's book *Totem and Taboo,* had been suggested by John de Menil.[92]

It was an exhibition of 230 non-Western sculptures and objects—from Africa, the South Seas, the Pacific Northwest, and Central and South America—presented in the soaring space of the just-completed Mies van der Rohe wing of the Museum of Fine Arts.

Houston patron Nina Cullinan at the opening of *Totems Not Taboo* at the Museum of Fine Arts, Houston. Photograph by Eve Arnold.

The new wing, Cullinan Hall, had been commissioned by Nina Cullinan, whose father, Joseph, had been a leading figure at the time of the great Spindletop oil fields and was a founder of Texaco. Never married, like Ima Hogg, Miss Cullinan was a major arts patron who believed in the new. "I wanted a building that would speak to the future," Nina Cullinan explained. "I guess because of my life experience in being an unmarried woman, where I've heard so much conservative 'hold onto what we have' thinking that I felt, 'Heavens, let's open things up.' "[93] To that end, Miss Cullinan specified that the Contemporary Arts Museum be allowed to hold regular exhibitions in the new wing.

The addition created by Mies was one vast, ten-thousand-square-foot area with a curved, two-story wall of steel and glass. The cavernous room, used as a gallery, had the ability to overwhelm any exhibition of art. Howard Barnstone called it a "castrating space."[94]

For *Totems Not Taboo*, MacAgy constructed in Cullinan Hall a series of stairways, walkways, and passages, with black wooden floors and white metal railings. Large, square plinths in white were built to elevate the dark wooden sculptures. White gravel was used along the floor, and the room was dotted with split-leaf philodendrons. René d'Harnoncourt, then the director of New York's Museum of Modern Art, said that *Totems Not*

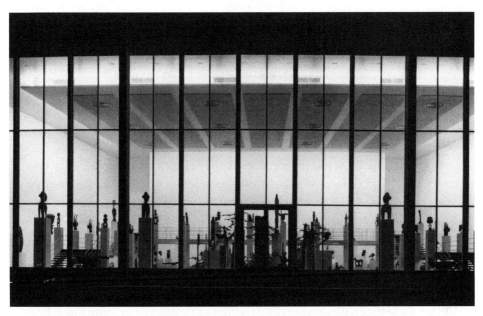

ABOVE: MacAgy's 1959 *Totems Not Taboo* show of 230 sculptures and objects in Mies van der Rohe's Cullinan Hall.
BELOW: The dramatic staging constructed for *Totems Not Taboo*.

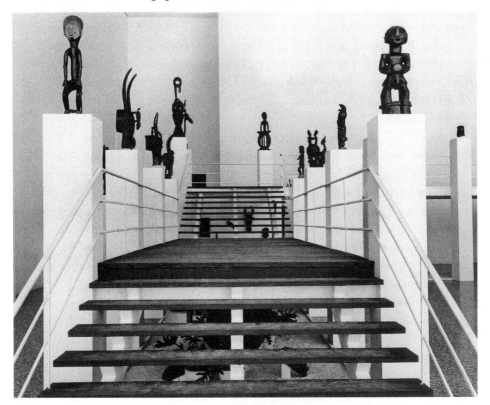

Taboo was one of the three most exceptional exhibitions he had seen in his life.

Totems Not Taboo contained some examples of important modern art—Brancusi, Modigliani, Picasso—but the focus was on the vast selection of non-Western sculptures and objects, such as a nail fetish figure by the Bakongo peoples, a geometric wood and brass funerary figure from the Bakota, a dark wooden ceremonial Baga drum, and an eighteenth-century Bambara queen with a helmet headdress.

"One of the most important loans is the collection of Ife pieces discovered at Ife in 1957 by a workman leveling a low mound," MacAgy wrote in the catalog.[95] John de Menil had seen some of the Ife sculptures at the Museum of Primitive Art in New York. They were then shipped to Paris to be shown at the Musée de l'Homme. Working with Nigerian officials, John offered to pay to have them shipped from Paris to Houston and on to Lagos. "May I again express my congratulations on the boldness of your offer and its, to me, unexpected acceptance by the Nigerian Government," Robert Goldwater, director of the Museum of Primitive Art, wrote to John. "I hope the exhibition, in addition to its undoubted aesthetic success, will have some of the social effects which you foresee for it."[96]

When futurist architect Buckminster Fuller saw *Totems Not Taboo,* he sent MacAgy a rather mad congratulatory telegram: "My personally most excitingly important exhibition experience in respect to total associative conceptioning [*sic*] and competence of mounting, cataloguing and comprehensive environmental considerations and event anticipations which went right out through its walls into the community and the nation and our historic times."[97]

Karl Kilian, then a student at St. Thomas High School with Fred Hughes, remembered, "*Totems Not Taboo* was just a real killer. One of the most amazing exhibits ever. I went to see *Totems Not Taboo* with Fred Hughes again and again and again; it was just spectacular."[98]

Museum of Fine Arts registrar Edward Mayo was also struck by the show. "Some said, 'Why, the de Menils spent $20,000 on that exhibition,'" Mayo recalled. "In the 1950s, that was a whale of a lot of money. But not only was it spectacular; it introduced Houston to the kind of art that had never been seen here."[99]

Stanley Marcus wrote to the president of the Museum of Fine Arts to congratulate him on *Totems Not Taboo.* "I have seen primitive exhibitions all over the world and nowhere have I seen one more beautifully or imaginatively mounted," Marcus wrote. "Please extend my very sincere congratulations to Miss MacAgy."[100] The Neiman Marcus chairman sent a copy of

the letter to John de Menil, with a note: "And special congratulations to you, John, for I understand you were the one who made this possible."[101]

Filling up a sensational new piece of modern architecture with hundreds of objects, primarily from Africa, was a daring gesture in 1959 in the segregated South. States were still fighting *Brown v. Board of Education,* the 1954 Supreme Court ruling. Not long before, the National Guard had been called in to protect nine black students trying to attend Central High School in Little Rock, Arkansas—only a few hours northeast of Houston— while the entire public school system in Prince Edward County, Virginia, had just been shut down to avoid integration. With *Totems Not Taboo,* MacAgy, and the de Menils, demonstrated the power and nobility of African art in the most important cultural center of a major southern city. The exhibition was an artistic act, of course, but it was also a social statement.

John de Menil was in Paris on a business trip for the opening of *Totems Not Taboo,* so Dominique fired off a telegram. In the staccato rhythms of the form, she summed up the reaction: "Opening was fantastic success. Harnoncourt told everyone his amazement: quality, objects, beauty, magnitude, display. *Time Magazine* and *Art News* sent remarkable girls. Nail hit this time."[102]

THE SKY IS THE LIMIT

They were here in the boondocks. And they always said, "You don't have to be the boondocks. You can be a Paris, yourself. You can be a New York, yourself." They loved doing that. And they loved taking untrained people and getting them engaged in art—getting them engaged in life.
—HELEN WINKLER ON DOMINIQUE AND JOHN DE MENIL[1]

T*otems Not Taboo* had been an indisputable triumph, a complete validation of the artistic vision of Jerry MacAgy and of Dominique and John de Menil. It took place, however, just as Mac-Agy was being forced out of the Contemporary Arts Museum. There was a group within the organization that wanted the museum to return to its all-volunteer roots, and some Houston artists were resentful that they were not asked to exhibit. A board majority, even though John was still chairman of the Contemporary Arts Association, voted not to renew MacAgy's contract.

Earlier that fall, MacAgy had conceived and installed an exhibition at the University of St. Thomas, to mark the opening of the first Philip Johnson buildings. The de Menils were intent on keeping her in Houston, and since they already had a relationship with the administration at St. Thomas, they proposed MacAgy to the school. The Basilian fathers accepted and created the fine arts department at the University in Jones Hall, one of the Philip Johnson–designed buildings; on the ground floor was an auditorium, and the upstairs was turned into an exhibition space.

MacAgy began to teach art history there and curate her thematic exhibitions. *The Visage of Culture: A Telescopic Survey of Art from the Cave Man to the Present* (November 6–December 31, 1959) was intended to be a visual aid for her art history classes, and its pieces included one of the de Menils' prehistoric deer carvings on a small piece of bone, one of their large canvases by Mondrian, *Composition with Yellow, Blue, and Blue-White* (1922), and a third century B.C. Grecian statue of Athena that came straight from Dominique and John's living room.

MacAgy was responsible for two exhibitions per year at St. Thomas, in

addition to fulfilling her contract to do several shows for the Contemporary Arts Association. She worked with students to organize the loans, design the display, and install the works of art. Her shows at St. Thomas quickly gained an audience.

And MacAgy had a galvanizing effect on students. Helen Winkler entered the University of St. Thomas in 1959, the same year MacAgy began teaching. She was immediately drawn to the art department. "She had a vision from the very beginning," Helen Winkler remembered of MacAgy. "She was the most infectious person speaking of art; people were very attracted to her and to what she did."[2]

One cool winter day, in February, Dominique arrived at the St. Thomas gallery. "She was a beautiful woman, with her hair in that French twist, and she was wearing a mink coat," recalled Kathy Davidson, a St. Thomas student who would later work for the de Menils. "We never saw fur coats like that. MacAgy said to her, 'Oh! I am so glad you are here. I want to show you everything.' I said, 'Freddy, Who is this?' "[3]

Freddy was another early University of St. Thomas student, Fred Hughes, who would also go on to be a de Menil protégé and then work closely with Andy Warhol. He and Kathy Davidson were the only art history students in their freshman class. She had vivid memories of Fred Hughes in their first year:

From left to right: Helen Winkler, Patricia Winkler, Fred Hughes, and Marion Wilcox at the University of St. Thomas in the 1960s.

He was very cute—a real Texan with this Texas accent. He drove a black Volkswagen bug. Sometimes we had to go pick up his brother from the Boy Scouts or his sister. They lived in a normal suburban house; I think his father was a shoe salesman. He was just an average kid from Houston. But he had a great sense of humor, and he was excited about studying art history. I learned a lot from him. He had a wonderful sense of gossip. He could pick up information that went completely over my head. He loved fashion. We were both paid fifty cents to sit in Jones Hall gallery and greet people when they came in and to answer the phone; it was a student job.

That day that Dominique de Menil walked in wearing her fur coat, Freddy was the first one to tell me who she was. He said, "Oh, yeah, she's the billionairess!"[4]

Helen Winkler remembered that Jerry MacAgy was cautious about how involved Dominique could be in the preparation of an exhibition. "Dominique would come, thinking she was going to help Jerry with the exhibit, and Jerry, of course, would have already done the installation. Dominique learned so much from her, but MacAgy didn't want her to interfere."[5]

Helen remembered, "MacAgy always said—which turned out not to be true, but it was an interesting observation because you see it often in the art world now—that it was a game for the de Menils but that it was her life. It was half of their life when they got involved . . . And she would have been very, very proud that it was not a game for these people—that in the end it was something incredible."[6]

•

Throughout the 1960s, Dominique and John de Menil greatly increased their presence in New York. In July 1962, John became a trustee of the Museum of Modern Art (having been vice president of the International Council since 1957). Aside from being an active member on other New York boards such as the American Federation of Arts and Sarah Lawrence College, where their daughter Adelaide had gone, John became, in April 1960, a trustee of the Museum of Primitive Art, the non-Western institution founded by Nelson Rockefeller in a town house at 15 West Fifty-Fourth Street, across from the Museum of Modern Art; the museum was closed in 1976, and its collection was absorbed into the Metropolitan Museum of Art. In 1962, the Museum of Primitive Art hosted *The John and Dominique de Menil Collection* (November 21, 1962–February 1, 1963) with 127 works the de Menils had gathered from Africa, Mela-

nesia, Polynesia, Australia, and the indigenous peoples of North America, Mexico, and South America.

The exhibit was the first time that a major part of the primitive art they had collected was displayed. "It is a large collection of which only a portion can be shown," wrote Robert Goldwater, director of the Museum of Primitive Art and husband of sculptor Louise Bourgeois, in his catalog introduction. "It is the issue of an inimitably successful fusion of French and American cultures and settings, at home on two continents and in the three cities of Houston, New York and Paris."[7]

The vast expanse of activities initiated by the de Menils throughout the 1960s cannot be separated from a key financial development in the era: in 1962, Schlumberger Limited was listed on the New York Stock Exchange.[8] Dominique noted the occasion in her date book: February 2, 1962.[9] What had started as La Pros, five decades before, became SLB, a major publicly traded multinational.

Dominique and John had always been generous financially with their children. In the late 1950s, Robert Thurman, who roomed with Georges at Exeter and Harvard, began dating Christophe de Menil. He was seventeen; she was twenty-six. John de Menil was very enthusiastic about Robert Thurman. "We really got on," Thurman recalled. "We went to Paris. He took me to restaurants. He bought me clothes." Thurman suggested to John that he was reluctant to marry Christophe because he hoped, at that time, to be a writer, so he would not be able to support her in a substantial way. John de Menil gave him a trust fund. "He made the marriage possible," Thurman recalled.[10]

When SLB went public, the de Menils were able to establish trust funds for their five children. The size of the combined trusts was said to have been half of Dominique and John's overall net worth, a lavish amount. Their initiative meant that the de Menil children, when they were in their twenties and thirties, received roughly $30 million apiece. And they were given complete independence. "Once the children had the disposal of their own fortunes," Dominique explained, "John and I never wanted to interfere."[11]

The public offering also allowed the family, in April 1961, to move into a spectacular new town house in New York, at 111 East Seventy-Third Street, between Park Avenue and Lexington.[12] It was a historic five-story structure in white limestone, which, before the de Menils purchased it, had been used as the Albanian embassy. They oversaw a complete renovation by Howard Barnstone, fashioning it into what became, for decades, the true center for the de Menil family (it would be sold by Dominique in 1995 and incorporated into the Buckley School next door). The two youngest children, Philippa and François, still in their teens in 1961, moved into the

house. It became known to all as "111 East Seventy-Third Street" or simply "One Eleven."

The facade had generous rows of windows and, at street level, three arched entrances. The central one had only a window, but the arched doorway on the right led directly into a large kitchen, a key room in the life of the house, usually ruled over by Gladys Simmons and Jacqueline Galleron, the de Menils' live-in French housekeeper and cook.

The arch on the left was the main entrance and opened onto a foyer with a stairway that led up five floors. Beyond was an elevator, along with a small staircase that went downstairs, and then a dining room with a balcony that looked out onto a sunken courtyard garden. It was a beautiful open-air space with light paving stones, tall wooden walls behind rows of large evergreens, and a grouping of bronze sculptures by Max Ernst. The garden was accessible from a basement bedroom, often used by Georges, and by an iron staircase that led down from the dining room.[13]

The second floor had a large living room overlooking the street and a study with a view of the courtyard. Between those rooms, opposite the stairway, was a bar. The third floor had one bedroom overlooking Seventy-Third Street as well as Dominique and John's bedroom with a view of the garden. On the fourth floor, François's bedroom was in front, while in back were two bedrooms, one for Philippa, the other for Gladys Simmons. The fifth floor held a guest room and a bedroom for Jacqueline Galleron.

John Richardson met the de Menils when he was living in France with Douglas Cooper. Richardson moved to New York in the 1960s, working for Christie's, and was a guest at the de Menils' house in its first years. As Richardson said about what he discovered there,

> What I loved about the collection is that it was utterly unconventional. One of the things that struck me when I first came to New York and saw every collection that there was to be seen was how terribly conformist they were. They were all basically the same Park Avenue collection. And then I worked out that it was because Alfred Barr was a sort of dictator of modern art to all these rich, mostly Jewish, Upper East Side people. They all had early Juan Gris, no late Juan Gris; no early Monets, only late Monets; they all had cubist paintings; if possible they all had one Mondrian; they had Klees; they had Braques but no Braques after 1914. It was absolutely as though someone had given them a pattern to follow and they all followed: one Fauve painting and so on. Some had rather more Klees than the others, and some had more Picasso drawings, et cetera. But basically, it was this tremendous sort of Alfred

The living room of the de Menils' town house at 111 East Seventy-Third Street, a renovation overseen by Howard Barnstone.

Barr conformism that made going around to the collections rather depressing.

And they had no idea what they had on the walls: Mirós of flying vaginas and phalluses all over the place and these nice ladies who would give you a drink and say, "My little girl likes it so much; she likes the spiders."

With Dominique, she knew *exactly* what the paintings were about. And there were some very radical surrealist images. And she knew what they represented, and she would discuss them. She liked the company of anybody who sort of understood what she was up to.[14]

Richardson also observed John's role in their relationship in those years. He felt that Dominique was attracted to opposites. Iolas was one

A corner of the de Menils' living room with two African sculptures, a de Chirico painting, and a corner of a Jasper Johns assemblage.

obvious example; John was another. "A lot of people expected Dominique to have a husband who was very *raffiné*, a French intellectual," Richardson recalled. "Not at all. John was a bluff businessman. Who, one found, greatly to one's surprise, also had a real understanding of painting and a great sense of humor."[15]

A French acquaintance of the de Menils', Bertrand Davezac, spent time at the New York town house beginning in the early 1960s. When he first met the couple, he was a young art historian studying with Meyer Schapiro at Columbia (he would later be hired by Dominique as a curator at the Menil Collection).[16] As Davezac recalled of 111 East Seventy-Third Street,

It was a typical Manhattan town house, narrow with rooms in front and back. In the basement was the laundry and Georges's

room, in which there was a beautiful painting by Christian Bérard. Many paintings that are now in the museum, especially the cubists and a few surrealists, I saw first in the house. In their bedroom, I saw Dominique and John's only Cézanne painting. On the fireplace of their bedroom was the Matisse, *Brook with Aloes.*

So, the space was typically New York, but inside it was also very French. There were the cubists, a Léger, meaning modern French school before the 1950s. In the dining room there were at least two, if not more, Rothkos: a yellow one and a purple one and a small Rothko over the fireplace. And the very big Braque interior, from during the war, was in the salon. It was replaced over the years, by Jasper Johns's *Voice,* a painting and assemblage that includes a windshield wiper.[17]

Davezac remembered the interesting people he met at the de Menils' as well as those he missed. "My wife and I were back visiting New York in the 1960s, and Dominique and John invited us to spend Christmas Eve alone with them and Marcel Duchamp," he remembered. "And we said no. I will never forgive myself for that little act of stupidity." Those kinds of low-key, high-wattage evenings were standard at One Eleven. Davezac did attend small dinners there with John Rewald, the art historian and scholar of impressionism, or the artist William Copley. "They weren't socialites," Davezac recalled. "They saw important people who could enrich them intellectually or would be helpful for their mission in Houston."[18]

The de Menils did host larger events, too, in New York. In April 1962, they had a dinner party for eighty-five people in honor of Max Ernst.[19] Six months later, they had a dinner for Jean Tinguely with thirty-eight guests. In November 1964, to mark the opening of *Architecture Without Architects,* an exhibition at MoMA, they hosted a dinner party that included architect Gordon Bunshaft, impressionist collector and philanthropist Margaret Kahn Ryan, and noted collector Joseph Hirshhorn, who would found the Hirshhorn Museum and Sculpture Garden in Washington, D.C.[20]

Dominique always paid great attention to detail. At one dinner on Seventy-Third Street to celebrate Christophe's birthday, Dominique had eighteen guests, placed at three round tables. Christophe and Rosamond Bernier presided over their table, while Dominique was joined by Lily and Douglas Auchincloss. The menu consisted of a chilled soup with pressed cucumbers and yogurt. The main course was a *filet de boeuf* with broccoli puree, French-style green beans, and steamed carrots. "Prepared the way I like, in a steamer using very little water, a big onion, cloves, bay leaves, and butter, allowing the carrots to cook in their own juice," Dominique

explained to her mother. "So flavorful! Dessert was a very creamy flan, made with a liter of milk, four egg whites, and six yolks, and topped with caramelized apples and a whiskey flambé."[21]

The New York town house even played its own role in the de Menils' attempts to lure people to Houston. In 1962, a young graduate student of art history at Yale University, Bill Camfield, was in New Haven but considering a return to his native Texas. One afternoon, Camfield's adviser, George Heard Hamilton, the noted historian and head of the department, had him paged. "You're thinking of going back to Texas; there is someone you should meet," Hamilton said to Camfield, suggesting he quickly go to the Yale Art Gallery. "With a little trouble, I managed to find Jerry MacAgy," Camfield recalled with a laugh. "She was down on her hands and knees, under an installation case." MacAgy was making notes on the case, an elegant, modern affair, with metal legs and a wood frame. "It was clear that she was not going to get up until she was finished. So we met there, on the floor in the art gallery."[22]

MacAgy, who was still the only art history professor at the University of St. Thomas, told Bill Camfield that she wanted him to meet some St. Thomas supporters who would be in New York.[23] So, along with his wife, Ginny, Camfield made plans to meet the couple from Houston at 111 East Seventy-Third Street. Dominique and John took them through a few rooms, telling them about works, answering questions. In the entrance hall, the Camfields saw a Matisse cutout in vivid green and yellow. In the ground-floor dining room, an oversize dark wooden bowl from the Sepik River in New Guinea was placed near a pair of the de Menils' splendid, large paintings by Rothko, one in pale yellow, the other in dark blue with a lighter blue stripe. "It was a little difficult to focus on the de Menils and the house and the artworks all together," Bill Camfield remembered. "We had never seen a private art collection like that, nor the knowledge or intensity that they exhibited."[24]

Dominique and John had plans that evening, so they were unable to invite the couple to dinner. "She seemed to be really upset about that, genuinely sorry," Camfield said. "Dominique took us down in the kitchen where she and Gladys, their housekeeper and friend, put together a lunch for us. I think we ate off of that for about three days—a brown bag lunch with enough meat and cheese and fruit to last for days. That disarmed us; the whole meeting disarmed us."[25] Bill Camfield joined the faculty at St. Thomas, becoming the second art history professor.

Although the de Menils became much more visible in New York throughout the 1960s, they tried to keep their focus on their plans for Houston. In 1963, they gave the Museum of Modern Art an important kinetic

piece by Takis, *Magnetic Sculpture* (1962). John wrote to Dorothy Miller, assuring her that they were pleased to be able to offer works to the museum that she or Alfred Barr had fallen in love with but that their priorities were elsewhere. "We don't like the mention of a fund because it has never been our intention to create a purchase fund at the Museum of Modern Art," John wrote to Miller. "As you know, our first responsibility is in Houston and that is where our efforts must be concentrated, because here we are almost alone."[26]

•

If Dominique and John had only supported Jerry MacAgy in Houston, their efforts would already have been impressive. But they were also fully invested in the Museum of Fine Arts. The Mies van der Rohe wing of the museum, Cullinan Hall, was inaugurated in the fall of 1958 with the opening exhibition *The Human Image,* but many felt that the exhibition was too tame to stand up to the striking architecture. "The hall is going to demand a more dramatic approach to exhibitions than any museum in these parts has been allowed to consider before," wrote the critic for *The Houston Chronicle.*[27]

Jerry MacAgy's *Totems Not Taboo,* the following year, showed how an exhibition could be just as powerful as a building, so the Museum of Fine Arts clearly needed someone who could also rise to the occasion. In 1959, a search committee was formed: philanthropist Nina Cullinan, architect S. I. Morris, and John de Menil. The following summer, the *Houston Chronicle* arts editor, Ann Holmes, read on a wire news service that James Johnson Sweeney was resigning from the Guggenheim. She immediately called John, who phoned Sweeney and offered him the job.[28]

Sweeney had been a leading figure in the New York art world for decades. Born in Brooklyn in 1900, he went to Georgetown University, then did graduate work at Cambridge University and postgraduate at the Sorbonne. He was a big man, with a booming voice, who had played football at Georgetown and rugby at Cambridge. In 1925, on a transatlantic crossing, he met Albert Barnes, whose writings inspired him and who encouraged him to establish personal relationships with artists.

Sweeney began as a curator and critic for the visual arts while also fully engaged with modernist literature. In the 1930s, he was the associate editor for *Transition,* the Paris-based experimental magazine founded by the American poet Eugene Jolas that published, from 1927 to 1938, the work of such major writers as James Joyce, Gertrude Stein, Dylan Thomas, Samuel Beckett, Henry Miller, and Kafka as well as the work of many artists.

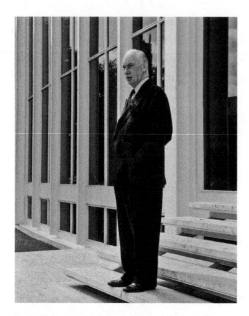

James Johnson Sweeney at the entrance of Mies van der Rohe's Cullinan Hall at the Museum of Fine Arts, Houston.

Sweeney also worked with James Joyce to edit his manuscript for *Finnegans Wake,* which had appeared in installments in *Transition.* By the 1940s, he was curating important retrospectives of the work of Paul Klee and Miró at the Museum of Modern Art. In 1943, Sweeney wrote the introduction for Jackson Pollock's first solo exhibition, at Peggy Guggenheim's Art of This Century gallery. Two years later, he joined the Museum of Modern Art as the director of the Department of Painting and Sculpture.

In 1952, Sweeney became the director of what was then known as the Museum of Nonobjective Painting. He worked with Frank Lloyd Wright to build the iconic structure on Fifth Avenue, which opened in October 1959 as the Solomon R. Guggenheim Museum.[29] "But Mr. Sweeney was not a fan of the Wright building, which he believed had not been designed to show pictures to best advantage," noted his obituary in *The New York Times.* "He devised a method of hanging them on rods projecting from the walls, but could not overcome the feeling that the building was less a museum than a monument to the architect."[30]

Securing James Johnson Sweeney for Houston, and a museum that had barely had one full-time director, was exceedingly ambitious. "Sweeney was world famous," said Dr. Peter Marzio, director of the Museum of Fine Arts, Houston, from 1982 until 2011. "Bringing in Sweeney in 1961, you brought together this great curator, now director, of great modern and contemporary art with the Mies van der Rohe architecture and this museum that basically had no collection, which is a weakness but is also a blank slate for a genius like Sweeney; it was really heady stuff."[31]

One of his first Houston exhibitions, *Three Spaniards: Picasso, Miró, Chillida* (February 6–March 4, 1962), revealed Sweeney's brilliance. On the lawn in front of the Mies van der Rohe building, he constructed a rectangular pool, approximately eighteen by thirty feet, replete with a diving

board. It was a wooden structure, painted white to match the exterior of the building. Lined with plastic, it was filled with water containing bluing to create the impression of depth.[32] In and around the pool, Sweeney positioned a group of playful sculptures by Picasso, *Bathers* (1956), six flat figures, made from scrap wood, many almost nine feet tall.[33]

Inside Cullinan Hall, and its ten-thousand-square-foot gallery, Sweeney placed only five works of art. Centered on the expansive rear wall was Picasso's *Nude Under a Pine Tree* (1959), a painting of abstracted flesh-colored forms, part-cubist, part-classical, over six and a half feet tall and nine feet wide. In the room, toward the right side, placed on an immense rectangular white plinth, was a monumental sculpture by Eduardo Chillida, *Abesti gogora* (1960). The piece, which weighed three thousand pounds, was made of rough, dark oak. It was over five feet tall, five feet deep, and eleven feet wide.[34] On the left half of the gallery, Sweeney placed a 1961 triptych by Miró, *Blue I, Blue II,* and *Blue III.* Each of the abstract paintings, in intense blues, reds, and black, was over six feet tall and nine feet

Picasso sculpture (1956), around the pool James Sweeney had built for the Museum of Fine Arts Houston exhibition *Three Spaniards.*

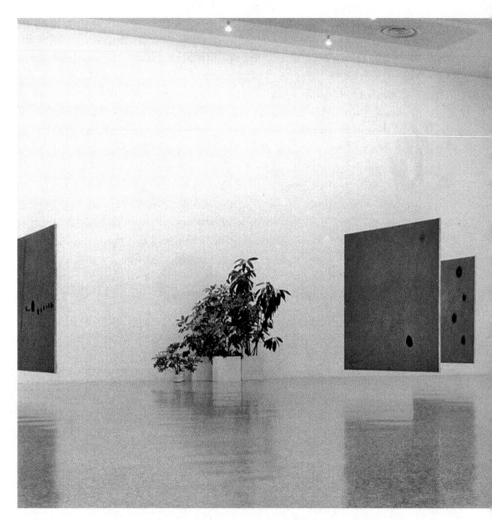

Three Spaniards: Picasso, Miró, Chillida (1962) showed Sweeney's flair for installation.

wide. The Miró canvases, suspended from above, appeared to be floating in the middle of the space. "I don't think there has been an exhibition to match it since," said Edward Mayo, MFAH registrar. "I think it was Sweeney's chef d'oeuvre."[35]

Sweeney went on to do a series of outstanding exhibitions for the Museum of Fine Arts, sharply edited shows and historical surveys like *The Heroic Years: Paris, 1908–1914* (October 21–December 8, 1965), where dozens of important early modernist and cubist paintings were suspended, using invisible wires, from the ceiling. "People now realize that Mr. Sweeney just picked up the Museum of Fine Arts and turned it around on its

axis," said Edward Mayo. "It was a completely different institution when he left than it had been when he arrived."[36]

And all of Sweeney's actions were supported in a major way by Dominique and John. Sweeney once said, "I could not imagine a member of a board of directors being more accommodating to a museum director than John de Menil has been to me."[37]

The de Menils acquired an impressive selection of art for the museum during Sweeney's tenure, some seventy outstanding paintings, sculptures, and objects,[38] including a monumental carved-wood dance mask from the Gurunsi peoples of Ghana; Calder's *Crab* (1962), a stabile in red steel that

was ten feet tall, twenty feet long, and ten feet deep; a miniature Egyptian relief (Amarna period, late eighteenth dynasty); and Jackson Pollock's *Number 6* (1949), a large drip painting that was, for three decades, the only work by the artist in the permanent collection.[39]

In 1963, the de Menils made a joint gift in honor of Conrad Schlumberger: a stunning ancient Roman bronze statue, a nude male torso that was over seven feet tall. It came to be known as *Portrait of a Ruler* (Severan period, A.D. 193–235), or, more colloquially, *Roman Ruler*. At the same time, in honor of Marcel Schlumberger, Dominique and John gave the museum Calder's *International Mobile* (1949), a majestic piece, twenty feet in diameter, in white aluminum, black rods, and wire. *Roman Ruler* and Calder's *International Mobile* debuted together in 1963, and both would remain essential pieces in the museum's permanent collection.

Another of the de Menils' grand gestures for the MFAH involved Jean Tinguely, whose kinetic sculptures had galvanized the art world. On March 18, 1960, at the Museum of Modern Art, Tinguely produced his *Homage to New York* (1960), a massive piece of sculpture, painted white, that was designed to self-destruct in the museum's courtyard. "During its brief operation, a meteorological trial balloon inflated and burst, colored smoke was discharged, paintings were made and destroyed, and bottles crashed to the ground," noted the Museum of Modern Art. "The machine's self-destruction was stopped short by the fire department."[40]

Four years later, in December 1964 at the Alexandre Iolas Gallery in Paris, John saw the exhibition of a dozen new sculptures by Tinguely. From the opening night, the whirring, whizzing pieces in black scrap metal and steel caused a huge sensation. French prime minister Georges Pompidou was in attendance, and crowds of onlookers caused traffic jams on the boulevard St.-Germain.

John thought the Houston museum should have the entire show. But he wanted the decision to be Sweeney's. When the director visited in January, Bénédicte Pesle tried to steer him toward that idea. When he inquired about prices, Bénédicte quoted one at $12,000. "His only comment," Bénédicte wrote to John, was "for $12,000 you can buy a Rolls-Royce." After a series of telegrams between Sweeney and John de Menil, the director eventually cabled, "Agree enthusiastically. If possible, take all." He signed it "Sweenguely," a flourish that John loved.[41]

The de Menils bought the entire exhibition for the MFAH.

Four months later, Sweeney scattered the dozen sculptures around the terrazzo floors of the Mies van der Rohe wing for *Jean Tinguely: Sculptures* (April 3–May 30, 1965). The opening was a de Menil–driven happening. Alexandre Iolas was in from Paris, staying with the de Menils for ten days.

Jean Tinguely also made the trip, with his companion and future wife, Niki de Saint Phalle. On opening night, a thousand guests poured into the museum. The artist appeared in black tie, studded with safety pins, while Nikki de Saint Phalle wore a full-length coat of vintage monkey fur.[42]

John de Menil was delighted with the new sense of vigor that Sweeney had given the museum. "The leadership of this man of worldwide reputation changed the museum from within as much as Cullinan Hall had changed its outward aspect," John wrote, several years into the director's time in Texas. "New pieces have been added to the collection, to be sure, but even what was there before now is displayed in an intriguing way."[43]

Peter Marzio, the later director of the MFAH, felt that Sweeney brought great prestige to the institution as well as a direct connection to such leading artists as Calder, Chillida, and Matta. "I think that he was the highest-paid museum director in the country at that point, because the Menils were paying him," Marzio said. "He brought in works that were almost still wet, they were that new. He inspired a lot of people; he angered a lot of people. If the de Menils hadn't been protecting him, he probably would have been gone after three or four years."[44]

In January 1966, Dominique and John gave fifteen shares of Schlumberger stock to the Metropolitan Museum of Art, explaining that, although they were pleased to make the gesture, their generosity was limited. "We

Sweeney's 1965 installation of Tinguely sculptures at the MFAH. The de Menils bought the entire show, originally at Iolas in Paris, for the museum.

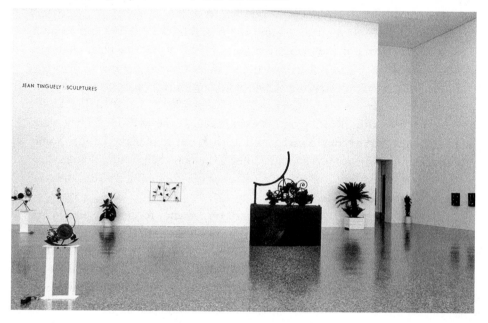

would like to contribute more but we are vastly over-given already with more than 60% of our income going in support of Jim Sweeney's work at the Museum of Fine Arts and of the pioneering efforts of the Art Department at the University of St. Thomas," John wrote to Arthur Houghton at the Met.[45] Regardless of how that was being measured, 60 percent of the de Menils' income, which was substantial in those years, was a considerable commitment.

The de Menils worked to encourage others in Houston to support Sweeney at the MFAH. In 1963, Dominique wrote to Alfred Glassell, a very successful oilman who collected Asian, African, and pre-Columbian pieces, many in gold, to persuade him to give more to the museum. As she wrote,

Dear Alfred:
 I have been given your card for the Museum's Operating Fund Drive. I am shocked to see that last year you gave only $100 to a cause which is so vital to the pride of Houston. Enjoying as you do the finer aspects of life, you know that $100 doesn't go very far. Thus, I am inviting you to join the $5,000 club. That is where you belong . . .
 Forgive me for being so frank with you: that is the privilege of friendship, and you know you have mine.
 My best to Clare and you,
 Yours sincerely,
 Mrs. John de Menil[46]

Alfred Glassell went on to join the board of the MFAH and to be a significant patron of the institution, but by 1967 it became clear that Jim Johnson Sweeney had not gained broad support from the board or other Houston patrons. "Sweeney was booted out because, I believe it was John Beck who said, 'Either he goes or my money goes,'" recalled Jim Love, who worked with Sweeney on his exhibitions at the MFAH. "They were pissed because Sweeney didn't stand at the door and shake hands. Some thought he wasn't in town enough. They didn't have sense enough to realize that when he was putting up shows all over the goddamned world, he was always from the MFA in Houston."[47]

Toni Beauchamp, who wrote a thesis on Sweeney for her master's in art history, studied the issue. She felt that the main issue was between Sweeney and John Blaffer, whose family had long been major patrons of the museum. "According to a number of sources, Sweeney antagonized the Blaffers by questioning the attribution of some of their proposed gifts of artworks," Beauchamp wrote. "A crisis was precipitated in 1964, when the Blaffers

wanted to give the museum a painting attributed to Fragonard, but Sweeney refused to accept it. A Bertucci panel was accepted instead, but the rupture was complete. Sweeney had alienated a powerful element of the Board."[48]

Regardless of the precise sources of the conflict, the de Menils and Sweeney had a view of the institution that differed from many in Houston. Sweeney resigned.

His final MFAH show was a retrospective of California artist Sam Francis (October 12–December 3, 1967). For the opening, Walter Hopps flew to Houston with the artist and Edward Janss, a leading collector. Hopps, who had just been fired as director of the Pasadena Art Museum, was taken with the power of Sweeney's installation. "He had them on wires, hanging down across the gallery," Hopps recalled of Sweeney's Francis exhibition. "And it worked perfectly for Sam's work, those wonderful airy paintings of the 1950s. Sweeney had them wired down but floating in the air—just amazing!"[49]

•

As Sweeney unveiled his stimulating shows at the MFAH, Jerry MacAgy continued to build the art history department at the University of St. Thomas, hiring new professors, and to advance the cause of art appreciation in Houston. MacAgy also played an active role in mentoring St. Thomas students. She could be seen driving around town in a blue Thunderbird convertible and often took her pair of black dachshunds to classes. She taught many of the art history students how to play bridge so that she would always be able to start a game. Thanks to MacAgy, a young Fred Hughes blossomed. "Fred, who in high school had been shy and self-contained, found his voice," remembered his friend and fellow student Karl Kilian. Though not a great student, Hughes was committed to the art history department and became active in organizing shows.[50]

Jerry MacAgy had long been a diabetic. Some thought that she was not particularly good at monitoring her health.[51] One weekend, she was expected over at the de Menils' house—it was her birthday—but had to cancel. John had his assistant, Chris Powell, deliver flowers to MacAgy's house. Later that weekend, she was taken to the hospital, where she slipped into a diabetic coma.[52] By Tuesday afternoon, February 18, 1964, Jermayne MacAgy, fifty years old, was dead.

MacAgy's funeral was held that Friday at St. Anne's, a beautiful Mediterranean-style Catholic church close to River Oaks, where both Dominique and John would also have their services. Her mother was still alive, in Cleveland, but it was felt that MacAgy was so much a part of the

University of St. Thomas campus that the de Menils and Father John F. Murphy, the president of St. Thomas, oversaw the funeral and High Mass. The long service, with its Latin and Gregorian chants and eulogies to MacAgy, took place on a chilly gray winter's day.[53] "When the funeral was over," said Gertrude Barnstone, "we turned to leave and looked toward the entrance of the church: it was snowing! You know, it doesn't snow much in Houston. Everybody looks and says, 'Jerry's not gone.' I still get chills thinking about it."[54]

The de Menils arranged for her burial plot in the Catholic section of the Forest Lawn Cemetery, near Brays Bayou, along a typical stretch of freeway on the south side of Houston. Although that portion of the cemetery had many elaborate headstones and tombs—some quite grandiose—her grave was indicated only by a simple bronze marker, rectangular, flush with the earth. There, in such an unremarkable spot, Jerry MacAgy and Dominique and John de Menil would all be buried together.

•

The spring exhibition that MacAgy had been preparing, which was due to open in less than a month, was *Out of This World: An Exhibition of Fantastic Landscapes from the Renaissance to the Present* (March 20–April 30, 1964). Dominique was named acting director of the art history department and immediately went to work on the exhibition. "When Jerry died, Dominique, who hadn't done this before, just stepped in," recalled Jim Love. "And it was damn near seamless. When no one was watching, she certainly did learn."[55]

Although Dominique had never participated in the process of installation, she had been very involved at every stage of the preparation of MacAgy's shows over the prior decade. The first contact with lenders, museums, dealers, or collectors was invariably made by Dominique or John.

Louise Ferrari, who worked closely with MacAgy, was also a friend of Dominique's. She would go on to be a noted art dealer in Houston (it was she, for example, who sold Louisa and Fayez Sarofim their Rothkos).[56] Together, they reviewed all of the planning that had been done for the exhibition.[57] Dominique finished securing the loans and installed *Out of This World*. She assembled eighty-six paintings, sketches, and engravings that included a late fifteenth-century panel painting by Venetian artist Lazzaro Bastiani, depicting Saint Jerome amid a mountainous column that extended to the heavens, a Monet painting of a bridge over his water lilies, *Pont japonais à Giverny* (1918–1920)—lent by Madame Marcel Schlumberger—and a surrealist landscape by Antoni Tàpies, *The Snare* (1951). Dominique

also oversaw the completion of the *Out of This World* catalog, the first of what would be many beautifully produced lyrical publications.

Dominique wrote to her mother in Paris about the black-tie, opening-night party:

> Last night, we had the opening of *Out of This World*. The crowd was astonished, really knocked out by the beauty of the paintings and Jerry's extraordinary installation. She had created a labyrinth filled with avenues leading to vistas. At the end of each vista, you would see a fantastic Gustave Moreau or a gigantic Gustave Doré. It was as though you were in the fields seeing in the distance a fortified château atop of a mountain. I am proud to have been able to obtain two paintings by Gustave Moreau, two pictures from the Louvre, and a Turner painting from the Tate Gallery.[58]

One of Dominique's memories of that opening night were two special guests, Alice and George Brown. The founder and president of Brown & Root, one of the largest engineering and construction companies in the world, responsible for vast projects nationally and internationally as well as such important local landmarks as the Johnson Space Center for NASA, George Brown, along with his brother Herman, was also known as the great financial backer of Lyndon Johnson. "George and Alice Brown were really solid behind the culture of Houston," Dominique remembered. "When they saw what John and I were trying to do, we became very close."[59]

Dominique admitted that MacAgy had never wanted her to participate in the process of installation. "I had to learn all the little tricks of installing, and there are plenty of them, for myself," Dominique said of working on *Out of This World*.[60] At that point, however, she had been living with works of art, and carefully installing them in her interiors, for over thirty years, so there was not as steep a learning curve as there might have been. And Dominique had been studying MacAgy's approach quite closely. "She could bring together a few apparently unrelated objects and they started to live, and express some mysterious relation," she wrote of MacAgy. "Her hand had a magic touch."[61]

Beginning with that first exhibition—and something that would continue throughout her life—Dominique, like Jerry MacAgy, placed paintings lower than was customary. For most standard paintings, she wanted the center of the picture to be fifty-six inches off the ground. Oversize works, regardless of height, were placed twelve inches off the ground. "It puts you closer to the work, in more intimate contact," Walter Hopps said of the approach. "MacAgy used her own body; she would say, 'I want my

tits right in the center of the work. Hit the tits!' And Dominique always quoted her on that: '*Hit the tits!*'"[62]

•

Dominique's temporary position as the chair of the art department at St. Thomas became permanent. She hired more professors for the school and, to house the expanding department, had Howard Barnstone renovate a two-story bungalow adjacent to the Philip Johnson buildings. That became the art department office, library, and slide library.

Dominique's engagement with the school begs a question: Why would this Parisian, with her big life and her impressive town house in New York, want to spend so much time and energy running the art history department of a tiny Basilian college in Houston, Texas? "There's a little term that Dominique used continually, 'For the children,'" recalled Jim Love. "Or, as she said in her accent, 'For the *shil-dren*.' She was always talking about trying to educate the children; they were to become the art audience."[63]

Fredericka Hunter, originally from Galveston, went to Wellesley College to study art history. "I quit Wellesley out of frustration over not being allowed to study contemporary art any further than the most superficial level," she remembered. "You couldn't go to graduate school in 1967; you could in 1969 but not in the mid-'60s." Hunter's brother-in-law, Eugene Aubry, was an architect in partnership with Howard Barnstone who had known the de Menils very well since the 1950s. So Fredericka Hunter began studying at St. Thomas and was immediately given a job working in the library. "We all did double duty, going to classes but also working," she remembered. "I was paid minimally, but I was in the library cataloging books. I had to make up a system for organizing contemporary arts catalogs. Others had to file all of her Sotheby's and Christie's catalogs, in order. And there were all of Jerry MacAgy's books."[64]

Occasionally, Dominique would also teach. Although some suggest that lecturing was not her strong point, she certainly made an impression. As Fredericka Hunter remembered,

> We'd be sitting in those little side arm plywood chairs in a little box of a room with a cross on the wall, and Mrs. de Menil would come in. She'd be dressed in a Chanel sleeveless shift, with some sort of fancy purse. Then she would open up the purse and pluck out a Cycladic figure—that Cycladic figure now happens to be worth several million dollars—but she pulled it out of her purse and would talk about it and pass it around and talk about what it

meant, its primal forms, and it had very broad hips, so, of course, it was a fertility goddess.[65]

Jerry MacAgy had encouraged the de Menils to build what she called a "teaching collection." The historical range was tremendous: a carved relief of the Egyptian deity Horus (1314–1197 B.C.), an ancient Greek painted terra-cotta amphora (520 B.C.), and *The Borghese Warrior* (seventeenth century), a miniature of *The Borghese Warrior* of Agasias from the Louvre. The grouping went from pre-Columbian terra-cotta bowls to nineteenth-century American folk art, from an eagle-headed wooden ladle from the Kwakiutl peoples of the Pacific Northwest to a standing female figure of carved wood by the Bambara people of Mali. And there were recent works to reflect contemporary concerns such as *Vietnam* (1965), an antiwar, painted collage on stainless steel by Michelangelo Pistoletto, a major figure in the arte povera movement.[66]

Dominique was also involved in other improvements to the campus. The Basilian fathers decided to create a student chapel, across from the main campus. It was housed in a small flat-roofed white concrete building that abutted a redbrick colonial-style house where Howard Hughes had spent his youth. A young seminarian and art history student, Glenn Heim, was allowed to design the chapel. Dominique worked with him closely and financed the project.[67]

The chapel had the exquisitely modest aesthetic that Dominique had been advocating since her work with Father Couturier on *L'Art Sacré* in the 1930s. It had white walls, low ceilings, rough wooden benches, and, behind the altar, a wall of glass framing views of a garden. The de Menils also put in works of art including a fourteenth-century *Virgin and Child* and an eighteenth-century Spanish corpus that was used as the central crucifix.

As the head of the art history department, Dominique gave the St. Thomas students opportunities that few would ever have. For a contemporary art course, she decided that they needed to see the latest work. So she assembled a small group including Fred Hughes, Kathy Davidson, Glenn Heim, and Sarah Cannon, a whip-smart young student from rural Arkansas. Dominique then took everyone out to the airport and piled them into the corporate airplane for an art fieldtrip to New York.

And, just as MacAgy had done, Dominique engaged students in the preparation of exhibitions. She reviewed the students' ideas for thematic shows and selected the proposal by Fred Hughes exploring the depiction of monsters in art. "She said, 'Freddy, you started it, so you are the point person,'" Kathy Davidson recalled.[68] It was clear that Hughes had become a favorite. As Dominique later explained, "I recognized in Fred Hughes a

The chapel at the University of St. Thomas, designed by
student Glenn Heim with Dominique.

young man who had not only an exceptional eye, but also an instinct for
what was important, for quality."[69]

When it came to leading the St. Thomas students, however, Dominique
was very much in charge. "She took over and we started looking for mon-
ster themes wherever we could find them," Kathy Davidson said. "And, of
course, she had the Louvre, the Museum of Modern Art, the Metropolitan.
And she had all of her friends—scholars, collectors, dealers, curators—that
she had known for years."[70]

The finished exhibition, with its title also by Fred Hughes, was *Con-
stant Companions: An Exhibition of Mythological Animals, Demons and
Monsters, Phantasmal Creatures, and Various Anatomical Assemblages*
(October 28, 1964–February 7, 1965). The opening took place just before
Halloween. Aline Saarinen, an arts writer married to the architect Eero
Saarinen, gave a twenty-minute preview of the exhibition that was broad-
cast nationally Sunday morning on NBC. Dominique sent out postcards

to promote the show, depicting *De monstris,* a seventeenth-century Dutch engraving of a male figure with a cloven hoof and assorted bats and flies buzzing about. As Dominique wrote on the back of the postcards, "You will have the privilege of a glimpse at some of the monsters in the exhibition opening next week in our gallery."

Constant Companions included 309 works of art from Christian Bérard to Francis Bacon, Gustave Moreau to Saul Steinberg. As Kathy Davidson remembered,

> We were all blown away by it, especially by the twentieth-century stuff. It was the first time I had seen Francis Bacon. Or Louise Bourgeois. There were lots of Brauners and Copleys, lots of Ernsts and Dubuffets. She painted the walls black, and you would walk into a kind of a dark labyrinth. You would turn a corner and be hit by some sort of horrific monster. It was creepy and fun; kids loved it. But you also learned about the history of monsters and mythology. It was the same thing that MacAgy would do: put something in there that would jar you and you would say, "Wait, why is that here?"[71]

Dominique also conceived such rigorous exhibitions as *Builders and Humanists: The Renaissance Popes as Patrons of the Arts* (March 24–May 22, 1966). It included over three hundred objects, rare books, and documents that covered two hundred years of papal patronage, from the fifteenth through the seventeenth century. The installation had walls, ceilings, and arched doorways that were painted in a vivid cardinal red.

"One of the greatest things was that she would just throw all this stuff out there and you had to make up your own mind," suggested Fredericka Hunter. "Which is how the house was, too. Everything was of the highest quality, or at least a uniquely felt combination, but there was a richness, a layering . . . Her shows were the same, a layering of information that you had to sort through; she wasn't going to help you through it, particularly."[72]

Builders and Humanists marked a turning point in the intellectual support for her shows at St. Thomas. "She did all of these exhibitions which people thought were beautiful . . . but she said at one point that until there was a scholarly apparatus backing it up, people were not going to ever take them as seriously as she wanted," remembered former St. Thomas student Karl Kilian.[73] The exhibition catalog was 368 pages, beautifully designed and printed, with essays by leading scholars; at the Metropolitan Museum it was accompanied by a lecture series with six important art historians, including Columbia's Rudolf Wittkower.

As part of the de Menils' mission of bringing artists and scholars to Houston, in 1965 Matta, Duchamp, and Magritte were all on the St. Thomas campus. Matta was there for an informal talk connected with *Constant Companions.* Duchamp dropped by to engage in a casual conversation with students. Magritte, making his first trip to the United States for the opening of his retrospective at MoMA, made sure to add a stop in Houston. "Alexander Calder came in," remembered Kathy Davidson. "We talked while he was designing the hangar for his sculpture placed in Welder Hall. Marcel Duchamp did an exhibition at the MFAH, so she brought him over to talk to the students. It was fun: here were real, live, flesh-and-blood artists who had created these great works."[74]

Henry Geldzahler, the legendary curator of American art from the Metropolitan Museum, went to St. Thomas to lecture on modern art, as did artist and critic Brian O'Doherty and composer Morton Feldman. The de Menils made sure it was amusing, because that was the way to pull everyone into what they were doing. "There was a crew of very funny people, many of them, having come out of Catholic educations, who were rebellious and hippies, and this was the permissive parent," recalled Fredericka Hunter. "Permissive for me because I wanted to study contemporary art; permissive for others in that there were lots of people around to do Mrs. de Menil's bidding and enjoy her company."[75]

Fred Hughes was definitely a source of humor. A fabulist, he liked to give the impression that he was related to Howard Hughes, which of course he was not. He often suggested he lived down the street from the de Menils, when, in fact, he lived on Vermont Street, the continuation of San Felipe, far from the manicured loveliness of River Oaks. Once, when Dominique and John were off in Europe, Hughes was asked to keep an eye on the art department. On her return, Dominique found a playful note. "Quite a number of the Greek vases were broken while you were away, but it is alright," Hughes wrote to Dominique. He assured her that everything was fine because he had locked a student into the art department who simply glued them all back together. Hughes then concluded helpfully, "P.S.: the plastic cases have rotted off the wall with bronze disease."[76]

But being a student under the de Menils was also hard work. Beginning with *Builders and Humanists,* Helen Winkler was hired to work full-time for Dominique, primarily assisting in the preparation of exhibitions and engaging in a myriad of other activities. For example, Helen, with one or two other students, would sit with Dominique at the printer's, reading and rereading the catalog proofs to ensure that every word was correct.

When Dominique met St. Thomas student Sarah Cannon, she asked her where she worked. "I said I didn't have a job, so she said, 'Oh, then you

work for me,'" Cannon recalled. "She had a lot going on at the time, so I became a helper. I was put on the payroll and paid whatever amount of money that she decided I was to have."[77]

For those students at St. Thomas, the connection with the de Menils was definitely an adventure. "It was fun, but it was also very serious," remembered Paul Winkler, Helen's younger brother. "We were very, very serious about quality and about style. We had a lot to live up to."[78]

A BIG SPLASH

Elegance is not to be confused with prettiness, even less so with weakness. Contemporary artists, in the broad public's eye, are known mostly for their adventurous and shocking probe of frontiers, but they also have a sense of splendor.
—JOHN DE MENIL[1]

By the middle of the 1960s, Dominique and John de Menil had initiated a range of remarkable projects that would take years, and in some cases decades, to see to completion.

In 1966, Dominique and John met Werner Spies, a noted German curator and art historian. He, too, was passionate about the work of Max Ernst. Together, they visited the artist in a lovely hillside village in the Var in southern France. Ernst and Dorothea Tanning lived on the outskirts of Seillans in a large new house with a handsome swimming pool surrounded by his massive sculptures. Dominique told Ernst that she and John had decided to fund Spies in the research and writing of a *catalogue raisonné* of his work. The artist was underwhelmed. "He did not like the idea at all," Werner Spies explained. "He was not particularly interested in the past. He snickered about the pretentiousness of artists who focused on keeping exact records of every work they ever created. At the time, not that much was known about Max. He asked, 'Are you sure anyone really cares?'"[2]

Ernst had been the subject of a Museum of Modern Art retrospective in 1961, his first in the United States, but at that time he did not have the stature in art history that he later assumed. Ernst had no archives, nor an inventory. So Spies began contacting museums, collectors, and friends of the artist around the world to gather data on his work. He placed ads in art publications soliciting more information. As images and information began to be assembled, Ernst softened. "Max finally said, 'Oh, that's interesting,' when we found a painting that he had forgotten. Or, 'show me that one—it's really pretty good.' And, of course, the de Menils loved that." The project continued for years. The first volume of the Max Ernst *catalogue raisonné* was published in 1975. The five-volume set, covering

every medium of Ernst's lengthy career, was over two thousand pages and included almost six thousand photographs of the artist's work.

When asked about the idea of a *catalogue raisonné*, why it mattered, Dominique explained,

> The catalogue raisonné of Max Ernst, which we backed, made everyone aware of the importance of Max Ernst. We knew all along that Picasso was the giant of his time, a colossal genius, typically Mediterranean. We did not know that Max Ernst was also a giant. He is the genius of the northern countries as Picasso is the genius of the southern countries. The catalogue raisonné of Max Ernst has revealed the vastness of his oeuvre, his inventiveness, his original-ity, his poetical dimension.[3]

By 1966, the de Menils were friendly with David Sylvester, the London curator and art critic. At the end of 1968, Dominique and John were work-ing with Sylvester on a Magritte retrospective he was curating for the Tate Gallery (held February 14–April 2, 1969). The de Menils lent at least eight of their paintings to the exhibition and proposed an idea to Sylvester: that he research and write a Magritte *catalogue raisonné*.[4] Sylvester agreed to take on the project, as long as he also had time for his own work. Domi-nique and John rented an office off Sloane Square, at 35 Walpole Street, for Sylvester and a team of researchers. "David has already spotted over a thousand paintings (including some gouaches)," Dominique wrote to John in December 1969. "He has found fifteen examples of the *Empire of Light*, just by reviewing catalogs and articles."[5]

Magritte had died in 1967, leaving his wife, Georgette, who was a friend of the de Menils', in charge of his legacy. "I think Magritte would have been appalled at the idea of a *catalogue raisonné*," said Sarah Whit-field, an art historian who worked closely with David Sylvester on the proj-ect. "Georgette was quite difficult about it. She wanted it to happen, but she wanted it to happen instantly. Magritte had made two lists, but as is often the case with artists, there were lots of mistakes, repetitions, and gaps. She couldn't really understand why this was taking so long."[6]

Others wondered as well. "I feel like shouting hurray and shooting fire works in every direction," John de Menil wrote to David Sylvester in December 1972. "I'm sending you, as a heavy brick, the files of our Ma-gritte collection, with the sculptures still to come." But John also wanted to check on the progress of the *catalogue raisonné*. "I am so proud of having laid my egg that I feel like asking you about your own."[7] The de Menils

were very enthusiastic about Sylvester, who was so dynamic and crackling with intelligence, and they became close friends, but as the project stretched on for years, there were some who felt that he was taking advantage of the de Menils' generosity. "It was horrible," said Werner Spies. "He really went too far. And he had a full-time collaborator, which I never had."[8]

Dominique would send Susan Barnes, a young art historian who was the daughter of her great friend Marguerite Barnes, over to London to help wrestle the book to completion. Later, Dominique would dispatch her son François to do the same, but Dominique could also be wry about the situation. David Sylvester was supposed to be spending three-quarters of his time on the Magritte *catalogue raisonné*. The remaining time was to ensure that he stayed active writing and doing exhibitions; as he said, he needed to "stay in the game." As Susan Barnes left for London, Dominique remarked, "But his ¼ is a very large ¼!"[9]

Sarah Whitfield remembered Dominique's visits to the office off Sloane Square. "She would come to London now and again to sort of crack the whip," Whitfield recalled. "She would come once a year to London, always extremely encouraging but saying, 'This can't go on forever.'"[10]

After more than two decades of patient, generous support from the Menil Foundation, David Sylvester, in 1991, began publishing the Magritte *catalogue raisonné*. He oversaw five volumes of beautifully designed and produced documentation of every stage of the artist's career. At more than twenty-one hundred pages, it has been considered one of the most exquisite *catalogues raisonnés* ever produced.

•

Dominique's schedule could be full and far ranging with little downtime. One workday, for example, a Friday in November 1964 when she was at their town house in New York, began at 7:00 a.m. with a phone conversation about upcoming exhibitions with the director of the Musée Guimet in Paris. Mid-morning, she had two scheduled calls: to a reporter at *Newsweek* who was planning to do a story on the arts scene in Houston and to Diana Vreeland at *Vogue,* who was organizing a feature on the de Menils' house in Houston. At midday, Dominique hosted a lunch at home, tête-à-tête, with Marlene Dietrich. Then, at 2:30 p.m., she went to Mark Rothko's Sixty-Ninth Street studio to meet with the artist. The next day, she took the Schlumberger jet to Houston.[11]

On one summer trip to London in 1963, John was a guest at Brooks's, the stuffy gentlemen's club on St. James's Street. It reminded him of their stays in London together in the 1930s when, having read enthusiastic

accounts of the city by French writer Paul Morand, they were fascinated by establishments like Brooks's. "We cast envious looks at this world that is really quite esoteric and, once you see it from the inside, pretty ridiculous," John wrote to Dominique. "So, I could not resist the desire to share this with you, a world that you will never be admitted to because you are a woman. *Idiots!*"[12]

On a trip to Paris, John experienced, with amusement, the drawbacks of a large, active family. "There were maybe four or five cars in the courtyard of rue Las Cases, and I found him at the front door getting ready to leave on foot," remembered Simon Jardin, the son of their great friend Jean Jardin. "He said, 'Will you walk with me? I'm going to the Schlumberger offices, and there are all these cars here, but not one of them is available for me.'"[13]

While Dominique was in Paris, she spent much of her time with her family—her mother, her sisters, John's relatives. In August 1963, Dominique had a small dinner at the rue Las Cases. She observed that evening that Philippa, who was now sixteen, was fully engaged in the conversation, had lively questions, and was generally charming. She also felt that their daughter, wearing a red velvet suit and having rinsed her hair with fresh eggs, was ravishing. Dominique noted her look: "*à la* Brigitte Bardot."[14] A few days later, Alexandre Iolas told Dominique about running into Philippa on the boulevard St.-Germain. He was seated at the Café de Flore. The dealer agreed about the de Menil daughter. "I think she is the most beautiful girl in Paris," he told Dominique.[15]

By the 1960s, Dominique rarely wore her Charles James clothes, usually only for a grand occasion. But in Paris, she had vendeuses at Givenchy and Balenciaga, where she regularly went to buy from the collections. The curator Jean-Yves Mock was struck by Dominique's quiet elegance. "She was beautifully dressed, but everything was so discreet," Mock said. "Her clothes were so unremarkable that you wouldn't have thought of the latest style. She was never seduced by an eccentric detail just because it was the latest thing." One day, Mock was staying with the de Menils in New York. He and Dominique had spent the morning working when she suggested they go for a walk. "She grabbed her coat, a beautiful heavy coat in blue wool, beautiful shoulders, perfectly cut sleeves," Mock recalled. "I said, 'Oh, that could be a Balenciaga.' Dominique said, 'Listen, Jean-Yves, it *is* Balenciaga.' It was as though she had been caught doing something wrong, buying from a grand couturier."[16]

In Houston, Dominique's cousin Pierre Schlumberger had married, in 1961, Maria da Diniz Concerçao, known as São, a striking young Portuguese woman. São Schlumberger had an elegant flamboyance, and a sense

of social ambition, that was very different from the rest of Dominique's family. "I thought they were fascinating," São Schlumberger remembered of Dominique and John. "They spoke about a world that I didn't know anything about. They spoke about art, sculpture, literature."[17]

Pierre Schlumberger had been head of the U.S. operations of the family company since 1941. Intelligent and cultured, he was probably not, however, meant to be the leader of a large corporation. "Because Conrad had three daughters and Marcel had two daughters, my father was the only boy in that ten-year generation," explained Anne Schlumberger. "I think all of the women, all of my aunts, were equally intimidating; it was an extremely matriarchal family, and they all exerted their influence on the company. But there was one boy, and only a son could be president of the company."[18]

Pierre Schlumberger had a difficult time with the death of his father, Marcel, in 1953, and the death of his first wife, who had a stroke, in 1959. His daughter Anne termed his response to both losses "a kind of breakdown."[19] Given the great growth of the company in the mid-1960s, it was felt that Pierre was no longer the right person to be leading it. "John de Menil supported Jean Riboud's presidency of Schlumberger by talking to all the family members," remembered Christophe de Menil. "He explained that Pierre wasn't the right person now and that Jean Riboud was."[20]

In 1965, John de Menil and the other members of the board forced Pierre Schlumberger's resignation. Madame Marcel, Pierre's own mother, voted against him.

As Pierre's daughter Anne said,

What I understood is that my grandmother had been given whatever stock she had in the company by my father after my grandfather died. The board of directors went to her and said, "Pierre is not able to fulfill his job, and if you don't vote your stock with us, we are all going to quit and the company that you and your husband spent all of these years building up is going to go down the tubes." So she agreed. They also said, "And we will put your daughter Françoise on the board, which is something that you have always wanted." That was the seedy part of it, I think. If they just said, "Look, he's not well." But they stuck in that little prize.[21]

As the board made its decision, John went over to Pierre's house in Houston to see his children. "He came to talk to me and my brother to try to explain what had happened," remembered Anne Schlumberger. "He said that my father had been ill and explained why they felt they had to do it; he was very sensitive to our feelings about it."[22] São Schlumberger's memory

was not as positive. "He certainly did not make an effort to bring any good news," she said of John. "In a way, the real tragedy was that there were five girls and only one son."[23]

Pierre Schlumberger and John de Menil had considered one another to be the best of friends. They would never speak again. São and Pierre moved back to Paris, into their Pierre Barbe–designed *hôtel particulier* on the rue Férou, just off the Luxembourg Gardens. São would become a flamboyant member of Paris, and international, society. Pierre was a very supportive husband to her, and an attentive father to their children and those from his first marriage, but was estranged from the rest of his family. "My father never spoke to his mother again the rest of his life," recalled Anne Schlumberger.[24]

Around the time that Pierre was being forced out, the decision was made, primarily by Jean Riboud and John de Menil, to move the Schlumberger headquarters from Houston to New York. The company took over the forty-third and forty-fourth floors of 277 Park Avenue, a glass and steel tower between Forty-Seventh and Forty-Eighth Streets. Howard Barnstone was chosen for the interior architecture and design. Completed in March 1966, the new Schlumberger offices were daring and modern, delineated by metal and glass partitions, and light sisal flooring. Many of the steel and

Schlumberger offices at 277 Park Avenue designed by Howard Barnstone, with art from the de Menils.

glass walls were angled, in order to produce hallways with open views of office interiors and encourage forward movement. The furniture was mid-century modern, much of it by Knoll. The art included Magritte's *Le grand style* (1951) in Riboud's office and an untitled 1962 painting by Max Ernst in Henri Doll's, but all of the offices, hallways, and reception areas were filled with important paintings and sculptures, mostly from the de Menils. Even the corporate jet, with its discreet, modern interior also designed by Howard Barnstone, often had a small painting by Max Ernst hanging on the back wall.

And the de Menils continued to build personal relationships with contemporary artists. One day, John was in the office in New York when he learned that Robert Rauschenberg was having some financial problems. Although his work was selling well by that point, John heard that there was a cash flow issue. Walter Hopps, who discussed the incident several times with the artist, recalled, "He gets Rauschenberg on the phone, at his studio on Broadway, and says, 'I hope I don't embarrass you, but I hear that Leo Castelli owes you serious money and its putting a strain on you, on your work, on taking care of your studio.'"

Rauschenberg admitted that he was having difficulties. "I know what it can mean when you don't have the money," John said. "I'd like to loan you some—what would make a difference?"

Rauschenberg replied, "I don't believe this! If I could just get $10,000, I could clean everything out and wouldn't have to worry." John asked if Rauschenberg would be at his studio that afternoon and had a check messengered over. The artist told many over the years that the $10,000 from John was a lifesaver. Rauschenberg also said, "You know, I never worked harder to repay a loan in my life!"[25]

On Saturday, June 3, 1967, the de Menils organized a fund-raiser for the Merce Cunningham Dance Company that included many of the artists they knew and admired. Co-hosted by Philip Johnson and held at his Glass House in New Canaan, the event was something of a crescendo of 1960s multidisciplinary creativity. It included a premier performance by Merce Cunningham and the eight members of his company. The music was by John Cage; the costumes were by Robert Rauschenberg; the artistic director was Jasper Johns. "Then, time to roam through Philip's lake pavilion, the Glass House and his underground museum," John de Menil wrote of their plans for the evening. "We'll have dinner on cushions under the trees, fireworks and dancing to Andy Warhol's Velvet Underground."[26]

For about two dozen guests, the event began in the afternoon at the de Menils' town house on Seventy-Third Street, with champagne and caviar. Joining Dominique and John were their young friends and protégés Fred

Hughes, Karl Kilian, and Helen Winkler.[27] Hughes had recently returned from a year in Paris that Dominique and John had funded. There, he studied French at the Sorbonne and volunteered at the Iolas Gallery, until he was suspended from school. "I know this will not come as too great a surprise despite my frequent promises to buckle down," Hughes wrote to Dominique. "School is great as long as you are being educated, are unsure of your goals or if you want to be a scholar. I feel compelled in another direction and am willing to make the necessary sacrifices."[28] So, a few months later, Fred Hughes was staying at the de Menils' town house, looking for his next move. Other guests at 111 East Seventy-Third Street that afternoon were Andy Warhol and some of the leading members of his Factory crowd including Viva, Paul Morrissey, and Gerard Malanga. The de Menils rented station wagons to drive everyone up to the Glass House.[29]

Dominique and John had assembled an impressive committee of New York cultural leaders to support the Cunningham fund-raiser, including Leo Castelli, Henry Geldzahler, William Lieberman, James Thrall Soby, Lily and Douglas Auchincloss, Gertrud Mellon, Amanda and Carter Burden, Phyllis Lambert, Paul Rudolph, Robert A. M. Stern, Jimmy Ernst, Mary Lasker, and Charles and Jane Engelhard. Many went up to New Canaan on a special train John had organized from Grand Central Terminal.[30]

The event itself was a happening. The Cunningham piece, a premiere titled *Museum Event No. 5,* was to a Cage score played on viola, gongs, radio, and three old cars—meaning the sounds of engines, windshield wipers, and slamming doors. "Balloons. Ballet. Boogaloo" was how the evening was described by *Vogue*.[31]

As the fund-raiser was moving into high gear, Karl Kilian kept an eye on one intriguing scene:

Fred Hughes and Andy Warhol, who had just been introduced by Henry Geldzahler, were seated on the edge of a low garden wall, about to embark on an epic conversation. While they talked, the Cunningham company performed to the score by John Cage. Fred and Andy talked during cocktails on the lawn, and the boxed dinner from the Four Seasons Brasserie. They talked through the fireworks and while the Velvet Underground began to play. They talked as some people, hot from dancing, jumped into the pool. They talked while others, chilly in the cool June air, decided, without knowing that the damper was closed, to light the logs in the Glass House fireplace. They may have talked until the police and firemen arrived, saying the party was over: a neighbor had complained about the music.[32]

Merce Cunningham was very grateful for the de Menils' fund-raiser. "Many people have spoken of their pleasure in the evening," Cunningham wrote to John, just after the night at the Glass House. "I hope you were pleased also. As for me, our debts are paid and the summer breezes are light and cool right now."[33]

The meeting between Fred Hughes and Andy Warhol was important for both the young man and the artist. As Kilian suggested, "The conversation that he and Fred started that night would continue until Warhol's death." The following Monday, Hughes reported for work at the Factory.[34] There had been a certain edge to the artist's early years that Hughes made sure was softened. He would become Warhol's most influential employee, business manager, and executor of his estate, organizing the famous 1988 Sotheby's auction of Warhol's collection that made possible the creation of the Andy Warhol Museum in his native Pittsburgh as well as the Andy Warhol Foundation for the Visual Arts.

According to his friend Karl Kilian, Fred Hughes called his connections with the de Menils "a sort of dowry." In his first months with Warhol, Hughes realized that, four years after the death of Jerry MacAgy, Dominique had yet to find a suitable memorial. So he suggested that Warhol use Dominique's favorite photograph of MacAgy, taken in 1958 by Eve Arnold, and create portraits on multiple canvases using his signature silk screen technique. The result was a series of seven silk screens by Warhol, *Portrait of Jermayne MacAgy* (1968).

"Those paintings became the first of what are called either the 'social' or 'commissioned' portraits," Karl Kilian explained. "The MacAgy paintings are historic; they began the process, and as Hughes and Warhol made their way through all those lunches and parties and trips in search of subjects, Fred's charm and Andy's peculiar magnetism proved mostly irresistible. The portraits would become the Factory's chief source of income."[35]

Bob Colacello, who joined the Warhol crowd in 1970, had a firsthand view of Fred Hughes's influence on the artist. "Fred had *style*—extraordinary, remarkable, one-of-a-kind style," Colacello wrote. His sway over the artist was far-reaching. According to Colacello,

He was the great collaborator, so to speak, of Andy's social life and art business—which for Andy were more or less the same thing. "I'm just a traveling portrait artist now," Andy started saying in interviews shortly after Fred started working with him in 1967. And to a large extent he was. "I just go where Fred tells me to go" was another of Andy's regular lines and it was true. Fred led and

Andy followed, complaining all the way there, counting his money all the way back.[36]

As it was happening, it was clear to many that the de Menils, through their support of Warhol and their close friend Fred Hughes, played a role in his development as an artist. "In a manner of speaking, she did create Warhol," John Richardson said of Dominique de Menil, "in that she gave Fred Hughes his first job, and through Fred Hughes, who was very devoted to her, she was very much a guardian angel to Andy. There were no loose ends in her mind at all; I think she knew exactly what she wanted to do and did it."[37]

•

There was another immense undertaking that Dominique and John initiated in the 1960s, just as they had James Johnson Sweeney in place as the director of the Museum of Fine Arts, Houston. They asked him, beginning in 1961, to send letters to museums around the world, requesting reproductions of works in their collections that depicted subjects of African descent.

As Dominique later characterized their intention,

> I came to America when segregation was the law of the land. Other than a relationship between employer and employees, which often were quite friendly, particularly between a lady boss and her black help, there was no communication between blacks and whites.
>
> Blacks were everywhere but it was as if they did not exist. They were non-persons. Except for entertainers—boxers, baseball players, stars like Marian Anderson and Louis Armstrong.
>
> Below a surface of relative amenity there was enormous resentment. The segregation law was inhuman. Slavery was not so far away and the threat of lynching was always hanging over any black male.
>
> I felt that the situation was intolerable and that, as a French woman, I should contribute something. Great masters, who had treated the subjects with blacks like the three kings or the baptism of the Eunuch, had depicted them as having great dignity and beauty. There was a message that had to be relayed.[38]

The groundwork for the project began in Paris in 1960, when Dominique was told of a young man, Ladislas Bugner, who had studied art his-

tory at the Sorbonne. He was first interviewed by the de Menils' great friend Jean Malaquais at Café de Flore. Malaquais mentioned the idea of research for an exhibition that involved the representations of blacks. He was given the phone number of the de Menils to make an appointment.

In the social directory, Ladislas Bugner saw the name of Baron de Menil and wondered what all of this was about. For his meeting with Dominique, it was agreed that he would go to their house in the country. He was told to take the train to Senlis, north of Paris. He waited outside the station with his suitcase until a small truck arrived and a tall woman in pants jumped out. Dominique first drove them to an ancient abbey in Senlis, to begin with a cultural connection, then to Pontpoint.[39]

The project Bugner was hired to supervise would be called *The Image of the Black in Western Art*. To begin, he contacted museums across Europe to send photographs of important works of art that contained blacks. And James Johnson Sweeney began sending his letters. "The Museum of Fine Arts, Houston is sponsoring an exploration of Negro subject matter in the fine arts," Sweeney wrote to fellow directors. "We will be grateful to you if you will send us two photographs of any work of art in your museum's collection which is specifically related to our research. There is no limitation as to period. We are equally interested in antiquity, the Middle Ages, the Renaissance, down to our days. There is no limitation to medium."[40] Thomas M. Beggs, the director of the National Collection of Fine Arts at the Smithsonian Institution, now the Smithsonian American Art Museum, set to work compiling a list for Sweeney. "Your request is of timely interest and we will cooperate with you in every way possible," Beggs wrote to Sweeney.[41]

Throughout the 1960s, Sweeney sent his letters, Ladislas Bugner did his research, and Dominique and John looked for examples at every museum they visited, from every collector they met. In 1963, Dominique was in Paris, where she and Bugner had their second meeting with the engravings curator at the Bibliothèque Nationale. "He is very interested in our project for the 'Negroes,'" Dominique wrote to John. "Two months ago, he bought as many engravings of blacks as he could find. He said, 'I knew, before too long, that someone would be interested in this subject.'"[42]

By 1964, it became clear that the research project needed to become a book, or a series of books. Sponsorship by the Museum of Fine Arts, Houston, became problematic. First, it had become too massive a project. Then the head of the MFAH board said the books might jeopardize fund-raising for the museum. So, beginning in January 1965, *The Image of the Black in Western Art* was taken over entirely by the Menil Foundation.[43]

The de Menils expanded the Paris facility, eventually taking space at

138, avenue de Suffren, close to the UNESCO headquarters. During those first years, Ladislas Bugner, his wife, Monique, and the other members of the team tracked down thousands of images of important works. In 1970, Bugner showed a mock-up of a book layout to John de Menil, with the text on one side, the images on the other. "He looked at the photos and, after ten minutes, closed the album and said, 'Everything has to be redone.'" Both Dominique and John were dissatisfied with the quality of the images. The photographs that had been assembled were fine for research but not good enough for publication. "I'm not sure John knew how much was involved in that decision," Bugner said. "But it was his way, his grand style, unaccepting of anything mediocre or only okay."[44]

So, beginning in 1972, the Paris office, along with a new office in Houston, engaged photographers and spent three years photographing around thirty-five hundred works of art. Bugner said that the photographic campaign for one year, 1973, cost more than the budget for the entire program with five employees from 1961 to 1972.

To oversee the Houston office, the de Menils, in 1973, hired Karen Dalton, who felt that the decision to reshoot was the right one. "The de Menils' perspective was that what these books could potentially do was not only alter the way white people viewed blacks but that it could allow black people in this country to see themselves in a manner that didn't involve caricature," Dalton explained. [45]

The first volume, *The Image of the Black in Western Art: From the Pharaohs to the Fall of the Roman Empire*, would be published in 1976 by Harvard University Press. More than 350 pages, it had an introduction by Dominique, historical essays by leading scholars, and splendid photography in color and black and white. As art critic John Russell characterized the book in *The New York Times*, "It has the kind of stately and illimitably generous presentation that is usually preserved for the white man's glorification of himself."[46]

Additional volumes of *The Image of the Black in Western Art*, exploring a vast expanse of art history, appeared in 1979 and 1989. In 1994, an agreement was reached between the Menil Foundation and the W. E. B. Du Bois Institute for Afro-American Research at Harvard University, transferring the entire venture to the university (where Karen Dalton continued to work on the project, which was directed by Henry Louis Gates Jr.).

"The decision in 1960 to launch a systematic investigation of the iconography of blacks in Occidental art did not proceed from any clear plan," Dominique wrote in the first volume of *The Image of the Black in Western Art*. "It was prompted by an intolerable situation: segregation as it still existed in spite of having been outlawed by the Supreme Court in 1954.[47]

Such a large effort and such an abundance of collected material bring sober-ing reflection," Dominique wrote. "The past is heavy. To face it, to assume it, facts must be brought candidly to light. The making of a more human world requires rigorous studies. It is the hope of the Menil Foundation to work toward this goal."[48]

•

The vast publishing project was an important example of Dominique and John de Menil's complete commitment to civil rights, an engagement that began shortly after they arrived in the United States and built through the 1950s, 1960s, and 1970s. Exhibitions were one means to transmit a mes-sage of racial inclusion. *Totems Not Taboo,* of course, was the first. Five years later, at the University of St. Thomas, Dominique curated another non-Western show, *Humble Treasures: An Exhibition of Tribal Art from Negro Africa* (October 15, 1965–February 20, 1966). Lenders included the Museum of Natural History, the Museum of Primitive Art, and J. J. Klej-man, all from New York, but many of the 215 masks, ancestral figures, and fetish objects were from the de Menils' collection. Six lectures were given by Mino Badner, a professor of non-Western art whom Dominique had brought to St. Thomas.

In the spring of 1969, Dominique and John helped fund the Black Arts Festival at TSU. They lent pieces from their African collection for an exhi-bition in the school library and provided the budgets to bring in such lead-ing African American writers as Maya Angelou and LeRoi Jones. "We had a great American poet in town Friday," John wrote to William P. Hobby Jr., publisher of *The Houston Post.* "He made a speech, aggressively black—and so intelligent. He read three of his poems and that was extraordinary. I would like to share with you my regret that the *Post* did not mention the visit of LeRoi Jones, a writer of whom America can be proud."[49]

Diana Hobby responded to John, enclosing a story the *Post* had written on the festival and explaining that they had tried to organize an interview with the writer but were unsuccessful. But John suggested that trying to arrange an interview with LeRoi Jones would have been much too difficult for the journalist. "The thing was to be in the auditorium and to listen," John wrote. "The speech was more informative than any interview could possibly have been. And the poems he read and pounded and chanted: that was extraordinary. It is great American literature. It would have been a rev-elation for a perceptive reporter, as it was for Dominique and me."[50]

•

In 1967, outside the Corcoran Gallery in Washington, D.C., John de Menil saw a monumental sculpture by Barnett Newman, *Broken Obelisk* (1966–1967) (Newman initially produced a pair; a third, done in 1969, was placed in the sculpture garden of the Museum of Modern Art).[51] Made from three tons of Cor-Ten steel, *Broken Obelisk* was a powerful abstract construction: a base made of a tall pyramid, its tip surmounted by an obelisk that had been turned upside down and lopped off, unevenly, at its height. The two classical forms, the pyramid and the obelisk, had a grace and power, while the point at which their two tips met gave the sculpture a sense of tension. The de Menils felt it to be a work of "tragic grandeur."[52]

The National Endowment for the Arts was offering matching grants for the purchase of contemporary sculpture by a living artist. So the de Menils proposed the City of Houston acquire *Broken Obelisk*. Once other donors were found, they would contribute to the purchase price. After a year, by 1969, the arts commission had found no other donors. "So we decided that to bring it to Houston, we would provide all of the matching funds," Dominique recalled. "It was big money, but John was absolutely in love with this sculpture."[53]

The de Menils decided to attach two conditions: that a prominent placement near city hall be found for the sculpture and that it would be dedicated to Dr. Martin Luther King Jr., who had been assassinated the year before. Houston mayor Louie Welch was at the de Menils' house when John told him of his wish. "You can't do that," Mayor Welch said of the dedication to King. "It will never go through."[54]

Even within the African American community, there had been mistrust of Dr. King toward the end of his life. "It may not seem like such a bold thing to do right now, but Dr. King had been speaking out against the Vietnam War," Deloyd Parker said of the de Menils' desire to dedicate the sculpture to King. "So it was revolutionary at that time. Some black ministers didn't want to be associated with Dr. King, because he had been against the war; it was unpopular to do that."[55]

During the summer of 1969, the de Menils went to a Houston City Council meeting to make the case for the dedication of *Broken Obelisk* to the civil rights leader. John was given a few minutes to speak. After reminding the council of the two-year history of the project, his advocacy for Dr. King was met with silence. As Dominique remembered, John asked, "Could I know why you would object?" He was told, "The council never gives reasons."[56]

Dominique and John, however, were convinced of the importance of the act. They decided to forgo the NEA funds and to buy *Broken Obelisk* outright. It was a sizable purchase, but the de Menils felt strongly about

both the artistic importance of the sculpture and the need for it to honor Dr. King.

After the council meeting John dashed off two letters. He wrote to Barnett Newman to keep him advised. "We had first wanted the *Broken Obelisk* to be dedicated to the memory of Martin Luther King but, revoltingly enough, the City Council wouldn't have it," John alerted the artist. "So we substituted the Biblical inscription you will see in the attached memorandum."[57]

That text, addressed to the city council, suggested an alternate: "Forgive them, for they know not what they do!"[58]

•

The de Menils were involved in civil rights in a very personal way. The Reverend William Lawson was a Baptist minister who had moved to Houston in August 1955, arriving, by chance, on the day that Emmett Till was murdered in Money, Mississippi, about an eight-hour drive northeast of Houston. Lawson had moved to Texas to be the chaplain at TSU. Later that year, when Rosa Parks refused to give up her seat on a bus in Montgomery, Alabama, TSU students began to plan their own sit-ins. "John de Menil was the kind of person to get involved in civil unrest, so he offered some help to the students," Lawson recalled. "At that time, I was pretty much a student leader and saw that he would help them personally."[59]

After John gave financial assistance to TSU student protesters, in 1956 and 1957, Lawson began to get to know the de Menils and was invited to their house; over the years, he would become close enough with the couple to speak at their funerals. "My first impressions were that they were not simply liberal but radical," Lawson recalled. "He was soft-spoken, but they were people who I would normally call 'high society,' wealthy people, and yet they were very interested in backing these black students." When asked if there were others in Houston who were helping, Lawson replied, "Not really. That was a very unpopular stance to take, but he was the kind of person who didn't care about popularity."[60]

In 1962, Lawson had left TSU to start the Wheeler Avenue Baptist Church, which became one of the leading African American churches in Houston. By 1963, Martin Luther King Jr. had spoken at Wheeler Avenue. At Dr. King's request, Lawson's young church became the Houston affiliate of the Southern Christian Leadership Conference, or SCLC, the civil rights organization begun six years before in Atlanta by King.

By the mid-1960s, Houston's postwar boom had been going for some two decades. Fortune 500 companies were relocating their headquarters

to the city, the massive Lyndon B. Johnson Space Center was being built for NASA, and the world's first great indoor stadium, the Astrodome, was completed in 1964. Houston was tagged "Space City": a place of the future. The last thing civic leaders wanted was the kind of civil unrest seen in other southern cities, such as the 1963 riots in Birmingham. So a group of leading businessmen, including John de Menil, met to determine a plan of action.[61]

As Lawson remembered,

> They decided that the best way to desegregate Houston was to take down all the white and colored signs but to do it silently. They chose just to take them down one day, and the media people— *The Houston Post, The Houston Chronicle,* and several television stations—decided not to publicize it. The idea was that people would go out and suddenly find that blacks are welcome: they can go to Woolworth, they can ride in the front of the buses, but there will be no publicity. Those of us who were here when it happened found one day that everything was opened: white and colored signs had vanished.[62]

Lawson said that the unusual approach had a very big impact on black residents, of course, and on smaller businesses that were not part of the group and had to quickly adapt. It was unconventional, but at least for the segregation of transportation and public areas, it seemed to have worked. "John de Menil played a very real role in that," according to Lawson.

While he worked behind the scenes, John also took positions publicly. In April 1965, when Houston schools were still completely segregated, he wrote a letter to *The Houston Post:*

> May I voice here my concern about the non-participation of Negro high schools in the projected trip to Bayreuth, Germany. All City Orchestra is trying to raise $65,000 to send to Germany a public school orchestra representative of the great musical center Houston has become. How could it be truly representative if only white children are included?
>
> What an opportunity missed to show the world that Houston is different from Selma![63]

Beginning in the 1960s, the de Menils befriended quite a number of African American civil rights activists. One was Deloyd Parker, who was just beginning the SHAPE Community Center, an acronym for "Self-Help for African People Through Education." The de Menils had a breakfast

meeting with Parker, agreeing immediately to help. For decades, they would provide monthly payments for the lease of the SHAPE Center, a facility in the Third Ward, not far from TSU, also paying salaries for Parker and for two teachers who provided free day care for children with working parents. "Beyond the regular payments, Mr. de Menil would give us money for such things as books for our library, office supplies and audio equipment," Parker explained. "When we grew out of our main center and needed more space, he bought a building for us and continued to pay rent on the other one."[64]

When he met Dominique and John, Deloyd Parker mentioned, almost as an aside, that it would be good for his development as an activist to visit Africa at some point. The next thing he knew, he was told to organize his passport and his vaccinations: the de Menils were funding a research trip for him to Africa. Parker and his wife spent thirty days on the continent, visiting Kenya and Tanzania. "I was already working to enhance and improve our knowledge of Africa and who we are as a black people," Parker recalled. "I was already learning black history. So the time in East Africa was a major part of who I became. My development was enhanced tremendously; when I got back, I was a born-again African."[65]

It has long been suggested that relations between blacks and whites were less highly charged in Houston than in other places in the South. There were no massive riots, it was pointed out, unlike other major southern cities. That was a little optimistic. As Parker explained,

> Race relations were worse then than it is now and it's bad now. Race relations in the mid- and late 1960s was the Chief Short race relations, the police brutality race relations. That's when they killed Bobby Joe Conner—kicked him to death—when they killed Joe Campos Torres and Randall Webster. When I say "they," I mean the police. This was a time when people moved in and brutalized, handcuffed, and threw your body in the bayou. So relations were very bad during that period.[66]

As one example of the highly charged environment, Parker cited a rally at the Houston Coliseum, held on October 17, 1967, with Martin Luther King Jr., Lena Horne, Aretha Franklin, and Harry Belafonte. The event, a fund-raiser for the Southern Christian Leadership Conference, was coordinated by Curtis Graves, a young member of the Texas State House of Representatives who became, in 1966, the first African American elected since Reconstruction.

Tickets for the Martin Luther King event were sold through Ticketron,

but after receiving death threats and having a smoke bomb thrown into one of its locations, the agency pulled out of the project. The day before the SCLC fund-raiser, Dr. King arrived in Houston. Curtis Graves was with King in his room at the Shamrock hotel, along with Harry Belafonte and the Reverend William Lawson. Graves informed King that because of the ticketing troubles they had not even sold half of the seats in the arena, that they might have barely broken even. "Martin kneeled down and started praying out loud," Curtis Graves recalled. "I had never seen anyone do that before—I was raised Catholic—we all kind of looked at one another. When he finished praying, after about ten minutes, he said, 'Give away the tickets. The bottom line is that we don't want to look bad. It will be made to look in the press like we could not manage to sell seats.' "[67]

So Graves and his team took over a friend's garage to try to handle a quick distribution of the remaining tickets, using African American churches, civic groups, and the like. The following morning, a car pulled up to their headquarters. "I'm the chauffeur for Mr. de Menil," he said. "And Mr. de Menil would like to buy some tickets." John's driver gave Graves an envelope containing a check for what he recalled was $25,000. Graves told the others to begin gathering up as many tickets as possible so that they could be given to John. "The chauffeur said, 'Mr. de Menil told me to tell you to give away all of the tickets.' They were the exact words that Martin had said the day before."[68]

If John's intervention meant the fund-raiser was a financial success, the event itself did not go as smoothly. Members of the Ku Klux Klan demonstrated outside the arena.[69] Inside, there was a coordinated effort to ignite stink bombs in multiple locations. Members of the audience choked back tears and held handkerchiefs over their mouths and noses. "We've had trouble here tonight," Martin Luther King Jr. said. "The forces of evil are always around."[70]

After another detonation, Harry Belafonte brought his performance to a halt. "I was told that if I came to Houston, I would fare no better than John F. Kennedy did in Dallas," Belafonte announced.[71]

That same year, earlier in the spring, there was one large-scale racial incident that had become notorious. As Deloyd Parker remembered,

> You say there was no major rebellion in the city; I beg to differ. When the police invaded Texas Southern University on May 17, 1967, when they invaded TSU and shot over five thousand rounds of ammunition into the dormitory, only to kill one of their own— that was a rebellion. But it was a police rebellion against a black university. Five students were arrested for inciting a riot and kill-

ing a police officer—who they did not kill. But according to the Riot Act, and this is where Mr. and Mrs. de Menil come in, if you are accused and convicted of starting a riot, then anything that happens subsequent to that riot, you are responsible for. So they accused them of inciting a riot; they accused Charles Freeman and four other students of starting a riot. The police invaded TSU to quell the riot, but they *caused* the riot. They were the only ones who were aggressive, and they were the only ones who were shooting. No gun was fired at them—nobody jumped on them—they tore up the dormitory. They went in and tore up the ceiling looking for guns; they found one that hadn't even been shot.[72]

It was estimated that 500 officers stormed Lanier Hall, a dormitory on the TSU campus, ransacking rooms and arresting 488 African American students. "They made us lie in the broken glass on the floor in our underwear," recalled Harvey Johnson, a young art student who was arrested. "The student in front of me got hit on the head with the butt of a gun. They piled us into a paddy wagon. As we were driving to the police station, the officers talked about how they were going to throw us in the bayou. At the station, the officer questioned me using the term 'nigger.' He insisted that I answer him with 'Yes, sir' and 'No, sir.'"[73]

One police officer had been killed, later determined to be by friendly fire, while two officers and at least several students were injured. The next day, all of the students were released from jail except for five young men who were charged with the murder of Officer Louis Kuba, a group that became known as the TSU Five. In the local African American community, the TSU Five became a cause célèbre. The de Menils, without anyone knowing, paid for the legal defense of the TSU Five. They also provided funds to rent buses so that students and community leaders could be transported two hours away, to Victoria, Texas, where the trial was held. The case went on for several years until a judge finally dismissed the charges, announcing that there was no evidence to prove the accusations and admitting that the officer probably died from a police bullet that ricocheted.[74] "The TSU Riot stands as the most violent episode in the struggle for black rights in Houston," wrote one historian.[75]

The de Menils were involved with other examples of police and judicial bias against the Houston black community. In 1968, Lee Otis Johnson, an activist student at TSU and officer in the Student Non-Violent Coordinating Committee, was arrested, charged with offering a joint of marijuana to an undercover officer. He was convicted by a white jury and sentenced

to thirty years. The outlandish sentence became a rallying cry for the civil rights movement: "Free Lee Otis!" The de Menils, again, paid for his legal case.[76]

What drove them to intervene in these instances? According to Deloyd Parker,

> He didn't think they received justice. He didn't think it was fair to accuse the TSU Five of something they didn't do. He didn't think it was fair for Lee Otis Johnson to be given thirty years for one marijuana cigarette. He recognized all of them as being political prisoners—that was what he told me. And he wanted to do what he could do. He couldn't do anything but offer whatever resources he had. And he did that. Those resources, in both situations, helped: the TSU Five got off, and one of them, Charles Freeman, became a lawyer.[77]

William Lawson felt that John's engagement with civil rights was connected to a larger concern. "He felt the underclass need to be given opportunities," Lawson explained. "He seemed to focus a great deal more on the underclass than he did on the powerful. I think his fundamental philosophy was to do whatever he could do to bring about justice and opportunity." There seemed to be a real sense of humility in their approach to civil rights, an honest desire to right social wrongs. "But it was a fearless humility," Lawson explains. "They were going to do what they thought was right. And they were stubborn about it—very stubborn."[78]

One of the de Menils' most meaningful civil rights relationships began at TSU. On a visit to the campus, John asked the university president about which students he felt were particularly promising. He was told of a pharmacy undergrad named Mickey Leland. Already a vocal civil rights leader as a student, Leland was smart and dynamic and possessed a certain swagger. Having been raised by his mother and grandmother in Houston's Fifth Ward, he graduated near the top of his class in high school and would obtain his pharmacy degree from TSU in 1970. His plan was to work at the university as an instructor of clinical pharmacy.[79]

John de Menil had already given financial support to African American candidates including Barbara Jordan, who, in 1966, became the first African American elected to the Texas Senate since Reconstruction and, in 1972, was the first woman elected to represent Texas in the U.S. Congress. Curtis Graves, having been elected to the Texas House in 1966, became, in 1969, the first African American candidate for mayor of Houston. John

supported Graves. "He must have given my campaign $35,000 or $40,000," he recalled, "which made a real difference." John also flew with Graves to New York, introducing him to others who could help.[80]

When John and Mickey Leland first met, the young man was considered "a rather flamboyant radical," as one journalist summarized, and a "black power advocate."[81] Leland was striking looking, with light eyes, freckles, and a large reddish Afro. He was known to favor jeans, sandals, and brightly colored dashikis. As the de Menils began to know Mickey Leland, they—really John—sensed that he would be an effective politician. And they began to offer him financial support and guidance. For Deloyd Parker, who was a friend and fellow activist with Leland, it was yet another example of the sweeping engagement of John de Menil:

> What about supporting Mickey Leland when Mickey was just a red-haired, big 'fro radical! He didn't wait for things to become powerful to do it; he did it because he thought they were the right things to do. I'm not trying to make him out to be a martyr; I'm just telling you my personal experience with him. It was good, wholesome, healthy.
>
> What I picked up in that household was that he was the conscience. I'm not putting down Dominique; she was wonderful. She was more into art and other things. But it was my perception that he was the conscience; he was the humanitarian. His level of consciousness—he was special.[82]

The de Menil backing of Mickey Leland was broad, generous, and long lasting. And it helped him to change the direction of his life. Dominique and John introduced Leland to others who could launch his career, sent him on an informational tour of Europe and Africa, and even assisted with an evolution of his personal style. Thanks to their encouragement, which was always behind the scenes, and Mickey Leland's hard work and charisma, he was elected to the Texas House in 1972, and then, in 1978, when Barbara Jordan chose not to seek reelection, he won her seat in the U.S. House of Representatives.

In the summer of 1972, the week before he was leaving for his de Menil–funded trip to Africa, Mickey Leland wrote a letter to John de Menil. "I want you to know that I sincerely cherish our relationship which has grown to be very sacred to me, not for the material things that you've done but for the faith and confidence you placed in me," Leland wrote. The two-page, handwritten letter expressed how the young man felt about their relationship. "Most of all, I love you for the guidance you've given me in making

decisions about my life," Leland wrote. "It is very dangerous for a Black man to endear fatherhood by a white man. I stand by my convictions, and our colorless relationship, and say that you have become the father I always wanted and never had."[83]

•

The de Menils' political engagement in the 1960s went beyond civil rights. They believed in progress, and they fought for it. "They made such major contributions and spoke about it so little, so it is difficult to measure what they did for Houston," said the Reverend William Lawson. "They convinced people in the political and financial leadership that they needed to recognize people who were not simply in the minority but who were poor. That was seen in their support of blacks, but they were also very supportive of poor white and poor Hispanic people. And I think both felt that way."[84]

In January 1964, Ted Law, who was married to Caroline Wiess, daughter of one of the founders of Humble Oil, invited Dominique and John to a dinner at their house in River Oaks. It was to be a gathering, Law explained, of "true conservatives."

John's reply was droll but also made a serious point:

> We hate to disappoint you because we consider ourselves as your friends and we like both of you. I am afraid we are not "true conservatives," Dominique and I. Actually, we are Kennedy Democrats . . . isn't it awful?
>
> Although we don't see eye to eye with you, we wish you good luck for your dinner.
>
> We also hope that there are projects on which we can see eye to eye and work shoulder to shoulder. Conservative or liberal politics are one thing—and an important one. But what we do with our power—our overwhelming power—to stand in history as a great civilization, that is important too, very important indeed. And this is a field in which conservatives and liberals can agree and pull together.[85]

It was a brief letter, but it contained so much of the character of John de Menil. He was unwilling to pretend that he was something he was not. He made an effort to defuse any tension with humor. And, perhaps most important, he sketched out the best possible outcome of a situation, presenting it as though it should be obvious that everyone would want to move

in that direction. It was a masterstroke of interpersonal communication, suggesting a sense of diplomacy and optimism that was useful in their lives in Houston.

It is true that the de Menils' political views were not always well received in such a conservative environment. "He was one of the only liberals in this town," Paul Winkler recalled. "The only reason all the conservative people respected him is because he was such a good businessman, he was chairman of Schlumberger."[86]

John was not shy about extending his political action beyond Texas. In the summer of 1968, after the assassinations of Martin Luther King Jr. and Bobby Kennedy, President Lyndon Johnson created the U.S. National Commission on the Causes and Prevention of Violence. It was chaired by Milton Eisenhower, president of Johns Hopkins University and the younger brother of Dwight Eisenhower, and included such conventional figures as Terence Cardinal Cooke, the archbishop of New York.

John had a telegram delivered to President Johnson. "Suggest that you appoint to your commission on violence some members of the younger generation who will know more about the problems and its roots than Mr. Milton Eisenhower and Archbishop Cooke to name but two," he wrote. "Hopefully, the commission will have a chance to consider the case of Vietnam. Yours Respectfully, Dominique and John de Menil."[87]

In the late 1960s, the de Menils organized an exhibition of their cubist collection. Shown first at St. Thomas, the exhibit was titled *Look Back: An Exhibition of Cubist Paintings and Sculptures from the Menil Family Collection* (March 13–September 13, 1968). After Houston, it traveled to eight museums around the United States and Canada, followed by five museums in France.

One stop, from April 29 to June 1, 1969, was the University Art Museum, University of California, Berkeley. The exhibition happened at the same time that antiwar protesters took over an abandoned lot near the Berkeley campus and occupied the space that they dubbed People's Park. Relations between antiwar protesters and the university, after several weeks of peaceful demonstrations, became tense. The site was fenced off by school officials, which led to a major confrontation between Berkeley city police, university police, and some four thousand protesters.

To quell the disturbance, California governor Ronald Reagan and his chief of staff, Ed Meese, sent in 791 officers from jurisdictions throughout Northern California. They stormed the site swinging billy clubs and firing live ammunition into the crowd. One bystander was killed by the police; hundreds were injured. It was the most violent episode in the history of Berkeley.

John sent a telegram to Governor Reagan, which he also forwarded to the *San Francisco Chronicle* and KQED, the local public television affiliate.

It was a one-line telegram for Governor Reagan: "The loan to Berkeley of our collection of Cubist art justifies expressing our indignation at the police brutality at Berkeley for which you are responsible. Sincerely, John de Menil."[88]

•

In the middle of the 1960s, when the de Menils were fully engaged in so many different causes, it began to be whispered that John was having an affair. It was said that he had a relationship with Simone Swan, who was on the board of the Menil Foundation.

Simone Swan, whose mother was Belgian and father was American, had grown up in Europe and in the Belgian Congo. In 1964, in her early thirties, she lived in New York, where she had started Withers Swan, a public relations firm, in her apartment overlooking the Guggenheim Museum. She arranged for a group of journalists to accompany the inaugural Air France flight from New York to Houston. Before she left, investment banker Paul Lepercq gave her the names of São and Pierre Schlumberger as well as Dominique and John. When she went to the de Menils' house, her first reaction focused on the Magritte paintings and two African bird sculptures in the entrance. "This little man in a gray suit opened the door," Simone Swan recalled. "We were introduced to one another, and I go off to smell the sculpture. And he asked, 'Why are you smelling my birds?' I said, 'Because the smell remains in the wood; they smell of Africa! And the villages where I grew up.' "[89]

A few weeks later, in New York, Swan invited Dominique to her apartment for lunch. "When I first met her, she was unsure of herself," Swan recalled of Dominique. "About her writing, about what she was trying to do, having suddenly become the director of the art department at St. Thomas. John helped her with self-confidence. He did that with everyone—with me and with countless others."[90]

Dominique showed Swan some of the charming catalogs that had been produced for St. Thomas. Knowing that there were really only three important art publications at the time, Simone asked if the catalogs were being sent to them. Dominique said they had not imagined doing such a thing. Simone, convinced of the significance of the exhibitions, said, "Well you are cheating the art world!"[91]

So Swan was hired to do public relations for the shows at St. Thomas. She began alerting newspapers and magazines about what the de Menils

were doing in Houston. And she quickly became a very active member of the board of the Menil Foundation. Swan was dating Ronald Hobbs, an African American literary agent in New York, a dynamic man with a thundering voice who was very well connected with black writers and artists on the East Coast.

When the possibility of John de Menil having an affair was mentioned to Jean Daladier, who had known the de Menils intimately since the 1940s and remained close to both throughout their lives, tears came to his eyes. "I never had the slightest sense of anything like that," Daladier said quickly. "That would shock me. Of course, anyone can do something stupid, but given his faith and his view of the world, which was always of the utmost rectitude—that he would have been sleeping around left and right is just not believable." If many in Houston, and New York, assumed an affair had happened, Daladier refused to accept the idea. "Perhaps people have been wrong about him, perhaps these stories are repeated because it is pleasant to say something vicious about someone who was so good," he said. "Perhaps this person of such morality and strength could rub others the wrong way. But, no, I do not believe that for a second."[92]

Only two people know for certain; one is dead, the other has denied it. Simone Swan remained on the Menil Foundation board long after the death of John de Menil. And, decades later, Dominique was still in contact with her and concerned about her well-being. The French are often tolerant of extramarital affairs, but such a sustained relationship with someone who had been the mistress of her husband would be surprising.

During the summer of 1965, John de Menil was at their house in Houston. Dominique was at the Gallia Palace Hotel, a beachfront resort in Tuscany, with Philippa and François. Their letters during the summer were often about the difficulty of finding time to be together—that he was kept in New York or Houston on business while she was in Europe. On that day, John wrote to Dominique about their summer plans, also suggesting that there had been some temptation involving Simone Swan:

> I am consumed with the desire for contact. I feel like I have stayed young in many ways, too young perhaps, but I have a great need for the warmth created by a climate of love and tenderness. I need to love and to be loved, not like a companion in arms in a shared struggle and adventure, one who is esteemed, but as a man. I need to be understood as much as I need to understand, understood as a human being, by a human being. No doubt, sex is important in this context but I would like for the explosive violence of passion to be

part of tender, easy moments of leisure. I would like to be able to say, from time to time, "We really had a great time."

Simone was a by-product of my need for presence, for feminine tenderness. The temptation was great. I did everything to make sure that an accident was impossible. St. Thomas is not the only beneficiary of the work I helped her launch herself into and which involved a close collaboration with you. And now she will be getting married, I believe. I hope so—I want that—I have done everything to encourage it. The temptation will be eliminated definitively.

You see, Dominique, that I love you and how much I love you. I expend so much effort for you through work and through friendships and I do it with the joy of participating in the creation of something extraordinary, the joy, also, of having helped you with the attainment of your extraordinary personality. Oh, Dominique, let's have a week unimpeded by anything else. But know that I do not wish for a life of leisure and that I am not "looking for a simple, quiet life in a lovely setting, doing as we please." I am not longing for the silly trip around the world. I like hard liquor, not soft drinks. I like our life with its fullness and its accomplishments. I would like to "live" with you a little, before we die.[93]

•

Two years later, in early 1967, John, who had just turned sixty-three, learned that he had prostate cancer. In March, at New York Hospital, he had what he termed "substantial surgery." He stayed in the hospital recovering for more than a month.[94] Their daughter, Philippa, remembered visiting the hospital and having a conversation in the hallway with Mark Rothko, also waiting to see her father. Afterward, John convalesced at their house in New York, while Dominique was in Houston working at St. Thomas. "Yes, I am doing well, quite well, I am told," John wrote to his old friend Jean Jardin. "I am just a little impatient because I would like it to move faster. The fact remains that the operation was a success and that is what matters."[95]

That summer, when John was still in New York and Dominique was in Paris, he had distressing news. The surgery was not as successful as initially thought. Dominique and John kept the news between themselves, but from the summer of 1967 they knew that he would be living with cancer. "Jean, my husband, I am with you, sharing everything with you, the past and the present and now this anguish that is yours," Dominique wrote. "I would

like to be able to find the words, the gestures, that might sting for a moment but then soothe."[96]

Dominique was uncertain of what to say to him, knowing how much he detested empty expressions of sympathy or insincere consolation. She confessed that she, too, had fears about dying. "It is anguishing to think that everything ends with our rotting bodies," Dominique wrote. "But what is ten years? What is twenty years? What is a hundred? What is one moment of happiness? And what an illusion to think that we can have even an instant of real happiness. And yet, yes, it is possible, even in the midst of pain, even during the ordeal that you are now facing."[97]

Although they were not on the same continent, Dominique wanted to ensure John that they were very much together. As she wrote,

> Jean, I am with you. I cry; I kiss you; I console you tenderly. You have lost nothing. The love we have transcends everything and will transcend death. It may be that this will be a kind of death for you, and yet there is something beyond and we will find it together. Do not cry over a mirage. Rejoice in the knowledge that our love is stronger than everything. I love you and I am with you every day, every minute.
> Do[98]

Several days later, still in the town house in New York, John woke up in the middle of the night and went down to the kitchen for a drink of water. There, under the mail drop, he found Dominique's letter. "More than any sip of water, your simple rich words were just what I needed, language both rigorous and tender," John wrote to Dominique at 2:00 a.m. "You are an extraordinary woman. If anyone can pull me out of my distress, it is you and only you."[99]

John was frank about his diagnosis. "What happened to me at the hospital was like a door to the world that slams shut." He assured Dominique, however, that he was not so attached to the earthly realm that he was unwilling to leave it. More difficult, he felt, was the idea of living with diminished capacities. But he wanted to be cautious about any predictions for the future. "Life has not prepared me for idle speculation and, even today, I have little time for leisure," John wrote to Dominique. "But life has given me a woman who is unique, marvelous, and someone who, with her letter this evening, held my heart in her hands."[100]

·

Wherever they were in the world in the mid-1960s, the de Menils continued their lives at an intense pace. In January 1968, John made a trip to Montreal with Phyllis Lambert, née Bronfman, to see a new performing arts center she had designed, the Saidye Bronfman Centre for the Arts. "Architecture is her life," John wrote to Dominique about his new friendship with Phyllis Lambert. "She is alone in Chicago but unworried about spending every evening on her own with her books, having the occasional dinner with Mies and only a few friends."[101]

In May 1968, for the first time, the American Association of Art Museum Directors held its annual meeting in Houston. For the occasion, Dominique hosted a dinner at the house for seventy-five. The following day, Dominique and John took all of the museum directors for lunch at the Stables, the Texas steak house.[102]

Dominique then left for New York, where two weeks later, on June 3, Andy Warhol was shot at the Factory by Valerie Solanas. The de Menils helped assemble a first-rate medical team to oversee the artist's recovery. Dominique recorded the shooting in her date book, also noting Warhol's phone number at his apartment and his room at Columbus Hospital on Nineteenth Street.[103] While in New York, she met with Pontus Hultén, the Swedish curator who was preparing an important exhibition for the Museum of Modern Art, *The Museum as Seen at the End of the Mechanical Age*. Dominique was planning to bring that exhibition to Houston, so she made notes on works to borrow. In her conversation with Hultén, she learned that Yves Klein had been inspired by what he saw as a transcendental aspect to the work of Kazimir Malevich. As Hultén told her, "Yves Klein once gave a lecture on Malevich: a few words, a tune that was played for ten minutes, then, '*Merci.*'"[104]

By the end of June, after a dinner given by Governor Rockefeller at the family estate in Tarrytown in honor of René d'Harnoncourt of the Museum of Modern Art, Dominique was off to Paris, where she spent most of her summers. There, her activities revolved around family and art.

During her weeks in Paris, she had meetings with art historians and curators, dinners with her mother at La Coupole, and fittings at Christian Dior. Dominique went to the Maeght Gallery, looking for information that would help date their Braque collage. And she had long conversations with art historian Christian Zervos about works by Léger and Picasso in their collection. John dipped into Paris for quick stays with Dominique during the summer. Occasionally, they both made time for a long weekend at their house at Pontpoint, for a rare moment of relaxation.[105]

By early September, Dominique had flown back to New York, while

John made a trip to Italy. From Parma, he wrote to Dominique, "As always, there is the feeling of being so privileged to be in a setting that is like a dream."[106] The Cathedral of Parma and its baptistery, both Romanesque and Gothic, was one of the most important medieval monuments in Italy. John sent Dominique a postcard from the cathedral, depicting a relief sculpture by Benedetto Antelami, *Deposition from the Cross* (1178). The marble panel, which John noted was one of the rare Romanesque works to be signed, was a poignant portrayal of Roman soldiers lowering Christ's body from the cross while two angels appeared from above to comfort his followers. "You are like these two angels," John wrote to Dominique. "I always feel your hand, warm and tender, that you place on my head during those moments when I no longer have the desire to keep living."[107]

•

In the later years of the 1960s, the de Menils continued, and magnified, their commitment to the University of St. Thomas. Dominique pushed forward with her exhibition program, curating such shows as *Made of Iron* (September 29, 1966–January 3, 1967), of more than 515 iron pieces, from throughout the centuries.[108] "Rare are exhibitions that undertake to illuminate a modest and unfashionable subject and then do so with taste, scholarship and critical intelligence," wrote Hilton Kramer in a rave review of *Made of Iron* in *The New York Times*.[109]

The following show was *Mixed Masters: An Exhibition Showing the Various Media Used by Contemporary Artists* (May 19–September 18, 1967). The exhibition, with an installation by Fred Hughes, explored the diverse media used in pop art. It included a grouping of Niki de Saint Phalle's colorful *Nana* sculptures; a Wayne Thiebaud painting, *Bananas* (1963); a massive soft sculpture by Claes Oldenburg, *Giant Soft Ketchup Bottle with Ketchup* (1967); and, on the exterior of the Philip Johnson building, a large, round sign by Robert Indiana, in lacquered steel and lights, that spelled out "eat."

That fall, Dominique unveiled *Visionary Architects: Boullée, Ledoux, Lequeu* (October 19, 1967–January 3, 1968). It included almost 150 remarkable drawings and watercolors, primarily from the Bibliothèque Nationale in Paris, by the trio of eighteenth- and early nineteenth-century French architects Étienne-Louis Boullée, Claude-Nicolas Ledoux, and Jean-Jacques Lequeu. *Visionary Architects* also traveled, to the de Young Museum in San Francisco, the Art Institute of Chicago, and the Metropolitan Museum of Art. "Visionaries of the 20th century, architects of the cos-

mic dream, artists of the Pop put-on, manipulators of the surreal landscape, meet your masters," wrote Ada Louise Huxtable in *The New York Times* of the version at the Met. "This is the biggest small show to hit New York in a long time."[110]

In fact, Dominique started to wonder if the ambitiousness of their programming would become an issue. The St. Thomas exhibitions were entirely run by Dominique, John, and the students. As Helen Winkler recalled with a laugh, "When she started getting loans from serious museums, doing exhibitions with the Louvre or the Bibliothèque Nationale or the Metropolitan Museum, she said she was afraid that people would find out the whole thing was just being run by kids."[111]

John, in particular, loved being with the students. "He liked pop music, and he loved to go dancing in black dance clubs with us," remembered Paul Winkler. "There was only one art movie house in Houston, the Alray; we used to go out with him a lot to see those movies. He took us to Jim Morrison concerts."[112] The de Menils brought the Lovin' Spoonful to campus, in the fall of 1966, for a benefit concert for the art department. In 1968, Douglas Cooper gave a talk on Picasso's sets for *Parade,* the Diaghilev ballet with music by Erik Satie, that was followed by a big party for students. And after film screenings at St. Thomas, Dominique and John would invite students—sometimes as many as fifty—out for dinner at the Stables.[113]

·

Beginning in 1967, John decided to expand the University of St. Thomas art department into film and photography. Dominique had been interested in cinema since she was in her twenties. John saw cinema as an artistic medium that could reach a larger public. The de Menils, along with Jean Riboud, were also incredibly supportive of Henri Langlois, the legendary founder of the Cinémathèque Française.

And their son François was already making films. Beginning in 1966, at the Moderna Museet in Stockholm, he shot an ephemeral collaboration between Jean Tinguely and Niki de Saint Phalle (and would continue documenting them for a decade). In 1968, at the de Menil town house in New York, François filmed the birthday party for Simone Swan.[114] The finished work, titled *The Party,* showed Dominique and John entertaining such guests as Norman Mailer, Jasper Johns, Robert Rauschenberg, Andy Warhol, Fred Hughes, and Jed Johnson, interior designer and Warhol's boyfriend. Gladys Simmons helped serve heaping platters of lobster. Elizabeth de Cuevas cleared the floor with her dancing. At one point, firemen arrived

on the scene. As the narrow entry filled up with guests and uniformed firemen, John said, "For God's sake, don't lean on the painting."

In *The Party*, Dominique, wearing her Charles James saffron opera coat, appeared deep in conversation with Warhol and Fred Hughes, who told a story about Viva and suggested that she was upset about having missed a trip to Houston. They all discussed her performance in *Lonesome Cowboys*. "She's so terrific you can put her in anything," Dominique said of Viva. "In the scene where she sings and makes love to the cowboy, she is extraordinary."

In order to begin building a film department at St. Thomas, the de Menils needed to find someone who could teach the subject. They heard, through Gertrude and Howard Barnstone, about Gerald O'Grady, whose Ph.D. was in medieval literature but who had a personal interest in cinema. That summer, he was at Butler Library at Columbia University preparing to teach graduate-level English at the State University of New York at Buffalo. The de Menils persuaded a skeptical O'Grady to move to Houston and begin teaching film. He spent the summer of 1967 in New York, immersed in the film program at the Museum of Modern Art, visiting a co-op just begun by Jonas Mekas, and meeting such innovative young filmmakers as Stan VanDerBeek, Albert Maysles, and D. A. Pennebaker.

O'Grady moved to Houston, where the de Menils set him up in a small bungalow near the St. Thomas campus. He realized that he would need a library. As O'Grady remembered,

> I learned that there was only one bookstore in the country then that sold film books: Larry Edmunds Bookshop in Hollywood, run by a man named Milt Luboviski. I flew out there and told him I was starting a film program. He asked what I would like. They had a large collection of books and a lot of journals, French journals, German journals, and there were no other film programs coming to buy the material because other film programs barely existed. So I looked around the store and said that, just to start, I would like to get one of everything. It came to something like $80,000, which was a lot of money then. He asked how I would pay. I said, "Here is a phone number; call this man in Houston." He got off the phone and said, "Oh, you can pay with cash." It was a joke to express the absurdity of the whole situation—it all transpired in about five minutes.
>
> We had about fifty boxes on the way to my little bungalow at 3812 Mount Vernon Street, and I suddenly had the best film library in the country.[115]

In addition to jump-starting that library, which included two thousand books and film journals, O'Grady and the de Menils energized the film program at St. Thomas. He taught a course titled "Contemporary Styles in World Cinema," with films by such masters as Ingmar Bergman, Michelangelo Antonioni, Alain Resnais, and Jean-Luc Godard. He began a thirteen-week series of films and discussions, "The History of Cinema," for adults. On Friday nights, O'Grady launched the Media Club, showing the best foreign and experimental films available.[116]

O'Grady and John hired animator Stan VanDerBeek to teach a course in filmmaking at St. Thomas.[117] VanDerBeek, the artist in residence at the Center for Advanced Visual Studies at MIT and Bell Labs, was a leader of American experimental cinema. "The de Menils met with him several times in Houston and later asked me to invite 25 members of 'The New Underground' for dinner at their home in New York," O'Grady recalled. "Jonas Mekas, Ed Emshwiller, Shirley Clarke and others were soon brought to Houston to screen their films as the de Menils eagerly embraced the most radical elements of the new American cinema."[118]

At Expo '67 in Montreal. Left to right: John de Menil, Andy Warhol, Simone Swan, Fred Hughes, Dominique de Menil, Howard Barnstone.

In March 1968, the University of St. Thomas welcomed Jean-Luc Godard for a screening of his 1967 dark comedy *La chinoise* and, in May, Andy Warhol, who showed ninety minutes from his twenty-five-hour-long *Four Stars* (1967) and *Imitation of Christ* (1967), starring Nico, Taylor Mead, and Brigid Berlin. After the screenings, Dominique and John hosted a small dinner back at their house.[119]

The de Menils purchased their first work by Warhol in 1965, a massive silk screen, *Flowers* (1964). Two years later, they bought *Little Electric Chair* (1963). During those years, the de Menils became increasingly interested in the complexity of Warhol as an artist, at a time when very few others viewed him in that way. As John de Menil wrote, "His human quality is usually distorted by the desire to turn him into a star of the sensational when his pioneering work is serious and deep."[120]

By the end of June 1967, soon after Fred Hughes had started working with the artist, the de Menils had commissioned him to create a work for HemisFair '68, the World's Fair to be held in San Antonio. Based on the strength of their exhibitions at St. Thomas, Dominique and John had been asked to help with the Vatican pavilion for the fair. "That gave Dominique and me the idea to commission a few of the important artists of today to do, following their own inspiration, pieces appropriate for a church," John wrote to Warhol. "We think the pavilion should be a church where various denominations would be in communion. Actually, we have suggested that it be called the Ecumenical Pavilion." The de Menils informed the artist that they were also approaching Robert Indiana, Jasper Johns, Roy Lichtenstein, Claes Oldenburg, and Robert Rauschenberg. Warhol proposed doing a film.[121] The de Menils enthusiastically agreed.

The next month, Dominique and John took a small group including Warhol, Hughes, and Simone to visit Expo '67 in Montreal. The trip was intended as research for an artistic intervention in a fair environment. Warhol then set about filming sunsets in New York, East Hampton, and San Francisco. His film, *Sunset,* remained uncompleted, and the San Antonio project never materialized.

When it came to Warhol, the de Menils did not seem to be fazed by any of the goings-on around him. John, of course, loved that kind of energy, but Dominique did not seem to have any reservations either. "She was pretty unshockable," John Richardson said of Dominique. "Which came as something of a surprise, that someone so restrained, so delicate in many ways, could take the Warhol Factory when it was at its worst, with junkies all over the place and people in drag and God knows what going on. Perhaps being French, she was sort of used to it and took it in her stride."[122]

•

After the de Menils unveiled the film program at the University of St. Thomas, their next project was photography. In the spring of 1968, Gerald O'Grady asked to hire Geoff Winningham, a twenty-five-year-old photographer who had graduated from Rice University and was just finishing his master's in photography at the Illinois Institute of Technology.

Winningham's interest in the discipline was solidified when he was an undergraduate. Larry McMurtry, who was on the English faculty at Rice, asked him if he was interested in photography. McMurtry also worked at a local used bookstore, the Bookman, and said that he had something he wanted to show him. "So I went by and it was a copy of *The Decisive Moment,* by Cartier-Bresson," Winningham said. "I remember opening that book, looking through it, and thinking, 'Oh my God! This is what I want to do with my life. I want to make pictures like that.'"[123]

Contacted by Gerald O'Grady about an opportunity at St. Thomas, he agreed to talk with Dominique and John. In the first meeting, at their town house in New York, John grilled him about what would be his dream for a department of photography. Winningham, though a little overwhelmed by it all, began working immediately. Over the summer, he was tasked with creating a photography department from scratch. He worked with Howard Barnstone to renovate and equip a two-story house just off campus, near the film department. "John clearly wanted all this to happen very fast," Winningham recalled.[124]

The photography department at St. Thomas opened in the fall, with classes for students, lectures, and continuing education. There was a great desire to create excitement around the new department. Winningham compiled a list of those he felt were the most important people in the world of photography. And he brought them all to St. Thomas to lecture. Participants included John Szarkowski, the photography curator from the Museum of Modern Art; Nathan Lyons, the director of Eastman House; and Robert Frank, the Swiss-born photographer and filmmaker.

As the new photography department was getting started, in the fall 1968 semester, the film series drew a dazzling list of directors who made the trip to St. Thomas. Roberto Rossellini showed *Paisan* (1946), a World War II drama that was a high point of Italian neorealism. Melvin Van Peebles presented *The Story of a Three-Day Pass* (1968), about an African American soldier who had an affair with a white Frenchwoman during a leave in Paris. Albert and David Maysles previewed *Salesman* (1969), their documentary about the relentless lives of four door-to-door Bible salesmen. In

each case, the director was there to introduce the film and then discuss the work.

And Andy Warhol returned, on November 17, 1968, to premiere *Lonesome Cowboys*, his send-up of Hollywood westerns, filmed in the Arizona desert and starring Joe Dallesandro, Taylor Mead, and Viva. "You just knew that these were advantages that no one else was getting, anywhere," said St. Thomas student Fredericka Hunter. "Andy Warhol was a big deal to all of us who were interested in art. And you got to talk to him and know him." Given all of the excitement the de Menils were intent on creating, there were times when it got out of hand. "When they showed Jack Smith's *Flaming Creatures*, they had to lock the doors because they were worried about the nuns," Hunter said with a laugh. "The pace was rather languorous, but it was still flapping penises and transvestites and an *Arabian Nights* kind of thing; it's a legendary underground film."[125]

Several days after the screening of *Lonesome Cowboys*, Dominique opened her fall exhibition, *Jermayne MacAgy: A Life Illustrated by an Exhibition* (November 21, 1968–January 5, 1969). The show, drawn primarily from MacAgy's private collection, included 181 paintings, objects, and sculptures. The catalog included a list of MacAgy's exhibitions throughout the decades, installation photographs of many of her shows, and photographs of the collection she had left to Dominique and John and the University of St. Thomas. On display were antiquities, pre-Columbian art, folk art, and non-Western pieces from throughout the world. And there were more than fifty paintings and sculptures by twentieth-century artists, from Matisse to Rothko.

One of the most recent pieces in the exhibition was Warhol's *Portrait of Jermayne MacAgy*. So, of course, the artist and his Factory crowd made it to St. Thomas for the opening-night party. Warhol had never met MacAgy, but he knew of her importance to the de Menils. The exhibition was also, after all, the premiere of his first portrait. "The gallery was on the second floor, and there were those outdoor stairways that Philip Johnson had done, very International Style," recalled Paul Winkler. "I was standing with Kevin Cassidy, another student. We looked up and we saw two priests watching Taylor Mead and another man kissing. And we said, 'This is probably the end of the St. Thomas years; the priests are never going to be able to take this!'"[126]

WORTH THE CANDLE

We are not going to do anything revolutionary but it may appear revolutionary. Whatever we will present will be a reflection of our time. And if it appears revolutionary it is because we live in revolutionary times.
—*DOMINIQUE DE MENIL*[1]

By October 21, 1968, just as those shows and events were being completed, the de Menils broke with the University of St. Thomas.[2] The relationship had lasted more than a decade. It came to an end for the most basic of reasons: Dominique and John had a vision for the future of the institution that was not shared by its Basilian administration. The de Menils wanted to modernize teaching methods, secularize the curriculum, and expand into graduate studies. They also hoped to broaden the membership of the board. Having already brought in non-Catholic board members, they were looking to add more well-known figures like John Cage. The school, still with only a thousand students, was not willing to continue in that direction.

So Dominique and John decided to relocate all of their activities two miles south of St. Thomas to the elegant, intellectual oasis of Rice University, transferring the ambitious exhibition program they had developed along with the professors they had hired for art history, film studies, and photography. They spent more than a year quietly negotiating the move with the two schools. Dominique was named the director of the new Institute for the Arts at Rice University.

Just as plans for the move were being finalized, the de Menils' permanent collection for St. Thomas was being showcased at the Museum of Fine Arts, in an exhibition titled *A Young Teaching Collection* (November 7, 1968–January 12, 1969). Inside the vast hall, Dominique and Fred Hughes created a series of spectacular white cubes to hold the more than 250 works of art. The objects were a concentrated look at the high points of art history: an ancient Egyptian painted bowl (New Kingdom, eighteenth dynasty, 1580–1350 B.C.); a sketch of three lions by Eugène Delacroix; a

Mayan sculpture of a head in rough limestone; and a pen-and-ink drawing by Picasso, *Three Dancers* (1925).

In the exhibition catalog, Dominique explained the idea behind the teaching collection. "The student can look at a painting day after day; he can observe a sculpture from all angles, feel its weight, smell it, caress it," Dominique wrote. "A work of art has invaded his territory and demands his response."[3] The impressive collection, so generously assembled, would be leaving St. Thomas with the de Menils. As part of their settlement with the school, Dominique and John paid to reacquire the objects and place them on extended loan to Rice University.[4]

"Art Benefactors Shift Their Field: De Menils Turning Houston Collection Over to Rice" was the headline in *The New York Times*. "'We are heartbroken at the move,' said Mrs. De Menil yesterday in Houston . . . 'But John and I are excited over the possibilities of opening up at Rice, and we see it as a further development of what was born at St. Thomas.'"[5] John, too, was upset about the move. "We do not leave, without emotion, the St. Thomas to which we have dedicated 10 years of our lives and in which we remain interested," he wrote to a supporter of their initiatives at the school. "But we had come to a crossroad. We were not of one mind with the administration and we felt that nothing great is ever accomplished by a divided team."[6]

•

Rice University had been chartered in 1891 by a Massachusetts-born businessman as the William Marsh Rice Institute for the Advancement of Literature, Science, and Art. It was intended to be a gift to the city where he had made his fortune, primarily in investments. In September 1900, at his apartment on Madison Avenue in New York, Rice was chloroformed by his valet, who, in conjunction with an unscrupulous lawyer, conspired to steal his fortune. The butler and the attorney were found guilty of murder, while the $4.6 million founding endowment allowed construction to begin on the school in Houston. The Rice Institute opened on September 23, 1912, the twelfth anniversary of the founder's murder; in 1960, it became Rice University.[7]

Rice was the first institution of higher learning in Houston.[8] By the time the de Menils were involved, it was considered one of the leading universities in the South. Although it offered courses in the humanities and architecture, Rice was strongest in engineering and the sciences. Located across from Hermann Park and the Texas Medical Center, and just west of the Museum of Fine Arts, Houston, the campus covered three hundred

beautifully landscaped acres lined with allées of live oak trees (with each undergraduate class limited to no more than several hundred, there was a saying that there were more trees on campus than students). Most buildings were low-rise and traditional, although a few modern laboratories were constructed in the 1950s as well as a towering concrete football stadium that seated seventy thousand.

Even before the relocation could be made, Dominique and John had to act quickly. One evening, John was having dinner at home in Houston with Eugene Aubry, the architect and partner of Howard Barnstone. Aubry was informed by John that a major exhibition was coming from the Museum of Modern Art and that they would need to construct a new building to house it at Rice. And, he explained, the new building would need to be finished in a matter of weeks.

John and the architect sketched out a plan at the dinner table. Maurice, the de Menils' French butler, brought a telephone to the table so that Aubry could ring the owner of a local construction company. He explained the idea for the new project and asked a surprising question: Could they start construction the following day? "He said, 'Absolutely,'" Aubry recalled. "So the next morning, they were at the Rice University parking lot with materials, and we started building the Barn."[9]

Officially called the Rice Museum but known to everyone as the Art Barn, it was intentionally modest and utilitarian. It was a long rectangular, gable-roofed structure made out of corrugated, galvanized sheet metal that

The Art Barn at Rice University, designed by Howard Barnstone and Eugene Aubry, was built very quickly for *The Machine as Seen at the End of the Mechanical Age* (1969).

measured 60 feet by 100 feet.[10] Soon, a companion building was added, the Rice Media Center for film and photography, which was the same size and used the same materials. Combined, the pair had 12,500 square feet of office and exhibition space. They were unlike anything else on the traditional campus. Their aesthetic was connected to metal barns, Quonset huts, and airplane hangars (and they were built a full nine years before Frank Gehry wrapped his house in Santa Monica in corrugated metal).

But the first reaction for many was one of horror. Neighbors across the street felt the structures were unsightly and were worried about the glare. Jim Love, who worked on the design and construction of the buildings, remembered that a member of the science faculty at Rice was opposed to the entire initiative. "By God, there was no room for this pansy-ass art at his school" was how Love characterized the professor's position. "He was powerful enough that he saw to it that we didn't have electricity. It was available, only fifty feet away, but the entire building was built with electrical compressors—rented compressors."[11]

When the Art Barn opened with its first exhibition, *The Machine as Seen at the End of the Mechanical Age* (March 25–May 18, 1969), both the building and the exhibit were a tremendous success. Originally curated by Pontus Hultén for the Museum of Modern Art, it was an exhibition that Dominique and John had been involved with for over two years. The *Machine* show contained over two hundred works of art depicting the mechanical, from Leonardo da Vinci's plans for a flying machine to a James Rosenquist pop art painting of a woman's rapturous profile, paired with the grille of a mid-century American car and titled *I Love You with My Ford* (1961).

Scattered across the simple pine plank floors were massive soft sculptures by Claes Oldenburg, raucous contraptions by Jean Tinguely, and one of Buckminster Fuller's 1930s Dymaxion cars. The bold tone was set at the entrance of the building, where a large model of the *Monument to the Third International* (1919–1920), better known as *Tatlin's Tower,* stood in the center of a circular, open-air courtyard. The constructivist design, by Vladimir Tatlin, was to have been built in St. Petersburg. Though never realized, it was a building that was to have been over four hundred feet tall; meant to commemorate the Russian Revolution, it was the Soviet answer to the Eiffel Tower. The Houston reconstruction of the model, over fifteen feet tall, required the skills of two carpenters from New York.

"Rice Gets an 'A' for Its Art Home" was the rave headline in *The Houston Post.*[12] A review in *Arts Magazine* was equally positive. "The new installation is an extraordinary one, quite different from the New York version," *Arts Magazine* stated.

Opening night of the *Machine* show, left to right: Claes Oldenburg, Niki de Saint Phalle, and Pontus Hultén, who curated the show.

In the main gallery of the *Machine* show, left, among other pieces, Buckminster Fuller's Dymaxion car, and, right center, a Claes Oldenburg fan.

Jean Tinguely making one of his kinetic sculptures in a gallery of the Art Barn.

The opening night of the *Machine* show was a major event, with over seven hundred guests flowing through the new building. The de Menils flew in Claes Oldenburg, Teeny Duchamp, the artist's widow, and Museum of Modern Art curator Jennifer Licht from New York as well as Pontus Hultén from Stockholm and Niki de Saint Phalle and Jean Tinguely from Paris. As *The Houston Chronicle* described the scene,

> A rope mesh cage enclosed a huge black machine that upchucked multi-colored balls lobbed into it by a glamorous lady in a white floor-length gown collared in cockatoo plumes.
>
> The pitcher was sculptress Niki de Saint-Phalle, friend of French artist Jean Tinguely, who created the amazing construction called *Rotozaza*. It satirizes the economics of overproduction by devouring its own output.
>
> "It's better than a merry-go-round," observed Houston's grand dame of society, Miss Ima Hogg, who was on the outside looking in.

After opening night, Ima Hogg was so thrilled with the *Machine* show that she hoped its run could be extended. "I wish to express my appreciation to you and John for all your contributions to the cultural life of Hous-

ton," she wrote to Dominique. "Your generosity and genius is boundless. And may I say how much I admire your vision and tenacity."[13]

·

Just as the Art Barn was being constructed, John de Menil retired from Schlumberger. On January 4, 1969, he reached the mandatory retirement age of sixty-five. He had worked for the family firm for thirty years, a period of remarkable growth that he had played a role in stimulating. "We agreed that there would be no fuss about my retirement as chairman," John wrote to company president Jean Riboud. "Just a letter from you, perhaps, and one from me."[14] John penned a brief open letter for all employees. "I will forever be grateful to Schlumberger for the opportunity, for the excitement and for the companionship," he wrote. "All those with whom I worked I enjoyed knowing as human beings, as well as partners in a common effort. The going was rough, at times, but the game was worth the candle."[15]

A few weeks before the *Machine* show, Dominique joined John in New York for several days. She went to the Greenwich Village studio of artist Robert Smithson, who was planning his *Spiral Jetty* (1970) in Utah's Great Salt Lake, and then the Brooklyn studio of Dennis Oppenheim, the conceptual artist. It was during that time that Dominique first became aware of the "earthworks" artists, a term coined by Smithson. Always wanting to keep track of new artistic developments,[16] she also noted the names of Joseph Beuys, Richard Long, and Bruce Nauman.

Dominique then returned to Houston to install the show. The exhibition space at the Art Barn was much larger than what she had worked with at St. Thomas, so she had to become used to working on a much more demanding scale, with many more works. "My first principle when we had a show at Rice was 'Let's not panic,'" Dominique recalled with a laugh. "When you first bring in what is going to go in a show, it looks like bric-a-brac. But then you place one thing, and it begins. Works of art are like people; some don't like to be together, while others, on the contrary, bring out one another. So let's find those and one thing will lead to another but *let's not panic!*"[17]

A young man who just moved to Texas from the Midwest had a vivid memory of seeing Dominique at that time. Jackson Hicks, who went on to be the leading caterer and event planner in Houston and worked very closely with Dominique, was at the Rice University campus visiting a friend in architecture school. They went to the Art Institute to see the new buildings. "And she pulled up in flowing pants and a casual jacket driving an open Jeep, and I thought, 'What an extraordinary woman,'" Hicks

recalled. "I didn't even know who she was. I was told, 'Oh, that's Mrs. de Menil—this is her exhibit.' You don't see lots of people who have hundreds of millions of dollars driving themselves around in an open Jeep, hair flowing in the wind."[18]

Dominique was in her early sixties, and Hicks remembered her as being striking. "I thought that she must have been a great beauty when she was young. She had these chiseled features and an aristocratic look about her, in her bearing and her carriage."[19]

After the *Machine* show was open, Dominique went off to London, to see David Sylvester in the closing days of his Magritte exhibition, then to Paris for several weeks, meeting with Werner Spies about his work on Max Ernst and Ladislas Bugner about *The Image of the Black in Western Art.* She met with art merchants and antiques dealers, the drawings curator from the Louvre, and such art historians as Charles Sterling and Andrei Nakov. When Dominique left for Texas, she carried with her six objects, ranging from a carved wooden Haida bowl to a small stone sculpture from Costa Rica.[20]

Once she was back in Houston, Dominique wrote to her mother in Paris, intending the letter to reach her on May 9, the anniversary of Conrad Schlumberger's death. "I want you to know that I will be with you in thought on that day," Dominique wrote. "The void left by *Papa* has never been filled, a void that is indicative of the scale of our love. Is it possible to love someone who does not exist? I don't think so."[21]

•

Soon after Dominique returned to Texas, Philippa said she wanted to marry a young Italian anthropologist named Francesco Pellizzi. In fact, the de Menils had met Pellizzi the year before through the composer Morton Feldman, and it was they who had introduced Pellizzi to their daughter. Originally from Rome, Pellizzi had also studied in Paris, writing his doctoral dissertation under the direction of Claude Lévi-Strauss. He was then studying for a master's in social anthropology at Harvard University, doing fieldwork among the Maya in the Chiapas region of Mexico.

On his way to Mexico, Pellizzi, who was twenty-seven years old, stopped in Houston to meet John. Helen Winkler was called to give him a tour of the city. He immediately sensed the unusualness of the environment. As Francesco Pellizzi explained,

Coming from Europe, Houston was this strange city where you went around by car as if you had a horse and you could park it

anywhere. You had this complete freedom of movement, in a very horizontal city with a downtown that didn't seem very important. But at the same time, you had these extremes of sophistication with people like John, so you had something extremely sophisticated in a setting that was still pretty wild, pretty raw in a way.

On the one hand, we were speaking in French, very cultivated and very European, discussing art, history, politics, civil rights, et cetera. Yet on the question of civil rights, for example, one could feel the tension. Those were the times of the terrible riots at Watts and Roxbury.

So all of this was in the air. And going around with Helen, who was very Texan, showing me everything in a very direct, fresh way, while John was very European. The contrast was fascinating.[22]

Pellizzi intended to spend only one day at the de Menils' house. He planned to drive down to the border of Mexico, leave his car, and take buses to Mexico City and then on to the highlands of the Chiapas to do his fieldwork. John encouraged him to stay longer. "You can leave your car here; I will get you a ticket, and you can fly directly to Mexico City, saving you a lot of time," John told the young man. "How could I say no?"[23]

At the end of the summer, Pellizzi returned to Houston and met Dominique. Staying again at the house, he spent an afternoon with Dominique in the living room, sitting on the Charles James sofa, looking at books, discussing ideas. "She was attractive, with an elegant, distinguished look," Pellizzi recalled. "She had beautiful eyes that also had an intensity; there was a great clarity in her gaze." He would become very close with Dominique. When asked whether she was warm, Pellizzi drew a distinction. "There was a warmth to her presence yet also a certain reserve and distance. She was not a pat-on-your-back kind of person. She did not have that American kind of warmth; she was more reserved, more astute."[24]

Dominique and John were very enthusiastic about Pellizzi and hoped to introduce him to their youngest daughter. They invited him to stay at their house in New York when Philippa was also there. Later, Dominique showed up in Cambridge with Philippa and made certain that they saw Pellizzi.

Dominique and John conspired, however, to bring Pellizzi and Philippa together. "As soon as I met him, I realized that John was right," Dominique wrote to her mother about the young man. "He said that he was very seductive intellectually, in terms of his sensibility, but also in his simplicity and seriousness and a desire to be nonconventional. I agreed with John that we had to make sure that he met Phip."[25]

So, not too long after they became acquainted, Philippa called her mother from New York to say that she and Pellizzi were to be married and that they wanted to have the wedding in Houston.[26] The date was set for May 16, 1969; bride and groom arrived several days before. All of Pellizzi's brothers and sisters traveled to Houston for the wedding. One morning at 7:30, Dominique telephoned Marion Wilcox, one of the couple's younger friends, to convey her excitement about the wedding and ask a favor: to organize a lunch outing for all of the Italians to Cleburne Cafeteria, known to all as Miss Annabel's, an old-school southern cafeteria famous for its broiled chicken, collard greens, black-eyed peas, rice, and corn bread. "They were charmed," Marion Wilcox recalled of the Roman contingent, having their first look at a local cafeteria. "It was perfectly unexpected— the unfailing de Menil intuition."[27]

All of Dominique and John's children also made their way to Houston for the wedding. Christophe arrived from New York with her second husband, the dashing Chilean artist Enrique Castro-Cid, and her nine-year-old daughter by Robert Thurman, Taya. Adelaide, who had become a professional photographer, was also in from New York, although her partner, the esteemed archaeologist Edmund Carpenter, was unable to make the trip because of academic obligations. Georges, having married the year before, came from Cambridge with his wife, Lois Pattison de Menil; he was teaching economics at MIT, where he had earned his Ph.D., while she was a teaching fellow and tutor at Harvard as she finished her Ph.D. thesis, "Germany in de Gaulle's Europe." François, who had studied at Columbia but left to pursue his career as a filmmaker, made the trip from New York to Houston. "And, naturally, Gladys was there too," Dominique wrote to her mother.[28]

The ceremony took place in the small chapel at St. Thomas. The bride wore a simple white knit dress; the groom an ecru cotton suit. Before the ceremony, it was discovered that Maurice, the French butler, and his wife, Edmonde, forgot to bring Emma and Annie, the two cooks. "They would have been horrified to miss the wedding," Dominique felt. So François drove back to the house and returned with them to the chapel. François was the witness for Philippa, while the groom was represented by his sister Giovanna Pellizzi, in from Rome. "Afterward, everyone went back to the house and the champagne flowed," Dominique wrote to her mother. "There was a very simple buffet: turkey, ham, and *salade niçoise*. Christophe brought a delicious cake from Colette in New York."[29]

Dominique and John asked Lois and Georges to stay in Houston for a relaxing weekend, while the newlyweds went to Cambridge, where Philippa met Francesco's professors. After a quick stop in New York, they went to

Paris so that Philippa could introduce him to Louise Schlumberger and John's family. Then they went to Rome so that she could meet the Pellizzi family and on to a honeymoon in the Greek islands.[30]

That summer, Dominique and John made a short trip together to Italy. In Rome, they met Philippa and Francesco, just back from Greece. The de Menils, their daughter, and their son-in-law had a Friday evening al fresco dinner on the Piazza del Popolo. From Rome, Dominique and John, along with Philippa, Francesco, his brother, and his mother, left for a driving tour of Tuscany. "We were taken by Roberto Rossellini, the director, who loves this region and wanted to show us so many little villages," Dominique wrote to her mother. "We were even able to see some painted Etruscan tombs that had just been discovered and, like Lascaux, were not open to the public."[31] The burial sites were in Tarquinia, in Lazio, and Dominique was pleased to note that applied geophysics, her father's innovation, was being used on the discoveries.[32]

After their stay in Italy, Dominique and John flew back to New York with Philippa and Francesco Pellizzi. "It is such a joy to see them together," Dominique wrote to Madame Conrad.[33]

•

By the end of November, after weeks in New York and Houston, Dominique flew from Paris to Stockholm for a long weekend with Niki de Saint Phalle and Jean Tinguely. "Pontus came to the airport to meet us and we went straight to his museum," Dominique wrote to John. "That evening, the four or five Black Panthers in exile in Stockholm had their own section of the exhibition. Titled *Poetry Should Be Made by All,* the show had photographs and documents that were fascinating to study but did not work visually; it was all too didactic, like propaganda in some party headquarters, Communist or fascist." *Poetry Should Be Made by All* was a highly charged event in twentieth-century art history, a late 1960s happening. But Dominique felt that its emphasis on the Russian Revolution and the events in Paris of May 1968 made it too confrontational for an American audience.[34]

Leaving the Moderna Museet, Pontus Hultén took Dominique, Saint Phalle, and Tinguely to a restaurant near the opera where they ate gravlax. The group also went to Denmark. "Copenhagen was a disappointment," Dominique wrote to John. "The national museum that has so many important modernist paintings has been closed for five years for a reinstallation. 'All of their Matisses are in storage and they do not even want to loan them,' Pontus explained."

Typical that Dominique would be up at 7:00 on a Saturday morning in Scandinavia, writing to her husband about their trip. She closed her letter to John with "I am enjoying my chat with you. See you soon. Love, Dominique."[35]

•

Earlier in 1969, the de Menils had made their first trip to Providence, Rhode Island. There, they were given a tour of the Museum of Art, the Rhode Island School of Design. As Dominique and John walked around the galleries, they started to hear a common refrain from the museum staff about all of the captivating works that were down in the basement storage. "You like American painting? You should see the Winslow Homers in the vault," they were told. In the antiquities galleries they were told, "But our finest Greek and Etruscan bronzes are in the cellar." Eventually, the de Menils asked if they could, in fact, go down to the basement.

John was impressed with the richness and variety of the collection, more than forty-five thousand objects, and felt that it was a shame that so much of it was never seen. "What would happen, Mr. de Menil wondered, if some important contemporary artist were to choose an exhibition from our reserve?" the museum director recalled. "If the only organizing principle would be whether or not he liked whatever he saw?"[36]

The de Menils called New York to ask Andy Warhol if he would like to curate an exhibition from the museum storage at RISD. He immediately accepted. Warhol made six trips to Providence, working with curators in the basement to select works that caught his eye. "The first objects to which he was led was a cabinet of shoes," recalled the museum director. "The curatorial staff knew that he would be interested in shoes but no one quite expected that he would order the whole cabinet." The curators were surprised at other choices made by Warhol. He skipped over antiquities, Asian art, and contemporary paintings. He picked a row of Windsor chairs but was uninterested in more important antique furniture. "He chose shoes, bandboxes and parasols but he did not choose dresses, hats or jewelry. He selected Indian baskets, wistfully remarking that he wished we had more and unfailingly he pointed to all the American Mound Builder's pots we had."[37]

The resulting exhibition at Rice University was *Raid the Icebox with Andy Warhol* (October 29, 1969–January 4, 1970), its title an idea by John de Menil. At the entrance of the Art Barn, to set the mood, Dominique hung the de Menils' large floral silk screen by Warhol, *Flowers*, which was

ten feet square. She constructed a low-ceilinged corridor to lead back to the galleries, with dozens of old wooden chairs suspended from railings on both walls. Inside the galleries were 404 objects chosen by Warhol from the basement storage. There were anonymous nineteenth-century portraits and an early Cézanne painting, *Still Life with Apples* (1879). Warhol selected a pair of Empire portraits, of a glamorous queen, Hortense of the Netherlands, and the debonair king William I, a younger brother of Napoleon's, Louis Bonaparte, framed pieces of wallpaper stacked against the wall, and a wooden case filled with a dozen Native American blankets. There were 56 parasols and 23 prehistoric clay pots, as well as 193 pairs of footwear, from eighteenth-century French slippers to nineteenth-century American ice skates. And many were displayed in the same cabinets that housed them in storage, although with each pair of shoes meticulously labeled. Almost two decades before the Warhol sale at Sotheby's, *Raid the Icebox* was a demonstration of the artist's singular approach to collecting.

Warhol and his entourage made the trip to Houston for the opening, held on Wednesday, October 29, 1969. Along with the artist was Fred Hughes, Warhol superstar Jane Forth, and Jed Johnson, as well as Henry Geldzahler from the Metropolitan Museum; the de Menils paid for the flights and hotel rooms for some twenty guests. In the afternoon, journalists were invited to meet the artist, Jane Forth, Geldzahler, and the RISD curators. According to the art critic of *The Houston Chronicle,*

> Andy swept through with his newest superstar Jane Forth, both of whom met the press as head-on as they probably ever have. Reporters parked on rungs of ladders or on old sofa cushions on the floor of a back gallery.
>
> "It took six trips," Warhol said. "Tiring trips. I looked at many things . . . Everything I saw I liked . . . I chose everything I saw . . . I rejected nothing," he said, if you telescope a little. Warhol speaks in the sotto voce of this century, one word at a time with great gaps of no-answer in between.
>
> He faced the crowd of about 20 assorted questioners. His hair is thatchy, white on white. His dark small eyes dart here and there with an almost painful expression. His mouth is sensitive like he's just been allowed to take out the bit.[38]

That evening at 7:00 the de Menils hosted a party for seventy, both Houstonians and visitors, at their house.[39] From there, everyone went to the Art Barn for the 9:00 p.m. opening, which, of course, was another scene.

Entrance to *Raid the Icebox with Andy Warhol* at Rice University, 1969.

Storage cupboards for shoes, umbrellas, and baskets, just as Warhol found them in the basement of the Rhode Island School of Design.

The *Chronicle* critic reported, "All the hippies and would-be hippies and all the hippie watchers turned out to marvel or frown at the odd things they were seeing."

•

For the de Menils, 1970 began with a small birthday party for John, on January 4, at Christophe's house in East Hampton. His gift from Dominique and the children: a beautifully designed small television, the Sony TV-110U.[40] "He was delighted," Dominique wrote to her mother. "He can have it in the bathroom or when we are having a meal. We realized that we missed a lot by not having a television, particularly the news and political commentaries."[41] Back in the city, Dominique had lunch with Bernard Bothmer, the noted Egyptian curator at the Brooklyn Museum, bought several Jasper Johns drawings from Leo Castelli, and had dinner with Dan Flavin.

Once they returned to Houston, Dominique and John participated in a performance piece that she organized at Rice University, La Monte Young and Marian Zazeela's *Dream House* (January 21–24, 1970). The Houston performances of *Dream House*, after successful iterations in New York and

Europe, took place on four continuous days from 10:00 a.m. to 10:00 p.m. The gallery had Oriental rugs placed across the floor, and there was an arc of more than a dozen electronic boxes and projections of pure beams of colored light. La Monte Young, bearded and bespectacled, wore white Indian garments, while Marian Zazeela, with long dark hair, wore Indian silks. "The sounds are unlike any song you're apt to hear again soon," wrote *Houston Chronicle* art critic Ann Holmes. "La Monte Young growls and hums and drones his own compositions against a continuing sine wave, which acts like a ground base. Marian's voice comes in to form, in total abstraction, chordal electro-human sound which is restful, strange, quite beautiful. It is long, patient, timeless."[42]

Dominique and John went to two performances of *Dream House*. They were delighted with the work and the audience it attracted to the museum. "Monotonous and engulfing," Dominique noted in her date books. "Hundreds of young people, all good-looking and elegant in their hippie costumes."[43]

•

In the spring of 1970, Dominique closely followed the first pregnancy of Lois and Georges in Cambridge. They were taking classes in natural childbirth.[44] "They are preparing for the arrival of the child in an almost religious way," Dominique wrote to her mother. "Georges will be a father like *Papa*. He is taking the same classes for the preparation for delivery as Lois! Everything is organized in the most minute detail by Lois. The nursery is ready; the cradle has been delivered."[45] On April 23, Dominique, in Houston, received a phone call from Georges: Lois gave birth to a son, Jean-Charles de Menil. Dominique and John went to Cambridge to meet their grandson, Jean-Charles or Jason. John marveled at Georges giving his newborn a bath in the sink. Dominique took advantage of the journey to spend a morning in the Conservation Department of the Fogg Museum, getting tips on the cleaning of marble statues and suggestions on the best way to remove labels from objects.[46]

In June, Dominique began her summer break in France. Christophe and Taya stopped on their way back from Majorca and went to the Val-Richer. Dominique's mother spent much of her time there in the summer at Braffy, her own manor house on the grounds of the château. Returning to Paris, Dominique had dinner with her cousin Geneviève and René Seydoux. She followed closely the developments of the three-day-long Schlumberger board meetings and had dinner the first night with company president Jean

Riboud. During her stay in France, she also met with curators at the Lou-
vre, welcomed David Sylvester to Paris, and made a trip down to the South
of France, to Seillans, to see Max Ernst.

The exhibitions she organized for that fall at Rice showed the range the
de Menils brought to the institution. First was a showing of New York pho-
tographer Danny Lyon, best known for his images of the civil rights move-
ment. The exhibit was *Conversations with the Dead: An Exhibition of
Photographs of Prison Life by Danny Lyon, with Letters and Drawings by
Billy McCune #122054* (September 10–October 11, 1970). Lyon had spent
fourteen months documenting life inside six penitentiaries around Texas.
The exhibition included forty-five of his photographs, which would be
published as a book the following year. In addition to Lyon's photography,
there were letters, drawings, and paintings by a prisoner, Billy McCune.
Although he had been diagnosed as psychotic, McCune was sentenced to
life for a violent rape (imprisoned in 1950, he was released in 1974). "The
material I have collected does not approach for a moment the feeling you
get standing for two minutes in the corridor of Ellis," Lyon wrote in the
catalog, referring to one of the more notorious Texas prison farms. "In the
letters and drawings of a supposed madman, I have found someone much
more eloquent than I to explain to the world what life in prison is like."[47]

Just a few days after *Danny Lyon* closed, Dominique opened a very dif-
ferent exhibition, *Ten Centuries That Shaped the West: Greek and Roman
Art in Texas Collections* (October 15, 1970–January 3, 1971). The elegant,
intellectual show included over two hundred Greek and Roman antiquities
from museums and collectors across the state. There were marble statues
and mosaics, bronze figurines, terra-cotta statuettes, painted amphorae,
and other objects ranging from a glass vase to a pair of third century B.C.
gold earrings. Dominique's introductory essay to the catalog, which she
spent the summer writing in Paris, went from ancient Greece and Rome
through centuries of art history. Surprisingly for an essay on Western civi-
lization, she also advocated for the importance of non-Western art. "The
approaches to man are infinite and the Greco-Roman tradition had to be
bypassed to expand the horizon," Dominique wrote. "It took Freud, Breton,
Picasso, Miro, Max Ernst before we could listen to the 'other voices' of the
world."[48]

NOTHING AND EVERYTHING

Since its dedication in 1971, the functions of the Rothko
Chapel have been both modest and very ambitious. On one
hand, the chapel is like a big old tree, in the shade of which
anyone can sit. On the other hand, it is a place dedicated to
transcend borders.
—DOMINIQUE DE MENIL

Just after the sudden death of Jerry MacAgy in February 1964, Dominique and John began to consider a suitable memorial to their friend. "When the floor collapses, it's time to make an act of faith," Dominique said.[1] So, still at the University of St. Thomas, the de Menils went to the Basilian fathers to suggest building a chapel for the school. Philip Johnson's master plan for St. Thomas had called for a small church to complete the quadrangle at its northern end. Their proposal was accepted. That marked the beginning of what would become the Rothko Chapel, a singular monument to spirituality and modern art. It would take seven years to complete, a process characterized by Dominique as "a long succession of deaths and failures and disasters."[2]

On February 9, 1960, four years before MacAgy died, Dominique and John had paid a visit to 222 Bowery, the New York studio of her great friend Mark Rothko.[3] Dominique was immediately struck by a spiritual side to Rothko's painting. "I felt I should walk softly and whisper," she later explained.[4] John, convinced that Rothko was one of the most important artists of the twentieth century, as great as Matisse, shared her impression of Rothko. "His paintings are pure color and through color he conveys joy or concentrated meditation," John wrote to Houston patron Alice Brown. "They create a multi-denominational feeling of religiosity."[5]

Their first studio visit took place just as Rothko was finishing his series of paintings for the Philip Johnson–designed Four Seasons restaurant in the Seagram Building, a grouping of wine-dark canvases with geometric forms that he had begun two years before. On that visit, the de Menils were able to see the bulk of the Four Seasons series. "John and I had the privilege to see the paintings hung as they were to be displayed in the restaurant,"

Dominique recalled. "They made for an extraordinary mystical environment, a mix of intimacy and transcendence that can be found in certain churches, certain mosques."[6]

Rothko decided to withdraw from the Four Seasons, feeling that such a luxurious, social environment was inappropriate for the seriousness of his work (nine canvases from the series were later given to the Tate in London, while several more went to the National Gallery in Washington, D.C.). "The refusal to deliver the paintings for the restaurant seemed to me to be fraught with meaning," Dominique wrote. "The decision suggested the metaphysical ambitions of Rothko. He understood that his paintings would be used for decorative means and he preferred to give up the great public recognition and generous compensation that would have been his."[7]

Two days after their first visit, the de Menils returned to see the artist in his work space on the Bowery. They suggested acquiring a group of the Seagram Building paintings for a future chapel in Houston. "In the end, Rothko demurred," wrote art historian Sheldon Nodelman, who closely studied the artist's work. "It would be impractical to adapt these paintings to a setting and purpose for which they had not been conceived. He proposed instead to create a series of paintings expressly for this purpose."[8]

The idea was on hold until April 1964, two months after MacAgy died, when Dominique, accompanied by MacAgy's friend Louise Ferrari, went again to visit Rothko in his studio on the Bowery. Dominique asked if he would consider making paintings for a Catholic chapel that she and John would build for the University of St. Thomas. "He said yes and seemed very pleased," Dominique wrote in her date book. "The meeting was very simple. He said he would devote all his time to the chapel. Figures were never advanced."[9]

Although Rothko was not a religious man, and not Catholic, the idea of a contemplative environment for his paintings had become progressively more interesting to the artist. The 1960 conversation with the de Menils was meaningful for him, although they did not act on the idea at that time. In 1962, when Rothko was working on a series of murals for Harvard University, one awestruck visitor suggested that a museum should be built especially for his work. "No, a chapel," was the artist's reply.[10] And he had been thinking more of a complete environment for his works. "Rothko had been dreaming of such a place," Dominique explained of his openness to the chapel. "He wanted to show his paintings in groups, rather than one at a time. He conceived them in relation to one another, like a Renaissance artist involved in a monumental project."[11]

The artist's daughter, Kate Rothko Prizel, who was fourteen when her father began working on the chapel paintings, felt that another reason he

responded to the proposal was Dominique and John. "It was impossible not to be in tune with their sincerity," Kate Rothko said. "He believed they were undertaking this project because it was something they loved and were committed to. My father was not a religious man, but I do think he was a spiritual man and he reacted to their spirituality. If it were not for that, I am not sure that he would have undertaken the chapel."[12]

The de Menils agreed to pay $250,000 for ten mural paintings by Rothko.[13] They also offered to pay his out-of-pocket expenses and to lease a splendid, cavernous carriage house, at 153 East Sixty-Ninth Street, for the artist to use as a studio.[14] They also hired Philip Johnson to work with Rothko on the design of the chapel.

That summer, 1964, art historian Dore Ashton visited Rothko when he was relaxing with his family in Amagansett. She sensed that the chapel commission was a great release for him. Ashton watched the artist sitting on his porch observing his baby son, Christopher, clapping his hands while Schubert's *Trout Quintet* played in the background. They had hamburgers for lunch and pleasant conversations about family affairs. "After, we walked on the beach, and he became unusually animated," Dore Ashton wrote. "He talked of the new studio and the commission. His idea was to 'make East and West merge in an octagonal chapel.'"[15]

By the fall of 1964, Rothko and Johnson had settled on the precise form and inner dimensions of the chapel. By December, the artist had a full-scale mock-up of three of the chapel walls built in his studio. Dominique stopped by the studio during those days. "He was making elaborate preparations: selecting assistants, acquiring wood to make frames, as well as ropes and pulleys to move the large canvases," she recalled.[16]

And then Rothko set to work on the paintings. As Dore Ashton described the process in her book *About Rothko,*

The huge studio with its central skylight shielded by parachute silk became a place as he imagined it, different day after day, and re-made each day . . . [T]here was little to distract him. A bed, a couple of canvas captain's chairs and hi-fi equipment were the only amenities visible. A series of young assistants came to help him build the huge stretchers . . . There were times when Rothko sat for hours in his canvas chair, contemplating the shape and size of the empty stretchers. His assistants would be called upon to change one or another as Rothko sought the absolute solution to his . . . scheme. Once the canvases had their "plum" grounds, they would be aligned in the replica of the chapel and Rothko would again sit and contemplate them. Finally, as Roy Edwards, one of his assis-

tants recounts, he would decide where to place a black rectangle and the assistant would dust it in with charcoal. These interior shapes were then contemplated for days, singly and in relation to others. Rothko would sometimes decide to change the distance of the dominant shape from the border by a quarter of an inch, or, if he had already painted the dark interior, he would put the canvas away and substitute another. Months went by with this elaborate procedure, with Rothko inching toward his vision.[17]

•

One of the first great challenges for the project was the architecture. Rothko and Johnson had quickly agreed on the basic plan of the interior, an octagon that would allow visitors to be engulfed by the paintings. In truth, the architect had ceded the interior scheme to the artist: the octagonal plan was conceived entirely by Rothko. The exterior of the building, however, was a difficult issue for artist, architect, and patrons. The Sixty-Ninth Street studio had a large skylight in the center of the room. Rothko had large pieces of fabric placed under the glass that he could open or close in order to modulate the light. He insisted the chapel have natural light—and only natural light—and wanted the source to be just like the skylight at his studio in New York.

By that time, Johnson had been working in the blinding South Texas sun for almost two decades. He understood the danger of a large open skylight in a setting so far south. So Johnson envisioned a structure, in white concrete, with a central spire, eighty-five feet tall, that was like an elongated pyramid, or a truncated cone, with an oculus at the top. The height of the roof was to allow for a filtering of the sunlight; by the time the light made its way down from above, it would have been softened. Dominique believed that Johnson's idea was indebted to the Pantheon in Rome, with its massive dome pierced in the center by an oculus that opened to the sky.

By 1965, Johnson had produced a scale model of his startling scheme. "It was awful," Dominique said. "It looked like a crematorium!"[18] Howard Barnstone was more specific. "It had a very, very large cone that Dominique and I felt looked like a crematorium in Sweden," he recalled. "There are many that look exactly like that: octagonal buildings with enormous chimneys. Dominique said, 'Philip, you can't have any cone on top of the building.'"[19]

The artist was more diplomatic, telling Johnson that he was displeased with the height and mass of the exterior.[20] But the elongated elevation,

roughly eight stories tall, would have dominated the horizontal, two-story campus.

The de Menils' objections were aesthetic and philosophical. In September 1965, Belgian Benedictine priest Frédéric Debuyst, director of the review *Art d'Église,* visited Houston. Very encouraging about the project with Rothko, Father Debuyst was disturbed by the architecture. "He particularly objected to what looked to him like a spire, the truncated cone," Dominique noted. "He looked at the model carefully and criticized the design for its triumphalism. He was very much in the mood created by Vatican II: the Church renouncing triumphalism, becoming aware of the plight of the poor."[21]

By the fall of 1967, having developed additional designs that were no more successful, Johnson withdrew from the project. Barnstone & Aubry had been the Houston architects, so they continued the assignment. Dominique wanted Eugene Aubry to work directly with Rothko, to make sure that everything on the building was to his liking. "I spent days in that studio with him, and all you ever had to drink was scotch, period," Aubry recalled. "There was no ice, no water, nothing! He would have all the paintings on ropes, adjusting them and then working on them for days. I documented exactly how they were to be positioned on the walls."[22]

For several years, Rothko toiled on the canvases in the Sixty-Ninth Street studio that had been provided by the de Menils. Dominique knew that once he had organized his work space, she would not be seeing the work until he was finished. "When Rothko had everything in place, he told me that he was going to closet himself," Dominique later wrote. "It would be an agonizing time for him; he would not see me. He would let me know when he was ready."[23]

Dominique understood that Rothko, cloistered inside his studio, was being meticulous. As she heard from one of his assistants, Roy Edwards, "He could work a solid month, experimenting on half an inch."[24] As Dore Ashton wrote,

> There were often visitors to the studio and Rothko would sit, contemplating his work in progress, awaiting responses, although no one could gauge how much he was dependent on response . . . Motherwell visited early in 1967 and came away with a profound respect. "They are truly religious," he commented, adding that Rothko had said that he had become "a master of proportion." Motherwell quoted Rothko as saying that in the beginning he had thought of them as pictures. But then, he considered that people

In his studio in New York, Mark Rothko standing between paintings for the Rothko Chapel.

praying would not want to be distracted by pictures. They wanted an ambiance.[25]

The de Menils, intent on allowing Rothko the time and freedom to fully implement his vision, were well aware of the somber direction of Rothko's work. After the burst of bright colors in the mid-1950s, his palette, though there had always been some darkness, had become progressively more subdued. In 1960, Rothko wrote, "I can only say that the dark pictures began in 1957 and have persisted almost compulsively to this day."[26]

Dr. David Anfam, author of the Mark Rothko *catalogue raisonné,* characterized the artist at the time when the de Menils first commissioned him. "What an untimely figure the Rothko of circa 1964 was," Anfam wrote. "Amid the jokiness of Pop Art and the bright seductions of post-painterly abstraction, he had become a latter-day artistic Savonarola to Andy Warhol's Oscar Wilde."[27] Anfam was also clear about the significance of the project to the artist. "The magnitude of the Menil project consumed Rothko, as a person and as an artist," he wrote. "The statistics of his annual output tells the story. On average, Rothko painted approximately 24 canvases every year from 1950 until 1964. By contrast, in 1965, there was not one canvas unrelated to Houston." The following year saw the creation of only one classic painting. And in 1967, as he was finishing the chapel paintings, he produced only five outside works.[28]

On April 18, 1967, Rothko called Dominique to say that it was time; he was ready to show his work. She walked the several blocks from their house on Seventy-Third Street to Rothko's Sixty-Ninth Street studio. As Dominique described her first encounter with the canvases,

> His studio was empty except for one painting, one of the four large, dark purplish monochromes. He had placed a chair for me about twenty feet in front of it and another chair for himself between the painting and me. He did not utter a word. He just looked at me.
>
> I felt instantly that not one muscle of my face should betray a surprise. I had expected bright colors! So, I just looked. Oh, miracle, peace invaded me. I felt held up, embraced and free. Nothing was stopping my gaze. There was a beyond.[29]

The panels that Rothko unveiled for Dominique were massive, fifteen feet tall with one triptych, out of a total of three, twenty-four feet wide. And the palette was dark, dark purple and black, which, on such a large scale could feel relentless, almost overpowering. "You doubtless have heard that the St. Thomas chapel to be will be illuminated all around with Rothko paintings," John wrote to Alice Brown in 1967. "The work is almost completed. It is deeply moving in a quiet yet powerful way."[30]

By the end of the year, Rothko had finished all of the panels, taken them off their stretchers, and moved them out of the studio to make room for new work. The series was stored at Daniel Goldreyer, Rothko's conservator, in Long Island City.[31] Dominique, working with the artist, made an inventory of the number of paintings intended for the chapel, a total of fourteen, and the dimensions. There were three large panels, eight by fifteen feet, to be hung together as the main triptych; two other triptychs, each measuring twenty by eleven feet; and four large panels, eleven by fifteen feet. Rothko had also produced four alternate paintings, eight by fifteen feet.[32]

Even before the paintings were fully completed, the artist was aware of the significance of the undertaking. In January 1966, he wrote to Dominique and John to thank them for their patronage. "The magnitude, on every level of experience and meaning, of the task in which you have involved me, exceeds all of my preconceptions," Rothko wrote. "And it is teaching me to extend myself beyond what I thought was possible for me."[33]

•

As the murals were being finished, and the de Menils' relationship with St. Thomas was unraveling, they made a new friend who played a key role in

their future plans. At the 1968 New York Film Festival, a timely film, *Oratorio for Prague,* by Czechoslovakian filmmaker Jan Němec, won standing ovations. The film's producer was a Czech national named Miles Glaser who had immigrated to the United States in 1949 and made his way from Chicago to Houston. Glaser, who owned a steel company in Texas, was friends with Němec and Miloš Forman. Earlier that summer, he returned to Czechoslovakia with the director during the famous period of liberation known as the Prague Spring. On August 21, Glaser and Němec were in a truck, driving to the airport in order to interview the Czech leader Alexander Dubček. Before they could speak with the politician, they saw tanks rolling out of Soviet planes.

They realized they were in the midst of the invasion sent from Moscow to crush the Prague Spring. Němec found a large hammer and sickle flag, told Glaser to hold it above their camera, and filmed the historical scenes. They followed the tanks into the city, where some residents, assuming they were Russians, pelted them with stones. They were able to smuggle the footage out of Czechoslovakia. First, from Austria, they gave some of the images to American television, making it the first broadcast coverage of the Soviet invasion.

Then, in Paris, Glaser and Miloš Forman worked to incorporate the footage into *Oratorio for Prague.* "It won a first prize, not because it was good, but because it was so topical," Glaser recalled of the film's New York success. "It was written up in all the newspapers, and I was cited as the producer." When word of his role in the making of *Oratorio for Prague* reached Texas, Glaser received a phone call. "How is it that someone from Houston has made this film and I don't know you?" John de Menil demanded.[34]

They had lunch at the de Menils' house in Houston and quickly became great friends. Miles Glaser had lost both of his parents in Auschwitz; only a teenager at the time he managed to survive his imprisonment in the camp. Irreverent, magnetic, and intensely liberal, Glaser was quickly named to the board of the Menil Foundation. He was particularly engaged with activities involving civil rights (he became close with Mickey Leland).

By December 1968, as the move to Rice was being announced, John informed school leaders that the Rothko Chapel would not be built at the University of St. Thomas.[35] So Miles Glaser's first official project was somewhat furtive: he was tasked with buying up properties throughout the residential neighborhood west of the campus, in order to house the chapel as well as a future museum that might hold the de Menils' collection.

The neighborhood, roughly five square blocks, was relatively modest, its streets lined with one- and two-story wood-frame houses dating from the 1930s and 1940s. Glaser acquired the houses one at a time. "John didn't

want to buy in his own name, so I was the trustee," Glaser recalled. "Some 90 percent of the properties were bought in my name because he thought, rightly so, that if his name were involved, prices would go up immediately. It took about two years; we bought very slowly and strategically."[36]

•

As part of the settlement agreement with St. Thomas, the de Menils gave the school some of the houses they had bought directly west of the campus to provide for its future expansion and used others to create a plot for the Rothko Chapel. The move from St. Thomas meant that there was no longer the requirement that it be a Catholic chapel, allowing the interior to be simplified. Barnstone & Aubry returned to a Philip Johnson plan from 1967, one of his most successful. The final design was completed by the Houston architects in 1969.

As the architecture was being finalized, the de Menils decided to add another work of art to the project: Barnett Newman's monumental sculpture *Broken Obelisk*. They wanted to position the piece near the chapel. In November 1969, Barnett Newman visited Houston to consider possible sites. He and John drove up and down all of the blocks around the chapel until Newman finally said, "If you drive us around anymore, these properties will all be too expensive."[37] The artist decided that his sculpture should be placed directly in front of the entrance of the still-unconstructed chapel.[38] And he wanted it to be placed in a reflecting pool.

Philip Johnson, although he had removed himself as architect, worked quietly behind the scenes to solve a host of issues. He determined the final siting for the chapel and designed the reflecting pool for *Broken Obelisk*. Aubry was unsure how to resolve the entrance, so he went to see the architect in New York. Johnson said, "We are going to sit here right now and design the front of the chapel. Our deal, however, is that you never say that I did it while I am alive."[39] Johnson took about fifteen minutes to come up with the perfect covered entrance, a single-story opening with brick walls that jutted out from the building at a forty-five-degree angle and, placed within, a set of wide double doors in thick black steel.

Aubry worked closely with the artist on many elements of the design. "Rothko was extremely concerned with every detail of the chapel building," Aubry said. "The width of every doorjamb to the fraction of an inch."[40] When discussing the floor, Aubry suggested trying to find asphalt paving stones, much like what Rothko saw every day when he walked to Central Park. "We managed to get some of those, and he absolutely went crazy over them," Aubry recalled. "He just loved them." In the studio, Rothko had

placed wooden benches in front of the paintings for protection. "He said, 'You know, you have to have something in front so that people will not go up and touch the paintings.'" That led to low brass railings, designed by Jim Love, that were the exact height of Rothko's benches.[41]

"After the chapel paintings had been completed, Rothko was left with a great void," wrote Dore Ashton, who was very close to the artist. "He had difficulties returning to the single easel painting. He felt displaced." Rothko was then able to produce several large, magnificent paintings, but in April 1968 he had an aortic aneurysm. The following year, Ashton visited him in his studio. As she characterized his state, "Highly nervous, thin, restless, Rothko chain-smoked and talked intermittently."[42]

In those years, however, he actively followed the progress of the chapel and continued to produce powerful works of art. The years 1968 and 1969 for Rothko were what David Anfam termed "a late burst of activity," with not only his *Black on Gray* series but also brightly colored acrylics on paper. "Nothing could be more poignant than the cautious return of positive tones," Anfam wrote. "Here a slow release begins of the blues, plum and other hues that were pent up in the chapel murals."[43]

In early 1970, Eugene Aubry made another trek to Rothko's studio to discuss the chapel. There was talk of the artist's trip to Houston to oversee the installation of the paintings. In February, the construction contract for the chapel was signed. Two days later, on February 25, 1970, Rothko committed suicide. He was found, in the Sixty-Ninth Street studio, having taken sedatives and having slashed the brachial arteries in his forearms.

•

By the beginning of 1971, the Rothko Chapel building was complete. The next challenge was to transport the paintings to Houston. Rothko had insisted they be stretched at Goldreyer in Long Island City; shipping the rolled-up canvases and having them stretched in Texas would have been much easier. Because of the size of the paintings, a special climate-controlled truck had to be located; one was found in California and driven cross-country to New York. As art historian Sheldon Nodelman noted in *The Rothko Chapel Paintings: Origins, Structure, Meaning*:

> The restretched paintings were too large to leave Goldreyer's studio by the normal exit and had to be extracted through the skylight with the aid of a crane. Loading was equally difficult: despite the oversized dimension of the van, the largest of the paintings cleared

its ceiling by a bare half inch. The van departed for Texas, following a circuitous route dictated by the need to avoid low overpasses—and telephone wires and other obstacles in the cities—and hampered along the way by severe snowstorms.[44]

It took five days for the paintings to make their way across the United States.[45] The massive panels arrived in Houston and were placed in the chapel on February 4, 1971, several weeks before the inauguration. A crane lowered them down through the skylight, which had been designed to accommodate them, but because it was a stormy, windy day, the canvases were tossed around like enormous kites. After they were safely inside, Dominique, Helen Winkler, and Eugene Aubry hung the paintings, following the last specifications left by the artist.

Once finished, the Rothko Chapel, as seen from the outside, was strict, serene, and startling. It was a windowless, buff brick, flat-roofed struc-

ture. The central skylight, octagonal like the interior, was a modernist construction in steel and glass. The heavy double doors led to an entrance, a low-ceilinged space with a floor of rough paving stones, that acted as a transition between outdoors and indoors. Wide corridors on either side of the entry led to the octagonal chapel, which measured fifty-six feet long and fifty feet wide, with walls that were eighteen feet high.[46]

On the far wall was the north apse triptych, three identical dark purple paintings, positioned together as one. The entrance wall held one smaller painting, the south panel, the first Rothko made in the series and the only one to have a

A panel being lowered through the skylight of the Rothko Chapel.

pronounced geometric form, a rectangle in a lighter purple. The east trip-
tych and the west triptych were almost identical black-purple canvases,
with slightly lighter borders. In both triptychs, the central panel was raised
approximately ten inches from the outside paintings. Each of the four other
walls contained single-panel paintings, all in dark purple.

By Friday, February 26, 1971, friends, family, and art world figures
gathered in Houston for the opening of the Rothko Chapel. Family included
Adelaide and Edmund Carpenter, Lois and Georges and their first son,
Jason, and François and a group of his friends from New York. Also pres-
ent were such close friends as Roberto Rossellini and Jean Riboud and a
host of art world figures, dealers, arts writers and critics, and such museum
directors as Alfred Barr.[47]

That Friday evening at 6:00 there was a reception for the members of
the Institute of Religion and Human Development, an ecumenical center
for graduate studies. "I am quite moved to be here because tonight is the
real event," Dominique announced to all assembled in front of the Rothko
paintings. "It is the first time that people are together in the chapel. Tomor-
row there will be heads of religious communities that have come from afar,
and it is wonderful. Tonight there is you, the people who are going to use
the chapel. The people who will give it life."

She acknowledged the difficulty of expressing ideas about such a mas-
sive abstract undertaking. "I am supposed to talk about the paintings but
I don't think I can explain them," Dominique said. "I think the paintings
themselves will tell us what to think of them, if we give them a chance."
And she quoted Mark Rothko on the subject: "A picture lives by compan-
ionship, expanding and quickening in the eyes of the sensitive observer. It
dies by the same token." Dominique also made a connection between the
openness to a work of art and the spiritual goal of the Rothko Chapel.
"This attitude of receptivity, indispensable in art, is also the attitude neces-
sary for ecumenism—to listen."

And, from that first evening, she tackled an important issue around
the experience of the Rothko panels: their darkness. As Dominique stated,

> At first we might be disappointed at the lack of glamour of the
> paintings surrounding us. The more I live with them, the more
> impressed I am. Rothko wanted to bring his paintings to the great-
> est poignancy they were capable of. He wanted them to be intimate
> and timeless. Indeed, they are intimate and timeless. They embrace
> us without enclosing us. Their dark surfaces do not stop the gaze.
> A light surface is active—it stops the eye. But we can gaze right
> through these purplish browns, gaze into the infinite.

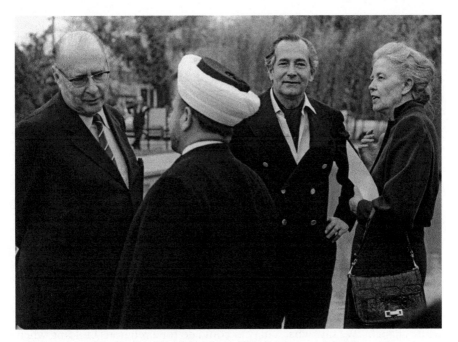

At the opening of the Rothko Chapel, February 1971, Dominique with, left to right, Roberto Rossellini, Sheikh Sobhi al-Saleh, and Schlumberger president Jean Riboud.

Dominique also believed that there was warmth to the paintings, a glow in the central panel. Rothko had told her that he had been inspired by a visit he made to the Cathedral of Santa Maria Assunta on Torcello, an island in the lagoon of Venice. The Byzantine church was one of the most ancient religious structures in the city. The artist told Dominique about the sense of tension in the Torcello church, between an entrance wall with dark mosaics on a somber gold background depicting a Last Judgment and, opposite, at the end of the central axis, a soaring, half-cupola apse with a bright gold mosaic of a Madonna with Child floating above a row of saints. Rothko hoped to create the same sense of opposition on the two main walls of his chapel.

"It took courage for Rothko to paint nocturnal murals," Dominique stated. "But I feel that it was his greatness. Painters become great only through obstinacy and courage . . . Rothko was prophetic in leaving us a nocturnal environment. Night is peaceful. Night is pregnant with life."[48]

•

The following day was the official opening of the Rothko Chapel. It began mid-afternoon with a reception for special guests, followed by an

opening for members of the press. The Sabbath concluded at 6:38 p.m., allowing the service, which lasted for forty-five minutes, to begin at 7:15 p.m. Present were leading representatives of many Christian faiths—Catholic, Episcopal, Baptist, Methodist, and Greek Orthodox—as well as leaders from the Jewish and Muslim traditions.

To those gathered inside the chapel, Dominique explained the genesis of the project. She stressed the influence of two key moments in their lives. First, the ecumenism lectures by Father Congar that the de Menils attended on eight consecutive days in Montmartre in January 1936, which Dominique explained, had broadened their thinking about belief. The ecumenical mission of the Rothko Chapel, she stated, sprang directly from the thinking of Father Congar. The second formative experience was the trip across France that Dominique and John had taken with Father Couturier in the summer of 1952. She explained how moved they were by Léger's brightly colored mosaics on the exterior of the church at Assy, by the simplicity and purity of the Matisse Chapel in Vence, and by the ambitious architecture at Ronchamp, where Le Corbusier was building his soaring white chapel. "We saw what a master could do for a religious building when he is given a free hand," Dominique said. "He can exalt and uplift as no one else." Dominique credited the idea of a spiritual setting built around great contemporary art to Father Couturier.

•

The next day, the first Sunday of Lent, was the dedication of *Broken Obelisk,* which the de Menils made sure was in honor of Martin Luther King Jr. Annalee Newman, the artist's widow, traveled to Texas for the event. Morton Feldman, who had been asked by the de Menils to compose a piece for the Rothko Chapel, also made the trip. There was a brunch at the Warwick Hotel, where out-of-town guests were staying. Then, beginning at 1:30 p.m., the first musical performances were held in the chapel: a chorale from the Houston Baptist College, then a Jewish group and, finally, a Catholic choir.

At 4:00 p.m., a crowd gathered outside around the reflecting pool and *Broken Obelisk*. Coretta Scott King was present, in order to make a few comments on the dedication. Also at the ceremony was the concert choir of Texas Southern University.[49] "I was especially moved by a group of young musicians who, while awaiting the beginning of the formal ceremony, started spontaneously strumming on their instruments and the people sitting around them started singing," recalled Annalee Newman. "So that by

the time the actual dedication began, everyone in the audience was already a participant in the occasion."[50]

Wearing a dark wool, long-sleeved dress, Dominique stood behind a microphone on a riser to tell the assembled the story behind the sculpture. Barnett Newman had worked on it for four years, she explained, from an idea he had first conceived in 1960. "The massive pyramid base suggests stability and determination," Dominique stated. "The obelisk resting on the apex suggests an upward thrust. The sudden break reminds us that interruptions, even dramatic interruptions, are part of life."

As was seen in the Houston City Council's reaction to the proposal to make the sculpture a memorial to Martin Luther King Jr., the decision to connect this monumental work to the civil rights hero was not universally admired. Dominique explained the idea and the reason for the pairing of the chapel with *Broken Obelisk*:

> As you know, books and art objects are often given to a library or a museum in memory of a friend. Having a profound admiration for the late Dr. Martin Luther King Jr., and wanting to honor him, John and I are giving this sculpture in his memory to the citizens of Houston.

Dominique at the dedication of *Broken Obelisk* with the concert choir of Texas Southern University.

We have here both a chapel and a monument. A place for wor-
ship and a memorial to a great leader. The association of these two
remarkable sites should tell us over and over again that spiritual life
and active life should remain united.

It should tell us over and over again that whoever believes he loves
God and does not love his neighbor is deceiving himself.

It should remind us over and over again that there is no love with-
out justice.[51]

•

From the beginning, many were effusive about what the de Menils had
helped create. "You have given the people of Houston a glorious gift—the
chapel, with its penetrating, self-searching beauty, and the *Obelisk,* stand-
ing majestically in its pool of golden shadows," Annalee Newman wrote
to Dominique and John. "It makes me remember something Barney once
wrote you. The *Obelisk,* he said, 'is concerned with life and I hope that I
have transformed its tragic content into a glimpse of the sublime.' "[52]

Reviews of *Broken Obelisk* were uniformly positive. "Had it been
designed for that specific site, it could not have been more perfect," wrote
Paul Richard, the art critic for *The Washington Post.* "It serves the chapel
precisely as a steeple serves a church or a minaret serves a mosque."[53]

There were also some more critical voices about the chapel. Bernard J.
Reis, who was the executor of the Rothko estate (until later that year, when
he, along with the Marlborough Gallery, was successfully sued by Kate and
Christopher Rothko to regain control), wrote to Dominique to complain
about several aspects of the installation, comments that he made clear he'd
heard from museum directors and critics. "The light in the Chapel is really
too harsh and every effort should be made to soften and dim the light,"
Reis wrote. Reis enclosed a review of the chapel by Henry Seldis of the *Los
Angeles Times,* which, although a very positive assessment of the paint-
ings and the humanist intentions of the chapel, was also critical about the
light.[54]

Dominique quickly responded to Reis. "We all agree that the light in
the chapel is too harsh," she wrote. "We did not have the time to make a
diaper that will filter the light. Rothko had one in his studio and he felt it
would be needed." As for the artificial lighting, Dominique explained that
they had brought in Edison Price, the lighting consultant who worked for
Mies van der Rohe, Philip Johnson, and many museums. But she agreed
that both natural lighting and direct lighting needed to be resolved.

Other of Reis's criticisms, however, Dominique disputed. On two of the

triptychs, he felt that the raised central panels were a mistake. "The trip-tychs on the east and west walls have been placed exactly as Mark wanted them," Dominique explained to Reis. "The question was discussed with him. Measurements were taken and everything was recorded while Mark was alive."

Reis felt the walls should be darker, closer to the color of the paintings. Dominique felt that both the texture and the color of the walls were correct. Reis also believed that doorways on either side of the two triptychs were a problem. "Because the space beyond the openings is darker, this almost creates another space itself," he wrote.[55] Dominique responded,

> Rothko was positively against any doors or any curtain closing the openings. It is true that he did not see the finished effect but I doubt very much that he would have changed his mind. I myself fought with him and he was so adamant that I do not feel that the matter should be reopened again. He knew that the space beyond the openings would be darker. For us who have been visiting the chapel often, I can assure you the openings are not disturbing in the least. They indeed create another space but what is wrong with that?
>
> We will work on the lighting and will keep you informed as the matter progresses. It was wonderful to have you and many other friends of Mark.[56]

Over the years, others have fussed about the chapel. "I think it is a remarkable experience," said Harry Cooper, curator at the National Gallery of Art in Washington, D.C., and a Rothko specialist. "At first there was too much light and now there is probably too little, and what light there is is leaking around the baffle and hitting the tops of the paintings, so it is not even enough."[57]

Alison de Lima Greene, curator of modern and contemporary art for the Museum of Fine Arts, Houston, has been incredibly enthusiastic about the works since she joined the museum in 1984, yet she also admitted there were faults. "The Chapel could also be called a magnificent failure," the curator explained. "In that it does not truthfully reflect the original intent of Rothko, or Philip Johnson, or Howard Barnstone, or the de Menils, or St. Thomas. The evolution of the chapel from its initial function and design led to some compromises, and some later interventions on the site have been problematic."[58]

Dr. David Anfam, long considered the leading expert on Rothko, who wrote the *catalogue raisonné* and has curated important exhibitions including the 2016 blockbuster *Abstract Expressionism* at the Royal Acad-

emy of Arts in London, is convinced of the success of the Rothko Chapel. "The Houston chapel marks a watershed in Rothko's trajectory and not just because it came at the very end of his life," Anfam explained.

> Seeing it is a powerful experience. I am certain that Rothko had gone beyond painting per se in order to create a total environment that would be about "place," about a kind of numinous world apart, which involves a clear sense of last things. In its concern with darkness and blankness or effacement, I find that the most overwhelming effect of the whole is one of uncanniness, of a site paradoxically dominated by absence and foreboding. In this sense, the chapel is the apotheosis of qualities that had pervaded all of Rothko's art— only now they are taken to a point of no return.[59]

In a 1974 interview for *Arts Magazine,* Dominique pointed to the way visitors experienced the Rothko Chapel as proof of its success. She spoke of the young people who went to meditate, an Islamic organization that went for weekly prayers, a yoga group that practiced every Monday, and weddings that sought a spiritual place without the pressure of an organized church. And she emphasized, of course, the mysterious power of the art:

> The Rothko paintings are very quiet, very silent. It's almost as if they were not there—they really do not demand any attention, yet they have a presence.
> They are like the veil in the temple of Jerusalem. When the Romans conquered Jerusalem and forced their way into the temple, they were very surprised to find nothing in the holy of holies. The Rothko Chapel provides the same kind of dialectical tension: nothing and everything. Concretely speaking, there is nothing there but stretched cotton duck soaked with a mixture of alizarin crimson and black. But aesthetically speaking, there is one of the most daring endeavors to express the infinite with the finite. This is a kind of tightrope walking. But isn't every great work of art tightrope walking?[60]

FAITH CAN BE ALIVE

Dominique in her unassuming way heads the Institute for the
Arts at Rice University. Her exhibitions have made her known
in this country and in Europe. She smoothly permeates her
surroundings with stimulating ideas. She also keeps me busy.
—*JOHN DE MENIL*[1]

As the Rothko Chapel was being unveiled, Dominique opened an exhibition in the Art Barn that captured a very different mood. The de Menils had commissioned painter and sculptor Larry Rivers to develop a multimedia installation that explored the African American experience in the United States. For the exhibition, *Some American History* (February 4–April 25, 1971), Rivers worked with six black artists—Peter Bradley, Ellsworth Ausby, Frank Bowling, Daniel LaRue Johnson, William T. Williams, and Joe Overstreet—all friends whose work he knew and admired. The panoramic environment was made up of forty-nine works of art, many of which, for a white audience at least, were provocative.

Rivers's sculptures were monumental. A *Slave Ship and Slaves* (1970), depicting the cavernous hull of a sailing vessel, with chained figures being transported, accompanied by a recording of the diary of a slave, was twenty-two feet long and over thirteen feet tall. *The Ghetto Stoop* (1969), over ten feet wide and thirteen feet tall, was replete with trash cans and a soundtrack of the difficulties of daily life in Harlem. Another full-scale painting-construction was *Passing Taxis* (1970), sixteen feet long and six and a half feet tall, with a hippie and an African American unable to flag down empty cabs.

Rivers's central piece was a large painted sculpture consisting of four six-foot-tall rectangular boxes, each suspended from rope, depicting, on two sides, a life-size *Hanged Man* (1970), one from Florida, one from Mississippi, and two from Indiana. It was based on a photograph. Rivers noted, "I chose to work in 3-dimensions rather than canvas to make the event come alive. James Haskins, the black writer of *Diary of a Harlem School-*

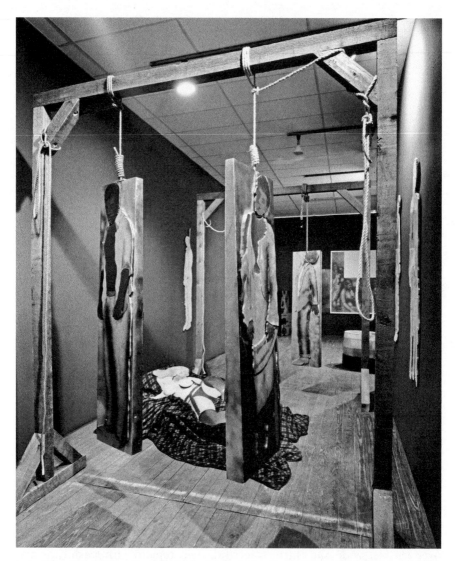

Larry Rivers's installation for the provocative *Some American History* at Rice University, 1971.

teacher, stopped by and looked behind each of the figures and said, 'Oh, I thought there would be a white chick on the reverse side.' "[2]

Rivers took that to mean that the work was incomplete without the presence of a white woman, often the justification—usually fictitious—for many lynchings. "So, I put her on the floor underneath the figures, to emphasize the sexual inference under the issue of race in this country."[3] The full title of the installation was *Caucasian Woman Sprawled on a Bed and Eight Figures of Hanged Men on Four Rectangular Boxes* (1970).

Works by the African American artists were just as confrontational. Joe

Overstreet's *New Aunt Jemima* (1964) reinterpreted the comforting carica-
ture, keeping her smile and decorative bandanna but placing a machine gun
in her hands that she sprayed out from the canvas. In *Time,* Robert Hughes
wrote, "It may be too early to tell whether *Some American History,* with
its sprawling dioramas and wide range of loaded subjects, will be taken as
propaganda, or history, or reality, or radical chic, or simply as an art show.
But it is a sign of the times that it could be commissioned and put on in
Texas at all."[4]

That *Some American History* was on display when the de Menils inau-
gurated the Rothko Chapel could only have been intentional.

•

After the opening of the Rothko Chapel, the de Menils flew to Paris
for an event that was important for them both artistically and personally.
To mark Max Ernst's eightieth birthday, Dominique had conceived and
curated an exhibition in his honor at the Orangerie, the classical building
in the Tuileries that is a part
of the Louvre. Dominique had
been working on the develop-
ment of the Ernst show with
French cultural ministers and
museum officials for two and
a half years.[5] The result, *Max
Ernst: A l'intérieur de la vue*
(April 2–May 31, 1971), con-
tained 104 paintings, sculp-
tures, and collages from the
de Menil family collections.
In addition to their holdings,
Dominique and the artist had
chosen 36 paintings, 1 water-
color, and 3 collages from
his personal collection and
from other private collections
throughout Europe.[6]

It was the first time that a
living artist had ever been the
subject of an exhibition at the
historic building.[7] The open-
ing was held on Friday, April 2,

At the Max Ernst show at the Orangerie, Paris,
1971, Dominique working with, foreground, the
artist, and art dealer Alexandre Iolas.

1971, the date of Max Ernst's eightieth birthday. At the entrance, the artist, accompanied by Dorothea Tanning, was given full honors by the French Republican Guard in their ceremonial uniforms with navy jackets, gold brocade and epaulets, and hats with striking red plumes. A crowd of journalists and well-wishers surrounded Ernst as he made his way into the Orangerie. Dominique had worked with Alexandre Iolas, Bénédicte Pesle, and Jean-Yves Mock on the choice of fabrics covering the walls and the installation of the galleries.[8] The artist, too, had been involved in arranging the exhibition.

The exhibition opening, which began at 11:00 a.m., was very festive, with Ernst, Tanning, the de Menils, French minister of culture Jacques Duhamel, and numerous dignitaries and art world professionals in attendance. From the Orangerie, the de Menils invited a group of fifty for lunch nearby at Maxim's on the rue Royale. Ernst held court at the head of his table in the ornate art nouveau room, receiving compliments about the show and opening birthday presents. From the other side of Maxim's, John rose to propose a toast to the artist he and Dominique had known for four decades.

•

After the Ernst opening, Dominique and John made a quick trip to Florence for the Easter weekend. They stayed in the historic center, at the Firenze Anglo American, and spent a day exploring the city together. Back in Paris, Dominique had an afternoon appointment with Pierre Rosenberg, paintings curator at the Louvre, who gave her a tour of the museum's new galleries. Later that afternoon, she went to the café around the corner from the rue Las Cases for coffee with Rosamond Bernier. "Peggy," as Dominique called her, wanted to show her a piece by Max Ernst that she had just bought.[9]

Dominique also took a moment to review the purchases of the Menil Foundation for the prior year. She determined that the foundation had spent approximately $171,000 on African art, $132,000 on ancient Greek pieces, $115,000 on twentieth-century paintings, and $156,700 on five sculptures by Tony Smith.[10] Those annual expenditures, $574,700, would be more than $3.5 million in 2017.[11]

Several days later, Dominique and John flew Air France back to Houston, where they hosted a black-tie dinner at the Ramada Club, a private club downtown, for a dozen Houston couples. The affair was for Art Investments, an organization they had founded in the mid-1960s with Aaron Farfel, a Houston investor who was a close friend of the de Menils'. The

initiative was meant to inspire Texans to engage with art for a reason that everyone could understand: as a financial asset. In those years, it was still a new concept. As John de Menil said at the time, "Houstonians would think nothing of spending $100,000 for a prize bull, but they would not pay $1,000 for a work of art."[12]

So the de Menils and Farfel found a group of like-minded people. Everyone invested $10,000, and the fund was used to buy paintings and sculptures that were then rotated among members. Every few months, a dinner was held at the Ramada Club, where members engaged with artists and scholars. Gail Adler, Aaron Farfel's daughter, noted, "The beauty of this group was that Dominique and John had access to all these top people. We learned about their work, and then it would end up in museums. A lot of people did try to copy it. They weren't as successful, though, because they didn't have Dominique and John."[13]

Another reason for the return to Houston was that Dominique had to finish her next exhibition at Rice, a charming and groundbreaking show, *For Children* (May 22–August 29, 1971). "People think that gearing an exhibition to children involves simplification and compromise," Dominique explained of the show. "In fact, the opposite is the case. Children demand sophistication, quality and excitement."[14]

The tone was set outside the Art Barn, where the courtyard contained a sculpture by Jim Love, *Jack* (1971), an oversized children's jack, as in the game of jacks, made of steel, that had been painted bright red. Nearby was a brightly colored Niki de Saint Phalle sculpture of a dragon. Both had clusters of children scaling the pieces. The exhibit encouraged young visitors to get involved, to climb up on ladders and peer through holes, to crawl over sculptures, to study small objects placed in glass cases. In one gallery, reached by a round door, they found a bouncy series of brightly colored beanbags and were encouraged to jump up and down, or lounge around, while screens on all four walls projected an eclectic array of images: Indians, engravings of pre-Columbian ruins, fish, wildlife, and fauna as well as biblical illustrations by Gustave Doré.

Dominique conceived of *For Children* as a succession of themes that would inspire the young: the circus, with historic carnival posters and a circus drawing and a wire figure of an acrobat by Calder; an electromagnetic sculpture by Takis where two corks were propelled back and forth in a sort of ballet; an elaborate labyrinth where children were encouraged to discover mysterious objects, including a life-size bronze sculpture by Magritte, *Le thérapeute* (1967) of a seated man, with a walking stick, his head and torso replaced by a birdcage. "Once over the first encounter's shock," Dominique observed, "the children love to climb on him."[15]

A light moment at Dominique's innovative *For Children* show at Rice University.

Over forty thousand children visited the summer exhibition. "They're Climbing the Walls to See This Art Show," announced a story in *The Houston Post*. "And lucky is the parent who is permitted to tag along."[16]

•

Later that summer, Dominique and John were behind another art initiative that had important social intentions. The 1969 *Harlem on My Mind* exhibition at the Metropolitan Museum of Art had been widely criticized as culturally patronizing and insensitive to the African American community; outrage about the spring 1971 *Contemporary Black Artists in America* at the Whitney Museum of American Art, and its ghettoization of nonwhite art, caused fifteen African American artists to drop out of the exhibition just before it opened; and the de Menils' *Some American History* earlier that year at Rice had also been criticized for having a white artist, Larry Rivers, address the black experience (even though African American artists were an important part of the show). So John de Menil decided to try a different approach. He spoke with New York–based African American painter Peter Bradley, who had contributed to *Some American History* but declined to participate in the Whitney show, about curating an exhibition in a dilapidated old movie theater in Houston's Fifth Ward, the predominantly African American neighborhood north of downtown. Bradley agreed. As long as the exhibition would include both black and white artists.

The De Luxe Theater was a formerly grand movie palace that had come down in the world. In less than six weeks, a de Menil–funded swarm of contractors and volunteers, black and white, worked virtually around the clock to turn the cavernous interior into seven thousand square feet of exhibition space, with twenty-two-foot ceilings, sandblasted concrete floors,

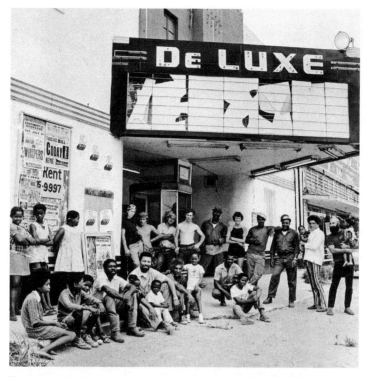

The team of workers and volunteers who turned a dilapidated theater in Houston's Fifth Ward into *The De Luxe Show*, a 1971 exhibition of contemporary art.

The opening night of *The De Luxe Show*, 1971.

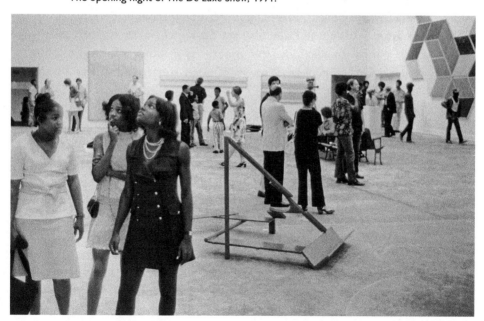

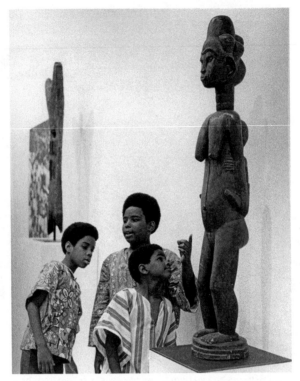

A young audience appreciating a piece from the de Menils'
African collection in the Black Arts Gallery.

and pristine white walls.[17] The exterior of the building was freshened up,
but the marquee was left in its derelict state, a sign of authenticity (this was
very much a John production; Dominique was in Europe for most of the
preparation and the opening). Bumper stickers started appearing around
town: "Hard Art at the De Luxe!"

The exhibition, *The De Luxe Show* (August 22–September 12, 1971),
with forty paintings, sculptures, and watercolors from nineteen artists, has
been considered one of the first fully integrated contemporary art exhibi-
tions in the United States. Bradley contributed to the show and secured
the participation of an impressive group of known and emerging abstract
and color-field artists including Kenneth Noland, Sam Gilliam, Anthony
Caro, Jules Olitski, Larry Poons, Darby Bannard, Richard Hunt, Virginia
Jaramillo, Al Loving, and William T. Williams. John asked Mickey Leland
to be the local liaison for the exhibition, encouraging other activists and
the community to get involved. "This represents an effort to bring major
pieces of art done by prominent artists of the western world to the com-
munity," Leland wrote to neighborhood residents, inviting them to the

opening. "This is an especially important show because it takes art of high quality from the isolation of inaccessible museums and brings it right to the people."[18]

John invited noted New York critic Clement Greenberg to Houston for the opening. "When the neighborhood people started coming in, I became aware of something like a tingle of exhilaration in the air," Greenberg wrote. "And the 'hard' art—the presence of it—seemed to be animating that neighborhood. People were really looking. They were taking the art seriously."[19] Activist Deloyd Parker remembers very well the reaction to *The De Luxe Show.* "That was revolutionary," he explained. "On Lyons Avenue—in the hood?—people really responded to it."[20]

After the exhibition closed, Dominique and John worked behind the scenes with activists Deloyd Parker and Dr. Earl Allen, of Hope Development, to turn the theater into the Black Arts Gallery. In the expansive space, the de Menils had some of their own superb examples of non-Western sculpture installed, in the engaging, nondidactic way that Dominique preferred. Busloads of schoolchildren from around the city were taken to see the exhibition. As TSU art historian Alvia Wardlaw observed, "It was like a wordless introduction for African Americans to a past that they could now celebrate."[21]

·

After *The De Luxe Show* was up and running, Dominique and John left for a remarkable trip around the world to discuss the Rothko Chapel with a vast range of spiritual leaders, an interfaith odyssey over a six-month period from October 1971 to March 1972. There were stops in Paris, Rome, northern Italy, Switzerland, Beirut, the Ivory Coast, Nigeria, Cairo, Tehran, and India. They compiled a detailed account of their travels in a series of documents they called "Exploration Logs." Their intention was to find a director for the Rothko Chapel and to determine what the programming should be for the institution. They took copies of the 1971 issue of *Smithsonian* magazine with a ten-page cover story on the chapel.

Their trip began in Rome, on October 13, 1971, when Dominique and John had an audience with Pope Paul VI. Also in Vatican City, they met with Archbishop Giovanni Benelli, the secretary of state for the Vatican, and Cardinal Willebrands, explaining to all the importance of the chapel as a place of ecumenical dialogue. "We were listened to with a great deal of interest and we were encouraged," they noted.[22] From Rome, Dominique and John drove across Italy to Ancona, where they visited with Archbishop Loris Francesco Capovilla, who had been secretary to Pope John XXIII.

"To him, the Chapel and its programs are in direct line with Pope John's impulse."[23] Such an enthusiastic response from a key figure of Vatican II was enormously validating for the de Menils.

Archbishop Capovilla also had an important suggestion: that basic religious texts be available at the chapel such as "Job on faith, Tobias on conjugal love, Koranic texts, Upanishad, Bhagavad-Gita, etc."[24] His idea became a Rothko Chapel custom. Since that time, placed on the wooden benches at the entrance are such works as the *Tao Te Ching,* the classic text of Taoism; *The Tibetan Book of the Dead;* the Holy Bible; *Prayers and Meditations by Bahá'u'lláh,* of the Baha'i faith; the Torah; the Bhagavad Gita, the great Hindu text; as well as *The Meaning of the Holy Qur'an.*

•

The next leg of their journey, in January 1972, was Beirut. On the first day in Lebanon, "hot off the plane," as they noted, at a dinner in their honor, they had a meeting with Nabila Drooby and her husband Dr. Ala' Eddine Drooby. As Dominique and John recorded in their "Exploration Logs,"

> Dr. Drooby was present at the dedication of the Chapel. He is a psychiatrist who believes in the importance of spiritual life. He is a liberal Sunnite Moslem and a scion of Syrian and Turkish families. He is brilliant and well read. He has a flair for intellectual speculation.
>
> Mrs. Drooby is remarkable: She's intelligent and possesses a high level of education and a gift to organize and moderate conversations in a discreet, efficient way. She belongs to a well-to-do Druze family. Her mother, through her philanthropic activities, had become such a prominent figure in the country that she received a national funeral (with flights of jet planes, etc. . . .). Dr. and Mrs. Drooby have established intimate contacts with spiritual leaders in Pondichery, and are influenced by the school of meditation they encountered there. Every day, they manage to set aside time for meditation.[25]

A few mornings later, Dr. Drooby insisted the de Menils visit the massive prehistoric and the Roman ruins of Baalbek, in the Beqaa Valley of eastern Lebanon. When they returned to Beirut, Dr. and Mrs. Drooby took them to meet Cardinal Meouchi, the Maronite patriarch. "Cardinal Meouchi looked as if he had stepped right out of a Titian painting," Dominique

and John wrote. "He received us in full regalia (bright red from cap to socks). A shrewd politician, he was obviously relieved to discover that neither money nor commitments were being asked of him, and becoming quite friendly, he assured us of his blessing to the Rothko Chapel project."[26]

At a subsequent dinner at the Droobys', the de Menils met other Lebanese thinkers. Dominique and John asked for suggestions about programs for the Rothko Chapel. The authoritarian impulse in organized religions was one suggested topic. "It was said that religion should be a source of love and inspiration—a fountain—not a whip or straight jacket. Religions should not instill fear."[27]

•

The following month, Dominique and John flew to Africa and the large port city of Abidjan on the Ivory Coast. There, they met with His Excellency Amadou Hampâté Bâ, an important historian, theologian, and novelist, and his French wife, an encounter that Dominique characterized as "extraordinary."[28] They lived in an unremarkable neighborhood and a modest apartment building. To reach them, the de Menils climbed three flights of stairs, the air filled with the smell of stew. Amadou Hampâté Bâ was handsome in his white robes and a small white headdress, his wife in traditional African dress with a large head wrap. The conversation quickly became intimate. "I cried when I received your telegram," Hampâté Bâ told the de Menils. "I was so overwhelmed. It was like the answer to my life's dream. I have always wanted to work to unite men. Disaccord is inherent in human nature: intelligence is dedicated to looking for new aspects, new expressions; it always diversifies."[29]

An ecumenical Muslim, Hampâté Bâ told the de Menils about having once been invited by Israeli foreign minister Golda Meir to visit the Holy Land. He asked his driver to take him to the three most sacred places in the country, sites important to all three revealed religions. As he told Dominique and John,

> This gave me the desire to pray on Mount Zion with a rabbi and a priest. The rabbi whom I asked to join me was enthusiastic. A Dominican was equally pleased. We were nine, including the ambassador to Ivory Coast, who had wanted to join us. It was night and we arrived near the summit, where a shop was still open. In the darkness we bought a candelabra and finished the climb by candlelight. Reaching the court of martyrs, the rabbi said, "You are the eldest, you must be the first to pray." I said that though I was the

eldest, my religion was the youngest, and that it was for him to begin as he represented the oldest tradition. When my turn came, I recited the thirty-sixth *surat* which is considered the heart of the Islamic faith.

I thought the candelabra had seven branches but found it had nine. We were nine. I said, "Let each of us place a prayer on one of the branches. They will then be united in a cluster offered to God."

When we left, the rabbi said to me, "Mr. Bâ, it was you who had the idea of this union of prayer. Take the candelabra to Africa. Take our union to Africa." I still have it and I've always thought that one day I would meet someone to whom I would pass it on. I want to give it to you for the chapel.[30]

Dominique and John then drove four hundred kilometers, to the edge of the rain forest and savanna, to the Benedictine monastery at Bouaké, a spiritual center for Muslims and Christians, and then back to Abidjan. "We arrived late in Abidjan with some 900 kilometers behind us and rather dusty," Dominique and John noted.[31]

On their last night in Ivory Coast, as they were packing to leave, they had a phone call from Amadou Hampâté Bâ. He asked for a last visit with Dominique and John, sending his nephew to pick them up at their hotel. Over dinner, he introduced them to visitors as *"mes amis,"* adding, "We met only yesterday but I feel I have known them all my life." After their second visit, the de Menils noted, "Indeed we have a friend and we are proud to be his friends. As we parted company, he pressed our hands and said, 'Let us bless each other.' "[32]

The next day, Dominique and John flew to Nigeria and the capital city of Lagos, the largest in Africa. "Nigeria was a blind date," they noted.[33] On their first day, the de Menils went to the National Museum of Lagos, where they had a positive meeting with the director of antiquities, who suggested several Nigerian contacts.[34] The next day, they drove a hundred miles to the city of Ibadan. "Huge traffic, heavy trucks, buses, narrow road, narrower bridges, repair zones with no one to regulate alternating traffic resulted in phenomenal traffic jams. Yet good humor was generally evident and contagious. While stalled, we could watch the quiet unconcerned life of a village by the river."[35]

After a night in Ibadan, they drove thirty miles to Ife, the ancient Yoruba city. Dominique and John went to the University of Ife, built only three years before on a large, beautiful campus. At the university, they happened to meet Dr. Ola Balogun of the Institute of African Studies. As they noted,

We felt immediately friendly. Balogun, young, intelligent, beautiful and kind, is writing a book on Shongo, the lightning god of the Yoruba. In France, where he lived for four years (two as Nigerian cultural attaché) he published a play in French on Shongo. Under the sponsorship of the University of Ife, he is making a film of Yoruba rituals for which he has recorded songs in village ceremonies. Lastly, he has shot a film on Shongo and needs help for the processing of his negative abroad.

The conversation which started in the classroom continued in his apartment, lasting about five hours. We met his unassuming, frail, yet strong French wife, and their two children. We drank palm wine, and ate fish from the river and yam from the field. We listened to recordings and read some writings.[36]

After Ife, the de Menils drove back to Lagos. Dominique was almost sixty-four, John was sixty-eight and not in perfect health, but they pressed on. "The hotel situation in Lagos is tight," they noted in the "Exploration Logs." "Mr. Dudley Reed, Schlumberger manager for southern Africa, was able to get us in Ikoyi Hotel. During the three days we were registered at this pleasant hotel, we were unable to draw one drop of water from the tap. We managed, the way most Nigerians do, with a bucket of water a day."[37]

In Lagos, Dominique and John met Chief Fagbemi Ajanaku, the Araba of Lagos, or head of the Ifa priests in Lagos. To reach Ajanaku, they went down a narrow, crowded street. Between two shacks, a small door had a sign over it with his name. "There was a short narrow corridor, a small courtyard, goats, a mother duck and her ducklings, and a bare breasted woman active with the wash," the de Menils wrote. "We walked under a sign that read 'Palace,' into a small assembly hall and up a narrow wooden stairway eroded by years of ascensions. At the top, the chief stood to greet us." Ajanaku offered the de Menils beer, which Dominique declined. Without saying anything else, he poured three large glasses of gin and served everyone. "Chief Ajanaku was captured by the *Broken Obelisk,* by the idea of a chapel which does not belong to any religion, by the negation of any missionary purpose, and by the desire to have authentic African religious leaders meet with others as peers."[38]

For her mother back in Paris, Dominique sent a postcard of the Ivory Coast. She told Madame Conrad of the great drives they had taken across forested areas and savanna. "No one has ever seen a lion around here," she assured her mother, "so don't worry about us."[39]

•

From Nigeria, Dominique and John flew to Cairo, where Nabila Drooby joined them. Her presence was vital to the success of the meetings. "Because the Droobys believe in the destiny of the chapel, they decided that Mrs. Drooby would leave behind her responsibilities in Beirut to help us in our quest," the de Menils noted. "She was thoroughly prepared with an educated list of names and letters of introduction, was persistent yet sensitive to the special demands of time and place."[40] The de Menils and Nabila Drooby spent five days meeting with Egyptian religious leaders.

After Cairo, Dominique, John, and Nabila Drooby spent eight days in Tehran. "Even though it is cold and the sky is gray, and we are concentrating not on religious sites but on religious leaders, we still have a vision of Persia," Dominique explained to her mother. "And our trips take us to neighborhoods that tourists never see; it's fascinating."[41]

At Tehran University, they met Dr. Seyyed Hossein Nasr, dean of the Faculty of Letters (who, since 1984, has been the professor of Islamic studies at George Washington University). "Dr. Nasr is a rare example of perfect harmony between eastern spirituality and western thought and life style," Dominique and John wrote. "He has a broad culture and is well acquainted with thoughts, experiences and leaders of various creeds throughout the world, yet has established his own conclusions and chosen his own philosophy of life. His mind is precise, organized, and quick." Dr. Nasr agreed to be involved in the chapel, to advise on future programs.[42]

•

After Iran, they spent almost two weeks in India. They stayed several days in New Delhi, planning their departure for the mountainous town of Dharamsala, home of the Tibetan government in exile, to meet His Holiness the Dalai Lama.

Nabila Drooby, however, had begun to be suspicious of one aspect of the de Menils. "I was worried about being affiliated with the CIA," she recalled. When she was with the de Menils in Cairo, after they finished working together on the "Exploration Logs," John said, "I'll go to the office and send the report to Houston." Nabila assumed that he probably knew someone in the American embassy. Then in Tehran, after they had discussed the latest report, John said that he was going to the office and would drop it off. In New Delhi, they learned that there were no sleeping cars available on the night train. So, as they sat having lunch at their hotel, John said, "I'll take the report to the office and see if they can secure a car."[43]

All Nabila Drooby really knew about Dominique and John was that they were American philanthropists of French origin who she felt were

charming and gracious and stimulating. So, in Delhi, she finally asked, "John, excuse me, but I would like to know, what is your office?" She learned, for the first time, about the connection with Schlumberger Limited. Nabila had attended a French Protestant college in Lebanon, and she knew of the Schlumberger family. "But I didn't know the business, that wasn't within my field of interest, so John explained his relationship with Schlumberger, that they had offices around the world and that Dominique was the daughter of the founder," Nabila concluded with a laugh.[44]

In New Delhi, Dominique, John, and Nabila Drooby were joined by Sonali Rossellini, Roberto Rossellini's wife, who had been born and raised in the Indian region of Bengal. Thanks to Schlumberger, they were able to secure a car and driver, and they left the capital for the long nighttime drive. They arrived in Pathankot by dawn, then climbed the remaining hours to Dharamsala. "There was a feeling of pilgrimage to this audience," they wrote.[45] The meeting, on March 14, 1972, was the result of a year of diplomacy by Sonali Rossellini. Final arrangements were made through the Dalai Lama's representatives in New Delhi and New York, including Robert Thurman, the de Menils' first son-in-law.

Dominique and John were struck by the warmth of the Dalai Lama. As they recorded of their meeting,

> The Dalai Lama lives on the uppermost part of the settlement, in Thekchen Choling. A friendly and intelligent young Tibetan, Mr. Lopsang Wanghuh, led us through the security registration and into a small, simple house. In the waiting room, a nostalgic architectural model of beautiful Lhasa in a corner. Four long haired American youths, ahead of us, sit cross-legged on the couches. We are shown in by a young monk, Tenzin Geyche, who will act as interpreter. He is hardly needed: His Holiness understands English and speaks it well. He listens to the story of the chapel. He hears us also when we express the wish to have one Tibetan Buddhist on the council of advisors. His reaction shows more and more favorable, and we extend an invitation to come to Houston with one or two of those close to him: he accepts. Asked when the visit could take place, he says with a smile, "I am but a monk yet I am called the Dalai Lama and that complicates things sometimes." If we can obtain the visa, he will come with great pleasure and interest. A good 45 minutes have passed and we take leave.[46]

As they walked toward the door, with John de Menil behind Dominique, Nabila Drooby, and Sonali Rossellini, the Dalai Lama reached out

for John. "He takes my hand and my forearm with a strong, affectionate pressure and does not release his grip until we reach together the exit at the other end of the veranda," John noted. "We all are moved by this show of kindness."[47]

Robert Thurman had spent time in Dharamsala the year prior, writing a dissertation and interviewing the Dalai Lama. He felt that the Tibetan leader must have sensed that John was ill. "He may have a premonition of John being close to passing," Thurman suggested, "and wanted to give him a special 'energy-blessing,' knowing it would be their last encounter."[48]

From Dharamsala, they drove to Beas, to see the guru Maharaj Charan Singh, spiritual leader of the Radha Soamis, a pan-religious, mystical group. After a return to Delhi, they traveled to Madras and Pondicherry, visiting ashrams, museums, and temples. As the de Menils saw the country, Dominique was fascinated by the layers of belief and history that she encountered in India. As she described it to her mother,

> This trip is mesmerizing. After the Muslim world, here we are in contact with the religious life of India, from the most primitive to the most sophisticated. There are statues carried on the street to the sound of tambourines and chants, a eunuch dancing at the head of the procession, dressed as a woman, her head covered with flowers and face painted violet. And then there are intellectuals influenced by the great Indian prophets of the nineteenth century: Ramakrishna, Vivekananda, Tagore.
>
> Yesterday, we went to meet an old Benedictine priest who has been infused by Indian spirituality. His small chapel looks like a little Hindu temple, and the liturgy for his Mass borrows many of the religious symbols of Hinduism. He reads the gospels kneeling like an Indian in an orange robe, like a Buddhist monk.
>
> Today, we visited a wise man of Hinduism, who is reminiscent of an Anchorite of Thebaid from ancient Egypt. He has not spoken for more than two years. He leaves his small hermitage only in the evening, but he can be seen by an opening in the wall of his little courtyard. He prays endlessly and occasionally turns toward visitors and stares at them intensely. That is how he blesses them.[49]

Back in New Delhi, again because of the intervention of Sonali Rossellini, the de Menils met with Indian prime minister Indira Gandhi. "There is nothing palatial about her residence," Dominique and John noted in their "Exploration Logs." "We were checked at the gate, of course, but with a

light touch. As we walked into the house, we heard her grandchildren." They were shown into her drawing room, a simple space with easy chairs and folk art paintings on white walls. With little wait, she appeared. "Mrs. Gandhi is shy and somewhat cool in her approach to the conversation," the de Menils wrote. "She listened attentively as we explained the chapel, its program and our quest for the spirituality of India. She looked carefully at the photos in the *Smithsonian* magazine and skimmed through the article. Her reaction was perceptive. She took the small file, which she will read, quickly but without missing anything."[50]

When her grandson walked into the room, Indira Gandhi asked Sonali Rossellini about her family; the meeting was over. Dominique and John already knew that Prime Minister Gandhi could be abrupt. As they noted, "On Sonali's previous visit to India, she had left without seeing Mrs. Gandhi. Shortly after her return to Rome, she received a note from the Prime Minister that had been written on board a helicopter: 'Next time, you must see your friends.' "[51]

Dominique and John de Menil concluded their voyage in Paris. There, they consulted a variety of religious leaders, including Father Congar.

•

Throughout those years, four decades into their marriage, the de Menils maintained their remarkable sense of intimacy. One fall day in 1969, John left Dominique a note that read, in its entirety, "I would like to go have a walk with you."[52] One spring morning in 1970, Dominique wrote the briefest of notes: "Jean! I need you. Do."[53]

By 1972, the de Menils had begun telling family and friends that John's cancer had returned. It is unclear, however, whether it was a new diagnosis or if he had had prostate cancer since 1967 and they preferred to keep his condition private. But by the summer of 1972, when he was sixty-eight, John had begun a treatment of chemotherapy, and it would have become obvious to all.

John's assistant Chris Powell remained at Schlumberger when he retired, but they stayed in close contact. As she recalled,

> I remember the day he told me that the cancer had come back and that he had such a short time to live. I went by the house after work, and he was by himself, sitting in that Belter rocker by the fireplace. None of the servants were there; nobody was there. I was afraid he was dead sitting there in that chair. His eyes had gotten bad, but I

remember he looked up, saw who it was, and smiled. But he always got up and dressed in a suit and a nice white shirt. He had a tie on, sitting there in that chair by himself, dressed as though he was going to work.[54]

Kevin Cassidy, the St. Thomas student who had become good friends with the de Menils, often mentored John in yoga. One pleasant afternoon, they prepared to practice their asanas outdoors in the garden, next to the massive Max Ernst sculpture *Capricorn*. Just before the session, John said to the young man, "Kevin, I'm dying."[55]

By the end of the year, there seemed to be improvement in John's health. Dominique felt that the radiation, cobalt therapy, was working and that the side effects were lessening. "The tumor seems to have been stopped," she wrote to her mother. "He is being treated with cortisone, which appears to be successful. He still is quite tired. Needing to rest often during the day, he spends no more than a few hours per day in his office. He often dictates letters from bed, to me first thing in the morning, then to his secretary."[56]

Dominique and John visited specialists in New York and in Houston for John's diagnosis and treatment. If there was any real improvement, both realized that the situation was very serious. "We are living day by day," Dominique admitted to her mother, "without being able to make any plans."[57] But the couple continued their lives. They were in Paris for the summer of 1972, but after that trip they stayed mainly in New York or Houston to be close to John's doctors. Dominique was busy preparing two upcoming exhibitions for Rice, the Houston version of the Max Ernst show, *Inside the Sight,* as well as a survey of grisaille paintings. And both de Menils were working toward the first major event to take place in the Rothko Chapel. The result of their trip to meet religious leaders would be a colloquium, for the summer of 1973, titled "Traditional Modes of Contemplation and Action."

At Rice, Dominique curated *Cornered Fluorescent Light from Dan Flavin* (October 5–November 26, 1972). A dramatically beautiful show, it had four partitioned areas, creating sixteen corners, containing his minimalist sculptures of bright, white fluorescent tubes. "They are the proof that beauty can be created out of anything, if one has talent," Dominique wrote to her mother.[58]

Back in New York, the de Menils were occupied with seeing friends and family and work associates. Dominique's schedule included lunch with National Gallery of Art director J. Carter Brown, meetings with Philip Johnson, and a lunch with the art historian Leo Steinberg. She made trips

Leo Castelli, Dan Flavin, and David Whitney at the opening of *Cornered Fluorescent Light from Dan Flavin* at Rice University, 1972.

to the apartments of collectors, such as Emily and Burton Tremaine, noting the works she could borrow for the grisaille show. She met with Leo Castelli, observing that he had a gray *No. 4* by Jasper Johns and recording his other suggestions: Robert Rauschenberg owned a small map by Johns, Ethel and Robert Scull had a Rosenquist grisaille, while there was a gray *Assumption* by a Flemish painter at the Isabella Stewart Gardner Museum.

One November day, before the Thanksgiving break, Dominique and John went to Grandparents Day at the Spence School, where Christophe's daughter, Taya Thurman, was a student. A few weeks later, John wrote to David Sylvester about the ongoing Magritte project. "If I am correct in my recollection, you announced in recent correspondence a first volume out in 1974," John wrote. "My health has deteriorated and I would like to see that."[59] And the de Menils continued to have houseguests at 111 East Seventy-Third Street, such as Werner Spies, and to entertain.

In the fall of 1972, Dominique and John went to the Brooklyn Academy of Music to see a performance by the whirling dervishes of Konya, Turkey. The program advised the audience that it was a religious ceremony and requested there be no applause. "It was not actually a performance," Dominique wrote to Madame Conrad. "They practiced their sacred dances

on stage, as though they were in a mosque. Applause was forbidden. They turned slowly and methodically. It is a devastating spectacle—like flowers that open and are carried away by the wind."[60]

•

In the final weeks of the year, John de Menil organized his funeral. His plans came in the form of a typewritten letter to Pierre, known as Pete, Schlumberger, the son of Dominique's cousin Pierre, an attorney who would be the executor of his estate. "I am a religious man deep at heart, in spite of appearances," John wrote. "I want to be buried as a Catholic, with gaiety and seriousness."[61]

He wanted the Mass and last rites to be conducted by Father Youakim Moubarac, a Lebanese-born, Paris-based priest and academic. The de Menils had met Father Moubarac in Beirut. Dark, handsome, and extremely intellectual, Moubarac shared the de Menils' expansive view of religion. Both his father and his grandfather were Maronite priests. Ordained in Paris and assigned to a parish in the Latin Quarter, he was a scholar of Islamic civilization with a doctorate from the Sorbonne and had been a participant in Vatican II.[62]

John wanted the funeral to be held at his local parish, St. Anne's, adjacent to River Oaks, and not at the Rothko Chapel, because it would set a bad precedent. "I want to be buried in wood, like the Jews," John wrote. "The cheapest wood will be good enough. Any wood will do. I would prefer a pickup or a flat bed truck to the conventional hearse."

He wanted the funeral to be filled with music, specifically Bob Dylan. John suggested that if Dylan was not available to perform, electric guitars could softly play his music. And he made a recording with the songs that were to be included. He wanted to begin with "Ballad of Hollis Brown," because it was evocative of the traditional tolling of bells known as the death knell. That was to be followed with "Blowin' in the Wind," "The Times They Are A-changin'," and "With God on Our Side." "Because, all my life, I've been, mind and marrow, on the side of the underdog," John explained.

He specified that the funeral director should be African American, selected six pallbearers, and requested that his eldest son, Georges, be seated with Dominique, Christophe, Adelaide, and Philippa. And he stated that the family section should include Helen Winkler, Simone Swan, Roberto Rossellini, Howard Barnstone, Jean Riboud, and Ame Vennema from Schlumberger Limited as well as Gladys Simmons. "I want no eulogy," John insisted. "These details are not inspired by a pride, which would be

rather vain, because I'll be a corpse for the meat wagon. I just want to show that faith can be alive."[63]

•

In Houston, on January 4, 1973, Dominique and John had a small dinner for his birthday. He was sixty-nine years old. Joining them were François de Menil, Philippa de Menil, Simone Swan, Miles Glaser, and Mickey Leland.

Only two months before, Leland had been elected to his first term in the Texas State House of Representatives, still exceedingly rare for an African American. He was profoundly grateful for John de Menil's role in his nascent career. "I was a rough and crude personality, and they polished me," Leland once explained. "People tend to think in terms of what the de Menils have done financially; that's not right. What the de Menils did for me was to turn me into a sophisticated human being who happened to make a career in politics."[64]

As the birthday dinner wound down, he had a personal gift for John. For years, Leland had often worn a striking necklace, interconnecting links of thick silver that were tied in a knot, a symbol of slavery. "Before leaving, Mickey gave him a link from the silver chain he always wears around his neck," Dominique recorded in her diary. " 'Because you are the one who helped me free myself from my chains.' "[65]

•

The following month was the opening at the Art Barn of *Max Ernst: Inside the Sight* (February 7–June 17, 1973). It was the fifteenth and final iteration of the exhibition, having traveled throughout Germany, France (after the Orangerie), and the United States. The artist and Dorothea Tanning made their way to Houston for the show. Rosamond Bernier was there as well and gave one of her captivating lectures on Ernst. She also presented her film on the artist. The de Menils, accompanied by Roberto Rossellini, took Ernst to the Art Barn to preview the exhibit. John looked as dapper as usual, wearing a white shirt, a vivid silk tie, and a jacket draped casually over his shoulders. As they entered the galleries, however, the others continued through the exhibition while John went to find a chair to sit down.

The next week, Dominique and John organized another trip to Houston for Leo Steinberg, inviting him to give two lectures at Rice on Leonardo da Vinci's *Last Supper*. The de Menils asked the art historian to stay at their house. Steinberg had been informed that John had cancer. One morning,

waking a little later than usual, he went into the kitchen for breakfast after his hosts had already eaten. As Steinberg recalled,

> John de Menil was there, and he sort of paced up and down, whistling; he knew that his days were numbered. He asked me what I was going to do that day, and I said I had to work on tomorrow's lecture. So he called the maid and said to her very quietly, "Would you please tidy up Mr. Steinberg's room; he's going to be working there all day." I thought, here's a man, whistling in the dark with cancer and still realizing what had to be done for a guest; that moved me.[66]

Maria Ruspoli, on a visit to Paris from her home in Aix-en-Provence, spoke with Alexandre Iolas about John's condition. "He told me that you were very ill, which was so upsetting," she wrote to John. "But he also told me that you were in a 'state of grace,' that you had such a strong spirit and such a loving heart that others around you felt lifted up, invigorated. I was very moved."[67]

In March, Dominique made a quick two-week trip to Paris. She had meetings with David Sylvester, checking up on the status of the Magritte project, and went to the office of *The Image of the Black in Western Art*. She saw her mother, of course, still living on the floor below at the rue Las Cases. And she had dinner with her sister Annette. Dominique also made time for art acquisitions. At the Galerie Sycomore, an antiquities gallery on the rue des Beaux-Arts, she found a Janus head from northern Nigeria, and she made a few purchases at Alexandre Iolas.[68]

From Houston, John wrote to the Museum of Modern Art in New York to resign from the board. "With much regret, your fellow trustees voted to accept your resignation and, at the same time, elected you an Honorary Trustee for Life," Blanchette Rockefeller wrote to John.[69]

When Dominique returned to Texas, she and John had cocktails with Alice and George Brown and then a dinner for Art Investments. It was decided, because of John's leadership role in the group, to begin the process of liquidating the holdings. Members would be allowed to bid for paintings, and the proceeds of those sold were to be distributed among the group.

Knowing that John's health was declining, friends and family traveled to Houston. While Dominique was in Paris, Lois and Georges de Menil, along with their young children, Jason and Joy, were staying with John at the house. Roberto Rossellini made sure to be in town, beginning in early April. Dominique's sister Annette arrived on May 10. She brought, as Dominique had requested, a French antianxiety medication, Dogmatil,

that had been recommended by a leading cancer specialist at the University of Texas at Galveston, Dr. William Levin. "Those few days were really moving for me," Annette wrote to Dominique after returning to Paris. "If faith is something that can be found, its source would be in everything I felt around you and John. Nothing else really matters."[70]

On May 25, Gladys Simmons arrived to help Dominique with John's care. On May 27, Adelaide de Menil and Ted Carpenter arrived in Houston, as did Simone Swan. In those final days in May, John was confined to bed.

Father Youakim Moubarac made his way to Houston from Paris. Father Congar, thanks to a conversation he had with Moubarac, sent the de Menils a letter, assuring both that he was thinking of them.[71] For two days, Father Moubarac performed Mass in John's bedroom, with readings from Corinthians and the book of Matthew.

On Thursday, May 31, throughout the afternoon and evening, John was in tremendous pain. Dominique was desperate to procure some morphine, but she was unable to reach Dr. Levin in Galveston or their doctor in Houston. At 10:00 p.m., Mickey Leland phoned. Dominique told him to come right away to the house. Leland summoned a friend of his, Dr. Garth, who quickly came and gave John an injection of morphine.

Dominique, along with Gladys, stayed with him in their bedroom that night. She remained by her husband's side, closely monitoring his condition. On Friday, June 1, at 6:30 a.m., she noted that John was barely breathing. By 7:30 a.m., Dominique felt his final pulse.

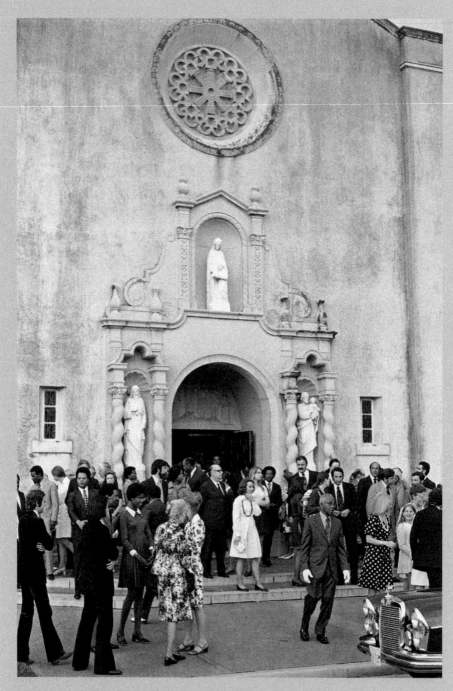

John de Menil's funeral at St. Anne's Catholic Church in Houston, June 1973.

PART FIVE

A VERY STRONG
WOMAN

TWENTY-FOUR

AFTERMATH

You have probably heard about the death of my husband on
the first of June. Even though he had cancer for the past year,
he continued to work and to dictate letters almost right up to
the end. I have not yet been able to comprehend his passing but
he leaves me with a mission that I must complete.
—DOMINIQUE DE MENIL[1]

News of John de Menil's death was published the next day in *The Houston Chronicle* and *The Houston Post,* while *The New York Times* ran a lengthy obituary. *Art in America* published reminiscences from good friends, artist Brian O'Doherty and composer Morton Feldman; both were most moving for Dominique. Feldman, recalling a 1966 party for the New York City Ballet at the de Menils' house on Seventy-Third Street, wrote,

> It was quite a party at the de Menils. The premiere of Merce Cunningham's re-choreographing of *Summerspace* for the Balanchine company was the occasion. I'd never heard of the de Menils until that evening. Though I was the composer for *Summerspace,* most of the guests didn't know it. I don't think Balanchine knew it either. So anonymous but not unhappy, I quickly drank at least eleven glasses of champagne and started down the long circular staircase; about six steps above the landing, I lost my balance—naturally— and with a full glass in hand glided the rest of the way without mishap. Only one man among so many people witnessed this tour de force; he walked over to me and said, "Anyone who could do that I have to know." It was John de Menil.
>
> Though this conveys the charm John de Menil certainly had, there's much more to it than that. He would have known that something a little unusual had happened on his staircase even if he was in another room. He had a gentle radar for the unusual. A crazy idea, a beautiful idea, an irreverent or a religious idea, as long as it had some "guts and personality" behind it, got immediate attention

and, many times, immediate support. Even a heavy man gliding down a staircase with a champagne glass in his hand became a very good friend of his.[2]

Jean Riboud, president of Schlumberger Limited, published an open letter in *Intercom,* the company's in-house magazine. "Only a handful of us know what Schlumberger owes to him," Riboud wrote, and as the letter noted in part:

> He had faith in Schlumberger worldwide when nobody thought there was much future outside the U.S.
>
> Faith and courage, from the first day I met him in 1946 until yesterday, without slipping once. But also, permeating all his being, an incredible generosity. John was the only rich man I have ever known who was totally, to the marrow of his bones, humble and generous.
>
> As I am leaving for John's funeral, I could not let *Intercom* go to press—*Intercom* which John de Menil founded—without saying from so deep in my heart how much I admired the man, how much I loved the friend.[3]

Family members continued to arrive in Houston. The responsibility for overseeing the ceremony was given to François de Menil. To fulfill John's request for an African American funeral director, Gladys Simmons suggested Ross Mortuary, on Lyons Avenue in the Fifth Ward. "He didn't want a white man to do his body," she said with a laugh.[4] Finding the plain, wooden box was more challenging than expected. Mickey Leland and Deloyd Parker went together to the funeral home. They were greeted by a representative who heard the name of the deceased and had visions of dollar signs. "The man was looking to sell us one of the most expensive coffins he had," Deloyd Parker remembered. "Of course, that's not the way Mr. D. wanted it. But across the street, in the garage, was an old wooden coffin. We said that was what we wanted. Instead of a big casket with all those beautiful decorations, here was a wooden coffin with just a rope on each end."[5]

Using a pickup truck or a flatbed for transportation was prohibited by city regulations.[6] Instead, it was decided to commandeer a Volkswagen Microbus, owned by former St. Thomas student Sarah Cannon, who was working with the de Menils for the Institute for the Arts at Rice. The classic VW van, in green and white, was normally enlisted to transport paintings and sculptures for Dominique's exhibitions. Just a few months before,

Dominique had been driving around in the van to local nurseries, selecting the plants for the Max Ernst exhibition.

For four full days, John de Menil's body lay in state in the de Menils' bedroom as friends and family stopped by the house to pay their respects. On the walls were Giorgio de Chirico's *Hector and Andromache,* a late painting by Paul Klee, a large Dubuffet, and a cubist Gris. Placed on top of a simple bier was a seventeenth-century African crucifix and a couple of sprigs of ivy that had been brought in from the de Menils' garden.[7]

The funeral took place on Tuesday, June 5. John's body was raised from the bed and placed in the simple pine coffin. Positioned on top of the casket was the green velvet pall that Dominique had first used for Jerry MacAgy's service. On the fabric was the seventeenth-century crucifix depicting a black Christ and a single red rose. There were eight pallbearers: François de Menil, Francesco Pellizzi, Mickey Leland, Miles Glaser, Ladislas Bugner from Paris, sculptor Jim Love, art history professor Bill Camfield, and Pete Schlumberger. They positioned the casket on their shoulders and carried it through the de Menil house and out the front door. They then lowered it into the back of the Volkswagen van, which had been parked on the drive at the front entrance.

Motorcycle officers escorted the van and the procession, led by Dominique in a black Mercedes hearse, a mile and a half east to the St. Anne's Catholic Church. A long circular drive extended from Westheimer Road to the front of the church, its tall facade in pale stucco and adjacent bell tower inspired by Spanish mission churches of the American Southwest. The pallbearers removed the casket from the van near the busy street, and a group of mourners walked behind it to the arched front door of the church.[8] "The plain coffin, the VW van, the procession walking behind the coffin, all of these were symbols that reminded us that working people or poor people or minority people have dignity," remembered the Reverend William Lawson. "In life and in death, he constantly affirmed the little people—that was his greatness."[9]

The church was filled with hundreds of mourners, including friends of the de Menils' from around the world, business leaders from Texas and New York, and, as the *Chronicle* reported, "a Mexican-American laborer in shirt sleeves who slipped in by a side door."[10] The service began with a "Veni, Creator Spiritus," one of the most meaningful hymns in John de Menil's life. It was sung in Latin by Father Pie Duployé, a Dominican priest whom the de Menils had brought to the University of St. Thomas to teach French, and recited in English by the parish priest of St. Anne's. Rabbi Robert I. Kahn of Houston's Temple Emanu El was the first participant in the service, stepping up into the pulpit to read Psalm 15 of the Hebrew Bible.

"It speaks volumes about John de Menil that a rabbi should be asked to participate in these rites," Rabbi Kahn suggested. Immediately after, Father Moubarac sang a verse from the Koran, while incense was burned at the side of the coffin, an offering from Sonali Rossellini.

Georges de Menil ascended the pulpit to read from the book of Revelation. After he finished, as he stepped down, the nave was suddenly filled with the sounds of Bob Dylan's "Blowin' in the Wind." François de Menil, along with A. C. Conrad, who had long provided the technical expertise for Dominique on her exhibitions, had installed, up in the choir at the back of the nave, high-tech speakers connected to a reel-to-reel tape player.[11] "We thought Bob Dylan was up in the choir loft," remembered Edward Mayo from the MFAH. "It was such a good loudspeaker system. Everybody was goggle-eyed; we had never seen anything like that."[12]

The next speaker was the Reverend Lawson, the African American pastor of the Wheeler Avenue Baptist Church. He read from *The Prophet,* by Muslim poet Kahlil Gibran, and, from the New Testament, the first letter of the apostle John to the churches. "Everyone up there speaking was of a different religion," remembered Chris Powell. "And it was probably the first and only time in Houston that a Catholic church had people of different faiths."[13]

Following Lawson was the offertory as the sound system blasted "The Times They Are A-Changin'." There was a prayer in French by Father Moubarac, a Paternoster in Latin sung by the congregation, and the Communion ceremony, accompanied by another Dylan song: "With God on Our Side." Father Moubarac offered a concluding prayer and blessed the casket. As the pine box was carried from the church, the recessional was a final piece by Bob Dylan, "Girl from the North Country," which had reminded John of the tolling of bells.

As the music played, the church doors were thrown open to a sudden darkness in the late afternoon, the first sign of an intense summer storm. "It was pitch-dark," remembered Simone Swan. "Then streaks of lightning came up that lit the clouds. It was so dramatic."[14] Glancing at the sky, Roberto Rossellini said, "This funeral is attended by the gods." François de Menil remembered the suddenness of the change. "There was a kind of biblical aspect to it," he recalled. "It seemed to come out of nowhere."[15]

The VW van slowly pulled away from St. Anne's, the procession of mourners following behind. It drove to the Rothko Chapel, stopping to observe a moment of silence. From there, the mourners made their way south to the cemetery, to the section of Forest Lawn that was reserved for Catholic burials. John's open grave was next to Jerry MacAgy's plot, with its simple bronze marker. A graveside tent had been constructed for shelter

and the skies seemed to explode as his coffin was lowered into the ground. The storm had arrived, with driving rain added to the thunder and lightning and darkness. George Oser, a school board member whose candidacy had been supported by the de Menils, stood next to Dominique, who turned to him and said, 'It is just like the day when Jesus died.' "[16]

•

Dominique was inundated with hundreds of letters, notes, and telegrams of sympathy, from friends, curators, museum directors in the United States and France, and Schlumberger employees and executives from all over the world. Norman Mailer sent a wire. "I have lost a friend of such character, taste and good will that it does not suffice to say he was unique," Mailer wrote to Dominique. "To me, he is irreplaceable."[17]

Cinémathèque Française founder Henri Langlois wired his sympathies; Michelangelo Antonioni sent a typed letter; photographer Cornell Capa sent a telegram; and Henri Cartier-Bresson dashed off a telegram as well as a handwritten note. "You know how much I owe to you and John," Cartier-Bresson wrote to Dominique. "His joy and his sense of precision have always been a benchmark for me and they will continue to be."[18]

So many spoke of John's quiet acts of generosity or personal kindness. David Sylvester mentioned a 1969 weekend at their country house. "I keep thinking of Pontpoint three summers ago," Sylvester wrote to Dominique. "Of how, when I arrived, he carried my heavy suitcase up the stairs, of how he covered sheets of paper with memos in that large round spaced out hand, of how you both took me to Le Bourget and, while my plane was delayed, sat there for ages in a crowded, dirty sandwich bar."[19]

Shortly after the funeral, Dominique left Houston for New York. One Sunday, which happened to be Father's Day, she presided over a board meeting for the Menil Foundation at 111 East Seventy-Third Street. She then flew to Paris, for the funeral of René Seydoux, who had died several weeks after John. From the Paris airport of Le Bourget, Dominique joined other family members in the Schlumberger plane for the short flight to Deauville. From there, she drove to the Val-Richer, where Seydoux was buried with other members of the family in the nearby cemetery of St.-Ouen.

Dominique also made a trip to Pontpoint, where she continued the process of having their possessions appraised for John's estate. Back in Paris, she focused on the event that they had planned for the Rothko Chapel, scheduled to begin on July 22. "Traditional Modes of Contemplation and Action" was to be a weeklong series of panel discussions with religious leaders and academics from around the world. The colloquium was the

first of many that would be held at the chapel. Those involved wondered if the event would have to be postponed. "Nobody thought that she would go ahead with the colloquium," remembered Nabila Drooby. "He had died only several weeks before. She sent a telegram to Lebanon that every single one was expected to be there."[20]

While she was in Paris, Dominique spoke with Father Congar, who suggested a host of academic journals she should contact to send transcripts of the colloquium discussions. Congar also invited her to attend Mass at the Dominican monastery at 20, rue des Tanneries, where she found herself seated next to François de Medeiros, a Dominican who was also a historian and had taught in Benin. Dominique also had a long conversation with John's sister Mirèse, asking her about details of the de Menil family history and specifics about John's early life. She made precise notes of what she learned from Aunt Mirèse.[21]

On returning to Texas, Dominique stood in the Rothko Chapel, in front of the enormous, brooding panels, welcoming some two dozen religious leaders and thinkers to the first Rothko Chapel colloquium. "When a child was born in my family, my father used to say, '*Elle est là!*' 'She is here!'" Dominique stated. "Because, in those days, there were only girls; boys came later. Well, 'You are here,' and to me it is a little like a birth."[22]

The group of participants had been organized by Dr. Yusuf Ibish, a professor of Islamic culture at the American University of Beirut with a Ph.D. in Middle Eastern studies from Harvard. Dominique and John had met Dr. Ibish on their trip to Beirut. "John decided that this time it is not the Christians who are going to invite other people," Dominique explained of the organization of the colloquium. "Instead, there will be a steering committee made of Muslims, Hindus, Zen Buddhists, and they will invite us. Which means," she finished with a laugh, "that the Christians were not very well represented."[23]

There were some twenty panelists from Africa, the Middle East, Europe, and America who had been brought to Houston for serious exchanges about belief and spiritual engagement. The conference also consisted of over fifty auditors. "We know it was not easy for you to come," Dominique said to the group. "You all have tight schedules and heavy commitments. So, I want to express to you our thanks. We are grateful to the steering committee who did such beautiful work, particularly to Professor Ibish. Without his devotion, patience and hard work this remarkable meeting would not have taken place."[24]

Nabila Drooby recalled that many in the chapel were impressed with how Dominique, just widowed at the age of sixty-five, was able to steer the

proceedings. "She opened the colloquium with a great deal of dignity and grace and inspired everybody who was there," Drooby said. "People were in awe—the proper awe—of this woman, who was able to lead a group of twenty-one men to discussions that were very positive and very productive."[25]

The topics for public lectures and panel discussions were weighty, and the religions included Tibetan Buddhism, Hinduism, the Eastern Orthodox Church, the Hesychastic tradition, Judaism, and Islam. Dinners were organized as well as performances by the Hindustani classical singer Pandit Pran Nath with La Monte Young and Marian Zazeela. The colloquium would be brought to a close with a dinner in the garden of the de Menil house.[26]

•

The first exhibit after her husband's death was *Gray Is the Color: An Exhibition of Grisaille Painting, XIIIth–XXth Centuries* (October 19, 1973–January 19, 1974). Even the gallery walls were painted in dark gray, and for the catalog epigraph Dominique selected a quote from Picasso: "Color weakens." As Dominique wrote, "Gray paintings are intrinsically disquieting: They seem to introduce us to a world of dreams, of anguish, of alienation."[27]

Even with close friends, Dominique was not known to share her more personal feelings. Working on the exhibition, she discussed its somber tones with Nabila Drooby: "She said, 'You know, this is providence. I started on *Gray Is the Color* years ago, but right now this really reflects my mood.' "[28]

Dominique had been preparing the exhibition for more than three years.[29] It included over 110 works in grisaille, from the Middle Ages to the present: paintings, drawings, stained glass, and illuminated manuscripts. Works were lent by dozens of museums, including the Metropolitan Museum of Art, the Museum of Modern Art, and the Louvre, as well as a host of private collectors. The exhibit was melancholic and masterful, jumping from a medieval stained-glass window to Warhol's shadowy silk screens of Elvis Presley, from Rubens's exquisite *The Road to Calvary* (ca. 1632) to an abstract grisaille painting by Josef Albers, *Never Before* (1971). "Grisaille, indeed a limited medium, provides a rigorous test of talent," Dominique wrote. "Stripped of color, deprived of any sensuous charm, the art of painting appears in its nakedness. It is reduced to the subject, the composition, the authority of the brushstroke and the style."[30]

In addition to tracking down the paintings, through queries of collectors and museum professionals, she asked participating artists about their

work in the show. Dominique wrote to Warhol, Jasper Johns, James Rosenquist, Robert Indiana, and Josef Albers. In her letter to Man Ray, about *Suicide* (1917), a painting she owned, she mentioned she had heard the artist had once considered killing himself in front of the canvas. Man Ray wrote to Dominique,

> I had been rather severely criticized for vulgarizing art with mechanical tools. That and other run-ins with galleries depressed me and I observed that I would sit behind the painting and arrange a gun in front so that I could pull a string and have the bullet go through to my heart. However, I feared this would provoke further criticism in resorting to another mechanical instrument. But there was also the thought that my suicide might give pleasure to some people. Just giving the title and remaining alive was a contradiction I would enjoy alive. So here I am.[31]

The Houston Chronicle called the show "a remarkable exhibition, thought to be the only one of its kind ever mounted in this degree of depth."[32]

The exhibition also marked a new emphasis on Dominique's desire to keep the focus off her and on her work. When a journalist from *The New York Times* suggested a profile of her connected to the exhibition, he was rebuffed. "I've discussed your project with Mrs. de Menil," wrote Simone Swan. "While we are most happy that you wish to report on the grisaille show, we feel you might be placing too much emphasis on an interview with Mrs. de Menil. Please count on our total cooperation, should you wish to concentrate on the grisaille exhibition."[33]

As so many of Dominique's shows had been, *Gray Is the Color* was greatly appreciated by the public. "Dear, dear, Dominique: Thank you for the beautiful show you gave to Houston," wrote patron Alice Brown. "I went again the last day. Each time I went, I enjoyed it more." The Browns wanted to make it clear to Dominique that her exhibitions, and the collection she and John had assembled, were valued locally. As Alice Brown continued, "We and all Houston, thank you for the years of work that went into this marvelous collection of art, which is so rare here . . . or, let us say, almost anywhere."[34]

WHAT NOW?

I'm after the excitement not the object per se—after the light,
not the bulbs. I'd like to provide for people plenty of bulbs to
switch on.
—*DOMINIQUE DE MENIL*[1]

Just before John had retired from Schlumberger in 1969, the de Menils had dinner at their house in Houston with their son Georges and his wife, Lois. The conversation turned to their plans after his retirement. "Dominique had always, up to a point, supposed that once John stopped being the chairman of the board of SLB, they would return to Paris," Lois de Menil explained. "She certainly told me that very clearly when Georges and I married. It was John who decided firmly that they would build their lasting dream in Houston."[2]

That night over dinner, John spoke of the reasons why: the sense of freedom he felt in Texas, the amount of sheer opportunity, and, as Lois recalled, "the confidence that you could do whatever you set out to do." Dominique pushed back. What about their family back in France? For her, the idea of being close again with her mother and sisters was particularly important. John became insistent. "Think of what a difference we could make here," he said with conviction, "and how Houston has shaped our lives." "Dominique was a bit crestfallen," Lois recalled. "He was passionate, as only John could be. He really did not want to retire to France, to take up his place in his family and Dominique's, to be a patron in the French sense, to be part of an elite."[3]

There would have been an ideal retirement waiting for the de Menils back in Paris. They had their apartment on the rue Las Cases, of course, and Pontpoint. They also had the possibility of regular visits to the Val-Richer, which had always been so important to Dominique. There was the warmth of the extended de Menil family and all of the fascinating figures in the Schlumberger family. And there were all of their friends they had known for decades, along with the cultural, artistic, and intellectual leaders they had befriended over the years.

But this was also true for New York. They had their town house on

Seventy-Third Street and close relationships with leading artists, collectors, scholars, and museum professionals. Their schedule in Manhattan, much of it centered on the art world, was always so dynamic and interesting. And all of their children and grandchildren were in, or around, the city.

Walter Hopps, who would collaborate so closely with Dominique, understood that there was a period after John's death when she weighed her next move. "Dominique was very much his partner in the art collecting, but she didn't really assume all the extraordinary activities on her own until after he died," Hopps suggested. "There was a year when she really had to think about what she was going to do next. Everyone wondered, 'What next?' But then she really plunged in."[4]

Paul Winkler was also aware that John's death meant a shifting of the gears for Dominique. "They were very different, but they were a fantastic team," Winkler said. "When he died, things petered out a little bit. The energy was different; things just sort of slowed down."[5]

Even within the family, many wondered what Dominique would decide to do. "We wondered, after John's death, with a museum still not built and their plans still largely incomplete, whether Dominique would fold up shop and return," Lois de Menil continued. "But she did not. Dominique dedicated herself to fulfilling their commitment to Houston, without looking back. Returning to France was no longer at issue."[6]

•

Throughout the 1970s, Dominique continued her impressive series of programs at the Art Institute at Rice. On December 7, 1974, the Philip Glass Ensemble performed the composer's *Music in Twelve Parts*. Considered Glass's magnum opus, the piece was over three and a half hours long, in addition to multiple intermissions and a break for dinner. Dominique had been instrumental in the production of the piece. Earlier in the year, she had given a matching grant for the debut performance of *Music in Twelve Parts* at New York's Town Hall. "That was crucial," Glass remembered of her patronage. "There would be scarcely anybody who would have helped me in the music world. After those first years she didn't sponsor any more work; she didn't need to."[7]

Dominique's exhibitions at Rice continued with *Art Nouveau: Belgium/France* (March 26–June 27, 1976), a massive installation of 640 works of art and 80 architectural studios and photographs, co-organized with the Art Institute of Chicago, to which it would later travel. The Musée des Arts Décoratifs in Paris played a leading role getting the show done, encouraging over seventy major museums and private collectors to lend from their

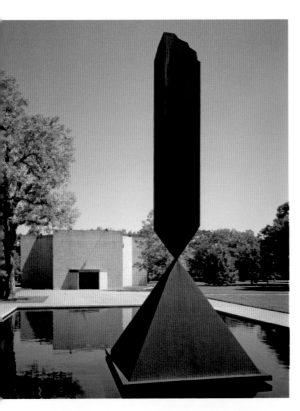

LEFT: Barnett Newman, *Broken Obelisk*, 1963–1967, Cor-Ten steel, 24' 7¼" x 10' 5½". The de Menils bought it in 1969 and dedicated it to Martin Luther King Jr.; they installed it in a reflecting pool in front of the Rothko Chapel in 1971.

BELOW: The interior of the Rothko Chapel with *Untitled* (northwest angle-wall painting), 1966, 177½" x 135"; *Untitled* (north apse triptych), 1965, 180" x 297"; and *Untitled* (northeast angle-wall painting), 1966, 177½" x 135", all of dry pigments, polymer, rabbit-skin glue, and egg/oil emulsion on canvas.

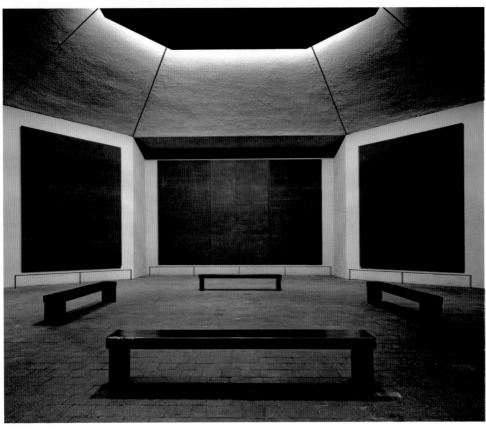

Pablo Picasso, *Seated Woman with a Hat*, 1938, oil and sand on wood, 21⅝" x 18⅛". One of John de Menil's favorite paintings, it was a portrait of Dora Maar acquired from Alexandre Iolas in Paris in 1969.

Jasper Johns, *Gray Alphabets*, 1956, beeswax and oil on newspaper and paper on canvas, 66⅛" x 48¾". This painting often hung in the entrance of the Houston house and was bought in 1968 from Ben Heller in New York.

Andy Warhol, *Lavender Disaster,* 1963, acrylic, silk-screen ink, and pencil on linen, 106" x 81⅞". Dominique bought this at Sotheby Parke Bernet in 1978, and one guest remembered seeing it in the dining room in Houston.

RIGHT: Robert Rauschenberg, *Glacier (Hoarfrost)*, 1974, solvent transfer on satin and chiffon with pillow, 120" x 74" x 5⅞". This large, lyrical painting by one of John de Menil's favorite artists was bought by Dominique from Leo Castelli in 1975 when she was planning her museum.

LEFT: Sir Joshua Reynolds, *A Young Black*, ca. 1770, oil on canvas, 31" x 25⅛"; In 1983 at the Hôtel Drouot in Paris, Dominique outbid the Louvre for this painting, convincing the then director it was more important for her museum.

RIGHT: Joseph Sacco, *Oeil de jeune femme*, 1844, tempera on ivory mounted on leather in glass and gilt frame placed in leather case with brass fillets and velvet lining, 4¾" x 3½" x ¾". This portrait of an eye of a secret lover was chosen by Dominique as the emblematic image for *La rime et la raison* at the Grand Palais in 1984.

THE FOUR OBJECTS CHOSEN BY DOMINIQUE AND WALTER HOPPS TO REPRESENT THE SCOPE OF THE COLLECTION WERE PLACED TOGETHER IN THE OPENING GALLERY OF *LA RIME ET LA RAISON:*

Reindeer, southwestern France, Paleolithic, 22,000–15,000 B.C., incised bone, 1½" x 4¼" x ¾". This was the most ancient object owned by the de Menils, which they bought from J. J. Klejman in 1966.

Reliquary, said to have come from Stobi (former Yugoslav republic of Macedonia), around 500, gold, 1¾" x 2⅝". This striking Byzantine object was also purchased at J. J. Klejman, in 1968.

LEFT: *Monolith,* possibly Bakor-speaking people, Nigeria, sixteenth to nineteenth century, stone, most likely basalt, 41" x 15" x 8". This anthropomorphic sculpture was bought by Dominique in 1977 at a Palais d'Orsay auction.

BELOW: Yves Klein, *La couronne,* ca. 1960, dry pigment in synthetic resin on sponge with metal rod mounts and base, $6^{11}/_{16}$" x $8\,^{3}/_{16}$" x $2^{5}/_{8}$". Klein's widow, Rotraut Klein-Moquay, gave Dominique this tiny sculpture as a gift in 1982.

Jasper Johns, *Star*, 1954, oil, beeswax, and house paint on newspaper, canvas, and wood with tinted glass, nails, and fabric tape, 22½" x 19½" x 1⅞". This earliest existing work by Johns was discovered by Walter Hopps and bought in 1985 by Dominique from the Middendorf Gallery in Washington, D.C.

LEFT: Robert Rauschenberg, *Crucifixion and Reflection,* ca. 1950, oil, enamel, water-based paint, and newspaper on paperboard attached to wooden support, 47¾" x 51⅛". Originally shown at the artist's first solo exhibition at the Betty Parsons Gallery in 1951, this Rauschenberg was bought in 1984 from the Middendorf Gallery.

BELOW: James Rosenquist, *Promenade of Merce Cunningham,* 1963, oil on canvas, 70" x 60". This painting was formerly owned by Christophe and acquired by Dominique in 1986.

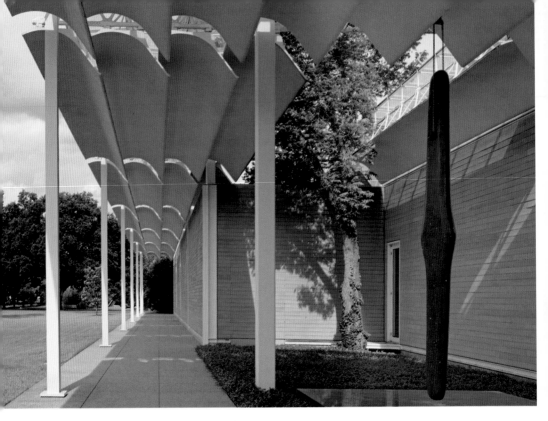

The Menil Collection, 1987, was Renzo Piano's first project in the United States and is still considered his masterwork; on right, Michael Heizer's *Charmstone*, 1991, modified concrete aggregate, 180" x 27" x 9".

The de Menils acquired the many 1930s and 1940s bungalows, all painted the same shade of gray with white trim that line the streets around the museum and the Rothko Chapel; note the view of the Menil across the street.

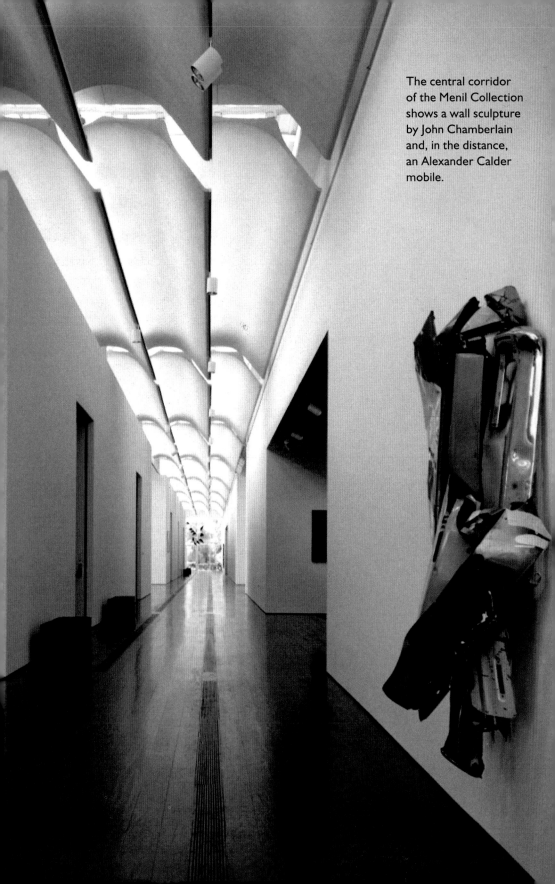

The central corridor
of the Menil Collection
shows a wall sculpture
by John Chamberlain
and, in the distance,
an Alexander Calder
mobile.

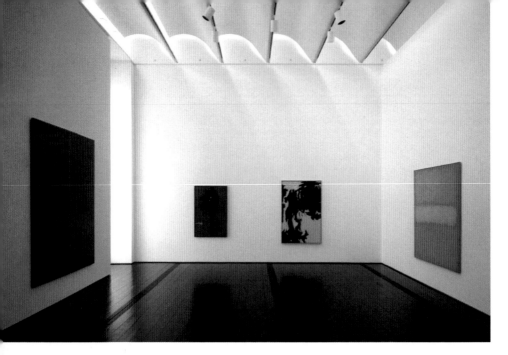

A view of the original installation of the Menil Collection's twentieth-century galleries with, left to right, Barnett Newman, *Be I,* 1949, oil on canvas, 94" x 76"; Clyfford Still, *Untitled,* 1946, oil on canvas, 51" x 32⅞"; Clyfford Still, *1947-H-No. 2,* 1947, 63⅛" x 40¾"; and Mark Rothko, *No. 10,* 1957, oil on canvas, 69¼" x 62".

This is the first installation of the surrealist galleries with, in the foreground, works by René Magritte and, behind, Max Ernst.

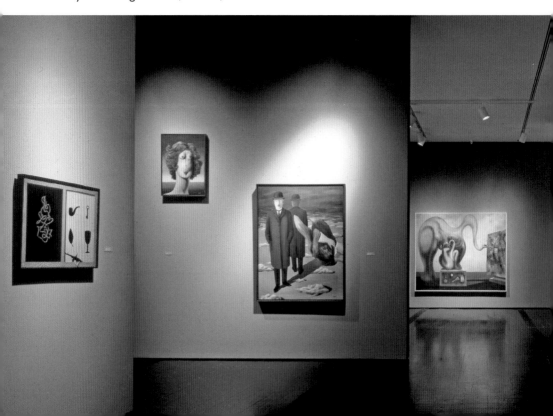

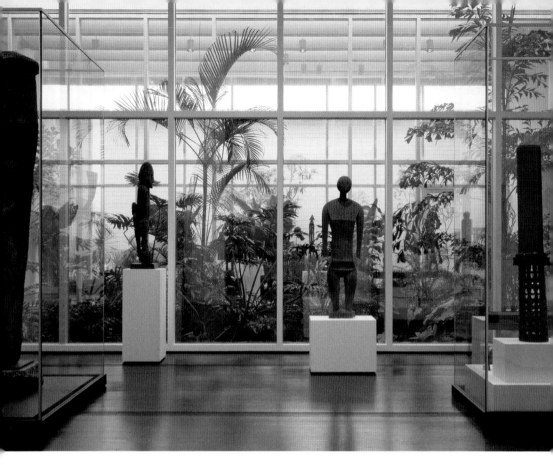

The Oceanic galleries including, on the far left, a towering fernwood sculpture from Melanesia, formerly New Hebrides, and, far right, a rare ceremonial drum from the Austral Islands in Polynesia.

A case custom built by Dominique and her team for the most ancient pieces in the museum: objects from the Paleolithic, Neolithic, and Bronze Age, as well as a selection of anthropomorphic Cycladic and Anatolian idols in marble, dating from 3200 to 2400 B.C.

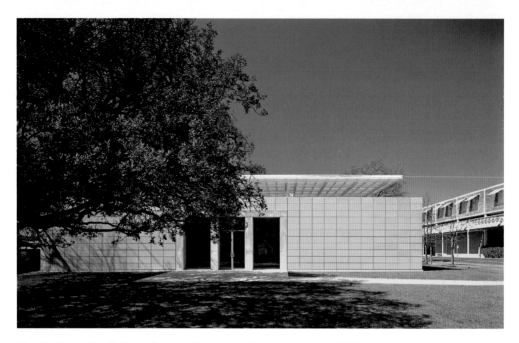

The Cy Twombly Gallery, designed by Renzo Piano, opened in 1995. It is across from the Menil, right.

In the Twombly Gallery, a view of Cy Twombly, *Untitled (Say Goodbye, Catullus, to the Shores of Asia Minor)*, 1994, oil, acrylic, oil stick, crayon, and graphite on three canvases, 157½" x 624", gift of the artist; in the adjacent gallery, a fragment of Cy Twombly, *Untitled (A Painting in Nine Parts)*, 1988, gift of the artist.

ABOVE: The Byzantine Fresco Chapel, which was designed by François de Menil, is a modernist steel, stone, and concrete chapel built originally to exhibit ancient sacred art.

RIGHT: The interior structure of black steel and glass, like a modernist reliquary, contained the restored thirteenth-century frescoes from a Byzantine chapel in Lysi, Cyprus, which were returned in 2012.

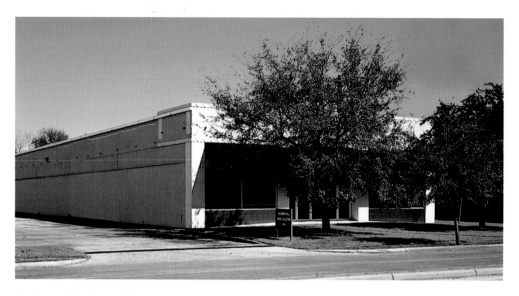

Richmond Hall is a 1930 supermarket converted into a permanent installation of works by Dan Flavin, including *untitled*, 1996, green fluorescent light and metal fixtures, a pair of light sculptures that runs 184 feet, the length of the exterior walls.

Dan Flavin, *untitled*, 1996, pink, yellow, green, blue, and ultraviolet fluorescent light and metal fixtures, 8½' x 49' x 124'. This was the central gallery of Dominique's final commission.

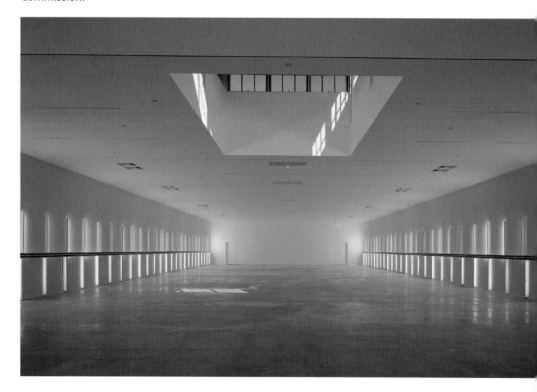

holdings. The main concentrations were painting and graphic arts, posters, sculpture, and decorative arts as well as architecture and architectural details. The catalog was over five hundred pages, with illustrations of important works and texts by some of the most respected curators in Europe and America.

Art critics were rapturous about the show. In *Time,* Robert Hughes looked at the exhibition in light of the recent resurgence of the movement. "The popularity of Art Nouveau, revived in the 60s, has provoked an enormous curiosity about the style," Hughes wrote. "What was the taste of 1900? Where did it originate? Was it, after all, as effete as we were told? No exhibition now, or in the near future, is likely to satisfy that curiosity better than *Art Nouveau: Belgium/France.*"[8]

The exhibition began with artists connected to the movement: the symbolists—particularly Gustave Moreau, the Nabis, including Paul Gauguin, Édouard Vuillard, and Pierre Bonnard, along with great art nouveau posters of Alphonse Mucha, Henri Thiriet, and Henri de Toulouse-Lautrec. Works ranged from a dramatic chalice by René Lalique, with opaline glass vase covered by elongated leaves of silver, to Hector Guimard's swirling lines of steel and glass created for the entrance canopies of Paris Metro stations.

Later that year, Dominique opened a smaller exhibition with one of her most theatrical installations. *Secret Affinities: Words and Images by René Magritte* (October 1, 1976–June 19, 1977) was a relatively modest exhibition, forty paintings and eight sculptures by Magritte. Affixed to walls were enigmatic quotations by the artist that had been painted on signs in the form of large, puffy clouds. "Mystery is not just one of the possibilities of the real," one announced. "It is absolutely necessary that the real be mysterious if there is to be any real at all."

The exhibition design was spectacular, an extension of Magritte's dreamlike imagery. Gallery ceilings were made low, often with light filtered by sheer white fabrics, while the walls were painted gray. A pair of French doors opened onto a small, low-ceilinged gallery containing only Magritte's massive bronze sculpture *David's Madame Récamier,* placed on an Oriental rug. The painting *The Invisible World,* of a large boulder inside a room that had been so captivating for Norman Mailer, now appeared even more dramatic in its own confining space, an eight-foot-tall ceiling crowding the canvas that was six and a half feet in height. *Delusions of Grandeur* (1967), a monumental bronze sculpture of stacked female torsos, was framed behind a doorway with red velvet curtains, much like those Charles James had designed for Dominique's dressing room. Mysterious Magritte paintings, in gilded frames, were hung alone on a gray wall but

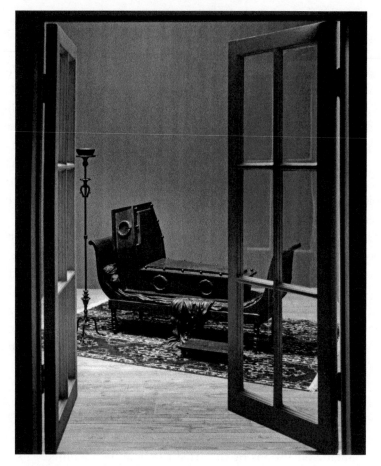

David's *Madame Récamier* in Dominique's theatrical Magritte exhibition,
Secret Affinities, at Rice University, 1976.

placed to draw the eye to another canvas in an adjacent gallery or down a
corridor that culminated with a massive sculpture. "One step beyond Sur-
realism," *The Houston Chronicle* wrote of the installation.[9] As *ARTnews*
reported, "De Menil herself designed the exhibition, intending it to be less
of a scholarly show than a Magritte 'environment,' or what she calls an
'incantation.' "[10]

Dominique also curated and installed *Joseph Cornell* (September
16–December 31, 1977), a poetic display of over sixty of Cornell's mixed
media shadow boxes, objects, and collages along with ephemera collected
by his friends. Held only five years after the artist's death, the exhibition
included works from Cornell's estate, overseen by the New York dealers
Richard Feigen and Leo Castelli. Because of their fragility, Dominique had
many of the Cornell boxes hand carried from New York by private jet.[11] She

created a simple installation with many of the boxes inset into the walls, to let the viewer peer through their glass fronts into ethereal and fantastic tiny universes.

Another of her shows involved a powerful installation for *arte povera* artist, *Michelangelo Pistoletto: Mirror Works* (February 16–April 15, 1979). The exhibition, Pistoletto's first in the United States, included sculptures and paintings using mirrors from the 1960s as well as site-specific pieces the artist created in the galleries at Rice. The opening-night invitation was printed on Mylar. "I believe Pistoletto is a more important artist than critics have thought and this project will introduce him more widely to the American public," Dominique wrote to the New York–based collector Nicola Bulgari, to request the loan of a mirror sculpture he owned.[12]

The installation, conceived by Dominique with Pistoletto, was a minimalist fantasy in all white, which the artist felt was as important as the works themselves. "It was one of the most beautiful exhibitions I have ever seen in my life," said Pompidou curator Jean-Yves Mock. "The walls were white. The floor was white. You went up, you came back down, and there was nothing; it was a voyage to the interior of the self. It was *sublissime!*"[13]

·

For the noted 1967 exhibition *Visionary Architects* at the University of St. Thomas, the de Menils brought Louis Kahn to Houston to deliver a lecture. Kahn's talk, titled "The Architecture of the Incredible," was given on November 2, 1967. They had been aware of his work for years, and it had been suggested, early in the design process that Kahn should design the Rothko Chapel.[14] In January 1967, the de Menils had gone out of their way to visit Kahn's Erdman Hall dormitories at Bryn Mawr College.[15] And they had entertained the architect at dinner at their town house in New York.[16]

Michelangelo Pistoletto in front of one of his mirror pieces from the 1979 Rice University exhibition.

By the time Domi-

nique and John had moved to Rice University, they had increased their contact with Kahn. In the spring of 1970, when Kahn was working on the Kimbell Art Museum in Fort Worth, they went to visit him at his office in Philadelphia.[17] In November 1972, when John was ill, they brought Kahn to Houston for several days to work on his design of a building for their collection.[18]

The idea the de Menils discussed with Kahn was a "storage building" for the collection. It was described in *The Art Museums of Louis I. Kahn* as "a gallery with open storage, a concept more reminiscent of the open stacks of a library than a traditional museum."[19] The architect developed site plans and architectural drawings. Inspired by Dominique and John's program, Kahn wrote that the Houston project had "stimulated the sense of the great variety of spaces."[20]

A site was chosen west and south of the Rothko Chapel. The intention was to create a center for a variety of artistic and educational programs: conferences, performances, lectures, and so on. The goal was to respect the small-scale nature of the neighborhood, with its one- and two-story bungalows, while also adding housing units, conference facilities, and even a hotel.[21] To house the collection, Kahn proposed a long, low building directly west of the Rothko Chapel, with an open lawn connecting them. In February 1973, at the time of the Max Ernst exhibition at Rice, Kahn returned to Houston for talks about the project with the de Menils.

As the design progressed, however, John died; in fact, Kahn was scheduled to arrive in Houston the day after John's death.[22] Dominique and the architect continued to work together, intending the finished building to be part of John's legacy. In February 1974, Kahn made another trip to Houston to work with Dominique on the project.[23] The following month, Kahn died unexpectedly of a heart attack at age seventy-three.

Dominique then turned to Howard Barnstone to design his version of an art storage facility. From 1974 until 1979, they collaborated on a variety of schemes.[24] "Howard was imaginative, optimistic, full of good ideas," Dominique later remembered. "Rather than a museum, it was more a place where paintings would be deposited and loaned to various institutions. There was the idea that you could open it up like a study collection—to collectors, art historians, critics—but not open to the public."[25]

Dominique was deluged with ideas about architects. She met many, studied their books, went to look at buildings. She made a systematic tour of Europe to study cultural centers that had opened in recent decades. "I went through Holland, Germany, Switzerland to visit all the new museums that had been built since the war," she recalled. "It was always the work of an architect for himself, a monument by the architect. It was never done

from the standpoint of people who work in the museum, which I had been doing myself, learning how difficult it is to operate, to make exhibitions."[26]

In 1976, Dominique organized a trip for her team around the United States to survey museum buildings that had been built in recent decades. She went with a group that included Philippa, Howard Barnstone, Harris Rosenstein, an art historian the de Menils had brought from New York to teach at the Institute for the Arts at Rice, and Mary Jane Victor, the former St. Thomas student who had been working with the de Menils for years, cataloging the collection. The group was flown around in François's plane, a Swearingen Aircraft Merlin IIIA twin-engine turboprop.

From New York's La Guardia, the first stop was Pittsburgh to see the Carnegie Institute of Art and the Sarah Mellon Scaife Gallery, which had been designed by Edward Larrabee Barnes and opened two years before. Dominique made sure to note the cost of the building, $12.5 million. Her observations on the design:

> Massive architecture—Mussolini style. Beautiful sloping court with cascade stairs, trees and sculpture. A nice feature: the restaurant is right at the entrance looking onto the street. Dark green carpet and round marble tables of two different sizes. Uniform galleries with creamy walls. Pictures lined up like postage stamps in an album. Terrible whitish floor in poured plastic, imitating terrazzo. The director admits it was a mistake. An innovative feature: galleries receive natural light from a clerestory. The upper part of the wall is concave and white. It reflects light in the room. Drop ceilings are said to be 18 ft. high, yet they seem to hang down low. The installation is sophisticated and theoretically should have worked. Yet, somehow, it was not pleasant. Proportions were not right, and the aggressive floor would have disrupted any otherwise well planned solution.[27]

At the Cleveland Museum of Art, Dominique made notes on the size of the staff, 250, and the cost of a 1971 north wing by Marcel Breuer, $10 million. "A modern fortress in striped granite," she recorded. "No windows. No skylights." She appreciated, however, a sculpture garden with trees that was used as an extension of the restaurant and closely observed the display of artworks. "Some of their most precious drawings are left in their antique frames," Dominique noted. "They hang on a rack in front of which a curtain is drawn."[28]

Dominique and the group continued on to the Toledo Museum of Art and then flew to Detroit. They began the next day at the Detroit Institute

of Arts, then flew to the Milwaukee Art Center and spent the night in Des Moines. The next day, they began at the Des Moines Art Center and I. M. Pei's 1968 addition, a modernist structure in glass and concrete. Dominique was struck by a large sculpture court. "It is a pleasant surprise to emerge into a generous space full of natural light," she noted. Next was Minneapolis, to see the Walker Art Center and its 1971 addition by Edward Larrabee Barnes. Dominique characterized it as "the most talked-about museum in the country."[29]

They moved on to the William Rockhill Nelson Gallery in Kansas City. The imposing 1933 beaux arts museum had two wings that were completed in 1971 and 1976. "It is neo-Greek revival, with black polished marble floors and columns," Dominique noted of the building. "There is very little light from the outside. *Oppressive.* The semi-darkness prevails throughout the museum, but it suits the great Asiatic collections, which are displayed beautifully."[30]

Dominique also kept track of many details she discovered at the museum, from the size of the monthly electricity bill, $3,700, to the dimensions of sandbags used by the conservator to secure works on his cart, two inches by twelve inches.[31] "The day we spent with you in your museum was the highlight of our trip," Dominique wrote to the director of the Nelson Gallery. "We still talk about it, my colleagues and I."[32]

At 6:00 the following morning, the phone rang in Dominique's room of the Alameda Plaza in Kansas City. Her son Georges was calling to say that during the night, her ninety-two-year-old mother had died in Paris. "*Jour de tristesse*," she wrote in her date book. Dominique immediately took François's plane back to New York, bringing the trip to a halt. She called her sister Sylvie in Paris, who told her that Madame Conrad had died of a pulmonary embolism at home on the rue Las Cases, attended by a nurse. Dominique and François then flew to Paris for her mother's service at the Val-Richer and burial in the nearby cemetery, next to her husband.[33]

The day after the funeral, Dominique, her sister Annette, and her sister Sylvie with her husband, Eric, were in Madame Conrad's apartment on the rue Las Cases. "We opened the desk of *maman*," Dominique noted. "All of the letters from *papa* are there, including from the first years of their marriage and those from World War I—devastating!"[34]

•

Back in Houston, Dominique continued to think about her next step. Fred Hofheinz, whose father had been mayor of Houston in the 1950s, had known the de Menils since the 1960s, when they supported his nascent

political career. Beginning in 1974, Fred Hofheinz served two terms as Houston mayor. Weeks after he finished, in January 1978, he received a phone call from Dominique asking him to lunch at the house. "She had been approached by unnamed institutions in Paris to display her and John's art back in France," Hofheinz recalled. "She was unsure. She preferred to do it in Houston, but she did not know how seriously Houston would want it."[35]

Many were worried that the de Menils' collection would not stay in Texas; Hofheinz understood the need to ensure that it did. "The first thing was to convince her there was adequate support in Houston," he recalled. "That is probably the only thing I did. I introduced her to people that were happy to do that. All of whom got really excited. But the first question was always, 'Tell us what it is that we are talking about. We have heard all these rumors about it, but we have never seen it.' "[36]

By that time, the de Menils' collection was approaching ten thousand pieces. Dominique always downplayed its importance. "With prints, it adds up quickly. I was fortunate to be there at a fantastic time when you could buy a print on Third Avenue in New York for nothing. For $20, you had something good; for $35, you could find a Goya. So I took advantage of that; at those prices, you buy a dozen prints as if they were nothing."[37] As the size of the holdings grew, all of the paintings, drawings, sculptures, objects, and prints could not be kept together. Dominique and John's collection was scattered around the world, in their houses in Houston, New York, and Paris or in storage spaces at Rice University and in Manhattan.

Only fragments had been seen publicly: the cubists in the spring of 1968, the teaching collection in the fall of 1968, Max Ernst in 1973, some of the Magrittes in 1976. The only people who really understood the magnitude of the holdings were the three women who had been working at the de Menil house, in the garage that had been converted into the Collection Room: curators Kathy Davidson and Mary Jane Victor and collections registrar Mary Kadish. And they were certainly not telling. The trio, along with others such as Helen Winkler and Elsian Cozens, were considered so dedicated to the de Menils and the sense of privacy they desired, so much a part of the inner sanctum, that they were known around town as the "Vestal Virgins."

Dominique, as the scale and importance of the collection became clear, wanted to assess the level of interest in Houston. "The de Menils did a lot with their own money, there's no doubt about that, but they also wanted others to be involved," remembered MFAH registrar Edward Mayo. "Dominique once said, 'If Houston wants this museum, they have to show it.' "[38] Fred Hofheinz certainly understood her position. "It was probably a carry-

over from John's practicality," he said. "If the museum is to do well over the years, you need support for it. My impression was that she was also driven to find that support in Houston because she already had it in France; she was trying to resist the Parisian temptation."[39]

Hofheinz set up meetings for Dominique with Alice and George Brown, with Caroline Wiess Law, and with Nina Cullinan; although she had known everyone for years, these meetings were different. "Dominique was very, very shy about asking people for money," Hofheinz explained. "I was not. So I made these introductions, all of whom expressed tremendous interest. I put her in front of people who could get it done; she took it from there."[40]

Dominique and John had long planned to build in the neighborhood of the Rothko Chapel, but Hofheinz, Alice Brown, and Nina Cullinan spent several afternoons driving around the city with Dominique to evaluate other sites. There was one near the Museum of Fine Arts, Houston, that all thought was perfect. Hofheinz felt the city of Houston would have participated in its purchase. Dominique declined, however, because she felt a commitment to the area around St. Thomas. "She also said that a museum ought to be in a living circumstance," Hofheinz recalled. "Putting it over in the Museum District, next to all those institutions, did not feel right. It needed to be where people are, where they go to sleep every night and wake up every morning."[41]

So, by the end of the 1970s, Dominique had settled on the general location of the museum she hoped to build and had been assured that a group of Houston patrons would help support her initiative. But, as John had long felt, she was fully convinced of the need to anchor their collection to Texas. "Why bring coals to Newcastle?" Dominique asked. "What do New York and Paris need with another museum?"[42]

OTHER VOICES, OTHER LANDS

My husband was always passionate about art; it was part
of his personality. He loved the good life: good wine, good
paintings, good music. He loved everything that was beautiful,
splendid. And he had a very generous spirit, whereas I needed
to be freed from some of my limitations, my sense of reserve.
—DOMINIQUE DE MENIL[1]

On June 1, 1971, Dominique and John had been together in Paris, where they were invited to dinner at the Palais de l'Élysée, the French presidential palace, by President and Mrs. Georges Pompidou.[2] The evening was held in one of the historic rooms in the private apartments and was the first time the couples had met. It was a dinner for four: Claude and Georges Pompidou, Dominique and John de Menil.[3]

The former prime minister under Charles de Gaulle, Pompidou had been elected president of France in 1969, following the general's resignation. In what would be only five years in power—Pompidou would die in office in April 1974—he was responsible for a host of initiatives to modernize French society including the TGV and the Arianespace program. Claude and Georges Pompidou also made the decision to hire contemporary designer Pierre Paulin to renovate some of the private spaces in the historic presidential residence. Paulin created startling designs for a dining room, smoking room, and library: low-slung, biomorphic-shaped seating in beige upholstery, round tables covered with smoky, reflective glass, and curved side chairs, in earth tones, made of molded plastic. "I want modernity to be introduced into the Élysée," Pompidou proclaimed with a flourish.[4]

The de Menils had been invited to dinner to discuss an area of interest dear to the French president. At the age of seventeen, and still living in the provinces, Georges Pompidou had purchased a book with 1920s illustrations by Max Ernst. A lifelong enthusiasm for art was sparked by his teenage acquisition. By the time he was in power, Pompidou knew of the de Menils' artistic engagement. He wanted to meet to discuss plans he had in mind for a new cultural center in Paris, the Centre Beaubourg, what would

later be known as the Centre Pompidou. "The project my husband put forth that evening was to open to all—access to art, in every artistic discipline, brought together in one institution," Claude Pompidou said about that dinner with the de Menils. "It was about access to all disciplines, that is to say music, painting, sculpture, cinema—every kind of contemporary art."[5]

The idea the French leader had envisioned was far from universally embraced. Particularly in France—where art museums were historical repositories that seemed designed to impress and to be remote—such a populist project was bound to raise eyebrows. "When we saw people, my husband rarely spoke about it," said Madame Pompidou. "There were people who didn't understand it at all. There are some who still drag their feet today, so you can imagine what it was like then." The democratic spirit of the initiative, however, appealed immediately to the de Menils. As did the multidisciplinary approach; it was just how they conceived the role of art in the modern world. "John de Menil was very, very enthusiastic about the project and completely committed," remembered Madame Pompidou. "They promised to help, which they did, by the way."[6]

By the time of the dinner, Dominique had been working full-time in the art world for seven years. She had actually heard about the plans for the center two months before, when she had a Sunday afternoon meeting at the rue Las Cases with Sébastien Loste, a Gaullist politician who had long been involved with cultural affairs and who would oversee the creation of the Pompidou Center.[7] During the evening at the Élysée, however, it was John who took the lead. "We got along very, very well but especially my husband and John de Menil, who, at that time, mattered more than she did," Madame Pompidou said matter-of-factly. "Dominique was very reserved—charming, absolutely, but very reserved. John was the one who was running things; he was out in front; he was the one who decided. Later, of course, she was terrific, as a wife can be after her husband, *non?*"[8]

•

Shortly after John died, Dominique began planning a remarkable gift in his honor to the institution they discussed that night, the Musée National d'Art Moderne at the Centre Pompidou. She decided to give a selection of important American art to the French institution in honor of her husband. The de Menil gift, begun in 1976, the year before the museum opened, consisted of five significant works of art. The paintings and sculptures were some of the first important examples of postwar American art to enter French museums. They were also selected to be meaningful for the memory of her husband.

The grouping was led by *The Deep* (1953), one of Jackson Pollock's final monumental works, a tremendous black-and-white cloud of paint with flashes of red. Purchased from New York collector Sam Wagstaff and offered by Dominique and the de Menil children, it was the first Pollock to enter a French museum. Also given was Claes Oldenburg's *Soft Drums* (1972), one of the artist's oversize, monochromatic mixed-media sculptures that had been favorites of John de Menil's since the early 1960s.

Larry Rivers's *I Like Olympia in Black Face* (1970), a painted sculpture that turned Manet's *Olympia* into a forceful civil rights statement, and Andy Warhol's *Big Electric Chair (Red and Dark Blue Version)* (1967) also went to the Pompidou. The final work in the gift was Miró's *Bleu II* (1961), the center painting of the Spanish painter's monumental triptych in a vivid blue (which had been shown by James Johnson Sweeney at the MFAH in his 1962 exhibition *Three Spaniards*). The huge canvases, each over two and a half meters high by three and a half meters wide, were considered by Miró to be the greatest accomplishment of his career.[9] After the de Menil gift, Sylvie and Eric Boissonnas were the lead donors in a group that enabled the Centre Pompidou to assemble all three, acquiring *Bleu III* in 1988 and *Bleu I* in 1993.

Taken together, the five pieces given by Dominique made a strong statement. The gift was undeniably generous, but some in the family had questions about the gesture. "I have to say my heart is broken that they gave *The Deep*, Pollock's absolutely greatest, greatest painting, to France," said Christophe de Menil. "We should have it. Americans need to know their own masters. In France, it's just a curiosity; it doesn't have the same impact. *The Deep* is the greatest painting that Pollock ever did; it is not as famous as *Blue Poles,* but it is more important, greater, more glorious."[10] The selection of works meant that Dominique, as well as her children, became founding members of the Pompidou Center. It was a small group that also included the artist Victor Vasarely and the widows of Ernst, Duchamp, and Kandinsky, as well as São and Pierre Schlumberger, Dominique's cousin.[11]

In addition to the grouping of works, Dominique approached Madame Pompidou with another proposal. "It was her idea, but I was completely in agreement," remembered Claude Pompidou, "to start a foundation that was called the Georges Pompidou Art and Culture Foundation. It was to build support in the United States, and around the world, for the museum."[12]

From the beginning, Dominique was very involved with the Pompidou Center. When her good friend Pontus Hultén was named director in 1974 to help with the creation of the museum, the decision to give that position to a foreigner was heavily criticized in the French press. Dominique wrote to French minister of culture Sébastien Loste,

It is only arriving in Paris a few days ago that I learned of the nomination of Pontus Hultén to be the new director. I leave soon for Houston but cannot go without letting you know how pleased I am and congratulating you. I sense your hand in the choice and your way of thinking.

Pontus is the man who can bring the Centre Beaubourg to life. I have no doubt that it will be recognized eventually by the press, so stupidly xenophobic. Paris cannot be the artistic center of Europe without inviting the best, regardless of where they might have been born. Pontus will be as impressive in Paris as he is in Stockholm, Berlin, London, or New York.[13]

•

In September 1979, Dominique brought to Houston for the first time His Holiness the Dalai Lama. She organized two days of meetings at the Rothko Chapel with the Tibetan leader and a variety of scientists and religious figures. Participants included the poet Octavio Paz, Dom Hélder Câmara, the Brazilian archbishop who was an advocate of liberation theology, Rabbi Arthur Hertzberg from Columbia University, and Father André Scrima, the Eastern Orthodox priest from Beirut who had become a confidant of Dominique de Menil's. Also participating was Columbia University professor Robert Thurman.

Nabila Drooby, director of the Rothko Chapel, worked with Dominique to plan the event. "I told her that she would have to go meet him at the airport and drive with him," Drooby recalled. "She turned around and said, 'And what do I talk about, forty-five minutes with the Dalai Lama?' I knew that she could talk with anyone . . . and they did."[14] She had first met him, of course, when she and John went to India. But earlier that summer, Dominique had flown from Paris to Geneva to have another visit.[15] When the Tibetan leader stepped off the plane at Houston's Intercontinental Airport, Dominique was there to greet him. They proceeded to a VIP lounge where the Dalai Lama placed a white scarf around her neck, a customary gesture of friendship, and they exchanged bows. There were television crews and representatives of the mayor's office with an official proclamation.

"Uninterrupted torrential rain," Dominique noted in her date book. "East Meets Wet" was the headline of the story about the visit in *Texas Monthly*. "In the midst of storms and flooding, the Dalai Lama arrived in Houston. His Holiness took one look at the place . . . and giggled."[16]

On his morning visit to the Phat Quang Vietnamese Buddhist Pagoda

Dominique presenting a khata to the Dalai
Lama at the Houston airport, 1979.

in south suburban Houston,
His Holiness did indeed let out
a laugh of pleasure. Later, there
was a news conference at the
Rothko Chapel followed by, in
the evening, a public address by
the Dalai Lama and then ques-
tions from the audience. All
the participants, including the
Tibetan leader, then met at the de
Menil house. It was a very pleas-
ant evening, with dinner served
around a low table in the living
room. On the menu: oysters,
couscous, cheese, and grapes.[17]

The following morning, at
the panel discussion, the diverse
group seemed to have diffi-
culty finding common ground. After a buffet lunch at the University of St.
Thomas, a more intimate discussion was held in one of the small bungalows
across from the chapel.[18] The informality of the setting seemed to encour-
age a better exchange.

The conclusion was described by Michael Ennis in *Texas Monthly,*

> Father Scrima asked His Holiness to recite a closing mantra as the
> rain crashed down still harder and a chill gripped the room. "When
> we depart here, each individual must remember what he can con-
> tribute to the happiness of mankind," prefaced His Holiness. "I am
> still just a simple Buddhist monk. You cannot gain your purpose
> from me. So my prayer is really just an empty prayer." Then he
> began a dulcet recitation, a rapid trilling that sounded like no other
> human sound. Mrs. de Menil cupped her hands in the Buddhist
> attitude of prayer and everyone bowed their heads.[19]

•

An equally exotic and spiritual event occurred when Dominique man-
aged to bring the whirling dervishes to the Rothko Chapel. The Mevlevi
dervishes were a Sufi order from Konya, Turkey, that was founded in the
thirteenth century by followers of the poet Rumi. The Mevlevi had long
performed a Sema ceremony involving the spinning form of meditation that

The whirling dervishes in front of the Rothko Chapel, October 1978.

earned them their name. The ritual symbolized a spiritual journey, moving away from ego, turning toward truth, achieving enlightenment and openness to others. Dominique and John had seen the dervishes together in New York, just months before he died. He had hoped to bring them to Texas, so Dominique continued that effort. Turkey, however, was reluctant in those years to promote the dervishes, whose performance was considered a religious ceremony. So Dominique and Nabila Drooby went to Istanbul and Konya to persuade the Sufi and the Turkish authorities to allow the Mevlevi to come to Texas. "This man who was their leader had connections with the Ministry of Tourism," Drooby remembered. "So we did not mention that we wanted them for a spiritual event. We said only that we wanted

them to promote friendship between America and Turkey, which was also true. But she really did it as a memorial to John."[20]

While they were in Istanbul, Nabila Drooby had a revealing outing with Dominique. She asked her to come along on a trip to the market, explaining that it was essential for understanding the everyday life of Turkey. "She said that she went at first only to be nice to me," Drooby recalled. "Then, this man there had a box filled with antique objects. She started looking, with her look, and she asked me to have him show her this and that. He showed her and then she bought them. He looked at me and said, 'Who is this woman? She knows things that others don't.'"[21]

Thanks to their shared efforts in Turkey, Dominique was able to bring twenty of the Mevlevi dervishes to Houston in October 1978 to enact six of their remarkable Sema celebrations over eight days in and around the Rothko Chapel. They performed on a specially built stage on the plaza near the front entrance, between the chapel and *Broken Obelisk*. An audience of hundreds surrounded the celebrants on all four sides. Members of the order wore short white waistcoats, wide black sashes, and long white overcoats that filled with air and rose and fell as they spun. Each member's head was crowned by a tall brown hat, or *sikke,* in the shape of a tombstone to symbolize the burial of ego. Their arms were raised as they circled around in their hypnotic way.

Dominique had the Mevlevi stay in the bungalows around the chapel, in order for them to feel comfortable in the neighborhood. Their refrigerators were filled every day with juice and cookies and cheeses, what she had learned they would like. "It was a marvelous experience," Nabila Drooby recalled. "When they walked in and saw the chapel, they said, 'Oh, this is *tekke*!' In Konya, their meeting space, or whirling space, is also an octagon."[22]

Dominique and Nabila arranged the interior of the Rothko Chapel in order to accommodate a performance for around 150 guests. "They needed the space in the middle to work, so on one side they had the orchestra and on the other side they had the sheikh, the person who would be leading the event," Nabila Drooby remembered. "It was superb. That evening, I felt there was grace in the chapel; you felt it was different."[23]

Surrounded on all sides by Mark Rothko's massive dark panels, the dervishes enacted their entrancing spiritual ceremony, spinning around with their arms in the air accompanied by the Mevlevi musicians. "Timeless," Dominique wrote in her date books of the performance. "Tears and joy. Tears. Joy."[24]

After the final Sema ceremony in the chapel, Dominique thanked everyone involved, those who had made the trip possible and those who had

participated in the ceremonies. "I want to thank the musicians, but I will not pronounce their names for fear of scratching their ultra-sensitive ears," Dominique said. "Yet I would like them to know that we have enjoyed each one of them immensely. Each one has contributed something very special. Singers and instrument players have warmed our hearts and lifted our souls so much that our walk will be lighter from now on."

Dominique concluded her remarks by putting the mystical Sufi ceremony in a larger context:

> You have brought to us in a most beautiful way the message of Mevlana: a message of love and joy, a message of universal brotherhood. The world is sick for lack of brotherhood and you have shown us that it can flourish. Many people have received this message through you. They were so moved that they could not express it: *it is beyond words,* I often heard. The little seed you have sown here will grow with Allah's rain.[25]

TOWARD A NEW MUSEUM

I am writing to extend an invitation to you to join in a
competition among selected architects for the design of a new
museum at Houston, Texas, to house and exhibit the Menil
Collection. The collection has been gathered over a long period
of time by myself and my late husband as a source of material
for the interpretation of cultures and the history of civilization,
as well as for the pure enjoyment of art. The diverse material
ranges from Paleolithic to contemporary art and continues to
grow annually.
—DOMINIQUE DE MENIL[1]

Dominique had been given a clear indication that there was
a group of individuals and foundations in Houston pre-
pared to help her build a museum. She continued to try to assess enthusiasm
for the new endeavor. In the spring of 1979, she invited the collector Caroline
Wiess Law over to the house. In John's office, Dominique showed her the
collection of small objects and antiquities that lined the shelves on the north
wall. The grouping, shown to only a select few, ranged from small African
masks of ivory to Greek horse figurines in bronze to marble Cycladic idols
that could be held in the palm of a hand. "She was enchanted," Dominique
noted of the viewing.[2]

That summer, the sculptor Jim Love wrote a charming letter to Domi-
nique, arguing for a museum. He described his interest in the New York
lawyer John Quinn (1870–1924), who had been one of the first American
collectors of modernist art and was instrumental in bringing about the 1913
Armory Show. As Love learned more about Quinn, he saw a connection
with the de Menils. "I began to realize that in certain isolated and rare
cases, people whose lives and intellectual curiosities are of sufficient sub-
stance as to be worth legitimate inquiry and provoke the intellectual curios-
ity of others, have somehow added some remote and haunting something
to the art that they have acquired," Love wrote. Knowing that there was
still some hesitation on Dominique's part, he made a small sculpture titled

The Reluctant Matriarch and encouraged her to push forward, assuring her that no one else would be able to do it in the way it needed to be done. As Love continued, "I am sure there is a good bit of John's 'let's get on with it' floating around the house which he would be happy to loan out for a cause such as this."[3]

Dominique began to build a team and within a matter of months had the two major figures in place. Paul Winkler, Helen's younger brother, had been a student at the University of St. Thomas and then at Rice. After school, he moved to Santa Fe, where he worked with the noted collector Alexander Girard on what is now called the Girard Wing of the Museum of International Folk Art, a grouping of over 100,000 folk objects including toys, miniatures, and textiles. In the mid-1970s, Dominique asked Winkler to look at some plans for an early iteration of the museum that had been drawn up by Howard Barnstone. He felt the scheme was uninspired and that Dominique was not entirely sure what she wanted the building to be. As she moved closer toward constructing a new museum, Dominique hired Paul Winkler to help.[4] "I moved back because I could tell a serious effort was being made to get this done," Winkler recalled. "So my role was to be liaison with the architect, if we ever found an architect."[5]

In the late 1970s, Dominique proposed to Pontus Hultén, director of the Pompidou Center, doing a major retrospective of Yves Klein, the French artist she felt was important and overlooked.[6] The two decided to organize a Klein retrospective that would begin in Houston and finish in Paris. Dominique's children, particularly Christophe and François, were friendly with Walter Hopps, the legendary curator and museum director, and suggested she collaborate with him. So, although Dominique remained the official curator of the Yves Klein show, she asked Hopps to work on it with her. "Dominique was very secretive," Paul Winkler suggested. "Everyone knew a little bit of everything, but no one knew everything about anything. That was her way of operating; I don't even know if she was conscious of it. For example, she never told anyone that she had hired Walter. He was helping her with the Yves Klein show, and then one day she said, 'Oh, by the way, I've appointed Walter as director of the museum.'"[7]

For more than two decades, Walter Hopps had been one of the most exciting figures on the American art scene. After being inspired by Jerry MacAgy's exhibitions at the California Palace of the Legion of Honor in San Francisco, Hopps began his career in 1955 in Los Angeles, organizing a series of innovative shows and then, in 1957, launching, with artist Edward Kienholz, the groundbreaking Ferus Gallery. In 1962, he became director

of the Pasadena Art Museum, now the Norton Simon Museum, making him, at thirty, then the youngest museum director in the country. There he curated the first important survey of pop art, a major exhibition of Joseph Cornell, and a legendary retrospective of Marcel Duchamp, which included a game of chess between the artist and the writer Eve Babitz, who chose to play nude. Within five years, Hopps was fired. "I was eventually put out of Pasadena because of heroin," Hopps explained. "I just collapsed with that."[8] He moved to Washington, D.C., first as director of the Corcoran Gallery of Art, then as curator of twentieth-century American art at what is now the Smithsonian American Art Museum.

In June 1978, Hopps was in Paris, with the curator David Whitney, to dismantle and pack the Jasper Johns exhibition at the Pompidou Center. Dominique had a dinner with Hopps, inviting him to join her on the board of the Pompidou Foundation. By early November, back in Washington, he received a phone call from Dominique asking him to visit Houston. During that trip, in the fall of 1978, he was interviewed by Dominique and Miles Glaser, business manager of the foundation. "She explained she wanted to do a new museum, was keeping that very quiet, and she wanted me to be the founding director," Hopps recalled.[9]

He was immediately struck by Dominique, the collection, and her plans for the museum. Hopps's passion for art had begun with the high school visits he made to the house of Los Angeles collectors Louise and Walter Arensberg, so he understood collectors with a strong point of view. And he appreciated the French-American dialogue that the de Menils represented, not to mention the breadth of the collection. "We talked about the interest in antiquities they had brought to Houston, about their interest in tribal arts—I was impressed that she used tribal right off the bat—and she said that she had some medieval art, which I hadn't seen, but its great strength was surrealism and other twentieth-century art," Hopps explained. "She made it really clear that she didn't want it to be like just another museum."[10]

Hopps, who was forty-eight years old, started commuting from D.C. to Texas, on an irregular schedule, and stayed with Dominique at the house as he began to study the collection. He started by focusing on the Collection Room, the former garage. "Three young women came to work there every day, the first registrars and organizers of the collection," Hopps recalled. "They had created master files with data about every work and little black-and-white photographs." Instead of trying to see all of the paintings, sculptures, and objects in person, Hopps pored over the card file to familiarize himself with the holdings.[11]

Caroline Huber, who also worked for an arts organization in Washington, D.C., began dating Walter Hopps in the 1970s and married him in February 1983. Everyone knew that Hopps was notoriously late. It was partly caused by his eccentric schedule: he would work all night and sleep during the day, which he was, for the most part, able to get away with because he was so talented. The phrase "Walter will be here in 20 minutes" was printed on buttons by his various co-workers. "Apparently, there was a rumor that when he was involved with the Smithsonian, the director would say, 'Do you know where Walter is because if you do I want to fire him,'" remembered Caroline Huber. "But when he started going to Houston and became involved with the Menil Foundation, that changed completely. When he was with her, there was nothing to rebel against anymore. There was no structure to push against anymore. She didn't care about that stuff."[12]

•

Working out of one of the bedrooms in the house, with her trusted assistant Elsian Cozens beside her, Dominique had successfully assembled a team: the innovative founding director, a young museum professional with building experience, the collections' curators and registrars, and several art history professors working at Rice University. But the question of who could design this museum was still up in the air.

Christophe had advocated for the great Mexican architect Luis Barragán, bringing Dominique copies of his books.[13] Contacts were made and plans drawn up, but Dominique demurred. With François, Dominique had a conversation about Peter Eisenman, "the theorist of contemporary architecture," as she noted. Alexandre Iolas made a case for I. M. Pei, suggesting that he could do much better than the East Wing of the National Gallery of Art in Washington, D.C., which she felt was too strong an architectural statement. "His sensitivity is his great advantage but, up to now, no one has been able to take advantage of it," Iolas said of Pei.[14] The next month, Dominique met with Pei. Nothing came of it.

Paul Winkler recalled that the de Menil children would write discreet letters to architects, asking for information, without divulging the project.[15] Walter Hopps said that Dominique had accumulated so many books on architecture on the third floor of the town house in New York that some were afraid the floor was going to cave in.[16]

•

The week of November 17, 1980, was not particularly unusual. Dominique had been in Paris for ten days, attending a meeting at her sister Annette's house for her foundation, having dinner with Father André Scrima, working on the Yves Klein exhibition. On Monday, two visitors arrived from Houston: Paul Winkler and Glenn Heim, the former student who had designed the chapel at St. Thomas and who had been hired by Dominique to assist with the museum project. The following morning, Dominique drove out to the western suburb of St.-Cloud to the house of French artist Jean-Pierre Raynaud. There she purchased a modernist work of black and white stained glass. Following was a working lunch with Paul Winkler and Glenn Heim, a visit with Christophe and granddaughter Taya, and another conversation with Father Scrima. At 5:30 p.m., she had her first meeting with Renzo Piano.

It was an encounter that almost did not take place. Dominique had been reluctant to meet with Piano because of how she felt about the architecture of the Pompidou Center, finished three years before, which he had co-designed with Richard Rogers. Pontus Hultén, who had worked with Piano on the building of the Pompidou Center, had suggested him before. Seeing that she had not been able to find someone else, Hultén finally insisted. "Why don't you talk to him," he said to Dominique about Piano. "He's a great humanist, he's willing to listen, and I know that you have very specific ideas about what this is to be."[17] The endorsement from Hultén was finally key for Dominique.

She left a phone message at Piano's Paris office. And then silence. "We got the call from this lady, and nobody understood that it was Dominique de Menil," Piano explained. "I called back maybe a few weeks later—I felt so stupid—it was very impolite. I called because I finally understood that this was Dominique de Menil, the lady in Houston, Texas."[18]

So Piano went over to the rue Las Cases to meet with Dominique, Paul Winkler, and Glenn Heim. He climbed the two flights of the grand stairway, with its polished banisters and red carpet. He walked into the apartment that Dominique and John had designed with Pierre Barbe almost five decades before, across the modernist entrance corridor in light gray, and into the living room with its mix of historical furniture, 1930s designs by Barbe, and eclectic, astonishing collection of art. "I sat," Piano recalled. "And she watched me."[19]

Her opening line to the architect was certainly not encouraging. "Before we begin," Dominique said, "I have to tell you, Monsieur Piano, that I don't like the Pompidou Center at all."[20]

Piano remained silent. Dominique continued by making it clear that

the earlier design was far from what she had in mind for her museum. She did say, however, that she respected the fact that an attempt had been made, that something new had been created. "It was almost like saying, 'It was a dirty job but somebody had to do it,'" the architect said. "Not quite that, she was extremely articulate. So I said, 'Fine. Fair enough. I am used to people saying that they don't like this or they don't like that.'"[21]

Then they began the conversation in earnest, speaking about art, his experience with artists, and her ideas for a museum. One of the ideas she suggested that afternoon became a mantra for design. "I want a building that is small on the outside but big on the inside," Dominique said to Piano. "She articulated it quickly, and it sounded a bit funny at the time," he recalled. "But she explained, 'I want a building that is not monumental outside, not big, not aggressive, not pretentious. But at the same time, I want a building that when you are inside, you feel the sense of space, and you feel the light.' So, that was a constant from that first conversation: natural light."[22]

The meeting lasted only forty-five minutes. Later that evening, Dominique went to dinner at her sister Sylvie's house. That night, in her date book, she recorded her personal thoughts on the meeting with Piano: "Work session. Everything will be done based on real criteria studied in the most minute detail. *C'est lui*—he's the one!"[23]

·

Dominique had been trying to find the right architect for years. And then suddenly, in one forty-five-minute meeting, with someone whose biggest project to date she disliked, she made her choice. How could that have happened? "I am trying to find a reason because I am not that charming," Piano said with a laugh. "And I was not very well dressed, I am sure. We were not drunk."[24] Pressed about what would have made Dominique so certain about her decision, Piano responded,

> I think it was because I didn't talk about anything too intelligent. I didn't address grand theories about architecture. I only talked about construction—about the scale of the building—about how to have a structure that is not too heavy, how it can be like lace. Our conversation was not about the destiny or the philosophy of art. It was about me being a filter—a *bâtisseur*. In French, *bâtisseur* is more than only a builder, it is someone who sits down and puts things together; it is about the craft of building.

She was not looking for an artist; she already had the artists. She

was looking for somebody to build. And she saw me as a *bâtisseur*, someone who understood the craft of building.[25]

Jean-Yves Mock, who was working closely with Dominique at the time she met Piano, had the feeling that he would be the perfect choice for her. "She had not been able to find an architect who was sufficiently forceful and modest to do what she had imagined," Mock explained. "Renzo Piano is the most civilized of all contemporary architects; there is no one at the same level when it comes to listening and interpreting."[26]

From their first contact, Dominique understood that Piano was an architect she could work with. And she intended to be very involved in the process. "One thing I loved about Dominique that I don't think people understand is that she really loved to get involved in everything," Paul Winkler recalled. "She had a gardener, but she loved doing the gardening herself, getting her hands into the ground, smelling everything. She loved cooking. She loved mixing her own colors; she had a very beautiful color sense, a very European sense of color. You'd bring her three or four pints of paint, and she would end up mixing everything herself."[27]

By the end of the week, Dominique delivered a one-page, handwritten note to Piano. "I am writing to confirm what we said in our recent discussions concerning your engagement as architect for the proposed museum to house the Menil collection in Houston, Texas," she wrote. "I am delighted that you are willing to join the project. It is an endeavor which demands great creative thought and hard work."[28]

The following Tuesday, Dominique, Piano, and Glenn Heim flew from Paris to Tel Aviv. There, they met with Ayala Zacks-Abramov, a leading Franco-Canadian-Israeli collector and patron. Following another suggestion of Pontus Hultén's, Ayala drove Dominique, Piano, and Heim north from Tel Aviv, toward the Sea of Galilee, to the Museum of Art, Ein Harod. Located on a kibbutz, Ein Harod was the first art museum in Israel. It included a modernist building, designed by architect Samuel Bickels in 1948, with skylights that diffused the strong Mediterranean light—considered the first modern museum to rely on natural light. Back in the capital, they met with longtime mayor Teddy Kollek and visited the Tel Aviv Museum of Art. On stationery from the King David Hotel, Piano sketched the basic idea of a light-filtering system of louvers positioned above a glass ceiling. On the flight back to France, he drew an even more detailed perspective in Dominique's notebook; within days, the architect had come up with the essential idea of the new building.

From Israel, they flew to Nice to visit the Musée Marc Chagall and, meaningfully for Dominique, the Matisse Chapel in nearby Vence, the art-

ist's great collaboration with Father Couturier. But for the architect, the most revealing aspect of the trip was spending time with Dominique and learning what was important to her. "It was to build up a passion about this idea of the light," Piano said of the trip. "Natural light."[29]

Back in Houston, Paul Winkler sent Piano a massive package with guides on Houston architecture and more than two dozen of Dominique's exhibition catalogs from the University of St. Thomas and Rice. And a trip was planned to Texas for the following month, January 1981. Piano brought into the project two people from the firm of Ove Arup in London: Peter Rice, a brilliant structural engineer who played a key role in the execution of the design, and Tom Barker, a mechanical engineer. Both engineers were responsible for translating Piano's vision into something concrete; they had all worked together before, and all were fascinated by design innovation. "This was a very highly sophisticated group of people as far as building goes," Winkler recalled. "It turned out that we all had a great relationship and the whole engineering side of it fascinated Dominique because of her scientific background."[30]

As Piano said, "She was a very stubborn lady, that is for sure. But at the same time, she had this capacity to be light; she knew what she wanted, but at the same time she listened. That's quite unique."[31]

Piano was very interested in Dominique's dichotomies. When asked what made Dominique a good client, Piano elaborated on her contradictions:

> A funny combination of practicality and spirituality. Architecture can be very pragmatic. It is about putting things together. Architecture is about fighting against the force of gravity. You have to do very practical things: you have to decide where to place columns, where to put beams. She was very keen about that; she wanted to make a building that would last forever. But at the same time, she was very keen about the spirituality of the building. Architecture is about need, but it is also about desire, or about dreams. She was able to, in a one-hour meeting, use half an hour to talk about needs—lifts, stairs, freight elevator, and all that.
>
> But for the other half hour she was able to dream. And to talk about beauty. A beauty that can save the world. Beauty is an intense emotion. Some people don't understand that; they believe that beauty is a romantic idea. Beauty is not; it is a very strong emotion. Beauty is one of the strongest emotions in human life. Beauty in Art. Beauty in Nature. Beauty in Love. Beauty! It is probably one of the driving forces of the universe, our little universe. Sometimes

even stronger than war or fighting, or power, or money, or even hunger. Sometimes even stronger.

She was able to talk about beauty, sometimes just by looking at a big rock of Magritte flying in the air—just observing this. So she was a good client because she had those two qualities: to be very practical and at the same time so spiritual.[32]

GLOBAL VISIONS

The delicious presence of a work of art—its resonances,
its epiphanies—is felt only by those who are open to it. Art
requires action; passivity is fatal.
—*DOMINIQUE DE MENIL*[1]

In the spring of 1984, a mysterious hazel eye began popping up on hundreds of posters all across the city of Paris. It was heavy-lidded with just a trace of eyebrow and slight reflection of what might be a window. It was framed behind a gilded oval and floating in a square of dark crimson velvet. The only message: *La rime et la raison,* National Gallery at the Grand Palais, April 17–July 30, 1984. It turned out to be a cryptic announcement of an exhibit of art that would fascinate Paris: *La rime et la raison,* or *Rhyme and Reason, Les Collections Ménil (Houston–New York).* Spilling over three floors of the Grand Palais, the belle epoque fantasy just off the Champs Élysées, it was an enormous show of more than six hundred paintings, sculptures, and objects.

Rhyme and Reason gave the world its first large-scale look at the art assembled by Dominique and John de Menil and their five children. The title, chosen by Dominique, was a declaration that both poetry and logic were necessary for art.[2] "Rhyme and reason, song and speech, instinct and intellectual speculation," she wrote in the exhibition catalog. "All come together in grasping a work of art."[3]

The eye on the poster, also selected by Dominique, was a nineteenth-century artifact called simply *Œil de jeune femme* (1844) by a little-known artist, Joseph Sacco. The surreal object, made a century before the surrealists, was painted on ivory and enclosed in a rough leather box, lined with velvet. It had been used as a portrait for a lover who could not—or preferred not to—reveal too much. "Those objects were made for gentlemen in the old days, to be with the eye of their beloved," said Walter Hopps, who curated *Rhyme and Reason* for Dominique. "They would travel with them and carry them. It was a private thing . . . without a stranger being able to stare at the whole face. It was a secret portrait."[4] Dominique chose the

enigmatic eye to symbolize the act of perception, on the part of the artist, the collector, and the audience.

Dominique commissioned French artist Jean-Pierre Raynaud to turn the entry itself into an installation. The floor and walls of the space, called Espace Zéro, were entirely covered in shiny white ceramic tiles. At eye level, four glass cases held wildly different objects that made it clear this was a collection which careened through art history: a small, carved Paleolithic bone fragment; a miniature sixth-century solid gold Byzantine reliquary; an imposing seventeenth-century stone ancestral figure from Nigeria; and *La couronne* (1960), an Yves Klein sculpture of a crown, fashioned from a sponge, in his famous International Klein Blue.

Held almost three years after Socialist president François Mitterrand swept into office, *Rhyme and Reason* was one of the first important art shows organized under the Socialists. It was inaugurated by Mitterrand and Minister of Culture Jack Lang, who saw it as a manifesto for the French president's ambitious new approach to culture, a bold combination of the ancient and the modern. "It was as much a manifesto for her as it was for us," remembered Lang. "She felt just as strongly about blending history and modernity, tradition and innovation. There was a clear compatibility, a shared intellectual heritage. It was an important event that served as a symbol—strong, original, singular."[5]

•

The idea for *Rhyme and Reason* actually began two years before, at the retrospective for Yves Klein at Rice. Walter Hopps was staying with Dominique at the house as they prepared the Klein exhibition. "I laid out that catalog on her kitchen table," he recalled. "When I needed more room at night, I often worked in her kitchen." Having gotten to know the artist when Klein visited America in 1961, Hopps was thrilled to be working on the exhibition with Dominique. "That was the first really important one," he remembered. "It was amazing to do that in the old Rice museum. It then went to the Museum of Contemporary Art in Chicago, the Guggenheim in New York, and the Pompidou in Paris."[6]

Yves Klein, 1928–1962: A Retrospective (February 5–May 2, 1982), which Dominique had worked on for more than three years, contained 108 works by Klein, whom she considered the most important French artist since World War II. "Using natural elements—pure pigments, gold leaf, female bodies, fire and water—Klein created works of stunning beauty," Dominique wrote. "His monochrome paintings shine today with a magic

glow, his body imprints have the mysterious fascination of ancient and for-gotten signs . . ."[7] The leading figure of a movement called *nouveau réal-isme*, Klein was best known for his monochromes in vivid blue pigment known as International Klein Blue as well as such stunts as *Leap into the Void* (1960), a photograph that appeared to show the artist taking a swan dive onto a city street. "The greatest provocateur I have ever known," his friend Jean Tinguely said of Yves Klein. The iconoclastic artist proved to be an innovator in the fields of conceptualism, minimalism, and performance. "It is necessary to be like an untamed fire," Klein said of his approach. "It is necessary to contradict yourself."[8]

After the artist's death from a heart attack in 1962 at the age of thirty-four, he had been the subject of only a few major exhibitions. As Domi-nique put it, "Silence settled over the golden tomb Yves Klein had built and on which he had laid a blue sponge wreath and a spray of pink artificial roses. The void he had conjured engulfed him; the music and dance were elsewhere."[9] The exhibition included major works from every period of his career and the 350-page catalog broke new ground on scholarship. "The Houston installation is as remarkable as Rice Museum audiences have come to expect, thanks to its director, Dominique de Menil," wrote the critic for *The Dallas Morning News*. "So is the documentary material that accompanies the art."[10]

Leading members of the French cultural establishment traveled to Houston for the opening: Claude Pompidou; Monique Lang, the wife of Jack Lang; Rotraut Klein-Moquay, the artist's widow; Dominique Bozo, who had replaced Pontus Hultén as the head of the Pompidou Center; many of the museum's curators; and Alexandre Iolas, who had been selling Klein since the 1960s. "I came back thrilled by my visit to Houston," Madame Pompidou wrote to Dominique after the opening. "Your house, so simple and splendid at the same time, the lunch when I felt like I was among family and, of course, the superb Yves Klein exhibition."[11]

Jean-Yves Mock, who was the leading Paris curator for the show, spent weeks in Houston with Dominique and Walter on the preparation of the exhibition. Working so closely with Dominique, he was struck by how much of a perfectionist she was, even when it came to the menu she would be serv-ing her guests in town for the Klein show. "I was there for two weeks, and we tasted a crème caramel every day for those two weeks," Mock recalled. "There was a chef from Houston and also a chef from New York. Every day in the kitchen at lunch, we participated in the perfecting of the recipe for crème caramel; it was sublime. It is said that God exists only in the details. Well, God existed a lot in the life of Madame de Menil, and in every way."[12]

Mock also saw how fascinated Jack Lang was by Dominique and her

two sisters. "He was staggered by their generosity toward the French government and the nation, as well as the phenomenal discretion of each of these three women," Mock said of Lang. The former minister of culture recalled, "I teased them a little by calling them *les trois frangines,* the three little sisters, an overly familiar, slangy expression in French."[13] Aware of the sense of excitement around the Yves Klein show, Lang told Dominique that he would like her to do whatever kind of an exhibition she would care to do in Paris. "Although he didn't open up his wallet for Mrs. de Menil," Mock explained, "it was thanks to Jack Lang that we could do *Rhyme and Reason.*"[14]

That summer, in June, Dominique and Lang met in Paris. He told her that although the National Gallery of the Grand Palais was really in need of restoration, he wanted to offer her the galleries for an exhibition, a "partial display" of her collection. The only question for Lang was when she might want to do it.[15] For Dominique, it was a massive undertaking. It would be, essentially, an out-of-town tryout for her museum, in the city where she and John had been born, five thousand miles away from where most of the collection was stored and where her staff was based. "If I have been slow to respond, it is because the size of the challenge frightens me," Dominique wrote to Lang. "How to do justice to such a generous offer? How can a coherent ensemble be fashioned from such a diverse array of collections?"[16]

•

After she considered the offer, and spoke with her team, Dominique knew just how she intended to approach the Paris exhibition. She would focus on several strong points of the collection, including non-Western objects—African, Oceanian, and the Pacific Northwest—prehistoric antiquities, and Greco-Roman. "Around these ensembles, our most beautiful paintings will intertwine, free from any academic or didactic concerns," Dominique explained to Lang. "Paintings will offset and frame the sculptures, all according to mysterious connections more than chronologies or schools. Everything will be documented with precision. But what is most important will be to create a place of enchantment."[17]

The show would be not only a preview of the museum they were starting to build but it would also be the first time that Dominique and Hopps worked with the family collection. It was, as he recalled, the largest exhibition he would ever do. "It was an incredible crazy show," Hopps said. "Choosing and installing over six hundred objects, from something that was about a quarter of an inch up to twenty-four feet. But the opportunity to have this grand survey was appealing."[18]

Galeries Nationales du Grand Palais

La rime et la raison
Les collections Ménil
Houston - New York
18 avril 30 juillet

Dominique with her assistant Elsian Cozens leaving the Grand Palais after a day working on the exhibition *Rhyme and Reason,* 1984.

One of Hopps's first curatorial ideas was unexpected. He informed Dominique that he wanted a reverse chronology: starting with the most recent works on the ground floor and working up to antiquities on the third level. "I told her that I wanted it to be like a journey backward in time to the end of the cave," Hopps recalled. "You have Paleolithic art, objects that were actually from caves, and that is very rare. They are going to be some of the smallest things in the whole show, but they're going to be some of the last things that people see.' "[19] Hopps had first used the reverse chronology method when he organized Robert Rauschenberg's mid-career retrospective at the Smithsonian American Art Museum in 1976 for the American bicentennial. "It means starting in the present and then asking, 'Well, how did we get here?' "[20]

Jean-Yves Mock, in addition to his job as the assistant to the director of the Pompidou Center, worked on *Rhyme and Reason* for more than a year. He felt strongly that, as Dominique had desired, connections should be made between the vast timeline of the objects. Mock recalled, "Everywhere, there were echoes between eras—references, bouquets."[21] As Hopps explained,

> Dominique really believed, as did John, that a great deal of pre-Renaissance art connected, in spirit, with modern art as well as with non-Western art. We know how important African art was to cubism, led by Picasso. But other non-Western arts were absolutely electrifying and fascinating to the surrealists . . . Some of the non-Western pieces were shown in juxtaposition with the surrealist art, connections that had not often been made . . . Way back, the great Barnett Newman had actually organized some shows with tribal art, in the early days of Betty Parsons, when she was at the Wakefield Bookshop in New York, even before there was a Betty Parsons Gallery. And others had the same stance, the French surrealist Matta and, absolutely, Max Ernst.[22]

Bertrand Davezac, the art historian whom Dominique had known since the early 1960s and whom she had brought to Houston to teach at Rice in 1979, also worked on the medieval and Byzantine pieces in the exhibition. Davezac, too, felt that the relationships between eras were an essential part of the exhibition. "The connection was a modernity that favored the simplification of forms, the reduction of forms," Davezac explained. "Abstraction belonged to the same schematic as prehistoric antiquities from the Mediterranean. It was in the same spirit that André Malraux wrote *The Voices of*

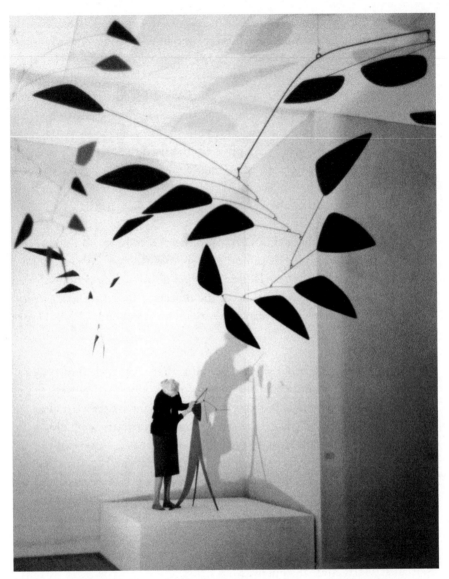

Dominique installing a Calder stabile (1969) for *Rhyme and Reason* at the Grand Palais.

Silence, that through modernity it was possible to understand the spirituality of other more ancient styles."[23]

Once the collection arrived in Paris, it took more than three weeks to unpack in the Grand Palais and to install. Dominique, as always, worked very closely with Hopps on the installation. The Friday before the opening, Dominique noted, "We are moving forward, but very, very slowly, We are just finishing the African and Oceanic sculptures." Alexandre Iolas had

come by that morning, and Pontus Hultén stopped by in the afternoon; both were encouraging.[24]

Caroline Huber and Walter Hopps stayed at Dominique's apartment on the rue Las Cases, so Huber had an up-close view of the proceedings. "Everyone realized that the exhibition was the last time the collection could be seen before the museum opened," Huber recalled. "It became a celebration of the de Menils being French but also a first glimpse of what was to come when the building opened and the collection was given to Houston. So it felt like both a last hurrah and a new beginning."[25]

•

For the multiple openings of *Rhyme and Reason,* there were dozens of friends from Houston and New York who made the trip to Paris. During one of the high-energy events, John de Menil's older sister Mirèse was seated, taking in the collection and the crowd it had attracted. A woman walked up to her, a journalist from Houston, most likely Marguerite Barnes. "I'm so happy to meet you because I admired John so much," she said to Mirèse de Menil. "When they arrived, we were drowning in our oil, but John brought us art, he brought us culture . . . he gave Houston a soul."[26]

The official opening of the exhibition was at 10:00 a.m. on Tuesday, April 17, 1984. Dominique, wearing a vintage dark suit and hat by Charles James, stood outside the Grand Palais to greet François Mitterrand and Jack Lang. Double rows of Republican Guards in full regalia lined the massive stone staircase leading to the entrance. Dominique accompanied the French president, the culture minister, and a swarm of European cultural dignitaries up the steps and into the exhibition. They went through the white-tiled Espace Zéro, by Jean-Pierre Raynaud, and into the modern and contemporary section, with its selection of leading postwar American artists: Mark Rothko, Barnett Newman, Robert Motherwell, Willem de Kooning, and Clyfford Still. Also in the first galleries were works by the newer generation of American artists: the twisted metal sculptures by John Chamberlain, light sculptures by Dan Flavin, minimalist aluminum pieces by Donald Judd and Walter De Maria, and paintings by Robert Rauschenberg, Jasper Johns, James Rosenquist, Ed Ruscha, Cy Twombly, and Andy Warhol.

Dominique walked with Mitterrand and Lang throughout the exhibition, discussing the lesser-known American artists, explaining the contents of cases filled with antiquities, and answering questions about non-Western objects. They went through the great surrealist collection paired with historical paintings and objects that were surreal *avant l'heure.* Walking

to the upper floors, at the top of one of the building's grandiose marble stairways, they saw a massive construction by Jean Tinguely, *Dissecting Machine* (1965), a contraption of black steel that also incorporated saws and limbs from a pale mannequin.

At the official opening, Rosamond Bernier was struck by the public reaction. "I have never seen the place so alive, crackling with visual and intellectual excitement," she wrote to Dominique. "It was gratifying to see so many Houstonians showing pride and pleasure in your accomplishments. Goodness knows I witnessed part of the struggle and can remember your and John's courage at combatting indifference."[27]

The French cultural world was astounded. "I was unaware of the scope of the collection and that it was as important as it was in such diverse disciplines," recalled Alfred Pacquement, who was then the curator of contemporary art for the Centre Pompidou and would be the director of the National Museum of Modern Art at the Pompidou from 2000 until 2013. "I was struck by the quality of many of the works and the desire to gather an ensemble that was not conceived in the traditional way of a museum. It

Dominique walking through the exhibition with François Mitterrand and, behind them, French culture minister Jack Lang and Danielle Mitterand.

was a much more original and personal approach, yet it took on the dimension of a museum through the size of its holdings." The exhibition was also a novelty for the country. Most contemporary French collectors, primarily for tax reasons, had always gone to tremendous efforts to shield their holdings. "A public exhibition of a private collection is much less frequent in France than elsewhere," Pacquement said. "So it was very impressive for everyone to see how one person, one family, could have brought together such a large number of objects of such quality."[28]

There were other events held to mark the exhibition. The Pompidou Center installed a companion exhibition, *Gifts of the de Menil Family to the National Museum of Modern Art.* Given several galleries of the permanent collection on the fourth floor, the museum showed four paintings and sculptures that had been given in honor of John de Menil. Also included was Joseph Cornell's *Owl Box* (1945–1946), given by François de Menil in honor of his father, as well as Helen Frankenthaler's monumental *Spring Bank* (1974), given by Lois and Georges de Menil. A special painting Dominique had given in 1980 was also in the show, Luis Fernández's *Portrait of Marie-Laure de Noailles* (1945), a large study of the historic Paris collector and patron.[29]

Sylvie Boissonnas gave a dinner at her house in honor of her sister. Another was held at the apartment of a Paris patron near the Eiffel Tower. "Marlene Dietrich was living in Paris, and we were all hoping to get to see her," Walter Hopps recalled. "But Dietrich wasn't coming out in public, at that point, so Dominique visited her privately."[30]

After the official opening of *Rhyme and Reason,* there was a lunch for fifty guests at the Culture Ministry, in the grand offices at the Palais-Royal on the rue de Valois, where, in the Cour d'Honneur the following year, Jack Lang unveiled the *Colonnes de Buren,* the great grid of black-and-white concrete columns and running water that would cause such an outcry. The lunch included all of Dominique's children who were in Paris, close friends, and French cultural leaders. Dominique was seated next to the culture minister.[31] Lang praised Dominique for her passion about art and for "collecting with the long-term patience of love." Sidestepping his tribute, she toasted to French-American friendship and "to artists, who are the really important ones."[32]

Rhyme and Reason was then open for invited guests for the rest of the day.[33] Rosamond Bernier recalled how distinctive Dominique was in her black suit by Charles James, with the matching matador's hat, and only a single silver broach by the jeweler Jean Schlumberger. "She had the conviction of her taste quite correctly," Bernier recalled. "For this big opening, she wore a thirty-year-old Charlie James and looked better than anybody."[34]

It was, of course, her husband who loved to see her wearing Charles James. And as much praise as Dominique received that day for the collection, there was another exchange that was very meaningful. Alexandre Iolas scrutinized what she had chosen to wear for the occasion and whispered to Dominique, "You know, John sees all that."[35]

•

Rhyme and Reason attracted more than 130,000 visitors during the three months it was up. And sales of published materials were brisk: 7,000 copies of the exhibition catalog, which was more than four hundred pages and dedicated to John de Menil; 31,000 copies of *Le Petit Journal,* a newsletter on the event that was produced by the French National Museums; and 42,500 postcards.[36] The exhibit unleashed a storm of press coverage in France including the dailies *Le Monde, Libération,* and *Le Quotidien de Paris,* newsweeklies such as *Le Point, L'Express,* and *Le Nouvel Observateur,* and art journals such as *Connaissance des Arts* and *Beaux Arts.* International reporting included *Newsweek, The New York Times, The Washington Post, Die Welt,* and many publications back in Texas. "Houston Comes to Paris" was the headline in *Newsweek.* "The amazing Menil Collection is unveiled not at home but abroad."[37]

Grace Glueck, in *The New York Times,* called the exhibition "a smashing show."[38] Like many, the critic of *Le Monde* was impressed with the connections made between eras. "Next to the marmoreal whiteness of a Cycladic vase, you run right into a little watercolor by Cézanne, a small sheet of paper with a few faded blots, an unfinished landscape of Mont Saint-Victoire, which was the picture that started it all." And, of course, the collection of surrealist paintings, sculpture, and objects stood out. According to *Le Monde,* "There is a richness of surrealist works, a grouping that is unequaled in terms of size and quality."[39]

•

Several years before, in November 1980, when Dominique was in Paris preparing the Yves Klein retrospective, she had lunch with Pontus Hultén and Jean-Yves Mock. Hultén was leaving the Pompidou Center and would be going to Los Angeles, to become the founding director of the Museum of Contemporary Art. Dominique had been asked to be on the board of trustees, but she declined. After their conversation, she sent a telegram to the collector Eli Broad in Los Angeles, announcing that she was changing her mind and would accept to be on the board of the new MOCA.[40]

Richard Koshalek, who was deputy director under Hultén, later director when Hultén left in 1982, remembered why it was important to have trustees from outside Los Angeles. "I am trying to put this as discreetly as possible, but boards in L.A. have had troublesome relationships with directors," Koshalek recalled, pointing to earlier difficulties at the Los Angeles County Museum of Art and other Southern California institutions. "Pontus and I decided that if we could put some international collectors on the board, it could give a certain recognition to the museum and also prevent bad behavior, let's put it that way." In addition to Dominique, MOCA trustees included the Italian collector Count Giuseppe Panza di Biumo and the German collector Peter Ludwig. "We thought that that would allow us to deal with any problems, that other trustees would listen to Dominique."[41]

Surprisingly, Dominique de Menil was actively involved in the early years of MOCA. "She was nothing short of extraordinary," Koshalek said of Dominique. "She had such reverence for the work of art and for the artist that it was an education for our trustees. It truly was. They respected her enormously. She participated in a very active way; she talked about institutional integrity. And she really, really participated in the process of the founding of MOCA."[42]

Dominique's emphasis on the creative act was a key factor in her role in Los Angeles. Koshalek saw Dominique interact with artists, whether it was Sam Francis, who was also a MOCA trustee, or the sculptor John Chamberlain. "The artists knew her and respected her," Koshalek said, "and she knew the artists and respected the artists. She never judged an artist by whether they misbehaved. She respected people who had a creative contribution to make."[43]

In 1983, MOCA's inaugural exhibition in its renovated warehouse by Frank Gehry, called the Temporary Contemporary, was *The First Show: Painting and Sculpture from Eight Collections, 1940–1980.* Curated by Pontus Hultén, Richard Koshalek, and Julia Brown Turrell, the exhibition included works loaned by Los Angeles collectors Jean and Howard Lipman, Irene and Peter Ludwig, and Marcia and Fred Weisman. The collectors from outside the city were Dominique, Giuseppe Panza, and Charles Saatchi. Dominique lent twenty works to the show, ranging from a trio of Cornell boxes to the massive painting by Yves Klein *People Begin to Fly.*[44] The goal of the exhibit was not only to give a sense of these impressive collections from around the world but also to connect the museum to Los Angeles collectors.[45]

Schlumberger president Jean Riboud wanted to see the Temporary Contemporary. So Dominique flew from Houston to join him and his wife, Krishna Riboud, on a tour of an exhibition. They had lunch with Hultén

and Koshalek in a barnlike space designed by Gehry above the museum. "It was one of the most moving experiences," Koshalek recalled. "Because Jean Riboud also had this wonderful respect for the creative artist, so to see this exchange between the two of them was quite remarkable. They had a special relationship. It was a business relationship that was also based on their shared interest in the creative world."[46]

•

At the same time that she was so involved with MOCA in Los Angeles and building her own museum, Dominique was also very active on behalf of the Pompidou Center. It was an ambitious undertaking, not an easy institution to get off the ground, so her engagement was very welcome. Pontus Hultén wrote to Dominique in 1975,

> The support you are giving us is wonderful. It means so much to feel that confidence. For morale, it has been more important than anything else that has happened. We still have lots of trouble and pain and sometimes the days are a completely crazy series of catastrophes.
> And sometimes, there is very good news . . . mostly coming from you.[47]

In addition to the generous contributions of American painting and sculpture, Dominique was involved with the acquisitions committee for the Pompidou Center and underwrote such important initiatives as the massive art historical research that was required for *Paris–New York,* the inaugural exhibition in the summer of 1977. At Hultén's request, in 1978 Dominique was named chairman of the Pompidou Foundation. "I accepted because I saw a double opportunity," she explained. "The foundation could contribute, however modestly, to the artistic life of such a remarkable center. And through our association with the Pompidou Center, we could contribute also to the cultural life of the United States."[48]

The goal of the group was to support and promote the center outside France and to encourage cultural exchanges between the two countries. It underwrote exhibitions, provided funds for fellowships, produced budgets for publications, and contributed art to the institution.[49] Brice Marden's *Thira* (1979–1980) was a massive color-field painting that Dominique gave the museum, in conjunction with the Pompidou Art Foundation, in honor of Pontus Hultén.[50]

Dominique quickly assembled an impressive board for the group includ-

ing New Yorkers Michel David-Weill, chairman of Lazard Frères; Ashton Hawkins, an attorney and longtime trustee of the Metropolitan Museum; David Whitney, the noted curator and partner of Philip Johnson; and Lois de Menil. Paris members included Hélène Rochas and Pierre Schlumberger. Dominique and Walter Hopps were also official members, while museum officials Pontus Hultén, Dominique Bozo, and Jean-Yves Mock were advisory members. And she asked Claude Pompidou to serve as honorary president.

Of course, the group was formed to boost the institution, but it was also a continuation of Dominique's insider education in the international art world, what Jean-Yves Mock called her "on-the-job training." On January 25, 1979, Dominique led a board meeting of the Pompidou Foundation at her New York town house. Present were Pontus Hultén, Jean-Yves Mock, Walter Hopps, and Lyn Kienholz, the artist's wife. Following the meeting, Dominique served an early dinner. Afterward, they jumped into two taxis and went downtown to the Heiner Friedrich Gallery to see Andy Warhol's *Shadows*. In the taxi on the way back uptown, Hultén told Dominique that he was convinced Andy Warhol was a profoundly religious artist.[51] The idea came to him when he curated Warhol's first European retrospective, a legendary exhibition held at the Modern Museet in 1968, and had to defend the show against criticism. Although he said it was difficult to put into words, he felt very strongly a spiritual quality to Warhol. The repetitive nature of the work—"even the Campbell Soup cans, even the dollar bills"—felt like litanies to Hultén. "Of all of the Pop artists, Warhol is the one who touches me the most, who might be the most important," the director told Dominique. "Each time, he bets it all. He doesn't keep anything back—he puts it all on the line."[52]

By 1980, Dominique had changed the name of the group to the Georges Pompidou Art and Culture Foundation. "I am delighted that you have agreed to stay as our honorary president," Dominique wrote to Madame Pompidou. "I need your support to enable our group to become even more active."[53] The following year, after another board meeting at the house in New York, Dominique hosted a reception for Madame Pompidou. Joining all of the Pompidou Foundation board members and members of the French Cultural Services of the French embassy was a high-powered group that included Prince and Princess Michael of Greece, Andy Warhol, Annalee Newman, Louise Nevelson, Dorothea Tanning, Rosamond Bernier, Jerry Zipkin, John Richardson, Bob Silvers, and Susan Sontag.[54]

One of the interesting activities of the organization was what Dominique called "Art Trips." She took groups of foundation members on tours of museums, private collectors' homes, and artists' studios. "Every year, for

eighteen or twenty years, we organized a big trip in Europe, which allowed Madame de Menil to travel with the American supporters for two weeks and, as we say in Protestant countries, pass the plate," Jean-Yves Mock remembered. "We made these trips every year in Germany, Switzerland, France, England, or Spain."[55]

Many cultural institutions have since begun similar tours, but Dominique's were among the earliest. Her initiative was not unlike the traveling meetings for the International Council of MoMA, which she and John had participated in since they began in the 1960s. But thanks to her decades of involvement in the art world and her European connections, Dominique was able to organize spectacular trips for the supporters of the Pompidou Foundation.

In May 1980, she led a small group including Elsian Cozens, Jean-Yves Mock, and Bertrand Davezac to the southwest of France, including the Dordogne, where Davezac's family had a house and which he knew quite well. They took a train from Paris to Toulouse before using a small bus to travel around the region. In Bordeaux, they had lunch in the city hall with Micheline and Jacques Chaban-Delmas, the former prime minister under Georges Pompidou and longtime mayor of the city. "She is gracious and easy going," Dominique noted about the couple. "He speaks well but it sounds hollow—he plays on emotion but his mind remains cold."[56] In the Dordogne, they visited the Cistercian monastery at Cadouin. The priest showed everyone the Shroud of Cadouin, a relic from the twelfth century, as well as some remarkable illuminated manuscripts from the Middle Ages. "He turns the pages casually," Dominique noted of the priest. "Some of the images contain facial profiles from two sides, like something by Picasso. I ask for photos."[57] They also visited the historic town of Souillac, where they had a dinner for twenty-eight including a large group from the Dordogne; the medieval fortress of the Château de Castelnaud, where they enjoyed a dinner on the farm; and they had an exceedingly rare, private visit to the Lascaux Caves, when the already-small group had to split into two. The tour ended at Les Treilles, Annette's estate in the Var, designed by Pierre Barbe and filled with her impressive collection of art and sculpture. They were greeted by Dominique's sister and the architect. After the rest of the group returned to Paris, Dominique stayed with her sister and Barbe for some rest.[58]

The trips, particularly the earliest ones, were not luxurious. The hotels were certainly fine, and there was always great attention paid to the meals, but there was a sense that everyone was roughing it. "Dominique had not yet figured that people wanted to stay in nice hotels," said Houston collector Sissy Kempner, who went on some of the later ones. "Those first trips were

very rigorous."⁵⁹ Dominique made sure that the purpose of the travel was clear: art and history. "All these women on these tours would have liked to go shopping or buy some china, but there was no time," remembered Anne Schlumberger, the daughter of Dominique's cousin Pierre. "You were there to see art; there was no time to shop or do something that wasn't serious." Dominique was in her early seventies as she began these trips, but she was still very vigorous. "She would sleep for fifteen minutes on the bus, then wake up and be ready to go," Anne Schlumberger said. "These other people, she would just wear them out with her energy."⁶⁰

Marilyn Oshman was a Houstonian who lived around the block from Dominique, at the corner of San Felipe Road and River Oaks Boulevard, in a beautiful, three-story brick house, surrounded by live oaks and high walls covered with ivy. Her father had founded Oshman's, a well-known sporting goods chain. In 1972, still very young, Oshman became president of the board of the Contemporary Arts Museum in Houston. She wanted to find out why some who had supported the institution were no longer involved, including the de Menils. "I really didn't know them, and they kind of scared me," Marilyn Oshman recalled. "I thought that now I am the president of this museum they won't want to talk to me at all because they don't like the institution." So she hoped for a neutral introduction and eventually, she met Miles Glaser, who arranged a lunch with Dominique. Oshman's first impression was that talking with Dominique was challenging. "Over time, we developed a relationship, and I noticed that everyone was intimidated to talk to her," Oshman said. "She had this bearing about her, this presence. But the truth of the matter is that she couldn't wait to be engaged in real conversation with anyone who was engaged with her. But it took me a while to get there."⁶¹

In the following years, Dominique was supportive of Oshman at the Contemporary Arts Museum, but they were not particularly close, until one day she issued an invitation. "I want you to come and take this trip with me," Dominique said. "We are going to see some interesting things." She did not mention it was for the Pompidou Center nor tell her much more about it other than that the destination was Switzerland. Dominique and Oshman bonded during their travels, over the works they were seeing and the shared difficulties of leading cultural institutions. "I told her that there are a lot of other young women in Houston who are interested in art besides me who would benefit so much from this trip, if she decided to have the group a little bigger. I said I thought she could really affect people's thinking about how to look at art."⁶²

That trip to Switzerland took place over one week in June 1982. It began in Geneva, with a visit to the twelfth-century mansion of Monique and

Jean-Paul Barbier-Mueller. "Their fabulous collection, which was started by Mr. Mueller, the father, includes superb examples from the great masters of the twentieth century: Cézanne, Matisse, Picasso, early Miró, and American works such as a magnificent silvery Frank Stella," Dominique wrote of the visit for a report she gave after the trip to attendees. "They have primitive art in abundance, with some of the rarest pieces housed in the Barbier-Mueller museum, a small, elegant museum also in the heart of the city." Mid-afternoon, the group drove to the medieval Château de Ripaille, on the edge of Lac Léman, owned by Mrs. Harold Necker, whose husband was a descendant of the French finance minister under Louis XVI, Jacques Necker. Her son, Alfred Necker, gave the group some of the château's *vin de Ripaille* and homemade sugar cookies before a trek to the arboretum. "This walk gave us the appetite to enjoy a delicious *poulet aux morilles* in the village of Jussy."[63]

The following morning, they left for Lausanne, visiting the Collection de l'Art Brut, a collection of outsider art assembled primarily in Paris and donated to the city by Jean Dubuffet. "An unparalleled and stunning experience was the consensus," Dominique noted. From there, they stopped in the picturesque old village of Gruyère, having lunch at an outdoor café where the only choices were a fondue or a raclette. "Two ways of eating melted cheese," Dominique wrote. "Both as delicious as they are undistinguished." When the group reached Bern, they were received into the house of Mrs. Hans Robert Hahnloser, whose husband was a well-known art historian and whose father-in-law was friends with the impressionists and the Nabis. "We are confronted with paintings we had never seen before, rarely reproduced," Dominique wrote of the afternoon visit. "Incredible treasures worthy of a great museum in a very modest house, as modest and comfortable as a Vuillard interior. Some of the finest Vallottons are there. Also an incredibly beautiful Van Gogh of Auvers, works by Cézanne and Bonnard and others."[64]

In Bern, Marilyn Oshman spotted an older woman on the street with a striking look, somewhat mannish and very distinctive. She boldly went up and introduced herself and found she was face-to-face with the surrealist artist Meret Oppenheim. "I said, 'You are Meret Oppenheim? You are one of my very favorite artists! I am visiting here from Texas, and I am here with Mrs. de Menil.'" Oppenheim said she would love to meet Dominique. Oshman asked if she had a studio and whether the small group could come by. "So I go up and tell Dominique that I have just met this artist. I take her over and introduce them, and of course Meret Oppenheim was just thrilled to meet her. Whatever dinner plans we had were put on hold."[65] As Dominique characterized Oppenheim for the group, "an excellent artist now in

her 70s, famous for her *Cup Lined with Fur* [*Object*, 1936], exhibited at the Surrealist Show of 1938 at the Museum of Modern Art, New York."[66]

The following day in Bern, they went to the Kunstmuseum to see the extensive holdings of Paul Klee, then to the Kornfeld Gallery, which had an exhibition of important twentieth-century prints. The gallery was located in a historic house with a garden. As Dominique wrote,

> Already charmed by this lovely place, we can hardly imagine that the Kornfeld house, where we are invited for lunch, is even more extraordinary. It is an old Bernese house, surrounded by meadows and trees. An exquisite collection of small masterpieces (drawings, watercolors, and collages by Seurat, Picasso, Ernst, Klee, Miró, Tanguy, Tinguely, etc.) and a couple of large masterpieces (Cézanne, Braque, etc.). The furniture in the room where we ate lunch was designed by Giacometti: chairs, tables, lamps, and candelabras. We had lunch on two long refectory tables in front of large, colorful Alfred Jensen paintings.[67]

That evening they went to the opening of a group exhibition at the Bern Kunsthalle by a curator who had been at the Pompidou Center, followed by a popular banquet on the terrace of a café, with a view out over the Aare River. The next day, they immersed themselves in the work of Paul Klee, visiting Catherine Bürgi, who had known the artist well. "Listening to her firsthand account of Klee's life, while roaming from room to room in search of ever so many Klees, was an exceptional experience." Next was a visit to the apartment of Felix Klee, the artist's son, where the walls were practically covered with Klee paintings.[68]

For Marilyn Oshman, that visit was a revealing moment. "It was a teeny little place and it was loaded with pictures, and this man started to address the ten of us in French," Oshman recalled. "And it was technical and personal what he was saying." Knowing that Oshman and another Texan, Nancy Negley, did not speak French, Dominique said, "I want you girls to come up here." She asked the artist's son to speak slowly so that she could translate for Oshman and Negley. "That was one of those magic moments when I realized that she really wanted us to get it. She wanted to make sure that we absorbed everything."[69]

The following day, they traveled to Basel, to see an exhibition at the Beyeler Gallery, followed by Ernst Beyeler taking them to see some of his favorite paintings. They also visited Maja Hoffmann Sacher, then in her eighties, who had been friends with many great artists of her generation: Duchamp, Kandinsky, Braque, and Ernst. "Mrs. Sacher lives in a house

that she designed herself in the 1920s. Far removed from any other agglomeration, it is superbly set on a hill surrounded by orchards and meadows." From that bucolic modernist setting, they drove to Zurich for the opening of a Jean Tinguely retrospective at the Kunsthaus Museum. Afterward was a late supper at the well-known Zurich restaurant Kronenhalle. "There one is liable to run into Chagall, Nureyev, or Yves Saint Laurent," Dominique noted. "They come not to be seen but to eat well. Indeed, they tend to vanish amid the habitués of this extraordinary place. It is filled with works by Renoir, Vuillard, Braque, Picasso, and others. Mrs. Zumsteg, who owns and runs the restaurant, is herself an institution as she visits with her prominent guests."[70]

After Zurich, the group slipped across the border into France and Dominique's ancestral region of Alsace. They went to Colmar to see the Isenheim Altarpiece, the sixteenth-century masterpiece by Matthias Grünewald, then to Strasbourg for a visit to the cathedral and museum. The next stop was the Château Kolbsheim, with its Pierre Barbe restoration that had been so important for the de Menils, where the group was welcomed by Dominique's cousin Antoinette Grunelius. The trip ended in a suitably impressive fashion with a pilgrimage to the Chapel of Notre Dame du Haut in Ronchamp to see that architectural masterwork, created by Le Corbusier and Father Couturier, in soaring white concrete and stained glass.

The mentoring friendship that began on those trips continued back in Texas. In the 1970s, Oshman had encountered a visionary Houston folk artist named Jeff McKissack, who had spent decades creating an environment he called the Orange Show. An ode to his favorite fruit, it was a mix of walkways, balconies, and arenas covered with brightly colored mosaics. When he died in 1980, Oshman had to decide what to do with the Orange Show. Thinking that it might be good as a children's museum, she invited Dominique to see it. "Marilyn, everyone will try to convince you that this is important for children," Dominique told Oshman as they strolled around the installation. "By all means, do children's events. But if you take this on, you have to remember that this is an important work of art and it must be treated that way."[71]

Her feedback encouraged Oshman to act. She paid $10,000 to acquire the Orange Show and set out to find twenty other co-owners, who would each contribute $500. So Dominique became one of the first twenty-one funders of the Orange Show, certainly the only time she was in the same group as the elaborately bearded Texas rockers ZZ Top. The organization has since expanded into the Orange Show Center for Visionary Art, also including the Beer Can House, the Art Car Parade, which draws tens of thousands onto the streets every year to see a procession of fantastically

extravagant vehicles, and Smither Park, a public park next to the original Orange Show; it has become one of the most energetic folk art groups in the country.[72]

The trips to Europe began with a group of eight to ten; in later years, two dozen would go. Marilyn Oshman noticed that at some meals there would be an empty seat next to Dominique, some were intimidated, perhaps, or simply wanted to give her some privacy. "You think of her as a myth," Oshman said, "and you forget that she was a woman. She definitely had a sense of humor. She loved to laugh at things. She could be very flirtatious." On one of the Pompidou trips to Venice, the group was given tours by Pontus Hultén, then director of the Palazzo Grassi. As they were taking a gondola to dinner, Dominique was seated next to the museum director. "I never saw her do anything like this before, but," Oshman recalled, "because he was there, she was sort of straightening out her skirt and started acting like a teenage girl. It blew my mind, I loved it, it was just wonderful; she was a real person."[73]

So many who went on those trips had vivid memories of their travels. On a trip to Prague, where he had been born, Miles Glaser organized a visit to the historic Jewish Cemetery and the Židovské Muzeum v Praze, the Jewish Museum. Glaser had explained to the director who Dominique was and what the group was doing, so he opened the museum on the day it was normally closed. Because the director of the museum was fluent in French, he, Glaser, and Dominique spoke in her native language. As they walked in, there was a big cover of an ancient Torah on the wall facing the entrance. The director explained that it dated from the thirteenth century and was from a synagogue in Ukraine. "She looked at it and said, 'You're wrong,'" Glaser remembered with a laugh. "'*Ce n'est pas vrai!*' I mean, as we were walking in; I'll never forget that." Dominique insisted to the director that it was, in fact, a Sephardic Torah cover from Turkey. He explained that the piece was on the cover of their catalog, that he knew its history very well. Dominique repeated herself: "*Ce n'est pas vrai!*" Glaser could tell that the director was upset. "Three months later, I got a letter from the director and he says, in Czech, 'I cannot believe this, but we had a specialist from Haifa University here, and they convinced me that we were wrong about this Torah cover. It is from Istanbul or somewhere in Turkey. And would you please extend my deep apologies to Madame de Menil; she was absolutely right.'"[74]

A MUSEUM WITH WALLS

We were all young, even Dominique was around seventy,
which is young. We were also a little like bad boys. We were
pleased to do something so magical, so quiet, so spiritual in
the middle of the city of Houston, which was growing and was
really a symbol of growth. Power; money; building, building,
building; taller, bigger, stronger! It was rebellious to work on
so spiritual a job. It was small, simple, and low, modest in size
and modest in scale, yet so strong and powerful in spirit.
We felt like little bandits.
—*RENZO PIANO*[1]

On January 6, 1981, Dominique was in New York viewing a major Joseph Cornell retrospective at the Museum of Modern Art. She noted the pieces that had been lent by her family, including Christophe and François, as well as those connected with Leo Castelli, Richard Feigen, and James Corcoran. Two boxes particularly stood out for her, one with no object inside, only a reproduction of a Titian painting of a young woman sprinkled with pink. The other was a white construction with an interior of broken glass. And she assessed the overall quality of the installation, determining that it was, in fact, very beautiful. But the conclusion of her notes indicated her priorities at that moment: "MoMA Alfred Barr Gallery measures 8 meters by 23 meters," "as walked by me."[2]

At the beginning of 1981, Dominique was completely focused on every aspect of the design process for her new museum, although news of her decision to begin the project and the selection of Piano as architect was kept strictly confidential. On January 19, Renzo Piano arrived on his first trip to Texas. He spent time with Dominique and her team, getting to know her. He walked around the site, trying to gain a sense of the neighborhood. He saw the Rothko Chapel and the Art Barn at Rice. And he tried to understand the environment—the strong light, the humidity—which would have an impact on the engineering. "The first thing Renzo said when I saw him here," Hopps recalled, "was Houston is a very wet place."[3]

From the beginning of the design process, the primary issue was about

the importance of natural light. But Piano pushed the discussion. "But what do you mean by natural light?" he asked everyone. "We realized that Dominique had one opinion, I had a different opinion, Walter had a different opinion, and Renzo had a different opinion," remembered Paul Winkler. "So we had to come to a consensus about what we meant because it can be approached in so many ways." Piano's prodding helped clarify the goal. As Winkler explained,

> Renzo helped us to focus on what we really meant by natural light. So it came around to wanting it to have a more domestic feeling rather than an institutional one. It became about how you experience light in a house, when there is not even illumination on every wall. You are aware of the time of the day. You are aware when a cloud passes over. You are aware of the season because the intensity of the brightness in the summer is different than the winter.[4]

To expand their thinking on the subject of light, Dominique brought to Houston the English-born architectural critic and theorist Reyner Banham. Although Piano had never met Banham, he was very familiar with his work. "Reyner Banham wrote a beautiful book a long time ago which was called *The Architecture of the Well-Tempered Environment*," Piano said. "It was about architecture made of light and immateriality, architecture not made only by walls and floors. He was concentrated on the idea that architecture can become magic by things that you don't touch: atmosphere, light on multiple planes, a sense of depth, a sense of distance." Banham visited the site two or three times before construction began. His thoughts, according to Piano, influenced the thinking on the design.[5]

Scale was another major concern from the beginning, because it was important that the museum not overwhelm its surroundings. All the one- and two-story houses that lined the blocks around the site had been painted the same shade of gray, a suggestion of Howard Barnstone's, following the exhibition *Gray Is the Color*. The unity of the bungalows could not be sacrificed to a new structure. "Just ten years before, Louis Kahn had come up with a plan that basically obliterated the entire neighborhood," Winkler recalled. Winkler felt that Kahn's approach, with modern buildings and town houses surrounding a museum building, was very much in the spirit of John. The approach a decade later was the opposite, creating something new but protecting what was already there, which was more in the spirit of Dominique. "She loved the humble quality of those bungalows," Winkler said. "Renzo saw immediately what happens in Houston: this big downtown made by tearing down the Fourth Ward in order to erect these tall

towers . . . and then this very quiet neighborhood, which is basically hori-
zontal, with a scale that is very human. His desire to protect that appealed
immediately to Dominique."[6]

"I have always thought that in some ways Paris has too much memory,"
Piano explained. "We were able to break rules with Beaubourg to break
with the past. But Houston, Texas, was without memory at all. So that
building became a place where people could go to have a sense of history,
of depth, of memory."[7]

In the spring, Dominique, Walter Hopps, and Paul Winkler went to
Genoa to visit Renzo Piano in his home office. "We made a number of
mock-ups, but the first one was made in my little garden in Genoa," Piano
remembered. "She came to Genoa—she flew economy, of course—and we
actually spent one hour looking at this modest mock-up lying on the grass,
watching, dreaming, and talking, talking. She was extremely interested not
just in drawings but also in observing, testing things."[8]

Behind Piano's desk at his house, with his books on design, were many
volumes about some of the leading Southern California modernists. "My
heart leapt," Hopps recalled. "He had books on all my favorites, people I
had wanted to do the Pasadena Art Museum, like Craig Ellwood, Richard
Neutra, Charles Eames. So I realized that he was interested in a very clean
kind of modernist architecture. He made it really clear that he wanted to
invent things."[9]

On that first stay in Genoa, Winkler remembered there was some sty-
listic concern. "The first thing he showed us was a mock-up, painted white,
with wood siding," Winkler recalled. "Well, a museum of wood? We would
never be able to accept that. Then we started talking about concrete and
all of these other materials, but we ended up with that; that was the right
decision."[10]

There was still some discussion about the design of leaves that Piano
had proposed to filter the light. But all were in agreement with the general
direction. And, back in Houston, Dominique and Miles Glaser had quietly
secured financial commitments: $5 million from the Brown Foundation,
$5 million from the Cullen Foundation, $1 million from Caroline Wiess
Law. Dominique would be handling the rest of the $25 million budget and,
of course, providing all of the contents.

•

In August 1981, Dominique sent a short note to journalists, staff, and
friends. "I would like to share with you some exciting news. Please join me
at the Media Center Auditorium on Monday, August 24th at 12:15 p.m.

Barbeque lunch to follow."[11] There were whispers throughout the city that the de Menils' holdings would find a home elsewhere, primarily in New York or Paris. So there was a tremendous sense of relief when Dominique stood in front of the crowd to announce the building of a museum, the hiring of Walter Hopps as founding director, and the selection of Renzo Piano as architect.

Although no drawings were presented, Dominique gave some sense of how she saw the building. "This museum won't look like the Beaubourg," she informed the audience. "But it will use advanced high technology on a very human scale. It will be avant-garde and it will blend in with its environment. All of us will try to make Houston an exciting place to live."[12] *The Houston Chronicle* characterized the news as "one of the most significant developments in the city's art life." "I wanted Houston," Dominique told the *Chronicle*. "It was always my choice. This is my city. I simply had not been sure I'd get support and I knew I couldn't do this alone."[13]

Four months later, on December 2, 1981, in the Hamman Hall auditorium at Rice University, Renzo Piano, Peter Rice, and Tom Barker unveiled the design for the Menil Collection. *The Houston Post* called the plans "an anti-monumental, anti-dramatic exterior with all the excitement inside." As Piano explained of the design, "The whole concept of the museum is that of a small village. The exterior area is part of the old town of Houston and the interior is the new town, the future. Instead of destroying the old town, we want to preserve it."[14]

•

In order to determine the right height for the new building, Dominique devised a novel solution. "We got a helium balloon and a little piece of cord, and she stood out on the property, flying that thing up and down in the air," Walter Hopps recalled. "She used the balloon to establish a height for the roofline that she could stand in the neighborhood. She recorded that, and then Piano worked backward, established our maximum for the galleries inside."[15]

The team was no less rigorous about Piano's solution for filtering the light: poetic, high-tech forms that were to crown the building, three hundred leaves, each forty feet long, all painted white. The material was to be ferroconcrete, an iron-rich material, and ductile iron, which allowed for thinness and shaping without sacrificing strength. The forms involved approximately eight thousand pieces of cast iron and were clearly the most prominent feature of the building. "Renzo called them 'leaves,' because they worked very much like a leaf," said Paul Winkler. "They are struc-

tural ribs, but they let light through and they protect from the rain, so they have to do everything. We were worried that those were going to be too heavy; we couldn't fully conceive what it was."[16] The trip to Piano's home office was the first time the team was able to evaluate the leaves and get a sense of how they worked. "Piano, who loves to sail, said the inspiration for his leaves came from sailboats," said Hopps. "He loved the way the light looked on the canvas sail."[17]

Piano had placed the leaves on an adjustable platform in order to get the proper angle to simulate the South Texas sun. After studying it, Dominique had one area of disagreement. "Look, this is too dark; I want to have more light," she said to Renzo and their teams. The idea for the museum had always been to show only a small fraction of the collection, and then the rest would be placed in storage. Dominique realized that the time they were away from the light, sleeping as they called it, meant they would be able to tolerate higher levels when they were on view. "Up to that moment, no one had considered that if you put a painting to sleep for ten years, then you put it into a stronger light for six months, that the damage is not significant because it is a relatively short time," Piano recalled. "It is like exposing the same painting for ten years to much lower lighting because what is important is the amount of ultraviolet that you expose to the painting. So it was a declaration of love, really—saying that if you put this painting in a lower light you kill the painting."[18]

Renzo Piano with, from left, the engineer Peter Rice and his assistant, Shunji Ishida, presenting the model of the museum to Lois and Georges de Menil.

Dominique's realization meant that they could accept a more robust light and still satisfy conservation requirements, yet there was still need for the leaves to do a tremendous amount of work. "The light level in Houston is often around 100,000 lux," said Paul Winkler. "We were using less than a half of 1 percent of that to light the inside of the building. So we were building a system that blocks 99.5 percent of the light but allows in just enough, and true light, that it gives the dynamic quality we wanted. So it was extremely sophisticated."[19]

After Genoa, they had a model of the entire building constructed at a one-inch scale. "We still couldn't quite understand," Winkler said. "Would these be so dominant that they were going to look like a technical building and not have the feel that we wanted?" After mocking up different versions, they decided to construct behind one of the small houses near the site one module of the building at full scale. The twenty-foot-by-forty-foot section included four forty-foot-long leaves. "Going full scale allowed for the refining of certain elements, so we got an even better operating and lighting system. It felt stupid not to do it."[20]

There were many times during the design process when Dominique sought to limit costs. The floors of the museum would be, like the de Menil house, black. Piano had proposed teak floors, which would have been very elegant and very expensive. Dominique chose pine, suggesting that there would be something poetic about how the stained floors weathered with foot traffic. But there were other choices where she opted to spend. A traditional elevator would have required mechanical elements above, and Dominique did not want an unsightly bump on the roof. Instead, hydraulic lifts were installed, eliminating anything above. One day, Dominique was having lunch on the top floor of the Warwick Hotel, near the Museum of Fine Arts, with Miles Glaser and Ralph Ellis, manager of the Menil Foundation real estate. Looking toward the site of the museum, she pointed out Richmont Square, an undistinguished, ten-acre apartment complex several blocks south. "You know, Ralph, someone is going to buy those properties, build a high-rise, and then we will have a shadow on the museum," Dominique said at lunch. "I want you to go buy those apartments for me."[21] Buying the complex would greatly expand the property holdings of the foundation, but Dominique believed it was essential. "It was at a time when the financial situation was sort of tight," Paul Winkler recalled. "But she went out and bought the complex."[22]

Construction of the Menil Collection began on February 25, 1983, just over two years after Dominique had that first work meeting with Renzo Piano on the rue Las Cases in Paris. Construction was not finished until three and a half years later, on October 17, 1986.[23]

•

Between 1980, when the effort to build a new museum began, and 1987, when the Menil Collection opened, Dominique de Menil acquired over eighteen hundred works of art. As she moved closer to the reality of the museum, she made a concerted effort to fill in areas where the collection could be stronger and to push into new realms.

Dominique bought a splendid thirteenth-century medieval sculpture of the head of a bearded man in pale stone—a purchase encouraged by Bertrand Davezac—as well as a series of eight sixteenth-century prints, illustrating human dissection, that were often shown with surrealist works. In 1981, she acquired a pair of important terra-cotta figures from the Inland Niger Delta culture (eleventh to seventeenth centuries) for the African collection; a major Frank Stella painting, *Avicenna* (1960); and a spectacular late seventeenth-century golden Anastasis icon. In 1983, she acquired a trio of major works by Yves Klein in three distinctive styles: *Hiroshima* (1961), in International Klein Blue; *Untitled Fire Painting* (1961), using blowtorches on canvas; and *Untitled (Monogold)* (1960), a monochrome covered entirely with gold leaf.

Christophe helped push her mother toward more outstanding modern and contemporary works. Some that Christophe had owned were acquired by Dominique during those years, including such key pieces as James Rosenquist's *Promenade of Merce Cunningham* (1963), a playful pop art tribute to the choreographer, and Michael Heizer's *Isolated Mass/Circumflex (#2),* one of the artist's massive "negative sculptures" that would be laid into the ground on the front lawn of the new museum. There were also two important Barnett Newman paintings, *Ulysses* (1952) and *Now II* (1967), as well as a pair of big, bright Willem de Kooning paintings, *Untitled IV* (1976) and *Untitled VI* (1977). Christophe would steel her mother, if she started to waver about a work that was important. In November 1979, Sotheby Parke Bernet held a record-setting sale of works owned by the artist William Copley. Dominique acquired many paintings and sculptures from the auction, including a major Man Ray, *Imaginary Portrait of the Marquis de Sade* (1938), a profile of the notorious author with the Bastille burning in the background, and an early Magritte, *The Meaning of Night* (1927), depicting two suited, bowler-hatted men standing on a crepuscular beach next to a mysterious fur-covered form.

Adelaide and her husband, Edmund Carpenter, were instrumental in Dominique's acquisition of many important sculptures and objects from Oceania and the Pacific Northwest, and many works from their own collection were included at *Rhyme and Reason*. Dominique also bought many

important paintings and sculptures from her son François. In just one year, 1983, she purchased nine major works that had been a part of François's collection, including Magritte's *Survivor* (1950), a powerful painting of a rifle, propped against a wall, creating a pool of blood; an early Jasper Johns, *Untitled, 1954,* a dark green abstraction; and one of Warhol's pop art masterworks, *Big Campbell's Soup Can (Beef Noodle)* (1962). She also acquired from François an exquisite drawing by Georges Seurat, *Corner of a Factory* (1883), and Jean Tinguely's *Dissecting Machine,* the massive sculpture that was given pride of place on the stairway of the Grand Palais.

Walter Hopps also encouraged Dominique to continue with the kind of bold twentieth-century art that John had liked. Under his influence, Dominique acquired multiple works by Barnett Newman, an important early Jackson Pollock painting, *The Magic Mirror* (1941), a pair of Pollock drawings, a series of over two hundred photographs by Walker Evans from the 1930s and 1940s, and the earliest work still in existence by Jasper Johns, *Star* (1954). "Thanks to you, the collection has been greatly expanded in post-war American art," Dominique said to Hopps in front of the museum staff. "Without you, I would never have had the courage to buy some of the treasures that contribute so much to our reputation."[24]

•

When it came to the acquisition of a work of art that she believed in, Dominique was relentless. In October 1983, she welcomed to Houston an astute Paris dealer she had known for decades. Hubert Prouté, whose grandfather had founded the Paul Prouté Gallery on the Left Bank, specialized in European drawings and prints from the sixteenth to the twentieth century.

Dominique asked for Prouté's assistance on a painting that was coming to auction later that month in Paris, *Study of a Black Man* (1770), a majestic portrait by the great eighteenth-century English painter Sir Joshua Reynolds. It was a large canvas, unfinished, depicting a light-skinned black man who might have worked for the painter or for the writer Dr. Samuel Johnson. In Reynold's personal collection when he died, by the turn of the century the painting had made its way to Paris. It was sold by Knoedler to the collector and couturier Jacques Doucet, then to perfumer François Coty, and, finally, to Singer sewing machine heiress Daisy Fellowes. Her eldest daughter, Emmeline de Castéja, put the painting up for sale at the Paris auction house Hôtel Drouot. The painting was deemed significant enough to be placed on the cover of the sale catalog.

Dominique asked Prouté to attend the auction at Drouot, on Thurs-

day evening, October 20, in order to bid on the Reynolds painting on her behalf. That night, Prouté called Dominique in Houston: Reynold's *Study of a Black Man* was hers. Prouté said that the pace of the sale was very fast, until its rather abrupt conclusion, and that afterward he was surrounded by curators from the Louvre wanting to know the identity of his client. Prouté told Dominique that he had the impression that the underbidder was Charles de Beistegui, the flamboyant decorator, collector, and society host.[25]

Exactly one week later, Dominique received a phone call at her house in Houston from Michel Laclotte, the director of the Louvre. He told her that Charles de Beistegui was indeed the underbidder and that he was there to buy the portrait, which he would eventually give to the Louvre. Laclotte informed Dominique that it was an important enough painting that he was prepared to block its export. He intended to initiate a national trust that would buy the portrait for the Louvre.

This was a work that Dominique was prepared to fight for. She explained to Laclotte that the painting was indispensable for a collection that concentrated on the black experience, which hers did and which the Louvre's, obviously, did not. She also said to him that he would have to agree that the Louvre had so many "beautiful pieces of painting," one more was not going to make that much of a difference.

On their phone call, Dominique was able to convince the Louvre director that her purchase should go through. As she noted in her date book, "*Michel, très gentiment s'incline*," a confirmation that he conceded, although the literal meaning was "Very kindly, Michel bowed down."[26]

•

Dominique continued her personal engagement with artists. On one trip to Paris, in December 1985, she had a dinner with Matta at his apartment in a beautiful eighteenth-century building at 71, rue de Lille, across from the Musée d'Orsay. They talked about his family, his childhood, and gossiped about the art world: Matisse and all of his children, Teeny and Marcel Duchamp. "Matta was unbelievably amusing," Dominique noted in her datebook. She then returned to the rue Las Cases at 11:30 p.m., for a late-night meeting with Walter about various projects for the museum.[27]

Dominique also stayed very involved with Schlumberger Limited, particularly because, earlier that summer, the company had entered a period of crisis. Jean Riboud, who had led the company for over twenty years, first as president then also as chairman, was battling cancer and having turned sixty-five was at the age of mandatory retirement. In July, at the SLB board

meeting in New York, Riboud assured the board that his doctors were pleased with his progress, and he made a startling proposal: to issue a large number of preferred shares, at a very low rate, that would be controlled by a small group of loyalists and insiders (Dominique noted the plan to involve 200,000 preferred shares for $2 million).[28] Georges de Menil, who was on the Schlumberger board from 1970 until 1987, immediately sensed the danger for all SLB shareholders that their stock would be diluted. Along with other board members, he was able to have the issue tabled. Georges quickly contacted New York attorney Henry King, chairman and managing partner of the leading firm Davis Polk, and the following week he alerted his mother at her apartment on the rue Las Cases.

Dominique met with the Schlumberger chairman to discuss the scheme. "Very unpleasant meeting with Jean Riboud," she noted in her datebooks. "He was unbelievably harsh about Georges."[29] She began to marshal the support of the other members of her family. On August 15, Davis Polk filed a request for an injunction against the proposal.[30] By the end of September, Dominique was meeting with Georges and Henry King at his office on the Place de la Concorde, assuring the attorney that all five members of her generation of the Schlumberger family were unanimous in opposition to the plan.[31]

The following month, Riboud, who had been such a masterful chairman, died at home on the Avenue de Breteuil in Paris. Although the preferred stock scheme was resolved by the beginning of 1986, another issue became clear: Michel Vaillaud, whom Riboud had insisted the board approve as his successor at the board meeting in September, was not the right man for the job. Dominique began another round of conversations with her family and major shareholders to explain the sense of urgency and to help find a solution. She had meetings in Paris with Nicolas Seydoux and Jérôme Seydoux, the powerful sons of her cousin Geneviève, and flew to Switzerland to spend the day with her cousin Françoise Primat.

One longtime Schlumberger executive, the Scottish-born Euan Baird, was seen by the family as the best candidate to replace Michel Vaillaud. In the search process, Baird, along with his French-born lieutenant Roland Génin, met once with each of the five daughters of the Schlumberger founders, known to all as *les cinq filles*. With Dominique, who was seventy-eight at the time, they met three times. "Because she had spent a lot of time when she was young in the field, she had a surprising amount of knowledge about the company," Baird said. "She knew everything." Baird also noticed an amusing example of Dominique's Protestant frugality. During lunch at the rue Las Cases, he and Génin were served wine from a bottle that had already been opened, something that was never done in France.[32]

Throughout 1986, Dominique maintained close contact with her extended family and with other major shareholders. She flew to Nice to meet with Michel David-Weill, chairman of Lazard Frères, at "Sous les Vent," his estate in Cap d'Antibes. Before and after lunch, Dominique and David-Weill phoned SLB board member Felix Rohatyn, also with Lazard, on his summer holiday in Gstaad.[33] On August 19, Dominique was back in Paris at the Place Vendôme offices of Henry King with her cousins Geneviève and Françoise, her sister, Sylvie, and her husband, Eric, signing a document demanding the resignation of Vaillaud.[34]

At the same time, the two Schlumberger executives were, understandably, reluctant to inform the head of the company that they no longer had confidence in his leadership. On August 28, a date she noted was "pivotal," Dominique had Baird, Génin, and Georges over for dinner at the rue Las Cases. "My father and my husband gave their lives to Schlumberger," Dominique explained, to clarify why she cared so deeply, and urged Baird and Génin to act. "You hold the cards in the hand that is now being played. Will you fold? There is a risk. But if you are in, with the family behind you, the hand will be won."[35]

At the end of August, Dominique took the Concorde back to New York with Georges in order to be in the city on September 6 for an all-day emergency board meeting held at the Knickerbocker Club. That night, at 111 East Seventy-Third Street, Dominique had Baird and Génin over for a dinner she termed "very friendly." As she noted of the board meeting: "The turning point was Baird's presentation—brief and very firm. Any reluctant stockholders now understand that Vaillaud must go."[36]

A managerial coup had taken place at Schlumberger Limited: Michel Vaillaud was replaced as chairman and chief executive officer by Euan Baird. A month later, when the news was announced, Dominique wrote Baird a warm letter of congratulations. "In the midst of the difficult debates that we have just endured, I have so admired your courage and that of Roland Génin."[37] She also wrote Génin, who became vice-chairman of SLB. "Now, the page has been turned and Schlumberger can, once again, be what it has always been: one large family, united and conquering."[38]

•

While the museum had been under construction, in 1984, Dominique went to Antibes with her two sisters, attending the opening of an exhibition of sculpture at the Picasso Museum, housed in the Château Grimaldi, a stone structure on the Mediterranean dating from the fourteenth century. Annette was eager to see the exhibition, particularly a Picasso painting that

Dominique working with Walter Hopps on the first installation of the Menil in her Houston dining room with a Magritte on the wall.

had been lent for the occasion by Sylvie. For her part, Dominique took in the exhibition, of course, but she also studied the galleries in the old fort. She went everywhere with a tape measure, recording the size of the rooms. In the smallest, which was the former chapel, she was down on her hands and knees, measuring the space. "You see," she said to her sisters, "even in small spaces, you can put a lot of things."[39]

Dominique and her team retained the right to oversee the design of the galleries of the museum. "Renzo Piano, who's a great architect, wanted a more rigid system inside," Walter Hopps recalled. "Dominique backed me up. The bones, the real structure, was Piano's, but the insides, the galleries, were designed by us." It took eight months to build out the galleries and install the collection.[40]

They developed a large model of all the galleries in the museum, built at a 1:12 scale and in four parts that could easily be moved around. Along with the model, they made miniature reproductions of every work of art that was to be displayed—tiny paintings in International Klein Blue, little Calder mobiles, African totems the size of a Magic Marker. Before they worked with the actual objects, they used a periscope to peer down into galleries of the model to plan their installations. "She was absolutely keen on the use of the models," Hopps said of Dominique. "We worked with models for the permanent installation or for a temporary exhibit, in order to adjust the art we selected to see what would work."[41] The large model

and the thousands of miniature works of art are still used by the curatorial staff to mock up exhibitions of the Menil Collection.

Initially, as was done with *Rhyme and Reason,* there was a desire to mix periods in some way throughout the museum. "But it turned out that there was such a beautiful clarity of the building's architecture that we decided just to segregate the four zones of the collection," Winkler said. "So we did the antiquities section, behind which was Byzantine, then African and primitive art, then twentieth century along with surrealism."[42]

On that opening night of June 3, 1987, many were struck by how the collection had been so rigorously edited. Limiting the number of paintings and objects to several hundred made everything sing just a little more. "Madame de Menil felt that huge exhibits were monstrous, that they had ruined art," said Jean-Yves Mock. "It's ridiculous to make an exhibit, as was done by the Beyeler Foundation in Basel, with a hundred Rothkos. Showing twenty is exciting enough. It's like force-feeding geese."[43]

There were many elements of the finished museum that were moving to its first guests. But the overarching feeling that most visitors responded to was that sense of humility that Piano said was so important to the design, a sense of calm and quiet, and a complete concentration on the works of art.

•

Two years after the opening, on February 10, 1989, Dominique went through the museum with Frank Stella, an artist she and John had collected since the 1960s. "Medium size, wiry, swarthy complexion, grey and fluffy hair, dark eyes constantly moving, intense gaze, quick gestures," Dominique noted of Stella, meticulously recording his visit in her personal notebook.[44]

The artist had already taken a look inside the museum. "You have *Ulysses,* don't you?" Stella asked Dominique, about the seminal Barnett Newman painting. Stella wanted to go directly to the twentieth-century galleries on the east end of the building.

Dominique noted that Stella walked by the large gray Cy Twombly painting, *Untitled 1968,* without saying a word and then stopped in front of Jasper Johns's *Voice* (1964–1967), a striking gray canvas and assemblage measuring six feet by eight feet. Stella's only comment: "For Jasper, this is a very large painting."

Stella had a cigar in his hand. Dominique asked him not to smoke. They stopped in front of one of Stella's paintings, a modestly scaled, U-shaped canvas that used copper paint. He studied it. Dominique mentioned that it

looked soiled in places. "It doesn't matter," Stella replied. "Leave it as it is. Paintings change color with time."

They stopped in front of Stella's large gray canvas, *Avicenna,* a pattern of concentric dark gray lines around a rectangular white void. "He contemplates his gray painting with obvious satisfaction," Dominique noted. Stella was standing so that he could see both his piece and Jasper Johns's *Gray Alphabets* (1956). The artist told Dominique that they had become closer in tone than when they were first made, that his painting had become lighter and Johns's had darkened. Stella walked by works by Robert Rauschenberg, mumbling pleasant comments, before coming face-to-face with Jasper Johns's *Star,* a small, pale construction, in oil beeswax and house paint, of a Star of David. Stella gasped. "How did you get it?" he demanded of Dominique. "I told him that Walter had kept track of it and grabbed it when it suddenly appeared on the market. It is a high point of the collection for him."

They walked up to a pair of paintings by Barnett Newman. Stella looked at Newman's large, intense red canvas, *Be I* (1949), with a thin white line that ran down the center. But he was particularly struck by *Ulysses,* the important abstract expressionist painting that had once belonged to Christophe. Stella took a few steps back and looked intently at *Ulysses.* "It is Newman at his best," he exclaimed to Dominique. "He knew what he was doing when he painted *Ulysses.* He was almost ecstatic. 'It rises! It rises! Yet it is dense. It's like a cathedral. Cathedrals are strong, but they seem weightless.' He looked at it from a great distance and just said, 'It soars!'"

Dominique and Stella continued their visit to the twentieth-century galleries. The artist studied her Mondrian paintings with an obvious interest and a Brancusi sculpture, which he felt would be better displayed in the middle of the gallery so that it could be seen from all sides. Stella paid great attention to the cubist paintings but did not even glance at the Cézanne watercolor. As they walked back to the entrance of the museum, the artist told Dominique how much he loved the architecture of the building. He said that he expected it to be downtown and several stories tall, that it was so refreshing to find that it was in a neighborhood and that it fit in so well. "He likes everything about the museum," Dominique noted, "the covered walks, the classical feeling, the chalk white walls. He is almost emotional about it and tries to press me on how good it is. He understands that I do understand how he feels and our handshake has the warmth of an embrace. He hops in his car and is gone."[45]

FROM CIVIL RIGHTS
TO HUMAN RIGHTS

*As I reflect on where we have been, where we are, and where
we are going, I feel the principal defining character of this
moment for our human rights program is its maturity and the
recognition it has achieved around the world. We have built
a program that supports and does not threaten other human
rights actors and institutions and, more to the point, that fills
important gaps and meets concerns that others are unwilling
or unable to address.*
—*JIMMY CARTER TO DOMINIQUE DE MENIL*[1]

In January 1973, Dominique and John were together at their
house in Houston, meeting with Ivan Illich (1926–2002),
someone they had been in contact with since the 1950s. Born in Vienna,
Illich was a Catholic priest, a philosopher, and a fierce advocate for social
justice. His obituary in *Le Monde* noted, "At the beginning of the 1970s,
Ivan Illich was a provocateur and a lucid, implacable critic of industrialized
society. Institutional education, health care, industrial development, and
energy consumption were all the targets of his powerful discourse."[2]

As Dominique and John planned their events for the Rothko Chapel,
they spoke with Illich about others they should contact in Central and
South America. He told them about Dom Hélder Câmara (1909–1999),
the Brazilian Roman Catholic archbishop of the historic cities of Olinda
and Recife on the northeastern coast of Brazil. Dom Hélder Câmara was
a leading proponent of liberation theology, the doctrine that advocated for
the liberation of the poor and the oppressed. According to *The New York
Times*,[3] he was "the little priest who stands up to Brazil's generals."[4]

Ivan Illich phoned Dom Hélder Câmara from the de Menils' house so
that Dominique and John could speak with him. They invited the arch-
bishop to participate in the second Rothko Chapel colloquium, "Human
Rights/Human Reality," which was planned for later in the year. Held on
December 8 and 9, 1973, and coordinated by Roberto Rossellini and Si-
mone Swan, it was intended to explore the issue of international human
rights on the twenty-fifth anniversary of the acceptance of the Universal

Declaration of Human Rights, which had been ratified in Paris on December 10, 1948.

Dom Hélder Câmara joined four other speakers over the two-day event: Dr. Giorgio La Pira, the former mayor of Florence; Dr. John Calhoun, an ecologist, psychologist, and research fellow at the National Institute of Mental Health; Dr. Joel Elkes, director of psychiatry and behavioral science at Johns Hopkins School of Medicine; and Dr. Jonas Salk, inventor of the polio vaccine and founder of the Salk Institute for Biological Studies in La Jolla. For his talk, Dom Hélder Câmara made a forceful statement against torture in totalitarian regimes.

The intervention of Dom Hélder Câmara, whose talk that day was excerpted in *The New York Times,* had an impact on the direction of the Rothko Chapel and of Dominique's later years. "That conference gave the chapel its interest in human rights," recalled Nabila Drooby, who had moved to Houston from Beirut to be the founding director of the Rothko Chapel. "Before, we were mainly focused on religion and, of course, civil rights. But Dom Hélder insisted that we consider human rights as well; he opened our eyes."[5]

Dominique became very friendly with Dom Hélder and brought him to the Rothko Chapel many times. "He was a small priest, unpretentious, who couldn't speak English well, but there was something extraordinary in him," Drooby recalled. "He was charismatic. He could communicate his faith, his concern for the poor, his concern for the direction politics were taking in those days and have taken since. He was an inspiring leader for us."[6]

December 10, Human Rights Day, would become an important date on the annual calendar of the Rothko Chapel, with a human rights event and speakers such as Texas congressman Bob Eckhardt, a group of leading Soviet dissidents, or James Victor Gbeho, the Ghana ambassador to the United Nations and a member of the UN Special Committee Against Apartheid. Over the years, there would always be a ceremony on January 15 to mark the birthday of Martin Luther King Jr., at a time when many were actively working against recognition of the slain civil rights leader.

In the same spirit, in June 1981, to mark the tenth anniversary of the chapel, Dominique began the Rothko Chapel Awards for Commitment to Truth and Freedom. "Everyone is asking me why," Dominique said before the ceremony, "why are we here? Every day, I read things that just make me feel we have to do something and the 10th anniversary of the Rothko Chapel seemed as good an occasion as any."[7] She had spent months selecting a dozen recipients of the first awards, bringing the honorees to Houston and awarding each $10,000. "The Rothko Chapel is a sanctuary open to all, a

no-man's-land of God—named or unnamed—thus every man's land," she announced at the beginning of the ceremony.

Recipients ranged from Roberto Cuéllar, director of legal aid for the archdiocese of San Salvador, to New York poet Ned O'Gorman, founder of the Harlem school the Children's Storefront, to the Mothers of the Plaza de Mayo, the organization of Argentinian mothers searching for the tens of thousands of their children who had been "disappeared," kidnapped and killed by the military dictatorship.

Dominique continued her advocacy on behalf of African Americans while expanding her perspective toward similar battles for justice around the world. Her work in both areas—civil rights and human rights—was not always viewed favorably by the more conservative elements in the southern city of Houston. In December 1978, Barnett Newman's *Broken Obelisk* was vandalized, swastikas spray painted onto the base of the pyramid along with the words "White Power."

Disinformation about the chapel was spread by many, including followers of Lyndon LaRouche, who stood at the airports handing out conspiratorial leaflets about the activities there. In the midst of that, in the spring of 1980, Lynn and Oscar Wyatt invited Dominique for a small dinner at their grand house. Mr. Wyatt was outraged about the defamation at the

A demonstration was held against the racist vandalism on Barnett Newman's sculpture, which had been dedicated in 1971 to Martin Luther King Jr.

Rothko Chapel and offered to help pay for plainclothes security guards. Henry Taub, who had been a good friend of John's, was there as well. "Ask Henry now that you have him in a good mood," Oscar Wyatt joked to Dominique. "Henry agrees," Dominique noted in her date book. "With me, we are three."[8]

Although there was goodwill, and generosity, that night *chez* Wyatt, Dominique and others on the Menil Foundation board were concerned that the increasingly visible activities of the chapel, as well as other Menil Foundation projects such as *The Image of the Black in Western Art,* could endanger fund-raising for the museum. Almost everyone believed in what Dominique was doing artistically; it was all of these other activities that were difficult for some to grasp. So, during the fund-raising process, the decision was made to spin off the museum into its own foundation. The move allowed the Menil Collection to focus fully on art and the Rothko Chapel Foundation to continue its uncompromising programming.

And, as she had often been, Dominique was very hands-on in these activities. In 1974, she had visited Chile in the year after the imposition of military dictatorship by General Augusto Pinochet. While she was there, Dominique also had meetings with the French ambassador to Chile and noted that the embassy was still housing seventeen political refugees; she met with peace activists, with a Dutch priest who was helping Chileans escape the country, and with a bishop who told her, "So many priests have been executed. Bands of prisoners are hauled away, shot on bridges or on the banks of rivers. They are then buried by Mapuche Indians."[9] During the 1980s and 1990s, Dominique's trips to Central and South America, and her engagement with refugees in the United States, would have some members of her family worried for her safety.

•

In January 1983, Rosalynn and Jimmy Carter went to Houston to meet Dominique. The former president was formulating his plans for the Carter Center, which would open in 1986. She gave them a tour of the Rothko Chapel, then had a long conversation back at the de Menil house. From that first encounter with the former president, Dominique noted, "He wants to dedicate his life to human rights."[10] Dominique invited Carter to be the featured speaker for Human Rights Day, December 10, 1984, at the Rothko Chapel.[11] A large tent was erected on the lawn. Four years after he had left the White House, Carter drew such a sizable crowd that the sides of the tent had to be raised in order to give everyone a view. Dominique received him before his talk in one of the small gray houses across the street from the

chapel. "Huge applause, as soon as he appeared," Dominique noted as they walked toward the chapel.[12]

She introduced Carter as "a great human rights leader who, when he announced his candidacy, had hoped that our country would set a standard of courage, compassion, integrity, and dedication to basic human rights. The country, as a whole, did not rise to this challenge. As to human rights, the powerful remained, as usual, indifferent to injustice and oppression." Dominique told of a 1978 trip that President Carter took to Brazil, where he was received coolly by the military government. Wanting to meet with the archbishop of São Paulo, Cardinal Paulo Evaristo Arns, who was one of the few to speak out against tyranny, Carter could do it only in secret. "Returning to Brazil this past October, he was openly welcomed by Cardinal Arns and greeted warmly by civilian politicians who credited him with having reduced human rights violations and hastened the end of military dictatorships throughout Latin America," Dominique said. "What a tribute!"

Dominique and Carter had a late dinner together at the de Menil house, where they further discussed the issue of human rights and how they might be able to work together. "Modest, precise, intelligent, and a man of deep faith" was how Dominique characterized him that night in her date book.[13] "I looked at her as an aristocrat," Carter said of his first impressions of Dominique. "Because of her demeanor, her reputation, her wealth, her background as a European, she did seem to be aristocratic. But she was still very honest and frank and friendly; she never held me apart. But I did feel a little like a peanut farmer in the presence of some kind of semi-royalty."[14]

Three months later, Dominique, accompanied by Miles Glaser, went to Plains, Georgia, to stay with the Carters. The first evening, they went to a local Baptist church. "Sentimental, evangelical clichés," Dominique noted of the sermon. But she enjoyed meeting members of the congregation, observing that it also included African Americans, and was introduced by Carter to Millard Fuller, the founder of Habitat for Humanity.[15] "That was a very exciting time for me and Rosalynn to have her come down to our home because we looked on Mrs. de Menil as a heroine," Carter remembered.[16]

She spent the night at the Carters' house, then, after a breakfast of scrambled eggs, grits, bacon, and coffee, Jimmy Carter presented his ideas on how they might work together. "The term 'partnership' has a warm connotation which I like yet 'collaboration' might be closer to reality," Dominique wrote, once she had returned to Houston. "I do not see an integrated organization but rather a cooperative relationship by which the common goals of the Carter Center and Rothko Chapel could be implemented."[17]

Semantics aside, Dominique—instead of working on behalf of the Carter Center—envisioned a joint program that would benefit and draw on the strengths of both organizations.

That fall, on October 10, 1985, she invited a group to her New York town house for an event she called the Human Rights Luncheon. There were fifteen around the dining room table, with Carter at one end and Dominique at the other. Guests included former deputy secretary of state Warren Christopher; Robert Bernstein, chairman of Helsinki Watch; Jack Healey, executive director of Amnesty International; Michael Posner, director of the Lawyers Committee for Human Rights; and Orville Schell and Aryeh Neier of Americas Watch (which in 1988 became Human Rights Watch).

By the following month, November 1985, Dominique and Carter had finalized plans for their working relationship, initiating a program they titled the Carter-Menil Human Rights Prize.[18] They resolved to search throughout the world, identifying human rights heroes they would honor with the award and a $100,000 prize. It would be, as Dominique had wanted, a joint venture. "She was not at all willing just to give us 100,000 bucks a year and see the Carter Center give it away," Jimmy Carter recalled. "She was intimately involved. In fact, I would say she was the dominant factor." The former president recalled that if they had a disagreement about who should be the recipient, her opinions tended to be more focused than his. "If we did have a disagreement, invariably, I deferred to her," Carter said. "She knew what she wanted and she had very strong opinions. She was not in any way unpleasant, but she was fairly inflexible."[19]

It was unusual for a private individual to be so involved in issues of international relations along with statesmen, rights activists, and a former president. Dominique, however, showed herself to have a firm grasp of world affairs.

The discussions that Dominique had with Carter about international rights issues, impressively, helped give focus to his post-presidency. "She was an inspiration to me; she led me to be much more bolder than I, perhaps, would have been in endorsing the concept of human rights as a major project."[20] As she and Carter began working together, Dominique had a revealing interaction with his successor. In July 1986, President Ronald Reagan invited her to the White House to be awarded a prestigious National Medal of Arts. It was a luncheon ceremony that also honored Willem de Kooning, Aaron Copland, Agnes de Mille, Eudora Welty, and Marian Anderson. Just a few months later, Dominique, showing that honors were less important than principles, particularly when it touched on human rights, spoke out against the president. "I don't think the administration is doing

enough—no, certainly not," she said of Reagan policies in San Salvador, Guatemala, and Nicaragua. "I'm very worried about what is happening in Central America."[21]

The first Carter-Menil Human Rights Prize was awarded in a ceremony at the Rothko Chapel on December 10, 1986. It was also the occasion of the second Rothko Chapel Awards for Commitment to Truth and Freedom, honoring a host of rights leaders from Czechoslovakia, South Africa, and the U.S.S.R., as well as the first Óscar Romero Award; awarded every other year, the latter was named after the archbishop of San Salvador who spoke out against social injustice and torture and was gunned down in March 1980 while conducting Mass. The first Óscar Romero Award was given to Bishop Leonidas Proaño Villalba, from Ecuador, who had been a friend and mentor to Bishop Romero. To offer those awards, Dominique brought to the chapel Desmond Tutu, the first black Anglican archbishop of Cape Town and a leading figure in the fight against apartheid.

Carter presented the Carter-Menil Human Rights Prize to Yuri Orlov, the scientist and Soviet dissident who had been released only weeks prior from nine years of harsh imprisonment, work camps, and exile in Siberia, and to the Group for Mutual Support, a Guatemalan organization that provided aid to families persecuted by the regime.

Equally important as the $100,000 grant was the attention it could bring to the causes. In advance of many of the ceremonies, Carter or Dominique would write an op-ed piece for *The New York Times, The Washington Post,* or *USA Today.*[22] Anne Schlumberger remembered Dominique's moments of frustration. "She was trying to get *The New York Times* or another paper to write about the refugee problem, and all they wanted to write about was the art."[23]

Over the years, Dominique and Carter organized many events around the world. In 1988, at the Carter Center in Atlanta, they awarded the Carter-Menil Human Rights Prize to members of the Sisulu family from South Africa: Walter Sisulu, the secretary-general of the African National Congress who had been a political prisoner for a quarter of a century, and Albertina Sisulu, a leading figure in the South African women's movement who had been under house arrest for most of those twenty-five years; many of their seven children had also been imprisoned, harassed, or exiled for their advocacy.

In her speech that day, Dominique stated emphatically that the South African government was in violation of the Universal Declaration of Human Rights, particularly Article 19, guaranteeing freedom of expression, and Article 21, ensuring participation in government individually or through representatives. As Dominique said,

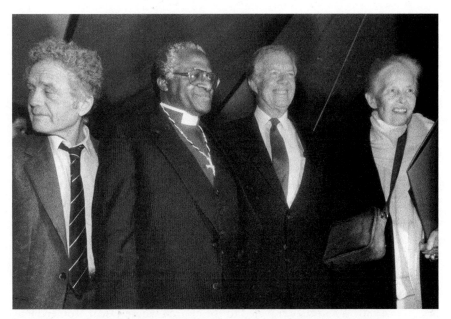

Dominique with, from left, Soviet dissident Yuri Orlov, Archbishop Desmond Tutu, and Jimmy Carter for the 1986 Carter-Menil Human Rights Prize at the Rothko Chapel.

I am a naturalized American, and I fundamentally adhere to the basic tenets of the United States. I thoroughly believe in democracy. Thus, I am upset when I find great discrepancy, even contradictions, in our behavior concerning democracy. In our dealings with certain countries, we want to enforce democracy at almost any cost. We are belligerent missionaries for democracy. This has been, and is, the attitude toward Nicaragua. Arms were provided to rebels who wanted to overthrow the government by nondemocratic methods, indeed by totally undemocratic methods.

On the other hand, we give only lip service to the brave people who fight for democracy in South Africa. Even a ten-year-old child can see that we are not using the same measuring sticks, the same scales, with every country.

In 1989, at the Carter Center in Atlanta, the Carter-Menil Human Rights Prize was shared by two groups in the Holy Land, Al-Haq, a Palestinian organization that was the West Bank affiliate of the International Commission of Jurists, and B'Tselem, an Israeli group of lawyers, journalists, and legislators. It was a particularly meaningful award for Carter. Although Carter knew the region very well, Dominique was more aware of the internal workings of these two rights organizations. "Before we had

this enlightening conversation, I did not know that these were two, not competitive, but cooperative, groups in B'Tselem and Al-Haq," Carter said. "Although one was exclusively Israeli and the other was exclusively Palestinian, they coordinated their work because they had common problems of human rights abuse. So we decided to give both of them the awards and brought them together in the same ceremony."[24]

But Dominique was not reliant on Carter for her human rights action. She continued to do so much on her own for the Rothko Chapel. Don Easum, a longtime diplomat in the U.S. Foreign Service, had been the American ambassador to Upper Volta (1971–1974) and Nigeria (1975–1979) as well as the assistant secretary of state for African affairs under the Nixon and Ford administrations. President of the New York–based Africa-America Institute from 1980 to 1988, Easum had been a board member of the Rothko Chapel since 1983. He, along with Nabila Drooby, accompanied Dominique on some of her more adventurous trips to locate recipients. In 1990, they went to El Salvador, at the height of the civil war that had begun in 1980. When they traveled to the church where Óscar Romero had been assassinated, Dominique knelt in prayer and kissed the base of his tomb. The day, March 23, also happened to be her eighty-second birthday. As Dominique noted in her diary, "It could not have been a more extraordinary birthday."[25]

Also on the trip, they met with officials of the American embassy and a Salvadoran army general and government delegation who wanted to fly everyone by helicopter into the jungle to show them what difficulties they were facing with the rebels. Dominique declined. Dominique did meet with Medardo Gómez, the Lutheran bishop of San Salvador, and María Julia Hernández, a layperson who was director of the human rights office for the Salvadoran Catholic church. They had been identified as the next recipients of the Óscar Romero Award, to be given in Washington, D.C., the following month.

In 1993, Dominique traveled to Vienna in conjunction with the UN World Conference on Human Rights. There, in the gilded eighteenth-century Palais Pallavicini, she presented the Rothko Chapel Óscar Romero Award to *Oslobodenje* (Liberation), a daily newspaper in Sarajevo that had continued to publish independent reporting even as its city, including its own building, was demolished by shelling, street battles, and sniper fire. "I am supposed to make a few remarks," Dominique said in Vienna. "I would rather remain silent. So much has been said about the atrocities in Bosnia-Herzegovina and so little has been done. Talking sounds almost offensive."[26]

She went on to make a case, however, for why it was important to honor

the newspaper. "To become independent of the nationalist propaganda, people need to know facts and to judge objectively," Dominique stated. "So strong is the power of the media that it can turn a friend against a friend, a brother against a brother. Joseph Goebbels was a master at handling the media. With enough savoir faire, brains can be washed collectively within months. Only the strong resist." She singled out the four editors at *Oslobodenje*, whom she had brought to Vienna. She also cited other independent newspapers that were fighting the same combat in Sarajevo and several independent radio stations. "The strength of such clear-minded, generous, and determined people is heart lifting. It is with such people that the future lies."[27]

•

On February 10, 1990, Dominique was at home in New York when a remarkable piece of news was broadcast, as historic, in its own way, as the fall of the Berlin Wall only three months before, on November 9, 1989: African National Congress leader Nelson Mandela, after twenty-seven years as a political prisoner in South Africa, would be released the following day from the Victor Verster Prison in Paarl. Dominique noted that the French national news, on Antenne 2, "showed detailed scenes of the white community with swastika flags and banners reading, 'Hang Mandela.'"[28]

Dominique was in New York for a Rothko Chapel board meeting. The following morning, she and Nabila Drooby were at breakfast. "The television was in the kitchen," remembered Drooby. "We were watching the television, and there walks Nelson Mandela out of prison. I remember saying to Dominique, 'That's a man we should have in the chapel.' She said, 'Oh, you're not ambitious are you?'"[29]

Dominique, however, wanted to try. By 11:00 a.m., she had asked Don Easum over to the house for a meeting. What followed were interventions by Easum, Carter—who had already met Mandela—and many of the South African contacts Dominique had developed, in an attempt to persuade Mandela to make the trip to Houston.

Those months of dialogue led to one of the most meaningful public events in Dominique de Menil's life. On December 7 and 8, 1991, to commemorate the twentieth anniversary of the Rothko Chapel, were two days of ceremonies that included the Carter-Menil Human Rights Prize, the Óscar Romero Award, and the Rothko Awards for Commitment to Truth and Freedom. The keynote speaker was Nelson Mandela.

The ceremonies began on Saturday morning with a Mass at the Rothko Chapel in honor of those who had died from violations of human rights,

particularly six Salvadoran priests who had been murdered in El Salvador in 1989 and were being awarded posthumously the Carter-Menil Human Rights Prize. That evening was a gala dinner at the Menil Collection.

Joining Dominique, Carter, and Mandela were Texas governor Ann Richards, Houston mayor Kathy Whitmire, the Reverend Bill Lawson, all of the award recipients, and such human rights advocates as Bianca Jagger. There was a reception in the grand hallway, while Dominique gave the South African leader a tour of the galleries. The candlelit dinner was held in the entrance of the museum, where Robert Indiana's *Love Cross* (1968), a fifteen-foot-tall sculpture in bold red letters on a background of blue that Dominique and John had commissioned from the artist, was on the main wall behind the guests of honor.[30]

As Dominique stated that evening,

Mr. Mandela shows us that we can be strong and yet have an optimistic and open attitude.

The world is not a peaceable kingdom. Indeed, strength is needed. But strength to unite with one another or else the world will disunite. Strength to integrate our efforts or else the world will disintegrate.

Apartheid makes life unlivable for black Africans. It has been

Dominique and Nelson Mandela at the Carter-Menil Human Rights Prize, 1991.

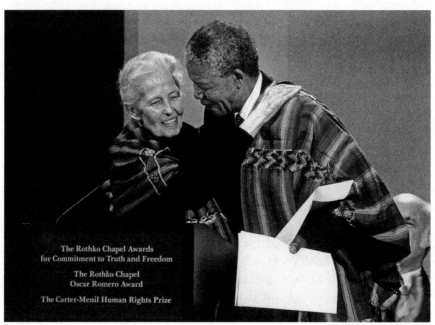

condemned by the United Nations and by nations individually. In his fight against apartheid, Nelson Mandela endured 27 years of prison without letting bitterness enter into his heart and obscure his judgment.

This noble attitude gives us the conviction that the force of justice and the power of goodness bear fruit.

It gives us the conviction that what is best in us will prevail.[31]

Sitting at the main table, under the Indiana sculpture, Dominique and Mandela spoke throughout the evening. Jimmy Carter had the impression that she had a vast reserve of topics stored in her mind that she had hoped to discuss with him. "I hate to say it, but I kind of felt left out," Carter recalled. "Once they finished discussing one subject, she had another immediately to put on the table between them. And I kind of sat in the background, without really a chance to participate, but he was obviously revered by her."[32]

The ceremony took place the following evening in the Rothko Chapel and in a big tent erected outside, with large screens broadcasting the speeches and presentations. Carter gave the Carter-Menil prize to the University of Central America in San Salvador in honor of the six Jesuit priests at the school who had been killed two years earlier when masked members of an elite unit of the Salvadoran army burst into their residence and gunned down everyone (including a housekeeper and her daughter).

Mandela, who had spoken in the museum the night before about the ANC and the need for support of the struggle in South Africa, expanded his vision for the keynote address, delivering a rousing talk on the importance of standing up for rights around the world. "Our common humanity transcends the oceans and all national boundaries," Mandela stated. "It binds us together to unite in a common cause against tyranny, to act together in defense of our very humanity. Let it never be asked of any one of us, what did we do when we knew that another was oppressed?"[33]

At the end of the ceremony, Dominique called Mandela to the podium. In an unplanned gesture, she made a concrete act in support of the South African leader. "As always, when men or women commit themselves totally to an indisputable just cause, our hearts and souls respond with fervor and gratitude," Dominique said. "To express this fervor and gratitude, the Rothko Chapel is presenting to you, Mr. Mandela, a very exceptional award for Truth and Freedom of $100,000. May it be a token of our solidarity with your fight against apartheid, which has become today a universal concern of humanity."[34]

Perhaps one of the more charming moments of the weekend occurred earlier in the evening, during the distribution of the Rothko Chapel Awards

for Commitment to Truth and Freedom. There were a total of eight individuals and small groups from Guatemala, Honduras, and El Salvador. Sebastian Suy Perebal, the youngest of the recipients, was from a small village in Guatemala. He had been carrying a plastic bag with him throughout the evening. "We had tried to take this bag away from him because we wanted the decorum to be right," recalled Nabila Drooby. "He clung to it, so we left it." During the ceremony, Perebal opened the bag and unfurled four shawls that had been hand woven in his village and presented them to Dominique, Mandela, Carter, and Ann Richards. Mandela immediately draped it over his left shoulder and wore it throughout the ceremony.

During his stay in Houston, Nelson Mandela met with local business leaders and spoke at Texas Southern University. He was emphatic about the importance of the Rothko Chapel initiatives. "As long as there are men and women like Jimmy Carter and Dominique de Menil," Mandela replied, when asked why he had made the long journey from South Africa to Texas, "the fight for human rights will rage on and we will win."[35]

BYZANTIUM

*The icon is the presence of the divine in the world. To express
this sacredness, it had to be unrealistic, appear as from another
world. Mosaics; no depth; the figures seem to float. Their
frontality, their intense gaze are almost hypnotic. They have a
power of incantation.*
—*DOMINIQUE DE MENIL*[1]

When Dominique was growing up, there was only
one member of her entire extended family who was
engaged in a serious way with the world of art. Gustave Schlumberger
(1844–1929), an important historian, numismatist, and author who spe-
cialized in the Byzantine Empire, was a grandson of the younger brother
of Nicolas Schlumberger, Dominique's great-great-grandfather. When she
was still a teenager, Dominique was in contact with her relative, then in
his eighties. "My dear, charming niece," Gustave Schlumberger wrote to
Dominique when she was eighteen. "The delicious letter you sent me this
morning has delighted me. It would be impossible to say anything kinder in
a more spiritual way. Why don't you come to see me on a Friday morning,
say 10:00; I could give you some of my books that might interest you."[2]

Born in Guebwiller, Gustave Schlumberger moved to Paris in 1863 to
study medicine. During the Franco-Prussian War, he served in the French
army as a medic. After traveling extensively—North Africa, Syria, Anato-
lia, and throughout the Mediterranean—he began his intensive research
into the history of the Crusades and Byzantium. He was president of the
Société des Antiquaires de France and a member of the Académie des
Inscriptions et Belles-Lettres and, in 1903, was awarded the Medal of the
Royal Numismatic Society from London. Gustave Schlumberger has been
considered the founder of the French field of Byzantine studies and has been
credited with popularizing the field internationally.[3] "Heir of the ancient
Roman Empire, straddling the limits between East and West, it defended
itself for one thousand years with an unparalleled energy," he wrote of the
Byzantine world.[4]

Gustave was also a noted collector. At his death, shortly after Domi-

nique turned twenty-one, he left to the Louvre Museum a significant grouping of antiquities: Greek and Roman bronzes, Greek terra-cotta vases, bronze plaques from the neo-Assyrian Balawat Gates, and stylized Egyptian sculptures in stone and alabaster. To the Bibliothèque Nationale de France, and its Cabinet des Médailles, he left a remarkable collection of Roman coins as well as Byzantine rings, amulets, seals, and devotional objects. For the Museum of Strasbourg in the historic Palais Rohan, now the Musée Archéologique, Gustave Schlumberger left an impressive collection that included ancient Egyptian, Greek, Roman, and Etruscan statuettes and bronzes along with Byzantine sculptures and bas-reliefs.[5]

Dominique and John had several of his books in their library at the rue Las Cases, including a nine-hundred-page study of Nikephoros II Phokas, the tenth-century Byzantine emperor (*Un empereur byzantin au dixième siècle*) and a treatise on the fifteenth-century fall of Constantinople that ended the Byzantine Empire (*Le siège, la prise et le sac de Constantinople par les Turcs en 1453*). The volumes were important enough for the de Menils that they transferred them to their personal library in Houston.[6]

In the summer of 1957, Dominique had lunch with Meyer Schapiro, who was effusive about Gustave Schlumberger. "His book on the Byzantine seals is a classic," Schapiro told Dominique. "He learned Greek, Armenian, ancient Aramaic, and so on in order to be able to read the texts himself; he went straight to the original sources."[7] In the spring of 1977, Dominique took detailed notes on another text by Gustave Schlumberger, *Byzance et croisades: Pages médiévales*.[8]

And in November 1988, Dominique stood in an auditorium at the University of St. Thomas, welcoming over a hundred international art historians and scholars to the Fourteenth Annual Byzantine Studies Conference. "It is an honor for Houston and for the museum to welcome you," she told the assembled scholars. "For me, it is a very special pleasure because there was always a love and a reverence for Byzantium in my family, thanks to Gustave Schlumberger. Maybe this is the reason I have been attracted, almost compelled, to acquire a few artifacts from Byzantium as tangible proof of its past existence."[9]

•

Dominique and John de Menil, rare for such accomplished collectors of contemporary art, had a long, profound relationship with the culture of Eastern Christianity. It began when Dominique took that business trip in 1933 to Moscow with her father and she found that large sixteenth-century Russian Orthodox icon of Saint George slaying the dragon. Dominique and

John always considered the icon the first painting that they had bought together.

Once the panel arrived in Paris, the de Menils took it to an expert artisan, Chauffrey et Muller at 17, Quai des Grands Augustins, who transferred it onto a new wooden board. In May 1940, during World War II, Dominique had felt strongly enough about the Saint George icon to carefully wrap it up and carry it with her as she evacuated Paris for her mother's house in Clairac in the midst of the mass exodus as France fell to the Nazis.

•

In February 1961, on a snowy evening in New York, Dominique had dinner at a Chinese restaurant with Christophe de Menil, Robert Thurman, and Alexandre Iolas. The young couple had just been to visit the dealer J. J. Klejman, where they had been intrigued by some examples of Asian art. Iolas shifted the conversation to Byzantium and the innovations of the art of the empire. "It was the booming West of the time," the dealer said with enthusiasm. Iolas went on to make a connection between the folding of robes on ancient Greek sculptures at the Parthenon and Byzantine art, a discourse Dominique felt was illuminating and poetic.

In 1964, Dominique and John were told by J. J. Klejman of an exciting collection of small Byzantine artifacts. They bought more than eight hundred small objects that had been gathered over thirty years by the dealer George Zacos, who had a stand in the Grand Bazaar of Istanbul. They were objects of daily living, from the seventh century to the twelfth century, many in bronze, including ornate keys and locks, seals, rings, scales, weights, and measures.

To catalog the collection of artifacts, the de Menils hired Marvin Ross, the curator of the Marjorie Merriweather Post Collection at the Hillwood Estate Museum in Washington, D.C. Ross had also worked with Dumbarton Oaks Research Library and Collection, the noted center for Byzantine studies in Georgetown. Because he also had a professional relationship with J. J. Klejman, John decided to have the objects sent directly to Ross in Washington. The curator then studied the pieces, numbered them, took photographs, and began making notes. The de Menils hoped to mount an exhibition of the distinctive collection, so, as Ross completed his work, he sent the pieces to Houston.

The cataloging stalled before it was halfway finished until one day in 1975 when the curator phoned Houston to say that he was ready to continue. Dominique asked collections curator Mary Jane Victor to go with her into one of the children's bedrooms where the pieces Ross sent had been

stored for many years. They had been placed in file drawers, packaged in brown paper, and wrapped with twine. As Dominique and Mary Jane carefully unwrapped and opened the hundreds of small packages, both were delighted to discover these artifacts of daily life in Constantinople. After a visit to Houston to consult the pieces there, Ross died in April 1977.[10]

The following year, Dominique de Menil hired Dr. Gary Vikan, a young curator at Dumbarton Oaks, to continue cataloging the unusual collection and to organize an exhibition. *Security in Byzantium: Locking, Sealing, and Weighing* at the Institute for the Arts at Rice University (March 15– May 24, 1981) contained almost three hundred objects made from bronze, lead, gold, terra-cotta, glass, and various gemstones. The vast majority came from the de Menils, but there were also loans from Dumbarton Oaks and the Fogg Museum.

Security in Byzantium traveled internationally to Vancouver, at the University of British Columbia's Museum of Anthropology, and to Vienna, at the Museum für Völkerkunde. Its final European venue, at Dominique's request, was the Cabinet des Médailles at the Bibliothèque Nationale in Paris in honor of Gustave Schlumberger.

•

In the years when the de Menils were documenting that first Byzantine collection, they made other purchases. The most important, bought in 1968, also from J. J. Klejman, was the miniature gold reliquary that Dominique installed in the opening gallery of *Rhyme and Reason*. Measuring only one and three-quarters inches high, two and a half inches long, and one and three-eighths inches wide, it dated to around 500 A.D. and was said to have come from Stobi, in the former Yugoslav Republic of Macedonia.

In June 1979, Dominique had lunch in Basel with the Dumbarton Oaks curator, Gary Vikan, and the Turkish dealer George Zacos, who had moved from Istanbul to Switzerland, and his wife, Janet. After lunch, Zacos showed Dominique and Vikan a stack of small eleventh-century bowls from a shipwreck off the coast of Turkey; she sifted through the objects, selecting examples with human or animal figures that she decided to use as Christmas presents that year. On the living room floor, Zacos laid out two hundred small objects, clearly related to the first grouping of eight hundred that the de Menils owned, from dozens of fifth- and sixth-century bronze stamps with inscriptions to engraved, painted medallions from the twelfth and thirteenth centuries. Dominique bought the entire collection. "Then followed the most amazing moment in an amazing day," Vikan recalled.

"George looked at me after Dominique de Menil left his apartment and said, 'Who was that?'"[11]

In the spring of 1985, during the period that Dominique was sharpening the collection before opening the museum, she was presented with the opportunity of expanding her Byzantine holdings in a spectacular way. Eric Bradley (1924–2002) was an English collector who had assembled sixty-one Russian and Byzantine icons of exceptional quality; he had purchased most of his icons in the 1960s and 1970s through a very well-respected dealer, Richard Temple, founder of the Temple Gallery in London. Bradley lived with his family on Keats Grove in Hampstead, North London. By the mid-1980s, Bradley was prepared to sell his entire collection. He spent a year discussing the purchase with the British Museum, which was unable to come up with the necessary funds.

Bradley was working with Yanni Petsopoulos, a London dealer of antiquities, from whom Dominique had bought two other icons. Bertrand Davezac, the chief curator for the Menil Collection, had met with Petsopoulos, had seen Bradley's collection, and was encouraging Dominique to buy it all. She was hesitant, afraid that this collection was too large, too expensive, and too ambitious in comparison with her other Byzantine holdings. Dominique flew to London to meet Bradley. She was delighted by the collector, whom she found to be knowledgeable and passionate, charmed by the gallery he had built in his basement, and astounded by the collection. "At the entrance were two angels," Dominique noted in her date book. Those first panels she saw were *Entry into Jerusalem* (Russia, Moscow School, sixteenth century) and *Raising of Lazarus* (Russian, Novgorod School, 1400). "Such nuances of rose, verdigris, umber, and geranium—mind-blowing!"[12]

Back in Houston, Dominique considered the purchase and negotiated a price. Then, on March 23, only eight days after their first meeting, Bradley agreed to sell her fifty-eight icons from his collection (he kept three panels to leave for his children). It was a considerable sum: 2.5 million pounds. To cover the funds, Dominique had eighty thousand shares of Schlumberger transferred to the Menil Foundation.

Annemarie Weyl Carr, an art historian teaching at Southern Methodist University in Dallas who specialized in the Byzantine world, felt that Dominique was ahead of many others in appreciating icons. Gary Vikan said of the icon group, "It's a superb collection, one of the best ever put together for a private individual."[13] Princeton University's Kurt Weitzmann, considered the most important American Byzantine scholar of the twentieth century, concluded a keynote address by singling out the Menil Collection icons as a major event in the history of collecting Byzantine art in America.[14]

•

In early June 1983, in the Collection Room at the de Menil house in Houston, a phone call from London marked the beginning of a remarkable adventure that would last almost fifteen years, involving a little-known Byzantine masterpiece, shadowy art thieves, and a noble, novel approach to the thorny issue of cultural heritage. Yanni Petsopoulos, the London dealer, called Dominique's office to say that he had come across something absolutely exceptional; the message was given to Bertrand Davezac, who, at that point, had been part of Dominique's team for four years. Their working relationship started on November 9, 1978, when Dominique was in Paris to attend the opening of an exhibition at the Decorative Arts Museum in Paris, *La traversée du temps perdu,* which had used archival correspondence, antique clothing, and decorative arts from Dominique's maternal ancestors in the southwest of France. As Dominique approached the museum, she ran into Davezac, whom she had met in New York and who was staying in Paris with her sister Sylvie Boissonnas. "I was waiting for the exhibition to open, it was terribly cold, and I see Dominique de Menil arrive," Davezac recalled. "She said to me, in her very decisive way, 'I hear that you are thinking of returning to France, but you know there is nothing for you here. Why don't you come join me in Houston?'"[15]

Davezac had been in the United States since the 1950s. After gaining his Ph.D. in art history from Columbia, he taught art history at Indiana University and then at Penn State, specializing in the Middle Ages. Dominique told him to meet her at the rue Las Cases at 10:00 p.m. "That was typical, absolutely no sense of time, and it pleased me enormously," Davezac recalled. When he returned to the Boissonnas house, he found a message from Dominique, explaining that her plans had changed and would he come instead at midnight. "She didn't even ask if it might be an issue for me, if I might be sleeping perhaps—nothing like that—and I loved it."[16]

Within two months, Dominique brought Davezac to Houston for his first visit, arranging his entrance onto the faculty at Rice University and beginning to familiarize him with the collection.[17] In early June 1983, when Davezac was given the message from Petsopoulos, he was preparing to join Dominique in Paris for one of her Pompidou Center trips. "So I stopped by London to see this Yanni Petsopoulos, who was also a friend," Davezac recalled. "I said to him, 'Yanni, what could you have said to Mary Jane—she said that you had something absolutely exceptional?'" Petsopoulos, giving the impression that he did not know what he was talking about, showed the curator an icon. "It's lovely," Davezac said. "But I don't think it's that. Apparently, it's something completely out of the ordinary

that might interest us or that you would consider proposing to Dumbarton Oaks." After a moment, the dealer said, "Oh, yes! It is not something I have seen yet. It is a collector in Munich who has proposed it to us. I have some photos but they are not too good." Only then did Petsopoulos reveal what he had to offer, taking out black-and-white photographs of a complete interior of a Byzantine votive chapel, in situ, with a series of beautiful frescoes that covered the cupola and the apse.

The following day, Davezac was in Paris, meeting Dominique at the Meurice hotel, where the Pompidou group was staying. As a medievalist, he was to accompany them to Chartres to explain the cathedral. In the lobby of the Meurice, Davezac spoke passionately about the frescoes. Dominique asked about the cost, suggesting that it must be unaffordable. "I told her the price, around $600,000, and she said, 'That's all?' "[18]

The next day, Dominique and Walter Hopps decided that they would like to see the frescoes. They had been cut up into thirty-eight pieces, had been removed from their site, and were being stored in Munich by a shadowy figure Petsopoulos called a collector but who was, in fact, an art thief. Aydin Dikmen was a Turkish businessman who said that the frescoes had been discovered in Turkey when a construction site exposed the chapel and that they had been legally removed. Five years later, Dikmen would become notorious when he sold for $1 million stolen sixth-century mosaic fragments from Cyprus to Indianapolis dealer Peg L. Goldberg; in 1991, her purchase was overturned in court and she was forced to return the objects to Cyprus. Dominique, Hopps, and Davezac made plans to go to Munich to see the frescoes.

•

Actually, Petsopoulos had already discussed the frescoes in the United States weeks before he called Houston. On April 28, 1983, Gary Vikan, who had become the senior associate at Dumbarton Oaks, welcomed Petsopoulos into his second-floor office at the museum. The dealer closed the door and asked if they could discuss something in complete confidence. He showed a rough sketch of a Byzantine church, possibly thirteenth or fourteenth century, on what appeared to be a rock ledge. "Yanni told me that this church had been discovered accidently by workmen bulldozing the dirt from a hillside to build a youth hostel in the area of Binbirkilise in southeastern Turkey," Vikan wrote in his memoirs. Vikan was skeptical about the story. Petsopoulos then showed him two photographs of the frescoes, which he would later show to Davezac.

The conversation conjured up images of an underworld figure with

a rotary saw and individual frescoes that would be dispersed into private apartments in Geneva or London. The dealer told him that his mission was to save the frescoes. As Vikan wrote,

> I recall saying immediately that Dumbarton Oaks could not get near these frescoes, given that no matter what the circumstances of discovery, this was a real church, with real frescoes, in a real place and no public institution could get involved as the beneficiary of its recent desecration.
>
> It was obvious to me that Yanni's rescue plan was a combination of public spiritedness (after all, he is Greek and a passionate connoisseur of all things Byzantine) and a dealer's self interest, since he would stand to make a lot of money brokering the rescue. But what worked so neatly for Petsopoulos seemed to me a practical and ethical hornet's nest for any institutional buyer.[19]

Yanni Petsopoulos brusquely declined to participate in this account of the Byzantine frescoes.[20]

•

On June 21, 1983, Dominique de Menil, her assistant Elsian Cozens, Walter Hopps, Bertrand Davezac, and Yanni Petsopoulos arrived in Munich to meet this collector and inspect the frescoes. There were serious concerns about the trip. What were the implications if the institution were to be involved firsthand with smugglers? And there were real questions about personal safety. François de Menil was concerned enough that he went to a police supply store in New York to buy his mother a bulletproof vest, which she wore for the meeting.

Under an oppressive heat, Dominique and the group went to the Eden Hotel Wolff, across from Munich's main train station, to meet with two Turkish men, Aydin Dikmen and an associate. Neither spoke English, so the conversation had to be translated from Turkish to Greek, then Greek to English. "We failed to appreciate the comedy of the situation as we soon gained the chilling impression that something was wrong," Davezac later wrote. The curator detailed what happened next:

> After preliminary inquiries about the murals, we were driven off to see them. We were taken to a small flat in a lower middle-class section of Munich. The one-room apartment was very dark and . . . in the recesses of the room, two candles were burning dimly next

to two frescoed panels propped on a low ledge and leaning against the wall: on one panel was an angel and on the other the Baptist, both set off against a grimy dark blue background. That is all that we were shown. A huge doleful crate standing by the wall occupied much of the room space. It contained the cut-out plaster segments of the murals, stacked up like beehive honeycomb racks, one against another.[21]

Dominique was sickened by the sight of such a spiritual work treated in such a sacrilegious way. "The pieces were too chopped up to derive any impression of beauty," she later explained. "It was like a miserable human being that has to be brought to the hospital."[22]

The abandoned apartment with no electricity was not a place they could discuss any business so Dikmen drove everyone to his apartment in another section of Munich. Petsopoulos was the only person Dikmen knew by name; Dominique did not reveal her identity nor that of the foundation. Dikmen explained that his main business was the salvage of derelict ships for scrap metal but that he had recently been involved in building a small resort in southern Anatolia. He claimed that as a hillside was being bulldozed, a small church was discovered under the rubble; the same story Petsopoulos had told to Vikan. Dikmen said that the frescoes had been found in this chapel, and he presented an official export permit granted by the Turkish authorities.

Dominique and her team knew that he was lying. So their first consideration was to determine the actual origin of the murals. They also noticed that Dikmen was very nervous. "Because he knew neither our identities nor our intent, we feared for the very safety of the murals," Davezac wrote. "He might just spirit them away or fragment them further for easier piecemeal disposition or even destroy them as incriminating evidence."[23]

Dominique was determined to act. As she later said of her decision, "If someone is drowning in front of you, even though you can hardly swim, you are tempted to jump into the water."[24]

•

All of Dominique's colleagues agreed about the importance of trying to save the frescoes. To buy them, restore them, and bring them back to Houston, however, was a daunting task and an ethical minefield. Yet even Walter Hopps, who was much more comfortable in modern and contemporary art, was insistent about the significance of the undertaking. Dominique said to him, "This is going to cost more than a Jackson Pollock and you love a

Pollock; why are you pursuing this so diligently?" Hopps felt the frescoes fit perfectly into the artistic mission in Houston. "There are museums all around the world where there will be great Pollocks, but there will be no other place where a mid-twentieth-century iconoclast, the Rothko Chapel, will be a few minutes' walk from the height of Christian iconography that will be the Byzantine Chapel," Hopps explained to Dominique. "It's the possibility of having both, both absolutely spiritual works that could not be more different; that will be unique in the world."[25]

By the end of June, Dominique had engaged Herbert Brownell Jr., the former attorney general under President Dwight D. Eisenhower, of the New York law firm of Lord, Day & Lord, to handle all legal issues related to the frescoes. Brownell described to Dominique the uncertainty of the laws covering the purchase of art from a dealer who could not definitely establish the provenance of the art. They discussed UNESCO conventions, which, because they focused on the repatriation of works of art, did not seem to apply. As Brownell recalled, "Mrs. de Menil decided that regardless of legal rules and untested standards, she would exert every effort to find the true owner of the frescoes."[26]

At the end of July, Bertrand Davezac contacted Southern Methodist University's Annemarie Carr, considered the leading scholar on Cypriot frescoes. When he showed her the same two black-and-white photographs of the works in situ, she immediately understood their significance. As she told Davezac, "It is a scholar's dream to discover an unknown work of art, but this is a masterpiece falling into my lap!" Dominique brought Professor Carr down to Houston, asking her to stay in the house for a week, so that she could begin to research and write about the Lysi frescoes. "And from the photos, I was persuaded they were Cypriot," Carr later explained. "Just the character of the forms fit so well."[27]

In August, Herbert Brownell sent registered letters to the governments of nine countries that had been in the territory of the Byzantine Empire: Bulgaria, Cyprus, Greece, Israel, Lebanon, Romania, Syria, Turkey, and Yugoslavia. The letter, which did not identify the law firm's client, included photographs of the frescoes and what was known of their origin and asked for any information that might prove their provenance.

By the first week in September, the embassy of Cyprus informed Brownell that the mural paintings had belonged to the chapel of St. Themonianos, near the village of Lysi, on the Turkish sector of the island. The frescoes had been removed from the small church some time after the 1974 Turkish invasion and occupation. The proof offered by Cyprus was convincing, so negotiations began with the government and the Holy Archbish-

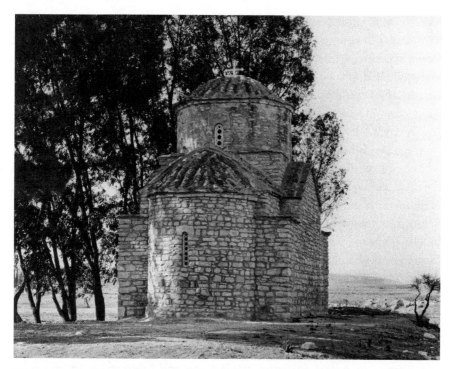

The chapel of St. Themonianos near Lysi, which had contained the stolen thirteenth-century frescoes.

opric of Cyprus in Nicosia. In late October, Dominique traveled to Nicosia to meet with the director of the Department of Antiquities.

On November 11, it was agreed that the Menil Foundation would buy the frescoes for the Church of Cyprus and pay to have them restored and that the church would agree to their extended loan to the foundation. By the end of the year, the funds for the purchase were placed in an escrow account of a Swiss bank, Lloyds Bank International in Geneva, to be released to Dikmen only once the fragments had been transferred to London, where they would be inspected and verified. In January 1984, the Lysi frescoes were transported from Munich to London. In Greenwich, a conservation studio was established for a complete restoration by Laurence Morrocco, an expert in Byzantine painting and mosaic. Other members of the team were the engineer Peter Rice, of Ove Arup in London, and Carol Mancusi-Ungaro, chief conservator of the Menil Collection. The shape of the original dome and apse was unknown and had to be imagined by taking precise measurements of the fragments and trial and error in their assembly.

At one point in the process, Dominique despaired of being able to com-

plete such an ambitious, costly project. Walter Hopps suggested that per-
haps it was beyond their capabilities, that perhaps they should talk to the
Getty Museum, which might have the resources. "She looked at me fiercely
and said, 'I don't want the Getty to have my frescoes,'" Hopps remem-
bered. "She was determined, both on the quality of the art and the spiritual
connection."[28]

In April 1988, after almost four years of meticulous cleaning, restora-
tion, reassembling, and inpainting, the reconstruction of the Lysi frescoes
was complete. The twenty-six pieces of the dome and twelve segments of
the apse had been brought back to life. The dome, approximately nine feet
in diameter and four feet in height, depicted the bust of the Christ Pantokra-
tor in the center, his eyes fixed on the viewer, surrounded on the exterior
by His Prepared Throne and fourteen winged angels. The apse, a curving
form approximately eight feet wide and three feet in height, depicted a full-
length Virgin, standing in a praying posture with both hands outstretched,
surrounded on either side by archangels. The palette of both murals was
shades of brown, tan, and gold. One of the most dominant colors—used
for the Virgin's gown, the Christ's robe, and the celestial background—was
a vivid blue.

After tremendous amounts of planning and preparation by the con-
servation team, half a dozen art movers descended on the Greenwich stu-
dio, carefully packing the two pieces and building crates around them. The
wooden container for the dome was over ten feet square and weighed more
than one ton. Workers had to demolish part of the wall of the studio in
order to create a large enough doorway. The objects were then forklifted
onto a truck, driven overnight to Paris, and then flown to Houston.[29]

•

Friday, November 11, was the opening of the Byzantine Studies Confer-
ence at the University of St. Thomas. After Dominique welcomed attend-
ees, the first day of the conference featured five sessions about a vast range
of topics, with titles such as "A History and Internal Life of the Empire"
and "Byzantine Literature: Language and Image." At the end of the day,
from 6:00 p.m. to 8:00 p.m., was a reception at the Menil Collection, where
the group of scholars discovered a pair of special surprises.

*Spirituality in the Christian East: Greek, Slavic, and Russian Icons
from the Menil Collection* (November 12, 1988–June 4, 1989) was the first
public exhibition of forty-eight of the Menil's Byzantine and Russian icons,
ranging from the sixth to the seventeenth century, many of which had come
from the Bradley collection. They were hung low, as Dominique liked, on

dark crimson walls that set off the muted colors and flashes of gold of the panels.

Dominique had another treat for the assembled guests. She arranged for Walter Hopps to accompany groups of scholars down into the basement storage area of the museum, where, for the first time, the restored Lysi frescoes were displayed. Impeccable lighting had been installed in the high-ceilinged space, and Professor Carr remembered, "People were ravished by them. The dome was just set upside down like a teacup. You could look into it, that extraordinary face of Christ."[30]

The issue of cultural heritage, however, was complex: Was it morally defensible to have ransomed these works and brought them back to Texas? Carr, who had been involved with the project for more than five years at that point, was conflicted. She had long known that they were being acquired and restored for the Church of Cyprus. She had not understood, however, that they were being brought to Texas. Other scholars had challenged Professor Carr about her involvement. "I was just trying to work my way through the basic questions," Carr recalled. "What is an art historian's relation to stolen objects? And what emerged was a fundamental trust of Mrs. de Menil. Yes, these are stolen objects, but they are being treated in a way that is exceptional and honorable—that is the imprimatur—I trust her."

•

The next question for Dominique de Menil, once the Lysi frescoes had safely arrived in the United States, was what to do with them. Some, including Bertrand Davezac, were encouraging her to place them permanently in the Menil Collection. Dominique wrote in the spring of 1989, "It leaves out their spiritual importance and betrays their original significance. Only a consecrated chapel, used for liturgical functions, would do spiritual justice to the frescoes."[31]

Dominique settled on a piece of land, just south of the Rothko Chapel and southeast of the museum, and approached the engineer Peter Rice about the project. The problem, she realized, was that referring to the original chapel in Lysi would lead to nothing more than an architectural simulacrum. As she admitted, "It would smack of Disneyland."[32]

Dominique discussed the situation with Walter Hopps, Paul Winkler, and Miles Glaser and came to the conclusion that she should approach her son François, who had received his architectural degree from Cooper Union in 1987 and was working for Kohn Pedersen Fox before opening his own practice. "I need you," Dominique wrote to François on April 25, 1989. "I

need your help to design a building for the Cypriot frescoes." She stressed that what they were doing was an innovation in museum policy. "For the first time, important fragments of a religious building are not considered only as antiquities. They are approached also as relics and consideration is given to their religious nature."[33]

A new foundation was formed, a fund-raising campaign was launched, and a name was chosen, the Byzantine Fresco Chapel. Dominique had spent over $2.5 million to buy the murals and restore them on behalf of the Church of Cyprus; the capital campaign raised over $4 million, primarily from foundations and individuals in New York and Houston, including the local Greek and Cypriot communities.

One day, Houston socialite and patron Lynn Wyatt received a phone call from Elsian Cozens, asking if she would like to meet Mrs. de Menil, not at the museum, but at Richmond Hall, another building she owned a couple blocks south. Originally a supermarket, it was a long, rectangular space with very high ceilings and concrete floors. As she entered the cavernous room, Dominique was sitting toward the opposite end. "Hello, Lynn, please start walking forward," Dominique said. "When I was about eight feet away from her, she said, 'Now stop and look up,'" Lynn Wyatt remembered. "Well, I looked straight up and there are these gorgeous frescoes, delicate and yet so powerful. They were so beautiful that I lay down on the floor to have a better look."[34] Dominique had transported the dome from the museum to the nearby building, providing patrons a dramatic preview of the thirteenth-century masterpiece.

François de Menil's design for the Byzantine Fresco Chapel—a $4 million, four-thousand-square-foot building—was a striking structure, both modern and soulful. The exterior was a bold cube of vertical planes of light gray concrete, surrounded by a stone wall, a subtle reference to the original chapel in Cyprus. Past a reflecting pool, which made the exterior seem to float, were deeply inset entrance doors of black steel. The interior spaces contained rough stones, opaque glass, and rich woods. Visitors were advised to take a moment in an anteroom of the chapel, where low light levels allowed their eyes to adjust. Stepping into the main space revealed a concrete box, forty-seven feet long, thirty feet wide, and twenty-nine feet tall. Within the walls was a second, smaller box in black steel, its width and length two feet less than the exterior walls. The inner box was suspended from above, also supported on the sides by black steel beams, and seemed to hover eight feet above the floor. Rows of skylights were positioned around the perimeter of the ceiling, bathing the concrete in sunlight and heightening the drama of the dark steel box; it was a modernist reliquary to contain the frescoes.

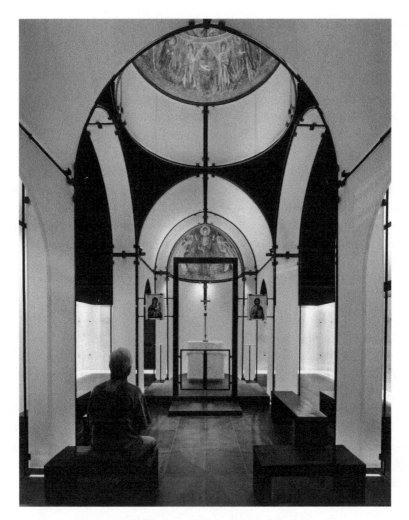

The restored dome and frescoes in the Byzantine Fresco Chapel,
the museum built for them.

In the center of the room were panes of frosted glass, supported by black steel, that were abstracted echoes of the interior arches and walls of the original chapel. Positioned within were rows of black wooden benches. A pair of Byzantine icons hung on either side of the altar. And installed in the exact same positions they had been in before being sliced out of the chapel in Lysi were the central dome and apse, glowing after their restoration. "It ranks as one of the most ambitious small religious buildings of recent years," wrote Paul Goldberger in *The New York Times*. "As a metaphor for the purpose of religious architecture, this could not be more clear: it is light within darkness within light, or the grace of the frescoes within the

hardness of the metal and concrete. Yet the metaphor is subtle and depends on the power of architecture as well as that of religious icons to achieve its spiritual effect."[35]

The Byzantine Fresco Chapel was inaugurated on Saturday, February 8, 1997. Dominique, after thanking former first lady Barbara Bush for her surprise visit to the ceremonies, told guests about the story of the pillage of the frescoes, their ransom, and the fourteen-year-long odyssey.[36] She introduced George H. W. Bush, who spoke about the significance of the chapel for Houston. Dominique spent the day in the chapel with its first visitors. As she wrote that night in her date book, "It's a triumph."[37] The following day, she returned, staying in the chapel from 11:00 a.m. to 7:00 p.m., observing how it was received. As Dominique noted that evening, there were "1,285 visitors. Extraordinary reaction from the public: enthusiasm, tears, a feeling of perfection."[38]

•

In June 1997, His Beatitude Archbishop Chrysostomos, the head of the Church of Cyprus, made the journey to Houston. In a lengthy religious ceremony, he officiated at the consecration of the Byzantine Fresco Chapel. The structure became a sanctioned sacred space.

When the design for the chapel was presented and approved in February 1992, Archbishop Chrysostomos had restarted the timing of the loan agreement for the frescoes: it would be for a period of twenty years from that moment. It had always been assumed that the loan agreement would be extended for periods of five or ten years, particularly considering that the island of Cyprus remained divided, with Lysi still occupied by the Turkish. But in the fall of 2011, the new head of the Church of Cyprus, His Beatitude Archbishop Chrysostomos II, who had been elected five years before, decided that he wanted the panels returned.

In February 2012, the frescoes were taken down from the chapel that had been built for them, moved to the Menil Collection for crating, and then flown back to Cyprus. In Nicosia, they were put on view at the Archbishop Makarios III Foundation Museum and Gallery until they can be placed back in the modest stone chapel at Lysi. The building in Houston was deconsecrated—the holy relic removed from the altar by a representative of the archbishop of Cyprus—stripped of its interior ornamentation that referred to the original chapel, and converted by the museum into a space for long-term installations of contemporary art. The first, *The Infinity Machine* (January 31, 2015–February 28, 2016) by Janet Cardiff and George Bures Miller, was a massive mobile of gilded mirrors that slowly

rotated in the center of the room, accompanied by a collage of recordings made by the NASA *Voyager* interstellar missions.

In recent decades, questions about cultural heritage, artistic looting, and the repatriation of antiquities have become only more pressing. It could be argued that it was wrong of Dominique to engage with thieves, that authorities should have been notified immediately. But would that have led to the frescoes' destruction or being broken up and scattered around the world? Instead, she chose to rescue the works, keep them together, have them restored, and ensure their existence for the future. Dominique de Menil's stewardship of the Lysi frescoes was only temporary, lasting a total of three decades. But there is no doubt that she approached the issue with tremendous generosity, integrity, and humility, qualities rarely associated with the world of plundered art and antiquities.

A NEW GENERATION

When they appear, great artists are not easily recognizable.
They use a new language that we have to learn before we can
understand them. They are at the heart of life, in tune with its
poignancy, expressing the inexpressible. They are explorers
of the unknown, the ministers of a mystery that cannot be
fathomed, the mystery of the world.
—DOMINIQUE DE MENIL[1]

One of Helen Winkler's responsibilities as a de Menil insider was to show visitors around the city, the house, and the Rothko Chapel. So, in the summer of 1971, when Heiner Friedrich, a thirty-three-year-old German-born dealer, visited Houston, the de Menils, who were not in town, asked her to take care of him. At his galleries in Munich and Cologne, Friedrich had done compelling exhibitions of such artists as Joseph Beuys, Sigmar Polke, Gerhard Richter, La Monte Young, Donald Judd, Walter De Maria, Dan Flavin, John Chamberlain, and Cy Twombly. Beginning in 1968, in conjunction with the 1972 Olympics in Munich, he worked to develop a plan for permanent installations by Andy Warhol, De Maria, and Flavin. When West German officials passed on the idea, Friedrich decided to move to New York, feeling that the American system of art foundations would be more conducive to his plans. In 1971, he opened the Heiner Friedrich Gallery at 141 Wooster Street in SoHo.

Friedrich had met the de Menils in Paris several years earlier and seen them before in Houston, but the 1971 trip was his first since the Rothko Chapel had been completed, earlier that year. As the official guide, Helen Winkler had her own set of keys for the chapel. Knowing that the light was best at sunrise and sunset, she made plans with Friedrich to be there throughout the day and night. "He was the first person in the art world who had come through, that I thought really understood what these paintings were actually about," Winkler explained. As she recalled, they spent the better part of forty-eight hours in the chapel. As Heiner Friedrich remem-

bered, however, "Helen and I spent seven nights at the Rothko Chapel."[2] Regardless of the exact number, Winkler and Friedrich experienced the massive Rothko panels under the best possible conditions, with the variations of light—from dawn to dusk to darkness—illuminating their complexity. "Heiner said, 'This is how it should be done; artists should be given this opportunity,'" Helen recalled. "And he started telling me about the artists he was working with, about Mike Heizer and Walter De Maria, and Dan Flavin. And that, for me, was the beginning of Dia."[3]

Friedrich was planning a trip out west to see some of the projects he was excited about and wanted the de Menils to go with him. John was battling cancer, so they asked Helen Winkler to go in their place. The following spring, she and Friedrich set off for the deserts of Nevada. Around eighty miles northeast of Las Vegas, they visited Michael Heizer's *Double Negative* (1969–1970), his first prominent earthwork and a seminal piece of what is usually termed land art, the movement that took as its canvas the vast American landscape. Built on property purchased for the artist by New York dealer Virginia Dwan, *Double Negative* consisted of two trenches 1,500 feet long, 50 feet deep, and 30 feet wide that Heizer dug into the edge of the Mormon Mesa; some 240,000 tons of desert rocks, primarily rhyolite and sandstone, had been carted out to create the piece.[4] The artist's term "negative sculpture" came from his conviction that absence, the space created by the trenches, was, in fact, sculptural.

Winkler and Friedrich also made the trek to see Walter De Maria's *Las Vegas Piece* (1969). The experience, for Helen Winkler, was profound, life changing:

> It is a piece by Walter De Maria that's cut diagonally north, south, east, and west in the center of the Tule Desert, several hours northeast of Las Vegas. You end up taking an impossible road for thirty-seven miles that you just have to know where to turn, at what cattle guard, and where to park. Then you start walking for about three-quarters of a mile until you literally step on this piece: this cut in the desert, eight feet wide, one foot deep, and one mile long. We got there and Heiner said, "You go this way, I'm going to go this way, do whatever you want, and we'll eventually meet back."
>
> So for hours, I was just totally alone; you fall asleep, wake up, dream. I had already gotten great energy from art, but I had the most incredible experience there that I have ever had. It filled me with such energy that, from that point on, all I wanted to do was just work with these artists.[5]

Friedrich insisted that they see both works at sunrise and sunset. So, over two days, they drove back and forth between Heizer's *Double Negative* and De Maria's *Las Vegas Piece*.

They also made a trip to Los Angeles and a Santa Monica installation by James Turrell. *Mendota Stoppages* (1967) was a pivotal work for the artist, housed in the former Mendota Hotel, that used light, space, architecture, and projection as sculpture. "My lifetime investigation of light began in those Mendota spaces," Turrell has said. "It was the ability to change the space itself by how light enters from the outside that began to extend my ideas and art practice."[6]

Helen Winkler returned to Houston convinced of the importance of this new generation of artists. That fall, she assisted Dominique with the planning of the Dan Flavin exhibition at Rice, an opportunity to work directly with the artists Friedrich believed in. Winkler became increasingly insistent to the de Menils about this group, extolling their virtues, underscoring their significance. She was so persistent that it became exhausting for Dominique and John. "I thought we should do this and we should do that," Winkler recalled. "It was a time that they really felt they needed to be clear about everything because John was dying."[7]

Helen Winker and the de Menils always began their workdays with breakfast in the kitchen at the house. One morning in September 1972, she was greeted by Dominique in an unusual way: "I have something to tell you but I can't tell so you have to come here and read this." Winkler sat down to read a handwritten letter from Dominique. It explained that they were not able to continue any longer, that they wanted her to take a year to do what she really wanted to do. "A one year sabbatical, starting immediately," was how the letter was phrased.[8] From Helen Winkler's point of view, it felt as if she were being fired. "It just crushed me," she recalled. "I was with them night and day, all the time. I couldn't believe it had come to that—and no one else could either—it was really shocking to everybody."[9]

Philippa was very surprised about her parents' decision. "It was harsh," she recalled. "But it was also like pushing the bird out of the nest. Sometimes, the parents know what will be better for the children."[10]

And, as they often were, the de Menils were remarkably generous. They had already started a trust for Winkler, funds for her to use specifically for real estate or medical expenses. When Dominique and John decided on the sabbatical, they gave her a car, a salary for a full year, and full expenses. As Helen Winkler finished reading the letter, John was waiting for her in the kitchen. "He said, 'I know how hurt you are.' I mean, I was just sobbing. He added, 'But I promise you that this is the best thing we could have done

for you.' And, of course, it was, because, after that, we went out and started Dia."[11]

•

Winkler decamped for New York and began investigating the availability of land in New Mexico for Walter De Maria, for what would eventually become *The Lightning Field* (1977), and stayed in contact with James Turrell about his plans for what became *Roden Crater.* And she made more trips to the Nevada desert to see the pieces by Heizer and De Maria.

In the 1960s, Helen Winkler, at the encouragement of Jerry MacAgy, entered the Institute of Fine Arts at New York University to get a master's degree in art history. She discovered that she was not interested in graduate school and lasted only a semester. But, staying at the de Menils' town house, she became very friendly with Philippa, then in her final year at the Brearley School. So, in August 1973, Winkler invited Philippa and Francesco Pellizzi to make the pilgrimage to see *Double Negative* and *Las Vegas Piece.* They, too, were astounded. "I brought Phip in," Winkler explained. "Actually, I didn't; the art did."[12]

In September 1974, in New York, Philippa de Menil, Heiner Friedrich, and Helen Winkler founded a new kind of cultural organization: the Dia Art Foundation, as it was originally called. "The purpose of Dia was to help realize large-scale works of art, maintain them, and dedicate them to the public in the best manner possible," explained Winkler. They chose to call their group Dia, from the Greek word meaning "through," suggesting that it was intended to be a conduit between the artist and the public. Dominique agreed to be on the advisory council.

"Dia was a great adventure," Philippa recalled. "My relation to Heiner reminds me a bit of my relation to my parents. It was very productive; we just had that chemistry. He was very much a doer; Dia is really his child, along with the artists. But I plunged in. I started bringing funds to it, and then that is when we started becoming very active, very quickly."[13]

Throughout the 1970s and into the 1980s, Dia financed and supported many extraordinary projects. *The Lightning Field,* in the high desert of western New Mexico, near the small town of Quemado, was a vast field in an isolated valley, one mile long and one kilometer wide, with four hundred polished stainless steel poles sunk into the ground in a grid, spaced 220 feet apart and, though the ground elevation varied, culminating at the same height. Winkler and her husband, Robert Fosdick, spent about three and a half years in New Mexico helping to execute *The Lightning Field.* "I went

out to be the chief cook, bottle washer, check writer, and peacemaker," she recalled. "We built the field and then had to figure out how people should see it and the whole structure around it."[14]

For Donald Judd, Dia bought Fort Russell—an abandoned army post on 340 acres of scrubland in the high desert of West Texas—and a dusty old town called Marfa. From 1979 through 1994, Judd created and installed at Marfa many examples of his work as well as those by artist friends such as Dan Flavin and John Chamberlain. His rigorous aesthetic, and Dia's largesse, turned two massive former artillery sheds into one of the high points of minimalism, *100 Untitled Works in Mill Aluminum* (1982–1986).

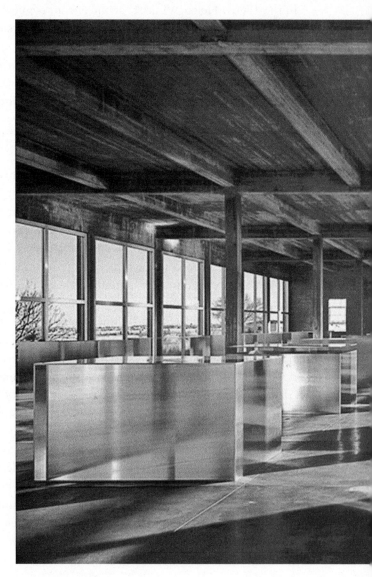

100 Untitled Works in Mill Aluminum (1982–1986) by Donald Judd, in one of the artillery sheds at Marfa.

Judd built soaring new metal roofs on the buildings, polished the expansive concrete floors, and replaced the southern walls with floor-to-ceiling glass that flooded the spaces with sharp sunlight and views of the scrubland and mountains in the distance. Lined up along the floors were a hundred gleaming rectangular boxes, each with the same dimensions, forty-one by fifty-one by seventy-two inches. The size and outer dimensions were exactly the same, but each box contained a unique configuration of interior planes. Dia spent $5 million on Judd's vision in Marfa.

In 1977, Friedrich's SoHo gallery became a permanent site for Walter De Maria's *New York Earth Room*, 280,000 pounds of dirt trucked in and

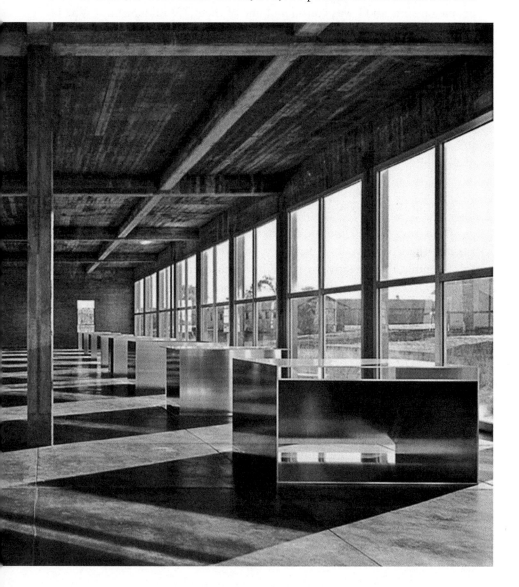

spread twenty-two inches deep across the thirty-six-hundred-square-foot space. In 1979, Dia lavished $4 million on *Dream House* by La Monte Young and Marian Zazeela in a building at 6 Harrison Street in Tribeca, the most elaborate manifestation of Zazeela's light projections and Young's hypnotic electronic music. They funded James Turrell as he began his *Roden Crater* in Arizona, and they organized an ongoing series of performances by Robert Whitman in New York. "It was a great time, the early days of Dia," recalled Helen Winkler. "We were able to get a lot of people interested in those works." Awareness and participation in the organization snowballed as well. "Before I left New York to live at *The Lightning Field*, Dia had two people on staff and I was considered one of them," Winkler said. "When I came back, there were over a hundred people working for Dia."[15]

Philippa and Heiner Friedrich also fell in love, marrying in 1979, two years before she became a Sufi and adopted the name Fariha. The organization that they founded seemed to take the generous patronage of the de Menils, and their complete respect for the artistic act, and apply it to an entirely new generation of artists. So were her parents encouraging about this venture? "Yes, in the beginning," she said. "But then my mother was afraid that I was going to lose all of my money. Which is what happened."[16]

•

Over the years, Dominique was captivated by some of the Dia artists and their projects. In April 1979, she went with her daughter to see a Cy Twombly retrospective at the Whitney Museum. "For the first time I really *saw* Twombly," she noted in her date book.[17] Writing to Father André Scrima, her great confidant, Dominique mentioned that the Twombly show made her realize what a positive impact the Dia adventure was having on her youngest child. "She was delicious, alive, tender," Dominique wrote of Fariha. "Heiner seems to give her that which she needs the most: a reason to live. She is living not for Heiner, however, but for the artists that she works with who are all of the first order: La Monte Young, Walter De Maria, Dan Flavin, Cy Twombly, and a few others. Heiner allows her to make things happen."[18]

In September 1980, Dominique, then seventy-two years old, made the trek to *The Lightning Field*. She took an early morning flight from Houston to Albuquerque, traveling with a young French art historian and curator, Hélène Lassalle. In the New Mexico capital, they had lunch with Helen Winkler before driving several hours west and south toward the site. It was cold and had been raining for days. "Long trip over muddy and bumpy roads," Dominique noted that night in her date book. At the site, the mud

was so thick that she was not able to walk farther than the first row of poles. "The effect of the work is extraordinary—indescribable," Dominique recorded in her diary.[19] She spent the night in the cabin, immersing herself in the piece the way it was intended to be. "She was absolutely determined," remembered Helen Winkler of their washed-out visit. Years later, Dominique said of *The Lightning Field*, "I think it is the greatest work of art in the mid-century."[20]

In June 1987, when the Menil Collection opened, its first temporary exhibition was the colorful, crumpled car sculptures and drawings of John Chamberlain, a Dia artist. Dominique had been incorporating his work into her shows since 1966, but using him for the first major show was a real statement (and a decision driven by Walter Hopps). Of the twenty-three Chamberlain sculptures in that exhibition, twenty were lent by Dia. Concurrently, for the inaugural exhibition at nearby Richmond Hall, a few blocks south, Dominique exhibited Andy Warhol's *Shadows* (1978–1979). All four walls of the big, rectangular space were filled with fifty-four of Warhol's massive panels, variations on a jagged form in black with vivid splashes of colors. *Shadows* had been commissioned by Heiner and was owned by Dia; this was their first showing since the original exhibition in 1979 at 393 West Broadway, another early Dia building.

Dominique had honed her aesthetic and sharpened her artistic choices for decades. She did not love every Dia artist; some, including Dan Flavin and La Monte Young, she had worked with prior to Dia; while others, like Andy Warhol and Barnett Newman, the de Menils already knew quite well. But it was clear that—aesthetically, artistically, intellectually—there was a lot of cross-pollination between Dominique and Dia.

•

As for all of the money being spent, Fariha was philosophical. "I have lost most of it by now," she admitted much later, "but that's okay."[21] In fact, she has said to some that she always felt that was the goal: to get rid of her fortune. Dominique was not nearly as tranquil.

Dia had entered into lavish, long-range contracts with a host of artists, with the goal of freeing them up for the short-term demands of the market. As Fariha recalled,

> Every artist had his own studio and assistants and place where their art would be shown. At its peak we owned all this real estate in Manhattan: one building per artist with a whole team of assistants.[22]

So, throughout the 1970s and the early 1980s, Dia was burning through de Menil money. The foundation had also begun collecting a huge amount of its artists' work, which was not the idea originally. In fact, the collecting branch began as a separate entity, called the Lone Star Foundation until it was merged with Dia in 1980. "I had been saying for a long time that Dia was overextended," Winkler recalled. "And I fought Heiner on it daily, but it didn't have much effect."[23]

Although it was estimated that Fariha had run through $35 million of her inheritance, Heiner believed that the expenditures were controlled.[24] "In the 1970s, the amount spent was growing very much, but I never touched the capital," he said. "Instead, I had been working with loans on the capital."[25] Utilizing dividends from Schlumberger Limited and the stock as collateral was fine as long as the family company continued to grow, which it always had. In the early 1980s, however, the oil bust began, and the value of Schlumberger stock cratered. On December 31, 1980, the closing price for SLB was $175.50. Five years later, it was $36.50. So the value of collateral being used for an array of loans had dropped 80 percent.

At that challenging moment, a very talented, irascible Dia artist got involved. As Helen Winkler recalled,

> Although we did get public support from other areas—from the National Endowment, from New York State and other private individuals—mostly it was Schlumberger stock. When the stocks plummeted, everything had to be cut back.
>
> And Donald Judd just didn't believe that. I always sided with the artist if there was some kind of problem. But in this case, I told Judd, "It's really true, that if we spend this now, we won't have any to take care of everything else—it's not just you—everything has to be cut back." And he stopped speaking to me, which was very typical of Donald Judd. As it happened, an investigation was done or calls were made to the New York Attorney General's office. And at that point, I think it absolutely freaked Dominique out.[26]

As Heiner Friedrich said, "Don Judd threatened the foundation with a lawsuit. Nineteen eighty-five was a very dramatic year."[27]

Dominique was in the middle of building her new museum and having her own concerns about the diminishing value of SLB stock. She had long worried about Dia expenditures, but in the fall of 1984 Fariha advised her mother of the financial and legal problems. A very alarmed Dominique, intent on protecting her youngest child, went to see Lois and Georges de Menil in New York to discuss the situation. "She had asked me if I would

take over Dia," Lois de Menil recalled. "Would I lead Dia and solve the problem basically? I said, 'Nothing doing! Not that way. I just can't get into this; it is really a no-win for me.'" Lois had four children, an already full life, and little interest in taking on such a major challenge.[28]

When Lois refused, Dominique was not sure what to do. Lois suggested a longtime friend, Ashton Hawkins, general counsel for the Metropolitan Museum who had also been, with Lois, on the board of Dominique's Pompidou Foundation. When she approached Hawkins, he said he would only do it with Lois. "Talk about passing the buck," Lois said with a laugh. "So Dominique came back to me and said, 'Well, Ashton won't do it if you don't do it with him.' At that point, how could I say no?"[29] Both Heiner and Fariha, however, were resistant to leaving the organization they had founded and that they felt so passionately about.

On January 18, 1985, the extended family was in Houston for the wedding of Susan and François de Menil. It was a pleasantly crisp winter day that began with an 8:30 a.m. conversation with Heiner, led by Dominique, Georges, and François. The wedding was at noon, in front of the massive panels at the Rothko Chapel. It was a simple ceremony: a text was read, there was an exchange of rings, a chamber music ensemble played Bach's Brandenburg Concerto No. 6. Afterward, back at the de Menil house, Dominique hosted a buffet luncheon. Given the lovely weather, most stayed outside on the terrace.

Later that afternoon, however, at 5:00, was a much different gathering. In the "Wee House," one of those charming gray houses with white trim across from the Rothko Chapel, was a pointed family meeting with Heiner Friedrich. It was designed to be an intervention. Dominique's note in her date book: "*Blitzkrieg!*"

•

Also down for the weekend, at Dominique's request, was a leading New York attorney, Henry King, chairman and managing partner of Davis Polk. Dominique wanted to ensure that Heiner would resign from the board and Fariha would relinquish control of her finances.[30] By the following day, Heiner had agreed to resign, and Fariha had consented to having her funds overseen by a trust. "She signed the agreement," Henry King said to Dominique about Fariha. "She is relieved."[31] So was Dominique. A decade later, when asked about having to force out her son-in-law, she said, "Times were trying, and Heiner lacked the prudence which he acquired later."[32]

Fariha called Helen Winkler to tell her that Dominique wanted her to resign as well. She refused. "I certainly had not done anything wrong, and

as far as I could tell, Dia had not done anything wrong, except that Phip's money was being spent," Winkler explained. "She thought that the de Menil name was going to be smirched, so she called in the lawyers and they just came in and absolutely took over." After a further conversation with Fariha and a quick, awkward talk with Dominique, she resigned. The swift legal resolution of the crisis was impressive to witness. As Helen Winkler said,

> It was a real awakening. I had always lived this wonderful life with the de Menils and thought that that's the way it was out in the world. But in this instance, she just came right down, brought in her resources, and wham, bam, get us out of this, whatever *this* is. And I was real impressed, actually. But it made me angry, too. She was frightened, so she just turned it over to lawyers, which John de Menil never would have done. She did, though, and I'm sure she believed that what she was doing was right.[33]

A new board of trustees was in at Dia, led by Ashton Hawkins and Lois de Menil. It was a high-powered New York group that included the attorney Herbert Brownell, John C. Evans of Morgan Stanley, and the future Supreme Court justice Stephen Breyer. In 1986, the board named as director Charles Wright, the attorney son of noted Seattle art collectors Virginia and Bagley Wright. The new crowd had little connection with the Dia generation of artists, but they were very effective at righting the ship. "It was not just righting the ship," said Ashton Hawkins. "It was also building the ship because there was no ship! Essentially, they were in a rowboat."[34]

Over the next decade, the lawyer-heavy board of trustees sold off much of the Dia property. Dominique gave them a $5 million loan to allow them a little breathing space.[35] In November 1985 at Sotheby's in New York, they auctioned twenty-three paintings and sculptures from the Dia collection including works by Donald Judd, Dan Flavin, Walter De Maria, Barnett Newman, Fred Sandback, Cy Twombly, and Andy Warhol. Selling art and real estate is a difficult step for any institution to take, particularly one that so revered its artists. And it was clearly not a sensible long-term strategy. But during those years, the new trustees also managed to turn Dia into a serious, professional nonprofit.

Dominique continued to follow the work begun by Dia. In November 1986, she chartered a plane to fly from Houston to Marfa, going out with Christophe, Miles Glaser, and Elsian Cozens. They went first to Donald Judd's house, known as "The Block," seeing the artist and his children, Flavin and Rainer. They sat down for lunch and the table, Dominique noted, was "covered with small, spicy dishes." She loved the building across the

courtyard that Judd had turned into his library. "It is the kind of library that Father Couturier would have had—all of the classics are there." The artist gave them a tour of his work in Marfa: a hall of Chamberlain sculptures, the artillery sheds, and the outdoor sculptures in concrete. "A very cold and clear day," Dominique noted in her datebook. "The atmosphere is exhilarating. Judd seems pleased—as we leave, he gives me a big hug."[36]

In October 1992, Dominique spoke at the Dia Gala, a glittering annual event started by the new board. Dominique credited the original founders for creating room for great artists and for building such a singular collection. She also celebrated the current board and its vision. "The Andy Warhol Museum, a joint venture of Dia, of the Andy Warhol Foundation, and of the Carnegie Museum of Art, will open its doors in Pittsburgh in the spring of 1994. An exciting joint project with Cy Twombly, involving Dia and Menil Foundation, should be ready in Houston the same year."[37]

Three years later, there was another coup at Dia. In August 1994, Michael Govan, then a thirty-year-old protégé of Thomas Krens's at the Guggenheim, was hired as the director of Dia. Govan made an effort to reach out to the founders of Dia and built particular alliances with some of the trustees. In December 1995, Ashton Hawkins was forced to announce that he was stepping down as chairman in six months, to allow for the orderly transition of a new team. Barely more than a month later, on February 2, 1996, Hawkins was out. "The fragile truce holding together the board of the Dia Center for the Arts deteriorated rapidly this week as nearly half of the 21 trustees resigned," Carol Vogel reported in *The New York Times*. "Ashton Hawkins, chairman of the board since 1985, announced he would resign at the annual board meeting on Feb. 13, more than three months before the date that had been agreed upon after a series of contentious board meetings in December. His resignation prompted seven other board members to follow him."[38]

Dominique joined the new board, which seemed, to some, to be a validation of the coup and a slap in the face to the team that she had helped install, when her participation was actually an attempt to provide stability and art world credibility to an institution in trouble. Michael Govan, with the financial support of new trustee Leonard Riggio, chairman of Barnes & Noble, went on to build the spectacular Dia:Beacon. Opened in May 2003, the former Nabisco factory on the Hudson was converted into a 300,000-square-foot permanent installation: Walter De Maria's *Equal Area Series* (1976–1977), twenty-five pairs of circles and squares in polished stainless steel lined along hardwood floors; Michael Heizer's *North, East, South, West* (1967–2002), four monumental three-dimensional geometric forms cut into the museum's floor; a massive skylit gallery with all

102 panels of Andy Warhol's *Shadows;* a series of pale gridded canvases by
Agnes Martin; in the attic, Louise Bourgeois's *Crouching Spider* (2003);
and a cavernous, windowed basement gallery given over to Richard Serra's
Double Torqued Ellipse (1997) and its hulking, curvilinear forms in rusted
steel.

The Dia saga involved no shortage of hurt feelings. Helen Winkler was
upset for two years about being forced out; Heiner was estranged from
Dominique for some five years; members of the second board, including
Lois de Menil and Ashton Hawkins, were displeased with what they felt
was Dominique's lack of loyalty and respect for their accomplishments.
Many have tried to turn the story into high drama: the original founders
versus the lawyers; the establishment board versus the sharp-elbowed arri-
vistes; Dominique de Menil as Machiavelli.

What if the truth were more prosaic? The founders had a remarkable
vision and helped create some of the more powerful contemporary art of
the twentieth century. The second board brought a sense of structure and
financial control to an organization that had very little. And the subsequent
group built on both to produce a significant new museum and allow Dia
to continue to flourish. That interpretation, though less histrionic, would
mean that each played a role that helped advance the institution. "And in
the end, the art won out," said Helen Winkler. "And that's what matters."[39]

•

Cy Twombly (1928–2011), the Virginia-born artist who spent most of
his life and career living in Italy, was not a figure often associated with Dia.
Yet between 1976 and 1990, through dealers and at auction, Dia acquired
eighteen Twombly paintings and drawings. During the planning of the 1987
opening of the Menil Collection, Dominique, Walter Hopps, and Paul Wink-
ler had considered combining two single-artist shows, John Chamberlain
and Cy Twombly. They were unable, however, to engage Twombly on the
subject. A year later, having heard good things about the museum, the art-
ist called asking if there would still be interest in doing something together.
And the Menil Collection organized a major show, *Cy Twombly* (Septem-
ber 7, 1989–March 11, 1990), with twenty-seven paintings and drawings
and two sculptures. Paul Winkler, director of the Menil Collection by that
point, went to Rome to coordinate the exhibition. And he and the artist
began discussing the idea of a permanent home for the works owned by Dia
and the Menil Collection.

To pursue the idea, Dominique, Fariha and Heiner Friedrich, and Paul
Winkler went to Rome to meet with Cy Twombly in September 1990. They

stayed at the Hotel Raphaël, off Piazza Navona.[40] Their first morning, Twombly stopped by the hotel to meet everyone and walk them to his apartments. On the way, they visited the sixteenth-century church San Luigi dei Francesi to see the cycle of paintings by Caravaggio on the life of Saint Matthew. At Twombly's apartment, on the third floor of a palazzo at 149 via di Monserrato, they spent much of the morning talking with the artist, who also introduced his wife, Tatiana Franchetti. "Extraordinary lunch," Dominique noted in her date book. "A large vegetable soufflé; a caviar salad with thin crepes made by Tatia; green salad with soft goat's cheese; sliced fresh peaches and plums for dessert."[41]

After lunch, Twombly gave them a tour of his remarkable home, where he had lived since 1959. As Dominique noted, "Room after room of sculptures—his and other artists'; paintings stacked against the wall, one or two visible; and antiquities: sculptures of Marcus Aurelius, Hadrian, a bust of Venus."[42]

The following morning, they returned to Twombly's house. The idea of doing something with him had been in the air for a year, but Heiner Friedrich, as he recalled, tried to elevate the possibilities with Dominique. On the walk over, he said that the way to ensure the artist's participation was to make it clear that they were committed to the project in a major way. "When Cy opened the door," remembered Friedrich, "she said, 'Cy, we want to build a museum for you.'"[43] That day, he offered to add paintings and sculptures in his personal collection and even sketched out a plan for the building.

Twombly's initial idea, which carried through to completion, was a classical square structure, much like a Palladian villa, with a grid of nine square, equally sized galleries. The following spring, Twombly visited Houston to see the Menil Collection.[44] After that trip, Paul Winkler, who had become the point person for the project, entered into discussions with Renzo Piano. "Cy was most interested in the beautiful light in the Menil Collection building and wondered if it was possible to adapt the system to this new space," Winkler wrote to Piano. "While his desire is to maintain very simple architecture from the point of view of materials, the building should have an identity separate from the museum."[45]

The artist was very involved with every aspect of the new building. "He dictated the size and arrangement of the galleries, suggested materials, and offered opinions on the proportions and relationships of the building's spaces and openings," Winkler wrote. "Most importantly, and over a period of time, he refined the selection of paintings and sculptures to be included in the gallery and then gave a majority of them to the Menil Collection."[46] Construction began in 1993. "It is a joy to see the Cy Twombly growing and

stretching," Dominique wrote to the artist on August 22, 1994, as the new building was nearing completion. "We all share this joy—I do intensely."[47]

The Cy Twombly Gallery, a $4.1 million, ninety-three-hundred-square-foot structure by Renzo Piano Building Workshop, Richard Fitzgerald & Associates, and Ove Arup & Partners International, was inaugurated on February 10, 1995. Piano's design was serene and classical with beautifully integrated modernist engineering. Located across the street from the museum, just to the southeast, the entrance was turned ninety degrees from the street, facing east onto a lawn with a monumental live oak tree, its elaborately outstretched limbs like something from a fairy tale. Along the street was an unbroken facade—approximately a hundred feet long—made of large, uniformly sized, custom-made concrete blocks. The walls were made using sand from a quarry near San Antonio, which gave the concrete a warm buff color and distinguished it from the grays of the museum and surrounding bungalows. A white steel and glass roof floated above the building. It contained a series of light-filtering planes, louvers, ultraviolet-filtering glass, and, as the ceiling inside, huge expanses of white cotton fabric stretched across the galleries like sails. "The Cy Twombly Gallery is a gem," Dominique wrote to Renzo Piano.[48]

The galleries had light wide-planked wood floors, white walls, massive rectangular doorways, and several floor-to-ceiling windows covered

At the opening of the Cy Twombly Gallery in 1985, Dominique with the artist.

with white screens. "Always capable of fetishizing technology, Piano has underplayed it here," *Architecture* magazine suggested in its review. "From the outside, the elaborate roof appears, in Piano's words, 'like a butterfly alighting on a firm surface.' "[49]

The installation included thirty-five major Twombly works from 1954 through 1994: paintings, sculptures, and works on paper. The artist donated twenty-six important pieces; six others were from Dia and three from the Menil.[50] One gallery contained a series of five large paintings from 1959, with subtle graphite notations on expansive, textured white backgrounds. Another held *Untitled (A Painting in Nine Parts)* (1988), a series of eight green and white canvases, incorporating quotations from the poetry of Rainer Maria Rilke, originally done for the 1988 Venice Biennale. Perhaps no single painting was more indicative of Twombly's virtuosity than the one in the double gallery, containing a single painting along the north wall, *Untitled (Say Goodbye, Catullus, to the Shores of Asia Minor)* (1994). Made of oil, acrylic, oil stick, crayon, and graphite pencil on three canvases combined into one, the painting measured thirteen feet in height and fifty-two feet in length.

For the inauguration, Dominique hosted three hundred guests at a private viewing of the new building followed by dinner at the Menil Collection. The menu was crawfish cayenne, rack of baby lamb with Pinot Noir, and orange mousse with crème anglaise. Following dinner, guests were invited to a preview of an exhibition in the museum, *Cy Twombly: A Retrospective* (February 12–March 19, 1995). It was a large show of nearly a hundred paintings, sculptures, and works on paper, curated by Kirk Varnedoe, Paul Winkler, and the artist. The retrospective, which had originated at MoMA, traveled afterward to MOCA and the Neue Nationalgalerie, Berlin.

When Dominique addressed her guests, she spoke of having met Twombly through her daughter and Heiner Friedrich. "They had a particular love and devotion to Cy, and Heiner's generous activity had a strong impact on the chain of events culminating in the Cy Twombly Gallery," Dominique stated. But, as was often the case, she emphasized the artist, who had made the trip to Texas from Rome. "I want to thank Cy for the gift he made to this city," Dominique said. "It is a gift of such magnificence that it will take a while for America and the world to become fully conscious of it."[51]

UN ACTE FINAL

Hers is one of the noblest and most heroic lives lived
this century.
—LEO STEINBERG[1]

In the two decades after the death of her husband, Dominique de Menil instigated or saw to completion a vast number of projects and initiatives. *The Image of the Black in Western Art* continued with multiple volumes in 1976, 1979, and 1989. Dominique also directed the processing of Father Couturier's extensive correspondence and personal papers. For twenty years, Dominican priests and archivists working in the maids' rooms of her apartment on the rue Las Cases organized the mass of material, with the resulting archives donated to the Dominican library in Paris, the Bibliothèque du Saulchoir, and a copy given in 1994 to the Yale Institute of Sacred Music. In addition, that archival research led to Dominique overseeing the publication of two volumes of Couturier's writings, *La vérité blessée* (1984) and *Sacred Art* (1989), as well as a scholarly, detailed book of one of his most important projects, *Henri Matisse: The Vence Chapel: The Archive of a Creation* (1999).

In the late 1970s, Dominique was approached by Italian historian Giuseppe Alberigo, founder of the Institute for Religious Science in Bologna, Italy, who was interested in studying Pope John XXIII and the Second Vatican Council. Beginning in 1981, and continuing for two decades, the Menil Foundation underwrote half the cost of a multimillion-dollar project that became, in essence, papal archives and also produced such scholarly work as the multivolume history of Vatican II that was translated into dozens of languages. Then there were the myriad activities at the Rothko Chapel—colloquiums, awards ceremonies, concerts, performances, religious services—that she oversaw for more than a quarter century.

At the Menil, under Dominique's direction, Walter Hopps and the curatorial staff produced powerful, acclaimed exhibitions. *Andy Warhol: Death and Disasters* (October 21, 1988–January 8, 1989), which opened the year after Warhol's death and two months before his important retrospective at the Museum of Modern Art, contained thirty-eight of the artist's

more political statements. The hushed galleries of the museum were filled with potent images of electric chairs, race riots, mug shots, car crashes, the Kennedy assassination, and the atomic bomb. "Andy Warhol is one of the most important artists of the twentieth century," Walter Hopps wrote in the exhibition catalog, a statement not shared by everyone in the art world at the time. "I deeply regret that Warhol's recent tragic death has disallowed his participation."[2]

To underscore the institutional belief in the artist, and to commemorate Ash Wednesday in March 1990, the museum entrance was given over to Warhol's *Camouflage Last Supper* (1986), a massive silk screen, over twenty-five feet long, that superimposed imagery from Leonardo da Vinci's famous fifteenth-century wall painting with a camouflage print. It was the first showing of the monumental piece that Dominique had bought from Warhol's final show, organized by Iolas in Milan.

Robert Rauschenberg: The Early 1950s (September 27, 1991–January 5, 1992), also curated by Hopps, was another brilliant and prescient exhibition of over a hundred of the artist's early photography, printmaking, painting, collage, sculpture, and conceptual artworks, including his notorious *Erased de Kooning Drawing* (1953). The exhibit traveled to the Corcoran Gallery of Art in Washington, D.C., the Museum of Contemporary Art in Chicago, the San Francisco Museum of Modern Art, and the Guggenheim Museum in SoHo. David Sylvester and Sarah Whitfield curated a vast retrospective, *Magritte* (December 19, 1992–February 21, 1993), including more than 150 works, and 26 that had belonged to Dominique and John. From the Hayward Gallery in London, it went to the Metropolitan Museum of Art in New York and the Art Institute of Chicago. The show coincided with the publication of the first of the five volumes of Sylvester's Magritte *catalogue raisonné*, which the de Menils had funded since 1969, as well as a monograph, *Magritte: The Silence of the World,* also authored by Sylvester and funded by the Menil Foundation.

Then, marking the fifth anniversary of the museum, Walter Hopps and Paul Winkler curated *Six Artists* (May 29–September 20, 1992), a selection of thirty-five works by six European and American artists important to the de Menils: Yves Klein, Jean Tinguely, Willem de Kooning, Brice Marden, John Chamberlain, and Andy Warhol. De Kooning's large, gestural canvases from the late 1970s and the 1980s were placed near early Chamberlain sculptures from the late 1950s and the 1960s in order to show the aesthetic connection between abstract expressionist paintings and the sculptor's treatment of "found" car parts. A parallel was drawn between Tinguely's motorized, anthropomorphic machines and Klein's transcendental paintings that had been made using the female form.

While Dominique was still planning the museum, in 1979, she had met Carol Mancusi-Ungaro, then a young conservator, who had moved to Houston with her husband. She and Dominique began talking about the condition of the Rothko Chapel paintings. A mysterious white film had appeared on some of the panels. Mancusi-Ungaro said that conservation was difficult because no one really knew how the paintings were made. Dominique's response: "Well, find out." That directive led to an attempt to track down every studio assistant of Mark Rothko's to interview them about the process of making the paintings, leading to a much more informed conservation treatment of the panels, overseen by Mancusi-Ungaro, in 1981 and again in 1986.

Once the Menil Collection opened, Mancusi-Ungaro was named chief conservator. Working in the beautiful laboratory Renzo Piano had designed with northern light and views out to gardens, she realized the advantage she had for conducting detailed, one-on-one interviews with artists who visited the museum. So in 1990, supported by Dominique and the Andrew W. Mellon Foundation, Mancusi-Ungaro expanded and formalized those interview efforts. The Artists Documentation Program, the first of its kind, became a massive project to interview contemporary artists, on video, about the creation of their work. The ADP, which continues to this day, gathered vital conservation information from dozens of artists including Jasper Johns, Cy Twombly, James Rosenquist, Brice Marden, and Ed Ruscha.

In the last years of her life, Dominique was the subject of constant praise, so much that it could be uncomfortable. At the dedication of the Byzantine Fresco Chapel in 1997, after a succession of speakers raving about Dominique's decision to rescue the Lysi frescoes, Dominique said, "I came here today to praise God, not to be praised."

In April 1982, at the Ministry of Culture in Paris, Jack Lang made her an officer of the Order of Arts and Letters. "Listening to you, I was thinking about all of the things that I have not done particularly well as well as all of the things that I should have done but have not," Dominique said to the minister of culture.[3] In May 1985, the French ambassador to the United States, Emmanuel de Margerie, presented Dominique with the Légion d'Honneur at a ceremony at the de Menil house in Houston. "I take it less as a sign of recognition than one of encouragement," Dominique said. "Encouragement to keep moving forward on the path I have chosen—following the footsteps of John de Menil—promoting knowledge and understanding, certainly between the two countries that are dearest to me, France and America."[4] In June 1992, at the French Ministry of Foreign Affairs on the Quai d'Orsay in Paris, she was named Commandeur des Arts et des Lettres in the company of her extended family including her grandchildren

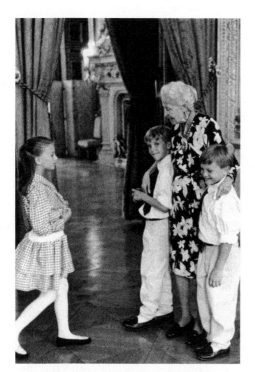

Dominique with great-grandchildren, left to right, Caroline, Dash, and Max Snow at the French Ministry of Foreign Affairs in 1992, after getting the Commandeur des Arts et des Lettres.

and great-grandchildren. The French foreign minister, Roland Dumas, was detained on a mission in Jeddah, Saudi Arabia, so an undersecretary delivered a discourse that Dominique characterized in her date books as "overly flattering and filled with mistakes."[5]

Dominique was given an honorary degree at Harvard University in June 1992, an honorary Doctor of Humane Letters from Loyola University, New Orleans, in May 1990, and an honorary Doctor of Laws degree from Emory University in Atlanta in May 1992, sharing the stage with former president of the Soviet Union Mikhail Gorbachev.[6] "A lot of the public things she really didn't like, getting awards and prizes," recalled Anne Schlumberger. "Her assistant, Elsian Cozens, was very good in her later years when Dominique was alone in Houston. She would call me and say, 'The American Institute of Architects wants to give her a medal, can you take her?'" Dominique told her niece that she would have preferred not going to those events. "I think she was much more aware of what her duty was, what she should be doing," Anne Schlumberger said. "Whereas John, I think, would have just loved the attention."[7]

•

On Monday, September 13, 1993, a historic event took place on the South Lawn of the White House, the signing of the Oslo Accords, formalizing a two-state solution between Israel and Palestine. "Rabin and Arafat Seal Their Accord as Clinton Applauds 'Brave Gamble,'" announced *The New York Times,* over all six columns of the front page, above a famous photograph of the American president standing between the two Middle Eastern leaders, looking to all the world as though he had orchestrated their handshake.[8]

President Jimmy Carter attended the ceremony. He had been involved in the background while the agreement was being negotiated and knew those who had been instrumental in the process. "The United States had not done anything at all to bring about the Oslo agreement," Carter explained. "They didn't even know about it when it was going on. I knew about it through Arafat and Shimon Peres, but it was kept secret from the United States." The real architects of the accord, Carter knew, were the foreign minister of Norway and a scientific nongovernmental organization, the Norwegian Institute of Applied Social Science.

"Since I was a former president, I sat in the front row," Carter said. "My wife, Rosalynn, sat in the second row. The foreign minister of Norway sat in the fourth row, and he was never mentioned; Clinton never acknowledged at all that the Norwegians had played any role in it." Carter was embarrassed and disappointed. So that night he mentioned it to Dominique. "Why don't we have a special ceremony?" Dominique suggested to Carter. "Instead of honoring a human rights hero, why don't we honor the people of Norway?"[9]

In May 1994, Dominique, Jimmy Carter, Yasser Arafat, and Shimon Peres were in Oslo to present the Carter-Menil Human Rights Prize to the Norwegian Institute of Applied Social Science. In addition to the $100,000 award, Dominique decided to give to the city of Oslo a monumental sculpture by Tony Smith, *Marriage* (1961), an abstract arch in steel that had been painted black. She invited the artist's widow, Jane Smith, and Paula Cooper, the dealer for the Tony Smith estate, to Oslo for the events. Cooper had long known Dominique as a collector. Several years before, she had a show of the drawings of John Cage. The night before the exhibition opened, Dominique stopped by the gallery. The drawings had not yet been hung so she got down on the floor to inspect them. Asked if that was something unusual, Cooper replied, "Well, I've never seen a collector down on her hands and knees."[10]

Dominique, Jane Smith, and Cooper all flew together from New York's Kennedy Airport on a Sunday night, May 15, just after Dominique had returned from two days of festivities in Pittsburgh to mark the opening of the Andy Warhol Museum. "She was tired and cranky as we got on the plane," the dealer remembered. "And she said, 'The only reason I am going business class is because of you! Otherwise, I would be in economy.'"[11]

Dominique's mood brightened once they reached Oslo and the several days of events began. Cooper was struck by how intimate it was. The gatherings consisted of Shimon Peres and his team, Yasser Arafat and his team, and, of course, the Norwegians. The American group was made up primarily of Dominique, Rosalynn and Jimmy Carter, Andrew Young, and Nabila Drooby. Dominique's sister Sylvie Boissonnas and her husband, Eric, made

Dominique with the participants of the Oslo Accords, from left: Terje Rød Larsen, Yasser Arafat, Bjørn Tore Godal, Jimmy Carter, Shimon Peres, and Jan Egeland, there to present the Carter-Menil Human Rights Prize to the Norwegian Institute of Applied Social Science.

the trip from Paris. "Oh, I am so proud of her," Sylvie said of her older sister.[12]

As Cooper remembered,

At our first lunch, Shimon Peres had not yet arrived. So Arafat spoke to everyone during the lunch. He had an interpreter at first but then corrected one of the translations and finished his remarks in English. For the ceremony giving the sculpture to the city, we were outside, of course. There were bodyguards, but everyone was all under a little tent, totally exposed. Later, the Norwegians told how the agreement had transpired, how they had sneaked up to the room where Norwegian independence had been signed, how they drank champagne and signed the papers at that desk. It took place at midnight, and nobody could know that it was happening. At the last dinner, all the Palestinians and the Israelis were there together. They were all remembering and recounting the process; it was quite extraordinary.[13]

Dominique, who had just turned eighty-six, had made an earlier trip to Norway to choose just the right location for the gift of the Tony Smith sculpture, settling on a prominent site in a public park, Kontraskjæret, overlooking the fjord, between the stone walls of a sixteenth-century fortification

The Tony Smith sculpture given to the city to honor its role
in the Oslo Accords.

and Oslo City Hall. At the unveiling of the statue, Dominique addressed
the audience, including the king of Norway, Harald, and the Norwegian
minister of foreign affairs, Bjørn Tore Godal. "The superb antique Viking
ships discovered in a burial site not so long ago remind us of the venturous
spirit of the Norwegians," she stated. "It is with the same courage that in
the twentieth century Norwegians have gone out to help the world."[14]

Dominique explained how she chose the sculpture, suggesting that it
had a grandeur that was appropriate for the occasion and that its abstract
form was like a magnificent door that opened out to the sea.

That evening, at the presentation of the Carter-Menil Human Rights
Prize, Dominique again spoke. Paula Cooper had the feeling that Yasser
Arafat was unconvinced by Dominique. Perhaps he was unaccustomed to
see women in leadership positions. Her remarks that evening, however,
focused his attention. After establishing the Norwegian historical context
for helping in the peace process and singling out all of those involved, Do-
minique said,

> Human beings are normally resistant. They can endure a lot of
> hardship without falling apart. But when they fall apart, they
> resort to violence.
>
> A bull is said to have killed a butcher in a slaughterhouse. Pales-
> tinians have acted like the bull.
>
> Israelis, too, are violent. Their violence has been less obvious,
> more legalistic, but quite ruthless.
>
> I believe that with enough intelligence and compassion on our

part, Israelis and Palestinians will talk themselves into a different behavior.[15]

Cooper remembered that Dominique's criticism of both sides certainly got everyone's attention. "I think she shocked Arafat," the dealer recalled.[16] But the Palestinian leader, Cooper felt, seemed to view Dominique with a new respect.

As Cooper recounted the various events and exchanges in Oslo, she had the distinct feeling that Dominique was seen by all as being on the same level as the other participants, primarily statesmen and world leaders. "Oh, it was her show," Cooper said emphatically of Dominique. "This was a very strong woman."[17]

•

Eight years after those ceremonies, Jimmy Carter would return to Oslo. On December 10, 2002, as the final, false justifications were being made for the American invasion of Iraq, Carter was awarded the 2002 Nobel Peace Prize.

On that cold Scandinavian night, Carter remembered that earlier trip to Oslo. The city hall was adjacent to the site where Dominique had placed the Tony Smith sculpture. The dark steel arch of *Marriage* still held its place on a hill, overlooking the harbor, with the historic stone walls behind it. "As soon as I left the Nobel ceremony, I walked over to the sculpture," Carter recalled. "It was a very cold night; there was snow on the ground. I walked up to it, picked up two or three stones from the base, and held them in my hand. I went there just to think about Mrs. de Menil and about how her influence had been a contributing factor in my receiving the Nobel Peace Prize."[18]

•

The events Dominique orchestrated in Oslo would be the final Carter-Menil Human Rights Prize. Two years before, in May 1992, Carter had written to her about the possibility of continuing the program. The hope was that the Carter-Menil Human Rights Foundation would continue to administer the prize and seek contributions from others. "I want the human rights program to stand out forever with its own merits and name, even though closely and integrally linked with The Carter Center," he wrote to Dominique. Carter suggested that $5 million would endow the project, allowing the organization to operate in perpetuity.[19] In response, Domi-

nique thanked President Carter and assured him that she shared his belief in the importance of the program they had begun. "I wish I could tell you that I will, at least partly, endow the program, but at the present time this is not possible," Dominique wrote. "Before committing any large amount of money I must terminate certain programs which are still draining my resources, and it will take several years. I am in a period where I have to be extremely cautious and it makes me unhappy. I wish so much I could respond more positively to your excellent suggestion."[20]

By the time they had made their trip to Norway, it was clear that she would not be able to make a lasting $5 million commitment. It was a great personal disappointment to her, probably one of the biggest in her life. "It was a great disappointment to me as well," Jimmy Carter recalled. "I understood later that it was because her enormous estate had gone down, to some degree. She was maybe more cautious than she needed to be, but I can certainly understand."[21]

Rothko Chapel director Nabila Drooby was also disappointed about the decision, feeling that it would have perpetuated Dominique's name in a field other than art. "But there was the pull of different people who were influencing her financial life," Drooby pointed out. "At the end of her life, everybody was making her feel that she had barely enough money left to live. That was not really true, but everybody was trying to grab whatever they could of her endowment, her contributions."[22]

As she aged, Dominique began to have serious financial concerns. Her innate Protestant ethos about spending money carefully only increased in later years. Miles Glaser, the financial adviser for the foundation, felt that Dominique, in her eighties, would appreciate having a television in her bedroom, instead of having to walk across the house to the kitchen. So he gave her a small set as a gift. "She got terribly upset," Glaser recalled. "She said, 'I will not have a television in my bedroom. I am sorry—that is too luxurious—I will never accept that.'" Instead, the new television replaced the old one in the kitchen.[23]

Walter Hopps was struck by a small painting she kept in her bedroom, in a very prominent position above the doorway to the dressing room. It was a Warhol silk screen of a dollar sign. "That is a very special icon for me," Dominique told Hopps. "One of my most important jobs is to make sure that we always have dollars."[24]

•

In December 1989, Dominique had a meeting at François's office in New York with Miles Glaser and Paul Winkler, all board members of the

Menil Foundation. Her son expressed concern about the projects that were being taken on in addition to the museum. Dominique explained her view of the importance of *The Image of the Black in Western Art,* the Couturier archives, and other initiatives. François spoke of the need to make sure that expenditures were in line with revenues. "Miles assured him that the foundation would be on solid financial footing within two years," Dominique noted. "And the tone of the exchange was very cordial." That evening, however, the mood shifted. "Call from François—he explodes," Dominique wrote. "Decides to quit the board; he can no longer stay given the conditions under which we are operating."[25]

There was a period of many years when Dominique, surprisingly, felt that the foundation and the museum were hemorrhaging money and that she was powerless to control it. She began to feel marginalized from her own museum. For someone who, when she was growing up, noted every penny she spent in a ledger, it is mystifying that she would have found herself in the position of not knowing what was going on financially, of not establishing clear budgets for the staff. It was estimated that in the first seven years the museum was open, Dominique had signed over $15.5 million of her estate to cover operating expenses.

So in the summer of 1994, Dominique called on someone she had known for decades, Dr. Susan Barnes, the forty-six-year-old daughter of her great friend Marguerite Barnes. Having studied art history at St. Thomas and at Rice, Barnes received her master's and Ph.D. from New York University's Institute of Fine Arts. She wrote her dissertation on Anthony Van Dyck and was named a fellow of the American Academy in Rome and at the National Gallery of Art in Washington, D.C. She also published *Van Dyck 350,* a *catalogue raisonné* of the great Flemish portraitist. Her current position was deputy director and chief curator at the Dallas Museum of Art.

Dominique had worked closely with Susan Barnes over the years, beginning when she played an important role on the research for the 1976 art nouveau exhibition at Rice. When Dominique felt the need to publish an official account of the chapel, she asked her to research and write it; the result, *The Rothko Chapel: An Act of Faith,* was published in 1989. And Barnes had also been dispatched to London for help trying to control David Sylvester's Magritte project. Her fluency in French was one reason Dominique was close with the young woman. Barnes, it seemed, was just the person to help her regain control over her own museum. "I don't know what is happening," Dominique said to Barnes. "I just know that no one will tell me. And I know that my fortune is disappearing."[26] Barnes assured Dominique that they would be able to find the answers.

"Dominique de Menil, President of the Menil Foundation, announced today the appointment of Susan J. Barnes to the newly created position of vice president and chief operating officer of the Menil Foundation," announced a press release in August 1994. "Dr. Barnes will have oversight of all the activities of the Menil Foundation."[27] The announcement also included glowing statements about Barnes from Earl A. Powell III, director of the National Gallery of Art, and J. Carter Brown, the former National Gallery director. So Susan Barnes joined the staff at the Menil and ran right into a buzz saw.

•

"After the 'beautiful gesture' of Oslo, the insane undertaking of the Byzantine Chapel and now the absurd nomination of Susan Barnes, what could you possibly have in store for us next," chief curator Bertrand Davezac demanded in a letter to Dominique. He was referring to her decision to deaccession the Tony Smith statue for Oslo, which displeased the curatorial staff, and the high cost of building a chapel for the Lysi frescoes. His letter went on to disparage Barnes's professional reputation and wonder how she must have schemed in order to be given such an appointment. "She will not be welcomed with open arms."[28]

Dominique's response was firm. "As harsh as your letter was, I thank you for your frankness," she wrote to Davezac. "I owe you mine in return. I asked Susan Barnes to join our team because I find myself excluded from decisions involving museum spending." Dominique made it clear that at eighty-six years old she was concerned about how much time she had to organize everything. "I am sure that I have only a few years left," she continued. "I am confident that a reasonable structure can be found for the future. Let's leave it there and work to establish a solid financial base for the Menil Foundation."[29]

Years later, Bertrand Davezac admitted that he had been a little severe. "We had very open exchanges, but two or three times I either hurt her or went too far," the curator said. "But it was a catastrophe when she named Susan Barnes. She introduced a foreign body. I understand why: she was very old and was tiring, though not intellectually. But, yes, with that letter I went a little too far—absolutely."[30]

Barnes began asking the right questions regarding the business side of the museum and studying the numbers. She found a serious structural deficit: $2.8 million and increasing. In a few more months, it was expected to be $4 million. The first objective was to get a handle on the spending. Strict budgets were imposed—apparently the first the staff had ever had—and

seventeen employees were fired. The annual operating budget was reduced from $7.4 million in 1994 to $5.8 million for the following year.

Dominique was upset about the firings but stoic in the face of the dire financial news. "She was very strong," Susan Barnes later explained. "The good news was that there wasn't malfeasance. There was, I guess you could say, waste, there was no sense of concern for the future, but thank God there wasn't anything criminal; that one piece of bad news I didn't have to give her."[31]

The museum staff continued to be wildly opposed to the involvement of Susan Barnes. On Friday, February 24, two weeks after the opening of the Twombly Gallery, ten senior staff members went to the de Menil house to confront Dominique. The meeting took place in John's study: Paul Winkler, Miles Glaser, Bertrand Davezac, Walter Hopps, Carol Mancusi-Ungaro, and other curators and department heads attended. Winkler began by stressing that everyone loved Dominique but that they could not understand her need to hire Susan Barnes.

According to the minutes of the meeting, Dominique, who was just shy of her eighty-seventh birthday, explained,

> Miles alerted me but not energetically enough that we would be in a financial catastrophe in two years. We never had a budget we could operate on and I blame myself. Miles, you should have done what François de Menil did and said "I don't want to be on the board anymore." Though I reduced the museum in size from our initial plans, we didn't have the budget to operate it and now we have a $4 million debt in the bank.

Glaser said that it had been clear for five years that deficits were being run. "You were always making up the deficit, as I had been telling you for years," he explained.

"You should have said, as François did, 'You will have my resignation,'" Dominique replied.

When Davezac questioned why it would have come to such a crisis, Dominique snapped, "What has Susan Barnes ever done to you, Bertrand?"

Winkler said that he wanted to have weekly department head meetings and curatorial meetings and hoped that she would be there. "Great, in the past, I have had to extract teeth to get involved," Dominique replied. Winkler also made it clear, however, that Susan Barnes would not be invited to the new staff meetings.

Dominique stressed that she did not want the quality of the institution to be diminished. She suggested that the number of exhibitions or publica-

tions might have to be scaled back or that more community support would have to be found. And she wanted everyone to get used to working within budgets. "We still have $4 million to reimburse," she said. "I am terminating and postponing all the projects of the foundation—I now see that I cannot even pay the things I am absolutely committed to—that is why I became worried." She also reiterated that she needed to be more involved in the museum and to solve this financial dilemma. "I have to have a little money to finish the many projects that my husband and I started," she explained. "I am a dreamer. He decided these projects and now I have to finish."

Dominique reiterated that she felt the institution was in a moment of crisis. She said that she would have to be firm about saying no and making cuts, including, perhaps, closing part of the museum. "But your museum is already so small," said Paul Winkler. "How can we close it?"

Dominique also attempted to reassert her authority. "I want to be very precise," she said. "I want things in writing. Think it over this weekend and, on Monday, I want each of you to put in writing that you respect my leadership or resign."

"Why would you question our loyalty," asked Paul Winkler. Carol Mancusi-Ungaro said, "I feel that my loyalty to you as a leader has been demonstrated and, if you request this letter of me, it is reflective of something else." Bertrand Davezac added, "We are behind you and proved it by all the years we have been here—it is hurtful." As Winkler continued, "We have given with our lives, our blood and sweat."

Dominique's final comment: "You have had a more interesting life than many others in other museums."[32]

•

The idea of a statement of loyalty was a little silly. "It was like Roy Cohn," Paul Winkler remembered years later, still incredulous. "And I said to Dominique, 'We know that this is Susan Barnes talking.' Bertrand finally said, 'Yes, Dominique, you have given us a wonderful life, but we have given you a wonderful life also.'"[33]

The request might have been ill-advised, but the fact was that the museum founder, and primary funder, had hired someone to help stabilize spending and that many members of the staff refused to respect her decision. The day after the meeting, Susan Barnes wrote a confidential memo to Dominique:

Being excluded from decisions was one of your chief complaints when we first spoke last summer. Now I see that you were right.

Together Miles and Paul have marginalized you over the past years, speaking for you, assuming the leadership of your foundation and your collection without consulting you and pursuing their own social political and artistic agendas with your money and your prestige.

When I came, we put an end to that. You are now not only involved; you are in charge again.

Miles and Paul both want me to leave and they will continue to work on every front—insulting and excluding me in myriad, petty ways, undermining me to the board, the staff and your family—to make me quit or to persuade you to let me go. Make no mistake about it: they will not stop until it is decided one way or another.[34]

Dominique phoned Louisa Stude Sarofim, the Houston collector and patron who had been on the Menil board since 1990, to ask her advice.[35] By the summer, Dominique realized that the choice came down to keeping Barnes or losing much of her team. Susan Barnes resigned. "I didn't need to stay," Barnes later explained. "The work was done. We closed the hole in the deficit. We expanded the board membership. That was enough. Dominique was very grateful and gracious; that was more than I could hope."[36] Susan Barnes left the art world, earned a master of divinity, became an ordained priest, and is now the rector of St. John's Episcopal Church in Minneapolis.

Dominique, for her part, was right to be concerned about finances. She and John had done a tremendous amount with their fortune over the decades: all of the art they acquired, the buildings they had built, the projects and individuals they had supported. And, in the 1960s, they had given half of their Schlumberger stock to their children. As a result of their great generosity, however, her resources had dwindled considerably. She had long intended to give the bulk of her estate to the Menil Foundation. After she died, it was determined that her net worth was $169 million. Over $85 million of that, though, was a modest valuation of her personal art collection, which was going to the museum and would not be sold. Deducting the value of the art and the real estate, the amount of stocks, bonds, and liquid assets was $79 million.[37]

Certainly compared with other fortunes in Houston, an estate of $79 million was modest. But a net worth below $80 million lent a new perspective to figures such as $5 million to fund the Carter-Menil Human Rights Award or $15 million to cover the operating expenses for the museum for seven years. The need for Dominique to get a handle on spending was real and urgent.

•

The final eighteen months of Dominique de Menil's life was like a great unfurling of biographical passages. The exhibitions at the Menil Collection seemed, coincidentally, to be a string of shows that referred to her life.

Georges Rouault: The Inner Light (April 26–August 25, 1996) contained fifty-five paintings by the spiritual artist whom Dominique and John had collected at the suggestion of Father Couturier. Dominique curated the exhibition with a colleague, Ileana Marcoulesco. *Louis Fernández* (July 29, 1996–January 5, 1997) contained thirty-two paintings and works on paper by a personally meaningful artist for Dominique. She curated the exhibition; lenders, underscoring the personal nature of the show, included Adelaide and Edmund Carpenter, Sylvia de Cuevas (the niece of Alexandre Iolas), and Francesco Pellizzi.

Mark Rothko: The Chapel Commission (December 13, 1996–March 30, 1997) was an exhibition of thirty-eight Rothko paintings that traced the evolution of the chapel panels and coincided with the twenty-fifth anniversary of the Rothko Chapel. Included in the show were the four alternate panels Rothko painted for the chapel, large oversize canvases, in pristine condition, with tremendous depth and texture.

Braque: The Late Works (April 30–August 31, 1997) featured forty-five paintings from the 1940s through the early 1960s, organized by the Royal Academy of Arts, London. Braque, of course, was one of Dominique's favorite artists and one whom she and John had met with Father Couturier fifty years before. In addition to the main exhibition, a smaller show was *Georges Braque: Menil/Schlumberger Family Collections,* with sixteen works owned by Dominique, her children, and her French family.

The Braque exhibitions were timed to coincide with the tenth anniversary of the Menil Collection. A gala dinner was held at the museum on Wednesday, April 23, marking the occasion as well as the ninetieth year of Dominique de Menil (who had just turned eighty-nine). The cover of the evening's program was a graffiti tag, spelling out "Dominique" and "Menil Collection," by her great-grandson Dash Snow, who was fifteen years old.

The evening began with a reception in the museum, then dinner in a tent constructed on the front lawn. There were 450 guests including Robert Rauschenberg, Cy Twombly, Edward Albee, Larry Gagosian, Johnny Pigozzi, and Cecily Brown. The gala raised $1.1 million for the operating endowment. At the initiative of Bertrand Davezac, funds were raised from Houston friends to surprise Dominique with a gift of a spectacular Byzantine icon, *Entry into Jerusalem* (early to mid-fifteenth century). After dinner, Paul Winkler introduced David Sylvester and Leo Steinberg, who

delivered tributes to Dominique. "Goethe said, it is necessary to see the Sistine ceiling to have any conception of what it is possible for one man to accomplish," Steinberg said. "Now it is necessary to go to Houston and see Dominique's work to have any conception of what one woman can accomplish." In addition to being imprecise—eliding the role of John de Menil—it was a cringe-making compliment. As Steinberg recalled, "I watched Dominique as I said that, and she slouched, with her head down, covering her face with her fists."[38]

•

Dominique's final project was to work with Dan Flavin to turn Richmond Hall, the former grocery store south of the museum, into a Flavin installation. In August 1997, Dominique noted, "I would like to complete the Dan Flavin project—no more than $700,000—and will personally pay for it."[39] Richmond Hall was completed in 1998, after the deaths of artist and patron. The massive main room contained, along both walls, *Untitled, 1996,* columns of horizontal fluorescent lights in pink, yellow, green, and blue, intersected by a horizontal row of black lights, 8½ feet tall and 124 feet long. The colors and shapes of Flavin's sculptures reflected off the polished concrete floors and stretched into infinity.

Houston had long been known as the only major city in the United States without zoning. The lack of coherent planning meant that houses were built next to warehouses, a church could be adjacent to a strip mall, run-down gas stations were positioned next to luxury condominiums, and everything was surrounded by a colossal and constantly growing complex of highways. The lack of planning could give the city a sense of surreal energy. But the neighborhood created by the de Menils was the opposite: a serene, sacred environment based on tremendous reflection and careful consideration. It was an exceedingly sophisticated urban ensemble, in this unruly patch of South Texas, which managed to be important artistically, architecturally, historically, and spiritually.

•

In 1996, Dominique sold her New York town house on Seventy-Third Street to the Buckley School next door for $4.5 million.[40] Mary Jane Victor was responsible for doing a complete inventory of the contents, distributing some personal objects to family and friends in New York and arranging to have the furniture and art shipped to Houston.

Dominique spent months at home in Texas organizing her extensive

archives. She reviewed the thousands of letters that she and John had kept: their correspondence beginning from the moment they met in 1930, letters to and from their families and friends. She clarified the spelling of some words and identified some of the names. She also focused on captioning the thousands of family photographs they had kept. Adelaide came down from New York, spending days with her mother organizing the photographs. Dominique faxed images to her sister Sylvie in Paris to identify Schlumberger family members and to John's niece Bénédicte Pesle to correct the names of the de Menil ancestors. She made copies of some of the important letters and sent them to her children. In one of the notebooks she always kept handy for jotting down thoughts, Dominique wrote, "An old person who dies is like a library that burns."

In May 1997, Sylvie and Eric Boissonnas flew to Houston to spend a week with Dominique. They took in the Braque exhibition at the museum and saw the Byzantine Fresco Chapel for the first time. There were dinners together at Dominique's house and lunches with Bertrand Davezac.

At the end of May, a violent thunderstorm swept over the house in the middle of the night. "Terrifying storm," Dominique noted. "Lightning strikes, stripping the bark off two trees and burning three others."[41] Nora Fuentes, a Guatemalan-born home health worker who was staying overnight at the house, was frightened by the intensity of the storm. Before she was able to check on Dominique, she heard her coming toward her room. "Are you okay, Nora?" When Dominique saw how afraid she was, she suggested they go into the kitchen to make some tea and eat something. That way, if anything did happen, they would be prepared. "One of the things I liked the most about her was that she always focused, not on your problem, but how we are going to solve your problem," Fuentes recalled.[42]

On June 1, Dominique made a cross in her date book, in red ink, and wrote "Jean"; it was the anniversary of his death. Throughout 1997, Dominique's full daily schedule continued: attending board meetings for the Rothko Chapel, organizing exhibitions, seeing family and friends. During the summer, she made a trip to Long Island, seeing her granddaughter Taya and her son Dash Snow, taking long walks on the beach in Bridgehampton. "Heiner takes me to a beautiful, remote beach, very far away," Dominique wrote in her date book. "I put my feet in the ocean."[43] In New York, she had an appointment with Dr. Howard Fillit, a specialist in geriatric medicine and palliative care who had helped Philip Johnson. He told her to be sure to prepare a living will and make sure she organized a power of attorney for health care. He also advised her to consume twenty-five hundred to three thousand calories per day and to eat six times daily. "She was not eating enough," Nora Fuentes said. "She was too thin. I remember her having this

piece of fish with rice. I said, 'Madame, I can count how many grains of rice you are having with this fish.' "[44]

On September 5 back in Houston, she and Nora made a point to wake up in the middle of the night at 4:00 a.m., or 10:00 a.m. London time. They were in the kitchen, gathered around the television to watch the funeral of Princess Diana.[45]

Later that month, Dominique asked David Whitney to be on the board of the Menil Foundation; he accepted "with great pleasure."[46] She had had a long conversation with Francesco Pellizzi about the future of the museum. They both agreed that she should ask Louisa Sarofim to be her successor.[47] Five days later, Louisa agreed to be named to the presidency of the Menil Foundation.

At the end of October, Philip Glass was in Houston for a Society for the Performing Arts production of *La Belle et la Bête,* his film/opera that was inspired by Cocteau. Fredericka Hunter took Dominique to the performance. On Saturday, November 1, Glass and Fredericka went to the house for a visit. Dominique ushered them in, wearing brown cashmere sweatpants and top. "I think that he wanted to thank her, in a way," Fredericka Hunter recalled. "We sat in the living room, having sherry and walnuts. She seemed to be thrilled he was there. He asked about the Rothkos. When we left, Philip said that we would not see her alive again."[48]

Two exhibitions at the museum that fall were *Joseph Cornell* (October 3, 1997 to January 4, 1998): seventy-four works by the surrealist the de Menils had been collecting since the 1950s; and *The Drawing Speaks: Works by Théophile Bra* (December 12, 1997 to March 29, 1998): fifty works on paper by the nineteenth-century French Romantic sculptor curated by Jacques de Caso and Dominique, the last exhibition she curated. She was still planning future shows, however, including one of Charles James. Anne Schlumberger persuaded Dominique to sell her a carved wooden saint that had belonged to James. Knowing that she always had to approach any purchase with care, she wrote her a note and then called her. "I will sell it to you—you can make a donation to the museum—but when I do my Charles James show, I want you to promise that you will loan this back," Dominique said. As Anne Schlumberger recalled, "Here she is in her late eighties, and she's planning in the next ten years all the things that she still wants to do."[49]

•

Dominique de Menil was hospitalized several times in the last year of her life, usually with a bronchial infection or pneumonia. During one of

her hospitalizations, she told the doctors that she hoped they could help her have just a little more time. "I need another year," she told them. "I have a lot to do."[50]

Her final hospitalization took place at the end of November through early December. Dominique wanted to go home, but the doctors would not let her. One day, she summoned the medical staff into her room. She said that she had decided to commission a statue that she would place in a prominent location and then dedicate it to the staff of the hospital; it would be called *The Torturers*! "They decided to release her," recalled Aziz Friedrich, her grandson.[51]

Many members of her family had gathered in Houston, including Christophe, Adelaide and Edmund Carpenter, and Fariha and Heiner Friedrich, along with their children, Aziz and Doha. The Friedrich family spent three weeks at the house with Dominique. Occasionally, she would be strong enough to go to dinner. Or they would all go into her room after the meal to spend time with her.

Dominique told stories about the times she and John spent in South America. About that moment in the Alps shortly after they first met, when they walked across the glacier to be together. And one evening, in her wheelchair in the entrance of the house, Dominique repeated a joke that she said was one of John's favorites. It involved three life insurance salesmen trying to convince a client. The first said, "Well, our policy is the best, obviously—it's fail proof, it covers you from cradle to grave." The second scoffed and said, "That's nothing—our is much better—it covers you from sperm to worm." The third laughed and said, "That's ridiculous—ours is so much better than both of yours—it covers you from erection to resurrection!"[52]

As she became physically weaker, it was clear to Dominique that she was dying. Jean Daladier, the couple's great friend from the 1940s, was in Switzerland for the holidays and had a sudden urge to call her. He went to a phone booth and was able to reach Houston. "She told me, 'Oh, it makes me so happy that you have called,'" Daladier remembered. "'You know that it is over now; I am going to die.' We said that we loved one another; that was the day before New Year's Eve."[53]

Dominique Schlumberger de Menil, eighty-nine years old, died during the night of Wednesday, December 31, 1997, from a pulmonary infection, surrounded by family and friends.

•

"Humanitarian, Patron of the Arts de Menil, 89, Dies" was the front-page headline in *The Houston Chronicle*.[54] John Russell, whom Domi-

nique and John had known for years, wrote the obituary for *The New York Times,* and *Le Monde* eulogized her enduring cultural engagement.

The French Foreign Ministry, on the Quai d'Orsay in Paris, issued an official statement titled "The Death of Dominique de Menil: A Great Loss for France." "She was a permanent connection between France and the United States," noted the statement, "a living representation of French culture."[55]

For three days, Dominique's body, just as John's had, lay in state in the bedroom of their house, with its pale walls and floor-to-ceiling glass set off by dark taffeta curtains. Books were piled high on the eighteenth-century chest next to her bed and filled the low cases that ran along the interior wall. Over the entrance to her dressing room was Giorgio de Chirico's *Symbols of War* (1916), one of his metaphysical abstractions, next to a wooden mask from Gabon. The door to the dressing room was covered with notes, news clippings, snapshots, and postcards that Dominique had pinned onto a felt-covered board. To the right was a wooden carousel with coordinated pale-colored leather binders, filled with photographs and clippings she had amassed over the years. On the left of the doorway was her personal desk, made from two gray metal filing cabinets that supported a board she had covered with olive-green felt. It was at that makeshift desk, sitting on a simple wooden stool from Africa, that Dominique did most of her writing. On the desktop was one of the most private elements in the entire house: four decades of her copiously notated personal date books, from 1960 through 1997, intended only for Dominique.

Her funeral, on Saturday, January 3, took place, as John's had, at the nearby St. Anne's Catholic Church. Unlike her husband, she had left no instructions for her funeral, other than that she wanted to be "buried as a Catholic." Her body was placed in a simple pine casket, with rope handles, that had been meticulously constructed by workers in the museum's shop. The casket was transported from the house to St. Anne's in a big black SUV, a Chevrolet Suburban, owned by the Menil Foundation. Pallbearers were Dominique's grandchildren Jason de Menil, John de Menil, and Aziz Friedrich, Anthony Allison (who was married to her granddaughter Taya), Friedrich Moeller (Heiner Friedrich's son from his first marriage), and two great-grandchildren, Max Snow and Dash Snow.

The cover of the program was a reproduction of Henri Matisse's *Feuille noire sur fond vert* (1952), a bright green cutout of a leaf, which the artist had made in one of the last years of his life, a piece that Dominique and John had hung in the kitchen of their house. And the epigraph for the service was a statement Dominique had made to her family near the end of her life: "Everything I learned, I learned from love."

Over seven hundred mourners filled the church, a standing-room-only crowd. "In perhaps the greatest tribute to de Menil's work, the church was filled with a cross-section of people from various races, classes and ethnic groups," reported *The Houston Chronicle*. "Elected officials mingled with old-guard Houstonians and Menil workers."[56] Mourners included Philip Johnson in from New York; prominent Houstonians such as Louisa Sarofim, Lynn Wyatt, Carolyn Farb, and Jane Blaffer Owen; politicians such as former mayor Fred Hofheinz, U.S. representative Sheila Jackson Lee, and Sissy Farenthold, a former candidate for Texas governor and board member of the Rothko Chapel; as well as de Menil and Schlumberger family from across the United States and France. In order to allow all museum employees to attend, simple signs were placed on the glass doors of the building, "In memory of our founder, Dominique de Menil, the Menil Collection will be closed."

The service, a Mass that lasted ninety minutes, began with Sufi music, played on a sitar by Ali Rahman from New York, followed by Houston cellist Norman Fischer playing Johann Sebastian Bach's *Prelude* and *Sarabande* from *Suite in C Major*. The first reading was by Lois de Menil, from Exodus; grandsons Aziz Friedrich and John de Menil read Psalm 23; while Georges de Menil cited passages from John.

The homily was delivered by the Reverend William J. Young, the Basilian priest who was also the president of the University of St. Thomas.

During the liturgy of the Eucharist, the men from St. Paul's Choir School on Harvard Square in Cambridge, performed a "Veni, Creator Spiritus," the Gregorian chant that was always the favorite of John de Menil. The Eucharistic prayer was offered by the bishop of the Archdiocese of Galveston-Houston, the Most Reverend Joseph Fiorenza. "Her greatness as a patron of the arts is her wonderful legacy to the city of Houston," Bishop Fiorenza said. "Her greatness as a champion of the poor and a defender of civil rights is her beautiful legacy to the world."[57]

To the recessional, "Jesu, Joy of Man's Desiring" by Bach, played on piano by Sarah Rothenberg, the artistic director of Da Camera of Houston, the pallbearers carried the casket back out the front door of the church.

The pine box was then put in a black SUV, driven by Ralph Ellis, with Susan and François de Menil in the back with the casket, to go to Forest Lawn Cemetery. The procession first drove south on Shepherd Drive. As it pulled onto the first highway, U.S. 59 going east, and then onto the second, I-45 headed south, mourners discovered all lanes of the highways in their direction, meaning five to seven lanes, had been closed to traffic. Approximately two hundred attended the burial. As the coffin was lowered into

the ground by ropes, the graveside mourners took turns passing by, tossing down handfuls of flower petals and dirt. Twenty-four years and six months after his death, Dominique was laid to rest next to her husband.

Dominique's funeral, January 3, 1998, at St. Anne's Catholic Church, Houston.

•

A series of services in her honor were also organized. On January 7, the University of St. Thomas held a memorial Eucharist at the Chapel of St. Basil, a 1997 structure by Philip Johnson, at the end of his modernist quadrangle, in the position originally intended for the Rothko Chapel.

In Paris, on January 26, the Pompidou Center hosted "Hommage à Dominique de Ménil," held in the museum's theater. Some two hundred friends and family members attended; in the center of the stage hung paintings that had been donated to the museum by Dominique. The director of the Pompidou, Jean-Jacques Aillagon, spoke first, followed by Madame Pompidou, who told of her personal memories of Dominique, her founding of the Georges Pompidou Art and Culture Foundation, and her discreet but significant support of the museum. Following were allocutions by Renzo Piano and Werner Spies. A Paris-based, Romanian-born cellist, Diana Ligeti, performed from the *Suite No. 2 in D Minor* by J. S. Bach. Another allocution was delivered by Danielle Mitterrand, as well as Father Michel Albaric, O.P., a Dominican priest and director of the Bibliothèque du Saulchoir. The service concluded with a performance from Mozart's great sacred composition the "Laudate Dominum" from *Vesperae solennes de confessore,* sung by soprano Victoria de Menil, Dominique's granddaughter.

Another homage took place on February 28, 1998, at the Rothko Chapel with a performance of Sufi music, played on a sitar, a Jewish prayer, and prayers from a wide variety of faiths: Baha'i, Zoroastrian, Hindu, Christian, and Muslim—as well as a Buddhist meditation. Nabila Drooby, Lee Brown, the mayor of Houston, and Louisa Sarofim all spoke. The event concluded with reflections on her mother by Fariha. And a reception followed at the Menil Collection.

In the days and weeks after Dominique's death, sympathy letters were sent to the museum and to the immediate family from friends, other family members, and colleagues from around the world. Notes arrived from artists such as Henri Cartier-Bresson, Christo and Jeanne-Claude, Niki de Saint Phalle, Eve Arnold, David Novros, Bob Wilson, and Yves Klein's widow, Rotraut Klein-Moquay; art collectors such as Giuseppe Panza, Agnes Gund, and Ernst Beyeler; untold art dealers, auction houses, critics, curators, and museum directors; and a diverse range of dignitaries from Paris Egyptologist Jean Leclant to Cardinal Paulo Evaristo Arns of São Paulo to Texas's former governor Ann Richards to Jack Lang. As Renzo Piano wrote to Dominique's family, "She was the best client and the best Maecenas you can get as an architect in your entire life."[58]

So many friends and family members wrote of the profound, lifelong connection between the de Menils. And there was no doubt that at the end of her life Dominique's relationship with her husband, sixty-seven years after it had begun, was very much on her mind. More than once, she had told a friend grieving the loss of her husband, "The way I think about it, John is just around the corner."[59]

In those years when Dominique had been organizing her personal papers, she pored over all of the letters that she and John had written one another, which they had so meticulously preserved. One was particularly striking: undated, though from the fall of 1930, it was a thirty-nine-page *lettre d'adieu* that was, in turns, feverish, playful, and distraught. It looked not unlike a surrealist object, with her urgent handwriting filling up torn scraps of paper, backs of envelopes, and used business labels that had been addressed to her father. She also included a table of contents, to ensure that everything was read in the proper order.

The missive began after Conrad Schlumberger, angry about their clandestine trip to Venice, and disturbed by gossip he had heard about this young man, asked them not to see each other so that he could investigate. Dominique, crushed, was afraid the relationship might be over. She explained to John that she would not call or write for several months. She also decided to return many of the gifts that he had given her, except for books and Tahitian records he had brought back from his travels. She planned to wrap up everything in an unmarked package and leave it with the concierge so that he could discreetly collect it. *"Cher ami de moi,"* Dominique wrote, halfway through the mailing, "I plan on working very hard to obtain my independence. You do the same."[60]

Several months later, however, on February 12, 1931, Dominique and John celebrated their engagement party at the rue Las Cases. The morning after such a lovely occasion could be sad, Dominique felt. So the afternoon before the party, still working at the Schlumberger offices, she sat down to write a letter to her fiancé. Mailing it then meant that he would receive it first thing the following morning at the rue de Vaugirard, softening, she hoped, any melancholy he might have. As Dominique wrote:

Cher ami de moi, as I called you in my long letter of separation, a day when for the first time I was so moved to feel growing inside of me a great sadness for you. It was a tenderness so new and fresh. Now this tenderness, though it has lost some of its novelty, is still just as fresh. Don't you think that as we age, instead of withering away, it will retain its bloom and become only more and more intimate? Just the thought of it is dazzling.[61]

NOTES

EPIGRAPH

1. John de Menil and Dominique de Menil, "The Delight and the Dilemma of Collecting," April 9, 1964, MA.
2. Dominique de Menil, in Clifford Pugh, "The Magnificent Obsession: Dominique de Menil, Life in the Arts," The Magazine of the *Houston Post*, May 31, 1987, 8.

CHAPTER ONE: FANFARE

1. John de Menil to Frank Dent, July 29, 1971, MA.
2. *Houston Chronicle*, Oct. 5, 2001, accessed Oct. 6, 2010, www.chron.com.
3. Dan Zimmerman, e-mail to the author, Oct. 6, 2010.
4. "At Least Two Deaths Blamed on Rain," *Houston Post*, June 4, 1987, 7B.
5. "The Menil Collection Opening, Schedule of Events," MA.
6. Miles Glaser, interview by the author, March 29, 2003.
7. Dominique de Menil, Opening Speech, the Menil Collection, June 4, 1987, MA.
8. Dominique de Menil, in Grace Glueck, "Houston's Elegant Menil Collection," *New York Times*, May 26, 1987, C13.
9. Walter Hopps, interview by the author, Sept. 3, 2001.
10. Henriette de Vitry, interview by the author, June 2, 2006.
11. Hopps, interview by the author, Sept. 3, 2001.
12. Ralph Ellis, interview by Mary Jane Victor, June 22, 2011.
13. Susan de Menil, interview by the author, March 2, 2017.
14. Robert Wilson, e-mail to the author, Oct. 10, 2015.
15. Fredericka Hunter, interview by the author, Aug. 17, 2001.
16. Alfred Pacquement, interview by the author, Sept. 5, 2001.
17. Jean-Yves Mock, interview by the author, Sept. 5, 2001.
18. Auletta, *Art of Corporate Success*, 28.
19. Stephen Harris, e-mail to the author, Nov. 2, 2010.
20. Bowker, *Science on the Run*, 19.
21. Glueck, "The de Menil Family."
22. Diana Geddes, "One Family Dominates French Wealth League—Schlumbergers Are the Wealthiest People in France," *Times* (London), Oct. 19, 1985.
23. Manjeet Kripalani, "Seydoux/Schlumberger Family," *Forbes*, July 23, 1990, 205.
24. Giraudy, *Le regard d'un mécène*, 3.
25. Johnson, Fox, and Lewis, *Architecture of Philip Johnson*, 72–73.
26. "Domaine du Cap Bénat," accessed Oct. 20, 2010, www.capbenat.org.
27. Eric Boissonnas et al., *La culture pour vivre—Donations des Fondations Scaler et Clarence-Westbury* (Paris: Éditions du Centre Georges Pompidou, 2002), 21–27.
28. Hopps, interview by the author, Jan. 31, 2008.
29. Hopps, interview by the author, Sept. 13, 2002.
30. Jackson Hicks, interview by the author, Dec. 8, 2006.
31. Renzo Piano, interview by the author, June 17, 2015.
32. John Richardson, interview by the author, Aug. 22, 2002.
33. De Menil and de Menil, "The Delight and the Dilemma of Collecting."
34. Emile Souvestre, in Hau and Stoskopf, *Les dynasties alsaciennes*, 53.
35. Roberto Matta, interview by Adelaide de Menil, "Souvenirs," MA.

36. Eyewitness News, Channel 13, KTRK-TV, June 4, 1987.
37. Dominique de Menil, Comments on the Menil Collection, Exhibition History, Menil Collection, Public Relations and Press, MA.
38. Lois de Menil, interview by the author, Dec. 1, 2012.
39. Anne Schlumberger, interview by the author, June 19, 2007.
40. George Oser, interview by the author, Sept. 4, 2009.
41. Deloyd Parker, interview by the author, Sept. 10, 2004.
42. Remo Guidieri, interview by the author, March 9, 2015.
43. Chris Powell, interview by the author, March 3, 2003.
44. Fredericka Hunter, interview by the author, Aug. 17, 2001.
45. Hopps, interview by the author, Sept. 13, 2002.
46. Bertrand Davezac, interview by the author, Nov. 29, 2004.
47. Christophe de Menil, interview by the author, July 6, 2006.
48. John de Menil to Dominique de Menil, Oct. 1971, RCA.
49. Dominique de Menil, Oct. 21, 1996, Object Files, TMC.
50. Pastier, "Simplicity of Form, Ingenuity in the Use of Daylight," 84.
51. Georges de Menil, "Dinner Toast, Opening of the Menil Collection," June 3, 1987.
52. "The Menil Collection, Opening Day," schedule, MA.
53. Claude Pompidou, interview by the author, May 6, 2006.
54. Papademetriou, "Responsive Box," 93.
55. Pastier, "Simplicity of Form, Ingenuity in the Use of Daylight," 86.
56. Zac Stayton, e-mail to the author, Nov. 5, 2010.
57. Pastier, "Simplicity of Form, Ingenuity in the Use of Daylight," 88.
58. Ibid.
59. Macchi and Romanelli, *Renzo Piano Building Workshop Exhibit Design,* 98.
60. Paul Winkler, interview by the author, March 3, 2003.
61. Kathryn Davidson notes, Curatorial Museum Exploration, Storage Museum Overall Purpose, Oct. 15, 1976, MA.
62. Dominique de Menil, Comments on the Menil Collection, Exhibition History, Menil Collection, Public Relations and Press, MA.
63. Buchanan, *Renzo Piano Building Workshop,* 1:140.
64. Geri Aramanda, e-mail to the author, Nov. 4, 2010.
65. Object Files, TMC.
66. Newman, Temkin, and Shiff, *Barnett Newman,* 104.
67. Ibid., 278.
68. Deborah Velders, e-mail to Mary Kadish, July 21, 2003, Object Files, TMC.
69. Paul Winkler, interview by the author, Nov. 2, 2010.
70. Hopps, interview by the author, Sept. 3, 2001.
71. Pastier, "Simplicity of Form, Ingenuity in the Use of Daylight," 88.
72. Object Files, TMC.
73. Hopps, interview by the author, Jan. 31, 2005.
74. Hopps, interview by the author, Sept. 3, 2001.
75. Reyner Banham, "In the Neighborhood of Art," *Art in America,* June 1987, 125.
76. Hopps, interview by the author, Sept. 3, 2001.
77. Pacquement, interview by the author, Sept. 5, 2001.
78. Menil Collection, Milestone Dates for Design and Construction, n.d., MA.
79. Paul Winkler, interview by the author, March 3, 2003.
80. Tony Frederick, interview by Mary Jane Victor, May 27, 2010.
81. Menil Collection, Milestone Dates for Design and Construction.
82. Winkler, interview by the author, Nov. 2, 2010.
83. J. Carter Brown to Dominique de Menil, June 8, 1987, MA.
84. Philip Johnson to Dominique de Menil, n.d., MA.
85. Dorothea Tanning to Dominique de Menil, June 6, 1987, MA.
86. Carol Mancusi-Ungaro, interview by the author, July 31, 2007.
87. Elsian Cozens, e-mail to the author, Nov. 3, 2010.
88. "Herman Brown," *Handbook of Texas Online,* accessed Oct. 15, 2010, www.tshaonline.org.

89. "The Texas 100," *Texas Monthly,* Aug. 1989, 124.

90. Frank Welch, e-mail to the author, Oct. 21, 2010.

91. Mimi Kilgore, interview by the author, Oct. 10, 2010.

92. Mary Kadish, e-mail to the author, Nov. 1, 2010.

93. Barnstone, *Architecture of John F. Staub,* 171–79.

94. Lynn Wyatt, interview by the author, Oct. 12, 2010.

95. Stephen Fox, e-mail to the author, Oct. 10, 2010.

96. Mary Cullen, interview by Mary Jane Victor, Oct. 22, 2010.

97. Caroline Huber, interview by the author, June 10, 2015.

98. Mike McLanahan, interview by the author, Oct. 18, 2010.

99. Fox, *Houston Architectural Guide,* 215.

100. Stephen Fox, "Howard Barnstone (1923–1987)," in Scardino, Stern, and Webb, *Ephemeral City,* 235–36.

101. Presley, *Saga of Wealth,* 139.

102. Barnstone, *Architecture of John F. Staub,* 275–77.

103. "The Collection," Museum of Fine Arts, Houston, MFAH.org, accessed Oct. 28, 2010, www .mfah.org.

104. Presley, *Saga of Wealth,* 68.

105. Barnstone, *Architecture of John F. Staub,* 180–81.

106. Marzio, *Spirited Vision,* 4–7, 10–56.

107. Ibid., 26–29.

108. Marian Wilcox, interview by the author, Oct. 16, 2010.

109. "The Philanthropy 50: Americans Who Gave the Most in 2004," *Chronicle of Philanthropy,* accessed Oct. 15, 2010, philanthropy.com.

110. Cullen, interview by the author, Oct. 8, 2010.

111. Dominique de Menil, notebooks, Aug. 3, 1953, MA.

112. Dominique de Menil, date books, Dec. 19, 1961, DMFA.

113. Davezac, interview by the author, Nov. 29, 2004.

114. Dominique de Menil, date books, April 13, 1961, DMFA.

115. Hopps, interview by the author, Jan. 31, 2005.

116. John de Menil to Dorothy Miller, Jan. 15, 1964, MoMA.

117. "The Menil Collection, Opening Day," schedule, MA.

118. Colacello, "Remains of the Dia," 181.

119. "Years of Readjustment (1945–1950)," *Houston History,* accessed Oct. 25, 2010, www.hous tonhistory.com.

120. "Timeline 1930–1940," *Houston History,* accessed Oct. 15, 2010, www.houstonhistory.com.

121. Marzio, *Permanent Legacy,* 11.

122. "Sam Houston Coliseum and Music Hall," *Houston Deco,* accessed Oct. 15, 2010, www .houstondeco.org.

123. Fuermann, *Houston,* 174.

124. Winningham, *Friday Night in the Coliseum,* 73.

125. Jay Hall, quoted in Presley, *Saga of Wealth,* 228.

126. "Booming Houston," 109.

127. McComb, *Houston,* 86.

128. Dominique de Menil to Alice Gordon, Dec. 18, 1982, MA.

129. Carol Christian, "Oil Heiress Owen Devoted Life to Giving," *Houston Chronicle,* June 27, 2010, accessed Oct. 20, 2010, www.chron.com.

130. Owen, interview by the author, April 12, 2010.

131. Fuermann, *Houston,* 46.

132. Joanie Blaffer Johnson, interview by the author, Nov. 1, 2010.

133. Jane Blaffer Owen, interview by the author, April 12, 2010.

134. Kirkland, *Hogg Family and Houston,* 219.

135. Bernhard, *Ima Hogg,* 10.

136. Barnstone, *Architecture of John F. Staub,* 112.

137. Bernhard, *Ima Hogg,* 7.

138. Kirkland, *Hogg Family and Houston,* 238.

139. Bernhard, *Ima Hogg,* 9.
140. David Warren, interview by the author, Oct. 19, 2010.
141. "Business: Codes for Counters," *Time,* Oct. 16, 1933, accessed Oct. 25, 2010, www.time.com.
142. Dominique de Menil, biographical interview by Paul Winkler and Carol Mancusi-Ungaro, Sept. 25, 1995, MA.
143. Dominique de Menil, interview by Pierre Daix, "Désir des arts: La rime et la raison," 1984, MA.
144. Object Files, TMC.
145. Ashbel Smith to Copes, June 25, 1838, quoted in McComb, *Houston,* 5.
146. Miller, *Ray Miller's Houston,* 166.
147. McComb, *Houston,* 128.
148. Marzio, *Permanent Legacy,* 15.
149. "Booming Houston."
150. *Time,* n.d., quoted in Fuermann, *Houston,* 112.
151. Georges de Menil, interview by the author, Aug. 12, 2002.
152. "Booming Houston."

CHAPTER TWO: A FAMILY CHÂTEAU

1. Guizot, *Memoires pour servir a l'histoire de mon temps,* 4:139–40.
2. Tomkins, "Benefactor," 54.
3. Gide, *L'immoraliste,* 81–82.
4. Jean Schlumberger, *Saint Saturnin,* 4.
5. Pénault, *Du Val-Richer à la Roque-Baignard,* 26.
6. Broglie, *Guizot,* illustrations 276–77.
7. Pauline Lartigue, interview by the author, Dec. 14, 2009.
8. Pénault, *Du Val-Richer à la Roque-Baignard,* 31.
9. Theis, *François Guizot,* 32.
10. Ibid., 338.
11. Pineton Chambrun, *Nos historiens.*
12. Tocqueville to Gustave de Beaumont, Aug. 30, 1829, in Broglie, *Guizot,* 101.
13. Brogan, *Alexis de Tocqueville,* 94.
14. Theis, *François Guizot: Lettres à sa fille Henriette,* 13.
15. Broglie, *Guizot,* 102.
16. Pouthas, *Une famille de bourgeoisie française de Louis XIV à Napoléon,* 72–73.
17. Ibid., 166.
18. Broglie, *Guizot,* 15.
19. Ibid., 16.
20. Ibid., 18–19.
21. Pouthas, *La jeunesse de Guizot,* 114–15.
22. Broglie, *Guizot,* 18.
23. Witt, *Monsieur Guizot in Private Life,* 11–12.
24. Pouthas, *La jeunesse de Guizot,* 235.
25. Ibid., 167.
26. Ibid., 161.
27. Chateaubriand, *Itinéraire,* in ibid., 232.
28. Pouthas, *La jeunesse de Guizot,* 320–21.
29. Broglie, *Guizot,* 36.
30. Pouthas, *La jeunesse de Guizot,* 244.
31. Witt, *Monsieur Guizot in Private Life,* 41.
32. Broglie, *Guizot,* 38.
33. Ibid., 99.
34. Witt, *Monsieur Guizot in Private Life,* 46.
35. Pénault, *Du Val-Richer à la Roque-Baignard,* 16–17.
36. Broglie, *Guizot,* 80.
37. Pénault, *Du Val-Richer à la Roque-Baignard,* 17.

38. Theis, *François Guizot*, 181.
39. Ibid., 183.
40. Theis, *François Guizot: Lettres à sa fille Henriette*, 13.
41. Pénault, *Du Val-Richer à la Roque-Baignard*, 20–21.
42. Lois de Menil to the author, Dec. 6, 2012.
43. Pénault, *Du Val-Richer à la Roque-Baignard*, 23.
44. Broglie, *Guizot*, 154–62.
45. Ibid., 92.
46. Ibid., 187.
47. Académie des Sciences Morales et Politiques, Histoire, accessed Jan. 31, 2013, www.asmp.fr.
48. Broglie, *Guizot*, 129–30.
49. Lois de Menil to the author, Dec. 6, 2012.
50. Broglie, *Guizot*, 99.
51. Ibid., 175.
52. Pénault, *Du Val-Richer à la Roque-Baignard*, 20.
53. Theis, *François Guizot: Lettres à sa fille Henriette*, 13.
54. Theis, *François Guizot*, 186.
55. Broglie, *Guizot*, 178.
56. Ibid., 205.
57. Ibid., 201–2.
58. Guizot, *Memoires pour servir a l'histoire de mon temps*, 4:139–40.
59. Broglie, *Guizot*, 203.
60. Kirsten Borg, "Princess Lieven: A New Interpretation of Her Role" (Ph.D. diss., University of Illinois at Chicago, 1978), 51, quoted in Kale, *French Salons*, 151.
61. Lois de Menil to the author, Dec. 6, 2012.
62. Ibid.
63. Broglie, *Guizot*, 213.
64. Ibid., 219.
65. Lady Palmerston, *The Lieven-Palmerston Correspondence*, in Theis, *François Guizot*, 263.
66. Theis, *François Guizot*, 274.
67. Broglie, *Guizot*, 232–33.
68. Ibid., 254–55.
69. Ibid., 270.
70. Ibid., 355.
71. Ibid., 355–64.
72. Theis, *François Guizot: Lettres à sa fille Henriette*, 15.
73. Hugo, Jan. 10, 1849, in Broglie, *Guizot*, 378.
74. Broglie, *Guizot*, 371.
75. Pénault, *Du Val-Richer à la Roque-Baignard*, 39.
76. Theis, *François Guizot*, 199.
77. Ibid., 209.
78. André Gide, in Pénault, *Du Val-Richer à la Roque-Baignard*, 39.
79. Theis, *François Guizot*, 352.
80. Theis, *François Guizot: Lettres à sa fille Henriette*, 10.
81. Theis, *François Guizot*, 251.
82. Broglie, *Guizot*, 413.
83. Theis, *François Guizot: Lettres à sa fille Henriette*, 15.
84. Broglie, *Guizot*, 207.
85. Ibid., 487.
86. Ibid., 475–76.
87. Pénault, *Du Val-Richer à la Roque-Baignard*, 51.
88. Broglie, *Guizot*, 490.
89. Lartigue, interview by the author, May 30, 2006.
90. Pénault, *Du Val-Richer à la Roque-Baignard*, 61.
91. Sheridan, *André Gide*, 21.
92. Gide, *Si le grain ne meurt*, 172.

93. Ibid., 174.

94. Pénault, *Du Val-Richer à la Roque-Baignard,* 93–94.

95. Lartigue, interview by the author, Dec. 14, 2009.

96. Léon Schlumberger, *Tableaux généalogiques de la famille Schlumberger,* 1:2101.

CHAPTER THREE: A PROTESTANT DYNASTY

1. Kahn, *My Father Spoke French,* 27.

2. Vizetelly, *True Story of Alsace-Lorraine,* 15–18.

3. Putnam, *Alsace and Lorraine,* 44–45.

4. L'Hermine, *Guerre et paix en Alsace au XVIIe siècle,* 19.

5. "A Little History," accessed May 26, 2010, www.visit-alsace.com.

6. Heumann, *La guerre des paysans d'Alsace et de Moselle,* 9.

7. "La Maison Loewenfels, rue des Franciscains à Mulhouse, histoire," accessed April 23, 2010, lefuretmulhousien.fr.

8. "Petite boulangerie et boulangerie fine," Les Artisans Boulangers-Pâtissiers de la Suisse Romande, accessed May 14, 2010, www.lepain.ch.

9. "Schlumberger in Few Lines," accessed April 23, 2010, www.domaines-schlumberger.com.

10. Anne Schlumberger, interview by the author, June 19, 2007.

11. Léon Schlumberger, *Tableaux généalogiques de la famille Schlumberger,* 1:1993.

12. NSC Groupe, *Rapport Annuel 2008,* 8, 13.

13. Ann-Lucie Danjean, e-mail to the author, June 8, 2010.

14. Léon Schlumberger, *Tableaux généalogiques de la famille Schlumberger,* 1:1590.

15. Clarisse Schlumberger, *Schlumberger: Racines et paysages,* 14–16.

16. Ibid., 19.

17. Ibid., 21.

18. Aaron, *L'exode,* 79.

19. Livet and Oberlé, *Histoire de Mulhouse des origines à nos jours,* 49.

20. Ibid., 87.

21. Léon Schlumberger, *Tableaux généalogiques de la famille Schlumberger,* 1:1605.

22. Ibid., 1620–95.

23. Clarisse Schlumberger, *Schlumberger: Racines et paysages,* 39.

24. Léon Schlumberger, *Tableaux généalogiques de la famille Schlumberger,* 1:1694.

25. Ibid., 1695.

26. Ibid., 1694.

27. Hau and Stoskopf, *Les dynasties alsaciennes,* 30.

28. Clarisse Schlumberger, *Schlumberger: Racines et paysages,* 42.

29. Léon Schlumberger, *Tableaux généalogiques de la famille Schlumberger,* 1:1760.

30. *La Maison Loewenfels, rue des Franciscains à Mulhouse, histoire.*

31. Léon Schlumberger, *Tableaux généalogiques de la famille Schlumberger,* 1:1760.

32. Hau and Stoskopf, *Les dynasties alsaciennes,* 33.

33. Clarisse Schlumberger, *Schlumberger: Racines et paysages,* 55.

34. Ibid., 113.

35. "Nouvelles locales," 1.

36. *"Congrès Schlumberger 84,"* Mulhouse-Guebwiller, May 11–13, 1984, MA.

37. Teissonnière-Jestin, "Itinéraire social d'une grande famille mulhousienne," 11.

38. Clarisse Schlumberger, *Schlumberger: Racines et paysages,* 86.

39. Ibid.

40. Leuilliot, *L'Alsace au début du XIXeme siècle,* 2:364.

41. Ibid., 485.

42. Teissonnière-Jestin, "Itinéraire social d'une grande famille mulhousienne," 12.

43. "Nouvelles locales," 1.

44. Clarisse Schlumberger, *Schlumberger: Racines et paysages,* 112.

45. *"Congrès Schlumberger 84."*

46. Leuilliot, *L'Alsace au début du XIXeme siècle,* 2:485.

47. Ibid., 391–92.

48. N. Schlumberger et Cie., *N. Schlumberger et Cie., Guebwiller, France, 1808–1958,* 9.
49. Lawrence, *Fundamentals of Spun Yarn Technology,* 238.
50. Teissonnière-Jestin, "Itinéraire social d'une grande famille mulhousienne," 17.
51. "Guebwiller, paroisse réformée," accessed May 10, 2010, www.wiki-protestants.org.
52. Teissonnière-Jestin, "Itinéraire social d'une grande famille mulhousienne," 15.
53. Clarisse Schlumberger, *Schlumberger: Racines et paysages,* 162.
54. Ibid., 163.
55. Léon Schlumberger, *Tableaux généalogiques de la famille Schlumberger,* 1:1863.
56. Clarisse Schlumberger, *Schlumberger: Racines et paysages,* 190.
57. Ibid., 191.
58. Hau and Stoskopf, *Les dynasties alsaciennes,* 174.
59. "Nouvelles locales," 1.
60. Horne, *La Belle France,* 270.
61. Shirer, *Collapse of the Third Republic,* 36.
62. Hau and Stoskopf, *Les dynasties alsaciennes,* 341.
63. Kahn, *My Father Spoke French,* 32.
64. Aaron, *L'exode.*
65. Hau and Stoskopf, *Les dynasties alsaciennes,* 240.
66. Kahn, *My Father Spoke French,* 32.
67. Hau and Stoskopf, *Les dynasties alsaciennes,* 240.
68. Ibid., 140.
69. Raymond Poidevin, "Les industriels Alsaciens-Lorrains entre la France et l'Allemagne (janvier à août 1871)," in Kahn, *My Father Spoke French,* 129.
70. Clarisse Schlumberger, *Schlumberger: Racines et paysages,* 200.
71. Léon Schlumberger, *Tableaux généalogiques de la famille Schlumberger,* 1:1993.
72. Hau and Stoskopf, *Les dynasties alsaciennes,* 256.
73. Léon Schlumberger, *Tableaux généalogiques de la famille Schlumberger,* 1:1993.
74. Clarisse Schlumberger, *Schlumberger: Racines et paysages,* 200, 201.
75. Anne Gruner Schlumberger, *Schlumberger Adventure,* 4–5.
76. Ibid., 5.
77. Jean Schlumberger, *Éveils,* 16.
78. Pauline Lartigue, interview by the author, May 30, 2006.
79. Schlumberger and de Menil, *Conrad Schlumberger,* 14–15.
80. Bromberger, *Comment ils ont fait fortune,* 12.
81. Schlumberger and de Menil, *Conrad Schlumberger,* 12.
82. Jean Schlumberger, *Éveils,* 14.
83. Schlumberger and de Menil, *Conrad Schlumberger,* 13.
84. Jean Schlumberger, *Éveils,* 17.
85. Schlumberger and de Menil, *Conrad Schlumberger,* 10–11.
86. Ibid., 19–20.
87. Jean Schlumberger, *Éveils,* 38.
88. Ibid., 45.
89. Ibid., 20.
90. Ibid., 47.

CHAPTER FOUR: RETURN TO FRANCE

1. Dominique de Menil to Anne Postel-Vinay, n.d., MA.
2. Odile de Rouville, interview by the author, April 25, 2007.
3. Schlumberger and de Menil, *Conrad Schlumberger,* 24–25.
4. Ibid., 26.
5. Jean Schlumberger, *Éveils,* 54.
6. Lajeunesse, *Grands mineurs français,* 231.
7. Schlumberger and de Menil, *Conrad Schlumberger,* 24–25.
8. Dominique de Menil, notes, n.d., FCS.
9. Lajeunesse, *Grands mineurs français,* 231.

10. Schlumberger and de Menil, *Conrad Schlumberger,* 30–31.
11. Dominique de Menil, notes, n.d., FCS.
12. Léon Schlumberger, *Tableaux généalogiques de la famille Schlumberger,* 2:343.
13. Christophe de Menil, interview by the author, July 6, 2006.
14. Fonds Oberkampf de Dabrun, accessed May 31, 2010, www.cg47.fr.
15. Oberkampff de Dabrun, *Notice sur la famille Oberkamp.*
16. Claire Delpech, interview by the author, Nov. 1, 2006.
17. Essie McGaughy Barnes, *I Went with the Children,* 203.
18. Ibid., 199.
19. Clair Morizet, e-mail to the author, April 26, 2016.
20. Clair Morizet, "Clairac: Mystérieuse fontaine de Roche," *Le Festin* (Fall 2015): 66.
21. Essie McGaughy Barnes, *I Went with the Children,* 199.
22. Morizet, "Clairac." 69.
23. Essie McGaughy Barnes, *I Went with the Children,* 199.
24. Delpech, interview by the author, Nov. 1, 2006.
25. Anne Gruner Schlumberger, *Schlumberger Adventure,* 8.
26. Henry James, *The American* (New York: Signet Classics, 1963), 41.
27. Pérouse de Montclos, *Le guide du patrimoine: Paris,* 224.
28. Dr. Raymond Sauvage, interview by Adelaide de Menil, "Souvenirs," MA.
29. Clarisse Schlumberger, *Schlumberger: Racines et paysages,* 203.
30. Lois de Menil, interview by the author, Dec. 1, 2012.
31. "Paris Women Thank Wilson," *New York Times,* Sept. 10, 1918, 11.
32. Marguerite de Schlumberger to Pierre Schlumberger, Dec. 29, 1922, in Schlumberger Bohnn, *Les ordres de grandeur,* 47.
33. Dominique de Menil to Anne Postel-Vinay, n.d., MA.
34. Dominique de Menil, interview, in "Au Val-Richer, la vie des femmes," July 1992, MA;
35. Sylvie Boissonnas, interview, in "Au Val-Richer, la vie des femmes."
36. Anne Gruner Schlumberger, *Schlumberger Adventure,* 8.
37. Léon Schlumberger, *Tableaux généalogiques de la famille Schlumberger,* 2:231–344.
38. Odile de Rouville, interview by the author, April 25, 2007.
39. Léon Schlumberger, *Tableaux généalogiques de la famille Schlumberger,* 1:1993.
40. Gide and Schlumberger, *Correspondance, 1901–1950,* x.
41. Jean Schlumberger, *Notes sur la vie littéraire,* 384.
42. Jean Schlumberger, *Éveils,* 150.
43. Gide and Schlumberger, *Correspondance, 1901–1950,* xi–xii.
44. Lepape, *André Gide,* 228.
45. "*La Nouvelle Revue Française,* un cabinet de curiosités et un étalage de gourmandises," accessed June 4, 2010, www.gallimard.fr.
46. Jean Schlumberger, "Considerations," *La Nouvelle Revue Française,* Feb. 1909, 11.
47. Gide and Schlumberger, *Correspondance, 1901–1950,* xiv.
48. Ibid., xvi.
49. Ibid., xx.
50. "Gallimard, 5, rue Sébastien-Bottin," *L'Express.fr,* July 11, 2002, accessed Oct. 25, 2011, www.lexpress.fr.
51. Paul Webster, "The French Connection," *Guardian,* July 28, 2000, accessed Oct. 25, 2011, www.guardian.co.uk.
52. "Gallimard, 5, rue Sébastien-Bottin."
53. Gide and Schlumberger, *Correspondance, 1901–1950,* xvii.
54. Albert Camus, "Copeau, seul maître," in *Théâtre, récits, nouvelles* (Paris: Pléiade, 1962), 1698.
55. Bedé and Edgerton, *Dictionary of Modern European Literature,* 200.
56. François Chaubet, "Les décades de Pontigny (1910–1939)," *Vingtième Siècle: Revue d'Histoire* 57 (1998): 37.
57. Ibid., 40.
58. Sheridan, *André Gide,* 205.
59. Gide and Schlumberger, *Correspondance, 1901–1950,* xii.

60. Mercier, in Jean Schlumberger, *Notes sur la vie littéraire,* 13.
61. Sheridan, *André Gide,* 206.
62. Gide and Schlumberger, *Correspondance, 1901–1950,* ix.
63. Lepape, *André Gide,* 202.
64. André Gide, unpublished letter, Dec. 9, 1904, in ibid., 209.
65. Sheridan, *André Gide,* 210.
66. Ibid., 271.
67. Gide, Nov. 30, 1912, in Gide and Schlumberger, *Correspondance, 1901–1950,* 497.
68. Gide, Aug. 1, 1915, in Gide and Schlumberger, *Correspondance, 1901–1950,* 591–92.
69. Gide, Oct. 22, 1909, in Gide and Schlumberger, *Correspondance, 1901–1950,* 224.
70. Marguerite Yourcenar, "Ebauche d'un Jean Schlumberger," *La Nouvelle Revue Française,* March 1, 1969, 324.
71. Jean Schlumberger, *Éveils,* 41.
72. *L'école dans ses murs* (Paris: emsmp, n.d.), 5.
73. Dominique de Menil, notes, n.d., FCS.
74. Conrad Schlumberger to Dominique Schlumberger, postcard, July 12, 1912, DMFA.
75. Ann Holmes, "A New Kind of Patroness in a Changing Art Scene," *Houston Chronicle,* May 26, 1968.
76. Henriette de Vitry, interview by the author, June 2, 2006.
77. Catherine Coste, interview by Anaïs Beccaria, Nov. 3, 2008.
78. Dominique de Menil, interview, in "Au Val-Richer, la vie des femmes."
79. Catherine Coste, interview by the author, May 31, 2007.
80. Inventaire général du patrimoine culturel, Architecture—Mérimée, accessed June 9, 2013, www.culture.gouv.fr.
81. "Notre Histoire," La site du Lycée et du Collège Victor Duruy à Paris, accessed June 9, 2013, www.victor-duruy.org.
82. Catherine Coste, interview by Anaïs Beccaria, Nov. 3, 2008.
83. Fariha Friedrich, interview by the author, June 23, 2012.
84. Walter Hopps, interview by the author, Sept. 13, 2002.
85. Sylvie Boissonnas, Dominique de Menil, and Odile de Rouville, in "Au Val-Richer, la vie des femmes."
86. Dominique de Menil, "Souvenirs," June 1997, text e-mailed to the author by Jason de Menil, March 21, 2014.
87. Sylvie Boissonnas, interview, in "Au Val-Richer, la vie des femmes."
88. Anne Bohnn Brown, interview by the author, Dec. 16, 2009.
89. Pauline Lartigue, interview by the author, May 30, 2006.
90. Sylvie Boissonnas, Dominique de Menil, Odile de Rouville, in "Au Val-Richer, la vie des femmes."
91. Christophe de Menil, interview by the author, July 6, 2006.
92. Dominique Schlumberger to Conrad Schlumberger, April 18, 1924, DMFA.
93. Dominique Schlumberger to Louise Schlumberger, May 19, 1923, DMFA.
94. Dominique Schlumberger to Louise Schlumberger, July 20, 1923, DMFA.
95. Dominique Schlumberger, photo album, box CW 27.2, DMFA.
96. Lartigue, interview by the author, May 30, 2006.
97. Mary Jane Victor, interview by the author, Dec. 16, 2009.
98. Sylvie Boissonnas, interview, in "Au Val-Richer, la vie des femmes."
99. Dominique de Menil, interview, in "Au Val-Richer, la vie des femmes."
100. Pierre Schlumberger, letter, n.d., in Schlumberger Bohn, *Les ordres de grandeur,* 57.
101. Pierre Schlumberger, July 2, 1929, in Schlumberger Bohn, *Les ordres de grandeur,* 56–57.
102. Dominique de Menil to Françoise Schlumberger-Primat, Aug. 29, 1989, MA.
103. Dominique de Menil, notes for introduction to *For Children* (1971), MA.
104. Brown and Johnson, *First Show,* 35.
105. Mary Kadish, e-mail to the author, May 7, 2010.
106. Mary Jane Victor, interview by the author, May 7, 2010.
107. Kadish, e-mail to the author, May 7, 2010.
108. Dominique de Menil, notes for introduction to *For Children.*

109. Brown and Johnson, *First Show,* 35.
110. Dominique de Menil, note, n.d., MA.
111. Brown and Johnson, *First Show,* 35.
112. Browning, "What I Admire I Must Possess."
113. Sylvie Boissonnas, interview, in "Au Val-Richer, la vie des femmes."
114. Ibid.
115. Dominique de Menil, interview, in "Au Val-Richer, la vie des femmes."
116. Dominique de Menil, note, n.d., MA.
117. Dominique de Menil, biographical interview by Winkler and Mancusi-Ungaro.
118. Dominique de Menil, "Souvenirs," June 1997.
119. Dominique de Menil, biographical interview by Winkler and Mancusi-Ungaro.
120. Dominique de Menil to Anne Postel-Vinay, n.d., MA.
121. Dominique de Menil, interview, in "Au Val-Richer, la vie des femmes."
122. Nabila Drooby, interview by the author, Dec. 18, 2009.
123. Davidson, "Dominique de Menil," 12.

CHAPTER FIVE: FOREIGN AFFAIRS

1. John de Menil, notes for *Intercom,* May 1954, FCS.
2. Keegan, *First World War,* 67.
3. Jean Schlumberger, *Éveils,* 249.
4. Ibid., 246.
5. Dominique de Menil, interview, in "Au Val-Richer, la vie des femmes."
6. Conrad Schlumberger to Annette and Dominique Schlumberger, July 31, 1914, DMFA.
7. Schlumberger and de Menil, *Conrad Schlumberger,* 37.
8. Conrad Schlumberger to Annette and Dominique Schlumberger, July 31, 1914, DMFA.
9. Schlumberger and de Menil, *Conrad Schlumberger,* 60.
10. Ibid., 37–39.
11. Dominique de Menil, 1997 note, family photographs, DMFA.
12. Dominique de Menil, notes, 1997, DMFA.
13. Christophe de Menil, interview by the author, July 6, 2006.
14. Louise Schlumberger, n.d., DMFA.
15. Conrad Schlumberger, journal, Feb. 25, 1916, DMFA.
16. Schlumberger and de Menil, *Conrad Schlumberger,* 43.
17. François Conrad Schlumberger (1878–1936), Annales.org, accessed Aug. 27, 2014, www
 .annales.org.
18. Dominique de Menil to Ken Auletta, July 20, 1983, MA.
19. Dominique de Menil, drawing, Aug. 30, 1914, box CW 27.2, DMFA.
20. Dominique de Menil to Conrad Schlumberger, n.d., DMFA.
21. Dominique de Menil, interview, in "Au Val-Richer, la vie des femmes."
22. Sylvie Boissonnas, interview, in "Au Val-Richer, la vie des femmes."
23. Ibid.
24. Dominique de Menil, interview, in "Au Val-Richer, la vie des femmes."
25. Conrad Schlumberger to Louise Schlumberger, June 5, 1915, DMFA.
26. "Mr. Marcel Schlumberger: Lucas Medal," *Oil & Gas Journal,* Nov. 23, 1940, SLB Archives.
27. *Guerre de 1914–1918: Tableau d'honneur: Morts pour la France* (Paris: Publications de la
 Fare, 1921), 873.
28. Léon Schlumberger, *Tableaux généalogiques de la famille Schlumberger,* 2:345.
29. Conrad Schlumberger, journal, Feb. 25, 1916, DMFA.
30. Conrad Schlumberger to Louise Schlumberger, June 9, 1918, DMFA.
31. Dominique de Menil to Ken Auletta, July 20, 1983, MA.
32. Conrad Schlumberger to Louise Schlumberger, June 9, 1918, DMFA.
33. Dominique de Menil, note, n.d., box CW 27.3, DMFA.
34. Schlumberger and de Menil, *Conrad Schlumberger,* 45–46.
35. Dominique de Menil, notes, 1997, DMFA.
36. Jeanne Schlumberger, interview by Maurice Martin, Feb. 6, 1972, FCS.

37. Schlumberger and de Menil, *Conrad Schlumberger,* 48–49.
38. Shirer, *Collapse of the Third Republic,* 108.
39. Ampère et l'histoire de l'électricité, "Chronologie des découvertes et inventions," accessed Aug. 7, 2014, www.ampere.cnrs.fr.
40. Thierry Paquot, "Paris 1900: Le Palais de l'Électricité," *Lux des Lumières aux Lumières* 10, no. 2 (2000), accessed July 28, 2014, mediologie.org.
41. Paul Morand, *1900* (Paris: Les Éditions de France, 1933), in ibid.
42. Julie Des Jardins, "Madame Curie's Passion," *Smithsonian,* Oct. 2011, accessed Aug. 7, 2014, www.smithsonianmag.com.
43. Anne Gruner Schlumberger, *Schlumberger Adventure,* 2.
44. Conrad Schlumberger, *Les puits qui parle,* April 1921, as quoted in Schlumberger and de Menil, *Conrad Schlumberger,* 61–62.
45. Schlumberger and de Menil, *Conrad Schlumberger,* 70.
46. Auletta, *Art of Corporate Success,* 23–24.
47. Maurice Martin, interview by Adelaide de Menil, "Souvenirs," MA.
48. Jeanne Schlumberger, interview by Maurice Martin, Feb. 6, 1972, FCS.
49. "Auguste Rateau, 1863–1930," *Nature,* May 6, 1933, accessed June 5, 2013, www.nature.com.
50. Jeanne Schlumberger, interview by Maurice Martin, Feb. 6, 1972, FCS.
51. Ibid.
52. Schlumberger and de Menil, *Conrad Schlumberger,* 16.
53. Ibid., 35–36.
54. Paul Schlumberger, Nov. 19, 1919, in W. J. Gillingham and Jean Riboud, "Schlumberger: The First Years" (1977).
55. Paul Schlumberger to Marcel Schlumberger, Nov. 20, 1919, in Gillingham and Riboud, "Schlumberger."
56. Conrad Schlumberger, 1913, quoted by Dominique de Menil, date books, Nov. 20, 1976, DMFA.
57. Yergin, *Prize,* 11–12.
58. Dowling, *World War I,* 129.
59. Keegan, *First World War,* 297.
60. Colonel, Sous-Directeur de l'Artillerie d'Assault, to Marcel Schlumberger, Oct. 4, 1919, in Schlumberger Bohnn, *Les ordres de grandeur,* 38.

CHAPTER SIX: HONOR AND SACRIFICE

1. Dominique de Menil, interview by Adelaide de Menil, "Souvenirs," MA.
2. Bénédicte Pesle, interview by the author, March 29, 2004.
3. Patrice de Menil, interview by Adelaide de Menil, "Souvenirs," MA.
4. Ibid.
5. Hazan, *L'invention de Paris,* 240.
6. Bénédicte Pesle, interview by the author, May 31, 2006.
7. Bénédicte Pesle, interview by the author, April 6, 2011.
8. Bénédicte Pesle, interview by the author, March 29, 2004.
9. Adelaide de Menil, e-mail to the author, March 24, 2011.
10. Bénédicte Pesle, interview by the author, May 31, 2006.
11. Christophe de Menil, interview by the author, July 6, 2006.
12. "Plan parcellaires de Paris et des communes annexées (XIXe siècle)," Archives de Paris, accessed March 15, 2011, canadp-archivesenligne.paris.fr.
13. Essie McGaughy Barnes, *I Went with the Children,* 63.
14. De Menil family photographs, DMFA.
15. François Bonnet, in *Rue de Vaugirard,* documentary by François Bonnet, Oct. 2010, DMFA.
16. Bénédicte Pesle, interview by the author, May 31, 2006.
17. "Cadastre révisé des communes annexées (1830–1850)," Archives de Paris, accessed March 15, 2011, canadp-archivesenligne.paris.fr.
18. Bénédicte Pesle, interview by the author, April 6, 2011.
19. Patrice de Menil, interview by Adelaide de Menil, "Souvenirs," MA.

20. Nicolas Lecervoisier, e-mail to the author, April 4, 2011.

21. L'Abbé Nicolas, *Marcel de Ménil,* 1.

22. Patrice de Menil, interview by Adelaide de Menil, "Souvenirs," MA.

23. Ibid.

24. Edmund Carpenter to the author, Sept. 19, 2002.

25. Quintin and Quintin, *Dictionnaire des colonels de Napoléon,* 11.

26. Ibid., 23.

27. "Généalogie de Ménil," François Bonnet, e-mail to the author, April 3, 2011.

28. Mirèse de Menil, interview by Adelaide de Menil, "Souvenirs," MA.

29. Menu de Ménil Genealogy, John de Menil to Jeanne Vielliard, Sept. 15, 1954, MA.

30. Edmund Carpenter to the author, Sept. 19, 2002.

31. Delmas, *Histoire militaire de la France,* 2:239.

32. "Les bataillons de volontaires nationaux Fédérés," accessed Aug. 3, 2011, lesbataillonsdevo
lontaires.wifeo.com.

33. Edmund Carpenter to the author, Sept. 19, 2002.

34. Delmas, *Histoire militaire de la France,* 2:293.

35. Napoleon, *Vues politiques* (Paris: Fayard, 1939), 173, in Tulard, *Napoléon et la noblesse d'Empire,* 25.

36. Tulard, *Napoléon et la noblesse d'Empire,* 57.

37. Ibid., 59–61.

38. Bénédicte Pesle, e-mail to the author, April 8, 2011.

39. Pierre Marlier, "Les Martinet: Essai d'histoire familiale," Nov. 2001, Jacques Demonsant, e-mail to the author, Aug. 10, 2011.

40. Mirèse de Menil, interview by Adelaide de Menil, "Souvenirs," MA.

41. Lois de Menil to the author, April 29, 2012.

42. Delmas, *Histoire militaire de la France,* 2:299.

43. Tulard, *Napoléon et la noblesse d'Empire,* 184–87.

44. P. Lefranc, "Conscription dorée, conscription des filles," *Revue de l'Institut Napoléon* (1977): 48, in ibid., 185.

45. Les Amis des Monuments Rouennais, *Bulletin: Année 1906,* 118–19.

46. Jacques Demonsant, e-mail to the author, Aug. 13, 2011.

47. Roger Rodière, *Les vieux manoirs du Boulonnais* (Rennes: Editions de la Découvrance, 2001), 167, in Marlier, "Les Martinet."

48. "Les chateaux du Pas de Calais," accessed Sept. 8, 2011, Pas-de-Calais62.fr, www.pas-de
-calais62.fr.

49. Schom, *Napoleon Bonaparte,* 444.

50. Delmas, *Histoire militaire de la France,* 2:349.

51. Edmund Carpenter to the author, Sept. 19, 2002.

52. Schom, *Napoleon Bonaparte,* 442.

53. Quoted in Esdaile, *Napoleon's Wars,* 283–84.

54. Edmund Carpenter to the author, Sept. 19, 2002.

55. Tulard, *Napoléon et la noblesse d'Empire,* 65.

56. Jérome-Francois Zieseniss, "Napoléon et la noblesse impériale," accessed Aug. 24, 2011, www.napoleon.org.

57. Tulard, *Napoléon et la noblesse d'Empire,* 283, 111.

58. Ibid., 113.

59. Campardon, *Liste des membres de la noblesse impériale,* 129.

60. Letters Patent, "Titre de chevalier, accordé à Paul-Alexis-Joseph Menu, a la suite du décret du 25 prairial an XII, le nommant membre de la Légion d'honneur et du décret du 4 juin 1809 lui accordant une dotation, Paris," 9 Dec. 1809, BB/29/971, 26, AN.

61. Lorblanchès, *Les soldats de Napoléon en Espagne et au Portugal,* 9.

62. Edmund Carpenter to the author, Sept. 19, 2002.

63. Lorblanchès, *Les soldats de Napoléon en Espagne et au Portugal,* 524.

64. Ibid., 525.

65. Edmund Carpenter to the author, Sept. 19, 2002.

66. Delmas, *Histoire militaire de la France,* 2:357–59.
67. Schom, *Napoleon Bonaparte,* 614.
68. Ibid., 640.
69. Letters Patent, "Titre de baron, accordé par décret du 14 juin 1813, à Paul-Alexis-Joseph Menu de Ménil, Saint-Cloud," BB/29/969, 151, AN.
70. Ibid.
71. François R. Velde, e-mail to the author, Aug. 27, 2011.
72. Edmund Carpenter to the author, Sept. 19, 2002.
73. Baines, *History of the Wars of the French Revolution,* 2:290.
74. Edmund Carpenter to the author, Sept. 19, 2002.
75. Schom, *Napoleon Bonaparte,* 703.
76. Ordre Royal et Militaire de Saint-Louis, "Liste des membres de l'Ordre, Chevaliers, Commandeurs et Grand Croix nommés de 1814 à 1830," accessed Aug. 24, 2011, www.saint-louis .info.
77. Delmas, *Histoire militaire de la France,* 2:294.
78. Jacques Demonsant, e-mail to the author, Aug. 7, 2011.
79. Ordre Royal et Militaire de Saint-Louis, "Insignes," accessed Aug. 24, 2011, www.saint-louis .info.
80. Edmund Carpenter to the author, Sept. 19, 2002.
81. Schom, *Napoleon Bonaparte,* 752.
82. Delmas, *Histoire militaire de la France,* 2:369.
83. Edmund Carpenter to the author, Sept. 19, 2002.
84. "Avis de décès," Paul-Alexis Menu de Mésnil, Dec. 30, 1834, Archives Départementales de l'Orne.
85. Edmund Carpenter to the author, Sept. 19, 2002.
86. "Repertoire des nouveaux nés," Archives Departementales du Doubs, 14F17, Besançon 1793–1812 (1674).
87. "Evénements marquants: Siècle des lumières," École des Ponts ParisTech, "Historique," accessed Sept. 14, 2011, www.enpc.fr.
88. Sophie Mouton, "Brest, plateau des Capucins, présentation historique," Sophie Mouton: Médiation culturelle et valorisation du patrimoine, accessed Sept. 5, 2011, sophie-mouton .info.
89. *Notices sur les modèles, cartes et dessins relatifs aux travaux publics* (Paris: E. Thunot, 1867), 466–69.
90. Mouton, "Brest, plateau des Capucins, présentation historique."
91. Fichier Richard, 12, "Biographie," Archives, École Nationale des Ponts et Chaussées.
92. "Famille Riou-Kerhalet," "Notes parues dans l'écho paroissial de Brest," 13, Aug. 1899, Archives Municipales et communautaires de Brest.
93. Annales des Ponts et Chaussées, July 24, 1862, 158.
94. "Généalogie de Ménil," François Bonnet, e-mail to the author, April 3, 2011.
95. Dominique de Menil, interview by Adelaide de Menil, "Souvenirs," MA.
96. Mirèse de Menil, interview by Adelaide de Menil, "Souvenirs," MA.
97. "Mirèse raconte," interview with Mirèse de Menil by François Bonnet and Odile Bonnet, Dec. 1982, e-mail to the author from François Bonnet, April 3, 2011, 13.
98. État des services, "Georges Menu de Ménil," No. 779, AN.
99. "Col. Georges de Menil," photograph, n.d., DMFA.
100. Renseignements à l'appui d'une proposition de nomination ou de promotion dans l'Ordre de la Légion d'Honneur, April 22, 1924, AN.
101. Mirèse de Menil, interview by Adelaide de Menil, "Souvenirs," MA.
102. Pierre Marlier, "Les Martinet."
103. Fichier Richard, 15, "Rougier, Jean Baptiste Louis Marcellin (1823–1901), IPC 1848, Biographie," Archives, École Nationale des Ponts et Chaussées.
104. "Chemins de fer du Paris-Orléans," Voies Ferrées de Gironde, accessed June 9, 2010, voiesferreesdegironde.e-monsite.com.
105. Mirèse de Menil, interview by Adelaide de Menil, "Souvenirs," MA.

106. "Historique du Château Simone," accessed Sept. 6, 2011, www.chateau-simone.fr.
107. Extrait du Registre matricule des élèves, No. 1, 1827–1862, MS 3274, Archives, École Nationale des Ponts et Chaussées.
108. Habuet, *L'Orléans à toute vapeur,* 3–5.
109. Ibid., 71–76.
110. J. C. Comert, "Propos de Madame Jean de Menil," July 4, 1973, MA.
111. "Bordeaux la passerelle Gustave Eiffel," accessed June 9, 2010, www.33-bordeaux.com.
112. Mirèse de Menil, interview by Adelaide de Menil, "Souvenirs," MA.
113. Marcellin Rougier, GeneaNet, accessed June 5, 2010, gw1.geneanet.org.
114. *Vue pittoresques du chemin de fer de Paris à Orléans, 7.*
115. Mirèse de Menil, interview by Adelaide de Menil, "Souvenirs," MA.
116. "Généalogie de Ménil," François Bonnet, e-mail to the author, April 3, 2011.
117. "Mirèse raconte," 3.
118. Ibid.
119. Ibid.
120. "Généalogie succincte Rougier," Jean Rougier, e-mail to the author, April 2, 2004.
121. "Mirèse raconte," 13.
122. État des services, "Georges Menu de Ménil," No. 779, AN.
123. Hubert Pesle, in *Rue de Vaugirard.*
124. Acte de naissance, Service Etat civil, Mairie du 7eme Arrondissement.
125. Extrait des Minutes des Actes, Letter from Mairie du 7eme Arrondissement, July 3, 1970, Rose-Marie Cavazzini, e-mail to the author, Oct. 3, 2011.
126. Hillairet, *Connaissance du vieux Paris,* 194–95.
127. Pérouse de Montclos, *La guide du patrimoine: Paris,* 334.
128. Louis Chaigne, *Histoire et vocation d'une chapelle: Les Bénédictines de la rue Monsieur* (Strasbourg: F.-X. Le Roux, 1950), 32–34.
129. La Pagode, CinemaTreasures.org, accessed Sept. 18, 2011, cinematreasures.org.
130. Bénédicte Pesle, interview by the author, April 6, 2011.
131. "Mirèse raconte," 25.
132. Hubert Pesle, interview by Adelaide de Menil, "Souvenirs," MA.
133. Mirèse de Menil, in *Rue de Vaugirard.*
134. Mirèse de Menil, interview by Adelaide de Menil, "Souvenirs," MA.
135. Dominique de Menil, interview by Adelaide de Menil, May 18, 1985, "Souvenirs," MA.
136. Philippe Auriau, in *Rue de Vaugirard.*
137. Bénédicte Pesle, in ibid.
138. Mirèse de Menil, interview by Adelaide de Menil, "Souvenirs," MA.
139. "Généalogie succincte Rougier."
140. "Note etablie par Stanislas Rougier, le 29 aôut 1904," Jean Rougier to Adelaide de Menil, May 2, 1991, MA.
141. Jean Rougier to Adelaide de Menil, May 2, 1991, MA.
142. "Note etablie par Stanislas Rougier, le 29 aôut 1904."
143. Ibid.
144. Jean Rougier, interview by Adelaide de Menil, "Souvenirs," MA.
145. Ibid.
146. Jean Rougier to Adelaide de Menil, May 2, 1991, MA.
147. Dominique de Menil, interview by Adelaide de Menil, "Souvenirs," MA.
148. Jean Rougier, interview by Adelaide de Menil, "Souvenirs," MA.
149. Bénédicte Pesle, interview by Adelaide de Menil, "Souvenirs," MA.
150. Jean Rougier, interview by Adelaide de Menil, "Souvenirs," MA.
151. Bénédicte Pesle, quoted by Georges de Menil, interview by the author, Dec. 1, 2012.
152. François Bonnet, *Rue de Vaugirard.*
153. Acte de mariage, Jean de Menil and Dominique Schlumberger, May 8, 1931, Mairie du 7ème Arrondissement.
154. Jean Rougier to Adelaide de Menil, May 2, 1991, MA.
155. Jean Rougier, interview by Adelaide de Menil, "Souvenirs," MA.

156. *The Letters of Henry James,* ed. Percy Lubbock (New York, 1920), 2:384, in Fussell, *Great War and Modern Memory,* 8.

157. État des services, "Georges Menu de Ménil," No. 779, AN.

158. État des services, "Marcel Menu de Menil," Rose-Marie Cavazzini to Adelaide de Menil, March 19, 1985, DMFA.

159. Mirèse de Menil, interview by Adelaide de Menil, "Souvenirs," MA.

160. Ibid.

161. État des services, "Marcel Menu de Menil," Rose-Marie Cavazzini to Adelaide de Menil, March 19, 1985, DMFA.

162. L'Abbé Nicolas, *Marcel de Ménil,* 2–3.

163. *État des services,* "Emmanuel Menu de Menil," Rose-Marie Cavazzini to Adelaide de Menil, March 19, 1985, DMFA.

164. Mirèse de Menil, interview by Adelaide de Menil, "Souvenirs," MA.

165. Baudrillart, *Emmanuel de Ménil.*

166. Mirèse de Menil, interview by Adelaide de Menil, "Souvenirs," MA.

167. Keegan, *First World War,* 285.

168. "Marcel, Georges, Emmanuel de Menil," photograph, July 9, 1917, DMFA.

169. Mirèse de Menil, interview by Adelaide de Menil, "Souvenirs," MA.

170. Baudrillart, *Emmanuel de Ménil,* 1.

171. Sépultures communales individuelles de militaires de toutes époques et de morts pour la France, accessed April 8, 2011, seynaeve.pagesperso-orange.fr.

172. Alfred Baudrillart, AcademieFrançaise.fr, accessed Sept. 20, 2011, www.academie-francaise .fr.

173. Baudrillart, *Emmanuel de Ménil,* 3.

174. Horne, *Seven Ages of Paris,* 321.

175. Rollin Smith, *Louis Vierne: Organist of Notre-Dame Cathedral* (Hillsdale, N.Y.: Pendragon Press, 1999), 330.

176. Mirèse de Menil, interview by Adelaide de Menil, "Souvenirs," MA.

177. État des services, "Marcel Menu de Menil," Rose-Marie Cavazzini to Adelaide de Menil, March 19, 1985, DMFA.

178. L'Abbé Nicolas, *Marcel de Ménil,* 5.

179. Historique de Régiments, chtimiste.com, accessed April 6, 2011, www.chtimiste.com.

180. L'Abbé Nicolas, *Marcel de Ménil,* 3.

181. Ibid., 4–5.

CHAPTER SEVEN: *MONSIEUR LE BARON*

1. Fariha Friedrich, interview by the author, June 23, 2012.

2. Fohlen, *La France de l'entre-deux-guerres,* 26–28.

3. Bouvet and Durozoi, *Paris, 1919–1939,* 57.

4. André Armengaud, in Fohlen, *La France de l'entre-deux-guerres,* 27.

5. Fohlen, *La France de l'entre-deux-guerres,* 50.

6. Ibid., 32–33.

7. Ibid., 69.

8. John Maynard Keynes, *The Economic Consequences of the Peace* (New York: Harcourt, Brace and Howe, 1920), chap. 5.

9. Mirèse de Menil, interview by Adelaide de Menil, "Souvenirs," MA.

10. Bénédicte Pesle, in *Rue de Vaugirard.*

11. Bénédicte Pesle, interview by Adelaide de Menil, "Souvenirs," MA.

12. François Bonnet, in *Rue de Vaugirard.*

13. Bénédicte Pesle, in *Rue de Vaugirard.*

14. Mémorial GenWeb, accessed April 8, 2011, www.memorial-genweb.org.

15. Bénédicte Pesle, in *Rue de Vaugirard.*

16. Photographs, DMFA.

17. Hubert Pesle, interview by Adelaide de Menil, "Souvenirs," MA.

18. Mémorial GenWeb, accessed April 8, 2011, www.memorial-genweb.org.
19. Mary Jane Victor, interview by the author, Sept. 21, 2011.
20. Mirèse de Menil, interview by Adelaide de Menil, "Souvenirs," MA.
21. Hubert Pesle, interview by Adelaide de Menil, "Souvenirs," MA.
22. Jean de Menil to Dominique de Menil, Oct. 3, 1939, DMFA.
23. Mirèse de Menil, interview by Adelaide de Menil, "Souvenirs," MA.
24. Jean Rougier, interview by Adelaide de Menil, "Souvenirs," MA.
25. Bénédicte Pesle, in *Rue de Vaugirard.*
26. *La séparation de l'église et de l'état en France: Exposé et documents* (Rome, 1905), 5.
27. Shirer, *Collapse of the Third Republic,* 72–73.
28. Ibid., 93.
29. Mirèse de Menil, interview by Adelaide de Menil, "Souvenirs," MA.
30. Lois de Menil, e-mail to the author, April 29, 2012.
31. Dominique de Menil, biographical interview by Winkler and Mancusi-Ungaro.
32. Fohlen, *La France de l'entre-deux-guerres,* 63.
33. Jean de Menil to Charles Maurras, Jan. 5, 1927, 1, MA.
34. Ibid., 10.
35. Bouvet and Durozoi, *Paris, 1919–1939,* 60–61.
36. Shirer, *Collapse of the Third Republic,* 94.
37. Dominique de Menil, interview by Adelaide de Menil, "Souvenirs," MA.
38. Ibid.
39. Mirèse de Menil, interview by Adelaide de Menil, "Souvenirs," MA.
40. Patrice de Menil, interview by Adelaide de Menil, "Souvenirs," MA.
41. Mirèse de Menil, interview by Adelaide de Menil, "Souvenirs," MA.
42. Comert, "Propos de Madame Jean de Menil."
43. Lois de Menil, e-mail to the author, April 29, 2012.
44. Michel Janicot, interview by Adelaide de Menil, "Souvenirs," MA.
45. Ellen Middlebrook, "Titled Texan: Jean de Menil's Inspiration for Study Came Late," *Houston Post,* Sept. 22, 1957.
46. Ann Holmes, "Neighbor of Note: John de Menil's Life Is Fabulous," *Houston Chronicle,* March 8, 1957, B10.
47. Comert, "Propos de Madame Jean de Menil."
48. Curriculum Vitae of Jean Menu de Menil, n.d., DMFA.
49. Michel Janicot, interview by Adelaide de Menil, "Souvenirs," MA.
50. Dominique de Menil, interview by Adelaide de Menil, "Souvenirs," MA.
51. Middlebrook, "Titled Texan."
52. Dominique de Menil, interview by Adelaide de Menil, "Souvenirs," MA.
53. Curriculum Vitae of Jean Menu de Menil, n.d., DMFA.
54. Alain Garrigou, "Sciences-Po: Laminoir des élites françaises," *Le Monde Diplomatique,* March 1999.
55. Rain, *L'École Libre des Sciences Politiques,* 31–36.
56. École Libre des Sciences Politiques, "Examens 1922–1923, 1923–1924," Dominique Parcollet (archivist, Archives d'Histoire Contemporaine, Centre d'Histoire de Sciences Po), e-mail to the author, April 11, 2007.
57. Mirèse de Menil, interview by Adelaide de Menil, "Souvenirs," MA.
58. Parcollet, e-mail to the author, April 11, 2007.
59. Claude Peuch, interview by Adelaide de Menil, "Souvenirs," MA.
60. Rain, *L'École Libre des Sciences Politiques,* 73–74.
61. "André Siegfried (1875–1959)," academie-francaise.fr, accessed Sept. 22, 2011, www.academie-francaise.fr.
62. Siegfried, *La crise de l'Europe,* 51–52.
63. Rain, *L'École Libre des Sciences Politiques,* 72.
64. Sir Robert Cahill, in Fohlen, *La France de l'entre-deux-guerres,* 71.
65. Fohlen, *La France de l'entre-deux-guerres,* 79.
66. Stein, *Paris France,* 11.
67. Michel Janicot, interview by Adelaide de Menil, "Souvenirs," MA.

68. Patrice de Menil, interview by Adelaide de Menil, "Souvenirs," MA.
69. Mirèse de Menil, interview by Adelaide de Menil, "Souvenirs," MA.
70. Patrice de Menil, interview by Adelaide de Menil, "Souvenirs," MA.
71. Mirèse de Menil, interview by Adelaide de Menil, "Souvenirs," MA.
72. Michel Janicot, interview by Adelaide de Menil, "Souvenirs," MA.
73. Edmond Lebée (École Libre des Sciences Politiques) to Georges de Menil, Aug. 11, 1924, MA.
74. Dominique de Menil, interview by Adelaide de Menil, "Souvenirs," MA.
75. "Sept lauréats des grandes écoles commencant aujourd'hui le voyage autour du monde," *Le Journal,* Oct. 16, 1924, DMFA.
76. Edmond Lebée (École Libre des Sciences Politiques) to Georges de Menil, Aug. 11, 1924, MA.
77. Dominique de Menil, biographical interview by Winkler and Mancusi-Ungaro.
78. Henri-Charles Peuch, interview by Adelaide de Menil, "Souvenirs," MA.
79. Dominique de Menil, interview by Adelaide de Menil, "Souvenirs," MA.
80. Jean de Menil to Dominique de Menil, Feb. 10, 1944, DMFA.
81. De Menil family photographs, DMFA.
82. Claude Peuch, interview by Adelaide de Menil, "Souvenirs," MA.
83. Ibid.
84. Adelaide de Menil, "Souvenirs," MA.
85. Family photographs, box 35 4_3, DMFA.
86. Jean de Menil to Dominique de Menil, Aug. 25, 1930, DMFA.
87. Ibid.
88. Marguerite Johnston, "The de Menils: They Made Houston a More Beautiful Place in Which to Live," *Houston Post,* 1A.
89. Claude Peuch, interview by Adelaide de Menil, "Souvenirs," MA.
90. Jean de Menil to Dominique de Menil, Feb. 10, 1944.
91. Ibid.
92. Curriculum Vitae of Jean Menu de Menil, n.d., DMFA.
93. Mirèse de Menil, interview by Adelaide de Menil, "Souvenirs," MA.
94. X. Yacono, "Rebels in the Rif: Abd el-Krim and the Rebellion," *Revue Historique,* Oct.–Dec. 1970, 523–24.
95. Dominique de Menil, interview by Adelaide de Menil, May 18, 1985, "Souvenirs," MA.
96. Curriculum Vitae of Jean Menu de Menil, n.d., DMFA.
97. États de Services, Jean Marie Joseph Menu de Menil, DMFA.
98. Ibid.
99. Dominique de Menil, interview by Adelaide de Menil, May 18, 1985, "Souvenirs," MA.
100. Adelaide de Menil, "Souvenirs," May 18, 1985, MA.
101. Michel Janicot, interview by Adelaide de Menil, "Souvenirs," MA.
102. "Mirèse raconte," 22.
103. Dominique de Menil, interview by Adelaide de Menil, May 18, 1985, "Souvenirs," MA.
104. Johnston, "The de Menils," 1A.
105. Jean de Menil, "Renseignements recueillis au cours d'une croisière autour du monde," March 1925, DMFA.
106. Mirèse de Menil, interview by Adelaide de Menil, "Souvenirs," MA.
107. Banque de l'Union Parisienne to Jean Menu de Ménil, Dec. 28, 1929, DMFA.
108. Appointments annuels: Jean Menu de Ménil, Banque de l'Union Parisienne, DMFA.
109. Ellis, *Interpreting the Musical Past,* 149n.
110. Theodore Baker, *Baker's Biographical Dictionary of Musicians* (New York: G. Schirmer, 1919), 603.
111. A. Schinz, "Esperanto: The Proposed Universal Language," *The Atlantic Monthly* (Boston: Houghton, Mifflin, 1906), 77.
112. Bénédicte Pesle, interview by the author, March 29, 2004.
113. Bénédicte Pesle, e-mail to the author, Aug. 12, 2011.
114. Bénédicte Pesle, e-mail to the author, Aug. 10, 2011.
115. Middlebrook, "Titled Texan."
116. M. de Saulieu (Association d'Entraide de la Noblesse Française), interview by the author, Oct. 10, 2011.

117. "Mirèse raconte," 23.
118. Dominique de Menil, biographical interview by Winkler and Mancusi-Ungaro.
119. Dominique de Menil, Welcoming Speech, Rothko Chapel Colloquium, July 22, 1973, RCA.
120. Jean de Menil to Dominique de Menil, n.d. 1930, DMFA.
121. Dominique de Menil, notes on family photographs, DMFA.
122. Patrice de Menil, interview by Adelaide de Menil, "Souvenirs," MA.

CHAPTER EIGHT: AT FIRST SIGHT

1. Dominique Schlumberger to John de Menil, Feb. 24, 1931, DMFA.
2. John de Menil to Dominique Schlumberger, n.d. 1930, DMFA.
3. Jean de Menil to Dominique Schlumberger, April 30, 1940, DMFA.
4. Marie-Alain Couturier to Dominique de Menil, November 8, 1948.
5. Bouvet and Durozoi, *Paris, 1919–1939,* 188.
6. Ibid., 378–80.
7. Bénédicte Pesle, interview by Adelaide de Menil, "Souvenirs," MA.
8. Catherine Coste and Fariha Friedrich, interview by the author, June 23, 2012.
9. Georges de Menil, interview by the author, December 1, 2012.
10. Anne Gruner Schlumberger, *Schlumberger Adventure,* 33.
11. Henriette de Vitry, interview by the author, June 2, 2006.
12. Anne Gruner Schlumberger, *Schlumberger Adventure,* 35.
13. Jean-Yves Mock, interview by the author, Jan. 17, 2003.
14. Dominique Schlumberger to Jean de Menil, n.d. [1930], DMFA.
15. Dominique d'Hauteville Cook to the author, Sept. 19, 2015.
16. Mirèse de Menil, interview by Adelaide de Menil, "Souvenirs," MA.
17. Dominique de Menil, interview by Adelaide de Menil, "Souvenirs," MA.
18. Sylvie Boissonnas, interview by Adelaide de Menil, "Souvenirs," MA.
19. Dominique de Menil, interview by Adelaide de Menil, "Souvenirs," MA.
20. John de Menil to Dominique Schlumberger, Jan. 1, 1931, DMFA.
21. Sylvie Boissonnas, interview by Adelaide de Menil, "Souvenirs," MA.
22. Mirèse de Menil, interview by Adelaide de Menil, "Souvenirs," MA.
23. Jean de Menil to Dominique Schlumberger, May 20, 1930, DMFA.
24. Dominique Schlumberger to Jean de Menil, Aug. 25, 1930, DMFA.
25. Dominique Schlumberger to Jean de Menil, Sept. 2, 1930.
26. Jean de Menil to Dominique Schlumberger, Oct. 25, 1930, DMFA.
27. Ibid.
28. Fabre, *Les protestants en France depuis 1789,* 6.
29. Dominique Schlumberger to Jean de Menil, Oct. 19, 1930.
30. Dominique Schlumberger to Jean de Menil, Oct. 13, 1930, DMFA.
31. Fabre, *Les protestants en France depuis 1789,* 6.
32. Ibid., 10.
33. Ibid., 53.
34. Boegner, Siegfried, and Lestringant, *Protestantisme français,* 29.
35. Ibid., 30.
36. Dominique Schlumberger to John de Menil, Feb. 24, 1931, DMFA.
37. Dominique de Menil to Jean de Menil, Jan. 21, 1938, DMFA.
38. Dominique de Menil, "Souvenirs," June 1997.
39. "Le train du Montenvers: Entrez dans la légende," CompagnieDuMontBlanc.fr, accessed Sept. 22, 2014, www.compagniedumontblanc.fr.
40. Conrad Schlumberger to Dominique Schlumberger, July 31, 1930, DMFA.
41. "Le train du Montenvers."
42. Dominique de Menil to Jean de Menil, Jan. 21, 1938, DMFA.
43. Dominique de Menil, "Souvenirs," June 1997.
44. Dominique de Menil to Jean de Menil, Jan. 21, 1938, DMFA.
45. Dominique de Menil, "Souvenirs," June 1997.

CHAPTER NINE: *UNE JEUNESSE*

1. Annemarie Schwarzenbach to Dominique Schlumberger, May 22, 1927, MA.
2. Conrad Schlumberger to Dominique Schlumberger, Oct. 21, 1927, DMFA.
3. Conrad Schlumberger to Annette Schlumberger, postcard, July 2, 1920, DMFA.
4. Conrad Schlumberger to Dominique Schlumberger, postcard, July 5, 1920, DMFA.
5. Conrad Schlumberger to Dominique Schlumberger, March 19, 1918, DMFA.
6. Conrad Schlumberger to Dominique Schlumberger, Aug. 19, 1919, DMFA.
7. Conrad Schlumberger to Dominique Schlumberger, March 4, 1927, DMFA.
8. Dominique de Menil, note, n.d., box CW 27.3, DMFA.
9. Conrad Schlumberger to Dominique Schlumberger, July 19, 1927, DMFA.
10. Conrad Schlumberger to Dominique Schlumberger, Jan. 26, 1929, DMFA.
11. "Le nouveau paquebot S.S. France," vintage brochure, GG Archives, accessed Sept. 12, 2014, www.gjenvick.com.
12. Conrad Schlumberger to Dominique Schlumberger, Sept. 19, 1926, DMFA.
13. Conrad Schlumberger to Dominique Schlumberger, April 24, 1926, DMFA.
14. Dominique Schlumberger to Conrad Schlumberger, Sept. 20, 1924, DMFA.
15. Conrad Schlumberger to Dominique Schlumberger, postcard, Sept. 26, 1926, DMFA.
16. Marcel Schlumberger to Conrad Schlumberger, July 4, 1925, FCS.
17. Conrad Schlumberger to Louise Schlumberger, Nov. 6, 1926, DMFA.
18. Fariha Friedrich, interview by the author, June 23, 2012.
19. Dominique de Menil, as told to Walter Hopps, interview by the author, Sept. 13, 2002.
20. Registres des procès-verbaux par année 1870–1946, Baccalauréat 1925, Cote: AJ[16] 3946, AN.
21. Christen-Lecuyer, "Les premières étudiantes de l'Université de Paris," 38–45.
22. Répertoire alphabétique des candidats 1927–1928, Cote: AJ[16] 5159, AN.
23. Dominique Schlumberger to Louise Schlumberger, Aug. 16, 1925, DMFA.
24. Dominique Schlumberger to Louise Schlumberger, Feb. 14, 1927, DMFA.
25. Dominique Schlumberger to Louise and Conrad Schlumberger, April 13, 1926, DMFA.
26. Dominique Schlumberger, photo album, box CW 27.2, DMFA.
27. Hannelore Gleinser (Hochalpines Institut Ftan AG), e-mail to Anaïs Beccaria, May 7, 2009.
28. Conrad Schlumberger to Dominique Schlumberger, March 4, 1927, DMFA.
29. Dominique Schlumberger to Louise Schlumberger, Jan. 4, 1927, DMFA.
30. Dominique Schlumberger to Louise Schlumberger, n.d. [Jan. 1927], DMFA.
31. Dominique Schlumberger to Conrad Schlumberger, Feb. 7, 1927, DMFA.
32. Dominique Schlumberger to Louise Schlumberger, Jan. 4, 1927, DMFA.
33. Miermont, *Annemarie Schwarzenbach,* 90.
34. Ibid., 43.
35. Ibid., 45.
36. Dominique Schlumberger to Conrad Schlumberger, July 21, 1927, DMFA.
37. Fariha Friedrich, interview by the author, June 23, 2012.
38. Dominique Schlumberger to Jean de Menil, n.d. [1930], DMFA.
39. Annemarie Schwarzenbach to Dominique Schlumberger, June 25, 1927, MA.
40. Annemarie Schwarzenbach to Dominique Schlumberger, Oct. 22, 1927, MA.
41. Dominique Schlumberger to Louise Schlumberger, Aug. 5, 1929, DMFA.
42. Annemarie Schwarzenbach to Dominique Schlumberger, July 22, 1929, MA.
43. Dominique Schlumberger, photo album, box CW 027.2, DMFA.
44. Ibid.
45. Renée Schwarzenbach to Dominique Schlumberger, Oct. 30, 1929, MA.
46. Dominique Schlumberger to Louise Schlumberger, Jan. 5, 1930, MA.
47. Dominique Schlumberger, photo album, box CW 027.2, DMFA.
48. Dominique Schlumberger to Conrad Schlumberger, July 22, 1927, DMFA.
49. Dominique Schlumberger to Conrad Schlumberger, Aug. 30, 1929, DMFA.
50. Dominique Schlumberger, photo album, box CW 027.2, DMFA.
51. Ibid.
52. Dominique Schlumberger to Louise Schlumberger, Oct. 16, 1928, DMFA.

53. Dominique Schlumberger to Conrad Schlumberger, Oct. 22, 1928, DMFA.
54. Dominique Schlumberger to Louise Schlumberger, Oct. 16, 1928, DMFA.
55. Dominique Schlumberger to Louise Schlumberger, Oct. 28, 1928, DMFA.
56. Dominique Schlumberger to Louise Schlumberger, Oct. 18, 1928, DMFA.
57. Dominique Schlumberger to Conrad Schlumberger, Oct. 22, 1928, DMFA.
58. Schlumberger Bohnn, *Les ordres de grandeur*, 82.
59. Dominique Schlumberger to Louise Schlumberger, Jan. 1, 1930, DMFA.
60. John de Menil, notes for a talk, Aug. 1964, John de Menil Correspondence Business (1963–1964), DMFA.
61. Schlumberger Bohnn, *Les ordres de grandeur*, 85.
62. Conrad Schlumberger to Dominique Schlumberger, Oct. 21, 1928, DMFA.
63. Dominique Schlumberger to Louise and Conrad Schlumberger, Nov. 15, 1927, DMFA.
64. John de Menil, notes for a talk, Aug. 1964.
65. Annemarie Schwarzenbach to Dominique Schlumberger, July 9, 1929, MA.
66. Annemarie Schwarzenbach to Dominique Schlumberger, Aug. 17, 1929, MA.
67. Eddi Vend, "Annemarie Schwarzenbach und Karl Vollmoeller," Karl Vollmoeller: Dichter—Kulturmanager—Talentförderer, accessed Feb. 18, 2015, karl-vollmoeller.de.
68. Dominique Schlumberger to Conrad Schlumberger, Sept. 9, 1929, DMFA.
69. Dominique Schlumberger to Louise Schlumberger, Jan. 7, 1930, DMFA.
70. Jean de Menil to Dominique Schlumberger, Jan. 31, 1931, DMFA.
71. Dominique Schlumberger to Louise Schlumberger, Jan. 7, 1930, DMFA.
72. John de Menil, notes for a talk, Aug. 1964.
73. Ibid.
74. Dominique de Menil, handwritten notes, March 1954, DMFA.
75. Dominique Schlumberger, "Courrier de Berlin," 60.
76. Gerald O'Grady to Adelaide de Menil, Feb. 20, 2001, MA.
77. Dominique Schlumberger, "Les divers procédés du film parlant."
78. John de Menil, notes for a talk, Aug. 1964.
79. Henriette de Vitry, interview by the author, June 2, 2006.
80. Dominique Schlumberger to Conrad Schlumberger, n.d., DMFA.
81. Annemarie Schwarzenbach to Dominique Schlumberger, Nov. 25, 1929, MA.

CHAPTER TEN: HORIZONS BROADENED

1. Odile de Rouville, interview by the author, April 25, 2007.
2. Conrad Schlumberger to Dominique Schlumberger, Aug. 2, 1930, DMFA.
3. Jean de Menil to Dominique Schlumberger, Aug. 25, 1930, DMFA.
4. Dominique Schlumberger to Jean de Menil, Aug. 15, 1930, DMFA.
5. Dominique Schlumberger to Conrad Schlumberger, Sept. 9, 1930, DMFA.
6. Dominique de Menil, "Souvenirs," June 1997.
7. Dominique Schlumberger to Conrad Schlumberger, Sept. 9, 1930, DMFA.
8. Ibid.
9. Dominique Schlumberger to Jean de Menil, Oct. 13, 1930, DMFA.
10. Jean de Menil to Dominique Schlumberger, n.d. [probably Sept. 1930], DMFA.
11. Dominique Schlumberger to Jean de Menil, Oct. 19, 1930, DMFA.
12. Jean de Menil to Dominique Schlumberger, Oct. 25, 1930, DMFA.
13. Dominique Schlumberger to Jean de Menil, n.d. [probably Oct. 1930], DMFA.
14. Ibid.
15. Dominique de Menil to Anne Postel-Vinay, n.d. [1993], MA.
16. Dominique Schlumberger to Jean de Menil, n.d. [probably Sept. 1930], DMFA.
17. Dominique de Menil to Jean de Menil, Aug. 16, 1935, DMFA.
18. Dominique Schlumberger to Jean de Menil, n.d. [probably Sept. 1930], DMFA.
19. Mirèse de Menil, interview by Adelaide de Menil, "Souvenirs," MA.
20. Dominique Schlumberger to Jean de Menil, Sept. 23, 1930, DMFA.
21. Jean de Menil to Dominique Schlumberger, n.d. [probably Sept. 1930], DMFA.
22. Dominique Schlumberger to Jean de Menil, Oct. 7, 1930, DMFA.

23. Dominique Schlumberger to Jean de Menil, n.d. [probably Sept. 1930], DMFA.
24. Mirèse de Menil, interview by Adelaide de Menil, "Souvenirs," MA.
25. Conrad Schlumberger to Jean de Menil, n.d., DMFA.
26. Dominique Schlumberger to Jean de Menil, n.d. [probably Oct. 1930], DMFA.
27. Jean de Menil to Dominique Schlumberger, Nov. 22, 1930, DMFA.
28. Jean de Menil to Dominique Schlumberger, n.d. [probably Dec. 1930], DMFA.
29. Dominique Schlumberger to Jean de Menil, Dec. 29, 1930, DMFA.
30. Ibid.
31. Jean de Menil to Dominique Schlumberger, n.d. [probably Jan. 4, 1931], DMFA.
32. Ibid.
33. Conrad Schlumberger to Henriette Delpech, Jan. 28, 1931, DMFA.
34. Ibid.
35. Conrad Schlumberger to Jean de Menil, Feb. 1, 1931, DMFA.
36. Jean de Menil to Dominique Schlumberger, Jan. 31, 1931, DMFA.
37. Conrad Schlumberger to Jean de Menil, Feb. 1, 1931, DMFA.
38. Jean de Menil to Conrad Schlumberger, n.d. [probably Feb. 1931], DMFA.
39. Dominique Schlumberger to Jean de Menil, Feb. 12, 1931, DMFA.
40. François de Menil, e-mail to the author, Aug. 4, 2015.
41. Christophe de Menil, interview by the author, July 6, 2006.
42. Marriage Contract, Dominique Schlumberger and Jean de Menil, April 20, 1931, DMFA.
43. Marriage Contract, Dominique and Jean de Menil, June 16, 1931, DMFA.
44. "Acte de Mariage," Dominique Schlumberger, Service État civil, Mairie du 7ème Arrondissement.
45. Dominique de Menil, interview by Adelaide de Menil, "Souvenirs," MA.
46. Dominique de Menil to Louise Schlumberger, Aug. 5, 1929, DMFA.
47. Marriage Certificate, Dominique Schlumberger and Jean de Menil, May 9, 1931, Service État civil, Mairie du 7ème Arrondissement.
48. Dominique de Menil, interview by Adelaide de Menil, "Souvenirs," MA.
49. "Chapelle St Dominique," L'Église Catholique à Paris, accessed Sept. 23, 2014, www.paris .catholique.fr.
50. Dominique de Menil, notes on family photographs, box 32A/B, DMFA.
51. Dominique de Menil to Henriette Delpech, May 22, 1931, DMFA.
52. Sylvie Boissonnas, interview by Adelaide de Menil, "Souvenirs," MA.

CHAPTER ELEVEN: A SHARED LIFE

1. Dominique Schlumberger to John de Menil, Feb. 24, 1931, DMFA.
2. Dominique de Menil, biographical interview by Winkler and Mancusi-Ungaro.
3. "Parc et Jardin du Château de Kolbsheim," Comité des Parcs et Jardins de France, accessed May 1, 2015, www.parcsetjardins.fr.
4. Michaël Grunelius, interview by the author, July 4, 2006.
5. Minnaert, Pierre Barbe, 151–57.
6. Dominique de Menil, biographical interview by Winkler and Mancusi-Ungaro.
7. Ibid.
8. Dominique de Menil, interview by Adelaide de Menil, May 19, 1985, "Souvenirs," MA.
9. Minnaert, Pierre Barbe, 26.
10. Ibid., 120–23.
11. Ibid., 171–89.
12. Ibid., 31.
13. Lois de Menil, e-mail to the author, April 22, 2015.
14. Dominique de Menil, interview by Adelaide de Menil, May 19, 1985, "Souvenirs," MA.
15. Ibid.
16. "Appartement de D. de Ménil," Dossier: 153 Ifa 77/39, Fonds Pierre Barbe, SIAF/Cité de l'architecture et du patrimoine/Archives d'architecture du XXe siècle.
17. "Exposition de l'Union des artistes modernes," L'Architecture d'Aujourd'hui, Jan.–Feb. 1932, 53.

18. Lois de Menil, e-mail to the author, April 26, 2015.
19. Pierre Barbe, interview by Adelaide de Menil, "Souvenirs," MA.
20. Dominique de Menil to Jean de Menil, April 24, 1933, DMFA.
21. Dominique de Menil, interview by Adelaide de Menil, May 19, 1985, "Souvenirs," MA.
22. Barbe, interview by Adelaide de Menil, "Souvenirs," MA.
23. Lois de Menil, interview by the author, Dec. 1, 2012.
24. Minnaert, *Pierre Barbe,* 262–81.
25. Ibid., 240–51.
26. Ibid., 234–39.
27. Pauline Lartigue, interview by the author, May 30, 2006.
28. Solange Picq, interview by the author, Oct. 31, 2006.
29. Object File CA 3101, TMC.
30. Object File CA 3205, TMC.
31. Van Dyke, *African Art from the Menil Collection,* 18.
32. Dominique de Menil, biographical interview by Winkler and Mancusi-Ungaro.
33. Ulrich Bischoff, *Max Ernst, 1891–1976: Beyond Painting* (Cologne: Taschen, 1988), 50.
34. Dominique de Menil, note, n.d., Object File CA 3401, TMC.
35. Werner Spies, interview by the author, Nov. 25, 2010.
36. Dominique de Menil, note, n.d., Object File CA 3401, TMC.
37. Werner Spies, *Max Ernst: Oeuvre-Katalog,* vol. 4, *Werke 1929–1938* (Cologne: DuMont; Houston, Tex.: Menil Foundation, 1979), 74.
38. Dominique de Menil, note, n.d., Object File CA 3401, TMC.
39. Lois de Menil, e-mail to the author, April 26, 2015.
40. Dominique de Menil, note, n.d., Object File CA 3401, TMC.
41. Dominique de Menil, biographical interview by Winkler and Mancusi-Ungaro.
42. Henri Béhar, "Jacques Viot," *Le surréalisme au jour le jour,* Feb. 2006, accessed Sept. 27, 2014, melusine.univ-paris3.fr.
43. Object File CA 3203, TMC.
44. Ibid.
45. Rivière to Jean de Menil, March 25, 1933, Object File CA 3203, TMC.
46. Philippe Peltier, "L'art océanien entre les deux guerres: Expositions et vision occidentale," *Journal de la Société des Océanistes* 35, no. 65 (1979): 282.
47. Object File CA 3301, TMC.
48. Dominique de Menil to Jean de Menil, Dec. 7, 1933, DMFA.
49. Christian Bérard Chronology, Iolas Jackson Gallery, Object File, CA 5117, TMC.
50. Jean de Menil to Jacques Viot, Nov. 1, 1963, Object File, CA 3402, TMC.
51. Object File, CA 5117, TMC.
52. Dominique de Menil to Jean de Menil, Aug. 16, 1935, DMFA.
53. Christophe de Menil, interview by the author, July 6, 2006.
54. Dominique de Menil to Jean de Menil, April 2, 1933, DMFA.
55. Dominique de Menil to Henriette Delpech, 1935, DMFA.
56. Dominique de Menil to Jean de Menil, Aug. 16, 1935, DMFA.
57. Anne Gruner Schlumberger, interview by Adelaide de Menil, "Souvenirs," MA.
58. Curriculum Vitae of Jean Menu de Menil, n.d., DMFA.
59. "Trois Passions d'Alfred Pose: L'Université, la B.N.C.I. et le Pays Basque," *L'Enterprise,* Oct. 29, 1957, 26.
60. Dominique de Menil to Jean de Menil, May 22, 1933, DMFA.
61. Dominique de Menil, interview by Adelaide de Menil, "Souvenirs," MA.
62. Dominique de Menil to Jean de Menil, Aug. 22, 1932, DMFA.
63. Dominique de Menil to Jean de Menil, Aug. 29, 1932, DMFA.
64. Mirèse de Menil to Jason de Menil, Aug. 14, 1987, e-mailed to the author by Jason de Menil, April 4, 2014.
65. Dominique de Menil, interview by Adelaide de Menil, "Souvenirs," MA.
66. "Mirèse raconte," 19.
67. Dominique de Menil to Jean de Menil, April 9, 1933, DMFA.
68. Dominique de Menil, interview by Adelaide de Menil, "Souvenirs," MA.

69. Dominique de Menil to Jean de Menil, Dec. 16, 1932, DMFA.
70. Dominique de Menil, interview by Adelaide de Menil, "Souvenirs," MA.
71. Grunelius, interview by the author, July 4, 2006.
72. Dominique de Menil, interview by Adelaide de Menil, "Souvenirs," MA.
73. Dominique de Menil to Jean de Menil, Dec. 16, 1932, DMFA.
74. Dominique de Menil, interview by Adelaide de Menil, "Souvenirs," MA.
75. Dominique de Menil, biographical interview by Winkler and Mancusi-Ungaro.
76. Dominique de Menil, interview by Adelaide de Menil, "Souvenirs," MA.
77. Dominique de Menil to Jean de Menil, Aug. 10, 1932, DMFA.
78. Dominique de Menil to Jean de Menil, Dec. 16, 1932, DMFA.
79. Dominique de Menil, interview by Adelaide de Menil, "Souvenirs," MA.
80. Dominique de Menil, "Pour l'unité du monde chrétien," *La Vie Intellectuelle,* Feb. 10, 1936, 383.
81. Dominique de Menil, address for the opening of the Rothko Chapel, Feb. 27, 1971, MA.
82. Congar, *Chrétiens désunis,* 173–74.
83. Schloesser, *Jazz Age Catholicism,* 205.
84. Dominique de Menil, "Pour l'unité du monde chrétien," 388.
85. Congar, *Chrétiens désunis,* 340.
86. Ferdinando Antonelli, in O'Malley, *What Happened at Vatican II,* 130.
87. Martin, *Le théâtre divin,* 350.
88. Jacqueline Sauvageot, *Ella Sauvageot: L'audace d'une femme de presse, 1900–1962* (Paris: Atelier, 1962), 103.
89. Father Clifford Howell, S.J., in J. Anthony Gaughan, "The Dialogue Mass," *Furrow,* May 1984, 338–39.
90. Dominique de Menil to Jean de Menil, Dec. 1, 1935, DMFA.
91. Aline Coutrot, in Sevegrand, *Temps présent,* 1:55.
92. Dominique de Menil to Jacques Maritain, Feb. 8, 1936, JM.
93. Simone Jardin, interview by Adelaide de Menil, "Souvenirs," MA.
94. Sauvageot, *Ella Sauvageot,* 103.
95. Jean de Menil to Dominique de Menil, April 22, 1936, DMFA.
96. Jean de Menil to Dominique de Menil, Oct. 21, 1936, DMFA.
97. Keith F. Pecklers, S.J., "Roman Catholic Liturgical Renewal Forty-Five Years After Sacrosanctum Concilium: An Assessment," accessed March 5, 2015, ism.yale.edu.
98. Aline Coutrot, in Sevegrand, *Temps présent,* 1:55.
99. Simone Jardin, interview by Adelaide de Menil, "Souvenirs," MA.
100. Ibid.
101. Ibid.
102. Simon Jardin, interview by Adelaide de Menil, "Souvenirs," MA.
103. Schlumberger and de Menil, *Conrad Schlumberger,* 80–81.
104. Anne Gruner Schlumberger, *Schlumberger Adventure,* 27.
105. Schlumberger and de Menil, *Conrad Schlumberger,* 84.
106. Ibid., 87–88.
107. Auletta, *Art of Corporate Success,* 27.
108. Anne Gruner Schlumberger, *Schlumberger Adventure,* 53.
109. Schlumberger and de Menil, *Conrad Schlumberger,* 88.
110. Anne Gruner Schlumberger, *Schlumberger Adventure,* 66.
111. Allaud and Martin, *Schlumberger,* 173.
112. Ibid.
113. Charrin, in Bowker, *Science on the Run,* 62.
114. Dominique de Menil to Jean de Menil, May 22, 1933, DMFA.
115. Mikhail Opochinin, in Anne Gruner Schlumberger, *Schlumberger Adventure,* 67.
116. Anne Gruner Schlumberger, *Schlumberger Adventure,* 66–67.
117. Schlumberger and de Menil, *Conrad Schlumberger,* 54–55.
118. Anne Gruner Schlumberger, *Schlumberger Adventure,* 53.
119. Ibid., 67.
120. Maurice Martin, interview by Adelaide de Menil, "Souvenirs," MA.

121. Schlumberger and de Menil, *Conrad Schlumberger,* 92.
122. Anne Gruner Schlumberger, *Schlumberger Adventure,* 68–69.
123. Ibid., 69–70.
124. Dominique de Menil to Jean de Menil, May 2, 1936, DMFA.
125. Dominique de Menil to Jean de Menil, April 17, 1936, DMFA.
126. Dominique de Menil to Jean de Menil, April 9, 1936, DMFA.
127. Dominique de Menil to Jean de Menil, May 7, 1936, DMFA.
128. Tina Larsson (Stockholm Visitors Board), e-mail to the author, March 17, 2015.
129. Anne Gruner Schlumberger, *Schlumberger Adventure,* 69.
130. "Nécrologie, M. Conrad Schlumberger, Saint-Ouen-le-Pin," n.d., DMFA.
131. Ibid.
132. Dominique de Menil, date books, Feb. 19, 1977, DMFA.

CHAPTER TWELVE: ENGAGED

1. Jean de Menil to Dominique de Menil, Sept. 25, 1938, DMFA.
2. Deal Wyatt Hudson, *Understanding Maritain: Philosopher and Friend* (Macon, Ga.: Mercer University Press, 1987), 124.
3. Jacques Madaule, *L'absent* (Paris: Gallimard, 1973), 11–14, in ibid., 123.
4. "Notre habit," Dominicains de la Province de France, accessed April 16, 2015, www.domini cains.fr.
5. Dominique de Menil, biographical interview by Winkler and Mancusi-Ungaro.
6. Rubin, *Modern Sacred Art and the Church of Assy,* 7.
7. Pie-Rayond Régamey, "Les étapes de l'académisme," *L'Art Sacré,* Oct. 1947, 245–87, in ibid., 8.
8. Dominique de Menil, biographical interview by Winkler and Mancusi-Ungaro.
9. Ibid.
10. Antoine Lion, "Art sacré et modernité en France: Le rôle de P. Marie-Alain Couturier," *Revue de l'Histoire des Religions* 1 (2010), accessed Sept. 12, 2015, rhr.revues.org.
11. Caussé, *La revue "L'Art Sacré,"* 49.
12. Ibid., 51.
13. Robert Schwartzwald, draft of unpublished introductory essay for English translation of *La vérité blessée* (1994), MA.
14. Caussé, *La revue "L'Art Sacré,"* 639n.
15. Dominique de Menil to Jean de Menil, Oct. 18, 1937, DMFA.
16. Dominique de Menil, biographical interview by Winkler and Mancusi-Ungaro.
17. Dominique de Menil to Jean de Menil, Oct. 18, 1937, DMFA.
18. Joost de Geest, *500 chefs-d'oeuvre de l'art belge* (Brussels: Racine Lanoo, 2006), 245.
19. Dominique de Menil, "Leçons d'une chapelle japonaise," *L'Art Sacré,* no. 18 (1937): 119.
20. Ibid., 90–91.
21. Jean de Menil to Dominique de Menil, June 3, 1937, DMFA.
22. Gerald Thompson, interview by Adelaide de Menil, "Souvenirs," MA.
23. Sir John Thompson Papers, National Archives, British Library, accessed Jan. 2, 2016, discovery.nationalarchives.gov.uk.
24. "Gerald Thompson," obituary, *Times* (London), April 11, 1994.
25. Dominique de Menil to Jean de Menil, June 28, 1939.
26. Gerald Thompson, interview by Adelaide de Menil, "Souvenirs," MA.
27. Christophe de Menil, interview by the author, July 6, 2006.
28. Thompson, interview by Adelaide de Menil, "Souvenirs," MA.
29. Best, interview by Adelaide de Menil, "Souvenirs," MA.
30. Thompson to Dominique de Menil, April 8, 1938, DMFA.
31. Dominique de Menil to Henriette Delpech, postcard, Aug. 17, 1937, DMFA.
32. Dominique de Menil to Henriette Delpech, Oct. 29, 1937, DMFA.
33. Gerald Thompson, interview by Adelaide de Menil, "Souvenirs," MA.
34. Dominique de Menil to Jean de Menil, July 8, 1939, DMFA.

35. Philippa Thompson to Dominique de Menil, Sept. 15, 1938, DMFA.
36. Gerald Thompson to Dominique de Menil, Aug. 21, 1938, DMFA.
37. Gerald Thompson to Dominique and Jean de Menil, May 30, 1938, DMFA.
38. Dominique de Menil to Jean de Menil, Dec. 6, 1939, DMFA.
39. Simon Jardin, interview by Adelaide de Menil, "Souvenirs," MA.
40. Jean de Menil to Marcel Schlumberger, draft, n.d. [probably May 1938], DMFA.
41. Allaud and Martin, *Schlumberger,* 173–74.
42. "Statistical History of Schlumberger Well Surveying Corporation," FCS.
43. "Schlumberger Well Surveying Corporation Price Schedule," Aug. 1, 1938, FCS.
44. "Statistical History of Schlumberger Well Surveying Corporation."
45. "Historique," Fondation René Seydoux, accessed May 16, 2015, www.fondation-seydoux .org.
46. Allaud and Martin, *Schlumberger,* 174.
47. Marcel Schlumberger to Henri Doll, Feb. 22, 1941, FCS.
48. Christophe de Menil, interview by the author, July 6, 2006.
49. Jean de Menil to Marcel Schlumberger, draft, n.d. [probably May 1938], DMFA.
50. Ibid.
51. Ibid.
52. Michaël Grunelius to Jean de Menil, May 24, 1938, DMFA.
53. Jean de Menil to Dominique de Menil, July 4, 1938, DMFA.
54. Ibid.
55. Jean de Menil to Dominique de Menil, Oct. 20, 1939, DMFA.
56. Anne Gruner Schlumberger, interview by Adelaide de Menil, "Souvenirs," MA.
57. Curriculum Vitae of Jean Menu de Menil, n.d. [probably 1940–1941], MA.
58. Dominique de Menil to Jean de Menil, Dec. 25, 1938, DMFA.
59. Bénédicte Pesle, interview by the author, March 29, 2004.
60. Jean de Menil to Dominique de Menil, Dec. 28, 1938, DMFA.
61. Jean de Menil to Dominique de Menil, Jan. 10, 1939, DMFA.
62. Jean de Menil to Dominique de Menil, Jan. 15, 1939, DMFA.
63. Schlumberger Bohnn, *Les ordres de grandeur,* 111.
64. Jean de Menil to Dominique de Menil, Jan. 15, 1939, DMFA.
65. Dominique de Menil to Henriette Delpech, Jan. 29, 1939, DMFA.
66. Jean de Menil to Dominique de Menil, March 22, 1939, DMFA.
67. Curriculum Vitae of Jean Menu de Menil, n.d., DMFA.
68. Jean de Menil to Henriette Delpech, May 31, 1939, DMFA.
69. Jean de Menil, interview by Maurice Martin, April 26, 1972, FCS.
70. Ibid.
71. André Poirault, interview by Adelaide de Menil, "Souvenirs," MA.
72. Jean de Menil, interview by Maurice Martin, April 26, 1972, FCS.
73. Dominique de Menil to Henriette Delpech, June 17, 1939, DMFA.
74. Dominique de Menil to Jean de Menil, Aug. 27, 1939, DMFA.
75. Dominique de Menil to Jean de Menil, Oct. 1, 1939, DMFA.
76. Dominique de Menil to Jean de Menil, June 4, 1940, DMFA.
77. Adelaide de Menil, interview, "Souvenirs," MA.
78. Jean de Menil to Dominique de Menil, Sept. 8, 1939, DMFA.
79. Dominique de Menil to Henriette Delpech, Dec. 21, 1939, DMFA.
80. "Pierre Angot," Mairie de Montrejeau, accessed Oct. 6, 2015, www.mairie-montrejeau.fr.
81. Dominique de Menil to Jean de Menil, Aug. 8, 1932, DMFA.
82. Thompson to Dominique de Menil, March 21, 1938, DMFA.
83. Jean de Menil to Dominique de Menil, Sept. 11, 1938, DMFA.
84. Dominique de Menil to Jean de Menil, Sept. 10, 1938, DMFA.
85. Dominique de Menil to Jean de Menil, Sept. 18, 1938, DMFA.
86. Dominique de Menil to Jean de Menil, Sept. 14, 1938, DMFA.
87. Dominique de Menil to Jean de Menil, Sept. 25, 1938, DMFA.
88. Dominique de Menil to Jean de Menil, Sept. 28, 1938, DMFA.

89. Dominique de Menil to Jean de Menil, Sept. 30, 1938, DMFA.
90. Winston Churchill, House of Commons speech, "The Munich Agreement," Oct. 5, 1938, accessed Oct. 4, 2015, www.winstonchurchill.org.
91. Dominique de Menil to Jean de Menil, Oct. 13, 1939, DMFA.
92. Thompson to Dominique de Menil, Nov. 13, 1938, DMFA.
93. Thompson to Dominique de Menil, Nov. 20, 1938, DMFA.
94. Jean de Menil to Henriette Delpech, May 31, 1939, DMFA.
95. Jean de Menil to Dominique de Menil, May 23, 1939, DMFA.
96. Jean de Menil to Maritain, March 19, 1939, JM.
97. Dominique de Menil to Jean de Menil, May 27, 1940, DMFA.
98. Dominique de Menil to Jean de Menil, June 4, 1939, DMFA.
99. Dominique de Menil to Jean de Menil, July 8, 1939, DMFA.

CHAPTER THIRTEEN: *DRÔLE DE GUERRE*

1. Dominique de Menil to Jean de Menil, May 11, 1940, DMFA.
2. Azéma, *1940,* 26.
3. Dominique de Menil, interview by Adelaide de Menil, "Souvenirs," MA.
4. Jean de Menil to Dominique de Menil, Aug. 26, 1939, DMFA.
5. Dominique de Menil to Jean de Menil, Aug. 27, 1939, DMFA.
6. Ibid.
7. Dominique de Menil to Jean de Menil, Aug. 29, 1939, DMFA.
8. Dominique de Menil to Jean de Menil, Aug. 30, 1939, DMFA.
9. Dominique de Menil to Jean de Menil, Sept. 3, 1939, DMFA.
10. *De Neuflize, Schlumberger & Cie., 1800–1950* (Paris: Keller, 1950), 21.
11. Dominique de Menil to Jean de Menil, Sept. 3, 1939, DMFA.
12. Jean de Menil to Dominique de Menil, Sept. 1, 1939, DMFA.
13. Ibid.
14. Dominique de Menil to Jean de Menil, Sept. 3, 1939, DMFA.
15. Ibid.
16. Ibid.
17. Ibid.
18. Jean de Menil to Dominique de Menil, Sept. 4, 1939, DMFA.
19. Ibid.
20. Jackson, *France: The Dark Years,* 113.
21. Dominique de Menil to Jean de Menil, Oct. 7, 1939, DMFA.
22. Jean de Menil to Dominique de Menil, Sept. 5, 1939, DMFA.
23. Ibid.
24. Dominique de Menil to Jean de Menil, Oct. 7, 1939, DMFA.
25. Dominique de Menil to Jean de Menil, Oct. 1, 1939, DMFA.
26. Ibid.
27. Dominique de Menil to Jean de Menil, Oct. 17, 1939, DMFA.
28. Jean de Menil to Dominique de Menil, Nov. 5, 1939, DMFA.
29. Dominique de Menil to Jean de Menil, Nov. 10, 1939, DMFA.
30. Dominique de Menil to Jean de Menil, Nov. 15, 1939, DMFA.
31. Jean de Menil to Dominique de Menil, Nov. 21, 1939, DMFA.
32. Dominique de Menil to Jean de Menil, Nov. 21, 1939, DMFA.
33. Ibid.
34. Ibid.
35. Ibid.
36. Dominique de Menil to Jean de Menil, Nov. 25, 1939, DMFA.
37. Dominique de Menil to Jean de Menil, Nov. 24, 1939, DMFA.
38. Jean de Menil to Dominique de Menil, Nov. 27, 1939, DMFA.
39. Dominique de Menil to Jean de Menil, Dec. 6, 1939, DMFA.
40. Dominique de Menil, interview by Adelaide de Menil, "Souvenirs," MA.
41. Jean de Menil to Dominique de Menil, Sept. 8, 1939, DMFA.

42. Jean de Menil to Dominique de Menil, Oct. 2, 1939, DMFA.
43. Dominique de Menil to Henriette Delpech, Dec. 21, 1939, DMFA.
44. Maurice Martin, interview by Adelaide de Menil, "Souvenirs," MA.
45. Boissonnas, interview by Adelaide de Menil, "Souvenirs," MA.
46. Ibid.
47. Christophe de Menil, interview by the author, July 6, 2006.
48. Boissonnas, interview by Adelaide de Menil, "Souvenirs," MA.
49. Ibid.
50. Tanguy, as told to Maurice Martin, interview by Adelaide de Menil, "Souvenirs," MA.
51. Boissonnas, interview by Adelaide de Menil, "Souvenirs," MA.
52. Dominique de Menil, interview by Adelaide de Menil, "Souvenirs," MA.
53. Boissonnas, interview by Adelaide de Menil, "Souvenirs," MA.
54. Dominique de Menil, interview by Adelaide de Menil, "Souvenirs," MA.
55. Boissonnas, interview by Adelaide de Menil, "Souvenirs," MA.
56. "Order No. 1070, Republique Française, Guerre 1939–1945, Citation," *Journal Officiel,* July 31, 1941, 432, MA.
57. Dominique de Menil, interview by Adelaide de Menil, "Souvenirs," MA.
58. A. Thierry (French embassy in Romania) to Jean de Menil, July 19, 1940, DMFA.
59. Dominique de Menil to Henriette Delpech, Feb. 17, 1941, DMFA.

CHAPTER FOURTEEN: THE DEBACLE

1. Jean de Menil to Dominique de Menil, May 14, 1940, DMFA.
2. Dominique de Menil to Henriette Delpech, April 20, 1941, DMFA.
3. Ibid.
4. Guica, interview by Adelaide de Menil, "Souvenirs," MA.
5. Ibid.
6. Dominique de Menil, April 23, 1940, DMFA.
7. Jean de Menil to Dominique de Menil, April 22, 1940, DMFA.
8. Ibid.
9. Dominique de Menil to Jean de Menil, May 3, 1940, DMFA.
10. Dominique de Menil to Jean de Menil, May 6, 1940, DMFA.
11. Odile de Rouville, "Au Val-Richer, la vie des femmes."
12. Dominique de Menil to Jean de Menil, May 14, 1940, DMFA.
13. Dominique de Menil to Jean de Menil, May 29, 1940, DMFA.
14. Dominique de Menil to Jean de Menil, May 14, 1940, DMFA.
15. "Invasion of France Timeline," Second World War History, accessed Jan. 16, 2016, www .secondworldwarhistory.com.
16. Mlle. Rigal, "Journal de guerre de Mlle Rigal (10 mai–25 juin 1940)," in Schlumberger Bohnn, *Les ordres de grandeur,* 154.
17. Dominique de Menil to Jean de Menil, May 10, 1940, DMFA.
18. Azéma, *1940,* 9.
19. "Invasion of France Timeline."
20. Dominique de Menil to Jean de Menil, May 14, 1940, DMFA.
21. Ibid.
22. Azéma, *1940,* 85.
23. Ibid.
24. Jackson, *France: The Dark Years,* 118.
25. Mlle. Rigal, "Journal de guerre de Mlle Rigal (10 mai–25 juin 1940)," 155.
26. Dominique de Menil to Jean de Menil, May 16, 1940, DMFA.
27. Dominique de Menil to Jean de Menil, May 18, 1940, DMFA.
28. Dominique de Menil to Jean de Menil, May 19, 1940, DMFA.
29. Sylvie Boissonnas, "Au Val-Richer, la vie des femmes."
30. Jean de Menil to Dominique de Menil, May 16, 1949, DMFA.
31. Ibid.
32. Jean de Menil to Dominique de Menil, June 9, 1940.

33. Dominique de Menil to Jean de Menil, May 19, 1940, DMFA.
34. Jean de Menil to Dominique de Menil, May 12, 1940, DMFA.
35. Jean de Menil to Dominique de Menil, May 18, 1940, DMFA.
36. Mlle. Rigal, "Journal de guerre de Mlle Rigal (10 mai–25 juin 1940)," 155.
37. Dominique de Menil to Jean de Menil, May 27, 1940, DMFA.
38. Ibid.
39. "Invasion of France Timeline."
40. Mlle. Rigal, "Journal de guerre de Mlle Rigal (10 mai–25 juin 1940)," 155.
41. Azéma, *1940*, 110.
42. Dominique de Menil to Jean de Menil, June 2, 1940, DMFA.
43. Azéma, *1940*, 114–15.
44. Dominique de Menil to Jean de Menil, May 30, 1940, DMFA.
45. Mlle. Rigal, "Journal de guerre de Mlle Rigal (10 mai–25 juin 1940)," 156.
46. Ibid.
47. Dominique de Menil to Jean de Menil, June 5, 1940, DMFA.
48. Mlle. Rigal, "Journal de guerre de Mlle Rigal (10 mai–25 juin 1940)," 157.
49. Ibid.
50. Odile de Rouville, interview in "Au Val-Richer, la vie des femmes."
51. Marc Bloch, *L'étrange défaite*, 21, quoted in Shirer, *Collapse of the Third Republic*, 22.
52. William Shirer, *Berlin Diary*, 330, quoted in Shirer, *Collapse of the Third Republic*, 22.
53. Mlle. Rigal, "Journal de guerre de Mlle Rigal (10 mai–25 juin 1940)," 157.
54. Ibid.
55. Henri Amouroux, *La vie des français sous l'occupation*, 69, quoted in Shirer, *Collapse of the Third Republic*, 23.
56. Shirer, *Collapse of the Third Republic*, 24–25.
57. Beauvoir, *Journal de guerre*, 302–3.
58. Mlle. Rigal, "Journal de guerre de Mlle Rigal (10 mai–25 juin 1940)," 157.
59. Dominique de Menil to Jean de Menil, Sept. 4, 1940, DMFA.
60. Mlle. Rigal, "Journal de guerre de Mlle Rigal (10 mai–25 juin 1940)," 157.
61. Christophe de Menil, interview by the author, July 6, 2006.
62. Dominique de Menil to Jean de Menil, Sept. 4, 1940, DMFA.
63. Sylvie Boissonnas, interview in "Au Val-Richer, la vie des femmes."
64. Dominique de Menil to Jean de Menil, Sept. 4, 1940, DMFA.
65. Azéma, *1940*, 120, 121, 127.
66. Shirer, *Collapse of the Third Republic*, 27.
67. Ibid., 25.
68. Dominique de Menil to Jean de Menil, Sept. 4, 1940, DMFA.
69. Christophe de Menil, interview by the author, July 6, 2006.
70. Dominique de Menil to Jean de Menil, Sept. 4, 1940, DMFA.
71. Sylvie Boissonnas, interview in "Au Val-Richer, la vie des femmes."
72. Dominique de Menil to Jean de Menil, Sept. 4, 1940, DMFA.
73. Sylvie Boissonnas, interview in "Au Val-Richer, la vie des femmes."
74. Dominique de Menil to Jean de Menil, Sept. 4, 1940, DMFA.
75. Jean de Menil to Dominique de Menil, June 13, 1940, DMFA.
76. "Appel du 18 juin 1940 du général de Gaulle: Texte et circonstances," Charles-de-Gaulle.org, Charles de Gaulle Foundation, accessed April 20, 2016, www.charles-de-gaulle.org.
77. Dominique de Menil, interview in "Au Val-Richer, la vie des femmes."
78. Clair Morizet, e-mail to the author, Sept. 18, 2011.
79. Dominique de Menil to Jean de Menil, Sept. 4, 1940, DMFA.
80. Dominique de Menil to Jean de Menil, Sept. 21, 1940, DMFA.
81. Dominique de Menil to Jean de Menil, Oct. 29, 1940, DMFA.
82. Dominique de Menil to Jean de Menil, n.d. [presumed July] 1940, DMFA.
83. Ibid.
84. Ibid.
85. Dominique de Menil, journal, July 7, 1940, DMFA.
86. Ibid.

87. Ibid.
88. Ibid.
89. Jean de Menil to Dominique de Menil, June 13, 1940, DMFA.
90. Jean de Menil to Robert, Lord Hankey, July 28, 1940, DMFA.
91. Sylvie Boissonnas, interview by Adelaide de Menil, "Souvenirs," MA.
92. Ibid.
93. Ibid.
94. Ibid.
95. Ibid.
96. Jean de Menil to Dominique de Menil, Aug. 9, 1940, DMFA.
97. Ibid.
98. Ibid.
99. Dominique de Menil to Jean de Menil, n.d. [Aug. 1940], DMFA.
100. Ibid.
101. Dominique de Menil to Jean de Menil, Sept. 21, 1940, DMFA.
102. Dominique de Menil to Jean de Menil, Sept. 29, 1940, DMFA.
103. Dominique de Menil to Jean de Menil, n.d. [presumed July] 1940, DMFA.
104. Dominique de Menil, interview in "Au Val-Richer, la vie des femmes."
105. Dominique de Menil to Jean de Menil, n.d. [presumed July] 1940, DMFA.
106. Ibid.
107. Jean de Menil to Dominique de Menil, Aug. 14, 1940, DMFA.
108. Jean de Menil to Dominique de Menil, postcard, Aug. 20, 1940, DMFA.
109. Jean de Menil to Dominique de Menil, Aug. 21, 1940, DMFA.
110. Boissonnas, interview by Adelaide de Menil, "Souvenirs," MA.
111. Jean de Menil to Dominique de Menil, Oct. 15, 1940, DMFA.
112. Maurice Martin, interview by Adelaide de Menil, "Souvenirs," MA.
113. Jean de Menil to Dominique de Menil, Oct. 15, 1940, DMFA.
114. Jean de Menil to Dominique de Menil, telegram, Sept. 26, 1940, DMFA.
115. Jean de Menil to Dominique de Menil, Oct. 15, 1940, DMFA.
116. Jean de Menil to Dominique de Menil, postcard, Oct. 14, 1940.
117. Jean de Menil to Dominique de Menil, Oct. 15, 1940, DMFA.
118. Jean de Menil to Dominique de Menil, Oct. 16, 1940, DMFA.
119. Jean de Menil to Dominique de Menil, Oct. 17, 1940, DMFA.
120. Jean de Menil to Dominique de Menil, Oct. 18, 1940, DMFA.
121. Jean de Menil to Dominique de Menil, Nov. 4, 1940, DMFA.
122. Jean de Menil to Dominique de Menil, postcards, Oct. 28, 1940, DMFA.
123. Dominique de Menil to Jean de Menil, Oct. 30, 1940, DMFA.
124. Dominique de Menil to Jean de Menil, Oct. 20, 1940, DMFA.
125. Dominique de Menil to Jean de Menil, Sept. 12, 1940, DMFA.
126. Dominique de Menil to Jean de Menil, Sept. 4, 1940, DMFA.
127. Clair Morizet, e-mail to the author, Sept. 19, 2011.
128. Dominique de Menil to Jean de Menil, Sept. 29, 1940, DMFA.
129. Dominique de Menil to Jean de Menil, Oct. 30, 1940, DMFA.
130. Christophe de Menil, interview by the author, July 6, 2006.
131. Marie de Menil to Jean de Menil, Oct. 26, 1940.
132. Dominique de Menil, note, n.d., in Jean de Menil to Dominique de Menil, May 9, 1944, DMFA.
133. Dominique de Menil, "Bulletin de nouvelles," n.d. [presumed Oct. 1940], DMFA.
134. Dominique de Menil to Jean de Menil, Oct. 20, 1940, DMFA.
135. Dominique de Menil to Jean de Menil, Sept. 21, 1940, DMFA.
136. Dominique de Menil to Jean de Menil, Nov. 3, 1940, DMFA.
137. François Guizot, *George Washington,* quoted in ibid.
138. "Notre-Dame des Neiges a L'Alpe d'Huez sera inaugurée le 21 novembre," *Le Petit Dauphinois,* Nov. 14, 1940.
139. Ibid.
140. Ibid.

141. Dominique de Menil to Jean de Menil, Oct. 30, 1940, DMFA.
142. Dominique de Menil to Jean de Menil, Nov. 15, 1940, DMFA.
143. "Notre-Dame des Neiges a L'Alpe d'Huez sera inaugurée le 21 novembre."
144. "Chapelle sans clocher," *Le Journal d'Huez* (1972): 20.
145. Dominique de Menil to Jean de Menil, Dec. 3, 1940, DMFA.
146. Anne Gruner Schlumberger, interview by Adelaide de Menil, "Souvenirs," MA.
147. Jean de Menil to Dominique de Menil, Dec. 6, 1940, DMFA.
148. Jean de Menil to Sylvie Boissonnas, March 17, 1941, DMFA.
149. Jean de Menil to Dominique de Menil, Dec. 6, 1940, DMFA.
150. Jean de Menil to Dominique de Menil, Dec. 13, 1940, DMFA.
151. Ibid.
152. Jean de Menil to Dominique de Menil, Jan. 5, 1941, DMFA.
153. Jean de Menil to Dominique de Menil, Jan. 19, 1941, DMFA.
154. Ibid.
155. Dominique de Menil to Jean de Menil, telegram, Dec. 5, 1940, DMFA.
156. Dominique de Menil to Jean de Menil, Oct. 11, 1940, DMFA.
157. Dominique de Menil, interview by Adelaide de Menil, "Souvenirs," MA.
158. Dominique de Menil to Jean de Menil, Jan. 13, 1941, DMFA.
159. Christophe de Menil, interview by the author, July 6, 2006.
160. Dominique de Menil to Louise Schlumberger, n.d. [1941], DMFA.
161. Dominique de Menil, as quoted by Christophe de Menil, interview by the author, July 6, 2006.
162. Dominique de Menil to Louise Schlumberger, n.d. [1941], DMFA.
163. Dominique de Menil to Jean de Menil, Jan. 13, 1941, DMFA.
164. Dominique de Menil to Louise Schlumberger, n.d. [1941], DMFA.
165. Christophe de Menil, interview by the author, July 6, 2006.
166. Dominique de Menil to Jean de Menil, Jan. 13, 1941, DMFA.
167. Ibid.
168. Jean de Menil to Dominique de Menil, telegram, Jan. 28, 1941, DMFA.
169. Marcel Schlumberger to Jean de Menil, Feb. 26, 1941, DMFA.
170. Dominique de Menil passport, DMFA.
171. Christophe de Menil, interview by the author, July 6, 2006.
172. Dominique de Menil to Henriette Delpech, May 11, 1941, DMFA.
173. Dominique de Menil passport, DMFA.
174. Dominique de Menil to Henriette Delpech, May 19, 1941, DMFA.
175. Dominique de Menil passport, DMFA.
176. Dominique de Menil to Henriette Delpech, May 19, 1941, DMFA.
177. "El transatlántico *Marqués de Comillas*," accessed May 3, 2016, funkoffizier.com.
178. "Compañía Transatlántica Española," accessed May 3, 2016, www.buques.org.
179. Dominique de Menil to Henriette Delpech, May 19, 1941, DMFA.
180. Dominique de Menil to Louise Schlumberger, May 22, 1941, DMFA.
181. Dominique de Menil passport, DMFA.
182. Dominique de Menil to Louise Schlumberger, May 22, 1941, DMFA.
183. Dominique de Menil to Henriette Delpech, May 19, 1941, DMFA.
184. Evelyn Best, interview by Adelaide de Menil, "Souvenirs," MA.
185. Dominique de Menil to Henriette Delpech, May 19, 1941, DMFA.
186. Ibid.
187. Christophe de Menil, interview by the author, July 6, 2006.
188. Ibid.
189. Dominique de Menil to Henriette Delpech, June 2, 1941, DMFA.
190. Ibid.
191. Christophe de Menil, interview by the author, July 6, 2006.
192. Best, interview by Adelaide de Menil, "Souvenirs," MA.
193. Dominique de Menil to Henriette Delpech, June 7, 1941, DMFA.
194. Ibid.
195. Christophe de Menil, interview by the author, July 6, 2006.
196. Dominique de Menil to Henriette Delpech, June 9, 1941, DMFA.

197. Dominique de Menil to Louise Schlumberger, June 14, 1941, DMFA.
198. Dominique de Menil to Louise Schlumberger, June 12, 1941, DMFA.
199. Dominique de Menil to Louise Schlumberger, June 14, 1941, DMFA.
200. Dominique de Menil to Louise Schlumberger, June 12, 1941, DMFA.
201. Dominique de Menil to Louise Schlumberger, June 14, 1941, DMFA.
202. Dominique de Menil to Henriette Delpech, June 16, 1941, DMFA.
203. Dominique de Menil to Louise Schlumberger, June 14, 1941, DMFA.
204. Dominique de Menil to Louise Schlumberger, June 16, 1941, DMFA.

CHAPTER FIFTEEN: LANDINGS

1. Couturier to Dominique de Menil, Dec. 14, 1945, Couturier Collection, Yale University.
2. Henriette de Vitry, interview by the author, June 2, 2006.
3. Dominique de Menil to Louise Schlumberger, June 29, 1941, DMFA.
4. Dominique de Menil to Louise Schlumberger, June 12, 1941, DMFA.
5. Dominique de Menil, "Father Couturier," notes for a dialogue with Pontus Hultén for *The Collectors,* MA.
6. Marie-Alain Couturier, note, n.d., Catégorie Chronologique, Couturier Collection.
7. Marie-Alain Couturier, journal, Feb. 9, 1940, Couturier Collection.
8. Henri Laugier, note, Catégorie Chronologique, Couturier Collection.
9. Ibid.
10. Miribel, quoted in Schwartzwald, draft of unpublished introductory essay for English translation of *La vérité blessée.*
11. Schwartzwald, draft of unpublished introductory essay for English translation of *La vérité blessée.*
12. Ibid.
13. Bessie de Cuevas, interview by the author, March 22, 2011.
14. Schwartzwald, draft of unpublished introductory essay for English translation of *La vérité blessée.*
15. Evelyn Best, interview by Adelaide de Menil, "Souvenirs," MA.
16. De Menil and de Menil, "The Delight and the Dilemma of Collecting."
17. James Johnson Sweeney, "Collectors' House," *Vogue,* April 1966, 187.
18. Jean-Yves Mock, interview by the author, Sept. 5, 2001.
19. Dominique de Menil to Louise Schlumberger, June 12, 1941, DMFA.
20. Fernand Léger, quoted in Schwartzwald, draft of unpublished introductory essay for English translation of *La vérité blessée.*
21. Couturier to Mme. Gadbois, June 23, 1941, Couturier Collection.
22. Couturier to Barnes, June 29, 1941, Barnes Foundation Archives.
23. Couturier to Dominique de Menil, Aug. 9, 1945, Couturier Collection.
24. Best, interview by Adelaide de Menil, "Souvenirs," MA.
25. Museum of Fine Arts, Houston, Archives, Exhibition Files.
26. Robert Sakowitz, interview by the author, July 17, 2016.
27. Anne Gruner Schlumberger, in Oristaglio and Dorozynski, *Sixth Sense,* 162–63.
28. Henriette de Vitry, interview by the author, June 2, 2006.
29. Christophe de Menil, interview by the author, July 6, 2006.
30. De Vitry, interview by the author, June 2, 2006.
31. Dominique de Menil to Henriette Delpech, Aug. 13, 1941, DMFA.
32. Lepercq to Georges de Menil, Jan. 5, 1998, DMFA.
33. Édouard Souchon, diary, Aug. 14, 1941, Eduardo Souchon to the author, Aug. 24, 2009.
34. Lieuwen, *Petroleum in Venezuela,* 87–88.
35. Ibid., 89.
36. Ibid.
37. Jean de Menil, interview by Maurice Martin, April 26, 1972, FCS.
38. Dominique de Menil, biographical interview by Winkler and Mancusi-Ungaro.
39. Henri de Chambrier, interview by Adelaide de Menil, "Souvenirs," MA.
40. Dominique de Menil to Henriette Delpech, Aug. 13, 1941, DMFA.

41. Ibid.
42. Chambrier, interview by Adelaide de Menil, "Souvenirs," MA.
43. Ibid.
44. Ibid.
45. Jean de Menil, interview by Maurice Martin, April 26, 1972, FCS.
46. Ibid.
47. Chambrier, interview by Adelaide de Menil, "Souvenirs," MA.
48. Interview by Adelaide de Menil, "Souvenirs," MA.
49. Interview by Adelaide de Menil, "Souvenirs," MA.
50. Chambrier, interview by Adelaide de Menil, "Souvenirs," MA.
51. Dominique de Menil to Louise Schlumberger, Sept. 17, 1941, DMFA.
52. Potier, interview by Adelaide de Menil, "Souvenirs," MA.
53. Interview by Adelaide de Menil, "Souvenirs," MA.
54. Dominique de Menil to Louise Schlumberger, Sept. 7, 1941, DMFA.
55. Ibid.
56. Dominique de Menil to Louise Schlumberger, Dec. 15, 1941, DMFA.
57. Dominique de Menil to Louise Schlumberger, Sept. 7, 1941, DMFA.
58. Édouard Souchon, diary, Eduardo Souchon to the author, Aug. 24, 2009.
59. Dominique de Menil to Louise Schlumberger, Sept. 17, 1941, DMFA.
60. Ibid.
61. Ibid.
62. Dominique de Menil to Louise Schlumberger, postcard, Oct. 3, 1941, DMFA.
63. Dominique de Menil to Louise Schlumberger, Oct. 26, 1941, DMFA.
64. Ibid.
65. Dominique de Menil to Louise Schlumberger, Nov. 12, 1941, DMFA.
66. Dominique de Menil to Louise Schlumberger, Nov. 26, 1941, DMFA.
67. Ibid.
68. Pierre Verger, *Pierre Verger: 50 años de fotografia,* trans. Farès el Dah-dah (Salvador: Corrupio, 1982), 166.
69. Verger to Jean de Menil, April 8, 1942, DMFA.
70. Ibid.
71. Pierre Verger, *Le messager: Photographies, 1932–1962* (Paris: Revue Noire, 1993), 225.
72. Pierre Verger, *Fiestas y danzas en el Cuzco y en los Andes,* intro. Luis E. Valcárcel (Buenos Aires: Editorial Sudamericana, 1945), 9–22.
73. Alex Baradel, e-mail to the author, Dec. 6, 2007.
74. Dominique de Menil to Louise Schlumberger, postcard, Dec. 31, 1941, DMFA.
75. Dominique de Menil to Jean de Menil, Jan. 12, 1942, DMFA.
76. Dominique de Menil to Henriette Delpech, April 28, 1942, DMFA.
77. Surpik Angelini, interview by the author, Feb. 9, 2012.
78. Surpik Angelini, e-mail to the author, Feb. 10, 2012.
79. Alfred H. Barr, "The Latin American Collection of the Museum of Modern Art," in *Resisting Categories: Latin American and/or Latino?,* ed. Mari Carmen Ramírez and Héctor Olea (New Haven, Conn.: Yale University Press, 2012), 558.
80. Holland Cotter, "Modernist in Loincloth and Feathers," *New York Times,* Feb. 9, 2007, E31.
81. Mariano Picon-Salas, "Arte: Reverón," *Revista Nacional de Cultura* 2, no. 13 (Nov. 1939): 64.
82. "Maurice Emile Henri Rotival (1892–1980)," Transatlantic Perspectives, accessed July 22, 2016, www.transatlanticperspectives.org.
83. Jean-François Lejeune, *Cruelty and Utopia: Cities and Landscapes of Latin America* (New York: Princeton Architectural Press, 2005), 242–43.
84. "Ciudad Universitaria de Caracas," UNESCO World Heritage Center, accessed July 22, 2016, whc.unesco.org.
85. Surpik Angelini, e-mail to the author, Feb. 9, 2012.
86. André Stoll, interview by Adelaide de Menil, "Souvenirs," MA.
87. Dominique de Menil to Jean de Menil, Jan. 1, 1943, DMFA.
88. Ibid.

89. Stoll, interview by Adelaide de Menil, "Souvenirs," MA.
90. Adelaide de Menil, interview by the author, Aug. 3, 2007.
91. Angelini, interview by the author, Feb. 9, 2012.
92. Dominique de Menil to Louise Schlumberger, Feb. 14, 1942, DMFA.
93. Ibid.
94. Ibid.
95. Henri de Chambrier, interview by Adelaide de Menil, "Souvenirs," MA.
96. Ibid.
97. Jean de Menil to Dominique de Menil, March 1, 1942, DMFA.
98. Dominique de Menil to Jean de Menil, March 19, 1942, DMFA.
99. Jean de Menil to Dominique de Menil, March 27, 1942, DMFA.
100. Dominique de Menil to Jean de Menil, April 1, 1942, DMFA.
101. Dominique de Menil to Gerald Thompson, Sept. 6, 1942, DMFA.
102. Dominique de Menil to Henriette Delpech, April 28, 1942, DMFA.
103. Couturier to Dominique de Menil, Dec. 15, 1941, Couturier Collection.
104. Jean de Menil to Dominique de Menil, March 16, 1942, DMFA.
105. Dominique de Menil to Henriette Delpech, July 12, 1942, DMFA.
106. Pierre Schlumberger to Jeanne Schlumberger, March 3, 1942, in Schlumberger Bohnn, *Les ordres de grandeur,* 175.
107. Jean de Menil to Dominique de Menil, Jan. 19, 1943, DMFA.
108. DMFA.
109. John de Menil, interview by Maurice Martin, April 26, 1972, FCS.
110. "Send Back Silk," *Trinidad and Tobago Newsday,* Jan. 4, 2012, accessed May 11, 2016, www .newsday.co.tt.
111. Jean de Menil to Dominique de Menil, March 16, 1942, DMFA.
112. John de Menil, interview by Maurice Martin, April 26, 1972, FCS.
113. Ibid.
114. Interview by Adelaide de Menil, "Souvenirs," MA.
115. Jean de Menil to Dominique de Menil, March 19, 1942, DMFA.
116. Jean de Menil to Dominique de Menil, March 27, 1942, DMFA.
117. Jean de Menil to Dominique de Menil, Aug. 27, 1942, DMFA.
118. Ibid.
119. Jean de Menil to Dominique de Menil, March 1, 1944, DMFA.
120. Dominique de Menil to Thompson, Sept. 6, 1942, DMFA.
121. Couturier to Dominique de Menil, April 5, 1943, Couturier Collection.
122. Nancy Brown, "At Home in Houston: Mrs. John de Menil," *Entre Nous,* Feb. 25, 1957.
123. Jean de Menil to Dominique de Menil, Jan. 24, 1943, DMFA.
124. Dominique de Menil to Henriette Delpech, April 28, 1942, DMFA.
125. Ibid.
126. "Biographical Sketch," Jean Malaquais: An Inventory of His Papers at the Harry Ransom Center, accessed July 19, 2016, norman.hrc.utexas.edu.
127. Gide and Malaquais, *Correspondance, 1935–1950,* 13–14.
128. "Découvrir le monde avant qu'il ne dispairaisse," Planète Malaquais: Le site de la Société Jean Malaquais, accessed July 19, 2016, www.malaquais.org.
129. "Biographical Sketch," Jean Malaquais: An Inventory of His Papers at the Harry Ransom Center.
130. James Kirkup, "Obituary: Jean Malaquais," *Independent,* Jan. 5, 1999, accessed July 19, 2016, www.independent.co.uk.
131. Gide and Malaquais, *Correspondance, 1935–1950,* 13.
132. Ibid., 10.
133. Kirkup, "Obituary: Jean Malaquais."
134. "L'entrée en littérature," Planète Malaquais: Le site de la Société Jean Malaquais.
135. Malaquais to Gide, July 14, 1943, in Gide and Malaquais, *Correspondance, 1935–1950,* 167–68.
136. Ibid., 169.
137. Ibid.

138. Gide to Malaquais, Nov. 21, 1943, in Gide and Malaquais, *Correspondance, 1935–1950,* 169.
139. Dominique de Menil to Jean de Menil, telegram, Jan. 23, 1943, DMFA.
140. Dominique de Menil to Gerald Thompson, May 29, 1943, quoted in Gerald Thompson to Dominique de Menil, Aug. 4, 1943, DMFA.
141. Gerald Thompson to Dominique de Menil, Aug. 4, 1943, DMFA.
142. U.S. Department of Justice, Federal Bureau of Investigation, FOIPA No. 1097619-000, Aug. 6, 1943, to the author, June 6, 2008.
143. Dominique de Menil to Louise Schlumberger, Nov. 23, 1944, DMFA.
144. Dominique de Menil to Jean de Menil, Jan. 12, 1942, DMFA.
145. Dominique de Menil to Jean de Menil, Feb. 15, 1944, DMFA.
146. Dominique de Menil to Jean de Menil, April 30, 1944, DMFA.
147. Dominique de Menil to Louise Schlumberger, Nov. 23, 1944, DMFA.
148. Dominique de Menil to Jean de Menil, Feb. 21, 1944, DMFA.
149. Dominique de Menil to Jean de Menil, March 16, 1944, DMFA.
150. Dominique de Menil to Jean de Menil, April 26, 1944, DMFA.
151. Dominique de Menil to Jean de Menil, April 30, 1944, DMFA.
152. Jean de Menil to Dominique de Menil, April 5, 1944, DMFA.
153. John de Menil, interview by Maurice Martin, April 26, 1972, FCS.
154. Ibid.
155. Whittaker, interview by the author, Jan. 18, 2012.
156. Jean de Menil to Dominique de Menil, April 21, 1944, DMFA.
157. Whittaker, interview by the author, Jan. 18, 2012.
158. Jean de Menil to Dominique de Menil, April 21, 1944, DMFA.
159. Dominique de Menil to Louise Schlumberger, Nov. 23, 1944, DMFA.
160. Jean de Menil to Dominique de Menil, April 20, 1944, DMFA.
161. Dominique de Menil to Jean de Menil, Nov. 13, 1944, DMFA.
162. Dominique de Menil to Louise Schlumberger, Nov. 23, 1944, DMFA.
163. Ibid.
164. Dominique de Menil to Jean de Menil, April 28, 1945, DMFA.
165. Ibid.
166. Dominique de Menil, biographical interview by Winkler and Mancusi-Ungaro.
167. Ibid.
168. Annette Gruner Schlumberger, interview by Adelaide de Menil, "Souvenirs," MA.
169. Flanner, *Paris Journal, 1944–1955,* 27–28.
170. Ibid., 15–16.
171. Dominique de Menil to Louise Schlumberger, Aug. 29, 1945, DMFA.
172. Dominique de Menil to Henriette Delpech, July 13, 1945, DMFA.
173. Jean Rougier, interview by Adelaide de Menil, "Souvenirs," MA.
174. Bénédicte Pesle, interview by Adelaide de Menil, "Souvenirs," MA.
175. Bénédicte Pesle, interview by the author, March 29, 2004.
176. Bénédicte Pesle, in *Rue de Vaugirard*.

CHAPTER SIXTEEN: POSTWAR

1. Couturier to Dominique de Menil, Aug. 8, 1945, Couturier Collection.
2. Dominique de Menil to Jean de Menil, Aug. 7, 1945, DMFA.
3. Dominique de Menil to Jean de Menil, July 29, 1945, DMFA.
4. Ibid.
5. Dominique de Menil to Jean de Menil, July 25, 1945, DMFA.
6. Dominique de Menil to Jean de Menil, Aug. 7, 1945, DMFA.
7. Dominique de Menil to Louise Schlumberger, Aug. 29, 1945, DMFA.
8. Dominique de Menil to Louise Schlumberger, Aug. 28, 1945, DMFA.
9. Ibid.
10. Édouard Souchon, diary, Sept. 3, 1945, Eduardo Souchon to the author, Aug. 24, 2009.
11. Dominique de Menil to Louise Schlumberger, Sept. 28, 1945, DMFA.

12. Ibid.
13. Ibid.
14. Dominique de Menil to Jean de Menil, March 27, 1946, DMFA.
15. Jean de Menil to Dominique de Menil, March 12, 1946, DMFA.
16. Fariha Friedrich, interview by the author, June 23, 2012.
17. Jean de Menil to Dominique de Menil, March 12, 1946, DMFA.
18. Jean de Menil to Dominique de Menil, March 15, 1946, DMFA.
19. Dominique de Menil, in Jean de Menil to Dominique de Menil, March 18, 1946, DMFA.
20. Jean de Menil to Dominique de Menil, March 18, 1946, DMFA.
21. Ibid.
22. Dominique de Menil, in Jean de Menil to Dominique de Menil, March 24, 1946, DMFA.
23. Dominique de Menil, in Jean de Menil to Dominique de Menil, March 28, 1946, DMFA.
24. Jean de Menil to Dominique de Menil, Feb. 24, 1946, DMFA.
25. Ibid.
26. Dominique de Menil to Jean de Menil, March 7, 1946, DMFA.
27. Dominique de Menil to Jean de Menil, Feb. 21, 1946, DMFA.
28. Dominique de Menil to Jean de Menil, March 7, 1946, DMFA.
29. Schlumberger Bohnn, *Les ordres de grandeur,* 127.
30. Ibid., 129.
31. Ibid.
32. Anne Gruner Schlumberger, interview by Adelaide de Menil, "Souvenirs," MA.
33. Dominique de Menil, in Essie McGaughy Barnes, *I Went with the Children,* 45.
34. Owen, interview by the author, April 12, 2010.
35. Anne Gruner Schlumberger, interview by Adelaide de Menil, "Souvenirs," MA.
36. Dominique de Menil, biographical interview by Winkler and Mancusi-Ungaro.
37. Dominique de Menil to Jean de Menil, Feb. 21, 1946, DMFA.
38. Dominique de Menil to Jean de Menil, March 9, 1946, DMFA.
39. Jean de Menil to Dominique de Menil, March 27, 1946, DMFA.
40. Gertrude Barnstone, interview by the author, April 3, 2003.
41. Henriette de Vitry, interview by the author, June 2, 2006.
42. Christophe de Menil, interview by the author, July 6, 2006.
43. Édouard Daladier, interview by the author, May 29, 2006.
44. Solange Picq, interview by the author, Oct. 31, 2006.
45. Daladier, interview by the author, May 29, 2006.
46. Ibid.
47. Ibid.
48. Marguerite Johnston Barnes, interview by the author, March 29, 2003.
49. Ibid.
50. Marguerite Johnston, interview by Ellen Beasley, Feb. 27, 2001, De Menil House Oral History, MA.
51. Edward Mayo, interview by the author, Sept. 7, 2002.
52. Dominique de Menil, interview by Deborah Brauer, Oct. 21, 1992, T 606, Object Files, TMC.
53. Evelyn Best, interview by Adelaide de Menil, "Souvenirs," MA.
54. Jean Mathieu, interview by Adelaide de Menil, "Souvenirs," MA.
55. Dominique de Menil, biographical interview by Winkler and Mancusi-Ungaro.
56. Rothschild to Couturier, May 26, 1945, Couturier Collection.
57. Kelly for Barnes to Rothschild, May 24, 1945, Couturier Collection.
58. Couturier to Dominique de Menil, Nov. 7, 1946, Couturier Collection.
59. Dominique de Menil, biographical interview by Winkler and Mancusi-Ungaro.
60. De Menil and de Menil, "The Delight and the Dilemma of Collecting."
61. Ibid.
62. Jean de Menil to Dominique de Menil, March 12, 1946, DMFA.
63. Rapazzini, *Élisabeth de Gramont,* 147.
64. Ibid., 226–27.

65. Mouton, *Journal de Roumanie,* 13.
66. Dominique de Menil, biographical interview by Winkler and Mancusi-Ungaro.
67. Gourdin, *Les Hugo,* 372.
68. Mouton, *Journal de Roumanie,* 13.
69. Ibid., 21.
70. André Mourges, interview by the author, Oct. 20, 2005.
71. Dominique de Menil, biographical interview by Winkler and Mancusi-Ungaro.
72. Ibid.
73. Elizabeth Ann Coleman, *The Genius of Charles James* (New York: Holt, Rinehart and Winston, 1982), 93.
74. Dominique de Menil to Jean de Menil, Feb. 18, 1946, DMFA.
75. Jean de Menil to Dominique de Menil, March 22, 1946, DMFA.
76. Dominique de Menil to Jean de Menil, March 27, 1946, DMFA.
77. Dominique de Menil to Jean de Menil, March 20, 1946, DMFA.
78. Dominique de Menil to Jean de Menil, Feb. 18, 1946, DMFA.
79. Dominique de Menil, biographical interview by Winkler and Mancusi-Ungaro.
80. Dominique de Menil to Jean de Menil, Feb. 18, 1946, DMFA.
81. Ibid.
82. Ibid.
83. Ibid.
84. Dominique de Menil, "Father Couturier," notes for a dialogue with Hultén for *The Collectors.*
85. Dominique de Menil, biographical interview by Winkler and Mancusi-Ungaro.
86. Sevasti Eva Fotiadi, "Alexander Iolas: Analysis of a Collector" (master's thesis, University of Leicester, 2001), 8, MA.
87. Daniel Abadie, *Magritte* (Paris: Ludion/Galerie Nationale du Jeu de Paume, 2003), 267.
88. Iolas to Magritte, Feb. 5, 1948, MA.
89. Iolas to Magritte, Jan. 18, 1950, MA.
90. Magritte to Iolas, Feb. 9, 1950, MA.
91. John Russell, "Alexander Iolas, Ex-dancer and Surrealist-Art Champion," *New York Times,* June 12, 1987.
92. Iolas, interview by Maurice Rheims, *Vogue Paris,* Aug. 1965, in *Alexander the Great: The Iolas Gallery, 1955–1987* (New York: Paul Kasmin Gallery, 2014), 16.
93. Adrian Dannatt, "Character Study," in *Alexander the Great,* 16.
94. Peter Dragadze, "Alexander Iolas' Temple of Art," *Town & Country,* May 1984, 231–40.
95. Thibaudat, "Alexandre Iolas," 27.
96. Dragadze, "Alexander Iolas' Temple of Art."
97. Dannatt, "Character Study," 14.
98. Thibaudat, "Alexandre Iolas," 27.
99. Fotiadi, "Alexander Iolas," 6.
100. Mourges, interview by the author, Oct. 20, 2005.
101. Thibaudat, "Alexandre Iolas," 27.
102. Bénédicte Pesle, interview by the author, March 29, 2004.
103. Ibid.
104. Mourges, interview by the author, Oct. 20, 2005.
105. Thelma Sweetinburgh, "Iolas," *Women's Wear Daily,* March 29, 1968.
106. Jean-Yves Mock, interview by the author, Sept. 5, 2001.
107. Richardson, interview by Adrian Dannatt, *Alexander the Great,* 82.
108. Iolas, interview by Adelaide de Menil, "Souvenirs," MA.
109. *Max Ernst: Inside the Sight* (Houston, Tex.: Institute for the Arts, Rice University, 1973), 75.
110. Mary Jane Victor to Marc Riboud, March 5, 1984, MA.
111. Dominique de Menil, biographical interview by Winkler and Mancusi-Ungaro.
112. Alexandre Iolas, interview by Adelaide de Menil, "Souvenirs," MA.
113. Ibid.
114. Dominique de Menil, biographical interview by Winkler and Mancusi-Ungaro.

115. Object Files, Acc. 022, TMC.
116. Couturier to Dominique de Menil, Nov. 7, 1946, Couturier Collection.
117. Iolas, interview by Adelaide de Menil, "Souvenirs," MA.
118. Object Files, Acc. T 703, TMC.
119. Mourges, interview by the author, Oct. 20, 2005.
120. Dominique de Menil, interview by Daix, "Désir des arts."
121. Iolas, interview by Adelaide de Menil, "Souvenirs," MA.
122. Ibid.
123. Barr to Dominique and Jean de Menil, Sept. 27, 1955, V 001, Object Files, TMC.
124. Susan Davidson, Curatorial Memorandum, Feb. 19, 2002, V 001, Object Files, TMC.
125. Iolas, interview by Adelaide de Menil, "Souvenirs," MA.
126. Ibid.
127. Coleman, *Genius of Charles James,* 8–9.
128. Jan Glier Reeder, "The Personal and Professional Life of Charles James," in Harold Koda and Jan Glier Reeder, *Charles James: Beyond Fashion* (New York: Metropolitan Museum of Art, 2014), 31–33.
129. Maria Hugo to Dominique de Menil, n.d., DMFA.
130. Reeder, "Personal and Professional Life of Charles James," 33–34.
131. Acc. 98-018.01 E, Object Files, TMC.
132. Acc. 98-018.36 E, Object Files, TMC.
133. Acc. 98-018.35 E, Object Files, TMC.
134. Acc. 98-018.01 E, Object Files, TMC.
135. Acc. 98-018.221 E, Object Files, TMC.
136. Dominique de Menil to Jean de Menil, Sept. 28, 1947, DMFA.
137. Ibid.
138. Jean de Menil to Dominique de Menil, March 22, 1946, DMFA.
139. Friedrich, interview by the author, June 23, 2012.
140. Dominique de Menil, interview by Adelaide de Menil, Feb. 14, 1993, MA.
141. Reeder, "Personal and Professional Life of Charles James," 33.
142. Dominique de Menil, interview by Adelaide de Menil, Feb. 14, 1993, MA.
143. Dominique de Menil, notes on Charles James, n.d. [1997], MA.
144. Dominique de Menil to Jean de Menil, Aug. 3, 1947, DMFA.
145. Best, interview by Adelaide de Menil, "Souvenirs," MA.
146. Ibid.
147. Our Mother of Mercy, History of the Church, accessed Aug. 4, 2015, www.ourmotherof mercy.net.
148. Gladys Simmons, interview by the author, Aug. 13, 2002.
149. Ibid.
150. François de Menil, interview by the author, Aug. 2, 2007.
151. Fariha Friedrich, interview by the author, June 23, 2012.
152. François de Menil, interview by the author, Aug. 2, 2007.
153. Simmons, interview by the author, Aug. 13, 2002.
154. Ibid.
155. François de Menil, interview by the author, Aug. 2, 2007.
156. Ibid.
157. Ibid.
158. John de Menil, "A Provincial Town," in Cadoret and l'Épine, *Houston,* 127.
159. Ibid., 128.

CHAPTER SEVENTEEN: HOME

1. Dominique de Menil, notes, n.d., MA.
2. Couturier to Dominique and Jean de Menil, Jan. 19, 1952 (*sic*), Couturier Collection.
3. Dominique de Menil, notes for a talk, "How J&D Started Collecting," n.d., MA.
4. Ibid.

5. Dominique de Menil, in Jean-François Fogel, "Musée: L'art sans manières," *Le Point,* Nov. 16, 1987, 105.
6. Dominique de Menil, biographical interview by Winkler and Mancusi-Ungaro.
7. Dominique de Menil, in Welch, *Philip Johnson and Texas,* 41–43.
8. Johnson, in ibid., 35.
9. Rosamond Bernier, "A Gift of Vision," *House & Garden,* July 1987, 180.
10. Barnes, in Welch, *Philip Johnson and Texas,* 41–43.
11. Johnson to Dominique and John de Menil, July 19, 1948, MA.
12. Dominique de Menil, notes, n.d., MA.
13. Sweeney, "Collectors' House," 190.
14. Dominique de Menil, biographical interview by Winkler and Mancusi-Ungaro.
15. Christophe de Menil, interview by the author, July 6, 2006.
16. Philip Johnson, "House for Mr. and Mrs. Jean Menil," Oct. 22, 1948, MA.
17. Johnson to Dominique de Menil, Nov. 12, 1948, MA.
18. Johnson to Dominique and John de Menil, Feb. 16, 1949, MA.
19. Leo Steinberg, interview by the author, Jan. 20, 2004.
20. Johnson to Dominique de Menil, Nov. 12, 1948, MA.
21. Johnson to Dominique de Menil, n.d., MA.
22. Mabel C. Haeberly, "All-Glass Home on Ponus Ridge Startles New Canaan Residents," *New York Times,* Dec. 12, 1948.
23. Johnson to Dominique and John de Menil, Feb. 16, 1949, MA.
24. Ibid.
25. Marguerite Johnston Barnes, interview by the author, March 29, 2003.
26. Lisa Barkley, e-mail to the author, Sept. 20, 2016.
27. Lisa Barkley, e-mail to the author, Sept. 19, 2016.
28. Ibid.
29. Ibid.
30. Stephen Fox, "Framing the New: Mies van der Rohe and Houston Architecture," in Scardino, Stern, and Webb, *Ephemeral City,* 253–54.
31. Couturier to Dominique de Menil, Nov. 8, 1948, Couturier Collection.
32. Dominique de Menil, biographical interview by Winkler and Mancusi-Ungaro.
33. Ibid.
34. Ibid.
35. Cowles to James, May 16, 1950, MA.
36. Johnson to Dominique de Menil, May 2, 1950, MA.
37. Ibid.
38. Johnson to Dominique de Menil, n.d., MA.
39. Philip C. Johnson Archive, PJ, III.7, MoMA.
40. Dominique de Menil, biographical interview by Winkler and Mancusi-Ungaro.
41. Ibid.
42. Bernier, "Gift of Vision," 182.
43. Dominique de Menil, interview by Adelaide de Menil, Feb. 14, 1993, MA.
44. Christophe de Menil, interview by the author, March 10, 2004.
45. Dominique de Menil, interview by Adelaide de Menil, Feb. 14, 1993, MA.
46. Ibid.
47. Ibid.
48. Sweeney, "Collectors' House," 199.
49. Dominique de Menil, interview by Adelaide de Menil, Feb. 14, 1993, MA.
50. Ibid.
51. Ibid.
52. Object Files, TMC.
53. Charles James, invoice, April 21, 1950, MA.
54. Charles James, invoice, May 22, 1950, MA.
55. Dominique de Menil, biographical interview by Winkler and Mancusi-Ungaro.
56. Ibid.

57. Christophe de Menil, interview by the author, March 10, 2004.
58. Dominique de Menil, biographical interview by Winkler and Mancusi-Ungaro.
59. John de Menil, in Sweeney, "Collectors' House," 199.
60. Anderson Todd, interview by the author, March 5, 2004.
61. Christophe de Menil, interview by the author, March 10, 2004.
62. François de Menil, interview by the author, March 4, 2004.
63. Fariha Friedrich, interview by the author, June 23, 2012.
64. John de Menil to Dominique de Menil, Aug. 31, 1950, DMFA.
65. Dominique de Menil to John de Menil, June 15, 1957, DMFA.
66. Ibid.
67. Gladys Simmons, interview by the author, Aug. 13, 2002.
68. Dominique de Menil to Couturier, Aug. 25, 1951.
69. Dominique de Menil, "Impressions américaines en France," 2.
70. Ibid., 4–5.
71. Ibid., 5.
72. Ibid.
73. Ibid., 30.
74. Dominique de Menil, notes, July 22, 1952, MA.
75. Dominique de Menil, "Impressions américaines en France," 31.
76. Sweeney, "Collectors' House," 187.
77. Ibid., 193.
78. Fariha Friedrich, interview by the author, June 23, 2012.
79. Sweeney, "Collectors' House," 187.
80. Ibid.
81. Mary Jane Victor to Riboud, March 5, 1984, MA.
82. Ibid.
83. Bernier, "Gift of Vision," 20–21.
84. Mary Jane Victor to Marc Riboud, March 5, 1984, MA.
85. Ibid.
86. Bernier, "Gift of Vision," 126–27.
87. Mary Jane Victor to Marc Riboud, March 5, 1984, MA.
88. Jean de Menil to Eli Cartier-Bresson, Jan. 13, 1964, DMFA.
89. Dominique de Menil to Alice Gordon, Dec. 18, 1982, MA.
90. Malaquais, interview by Adelaide de Menil, "Souvenirs," MA.
91. "Arizona Visitors," *Houston Press,* n.d., MA.
92. Ibid.
93. Dominique de Menil, biographical interview by Winkler and Mancusi-Ungaro.
94. John de Menil to Hobby, Nov. 2, 1951, MA.
95. John de Menil, André Siegfried itinerary, Nov. 15, 1951, MA.
96. Dominique de Menil, notes, Nov. 15, 1952, MA.
97. Ginny Camfield, interview by the author, Jan. 17, 2009.
98. John de Menil to Sweeney, Feb. 19, 1962, MFAH.
99. "Marlene, Mrs. de Menil to Renew Friendship," *Houston Post,* Sept. 21, 1964, sec. 2, 2.
100. Dominique de Menil, notes, March 1954, MA.
101. Barnes, interview by the author, March 29, 2003.
102. John de Menil to Jack Valenti, telegram, n.d. [1964], DMFA.
103. "Listening to René Magritte," in *Secret Affinities: Words and Images by René Magritte* (Houston, Tex.: Institute for the Arts, Rice University, 1976), n.p.
104. Hunter, interview by the author, Aug. 17, 2001.
105. Feldman, "John de Menil 1904–1973," 41.
106. O'Grady, interview by the author, May 12, 2006.
107. Ibid.
108. Ibid.
109. Helen Winkler, interview by the author, Sept. 13, 2002.
110. Gertrude Barnstone, interview by the author, April 3, 2003.

111. Patricia Winkler, e-mail from Marion Wilcox, Sept. 16, 2016.
112. Helen Winkler, interview by the author, Sept. 13, 2002.
113. Barnstone, interview by the author, April 3, 2003.
114. Helen Winkler, interview by the author, Sept. 13, 2002.
115. Kilian, interview by the author, April 5, 2004.
116. Patricia Winkler, e-mail from Marion Wilcox, Sept. 16, 2016.
117. Barnstone, interview by the author, April 3, 2003.
118. Mailer, *Of a Fire on the Moon,* 132.
119. Ibid.
120. Ibid., 133.
121. Ibid., 134.
122. Ibid., 138–39.
123. Ibid., 133.
124. Ibid., 133–34.
125. Dominique de Menil, date books, Feb. 10, 1974, DMFA.
126. Dominique de Menil, date books, May 4, 1960, DMFA.
127. Steinberg, interview by the author, Jan. 20, 2004.
128. Ibid.
129. Ibid.
130. Ibid.
131. Leslie Camhi, "Rosamond Bernier: The Flaming Debutante," *Vogue,* Oct. 10, 2011, accessed Sept. 21, 2016, www.vogue.com.
132. Rosamond Bernier, interview by the author, Nov. 22, 2011.
133. Bernier, "Gift of Vision," 121.
134. Gallagher, *Adventures of Roberto Rossellini,* 601.
135. Dominique de Menil, date books, April 6, 1973, DMFA.
136. Dominique de Menil, date books, March 10, 1976, DMFA.
137. Dominique de Menil, notebook, 1977, DMFA.
138. Dominique de Menil, date books, Oct. 17, 1973, DMFA.
139. Philip Glass, interview by the author, Sept. 19, 2015.
140. Jasper Johns, e-mail with the author, April 17, 2015.
141. Ibid.
142. Anne Duncan, interview by the author, Feb. 15, 2012.
143. Chris Powell, interview by the author, April 3, 2003.
144. Elsian Cozens, interview by the author, Feb. 16, 2007.
145. Ann Holmes, "A Law unto Themselves: John and Dominique de Menil," *Art Gallery,* May 1970.
146. Richard Koshalek, interview by the author, Nov. 8, 2005.
147. Walter Hopps, interview by the author, Sept. 3, 2001.
148. Ibid.
149. Ibid.
150. Ibid.
151. Renzo Piano, interview by the author, June 10, 2015.
152. Ibid.
153. Ibid.
154. Dominique de Menil, notes for a talk, "How J&D Started Collecting."

CHAPTER EIGHTEEN: NAIL HIT THIS TIME

1. Dominique de Menil, interview, n.d., MA.
2. Marguerite Johnston, "Van Gogh Brought to Life in Display Here," *Houston Post,* Feb. 4, 1951.
3. Dominique de Menil to Schapiro, Feb. 7, 1951, Meyer Schapiro Collection, Rare Book & Manuscript Library, Columbia University.
4. Christophe de Menil, interview by the author, July 6, 2006.
5. Ibid.

6. Dominique de Menil, biographical interview by Winkler and Mancusi-Ungaro.
7. *Vincent van Gogh: Catalogue of a Loan Exhibition at the Contemporary Arts Museum* (Houston, Tex.: Contemporary Arts Association, 1951), 10.
8. Alfred Barr to John de Menil, Feb. 14, 1951, MoMA.
9. Marguerite Johnston, "Van Gogh Brought to Life in Display Here," *Houston Post,* Feb. 4, 1951.
10. Frank Dolejska, "Report to Members of the Board on the Van Gogh Exhibition," Feb. 13, 1951, MFAH Archives.
11. Richard Gonzalez to the board of directors, Contemporary Arts Association, March 9, 1951, MFAH Archives.
12. John Hay Whitney to John de Menil, Feb. 16, 1951, MA.
13. "Whitneys' Van Gogh Gift," *Houston Post,* March 1, 1951, 2.
14. Gertrude Barnstone, interview by the author, April 3, 2003.
15. Dominique de Menil, notes, July 1945, MA.
16. Dominique de Menil, notes, Aug. 3, 1952, MA.
17. Ibid.
18. Ibid.
19. Dominique de Menil to John de Menil, Oct. 6, 1954, DMFA.
20. Dominique de Menil, notes, Aug. 24, 1954, MA.
21. Dominique de Menil, notes, 1957, MA.
22. Dominique de Menil, notes, Dec. 8, 1951, MA.
23. Acc. CA 5107, Object Files, TMC.
24. Dominique de Menil, in Brown and Johnson, *First Show,* 37.
25. Van Dyke, *African Art from the Menil Collection,* 15–16.
26. Dominique de Menil, in Brown and Johnson, *First Show,* 39.
27. Dominique de Menil, in ibid.
28. Dominique de Menil, in ibid., 41.
29. J. K. Thannhauser to John de Menil, June 13, 1951, Object Files 1978-172 E, TMC.
30. John de Menil to Dominique de Menil, Feb. 1960, DMFA.
31. De Menil and de Menil, "The Delight and the Dilemma of Collecting."
32. Ibid.
33. "1950s: New Technology, Strategic Acquisitions," SLB.com, accessed Sept. 26, 2016, www.slb.com.
34. B. Kogut, "Multinational Corporations," Columbia Business School, accessed Sept. 27, 2016, www.gsb.columbia.edu.
35. The Museum of Modern Art, July 1, 1962, press release, accessed Sept. 27, 2016, www.moma.org.
36. "1950s: New Technology, Strategic Acquisitions."
37. "Economic Status," MeasuringWorth.com, accessed Sept. 26, 2016, www.measuringworth.com.
38. Henriette de Vitry, interview by the author, June 2, 2006.
39. Ibid.
40. Dominique de Menil to John de Menil, Aug. 27, 1950, DMFA.
41. Dominique de Menil to John de Menil, April 16, 1955, DMFA.
42. Dominique de Menil to John de Menil, Jan. 1959, DMFA.
43. Ibid.
44. Dominique de Menil to John de Menil, Jan. 1959, DMFA.
45. Dominique de Menil to John de Menil, Jan. 1, 1955, DMFA.
46. Dominique de Menil to John de Menil, Nov. 6, 1954, DMFA.
47. John de Menil to Dominique de Menil, Oct. 23, 1954, DMFA.
48. Goldberger, *City Observed,* 248.
49. François de Menil, e-mail to the author, July 20, 2016.
50. Bénédicte Pesle, interview by the author, May 31, 2006.
51. Dominique de Menil to John de Menil, June 24, 1955, DMFA.
52. Ibid.
53. Dominique de Menil, notes, June 11, 1954, MA.

54. Dominique de Menil, June 24, 1955, DMFA.
55. John de Menil to Parkinson, May 12, 1958, DMFA.
56. John de Menil to Dr. J. L. McDonald, Sept. 1, 1950, DMFA.
57. Powell, interview by the author, April 3, 2003.
58. Ibid.
59. Ibid.
60. Edward Mayo, interview by the author, Sept. 7, 2002.
61. Chris Powell, interview by the author, April 3, 2003.
62. Pierre Pelen, interview by Adelaide de Menil, "Souvenirs," MA.
63. Johnson to Barnstone, Nov. 20, 1952, MA.
64. Dominique de Menil, biographical interview by Winkler and Mancusi-Ungaro.
65. Teana Sechelski, ed., *University of St. Thomas, Celebrating Fifty Years, 1947–1997* (Houston, Tex.: University of St. Thomas, 1997), 42–47.
66. Dominique de Menil, biographical interview by Winkler and Mancusi-Ungaro.
67. Ibid.
68. Barnstone to Dominique de Menil, telegram, Oct. 8, 1956, MA.
69. Barnstone to Dominique de Menil, telegram, Oct. 11, 1956, MA.
70. Ladislas Bugner, interview by the author, June 5, 2006.
71. Simon Jardin, interview by Adelaide de Menil, "Souvenirs," MA.
72. Ibid.
73. "Un manoir en Ile-de-France," in *L'oeil du décorateur: Les plus belles et plus intéressantes demeures d'Europe* (Lausanne: Julliard, 1963), 127.
74. Jardin, interview by Adelaide de Menil, "Souvenirs," MA.
75. Dominique de Menil to John de Menil, Feb. 15, 1958, DMFA.
76. Jermayne MacAgy, Biography, n.d., MA.
77. Rothko to Dominique de Menil, Sept. 13, 1968, MA.
78. Still to Dominique de Menil, Sept. 18, 1968, MA.
79. De Menil and de Menil, "The Delight and the Dilemma of Collecting."
80. Walter Hopps, notes for the Menil Collection, n.d., MA.
81. John de Menil to Daniel Wildenstein, Jan. 18, 1964, MA.
82. Jermayne MacAgy, Report to the Board of the Contemporary Arts Association, April 24, 1952, MA.
83. Dominique de Menil, biographical interview by Winkler and Mancusi-Ungaro.
84. Mayo, interview by the author, Sept. 7, 2002.
85. Barnstone, interview by the author, April 3, 2003.
86. Stout, interview by Sandra Curtis, Nov. 1979, Texas Project, Oral History Transcripts, Archives of American Art, Smithsonian Institution.
87. Ibid.
88. American Federation of Arts, 1957 Convention, Program, MA.
89. Ibid.
90. Marcel Duchamp, in Tomkins, *Duchamp,* 510.
91. American Federation of Arts, 1957 Convention, Program, MA.
92. Christophe de Menil, interview by the author, July 6, 2006.
93. Nina Cullinan, interview by Susan Bodin, Oct. 1975, Texas Project, Oral History Transcripts, roll 3752, Archives of American Art, Smithsonian Institution.
94. Barnstone, in Toni Ramona Beauchamp, "James Johnson Sweeney and the Museum of Fine Arts, Houston: 1961–1997" (master's thesis, University of Texas at Austin, 1983), 21.
95. Jermayne MacAgy, *Totems Not Taboo* (Houston, Tex.: Contemporary Arts Museum, 1959).
96. Goldwater to John de Menil, Dec. 3, 1958, MA.
97. Fuller to MacAgy, telegram, March 2, 1959, MA.
98. Karl Kilian, interview by the author, Sept. 10, 2001.
99. Mayo, interview by the author, Sept. 7, 2002.
100. Marcus to Theodore E. Swigart, March 10, 1959, MA.
101. Marcus to John de Menil, March 10, 1959, MA.
102. Dominique de Menil to John de Menil, telegram, Feb. 27, 1959, DMFA.

CHAPTER NINETEEN: THE SKY IS THE LIMIT

1. Paul Winkler, interview by the author, March 30, 2003.
2. Helen Winkler Fosdick, interview by the author, Sept. 13, 2002.
3. Kathy Davidson, interview by the author, July 14, 2011.
4. Davidson, interview by the author, Sept. 28, 2011.
5. Fosdick, interview by the author, Sept. 13, 2002.
6. Ibid.
7. Robert Goldwater, foreword to *The John and Dominique de Menil Collection* (New York: Museum of Primitive Art, 1962), n.p.
8. "1960s: From the Ocean Depths to the Moon," slb.com, accessed Sept. 26, 2016, www.slb.com.
9. Dominique de Menil, date books, Feb. 2, 1962, DMFA.
10. Robert Thurman, interview by the author, March 15, 2013.
11. Glueck, "The de Menil Family," 38.
12. Dominique de Menil, date books, April 13, 1961, DMFA.
13. François de Menil, e-mail to the author, Aug. 1, 2015.
14. John Richardson, interview by the author, Aug. 22, 2002.
15. Ibid.
16. Bertrand Davezac, interview by the author, Nov. 22, 2004.
17. Davezac, interview by the author, Nov. 29, 2004.
18. Ibid.
19. Dominique de Menil, date books, April 2, 1962, DMFA.
20. Museum of Modern Art, press release, Nov. 10, 1964, accessed Oct. 8, 2016, www.moma.org.
21. Dominique de Menil to Louise Schlumberger, n.d., DMFA.
22. Bill Camfield, interview by the author, Feb. 9, 2005.
23. Camfield, interview by the author, Jan. 17, 2009.
24. Camfield, interview by the author, Feb. 9, 2005.
25. Ibid.
26. John de Menil to Dorothy Miller, Jan. 15, 1964, Lieberman Files IIA/9/74, MoMA.
27. Ann Holmes, *Houston Chronicle,* in Beauchamp, "James Johnson Sweeney and the Museum of Fine Arts, Houston," 20.
28. Beauchamp, "James Johnson Sweeney and the Museum of Fine Arts, Houston," 24.
29. Ibid., 29–68.
30. Grace Glueck, "James Johnson Sweeney Dies; Art Critic and Museum Head," *New York Times,* April 15, 1986, accessed Oct. 8, 2016, www.nytimes.com.
31. Peter Marzio, interview by the author, Nov. 6, 2007.
32. Edward Mayo, interview by the author, Sept. 7, 2002.
33. Peter Schjeldahl, "Another Dimension: Reconsidering Picasso the Sculptor," *New Yorker,* Sept. 21, 2015, accessed Oct. 8, 2016, www.newyorker.com.
34. Beauchamp, "James Johnson Sweeney and the Museum of Fine Arts, Houston," 96–97.
35. Mayo, interview by the author, Sept. 7, 2002.
36. Ibid.
37. Ibid.
38. Julie Bakke, e-mail to the author, July 21, 2015.
39. Mayo, interview by the author, Sept. 7, 2002.
40. Jean Tinguely, *Fragment from Homage to New York* (1960), Museum of Modern Art, accessed Oct. 9, 2016, www.moma.org.
41. John de Menil to Sweeney, Jan. 8, 1964, MFAH Archives.
42. Beauchamp, "James Johnson Sweeney and the Museum of Fine Arts, Houston," 114.
43. John de Menil to J. C. Denneny, Feb. 27, 1964, DMFA.
44. Marzio, interview by the author, Nov. 6, 2007.
45. John de Menil to Houghton, Jan. 4, 1966, Metropolitan Museum of Art Archives.
46. Dominique de Menil to Glassell, Feb. 4, 1963, MFAH Archives.
47. Jim Love, interview by the author, Sept. 11, 2002.

48. Beauchamp, "James Johnson Sweeney and the Museum of Fine Arts, Houston," 146.
49. Walter Hopps, interview by the author, Jan. 31, 2005.
50. Karl Kilian, e-mail to the author, July 2, 2014.
51. Love, interview by the author, Sept. 11, 2002.
52. Chris Powell, interview by the author, April 3, 2003.
53. Kathy Davidson, interview by the author, Sept. 28, 2011.
54. Gertrude Barnstone, interview by the author, April 3, 2003.
55. Love, interview by the author, Sept. 11, 2002.
56. Sissy Kempner, interview by the author, March 18, 2011.
57. Kathy Davidson, interview by the author, Sept. 28, 2011.
58. Dominique de Menil to Louise Schlumberger, March 20, 1964, DMFA.
59. Dominique de Menil, biographical interview by Winkler and Mancusi-Ungaro.
60. Browning, "What I Admire I Must Possess," 198.
61. Dominique de Menil, "Jermayne MacAgy," *Out of This World* (Houston, Tex.: University of St. Thomas, 1964), n.p.
62. Hopps, interview by the author, Sept. 3, 2001.
63. Love, interview by the author, Sept. 11, 2002.
64. Fredericka Hunter, interview by the author, Aug. 17, 2001.
65. Ibid.
66. *A Young Teaching Collection* (Houston, Tex.: University of St. Thomas, 1968).
67. Heim, e-mail to Stephen Fox, Sept. 10, 2006, MA.
68. Davidson, interview by the author, Sept. 28, 2011.
69. Dominique de Menil, as told to Karl Kilian, e-mail to the author, July 2, 2014.
70. Davidson, interview by the author, Sept. 28, 2011.
71. Ibid.
72. Hunter, interview by the author, Aug. 17, 2001.
73. Kilian, interview by the author, Sept. 10, 2001.
74. Davidson, interview by the author, July 14, 2011.
75. Hunter, interview by the author, Aug. 17, 2001.
76. Hughes to Dominique de Menil, n.d., MA.
77. Cannon, interview by Mary Jane Victor, Oct. 14, 2009.
78. Paul Winkler, interview by the author, March 30, 2003.

CHAPTER TWENTY: A BIG SPLASH

1. John de Menil to Alice Brown, Feb. 27, 1967, DMFA.
2. Werner Spies, interview by the author, Nov. 25, 2010.
3. Dominique de Menil, questionnaire, n.d., 18, MA.
4. Sarah Whitfield, interview by the author, March 4, 2014.
5. Dominique de Menil to John de Menil, Dec. 1, 1969, DMFA.
6. Whitfield, interview by the author, March 4, 2014.
7. John de Menil to Sylvester, Dec. 11, 1972, MA.
8. Spies, interview by the author, Nov. 25, 2010.
9. Susan Barnes, e-mail to the author, Sept. 10, 2014.
10. Whitfield, interview by the author, March 4, 2014.
11. Dominique de Menil, date books, Nov. 13, 1964, DMFA.
12. John de Menil to Dominique de Menil, July 13, 1963, DMFA.
13. Simon Jardin, interview by Adelaide de Menil, "Souvenirs," MA.
14. Dominique de Menil to John de Menil, Aug. 25, 1963, DMFA.
15. Dominique de Menil to John de Menil, Aug. 28, 1963, DMFA.
16. Jean-Yves Mock, interview by the author, Sept. 5, 2001.
17. São Schlumberger, interview by the author, May 6, 2006.
18. Anne Schlumberger Brown, interview by the author, April 5, 2003.
19. Ibid.
20. Christophe de Menil, interview by the author, July 6, 2006.
21. Anne Schlumberger Brown, interview by the author, April 5, 2003.

22. Ibid.
23. São Schlumberger, interview by the author, May 6, 2006.
24. Anne Schlumberger Brown, interview by the author, April 5, 2003.
25. Walter Hopps, interview by the author, Sept. 13, 2002.
26. John de Menil to patrons, May 5, 1967, DMFA.
27. Karl Kilian, e-mail to the author, July 2, 2014.
28. Hughes to Dominique de Menil, Feb. 1, 1967, DMFA.
29. Kilian, e-mail to the author, July 2, 2014.
30. Ibid.
31. "Party Scored for Cunningham, Cage, and Velvet Underground," *Vogue,* Aug. 1967, 11.
32. Kilian, e-mail to the author, July 2, 2014.
33. Cunningham to John de Menil, n.d., DMFA.
34. Kilian, e-mail to the author, July 2, 2014.
35. Ibid.
36. Bob Colacello, *Holy Terror: Andy Warhol Close Up* (New York: Cooper Square Press, 2000), 90.
37. John Richardson, interview by the author, Aug. 22, 2002.
38. Dominique de Menil, questionnaire, n.d., 19–20, MA.
39. Ladislas Bugner, interview by the author, June 5, 2006.
40. Sweeney to Thomas M. Beggs, June 25, 1963, MFAH Archives.
41. Beggs to Sweeney, June 28, 1963, MFAH Archives.
42. Dominique de Menil to John de Menil, Nov. 10, 1963, DMFA.
43. Malcolm McCorquodale Jr. to Ladislas Bugner, Jan. 5, 1964, MFAH Archives.
44. Bugner, interview by the author, June 5, 2006.
45. Karen Dalton, interview by the author, March 11, 2014.
46. John Russell in Marguerite Johnston, "De Menil Launched Vast Study on Race," *Houston Post,* 1977.
47. Dominique de Menil, *The Image of the Black in Western Art,* vol. 1, *From the Pharaohs to the Fall of the Roman Empire,* ed. Ladislas Bugner (New York: William Morrow, 1976), ix.
48. Ibid., x–xi.
49. John de Menil to William P. Hobby Jr., May 11, 1969, DMFA.
50. John de Menil to Diana Hobby, May 26, 1969, DMFA.
51. Susan Barnes, *Rothko Chapel,* 93.
52. Ibid., 90.
53. Dominique de Menil, biographical interview by Winkler and Mancusi-Ungaro.
54. Ibid.
55. Deloyd Parker, interview by the author, Sept. 10, 2004.
56. Dominique de Menil, biographical interview by Winkler and Mancusi-Ungaro.
57. John de Menil to Newman, May 27, 1969, MA.
58. Susan Barnes, interview by the author, Sept. 16, 2014.
59. William Lawson, interview by the author, Feb. 11, 2011.
60. Ibid.
61. Ibid.
62. Ibid.
63. John de Menil to "Sound-Off," *Houston Post,* April 9, 1965, DMFA.
64. Deloyd Parker, "In Good Faith: Remembering John de Menil," in Helfenstein and Schipsi, *Art and Activism,* 114–15.
65. Parker, interview by the author, Sept. 10, 2004.
66. Ibid.
67. Curtis Graves, interview by the author, Oct. 17, 2016.
68. Ibid.
69. Ibid.
70. J. R. Gonzales, "Stink Bombs Cast Pall over Martin Luther King Visit," *Bayou City History* (blog), *Houston Chronicle,* Jan. 16, 2012, accessed July 11, 2015, blog.chron.com.
71. Ibid.
72. Parker, interview by the author, Sept. 10, 2004.

73. Johnson, in Wardlaw, "John and Dominique de Menil and the Houston Civil Rights Movement," 103.

74. Brian D. Behnken, in *Encyclopedia of American Race Riots,* ed. Walter C. Rucker Jr. and James N. Upton (Westport, Conn.: Greenwood Press, 2007), 2:636.

75. Ibid., 636A.

76. Parker, interview by the author, Sept. 10, 2004.

77. Ibid.

78. Lawson, interview by the author, Feb. 11, 2011.

79. "Mickey Leland," Mickey Leland Center profiles, accessed Oct. 14, 2016, mlc.tsu.edu.

80. Graves, interview by the author, Oct. 17, 2016.

81. Jane Ely, "Leland a Lot Like His Favorite Folk," *Houston Post,* May 28, 1978, 4D.

82. Parker, interview by the author, Sept. 10, 2004.

83. Leland to John de Menil, Aug. 6, 1972, MA.

84. Lawson, interview by the author, Feb. 11, 2011.

85. John de Menil to Law, Jan. 13, 1964, DMFA.

86. Paul Winkler, interview by the author, March 30, 2003.

87. Dominique and John de Menil to Johnson, telegram, June 6, 1968, DMFA.

88. John de Menil to Reagan, telegram, May 21, 1969, DMFA.

89. Simone Swan, interview by the author, Oct. 15, 2005.

90. Ibid.

91. Ibid.

92. Édouard Daladier, interview by the author, May 29, 2006.

93. John de Menil to Dominique de Menil, Aug. 8, 1965, DMFA.

94. John de Menil to Edward Rotan, April 5, 1967, DMFA.

95. John de Menil to Jardin, April 21, 1967, DMFA.

96. Dominique de Menil to John de Menil, June 24, 1967.

97. Ibid.

98. Ibid.

99. John de Menil to Dominique de Menil, June 29, 1967, DMFA.

100. Ibid.

101. John de Menil to Dominique de Menil, Jan. 15, 1968, DMFA.

102. Dominique de Menil, date books, May 21, 1968, DMFA.

103. Dominique de Menil, date books, June 3, 1968, DMFA.

104. Dominique de Menil, date books, June 8, 1968, DMFA.

105. Dominique de Menil to John de Menil, July 19, 1968, DMFA.

106. John de Menil to Dominique de Menil, Sept. 16, 1968, DMFA.

107. John de Menil to Dominique de Menil, Sept. 15, 1968, DMFA.

108. *Made of Iron* (Houston, Tex.: University of St. Thomas Art Department, 1966), 15–16.

109. Hilton Kramer, "Art: Big Show on Campus; 'Made of Iron' Is Tasteful Survey Offered by Little U. of St. Thomas in Houston," *New York Times,* Oct. 14, 1966.

110. Ada Louise Huxtable, "Buildings That Stretch the Mind," *New York Times,* April 21, 1968.

111. Helen Winkler Fosdick, interview by the author, Sept. 13, 2002.

112. Winkler, interview by the author, March 30, 2003.

113. Geoff Winningham, interview by the author, Feb. 2, 2012.

114. Dominique de Menil to John de Menil, Nov. 30, 1969, DMFA.

115. Gerald O'Grady, interview by the author, May 12, 2006.

116. Gerald O'Grady, "Lessons in Development: John and Dominique de Menil and the Media Arts," in Helfenstein and Schipsi, *Art and Activism,* 79.

117. O'Grady, interview by the author, May 12, 2006.

118. O'Grady, "Lessons in Development," 80.

119. Dominique de Menil, date books, May 3, 1968, DMFA.

120. John de Menil to Nathan Fain, Nov. 12, 1968, DMFA.

121. John de Menil to Warhol, June 26, 1967, MA.

122. Richardson, interview by the author, Aug. 22, 2002.

123. Winningham, interview by the author, Feb. 2, 2012.

124. Ibid.

125. Hunter, interview by the author, Aug. 17, 2001.
126. Winkler, interview by the author, March 30, 2003.

CHAPTER TWENTY-ONE: WORTH THE CANDLE

1. Dominique de Menil, note, Sept. 8, 1969, MA.
2. Dominique de Menil, date books, Oct. 21, 1968, DMFA.
3. *Young Teaching Collection,* 10.
4. Ibid., 4.
5. Grace Glueck, "Art Benefactors Shift Their Field: De Menils Turning Houston Collection Over to Rice," *New York Times,* Dec. 19, 1968.
6. John de Menil to Mrs. T. L. Schexnader, Dec. 23, 1968, DMFA.
7. "A Brief Rice History," Rice University, accessed Oct. 27, 2016, explore.rice.edu.
8. Johnston, *Houston,* 156.
9. Eugene Aubry, interview by the author, Oct. 7, 2011.
10. Dominique de Menil to Peter Agostino, Jan. 28, 1969, MA.
11. Jim Love, interview by the author, Sept. 11, 2002.
12. Helaine Wayne, "Rice Gets an 'A' for Its Art Home," *Houston Post,* March 27, 1960, sec. 5, 2.
13. Hogg to Dominique de Menil, March 26, 1969, MA.
14. John de Menil to Riboud, Jan. 9, 1969, DMFA.
15. John de Menil, open letter to Schlumberger employees, Jan. 9, 1969, DMFA.
16. Dominique de Menil, May 5, 1969, DMFA.
17. Dominique de Menil, biographical interview by Winkler and Mancusi-Ungaro.
18. Jackson Hicks, interview by the author, Dec. 8, 2006.
19. Ibid.
20. Dominique de Menil, date books, April 17, 1969, DMFA.
21. Dominique de Menil to Louise Schlumberger, May 7, 1969, DMFA.
22. Francesco Pellizzi, interview by the author, May 8, 2014.
23. Ibid.
24. Ibid.
25. Dominique de Menil to Louise Schlumberger, May 28, 1969, DMFA.
26. Ibid.
27. Marion Wilcox, e-mail to the author, Nov. 3, 2016.
28. Dominique de Menil to Louise Schlumberger, May 28, 1969, DMFA.
29. Ibid.
30. Ibid.
31. Dominique de Menil to Louise Schlumberger, July 13, 1969, DMFA.
32. Dominique de Menil, date books, July 12, 1969, DMFA.
33. Dominique de Menil to Louise Schlumberger, July 13, 1969, DMFA.
34. Dominique de Menil to John de Menil, Nov. 29, 1969, DMFA.
35. Ibid.
36. Daniel Robbins, in *Raid the Icebox I, with Andy Warhol* (Providence: Museum of Art, Rhode Island School of Design, 1969), 14.
37. Ibid.
38. Ann Holmes, "Raiding Exhibit Warhol Wilderness," *Houston Chronicle,* Oct. 30, 1969.
39. "*Raid the Icebox,* Party at de Menils' House," Oct. 29, 1969, MA.
40. Dominique de Menil, date books, Jan. 4, 1970, DMFA.
41. Dominique de Menil to Louise Schlumberger, Jan. 4, 1970, DMFA.
42. Ann Holmes, "Strange Beauty of Sine Waves in Concert," *Houston Chronicle,* Jan. 22, 1970.
43. Dominique de Menil, date books, Jan. 20, 1970, DMFA.
44. Lois de Menil, e-mail to the author, Oct. 27, 2016, DMFA.
45. Dominique de Menil to Louise Schlumberger, March 31, 1970, DMFA.
46. Dominique de Menil, date books, April 27, 1970, DMFA.
47. Danny Lyon, *Conversations with the Dead: An Exhibition of Photographs of Prison Life by Danny Lyon, with Letters and Drawings by Billy McCune #122054* (Houston, Tex.: Institute for the Arts, Rice University, 1970), n.p.

48. Dominique de Menil, introduction to *Ten Centuries That Shaped the West: Greek and Roman Art in Texas Collections,* by Herbert Hoffmann (Houston, Tex.: Institute for the Arts, Rice University, 1970), xviii.

CHAPTER TWENTY-TWO: NOTHING AND EVERYTHING

1. Dominique de Menil, in Susan Barnes, *Rothko Chapel,* 42.
2. Paul Richard, "Of Shadows Soaked in Blood," *Washington Post,* March 7, 1971.
3. Dominique de Menil, date books, Feb. 9, 1960, DMFA.
4. Dominique de Menil, in Ann Holms, "The Rothko Chapel, Six Years Later," *ARTnews,* Dec. 1976, 36.
5. John de Menil to Brown, Feb. 27, 1967.
6. Dominique de Menil to Madeleine Deschamps, n.d. [ca. 1975], MA.
7. Ibid.
8. Nodelman, *Rothko Chapel Paintings,* 34.
9. Dominique de Menil, date books, April 17, 1964, note made June 2, 1975, DMFA.
10. Nodelman, *Rothko Chapel Paintings,* 40.
11. Dominique de Menil, questionnaire, n.d., MA.
12. Kate Rothko Prizel, interview by the author, Nov. 9, 2016.
13. Dominique de Menil, date books, Dec. 5, 1964, DMFA.
14. Susan Barnes, *Rothko Chapel,* 48.
15. Ashton, *About Rothko,* 169.
16. Dominique de Menil, in Nodelman, *Rothko Chapel Paintings,* 9.
17. Ashton, *About Rothko,* 172–73.
18. Dominique de Menil, biographical interview by Winkler and Mancusi-Ungaro.
19. Barnstone, interview by Adelaide de Menil, May 19, 1985, "Souvenirs," DMFA.
20. Nodelman, *Rothko Chapel Paintings,* 69.
21. Dominique de Menil, date books, Sept. 5, 1965, DMFA.
22. Eugene Aubry, interview by the author, Oct. 7, 2011.
23. Dominique de Menil, in Nodelman, *Rothko Chapel Paintings,* 9.
24. Dominique de Menil, notebooks, May 20, 1970, DMFA.
25. Ashton, *About Rothko,* 174.
26. In David Anfam, "Dark Illumination: The Context of the Rothko Chapel," in *Mark Rothko: The Chapel Commission* (Houston, Tex.: Menil Foundation, 1996), 6.
27. Ibid., 9.
28. Ibid., 13.
29. Dominique de Menil, in Nodelman, *Rothko Chapel Paintings,* 9.
30. John de Menil to Brown, Feb. 27, 1967.
31. Nodelman, *Rothko Chapel Paintings,* 134.
32. Dominique de Menil, date books, Sept. 9, 1968, DMFA.
33. Rothko to Dominique and John de Menil, Jan. 1, 1966, RCA.
34. Miles Glaser, interview by the author, March 29, 2003.
35. Dominique de Menil, date books, Dec. 13, 1968, DMFA.
36. Glaser, interview by the author, March 29, 2003.
37. Fariha Friedrich, interview by the author, June 23, 2012.
38. Nodelman, *Rothko Chapel Paintings,* 75.
39. Aubry, interview by the author, Oct. 7, 2011.
40. Aubry, in Holms, "Rothko Chapel, Six Years Later," 36.
41. Aubry, interview by the author, Oct. 7, 2011.
42. Ashton, *About Rothko,* 187–88.
43. Anfam, "Dark Illumination," 13.
44. Nodelman, *Rothko Chapel Paintings,* 141–42.
45. Richard, "Of Shadows Soaked in Blood."
46. Dominique de Menil, date books, April 4, 1972, DMFA.
47. Dominique de Menil, date books, Feb. 26, 1971, DMFA.
48. Dominique de Menil, Rothko Chapel address, Feb. 26, 1971, MA.

49. Thompson L. Shannon to supporters, Feb. 19, 1971, MA.
50. Newman to Dominique and John de Menil, July 8, 1971, MA.
51. Dominique de Menil, address for the dedication of *Broken Obelisk,* Feb. 28, 1971, MA.
52. Newman to Dominique and John de Menil, July 8, 1971, MA.
53. Richard, "Of Shadows Soaked in Blood."
54. Henry J. Seldis, "Rothko Chapel Dedicated," *Los Angeles Times,* n.d.
55. Reis to Dominique de Menil, March 6, 1971, MA.
56. Dominique de Menil to Reis, March 10, 1971, MA.
57. Harry Cooper, e-mail to the author, Nov. 5, 2016.
58. Alison de Lima Greene, e-mail to the author, Nov. 6, 2016.
59. David Anfam, e-mail to the author, March 17, 2017.
60. Dominique de Menil, "Commentary on the Rothko Chapel by Dominique de Menil," interview by Les Levine, *Arts Magazine,* March 1974.

CHAPTER TWENTY-THREE: FAITH CAN BE ALIVE

1. John de Menil to Gerald Thompson, Jan. 6, 1970, DMFA.
2. Larry Rivers, in *Some American History* (Houston, Tex.: Institute for the Arts, Rice University, 1971), 17.
3. Ibid.
4. Robert Hughes, "Bronx Is Beautiful," *Time,* Feb. 8, 1971, 68.
5. Dominique de Menil to Jean Leymarie, Sept. 30, 1969, MA.
6. Jacqueline Hériard Dubreuil to Dominique de Menil, Jan. 5, 1971, MA.
7. "L'iconographie subversive de Max Ernst," *Le Monde,* April 7, 1971.
8. Jacqueline Hériard Dubreuil to Dominique de Menil, Jan. 5, 1971, MA.
9. Dominique de Menil, date books, April 9, 1971, DMFA.
10. Dominique de Menil, date books, April 8, 1971, DMFA.
11. U.S. Inflation Calculator, accessed Nov. 24, 2016, www.usinflationcalculator.com.
12. Gail Adler, interview by the author, Aug. 16, 2014.
13. Ibid.
14. "A Sense of Mystery," *Houston Chronicle,* May 22, 1971, 14.
15. Dominique de Menil, *For Children,* curatorial notes, n.d., MA.
16. Betty Ewing, "They're Climbing the Walls to See This Art Show," *Houston Post,* June 2, 1971, sec. 7, 1.
17. Darby English, *1971: A Year in the Life of Color* (Chicago: University of Chicago Press, 2016), 202.
18. Leland, invitation to the opening of *The De Luxe Show,* Aug. 19, 1971, MA.
19. Greenberg, interview by Simone Swan, 1971, MA.
20. Deloyd Parker, interview by the author, Sept. 10, 2004.
21. Wardlaw, "John and Dominique de Menil and the Houston Civil Rights Movement," 110.
22. Dominique and John de Menil, "Exploration Logs," No. 1, Oct. 13, 1971, MA.
23. Dominique and John de Menil, "Exploration Logs," No. 2, Nov. 15, 1971, MA.
24. Ibid.
25. Dominique and John de Menil, "Exploration Logs," No. 3, Jan. 5, 1972, MA.
26. Dominique and John de Menil, "Exploration Logs," No. 3, Jan. 9, 1972, MA.
27. Dominique and John de Menil, "Exploration Logs," No. 3, Jan. 11, 1972, MA.
28. Dominique de Menil, date books, Feb. 23, 1972, DMFA.
29. Dominique and John de Menil, "Exploration Logs," No. 4, Feb. 23, 1972, MA.
30. Ibid.
31. Dominique and John de Menil, "Exploration Logs," No. 4, Feb. 24, 1972, MA.
32. Dominique and John de Menil, "Exploration Logs," No. 4, Feb. 26, 1972, MA.
33. Ibid.
34. Dominique de Menil, date books, Feb. 27, 1972, DMFA.
35. Dominique and John de Menil, "Exploration Logs," No. 4, Feb. 27, 1972, MA.
36. Dominique and John de Menil, "Exploration Logs," No. 4, Feb. 28, 1972, MA.
37. Dominique and John de Menil, "Exploration Logs," No. 4, Feb. 29, 1972, MA.

38. Ibid.
39. Dominique de Menil to Louise Schlumberger, postcard, n.d., DMFA.
40. Dominique and John de Menil, "Exploration Logs," No. 5, March 7, 1972, MA.
41. Dominique de Menil to Louise Schlumberger, postcard, March 9, 1972, DMFA.
42. Dominique and John de Menil, "Exploration Logs," No. 5, March 10, 1972, MA.
43. Nabila Drooby, interview by the author, April 2, 2003.
44. Ibid.
45. Dominique and John de Menil, "Exploration Logs," No. 6, March 14, 1972, MA.
46. Ibid.
47. Ibid.
48. Robert Thurman, e-mail to the author, March 16, 2013.
49. Dominique de Menil to Louise Schlumberger, March 20, 1972, DMFA.
50. Dominique and John de Menil, "Exploration Logs," No. 6, March 23, 1972, MA.
51. Ibid.
52. John de Menil to Dominique de Menil, Oct. 1969, DMFA.
53. Dominique de Menil to John de Menil, March 1970, DMFA.
54. Chris Powell, interview by the author, April 3, 2003.
55. Kevin Cassidy, e-mail to the author, Sept. 14, 2016.
56. Dominique de Menil to Louise Schlumberger, Dec. 14, 1972, DMFA.
57. Dominique de Menil to Louise Schlumberger, Jan. 1, 1973, DMFA.
58. Dominique de Menil to Louise Schlumberger, Aug. 26, 1972, DMFA.
59. John de Menil to Sylvester, Dec. 11, 1972, MA.
60. Dominique de Menil to Louise Schlumberger, Jan. 1, 1973, DMFA.
61. John de Menil to Pierre Schlumberger, Dec. 13, 1972, MA.
62. John de Menil, Memo to the Board, Jan. 29, 1972, MA.
63. John de Menil to Pierre Schlumberger, Dec. 13, 1972, MA.
64. Browning, "What I Admire I Must Possess," 206.
65. Dominique de Menil, date books, Jan. 4, 1973, DMFA.
66. Steinberg, interview by the author, Jan. 20, 2004.
67. Ruspoli to John de Menil, Feb. 22, 1973, DMFA.
68. Dominique de Menil, date books, March 16, 1973, DMFA.
69. Mrs. John D. Rockefeller III to John de Menil, April 26, 1973, DMFA.
70. Annette Gruner Schlumberger to Dominique de Menil, May 20, 1973, DMFA.
71. Congar to Dominique and John de Menil, May 17, 1973, DMFA.

CHAPTER TWENTY-FOUR: AFTERMATH

1. Dominique de Menil to Sébastien Loste, July 5, 1973, MMA.
2. Feldman, "John de Menil 1904–1973," 41.
3. Jean Riboud, "Letter from Jean Riboud," *Intercom,* June 1973, MA.
4. Gladys Simmons, interview by the author, Aug. 13, 2002.
5. Deloyd Parker, interview by the author, Sept. 10, 2004.
6. Ibid.
7. Eleanor Freed, "John de Menil, Art Patron" *Houston Post,* June 10, 1973.
8. The Reverend William Lawson, interview by the author, Feb. 11, 2011.
9. Lawson, interview by Dominique de Menil, "Souvenirs," DMFA.
10. Ed Deswysen, "Funeral of John de Menil Was in the Style He Lived," *Houston Chronicle,* June 6, 1973, 1.
11. François de Menil, interview by the author, Dec. 1, 2016.
12. Edward Mayo, interview by the author, Sept. 7, 2002.
13. Chris Powell, interview by the author, April 3, 2003.
14. Simone Swan, interview by the author, May 9, 2014.
15. François de Menil, interview by the author, Dec. 1, 2016.
16. George Oser, interview by the author, Sept. 4, 2009.
17. Mailer to Dominique de Menil, telegram, June 2, 1973, DMFA.
18. Cartier-Bresson to Dominique de Menil, June 7, 1973, DMFA.

19. Sylvester to Dominique de Menil, June 7, 1973, MA.
20. Nabila Drooby, interview by the author, April 2, 2003.
21. Dominique de Menil, date books, July 4, 1973, DMFA.
22. Dominique de Menil, welcoming speech, Rothko Chapel Colloquium, July 22, 1973, RCA.
23. Dominique de Menil, biographical interview by Winkler and Mancusi-Ungaro.
24. Dominique de Menil, welcoming speech, Rothko Chapel Colloquium, July 22, 1973, RCA.
25. Drooby, interview by the author, April 2, 2003.
26. Traditional Modes of Contemplation and Action: A Colloquium at the Rothko Chapel, program, July 22-30, 1973, MA.
27. Dominique de Menil, foreword to *Gray Is the Color* (Houston, Tex.: Institute for the Arts, Rice University, 1974), 9-10.
28. Drooby, interview by the author, April 2, 2003.
29. Dominique de Menil to Charles Buckley, Dec. 21, 1972, MA.
30. Dominique de Menil, foreword to *Gray Is the Color,* 9.
31. Man Ray to Dominique de Menil, Oct. 20, 1973, MA.
32. Ann Holmes, "Grey Is the Color of Unique Art Show," *Houston Chronicle,* n.d.
33. Swan to Paul Gardner, Sept. 12, 1973, MA.
34. Brown to Dominique de Menil, Jan. 21, 1974, MA.

CHAPTER TWENTY-FIVE: WHAT NOW?

1. Dominique de Menil, "Mrs. John de Menil," *Art-Rite,* no. 3 (1973): 2.
2. Lois de Menil, e-mail to the author, Sept. 28, 2015.
3. Ibid.
4. Walter Hopps, interview by the author, Sept. 13, 2002.
5. Paul Winkler, interview by the author, March 30, 2003.
6. Lois de Menil, e-mail to the author, Sept. 28, 2015.
7. Philip Glass, interview by the author, Sept. 19, 2015.
8. Robert Hughes, "The Snobbish Style," *Time,* Sept. 13, 1976.
9. Charlotte Moser, "Magritte's Show Is One Step Beyond Surrealism," *Houston Chronicle,* Oct. 3, 1976.
10. Charlotte Moser, "Surrealism and Voyeurism," *ARTnews,* Dec. 1976, 78.
11. Frances Beatty, "Cornell in Houston," *Art/World,* Sept. 24, 1997.
12. Dominique de Menil to Anna and Nicola Bulgari, Dec. 4, 1978, MA.
13. Jean-Yves Mock, interview by the author, Sept. 5, 2001.
14. Dominique de Menil, date books, Sept. 5, 1965, DMFA.
15. Dominique de Menil, six date books, Jan. 1964, DMFA.
16. Dominique de Menil, date books, April 19, 1967, DMFA.
17. Dominique de Menil, date books, April 22, 1970, DMFA.
18. Dominique de Menil, date books, Nov. 21-23, 1972, DMFA.
19. Loud, *Art Museums of Louis I. Kahn,* 245.
20. Kahn to Frederick J. Stock, March 2, 1974, quoted in ibid.
21. Loud, *Art Museums of Louis I. Kahn,* 246-47.
22. Dominique de Menil, date books, June 2, 1973, DMFA.
23. Dominique de Menil, date books, Feb. 3, 1974, DMFA.
24. Stephen Fox, "Dominique and John de Menil as Patrons of Architecture, 1932-1997," in Helfenstein and Schipsi, *Art and Activism,* 209-10.
25. Dominique de Menil, biographical interview by Winkler and Mancusi-Ungaro.
26. Ibid.
27. Dominique de Menil, notes, Carnegie Institute of Art, June 28, 1976, MA.
28. Dominique de Menil, notes, Cleveland Museum, June 29, 1976, MA.
29. Dominique de Menil, notes, Walker Art Center, July 1, 1976, MA.
30. Dominique de Menil, notes, William Rockhill Nelson Gallery, July 2, 1976, MA.
31. Ibid.
32. Dominique de Menil to Ralph T. Coe, July 16, 1976, MA.
33. Dominique de Menil, date books, July 3-7, 1976, DMFA.

710 NOTES TO PAGES 534-547

34. Dominique de Menil, date books, July 8, 1976, DMFA.
35. Hofheinz, interview by the author, June 9, 2005.
36. Ibid.
37. Dominique de Menil, "Dans les jardins de Houston," *Le Monde,* April 12, 1984.
38. Edward Mayo, interview by the author, Sept. 7, 2002.
39. Fred Hofheinz, interview by the author, June 9, 2005.
40. Ibid.
41. Ibid.
42. Browning, "What I Admire I Must Possess," 209.

CHAPTER TWENTY-SIX: OTHER VOICES, OTHER LANDS

1. Dominique de Menil, "Dans les jardins de Houston."
2. Dominique de Menil, date books, June 1, 1961, DMFA.
3. Claude Pompidou, interview by the author, May 6, 2006.
4. Georges Pompidou, in Vanessa Schneider, "Quand Paulin modernisait l'Élysée," *Le Monde,* April 6, 2015.
5. Claude Pompidou, interview by the author, May 6, 2006.
6. Ibid.
7. Dominique de Menil, date books, April 11, 1971, DMFA; "Fonds Sébastien Loste," Centre Historique des Archives Nationales, accessed Nov. 24, 2016, www.archivesnationales.cul ture.gouv.fr.
8. Claude Pompidou, interview by the author, May 6, 2006.
9. Brigitte Leal, in the catalog *Collection art moderne: La collection du Centre Pompidou, Musée national d'art moderne,* "L'oeuvre Bleu II," Centre Pompidou, accessed July 25, 2015, www.centrepompidou.fr.
10. Christophe de Menil, interview by the author, July 6, 2006.
11. Centre Pompidou communiqué, n.d., accessed July 25, 2015, www.centrepompidou.fr.
12. Claude Pompidou, interview by the author, May 6, 2006.
13. Dominique de Menil to Sébastien Loste, July 5, 1973, MMA.
14. Nabila Drooby, interview by the author, April 2, 2003.
15. Dominique de Menil, date books, July 15, 1979, DMFA.
16. Michael Ennis, "East Meets Wet," *Texas Monthly,* Nov. 1979, 170.
17. Dominique de Menil, date books, Sept. 18, 1979.
18. Dominique de Menil, date books, Sept. 19, 1979.
19. Ennis, "East Meets Wet," *Texas Monthly,* 176.
20. Drooby, interview by the author, April 2, 2003.
21. Ibid.
22. Ibid.
23. Ibid.
24. Dominique de Menil, date books, Oct. 14, 1978, DMFA.
25. Dominique de Menil, "Thanks to the Whirling Dervishes After Their Performance at the Rothko Chapel," Oct. 1978, RCA.

CHAPTER TWENTY-SEVEN: TOWARD A NEW MUSEUM

1. Dominique de Menil, letter of invitation, draft, Feb. 26, 1980, TMC.
2. Dominique de Menil, date books, April 30, 1979, DMFA.
3. Jim Love to Dominique de Menil, June 6, 1979, MA.
4. Dominique de Menil, date books, March 11, 1980, DMFA.
5. Paul Winkler, interview by the author, March 30, 2003.
6. Dominique de Menil, date books, Dec. 1, 1979, DMFA.
7. Winkler, interview by the author, March 30, 2003.
8. Walter Hopps, interview by the author, Jan. 31, 2005.
9. Hopps, interview by the author, Sept. 3, 2001.
10. Ibid.

11. Ibid.
12. Caroline Huber, interview by the author, June 10, 2015.
13. Dominique de Menil, date books, Feb. 10, 1980, DMFA.
14. Dominique de Menil, notebooks, Dec. 14, 1979, DMFA.
15. Winkler, interview by the author, March 30, 2003.
16. Hopps, interview by the author, Sept. 13, 2002.
17. Winkler, interview by the author, March 30, 2003.
18. Renzo Piano, interview by the author, June 10, 2015.
19. Ibid.
20. Ibid.
21. Ibid.
22. Ibid.
23. Dominique de Menil, date books, Nov. 18, 1980, DMFA.
24. Piano, interview by the author, June 10, 2015.
25. Ibid.
26. Jean-Yves Mock, interview by the author, Sept. 5, 2001.
27. Winkler, interview by the author, March 30, 2003.
28. Dominique de Menil to Piano, Nov. 21, 1980, MA.
29. Piano, interview by the author, June 10, 2015.
30. Winkler, interview by the author, March 30, 2003.
31. Piano, interview by the author, June 10, 2015.
32. Ibid.

CHAPTER TWENTY-EIGHT: GLOBAL VISIONS

1. Dominique de Menil, *La rime et la raison,* 11.
2. Walter Hopps, interview by the author, Sept. 3, 2001.
3. Dominique de Menil, *La rime et la raison,* 11.
4. Hopps, interview by the author, Sept. 3, 2001.
5. Jack Lang, interview by the author, Sept. 15, 2001.
6. Hopps, interview by the author, Sept. 3, 2001.
7. Dominique de Menil, "About Yves Klein," in *Yves Klein, 1928–1962: A Retrospective* (Houston, Tex.: Institute for the Arts, Rice University, 1982), 8.
8. Janet Kutner, "Yves Klein Was a 'Provocateur,'" *Dallas Morning News,* April 8, 1982, 16C.
9. Dominique de Menil, "About the Exhibition," in *Yves Klein, 1928–1962,* 8.
10. Kutner, "Yves Klein Was a 'Provocateur,'" 16C.
11. Claude Pompidou to Dominique de Menil, Feb. 10, 1982, MA.
12. Jean-Yves Mock, interview by the author, Sept. 5, 2001.
13. Lang, interview by the author, Sept. 15, 2001.
14. Mock, interview by the author, Sept. 5, 2001.
15. Lang to Dominique de Menil, June 29, 1982, MA.
16. Dominique de Menil to Lang, July 24, 1982.
17. Ibid.
18. Hopps, interview by the author, Sept. 3, 2001.
19. Hopps, interview by the author, Jan. 31, 2005.
20. Hopps, interview by the author, Sept. 3, 2001.
21. Mock, interview by the author, Sept. 5, 2001.
22. Hopps, interview by the author, Sept. 3, 2001.
23. Bertrand Davezac, interview by the author, Nov. 29, 2004.
24. Dominique de Menil, date books, April 13, 1984, DMFA.
25. Caroline Huber, interview by the author, June 10, 2015.
26. Mirèse de Menil, interview by Adelaide de Menil, "Souvenirs," DMFA.
27. Bernier to Dominique de Menil, May 11, 1984, MA.
28. Pacquement, interview by the author, Sept. 5, 2001.
29. *Dons de la famille de Ménil au Musée National d'Art Moderne,* press release, Musée National d'Art Moderne, Centre Georges Pompidou, June 11, 1984, MA.

30. Hopps, interview by the author, Sept. 3, 2001.
31. Dominique de Menil, date books, April 17, 1984, DMFA.
32. Grace Glueck, "France Lauds U.S. Family of Art Patrons," *New York Times,* April 19, 1984.
33. Davezac, interview by the author, Nov. 29, 2004.
34. Rosamond Bernier, interview by the author, Nov. 22, 2011.
35. Iolas, interview by Adelaide de Menil, "Souvenirs," MA.
36. Hubert Landais to Dominique de Menil, Sept. 18, 1984, MA.
37. John Ashbery, "Houston Comes to Paris," *Newsweek,* April 23, 1984, 60.
38. Glueck, "France Lauds U.S. Family of Art Patrons."
39. Jacques Michel, "L'éducation d'un amateur," *Le Monde,* April 21, 1984.
40. Dominique de Menil, date books, Nov. 12, 1980, DMFA.
41. Richard Koshalek, interview by the author, Nov. 8, 2005.
42. Koshalek, interview by the author, Nov. 8, 2005.
43. Ibid.
44. Brown and Johnson, *First Show,* 286.
45. Koshalek, interview by the author, Nov. 8, 2005.
46. Ibid.
47. Hultén to Dominique de Menil, Jan. 22, 1975, MMA.
48. Dominique de Menil, Georges Pompidou Art and Culture Foundation, Aug. 1982, PFA.
49. Georges Pompidou Art and Culture Foundation, Aug. 1982, PFA.
50. *Dons de la famille de Ménil au Musée National d'Art Moderne,* press release.
51. Dominique de Menil, date books, Jan. 25, 1979, DMFA.
52. Hultén in Dominique de Menil, notebooks, Jan. 25, 1979, DMFA.
53. Dominique de Menil to Claude Pompidou, Oct. 5, 1980, PFA.
54. Invitation List, 111 East Seventy-Third Street, March 16, 1981, PFA.
55. Mock, interview by the author, Sept. 5, 2001.
56. Dominique de Menil, date books, May 27, 1980, DMFA.
57. Dominique de Menil, date books, May 28, 1980, DMFA.
58. Dominique de Menil, date books, June 2, 1980, DMFA.
59. Sissy Kempner, interview by the author, March 18, 2011.
60. Anne Schlumberger Brown, interview by the author, April 5, 2003.
61. Marilyn Oshman, interview by the author, April 1, 2004.
62. Ibid.
63. Dominique de Menil, "Georges Pompidou Art and Culture Foundation, Art Week 1982," Aug. 18, 1982, PFA.
64. Ibid.
65. Oshman, interview by the author, April 1, 2004.
66. Dominique de Menil, "Georges Pompidou Art and Culture Foundation, Art Week 1982."
67. Ibid.
68. Ibid.
69. Oshman, interview by the author, April 1, 2004.
70. Dominique de Menil, "Georges Pompidou Art and Culture Foundation, Art Week 1982."
71. Oshman, interview by the author, April 1, 2004.
72. Ibid.
73. Ibid.
74. Miles Glaser, interview by the author, March 29, 2003.

CHAPTER TWENTY-NINE: A MUSEUM WITH WALLS

1. Renzo Piano, interview by the author, June 10, 2015.
2. Dominique de Menil, date books, Jan. 6, 1981, DMFA.
3. Walter Hopps, interview by the author, Sept. 13, 2002.
4. Paul Winkler, interview by the author, March 30, 2003.
5. Piano, interview by the author, June 10, 2015.
6. Winkler, interview by the author, March 30, 2003.
7. Piano, interview by the author, June 10, 2015.

8. Ibid.
9. Hopps, interview by the author, Sept. 13, 2002.
10. Winkler, interview by the author, March 30, 2003.
11. Dominique de Menil, announcement, Aug. 18, 1981, MA.
12. "Museum Planned: Building to Hold Menil Collection," *Houston Post,* Aug. 25, 1981.
13. Ann Holmes, "Major New Museum Set for Menil Art in Houston," *Houston Chronicle,* Aug. 25, 1981.
14. Mimi Crossley, "City's Culture Zone Gaining Village of Art," *Houston Post,* Dec. 6, 1981.
15. Hopps, interview by the author, Sept. 3, 2001.
16. Winkler, interview by the author, March 30, 2003.
17. Hopps, interview by the author, Sept. 13, 2002.
18. Piano, interview by the author, June 10, 2015.
19. Winkler, interview by the author, March 30, 2003.
20. Ibid.
21. Ralph Ellis, interview by Mary Jane Victor, June 22, 2011.
22. Winkler, interview by the author, March 30, 2003.
23. "The Menil Collection: Milestone Dates for Design and Construction," n.d., MA.
24. Dominique de Menil, notebooks, May 5, 1989, DMFA.
25. Dominique de Menil, date books, Oct. 20, 1983, DMFA.
26. Dominique de Menil, date books, Oct. 27, 1983, DMFA.
27. Dominique de Menil, date books, Dec. 5, 1985, DMFA.
28. Dominique de Menil, date books, July 22, 1985, DMFA.
29. Dominique de Menil, date books, July 31, 1985, DMFA.
30. Georges de Menil, interview by the author, Aug. 31, 2017.
31. Dominique de Menil, date books, Sept. 27, 1985, DMFA.
32. Euan Baird, interview with the author, May 25, 2006.
33. Dominique de Menil, date books, Aug. 16, 1986, DMFA.
34. Dominique de Menil, date books, Aug. 18, 1986, DMFA.
35. Dominique de Menil, date books, Aug. 28, 1986, DMFA.
36. Dominique de Menil, date books, Sept. 6, 1986, DMFA.
37. Dominique de Menil, letter to Euan Baird, Oct. 7, 1986. MA.
38. Dominique de Menil, letter to Roland Génin, Oct. 8, 1986, MA.
39. Danièle Giraudy, e-mail to the author, Aug. 7, 2015.
40. Hopps, interview by the author, Sept. 3, 2001.
41. Ibid.
42. Winkler, interview by the author, March 30, 2003.
43. Jean-Yves Mock, interview by the author, Sept. 5, 2001.
44. Dominique de Menil, "Visit of the Museum with Frank Stella," Feb. 10, 1989, MA.
45. Ibid.

CHAPTER THIRTY: FROM CIVIL RIGHTS TO HUMAN RIGHTS

1. Carter to Dominique de Menil, May 8, 1992, MA.
2. "La mort d'Ivan Illich, penseur rebelle," *Le Monde,* April 12, 2002.
3. Joseph Novitski, "Brazilian Bishop, Social Reformer, Symbolizes Trends in Latin Church," *New York Times,* Oct. 28, 1970, L6.
4. Joseph A. Page, "The Little Priest Who Stands Up to Brazil's Generals," *New York Times Magazine,* May 23, 1971, 26.
5. Nabila Drooby, interview by the author, April 2, 2003.
6. Ibid.
7. Dominique de Menil, in "Rights Awards Mark 10th Year of the Rothko Chapel in Houston," *New York Times,* June 23, 1981, A18.
8. Dominique de Menil, date books, March 6, 1980, DMFA.
9. Dominique de Menil, March 23, 1974, DMFA.
10. Dominique de Menil, date books, Jan. 28, 1983, DMFA.
11. Susan Barnes, *Rothko Chapel,* 115.

12. Dominique de Menil, date books, Dec. 10, 1984, DMFA.
13. Dominique de Menil, date books, Dec. 10, 1984, DMFA.
14. Jimmy Carter, interview by the author, May 17, 2007.
15. Dominique de Menil, date books, March 18, 1985, DMFA.
16. Carter, interview by the author, May 17, 2007.
17. Dominique de Menil to Carter, March 29, 1985, MA.
18. "Dominique de Menil," biography, April 28, 1994, MA.
19. Carter, interview by the author, May 17, 2007.
20. Ibid.
21. Mary Schlangenstein, "Award Recipients Criticize Reagan," UPI, Dec. 11, 1986.
22. Carter, interview by the author, May 17, 2007.
23. Ibid.
24. Ibid.
25. Dominique de Menil, date books, March 23, 1990, DMFA.
26. Dominique de Menil, "Remarks at the Ceremony for the Fifth Óscar Romero Award, Vienna, Austria," June 16, 1993, RCA.
27. Ibid.
28. Dominique de Menil, date books, Feb. 10, 1990, DMFA.
29. Drooby, interview by the author, April 2, 2003.
30. Dominique de Menil, in Shelby Hodge, "Human-Rights Leaders Gather in Spotlight," *Houston Chronicle,* Dec. 9, 1991, 1.
31. Dominique de Menil, "Remarks at a Dinner Honoring Nelson Mandela and Introducing Recipients of the 1991 Carter-Menil Human Rights Prize," in *The Rothko Chapel: Writings on Art and the Threshold of the Divine* (New Haven, Conn.: Yale University Press, 2010), 92.
32. Carter, interview by the author, May 17, 2007.
33. Dominique de Menil, "Remarks at the Ceremony for the Fifth Óscar Romero Award, Vienna, Austria."
34. Paula Dittrick, "Mandela Urges Citizens Worldwide to Promote Human Rights," UPI, Dec. 9, 1991.
35. Nelson Mandela, in Hodge, "Human-Rights Leaders Gather in Spotlight," 1.

CHAPTER THIRTY-ONE: BYZANTIUM

1. Dominique de Menil, notebooks, n.d., DMFA.
2. Gustave Schlumberger to Dominique de Menil, Jan. 11, 1927, DMFA.
3. Gary Vikan, interview by the author, Sept. 5, 2015.
4. Gustave Schlumberger, *Un empereur byzantin au dixième siècle: Nidéphore Phocas* (Paris: Firmin-Didot, 1890), 10.
5. "Les legs de Gustave Schlumberger aux musées de France," *Bulletin des Musées de France,* Aug. 1931, 165–84.
6. Eric Wolf, "Catalogue Publication Dates Between 1920 and 1940," e-mail to the author, Aug. 12, 2011.
7. Dominique de Menil, notes, July 14, 1957, MA.
8. Dominique de Menil, date books, March 20, 1977, DMFA.
9. Dominique de Menil, "Welcoming Words," Fourteenth Annual Byzantine Studies Conference, Nov. 11, 1988, MA.
10. Mary Jane Victor, Curatorial Notes, May 1977 and June 1995, Object Files, TMC.
11. Gary Vikan, *Sacred and Stolen: Confessions of a Museum Director* (New York: Select Books, 2016), 41–45.
12. Dominique de Menil, date books, March 15, 1985, DMFA.
13. Annemarie Weyl Carr, e-mail to Mary Kadish, June 18, 2012, Object Files, TMC.
14. Bertrand Davezac to David Sylvester, March 9, 1997, Object Files, TMC.
15. Bertrand Davezac, interview by the author, Nov. 22, 2004.
16. Ibid.
17. Dominique de Menil, date books, Jan. 14–18, 1979, DMFA.
18. Davezac, interview by the author, Nov. 29, 2004.

19. Vikan, *Sacred and Stolen,* 80–81.
20. Petsopoulos, e-mail to the author, March 13, 2017.
21. Bertrand Davezac, introduction to *A Byzantine Masterpiece Recovered: The Thirteenth-Century Murals of Lysi, Cyprus,* by Annemarie Weyl Carr and Laurence J. Morrocco (Austin: University of Texas Press, 1991), 8–9.
22. Dominique de Menil, in Helen Thorpe, "Whose Art Is It Anyway?," *Texas Monthly,* Jan. 1997, 125.
23. Davezac, introduction to *Byzantine Masterpiece Recovered,* by Carr and Morrocco, 10.
24. Dominique de Menil, Remarks, Dedication of the Byzantine Fresco Chapel, Feb. 8, 1997, MA.
25. Walter Hopps, interview by the author, Sept. 3, 2001.
26. Brownell, in Carr and Morrocco, *Byzantine Masterpiece Recovered,* 11.
27. Annemarie Weyl Carr, interview by the author, March 15, 2017.
28. Hopps, interview by the author, Sept. 3, 2001.
29. Laurence J. Morrocco, "The Reconstruction and Restoration of the Lysi Murals," in Carr and Morrocco, *Byzantine Masterpiece Recovered,* 154–56.
30. Carr, interview with the author, March 15, 2017.
31. Dominique de Menil to François de Menil, April 25, 1989, MA.
32. Ibid.
33. Ibid.
34. Lynn Wyatt, interview by the author, March 18, 2017.
35. Paul Goldberger, "A Modern Building's Timeless Soul," *New York Times,* Feb. 6, 1997.
36. Dominique de Menil, remarks, Dedication of Byzantine Fresco Chapel.
37. Dominique de Menil, date books, Feb. 8, 1997, DMFA.
38. Dominique de Menil, date books, Feb. 9, 1997, DMFA.

CHAPTER THIRTY-TWO: A NEW GENERATION

1. Dominique de Menil, comments, Dia Center for the Arts Gala, Oct. 28, 1992, MA.
2. Heiner Friedrich, interview by the author, March 3, 2017.
3. Helen Winkler Fosdick, interview by the author, Sept. 13, 2002.
4. "About *Double Negative,*" accessed March 20, 2017, doublenegative.tarasen.net.
5. Fosdick, interview by the author, Sept. 13, 2002.
6. Turrell, in Elaine King, "Into the Light: A Conversation with James Turrell," *Sculpture,* Nov. 2002, accessed March 23, 2017, www.sculpture.org.
7. Fosdick, interview by the author, Sept. 13, 2002.
8. Fosdick, e-mail to the author, March 22, 2017.
9. Fosdick, interview by the author, Sept. 13, 2002.
10. Fariha Friedrich, interview by the author, June 23, 2012.
11. Fosdick, interview by the author, Sept. 13, 2002.
12. Ibid.
13. Fariha Friedrich, interview by the author, June 23, 2012.
14. Fosdick, interview by the author, Sept. 13, 2002.
15. Ibid.
16. Fariha Friedrich, interview by the author, June 23, 2012.
17. Dominique de Menil, date books, April 11, 1979, DMFA.
18. Dominique de Menil to Scrima, April 22, 1979, DMFA.
19. Dominique de Menil, date books, Sept. 9, 1980, DMFA.
20. Dominique de Menil, in Colacello, "Remains of the Dia," 191.
21. Fariha Friedrich, interview by the author, June 23, 2012.
22. Ibid.
23. Fosdick, interview by the author, Sept. 13, 2002.
24. Colacello, "Remains of the Dia," 174.
25. Heiner Friedrich, interview by the author, March 3, 2017.
26. Fosdick, interview by the author, Sept. 13, 2002.
27. Heiner Friedrich, interview by the author, March 3, 2017.
28. Lois de Menil, interview by the author, Sept. 3, 2015.

29. Ibid.
30. Ibid.
31. Dominique de Menil, date books, Jan. 19, 1985, DMFA.
32. Dominique de Menil, in Colacello, "Remains of the Dia," 198.
33. Fosdick, interview by the author, Sept. 13, 2002.
34. Ashton Hawkins, interview by the author, June 21, 2012.
35. Ibid.
36. Dominique de Menil, date books, Nov. 30, 1986, DMFA.
37. Dominique de Menil, comments, Dia Center for the Arts Gala, Oct. 28, 1992, MA.
38. Carol Vogel, "Inside Art: Truce at Dia Center Breaks Down," *New York Times,* Feb. 2, 1996.
39. Helen Winkler, interview by the author, March 21, 2017.
40. Dominique de Menil, date books, Sept. 22, 1990, DMFA.
41. Dominique de Menil, date books, Sept. 23, 1990, DMFA.
42. Ibid.
43. Heiner Friedrich, interview by the author, March 3, 2017.
44. Paul Winkler to Lois de Menil, Oct. 20, 1994, MA.
45. Winkler to Piano, April 12, 1991, MA.
46. Paul Winkler, in Julie Sylvester and Nicola Del Roscio, eds., *Cy Twombly Gallery: The Menil Collection, Houston* (New York: Cy Twombly Foundation; Houston, Tex.: Menil Collection, 2013), 14.
47. Dominique de Menil to Twombly, Aug. 22, 1994, MA.
48. Dominique de Menil to Piano, April 14, 1995, MA.
49. David Dillon, "Cy Twombly Gallery Opens in Houston," *Architecture,* April 1995, 24.
50. Paul Winkler to Lois de Menil, Oct. 20, 1994, MA.
51. Dominique de Menil, Remarks at the Opening of the Cy Twombly Gallery, Feb. 10, 1995, MA.

CHAPTER THIRTY-THREE: *UN ACTE FINAL*

1. Leo Steinberg, interview by the author, Jan. 20, 2004.
2. Walter Hopps, *Andy Warhol: Death and Disaster* (Houston, Tex.: Fine Art Press, 1988), 7.
3. Dominique de Menil, April 1, 1982, MA.
4. Dominique de Menil, remarks on the Legion d'Honneur, May 16, 1985, MA.
5. Dominique de Menil, date books, June 30, 1992, DMFA.
6. "Dominique de Menil," biography, April 28, 1994, MA.
7. Anne Schlumberger Brown, interview by the author, April 5, 2003.
8. Thomas L. Friedman, "Rabin and Arafat Seal Their Accord as Clinton Applauds 'Brave Gamble,'" *New York Times,* Sept. 14, 1993, 1.
9. Jimmy Carter, interview by the author, May 17, 2007.
10. Paula Cooper, interview by the author, June 28, 2012.
11. Ibid.
12. Ibid.
13. Ibid.
14. Dominique de Menil, "Remarks at the Dedication of Tony Smith Sculpture *Marriage,*" May 18, 1994, MA.
15. Dominique de Menil, "Remarks at the Presentation of a Carter-Menil Human Rights Special Prize to Institute of Applied Social Science (FAFO)," May 18, 1994, MA.
16. Cooper, interview by the author, June 28, 2012.
17. Ibid.
18. Carter, interview by the author, May 17, 2007.
19. Carter to Dominique de Menil, May 5, 1992, MA.
20. Dominique de Menil to Carter, May 13, 1992, MA.
21. Carter, interview by the author, May 17, 2007.
22. Nabila Drooby, interview by the author, April 2, 2003.
23. Miles Glaser, interview by the author, March 29, 2003.
24. Walter Hopps, interview by the author, Sept. 3, 2001.
25. Dominique de Menil, date books, Dec. 5, 1989, DMFA.

26. Susan Barnes, interview by the author, Sept. 6, 2014.

27. Menil Foundation, press release, Aug. 29, 1994, MA.

28. Bertrand Davezac to Dominique de Menil, Sept. 29, 1994, MA.

29. Dominique de Menil to Davezac, Oct. 7, 1994, MA.

30. Davezac, interview by the author, Nov. 22, 2004.

31. Barnes, interview by the author, Sept. 14, 2016.

32. "Notes of Staff Meeting, Friday, February 14 [*sic*], 1995," MA.

33. Paul Winkler, interview by the author, Dec. 12, 2006.

34. Barnes to Dominique de Menil, memo, Feb. 25, 1995, MA.

35. Dominique de Menil, date books, March 6, 1995, DMFA.

36. Barnes, interview by the author, Sept. 14, 2016.

37. "Inventory Appraisement and List of Claims," Probate Court, Harris County, Texas.

38. Steinberg, interview by the author, Jan. 20, 2004.

39. Dominique de Menil, date books, Aug. 21, 1997, DMFA.

40. Colacello, "Remains of the Dia," 181.

41. Dominique de Menil, date books, May 31, 1997.

42. Nora Fuentes, interview by the author, Sept. 15, 2015.

43. Dominique de Menil, date books, July 6, 1997, DMFA.

44. Fuentes, interview by the author, Sept. 15, 2015.

45. Dominique de Menil, date books, Sept. 5, 1997, DMFA.

46. Dominique de Menil, date books, Sept. 29, 1997, DMFA.

47. Dominique de Menil, date books, Oct. 14, 1997, DMFA.

48. Fredericka Hunter, e-mail to the author, July 27, 2015.

49. Anne Schlumberger Brown, interview by the author, April 5, 2003.

50. Susan de Menil, e-mail to the author, April 2, 2017.

51. Aziz Friedrich, interview by the author, Feb. 22, 2017.

52. Ibid.

53. Jean Daladier, interview by the author, May 29, 2006.

54. Ann Holmes, "Humanitarian, Patron of the Arts de Menil, 89, Dies," *Houston Chronicle,* Jan. 1, 1998, A1.

55. "Death of Dominique de Menil: A Great Loss for France," Communiqué from the Foreign Ministry, Paris, Jan. 5, 1998.

56. Clifford Pugh, "De Menil Laid to Rest with Elegance, Simplicity," *Houston Chronicle,* Jan. 4, 1998, A33.

57. Pugh, "De Menil Laid to Rest with Elegance, Simplicity," A33.

58. Piano to the de Menil family, Jan. 8, 1998, DMFA.

59. Robin McCorquodale, interview by the author, April 12, 2011.

60. Dominique de Menil to Jean de Menil, n.d. [fall 1930], DMFA.

61. Dominique de Menil to Jean de Menil, Feb. 12, 1931, DMFA.

BIBLIOGRAPHY

ARCHIVAL SOURCES

ARCHIVES NATIONALES DE FRANCE (AN)

Registres des procès-verbaux par année, 1870–1946; Baccalauréat 1925

Registre des procès-verbaux de licence 1928

Répertoire alphabétique des candidats, 1925–1926

Répertoire alphabétique des candidats, 1927–1928

CERCLE D'ÉTUDES JACQUES ET RAÏSSA MARITAIN, KOLBSHEIM (JM)

DE MENIL FAMILY ARCHIVES (RESTRICTED ACCESS), MENIL COLLECTION, HOUSTON (DMFA)

ÉCOLE DES MINES DE PARIS, FONDS CONRAD SCHLUMBERGER, PARIS (FCS)

MENIL ARCHIVES, MENIL COLLECTION, HOUSTON, TEXAS (MA)

"Au Val-Richer, la vie des femmes: Souvenirs des guerres de 14–18 et 39–45." Transcript of interviews about World War I and World War II at the Val-Richer, July 1992.

Comment Books. Visitors' comments selected by Dominique de Menil. July 16–Oct. 16, 1987, 1990–1994.

"Congrès Schlumberger 84." Mulhouse-Guebwiller, May 11–13, 1984.

Davidson, Kathryn. Curatorial Museum Exploration, Storage Museum Overall Purpose. Notes, Oct. 15, 1976.

De Menil House Oral History. Interviews conducted by Ellen Beasley. Feb. 2001.

"Désir des arts: La rime et la raison." Interview of Dominique de Menil by Pierre Daix. Videotape. 1984.

Facility Program, Menil Collection. Building project memo and drawings, Jan. 1980.

Fotiadi, Sevasti Eva. "Alexander Iolas: Analysis of a Collector." Master's thesis, University of Leicester, 2001.

Magritte-Iolas Correspondence. Letters between René Magritte and Alexandre Iolas, 1946–1964.

Menil, Dominique de. Biographical interview by Paul Winkler and Carol Mancusi-Ungaro. Videotape. Sept. 25, 1995.

Menil, Dominique de. Comments on the Menil Collection, press release, June 1987.

Milestone Dates for Design and Construction, n.d.

"Souvenirs" (restricted access). Video and audio interviews about John de Menil by Adelaide de Menil, 1983–1985.

La vérité blessée. Introductory essay by Robert Schwartzwald for English translation (draft). 1994.

MODERNA MUSEET ARCHIVES, STOCKHOLM (MMA)

MUSEUM OF FINE ARTS, HOUSTON ARCHIVES (MFAH)

MUSEUM OF MODERN ART ARCHIVES, NEW YORK (MOMA)

POMPIDOU FOUNDATION ARCHIVES, LOS ANGELES (PFA)

ROTHKO CHAPEL ARCHIVES, HOUSTON, TEXAS (RCA)

THE MENIL COLLECTON (TMC)

BOOKS, CATALOGS, OTHER PUBLISHED MATERIAL

Aaron, Lucien. *L'exode.* Paris: Cahiers de la Quinzaine, 1914.

Allaud, Louis, and Maurice Martin. *Schlumberger: Histoire d'une technique.* Paris: Berger-Levrault, 1976.

Les Amis des Monuments Rouennais. *Bulletin: Année 1906*. Rouen: Lecerf Fils, 1907.

Andrew, Dudley, and Steven Ungar. *Popular Front Paris and the Poetics of Culture*. Cambridge, Mass.: Belknap Press of Harvard University Press, 2005.

Ashton, Dore. *About Rothko*. New York: Oxford University Press, 1983.

Auletta, Ken. *The Art of Corporate Success: The Story of Schlumberger*. New York: Penguin Books, 1984.

Azéma, Jean-Pierre. *1940: L'année noire*. Paris: Fayard, 2010.

Baines, Edward. *History of the Wars of the French Revolution*. Vol. 2. London: Longman, Hurst, et al., 1818.

Barnes, Essie McGaughy. *I Went with the Children*. Dallas: Story Book Press, 1953.

Barnes, Susan J. *The Rothko Chapel: An Act of Faith*. Houston, Tex.: Rothko Chapel, 1996.

Barnstone, Howard. *The Architecture of John F. Staub: Houston and the South*. Austin: University of Texas Press, 1979.

Barré, Jean-Luc. *Jacques et Raïssa Maritain: Les mendiants du ciel*. Paris: Stock, 1995.

Baudrillart, Monseigneur. *Emmanuel de Ménil: Allocution prononcée le 10 septembre 1918*. St.-Brieuc: René Prud'homme, 1920.

Beauvoir, Simone de. *Journal de guerre: Septembre 1939–janvier 1941*. Paris: Gallimard, 1990.

Bedé, Jean-Albert, and William B. Edgerton, eds. *Dictionary of Modern European Literature*. 2nd ed. New York: Columbia University Press, 1980.

Bernhard, Virginia. *Ima Hogg: The Governor's Daughter*. St. James, N.Y.: Brandywine Press, 1984.

Betancourt, Rómulo. *Venezuela: Oil and Politics*. Boston: Houghton Mifflin, 1979.

Boegner, Marc, André Siegfried, and Pierre Lestringant. *Protestantisme français*. Paris: Plon, 1946.

Bournon, Fernand. *Paris-atlas 1900*. Paris: Larousse, 1991.

Bouvet, Vincent, and Gérard Durozoi. *Paris, 1919–1939: Art et culture*. Paris: Hazan, 2009.

Bowker, Geoffrey C. *Science on the Run: Information Management and Industrial Geophysics at Schlumberger, 1920–1940*. Cambridge, Mass.: MIT Press, 1994.

Brogan, Hugh. *Alexis de Tocqueville: A Life*. New Haven, Conn.: Yale University Press, 2007.

Broglie, Gabriel de. *Guizot*. Paris: Perrin, 1990.

Bromberger, Merry. *Comment ils ont fait fortune*. Paris: Plon, 1954.

Brown, Julia, and Bridget Johnson. *The First Show: Painting and Sculpture from Eight Collections, 1940–1980*. Los Angeles: Museum of Contemporary Art; New York: Arts Publisher, 1983.

Buchanan, Peter. *Renzo Piano Building Workshop: Complete Works*. Vol. 1. London: Phaidon, 1993.

Bulletin de la Société Industrielle de Mulhouse. Vol. 75. Mulhouse: Veuve Bader, 1905.

Cadoret, Michel, and Sibylle de l'Épine. *Houston*. Marrero, La.: Hope Haven Press, 1949.

Campardon, Émile. *Liste des membres de la noblesse impériale*. Paris: Société de l'Histoire de la Révolution Française, 1889.

Carco, Francis. *Instincts; Promenade pittoresque à Montmartre; Panam*. Paris: Stock, 1924.

Caro, Robert A. *The Years of Lyndon Johnson: Means of Ascent*. New York: Alfred A. Knopf, 1990.

Caussé, Françoise. *La revue "L'Art Sacré."* Paris: Cerf, 2010.

Congar, M. J. *Chrétiens désunis: Principes d'un "oecuménisme" catholique*. Paris: Cerf, 1937.

Cooke, Lynne. *Dia: Beacon*. New York: Dia Art Foundation, 2003.

Corbin, Alain, ed. *Histoire de la virilité*. Vol. 2, *Le XIXe siècle: Le triomphe de la virilité*. Paris: Seuil, 2011.

Coutrot, Aline. *Un courant de la pensée catholique, l'hebdomadaire "Sept" (mars 1934–août 1937)*. Paris: Cerf, 1961.

Couturier, M.-A. *Sacred Art*. Edited by Dominique de Menil and Pie Duployé. Translated by Granger Ryan. Austin: University of Texas Press, 1983.

Cronin, Vincent. *Paris: City of Light, 1919–1939*. London: HarperCollins, 1994.

Delbreil, Jean-Claude. *La revue "La Vie Intellectuelle."* Paris: Cerf, 2008.

Delmas, Jean, ed. *Histoire militaire de la France*. Vol. 2. Paris: Presses Universitaires de France, 1992.

D'Ocagne, Mortimer. *Les grandes écoles de France*. Paris: Hetzel, 1887.

Dollinger, Philippe, Paul Spindler, and Jean Schlumberger. *La bourgeoisie alsacienne: Études d'histoire sociale*. Strasbourg-Paris: F. X. Le Roux, 1954.

Dowling, Timothy C., ed. *World War I: Personal Perspectives*. Santa Barbara, Calif.: ABC-CLIO, 2006.

Duclos, Charles Pinot. *The Secret Memoirs of the Regency*. Translated by E. Jules Meras. New York: Sturgis & Walton, 1910.

Edwards, George Wharton. *Alsace-Lorraine*. Philadelphia: Penn, 1918.

Ellis, Katharine. *Interpreting the Musical Past: Early Music in Nineteenth-Century France*. New York: Oxford University Press, 2005.

Esdaile, Charles. *Napoleon's Wars: An International History, 1803–1815*. London: Allen Lane/ Penguin, 2007.

Fabre, Rémi. *Les protestants en France depuis 1789*. Paris: La Découverte, 1999.

Filler, Martin. *Makers of Modern Architecture*. New York: New York Review of Books, 2007.

Flanner, Janet. *An American in Paris: Profile of an Interlude Between Two Wars*. New York: Simon & Schuster, 1940.

———. *Paris Journal, 1944–1955*. New York: Harcourt Brace, 1965.

Fohlen, Claude. *La France de l'entre-deux-guerres*. Paris: Casterman, 1966.

Fox, Stephen. *Houston Architectural Guide*. Houston, Tex.: American Institute of Architects, 1990.

Fuermann, George. *Houston: Land of the Big Rich*. New York: Doubleday, 1951.

Fussell, Paul. *The Great War and Modern Memory*. New York: Oxford University Press, 2000.

Gallagher, Tag. *The Adventures of Roberto Rossellini*. New York: Da Capo Press, 1998.

Gasparini, Graziano, and Juan Pedro Posani. *Caracas a través de su arquitectura*. Caracas: Armitano, 1998.

Gide, André. *L'immoraliste*. Paris: Mercure de France, 1998.

———. *Si le grain ne meurt*. Paris: Gallimard, 1955.

Gide, André, and Jean Malaquais. *Correspondance, 1935–1950*. Paris: Phébus, 2000.

Gide, André, and Jean Schlumberger. *Correspondance, 1901–1950*. Edited by Pascal Mercier and Peter Fawcett. Paris: Gallimard, 1993.

Giraudy, Danièle. *Le regard d'un mécène: La collection d'Anne Gruner Schlumberger pour la Fondation des Treilles*. Paris: La Fondation des Treilles, 2005.

Goldberger, Paul. *The City Observed: New York*. New York: Vintage Books, 1979.

Gourdin, Henri. *Les Hugo*. Paris: Grasset, 2016.

Guizot, François. *Memoires pour servir à l'histoire de mon temps*. Paris: Michel Levy Frères, 1861.

Habuet, Henry. *L'Orléans à toute vapeur*. Paris: Devambez, 1908.

Hanauer, M. L'Abbé. *Les paysans de l'Alsace au Moyen-Age*. Paris: Durand, 1865.

Hau, Michel, and Nicolas Stoskopf. *Les dynasties alsaciennes*. Paris: Perrin, 2005.

Hazan, Eric. *L'invention de Paris: Il n'y a pas des pas perdus*. Paris: Seuil, 2002.

Hesburgh, Theodore M., ed. *The Collected Works of Jacques Maritain*. Vol. 2, *Integral Humanism, Freedom in the Modern World, and A Letter on Independence*. Edited by Otto Bird. Translated by Otto Bird, Joseph Evans, and Richard O'Sullivan. Notre Dame, Ind.: University of Notre Dame Press, 1996.

Heumann, Gautier. *La guerre des paysans d'Alsace et de Moselle (avril–mai 1525)*. Paris: Sociales, 1979.

Hillairet, Jacques. *Connaissance du vieux Paris*. Paris: Rivages, 1993.

Horne, Alistair. *La Belle France: A Short History*. New York: Alfred A. Knopf, 2005.

———. *Seven Ages of Paris*. New York: Alfred A. Knopf, 2002.

Hulme, Edward Maslin. *The Protestant Revolution and the Catholic Reformation in Continental Europe*. New York: Century, 1924.

Hummer, Hans J. *Politics and Power in Early Medieval Europe: Alsace and the Frankish Realm, 600–1000*. New York: Cambridge University Press, 2005.

Jackson, Julian. *France: The Dark Years, 1940–1944*. Oxford: Oxford University Press, 2001.

Johnson, Douglas, and Madeleine Johnson. *The Age of Illusion: Art and Politics in France, 1918–1940*. London: Thames & Hudson, 1987.

Johnson, Philip, Stephen Fox, and Hilary Lewis. *The Architecture of Philip Johnson*. Boston: Bulfinch Press, 2002.

Johnston, Marguerite. *Houston: The Unknown City, 1836–1946*. College Station: Texas A&M University Press, 1991.

Kahn, Bonnie Menes. *My Father Spoke French: Nationalism and Legitimacy in Alsace, 1871–1914.* New York: Garland, 1990.

Kale, Steven. *French Salons: High Society and Political Sociability from the Old Regime to the Revolution of 1848.* Baltimore: Johns Hopkins University Press, 2004.

Keegan, John. *The First World War.* New York: Random House, 1998.

Kirkland, Kate Sayen. *The Hogg Family and Houston: Philanthropy and the Civic Ideal.* Austin: University of Texas Press, 2009.

Lajeunesse, Samuel R. *Grands mineurs français.* Paris: Dunod, 1948.

Landes, David S. *Dynasties: Fortunes and Misfortunes of the World's Great Family Businesses.* New York: Viking, 2006.

Lawrence, Carl A. *Fundamentals of Spun Yarn Technology.* Boca Raton, Fla.: CRC Press, 2003.

Lepape, Pierre. *André Gide: Le messager.* Paris: Seuil, 1997.

Leuilliot, Paul. *L'Alsace au début du XIXeme siècle.* Paris: Bibliothèque Generale de l'École Pratique des Hautes Études, 1959.

L'Hermine, H. de. *Guerre et paix en Alsace au XVIIe siècle.* Toulouse: Privat, 1981.

Lieuwen, Edwin. *Petroleum in Venezuela: A History.* Berkeley: University of California Press, 1955.

Livet, Georges, and Raymond Oberlé. *Histoire de Mulhouse des origines à nos jours.* Strasbourg: Éditions des Dernières Nouvelles d'Alsace, 1977.

Lombardi, John V. *Venezuela: The Search for Order, the Dream of Progress.* Oxford: Oxford University Press, 1982.

Lorblanchès, Jean-Claude. *Les soldats de Napoléon en Espagne et au Portugal, 1807–1814.* Paris: L'Harmattan, 2007.

Loti, Pierre. *Quelques aspects du vertige mondial.* Paris: Calmann-Lévy, 1928.

Loud, Patricia Cummings. *The Art Museums of Louis I. Kahn.* Durham, N.C.: Duke University Press, 1989.

Lynes, Russell. *Good Old Modern: An Intimate Portrait of the Museum of Modern Art.* New York: Atheneum, 1973.

Macchi, Giulio, and Marco Romanelli. *Renzo Piano Building Workshop Exhibit Design.* Milan: Lybra Immagine, 1992.

MacMillan, Margaret. *Paris 1919: Six Months That Changed the World.* New York: Random House, 2001.

Mailer, Norman. *Of a Fire on the Moon.* Boston: Little, Brown, 1970.

Mann, Carol. *Paris Between the Wars.* New York: Vendome Press, 1996.

Martin, Philippe. *Le théâtre divin: Une histoire de la messe XVIe–XXe siècle.* Paris: CNRS, 2010.

Marzio, Peter C. *A Permanent Legacy: 150 Works from the Collection of the Museum of Fine Arts, Houston.* New York: Hudson Hills Press, 1989.

———. *A Spirited Vision: Highlights of the Bequest of Caroline Wiess Law to the Museum of Fine Arts, Houston.* Houston, Tex.: MFAH, 2004.

Maurois, André. *Dialogues sur le commandement.* Paris: Grasset, 1925.

McComb, David G. *Houston: A History.* Austin: University of Texas Press, 1981.

Menil, Baron Antoine de. *Observations sur le réseau des chemins de fer de Bretagne.* Quimper: Lion Père, 1854.

Menil, Dominique de. *La rime et la raison.* Paris: Éditions de la Réunion des Musées Nationaux, 1984.

Meric, Monique. *Des Guizot de Saint-Geniès-de-Malgoirés et d'ailleurs.* Nîmes, 2005.

Miermont, Dominique Laure. *Annemarie Schwarzenbach; ou, Le mal d'Europe.* Paris: Payot, 2004.

Miller, Ray. *Ray Miller's Houston.* Austin, Tex.: Cordovan Press, 1984.

Minnaert, Jean-Baptiste. *Pierre Barbe: Architectures.* Paris: Mardaga, 1991.

Molières, Michel. *Les expéditions françaises en Portugal de 1807 à 1811.* Paris: Publibook, 2001.

Mouton, Jean. *Journal de Roumanie, 29 août 1939–19 mars 1946: La IIe guerre mondiale vue de l'Est.* Lausanne: L'Age d'Homme, 1978.

N. Schlumberger et Cie. *N. Schlumberger et Cie., Guebwiller, France, 1808–1958.* NSC Annual Report. Paris, 1958.

Nemer, Monique. *Corydon citoyen: Essai sur André Gide et l'homosexualité*. Paris: Gallimard, 2006.

Newman, Barnett, Ann Temkin, and Richard Shiff. *Barnett Newman*. Philadelphia: Philadelphia Museum of Art, 2002.

Nichols, Roger. *The Harlequin Years: Music in Paris, 1917–1929*. Berkeley: University of California Press, 2002.

Nicolas, L'Abbé. *Marcel de Ménil: Allocution prononcée le 26 novembre 1918*. St.-Brieuc, 1920.

Nodelman, Sheldon. *The Rothko Chapel Paintings: Origins, Structure, Meaning*. Austin: University of Texas Press, 1997.

Oberkampff de Dabrun, Émile. *Notice sur la famille Oberkamp: Son origine, modifications du nom, ses différentes branches*. N.d.

O'Malley, John W. *What Happened at Vatican II*. Cambridge, Mass.: Belknap Press of Harvard University Press, 2008.

Oristaglio, Michael, and Alexandre Dorozynski. *A Sixth Sense: The Life and Science of Henri-Georges Doll*. [Parsippany, N.J.?]: Hammer, 2007.

Pacquement, Alfred. *La culture pour vivre: Donations des Fondations Scaler et Clarence-Westbury*. Paris: Éditions du Centre Pompidou, 2002.

Pénault, Pierre-Jean. *Du Val-Richer à la Roque-Baignard: François Guizot, André Gide, Jean Schlumberger*. Pont l'Évêque: Éditions du Pays d'Auge, n.d.

Pérouse de Montclos, Jean-Marie, ed. *Le guide du patrimoine: Paris*. Paris: Hachette, 1994.

Petre, F. Loraine. *Napoleon's Campaign in Poland, 1806–1807*. London: Greenhill Books, 2001.

Piano, Renzo. *Logbook*. New York: Monacelli Press, 1997.

Pinet, G. *Histoire de l'École Polytechnique*. Paris: Librairie Polytechnique, Baudry, 1887.

Pineton Chambrun, Joseph Dominique Aldebert de. *Nos historiens: Guizot, Tocqueville, Thiers*. Paris: Calmann Lévy, 1888.

Pouthas, Charles-H. *Une famille de bourgeoisie française de Louis XIV à Napoléon*. Paris: Félix Alcan, 1934.

———. *Guizot pendant la Restauration: Préparation de l'homme d'état (1814–1830)*. Paris: Plon, 1923.

———. *La jeunesse de Guizot (1787–1814)*. Paris: Félix Alcan, 1936.

Presley, James. *A Saga of Wealth: The Rise of the Texas Oilmen*. New York: G. P. Putnam's Sons, 1978.

Putnam, Ruth. *Alsace and Lorraine: From Caesar to Kaiser*. New York: G. P. Putnam's Sons, 1915.

Quintin, Danielle, and Bernard Quintin. *Dictionnaire des colonels de Napoléon*. Paris: SPM, 2013.

Rain, Pierre. *L'École Libre des Sciences Politiques*. Paris: Fondation Nationales des Sciences Politiques, 1963.

Rapazzini, Francesco. *Élisabeth de Gramont: Avant-gardiste*. Paris: Fayard, 2004.

Reynolds, Siân. *France Between the Wars*. London: Routledge, 1996.

Rubin, William S. *Modern Sacred Art and the Church of Assy*. New York: Columbia University Press, 1961.

Saltzman, Cynthia. *Portrait of Dr. Gachet: The Story of a van Gogh Masterpiece, Money, Politics, Collectors, Greed, and Loss*. New York: Penguin, 1998.

Scardino, Barrie, William F. Stern, and Bruce C. Webb, eds. *Ephemeral City: "Cite" Looks at Houston*. Austin: University of Texas Press, 2003.

Schloesser, Stephen. *Jazz Age Catholicism: Mystic Modernism in Postwar Paris, 1919–1933*. Toronto: University of Toronto Press, 2005.

Schlumberger, Anne Gruner. *The Schlumberger Adventure*. New York: Arco, 1982.

Schlumberger, Christine. *Tableaux généalogiques de la famille Schlumberger, Vol. 1, de la 1er à la XIVe génération, supplément au cartulaire de la famille Schlumberger par Léon Schlumberger*. Mulhouse: Impr. Brinkmann, 1953.

———. *Tableaux généalogiques de la famille Schlumberger, Vol. 2, de la XVe à la XIXe génération, supplément au cartulaire de la famille Schlumberger par Léon Schlumberger*. Mulhouse: Impr. Brinkmann, 1956.

Schlumberger, Clarisse. *Schlumberger: Racines et paysages*. Strasbourg: Oberlin, 1998.

Schlumberger, Jean. *Éveils*. Paris: Gallimard, 1950.

———. *In memoriam; Anniversaires*. Paris: Gallimard, 1991.

———. *Madeleine et André Gide*. Paris: Gallimard, 1956.

———. *Notes sur la vie littéraire, 1902–1968*. Edited by Pascal Mercier. Paris: Gallimard, 1999.

———. *Saint Saturnin*. Translated by Dorothy Bussy. New York: Dodd, Mead, 1932.

Schlumberger, Jean, and Dominique de Menil. *Conrad Schlumberger: Sa vie, son œuvre*. Paris, 1949.

Schlumberger Bohnn, Anne Marie Louise. *Les ordres de grandeur*. 1987.

Schlumberger Ltd. *2007 Annual Report*.

Schom, Alan. *Napoleon Bonaparte*. New York: HarperCollins, 1998.

Sevegrand, Martine. *Temps présent: Une aventure chrétienne*. Vol. 1, *Un hebdomadaire, 1937–1947*. Paris: Temps Présent, 2006.

Sheridan, Alan. *André Gide: A Life in the Present*. Cambridge, Mass.: Harvard University Press, 1999.

Shirer, William. *The Collapse of the Third Republic: An Inquiry into the Fall of France in 1940*. New York: Simon & Schuster, 1969.

Siegfried, André. *La crise de l'Europe*. Paris: Calmann-Lévy, 1935.

———. *Les États-Unis d'aujourd'hui*. Paris: Armand Colin, 1927.

Silverman, Dan P. *Reluctant Union: Alsace-Lorraine and Imperial Germany, 1871–1918*. University Park: Pennsylvania State University Press, 1972.

Staal, Madame de. *Lettres de Mlle Delaunai (Madame de Staal) au chevalier de Ménil, au marquis de Silly et à M. d'Héricourt*. Vol. 2. Paris: Léopold Collin, 1806.

Stein, Gertrude. *Paris France*. New York: Charles Scribner's Sons, 1940.

Teissonnière-Jestin, Paulette. "Itinéraire social d'une grande famille mulhousienne: Les Schlumberger de 1830 à 1930." Master's thesis, Université de Limoges, 1982.

Theis, Laurent. *François Guizot*. Paris: Fayard, 2008.

———, ed. *François Guizot: Lettres à sa fille Henriette*. Paris: Perrin, 2002.

Tomkins, Calvin. *Duchamp: A Biography*. New York: Henry Holt, 1996.

Tuchman, Barbara W. *The Proud Tower: A Portrait of the World Before the War, 1890–1914*. New York: Macmillan, 1962.

Tulard, Jean. *Napoléon et la noblesse d'Empire*. Paris: Tallandier, 2003.

Valensise, Marina. *François Guizot et la culture politique de son temps*. Paris: Seuil, 1991.

Van Bever, Ad. *Anthologie littéraire de L'Alsace et de la Lorraine*. Paris: Delagrave, 1920.

Van Dyke, Kristina, ed. *African Art from the Menil Collection*. New Haven, Conn.: Yale University Press, 2008.

Véron, Eugene. *Les institutions ouvrières de Mulhouse et des environs*. Paris: Hachette, 1866.

Vizetelly, Ernest Alfred. *The True Story of Alsace-Lorraine*. New York: Frederick A. Stokes, 1918.

Vue pittoresques du chemin de fer de Paris à Orléans. Paris: Abel Ledoux, n.d.

Wake, Jehanne. *Kleinwort Benson: The History of Two Families in Banking*. Oxford: Oxford University Press, 1997.

Weber, Eugen. *Action Française: Royalism and Reaction in Twentieth Century France*. Stanford, Calif.: Stanford University Press, 1962.

———. *The Hollow Years: France in the 1930s*. New York: W. W. Norton, 1994.

Weber, Max. *L'éthique protestante et l'esprit du capitalisme*. Paris: Flammarion, 2000.

Welch, Frank D. *Philip Johnson and Texas*. Austin: University of Texas Press, 2000.

Winningham, Geoff. *Friday Night in the Coliseum*. Houston, Tex.: Allison Press, 1971.

Witt, Henriette de. *Monsieur Guizot in Private Life, 1787–1874*. Translated by M. C. M. Simpson. Boston: Estes and Lauriat, 1882.

Yergin, Daniel. *The Prize: The Epic Quest for Oil, Money, and Power*. New York: Simon & Schuster, 1991.

NEWSPAPER, JOURNAL, MAGAZINE ARTICLES

"Booming Houston." *Life,* Oct. 21, 1946, 108–17.

Browning, Dominique. "What I Admire I Must Possess." *Texas Monthly,* April 1983, 141–203.

Christen-Lecuyer, Carole. "Les premières étudiantes de l'Université de Paris." *Travail, Genre et Société,* Oct. 2000, 35–50.

Colacello, Bob. "Remains of the Dia." *Vanity Fair,* Sept. 1996, 173–204.

Davidson, John. "Dominique de Menil: The Woman Who Encouraged Houston to Blaze New Artistic Trails." *House & Garden,* March 1983, 10–12.

"En Alsace: Château de Kolbsheim à M. et Mme. Grunelius." *Art et Industrie,* Nov. 1931, 2–8.

Feldman, Morton. "John de Menil 1904–1973." *Art in America,* Nov./Dec. 1973.

Fontaine, V. de. "Les différentes origines de la noblesse française." *Revue Catholique et Royaliste,* Dec. 1901.

Glueck, Grace. "The de Menil Family: The Medici of Modern Art." *New York Times Magazine,* May 18, 1986, 28–113.

Menil, Dominique de. "Impressions américaines en France." *L'Art Sacré,* March–April 1953.

"Nouvelles locales." *Journal de Guebwiller,* Jan. 20, 1867, 1.

Papademetriou, Peter C. "The Responsive Box." *Progressive Architecture,* May 1987, 87–97.

Pastier, John. "Simplicity of Form, Ingenuity in the Use of Daylight." *Architecture,* May 1987, 84–90.

Schlumberger, Dominique. "Courrier de Berlin." *La Revue du Cinéma,* March 1930, 60.

———. "Les divers procédés du film parlant." *La Revue du Cinéma,* April 1930, 43–52.

"Schlumberger: Une aventure industrielle." *Sabix: Bulletin de la Société des Amis de la Bibliothèque de l'Ecole Polytechnique,* Sept. 2003, 1–48.

Snell, David. "Rothko Chapel: The Painter's Final Testament." *Smithsonian,* Aug. 1971, 46–55.

Thibaudat, Jean-Pierre. "Alexandre Iolas: Le Grand." *Libération,* April 20, 1984, 27.

Tomkins, Calvin. "The Benefactor." *New Yorker,* June 8, 1998, 52–67.

Vilades, Pilar. "They Did It Their Way." *New York Times Magazine,* Oct. 10, 1999, 85–94.

ILLUSTRATION CREDITS

FRONTISPIECE

(top) F. Wilbur Seiders, courtesy of Menil Archives, The Menil Collection, Houston. (bottom) Henri Cartier-Bresson/Magnum Photos, *Untitled [John de Menil in living room at 3363 San Felipe on Charles James Chaise]*, 20 Apr. 1957, The Menil Collection, Houston, Gift of the artist.

IN TEXT

xiv–1: Courtesy of Menil Archives, The Menil Collection, Houston. 2: Adelaide de Menil, courtesy of Menil Archives, The Menil Collection, Houston. 10: Courtesy of Adelaide de Menil. 12: Adelaide de Menil, courtesy of Menil Archives, The Menil Collection, Houston. 14: Courtesy of Menil Archives, The Menil Collection, Houston. 15: Crossley and Pogue, courtesy of Menil Archives, The Menil Collection, Houston. 18, 19: Hickey-Robertson, courtesy Menil Archives, The Menil Collection, Houston. 30, 35: Courtesy of Anne Schlumberger. 38: Nadar, Bibliothèque nationale de France. 53, 56, 59, 60, 62, 63, 66: Courtesy of De Menil Family Papers, Menil Archives, The Menil Collection, Houston. 68: © Archives Pontigny-Cerisy. 74, 81, 86, 90, 101, 102, 105, 108, 123, 128, 141, 149, 150, 157, 159, 160: Courtesy of De Menil Family Papers, Menil Archives, The Menil Collection, Houston. 164: © Fonds Barbe, SIAF/Cité de l'architecture et du patrimoine/Archives d'architecture du XXe siècle. 166: Courtesy of De Menil Family Papers, Menil Archives, The Menil Collection, Houston. 167: Lucien Debretagne, © Fonds Barbe, SIAF/Cité de l'architecture et du patrimoine/Archives d'architecture du XXe siècle. 178, 189: Courtesy of De Menil Family Papers, Menil Archives, The Menil Collection, Houston. 202: Keystone-France/Gamma-Keystone/Getty Images. 206, 208, 232, 238, 244, 247, 262, 269, 275, 278, 279, 286, 298, 302: Courtesy of De Menil Family Papers, Menil Archives, The Menil Collection, Houston. 304: Courtesy Jean-Charles de Ravenel. 309: Photo by Time-Life Pictures Inc., Getty Images. 312: Photo by Steve Schapiro, © Corbis Images. 316: Cecil Beaton, courtesy of Menil Archives, The Menil Collection, Houston. 317: Courtesy of De Menil Family Papers, Menil Archives, The Menil Collection, Houston. 321: Courtesy François de Menil. 324: Rodney Marionneaux, courtesy of Menil Archives, The Menil Collection, Houston. 329: Courtesy of De Menil Family Papers, Menil Archives, The Menil Collection, Houston. 333: C. Laughlin, courtesy of Menil Archives, The Menil Collection, Houston. 339: Courtesy of Menil Archives, The Menil Collection, Houston. 346: Eve Arnold/Magnum Photos, *Philippa*, 1958, Houston, The Menil Collection, Houston. 349: Larry Gilbert, courtesy of Menil Archives, The Menil Collection, Houston. 355: Janet Woodward, The Menil Collection, Houston. 376: Courtesy of De Menil Family Papers, Menil Archives, The Menil Collection, Houston. 382: Hickey-Robertson, courtesy of Menil Archives, The Menil Collection, Houston. 384, 385: Marc Riboud/Magnum Photos, courtesy of Menil Archives, The Menil Collection, Houston. 386: Eve Arnold/Magnum Photos, courtesy of Menil Archives, The Menil Collection, Houston. 388: Maurice Miller, courtesy of Menil Archives, The Menil Collection, Houston. 390: Henri Cartier-Bresson/Magnum Photos, *Marcel & Teeny Duchamp in Lobby of Shamrock Hotel*, 1957, The Menil Collection, Houston. 392: Eve Arnold/Magnum Photos, courtesy of Menil Archives, The Menil Collection, Houston. 393: Maurice Miller, courtesy of Menil Archives, The Menil Collection, Houston. 397: Courtesy of Marion Wilcox. 401, 402: Paul Hester, © Hester + Hardway Photographers. 406: Courtesy of Menil Archives, The Menil Collection, Houston. 407, 408–409: Hickey and Robertson, courtesy The Museum of Fine Arts, Houston Archives. 411: Courtesy The Museum of Fine Arts, Houston Archives. 418 : Hickey-Robertson, courtesy of Menil Archives, The Menil Collection, Houston. 427, 453, 459, 461 (top): Courtesy of Menil. 461 (bottom): Hickey-Robertson, courtesy of Menil Archives, The Menil Collection, Houston. 462: Henri Pauman, cour-

tesy of Menil Archives, The Menil Collection, Houston. **470–471:** Courtesy of Menil Archives, The Menil Collection, Houston. **472:** Stuart Lynn, courtesy of Menil Archives, The Menil Collection, Houston. **480:** Alexander Liberman, courtesy of Menil Archives, The Menil Collection, Houston. **485:** Hickey-Robertson, courtesy of Menil Archives, The Menil Collection, Houston. **487:** Hickey-Robertson, courtesy Rothko Chapel Archives. **489:** Hickey-Robertson, courtesy of Menil Archives, The Menil Collection, Houston. **494, 495:** Courtesy of Menil Archives, The Menil Collection, Houston. **498, 499, 500:** Hickey-Robertson, courtesy Menil Archives, The Menil Collection, Houston. **511:** Courtesy of Menil Archives, The Menil Collection, Houston. **516:** Courtesy of De Menil Family Papers, Menil Archives, The Menil Collection, Houston. **530:** Hickey-Robertson, courtesy Menil Archives, The Menil Collection, Houston. **531:** Courtesy of Menil Archives, The Menil Collection, Houston. **541, 542:** Hickey-Robertson, courtesy Rothko Chapel Archives. **558:** Marc Riboud/Magnum Photos, courtesy of Menil Archives, The Menil Collection, Houston. **560:** Adelaide de Menil, courtesy of Menil Archives, The Menil Collection, Houston. **562:** Courtesy of Menil Archives, The Menil Collection, Houston. **578:** David Crossley, courtesy of Menil Archives, The Menil Collection, Houston. **585:** Adelaide de Menil, courtesy of Menil Archives, The Menil Collection, Houston. **590:** Hickey-Robertson, courtesy Rothko Chapel Archives. **595:** Courtesy of De Menil Family Papers, Menil Archives, The Menil Collection, Houston. **598, 611:** Courtesy of Menil Archives, The Menil Collection, Houston. **615:** Paul Warchol, courtesy of Menil Archives, The Menil Collection, Houston. **622–623:** Photo by Douglas Tuck, courtesy of the Chinati Foundation. Donald Judd Art © 2017 Judd Foundation / Artists Rights Society (ARS), New York. **632:** Hickey-Robertson, courtesy Menil Archives, The Menil Collection, Houston. **637:** Courtesy of De Menil Family Papers, Menil Archives, The Menil Collection, Houston. **639, 640:** Anthony Allison, courtesy Rothko Chapel Archives. **655:** Buster Dean/© *Houston Chronicle.* Used with permission.

INSERT ONE

1 (top): Courtesy Jean-Marie Grunelius. **1 (bottom):** Dominique Delaunay, © Fonds Barbe. SIAF/ Cité de l'architecture et du patrimoine/Archives d'architecture du XXe siècle. **2:** Photo Guillaume de Laubier. **3 (top):** The Menil Collection, Houston, © 2017 Artists Rights Society (ARS), New York. Photo Paul Hester, The Menil Collection, Houston. **3 (bottom), 4 (top):** The Menil Collection, Houston. **4 (bottom):** The Menil Collection, Houston, © 2017 Succession H. Matisse / Artists Rights Society (ARS), New York, Photo Paul Hester, The Menil Collection, Houston. **5:** © 2017 Artists Rights Society (ARS), New York. **6 (top):** Photo Michael Stravato. **6 (bottom):** Courtesy of Menil Archives, The Menil Collection, Houston. **7:** © 2017 Artists Rights Society (ARS), New York. **8 (top):** Courtesy of Menil Archives, The Menil Collection, Houston. **8 (bottom):** Balthazar Korab, courtesy of Menil Archives, The Menil Collection, Houston. **9:** Courtesy of Menil Archives, The Menil Collection, Houston. **10 (top):** The Menil Collection, Houston. **10 (middle):** The Menil Collection, Houston, © 2017 Artists Rights Society (ARS), New York. **10 (bottom):** The Menil Collection, Houston. **11, 12, 13, 14, 15 (top):** The Menil Collection, Houston, © 2017 Artists Rights Society (ARS), New York. **15 (middle and bottom):** The Menil Collection, Houston. **16:** The Menil Collection, Houston, © 2017 Artists Rights Society (ARS), New York.

INSERT TWO

1 (top): The Menil Collection, Houston, © 2017 The Barnett Newman Foundation, New York / Artists Rights Society (ARS), New York, photo Hickey-Robertson. **1 (bottom):** The Rothko Chapel, © 2017 Artists Rights Society (ARS), New York, photo Hickey-Robertson. **2:** The Menil Collection, Houston, © 2017 Artists Rights Society (ARS), New York. **3:** The Menil Collection, Houston, © Jasper Johns/Licensed by VAGA, New York, NY. **4:** The Menil Collection, Houston, © 2017 Artists Rights Society (ARS), New York. **5 (top):** The Menil Collection, Houston, © Robert Rauschenberg Foundation. **5 (middle and bottom), 6, 7 (top):** The Menil Collection, Houston. **7 (bottom):** The Menil Collection, Houston, © 2017 Artists Rights Society (ARS), New York. **8:** The Menil Collection, Houston, © Jasper Johns/Licensed by VAGA, New York, NY. **9 (top):** The Menil Collection, Houston, © Robert Rauschenberg Foundation. **9 (bottom):** The Menil Collection, Houston, © Estate of James Rosenquist/Licensed by VAGA, New York, NY. **10 (top):** Paul Hester, courtesy Menil Archives, The Menil Collection, Houston. **10 (bottom):** Paul Hester, © Hes-

ter + Hardway Photographers. **11:** Hickey-Robertson, courtesy Menil Archives, The Menil Collection, Houston. **12:** Paul Hester, courtesy Menil Archives, The Menil Collection, Houston. **13:** Hickey-Robertson, courtesy Menil Archives, The Menil Collection, Houston. **14 (top):** Courtesy of Menil Archives, The Menil Collection, Houston. **14 (bottom):** The Menil Collection, Houston, Artworks © Cy Twombly Foundation, Rome. **15:** Paul Warchol, courtesy of Menil Archives, The Menil Collection, Houston. **16:** Hickey-Robertson, courtesy Menil Archives, The Menil Collection, Houston.

INDEX

Page numbers in *italics* refer to illustrations.

About Rothko (Ashton), 477–8
Abstract Expressionism (2016 exhibition), 491
abstract expressionists, 372, 373–4
Académie Française, 37, 40, 45, 107
Action Française, 113–15, 174
Adler, Gail, 497
African art, 19, *19*, 347–8, 363, 372–3, 384, 394, 398–9, *402*, 431, 434, 445, 496, *500*, 521, 545, 557, 559, 560, 580, 585
African National Congress (ANC), 594, 597, 599
Aillagon, Jean-Jacques, 656
Alain-Fournier, 65, 102, 233
Albaric, Michel, 656
Albee, Edward, 648
Alberigo, Giuseppe, 634
Albers, Josef, 24, 525, 526
Alexandre Iolas Gallery, 410, *411*, 429, 514
Allen, Earl, 501
Alpe d'Huez, 238–9, *238*
Alsace, 9–10, 47, 48–9, 50, 51, 54, 56, 57, 58, 59, 64, 69, 78, 82, 137, 162, *164*, 572
American Association of Art Museum Directors, 449
American Federation of Arts, 398
American Federation of Arts Convention (1957), 348, 390–1, *390*
Amis de *Sept*, 177
Anderson, Marian, 431, 593
Andy Warhol: Death and Disasters (1988–89 exhibition), 634–5
Andy Warhol Foundation for the Visual Arts, 430, 629
Andy Warhol Museum, 430, 629, 638
Anfam, David, 480, 484, 491–2
Angelini, Surpik, 266
Angelou, Maya, 434
Angot, Pierre, 197
Annonce faite à Marie, L' (Claudel), 216
Antonioni, Michelangelo, 352, 453, 523
Apollinaire, Guillaume, 65, 343
Arafat, Yasser, 638, 639, *639*, 640–1
Aragon, Louis, 65

Archbishop Makarios III Foundation Museum and Gallery, 616
Architecture, 633
Architecture d'Aujourd'hui, L' (1932 exhibition), 166
"Architecture of the Incredible, The" (Kahn talk), 531
Architecture of the Well-Tempered Environment, The (Banham), 575
Architecture Without Architects (1964 exhibition), 403
Archives Littéraires de l'Europe, Les, 39
Arden, Elizabeth, 305, 306, 315–16
Arensberg, Louise and Walter, 547
Argentina, 264–5, 272
Armies of the Night, The (Mailer), 354
Armory Show (1913), 545
Armstrong, Louis, 431
Arnheim, Rudolf, 391
Arnold, Eve, *346*, 430, 656
Arns, Paulo Evaristo, 592, 656
Arp, Jean, 170, 268, 332
Art Barn, Rice University, 459–60, *459, 461, 462–3, 462, 463–4*, 469, 484, 493, 497, 513, 556, 574
Art Car Parade, 572–3
Art in America, 21, 519
Art Institute of Chicago, 450, 528, 635
Art Investments, 496, 514
Artists Documentation Program (ADP), 636
Art Museums of Louis I. Kahn, The (Loud), 532
ARTnews, 395, 530
Art Nouveau, 529
Art Nouveau: Belgium/France (1976 exhibition), 528–9
Art Sacré, L', 187–8, 216, 252, 343, 345, 417
Arts Magazine, 460, 492
Ashton, Dore, 477–8, 479–80, 484
Assemblée Nationale (French Parliament), 41, 43
Assy, France, 344, 488
Atelier of Sacred Art, 187

Aubry, Eugene, 416, 459, 479, 483–4, 485
Auchincloss, Douglas, 403, 429
Auchincloss, Lily, 403, 429
Auletta, Ken, 180
Aurelius, Marcus, 631
Aurenche, Marie-Berthe, 169, 349
Auschwitz concentration camp, 482
Australia, 120, 123, 399
Austria, 97, 198, 199, 482
Avery, Sally and Nathan, 24
Avignon Festival, 377

Bâ, Amadou Hampâté, 503–4
Baalbek ruins, 502
Babitz, Eve, 547
Babouin, Guy, 377
Bacon, Francis, 19, 419
Badner, Mino, 434
Baga tribe, 347, 394
Baird, Euan, 583, 584
Baker, Josephine, 119
Bakongo peoples, 394
Balenciaga, Cristóbal, 315, 359, 425
Ballet de Cuevas, 310
Bal Nègre, 118
Balogun, Ola, 504–5
Balzac, Honoré de, 34, 103
Bambara people, 417
Banham, Reyner, 575
Bannard, Darby, 500
Banque de l'Union Parisienne (BUP), 116–17,
 118, 123–4, 125, 127, 151, 155, 172–3
Banque Nationale pour le Commerce et
 l'Industrie (BNCI), 173, 188, 191, 229
Barbe, Pierre, 162, 163–9, 164, 166, 167–9, 167,
 171, 238, 238, 239, 243, 383, 427, 549, 568,
 572
Barbier-Mueller, Jean-Paul, 569–70
Barbier-Mueller, Monique, 569–70
Bargeton, Anne, 133, 139, 141, 143, 148, 149,
 149, 151
Barker, Tom, 552, 576
Barnes, Albert C., 252–3, 301, 315, 405
Barnes, Charles, 299
Barnes, Edward Larrabee, 533, 534
Barnes, Essie, 296, 320
Barnes, Marguerite Johnston, 299, 329–30,
 332, 351, 424, 561
Barnes, Susan J., 424, 643–5, 646
Barnstone, Gertrude, 353, 354, 370, 389, 414,
 452
Barnstone, Howard, 24, 163, 353, 359, 363,
 378, 380, 381, 392, 399, 401, 416, 427, 427,
 428, 452, 453, 455, 459, 459, 478, 491, 512,
 532, 533, 546, 575

Barnstone & Aubry, 479, 484
Barr, Alfred, 267, 302, 313, 315, 350, 369–70,
 373, 400–1, 405, 486
Barragán, Luis, 548
Bass, Sid, 14
Baudelaire, Charles, 7
Baudrillart, Alfred, 107
Bayou Bend (Hogg residence and museum),
 28, 390
Bazaine, Jean René, 250
Beaton, Cecil, 171, 316
Beaubourg Foundation, see Georges Pompidou
 Art and Culture Foundation
Beauchamp, Toni, 412
Beauvoir, Simone de, 226
Beaux Arts, 564
Beggs, Thomas M., 432
Beirut, 231, 501, 502, 506, 512, 540
Beistegui, Charles de, 582
Belafonte, Harry, 438, 439
Belter, John Henry, 337
Bérard, Christian "Bébé," 165, 167, 171, 224,
 282, 300, 301, 314, 350, 384, 403, 419
Bergman, Ingmar, 453
Bergman, Ingrid, 360
Berlin, 145–6, 197, 225, 227, 231, 308
Berlin, Brigid, 454
Berman, Wallace, 307
Bernier, Rosamond, 359, 383, 403, 496, 513,
 562, 563, 567
Bern Kunsthalle, 571
Bess, Forrest, 350
Best, Evelyn, 190, 243, 244–5, 246, 248, 251,
 264, 273, 300, 320
Bethmann-Hollweg, Felix von, 197
Betty Parsons Gallery, 25, 559
Beuys, Joseph, 463, 618
Beyeler, Ernst, 571, 656
Beyeler Foundation, 586
Beyeler Gallery, 571
Bibliothèque du Saulchoir, 634, 656
Bibliothèque Nationale de France, 432, 450,
 451, 602, 604
Bilbao, 243, 244, 244
Bismarck, Clara, Countess, 142
Bismarck, Otto von, 54, 142
Black Arts Festival, 434
Black Arts Gallery, 500, 501
Black Panthers, 467
Blaffer, Camilla, 352, 354
Blaffer, John, 353, 412–13
Blaffer, Robert Lee, 27
Bloch, Marc, 225
Blonville-sur-Mer, 73, 130, 207, 209
Blue Angel, The (film), 146–7, 351
Boissonnas, Catherine, 226

Boissonnas, Eric, 8, 168, 192, 212, 213, 221, 231, 235, 534, 539, 584, 638, 650
Boissonnas, Sylvie Schlumberger, 7, 8, 33, 69–71, 72, 73, 77, 79, 81, *81, 86,* 129–30, 136, 138, 139, 143, 144, 148, 151, 152–3, 155, 156, 158, 161, 168, 192, 209, 210, 218, 219, 221, 226, 228, 229, 237, 239–40, 241, 242, 534, 539, 550, 563, 584, 585, 606, 638–9, 650
Bonnard, Pierre, 301, 344, 529, 570
Bonnet, Henri, 377
Boone, Mary, 13
Bothmer, Bernard, 472
Bouguereau, William-Adolphe, 24
Boulanger, Nadia, 361
Boulez, Pierre, 16
Boullée, Étienne-Louis, 450
Bourgeois, Louise, 419, 630
Bozo, Dominique, 556, 567
Bra, Théophile, 651
Bradley, Eric, 605
Bradley, Peter, 493, 498, 500
Braffy (the Val-Richer manor house), 68, 80, 473
Brancusi, Constantin, 391, 394, 587
Braque, Georges, 3, 8, 12, *18,* 20, 25, 253, 267, 300, 301, 313, 314, 317, 342, 344, 350, 364, 367, 371, 400, 403, 449, 571, 572, 648, 650
Braque: The Late Works (1997 exhibition), 648
Brauner, Victor, 300, 307, 312, 345, 350, 364, 370, 372, 373, 376, 384, 419
Brausen, Erica, 6
Brays Bayou, 195, 414
Brecht, Bertolt, 131
Breitbach, Joseph, 377
Breton, André, 7, 127, 170, 474
Breuer, Marcel, 8, 533
Breughel, Pieter, the Elder, 226
Breyer, Stephen, 628
British Columbia, University of, Museum of Anthropology at, 604
Broglie, Gabriel de, 38
Broglie, Victor de, 45
Broken Obelisk (Newman), 435–6, 484, 488, *489,* 505, 543, 590, *590*
Brooklyn Academy of Music, 511
Brooklyn Museum, 318, 472
Brooks's (gentlemen's club), 424–5
Brook with Aloes (Matisse), 315, 403
Brown, Alice, 14, 415, 475, 481, 514, 526, 536
Brown, Cecily, 648
Brown, George, 14, 415, 514, 536
Brown, Herman, 23, 415
Brown, J. Carter, 13, 22, 510, 644

Brown and Root, 23, 415
Brownell, Herbert, Jr., 610, 628
Brown Foundation, 14, 576
B'Tselem, 595–6
Bucharest, 196, 202–3, 205, 206, *206,* 207, 209, 211, 212, 214, 215, 216, 217, 221, 228, 231, 268
Buchenwald, 197
Buckley School, 399, 649
Buddhists, Buddhism, 120, 507, 508, 524, 525, 541, 656
Buenos Aires, 264, 266
Buffalo Bayou, 24, 26–7, 28, 255, 323
Bugner, Ladislas, 383, 431–3, 464, 521
Bugner, Monique, 433
Builders, The (Léger), 344
Builders and Humanists: The Renaissance Popes as Patrons of the Arts (1996 exhibition), 419
Bulgari, Nicola, 531
Bunshaft, Gordon, 343, 403
Buñuel, Luis, 147
Burden, Amanda and Carter, 429
Bush, Barbara, 616
Bush, George H. W., 616
Byzantine art and artifacts, 19, 20, 580, 586, 601–17, 648
Byzantine Fresco Chapel, 610, 613–16, *615,* 616, 636, 644, 650
Byzantium, 601–2, 603–17

Café de Flore, Paris, 425, 432
Cage, John, 428, 429, 457, 638
Cahiers d'Art, 377
Cahun, Claude, 170
Caillot, Monsignor, 239
Calder, Alexander, 3, 18, 268, 348–9, 350, 409–10, 411, 420, 497, *560,* 585
California, University of, at Berkeley, University Art Museum at, 444–5
California Palace of the Legion of Honor, 386, 546
Callery, Mary, 328, 329
Calvinism, 62
Câmara, Dom Hélder, 540, 588–9
Cambacérès, Prince-Arch-Chancellor, 95
Cambridge, University of, 143–4, 405
Camelots du Roi, 113, 114–15
Camfield, Bill, 363, 404, 521
Camfield, Ginny, 363, 404
Camouflage Last Supper (Warhol), 635
Camus, Albert, 67
Cannon, Sarah, 417, 420–1, 520
Chambrier, Henri de, 257, 258–9, 271
Capa, Cornell, 523

Capricorn (Ernst), 312, 510
Caracas, 256, 257, 262, 263, 264, 266, 267–70,
 269, 271, 272, 274, *275*, 277–8, *278*, 280,
 281, 283, 284, 318, 330
Caravaggio, 631
Cardiff, Janet, 616
Carnegie Institute of Art, 533, 629
Caro, Anthony, 500
Carpenter, Edmund, 466, 486, 515, 580, 648,
 652
Carpenter, Louise Adelaide de Menil, *see* de
 Menil, Louise Adelaide
Carr, Annemarie Weyl, 605, 610, 613
Carrington, Leonora, 391
Carter, Jimmy, 588, 599, 600, 638, *639,* 641
 Dominique and, 591–6, *595,* 597–8, 641–2
Carter, Patricia, 353–4
Carter, Rosalynn, 591, 592, 638
Carter Center, 591, 592–3, 594, 595, 641
Carter-Menil Human Rights Foundation, 641
Carter-Menil Human Rights Prize, 593, 594,
 595, *595,* 598, *598,* 599, 638, *639,* 640,
 641–2, 647
Cartier-Bresson, Henri, 348, 455, 523, 656
Case Study Houses, 16
Cassidy, Kevin, 357, 456, 510
Castelli, Leo, 428, 429, 472, 511, *511,* 530, 574
Castro-Cid, Enrique, 466
Catholics, Catholicism, 39, 45, 90, 91, 103,
 113–14, 132, 151, 153–6, 158, 173, 174,
 175–7, 186–8, 240, 250, 253, 265, 320, 356,
 357, 380, 414, 420, 439, 476, 484, 512, 522,
 588, 596
*Caucasian Woman Sprawled on a Bed and
 Eight Figures of Hanged Men on Four
 Rectangular Boxes* (Rivers), 493–4
Cavafy, Constantine, 308
Caves du Vatican, Les (Gide), 68
Central America, University of, San Salvador,
 599
Central Intelligence Agency (CIA), 506
Centre Pompidou, *see* Pompidou Center
Cercle d'Études Jacques et Raïssa Maritain,
 174
Cézanne, Paul, 3, 19, 253, 267, 285–6, 403,
 469, 564, 570, 571, 587
Chaban-Delmas, Micheline and Jacques, 568
Chagall, Marc, 572
Chamberlain, John, *2,* 13, 18, 561, 565, 618,
 622, 625, 629, 630, 635
 Menil exhibition of, 20
Chamberlain, Neville, 198, 199, 200, 219
Chamonix, 133–4, 148, *149,* 652
Champs-Élysées Theatre, 118–19
Chareau, Pierre, 165
Chasseurs Alpins, 106, 108

Chateaubriand, François-René de, 39, 134, 209
Chigot, Paul-Louis, 119
Children's Storefront, 590
Chillida, Eduardo, 347, 364, 406–7, 411
Chinoise, La (film), 454
Christian Dior, 449
Christians, Christianity, 175, 176, 200, 298–9,
 320, 364, 504, 568, 602, 610, 656
Christie's, 400, 416
Christo and Jeanne-Claude, 656
Christopher, Warren, 593
Chrysostomos, Archbishop, 616
Chrysostomos II, Archbishop, 616
Churchill, Winston, 88, 199, 219–20, 223
Church of Cyprus, 611, 613, 616
Church of St.-Sulpice (Paris), 186
Cinémathèque Française, 451, 523
Claudel, Paul, 66, 67, 118, 187, 196, 216, 233,
 277
Clements, William, 15
Cleveland Museum of Art, 386, 533
Clinton, Bill, 638
Cocteau, Jean, 70, 119, 168, 171, 179, 301, 305,
 309, 651
Colacello, Bob, 430–1
Collection de l'Art Brut, 570
Collège Stanislas, 91, 100
Columbia University, 402, 452, 540
Communist Manifesto, The (Marx), 36
Compagnie du Chemin de Fer de Paris à
 Orléans, 99–100
Compañía Transatlántica Española, 243
*Composition with Yellow, Blue, and Blue-
 White* (Mondrian), 312, 396
Congar, Yves Marie-Joseph, 6–7, 175, 177, 488,
 509, 515, 524
Congo, 18, 19, 142
Connaissance des Arts, 564
Conner, Bobby Joe, 438
Conrad, A. C., 522
*Constant Companions: An Exhibition of
 Mythological Animals, Demons and
 Monsters, Phantasmal Creatures, and
 Various Anatomical Assemblages* (1965
 exhibition), 418–19, 420
Contemporary Arts Association (CAA), 391,
 396, 397
 de Menils and, 367–70, 387, 388, 389
 MacAgy's report for, 387
Contemporary Arts Museum, Houston, 348,
 388–9, 569
 de Menils' Van Gogh exhibition at, 367–70
 MacAgy as first director of, *386,* 388–9, *388,*
 390–1, 392–5, 396
Contemporary Black Artists in America (1971
 exhibition), 498

Conversations with the Dead: An Exhibition of Photographs of Prison Life by Danny Lyon, with Letters and Drawings by Billy McCune #122054 (1970 exhibition), 474
Cooke, Terence Cardinal, 444
Cooper, Douglas, 9, 351, 400, 451
Cooper, Paula, 13, 638, 639, 640–1
Copeau, Agnès, 216
Copeau, Jacques, 67, 102, 187, 216
Copley, William, 307, 314, 403, 419, 580
Corcoran, James, 574
Corcoran Gallery of Art, Washington, D.C., 435, 547, 635
Corneille, Pierre, 46
Cornell, Joseph, 20, 307, 348, 372, 386–7, 530, 547, 563, 565, 574, 651
Cornered Fluorescent Light from Dan Flavin (1972 exhibition), 510, *511*
Coste, Catherine, 70
Coty, François, 581
Couronne, La (Klein), 555
Couturier, Marie-Alain, 249–53, 273, 277, 286, 289, *302,* 305, 313–14, 323, 327, 334, 342–3, 345, 371, 417, 488, 552, 572, 629, 643, 648
 background of, 186–7
 collecting great art seen as moral obligation by, 303
 de Menils and, 185–6, 187–8, 240–1, 249–50, 251–3, 255, 263–4, 286, 300, 319, 344, 488, 634, 648
 French Resistance and, 250–1
 Laugier's friendship with, 250
 modern art as passion of, 185, 250, 252
 in postwar return to France, 301–2
Cowles, Fleur, 335
Cozens, Elsian, 362–3, 364, 535, 548, *558, 568,* 608, 613, 628, 637
Crevel, René, 170
Cuevas, Baron de, 305
Cuevas, Elizabeth de, 451
Cuevas, Marquis de, 251, 309
Cuevas, Sylvia de, 648
Cullen, Hugh Roy, 23, 29
Cullen, Mary, 23–4
Cullen, Roy, 23–4, 25
Cullen Foundation, 14, 576
Cullinan, Joseph, 392
Cullinan, Nina, 392, 405, 536
Cullinan Hall, Houston Museum of Fine Arts, 328, 378, 392, *392, 393,* 405, *406,* 407, 410
Cunningham, Merce, 428, 429, 430, 519
Cup Lined with Fur [Object] (Oppenheim), 571
Curie, Marie, 83–4

Curie, Pierre, 83–4
Cycladic art, 416, 545, 564
Cyprus, 607, 610–11, 616
Cy Twombly (1989–90 exhibition), 630
Cy Twombly: A Retrospective (1995 exhibition), 633
Cy Twombly Gallery, 631–3, *632*
Czechoslovakia, 198, 208, 246, 482, 594
 Nazi invasion of, 200, 201

Daladier, Édouard, 199, 297, *298*
Daladier, Jean, 297–9, *298,* 446, 652
Dalai Lama, 506–8, 540–1, *541*
Dalí, Salvador, 267, 315
Dallas Museum of Art, 643
Dallas Museum of Fine Arts, 391
Dallesandro, Joe, 351, 456
Dalton, Karen, 433
D'Annunzio, Gabriele, 304
Dautry, Raoul, 178
Davezac, Bertrand, 12, 402–3, 559–60, 568, 580, 605, 606–9, 610, 613, 644, 645, 647, 648, 650
David, Jacques-Louis, 139
David's Madame Récamier (Magritte), 312, *529, 530*
Davidson, Kathy, 363, 397–8, 417, 418, 419, 420, 535
David-Weill, Michel, 567, 584
Davis, Stuart, 390, *390*
Davis Polk, 583, 627
de Brunhoff, Jean, 70
Debuyst, Frédéric, 479
Décades de Pontigny, 67, 68, *68*
de Chirico, Giorgio, 307, 309, 312, 314, 345, 350, 367, 372, *402,* 521, 653
Decisive Moment, The (Cartier-Bresson), 455
Decline and Fall of the Roman Empire (Gibbon), 27, 39
Deep, The (Pollock), 8, 539
Degas, Edgar, 27, 102, 388
de Gaulle, Charles, 229, 231, 233, 250–1, 277, 280, 283, 299, 537
de Kooning, Willem, 23, 24, 376, 561, 580, 593, 635
Delacroix, Eugène, 24, 186, 457
Delpech, Claire, 61
Delpech, Édouard, 59–60, *60,* 137
Delpech, Henriette Oberkampf, 59, *60,* 61, 152, 155, 229, 245, 246, 272–3, 278, 287
Delpech, Jacques, 61, 134
Delpech family, 60, 61
De Luxe Show, The (1997 exhibition), *499,* 500, 501
De Luxe Theater, 498–500

De Maria, Walter, 529, 561, 618, 619–20, 621, 623, 624, 628, 629
de Menil, Benjamin, 14
de Menil, Dominique, *128, 150, 208, 376, 453, 489, 541, 558, 562, 598, 637, 639*
 absences from children as source of guilt for, 296
 adjusting to life in Houston as difficult for, 294–5
 on art and artists, v, 4, 366, 554, 618
 as autodidact, 6–7
 on *Broken Obelisk,* 489
 in Bucharest, 205, *206,* 212, 214, 215, 216
 Carter and, 591–6, *595,* 597–8, 641–2
 in Chamonix, 133–4, 148
 Charles James clothes worn by, 316, 317–19, *317, 329, 335, 339, 349,* 425, 452, 561, 563–4
 on children and art, 75–6
 in Clairac, 230–1, 233, 236–7
 on collecting, 303, 327, 374
 in conversion to Catholicism, 173–5
 Cy Twombly Gallery and, 631–3, *632*
 death of, 652
 determination of, 5, 6
 Dia and, 624, 626–30
 European trips of, 464, 467–8, 473–4, 523, 576–3
 in evacuation to Clairac, 226–30
 exhibitions curated by, 5, 361, 363, 414–16, 418–19, 434, 450–1, 456, 457–8, 463, 474, 493, 495, 497–8, 510, 520–1, 525–6, 528–31, 546, 548, 555–6, 648
 on family traditions, 58, 89
 and father's electrical surveying, 84, 85, *86*
 father's relationship with, 135–7
 film as interest of, 144–7
 French Protestant background of, 9–10
 frugality of, 13
 funeral of, 653–5, *655*
 honors and awards of, 636–7
 human history as interest of, 28
 as human rights activist, 588–600
 humility of, 365
 humor of, 8
 on icons, 601
 on *Image of the Black* project, 431, 433–4
 Jean Schlumberger's relationship with, 69
 on John's 1924 world cruise, 125–6
 on John's aversion to mediocrity, 115
 John's Catholicism as issue for, 153–6
 on John's passion for art, 537
 La France boutique organized by, 277–8, *278*
 at La Pros, 128–9, 147
 L'Art Sacré articles by, 187–8

 last years of, 634–52
 Lyon trip of, 242
 Lysi frescoes and, 606–17
 Marseille trip of, 241–2
 memorial services for, 656
 and Menil Collection inauguration, *2,* 3–4, 13–16, *15,* 22–3, 25–6
 and Menil Foundation financial crisis, 643–7
 miscarriage of, 281
 on MOCA Los Angeles board, 564–5
 Mouseky and Frisky drawings of, 274, *275*
 in move to Houston, 243–8, *244*
 on museum architecture, 532
 in 1937 visit to London, 190
 in 1940 return to France, 216
 in 1944 return to Houston, 282
 Paris trips of, 449, 514, 523–4, 549, 582–3
 personal archives of, 649–50, 657
 philosophical interests of, 129
 Piano's relationship with, 9
 in planning of Menil Collection, 17, 18, 20–2, 363–5, 532–6, 545–53, 574–80, 585–6, *585*
 Pompidou Center and, 8, 538–9, 566
 Pontpoint renovation overseen by, 383
 pregnancies of, 175, 215, 218, 235, 281, 285
 in pre-war trips to Germany, 146, 197
 as Protestant, 132, 153–6, 303
 on revolutionary art, 457
 Rhyme and Reason exhibition and, 554–5, 557–64, *558, 560, 562*
 as Rice Institute for the Arts director, 457, 474, 493, 510, 520–1, 528–9
 on Rothko Chapel, 475, 481, 486–7, 490–1, 492
 as St. Thomas art department head, 414–21, 445, 450–1, 456
 at Schlumberger Trinidad headquarters, *262*
 small talk abhorred by, 5
 in solo trips to New York, 291–2, 303, 305–7
 as teacher, 416–17
 Trinidad monstrance designed by, 261, 276–7
 in trip to Romania, 196–7
 in wartime evacuation to Clairac, 222–4
 in wartime retreat to Val-Richer, 209–10, 217–18, 219–21
 World War I and, 80–1
de Menil, Dominique, childhood and adolescence of, 33, 63–4, *63*
 birth of, 62
 collecting as early passion of, 75, 76–7
 as daydreamer, 138
 education of, 69–71, 139–40, 143–4

father's tutoring of, 70
interest in art of, 139
in trips to England, 139, 143
at the Val-Richer, 71–4, *74*, 76–7, 78
World War I and, 79–80
de Menil, Emilie Riou-Kerhallet, 98
de Menil, François, 5, 7, 285, *286*, 289, 291,
 296, *321*, 322, 341–2, 399–400, 424, 446,
 451, 466, 486, 513, 520, 521, 522, 533, 534,
 546, 548, 563, 574, 580, 608, 613–14, 627,
 642–3, 645, 654
de Menil, Georges François Conrad, 7, 15–16,
 29, 241, 243, 244, *244*, 246, 247, 248, 256,
 263, 273, 274, 282, 285, 291, 296, 399,
 402–3, 466, 473, 486, 512, 514, 522, 527,
 534, 563, 578, 583, 584, 626, 627, 654
de Menil, Jean-Charles "Jason," 473, 486, 514,
 653
de Menil, John, *10, 128, 178, 286, 453*
 as Anglophile, 190
 aversion to mediocrity of, 115, 122, 433
 at BNCI, 188, 191
 in Bucharest, 205, 206, *206*, 207
 at BUP, 116–17, 118, 123–4, 125, 127, 172–3
 as Catholic, 114, 126, 132, 151, 153–6
 as chairman of Schlumberger executive
 committee, 375, 379–80
 in Chamonix, 134, 148, *149*
 on collecting, 374–5
 on contemporary art, 422
 convalescence of, 291–3
 Croix de Guerre of, 214
 culture of American West promoted by,
 11–12, 29
 death of, 515, 519
 De Luxe Show and, 498–500, 501
 as Deuxième Bureau agent in Romania, 209,
 212–14, 222
 and Dominique's concern about religious
 differences, 153–6
 on Dominique's desire for career, 145
 effect of brothers' deaths on, 111
 expanding cultural interests of, 125, 126
 and fall of France, 222
 as fascinated by Africa, 123
 as fourth baron de Menil, 124–5
 funeral of, *516*, 521–3
 German culture as enthusiasm of, 200
 heart attack of, 290–1
 incorporation of Schlumberger arranged by,
 275–6
 La Pros joined by, 192–4
 modernism's influence on, 118–19
 on MoMA International board, 379
 as MoMA trustee, 398
 Montreal trip of, 240

Moroccan military service of, 122–3, *123*,
 125
 in move to BNCP, 173
 in move to Houston, 239
 as Museum of Primitive Art trustee, 398
 New York trips of, 236, 240
 in 1924 world cruise, 119–22, *123*, 125, 126
 in 1937 London sojourn, 188, 189–91
 in 1940 relocation to U.S., 233, 235–6
 in 1945 trip to France, 287–8
 as opinionated, 11
 in planning of his funeral, 512–13
 prostate cancer of, 447–8, 509–10, 513–14,
 619, 620
 retirement of, 463, 527
 in Romania, 196, 215, 216–17, 222, 231
 rumored affair of, 445–7
 as Schlumberger Overseas president, 249,
 294
 as Schlumberger Surenco president, 249,
 256, 257–63, 270–3, 283–4, 294
 self-confidence of, 12–13
 sense of style of, 10
 in Turkey, 231–3, *232*, 234
 in Venezuela, 283–4
de Menil, John, childhood and adolescence of,
 102, 105
 birth of, 101
 as Camelots du Roi member, 114
 education of, 45, 91, 116–18
 and family's financial difficulties, 105–6
 in Vaugirard, 89–92, *90*
 World War I and, 89–90, 111–12
de Menil, John (grandson), 653–4
de Menil, John and Dominique
 in absences from children, 273–4, 295–7,
 321
 anti-Nazism of, 200–1, 205–6
 Argentinian trip of, 264–5
 Barbe and, 163–9
 in Brazil, 266
 in break with St. Thomas, 457–8
 Chevy Chase (Houston) home of, 282,
 284–5, 299, 320, 330
 civil rights activism of, 11, 434, 435–6, 439,
 440–3, 489–90, 493–5
 Colorado trip of, 289–90
 Contemporary Arts Association and,
 367–70, 387, 388, 389
 courtship of, 129, 130–4, 148–56
 Couturier and, 185–6, 187–8, 240–1,
 249–50, 251–3, 255, 263–4, 286, 301, 319,
 344, 488, 634, 648
 Cunningham fund-raiser organized by,
 428–9
 diverse relationships as important to, 306

de Menil, John and Dominique *(continued)*
 East Seventy-Third townhouse of, 25, 163,
 399–404, *402*, 424, 428–9, 451–2, 511,
 523, 527–8, 593, 621, 649
 engineers housing built by, 260, 271–2
 European trips of, 424–5, 450, 467, 495–6,
 510
 "Exploration Logs" of, 501, 502, 505–9
 film as mutual interest of, 451
 first meeting of, 127, 129
 Free French supported by, 277, 282–3
 French country house of, 163, 168
 generosity of, 358, 360, 374, 379–80,
 399–402, 438, 520, 620, 647
 Gladys Simmons and, 321–2
 Havana reunion of, 246
 honeymoon of, 158–61, *159*, *160*
 Image of the Black project of, 431–4
 inevitability of war with Germany accepted
 by, 200–1
 Inwood Drive (Houston) home of, 263
 liberalism of, 443–5
 modernist architecture and, 268, 328
 in move to Houston, 254
 Nazi threat downplayed by, 197–201
 New York apartments of, 303, 305, 317, 319,
 378
 New York trips of, 251–2, 253–4, 263, 282,
 289–90, 463, 510
 1971–1972 world trip of, 501–9
 Notre-Dame des Neiges chapel
 commissioned by, 238–9
 Paris apartment of, 25, 163–8, *166*, *167*, 179,
 206, 234, 302, 376–7, 425, 514, 527, 549,
 561, 602, 606, 634
 as partnership, 295–6
 Philadelphia trip of, 252–3
 Pontpoint manor house of, 383–5, 432, 449,
 523, 527
 in Romania, 295
 Rothko Chapel and, *see* Rothko Chapel
 St. Thomas University and, 380–1, *382*, 383,
 451–6, 482, 483
 Sans Souci (Caracas) house of, 269–70, *269*,
 279, 284
 in Trinidad, 256, 266
 in Venezuela, 256–63, 266–73, 291, 295
 wealth of, 7–8
 wedding of, 157–8, *157*
de Menil, John and Dominique, as collectors,
 299
 abstract expressionists, 373–4
 acquisitions after John's death, 580–2
 African art, 347, 363, 364, 373, 398–9, 434,
 496, *500*, 545, 557, 560, 580
 antiquities, 346–7, 496, 545, 557

 artists' lives as important to, 370–2, 428,
 465, 582
 Braque's meeting with, 371
 Byzantine and medieval art and artifacts,
 20, 171, 218, 580, 601–17, 648
 Couturier as mentor to, 249–50, 251–2, 255,
 263–4, 286, 300–3, 314, 648
 Cubists, 444
 detailed records kept by, 339, 362
 donations to other museums by, 8
 early acquisitions of, 169–71
 East Side townhouse as showcase for, 400–1
 Ernst and, 20, 169–70, 265, 268, 300, 302,
 311–12, 314, 347, 349, *349*, 373, 377, 403,
 422, 474, 495–6, 513
 Ernst *catalogue raisonné* funded by, 422–3
 Houston house as showcase for, 345–8, *355*,
 355, *356*, 364, 366
 indigenous American art, 398–9, 557, 580
 Iolas as mentor to, 307, 311–15, 373, 376,
 377, 401–2
 Klejman and, 372–3
 Magritte *catalogue raisonné* funded by,
 423–4, 511
 Magritte and, 11, *12*, 13, 20, 300, 312, 313,
 347, 351, 356–7, 373, 378, 465
 modernists as early focus of, 300
 Montagne as first significant purchase of,
 284–6
 Oceanic art, 372–3, 398–9, 557, 560, 580
 philosophy of, v
 Pontpoint house as showcase for, 384
 Rhyme and Reason exhibition of, 554–5,
 557–64, *558*
 surrealists, 300, 311–12, 373, 378, 561, 564
 total size of, 535
 twentieth-century art, 496, 561, 580
 see also Menil Collection
de Menil, John and Dominique,
 correspondence between, 129, 162, 185,
 194, 231, 289–90, 306, 446–7, 450, 509,
 657
 on art and artists, 285, 293, 306–7, 370, 395
 on business matters, 272, 284–5
 on children, 172, 296
 children and, 274
 on Conrad's death, 183
 courtship and, 129, 130–1, 149–50, 151, 156
 on European trips, 376, 467–8
 on Houston, 194, 239–40, 282, 284–5, 293–4
 Houston house and, 342
 John's cancer and, 447–8
 on New York trips, 291–2
 New York trips and, 303, 317–18, 319
 on Pontpoint house, 385
 religion and, 133, 153–4, 241

and run-up to World War II, 198, 200, 201
in South America, 276, 277–8
in wartime, 205–6, 207, 208, 209, 210–11,
 212, 215, 217, 218, 220, 221–2, 223–4,
 226–7, 230, 233, 234, 235–9, 242
de Menil, Joy, 514
de Menil, Lois Pattison, 116, 466, 473, 486,
 514, 527, 528, 563, 567, 578, 626–7, 628,
 630, 654
de Menil, Louise Adelaide, 7, 172, 182, 191,
 199, 207, 208, 209, 215, 219, 226, 230, 233,
 237, 241, 243, 244, 244, 246, 247, 247, 254,
 256, 263, 269, 273–4, 282, 289, 290, 293,
 295, 297, 305, 336, 341, 398, 466, 486, 512,
 515, 580, 648, 650, 652
de Menil, Marie-Madeleine "Christophe," 4,
 7, 12–13, 15, 156, 172, 182, 189, 191, 192,
 197, 199, 207–8, 208, 209, 211, 215, 219,
 226, 228, 230, 233, 237, 241, 243, 244, 244,
 246, 247, 247, 254, 256, 263, 273–4, 282,
 289, 290, 293, 295, 296, 297, 314, 331, 336,
 340–1, 368–9, 378, 399, 403, 426, 466,
 472, 473, 511, 512, 513, 539, 546, 548, 549,
 574, 580, 587, 603, 628, 652
de Menil, Philippa (Fariha Friedrich), 7, 141,
 291, 296, 318, 321–2, 342, 345–6, 346,
 399–400, 425, 446, 447, 464, 465–7, 512,
 533, 620, 630, 633, 652, 656
 Dia and, 621–4, 625–8
de Menil, Susan, 5, 627, 654
de Menil, Victoria, 14, 656
de Menil family, 114, 132, 172, 173, 191, 524,
 527, 650, 654
 Pompidou Center gifts of, 8, 538–9, 563, 566
de Menil house
 Antonioni dinner party at, 352–3
 Collection Room at, 363, 535, 547, 606, 649
 de Menils' active involvement in design of,
 330–1
 Dominique as active partner in interior
 design of, 340–1, 342
 as *gesamtkunstwerk*, 366
 houseguests at, 348–9, 351, 354–6, 357–61,
 363–5, 465, 513–15
 influence of Sans Souci on, 330
 intended as stimulus for Houston
 architecture, 330
 James as interior designer for, 334–41,
 365–6
 James's furniture for, 337–40, 339, 348
 Johnson as architect of, 329–35, 333, 335,
 336–7
 publication of, 343, 347, 348
 as showcase for art, 345–8, 355, 356, 364,
 366
 as workplace, 361–5

de Mille, Agnes, 593
Denis, Maurice, 187
Denmark, 216, 467–8
Department of Antiquities (Cyprus), 611
Department of Architecture and Design
 (MoMA), 328
Department of Painting and Sculpture
 (MoMA), 350, 406
Desiderio, Vincent, 347
Desjardins, Paul, 67
Des Moines Art Center, 534
Detroit Institute of Arts, 533–4
Deuxième Bureau, Le, 209, 212–14, 231
de Witt, Conrad, 44, 58
de Witt, Cornélis, 44
de Witt, François, 58
de Witt, Henriette Guizot, 41, 44, 46–7, 57,
 58, 62
de Witt, Johan, 44
de Witt, Pauline Guizot, 41, 42, 44, 45
de Witt family, 69
de Young Museum, 450
Dharamsala, 506–8
Dia Art Foundation, 621–30, 633
Dia:Beacon, 629–30
Diaghilev, Sergei, 119, 451
Diana, Princess of Wales, 651
Dietrich, Marlene, 146–7, 315, 350–1, 424, 563
Dikmen, Aydin, 607, 608, 609, 611
Dino, Duchess of, 45
Dior, Christian, 171, 315
Disquieting Muse, The: Surrealism (1958
 exhibition), 391
Dissecting Machine (Tinguely), 562, 581
*Divided Christendom: A Catholic Study of
 the Problem of Reunion* (Congar), 6–7,
 176, 186
Dogon people, 347, 373
Doll, Albert, 64
Doll, Anne Gruner Schlumberger "Annette,"
 5, 7, 8, 63, 69–70, 77, 79, 81, 135, 138–9,
 143, 150, 168, 172, 192, 194, 218, 220, 229,
 234, 237, 239, 240, 249, 255, 264, 273, 274,
 286–7, 291, 294, 295, 332, 375, 514, 534,
 549, 584
Doll, Henriette, 256
Doll, Henri-Georges, 143, 150, 147, 155, 156,
 179–80, 192, 237, 239, 249, 255, 264, 273,
 291, 294, 332, 428
Doll, Jacqueline, 66, 76, 156
Doll, Pauline Schlumberger, 55, 56, 58, 64, 234
Doll family, 151, 255
Dollfus, Jean-Henri, 51
Domínguez, Óscar, 307
Dominion of Light, The (Magritte), 313
Doré, Gustave, 415, 497

Double Negative (Heizer), 619–20, 621
Doucet, Jacques, 581
Drawing Speaks, The: Works by Théophile Bra (1997 exhibition), 651
Dream House (Young and Zazeela), 472–3, 624
Dries, Jean, 264, 282
Drooby, Ala' Eddine, 502–3
Drooby, Nabila, 502–3, 506–7, 524–5, 540, 542, 543, 597–8, 638, 656
 as Rothko Chapel founding director, 589, 596, 597–8, 642
Dubuffet, Jean, 8, 23, 75, 346, 347, 378, 419, 521, 570
Duchamp, Marcel, 305, 390, *390,* 391, 403, 420, 539, 547, 571, 582
Duchamp, Teeny, *390,* 462, 582
Dufy, Raoul, 165, 250
Duhamel, Jacques, 496
Dumas, Roland, 637
Dumbarton Oaks Research Library and Collection, 603, 604, 607, 608
Duncan, Anne, 362
Duncan, Isadora, 70–1
Dunkirk, Battle of, 223, 224
Duployé, Pie, 521
Dwan, Virginia, 619
Dylan, Bob, 512, 522

Eames, Charles, 75, 576
Easum, Don, 596, 597
École Centrale des Arts et Manufactures, 54, 85
École des Beaux-Arts, 268
École des Mines de Paris, 59, 69–70, 83, 84, 85, 179, 197
École Libre des Sciences Politiques (Sciences Po), 45, 117–18, 119, 132, 178, 193
École Nationale des Ponts et Chaussées, 97, 106
École Nationale Supérieure des Beaux-Arts, 163
École Niedermeyer, 124
École Normale Supérieure, 119
École Polytechnique, 59, 79, 85, 97, 100, 192, 197, 305
École St.-Geneviève, 98
École Spéciale Militaire de St.-Cyr, 98, 99
École Stanislas, 109
Edison, Thomas, 83
Éditions de la Nouvelle Revue Française (NRF), 65, 68, *68*
Éditions Gallimard (Librairie Gallimard), 65–7, 147
Edwards, Roy, 477–8, 479
Egeland, Jan, *639*

Église de la Madeleine, 39, 40
Église du Sacré-Coeur, 344
Église Notre-Dame de Toute Grâce at Assy, 344
Église St.-Lambert, 90
Egypt, 119, 307, 457, 506, 508
Egyptian art, 602
Eiffel, Gustave, 99
Eiffel Tower, 83, 158, 234, 460, 563
Ein Harod, 551
Eisenhower, Dwight D., 444, 610
Eisenhower, Milton, 444
Eisenman, Peter, 548
Eisenstein, Sergei, 147, 252
Elba, 96, 97
El Greco, 236, 250
Élisabeth of France, 129
Elizabeth Arden, 305, 315–16, 335
Ellis, Ralph, 5, 579, 654
Ellwood, Craig, 576
El Salvador, 596, 598, 600
Éluard, Paul, 170
Empire of Light (Magritte), 376, 423
Empire of Light, II (Magritte), 313
Engadin, Switzerland, 139–40
Ennis, Michael, 541
Entry into Jerusalem (Byzantine icon), 605, 648
Erased de Kooning Drawing (Rauschenberg), 635
Ernst, Jimmy, 390, 429
Ernst, Max, 3, 8, 13, 20, 165, 179, 265, 267, 297, 300, 302, 305, 307, 309, 311, 314, 342, 346, 347, 359, 367, 372, 373, 377, 400, 419, 428, 464, 495–6, *495,* 510, 513, 521, 532, 535, 537, 539, 559, 571
 catalogue raisonné of, 422–3
 de Menils' friendship with, 169–70, 349, *349,* 403, 422, 474, 495–6, 513
Espace Zéro, 555, 561
Essaouira, 161
Etruscan statuettes, 602
Eugénie de Montijo, empress of France, 45, 54
Evans, Walker, 581
Exeter school, 399
Expo '67, *453,* 454
Exposition Universelle of 1900, 83

Factory, 429, 430, 449, 454
Fanatiques, Les (Magritte), 13
Farb, Carolyn, 654
Farenthold, Sissy, 654
Farfel, Aaron, 496–7
Faubourg St.-Germain, 39, 61–2, 101, 128
Fazzini, Pericle, 376

Federal Bureau of Investigation (FBI), 281
Feigen, Richard, 530, 574
Feldman, Morton, 351, 420, 464, 488, 519–20
Fellowes, Daisy, 581
Fernández, Luis, 313, 347, 563, 648
Ferrari, Louise, 414, 476
Ferus Gallery, 546
Fez, Morocco, 159–60
Finnegans Wake (Joyce), 406
Finnigan, Annette, 28
Fiorenza, Joseph, 654
First Show, The: Painting and Sculpture from Eight Collections, 1940–1980 (1983 exhibition), 565
Fitzwilliam Museum, 144
Flair, 335
Flaming Creatures (film), 456
Flanner, Janet, 287
Flaubert, Gustave, 34
Flavin, Dan, 361, 472, *511,* 561, 618, 619, 620, 622, 624, 625, 628, 649
Florence, 303, 331, 496, 589
Flowers (Warhol), 454, 468–9
Fogg Museum, 385–6, 473, 604
Fondation des Treilles, 168
Fontana, Lucio, 24
For Children (1971 exhibition), 75, 497–8, *498*
Forest Lawn Cemetery, Houston, 414, 522–3, 654
Forman, Milos, 482
Forth, Jane, 469
Fosdick, Robert, 621
Foujita, Tsuguharu, 150
Fountain (Tinguely), 355, *355*
Four Seasons restaurant, 475–6
Four Stars (film), 454
Fox, Stephen, 334
Foyalier (sculptor), 41
Fragonard, Jean-Honoré, 413
France
 Catholics in, 113–14
 collaborationists in, 230–1, 237
 German invasion and occupation of, *202,* 217–30, 233–4, 246, 250
 Great Depression in, 132
 inter-war reconstruction in, 118
 persecution of Protestants in, 132–3
 Protestants in, 9–10, 129, 132–3, 303, 507
 railroads in, 99, 178
 refugees in, *202,* 226–7
 scientific and technological advances in, 83
 Vichy regime in, 230, 251, 281
 World War I devastation of, 110, 112
Franchetti, Tatiana, 631
Francis, Sam, 13, 413, 565
Franco, Francisco, 114, 201

Franco-Prussian War (1870–71), 45, 48, 54, 98, 117, 601
Frank, Robert, 455
Frankenthaler, Helen, 23, 24, *563*
Frankfurt, Treaty of, 54, 55
Franklin, Aretha, 438
Franz Ferdinand, Archduke of Austria, assassination of, 78
Free French, 198, 230, 233, 250, 251, 270, 277–8, 281, 282–3
Freeman, Charles, 357, 440, 441
French Dominican order, 159
French Foreign Legion, 122
French National Museum, 564
French National Railways (SNCF), 178
French Resistance, 229, 298, 299
 Couturier and, 250–1
 La France boutique as fundraiser for, 277–8, *278*
French Revolution, 37, 39, 41, 92, 94, 132, 237
Freud, Lucien, 388
Freud, Sigmund, 391, 474
Frey family, 53
Frick museum, 236
Friedrich, Aziz, 652, 653–4
Friedrich, Doha, 652
Friedrich, Fariha, *see* de Menil, Philippa
Friedrich, Heiner, 618–20, 621, 623, 624, 625, 626, 627, 630–1, 633, 650, 652, 653
Fuentes, Nora, 650–1
Fuller, Buckminster, 394, 460, *461*
Fuller, Millard, 592
Fundação Pierre Verger, 265

Gabon, 169, 653
Gagosian, Larry, 648
Galerie Pierre, 302
Galerie Sycomore, 514
Galleron, Jacqueline, 400
Gallimard, Gaston, 65
Gamelin, Maurice, 214
Gance, Abel, 145
Gandhi, Indira, 508–9
Gates, Henry Louis, Jr., 433
Gauguin, Paul, 61, 267, 374, 529
Gbeho, James Victor, 589
Gehry, Frank, 460, 565, 566
Geldzahler, Henry, 13, 420, 429, 469
Genet, Jean, 171
Geneva, 38, 39, 242, 307, 540, 569, 608, 611
Geneva, University of, 39
Génin, Roland, 583, 584
George, Saint, 171, 218, 241, 602
Georges Braque: Menil/Schlumberger Family Collections (1997 exhibition), 648

Georges Pompidou Art and Culture
 Foundation, 539, 547, 566–73, 627, 656
Georges Rouault: The Inner Light (1996
 exhibition), 648
Georgetown University, 405
George Washington University, 506
Germany, 48, 49, 50, 54, 78, 79, 88, 106, 118,
 146, 197, 205, 218, 241, 337, 437, 513, 532,
 568
Germany, Nazi, 142, 197–8, 200, 205–8, 209,
 212, 213, 215, 216, 217, 218–21, 223, 224,
 225–6, 227, 228, 229, 230, 234, 247, 257,
 275, 276, 277, 279, 282, 287, 305, 306, 603
Germany, West, 618
Getty Museum, 612
Geyche, Tenzin, 507
Ghana, 409, 589
Ghéon, Henri, 68, 187
Giacometti, Alberto, 8, 165, 292, 297, 346,
 370, 377, 388–9, 571
Gibbon, Edward, 27, 39
Gide, André, 34, 44, 46, 65, 66, 67–8, 68, 119,
 145, 233, 279, 280, 301
Gifts of the de Menil Family to the National
 Museum of Modern Art (1984
 exhibition), 563
Gilliam, Sam, 500
Gilson, Étienne, 119, 120
Girard, Alexander, 546
Giraudoux, Jean, 171, 200
Glaenzer, Olivier, 160
Glaser, Miles, 482–3, 513, 521, 547, 569, 573,
 576, 579, 592, 613, 628, 642–3, 645, 647
Glass, Philip, 25, 361, 651
Glassell, Alfred, 412
Glass House, 329, 331–2, 334, 428, 429, 430
Glueck, Grace, 564
Gnostic Gospels at Nag Hammadi, 119
Godal, Bjørn Tore, 639, 640
Godard, Jean-Luc, 351, 453–4
Goethe, Johann Wolfgang von, 37, 649
Golconde (Magritte), 20, 312, 385
Goldberg, Peg L., 607
Goldberger, Paul, 615
Goldreyer, Daniel, 482, 484
Goldwater, Robert, 399
Gorky, Arshile, 25
Govan, Michael, 629
Goya, Francisco, 135, 267, 535
Gramont, Antoine, 4th duc de, 312
Gramont, Antoine Agénor, 11th duc de, 304
Grand Ballet du Marquis de Cuevas, 251
Grand Meaulnes, Le (Alain-Fournier), 233
Grand Palais, 554, 557, 558, 560, 560, 561, 581,
 604
Graves, Curtis, 438, 439, 441–2

Gray Is the Color: An Exhibition of Grisaille
 Painting, XIIIth–XXth Centuries
 (1973–74 exhibition), 525–6, 575
Green, Julien, 277, 289
Greenberg, Clement, 501
Greene, Alison de Lima, 491
Green Stripe, The (Rothko), 373–4, 389
Grès, Madame, 359
Gris, Juan, 20, 400, 521
Grunelius, Alexandre "Alexis," 143, 162, 163,
 164, 174–5, 188, 193, 197, 198, 199, 211
Grunelius, Antoinette Schlumberger, 64, 66,
 82, 137, 143, 162, 163, 164, 174, 178, 182,
 188, 197, 198, 199, 572
Grunelius family, 162, 163
Grünewald, Matthias, 572
Gstaad, 144, 146
Guardini, Romano, 173
Guebwiller, France, 47, 49, 50, 52, 53, 53, 54,
 55, 56, 57, 58
Guggenheim, Peggy, 349, 376, 406
Guggenheim Museum, 350, 390, 405, 445, 555,
 629, 635
Guimard, Hector, 529
Guizot, André, 37–8
Guizot, Elisabeth Sophie Bonicel, 37, 39, 43
Guizot, Elisa Dillon, 40, 41, 42, 182
Guizot, François, 30, 36–47, 38, 55, 56, 58, 62,
 76, 145, 184, 234, 237, 241, 246
 death of, 45–6
 as historian and writer, 37, 39–41, 44,
 45, 74
 political career of, 36–7, 40–1, 42–3
 Val-Richer renovated by, 33, 34, 36, 41–2
Guizot, François-Jean, 39, 45
Guizot, Guillaume, 41, 45
Guizot, Jean-Jacques, 38, 39
Guizot, Pauline de Meulan, 39, 40
Guizot Law, 40
Gund, Agnes, 13, 656

Habitat for Humanity, 592
Hamilton, George Heard, 404
Hanover Gallery, 310
Harald, king of Norway, 640
Harlem, N.Y., 240, 251, 493, 590
Harlem on My Mind (1969 exhibition), 498
Harlem Renaissance, 251
Harnoncourt, René d', 392–4, 395, 449
Harvard University, 293, 399, 433, 464, 466,
 476, 524, 637
Harvard University Press, 433
Haskins, James, 493–4
Hau, Michel, 54
Haute Société Protestante (HSP), 9

Hauteville, René de Renusson, Comte d', 129, 130
Hauteville, Solange d', 129, 130
Hawkins, Ashton, 567, 627, 628, 629, 630
Hayward Gallery, 635
Healey, Jack, 593
Hearst, Mrs. William Randolph, 315
Hector and Andromache (de Chirico), 314, 345, 521
Heim, Glenn, 417, *418*, 549, 551
Heiner Friedrich Gallery, 567, 618, 623–4
Heizer, Michael, 4, 580, 619–20, 629
Hemingway, Ernest, 127
HemisFair '68, 454
Heroic Years, The: Paris, 1908–1914 (1965 exhibition), 408
Hertz, Heinrich, 83
Hertzberg, Arthur, 540
Hicks, Jackson, 9, 463–4
Hindus, Hinduism, 508, 524, 525, 656
Hirshhorn, Joseph, 403
Hitchcock, Henry-Russell, 329
Hitler, Adolf, 142, 198–9, 200, 201, 205, 207, 208, 216, 217, 219, 308
Hobbs, Ronald, 356, 446
Hobby, Diana, 434
Hobby, Oveta Culp, 350
Hobby, William P., 350
Hobby, William P., Jr., 434
Hochalpines Institut Ftan, 139, 141
Hofheinz, Fred, 534–6, 654
Hogg, Ima, 27–8, 390, 392, 462–3
Hogg, James Stephen, 27
Hohenlohe-Schillingsfürst, Prince, 57
Holland, 218–20, 245, 368, 532
Holmes, Ann, 405, 473, 529
Holy Archbishopric of Cyprus, 610–11
Homer, Winslow, 468
Hope Development, 501
Hopper, Dennis, 13, *14*
Hopps, Walter, 5, 8, 12, 13, 18, 20, 21, 22, 24, 25, 71, 387, 413, 415, 428, 528, 546–8, 554, 556, 559, 560, 561, 563, 567, 574, 575, 576, *585*, 587, 607, 608, 613, 630, 642, 645
 as Menil Collection founding director, 363–5, 546, 547–8, 577, 581, 582, 585–6, 587, 609–10, 612, 625, 634–5
Horne, Lena, 438
Houghton, Arthur, 412
Houston, Tex., *286, 302, 317, 516*
 architectural poverty of, 327–8
 artists in, 396
 climate of, 28–9
 de Menil house in, *see* de Menil house
 de Menils' first years in, 6–7, 26
 de Menils' influence on culture of, 526, 561

Fifth Ward of, 320, 441, 498, *499, 520*
Fourth Ward of, *575–6*
International Airport in, 540, *541*
John's decision to settle permanently in, 294
John's first visit to, 194–5
Menil Collection in, *see* Menil Collection
Menil Collection inaugural dinners in, 23–5
1980's oil crisis and, 3, 14
oil aristocracy of, 23–5, 27, 29
postwar boom in, 299, 436–7
racism and segregation in, 11, 29, 437–41
Schlumberger offices in, 236, 294, 362, 380
viewed as cultural desert, 26, 29
Houston, University of, 358
Houston Baptist College, 488
Houston Chronicle, 405, 437, 462, 469, 472, 473, 519, 521, 526, 529, 530, 577, 652, 654
Houston City Council, 435–6, 489
Houston Post, 299, 350, 368, 434, 437, 460, 498, 519, 577
Houston Symphony, 26
Howard University, 357
Huber, Caroline, 24, 548, 561
Hudson, Ed, 353–4
Hughes, Fred, 13, 25, 357, 394, 397–8, *397,* 413, 417–18, 420, 428–9, 450, 451–2, *453,* 454, 457, 469
Hughes, Howard, 417, 420
Hughes, Robert, 22, 495, 529
Hugo, François, 179
Hugo, François-Victor, 305
Hugo, Georges, 290, 305
Hugo, Jean, 305, 311
Hugo, Maria, 290, 303–7, *304,* 315, 317, 376, *376,* 514
 de Menils and, 305, 313, 316
Hugo, Victor, 44, 178, 305
Hugo Gallery, 306–8, 309, 310, 313, 315, 318
Hultén, Pontus, 13, 22, 449, 460, *461,* 462, 467, 539, 540, 546, 549, 551, 556, 561, 564–5, 567, 573
human rights, 588–600
Human Rights Day, 589, 591–2, 593
"Human Rights/Human Reality" colloquium, 588–9
Human Rights Watch, 593
Humble Oil, 24, 27, 255, 443
Hunt, Richard, 500
Hunter, Fredericka, 5–6, 351, 416–17, 419, 420, 456, 651
Huxtable, Ada Louise, 451
Huysmans, J. K., 102

Ibish, Yusuf, 524
Ife, University of, 504–5

Ife sculptures, 374, 394
Illich, Ivan, 588
Illinois Institute of Technology, 381, 455
Image of the Black in Western Art, The (multi-
 volume series), 363, 432–4, 464, 514, 591,
 634, 643
Indiana, Robert, 450, 454, 526, 598, 599
Infinity Machine, The (Cardiff and Miller),
 616–17
Inside the Sight (1972 exhibition), 510
Institut de France, 40
Institute for Religious Sciences, 634
Institute for the Arts, Rice University, 359, 361,
 528, 533, 604
 Dominique as director of, 457, 474, 493, 510,
 520–1, 528–9
Institute of African Studies, 504
Institute of International Education (IIE), 350,
 351
Institute of Religion and Human Development,
 486
Intercom, 520
International Colonial Exposition, 167
International Klein Blue, 555, 556, 580, 585
International Style, 268, 332, 334, 366, 456
International Style, The (Johnson and
 Hitchcock), 329
Iolas, Alexandre, 6, 307–15, *309, 312,* 351, 356,
 377, 410, 425, 496, 514, 548, 556, 560–1,
 564, 603, 635, 648
 as mentor to de Menils, 307, 311–15, 372,
 376, 377, 401–2
Isabella Stewart Gardner Museum, 511
Isenheim Altarpiece, 572
Ishida, Shunji, *578*
Islam, 511–12, 524, 525
 see also Muslims
Islamic art, 606
Isolated Mass/Circumflex (#2) (Heizer),
 580
Israel, 551, 610, 637, 639, 641
Istanbul, 231–3, 234, 543, 573
Istel, André, 293
Istel, Lepercq and Company, 256, 285
Ivory Coast, 501, 503–5

Jackson, Julian, 209
Jacob, Max, 102
Jacques (gallery), 170
Jagger, Bianca, 598
James, Charles, 163, 270, 305, 315–19, *316,*
 345, 347, 378, 379, 529, 563–4, 651
 clothes of, 316, 317–19, *317, 329,* 335, *339,*
 349, 425, 452, 561
 furniture by, 337–40, *339,* 347, 465

 as interior designer for de Menil house,
 334–41, 365–6
James, Henry, 61, 106
James, Nancy, 378
Janis, Sidney, 390
Jannings, Emil, 146–7
Janss, Edward, 413
Japan, 59, 120, 188, 235, 257
Jardin, Jean, 172, 178–9, *178,* 191, 200, 207,
 230, 237, 264, 425, 447
Jardin, Simon, 179, 191, 383, 384, 425
Jardin, Simone, 178, 179, 191, 237
Jeanmaire, Zizi, 168
Jean Tinguely: Sculptures (1965 exhibition),
 410
Jensen, Alfred, 571
*Jermayne MacAgy: A Life Illustrated by an
 Exhibition* (1968–69 exhibition), 456
J. J. Klejman Gallery, 372, 603, 604
John XXIII, Pope, 501–2, 634
John and Dominique de Menil Collection, The
 (1962–63 exhibition), 398–9
Johns, Jasper, 3, 12, 361, *402,* 403, 428, 451,
 454, 472, 511, 526, 547, 561, 581, 586, 636
Johns Hopkins School of Medicine, 589
Johns Hopkins University, 444
Johnson, Daniel LaRue, 493
Johnson, Harvey, 440
Johnson, Jed, 451, 469
Johnson, Lee Otis, 440–1
Johnson, Lyndon, 415, 444
Johnson, Philip, 5, 8, 11, 13, 22, 163, 270,
 328–9, *329,* 380, *382,* 428, 450, 456, 475,
 483, 490, 491, 510, 567, 650, 654, 656
 as de Menil house architect, 329–35, *333,*
 335, 336–7
 Rothko Chapel and, 477, 478–9, 483
 as St. Thomas University architect, 381–3,
 382, 383, 396
 as Schlumberger Research Center architect,
 332
Johnson, Samuel, 581
Johnson Space Center, 355, 415, 437
Jolivet, David, 357
Jones, Jesse, 29
Jones, LeRoi, 434
Jones Hall, 381, 396, 398
Jordan, Barbara, 441, 442
Joseph Cornell (1977 exhibition), 530–1
Joseph Cornell (1997 exhibition), 651
Jouvet, Louis, 171
Joy, Robert, 300
Joyce, James, 405
Judd, Donald, 561, 618, 622, *622,* 626, 628–9
Judd, Flavin, 628
Judd, Rainer, 628

Juge, Le (Rouault), 319, 384
Julien Levy, 171

Kadish, Mary, 363, 535
Kafka, Franz, 405
Kahlo, Frida, 388
Kahn, Louis, 531–2, 575
Kahn, Robert I., 521–2
Kamrath, Karl, 367
Kandinsky, Wassily, 28, 539, 571
Keegan, John, 78
Kempner, Sissy, 568–9
Kennedy, John F., 439, 443
Kennedy, Robert, 444
Keynes, John Maynard, 110
Kiefer, Anselm, 24
Kienholz, Edward, 13, 364, 546
Kienholz, Lyn, 567
Kilian, Karl, 352, 353, 354, 394, 413, 419, 429
Kimbell Art Museum, 532
King, Coretta Scott, 488
King, Henry, 583, 584, 627
King, Martin Luther, Jr., 435–6, 438, 439, 444, 483, 488, 489, 589, 590
King's College, Cambridge, 189
Kirstein, Lincoln, 267
Klee, Felix, 571
Klee, Paul, 28, 346, 348, 400, 406, 521, 571
Klein, Yves, 19, 307, 310, 313, 347, 364, 449, 546, 549, 555–6, 564, 565, 580, 635, 656
Klein-Moquay, Rotraut, 556, 656
Kleinwort, Sons & Company, 188, 189
Klejman, John J., 372–3, 434
Kline, Franz, 23, 24
Knoedler, 581
Kohn Pederson Fox, 613
Kolbsheim, Château de, 162–3, *164, 174, 178,* 182, 188, 191, 199, 572
Kollek, Teddy, 551
Konya, 511, 541, 542, 543
Kornfeld Gallery, 571
Koshalek, Richard, 13, 363, 565, 566
Kramarsky, Siegfried, 368–9
Kramer, Hilton, 450
Krens, Thomas, 629
Kristallnacht, 199, 200
Kronenhalle (restaurant), 572
Krüger, Emmy, 142
Ku Klux Klan, 439
Kunsthaus Museum, 572
Kunstmuseum, 571

Lacasse, Joseph, 188
Laclotte, Michel, 582

Lacordaire, Father, 45
La Coupole (brasserie), 127, 165, 449
La France (bookstore), 277–8, *278,* 283
Lagos, 394, 504–5
Laguilharre, Louis, *232*
Lalique, René, 529
Lambert, Phyllis Bronfman, 429, 449
land art, 619–21, 624–5
Landry, Richard, *14, 25*
Landshoff, Ruth, 145
Lang, Jack, 555, 556–7, 561–2, *562,* 563, 636, 656
Lang, Monique, 556
Langlois, Henri, 451, 523
Lanvin, 127
La Pira, Giorgio, 589
La Pros (Société de Prospection Électrique, Procédés Schlumberger), 87, 128–9, 137, 138, 147, 150, 160, 179–82, 210, 212, 215, 229, 231, 233, 234, 236, 242, 399, 657
 electrical logging process of, 179–80
 in evacuation to Clairac, 229
 growth of, 191–2, 193
 Houston branch of, *see* Schlumberger Well Surveying Corporation
 John's joining of, 192–4
 Romanian operations of, 196, 231
 Schlumberger family's involvement in, 192
 Southwest Asian offices of, 235
 Soviet Union and, 180, 181–2
 in wartime evacuation to Clairac, 222–3
 see also Schlumberger (company)
Large Interior with Palette (Braque), 313
LaRouche, Lyndon, 590
Larry Edmunds Bookshop, 452
Larsen, Terje Rød, *639*
Lartigue, Pauline, 47
Lascaux Caves, 568
Lassalle, Hélène, 624
Last Supper, The (Warhol exhibition), 307
Las Vegas Piece (De Maria), 619–20, 621
Lauder, Leonard, 13
Laugier, Henri, 250, 252
Laurens, Henri, 8
Lausanne, 148, 242, 570
Laval, Pierre, 230
Lavelle, Louis, 129
Law, Caroline Wiess, 24–5, 443, 536, 545, 576
Law, Ted, 24, 443
Lawson, William, 436, 437, 439, 441, 443, 521, 522, 598
Lawyers Committee for Human Rights, 593
Lazard Frères, 567, 584
Lebanon, 502, 507, 524, 610
Le Corbusier, 7, 185, 344, 345, 488, 572
Ledoux, Claude-Nicolas, 450

Lee, Sheila Jackson, 654

Léger, Fernand, 20, 165, 250, 252, 267, 268, 300, 313, 344, 348, 350, 359, 373, 380, 384, 403, 449, 488

Legion of Honor, 80, 82, 89, 93, 95, 96, 98, 100, 107, 122–3, 155, 636

Leland, Mickey, 11, 441, 442–3, 482, 500–1, 513, 515, 520, 521

Lenya, Lotte, 131

Leo Castelli Gallery, 374

Leonardo da Vinci, 460, 513, 635

Leopold, king of Belgium, 223

Lepercq, Paul, 256

Lequeu, Jean-Jacques, 450

Lesseps, Ferdinand de, 121

Lever House, 343

Levin, William, 515

Lévi-Strauss, Claude, 464

Libération, 564

Liberman, Alexander, 351

Liberman, Tatiana, 351

Librairie de France, 277

Librairie Gallimard (Éditions Gallimard), 65–7

Licht, Jennifer, 462

Lichtenstein, Roy, 454

Lieberman, William, 429

Lieven, Prince de, 42

Lieven, Princess Dorothée de, 42, 43, 45

Life, 29, 355, 390

Lightning Field, The (De Maria), 621–2, 624

Ligue Maritime et Coloniale, 119

L'inquiète paternité (Jean Schlumberger), 153

Lipman, Jean and Howard, 565

Lipchitz, Jacques, 370–1

Lisieux, 34, 78, 211, 220, 224, 225

Lloyds Bank International, 611

Loeb, Pierre, 302

London School of Economics, 189

Lonesome Cowboys (film), 452, 456

Lone Star Foundation, 626

Long, Richard, 463

Look Back: An Exhibition of Cubist Paintings and Sculptures from the Menil Family Collection (1968 exhibition), 444

Loplop Presents Loplop (Ernst), 311

Lorraine, 48, 54, 79

Los Angeles, Calif., 546, 547, 564, 565, 620

Los Angeles County Museum of Art, 565

Loste, Sébastien, 538, 539–40

Louis XIV, king of France, 48, 79

Louis XV, king of France, 49, 93

Louis XVI, king of France, 36, 62, 69, 102, 129, 132, 570

Louis XVIII, king of France, 96

Louis Fernández (1996–97 exhibition), 648

Louis Philippe, king of France, 33, 34, 36, 40, 41, 43, 45, 97

Louvre Museum, 102, 139, 255, 415, 416, 418, 451, 464, 474, 495, 496, 525, 582, 602

Love, Jim, 389, 412, 414, 416, 460, 484, 497, 521, 545–6

Lovin' Spoonful, 451

Lowe, Mary Ralph, 24

Loyola University, 637

Luboviski, Milt, 452

Ludwig, Irene and Peter, 565

Lurçat, Jean, 344

Luther, Martin, 103, 132

Luxembourg, 218–19

Luxembourg Gardens, 100, 105, 427

Lycée Condorcet, 58

Lycée et Collège Victor Duruy, 70–1, 139

Lycée St-Louis, 58–9

Lyon, Danny, 474

Lyons, Nathan, 455

Lysi frescoes, 606–17, *611*, 636, 644

Maar, Dora, 347

MacAgy, Douglas, 386, 387

MacAgy, Jermayne, 385–9, *392, 393,* 405, 414, 415–16, 417, 419, 430, 475, 476, 521, 522, 546, 621
 death of, 413
 as first director of Contemporary Arts Museum, 386, 388–9, *388,* 390–1, 392–5, 396
 at St. Thomas University, 396–8, 404, 413, 417

Machine as Seen at the End of the Mechanical Age, The (1969 exhibition), *459,* 460, *461,* 462–3, 464

Made of Iron (1966–67 exhibition), 450

Maeght, Adrien, 13

Maeght Gallery, 449

Magritte, Georgette, 351, 423

Magritte, René, 3, 13, 20, 297, 300, 307–8, 312, *312,* 313, 347, 350, 356–7, 367, 373, 376, 378, 385, 420, 428, 464, 497, 529–30, *530,* 535, 553, 580, 581, *585,* 635, 643
 catalogue raisonné of, 423–4, 511, 514
 de Menils' friendship with, 11, *12,* 351, 465

Magritte (1992–93 exhibition), 635

Mailer, Norman, 279, 354–6, 451, 523, 529

Maison Basse, *see* Pontpoint manor house

Majorca, 159, *159,* 161, 473

Malanga, Gerard, 429

Malaquais, Jean, 279–80, *279,* 281, 297–8, 348, 354, 431–2

Malevich, Kazimir, 449

Mali, 417

Mallarmé, Stéphane, 66
Mallet-Stevens, Robert, 165, 187
Malraux, André, 67, 299, 559–60
Mancusi-Ungaro, Carol, 611, 636, 645, 646
Mandela, Nelson, 597–600, *598*
Manet, Édouard, 27, 240, 539
Mann, Erika, 140
Mann, Heinrich, 67, 146
Mann, Klaus, 140
Mann, Thomas, 140
Marais, Jean, 168
Marconi, Guglielmo, 83
Marcoulesco, Ileana, 648
Marcus, Stanley, 14, 390, 394–5
Marden, Brice, 13, 566, 635, 636
Marfa, Tex., 622, *622*, 628–9
Margerie, Emmanuel de, 14, 636
Marie-Louise, empress of France, 95
Maritain, Jacques, 102, 174, 177, 185, 186, 200,
 240, 251
Maritain, Raïssa, 174, 185, 186, 240
Marjorie Merriweather Post Collection, 603
Mark Rothko (1957 exhibition), *388, 389*
Mark Rothko: The Chapel Commission
 (1996–97 exhibition), 648
Marlborough Gallery, 490
Marnes-la-Coquette, 168, 234
Marqués de Comillas (ship), 243–5, *244,
 246–7*
Marriage (Smith), 638, *639*–40, *640*, 641, 644
Marseille, 119, 120, 241, 242, 243
Martin, Agnes, 630
Martin du Gard, Roger, 66, *68*, 132, 140
 twentieth-century galleries of, 19–20, 586
Martinet, Augustin, 99
Martinet, Jean-Charles, 93
Martinet, Jean-Jacques, 93
Martinique, 120, 123
Marx, Karl, 36
Marzio, Peter, 406, 411
Massachusetts Institute of Technology (MIT),
 453, 466
Masterson, Carroll, 24
Masterson, Harris, 24
Mathieu, Jean, 300
Matisse, Henri, 28, 70, 250, 253, 267, 297, 301,
 315, 344, 345, 364, 367, 370, 374, 388, 403,
 404, 467, 475, 570, 582, 653
Matisse, Pierre, 253, 368, 370, 374
Matisse Chapel (Chapelle du Rosaire de
 Vence), 344, 488, 551–2
Matta, Roberto, 8–9, 10, 20, 293, 312, 373,
 384, 391, 411, 420, 559, 582
Maturín, 260–1
Mauriac, François, 102, 187, 238
Maurois, André, 209

Maurras, Charles, 113–14
Max Ernst: A l'intérieur de la vue (1971
 exhibition), 495
Max Ernst: Inside the Sight (1973 exhibition),
 513
Mayan art, 347, 458
Mayo, Edward, 299–300, 380, 388, 394, 408–9,
 535
Maysles, Albert, 452, 455
Maysles, David, 455
McCarthy, Glenn, 390
McCullers, Carson, 142
McCune, Billy, 474
McKim, Mead & White, 327–8
McKissack, Jeff, 572
McMurtry, Larry, 455
McNay Art Institute, 391
Mead, Margaret, 358
Mead, Taylor, 454, 456
Medeiros, François de, 524
Meese, Ed, 444
Megève, 194, 195
Meir, Golda, 503
Mekas, Jonas, 452, 453
Melanesia, 398–9
Méliès, Georges, 147
Melikian, Vahe, 181, 182
Mellon, Gertrud, 429
Menil Collection, *xiv*, 6, 13–23, 75, 169, 277,
 305, 341, 361, 373, 402, 528, 578, 582, 585,
 591, 598, 602, 605–6, 611, 616, 634–6,
 648, 654, 656
 antiquities gallery of, 19, 20, 586
 Barnstone and, 532, 533, 546
 Byzantine and medieval galleries of, 586
 conservation and framing studios of, 20–1
 critics' praise for, 22
 Davezac as chief curator of, 605, 606–7, 644,
 645, 647
 design of, 16–17, 574–81, 585–6
 Dominique in planning of, 17, 18, 20–2,
 363–5, 532–6, 545–53, 574–80, 585–6, 585
 Hopps as founding director of, 363–5, 546,
 547–8, 576, 581, 582, 585–6, 587, 609–10,
 612, 625, 634–5
 Houston as location for, 535–6
 inauguration of, 2, 3–5, 7, 9, 10, 13–16, 14,
 15, 22–3, 25–6, 586
 Kahn and, 531–2
 non-Western galleries of, 19, 19, 20, 586
 patrons of, 14
 Paul Winkler and, 546, 548–9, 551, 552,
 575, 577–8, 579, 586, 613, 630–2, 633,
 645–6
 Piano as architect of, 3, 9, 13, 16, 21–2, 163,
 270, 365, 549–53, 574–80, 585, 636

Menil Collection *(continued)*
 Richard Fitzgerald & Associates as
 architects of, 3
 tenth anniversary gala of, 648
 Treasure Rooms of, 21
 twentieth-century galleries in, *18*
Menil Foundation, 360, 364, 424, 433, 446,
 482, 496, 523, 548, *579*, 605, 611, 629, 634,
 635, 647, 651, 653
 financial crisis at, 642–7
 Image of the Black funded by, 432, 434
 separation of Rothko Chapel and, 591
Menu de Menil, Antoine, 97–8, 99, 100, 124
Menu de Menil, Antoine-Joseph, 92
Menu de Menil, Emmanuel, *90,* 101, *102,*
 106–7, 111
Menu de Menil, Félicien, 98, 124, 125
Menu de Menil, Georges, 89, *90,* 93, 98–9,
 100–3, *101,* 105, 106, 107, 110, 112, 115,
 119, 124–5, 152, 157, 214, 217, 237, 241,
 287–8, 289, 383
Menu de Menil, Jean, *see* de Menil, John
Menu de Menil, Jean-Paul-Claude, 92
Menu de Menil, Madeleine-Eléonore Martinet,
 93–4, 97
Menu de Menil, Madeleine Rougier, 89, 97, 99,
 100–1, *102,* 103, 110, 125
Menu de Menil, Marcel, *90,* 101, 106–9, *108,*
 111
Menu de Menil, Marguerite, *see* Pesle,
 Marguerite
Menu de Menil, Marie-Albertine Bruneau, 92
Menu de Menil, Marie-Madeleine Rougier,
 172
Menu de Menil, Marie-Noelle Desmoulin, 92
Menu de Menil, Marie-Thérèse Martinet, 98,
 99, 100
Menu de Menil, Mirèse, 101, 107, 108, 111,
 112–13, 116, 119, 125, 129, 130, 152, 174,
 206, 217, 288, 524, *561*
Menu de Menil, Monique, 101
Menu de Menil, Patrice, 89–90, *90,* 91, 92, 101,
 111, 116, 158, 222
Menu de Menil, Paul-Alexis-Joseph, first
 Baron, 92–3, 94–7
Menu de Menil, Simone, 101, 112, 116, 206
Menu de Menil family (France), 129
 as Catholics, 90, 103, 114, 132
 effects of World War I on, 106–9, 110–11
 financial difficulties of, 112–13, 114, 115
 Paris apartment of, 89–92, *90,* 101–3, *102,*
 105, 110, 112, 124, 126, 127, *128,* 206, 207,
 287–8
 Pontpoint house of, 217, 233, 237, 288, 383,
 384
 social isolation of, 105, 112, 114

Meouchi, Cardinal, 502–3
Merce Cunningham Dance Company, 428
Mer de Glace (Sea of Ice), 134, 652
Mers-el-Kébir, 230, 232
Metropolitan Museum of Art, New York, 13,
 102, 240, 247, 249–50, 255, 263, 359, 367,
 369, 372, 418, 419, 450, 451, 469, 498, 525,
 567, 627, 635
 Costume Institute at, 319
 de Menils' gifts to, 411–12
Meudon, 185, 186
Meulan, Aline de, 42
Meunier, Jean, 157
Meuse River, 219, 220
Mevlevi dervishes, 541–4, *542*
Mexico, 138, 245, 267, 280, 330, 345, *346,* 399,
 464, 465
Mexico, Gulf of, 27, 254
Mexico City, 280, 281, 465
Michael of Greece, prince and princess, 567
Michelangelo, 358, 372
Michelangelo Pistoletto: Mirror Works (1979
 exhibition), 531
Middle Ages, art of, 18
Middle East, 256, 524
Midway Island, 235
Mies van der Rohe, Ludwig, 328, 329, 331, 334,
 337, 342, 392, 406, *406,* 449, 490
 as Cullinan Hall architect, 378, 391, *392,*
 393, 410
Milan, 216, 307, 635
Milhaud, Darius, 118
Miller, Dorothy, 313, 350, 405
Miller, George Bures, 616
Miller, Henry, 405
Milwaukee Art Center, 534
Ministry of Foreign Affairs, French, 43, 636,
 637, 653
Ministry of the Interior, French, 39
Ministry of War, French, 101
Miribel, Élisabeth de, 250–1
Miró, Joan, 8, 24, 170, 267, 299, 319–20, 348,
 350, 359, 401, 406–8, 474, 539, 570, 571
Mitterrand, Danielle, 14, *15,* 562, 656
Mitterrand, François, 14, *555,* 561–2, *562*
*Mixed Masters: An Exhibition Showing the
 Various Media Used by Contemporary
 Artists* (1967 exhibition), 450
Mock, Jean-Yves, 6, 310, 425, *495,* 496, 531,
 551, 556–7, 559, 564, 567, 568, 586
Moderna Museet, 169, 451, 467, 567
*Modern Architecture: International
 Exhibition* (Johnson and Hitchcock),
 329
"Modern Cuban Painters" (Barr's MoMA
 show), 302

Modigliani, Amedeo, 394

Moeller, Friedrich, 653

Monde, Le, 564, 588, 653

Mondrian, Piet, 8, 165, 252, 312, 347, 364, 370, 396, 400, 587

Monet, Claude, 267, 400, 414

Montagne (Cézanne), 285–6

Montalembert, Charles Forbes René de, 46

Montesquiou, Count de, 377

Montmartre (Paris neighborhood), 91, 119, 175, 488

Montparnasse (Paris neighborhood), 150, 165, 187

Montparnasse Cemetery, 111

Montreal, 240, 250, 251, 449, *453, 454*

Montreal, University of, 250

Mont St.-Victoire, 99, 286, 564

Monument to the Third International (Tatlin's Tower) (Tatlin), 460

Moore, Henry, 23

Mooréa, 120

Morand, Paul, 83, 425

Moreau, Gustave, 415, 419, 529

Moreno, Rafael, 302

Morocco, 106, 122–3, *123,* 125, 137, 142, 159–61, *160,* 180, 193, 197

Morris, S. I., 405

Morrison, Jim, 451

Morrissey, Paul, 351, 429

Morrocco, Laurence, 611

Moscow, 181, 218, 602

Mother and Child (Léger), 313, 384

Mothers of the Plaza de Mayo, 590

Motherwell, Robert, 24, 479, 561

Moubarac, Youakim, 512, 515, 522

Moulin, Jean, 299

Mucha, Alphonse, 529

Mulhouse, 49, 50, 51, 55, 64

Munich, 607, 608–9, 611, 618

Munich Agreement, 199, 219

Murillo, Bartolomé Esteban, 45

Murnau, F. W., 147

Murphy, John F., 414

Musée Archéologique, 602

Musée de l'Homme, 377, 394

Musée des Arts Décoratifs, 59, 528

Musée d'Ethnographie, 170

Musée d'Orsay, 582

Musée Grimaldi (Musée Picasso), 345

Musée Guimet, 424

Musée Marc Chagall, 551

Musée National des Arts et Traditions Populaires, 377

Museo del Greco (Toledo), 24

Museum as Seen at the End of the Mechanical Age, The (1968 exhibition), 449

Museum Event No. 5 (Cunningham), 429

Museum für Völkerkunde, 604

Museum of Art, Ein Harod, 551

Museum of Art, Rhode Island School of Design, 468

Museum of Contemporary Art, Chicago, 555, 635

Museum of Contemporary Art, Los Angeles (MOCA), 13, 363, 564–5, 566, 633

Museum of Fine Arts, Houston (MFAH), 24, 25, 26, 28, 254–5, 295, 299, 380, 388, 390, 394, 406–13, 420, 457, 458, 491, 522, 535, 536, 539, 579

Cullinan Hall at, 328, 378, 391, 392, *392, 393, 405, 406,* 407, 410

de Menils and, 8, 404, 409–10, *411*

Sweeney as director of, 406–13, *407, 408,* 410, *411, 420,* 431, 432

Museum of International Folk Art, 546

Museum of Modern Art (MoMA), 25, 251–2, 255, 267, 302, 313, 315, 328, 330, 350, 367, 369, 370, 372, 373, 377, 387, 394, 398, 403, 405, 410, 418, 420, 422, 435, 449, 452, 455, 459, 460, 514, 525, 571, 574, 634

de Menil donations to, 8

Department of Architecture and Design at, 328

Department of Painting and Sculpture at, 350, 406

International Council of, 379, 398, 568

Museum of Natural History (Harvard), 293

Museum of Non-Objective Painting, 406

Museum of Primitive Art, 394, 398–9, 434

Museum of Strasbourg, 602

Music in Twelve Parts (Glass), 528

Muslims, 503, 504, 508, 656

Musset, Alfred du, 67

Mussolini, Benito, 200, 216

Nabis, 529, 570

Nabokov, Nicolas, 146, 162, 198, 240

Nadar, 44

Nakov, Andrei, 464

Napoléon (film), 145

Napoleon I, emperor of France, 39, 82, 89, 92, 94, 95, 96, 97, 98, 105, 132

Napoleon III, emperor of France, 45, 54

Napoleonic Wars, 48, 92–3

Napoleon's Russian Campaign (de Ségur), 95

NASA, 355, 415, 437

Nasr, Seyyed Hossein, 506

Nath, Pandit Pran, 525

National Collection of Fine Arts at the Smithsonian Institution, 432

National Endowment for the Arts, 435, 626

National Gallery (London), 190
National Gallery at the Grand Palais, 554, 557
National Gallery of Art (Washington), 13, 476, 491, 510, 548, 643, 644
National Guard, French, 43
National Institute of Mental Health, 589
National Medal of Arts, 593
National Mining Corps, 59
National Ministry of Education, 62
National Museum of Lagos, 504
National Museum of Lima, 265
Nauman, Bruce, 463
Necker, Alfred, 570
Necker, Jacques, 570
Necker, Mrs. Harold, 570
Negley, Nancy, 571
Neier, Aryeh, 593
Neiman Marcus, 336
Němec, Jan, 482
Nestor Café, 217
Neue Nationalgalerie, Berlin, 633
Neuflize Bank, 151
Neuhaus, Hugo, 332
Neuilly-sur-Seine, 61, 62, 124, 165
Neutra, Richard, 576
Neuville, Alphonse de, 45
Nevelson, Louise, 567
New Caledonia, 120
New Delhi, 506–7, 508
New Guinea, 19, 170, 235, 372–3, 404
New Hebrides, 120, 123
Newman, Annalee, 13, 488–9, 490, 567
Newman, Barnett, 12, 13, 17, 19, 156, 324, 435, 436, 483, 489, 559, 561, 580, 581, 586, 587, 590, 590, 625, 628
Newsweek, 424, 564
New Underground, 453
New York, N.Y.
 de Menils' apartments in, 303, 305, 317, 319, 378, 399; see also de Menil, John and Dominique, East Seventy-Third townhouse of
 de Menils' trips to, 251–2, 253–4, 263, 282, 289–90, 463, 510
 as new Schlumberger headquarters, 427
New York City Ballet, 519
New York Earth Room (De Maria), 623
New Yorker, 287
New York Film Festival, 482
New York Philharmonic, 240
New York Stock Exchange, 399
New York Times, 4, 11, 22, 63, 308, 331, 406, 433, 450–1, 458, 519, 526, 564, 588, 589, 594, 615, 629, 637, 653
New York Times Magazine, 7

New York University, Institute of Fine Arts at, 621, 643
Nico, 454
Nicolas Schlumberger & Cie (NSC), 49–50, 52, 53, 53, 54
Nicolson, Harold, 230
Nicosia, 611, 616
Nigeria, 19, 373, 374, 394, 501, 504, 514, 555, 596
Nikephoros II Phokas, Byzantine emperor, 602
Nîmes, 9, 39, 41
Noailles, Charles de, 163
Noailles, Marie-Laure de, 163
Nodelman, Sheldon, 476, 484–5
Noland, Kenneth, 500
Nomé, François de, 346, 347, 364
Normandy, 25, 34, 47, 73, 77, 81, 81, 130, 168, 172, 207, 208, 210, 217, 218, 222, 264, 371, 527
 Nazi invasion of, 221, 223–4
 refugees in, 220, 224
North, East, South, West (Heizer), 629
Norton Simon Museum, 547
Norway, 216, 221–2, 638–41
Norwegian Institute of Applied Social Science, 638, 639
Notre-Dame Cathedral, 107, 176–7, 178
Notre-Dame des Neiges (Alpe d'Huez), 238–9, 238
Notre Dame du Haut, Ronchamp, 185, 344, 488, 572
Nouméa, 120
Nouvelle Revue Française, 65–7, 119, 233, 377
Nouvel Observateur, Le, 564
Novros, David, 656
Now II (Newman), 17–18, 580
Nu debout (Giacometti), 346, 388
Number 6 (Pollock), 408
Nureyev, Rudolf, 572

Oberkampf de Dabrun, Émile, 59–60
Observatory Times: The Lovers (Ray), 338
Oceania, art of, 19, 170, 372–3, 391, 398–9, 557, 560, 580
Odalisque (Matisse), 315
O'Doherty, Brian, 420, 519
Oeil, L', 359, 383
Œil de jeune femme (Sacco), 554
Oeuvres complètes (Baudelaire), 7
Of a Fire on the Moon (Mailer), 355
Oficina, 257, 262, 263, 271
O'Gorman, Ned, 590
O'Grady, Gerald, 352, 452–3, 455

Ohm, Georg, 83
Oldenburg, Claes, 351, 450, 454, 460, *461,* 462, 539
Olitski, Jules, 500
Olmecs, 281
100 Untitled Works in Mill Aluminum (Judd), 622–3, *622*
Opochinin, Mikhail, 181
Oppenheim, Dennis, 463
Oppenheim, Meret, 570–1
Opunohu Bay, 120–1
Orangerie, 129, 495, *495,* 496, 513
Orange Show, 572, 573
Orange Show Center for Visionary Art, 572–3
Oratorio for Prague (film), 482
O'Reilly, Lennox, 276
Orlov, Yuri, 594, *595*
Óscar Romero Award, 594, 596, 597
Oser, George, 523
Oshman, Marilyn, 569, 570, 571, 572, 573
Oslo, 638–41, *639, 640,* 644
Oslo Accords, 637, *639, 640*
Oslobodenje, 596
Otero Silva, Clara de, 267
Othello (Bérard), *167,* 171
"Our Wrongs, Our Responsibilities" (Conrad Schlumberger; unpublished), 83
Out of this World: An Exhibition of Fantastic Landscapes from the Renaissance to the Present (1964 exhibition), 414–16
Ove Arup, 552, 611, 632
Overstreet, Joe, 493, 494–5
Owen, Jane Blaffer, 27, 295, 353, 654
Owen, Wilfred, 108

Pacific Northwest, art of, 19, 391, 557, 580
Pacquement, Alfred, 6, 21, 562–3
Palacios, Inocente, 267
Paleolithic art, 559
Palestine, 637, 639, 641
Paley, Babe, 315
Palmerston, Lady, 43
Panama, 121–2, 280
Panama Canal, 120, 121
Pantheon (Rome), 478
Panza di Biumo, Giuseppe, 565, 656
Papeete, 121
Papetoaï Bay, 120–1
Papua New Guinea, 170
Parade (Diaghilev), 451
Paris
 as center of modernism, 118–19
 de Menils' apartment in, *25,* 163–8, *166, 167,* 179, 206, 234, 302, 376–7, 425, 527, 549, 561, 602, 606, 634

Dominique's trips to, 449, 514, 523–4, 549, 582
 liberation of, 287, 296
 Nazi bombing of, 224
 1900 Exposition Universelle in, 83
 Schlumberger family in, 58
 World War II exodus from, 225
Paris, University of, *see* Sorbonne
Paris–New York (1977 exhibition), 566
Paris-Soir, 198, 239
Parker, Deloyd, 11, 435, 437–8, 439–40, 441, 442, 501, 520
Parkinson, Bliss, 379
Parks, Rosa, 436
Parma, 450
Parsons, Betty, 559
Parthenon, 603
Party, The (film), 451–2
Pasadena Art Museum, 413, 547, 576
Pascal, Blaise, 46
Passerelle Eiffel, 99
Pasteur, Louis, 83
Paulhan, Jean, 377
Paulin, Pierre, 537
Paul Prouté Gallery, 581
Paul VI, Pope, 501
Paz, Octavio, 540
Péguy, Charles, 277
Pei, I. M., 13, 534, 548
Pelen, Pierre, 380
Pellizzi, Francesco, 464–7, 521, 621, 648, 651
Pellizzi, Giovanna, 466
Pennebaker, D. A., 452
People Begin to Fly (Klein), 313, 347, 364, 565
Perebal, Sebastian Suy, 600
Peres, Shimon, 638, *639, 639*
Perriand, Charlotte, 165
Persia, 88, 142
Peru, 246, 265
Pesle, Bénédicte, 91, 111, 124, 288, 310, 378, 410, 496, 650
Pesle, Emmanuel "Pinchet," 173–5
Pesle, Marguerite, 101, 115, 173
Pétain, Philippe, 229, 230, 231, 277, 287
Petit, Roland, 168
Petite Gironde, La, 198, 231
Petit Journal, Le, 564
Petsopoulos, Yanni, 605, 606–8, 609
Phat Quang Vietnamese Buddhist Pagoda, 540–1
Philadelphia Museum of Art, 252, 253
Philip Glass Ensemble, 528
Piano, Renzo, *xiv,* 3, 9, 13, 16, 21–2, 163, 270, 365, 549–53, 574–80, *578,* 585, 586, 611, 631–3, 636, 656
Picabia, Francis, 20, 267, 305, 346, 391

Picasso, Pablo, 3, 8, 12, *18,* 20, 24, 27, 28, 165, 179, 250, 253, 264, 267, 300, 301, 305, 307, 312–13, 345, 346, 347, 350, 359, 364, 367, 370, 378, 384, 394, 400, 406–7, *407,* 423, 449, 451, 458, 474, 525, 559, 570, 571, 572
Picasso Museum, 584–5
Picq, Solange, 168, 297
Piero della Francesca, 236
Pierre Matisse Gallery, 293, 300
Pigozzi, Johnny, 648
Pinochet, Augusto, 591
Piranesi, Giovanni Battista, 391
Pistoletto, Michelangelo, 417, 531, *531*
Pitcher, Candlestick, and Black Fish (Braque), 314, 370
Pius X, Pope, 113
Pius XI, Pope, 114, 198
Planète sans visa (Malaquais), 297–8
Plum and Brown (Rothko), 389
Poetry Should Be Made by All (1969 exhibition), 467
Poincaré, Henri, 83
Poirault, André, 196
Poland, 94, 205, 207–8, 215, 279
Polke, Sigmar, 618
Pollock, Jackson, 8, 23, 406, 410, 539, 581, 609–10
Polynesia, 126, 399
Pompidou, Claude, 14, *15,* 16, 537–8, 539, 556, 567, 656
Pompidou, Georges, 14, 410, 537–8, 568
Pompidou Center, 6, 9, 13, 21, 22, 546, 547, 549, 555, 556, 559, 562, 564, 571, 606, 656
 de Menil family gifts to, 8, 538–9, 563, 566
 National Museum of Modern Art at, 538–9, 562
Pompidou Foundation, *see* Georges Pompidou Art and Culture Foundation
Pondicherry, 502, 508
Point, Le, 564
Poniatowska, Elena, 245
Pont japonais à Giverny (Monet), 414
Pontpoint manor house, 25, 217, 233, 237, 288, 359, 383–5, *384, 385,* 432, 449, 523, 527
Poons, Larry, 500
Portrait of a Ruler (Roman bronze statue), 410
Portrait of Dominique (Ernst), 169–70, 265, 302
Portrait of Dr. Gachet, The (van Gogh), 368–9
Portrait of Jermayne MacAgy (Warhol), 430
Portrait of Marie-Laure de Noailles (Fernández), 563
Portugal, 168, 241, 245
 in Napoleonic Wars, 94–5
Pose, Alfred, 173
Posner, Michael, 593

Poulenc, Francis, 118
Poussin, Nicolas, 301
Powell, Chris, 362, 379, 413, 509
Powell, Earl A., III, 644
Prado Museum, 135
Prague, 482, 573
Presley, Elvis, 525
Price, Edison, 490
Price, Vincent, 390
Primat, Françoise Schlumberger, 64, 192, 219, 426, 583, 584
Primat, Paul-Louis, 192
Prize, The: The Epic Quest for Oil, Money, and Power (Yergin), 88
Prizel, Kate Rothko, 476–7, 490
Promenade of Merce Cunningham (Rosenquist), 580
Prophet, The (Gibran), 522
Proselec, 129
Protestants, Protestantism, 9–10, 37, 39, 45, 47, 50, 59, 60, 61, 63, 64, 65, 69, 70, 116, 129, 134, 151, 153–6, 167, 174, 176, 184, 188, 240, 303, 507, 568, 583, 642
 French persecution of, 132–3
Protestant Temple de l'Oratoire, 40
Proust, Marcel, 34, 65, 66
Prouté, Hubert, 581–2
Provence, 37, 279, 280, 286
Prussia, 54, 94, 96
Puech, Henri-Charles, 119
Puiforcat, Jean, 187
Pulitzer, Joseph, 13

Qué Viva México! (Eisenstein), 252
Quinn, John, 545
Quotidien de Paris, Le, 564

Rabat, Morocco, 137, 160
Racine, Jean, 67
racism, 438–41
Radcliffe College, 385
Radha Soamis, 508
Rahman, Ali, 654
Raid the Icebox with Andy Warhol (1969–70 exhibition), 468–72, *470*
Rapp, Jean, 97
Rateau, Auguste, 85
Raul Levin Gallery, 309
Rauschenberg, Robert, 3, 12, 13, *14,* 428, 451, 454, 511, 559, 561, 587, 648
Ravel, Maurice, 119
Ray, Man, 20, 127, 309, 312, 338, 526, 580
Raynaud, Jean-Pierre, 549, 555, 561
Raysse, Martial, 307

Reagan, Ronald, 445–6, 593–4
Red and the Black, The (Stendhal), 103, 132
Reed, Dudley, 505
Reflections in a Golden Eye (McCullers), 142
Reformation, 50, 186
Régamey, Raymond, 187
Reis, Bernard J., 490–1
Reluctant Matriarch, The (Love), 546
Rembrandt, 190
Renoir, Pierre-Auguste, 240, 253, 263, 267, 572
Renoir Centennial Loan Exhibition, 1841–1941 (Metropolitan Museum), 263
Renzo Piano Building Workshop, 632
Resnais, Alain, 453
Reverón, Armando, 267, 270
Revolution of 1848 (France), 37, 43
Revue du Cinéma, La, 147
Revue Française, La, 40
Revue Nègre, 119
Rewald, John, 403
Reynaud, Paul, 220, 229
Reynier, Jean, 95
Reynolds, Joshua, 581
Rheims, Maurice, 308
Rhode Island School of Design, 468, 469, 472
Rhyme and Reason, Les Collections Ménil (Houston–New York) (1984 exhibition), 554–5, 557–64, *558, 560, 562,* 580, 586, 604
Ribbentrop, Joachim von, 205
Riboud, Jean, 377, 426, 427, 428, 451, 463, 473–4, 486, *487,* 512, 520, 565–6, 582–3
Riboud, Krishna, 377, 565
Riboud, Marc, 347, 383
Rice, Peter, 552, 576, 578, 611, 613
Rice, William Marsh, 458
Rice Museum, *see* Art Barn, Rice University
Rice University, 327, 357, 358, 359, 361, 455, 458–60, 463, 468, *470,* 472, 474, 482, 498, *498,* 510, *511,* 513, *530,* 531, *531,* 532, 535, 546, 548, 552, 555, 559, 577, 606, 620, 643
 de Menils and, 457–8, 459, 497
 Media Center at, 360, 460
 see also Institute for the Arts, Rice University
Richard, Paul, 490
Richard Fitzgerald & Associates, 3, 632
Richards, Ann, 598, 600, 656
Richardson, John, 9, 310–11, 400–2, 431, 454, 567
Richmond Hall, 614, 625, 649
Richter, Gerhard, 618
Riggio, Leonard, 629
Rilke, Rainer Maria, 71, 633

Rimbaud, 233
Rivera, Diego, 28
Rivers, Larry, 493–4, *494,* 498, 539
Rivière, Georges-Henri, 170, 377
Rivière, Jacques, 66, *68*
Robert, Pierre Jean, 114
Robert Rauschenberg: The Early 1950s (1991–92 exhibition), 635
Rochas, Hélène, 567
Roche, Château de, 60–1, 137, 152, 223, 229, 230, 233, 236, 285
Rockefeller, Blanchette, 514
Rockefeller, John D., 251
Rockefeller, Nelson, 372, 398, 449
Roden Crater (Turrell), 621, 624
Rodin, Auguste, 71, 388
Rogers, Millicent, 315, 368
Rogers, Richard, 22, 549
Rohatyn, Felix, 584
Rohl, J., 269
Rolland, Romaine, 65
Roman Empire, 601
Romania, 179, 180, 196–7, 199, 207, 210, 211, 212, 214, 216, 217, 218, 222, 231, 268, 274, 295, 610
Roman Ruler (Roman bronze statue), 410
Romero, Óscar, 594, 596
Rommel, Erwin, 220
Röntgen, Wilhelm, 83
Roosevelt, Franklin D., 198, 236, 350
Roosevelt, Theodora, *309*
Rosenberg, Pierre, 496
Rosenquist, James, 460, 511, 526, 561, 580, 636
Rosenstein, Harris, 533
Ross, Marvin, 603–4
Rossellini, Gil, 360
Rossellini, Isabella, 359
Rossellini, Isotta, 359
Rossellini, Roberto, 359–60, 455, 467, 486, *487,* 512, 513, 514, 522, 588
Rossellini, Sonali, 507, 508, 522
Rothenberg, Sarah, 654
Rothko, Christopher, 477, 490
Rothko, Mark, 3, 12, 19, 23, 156, 364, 373–4, 384, 386, 389, 402, 404, 416, 424, 447, 475–6, *480,* 483–4, 486–7, 491, 543, 561, 586, 636, 648, 651
Rothko Awards for Commitment to Truth and Freedom, 597, 599–600
Rothko Chapel, 13, 16, 25, *324,* 475, 476–81, *480,* 482, 483–92, *485, 487,* 493, 495, 510, 512, 522, 531, 532, 536, *542,* 574, 610, 613, 618–19, 627, 634, 636, 643, 648, 650, 654, 656
 colloquiums at, 523–5, 588–9

Rothko Chapel (continued)
 Dalai Lama at, 540–1
 de Menils' world trip in support of, 501–9
 human rights as focus of, 589–94, 596
 Mandela and, 597–600
 memorial for Dominique at, 656
 Mevlevi dervishes at, 541–4
 Nabila Drooby as director of, 524–5, 540,
 542–4, 589, 596, 597, 642
 separation of Menil Foundation and, 591
Rothko Chapel, The: An Act of Faith (Barnes),
 643
Rothko Chapel Awards for Commitment to
 Truth and Freedom, 589, 594
Rothko Chapel Foundation, 591
Rothko Chapel Paintings, The: Origins,
 Structure, Meaning (Nodelman), 484–5
Rothschild, Pauline de, 376–7
Rothschild, Philippe de, 376–7
Rothschild, Robert de, 301, 305, 306, 313
Rotival, Maurice, 268
Rouault, Georges, 102, 250, 301, 314, 319, 344,
 350, 372, 384, 648
Rougier, Albert, 104
Rougier, Caroline Regnard, 100
Rougier, Dominique, 107–8, 112
Rougier, Jean, 104, 112, 287
Rougier, Jean Baptiste Louis Marcellin,
 99–100, 101, 103–4, 125
Rougier, Marie-Madeleine, 100
Rougier, Stanislas, 100, 101, 103–4, 105, 107,
 111
Rougier family, 99, 105
Rousseau, Theodore, 367, 369
Rouville, Marie de, 224
Rouville, Odile Schlumberger de, 58, 64, 218,
 224–5
Royal Academy of Arts, London, 491–2, 648
Royal Air Force (RAF), 199, 304
Royal and Military Order of Saint Louis,
 96, 97
Rubens, Peter Paul, 525
Rubin, William S., 186
Rubinstein, Arthur, 305
Rubinstein, Helena, 309
Rudolph, Paul, 429
Ruscha, Ed, 13, 307, 561, 636
Ruspoli, Maria, 179
Ruspoli, Princess Clelia, 304
Ruspoli, Princess Maria, see Hugo, Maria
Ruspoli family, 303
Russell, John, 22, 308, 433, 652–3
Russia, 78, 96, 181, 205, 215, 295
Russian Orthodox Church, 167, 171, 602
Russian Revolution, 460, 467
Ryan, Margaret Kahn, 403

Saarinen, Aline, 418
Saarinen, Eero, 418
Saatchi, Charles, 565
Sacco, Joseph, 554
Sacher, Maja Hoffmann, 571–2
Sacred Art (Couturier), 634
sacred art movement, 186
Sacrosanctum concilium, 177
Saidye Bronfman Centre for the Arts, 449
St. Anne's Catholic Church, Houston, 413,
 512, 516, 521, 522, 653, 655
Saint-Exupéry, Antoine de, 65, 67, 377
Saint Laurent, Yves, 572
St.-Ouen-le-Pin, 34, 184, 523
Saint Phalle, Niki de, 307, 411, 450, 451, 461,
 462, 467, 497, 656
St. Themonianos chapel, 610, 611
St. Thomas, University of, 16, 351, 352, 357,
 363, 381–3, 382, 397, 404, 418, 434, 444,
 447, 466, 475, 476, 481, 482, 483, 491, 521,
 531, 536, 541, 546, 549, 552, 602, 643,
 654, 656
 Art Department at, 412
 Byzantine Studies Conference at, 612
 chapel of, 417
 de Menils and, 5, 352, 380–1, 382, 383,
 414–21, 450, 481, 483
 de Menils in break with, 457–8
 Dominique as head of art department at,
 414–21, 445, 450–1, 456
 film and photography departments at, 451–6
 MacAgy at, 396–8, 404, 413, 417
Saleh, Sobhi al-, 487
Salk, Jonas, 589
Sambre, Battle of the, 108, 108
Sand, George, 159
Sandback, Fred, 628
San Francisco Chronicle, 445
San Francisco Museum of Art, 386
San Francisco Museum of Modern Art, 635
San Jacinto Monument, 255
San Salvador, 590, 594, 596, 599
Sans Souci (de Menils' Caracas home), 269–70,
 269, 275, 279, 284, 330
Sarah Lawrence College, 398
Sarah Mellon Scaife Gallery, 533
Sarajevo, 78, 596, 597
Sargent, John Singer, 28
Sarofim, Fayez, 23, 416
Sarofim, Louisa Stude, 23, 359, 416, 647, 651,
 654, 656
Sartre, Jean-Paul, 65, 205
Satie, Erik, 118, 119, 451
Schapiro, Meyer, 25, 348, 368, 390, 402, 602
Scheffer, Ary, 41
Schell, Orville, 593

Schlumberger, Anna Catharina Hartmann, 51

Schlumberger, Anne, 11, 426, 427, 569, 594, 637, 651

Schlumberger, Anne Gruner "Annette," *see* Doll, Anne Gruner Schlumberger "Annette"

Schlumberger, Antoinette, *see* Grunelius, Antoinette Schlumberger

Schlumberger, Catharina Eck, 50

Schlumberger, Catherine Ermendinger, 51

Schlumberger, Christian, 82

Schlumberger, Claire, 168, 241, 247, 426

Schlumberger, Clarisse Dollfus, 55

Schlumberger, Claus, 50

Schlumberger, Conrad, 7, 8, 9, 33, 50, 55, 56, 57, 59, 62, 63, 68, 70, 73, 77, 78, 81–3, *81*, 106, 128, 133–4, 135–6, 137–8, 139, 140, 141, 143, 144, 145–6, 147, 155, 156, 157, *157*, 158, 160, 163, 165–6, 168, 171, 172, 179, 180, 192, 240, 271, 277, 281, 295, 305, 375, 410, 426, 464, 602, 657
 and courtship of Dominique and John, 148–9, 150, 152–3, 155–6
 Dominique's relationship with, 135–6
 education of, 58–9
 electrical surveying experiments of, 83, 84–8, *86*
 first U.S. trip of, 137–8
 Marcel's partnership with, 85–7
 military service of, 197
 Moscow trips of, 181
 pacifism of, 82, 197
 Paris apartment of, 61–2, *63*, 68, 71, 129, 157–8
 stroke and death of, 182, 183–4
 teaching career of, 69, 83
 in World War I, 79–80

Schlumberger, Daniel, 55, *56*, 64, 82

Schlumberger, Fanny de Turckheim, 64, 66, 82

Schlumberger, Françoise, *see* Primat, Françoise Schlumberger

Schlumberger, Françoise Monnier, 64, 234

Schlumberger, Georg Jacob, 51

Schlumberger, Gustave, 601–2

Schlumberger, Hans, 50

Schlumberger, Jean (Dominique's great-grandfather), 49, 54–5, 57, 64, 69

Schlumberger, Jean (Dominique's uncle), 34, 55–7, *56*, 58, 59, 64, 68–9, *68*, 71–2, 78, 80, 82, 87, 145, 146, 147, 152–3, 157, 181, 184, 216, 218, 223, 229, 230, 243, 280, 377
 Dominique's relationship with, 68
 literary and cultural activities of, 65–7, 68–9

Schlumberger, Jean Michel, 563

Schlumberger, Jeanne de Witt, 44, 47, 55, 56

Schlumberger, Jeanne Laurans, 64, 145, 233, 273, 274, 294, 414, 426, 427

Schlumberger, Léon, 47

Schlumberger, Louise Delpech "Madame Conrad," 59–60, 62, *63, 66*, 68, 73, 77, 84, 135, 138, 139, 142, 144, 146, 148, 153, 156, 157, 158, 163, 172, 179, 181, 182, 184, 207, 209, 219, 222, 226, 229, 236, 243, 244, 252, 263–4, 374, 376, 377, 425, 449, 473, 511–12, 514, 603
 death of, 534
 Dominique's letters to, 247, 248, 260, 261–2, 266, 270–1, 282, 285, 291, 415, 464, 465, 466–7, 472, 505, 508, 510
 marriage of Conrad and, 61, *62*
 World War I and, 79–80, 81–2

Schlumberger, Marcel, 7, 8, *56*, 64, 71, 78, 82, 83, 88, 139, 143, 144, 145, 148, 158, 180, 195, 214, 223, 224, 229, 230, 233, 234, 236, 242–3, 249, 259, 271, 275, 277, 285, 294, 410, 426
 as Conrad's business partner, 85–7
 death of, 375
 John recruited to La Pros by, 192–4

Schlumberger, Marguerite de Witt, *30*, 44, 46, 47, 50, 55–6, *56*, 58, 62, 63, 71, 72, 76, 78, 81, 184

Schlumberger, Maria da Diniz Concerção "São," 168, 350, 425–9, 445, 539

Schlumberger, Marie-Elisabeth Bourcart "Lise," 51–2, 53

Schlumberger, Maurice, *56*, 58, 64, 67–8, 71, 73, 134, 207, 209, 218, 219, 220, 222–3, 224, 229, 230, 234

Schlumberger, Nicolas, 51–4, 56, 57, 601

Schlumberger, Paul, *30*, 47, 50, 55, *56*, 58, 62–3, 71, 72, 76, 78, 83, 87, 184

Schlumberger, Pauline, 80–1

Schlumberger, Peter, 51

Schlumberger, Pierre, 63, 64, 144, 168, 192, 239, 241, 243, 247, 249, 273–4, 283, 294, 350, 425, 426–7, 445, 539, 567

Schlumberger, Pierre "Pete" (Pierre's son), 512, 521

Schlumberger, Raymond, 82

Schlumberger, Rémy, 134

Schlumberger, Suzanne Weyher, 64, 80–1

Schlumberger, Sylvie, *see* Boissonnas, Sylvie Schlumberger

Schlumberger & Cie. (bank), 207, 223, 229

Schlumberger-Doll Research Center, Johnson as architect for, 332

Schlumberger family, 7–8, 10, 27, 33, 36, 49, 56, 61, 71, 141, 168, 172, 191, 192, 194, 507, 527, 654
 history of, 48, 50–4

Schlumberger family *(continued)*
 in Houston, 294–5
 in Paris, 58–9, 61–2
 Protestantism of, 37, 45, 50, 59, 60, 61, 132,
 151, 303
 textile businesses of, 51
 in wartime evacuation to Clairac, 222–4,
 226–30
 in wartime retreat to Val-Richer, 219–21,
 223–5
Schlumberger Limited, 7, 12, 39, 104, 246, 247,
 275–6, 283, 284, 297, 360, 374, 379–80,
 411, *427,* 444, 473, 505, 507, 509, 512, 520,
 523, 527, 605, 647
 Dominique's continued involvement in,
 582–4
 Houston offices of, 255, 362, 380
 incorporation of, 275–6
 John's retirement from, 366, 527
 New York offices of, 246–8, *427, 427*
 1950s expansion of, 375
 1980s oil bust and, 626
 Paris office of, 297
 Pierre's forced resignation from, 426–7
 as publicly traded corporation, 399
 as showcases for de Menil collection, 380,
 428
 see also La Pros
Schlumberger Museum, 84
Schlumberger Overseas (Asia and Middle East
 division), 249, 281, 285, 294
Schlumberger Surenco (South American
 division), 249, 256, 257–63, 270, 276, 281,
 285, 294, 295, 330
 Dominique's involvement in, 260, 271–2
 housing for engineers of, 260, 271–2
 pay parity at, 283–4
 Trinidad office headquarters of, 261, *262*
Schlumberger Well Surveying Corporation
 (U.S. division), 180, 192, 194–5, 232, 233,
 249, 255, 285, 294, 300, 342, 362, 363,
 379, 380, 426
 New York offices of, 236
 see also Schlumberger Limited
Schuman, Robert, 48–9
Schwartzwald, Robert, 251
Schwarzenbach, Alfred, 142
Schwarzenbach, Annemarie, 135, 140–3, *141,*
 145, 147, 148, 149, *149*
Schwarzenbach-Wille, Renée, 142
Schweitzer, Albert, 143
Schweitzer, Helene, 143
Schwitters, Kurt, 348
Scrima, André, 540, 541, 549, 624
Scull, Ethel and Robert, 511
Seagram Building, 378, 475, 476

Season in Hell, A (Rimbaud), 119
Seated Woman with a Hat (Picasso), 347
Second Vatican Council, 177, 634
*Secret Affinities: Words and Images by René
 Magritte* (1976–77 exhibition), 529–30,
 530
*Security in Byzantium: Locking, Sealing, and
 Weighing* (1981 exhibition), 604
Ségur, Philippe Paul de, 95
Seillans, 422, 474
Seine-Inférieure (now Seine-Maritime), 222,
 224, 225
Seitz, William C., 390–1
Selden, Margie, 387
Seldis, Henry, 490
Sema celebrations, 541–2, 543
Sept, 177
Serge, Victor, 280
Serra, Richard, 630
Seurat, Georges, 571, 581
Seydoux, Geneviève Schlumberger, 64, 139,
 192, 195, 219, 224, 294, 375, 473, 583, 584
Seydoux, Jérôme, 583
Seydoux, Nicolas, 583
Seydoux, René, 192, 193, 195, 224, 283, 294,
 473, 523
Shadows (Warhol), 567, 625, 630
Shahn, Ben, 376
Shakespeare, William, 67, 103, 131, 344
Shankar, Ravi, 361
SHAPE Community Center, 437–8
Shaw, George Bernard, 144, 145
Sheridan, Alan, 68
Shirer, William, 115, 225, 227
Shongo, 505
Shroud of Cadouin, 568
Siberia, 181, 594
Sidney Janis Gallery, 373, 389
Siege of Paris (1871), 100
Siegfried, André, 117–18, 119, 120, 132, 349
Si le grain ne meurt (Gide), 46
Silvers, Bob, 567
Simmons, Gladys Mouton "Gaga," 320–2, *321,*
 342, 362, 400, 404, 451, 466, 512, 515,
 520
Simonton Rodeo, *12*
Singh, Maharaj Charan, 508
Sisulu, Albertina, 594
Sisulu, Walter, 594
Six Artists (1992 exhibition), 635
Slave Ship and Slaves, A (Rivers), 493
Smith, Jack, 456
Smith, Jane, 638
Smith, Tony, 13, 496, 638, 639, *640,* 641, 644
Smithson, Robert, 463
Smithsonian, 509

Smithsonian American Art Museum, 363, 432, 547, 548, 559
Snow, Caroline, 14, *637*
Snow, Dash, *637,* 648, 650, 653
Snow, Max, 14, *637,* 653
Snowden, Frank M., Jr., 357
Soby, James Thrall, 313, 373, 377, 390, 429
Société de Prospection Électrique Procédés Schlumberger, *see* La Pros
Société des Antiquaires de France, 601
Society for the Performing Arts, 651
Soft Drums (Oldenburg), 539
Solanas, Valerie, 449
Solomon R. Guggenheim Museum, 406
Some American History (1971 exhibition), 493–5, *494,* 498
Somme, battle of the, 80, 89, 223
Sontag, Susan, 360, 567
Sorbonne, 37, 39, 84, 117, 127, 129, 139, 144, 145, 405, 429, 432, 512
Sotheby's, 44, 314, 416, 430, 468, 580, 628
Souchon, Édouard, 262
South Africa, 594–5, 597, 599
South America, 256–7, 265, 266, 267, 270, 272, 275, 282, 296, 391, 399, 588, 591, 652
Southern Christian Leadership Conference (SCLC), 436, 438, 439
Southern Methodist University, 358, 605, 610
Soutine, Chaim, 314
Soviet Union, 171, 205, 215, 256, 460, 482, 589, 594, 595
 La Pros and, 180, 181–2
Spellman, Francis Cardinal, 251
Spence School, 511
Sphere of Mondrian, The (1957 exhibition), 389
Spies, Werner, 13, 169, 422, 424, 464, 511, 656
Spiral Jetty (Smithson), 463
Spirituality in the Christian East: Greek, Slavic, and Russian Icons from the Menil Collection (1988–89 exhibition), 612–13
Sri Lanka, 120, 121
Staël, Madame de, 39
Stalin, Joseph, 181, 205
Stanhope apartment hotel, 247, 253, 263, 289
Star (Johns), 581, 587
State University of New York, at Buffalo, 352, 452
Statue of Venus (ancient Greek sculpture), 345, 346–7
Stein, Gertrude, 118, 405
Steinberg, Leo, 358, 510, 513–14, 634, 648–9
Steinberg, Saul, 419
Stella, Frank, 24, 570, 580, 586–7
Stelzig Saddlery Company, 11–12
Stendhal, 103, 132

Sterling, Charles, 464
Sterling, Frank, 24
Stern, Robert A. M., 429
Sternberg, Josef von, 146
Still, Clyfford, 386, 561
Still Life with Apples (Cézanne), 469
Stockholm, 169, 183, 451, 467
Stoll, André, 267, 270
Story of a Three-Day Pass, The (film), 455
Stoskopf, Nicolas, 54
Stout, Richard, 389
Strachey, Lytton, 67
Strait Is the Gate (Gide), 233
Strake Hall, 381
Strasbourg, 49, 136–7, 572
Straus, Mrs. Robert, 390
Straus, Percy S., 28
Straus, Robert, 390
Strong, Margaret Rockefeller, 251
Study of a Black Man (Reynolds), 581–2
Sudetenland, 198, 199, 208
Suicide (Ray), 526
Suite No. 2 in D Minor (Bach), 656
Sullivan, Louis, 327
Summerspace (dance), 519
Sunflowers (van Gogh), 367
Sunset (film), 454
surrealism, surrealists, 20, 170, 310, 372, 373, 378, 530, 554, 559, 561, 564, 586
Surrealism and Painting (Ernst), 314
Surréalisme et la peinture, Le (Breton), 7, 20
Surrealist Show (1938), 571
Swan, Simone, 445–7, 451, *453,* 454, 512, 513, 515, 522, 526, 588
Swan Lake for Tamara Toumanova (Homage to the Romantic Ballet), A (Cornell), 372
Sweden, 96, 182
Sweeney, James Johnson, 330, 347, 350, 390, 405–9, *406,* 539
 de Menils' support of, 410–12
 Image of the Black project and, 431, 432
 as MFAH director, 406–13, *407, 408,* 409, 410, *411,* 431, 432
Swinton, Ernest Dunlop, 88
Sylvester, David, 13, 423, 464, 474, 511, 523, 528, 635, 643, 648–9
Szarkowski, John, 455

Tahiti, 120–1, 151, 170
Takis, 8, 307, 347, 405, 497
Talleyrand, Charles Maurice de, 40, 42
Tamayo, Rufino, 293, 299, 345, 350
Tanguy, Denis, 213, 293, 299, 571
Tanning, Dorothea, 13, 22, 349, 377, 422, 496, 513, 567

Tao Te Ching, 502
Tapas of Dutch New Guinea (1933 exhibition), 170
Tàpies, Antoni, 414
Tate Gallery, 415, 423, 476
Tati, Jacques, 344
Tatlin, Vladimir, 460
Tatlin's Tower (Monument to the Third International) (Tatlin), 460
Taub, Henry, 591
Teatrul National, 215, 216
Tehran University, 506
Teilhard de Chardin, Pierre, 357
Tel Aviv Museum of Art, 551
Temple, Richard, 605
Temple Gallery, London, 605
Temporary Contemporary, 565–6
Temps Présent, 200–1
Ten Centuries That Shaped the West: Greek and Roman Art in Texas Collections (1970–71 exhibition), 474
Texas Monthly, 540, 541
Texas Southern University (TSU), 11, 349, 357, 436, 438, 439–40, 441, 488, 489, 501, 600
 Black Arts Festival at, 434
Texturologie III (Dubuffet), 75
Thannhauser, Justin, 368
Théâtre du Vieux-Colombier, 67, 119, 216
Théâtre Montparnasse, 131
Thekchen Choling, 507
Thérèse of Lisieux, Saint, 211, 252
Thibaults, The (du Gard), 132
Thiebaud, Wayne, 450
Thira (Marden), 566
Thiriet, Henri, 529
Thirty Years' War, 48
Thomas, Dylan, 405
Thompson, Ada Lucia Tyrrell, Lady, 188, 189
Thompson, Gerald, 188–91, 189, 198, 199, 201, 206, 207, 211, 222, 240, 277, 281
Thompson, John Perronet, 188
Thompson, Philippa, 189, 190–1, 211, 239
Three Dancers (Picasso), 458
Threepenny Opera (Brecht and Weill), 131
Three Spaniards: Picasso, Miró, Chillida (1962 exhibition), 406–8, 407, 408, 539
Thurman, Robert, 399, 466, 507, 508, 540, 603
Thurman, Taya, 466, 473, 511, 549, 650, 653
Tibetan Book of the Dead, The, 502
Tibetan Buddhists, 508, 525
Time, 22, 29, 395, 495, 529
Times (London), 198, 200, 205
Tinguely, Jean, 307, 355, 355, 403, 410, 411, 411, 451, 460, 462, 462, 467, 556, 562, 571, 572, 581, 635
Titian, 574

Tocqueville, Alexis de, 37, 45
Toledo Museum of Art, 533
Tolstoy, Leo, 95
Torah, 502, 573
Torgsin Gallery, 171
Torres, Joe Campos, 438
Totems Not Taboo (1959 exhibition), 391, 392–5, 392, 393, 396, 405, 434
Toulouse-Lautrec, Henri de, 529
Toumanova, Tamara, 171
"Traditional Modes of Contemplation and Action" (1973 colloquium), 510, 523–5
Transition, 405, 406
Traversée du temps perdu, La (1978 exhibition), 606
Trees at Le Tholonet (Cézanne), 19
Treilles, Les, 8, 568
Tremaine, Emily and Burton, 511
Trinidad and Tobago, Republic of, 180, 256, 262, 264, 266, 272, 273, 275, 276, 277
 Schlumberger headquarters on, 261, 262
Trinity College, Dublin, 189
Trojan Horse, The: The Art of the Machine (1958 exhibition), 386, 391
Trotsky, Leon, 280, 281
TSU Five, 11, 440, 441
Turkey, 232, 233, 234, 511, 541–3, 573, 604, 607, 610
Turner, J. M. W., 415
Turrell, James, 620, 621, 624
Turrell, Julia Brown, 565
Tutu, Desmond, 594, 595
Two Acrobats (Calder), 349
Twombly, Cy, 286, 561, 586, 618, 624, 628, 629, 630–3, 632, 636, 648
Twombly Gallery, 645
Two Pigeons V (Fernández), 313
Two Pigeons VIII (Fernández), 313
Tyrrell, Robert Yelverton, 188–9

UFA studios, 146
Ulysses (Newman), 580, 586, 587
Union des Artistes Modernes (UAM), 163, 165, 166
Union Française pour le Suffrage des Femmes, 63
United Nations, 343, 589, 598
 Special Committee Against Apartheid, 589
 World Conference on Human Rights, 596
University Art Museum, University of California, Berkeley, 444
Universal Declaration of Human Rights, 588–9, 594
University City of Caracas, 268
Untitled (Johns), 581

Untitled, 1996 (Flavin), 649
Untitled (A Painting in Nine Parts) (Twombly), 633
Untitled IV (de Kooning), 580
Untitled VI (de Kooning), 580
Untitled 1968 (Twombly), 586
Untitled Fire Painting (Klein), 580
Untitled (Monogold) (Klein), 580
Untitled (No. 10) (Rothko), 374, 384
Untitled (Say Goodbye, Catullus, to the Shores of Asia Minor) (Twombly), 633
Upper Volta, 596
USA Today, 594

Vaillaud, Michel, 583, 584
Valentine Dudensing Gallery, 285, 300
Vallenilla, Pedro, 267
Vallotton, Félix, 570
Val-Richer, the (Guizot-Schlumberger family château), *30,* 33–6, *35,* 41–2, 44–5, 46–7, 57, 63, 64, 66, 68, 71–4, *74,* 76–7, 78, 80, 81, 84, 85, *86,* 137, 144, 145, *150,* 158, 168, 172, 173, 182, 183, 191, 196, 206, 222, 229, 237, 287, 473, 523, 527, 534
 in World War II, 209–11, 217–18, 219–21, 223, 226, 234, 247
VanDerBeek, Stan, 452, 453
Van Dyck, Anthony, 643
Van Dyke, Kristina, 373
Van Dyck 350 (Barnes), 643
van Gogh, Vincent, 19, 344, 367–70, 374, 570
Van Peebles, Melvin, 455
Van Vechten, Carl, 251
Varnedoe, Kirk, 633
Vasarely, Victor, 539
Vatican, 132, 201, 501
Vatican II, 357, 479, 502, 512, 634
Vauban, Sébastien Le Prestre de, 79
Vaugirard (Paris neighborhood), 89–92, 211
Velázquez, Diego, 267
Velvet Underground, 428, 429
Venezuela, 180, 260–3, 266–73, 274, 277–8, 280, 281, 283, 284, 291, 292, 295, 300, 330
 German submarine attacks on, 257
 oil production in, 256–61
Venice, 148, 216, 376, *376,* 487, 573, 657
Venice Biennale, 376, 633
Vennema, Ame, 512
Verdun, Battle of, 80, 106–7
Verger, Pierre, 264–6
Vérité blessée, La (Couturier), 634
Versailles, 41, 127, 129, 168, 271
Vers une architecture (Le Corbusier), 7
Victor, Mary Jane, 363, 533, 535, 603–4, 606, 649

Victoria, Queen of England, 43
Victor Verster Prison, 597
Vie Intellectuelle, La, 176
Vienna, 588, 596, 597, 604
Vietnam (Pistoletto), 417
Vignanello, 303
Vikan, Gary, 604–5, 607–8, 609
Villalba, Leonidas Proaño, 594
Villanueva, Carlos Raúl, 267, 268
Vilmorin, Louise de, 351
Violin on a Table (Picasso), 312
Violon sur une table (Picasso), 12
Viot, Jacques, 170, 175
Virgin and Child (statue), 364, 417
Virginia, University of, 381
Visage of Culture, The: A Telescopic Survey of Art from the Cave man to the Present (1959 exhibition), 396
Visionary Architects: Boullée, Ledoux, Lequeu (1967–68 exhibition), 450–1, 531
Vitry, Henriette de, 5, 297, 375
Viva, 429, 452, 456
Vogel, Carol, 629
Vogel, Susan, 13
Vogue, 347, 424, 429
Vogüé, Nelly de, 377
Voice (Johns), 403, 586
Voices of Silence, The (Malraux), 559–60
Vollmöller, Karl, 145–6, 148
Vreeland, Diana, 424
Vuillard, Édouard, 529, 570, 572

Wagstaff, Sam, 8, 539
Wakefield Bookshop, 559
Wake Island, 235
Walker Art Center, 534
Wallace Collection, 42
Wanghuh, Lopsang, 507
War and Peace (Tolstoy), 95
Wardlaw, Alvia, 501
Warhol, Andy, 3, 11–12, 13, 19, 23, 25, 307, 351, 397, 428, 429–31, 449, 451–2, 453, *453,* 454–6, 468–72, 472, 525, 526, 539, 561, 567, 581, 618, 625, 628, 630, 634–5, 642
Washington, George, 37, 241
Washington Post, 490, 564, 594
Waterloo, Battle of, 92, 97
Waters, Ethel, 251
W. E. B. Du Bois Institute for Afro-American Research at Harvard University, 433
Webster, Randall, 438
Weill, Kurt, 131
Weisman, Marcia and Fred, 565
Weitzmann, Kurt, 605

Welch, Frank, 23
Welch, Louie, 435
Wellesley College, 416
Welty, Eudora, 593
Western Reserve University, 386
Wheeler Avenue Baptist Church, 436, 522
Whitfield, Sarah, 423, 424, 635
Whitman, Robert, 624
Whitmire, Kathy, 13, 15, 598
Whitney, David, 511, 547, 567, 651
Whitney, George, 378
Whitney, John Hay, 368, 370
Whitney, Mrs. Cornelius Vanderbilt, 315
Whitney Museum of American Arts, 498, 624
Whittaker, Stephen, 284
Wiess, Harry C., 24
Wilcox, Marion, 397, 466
Wilde, Oscar, 67, 189
Wildenstein, Daniel, 350
Wildenstein, Georges, 350
Wilhelm II, German kaiser, 55, 88
Wille, Ulrich, 142
Willebrands, Cardinal, 501
William Rockhill Nelson Gallery, 534
Williams, William T., 493, 500
Willkie, Wendell, 236
Wilson, Robert, 5, 656
Wilson, Woodrow, 63
Winkler, Helen, 352, 353, 396, 397, 397, 398, 420, 429, 451, 464, 485, 512, 535, 618–24
 Dia and, 619, 621–6, 627–8, 630
Winkler, Patricia, 397
Winkler, Paul, 13, 22, 421, 444, 451, 456, 528, 546, 548, 549, 551, 552, 575–6, 577, 579, 586, 613, 630–2, 633, 635, 642, 645–7, 648
Winnicott, Donald, 297
Winningham, Geoff, 455
Winter, Gerry, 305
Winterhalter, Franz Xaver, 36
Withers Swan, 445
Witte Museum, 391
Wittenberg, 59
Wittkower, Rudolf, 419
Woman in a Red Armchair (Picasso), 312–13
Women's Wear Daily, 310
World War I, 48, 54, 65, 67, 77–83, 81, 85, 88, 89, 106, 107, 110, 112, 113, 117, 118, 139, 144, 162, 184, 187, 189, 197, 198, 218, 220, 222, 229, 277, 304
World War II, 7, 26, 29, 48, 167, 186, 209–12, 214, 215, 217, 218–31, 233–4, 238, 253, 267, 268, 275, 279, 283, 284, 288, 295, 297, 299, 302, 351, 360, 375, 603
 refugees in, 220, 223
 South America in, 257–63
 U.S. entry into, 257
Wortham, Gus, 353
Wortham, Lyndall, 353
Wright, Charles, 628
Wright, Frank Lloyd, 328, 350, 406
Wright, Virginia and Bagley, 628
Wyatt, Lynn, 23, 590, 614, 654
Wyatt, Oscar, 23, 590–1

Yale Art Gallery, 404
Yale Institute of Sacred Music, 634
Yale University, 404
Yergin, Daniel, 88
Yoruba peoples, 504–5
Young, Andrew, 638
Young, La Monte, 472–3, 525, 618, 624, 625
Young, William J., 654
Young Teaching Collection, A (1968–69 exhibition), 457–8
Yourcenar, Marguerite, 69
Yurkevich, Galy, 279, 281, 297, 348
Yves Klein, 1928–1962: A Retrospective (1982 exhibition), 555–7

Zabriskie Point (film), 352
Zacks-Abramov, Ayala, 551
Zacos, George, 603, 604–5
Zacos, Janet, 604
Zamenhof, Ludwik Lejzer, 124
Zazeela, Marian, 472–3, 525, 624
Zervos, Christian, 25, 377, 449
Židovské Muzeum v Praze, the Jewish Museum, 573
Zipkin, Jerry, 567
Zola, Émile, 103
Zurbarán, Francisco de, 347
Zurich, 142, 146, 205, 572
ZZ Top, 572

A NOTE ABOUT THE AUTHOR

William Middleton is a journalist and editor who has worked in New York and Paris. He has been the fashion features director for *Harper's Bazaar* and the Paris bureau chief for Fairchild Publications, overseeing *W* magazine and *Women's Wear Daily*. He has written for *The New York Times*, *The New York Times Magazine*, *Vogue*, *House & Garden*, *Esquire*, *Texas Monthly*, *Travel & Leisure*, *Departures*, and the *International Herald Tribune*.

A NOTE ON THE TYPE

The text of this book was set in Sabon MT, a typeface designed by Jan Tschichold (1902–1974), the well-known German typographer. Based loosely on the original designs by Claude Garamond (ca. 1480–1561), Sabon is unique in that it was explicitly designed for hot-metal composition on both the Monotype and Linotype machines as well as for filmsetting. Designed in 1966 in Frankfurt, Sabon was named for the famous Lyons punch cutter Jacques Sabon, who is thought to have brought some of Garamond's matrices to Frankfurt.

COMPOSED BY NORTH MARKET STREET GRAPHICS,
LANCASTER, PENNSYLVANIA

PRINTED AND BOUND BY BERRYVILLE GRAPHICS,
BERRYVILLE, VIRGINIA

DESIGNED BY MARIA CARELLA